CONTEMPORARY
MASTERWORKS

CONTEMPORARY ARTS SERIES

Contemporary Artists

Contemporary Architects

Contemporary Photographers

Contemporary Designers

Contemporary Masterworks

CONTEMPORARY
MASTERWORKS

Editor:
Colin Naylor

Picture Editor:
Leanda Shrimpton

Advisers:
Jean-Christophe Ammann, Andrea Arsenault, Arnold Friedmann
Helmut Gernsheim, Jorge Glusberg, Mark Haworth-Booth
Klaus Honnef, Udo Kultermann, David Mackay
Pedro Meyer, Per Mollerup, Chris Mullen
Andreas Muller-Pohle, Daniela Palazzoli, Wolfgang Pehnt
Jukka Pellinen, Tapio Periainen, Roger Remington
Aaron Scharf, Peter Selz

St J

ST. JAMES PRESS
CHICAGO AND LONDON

LIBRARY
COLBY-SAWYER COLLEGE
NEW LONDON, NH 03257

REF
N
6490
.C65675
1991

108817

Front cover: Arne Jacobsen: Butterfly chair, 1957

© 1991 by St. James Press
All rights reserved. For information, write:

25277433

ST. JAMES PRESS
233 East Ontario Street
Chicago 60611, U.S.A.
or
2–6 Boundary Row
London SE1 8HP, England

British Library Cataloguing in Publication Data

Contemporary masterworks.
 I. Naylor, Colin, *1944–*
709

 ISBN 155862-083-4

CONTENTS

EDITOR'S NOTE

Contemporary Masterworks features entries on 450 individual works of art, architecture, photography and design which have achieved the status of "masterpiece" or "classic" and have made a significant contribution to twentieth century culture. Although the main focus is on work produced since 1945, this volume includes a number of important works whose design originated in the early years of this century but which made their most profound cultural impact in the postwar period.

Each entry comprises: photos illustrating the featured work; catalogue-data entry on the work; a bibliographical listing of further references; a signed, critical essay, assessing the importance of the work in its artistic and cultural context. An index to artists, architects, photographers, designers, engineers, design studios and manufacturers is provided at the end of the book.

The selection of works is based on the recommendations of an Advisory Board of 20 distinguished scholars, critics, curators and historians whose names are listed on page ix. Some 160 specialists in the fields of fine art, architecture, photography and design have contributed evaluative essays.

Our research was carried out mainly in the libraries of the Victoria and Albert Museum, the Tate Gallery, the Royal Institute of British Architects, The Photographers' Gallery, and the Design Museum, London. For their generous support and advice, and assistance with illustrative material, thanks are due to the many archival experts, librarians, artists, designers and manufacturers, without whom this book would not have been possible.

ADVISERS/CONTRIBUTORS

Advisers

Jean-Christophe Ammann, Andrea Arsenault, Arnold Friedmann
Helmut Gernsheim, Jorge Glusberg, Mark Haworth-Booth
Klaus Honnef, Udo Kultermann, David Mackay
Pedro Meyer, Per Mollerup, Chris Mullen
Andreas Muller-Pohle, Daniela Palazzoli, Wolfgang Pehnt
Jukka Pellinen, Tapio Periainen, Roger Remington
Aaron Scharf, Peter Selz

Contributors

Libero Andreotti, Jessica Arah, Diego R. Armando
Andrea Arsenault, Clive Ashwin

Carlo Belloli, Jens Bernsen, Vladimir Birgus
Ryszard Bobrowski, Botond Bognar, Szymon Bojko
Anne Bolt, Camilla Boodle, Edwin Brierley
Edward Bryant

Susan Havens Caldwell, James Carmin, Mary-Ann Caws
Jean-Luc Chalumeau, Giuliano Chelazzi, Tracy Chevalier
Stephen Chovanec, Krzyzstof Ciezkowski, Nancy Ciolek
Hazel Clark, Marcia Corbino, Leslie Humm Cormier
Graham Coulter-Smith, Ann Crowe, David Crowley
James Stevens Curl

Kimberly Davenport, Melvin Day, Carlos L. Dibar
Philip Drew, William V. Dunning

Doreen Ehrlich, Kenji Ekuan, Adriaan Elligens
Mary Ellis, Muriel Emanuel, Carla Enbom

Ann Ferebee, Louis Finkelstein, Quentin W. Fitzgerald
Andreas Franzke, Ken Friedman, Arnold Friedmann
Gerolf Fritsch

Lynn Gipson, Paul Gleye, Jorge Glusberg
Edward Gottschall, Bonnie Grad, Judith Mara Gutman

Jerryll Habegger, Fiona Hackney, Mark Hawkins-Dady
Richard Hayhurst, Steven Heller, Ralph Hinterkeuser
Barbara Hodik, Klaus Honnef, Michael Horsham
Nancy House, Diana Emery Hulick

Dennis Ichiyama

Gianni Joppolo, Joseph Juhasz

Victoria Keller, Alicja Kepinska, Wolfgang Kil
Joshua Kind, Sheila Klos, Barbara L. Koerble
Richard Kostelanetz, Vladimir Krstic, Ewa Kruszewska
Udo Kultermann

Nadir Lahiji, Roberto Lambarelli, Michael Laurance
Krzyzstof Lenk, Adrian Lewis, Claire Lofting
Cecily Lowenthal

Otakar Macel, Enzostefano Manola, Andree Marechal-Workman
Henry Martin, Richard Martin, Philip Meggs
Jayne Merkel, Jan Michl, John Moffitt
Robert C. Morgan, Hans Morgenthaler, Chris Mullen
Joan Murray

Weston J. Naef, Garance Nienhuis

John T. O'Leary, Joseph H. Osman

Philip Pacey, Daniela Palazzoli, Andrew Parker
Diane Pascal, Wolfgang Pehnt, Brian Phipps
Bruce Poli, Tuula Poutasuo, Donato Prosdocimo

Vladimir Remes, Roger Remington, Martin Ries
John Robinson, Marlee Robinson, Arthur Rosenblatt
Mark Roskill, Charles Ross, Douglas Russell

Hernan Barbero Sarzabal, Henry M. Sayre, Lawrence Scarpa
Pamela Scheinman, Allon Schoener, Peter Selz
Gayla Jett Shannon, David Spaeth, Tim Spry
Philip Stokes, Maia-Mari Sutnik

Nick Thomas, Elisabetta Tolosano, Roman Tomaszewski
Melanie Tomlinson, Teal Triggs

David K. Underwood

Jan Van Geest, Aruna Vasudevan, Giorgio Verzotti
David Vestal, Karl Volkmar, Gregory Votolato

Russell Walden, Susannah Walker, Mary Jo Weale
Dennis Wepman, Neville Weston, David Wilkins
Sheldon Williams, Stephanie Williams, Val Williams
Alfred Willis, Gary Wolf, Johanna Wolf
Ann-Sargent Wooster

Steven Yates, Joseph Young

Giorgio Zanchetti, Italo Zannier, Nicholas Zurbrugg

CONTEMPORARY
MASTERWORKS

LIST OF WORKS

ART:

Marina Abramovic/Ulay: *Gold Found by the Artist*, 1981
Valerio Adami: *Sigmund Freud in Viaggio verso Londra*, 1972–73
Pierre Alechinsky: *Le Doute*, 1968
Carl Andre: *Equivalent VIII*, 1978
Giovanni Anselmo: *Senza Titolo (Struttura che mangia)*, 1968–86
Karel Appel: *Questioning Children*, 1949
Alice Aycock: *The Thousand And One Nights...*, 1983
Francis Bacon: *Figures at the Base of a Crucifixion*, 1944
Georg Baselitz: *Supper in Dresden*, 1983
Max Beckmann: *Two Spanish Ladies*, 1939–40
Joseph Beuys: *How to Explain Pictures to a Dead Hare*, 1965
Alighiero Boetti: *Tutto quattro lati*, 1988
Christian Boltanski: *Monument: La Fete de Pourim*, 1989–90
Pierre Bonnard: *The Breakfast Room*, c.1930–31
Georges Braque: *Le Billard*, 1944
Claudio Bravo: *Madonna*, 1979–80
George Brecht: *Water Yam*, 1959–62
Marcel Broodthaers: *La Soupe de Daguerre*, 1976
Daniel Buren: *Le Pavillon Coupe, Decoupe, Taille, Grave*, 1986
Alberto Burri: *Sack IV*, 1954
Reg Butler: *The Unknown Political Prisoner*, 1955–56
John Cage: *Not Wanting to Say Anything About Marcel*, 1969
Anthony Caro: *Emma Dipper*, 1977–78
Cesar: *Compression Plastique*, 1972
John Chamberlain: *Sweet William*, 1962
Judy Chicago: *The Dinner Party*, 1979
Eduardo Chillida: *Wind Combs*, 1977
Christo: *Valley Curtain*, 1970–72
Chuck Close: *Big Self-Portrait*, 1968
Joseph Cornell: *Untitled Construction*, 1943
Salvador Dali: *The Persistence of Memory*, 1931
Giorgio De Chirico: *Mystere et Melancolie d'un rue*, 1914
Willem De Kooning: *Woman I*, 1950–52
Walter De Maria: *The Lightning Field*, 1969–77
Nicolas de Stael: *Marathon*, 1948
Sonia Delaunay: *Colour Rhythm*, 1953
Paul Delvaux: *La Venus Endormie*, 1944
Jean Dubuffet: *La Metafisyx*, 1950
Marcel Duchamp: *The Bride Stripped Bare...*, 1915–23
Max Ernst: *The Temptation of Saint Anthony*, 1945
Maurice Esteve: *L'Aquarium*, 1944
Luciano Fabro: *Attaccapanni*, 1976
Ian Hamilton Finlay: *Poster Poem: Le Circus!*, 1964
Lucio Fontana: *Concetto Spaziale, Attese*, 1959
Sam Francis: *In Lovely Blueness*, 1955–57
Helen Frankenthaler: *Flood*, 1967
Lucian Freud: *Large Interior W11 (after Watteau)*, 1981–82
Naum Gabo: *Linear Construction no. 2*, 1970–71
Alberto Giacometti: *Landschaft bei Stampa*, 1952
Piero Gilardi: *Inverosimile*, 1990
Gilbert and George: *Wanker*, 1977
Leon Golub: *Interrogation II*, 1981
Arshile Gorky: *Agony*, 1947
Juan Gris: *The Pierrot*, 1922
Philip Guston: *Black Sea*, 1977

Renato Guttuso: *Crucifixion*, 1940–41
Richard Hamilton: *Just What Is It..?*, 1956
Michael Heizer: *Double Negative*, 1969–70
David Hockney: *Man in Shower in Beverly Hills*, 1964
Hans Hofmann: *Effervescence*, 1944
Jenny Holzer: *Expiring for Love is Beautiful but Stupid*, 1982
Edward Hopper: *Office in a Small City*, 1953
Rebecca Horn: *Paradise Widow*, 1975
Jasper Johns: *Flag*, 1958
Joan Jonas: *He Saw Her Burning*, 1982–83
Vasily Kandinsky: *Composition VI*, 1913
Allan Kaprow: *18 Happenings in 6 Parts*, 1959
Ellsworth Kelly: *Red, Blue, Green*, 1963–64
Anselm Kiefer: *Father, Son and Holy Ghost*, 1973
Edward Kienholz: *The State Hospital*, 1966
R. B. Kitaj: *Cecil Court, London W.C.2 (The Refugees)*, 1983–84
Paul Klee: *Motiv aus Hamammet*, 1914
Yves Klein: *Relief Eponge Bleu*, 1958
Franz Kline: *Accent Grave*, 1955
Oskar Kokoschka: *Jerusalem*, 1929–30
Joseph Kosuth: *One and Three Chairs*, 1965
Jannis Kounellis: *Civil Tragedy (Golden Wall)*, 1975
Barbara Kruger: *When I Hear the Word Culture...*, 1985
Frantisek Kupka: *Vertical Planes*, 1912
Fernand Leger: *La Grande Parade*, 1954
Roy Lichtenstein: *Whaam!*, 1963
Richard Long: *Circle in the Andes*, 1972
George Maciunas: *Expanded Arts Diagram*, 1966
Alberto Magnelli: *Equilibrio*, 1958
Rene Magritte: *The Threatened Assassin*, 1926–27
Giacomo Manzu: *Christ and the General*, 1942
Marino Marini: *Horseman*, 1947
Andre Masson: *Landscape with Precipices*, 1948
Henri Matisse: *The Snail*, 1953
Mario Merz: *Double Igloo*, 1969–81
Joan Miro: *Femmes, Oiseau au Clair de Lune*, 1949
Piet Mondriaan: *Composition with Yellow Lines*, 1933
Henry Moore: *Reclining Figure*, 1956
Robert Morris: *Observatory*, 1970–77
Bruce Nauman: *Self Portrait as a Fountain*, 1966–67
Barnett Newman: *Vir Heroicus Sublimis*, 1950–51
Isamu Noguchi: *Even the Centipede*, 1952
Sidney Nolan: *Ned Kelly*, 1946
Claes Oldenburg: *Giant Hamburger*, 1962
Meret Oppenheim: *Le Dejeuner en Fourrure*, 1936
Jose Clemente Orozco: *Zapatistas*, 1931
Nam June Paik: *TV Bra for Living Sculpture*, 1969
Mimmo Paladino: *Round Earth, Frugal Repast*, 1986
Giulio Paolini: *Giovane che guarda Lorenzo Lotto*, 1967
Eduardo Paolozzi: *Last of the Idols*, 1963–66
Mike Parr: *Language and Chaos II*, 1990
Pablo Picasso: *Guernica*, 1937
Michelangelo Pistoletto: *Venere degli Stracci*, 1967
Jackson Pollock: *Autumn Rhythm*, 1950
Mel Ramos: *Hippopotamus*, 1967

Robert Rauschenberg: *Monogram*, 1955–59
Germaine Richier: *Praying Mantis*, 1949
Gerhard Richter: *18 Oktober 1977*, 1988
Bridget Riley: *Cataract*, 1967
Larry Rivers: *Washington Crossing the Delaware*, 1953
Ulrike Rosenbach: *Ten Thousand Years I've Been Sleeping*, 1976
Mimmo Rotella: *The Assault*, 1962
Mark Rothko: *Green and Maroon*, 1953
Niki de Saint-Phalle: *Hon*, 1955–66
Carolee Schneemann: *Meat Joy*, 1964
Kurt Schwitters: *Merz 19*, 1920
George Segal: *Cinema*, 1963
Richard Serra: *Untitled/Belt Piece*, 1967
Ben Shahn: *Red Stairway*, 1944
David Smith: *Cubi XIX*, 1964
Robert Smithson: *Spiral Jetty*, 1970

Michael Snow: *Turn: Turning in the Paint*, 1961
Pierre Soulages: *Painting 1948–49*, 1949
Stanley Spencer: *Shipbuilding on the Clyde: Blast Furnaces*, 1946
Daniel Spoerri: *Mr. Bitos*, 1961
Frank Stella: *Tahkt 1–Sulayman 1*, 1967
Clyfford Still: *Untitled: 1957–K(PH–149)*, 1957
Rufino Tamayo: *Prometheus Bringing Fire to Mankind*, 1958
Antoni Tapies: *Grey with Red Streak at Base*, 1957
Jean Tinguely: *Hommage to New York*, 1960
Wen-Ying Tsai: *Dancing Rods: Double Diffraction*, 1971–80
James Turrell: *Meeting*, 1980–86
Cy Twombly: *Untitled Grey Painting (Bolsena)*, 1969
Victor Vasarely: *Orion MC*, 1964
Wolf Vostell: *You* de-coll/age happening, 1964
Andy Warhol: *Gold Marilyn Monroe*, 1962
Tom Wesselmann: *Great American Nude no. 57*, 1964

ARCHITECTURE:
Alvar Aalto: Paimio Tuberculosis Sanatorium, 1929–33
Franco Albini: La Rinascente store, Rome, 1957–61
Emilio Ambasz: Lucile Halsell Conservatory, San Antonio 1982–87
Tadao Ando: Koshino Residence, Hyogo, 1981–84
Siah Armajani: Irene Hixon Whitney Bridge, Minneapolis, 1988
Gunnar Asplund: Woodland Crematorium, Stockholm, 1935–40
Gae Aulenti: Musee d'Orsay interiors, Paris, 1986
Edward Larrabee Barnes: Minneapolis Sculpture Garden, 1988
Luis Barragan: San Cristobal, Mexico City, 1967–68
Gunter Behnisch: Hyosolar-Institute, Stuttgart, 1987–88
Gunnar Birkerts: Federal Reserve Bank, Minneapolis, 1967
Jorgen Bo/Wilhelm Wohlert: Louisiana Museum, Humlebaek, 1958–62
Ricardo Bofill: La Fabrica, Barcelona, 1973–76
Gottfried Bohm: Town Hall, Bergisch Gladbach, 1962–71
Mario Botta: Casa Rotonda, Stabio, 1981
Johannes Andreas Brinkman: Van Nelle factory, Rotterdam, 1926–29
Gordon Bunshaft: Lever House, New York, 1950–52
John Burgee/Philip Johnson: AT&T Headquarters, New York, 1984
Santiago Calatrava: Felip II/Bach de Roda bridge, Barcelona, 1988
Felix Candela: Church of the Miraculous Virgin, Mexico City, 1953
Coop Himmelblau: Rooftop Office, Vienna, 1983–89
Giancarlo De Carlo: Faculty of Education, Urbino, 1968–76
Charles Eames: Eames House, California, 1945–49
Egon Eiermann: Olivetti Headquarters, Frankfurt, 1967–72
Peter Eisenman: Wexner Centre, Ohio State University, 1983–89
Arthur Erickson: Museum of Anthropology, Vancouver, 1971–77
Ralph Erskine: Byker Wall housing, Newcastle, 1969–81
Norman Foster: Hongkong and Shanghai Bank, 1979–85
Hiromi Fujii: International Arts Festival Center, Ushimado, 1985
Frank O. Gehry: Vitra Design Museum, Weil am Rhein, 1987–89
Giorgio Grassi: Student Housing, Chieti 1976–80
Vittorio Gregotti: Zen Housing Development, Palermo, 1969–73
Walter Gropius: Staatliche Bauhaus, Dessau, 1926
Gwathmey/Siegel: Busch-Reisinger Museum, Massachusetts, 1991
Hiroshi Hara: Yamato International Building, Tokyo, 1987
Itsuko Hasegawa: Shonandai Cultural Center, Fujisawa City, 1989
Herman Hertzberger: Central Beheer offices, Apeldoorn, 1969–73
Charles Holden: Arnos Grove underground station, London, 1932–33
Hans Hollein: Stadtisches Museum, Monchengladbach, 1972–82
George Howe: Philadelphia Saving Fund Society Building, 1931–32
Arata Isozaki: Civic Center, Tsukaba City, 1978–83
Toyo Ito: "Silver Hut", Tokyo, 1984
Helmut Jahn: Terminal of Tomorrow, Chicago, 1987–88
John M. Johansen: Mummers Theater, Oklahoma City, 1968–70
Philip Johnson: Johnson "Glass" House, Connecticut, 1949

Louis I. Kahn: Salk Institute Laboratories, La Jolla, 1965
Kallmann/McKinnell/Knowles: City Hall, Boston, 1969
Kiyonori Kikutake: Hotel Tokoen, Yonago City, 1964
Josef Paul Kleihues: Berlin Refuse Collection Depot, 1969–78
Lucien Kroll: Medical Faculty Housing, Louvain, 1970–77
Kisho Kurokawa: Nagakin Capsule Tower, Tokyo, 1972
Le Corbusier: Chapel of Notre-Dame-du-Haut, Ronchamp, 1950–55
Ricardo Legorreta: Camino Real Hotel, Mexico City, 1968
Maya Ying Lin: Vietnam Veterans' Memorial, Washington, D.C., 1982
Berthold Lubetkin: Highpoint One and Two, London, 1935–38
Fumihiko Maki: Municipal Gymnasium, Fujisawa, 1984
Imre Makovecz: Catholic Church, Paks, 1990
Martorell/Bohigas/Mackay: Housing at Mollet, Barcelona, 1983–87
Kunio Mayekawa: Metropolitan Festival Hall, Tokyo, 1960–61
Richard Meier: Museum fur Kunsthandwerk, Frankfurt, 1985
Eric Mendelsohn: De La Warr Pavilion, Bexhill-on-Sea, 1935
Ludwig Mies van der Rohe: Farnsworth House, Illinois, 1945–50
Mitchell/Giurgola & Thorp: Australian Parliament, Canberra, 1980–88
Jose Rafael Moneo: Bankinter offices, Madrid, 1972–76
Charles Moore: Piazza d'Italia, New Orleans, 1975–79
Pier Luigi Nervi: Palazzo dello Sport, Rome, 1958–60
Richard Neutra: Kaufmann House, Palm Springs, 1946
Oscar Niemeyer/Lucio Costa: Ministry of Education and Health, Rio, 1937–43
Jean Nouvel: World Arab Institute, Paris, 1988
Juan O'Gorman: National Library, Mexico City, 1952–53
Frei Otto: Tent-structure pavilions, Cologne, 1957, 1971
J.J.P. Oud: Kiefhoek Workers' Village, Rotterdam, 1925–30
I.M. Pei: National Gallery East Building, Washington, D.C., 1978
Gustav Peichl: ORF Radio Stations, Austria, 1968–81
Cesar Pelli: World Financial Center, New York, 1982–88
Renzo Piano: Centre Georges Pompidou, Paris, 1976
Gio Ponti: Pirelli Tower, Milan, 1955–58
John Russell Pope: National Gallery, Washington, D.C., 1937–41
Jean Prouve: School in Villejuif, Val-de-Marne, 1957
Reichlin/Reinhart: Casa Tonini, Torricella, 1972–74
Gerrit Thomas Rietveld: Schroder House, Utrecht, 1924
Miguel Angel Roca: Cordoba City pedestrianization, Argentina, 1979–80
Kevin Roche: General Foods Headquarters, Rye, New York, 1982
Eero Saarinen: TWA Terminal, New York, 1962
Moshe Safdie: Habitat '67, Montreal, 1967
Carlo Scarpa: Querini Stampalia Library, Venice, 1961–63
Hans Scharoun: Philharmonie concert hall, Berlin, 1956, 1960–63
Kazuo Shinohara: Tokyo Institute of Technology, Tokyo, 1987
SITE Projects Inc.: Indeterminate Facade, Houston, 1975
Alvaro Siza: Banco Borges e Irmao, Vila do Conde, 1982–86
Luigi Snozzi: Parliament Building, Liechtenstein, 1987–90
Robert A. M. Stern: Point West Place Offices, Framingham, 1983–85

James Stirling: *Neue Staatsgalerie, Stuttgart*, 1977–84
Hugh Stubbins: *Citicorp Center, New York*, 1978
Minoru Takeyama: *Ichiban-kan building, Tokyo*, 1968–70
Kenzo Tange: *National Gymnasium, Tokyo*, 1961–64
Clorindo Testa: *Bank of London and South America, Buenos Aires*, 1959–66
Stanley Tigerman: *Anti-Cruelty Society Building, Chicago*, 1977–78
Susana Torre: *Fire Station no.5, Columbus, Indiana*, 1985–87
Bernard Tschumi: *Parc de La Villette, Paris*, 1982–91

Oswald Mathias Ungers: *Deutsches Architekturmuseum, Frankfurt*, 1979, 1981–84
Jorn Utzon: *Sydney Opera House*, 1965–73
Gino Valle: *Zanussi Factory, Pordenone*, 1956–61
Aldo van Eyck: *Hubertus House, Amsterdam*, 1975–79
Robert Venturi: *Vanna Venturi House, Pennsylvania*, 1961–63
Johan Otto von Spreckelsen: *Grande Arche de La Defense, Paris*, 1981–89
Evan Owen Williams: *Boots Factory, Nottingham*, 1930–32
Frank Lloyd Wright: *Guggenheim Museum, New York*, 1959

PHOTOGRAPHY:
Ansel Adams: *Moon and Half Dome, Yosemite National Park*, 1960
Eddie Adams: *Vietnamese General Executing Vietcong*, 1968
Manuel Alvarez Bravo: *El Trapo Negro*, 1986
Diane Arvus: *Retired Man and Wife in a Nudist Camp*, 1963
Richard Avedon: *Untitled (Dovima with Elephants)*, 1955
Lewis Baltz: *The New Industrial Parks near Irvine*, 1974
Cecil Beaton: *Gertrude Stein and Alice B. Toklas*, c.1936
Bernd Becher: *Water Towers, France*, 1982
John Blakemore: *Rock Pool, Friog, North Wales*, 1975
Jane Bown: *Cilla Black*, 1967
Brassai: *La Belle de Nuit*, 1933
Adam Bujak: *The Funeral of Our Lady*, 1962
Wynn Bullock: *Black Tree and Mountain*, 1956
Rene Burri: *Men on Rooftop, Sao Paulo*, 1960
Romano Cagnoni: *Biafran Mother and Children*, 1968
Harry Callahan: *Eleanor*, 1947
Robert Capa: *Collaborator, Chartres*, 1944
Paul Caponigro: *Pentre-Ifan Dolmen, Pembrokeshire*, 1972
Henri Cartier-Bresson: *The Banks of the Marne*, 1936–37
Larry Clark: *Tulsa – Pregnant Woman*, c.1969
Van Deren Coke: *The Dentist's Office*, 1958–66
Thomas Joshua Cooper: *Ceremonial Veil, Nesscliffe*, 1976
Bruce Davidson: *East 100th Street: Mother and Child*, c.1968
Paul De Nooijer: *Warmtebronnen/Heatsources*, 1986
Zbigniew Dlubak: *Untitled (Ocean)*, 1971
Robert Doisneau: *Wanda Wiggles her Hips*, 1953
Benedykt Jerzy Dorys: *Kazimier on the Vistula*, 1931
Frantisek Drtikol: *The Wave*, 1926
Bernard Faucon: *The Banquet*, 1978
Arno Fischer: *Staten Island Ferry*, 1978
Robert Frank: *The Americans: Political Rally – Chicago*, 1956
Leonard Freed: *Suspect in Police Car, New York City*, 1980
Lee Friedlander: *New York City*, 1974
Mario Giacomelli: *Scanno*, 1957
Fay Godwin: *Moonlight on Avebury*, 1985
Brian Griffin: *Sliced Bread*, 1986
John Gutmann: *Yes, Columbus Did Discover America*, 1938
Betty Hahn: *Starry Night Variation no.2*, 1977
Hiroshi Hamaya: *The Rice-Weeder*, 1955
Robert Heinecken: *Daytime Color TV Fantasy/Arm and Hammer*, 1976
Hiro: *Jewellery on Foreleg of Black Angus*, 1963
David Hockney: *Scrabble Game*, 1983
Thurston Hopkins: *All Night Vigil, London*, 1952
Eikoh Hosoe: *Barakei, or Ordeal by Roses*, 1961–62
Graciela Iturbide: *Mujer Angel (Angel Woman)*, 1980
Philip Jones-Griffiths: *Victim of Napalm Bombing, Vietnam*, 1967
Yousuf Karsh: *Winston Churchill*, 1941
Andre Kertesz: *Chez Mondrian*, 1936
Chris Killip: *In Flagrante: Man and Fire*, c.1982
William Klein: *Thanksgiving Day Parade, New York*, 1954
Josef Koudelka: *August 1968, Prague*, 1968
Natalia Lach-Lachowicz: *Artificial Photography*, 1978

Dorothea Lange: *Migrant Mother*, 1936
Annie Leibovitz: *Steve Martin in White Tails*, 1981
Giorgio Lotti: *Onda*, 1970
Marketa Luskacova: *The Sleeping Pilgrim*, 1970
Aleksandras Macijauskas: *In the Veterinary Clinic*, 1986
Man Ray: *Portrait of Margaret*, 1941
Roger Mayne: *Southam Street, London*, c.1960
Angus McBean: *Surreal Portrait of Frances Day*, 1983
Don McCullin: *Albino Child in Biafra*, 1970
Ralph Eugene Meatyard: *Untitled: Child with Mask*, c.1959
Susan Meiselas: *Soldiers searching bus passengers, El Salvador*, 1980
Joel Meyerowitz: *Broadway and 46th Street, New York City*, 1976
Duane Michals: *Spirit Leaves the Body*, 1968
Lee Miller: *Murdered Prison Guard in Canal, Dachau*, 1945
Richard Misrach: *Desert Cantos: Waiting*, 1983
Martin Munkacsi: *Lucile Brokaw in Beach Costume*, 1933
Ikko Narahara: *Two Ladies in Jackie Kennedy Masks*, 1970
Helmut Newton: *Elsa Peretti, New York*, 1975
Martin Parr: *Old Tyme Dancing at the De La Warr Pavilion*, 1978–79
Irving Penn: *Lisa Fonssagrieves-Penn in Rochas Mermaid Dress*, 1950
Josep Renau: *Peace is with Them (Descansen en Pau)*, 1956
Albert Renger-Patzsch: *Driving-Shaft of a Locomotive*, 1923
Marc Riboud: *Beijing*, 1965
Alexander Rodchenko: *Assembling for a Demonstration*, 1928
Marialba Russo: *Molise*, 1981
Sebastiao Salgado: *Women and Children on Dry Lake Bed, Mali*, 1985
Jan Saudek: *Another Child, David, Is Born: I Embrace Him*, 1966
Ferdinando Scianna: *Refugee Camp, Makale, Ethiopia*, 1984
David Seymour: *Prostitute in Essen*, 1947
Cindy Sherman: *Untitled, no. 96*, 1981
Aaron Siskind: *Terrors and Pleasures of Levitation*, 1953
Victor Skrebneski: *Vanessa Redgrave, Hollywood*, 1967
W. Eugene Smith: *Tomoko and Her Mother, Minamata*, 1972
Frederick Sommer: *Pine Cone*, 1947
Chris Steele-Perkins: *Traumatised children, Beirut*, 1982
Liselotte Strelow: *Joseph Beuys with his Son*, 1967
Josef Sudek: *A Memory of Dr. Brumlik*, 1969
Mieczyslaw Szczuka: *Smoke Over the City*, 1926
Michel Szulc-Krzyzanowski: *The Great Sand Dunes*, 1979
Shomei Tomatsu: *Melted Beer Bottle*, 1960
Oliviero Toscani: *United Colours of Benetton*, 1985–91
Arthur Tress: *Flood Dream*, 1971
Burk Uzzle: *All American: Dam Viewing Room*, c.1980
Ed van der Elsken: *Sweet Life: Black Machine Operator*, 1960
Weegee: *Drowned Man, Coney Island*, 1940
Edward Weston: *Pepper No.30*, 1930
Minor White: *Sequence no.4: Opposed Directions*, 1949
Garry Winogrand: *Hard Hat Rally, New York*, 1969
Stanislaw Ignacy Witkiewicz: *Multiple Portrait*, 1915–17
Mariana Yampolsky: *Huipil de Tapar*, 1965

DESIGN:

Alvar Aalto: *Savoy* vase, 1936
Eero Aarnio: *Ball/Pallotuoli* chair, 1963–65
Otl Aicher: *Pictograms for the XX Olympics,* 1972
Walter Allner: *Fortune* magazine cover, June 1962
Olof Backstrom: Fiskars scissors, 1965–67
Saul Bass: *Walk on the Wild Side* film titles, 1962
Herbert Bayer: *Ski in Aspen* poster, 1946
Lester Beall: International Paper Company program, 1958
Henry Beck: London Underground Diagram, 1931–59
Mario Bellini: *Persona* chair, 1979–84
Maria Benktzon: Tablewares for the disabled, 1980
Harry Bertoia: *Bertoia* chair, 1951–52
Flaminio Bertoni: Citroen DS–19 car, 1951
Flaminio Bertoni: Citroen 2CV car, 1936–48
BIB Design Consultants: *Durabeam* torch, 1980–84
Marcel Breuer: *B32/Cesca* cantilever chair, 1924–25
British Aerospace: Concorde supersonic aircraft, 1962–71
Neville Brody: Typeface Three, 1985
Erik Bruun: *Sea Eagle* poster, 1962
Achille/Pier Giacomo Castiglioni: *Mezzadro* chair, 1957
Ivan Chermayeff: *Churchill: The Wilderness Years* poster, 1982
Seymour Chwast: *Artone* alphabet and package, 1964
Ed Cole/Harley Earl: Chevrolet Bel Air car, 1957
Ed Cole/Harley Earl: Chevrolet Corvette Mk II car, 1956
Joe Colombo: *Colombo 281* table lamp, 1962
Andre Courreges: *Couture Future* clothing, 1963
Corradino D'Ascanio: Vespa motor-scooter, 1946
Robin Day: *Hillestak* stacking chair, 1949–50
Rudolph de Harak: Metropolitan Museum Egyptian displays, 1974–82
Designlab ApS: Kastrup Airport signage, Copenhagen, 1987–88
Christian Dior: *New Look* fashions, 1947
Louis Dorfsman: *Of Black America* advertisement, 1968
Charles Eames: *670* swivel chair and ottoman, 1956
Tom Eckersley: *Help Lepra Fight Leprosy* poster, 1975
Clarence Leo Fender: Stratocaster electric guitar, 1954
Enzo Ferrari: *Ferrari 250GTO* car, 1962
Ford USA: *Ford Mustang 1* car, 1964
Kaj Franck: *Kilta* ceramic tableware, 1948
Adrian Frutiger: *Univers* typefaces, 1954–55
Shigeo Fukuda: *Mona Lisa* posters, 1970
Richard Buckminster Fuller: U.S. Pavilion, *Expo '67*, Montreal, 1967
Abram Games: Cona coffee-maker, 1959
Marcello Gandini: Lamborghini Countach car, 1970–74
Milton Glaser/Seymour Chwast: *Push Pin Graphic*, 1953–80
William Golden: CBS symbol and identity programme, 1951
Kenneth Grange: Kenwood Chef food processor, 1960
Milner Gray: *Pyrex* oven-to-table glasswares, 1955–65
Pentti Hakala: *Lily 115* chair, 1985
George Hardie: *The Works* calendar, 1985
Niels Jorgen Haugesen: Haugesen folding table, 1984–87

Klaus Helweg-Larsen: Question-Mark telephone booth, 1980–84
Poul Henningsen: *PH Artichoke* lamp, 1958
Knud Holscher: *D-Line* fittings, 1975
Alec Issigonis: Austin Mini car, 1957–59
Arne Jacobsen: *Butterfly* chair, 1957
Yusaku Kamekura: *Hiroshima Appeals* poster, 1983
Poul Kjaerholm: *Model 91* folding stool, 1961
Helmut Krone: Volkswagen advertising, 1959–78
Lego Gruppen: *Lego* construction toys, 1954
Raymond Loewy: *Studebaker Starliner* car, 1953
Herbert Lubalin: *Avant Garde Gothic* typeface, 1967–70
Vico Magistretti: *Selene* stacking chair, 1968–69
Enid Marx: Textiles for London Transport, 1937–45
Ludwig Mies van der Rohe: *Barcelona Chair*, 1929
Laszlo Moholy-Nagy: *Vision in Motion*, 1947
Carlo Mollino: Orengo House, Turin, 1949
Stanley Morison: *Times New Roman* typeface, 1932
Josef Muller-Brockmann: Zurich Concert Hall posters, 1955–59
George Nelson: *Storagewall* system, 1944–45
Erik Nitsche: *Atoms for Peace* posters, 1955
Eliot Noyes: Mobil Design Program, 1955–65
Antti Nurmesniemi: *Antti* telephone, 1983–84
Verner Panton: *Panton* chair, 1959–67
Art Paul: Playboy logo and graphics, 1953
Gaetano Pesce: *Up-1* chair, 1959
Giancarlo Piretti: *Plia* folding chair, 1969
Gio Ponti: *Chiaravari Superleggera* chair, 1949–55
Ferdinand Porsche: Volkswagen "Beetle" car, 1933–38
Ferdinand (Ferry) Alexander Porsche: Porsche 911 car, 1963
Andree Putman: Minister of Finance offices, Paris, 1988–89
Mary Quant: Mini-dress and skirt, 1962
Paul Rand: IBM corporate identity program, 1956
Gerrit Thomas Rietveld: Red/Blue Chair, 1917–18
Jens Risom: *Model 650* chair, 1941–42
Eero Saarinen: *Model 151/Tulip* chair, 1953–56
Richard Sapper: *Tizio* desk lamp, 1972
Timo Sarpaneva: *Lansett II* glass, 1952
Afra Scarpa: *Model 121* chair, 1965
Sony Corporation: *Sony Walkman*, 1978–79
Ettore Sottsass, Jr.: *Valentine* typewriter, 1969
Philippe Starck: *Cafe Costes* chair, 1984
Stanislav Sutnar: Sweet's Catalog Program, 1943–60
Ilmari Tapiovaara: *Domus* stacking chair, 1946–65
Bradbury Thompson: *The Washburn Bible*, 1979
Henryk Tomaszewski: *Henry Moore* poster, 1959
George Tscherny: *Germany in the 19th Century* poster, 1980
Massimo Vignelli: Unigrid Design Program, 1976–77
Wolfgang Weingart: *Typographische Monatsblatter* designs, 1972–76
Tapio Wirkkala: *Chanterelle* glass vases, 1947
Benno Wissing: Schiphol Airport Program, Amsterdam, 1963
Marco Zanuso: *Model 4999* child's stacking chair, 1964

ART

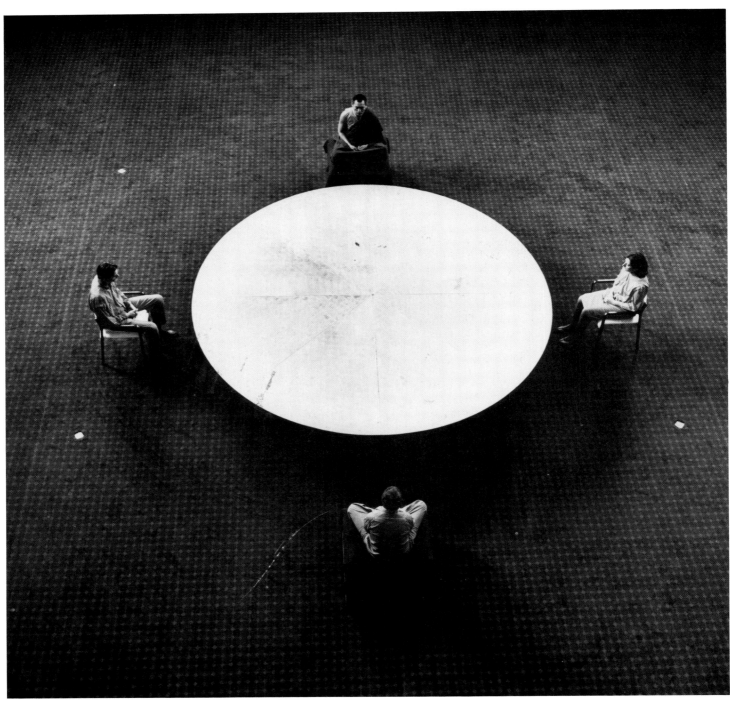

Performance in Sonestra Cupole, Amsterdam, 1983. Photo Hogen / Versluys

Marina Abramovic/Ulay (1946–)
Gold Found by the Artists (Nightsea Crossing) 1981
Performance work, Sydney, Australia; 16 days

Gold Found by the Artists is a performance work first presented in Sydney, Australia, and repeated several times afterwards as part of the work. It is also known as *Nightsea Crossing*. Like many other performance works, it was documented by photographs, and responded to in various journals.

The work involves the cooperative interaction of two artists, and explores the expressive experience of duration as it affects one's mind and body. *Gold Found by the Artists* grew out of the artists' experiences in the Australian Outback and contact with the Aborigines. Marina Abramovic/Ulay underwent a shamanic experience in the desert after which the Aborigines, who had ignored them before, allowed them to make contact. Initiated through personal ritual ordeal, they came to realize the power and insight possible through stillness, quiet, and watchfulness. Great personal insight was accompanied by greatly enhanced awareness of the external world. The Aborigines seem to have realized that internal changes had occurred within Abramovic/Ulay, and allowed them to become part of the Aboriginal world.

Abramovic/Ulay reflect the contemporary interest of many artists in exploring cognitive and non-cognitive epistemological systems outside the Western, rational tradition. Unlike the early twentieth century experiments of the Cubists and others, who borrowed form rather than content, their work more closely follows anthropological interests in which they seek to discover what other cultural systems know through sharing experiences rather than simply being observers. Unlike their anthropological counterparts, however, Abramovic/Ulay make no pretences or illusions about objectivity and the questions that raises about voyeurism.

The work also has conceptual roots in the Viennese concern with rituals, and performance as means of personal expression. Having explored ritualized pain earlier in her own work, Abramovic, now with Ulay, has expanded the idea of passivity and submission to include meditative investigations. They work with the revelatory potential of passive meditative situations in which will is suppressed.

Marina Abramovic/Ulay had pursued individual careers as performance artists before they met and realized that a karmic bond connected them. Their relationship to each other and the world became the basis of their subsequent work. Drawing from the traditions of esoteric and occult knowledge, such as Tibetan Tantric Buddhism, theosophy, and alchemy, *Gold Found by the Artists* is an investigation of duality and communication.

Gold Found by the Artists took place over a period of sixteen days. For seven hours each day, the artists, seated in chairs, faced each other from the ends of a long table. They fasted and remained silent during this entire period. Each time the piece was performed, it took place in a different architectural setting which could be outside, as in Chicago, or indoors. The objects on the table changed from performance to performance, and included a python coiled around a boomerang, as well as other talismanic objects. Bits of gold leaf might be suspended in a water cooler reserved for the spectators. Table designs changed, but always with attention paid to the alchemical and magical properties of the materials and the numerological significance of proportions.

Marina Abramovic/Ulay have substituted their bodies for the physical work of art. Their art consists of observed process rather than an object subject to the manipulations of an art world. They have extended the tradition of performance art that began with Marinetti and the Futurists, and their work reflects the shamanistic performances of Joseph Beuys. Yet the silence and immobility that are part of *Gold Found by the Artists* reinstate the tableau, for the audience observes an unchanging image during the duration of the performance. The reactions occur internally, like the Australian experience of Marina Abramovic/Ulay, and communication between artists and audience occurs on a nonmaterial level.

Gold Found by the Artists is an investigation of duality in many forms: The relationship between actual experience and symbolic ritual, the opposition of female and male, the interdependance of, or difference between, material and spiritual, and self as microcosm and world as macrocosm.

The performance exists primarily as experience. Although the presence of an audience implies a concern for the relationship between art and spectator, the audience becomes increasingly separated into its own space as the work evolves. The performance as experience value continues whether the audience is present or not. Like the sacred rituals and traditions of cultures which exist and have meaning for the participants regardless of the presence of observers, *Gold Found by the Artists* was an experience for the artists. They were transformed by it. If the audience chose to observe the entire performance, they would have been transmuted from observers to initiates.

The work exists as theater when the observer stops for only a short while. One remains an observer, and the separation represented by the proscenium arch that divides spectator from performance limits one's experience. To stay the while, however, would bring about an experience analogous to that of Marina Abramovic/Ulay, and the possibility of a harmonic bond developing between performers and spectators becomes real.

Thus, it is through experience that boundaries are broken and barriers torn down. In theater, the performers communicate through outward signs that may be simply acted rather than felt, and, while the spectators are transformed by the experience, the actors are not.

In *Gold Found by the Artists*, the artists are transformed by the experience, although the audience may not be. And if the audience does participate in the total experience, they will become one with the performers. The problem of subjective interpretation of art as object would not exist when all are in communication.

The means by which one usually defines the world, breaking up experiences of expanse, extent, duration, and finiteness into increments of time, volumes of space, and consciousness of uniqueness, become meaningless. Time becomes indefinite, space becomes continuous, and one's physical body seems to dissolve.

Fixing one's concentration on a single moment replicates the meditative process. The object observed by the spectator, and here Marina Abramovic/Ulay are each other's spectator, hides what occurs within. Changes occur through feeling and awareness; something comes into being, but it is something invisible and intangible. The audience/artist relationship parodies that between the artist's themselves.

Duality becomes one in ritual performance. And thus it is that Marina Abramovic/Ulay find gold. Gold is the supreme substance of the alchemical world, and represents the highest values of purity and beauty. Gold also purifies and cleanses. The eternal dream of the alchemist to transform dross material into gold is realized. For gold is light and knowledge. When Marina Abramovic/Ulay find gold, they achieve the highest goals of humanity, as art becomes the means of comunication through ritual experience.

—Karl F. Volkmar

Bibliography—

Maticevic, Davor, *Marina Abramovic*, exhibition catalogue, Zagreb 1974.
Demarco, Richard, and others, *Contemporary Yugoslav Art*, exhibition catalogue, Edinburgh 1975.
Abramovic, Marina, *Relation Work and Detour: First Complete Works*, Nijmegen 1980.

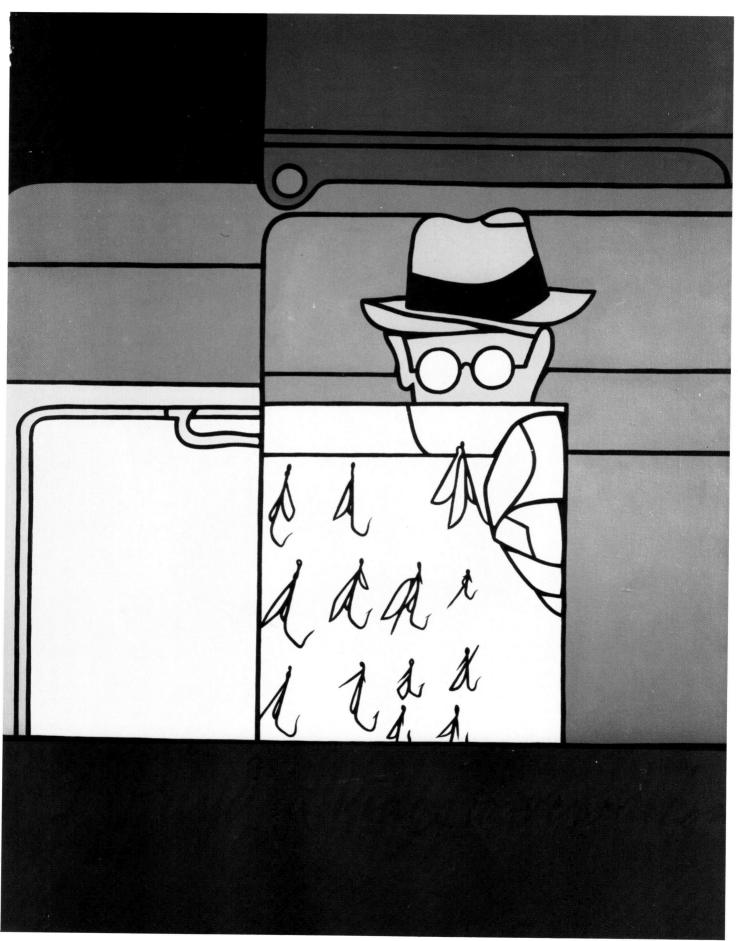

Photo Fondation Maeght. © ADAGP, Paris and DACS, London 1991

Valerio Adami
Sigmund Freud in viaggio verso Londra, 12/3/1972–25/7/1973
Oil on canvas; 97 × 131 cm.
Saint Paul de Vence, Fondation Maeght

Adami, with his stripped-down cartoon style, his bright comic-book colors and his deliberately veiled allusive manner, appeals to the child and the grownup in us. He likes, he reminds us, the beauty of reasoning along with Ruskin, above beauty itself, and it is a cold beauty.

In *Searching High and Low*. Dore Ashton remarks of Adami (about whom Fuentes, Calvino, Dupin, and Derrida have also written) that Adami's sign language, this idiom derived from comic strips and magazines and crowd-writing came to him because of having to communicate with his grandfather who could not hear, or pretended he could not hear. It is sign language indeed, but immensely sophisticated. His teacher from Ferrara, Achille Funi, taught him the light of the linear; and he shares, says Ashton, this sense of the linear with De Chirico, although he does not invoke his shadow. And with Blake he shares the despising of ambiguity. His images are not open, they are closed. They leave no space. Adami keeps his distance from his pictures and their heroes, remaining in the visual, non-discursive mode. They do not participate in the temporal, seem static, seem sealed off. They are deeply modern.

In his notebooks, Adami reminds himself to "Paint less and think more—the memory ruminates—you lose your ego, becoming an instrument, a violin or a piano. To advance in painting is to advance in the self. Further you go, the more the subject is reduced and fades, just as the coast disappears when you are going out to sea, and suddenly reappears,—earth! earth! and this is the end of the voyage."

In *Freud's trip to London* (*Sigmund Freud in viaggio verso Londra*, c. 1972), the sealing-off of the trip is blatant. In a purple hat, his opaque eyeglasses that entirely shut off his eyes from our own, and his straight-faced impenetrability, Sigmund Freud is looking out of a window, catching the insects walking up the glass—or is he? We see his immense hand, with two nails visible, see him grabbing an insect by the tail, with an air of the scientific. The bright yellow light of outside, in which the insects walk, each with a tail protruding like a fish hook, is totally contrasted with the purple and magenta and violet and dull blue hues of the inside carriage, into which only the lower part of Freud's face inserts itself, the mouth absent, only those glasses under the hatband giving any sense of person. The hat? Anyone's fedora, slightly turned up at the brim, with a darker purple ribbon, nattily bridging the color of the magenta stripes with the violet and blue of the chair of his compartment. Freud is in and out. The insects have something disturbingly jabbing to their line. The fingernail menaces. It is a very uncomfortable ride we are made to take, in these tempera paint colors, on this train to a London we won't be coming back from.

The work has odd interferences with others of Adami's figures: the figures to the left of the face of Bela Goldstein, Terrorist, of 1971 (in the work entitled *How Information Falsifies*), have the same uncomfortable spinniness as the insects crawling up the pane, whose lines lie somewhere between a fish-hook and the characters "d" and "t": this distance created between the observer staring out at us, and our own gaze, is strengthened by the effect of such unsettling strokes. Adami's was never a straightforward and

comfortable world, never a complete one. The picture of James Joyce, presented in orangish red and lavender against a black and tan background of "Araby in Dublin," shows the same shutting-off of the character behind his glasses. Even as he faces us, he is impersonalized—there is to the framing of these characters a post-modern sense that befits the work of Jacques Derrida which uses Adami for its illustration, the *Sense in Painting*. Adami is, above all, about angles, and framing, about distance and separation of one part of life and perception from another—thus the layering of bright colors, totally saturated. The face of the character is inserted between these layers of differing colors, working at once to imprison and deaden (as in *Sunday in Hamburg*) or to single out, but in a space far different from our own, as in *The Kiss of the Moon* or *Pirosmani/Melancholy*, in both of which the grey color of the central character sets him off from the rest. Neither time nor history are present in Adami's work, but the immortal moment of classicism is all the more self-aware. More interested by the past than the future, he declares: "In front of my paintings, you can refer to the classical tradition. And there is always in my works a central personage as in the classical conception of the Italian Renaissance. The true creator of my paintings is the tradition to which I belong." He has made his choice, as a painter, for what has been decided, for the stable and not for the moving. We have only to look at his *Ulysses* of 1976, and see the figure, his face turned sideways to us, standing bolt upright, the segments of his body the only brightly-colored elements in the work, to feel how strongly positioned is the heroic figure in relation to a non-temporal situation. All is drab but him.

Classical, unmoving, even in a train, separate, even in his analysis of himself or the insects crawling up a pane, Dr. Freud is all of us, forever apart. "This back turned by each to the others," says Jean-Pierre Lyotard of Adami's mood in his work, and indeed it is that mood that this masterpiece capture, even as it must be confronted face-on. We will never know any more than this about that figure; nor will it know anything of us. Psychoanalysis is, in its own way, a desertion of the human, Adami implies. Like everything else. That way, it gets to be fixed, even when we would think it on a moving train. We are not going anywhere.

—Mary Ann Caws

Bibliography—

Bouyere, C., "Adami ou metamorphosis," in *Cimaise* (Paris), November 1971.
Damisch, Hubert, and Martin, Henry, *Adami*, Paris 1974.
Baumeister, H., "Valerio Adami," in *Novum* (Munich), September 1974.
Damisch, H., "Adami: un portrait," in *Chroniques de l'Art Vivant* (Paris), November 1974.
Dupin, Jacques, *Valerio Adami: Sang*, Paris 1980.
Lyotard, Jean-Francois, *Adami: peintures recentes*, exhibition catalogue, Paris 1983.
Calas, Nicolas, and others, *Adami: Presence Contemporaine*, exhibition catalogue, Aix-en-Provence 1984.
Ashton, Dore, Pacquement, Alfred, and others, *Adami*, exhibition catalogue, Paris 1986.

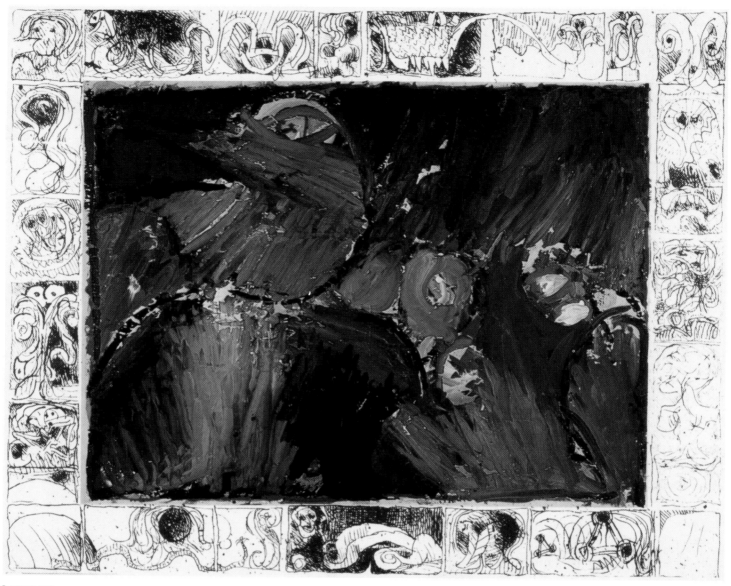

© DACS 1991

6

Pierre Alechinsky (1927–)
Le Doute 1968
Acrylic on canvas; 205 × 251cm.
Humlebaek, Louisiana Museum of Modern Art

Le Doute now in the Louisiana Museum, Humlebaek, Denmark, has a central image painted in acrylic with marginalia of 24 quadrangular drawings in black ink on an ivory ground. Described as *Entstanden in La Bosque und Bougival*, it was included in a big Alechinsky exhibition at the Kunstverein für Rheinlande und Westphalen, Düsseldorf and at the Kunsthalle, Bremen in 1969, and later at the Alechinsky show in the Zürich Kunsthaus (1975).

When one has threaded one's way through the draughtsmanship of the 2 dozen marginalia (a conglomeration of sex drawings plus abstractions and mountain landscapes) a vague comprehension of the workings of the mind of this ex-Cobra artist, international-Belgian and extensively individualistic creator brings one scarcely nearer visual translation of the picture's central theme which they enclose.

The colours of the "surrounded" Doute are sombre and fraught with an impelling menace that belies the jaunty encompassing fringe, and thereby perhaps come closer to the many-meanings nature of so much of the creativity emanating from Alechinsky . . . a frequent challenging contest of black humour against frivolous fun. Tucked inside the marginalia, the centre panel contains two voracious birds, each rendered in profile, both giving only the impression of wings, but image-wise cut off before any sign of legs appears. Strongly portrayed with plenty of black and deep brown, bodily their predominating colour is a brooding blue somewhere between pale and tenebrous. Is this pair the essence of "Doubt?"

Suffice it to say that *Le Doute* is an excellent summation of the multifaceted Alechinsky and, in its way, is surely a masterpiece of his extraordinary capacity for inducing mystery, impenetrable mystery, but none the less fascinating for us on the margin outside his genius for imparting imaginary puzzles. Virtually all his works vie with logic and wreak havoc on normal intellectual savoir-faire. Unquestionably, *Le Doute* scores a heavy bonus in this optically unfamiliar arena.

For many the cardinal factor of Alechinsky's cultural contribution may be that he was if not the first at any rate the most important instigator of the "Comic Strip" syndrome as a vital element in modern art, frequently letting it occupy a complete picture surface, but just as often (as in *Le Doute*) incorporating it as a continuing margin and sometimes adding scribbled comments providing almost a deft challenge to crossword compilers.

Although by no means always in attendance, the basic characteristic looming so large in Alechinsky's works is a compulsive non-stop linear tangle resorting here and there—but not always—in a confused confusing message. This is a complicated and anarchic teasing that captivates and entrances the viewer who strays into the picture-and-object world of Alechinsky.

The hectic account of Alechinsky's artistic progress—before and after the days of "Le Doute"—from his first exhibition at the Lou Cosyn Gallery in Brussels (1947) even to 1988; an enormous catalogue of exhibitions, acquisitions of important prizes both at home and abroad, his association with the Cobra group, his multi-directional styles and their expansions, his contacts and friendships with those whose lives intertwined with his own in different circumstances, and his actual divergent philosophical enthusiasms which permeate his life-pattern filtering into the constant stylistic inventions for which his art-story is famous are too complex to fit into short paragraphs.

Two voices from the past confirm what fellow artists believed best summed up this astonishing experimentalist from Brussels. The late Dotremont, until his death was a close friend and frequent collaborator with Pierre Alechinsky, of whom he wrote: "Language gets bogged down in Assemblies, colours in Schools, but the poet speaks the pure meaning, and so does the painter. I am thinking of Alechinsky. There is something quite rare about this guy. He does not believe that painting is any closer to life if it moves away from painting itself!"

Or the eccentric Ionesco has this to say of him: "Alechinsky is the painter-fisherman, the rod, the hook, the water flowing in the river, and the fish all rolled up into one."

Maybe the Romanian was able to observe in Alechinsky wayward talents that paralleled his own happy boulverseé of unexpected truths.

—Sheldon Williams

Bibliography:—

Riviere, Yves, ed., *Alechinsky a la Ligne: Catalogue Raisonne*, Paris 1973.
Arkus, Leon A., and Ionesco, Eugene, *Pierre Alechinsky: Paintings and Writings*, exhibition catalogue, Pittsburgh 1977.
Haenlein, Carl, *Pierre Alechinsky, ein Retrospektiv*, exhibition catalogue, Hannover 1980.

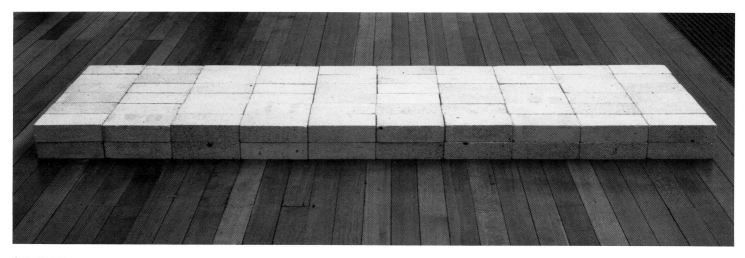

© DACS 1991

Carl Andre (1935–)
Equivalent VIII 1978
Firebricks; 5 × 27 × 90¼in.
London, Tate Gallery

Carl Andre was one of the founders of the art movement known as Minimal, Systemic, or ABC Art. It is an art that seeks to eliminate everything decorative, extraneous and additive, reducing all components to *art's* purest elements; it is precise, cerebral and austere rather than accessible. Andre once said that what was beautiful in art was "not that someone is original but that he can find a way of creating in the world the instance of his temperament." His own temperament is close to the tranquil philosophy of Taoism, and many critics refer to his work as "pacific."

He reveals little about himself. The men in the family tended to be in building or metal working trades; his father, a marine draftsman, was also an accomplished woodworker, and his grandfather was a bricklayer. In an interview video-taped for the Albright-Knox Gallery in Buffalo, New York, the artist said of Quincy, Massachusetts, where he was born: "The industry was granite-cutting and monument sculpture . . . My uncle and father mostly worked in the shipyards . . . In 1951 I went as a scholarship student to Phillips Academy, Andover [Massachusetts]. It was there that I first got to know the joys of making art." He was the youngest of three, the only male; his mother wrote poetry and his father took the children to museums and read aloud to them. He later worked at a steel company and on a railroad, traveled to Europe, joined the army. In 1964 he was invited to exhibit at the Hudson River Museum in a suburb outside of New York City. As Minimalism attracted critical attention, he began exhibiting in the city.

For his one-man exhibition at the Tibor de Nagy Gallery, the artist set out eight rectangular sculptures deployed on the gallery floor, each made of 120 bricks. "One hundred twenty is the number richest in factors," Andre explained, "arithmetic is only the scaffolding or armature of my work." *Equivalent VIII*, one of the eight works, was made two bricks high, six across, and ten lengthwise (technically and sometimes referred to as "2 high × 6 header × 10 stretcher"). The titles supposedly were derived from Alfred Stieglitz's series of photographs of clouds made in the 1920s and 1930s, called *Equivalents*. The sculptor's works have nothing to do with clouds, but in mathematical theory the Equivalence Relation has to do with the relation of sameness between elements, while in physics, the Principle of Equivalence demonstrates the distinction between inertial and gravitational forces—the sort of disciplines that concern Andre.

Emplacement, environment, and relativeness are important in all of this artist's works. "A place is an area within an environment which has been altered in such a way as to make the general environment more conspicuous," he said. "Everything is an environment, but a place is related particularly to both the general qualities of the environment and the particular qualities of the work which has been done." The bricks in *Equivalent VIII* are humble materials, basic to building, construction, and manufacture; by treating these cubic, tesserae-units as sculpture, we begin to view the work's physical reality as an esthetic phenomenon. And since placement generates and energizes the piece, *Equivalent VIII* and its surrounding environment become one work of art.

Carl Andre invariably works within a strict self-imposed modular system, using commercially available materials or objects, almost always in identical units or bar forms, such as timber, styrofoam, cement blocks, bales of hay, etc., with only one type of material per work. He considers the setting or placement an essential part of the work, and the form of each piece is largely determined by the space for which it is constructed. "I don't think spaces are that singular; I think there are generic classes of spaces. So its not really a problem where a work is going to be in particular. Its only a problem, in general, of the generic spaces: is it going to be the size of Grand Central Station or is it going to be the size of a small room?"

Equivalent VIII created considerable controversy in London and New York when newspapers ridiculed the Tate Gallery's purchase (the 1966 work had been dismantled; Andre made a new version for the Tate). Although the London *Sunday Times* referred to it as an "insouciant masterpiece," the *Evening Standard* called it a "pile of bricks," and even the venerable *Burlington Magazine* denounced the museum for squandering public monies on something that "might have occurred to any bricklayer." In New York City this writer defended it in a letter to the *New York Times*: "A lot of people find profound meaning in this abstract balance between the spiritual and the material, which manifests harmony, proportion and pure order." As a result of the notoriety, *Equivalent VIII*, of course, became one of the Tate's biggest attractions. Interestingly, Andre's cubical work is in a museum named after Henry Tate, who made his fortune manufacturing cubes of sugar.

Andre's emphasis on horizontality with the floor strikes at the traditional concept of sculpture as a vertical and anthropomorphic form. The artist's arrangement of his designated units were made on an orthogonal grid by mathematical means; and, like scientific and mathematical models, the physical manifestations of concepts and theories are often beautiful objects in themselves. The rectilinear systems of *Equivalent VIII* are vertical and horizontal coordinates which manifest themselves in a commensurable pattern of structural regularity and symmetry.

The correspondence of parts with reference to a median plane has its counterpart on the opposite side of that plane so that the two halves are geometrically related as a body and its mirror image. The Cartesian grid, a system in which we control our immediate environment, is the principle rule of this arranged composition ("arranged" implies a fixed notion to the parts and a pre-conceived idea of the whole). Andre's usual method of cohesion for his forms is inertia and gravity: no mortar or other binding material is used.

For the ancient Greeks, symmetry was first applied to the commensurability of numbers and agreement in dimensions, then to that of parts of sculpture or statues, and soon to the elegance of form in general. Symmetry was considered a "binding together" in a world of mutually related parts of the whole; it presupposed a way in which differences might be preserved yet integrated. Today we tend to regard symmetry as a bilateral arrangement of parts where the whole is divided into a number of identical elements or units which are uniformly distributed around a point, plane or line.

The order which Carl Andre imposes on his materials is not designed to create an art object to be gazed at, so much as to create a set of conditions which generates a perceptual response which we experience as art.

—Martin Ries

Bibliography—

"American Sculpture," special issue of *Artforum* (New York), Summer 1967.
Bourdon, David, *Carl Andre: Sculpture 1959–1977*, New York 1978.
Serota, Nick, *Carl Andre: Sculpture 1959–1978*, exhibition catalogue, London 1978.
Sandler, Irving, *The New York School: The Painters and the Sculptors of the Fifties*, New York 1978.
Januszczak, Waldemar, "Bricklaying with Andre," in *The Guardian* (London), 12 December 1985.

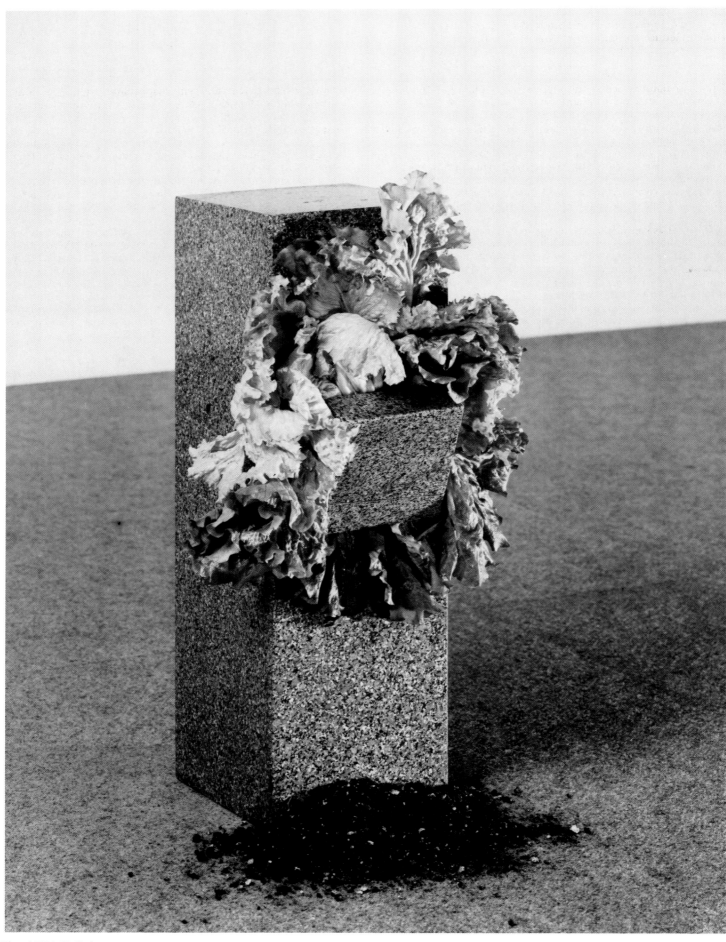

Photo M.N.A.M., Paris

10

Giovanni Anselmo (1934–)
Senza Titolo (Struttura che mangia), 1968–86
Granite, lettuce and copper wire; 70 × 23 × 37 cm.
Paris, Centre Georges Pompidou/Musee National d'Art Moderne

This is a sculpture in a constant process of evolution. A small block of granite is attached to a larger one of the same material by a copper wire. Between the piece of granite and the pillar is a lettuce which, as it wilts, destroys the equilibrium and causes the little block of stone to fall to the ground. The artist has executed a similar work with a piece of meat instead of the lettuce.

Here, Anselmo offsets a durable material which is fundamental to the history of sculpture and statuary against perishable matter. The organic, either animal or vegetable, forms with the mineral a moment of balance which must be re-examined with the passage of time.

The work is conceived as a living organism and with a life-span to match, which is why Alselmo has to recreate it year after year. "I myself, the world, things—we are all full of energy," he has written, "and we should not be trying to crystallise that energy. On the contrary, we must keep it alive and open to change in accordance with the way we live."

This evolving sculpture is a clear example of the poetics introduced by artists of the *Arte povera* movement, of which Anselmo is one of the leading representatives. The movement, which was founded in 1967, affirms the need to achieve a *material reduction* (*poverty*) of the work. But the application of the principle of *reduction* does not lead, as in the case of the American "minimalists," to the creation of *primary* shapes and structures. By the term *reduction* the artists of *Arte povera* mean the ephemeral, the subversive and the evolutionary. As suggested by the title of an exhibition organised in 1969 at the Kunsthalle in Berne by Harald Szeeman, *When Attitudes Become Form*, a "poor" work such as *Sans titre* is an attitude which flows into a form, that is to say an action-installation-happening which encapsulates a particular and unique moment in the psycho-physical energy flow of its creator and of the immediate environment in which he works. The result of the work is the production of the essential "poor" image, of a process, an action as it takes place in space and time.

This item by Giovanni Anselmo epitomises the aims of the artists of the *Arte povera* movement which, inspired by the student revolt of 1968 wanted to re-examine art by focusing less on the "object" than on the "action." Germano Celant, the movement's principal theorist, expounds this desire in a text written in 1968: "Our purpose is to escape the integrity of the 'object' and unleash a process of experimentation with 'happenings' while freeing ourselves from the alienation which the object represents. We must no longer think and stare, perceive and present, feel and at the same time block feeling by materialising it into an object by adding energy to the system. We must take action and get away from that energy, mingle both physically and mentally with reality to the point of complete annihilation."

So *Sans titre* is the tangible expression of a process which the artist can initiate at will. This means evolution rather than repetition. It is the monumentalisation of a series of different stages of evolution where "evolution" is defined as a process of transformation and not one of enrichment. A few "poor" works depend on this same methodology (see the principle of Mario Merz's "suite Fibonacci" or the Giuseppe Penone's "breaths" or even Anselmo's own "twists"). However, the works just quoted are still crystallisations in time and space, while *Sans titre* is a work which must be reactivated as time passes.

The plastic and visual "poverty" exposed to view in *Sans titre* is intended to oblige the viewer to reflect on energy, matter and time.

Thus the work of art is no longer conceived as a conceptual and manual act fixed in time and space in an immutable position. It is intended to be viewed as a living work in a period of gestation.

Giovanni Anselmo lives and works in Turin, the scene at the end of the 'Sixties of the exhibitions which made the greatest contribution to defining this fundamental movement known as *Arte povera*.

—Giovanni Joppolo

Bibliography—

Ammann, Jean-Christophe, *Giovanni Anselmo*, exhibition catalogue, Lucerne 1973.
Ammann, Jean-Christophe, and Fuchs, Rudi, *Giovanni Anselmo*, exhibition catalogue, Basel 1979.
Celant, Germano, ed., *Identite italienne: l'art en Italie depuis 1959*, exhibition catalogue, Paris and Florence 1981.
Celant, Germano, *The Knot: Arte Povera*, Turin 1985.
Page, Suzanne, *Anselmo*, exhibition catalogue, Paris 1985.
Centre Georges Pompidou, *La Collection du Musee National d'Art Moderne*, Paris 1987.

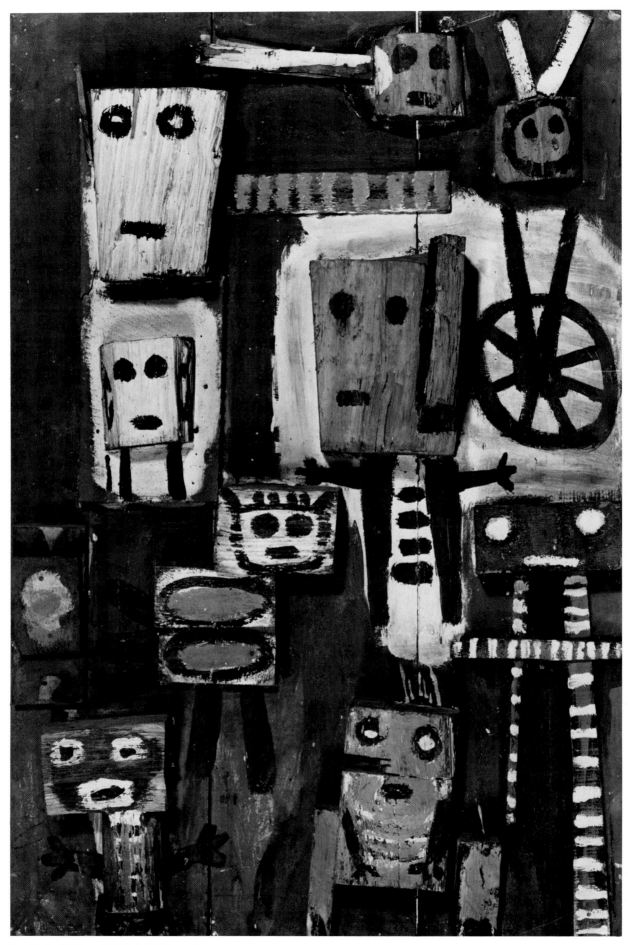

Questioning Children, **1949** (Stedelijk Museum)

Karel Appel (1921–)
Questioning Children 1949
Painted card relief on board; 100 × 60cm.
Amsterdam, Stedelijk Museum

The subject of this painting (what the artist calls one of his 'reliefs') was a recurring version—4 separate pictures in all—from Karel Appel over the period 1948/49. It certainly repeats the theme—always with strong variations but never abandoning the original spirit of the thrusting demand from the faces of the six children.

The first three pictures of the Enquiring Children each have the heads (full-frontal) of these inquisitive minds painted on oblong wooden panels adhering to the painting's surface. The fourth picture, last of the series, has one main difference in that the heads are painted on stiff card instead of wood. All four works were painted when Appel was in his late twenties.

To viewers in general, all those who admire the artist will be conscious of the tremendous resonance that each of the 4 pictures emanates. It is plain enough that these children of unsophisticated ages are making demands for serious response from adults. This particular situation caught the imaginative nature of Karel Appel in magnetic fashion, for if these young people were on the look-out for an extension of understanding at an early age this voyage of discovery has been a vivid symptom, oft repeated, of the artistic career of Appel ever since he became a co-founder of the COBRA Group in 1946.

His attitude is that everything you want to find out means embarking on a cruise (in his case frequently a short one) of experimentation.

Maybe children can learn something from torturing their elders with difficult questions, but for him "answers" only come forward when he has made himself the target of a personal inquisition, creating the previously unthinkable in violently unusual ways and extraordinary employment of materials in pictorial, sculptural or situational fashion.

The second version of this painting has been picked out because the briskness of its dramatic presentation and the way in which each of the children manages to give an individual contribution to the clamour of the enquiry thus underlining Appel's own demand for elucidation of any problem that crosses his path. So, in double fashion, Vragende Kinderen—not only in its title but also in its psychological stance—comes up with the sixty-million-dollar answer sought in the pursuit of knowledge alongside Appel's participation in this quest.

All four versions have been exhibited in a number of important exhibitions including Appel retrospectives, but the second version, apart from appearing at Stockholm's Moderna Museet (1966), the University of Arizona Art Gallery in Tucson, at Vassar College in Poughkeepsie, New York, was also on show at the Winterthur Kunstmuseum. So, what with its permanent place in the Stedelijk Museum, Amsterdam, it clearly substantiates a claim for special consideration.

Viewed in hindsight, this study stays comfortably in the memory. Despite underlying tension of the subject, some time after the first visual impact it is as if every sector of the picture fits happily in its place. The vibrancy of the colours and the extent of the fierce paint do nothing to affront—quite the opposite, it stands out as a fine and far from aggressive confrontation. At a casual glance, what might have betrayed disturbing features, subsequently settles down in the considering mind as a wonderful composition able to encompass drama, interest and aesthetic pleasure mingled in a rewarding experience.

—Sheldon Williams

Bibliography—

Claus, Hugo, *Karel Appel, Painter*, New York 1962.
Nocentini, Armondo, *Opere di Karel Appel*, Florence 1973.
Koster, Nico, and Wingren, Edward, *30 Years of Paintings by Karel Appel*, Venlo 1977.
Frankenstein, Alfred, *Karel Appel*, New York 1980.

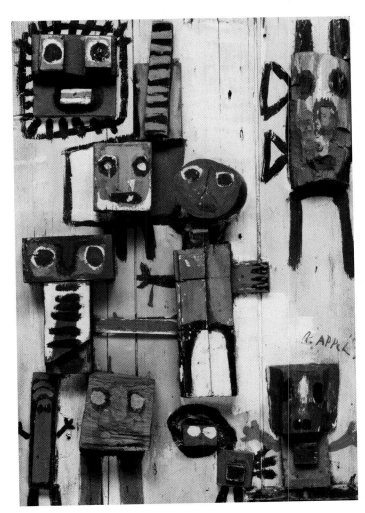

Questioning Children, **1949** (Tate Gallery)

14

Alice Aycock (1946–)
The Thousand and One Nights in the Mansion of Bliss, 1983.
Motorised electrical mixed media installation; 25 × 22 × 90 ft.
New York, private collection

Among the first of the Post-Minimalists was Alice Aycock who rejected Minimalism's art of pure simple forms by creating her Surreal *Low Building with Dirt Roof (for Mary)* (1973) with its overtones of personal narrative. The viewer must bend low to see inside the suffocating, constricted space. The building disturbs, functioning at once as cellar and foundation, as well as roof and attic of the generic houses of childhood.

Aycock's later, pseudo-scientific machines of the late 1970s–1980s employ the strategies of parody and metaphor to bring into focus the limitations of the logical mind. The true subject matter of her eccentric, psychic mechanisms is the playful, yet solemn drama of their own vulnerability. She has said, "I'm not in any way trying to place myself in the position of a scientist or anything like that . . . its more like using science as a muse. So ideas, especially ideas that have been thrown out, like the perpetual motion machine or the ether wind, that are poetic just to think about, become a source of fantasy for me.

Her installation at the Protetch McNeil Gallery in New York, entitled *The Thousand and One Nights in the Mansion of Bliss* (1983), is of interest for synthesizing some of Aycock's earlier concerns while also suggesting some of the directions that her art has taken since. The title contains a reference to mythic literature, as did many of her early works, like *Maze* (1972). *The Thousand and One Nights . . .* was a progression of six discrete sections, each one with its own meaning and resonance, yet acting together in lyrical concourse. Installed in a long, tall, narrow space which it totally filled, *The TONMB* projected some of the same claustrophobic compression of earlier sculptures like *Studies for a Town* (1977), which was inspired by Medieval towns and Egyptian tombs.

The first section of *The TONMB*, "The Glance of Eternity," is horizontal and kinetic, but defined within a framing device. Though the title suggests an old fashioned camera, its motorized saw-blade and pulley, suggestive of potential physical danger, is comparable to *The Machine That Makes the World*, (1979) with its guillotine-like gates. The sharp, curving blades in "The Glance of Eternity" is very close to a similar configuration that dominates ". . . *A Theory of Universal Causality*" (*Time/Creation Machines*) of 1982. Each of these machines embody a psychological "hook." Embedded in so many of Aycock's sculptures from the 1970s, the design components themselves address the viewer's fear of violence.

The second section, "Stars," is a fitting complement to the first, being as passive as the "The Glance of Eternity" is aggressive. "Stars" has an empty row-boat shaped center surrounded by three concentric shapes which perfectly repeat the center, a feminist configuration made popular in the plates of Judy Chicago's *Birthday Party* in the mid-70s. The next three sections, "The Loop, the Loop," "Donkey Kong" and "Quadruple Sommersault" are a sampling of amusement park and video game motifs. Their suspended loops and mid-air assemblies of floating ladders and trusses also suggest the theme of levitation and ecstasy which Aycock had addressed in *The Miraculating Machine, The Charmed Circle* (1981). The inter-penetrating ellipses of the final section of *The Thousand and One Nights . . .* is "The Nets of Solomon" (which also appeared in an installation at the Museum of Contemporary Art in Chicago, 1983). It is roughly based upon the trajectory of comets as they enter the solar system.

The playful sexual dimensions suggested by the interaction of the sections of *The TONMB* cannot be ignored. They complete the variety of delights possible in *The Thousand and One Nights* in Aycock's *Mansion of Bliss*.

The latent sexual and comic aspect of Aycock's work recalls the work of early Dadaists, like Picabia's *Amorous Procession* (1917) or Duchamp's *Bride Stripped Bare by Her Bachelors Even* (1915–23), both of which allude to human sexuality as a non-productive

encounter between machines. Neo-Dadaist Jean Tinguely's wondrous self-destruct machine *Homage to New York* (1960) is also a prototype for that aspect of Aycock's art which parodies the machine aesthetic. On one level the work of both Tinguely and Aycock share the Post-Conceptual Fallacy which celebrates the idea that theories crumble in direct proportion to the stress put upon them. In short, that all systems (and by extension, all machines) are flawed.

More recent sculptures also have comic overtones, like the buoyantly convoluted *Fantasy Sculpture* (wood, stone, steel, copper, Lucite and plaster, $20\frac{1}{2} \times 18 \times 33$ feet) installed at Storm King Art Center for her Retrospective, "Complex Visions" (1990). Painted white with a balcony, railings, picket fences, large rocks and a small tree, *Fantasy Sculpture* cheerfully alludes to horoscopes, astronomical signs, a wheel of chance and the zodiac. Underlying the comic elements of her art, however is the high seriousness that has characterized Aycock's work from its beginnings.

Aycock's work at the end of the 1970s became more expansive on every level, and embraced new materials as well as new subject matter. Her interest in history, myth and literature was joined by her growing concern with mystery and mystics, schizophrenics, ghosts and angels, gravitational pull, dreams, and the invisible forces of the universe. Works dealing with these concerns are usually accompanied by precise drawings and prose fragments, invented or historical, either affixed to the walls or available as gallery handouts. Her interest in psychic expansiveness found expression in some of the most haunting and compelling images of Aycock's career. Her provocative blend of spiritual and scientific imagery began with the series of works entitled *How to Catch and Manufacture Ghosts* (1979–80), and include *Explanation, An, Of Spring and the Weight of Air* (1979), *The Angels Continue Turning the Wheels of the Universe . . .* (1978), and *The Rotary Lightening Express (An Apparatus for Determining the Effects of Mesmerism on Terrestial Currents)* (1980).

As Jonathan Fineberg has noted, it is the processes of thought, hers and those of others, and not her references to history, science or myth, that make up the central subject matter of Aycock's art. Hence her fascination with alphabets, diagrams, hieroglyphs, mantras, maps, mandalas, games, story telling, and amusement parks. She said in 1983, "When we read (James) Joyce, we realize that he did decode a part of the way we think, he gave us access to our own thoughts . . . or the drawings of Leonardo . . . yes, its art, but its also something more . . . an act of decoding."

Alice Aycock is committed to decoding what lies beyond knowing, and her art is the record of her quest.

—Ann Glenn Crowe

Bibliography—

Kuspit, Donald, "Aycock's Dream House," in *Art in America* (New York), September 1980.
Fry, Edward, *Alice Aycock: Projects and Proposals 1979–81*, exhibition catalogue, Tampa 1981.
Fry, Edward, "The Poetic Machines of Alice Aycock," in *Portfolio* (Boulder, Colorado), November/December 1981.
Fox, Howard N., *Metaphor: New Projects by Contemporary Sculptors*, Washington, D.C. 1982.
Graevenitz, Antje von, "Alice Aycock," in *Museumjournaal* (Amsterdam), no.27, 1982.
Osterwold, Tilman, Fineberg, Jonathan, and others, *Alice Aycock: Retrospective of Projects and Ideas 1972–1983*, exhibition catalogue, Stuttgart 1983.
Paurier, Maurice, "The Ghost in the Machine," in *Artsmagazine* (New York), June 1984.
Fox, Howard N., *Avant-Garde in the Eighties*, exhibition catalogue, Los Angeles 1987.
Kimmelman, Michael, "Alice Aycock's Mighty Sculptures," in the *New York Times*, 6 July 1990.

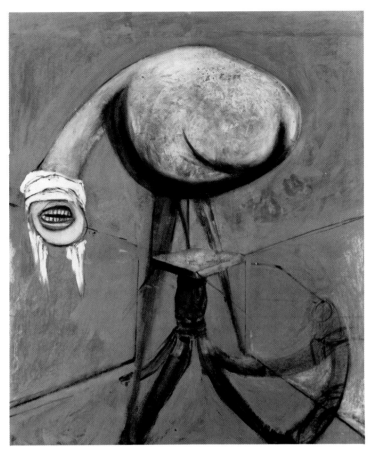

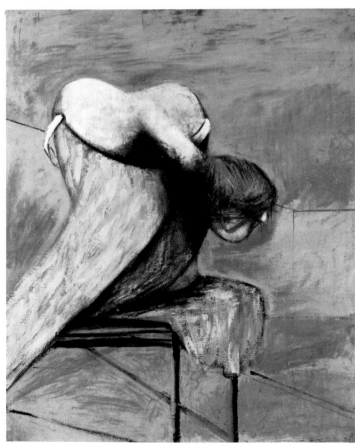

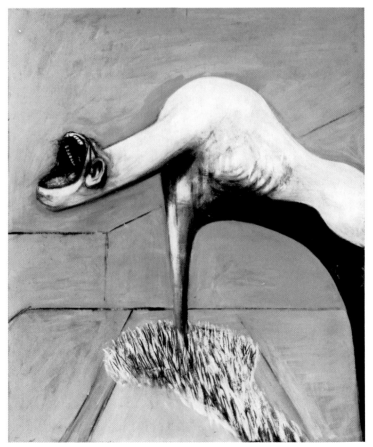

Francis Bacon (1909–)
Three Studies for Figures at the Base of a Crucifixion, 1944
Oil and pastel on hardboard; 37 × 29in. (97 × 74cm.)
London, Tate Gallery

Contemporary reports and subsequent recollections attest to the violence of the impact when Bacon's *Three Studies for Figures at the Base of a Crucifixion* were first exhibited at the Lefevre Gallery in New Bond Street in April 1945. It was not the shock of the new so much as an appalled recognition that this vision could be so expressive of the times, rather than the wistful Neo-Romantic images of a rural English past that had come to predominate in the later years of the war. There was something both unwelcome and inevitable, after the long years of war that were clearly coming to a close, in these terrifying images of creatures that appeared to be the results of genetic experiments that had gone wrong, or of some evolutionary blind-alley that had left them so malformed that they embodied nothing but extremes of pain and fury at their predicament. What added to the impact of these three panels was their formal organisation, the balance and sculptural coherence of these images, as well as the way in which a format which was invariably associated with Christian iconography and a title which referred to the supreme image of that inconography had been violently subverted for quite another purpose, one of utter negation.

The images still retain something of their power to shock, but familiarity and close examination serve to neutralise this, while the erection of a substantial subsequent oeuvre also has the effect of diluting the impact of these images by putting them in the context of variations and developments. The *Three Studies* stand apart from the rest of Bacon's work. They are on panels, rather than on the canvas he uses for almost all his paintings. More than in the case of any subsequent work, the three images are realised in so plastic and sculptural a form that one could in imagination travel right round them (appalling though the idea may be), and, apart from a few passages, they could conceivably be translated into three-dimensional sculptured forms—the strategic ambiguities of modelling and positioning which are so characteristic of Bacon's later work have no place here.

The *Three Studies* are the Opus One of Bacon's officially-recognised oeuvre: he had painted in the 1930s, but later repudiated all this pre-war work as a false start—there are, however, elements in these early works which seem to prefigure the images in the 1944 painting, especially *Crucifixion* (1933), *Abstraction* (c.1936, destroyed—clearly prefiguring the central panel) and *Figure Getting out of a Car* (c.1939–40, abandoned).

Human and animal elements combine in a way that remains disturbing—a head of hair ("the hairstyle of a female jailbird (or jailer)," in Russell's words), an unsymmetrical human mouth, a carefully modelled ear; the stumps of wings, the round body of a plump fowl, a mouth opening so far in a scream as to reduce the upper part of the face to a few small folds of puckered flesh. Russell writes, "Common to all three figures was a mindless voracity, an automatic unregulated gluttony, a ravening undifferentiated capacity for hatred. Each was as if cornered, and only waiting for the chance to drag the observer down to its own level."

The space in which the creatures are contained is unified without forming a continuity—the outer two panels echo one another, while the space of the central panel suggests a dislocation without completely divorcing it from the other two panels. In each case there is an extended, low-ceilinged structure without any door or window, and the obtuse angles of the walls serve to project the figures forward, into our space. The central panel has its own lateral balance, in terms of both the space and the figure which it contains, while elements of the figures in the outer panels echo and balance one another—the two diagonals of necks and bodies, the central vertical pivot on which the weight rests. There are elements of movement across the triptych—one head swoops down, another turns in a sightless snarl, the third lifts up sharply from its lowered neck. The left-hand figure seems to embody a mute despair, the right-hand one an undirected screaming fury, while only the central figure, although sightless, seems to direct the full force of its malice directly at the viewer. The narrow tonal range is likewise unified across the triptych—a livid grey-white for the bodies, a flat red-orange colour for the background, applied most evenly in the right-hand panel, least so in the left-hand one.

In conversation with David Sylvester, Bacon said, "I thought of them as the Eumenides and at the time I saw the whole Crucifixion in which these would be there, instead of the usual figures at the base of the cross. And I was going to put these on an armature around the cross, which itself was going to be raised, and the image on the cross was to be in the centre with these things around it. But I never did that; I just left these as attempts." The Eumenides or Furies appear in the *Oresteia* of Aeschylus, which has remained an important literary source for the artist and to which he returned in 1981 in his *Triptych Inspired by the Oresteia of Aeschylus*. Later, too, Bacon acknowledged that he had had in mind the Erinyes, the "spirits of punishment, avenging wrongs done to kindred, especially murder within the family or clan."

Commentators have often noted the indefinite article that qualifies the word "Crucifixion," as if generalising it away from Calvary and Christian Redemption, and Bacon is careful to emphasise that his interest in the subject is a formal one: "One of the things about the Crucifixion is the very fact that the central figure of Christ is raised into a very pronounced and isolated position, which gives it, from a formal point of view, greater possibilities than having all the different figures placed on the same level. The alteration of level is from my point of view very important." Elsewhere Bacon says, "I've always been very moved by pictures about slaughterhouses and meat, and to me they belong very much to the whole thing of the Crucifixion . . . I know for religious people, for Christians, the Crucifixion has a totally different significance. But as a non-believer, it was just an act of man's behaviour, a way of behaviour to another."

The term "studies" also requires comment, appearing as it does in many of Bacon's titles. Bacon says, "I use the word 'study' because I do not believe paintings are ever finished." The word is indicative more of uncompleted process than of something intendedly preliminary. Although the artist did not complete the full ensemble for which these studies were to be a part, he did return to the imagery of this work 44 years later: in February 1989, *Second Version of Triptych 1944* was exhibited at Marlborough Fine Art, a second version more than twice the size of the original, the red a much darker wine colour, each figure proportionally occupying much less of the surface-area of its panel, with various significant alterations of detail, such as two screws embedded in the flesh of the central turning figure. Richard Dorment commented on this new triptych, "There is something here more deliberate, more chosen and more willed than despair. Something vicious, and purely evil."

One enters this area, however, at one's peril. Bacon vigorously denies that he has ever made any statement in paint about the human condition or about any of the great abstractions one cares to mention: "I'm just trying to make images as accurately off my nervous system as I can. I don't even know what half of them mean." Interpretation is anathema to the artist.

—Krzysztof Z. Cieszkowski

Bibliography—

Trucchi, Lorenza, *Francis Bacon*, Milan 1975, London 1976.
Sylvester, David, *The Brutality of Fact: Interviews with Francis Bacon*, London 1975, 1987.
Russell, John, *Francis Bacon*, London 1971, 1979.
Davies, Hugh M., *Francis Bacon: The Early and Middle Years 1928–1958*, thesis, New York and London 1978.
Dorment, Richard, "Bacon's Changing Monsters," in *Daily Telegraph* (London), 23 February 1989.
Moorhouse, Paul, "The Crucifixion in Bacon's Art: A Magnificent Armature," in *Art International* (Zurich), Autumn 1989.

Georg Baselitz (1938–)
Supper in Dresden, 1983
Oil on canvas; 280 × 450 cm.
London, Saatchi Collection

Georg Baselitz, who today is considered to be amongst the leading German painters, began to develop his own, very personal work in Berlin during the early '60s. This work is still, after various changes, full of expressive immediacy and has a wide spectrum of artistic aspects. His early compositions were determined by an iconography that manifested itself most of all in the treatment of sexual taboos, whereas his themes and motives became more neutral in content after a series of heroic pictures.

During his development, Baselitz used the pretext more and more to accentuate problems primarily to do with painting itself in order to define the pictoral process, to make it visible step by step for the spectator. Baselitz emphasized this priority of formal artistic aspects over content after 1969 in a very distinct way: from this period he depicted all his motives (with the exception of his wooden sculptures) upside down, in order to subvert any superficial view of content, and create a level for spiritual understanding of his work. The painting *Nachtessen in Dresden* is an example of such a rigorous measure in which people gathered, upside-down, around a table. The neglect of spatial components corresponds with a general omission of objects that could resolve the situation more easily.

With the title *Nachtessen in Dresden*, Baselitz gives us a clue that he refers to the group of artists formed in 1905 in Dresden who called themselves *Die Bruecke*. Thus the painter uses this complex composition to pay homage to the expressionists gathered in the painting. Although the figures do not really resemble the individual characters, we can discern who Baselitz is referring to. The figure with the green bottle in front of the torse, the compositional quiet pivot roughly in the center of the picture, represents Karl Schmidt-Rottluff. Left of him, seated on the edge of the table with one arm high, gesticulating, we see Ernst-Ludwig Kirchner, and the figure with two heads on the very right is Erich Heckel and Otto Mueller. It is interesting that Baselitz depicted the Bruecke-artists again in a second, equally monumental format after the completion of his first composition, but this time standing.

The overall concept of the picture is clearly arranged and opposes apparently the subtle approach to the subject in a more indirect than explicit fashion, in order to achieve a visionary intensity of expression. Baselitz's hard, form-conscious articulation conveys a tension and a certain aura around the figures within compositional surroundings that reach the spectator directly with their atmosphere.

The artist achieves this primarily by alternating areas treated with less definition and areas where the single brushstrokes almost feel their way to coalesce into small pictorial entities. The observer can actually relive how the connections in the motive were developed out of the ductus of the brush and crystallized into subject matter. This formal approach reminds us of the artist's working method on his large wooden sculptures which he had been creating since 1979; they are cut and peeled right out of huge trunks by means of an axe or band-saw. The short, dry strokes of the axe correspond to the brushstrokes, shown for example in the two heads at the far right of the painting. The individual brushstrokes remain visible and effective in those faces, just as the crude lines which Baselitz uses to indicate the details of the bodies.

With compositions like *Nachtessen in Dresden* Baselitz does not only refer to German Expressionist painting thematically, but also in his method of painting, and in his conception of figures; with formal simplification which intensifies the expression, he follows their philosophy and practice. Baselitz, however, uses the expressive as a concept, as a means of an artistic strategy. This becomes apparent by the way in which the artist uses his motives merely as vehicles in order to convey a certain degree of abstraction; by reversing them, he is thus able to stress the representation of the medium.

Baselitz and his work have often unjustly been counted amongst the representatives of the Fauves. This assessment does not, however, take into account that the artist had already created varied works before neo-expressive tendencies became influental in the early '80s, and that Baselitz only chose the expressive so as to demonstrate a position for his paintings. His work is much too calculated to be counted amongst the "Young Wild."

—Andreas Franzke

Bibliography—

Fuchs, Rudi, *Georg Baselitz*, exhibition catalogue, Eindhoven 1979.
Gachnang, Johannes, and others, *Georg Baselitz: Biennale di Venezia 1980*, exhibition catalogue, Stuttgart 1980.
Serota, Nicholas, and Calvocoressi, Richard, *Baselitz: Paintings 1960–83*, exhibition catalogue, London 1983.
Ammann, Jean-Christophe, and Calvocoressi, Richard, *Georg Baselitz: Das malerische Wrerk 1960–83, Linolschnitte 1976–79*, exhibition catalogue, Basel 1984.
Royal Academy, *German Art in the 20th Century*, London 1985.
Haenlein, Carl-Albrecht, and others, *Georg Baselitz: Skulpturen und Zeichnungen 1979–1987*, exhibition catalogue, Hannover 1987.
Franzke, Andreas, *Georg Baselitz*, Munich, Paris and Barcelona 1988.

© DACS 1991

Max Beckmann (1884–1950)
Two Spanish Ladies 1939–40
Oil on canvas; 43 × 39.5cm.
Campione, R. N. Ketterer Collection

Max Beckmann was a contemporary of the three famous German Expressionist groups, *Die Brucke, Der Blaue Reiter*, and *Die Neue Sachlichkeit*, and yet he belonged to none of them. As an independent expressionist, a term he often deplored, his work is a kind of summary of expressionism as a style. He was influenced by his study of early Renaissance artists such as Piero Della Francesca and Signorelli in the direction of strong, monumental form, while his admiration of Van Gogh and Cezanne gave his work both intensity and a tendency toward strong outlined structure. Beckmann brought to his work not only monumentality of form but strong social rather than personal symbolism. Thus, he might have said that he wanted to give expressionism the solidity of classic museum works much as Cezanne had said about what he wanted to do for impressionism. His symbolic works usually involve broad, simple forms; the use of serenity in the midst of violence; brilliant colors within dark outlines; and sometimes the triptych concept from the late Gothic and Renaissance which gives his work the scale and monumentality of an altarpiece. He attempted to explain his methods in this way in comments made several years after he completed *The Departure*: "What I want to do in my work is to show the idea hidden behind reality, to penetrate the invisible world by means of the visible (which is the desire of most painters, and especially that of expressionists when the 'invisible world' is one of personal emotion). What helps me most in this penetration is . . . the penetration of space. . . . The expression of space, the organization of space on a two-dimensional canvas, need not imply decorative shallowness any more than it need imply illusions of space. The transformation is for me an experience full of magic in which I glimpse the fourth dimension, (beyond reality) . . . I use color (not only to) enrich the canvas, but to probe more deeply into the object. But . . . I am willing to subordinate color to the treatment of space and form because . . . [they] are the abstractions in which the painter has always spoken the essential truths of human experience."

Max Beckmann was one of the most forceful artists of the first half of the twentieth century—uncompromising and individualistic. Like his physical person which was broad-shouldered, slow-moving, and deliberate,—a person on whom all focused on his entry into a room—his art is steadfast, strong, and constant.

Beckmann was born in Leipzig, the son of a miller. From his earliest years he wanted to be a painter, and in 1900 he entered the Grand Ducal Academy of Art at Weimar. In 1906 he married Minna Tube and studied for a year in Florence during which time he became established as a German impressionist. In 1908 his only son was born. Even before World War I, catastrophe fascinated him in paintings like the sinking of the Titanic and an earthquake in Messina, but during the war, in which he served as a medical orderly, he drew everything, suffered greatly, and in 1915 had a nervous collapse. After the war he was still very depressed and chose to share a studio in Frankfurt-am-Main instead of returning to his wife and son. In 1925 he married Mathilde von Kambach who remained with him through all the difficult times to follow.

Beckmann's work remained bitter and cynical until about 1925, and then became brighter in color and more positive in outlook. But in the early thirties with the rise of Hitler he became both haunted and hunted. In 1932 he completed the triptych, *The Departure*, probably his most famous work, and in it a king and queen depart from contemporary evil framed by side panels of humanity tortured by demons. It was to be a prophetic work. In 1933 he was fired from his teaching post, his paintings were banned,

and in 1937 he slipped over the border to Holland. He remained in Europe throughout the war, and in 1947 accepted a teaching position at Washington University in St. Louis. He also taught at Mills College in Oakland, the University of Colorado in Boulder, and the school of the Brooklyn Museum of Art. He died in New York in 1950.

Beckmann's style, though it changed and developed over the years, was primarily expressionism with structure. He used the real world and fragments of it, and, by compressing and underlining such elements, he created powerful object-symbols. His aim was to use his compressed, structured symbolism to lift momentary events and daily objects to the universal level. Favorite subjects were clowns, women, individuals dressed in costumes, mythology, candles burning and snuffed out, and his own face and form to prove his own existence as in Rembrandt's self-portraits. Beckmann in notes written after he came to America had this to say about his art: "I do not talk to myself of symbolism at all. I am concerned only with the architecture of the painting. The subject is absolutely personal. What I do and help my students to do, is to bring the image to the surface."

In 1939 and 1940, when he was living an almost hidden life in Holland, Beckmann painted *Two Women* or *Two Spanish Ladies*, which amidst the horror of the times contains none of the cruelty and violence so often seen in Beckmann's work. It is a quiet piece filled with mystery and quietude. The work is composed in two dimensions, much flatter than many other Beckmann works, and the equilibrium of the work is realized in the balancing of the two-dimensional areas of the canvas as a whole, rather than the balance between the two female figures. The tablecloth is a mere rectangular grid without perspective, and the lady behind the table is as large as the one in the foreground, so in this two dimensional plan distance means nothing. The lush colors of the work are very satisfying and the balance in color is very carefully planned—as in the yellow flowers against the blue curtain, and in the blue flowerpot against the yellow tablecloth. Also the brownish purple of the right background is repeated in the back of the easy chair to the left, while the black mantilla adds balance to the other woman's deep black dress. In a first version of the work this mantilla is missing, and it is obvious that its addition adds solidity to the composition. Also originally there was a shadowy portrait of the artist in the frame on the table, but in the final version it becomes merely a mirror.

Thus Beckmann is always striving for pictorial cohesiveness and depth, and in the presentation of these ladies we have exotic, quietly beautiful female figures who are mysterious and attractive because we do not know who they are.

As *Time* magazine said in a review of his work on May 6, 1946, "His fiery heavens, icy hells, and bestial men showed why he is called Germany's greatest living artist. . . ."

—Douglas A. Russell

Bibliography—

Beckmann, Max, *Tagebucher 1940–1950*, Munich 1955, Frankfurt 1965.
Selz, Peter, *Max Beckmann*, New York 1964.
Lackner, Stephen, *Max Beckmann: Memories of a Friendship*, Miami 1969.
Fischer, Friedrich W., *Der Maler Max Beckmann*, Cologne 1972, London 1973.
Lackner, Stephen, *Max Beckmann*, New York 1977.

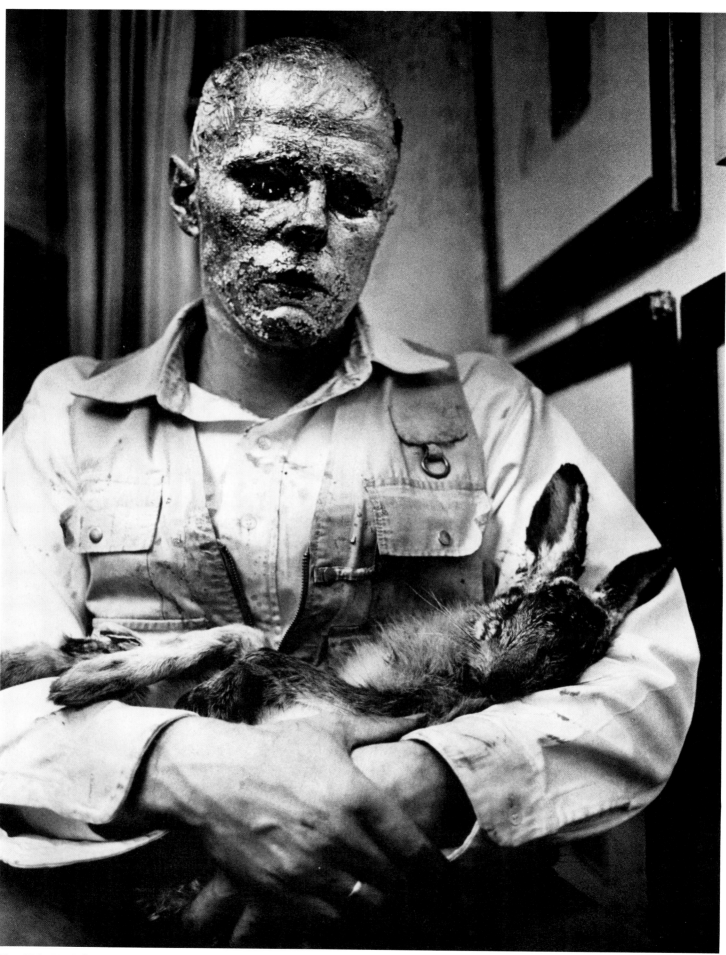

Photo Walter Vogel. © DACS 1991

22

Joseph Beuys (1921–86)
How to Explain Pictures to a Dead Hare, 1965
Performance work, Dusseldorf

The quintessentially "avant-garde" career of the German multi-media artist Joseph Beuys has been generally acknowledged to represent the most significant kind of artistic expression in postwar European culture. His by-now "classic" performance-piece, "*Wie man dem toten Hasen die Bilder erklärt*" (*editio princeps* in 1965), has served art critics as the touchstone of his entire life's work. As a mythic creation of voluminous art criticism (versus art history), Beuys' emblematic persona has previously been formally described or "interpreted," meaning mostly according to the largely subjective responses of an individual writer, usually a journalist. Although the scenario and specific details of Beuys' *How to Explain Pictures to a Dead Hare* are unique unto themselves, nevertheless this particularly well publicized performance "Action" represents wholly characteristic Beuysiana.

In the Schmela Gallery in Düsseldorf, then completely closed to the lay viewing-public, Joseph Beuys, his head covered with a thick application of honey (liberally sprinkled with gold-leaf), spent three hours patiently explaining his art to a very dead bunny reverently cradled in his lap. Reckoned both culturally and historically significant, the art-event was video-taped ("documented") in order to leave a living record to posterity. In interviews published after the fact, Beuys typically accorded sweeping levels of metaphorical significance to his curious zoomorphic and shamanistic manipulations, which, he said, represented: "a complex tableau, about the problem of language and about the problems of thought, of human consciousness and the consciousness of animals. This [dialogue] is placed in an extreme situation because this [hare] is not just an animal, but a *dead* animal. Even this dead animal has a special power to produce. The other question would be, how do plants communicate? . . . The sound of plants is more directed from the outside, while the sound of animals and humans comes from a closed inner system. . . . You could consider the structure of an animal as being like a plant internalized. . . . The hare has a direct relation to birth [and,] for me, the hare is a symbol of the Incarnation. . . . He incarnates himself into the Earth, which is what we human beings can only radically achieve with our thinking: he rubs, pushes, digs himself into *Materia*. Finally, the rabbit penetrates into its laws and, by this work, his thinking is sharpened. . . . In putting honey on my head, I am clearly doing something that has to do with thinking. Human ability is not to produce honey but to think, to produce ideas. In this way, the deathlike character of thinking becomes lifelike again as honey is undoubtedly a living substance. . . . Staying dead, human thinking expresses its lethalness in, for instance, the political and pedagogical fields. . . . This seems to be the *Aktion* that had most captured popular imagination. On one level, this must be because everyone, consciously or unconsciously, recognizes the problem of explaining things, particularly where art and creative work are concerned, or anything else that involves a certain mystery or questioning. . . . Imagination and inspiration, intuition and longing, these all lead people to sense that these other levels must also play a part in understanding. This must be the root of [positive] reactions to this *Aktion*. This why my tecnique has been to try to seek out the energy-points in the human power-field."

The lay person is, of course, completely bewildered by such recondite "explanations" (*Erklärungen*). On the other hand, avid *aficionados* of the latest in avant-garde oracular pronouncements find no problem in digesting all this, even if they, too, can not "explain" its real significance any more coherently to the befuddled bourgeoisie than did the endlessly acclaimed artist. Beuys' shamanistic opus of 1965, and above all its self-generated exegesis, are emblematic of the wholly different trends characterizing art activities after monotonous rhetoric became increasingly attached to the more prestigious kinds of artmaking, a trend beginning in the epoch of the Minimalist manifestos of the mid 1960s. No longer does an "artist" produce art *works*; now, only art "*activities*," mostly verbalized and thus wholly ephemeral, are required for validation of one's creative entitlement.

Instead of *artistes* (in the old, materialist, sense), now we have a plethora of *acteurs*. Since every actor needs an adoring audience, the role of the public—hushed spectators-as-testators—is evermore paramount.

The pseudo-theatrical avant-garde art-event is now a commonplace phenomenon. Joseph Beuys had, however, added a new wrinkle to a typically modernist cultural activity, and performance art is easily traced to Futurist and DaDa roots, before and during World War I. As recently published (1988) research now indicates, the decisive influence upon Beuys' distinctive *Aktionen* was a specific and rather peculiar kind of pseudo-philosophy, "Anthroposophy," expounded in an endless spate of publications written by an Austrian seer, Rudolf Steiner (1861–1925). Beuys openly acknowledged his unblinking allegiance to Steiner's self-described "occultist" beliefs on several occasions; in fact, he said that Steiner was the most significant thinker he had ever studied. Steiner's voluminous publications deal omnivorously with topics as diverse as Education, Religion, Agriculture, the Physical Sciences, Political Science, Poetry, Dance, Theatre, the Visual Arts—all topics of equally fervent interest to Joseph Beuys. In the specific case of Beuys' widely celebrated *Aktionen*, these may all simply be described as representing a revived, or updated, form of Steiner's "*Eurythmie*."

Steiner specifically defined "Eurythmy" (which he appears to have invented in 1912) as, on the one hand, an instrument of "education and healing," and, on the other, "a new art of movement in space, different from anything previously arisen." This kinetic and verbalized kind of proto-performance art is pre-eminently didactic in intention; from it, "there arises visible speech, visible music. . . . Purely eurythmic movements are the truest means of giving outward and visible expressions of all that is contained in the human soul." The real goal is therapeutic and shamanistic: "The curative action of Eurythmy can be effective," Steiner argued, "not only in the sphere of the moral-psychic life but also in the physiological-physical life." As I believe, it was Steiner who first gave us an accurate appraisal of the real significance of Joseph Beuys' uniquely philosophical performance art: "We have to look upon Eurythmy as an art of healing, just as in ancient clairvoyant times, when it was known that certain sounds, uttered with a special intonation, reacted upon the health of man. . . . In this sphere, everything intellectualistic is positively harmful. Eurythmy is, and must remain, an art."

Finally, according to another one of Rudolf Steiner's typically sweeping conclusions, "*The task of art is to carry the spiritual-divine life into the earthly*." Beuys first encountered Steiner's writings even before his harrowing military service during World War II, and these became the often-wounded, ex-Luftwaffe pilot's principal philosophical writs in the material and spiritual desert of the grim postwar years in Germany. In short, in this precarious and often dangerous cultural context, so vastly different from the materially comfortable roots of future American performance artists, Beuys and many other Europeans were able to derive necessary spiritual sustenance from esoteric writings that might appear merely lunatic to others. Likewise, as the writ appears in the art critics' hagiography, Joseph Beuys' uniquely shamanistic and expressly un-"intellectualistic" performance art—and just as Steiner foresaw—"is, and must remain, an art."

—John F. Moffitt

Bibliography—

Tisdall, Caroline, *Joseph Beuys*, London 1979.
McDermott, R. A., ed., *The Essential Steiner: Basic Writings of Rudolf Steiner*, New York 1984.
Adriani, G., Konnertz, W., and Thomas, K., *Joseph Beuys: Leben und Werk*, Cologne 1986.
Moffitt, John F., *Occultism in Avant-Garde Art: The Case of Joseph Beuys*, Ann Arbor 1988.

Photo courtesy Edward Totah Gallery, London

Alighiero Boetti (1940–)
Tutto quattro lati, 1988
Embroidery on canvas; 105 × 99cm.
London, Edward Totah Gallery

Boetti's work has always been concerned with the demythification of the work of art and of the role of the artist. His first attack on this myth has been that perpetrated against the concept of oneness. Boetti makes himself into a dual personality by signing himself Alighiero *e (ie and)* Boetti. He produces a series of works, or rather a series of propositions, which question the whole idea of individuality. In not executing the work single-handed the artist is deprived of his role of creator. He becomes a reference point, a coordinator, rather than an originator. The work is produced through a combined effort, rather than through the industry of a single artist, and this multiplicity is intrinsic to the finished product. Alighiero e Boetti drafts a project, a "design" (in Italian this term refers both to the design itself and to the process of mental planning, the mere intention to execute a work . . .) which is then carried out by a collective of unidentified workers.

Craftsmen, assistants and other collaborators who successively take their turn in the studio can oversee the project as it takes shape. Based on rudimentary rules, the project itself emerges as something neutral. Since it cannot be recognised as the work of a particular hand, the identity of the artist is lost amidst the multitude of anonymous hands which add tiny but continuous variations. This procedure so devoid of egocentricity (or at least far less egocentricity than is usual in the execution of a work of art) is most clearly evident in Boetti's tapestries, created over a number of years. The plurality, which runs counter to the notion of individuality, applies not only to the artist. In merging his creativity into the anonymous mass, he is ironically carrying out his own execution. At the same time the work is deprived of individuality. There are no "single pieces" in the work of Boetti, just simple, inoffensive multiples. We see here something more ambiguous, a series of works conceived in thematic cycles in a disjointed and unpredictable combination of novelty and tried and tested ideas. *Tutto Quattro Lati*, one of the most recent works, alludes to other tapestries executed in the early 1970s. The wording, laid out in a square format, is a collection of coloured letters which have the sense of a phrase, except that they have to be read from vertically rather than horizontally. *Mappe* is a cartographic representation of the world where each country is represented only by its national flag. The *Pack* series dating from 1975, a series of "abstract" tapestries, constructed from a mass of figures, each defined by the surroundings of the other, is the direct antecedent of the most recent *Tutto* series. The title of this series may be purely ironic but nonetheless paradoxically literal. The tapestries are composed of a mass of figurative elements crowded so close together that each element is a condition of the visibility of its nearest neighbour. Figurines in silhouette, letters of the alphabet, numbers, logos jostle one another for a place in the design. Here is the epitome of the meaning of the word "tutto" (everything), of the very totality of all that can be seen and all that can be named. It is a bewildering idea, like the work which is its incarnation, a genuine fragment of infinity, joyous but at the same time profound. It is an idea which in itself leads to knowledge. Each figurine, number or piece of writing is perfectly legible on all the four sides offered to the eyes of the viewer. The tapestry can be hung according to taste, giving infinite possibilities of learning. Boetti's art, anarchic though it may appear, is in fact based upon precise, rational and recognisable rules of growth, progression and development. However, these rules are themselves an anomaly—an anomaly that is an intrinsic element of a defined complexity. As such, it possesses its own internal microsystem which can become volatile and set up a series of internal disturbances which in turn destroy the system. Boetti's systems are not explosions such as accompany a catastrophic event but implosions, like those experienced by a country after the violent overthrow of its ruler. No matter that the rules are confirmed by the fact that they have been broken. What matters is that they are broken, and broken deliberately.

—Giorgio Verzotti

Bibliography—

Ammann, Jean-Christophe, *Alighiero E. Boetti*, exhibition catalogue, Lucerne 1974.
Boetti, Alighiero, *Alighiero & Boetti*, Milan 1979.
Boetto, Alberto, *Boetti*, exhibition catalogue, Ravenna 1984.
Tosi, Barbara, ed., *Roma in cornice*, Rome 1987.
Magnani, Gregorio, "Alighiero Boetti," in *Flash Art* (Milan), October 1987.

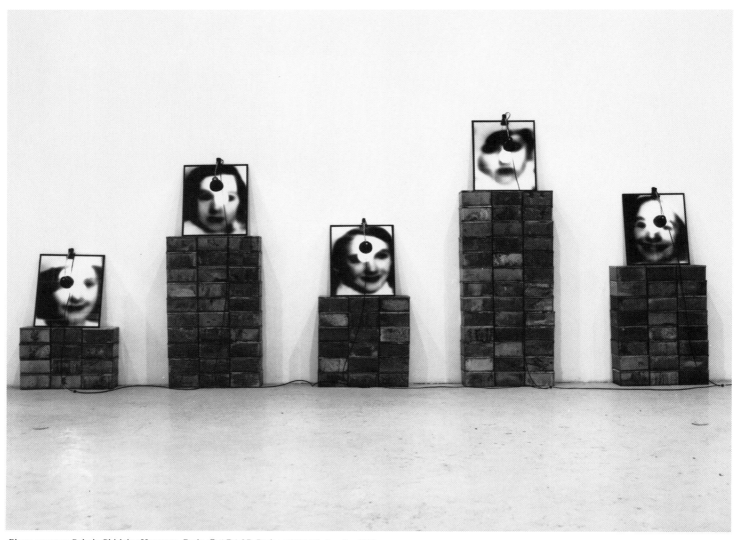

Photo courtesy Galerie Ghislaine Hussenot, Paris. © ADAGP, Paris and DACS, London 1991

Christian Boltanski (1944–)
Monument: La Fete de Pourim, 1989–90
Photographs, metal, and light installation; 220 × 540 × 23cm.

Boltanski's *oeuvre* is interrelated, and the *Monument* series has clear links with such earlier works as the *Lycée Chases* (The Chases School) series of altarpiece constructions of the earlier 'eighties. Both series use themes essential to Boltanski's art, that of "lost" lives or childhood states, the transience of life and the inevitability of death. Both series, in common with all Boltanski's work demand a great deal from the viewer. The two series also have in common the materials of their construction, most notably the use of enlarged photographs of anonymous faces.

Although Boltanski was born only a year before the ending of the Second World War, the experience of war and its aftermath underpins all his work. In their very titles the *Monuments* series indeed recall memorial sculpture of a type common in towns and villages throughout Europe erected after both First and Second World Wars to the "Unknown" soldier and focus of ritualised public commemoration each year. However, Boltanski's monuments are impermanent constructions, their perishability and method of making evident at first sight. The black and white photographs in their tin frames and the tangle of wires attached to the light bulbs used to illuminate the enlarged close-up photographs of anonymous children's faces have a haunting theatricality, a theatricality enhanced by the darkened atmosphere in which they are most effectively displayed. Boltanski has made frequent parallels between art and both magic and religion: his concurrent or "Les Ombres" (Shadows) series make extraordinary use of minute skeletal shadow puppets cut from copper lit by flickering candles (or stronger light sources) in an otherwise darkened room.

For the cover of his first book *Recherche et Presentation*, Boltanski used a school photograph of himself and his class when he was seven. He explains, "of all these children... I don't remember the names of any of them. I don't remember anything more than the faces in the photograph. It could be said that they disappeared from my memory, that this period of time was dead, because these children have become adults about whom I know nothing. It's for this reason that I felt the need to pay homage to those "dead," who in their image more or less resemble each other, like all cadavers." This idea persists through several Boltanski installations, notably the *Lycée Chases* (the Chases School) and the *Monument* series. The *Lycée Chases* series used a class photograph of Jewish children at a Viennese school in 1931. Boltanski rephotographed and enlarged each face to a degree which strips it of its individuality and subjected each face to harsh inquisitorial light

emotively evocative of the Nazis' treatment of the Jews. The *Monument* series uses a similar technique although the photographs, similarly displayed, are of anonymous faces photographically reproduced on shiny metallic papers, and enlarged to such a degree that they appear skeletal, even ghostly, particularly in the harsh light of the desk lamp that illuminates each of them. Lights and tangles of wires were also a feature of the *Monument: Les Enfants de Dijon*, 1986. In this work, as shown in Le Consortium, Dijon in 1986, some fifty black and white photographs were installed with one hundred and fifty lights in front of them like reliquary lights.

Monument: la Fête de Pourim (The Purim Festival) is again based upon a children's group portrait, in this case of a group of children in fancy dress at a Paris school in 1939, the first year of World War II. The rusting tin biscuit boxes which form the base of the installation are of the kind used by children to store small treasured objects. The boxes, which Boltanski has used in several installations of the eighties, are also reminiscent of document storage boxes. Here, as if to emphasise their reliquary aspect, they contain tiny fragments of cloth, further evoking associations of archival records of lost lives around the Second World War period. These fragments have no meaning in themselves, once separated from their one-time wearers, but their unseen presence adds another dimension to an already challenging work.

As with other Boltanski installations, the effect of *Monument* on the viewer is disturbing. Not the least disturbing aspect is that the glare of the desk lamps which might be expected to illuminate the images and our understanding of them serve further to obstruct them. Boltanski groups his *Monuments*, together with the *Lycée Chases* series under the collective title *Leçons de Ténèbres* (Lessons of Darkness) a title which evokes both the child's experience of the classroom and of the "night" of the dark side of human nature.

—Doreen Ehrlich

Bibliography—

Bozo, Dominique, and others, *Christian Boltanski*, exhibition catalogue, Paris 1984.
Jacob, Mary Jane, and Gumpert, Lynn, *Christian Boltanski: Lessons of Darkness*, exhibition catalogue, Chicago 1988.
Semin, D., ed., *Christian Boltanski*, Paris 1988.
Gumpert, Lynn, and others, *Christian Boltanski: Reconstitution*, exhibition catalogue, London 1990.

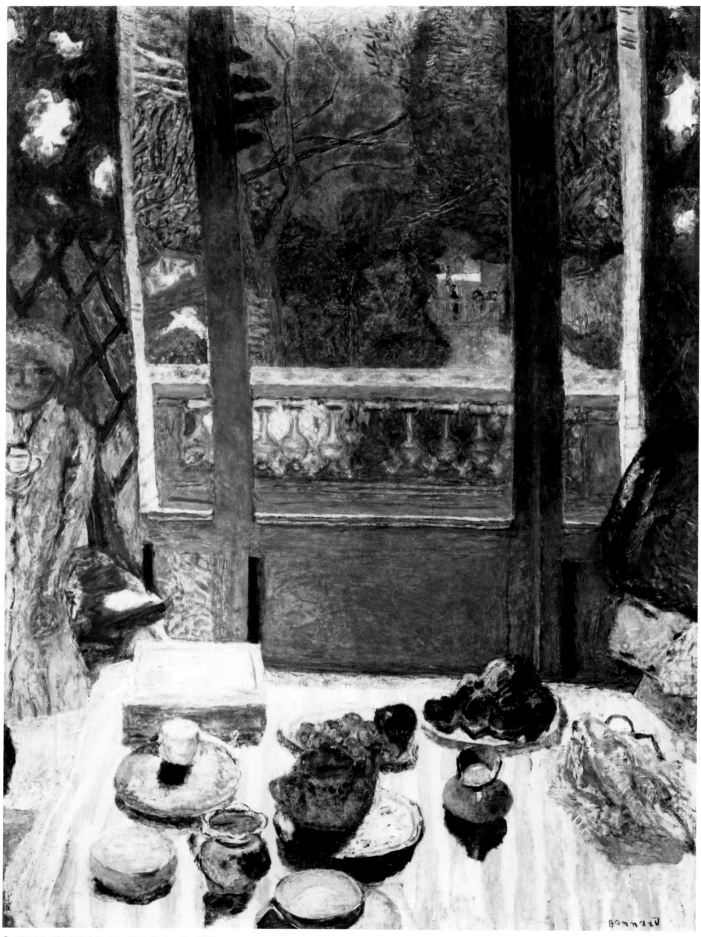

© ADAGP/SPADEM, Paris and DACS, London 1991

Pierre Bonnard (1867–1947)
The Breakfast Room, c. 1930–31
Oil on canvas; 62⅞ × 44⅞ in. (159.6 × 113.8 cm.)
New York, Museum of Modern Art

As often in his paintings, Pierre Bonnard found the subject matter of *The Breakfast Room* in his immediate surroundings. This time he preoccupied himself with a table, a chair, some coffee cups, a window—a room of his house with a view at a garden. That was pretext enough. It is one of the many *salles à manger* Bonnard painted during his life. His journey into his own intimate surroundings seemed to be endless.

The image is flat. Even the look outside through the room's "French windows" does not give the illusion of a real view into the distance. For that matter, the garden looks more like a multi-coloured tapestry hung behind a wooden framework. The door posts have become bars of colour themselves wherein orange is solved upwards into pink. The objects on the table are scarcely recognizable as such; first they are colour stains. At the left, a volumeless figure of a woman or a child—one often sees in Bonnard's paintings—is indicated in scribbles of paint, more groping than defining.

It is hard to say if Bonnard tried to grasp the ever-changing reflections of light or the never-fixed outlines of objects met by the human eye. Or, more likely, that he only was concerned with a sort of musical atmosphere that can be evoked by the things of nature. Whatever it may be, Bonnard had to cope above all with countless different problems when it came to painting those phenomena. In doing this, he used the loose brush strokes which are typical for a sketch. In *The Breakfast Room* this ultimately led to an monumental overall patchwork of strokes that least of all can be called a sketch.

By those results, one often has considered Bonnard as a late impressionist who continued far into this century the tradition of an art movement that flowered in the nineteenth. In some aspects, Bonnard is a late impressionist indeed, for instance in his enduring interest in the vibrating aspects of the visual world. He definitely is not a follower because he lacks the basically naturalistic attitude of the "old" impressionists. If Bonnard ressembles for instance Claude Monet (1840–1926), it is for a rather superficial feature. Like Monet in his late paintings of water-lilies, Bonnard (who actually was acquainted with Monet) did not seem interested in solid form. All forms are dissolved. Of the figure at the left is nothing left but a gaze.

However, for Bonnard the goal of painting was never the hasty—as if running against time—portrayal of a fragment of nature. For Bonnard the *motif* was, as in music, an occasion to play with. By encircling movements and repetitions, he painted something what can be considered as the equivalent in paint of a melody.

A reaction against impressionism marks Bonnard's beginnings as a painter. As the son of a French cabinet minister, he first studied law. Then, after changing a safe future for an uncertain painting career, he became during the last decade of the nineteenth century engaged in the so-called Nabi-group. For the "Nabis," like Maurice Denis, Paul Sérusier, Felix Vallotton and Edouard Vuillard, the paintings of, above all, Paul Gauguin were of ultimate importance. Colour achieved here its own a-naturalist, symbolical value. Together with Cézanne and Van Gogh, Gauguin belongs among those artists who tried to overcome the naturalist "superficial" attitude of the first generation impressionists.

At the end of the nineteenth century Bonnard, who was also influenced by the art of Toulouse Lautrec and the Japanese print, had already a name as a graphic artist and soon thereafter he was also a reknowned painter. Though his works at that time, including his paintings, show certain similarities with his admired examples, the decorative style he then developed is definitely his own. Together with his life-long friend Vuillard, he gave in painting an answer to a style that is mainly known form the applied arts—Art Nouveau.

Something of this background can still be seen in *The Breakfast Room* that belongs to his second and last period. When he made this painting he was about sixty-four and world famous. Modern, twentieth-century movements like cubism or surrealism had not touched him. Not only because he was rather old and settled, but also because he could not bring those art movements into accordance with his own artistic goals and interests. He did not change or expand but deepened his artistic search.

Perhaps the biggest revolution in his work was brought about by his personal rediscovery of painting *en plein air* in the South of France where he owned a villa. The southern sun gave him new impulses. To his preference for the most exquisite hues of colour was added now an interest in the flickering lights caused by sun rays, often filtered into the shades of a room. Those untouchable elements perceived by his eyes and represented by his virtuoso painterly technique constitute the atmosphere of *The Breakfast Room*—a peaceful day with fine weather everybody can remember.

—Jan van Geest

Bibliography—

Rewald, John, *Pierre Bonnard*, New York 1949.
Terrasse, Antoine, *Bonnard*, Geneva 1964.
Vaillant, Annette, *Bonnard*, Neuchatel 1965.
Fermighier, Andre, *Bonnard*, New York 1969.
Dauberville, Jean and Henry, *Bonnard: Catalogue Raisonne de l'Oeuvre Peint*, 4 vols., Paris 1965–74.
Galerie des Beaux-Arts, *Hommage a Bonnard*, Bordeaux 1986.

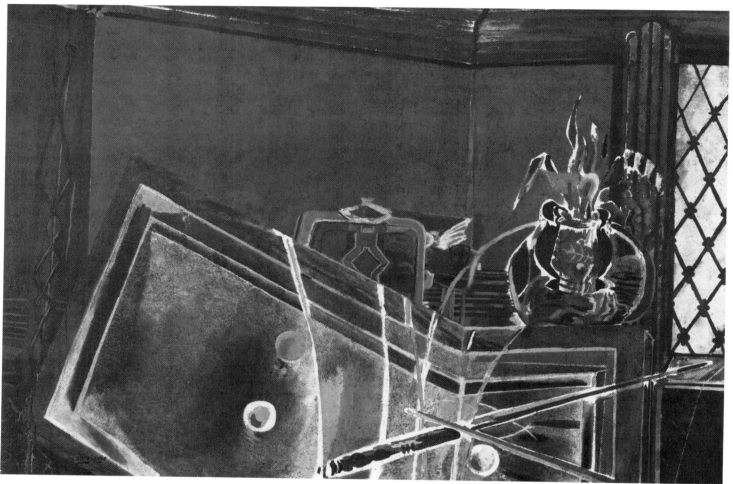

Photo M.N.A.M., Paris. © ADAGP, Paris and DACS, London 1991

Georges Braque (1882–1963)
Le Billard, 1944
Oil and sand on canvas; 130.5 × 195.5cm.
Paris, Musee National d'Art Moderne

Le Billard marks the completion of Braque's research and concentrates the essential qualities of all his painting.

As far back as 1908, 36 years earlier, at the time of Braque's first solo exhibition (Galerie Kahnweiler) which caused a scandal with the first cubist paintings, Guillaume Apollinaire was struck by the "Frenchness" of his style: moderate and well-balanced like Poussin, Chardin and Cézanne. After the cubist experiment, he did not try to take the "visible" apart again, but concentrated instead on its geometric and rhythmic reconstruction.

Apollinaire had realised the importance of what Braque was already foretelling: "his mind had voluntarily precipitated the twilight of reality and now a universal renaissance was developing from the point of view of form both within him and without him." This renaissance in and through painting was achieved during the Forties. In the middle of the war, shut away in his studio in the Parc Montsouris, Braque painted small, very bare, pictures, often of the simple food of this time of shortages. Also from this period was a symbolic painting *La Patience* (1942, private collection, Lausanne) which represents a thoughtful young woman playing cards alone, in a complex composition incorporating both the surrounding objects and the figure. The formal solutions which developed after the Liberation were already apparent.

From 1944, Braque's work was dominated by interiors which allowed him to introduce a new dynamic concept of the form in space and to assert the extreme coherence of his pictorial intentions. He started seven canvasses on the theme of the Billiard Table. The three most important are the first (1944) notable for the strange oblique view of the billiard table, the one in the Gelman collection in Mexico City (1945) and finally the last one (1949) currently hanging in the Museum of Caracas, arranged round a large horizontal with a remarkable lyrical intensity.

The first one, *Le Billard* (oil and sand on canvas), acquired by the French nation in 1946, is one of Braque's most outstanding works of art. This painting, which is quite large when compared with the painter's usual format (he had a horror of anything spectacular), is striking because of a disturbing and powerful imbalance. Braque is understood to have said: "what good is art if it does not disturb one?"—he is here in perfect harmony with his research carried out over a period of forty years. With remarkable inventiveness he exploits the partial or deformed views the player might have of the billiard table as he leans over the green baize.

The bold upward oblique line of the billiard table brings the top of it closer to the spectator's eye. This innovation can be understood by Braque's words in an art review of 1949, in which he said he intended "to suppress infinity" in his pictures.

Having abandoned the vanishing point as such, he set himself to "bring the picture closer to the spectator." From the point of view of colour, the picture is wonderfully composed, using ochres and browns, tobacco, walnut and buff (the artist's favourite shades) which bring out the greens and whites of the billiard table which are themselves punctuated by touches of red. Braque condenses his vision using lines, incisions and divisions which led people to compare this painting to the folds in newly formed land. Braque here uses his familiar technique of outlining objects in white (the vase of flowers, the pedestal table and the billiard cues) which detaches them from the background without actually breaking the union between volume and colour.

In this picture, Braque did not paint "things" but "between things." The work is broken into two parts following the angle of the walls, but no feeling of depth as such is created: on the contrary. The general "flattening" which Braque created leads to an almost abstract "frontality," even if each object is clearly identifiable and the colours are chosen with great care from the point of view of realism. Despite the extreme distortion of the billiard table, the picture emanates order and harmony: according to the poet Francis Ponge, there is something "magical" about it: "and who does not see that in Braque's last paintings, *Le Billard* for example, the magic touch has worked, far more commendably in fact, than in the collages" (*L'Atelier contemporain*, Paris, Gallimard, 1977, p.65).

Le Billard of 1944 won Braque first prize in the foreign painting category at the XXIVth Venice Biennale in 1948. After this, the artist did not paint anything of equal importance, except the ceiling of the Henry II room in the Louvre (1949–51). *Le Billard* is undoubtedly the last great *still life* in the history of art. If one excludes Morandi (whose work has often, significantly, been called "provincial" by the critics) and Picasso, of course, who handled all styles, no single artist of stature in Braque's lifetime, attempted still life on a long term basis.

After Braque (died 1963), painters on the whole gave up painting at the easel and those who stayed faithful to it, such as Francis Bacon or Balthus, put aside still life in preference for the figure which gave them the opportunity to tackle images of the human condition, eroticism, etc.

By looking at the example of *Le Billard*, contemporary painters would be forced to reflect on the fact that the great works of art are those in which the creative power of the mind has structured space, thus creating a superior reality: the essence of the spirit itself and therefore stronger than plain reality.

—Jean-Luc Chalumeau

Bibliography—

Cooper, Douglas, *Braque: Paintings 1909–1947*, London 1948.
Mangin, N., *Catalogue de l'Oeuvre de Georges Braque*, Paris 1960.
Masini, Lara Vinci, *Georges Braque*, Florence 1969.
Carra, M., and Valsecchi, M., *L'Opera Completa di Braque*, Milan 1971.
Oeuvres de Georges Braque (1882–1963), exhibition catalogue, Paris 1982.

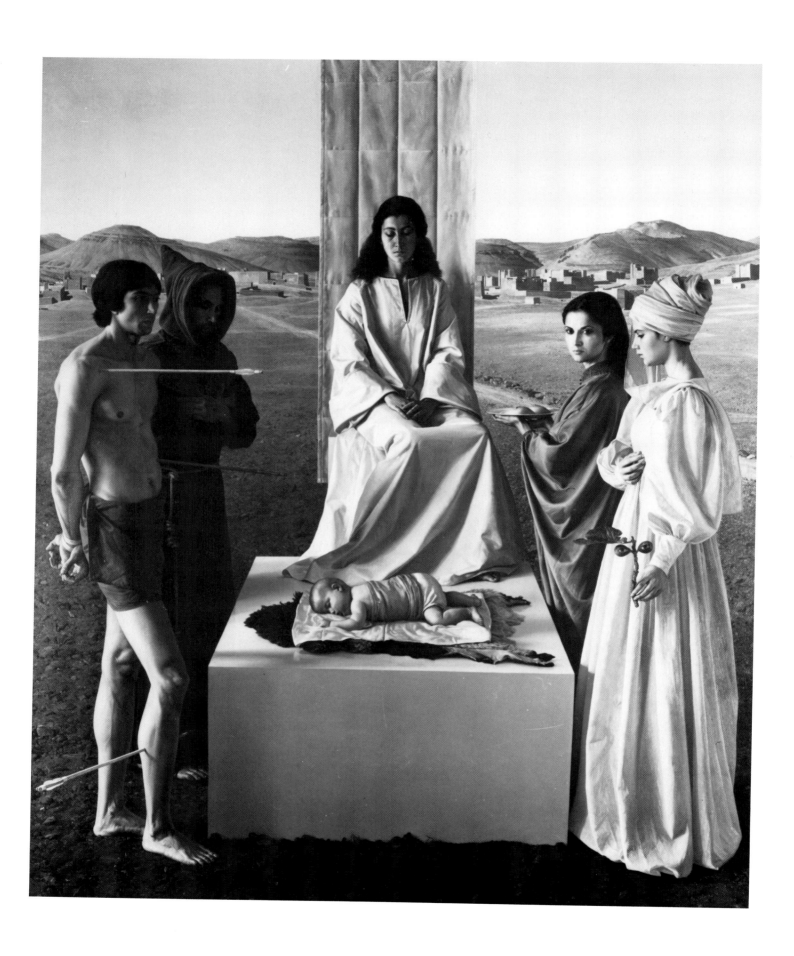

Claudio Bravo (1936–)
Madonna, 1979–80
Oil on canvas; 200 × 240cm.
Mainz, Landesmuseum

Post-war realist painting challenges comparison, not so much with the perceived world, as with our expectations of what painting is and what it ought to be. The question is not how well or badly it is done, but that it is done at all. Critical strategies question motivation, search out deeper conceptual programmes, and avoid the simplest, most direct explanation—the pleasure of imitating the perceived world, of ordering it and controlling it through this mimetic process.

Madonna takes the form of a large-scale altarpiece in the manner of a *sacra conversazione*. Initiated in the early 15th century by Domenico Veneziano, Filippo Lippi and Fra Angelico, this genre attempted to transform the formal, hieratic conventions of the gothic altarpiece into a more immediate, more naturalistic mode, by bringing together the figures represented (usually the Madonna and Child flanked by saints) and positioning them in a unified, coherent space. As well as replacing the flat gold background of the earlier genre with (usually) a naturalistic landscape and moving the individual figures out of their separate panels or compartments, the *sacra conversazione* developed a greater human intimacy by linking the figures together through gesture, pose and attitude—hands gesture towards the Madonna and Child, saints visibly respond to one another's presence, and, often, by making direct eye-contact with the viewer, establish a much more personal relationship between the figures represented and the spectator for whose benefit they are displayed.

All this is true of Bravo's painting. The Madonna sits enthroned in white before the cloth-of-honour which emphasises her high status, raised up on a plain white pedestal, and the Child lies asleep at her feet in an ungainly naturalistic pose. Four saints flank the seated Madonna, identifiable by their conventional attributes. St. Sebastian is pierced by three arrows—an officer in Diocletian's Praetorian guard, he was ordered to be shot to death with arrows and, left for dead, was nursed back to health by the widow Irene; captured again, he was beaten to death with clubs, and his body thrown into the Cloaca Maxima. St. Francis of Assisi bears the stigmata on his hands. The 3rd century virgin martyr St. Agatha was a Sicilian of noble birth, who rejected the Roman governor as suitor, was thrown into a brothel, and subjected to various tortures including the amputation of her breasts, and is usually depicted holding a dish on which these are displayed. St. Lucy, of Syracuse, was another high-born virgin martyr who suffered torture after rejecting a suitor, who denounced her as a Christian to the Emperor Diocletian; although her torments included the use of boiling oil and molten lead, and the amputation of her breasts, her conventional attribute refers to self-inflicted torment: because her unwelcome suitor constantly praised the beauty of her eyes, she plucked them out and sent them to him, and so is depicted with her eyes either on a dish, or sprouting like flowers from a stalk in her hand.

The figures stand in a unified space, against a desert background—the artist identifies this as the village of Imilchil in the High Atlas mountains, and points out that at a *moussem* or festival each September a marriage market is held in this village at which local women are able to choose their own husbands, just as the Virgin Mary chose St. Joseph for her husband. The painting was executed in Tangier, where the artist has lived since 1972.

Such background information would suffice for a Renaissance altarpiece: one would identify the attributes of the figures represented and establish an iconographic programme that includes them, one would identify indications of the likely setting, the pattern of patronage that operated, the likely destination of the painting, before going on to consider matters of execution, modelling, likely precedents and possible innovative elements. But this painting was produced in 1979–80 and not intended for the pious contemplation and spiritual edification of a religiously-motivated audience—in fact it has entered the collection of a major German museum, and so has by-passed assuming any more tangible and practical role than that of museum-exhibit. There is no reason to assume that this "altarpiece" was ever intended for the altar of a church: rather, the painter has taken the form and conventions of the *sacra conversazione* and produced a modern replica.

When one looks again at the figures depicted, though, they uniformly fail to convince—at any rate, if one is expecting the dignity and self-absorption of saints. Sebastian stands in a loose, rather uneasy pose, the arrows carried as if cosmetically applied; the monastic garb of St. Francis is constructed out of two Moroccan *djellabas*; the two female saints are young and pretty, and, confronted with such pleasing images, the details of the saints' martyrdoms seem merely pornographic. Only the model posed as the Virgin Mary has something of the dignity and the presence of her original, and the leftward sway of her knees, while subverting the hieratic frontal pose she assumes, adds to the sense of her humanity—similarly the sprawling pose of the sleeping Child is that of a real baby.

Bravo's painting represents, not so much the saints themselves, as ordinary people, models, who have dressed up and assumed the poses and attributes of these saints. The figure on the left is not St. Sebastian, but a slightly embarrassed young man asked to take up the pose of the saint. St. Francis's features are Moroccan rather than Umbrian. Although the woman dressed in blue makes eye-contact with us and so draws us into the picture, in her hands the saint's attributes become faintly ridiculous—jelly or blancmange on a dish. St. Lucy stands awkward and rather swamped by all the material she has been asked to wear.

And yet the painting has captured a kind of peace, a cool elegance that derives from the balanced composition, the coherence of the spatial disposition of figures and setting, the strong sense of air and light, the freshness of the colours of the fabrics depicted, the sense of unbroken distance and space, the youthfulness and presence of the models themselves. The painting never served the function of an altarpiece, but if it had done, the feelings and emotions it would have inspired would surely not have been entirely spiritual.

Claudio Bravo's paintings impress with the mastery of their technique, the cool elegance of their colouring, the wash of air and light that almost invariably pervades them. Ordinary people and banal objects are endowed with a great and mysterious clarity, as if the spectator were confronting them in a heightened state of awareness. They draw on, and belong to, a weighty tradition of figurative representation, and carry echoes of that tradition, reinterpreting established and venerable genres in a fresh and vibrant manner. Objects are arrayed on tables, models are caught in frozen momentary poses, there are echoes of Velasquez and Poussin, Caravaggio and Dutch domestic interiors, but always there is a stillness, an apartness from the world. Shadows are reduced to a minimum and serve only to define form, never to obscure it, the light is always pervasive and cool, and the textures of fabric and wood and stone are very tangible, very immediate.

Our expectations regarding realist painting are generally too timid and too circumscribed, too frequently defensive in the face of a 20th century orthodoxy that relegates representation to the merely photographic. Excellence of technique, an ability to realise images of the visible world and to hold them up to our scrutiny, an individual vision of an entire tradition transplanted into the clear air and pervasive light of Morocco—these too have a place.

—Krzysztof Z. Cieszkowski

Bibliography—

Moffett, Charles S., "On Claudio Bravo's realism, 1971–1973," in *Art International*(Lugano), 15 September 1975.
Sullivan, Edward J., *Claudio Bravo*, New York 1985.
Sullivan, Edward J., *Claudio Bravo: Painter and Draftsman*, exhibition catalogue, Madison, Wisconsin 1987.

LIBRARY
COLBY-SAWYER COLLEGE
NEW LONDON, NH 03257

108817

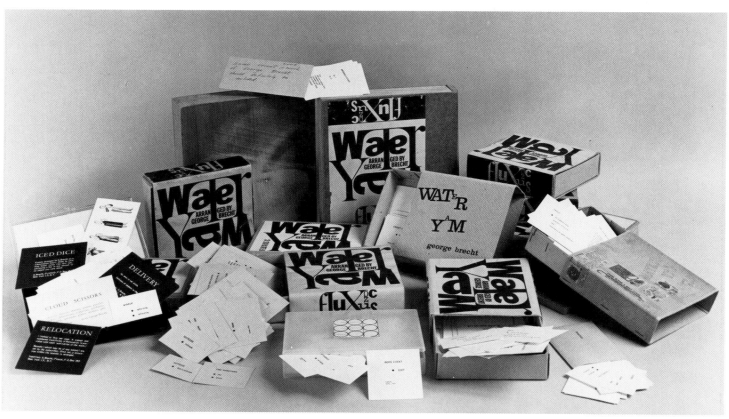

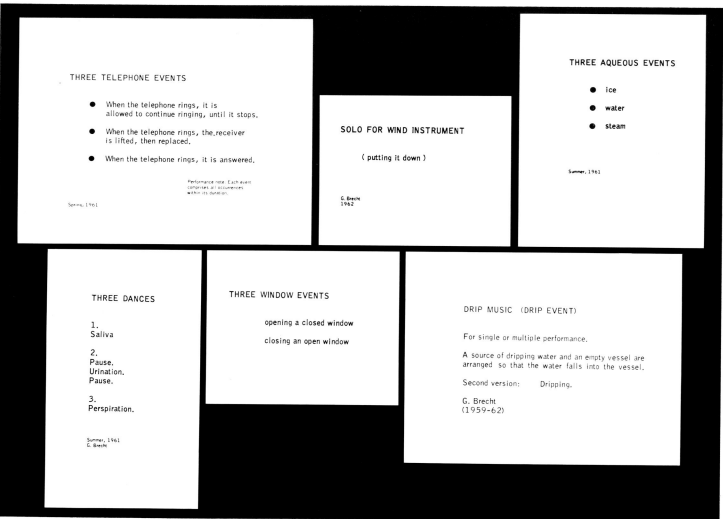

THREE TELEPHONE EVENTS

● When the telephone rings, it is
 allowed to continue ringing, until it stops.

● When the telephone rings, the receiver
 is lifted, then replaced.

● When the telephone rings, it is answered.

Performance note: Each event
comprises all occurrences
within its duration.

Spring, 1961

SOLO FOR WIND INSTRUMENT

(putting it down)

G. Brecht
1962

THREE AQUEOUS EVENTS

● ice

● water

● steam

Summer, 1961

THREE DANCES

1.
Saliva

2.
Pause.
Urination.
Pause.

3.
Perspiration.

Summer, 1961
G. Brecht

THREE WINDOW EVENTS

opening a closed window

closing an open window

DRIP MUSIC (DRIP EVENT)

For single or multiple performance.

A source of dripping water and an empty vessel are
arranged so that the water falls into the vessel.

Second version: Dripping.

G. Brecht
(1959–62)

Fluxus editions 1963 – c. 1970. Gilbert and Lila Silverman Fluxus Collection, Detroit / Photo Brad Iverson

George Brecht (1926–)
Water Yam, 1959–62
Approximately 100 printed cards, boxed; 15 × 17 × 4.5 cm.
Fluxus Editions, New York and Wiesbaden, 1962, 1964; Editions Daniel Templon, Paris, 1972; Editions Lebeer Hossmann, Brussels and
 Hamburg, 1986

Water Yam is a collection of one couldn't quite say what. Some of the texts have served as scores for events or assemblages, others have been realized as films, but one perhaps does best to think of it as a small personal cache (small? personal?) of images, ideas, and meditations for a spectrum of unspecified uses. Some of the earlier cards, from 1959 and 1960, are quite complex (the card entitled "CARD-PIECE FOR VOICES" gives instructions for a happening in which from one to fifty-four performers pronounce single phonemes from "one or more languages" according to a system of randomized cues that determine the beginning and end of the event as well as the duration of each sound and the "vocal organ"—specified here as "lips," "vocal cords and throat," "cheeks," and "tongue"—primarily to be employed for its production) but the subsequent cards, which make up the great majority, are far more simple and far more compressed. They might be instructions for a performer, but again they might not be; that performer might be yourself as the reader of the card, but wouldn't have to be; they could be indications of situations we might construct or arrange for, but again of situations we might simply notice, imagine, or remember, or attempt to remember; or perhaps we're to wait for a moment when they inevitably occur on their own. That smallest card of all, only two centimeters square, presents no more than two dots and two words:

raining
pissing

One can see that as a joke, or as point of departure for a serious meditation on the place of human and animal life within the history of the atmosphere; or perhaps one sees it as both: the *Water Yam* events, or pieces, or whatever one chooses to call them, are whatever one chooses to make of them.

Speaking of his work in general, in a conversation with Irmeline Lebeer (first published in *Art Vivant*, Paris, May 1973, and reprinted in: Henry Martin, *An Introduction to George Brecht's Book of the Tumbler on Fire*, Milan, 1978) George Brecht remarked: "In science, you use Occam's Razor. Between two equally valid hypotheses you choose the simplest. It's a question of doing the most with the least energy. Now, simplifying a bit, you could say that the plastic arts are concerned with matter and that music is concerned with energy. Consequently, I'm much more concerned with energy than with matter. For me, it's a question of doing the most—I'm not exactly sure of what—with the least amount of energy."

Another card, entitled "SMOKE," reads:

(where it seems to come from)
(where it seems to go)

Reading through *Water Yam* is an intensely personal experience, and one somehow grows forgetful of the artist who created it; it's as though the artist has found a way of creating a work that then remains untroubled by his presence. One wonders what these messages may mean, or one conjures up an image that satisfies the words, or perhaps one simply hears them as they echo momentarily in surrounding silence, but one seldom really wonders what the artist may have intended. One has much for which to thank him, but one also thanks him for his absence. That's another of the work's conundrums. One connects to a sense of shared experience, not to a sense of communicated experience. Each of the cards is the occasion for a meeting with something real, objective, and unadorned—something the artist has passed along in much the same condition that he found it. He presents us with spaces in which he himself has voyaged, suggesting the possibility of voyages of our own. His voyages and our voyages will not be the same voyages. George Brecht once remarked, ". . . for me, an object does not exist outside of people's contact with it. There is no "real" object as opposed to our idea of the object. The only object that exists is the object there and me here. You there with the object at a different moment is a different object." (From a conversation with Henry Martin, first published in *Art International*, Lugano, November 1967, reprinted in *An Introduction to George Brecht's Book of the Tumbler on Fire*, op. cit.).

Another of the *Water Yam* cards, entitled "MIRROR," reads:

reflecting
reflecting

Water Yam established the tones and intensities of attention that have ever since been typical of the whole of the work of George Brecht. Nothing is beneath or beyond his notice, and his work is a process of looking at things as carefully as possible, and more or less one at a time, then allowing them to seem to fall, virtually unassisted, into relationship with one another. He is an agent and recorder of juxtapositions that correspond not to the action of his will, but to his perception of their momentary inevitability. The distinction between feeling and perception is very slight. Though he sometimes turns to processes of chance and randomization as a way of circumventing will, he also has access to states of mind in which will is simply absent. The *Water Yam* box is proof of such states of mind. Brecht's world, moreover, is a world of things in movement, or of constantly shifting interests. Nothing is fixed into place; the cards shuffle about; everything is free to come and go. Nothing that the mind might look at is of greater importance than its looking at itself.

—Henry Martin

Bibliography—

Higgins, Dick, *Postface*, New York 1964.
Kaprow, Allan, *Assemblages, Environments and Happenings*, New York 1966.
Sohm, Hanns, and Szeemann, Harald, eds., *Happening and Fluxus*, Cologne 1970.
Martin, Henry, *An Introduction to George Brecht's Book of the Tumbler on Fire*, Milan 1978.
Dreyfus, Charles, *Happenings et Fluxus 1958–1988*, exhibition catalogue, Paris 1989.

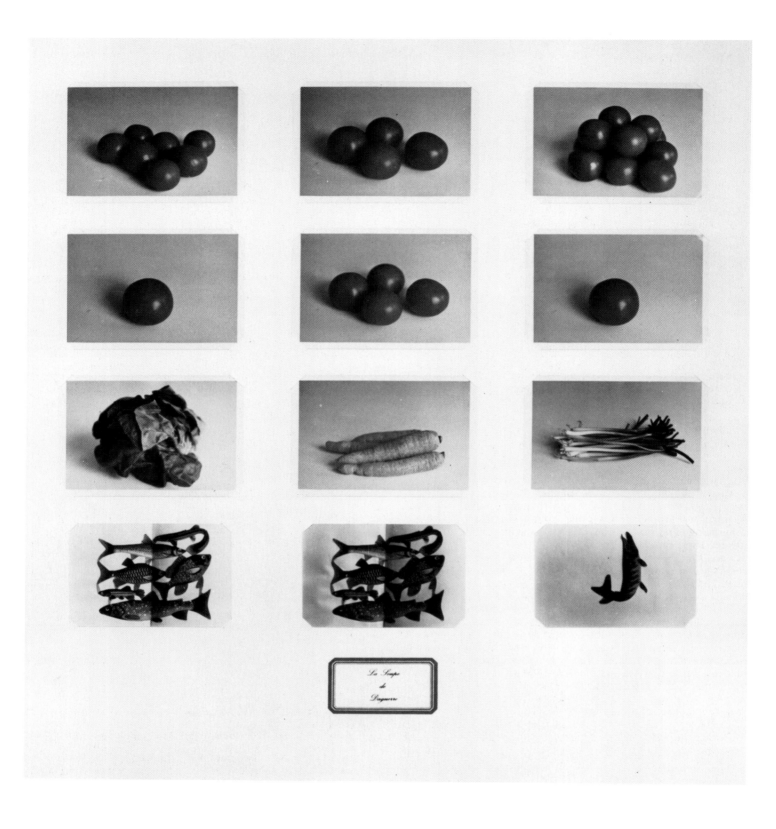

Marcel Broodthaers (1924–76)
La Soupe de Daguerre, 1975
Photographic silkscreen print; 23 × 23 in.
Multiples Inc., New York

La Soupe de Daguerre (1975) is one of Broodthaers' prints which becomes clearer and more sensible, as is characteristic of his work, through language. That Broodthaers was a poet before he was an artist is certain. Poets use language to extol the subtle, and it is precisely through language that one comprehends Broodthaers' assemblages.

Rene Magritte had an essential influence on Broodthaers' development. Yet Magritte reified visual and linguistic enigmas through painting. Broodthaers, as a conceptual artist, has no interest in reification. In this sense Broodthaers has an allegiance to Marcel Duchamp's preference for a style of living which at times precludes the necessity of artistic production. When discussing the range of Broodthaers' works, his assemblages, his prints, his visual works, and his poetry, it becomes clear that Broodthaers' medium is purely conceptual. Broodthaers is interested to arrange ideas. But how is a concept finally reified, through imagery or language?

La Soupe de Daguerre recalls Louis J. M. Daguerre's compositional *Still Life* (1837), in which Daguerre, as one of the inventors of photography, composed a series of ancillary but connected objects. The objects Daguerre chose for his *Still Life* were primarily artistic reproductions already: sculptural and bas-relief objects, a small framed painting, and a wine or water vessel—objects which were already aesthetic or ritualized. But what can be made of Broodthaers' "soup" of imagery? *La Soupe de Daguerre* is a photographic (Daguerrean) soup. Three photographs of fish are composed alongside photographs of lettuce, carrots, scallions, and six photographs of tomatoes. There is no admixture of the imagery. Is this the nature of photography—to impregnate with specificity and isolation and to deny compositional admixture? *La Soupe de Daguerre* is a highly analytic work. The twelve photographs are cut into, and then mounted onto, the paper of the print. The title of the work is silkscreened onto the print with a blue border and black script. The ink is slightly raised, and vies with the imagery of the photographs.

Broodthaers was a book dealer before he became an artist, and was interested in the processes of typography, binding and printing. *La Soupe de Daguerre* has perhaps more interest to Broodthaers as language, and as a form for concepts, than as visual imagery per se. One of the more famous of Broodthaers' statements is his idea of inventing something insincere. His claim is often considered to be an impetus for his art. We cannot take this quote too lightly. In an otherwise seemingly pristine and material modern European world, in a world where materiality is well-crafted by machines, the goal of the artist must be redefined: the artist must search for the humaneness of the insincere—of the fallible human gesture, as well as gestures which do not advertise their sincerity. Since the consumer world has become sincere, the artist seeks the insincere.

While Broodthaers was influenced by the work of the American Pop artists, he embarked on a campaign of quotation which was constructed from obverse principles. Broodthaers was interested to quote and to signify the remnants of high culture, rather than popular culture. Thus, for example, Broodthaers embarked upon a series of projects which portrayed the use of museums and their ritualized functions.

How is *La Soupe de Daguerre* to be read by the viewer? Does the silkscreened title "La Soupe de Daguerre" contradict the imagery? Or does the work of art exist solely in our discussion of its meaning, its concept, its signification? Unlike many conceptual artists who used the photograph as a documentation of conceptual art, Broodthaers' photographs do not document art, they exist as ideas of art.

Broodthaers' work as a whole is often referred to as a rebus. His work does not consist of riddles which seek to locate answers, but rather puzzles which seek to generate language. The work of Broodthaers is not visual in this sense, but is linguistic. His work thus negates Daguerre's goal of capturing the nature of an image and of a thing itself. Broodthaers' work exists as a series of conceptualized linguistic operations, rather than visual repositories. The visuality of the work fades into an operation of language and thinking. *La Soupe de Daguerre* emerges as a repositioning of that thinking.

As a "pure" conceptual artist, Broodthaers' ideas and ponderings are tangentially affixed to the concreteness of his works. *La Soupe de Daguerre*, a small work, less than two feet by two feet, exists in a print edition of sixty, and is formally unsolidified, as are the bulk of Broodthaers' objects. Broodthaers designated his wife to determine what comprised his oeuvre after his death. The designations remain moot. One continues to have a large quantity of objects and ideas to disentangle. But for Broodthaers, once an "idea" is disentangled so as to form an "object," it must be rethought and reconceptualized.

In a modern world of machine-made identities, the fabrication of the world of imagery is ubiquitous. In this case images of food are presented analytically. Broodthaers poses the problem of how this assemblage metamorphizes from imagery to food. Broodthaers is interested in labels, labeling, and titles. In one of his environmental installations of a museum exhibition, each object was placed next to a card which read "This is not a work of art." Similarly, *La Soupe de Daguerre* is not an image of photography, or of soup, or of Daguerre. Duchamp assigned the art function to "non art" objects, thus making them art. Broodthaers assigns "non art" status to works in museum settings so that a language of observation and ideation can return within the bourgeois art world itself, as well as to the "popular" world where Duchamp signified the quotidian. *La Soupe de Daguerre* is an ideational work, a reference to something else than what is seen, and other than its existential value.

—John Robinson

Bibliography—

De Vree, Freddy, *Marcel Broodthaers, Marcel Broodthaers*, Amsterdam 1979.
Tate Gallery, *Marcel Broodthaers*, exhibition catalogue, London 1980.
Museum Boymans-van Beuningen, *Marcel Broodthaers, 28.1.1924/ 28.1.1976*, exhibition catalogue, Rotterdam 1981.
Buchloh, Benjamin H. D., ed., *Broodthaers: writings, interviews, photographs*, Cambridge, Massachusetts 1987.
Bonnefantenmuseum, *Marcel Broodthaers in Zuid-Limburg*, Maastricht 1987.
Goldwater, Marge, and others, *Marcel Broodthaers*, Minneapolis and New York 1989.

Photo courtesy Daniel Buren

Daniel Buren (1938–)
Le Pavillon Coupe, Decoupe, Taille, Grave, 1986
Mixed media work in situ and in relief, French Pavilion, Venice Biennale

This work was done in situ in the French pavilion of the Venice Biennale in June 1986 where it won the *Lion d'Or*. It would be appropriate here to give a detailed description of the work in the artist's words, before fitting it into the overall picture of Buren's development.

The pavilion's area is cut into two equal parts down the middle: the right-hand side on entering has been worked on, while the other has hardly been touched, bare of any additions. The peristyle is also divided down the middle but perpendicular to the division of the pavilion itself. It is covered alternately in mirrors and blue-painted wood.

The right-hand side of the first room is covered with slats of black Formica leaving gaps exposed in the white wall of exactly the same width as the slats (8.7cm, the width of the famous "Buren stripes"). The canopy concealing the glass roof is made from yellow and white striped material and only half covers the former. In the room on the right the walls are covered in the same way as the first one, but the Formica is blue. In this room, the canopy completely obscures the glass roof. In one of the walls is a window connecting with a small room—on the right when one is in the peristyle. Through it can be seen, projected on to the wall, photos of the 80 drawings Buren made during the development of the project. The room on the left is just as Buren found it after the rebuilding of the pavilion: no canopy, nothing on the walls apart from a Formica frieze, which includes the **plinths** and the opening made by the door into the central room. In this room, which is symmetrical to the room covered with blue Formica slats, another window has been cut which is symmetrical to the one mentioned above. Through it can be seen the room on the left of the peristyle, completely empty and lit by a powerful spotlight. The last room has only been worked on the right-hand side, progressing up the wall in even steps, gradually removing the outer layers of plaster and cement until the bricks were revealed (thus exposing the framework of the building and reminding one of the many houses in Venice whose bricks appear through the crumbling roughcast). In this room as well, only half the glass roof is covered by the canopy.

In this building whose symmetry was suffocating, Buren's intention was to destabilize the false harmony. The artist destroyed what he considered to be a caricature of symmetry and replaced it by another, completely different.

The very essence of Buren's work is there. Jean-Hubert Martin

noted that Buren's work fitted in with the tradition of decorative painting and his links with architecture, which were the favourite themes of Fernand Léger, Henri Matisse and others, although their achievements were fewer. Unlike them, Buren did not try to fill a whole area, but insisted on being able to choose the location of his work. With him, the meaning is not in the sign, but in what he designs: *he accentuates a characteristic of the space, he points out an ideological or functional contradiction*

Like all his other work, Buren's work in Venice was 1) "a minimis" (he always used the same material: alternating stripes of 8.7 cm wide); 2) "in situ" (the work is wholly subject to the place which it is displaying); and 3) "tempore suo" (by its very nature the work determines its own lifespan). In the case of Venice, the work was demolished when the Biennale closed. This is a fundamental aspect of the Buren "process." A painting, whether abstract or not, is automatically made part of a more extensive context: its own lifetime is subject to one that is exterior (that of the studio, the gallery or the museum). Even Pollock's "all over" can be ruined by a "suitable" frame, remarked Buren who, in his own case, devised works which did not permit any interference by limiting from within their own lifetime, which is strictly equal to that of their inclusion in a setting.

A painting, which has no effect on the setting, is thus directly affected by the action of the latter (gallery, museum, art revue . . .). "What is this space that art theoreticians keep harping on about, when they forget—conveniently, so that their argument does not collapse—to talk about the space (walls and rooms included) on which and in which the work they are discussing is included? What is this reality of a painting would be completely alien to this other reality which allows it to exist?" (Daniel Buren, *Rebondissements*, Daleb/Gevaert editions, Brussels, 1977). From this, one understands the relentless war which Daniel Buren, artist "in situ," waged against museums in particular, as being the main "art manipulators." The work in Venice forms part of this battle which was begun in the sixties and is still going on today.

—Jean-Luc Chalumeau

Bibliography—

Buren, Daniel, *Photos-souvenirs 1965–1988*, Villeurbanne 1988.
"Daniel Buren," special monograph issue of *Opus International*(Paris), April/May 1989.

Photo courtesy Dallas Museum of Art, Texas

40

Alberto Burri (1915–)
Sack IV, 1954
Sacking, silk, glue and paint on black cotton; 114 × 76 cm.
France, private collection

When in 1947 Alberto Burri exhibited for the first time, in Italy the debate between realism and abstraction dominated. The main tendencies were a figurative style of neo-Cubist origin and an abstract painting inspired by Kandinsky, De Stijl and, more generally, by constructivism. Burri, from the beginning, distanced himself from the contemporary artistic scene. After all, he had started painting for existential reasons, rather than out of intellectual choice, as had the Concretists; or ideological reasons, as had the realist or "post-Picassian" painters. Quite rightly, some have identified a geometric pattern in his first works which suggest that he was indebted to the Concretists, but the sense of matter prevails, the value of the thick paint imposes itself with such vigour and vitality as to allow it to be linked with the vein of Informal art which characterised the 1950s.

The series of sacks which brought the painter fame, and to which *Sack IV* (1954) belongs, fits into this historical context. The establishment of abstraction has been interpreted by Brandi, in his 1963 monograph dedicated to Burri, as an extremely important event, because it brought to a close the modern Western tradition of painting that started in the Renaissance and lasted until the 19th century. The fact that Burri is one of the interpreters of this new historical contingency is demonstrated by his use of material in the creation of his works. Tar, sacks, wood, plastic, steel and much more, are the means by which he has battled with painting in order to unhinge it from within, to open it up to new expressive possibilities. What allowed him to start this adventure, which, since the very beginning, saw him as a forerunner, have been the conditions of his artistic birth, which took place outside the academic worlds and, above all, because of an inner expressive need.

His artistic origins are to be found in the war years. He was taken prisoner, and during the long period of imprisonment, he started drawing. At the beginning, perhaps, art was only a pastime, but soon it became a necessity; in fact, once he returned to Italy, he continued to draw and paint. The first works he exhibited were abstract compositions in which a particular attention to the use of matter was clear, and which, in some works from the years 1949–1952, is even evident from the title. An example is the small series of tars, or the various versions of *Moulds*, produced from 1950–1951. Those works, naturally, reflect the climate of those years. The Italian artistic culture, emerging from the Fascist autarchy, was trying to forge links with other European countries, especially France. What the Italian painters found, looking at Europe and the USA, were Informal and Action painting. Burri, free from any artistic prejudice, found his way by looking at contemporary international art. Arcangeli, who prefaced one of Burri's one-man exhibitions in Bologna in 1957, said that perhaps the sacks were born out of an idea which was enriched in its cultural content by the reaction of the well-educated public, annoyed and irritated by those collages. This gave Italian culture of the period a strong taste of modernisation.

The first *Sack* (at least the first work carrying this title) was made in 1950. After that came the works which made him famous: *Big Sack* (1952), *Sack and red* (1954) and so on. With the sack series, Burri makes the first step towards a personal language which developed in the following decades. If in the previous works the use of material was still reminiscent of traditional painting materials, oil and earth colours, in these works the use of a sack-cloth, even if still with a colouristic and material function, already refers to those factors which are typical of extra-artistic research. The use of sack-cloth, a "found object," fits into the Dada tradition, a movement also ahead of its time.

Burri entered a painting culture which had remained isolated and which had a strong desire to bridge the gap with the historical avant-garde. In a homage to Burri in 1961, Crispolti proposes a link with Prampolini's work. In 1944 he had published a pamphlet with the revealing title of: "Polimaterismo" [Polymaterism]. He states the need to react strongly and with courage to the nostalgia of colour and to pictorial reality, and the need to carry to its extreme consequence the concept, borrowed from Futurism, of totally substituting painted reality with the reality of matter. In this sense, a correlation with Futurism can be established. Certain cultural conditions in which Burri operates, and existential tensions which express themselves through matter, place Burri in a more advanced position. If Prampolini aimed at the intuition of the emotive and evocative value of matter, in its rhythmic and spatial game, Burri wanted to highlight the existential quality of matter, rather than its imaginative power. It was not the possible evocations which interested him so much as the intrinsic value of matter.

Calvesi has pointed out that Burri's "polymaterialism" went from a more generically pictorial suggestion to a direct expression of matter. In other words, if in a work such as *SZI* (1949) colour and matter are juxtaposed in a chromatic equilibrium and sack-cloths are inserted into the intersections of the painting in a continous dialogue, in *Sack IV* the sack-cloth dominates, unchallenged, the entire surface assuming all chromatic and pictorial qualities.

People have spoken often of an "esprit de géometrie," which in *Sack IV* is exemplified by the seams that divide the surfaces into several sections, in a rhythmic structure in which the holes and patches represent musical cadences. If people have spoken of a geometry in contradiction to the expressiveness of matter, in fact those two aspects merge. In this respect Argan has written: ". . . the geometry contradicts and destroys time, and matter contradicts and destroys space . . .". An annihilation, a negation from which the strictly existential value of this work, among the major works of its time, continuously resurfaces.

—Roberto Lambarelli

Bibliography—

Brandi, Cesare, *Burri*, Rome 1963.
Rubiu, Vittorio, *Alberto Burri*, Turin 1975.
Caroli, Flavio, *Burri: la forma e l'informe*, Milan 1979.
Royal Academy, *Italian Art in the 20th Century*, exhibition catalogue, London 1989.

Reg Butler (1913–81)
The Unknown Political Prisoner (working model), 1955–56
Iron, bronze and plaster; 88⅛ × 34⅝ × 33⅝in. (223.8 × 88 × 85.4cm.)
London, Tate Gallery

Although this work by Butler refers back to earlier sculptures of his, it cannot be isolated from the curious international competition which occasioned it, nor from either the maquettes which preceded it or the final, 300-foot high monument which it never became.

The *Unknown Political Prisoner* competition was announced in January 1952 by the Institute of Contemporary Arts in London, and its precise origins and motivation still remain obscure. The project appears to have been suggested to the I.C.A. by Anthony Kloman, former U.S. cultural attache in Stockholm, and although the I.C.A agreed to promote the project, Kloman and his own staff undertook the entire organisational work, from a separate office in the I.C.A. in Dover Street, where Kloman assumed the title of Organising Director. A sum of £11,500 was offered as prize money, but the source of this money remains a mystery—Kloman referred to "the generosity of an anonymous donor," apparently American, and there have been suggestions that the I.C.A.'s acronym, the C.I.A., was in some way involved. It is necessary to locate this project firmly in its period and among the anxieties of the time, the height of the Cold War, and to emphasise that its very indistinctness and ambiguity gave rise to a wide range of responses.

Which political prisoner? Butler believed the subject to refer to Nazi atrocities, to the millions imprisoned just a few years earlier for their nationality or their beliefs or for just happening to be in the wrong place, but this interpretation was not universally shared, and, in particular, the subsequent history of Butler's prize-winning design points in another direction. Herbert Read wrote, "The intention in suggesting such a theme was to pay tribute to those individuals who, in many countries and in diverse political situations, had dared to offer their liberty and their lives for the cause of human freedom. Our complex civilization has found its crisis in the contradiction that exists between individual concepts of truth and duty and totalitarian concepts of uniformity and blind obedience." As far as the I.C.A. was concerned, Read, its President, added, "Here, it seemed, was an opportunity to test our inspiration and redeem our age from a charge of moral and aesthetic indifference." So far so good; but what was this competition really *about?* what was its true subject? and who was paying the piper?

For some entrants the political prisoner in question belonged to the recent Nazi past, for others he was regarded as a victim of the society on the far side of the Iron Curtain—certainly the Soviet Union and its East European satellites understood this latter to be the purpose of the project and regarded it as an undisguised provocation, preventing their own sculptors from participating. For others still, the political and propagandist motives were irrelevant, and it was simply a sculpture competition with the promise of prizes at the end, so they merely adapted existing works to conform to the criteria of the competition.

By the closing date of 1 June 1952, a total of 3,500 entries from 57 countries had been received, the largest contingent being 607 from West Germany. These numbers far exceeded expectations, and so instead of collecting all the maquettes (whose maximum height was 18 inches) together in London, as originally intended, national competitions were held in the winter of 1952–3, and only the winning entries were brought to London. The British exhibition was held in the New Burlington Galleries in January 1953, and the winners included Lynn Chadwick, Barbara Hepworth, Elizabeth Frink, F.E. McWilliam, Eduardo Paolozzi and Butler. The international exhibition of work by 140 finalists opened in the Tate Gallery on 14 March 1953, and the jury, which included Herbert Read, Will Grohman and Alfred Barr, Jr., awarded the £4,500 Grand Prize to Butler, with £750 prizes going to Mirko Basaldella, Barbara Hepworth, Antoine Pevsner and Naum Gabo.

The following day, 15 March, a 28-year-old Hungarian refugee named Laszlo Szilvassy severely damaged the maquette, and explained that his motive in doing this was strictly aesthetic: "Those unknown political prisoners have been and are still human beings. To reduce them—the memory of the dead and the suffering of the living—into scrap metal is just as much a crime as it was to reduce them into ashes or scrap. It is an absolute lack of humanism."

The damaged maquette, later restored by the artist, remained the property of the I.C.A. and the Akademie der Bildenden Künste in Berlin, and was later sold to an American collector by Kloman. Butler made two replicas of this maquette, one of which (with the base in stone rather than plaster) went on display at the Tate Gallery—this maquette remained with the artist, while the other was acquired by the Museum of Modern Art, New York. In 1955–56 Butler made a larger version, four times the size of the maquettes, the "Working Model" that is now in the Tate Gallery—this was produced in response to a request that the Monument should be erected full-size in West Berlin, either in the Tiergarten or on Humboldt Höhe, in the district of Wedding, overlooking the frontier dividing the city, and confronting the Soviet-built monument to the Red Army in Trepkow Park. Ernst Reuter, Mayor of West Berlin until his death later in 1953, promoted this project, which also had the active support of Will Grohmann, in the face of opposition from the Bonn government; the project faded with Grohmann's death in 1968, and seems to have fallen victim to the antagonism that existed between Chancellor Adenauer and Willy Brandt, Mayor of West Berlin in 1957–66. The 300-foot high structure was never built, and only a photomontage by the artist indicates how it would have appeared on Humboldt Höhe. A remark by the sculptor was misinterpreted by the press and blown up into a campaign against the possibility that the Monument would be built on the cliffs at Dover.

Three preliminary maquettes (all in private collections) survive to document the development of the idea behind Butler's work—an open tripod structure on a rocky outcrop, a triangular horizontal platform, vertical elements including a rectangle with curved corners that now suggests a television screen, and a high single antenna stretching upwards. The three preliminary maquettes include two platforms, parallel horizontal elements suggesting television aerials or ladders, and sloping diagonal elements; above all, these maquettes incorporate a tall, attenuated human figure held by the verticals or impaled upon them—the political prisoner himself. This figure was dropped when Butler came to make his final maquette, and his presence is indicated obliquely through the figures of the three women located on the stone base, the "watchers" who stare upwards at the tower.

In a lengthy note explaining the meaning and the genesis of the Monument, Butler included the following remarks: "The monument is designed to provide interest both as seen from a distance, and close to . . . It consists of three elements: the *natural rock foundation* which provides a fundamentally "natural" setting even where the monument may be sited in the centre of a city; *the three women* in whose minds the unknown prisoner is remembered and who set the whole dramatic context of the monument; and *the tower* intended as an easily identified symbol which both suggests the tyranny of persecution and the capacity of man to rise beyond it."

—Krzysztof Z. Cieszkowski

Bibliography—

Tate Gallery, *International Sculpture Competition: The Unknown Political Prisoner*, exhibition catalogue, London 1953.
"Reg Butler: Working Model for The Unknown Political Prisoner," in *The Tate Gallery: Illustrated Catalogue of Acquisitions 1978–80*, London 1981.
Calvocoressi, Richard, "Reg Butler and the Unknown Political Prisoner," in *Art Monthly* (London), December 1981/January 1982.
Calvocoressi, Richard, "Reg Butler: The Man and the Work," in *Reg Butler*, exhibition catalogue, London 1983.

Plexigram V

Plexigram VIII

Photographs courtesy of Carl Solway Gallery, Cincinnati

John Cage (1912–)
Not Wanting to Say Anything About Marcel, 1969
Silkscreen on 8 plexiglas panels; 14 × 20 × ⅛ in.
Cincinnati, Eye Editions

By the 1990s, it is clear that John Cage is not just a composer or a "composer-writer" but a true *polyartist*, which is to say someone who has produced distinguished work in more than one non-adjacent art—the principal qualifier being *nonadjacent*. By contrast, sculpture and painting are adjacent visual arts, just as poetry and fiction are adjacent literary arts. However, music and writing are nonadjacent; likewise, painting and poetry. We can distinguish the polyartist from the master of one art who dabbles in another, such as Pablo Picasso, who, we remember, wrote modest poetry and plays; we can distinguish the polyartist from the dilettante who excels at nothing. Moholy-Nagy was a polyartist, and so, in different ways, were William Blake, Kurt Schwitters, Theo van Doesberg, and Wyndham Lewis.

It could be said that of the arts in which Cage has excelled he was slowest to come to visual art. In my 1970 documentary monograph on Cage is reproduced *Chess Pieces*, done around 1944 for the Julian Levy exhibition of works related to Marcel Duchamp's interest in chess. What we see is a square chess-checkerboard in which half of the sixty-four squares have bars of musical notes in black while those squares adjacent to them have notes in white, all against a continuous gray background. Because there is no notational continuity from square to square in any direction, or even from one black square to the next black square (likewise in any direction), Cage is suggesting that the boxes can be read (or played) in any order—from top to bottom, or the reverse; from inside out or outside in, or whatever. That is another way of saying that *Chess Pieces* has noncentered activity that is evenly distributed "all-over" to the very edges of the work.

Elsewhere in that monograph is reproduced an untitled drawing that Cage made in 1954 while cleaning his pen during a certain music composition. Rescued at the time by his colleague the composer Earle Brown, this piece of unintentional art resembles a Jackson Pollock, who was likewise concerned with all-over nonhierarchical distribution; the drawing additionally looks forward to the cross-hatching that Jasper Johns introduced in the 1970s. Finally, the visual arts world was always predisposed to appreciate the exquisite calligraphy of Cage's musical scores, many of which were exhibited at the Stable Gallery in New York in 1958. As Dore Ashton wrote in the *New York Times* at the time, "Each page has a calligraphic beauty quite apart from its function as a musical composition."

In 1969, the year after Marcel Duchamp's death at seventy-nine, Cage was a composer in residence at the University of Cincinnati. Alice Weston, a local art patron, "got the idea that though I had not done any lithographs, I could do some. Marcel had just died, and I had been asked by one of the magazines here to do something for Marcel. I had just before heard Jap [Jasper Johns] say, 'I don't want to say anything about Marcel,' because they had asked him to say something about Marcel in the magazine too. So I called them, both the Plexigrams and the lithographs, *Not Wanting to Say Anything About Marcel*, quoting Jap without saying so."

Not wanting to say anything particular with language, Cage decided to use chance operations to discover words in the dictionary. At the time, he was favoring the use of three coins which, when flipped, could yield Head-Head-Tail, HHH, HTT, THT, HTH, THH, TTH, TTT, which is to say eight different combinations. So he made squares with sixty-four options (8 × 8), flipping one sequence of three coins to get the vertical location of a chance-derived square and then another sequence to get its horizontal location. Therefore, any collection of possible artistic choices had to be divided into 64 alternatives. Taking the 1428 pages of *The American Dictionary* (1955), Cage defined 20 groups of 23 pages apiece and 44 groups of 22 pages apiece. Once the coin flips forced him to isolate one group of pages, he flipped again to find out which page. After counting the number of entries on that page, he did another set of flips to locate an individual word. Since some of these words had different forms (plural, past tense, gerund), he often flipped again to find out which one to use. Then

he had other charts dividing 1,041 typefaces available in a standard catalogue of press-on (aka Letraset) type. Once this was determined, he flipped again to discover whether to use uppercase letters or lowercase. And then another time to discover where in the available 14″ by 20″ space to locate the chosen word/typeface. And then again to discover in what direction the word should face. And finally yet another flip to discover whether the word should be perceived intact or have missing parts or "whether it is in a state of nonstructural disintegration." And so forth.

The effect of such chance operations, as always in Cage, is to divorce the details from any personal taste and then to give all the elements, whether whole words of just parts of letters, equal status in the work. Since he had nothing particular to say about Duchamp, it is scarcely surprising that the words behind the first plexigram, say, should be "agglutination, voltaic, wild rubber, trichoid, agro-logical, exstipulate, suc-, undershrub, shawl, advanced, moccasin flowers," and so forth. He used similar aleatory methods to collect images from a picture encyclopedia.

Regardless of what individual words, letters, parts of letters, or images appear, if you put such randomly chosen and randomly deconstructed images on Plexiglas, you're likely to get an evenly distributed, all-over field of linguistic/visual materials devoid of syntactic connection or semantic connotations. If you distribute different collections of such materials on a succession of eight Plexiglas sheets, stacked vertically on a single base, the chaotic effect is multiplied. What you see is a three-dimensional field that can be viewed variously, both horizontally and vertically, with the possibility of discovering continuously varying relationships between elements on the front Plexigrams and those in the back. As the Plexigrams can be removed from their slots, you are also free to reorder them. It is not for nothing, I've always assumed, that in its verticality and its inscriptional style the entire work resembles a gravestone. (Cage also derived from this research two lithographs on black paper, lesser works in my judgment; and they too have a dense, all-over field reminiscent of Pollock.)

Cage's principal collaborator on this project was the graphic designer Calvin Sumsion. "I composed it. I wrote it," Cage told an interviewer. "First we worked together, then I was able to tell him to do something, and then he would send back the work completed. Albers has used such methods—hasn't he with his own work?—or he gives it to some craftsman to do. Many artists now, when they don't know a particular craft, learn how to tell a craftsman what to do." Cage's other associates on this project included the lithographic printers Irwin Hollander and Fred Genis.

Some of Cage's works are minimal, having much less content than art previously had (beginning with his so-called silent piece, initially for solo pianist), while others are maximal, having a spectacular abundance of artistic activity. In my appreciation of his individual works, I've tended to favor the maximal over the minimal and thus prefer, among his strictly musical works, *Sonatas and Interludes* (1947–49) and *Williams Mix* (1953); among his theatrical works, *HPSCHD* (1969) and *Europera 1 & 2* (1987); among his writings, the Diary poems of twenty-years ago and *I–VI* (1990). Especially in comparison to the visual art following it, *Not Wanting to Say Anything About Marcel* represents his maximal imagination at its visual best.

—Richard Kostelanetz

Bibliography—

Cage, John, *To Describe the Processes of Composition Used in "Not Wanting to Say Anything About Marcel"*, Cincinnati 1969.
Cage, John, and Hiller, Lajaren, *HPSCHD*, New York 1969.
Rose, Barbara, "Not Wanting to Say . . . ," in Kostelanetz, Richard, ed., *John Cage*, New York, 1970, 1991 and London 1971.
Kostelanetz, Richard, *Conversing with Cage*, New York 1988 and London 1989.
Cage, John, *I–VI*, Cambridge, Massachusetts 1990.

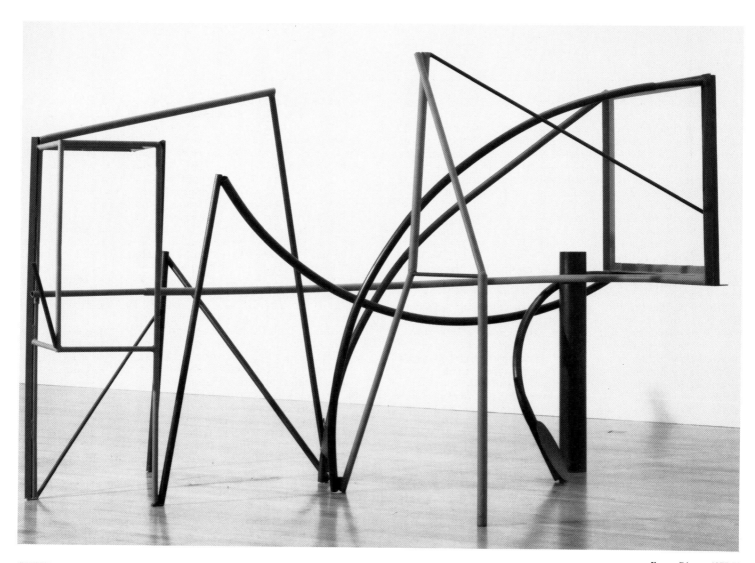

Emma Dipper, 1977-78

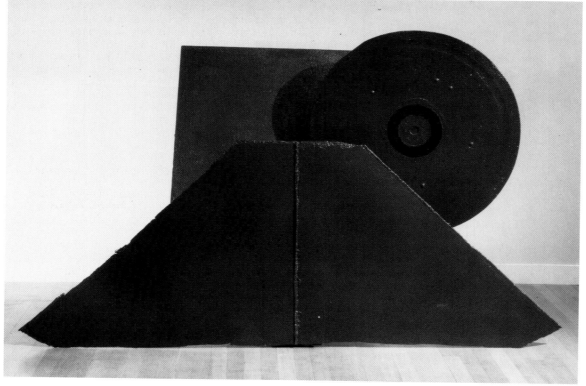

Twenty-Four Hours, 1960

Anthony Caro (1924–)
Emma Dipper, 1977–78
Steel, painted grey; 213.5 × 170 × 320cm.
London, Tate Gallery

Emma Dipper is one of a series of fifteen sculptures which all bear the name "Emma" in their titles. "Emma" does not refer to a person but to the locale in which the pieces were made—a woodland clearing at Emma Lake in Saskatchewan, Canada. Anthony Caro, a British artist, began work on this series during August 1977 at a Summer arts workshop run by the University of Saskatchewan, to which he had been invited as a guest artist. The curved elements in *Emma Dipper* seem to dip into the ground suggesting that "Dipper" might be a reference to the sculpture's formal qualities but Caro has stated that "the name Dipper comes from a Bar/Restaurant that we all went to one night whilst at the workshop" (Tate Gallery catalogue).

In keeping with Caro's post-1960 oeuvre, *Emma Dipper* is resolutely abstract, but pre-1960 Caro utilised the traditional methods of sculpture, modelling and carving, to produce monolithic, figurative pieces. After a conservative and somewhat restrictive training at the Royal Academy Schools, Caro worked as Henry Moore's assistant. Caro's "conversion" to radical abstraction took place during his first visit to the United States (1959–60). In America, he came into contact with the abstract painters Kenneth Noland and Jules Olitski, and the critic Clement Greenberg. Their work and comments acted as a catalyst upon the transition from figuration to abstraction which was already beginning to take shape within his work. He also met the sculptor David Smith, whose work with welded metal introduced Caro to the technique which he was to adopt after his return to England. Caro has referred to both Moore and Smith as his sculptural "fathers."

Twenty-Four Hours (1960, Tate Gallery collection), made in Caro's London garage, marks the turning-point: it was not only his first fully abstract sculpture but also his first welded steel sculpture. Welding pieces of metal together is an additive process akin to collage in three dimensions, a process radically different from the traditional methods of sculpture and the process Caro chose to develop and elaborate. The 1970s saw an incredible proliferation in his output; whereas in the early 1960s he worked on roughly one sculpture a month, by 1980 he had as many as forty pieces in his workshop at any one time. Much of the work of the 1970s has a spontaneity and freedom akin to musical improvisation as Caro explored new materials, new scales of work and their possibilities within his continually evolving abstract syntax. *Emma Dipper* is a product of this period.

With the *Emma* series, Caro worked on more than one piece at a time in close collaboration with an assistant, Douglas Bentham, a Canadian sculptor. Caro made several changes to the *Emma* pieces when he returned to Saskatoon several months later, and again before they were exhibited in New York City in October 1978. In fact, Caro reserves the rights to alter all his work at a later date. Caro works directly with his material (usually industrial metal, but also wood, paper and clay) in an improvisational manner without drawings, plans or maquettes, and has said that he needs to "feel" his materials before constructing a piece.

To some extent, the character of Caro's three-dimensional collages is determined by his choice of materials. The *Emma* pieces are made from light metal elements—tubes, rods and thin angles. Caro recalled, "We were working 200 miles North of Saskatoon on a gravel area with only a crane lift from the back of the truck. It was impossible to use heavy material. We were also a long way from a scrapyard" (Tate gallery catalogue). A piece such as *Durham Purse* (1973–4, Museum of Fine Arts, Boston), made from soft-ends of steel rollings with torn edges, has a gently heavy, somnolent quality, whereas *Emma Dipper*, made largely, though not exclusively, from steel tubing, is light and airy.

For Caro, abstraction does not preclude expression, "I want people to feel moved when they look at my art. I want to touch their deepest feelings, but I cannot twist their arms." (*Art Monthly*, no. 23, 1979). *Emma Dipper*, in keeping with most of Caro's work, is asymmetrical and has multiple focal points rather than a single centre. There is an almost casual play of arc and angle, gravity and weightlessness, openings and closures. The curved and straight elements which form *Emma Dipper* interact to energize and delineate volumes of space. Tension is generated between tautly demarcated and contained spaces, such as the rectangles at either end of the piece, and the open flow of linear forms through space.

The surface of *Emma Dipper* is rusted steel painted varying shades of grey. The colour, chosen by Caro's wife, painter Sheila Girling, was applied after the piece was "finished" in 1978 before the New York show. The paint unifies the work and enables the metal elements to appear to deny gravity as they trace and dance through space. The application of surface colour may minimalise the irregularities of natural colour and surface texture, but Caro is by no means a minimalist. His work is abstract, but his sculptural vocabulary is too rich and elaborate to conform to a minimalist aesthetic.

The *Emma* pieces bear a resemblance to Picasso's open wire constructions of the late 1920s but Caro, unlike Picasso, does away with pedestals or bases and all figurative references. *Emma Dipper* and "her" companions may nod to Picasso (they, too, are drawings in space) but they are firmly part of Caro's oeuvre. They can be compared to his earlier small-scale "Table pieces" and feed into his later "Writing pieces." Caro's sculptures, including *Emma Dipper*, evolve from the materials which form and inform them and his relentless exploration of the language of abstract sculpture, the language of materials, shapes, intervals and internal relations. In 1979 Caro commented "Twenty years ago, we were trying to find ways to make art with clarity and economy, to establish our grammar. Now we can write fuller sentences." Following this analogy, *Emma Dipper* is a full and complex sentence, complete with punctuation marks in the form of the small disc which rests on the ground and the solid rectangle which hovers just above the ground.

—Claire Lofting

Bibliography—

Blume, Dieter, ed., *The Sculpture of Anthony Caro: Catalogue Raisonne*, 5 vols., Cologne 1981–86.
Waldman, Diane, *Anthony Caro*, Oxford and New York 1982.
Fenton, Terry, *Anthony Caro*, London and Barcelona 1986.

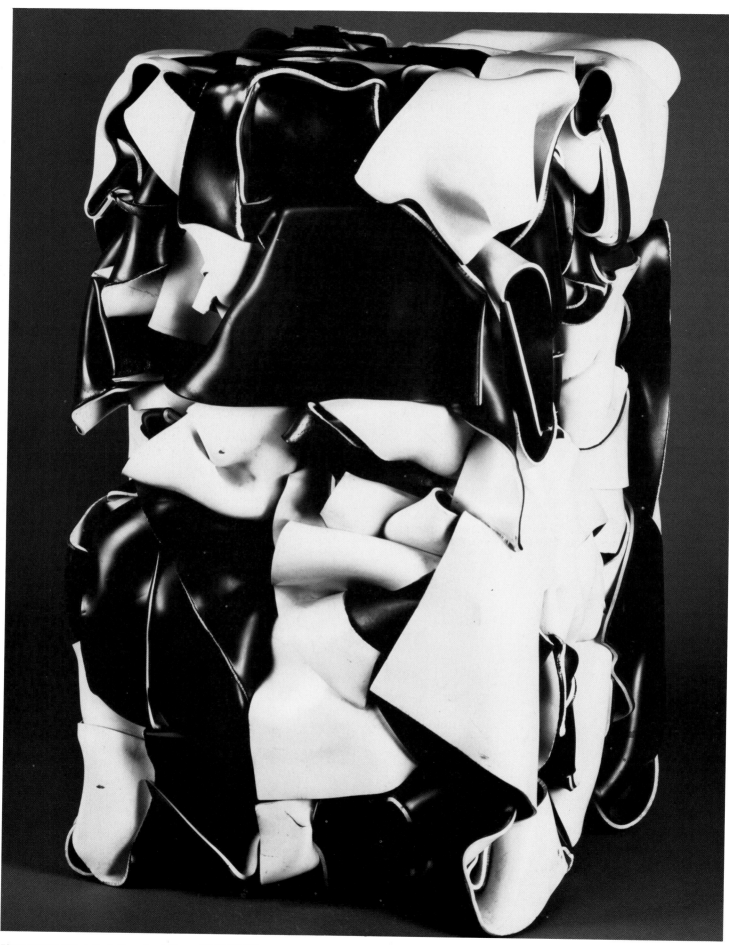

Photo courtesy Galerie Sonia Zannettacci, Geneva / © DACS 1991

Cesar (Baldaccini) (1921–)
Compression Plastique, 1972
Compressed plexiglass; 51 × 29 × 28 cm.
Geneva, Galerie Sonia Zannettacci

The plastic compressions of 1972 form an important stage in César's development which can be explained through the sequence of experiments instigated by the artist from 1965 onwards. At this time, César had decided to show a cast of his own thumb: he made it first of all, enlarged to 40 centimetres high, in translucent pink plastic. It was the first time that he had used plastic, in the formulation of a wish to objectivise a part of the body in isolation, which led him on to make various huge projects in different materials such as marble and bronze. It is interesting that the sculptor, up till then known and admired for his compressions and his welded metal sculptures, should have wanted to use casting, enlargement and, in particular, plastic. It was at this time that Ileana Sonnabend showed Claes Oldenburg's giant hot dogs in her gallery in Paris, and that pictures of George Segal's casts were spreading from the United States.

While looking for any technique which might advance the progress of his work, César, already interested in plastics, in 1967 discovered the amazing possibilities of polyurethane. Quite by chance, while trying to make a two-metre cast of his thumb using this, as yet unknown to him, synthetic foam, he let it overflow from the mould thus giving rise to his first "expansion" which filled him with enthusiasm. What followed, and the remarkable advantage César took of his discovery, is well known. The public demonstrations of his "expansions" took him all over the world from 1967 to 1970. César gradually perfected a method of making the polyurethane castings longer-lasting, by covering them with a film of glass wool. He also discovered a way of subtly grading the desired colours for each of his works. After a foray into the worlds of fine crystal (with the Maison Daum) and jewellery (mini-compressions in gold and silver from summer 1971), César was ready to return to large-scale compressions, this time in plastic. The *Compressions de matière plastique de 1971 et 1972* call to mind the traditional shape of the metal balls which brought the artist fame (for example, *Compression 1961*: automobile compression, 151 × 77 × 63 centimetres, at the Museum of Modern Art in New York). This new style was achieved by compressing sheets of polyester crumpled while hot. The process had the advantage of being infinitely variable, from the shape point of view (large or small) and also from that of the colour. César went from complete transparency to milky opalescence, and also experimented with fluorescence on the ridges.

The *Compression plastique 1972* reproduced here is one of the most successful: it combines sheets of black and white plexiglass with elegance and restraint. In this, one is reminded of the most aesthetically successful of César's "compressions automobiles," such as the one from 1960 in the Musée d'Art et d'Histoire in Geneva. César attached great importance to his plastic compressions: they represented a truly new departure in an already well-filled career, during which he had experimented in very different directions. It was significant that he chose to present them, in 1972, in the gallery which had organised his very first exhibition in 1954: Lucien Durand, that great "talent-scout," through whose doors had passed most of France's important artists.

These compositions in plastic are an essential variant of César's view of modern "nature," made up of a complete technical folklore which he alone transformed into artistic language. The demiurge of scrap-iron, the sculptor of welded bronzes, was able to appreciate the poetry of plastic, which until then had been the synonym of vulgarity and despised by artists (with the exception of certain pop artists, such as Oldenburg, who however, did not try for any aesthetic effect). By according his approval to plastic, César not only confirmed his incomparable mastery of the race of industrial artists: he also, in the words of his biographer, Pierre Restany, continued to be "the adventurer of the appropriative language."

—Jean-Luc Chalumeau

Bibliography—

Restany, Pierre, *Le Plastique dans l'Art*, Paris 1974.
Minkoff, Gerard, *Cesar en Images de 1970 a 1972*, Geneva 1980.
Restany, Pierre, *Cesar*, Paris 1988.

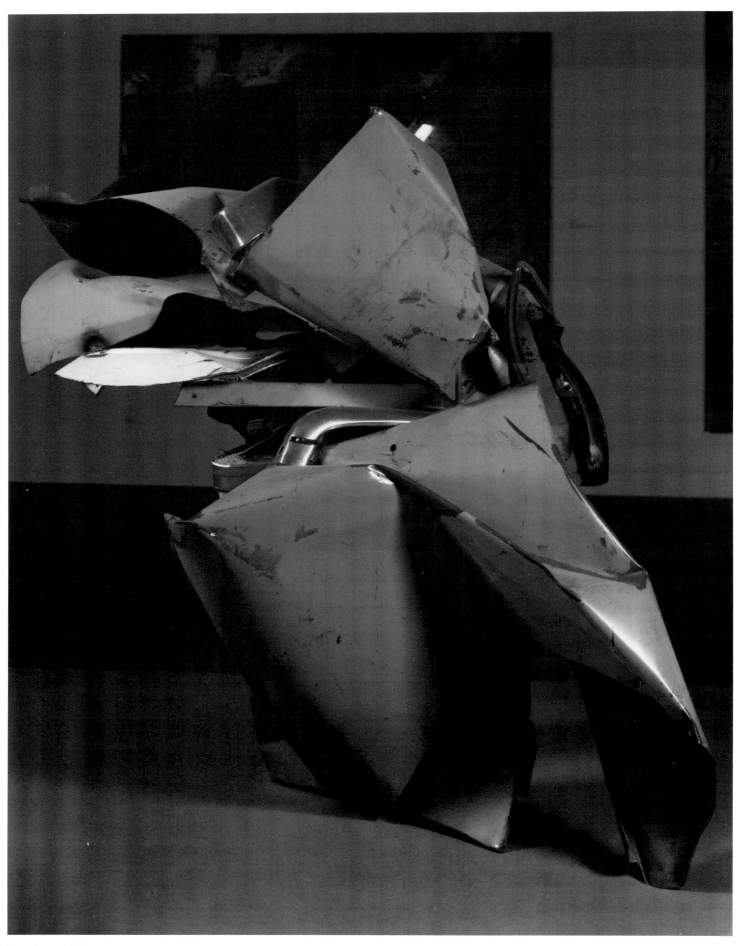

Photo Los Angeles County Museum of Art. Gift of Mr and Mrs Abe Adler

John Chamberlain (1927–)
Sweet William, 1962
Painted and chrome-plated steel; 69 × 46 × 62in. (175 × 117 × 157.7cm.)
Los Angeles County Museum of Art

Like all of John Chamberlain's sculptures, *Sweet William* stalwartly resists all opposing forces from both physical and philosophical sources. Its aggressive attitude is immediately obvious, along with signals of internal desperation. *Sweet William* embraces the pressure of its internal volatile configuration which contains the valid threat of spontaneously dangerous, explosive energy. The substantial size and jagged edges of the structure contributes to its aura of unpredictability. *Sweet William* is an important transitional work, created in 1962, three years after Chamberlain began using crushed auto parts as a medium for his sculpture.

In Chamberlain's early work, inspired by David Smith, metal rods and planes were arranged and then welded together like drawings in space. In contrast, *Sweet William* is volumetric and intuitive. Unlike the later, more Baroque work in which the parts are fitted together in a seemingly effortless interlocking manner with what Chamberlain terms "a sexual orientation," the components of *Sweet William* and other sculptures of the 1960s are stacked rather than fitted.

The base of *Sweet William* is gravity oriented, its dark box-like, shadowless cavity retains the balance of the trunk despite the pushing, shoving attack from the heavy slanting diagonal shafts of metal rising from ground level. The force is so powerful that the crest of the torso has shattered and segments have been ripped apart, spurting out the opposite side in a precariously cantilevered protuberance. The diagonal configuration of these shafts or stems delineates a curvilinear bisection of the vertical mass of the sculpture, which remains upright although slightly tilted. The spiral softens the gashing eruption of double-edged steel from the ravaged center section. Wiry projections are chaotically juxtaposed with dense chunks of metal, all in a frenzy of activation. Despite the feeling that a violent action has recently taken place, another blast may be imminent. The sculpture is not the captive of this quiet moment, but the master of subsequent action. Obviously the role of the artist is the transporter, not the enforcer.

Each fragment of metal retains its original derelict color—the harsh corroded surfaces of the basic blue, cheerful red and garish yellow so beloved by the auto industry. Streaks of honest rust add texture and authenticity to the original enamel. Iridescent gold and shiny chrome fragments are inserted as an integral part of the color strategy, adding the glimmer of an ersatz luminescence to the reflective surfaces. In his later work, Chamberlain has used additive color in calligraphic strokes resembling graffiti to break up the refractive surfaces of the metal. But *Sweet William* is more somber, less contrived in color, yet more agitated in stance than the work of the 1980s.

Throughout his career Chamberlain has been forced to declaim his medium as metaphor, although art critics sometimes refuse to accept crushed auto parts as a legitimate medium. Many continue to evoke images of car crashes, the American dream, or consumerism. Although the artist has drawn inspiration from Picasso and Gonzalez, who also used industrial materials to create sculpture, perhaps the challenge for Chamberlain in using common material far removed from the source is to lead viewers beyond categories into the essence of the work.

If there is indeed metaphor surrounding the sculpture—certainly a contradictory assumption—it is possible to arouse the figurative. From certain angles looms the spectre of a warrior figure in a pyramidal helmet, on the alert for an impending attack. His weapon is a black shaft with yellow gun sights. The larger than life-size of the sculpture evokes a sense of crisis and renders the figure unapproachable. Or if titles contain clues and *Sweet William* is based on a flower image, we can view the work as evolutionary. There are references to a plant bursting into flat dense clusters of varicolored flowers, bending in the wind as a torrent of raindrops bounces on the surface. But it is obvious that any attempt at metaphor is ultimately contradictory.

Physically, the work is about the closeness, contact and clasping of opposing forces—a non-violent relationship between the curvilinear and the rectilinear in which the elements are sequentially fitted into an interlocking orderly totality. Philosophically the work exists on its own terms and according to the artist "the meaning is somewhere else."

If we consider Chamberlain's alleged debt to the abstract expressionists such as de Kooning, we must acknowledge the likeness in concept but examine the difference in process. Chamberlain does not shatter reality into abstract forms. Rather, he begins with forms already abstracted from the indisputable reality of the automobile. And with this commercially fragmented medium he recycles a new reality of art object which is a whole rather than a sum of its parts. He reimposes logic on material in which the logic had been purposely destroyed. Basically, he has reversed the planned deliquescence of used auto parts.

The artist is still dominated by his decision to render the hard into the soft by pounding, hammering and crushing metal until the brutish nature of this material is transformed into an incomparable elegance, in which all past identity has been sacrificed. More violent than the action painters, Chamberlain discovered that he could crush, crumple, gash, rip and vent all his furies on this material without loss of intent. His work is an act of process in which he establishes a new iconography which still compels him to operate outside the categories of contemporary art history.

Chamberlain's sculpture first came to attention in *The Art of Assemblage* exhibition at the Museum of Modern Art in 1961. The following year his work was exhibited at the Leo Castelli Galleries in New York City, and in 1964 he was included in the American Section of the Venice Biennale.

Historically *Sweet William* is certainly a symbol of the 1960s in the United States. There is above all the resistance to traditional values in the forcefully induced change of material from the context of junk to the concept of art. There is both freedom and irony in the use of vulgar material which is so widely available. In creating order out of chaos, Chamberlain has awarded *Sweet William* an heroic stance and provocative complexities. The sculpture's attitude signified a new means of accepting what had not yet been acceptable in the art world.

—Marcia Corbino

Bibliography—

Waldman, Diane, *John Chamberlain: A Retrospective Exhibition*, catalogue, New York 1971.
Sylvester, Julia, *John Chamberlain: A Catalogue Raisone of the Sculpture 1945–1985*, Los Angeles 1986.

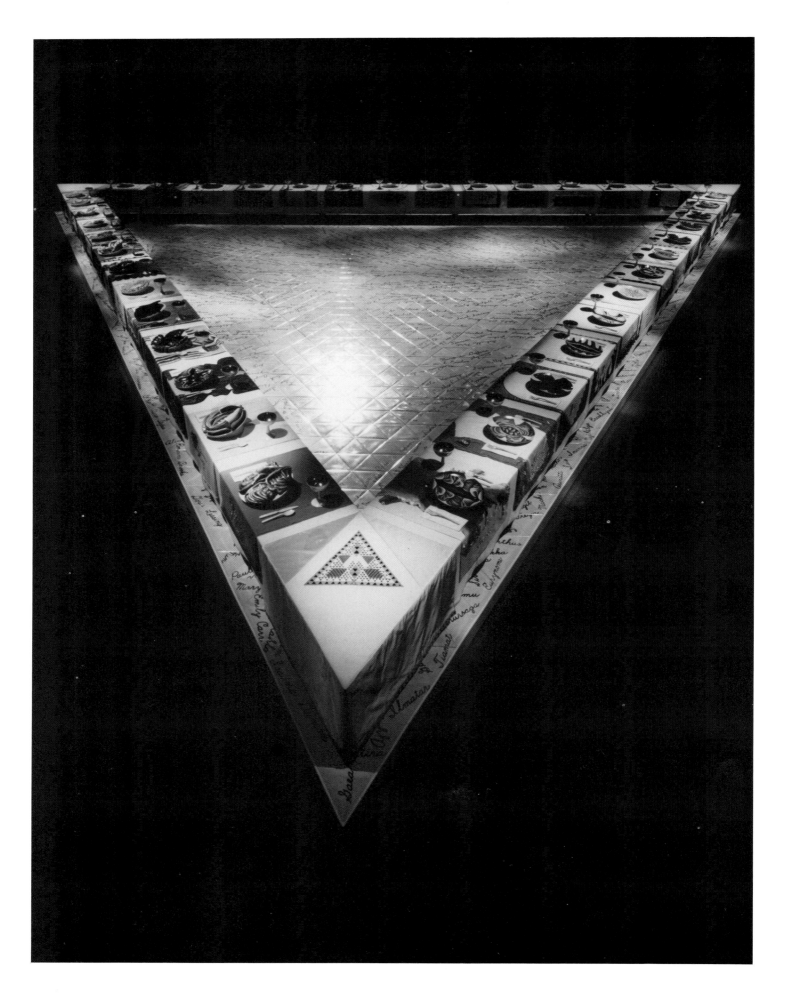

Judy Chicago (1939–)
The Dinner Party 1979
Mixed media sculptural installation; 576 × 576 × 576in.

The Dinner Party is a massive triangular table laid with thirty nine place settings, thirteen along each side. Each setting commemorates a particular goddess or a woman in Western history and consists of a decorated plate (painted or sculpted) a chalice, ceramic cutlery, a table napkin and an embroidered cloth designed to evoke each individual woman and her historical period. The designs on the plates are partly organic (floral and vegetable) and partly vaginal in their reference, while the plates rest upon embroidered runners which place the woman in context by being stitched in the style and technique of the woman's time. The ceramic tiled floor on which the table stands is covered with the names of nine hundred and ninety nine other historical women, some famous, some long forgotten. More than four hundred women and men worked with the American feminist artist Judy Chicago, whose concept the project was and who designed the settings. Chicago herself considers the work a celebration, a feast in honour of women through the ages.

The Dinner Party draws together and gives visual form to numerous threads of feminist thinking which evolved during the 'sixties and 'seventies and marks a significant point in feminist artistic practice; the incorporation of vaginal imagery is particularly significant. The use of vaginal imagery by feminists emerged as a strategy enabling women to take control of their own bodies through regaining control over the imaging of their bodies. As Germaine Greer writes in *The Female Eunuch*: "Women's sexual organs are shrouded in mystery . . . When little girls begin to ask questions their mothers provide them, if they are lucky, with crude diagrams of the sexual apparatus, in which the organs of pleasure feature much less prominently than the intricacies of tubes and ovaries . . . The little girl is not encouraged to explore her own genitals or to identify the tissues of which they are composed, or to understand the mechanism of lubrication and erection. The very idea is distasteful."

The acceptance and re-integration of the female genitals into art was seen as a specific political gesture rather than anything explicitly erotic; celebrating the mark of the "otherness" of women and replacing feelings of inferiority with those of pride. Like the self-examination health groups by which it was probably influenced, it is a strategy which promotes self-knowledge in an attempt to refute the Freudian concept of penis envy and the notion of woman as "The Dangerous Sex."

Chicago had earlier explored female sexuality in explicit images of women's sexual and bodily functions, notably in the installation *Menstruation Bathroom*, a project for the Los Angeles collective teaching programme *Womanhouse* (1971). The *Womanhouse* project resulted from the Feminist Art Programme which Chicago set up with Miriam Schapiro at CAL in Los Angeles. Working with a group of women art students, at first consciousness-raising about being women and then creating art in order to explore themselves as women, the class took over and renovated an empty downtown house and remade each of its rooms as a dramatic representation of women's experience of childhood, home, menstruation, marriage, eroticism, nurture and fantasy. Projects such as *Womanhouse* and Chicago's controversial print *Red Flag*, a print depicting a photographic image of a woman removing a tampon, challenged the long-standing taboos surrounding these areas of female experience.

Womanhouse was one of the first feminist art-projects to stress the importance of collective work and the relationship between discussion and making. It opposed the cult of the star individual genius in order to reclaim the history of women's creative relationships, summed up in the phrase "Anonymous was a woman," and was an attempt to forge new kinds of art work and thus a new understanding through woman's solidarity. As a focus of collective activity and as a monument to a new understanding, *The Dinner Party* is a direct descendent of the *Womanhouse* project.

The use of organic forms, part floral part vaginal, in *The Dinner Party* may be traced back to work Chicago was making in the earlier 'seventies such as, *The Rejection Quintet: female Rejection Drawing*

1974. Here, fleshy/floral forms radiate from a central core, clearly referring to the female genitals. Chicago, who previously exhibited large minimalist sculptures eschewing emotion in favour of formalist concerns, sees these works as, "clear abstract images of my feelings as a woman"; thus uniting her real concerns as a woman with the forms that the professional art community allowed a "serious" artist to use. She insists that the flower and genital forms are used as metaphoric symbols to suggest such complex ideas as the simultaneous presence of power and receptivity, strength and vulnerability. These images were primarily concerned with rejection, and each is accompanied by a text; here Chicago speaks of her rejection as a woman artist. Text is a consistent element in Chicago's work, reflecting both her concern that the work should be accessible to those who do not "read" abstract form and emphasis given to the direct expression of the individual woman's experience by the Women's Liberation Movement.

Despite Chicago's insistence on the positive and affirming nature of the reappropriation of women's sexuality, it is a strategy fraught with problems. Meanings in art depend on how images are seen and from which ideological position they are received; for this reason, depictions of the female body are easily absorbed within and co-opted by a male culture. They continue to assert woman in art as body, as sexual, as nature and object for male possession, as opposed to woman as embodying mind, culture and power.

The Dinner Party simultaneously challenges the categorisation of so-called craft and "fine art," a disjuncture which has marginalised the more anonymous craft worker (often female, particularly in the case of embroidery) while accrediting the fine artist (dominantly male and very occasionally female) with almost mythic status. Susan Hill, a photographer, became "Head of Needlework" after apprenticing herself to a group of traditional needleworkers. Under her direction, an embroidery sampler book was created to be used by Chicago when designing the runners. The intention was to place each woman represented by a place setting in context by stitching the runner in the style and technique of the woman's time. A symbolic relationship exists between the runners and the plates: for the place settings of the women of antiquity the embroidery is stitched on the edges of the runners; as the centuries pass, the embroidery approaches the plate. The embroidery acts as a metaphor for what Chicago describes as the "increasing restrictions on women's power that occurred in the development of Western History", adding, "occasionally there is an enormous visual tension between the plate and its runner as a symbol of the woman's rebellion against the constraints of the female role."

Again, as with the strategy of picturing the female body, the use of needlework has implicit problems, largely due to women's ambivalent relationship to embroidery. As Rozsika Parker writes in *The Subversive Stitch*, "the oppressive aspects of the construction of femininity which have been so closely linked with embroidery." In *The Dinner Party*, however, embroidery is utilised not as women's proper art form, as opposed to fine art, but rather as an integral part of a new type of art which explores, illustrates and celebrates the varied history of women.

—Fiona Hackney

Bibliography—

Chicago, Judy, and Schapiro, M., "A Feminist Art Program," in *Art Journal*(New York), no. 1, 1971.
Chicago, Judy, *Through the Flower*, New York 1973.
Chicago, Judy, and Hill, S., *Embroidering Our Heritage: The Dinner Party Needlework*, New York 1980.
"The Dinner Party," in *Ceramic Review*(London), September/October 1984.
Withers, J., "Judy Chicago's Birth Project: A Feminist Muddle?," in *New Art Examiner*(Chicago), January 1986.
Battatore, S., "Judy Chicago's Fiber Art: Revising History, Changing Society," in *Fiberarts*(Asheville, North Carolina), no. 17, 1990.

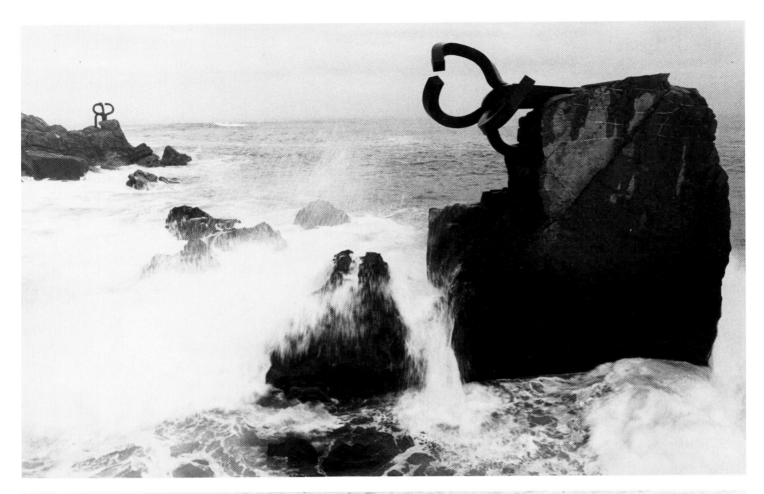

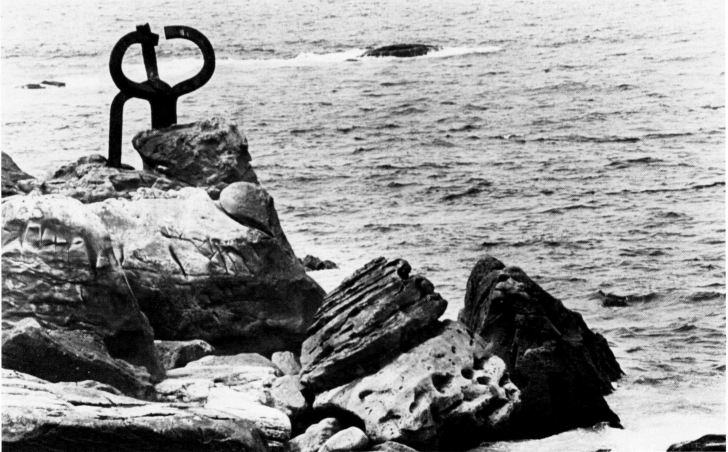

Photos by F. Catala-Roca, courtesy of Tasende Gallery, La Jolla, California

Eduardo Chillida (1924–)
Wind Combs, Donostia Bay, San Sebastian, 1977
Forged iron sculptures

Soon after Chillida returned from Paris to his native San Sebastian in 1951, he resolved to create a large environmental sculpture dedicated to the land, the wind and the sea at a very special site on the western boundary of the city. Between 1952 and 1978, the sculptor produced seventeen typologies of *Wind Combs*, which pertain to the relation of wind and sea. Each of these studies has a different configuration. The earlier ones were forged in iron—some of the later experiments were made in stainless steel and silver. After he received the International Grand Prize for Sculpture at the Venice Biennale in 1958 and his world-wide reputation was safely established, he received the commission to execute the work in 1975.

Working in collaboration with the Basque architect Luis Peña Ganchegui, Chillida began to convert the promontory into a theatre which is located on a natural ledge below the steep palisades on Ondaretta beach at the end of the urban area, and at the finger of land which the winds from the Gulf of Biscay first strike on their way to the city. This area, well known to the artist since childhood, was inaccessible before the construction of the work. Chillida wanted to reveal the "genus loci," the will of the place. Martin Heidegger, who was greatly interested in Chillida's concern with space and void, considered sculpture a thing occupying a place and showing forth in space. *Wind Combs* defines the space it occupies. It is set in the earth, in rock against the sky. But it also relates to the sea and its tides and it defines the wind. Like the three forces—air, rock and water—it consists of three pieces. They are like gigantic Jew's harps or pliers, grasping the sky. One comb is set into the cliff with its axis parallel to the ground, stretching three of its claws into the water, while the fourth one helps anchor it back into the rock. The second sculpture is fastened on a rock in the water and points toward the sky. The third comb is farther out in the sea, silhouetted against the horizon and oriented vertically, opening its arms to the sky. The three are engaged in a conversation which may be silent or highly animated, depending on the forces of nature. The two horizontal wind combs, the sculptor feels, relate to the past, the vertical comb opens to the future, which is unknown. The juxtaposition of horizontal and vertical axes also pertains to an elemental dwelling place. The water is an essential part of the sculpture, filling the void and invigorating it when the element decides to do so. The noise of the water is part of the *Gesamtkunstwerk*, as are the sea gulls overhead or the people below.

To give release to the often turbulent power of the sea under the esplanade, the sculptor drilled seven holes into the granite promenade so that the energy of the storm is liberated in seven vertical columns of water. These create hisses and geysers during a squall. The seven holes were named by the people of San Sebastian after the seven Basque provinces, a response that pleased the artist. He did not have the Basque provinces in mind when designing the work, but, proud of his Basque ancestry and a champion of freedom for the Basque people, he welcomed this fortuitous association, saying; "Just as the piece of land with its sculpture fights the waves and air to survive and attempts to communicate with the other two pieces nearby, the Basque people are struggling to survive as a distinct culture within Spain." The work is an homage to the Basque people as well as a romantic interpretation of nature.

The location itself is a site of remarkable rock formations. The layers of stratification, which actually are perpendicular to the sea, are powerful, visible reminders of the tremendous forces that formed the Pyrenees, which at this very spot rise from the ocean. The wind combs, reaching for each other, try symbolically to bring together again what was once united in remote geological times and broken asunder by natural eruption. The work deals, among other things, with the condition of separating and connecting, with the function of the artist as a negotiator between man and landscape, between form and world.

The approach to the *Wind Combs* has been carefully designed by the sculptor in cooperation with the architect. The paving stones of Porriño granite that came from ancient quarries are cut to the size of the people walking upon them. The space is used as a promenade, as a locale for games, for performances, for lectures, or as a place for silent meditation for observing the sea, the sky and mountains. Sometimes on a stormy day at high tide, the waves will fill the space with spectacular might and a tempest can even cover the sculptures completely. *Wind Combs* appears like ramparts defending the city against the sea. When the hair of the wind hits, it is combed by the elements of the sculpture on its approach to the city.

Unlike a great deal of sculpture that was placed in the public arena during the 1970s and thereafter, *Wind Combs* is not an addition to an already existing site. The sculpture does not adorn, beautify or deface an urban area. Like a small number of sculptors, like Brancusi and Noguchi, Chillida, who had studied architecture before turning to sculpture, gave aesthetic shape and meaning to an architectural environment that he himself created.

—Peter Selz

Bibliography—

Sweeney, James Johnson, *Eduardo Chillida*, Houston 1966.
Voulbot, Pierre, *Chillida*, Stuttgart 1967.
Heidegger, Martin, *Die Kunst und der Raum*, St. Gallen 1969.
Esteban, Claude, *Chillida*, Paris 1970.
Schmalenbach, Werner, *Eduardo Chillida*, Berlin 1977.
Paz, Octavio, *Chillida*, Paris and New York 1979.
Haenlein, Carl, *Eduardo Chillida*, Hannover 1981.
Chillida, Eduardo, and Pena Ganchegui, Luis, *El Peine del Viento*, Pamplona 1986.
Selz, Peter, *Chillida*, New York 1986.

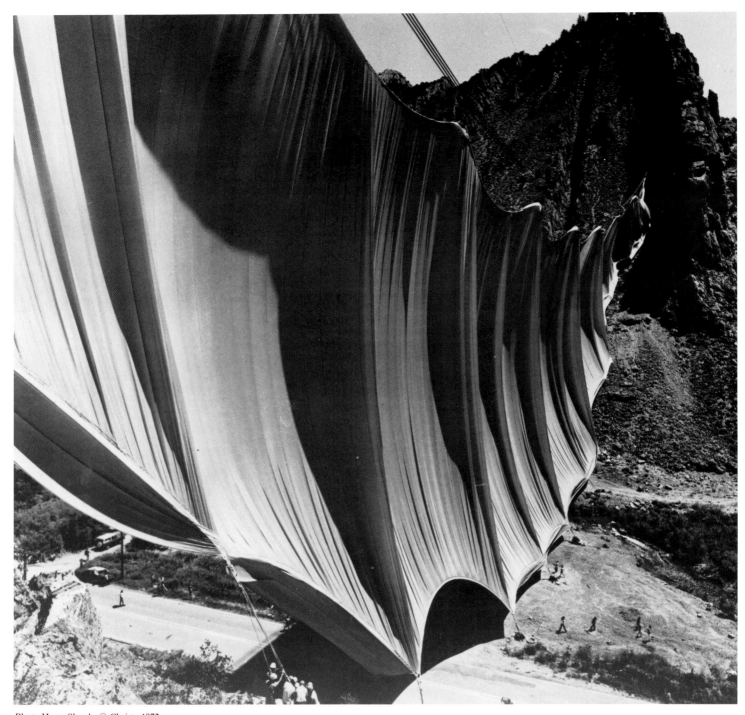

Photo Harry Shunk, © Christo 1972

Christo (Javacheff) (1935–)
Valley Curtain, Grand Hogback, Rifle, Colorado, 1970–72
Synthetic fabric; 417 m. long

When one sees photographs of Christo's wrapped buildings, gigantic running fence, packaged coastline or the curtained valley, one feels that he or she is not looking at a work of art but at an event or a happening taking place in the real world. There is no gallery setting; the work of art exists for only a limited length of time, and it certainly cannot be moved from one place to another. So what is this new kind of art that has been variously labelled environmental or ecological art? It is usually gigantic in size, firmly related to nature or the man-made world, and very ephemeral in character. Most of Christo's projects take several years to organize and carry out, yet when finished the final result may remain in place for as little as a month. Such projects draw huge crowds and much media attention and make a gallery out of nature, forcing viewers to look in a new way at the real world of nature before and after the existence of the project.

Christo was born in Bulgaria of a prominent family with strong connections to business, politics, and the arts. He travelled extensively as a child, until World War II made this impossible. Between 1953 and 1956 he studied painting and sculpture at the Art Academy in Sofia, and in 1957 at the Academy of Arts in Vienna. When he arrived in Paris in 1958, he began to develop the idea of wrapping everyday items as packages, and exhibiting them in a gallery. He was indebted to the Dadaist movement with its concept of recontextualising familiar everyday items, presenting them to the public as objects transformed into art.

Gradually, Christo began to move away from objects to larger projects, such as his store-front construction and the wrapping of buildings. In this way, he felt he was turning physical space into psychological space, and he began to use the technology of the twentieth century to assist him in his projects. He wanted to change our perception of space with a minimum of elaboration or detail, presenting a double image: the space and the objects in it, and the wrapping or barrier or addition that will recontextualize the space. Although his own ideas were well-formulated prior to the execution of such works, he always insisted that additional meaning and perception could follow upon the the completion of the project or event.

The *Valley Curtain Project* is an excellent example of all of these ideas. Christo had become fascinated with the idea of blocking a deep valley with a gigantic curtain, and set out on extensive travels through the mountains and valleys of the western American state of Colorado in search of an appropriate site. He finally chose a place 216 miles from Denver in the Grand Hogback area of the Rocky Mountains. The curtain was to weigh 25 tons and to consist of 250,000 square feet of orange woven synthetic fabric. After much planning, the specifications were at last drawn up by the Ken R. White Company, consulting engineers in Denver, Colorado, and the final result was to partition the valley on a northwest–southeast axis. In this location, the appearance of the curtain would be altered constantly by the changing light. As Christo wrote in his first notes in 1970: "It will be a curtain made of woven synthetic fabric, suspended on a steel cable, about 1,500 feet long, anchored to the two mountain tops with foundations. The Curtain will span 1,200 feet wide with a height curving from about 3,000 feet at the foundations to 180 feet at the centre of the Curtain. The synthetic fabric will be loosely woven and will therefore permit to see, through the Curtain, some of the other side of the valley."

The book of photographs and documents compiled to record the project demonstrates the complicated legal releases and contract negotiations involved, as well as the artist's own funding and the technical logistics that went into the planning. First, the United States was scouted for just the right valley configuration. Then came surveying, leases, contracts, state law changes, complex engineering plans, special telephone lines, and finally the construction.

When finished, the orange-red synthetic curtain had both great beauty and an overwhelming sense of seeing the valley in a new way. There is a sense of revelation and transformation through the size and grandeur of the concealing curtain; yet, it will not remain permanently in place. Christo combines in his work the theatrical effect of a stage setting with the size of a city, coastline, or mountain, while giving it all the excitement of a media event. Thus, he helps us see our world in a totally new way.

—Douglas A. Russell

Bibliography—

Prokopoff, Stephen, *Christo: Monuments and Projects*, exhibition catalogue, Philadelphia 1968.
Alloway, Lawrence, *Christo*, New York 1969.
Bourdon, David, *Christo*, New York 1970.
Christo, *Valley Curtain*, New York 1973.
Besset, Maurice, *Christo*, exhibition catalogue, Grenoble 1974.
Haenlein, Carl-Albrecht, *Christo*, exhibition catalogue, Munich 1978.
Hovdenakk, Per, *Christo: Complete Editions 1964–82*, Munich and New York 1982.
Lucie-Smith, Edward, *Movements in Art Since 1945*, London and New York 1984.
Nakahara, Yusuke, *Christo: Works 1958–1983*, Tokyo 1984.
Laporte, Dominique, *Christo*, Paris 1985, New York 1986.

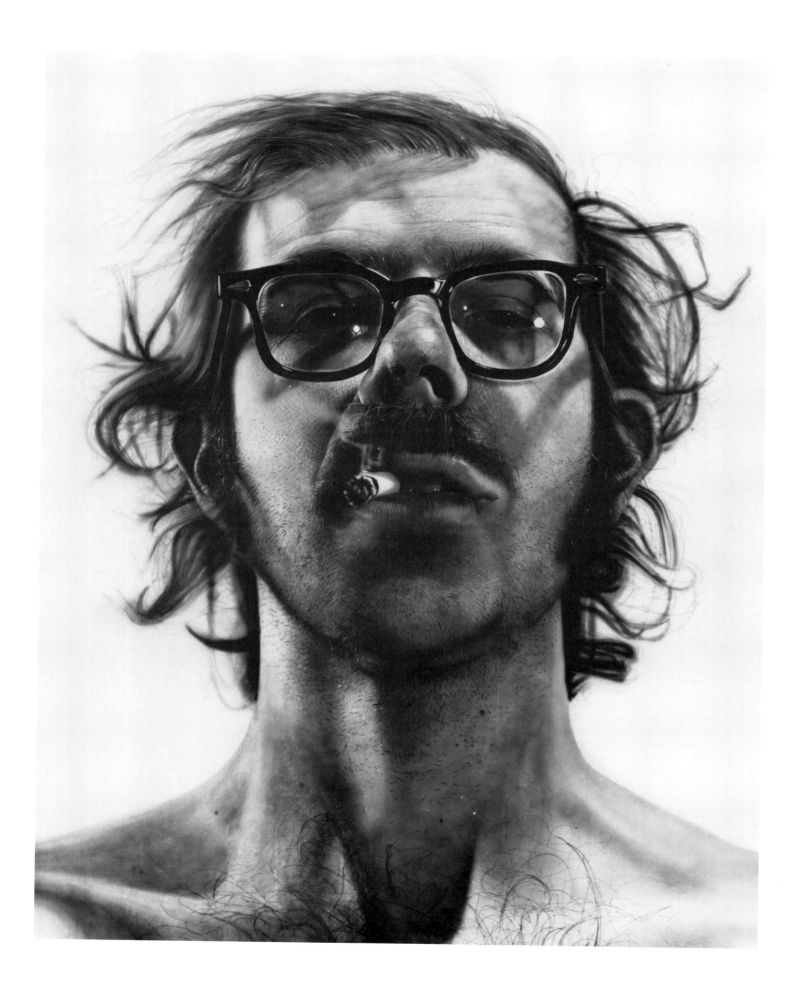

Chuck Close (1940–)
Big Self-Portrait, 1968
Acrylic on canvas; $107\frac{1}{2} \times 83\frac{1}{2}$ in.
Minneapolis, Walter Art Center

Chuck Close has created numerous self-portraits. Each self-portrait is reconstructed by the time period in which it was made, and by the medium which he has used. These two components, time and material, continue to negotiate Close's images of himself. Close creates portraiture out of photography. He paints directly from photographs, working on a single canvas often for a half year, and in some cases working longer than a year. His *Self-Portrait* (1968) has a particularly raw quality. It is dissimilar from the majority of his self-portraits in that Close appears shirtless. His hair is tasseled, and his eyes dominated by his glasses which are askew. This certain idea of "naturalness" and "photographic naturalness" was appropriate to the 1960s, and stands in contradistinction to the more recent self-portraits, particularly those of the late 1980s, which are more studied and have become more concerned with the medium of painting itself.

Photo-Realism as a movement sought to raise questions on the nature of surface appearances, and the compounded relation of photography to realistic representation. Close, in his own development, initially created works which were painted so as to appear to be photographs themselves. Yet these painterly photographs were always a critique of photography as an artistic system. Conversely, Close's paintings of the late 1980s maintained the photographic-like form of his earlier works, but were richly hued and textured. His later works are painted in mosaic patterns and appear abstract in comparison to the earlier photo-realistic paintings.

What is always operative in Close's work is a sense of scale. Generally his works are gigantic. But even the smaller works are filled so that the subject dominates the scale of the work. Usually the subject is a portrait, and the physiognomy is made brilliant. Close has admitted to the psychological difficulties of observing one's visage when it is magnified. His monumental *Self-Portrait* (1968), nine feet tall by seven feet wide, avoids the stare of the viewer, but also suggests a keen sensitivity to the viewer's presence. In an interview Close discussed the work, "It's difficult to deal with an image of yourself that size. I referred to it as him." Close's self-portraits can be used as therapeutic tools, as a form for magnified self-prognosis. The idea that enlargement of the image, the common language of advertising, can be a forum for self-reflection would seem almost antithetical to the current use of the gigantic. Yet Close works in such detail in his enlargements that a critical and analytic quality is evident in the work. Close's magnified images are not images of power, they are self-examined visages.

While Close originally worked, as in the *Self-Portrait* (1968), to use a system of painting as a way of building a photographic likeness of the subject, his later portraits and self-portraits are built to show the buttressing of this self-constructed system itself. His later work references many of the systems of image construction in the twentieth century through his use of a grid-like computer infrastructure. His recent *Self-Portrait* (1986), oil on canvas, is an analytic patchwork of color. While Close was originally interested to expose the thin separation between appearance and likeness, in his later work he is interested to expose the structural appearance of his own system. The transitional development in Close's use of the subject mimes the cultural and technological progression from photography to the computer screen. The self-portraits represent this transformation, exhibiting a displacement of the image from the 1960s to the 1980s. The photograph and the computer screen, as modern public images, are methods of interpretation and observation. Yet Close's self-portraits remain distinct from the seduction of both of these ideas. There exists in his portraiture the feeling of the individual which is separate from his critique of the systems of the images. The mythic qualities of the visage in Close's portraits do not become psychological, though, because they are focused on the relation of image to persona, and not on individual narratives.

Close is interested to paint the history of systems of image duplication. Some of his early portraits simulate the photomechanical processes of color reproduction. He has used red ink stamped on paper. Close shows how etchings, aquatints, and acrylic paint are phylogenic forms of photography and the computer grid. Close is a figurehead in the field of Photo-Realism in that his paintings serve to criticize image manipulation, while they simultaneously consider the relation of the individual to the image.

The experiment of Photo-Realism was to create precisely detailed photographic-like portraits. The work was often a response to Abstract Expressionism in its hyper-representation of what appears to be "real." Yet Close's dry and realistic early work led to his lush color portrait painting of the 1980s. While the portraits of the 1960s exhibit the detail of Close's eye, his later portraits amplify this detail so that it is evident without close examination. The dots, dabs, brushmarks, dot matrix patterns and grids can appear, depending upon their size and angle, as Pointillist, or Impressionist. When Close created a collage with a series of polaroids for his *Self-Portrait/Composite* (1980), the result was a Cubist looking work.

Can the "self," the soul, the persona be found in the *Self-Portrait* (1968)? There is a series of repetitions in this work: the sitter characterizes an acted role, the sitter is then photographed, the photograph is then painted. It is through these repetitions and through the magnification of the minute, that Close clarifies the relation of image to world, and size to power. Finally, the "self" is not seen in his paintings, existing always as a residue. The "self" exists in the building up of paint, the activity of the crafting, the choice of medium and materials, and the layering and blocking of paint. As in the history of portraiture, the "self" remains aloof, distant from its image, somewhere between the defocused eyes of the *Self-Portrait* (1968) and Close's glasses, and the physiognomy of the viewer approaching the image.

—John Robinson

Bibliography—

Nemser, Cindy, "An Interview with Chuck Close," in *Artforum* (New York), January 1970.
Scott, Gail, *Chuck Close: Recent Work*, exhibition catalogue, Los Angeles 1971.
Battcok, Gregory, ed., *Super-Realism: A Critical Anthology*, New York 1975.
Lyons, Lisa, and Friedman, Marin, *Chuck Close: Portraits*, exhibition catalogue, Minneapolis 1980.
Lyons, Lisa, and Storr, Robert, *Chuck Close*, New York 1987.

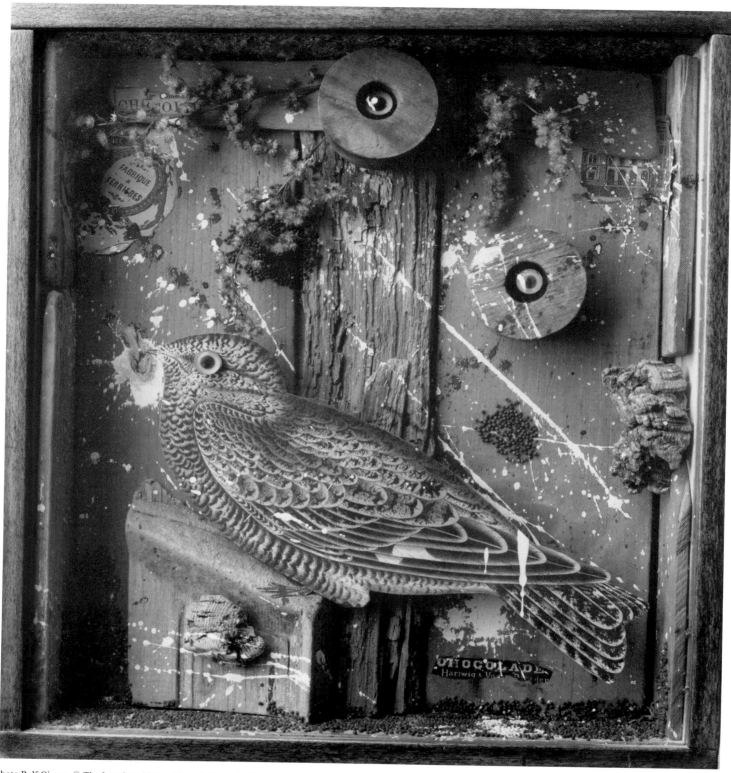

Photo Rolf Giesen. © The Joseph and Robert Cornell Memorial Foundation

Joseph Cornell (1903–72)
Untitled Construction, 1943
Mixed media construction; 31.9 × 29.2 × 7 cm.
Krefeld, Kaiser Wilhelm Museum (Sammlung Helga und Walter Lauffs)

Joseph Cornell, who lived in a nondescript white house in Flushing, made of the things he found about him, primary constructions. He was a primary constructor, and his boxes celebrate whatever nostalgia celebrates: memory, and the natural framed in artifice, forever. He framed moments, making what he called a *Metaphysics of Ephemera*, a lasting time out of what is trivial and passes. He was and remains a cult figure, loved for his love of literature and philosophy and dance and everything that was not the nature of life, but of what preserved its moments best. He was an American Surrealist, disliking the black side of surrealism, a post-dated Romantic, an American European in his sensitivity.

Cornell is best known for his three-dimensional framing of objects within a sealed box. This small room, like a mental theatre, preserves what it includes, and permits the lasting vision of whatever is thought sufficiently worthwhile to protect. At times, the atmosphere of the boxes is realistic, with elements of the outside world entering to confirm reality upon the text. Another time, it is idealized, stage-like, and across it dance the many beings Cornell loved: ballerinas and singers of all descriptions, starlets and movie stars.

Cornell's series called the *Bird Box* series begins in the 1940s: it is perhaps the most sustained of all his series (others include *Sand Boxes*, *Constellations*, *Hotels*, *The Romantic Ballet*). It has as its protagonists mainly owls, parrots and cockatoos (like the celebrated *Juan Gris Cockatoo*, about which there are at least fifty pages in his Source Files) always surrounded by other things, either referring directly to the scene, as a perch or a forest (real perches, real bark, gathered on his biking expeditions), feathers, corks, advertisements. They refer to the tradition of *trompe l'oeil* and the early American fascination for deception mixed up with realism, and have their own kind of American-style poetry, even as they have a European nostalgia—this is true of all of Cornell's work.

Specifically, many of these boxes participate in the series of birds and hotels at once. For example, the *Hotel Royal des Etrangers*, in which a grill is folded back upon itself to the left, and a painted bird rests upon a rectangular set of forms, including the Hotel Tivoli, and the Hotel Pelikan. These birds travel, and they alight. One of the most effective of all the *Bird Boxes* is the *Hotel de l'Europe—Olga Carini Aguzzi* of 1954. The perch is a painted one, upon which the blue-green bird is resting, but above a real bit of branch, whose wood stands out brownly against the white paint of the cracked wall behind the grill in front. Above the bird, an ad presenting the "Novelties of the Season, with a Great Choice of Straw-and-Felt-Hats, Specialties for Ladies and Children," behind a rod with a golden circle to be pushed across. A real cage, but half open, with a cork roundly resting on the bottom—but the cage is open, as half the grill is gone . . . we can get in; the things can get out. And so we share an imagination. These are officially termed assemblages—as if all the magic of the series had been assembled here, as in the other places creation can gather, and gather in.

The bird boxes partake of both atmospheres: generally, the cutout paper bird sits on a real branch, with real sawdust and cobwebs, and perhaps a real leaf included in the scene. For example, the *Owl Habitats*, the *Parrot Habitats*, and the *Woodpecker Habitats* each contain the species under discussion. Often a perch permits the bird to swing freely, while a sort of wire shows the caging in of the animal. The craftsmanship of Cornell speaks loudly in these boxes: for example, a *Grand Owl Habitat* of 1946 shows a centralized "cutout paper owl mounted on wood, perched on bark fragment with fungi, surrounded by thirty compartments. Compartments, divided by wooden strips covered with sawdust and cobwebs, each contain a dried leaf."

But the box can be far more poetic. One blue owl in his box, lit with a tiny electric light, is surrounded with dried leaves and sponge seen through an interior frame, has a glass front tinted blue, penetrated by nostalgia. On the other side of the owl is a fragment from a French book, as if to echo the nostalgia. Many of the bird boxes are nostalgic in mood, such as the *Box with Perched Bird* (1946–48), in which the glass front is tinted blue; the box is fitted with an electric light, but the bird is perched on tree bark. "Requires Blue Glass," we read on the verso, in a rubber stamp.

There is often something to do inside the cage. A *Parrot Habitat* of 1956–57 puts the paper parrot on wood backing, perches it on a wood bar, in an interior totally papered with collage fragments in Latin and French, newspaper pieces and ads for the Grand Hotel Ostende. Mirrors on each side of the perch permit reading the other side, so that the box becomes a whole environment unto itself, to be read. The bird, never to take flight but sometimes seeming just about to, hints at motion captured; whereas the mirrors—reflecting on the repetition and entrapment of the animal—serve to mock, as to reflect. But the entrapment is of a different kind than that of Marcel Duchamp with his *Glass to Look at With One Eye Closed for*. . . .

The motif of the Bird in the Box responds also to the surrealist image of the train whose motor is running, but which is entrapped forever in a virgin forest. Or still leaping in the station, like this bird about to take flight, but stopped, for the moment perhaps, and looking at the observer looking. . . .

—Mary Ann Caws

Bibliography—

Ashton, Dore, *A Joseph Cornell Album*, New York 1974.
Waldman, Diane, *Joseph Cornell*, New York 1977.
Starr, Sandra Leonard, *Joseph Cornell: Art and Metaphysics*, New York 1982.
"El mundo plastico de Joseph Cornell," in *Goya* (Madrid), May/June 1984.
"Papers of Joseph Cornell," in *Archives of American Art Journal* (Washington, D.C.), no. 1, 1986.
Brakhage, Jane, ed., *From the Book of Legends*, New York and Minneapolis 1989.

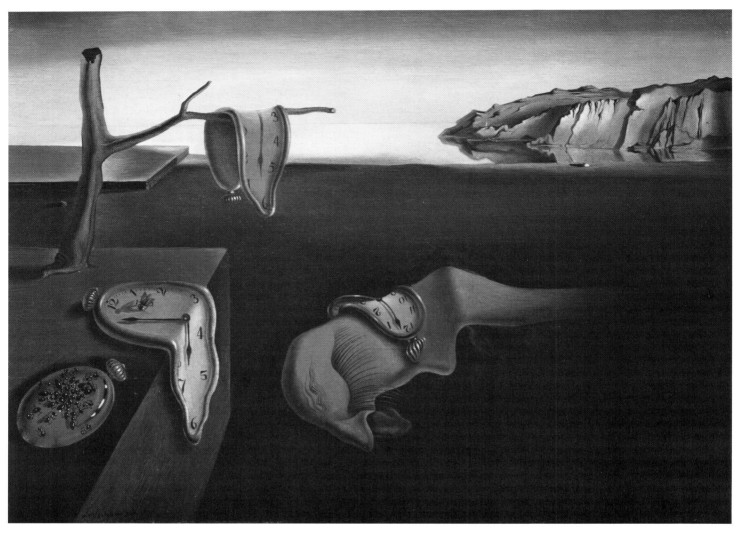

DEMART PRO ARTE BV/DACS 1991

Salvador Dali (1904–89)
The Persistence of Memory, 1931
Oil on canvas; 9½ × 13in.
New York, Museum of Modern Art

Dali showed precocious gifts in the local Catholic schools in Figueras, Spain where he was born, as well as at the National School of Fine Arts in Madrid where he studied art. He exhibited decided megalomania and impressed everyone as a troublemaker; he was expelled from school more than once and served jail terms for anti-government activities. While a student he met Federico Garcia Lorca, who later was murdered during the Civil War; he also wrote the script for the film, *Un Chien andalou* for Luis Buñuel before joining or even meeting the Surrealists.

Despite bizarre activities and outlandish statements, the sum total of his work, including his writings, represents much more than eccentricity, narcissism and slick posturing. Thus the tendency to dismiss Dali is not completely fair, considering his early articles in Catalonian and Spanish vanguard magazines during the 1920s, which are serious and without his familiar pretension. In 1927 he discovered Surrealism in the art magazines; it was a revelation and he painted *Blood Is Sweeter Than Honey*, which featured images that continued to obsess the artist. In the 1920s–30s Freud's theories became so common as to be taken for granted by the Surrealists. Freud used the psychoanalytic device of free association to trace the symbolic meaning of dream imagery to its source in the unconscious; Dali applied the same method to his pictorial imagery.

Based on psychoanalytic studies of paranoiac dementia, the artist consciously charged his paintings with psychological meaning which he called his "paranoiac-critical method," using countless symbols of persecution mania, sharp instruments (castration), sexual fetishes, and phallic images, many taken directly from case histories of paranoia in Dr. Richard von Krafft-Ebing's *Psychopathia Sexualis*, as well as from Freud's works. Paranoia is a mental disease characterized by delusions and projections of personal conflicts ascribed to the supposed hostility of others. Dali's work imitates paranoiac conditions, because while the paranoiac is able to find proof of persecution, Dali only simulated the illness. He used "paranoia" less in the psychiatric sense than the etymological meaning, para- (alternate) + mind; thus his "paranoiac-critical method" became a forced inspiration as his paintings submitted to the caprice of dream and wide-awake calculation. His images, based on readings in psychiatry, eventually began displacing experiences drawn from his own psyche.

The long-venerated Newtonian cosmos, shattered by Einstein's special theory of relativity, had to be discarded and replaced in the early part of this century; "at rest" was no longer a reality as the philosophical perception of time shifted from an absolute to an eternal state of becoming. Much discussion gave rise to questions about when time began, will it exist forever, and had it always existed. Philosopher Henri Bergson quipped: "Time is nature's way of preventing everything from happening at once." The Church thought of time as eternity, citing Thomas Aquinas's *Summa theologiae* where he compares completeness, perfection, and infinity, to God.

The deep perspective in *Persistence* suggests time past, with the viewer deserted and lost in infinity. Interestingly, Salvador ("Saviour") Dali's anti-clerical bias is reflected in his use of Christian and Freudian images in the painting; and as if to emphasize the reality of his hallucinations, his surreal iconography is placed in the landscape of the bay at Port Lligat on the Costa Brava, his home and studio. Although he describes the origin of the soft watches as derived from dreaming of Camembert cheese, Marcel Jean, in his *History of Surrealist Painting*, says they symbolize impotence: *montre* not only means watch in French, but is also the imperative form of the verb *montrer*, to show. A sick child must show his tongue to the doctor, *montrer la molle*, which sounds the same as *la montre molle* (soft watch).

Usually we think of these bent watches as referring to Einstein's theory in which our world is becoming a spatio-temporal continuum; the world's concept of time and space was certainly changing. The three open and vulnerable watches (past, present, future?) are within orthogonals which point to the top center of the painting

(heaven?). According to Freud, menstrual periodicity transforms the concept of time into a feminine symbol, and the fourth watch, closed, hard and impregnable, has been diagnosed as a feminine symbol. Certainly this watch in the foreground is a vital red, while the middle ground watch is softened to orange and the background timepiece is a lifeless gray. Could the hands on the flaccid watches refer to the traditional medical-scientific sign for male?

Ants usually suggest putrefaction and decay; the rigid watch is attacked by scavenger ants, indicating the inorganic is becoming organic and vulnerable. However, since the watch is closed and red with life, time is unattainable and the ants attack without success, implying triumph over death and decay via procreation or immortality. In Christian doctrine, ants signify provident man, the one who chooses the true doctrine and rejects heresy. The fly, on the other hand, has long been considered a bearer of pestilence and evil (Lord of the Flies, or Beelzebub, is from *Ba al-z' bub*, lord + fly, a god of the ancient Philistines, averter of insects). In Christian symbology, the fly symbolizes evil.

The amoeba or fetal image suggests the primordial beginnings of life, and like a lost soul in infinity, is stranded on a barren beach with its life-giving water (holy water?) in the far distance. This fetal image, usually interpreted as a self-portrait, appears in several other paintings, including *The Great Masturbator*. The soft tongue, similar to the limp watches, is a well known Freudian symbol for the penis; Dali, in his *Secret Life of Salvador Dali* makes public his anxieties about sexual dysfunction.

Trees, tall and erect, are male, according to Freud; but this tree is scrawny and lifeless. The extending phallic branch, with its post-coital watch, points to rock formations which in actuality are the granite outcroppings above the Bay of Cullero near Dali's home. "Geology has an oppressive melancholy," stated the artist, "this melancholy has its course in the idea that time is working against it." Again, the rock is a symbol of Christian steadfastness, and suggests the antithesis of the biological objects which are subject to the laws of change and disintegration. According to medieval Christian legend, the Tree of Knowledge of Good and Evil withered when Adam and Eve ate the forbidden fruit. Thus the dead tree in Giotto's *Lamentation*, della Francesca's *Resurrection*, and Michelangelo's *Fall and Expulsion*, all refer to original sin, otherwise known as Freud's Oedipus Complex. The cubes on the left may possibly have some reference to Cubism, although again, they are symbols of stability in Christian iconology. Ants, the fly, yielding watches, fetus, open horizon, all suggest the transitoriness and impersistence of time.

Realism dominates Dali's work because the visual logic of the picture makes itself felt in the sense that the dreamlike emphasis can be conveyed only when the objects are neither stylized nor abstracted, but factually rendered. Only in this way can the iconology be realized and the "irrationalism" of Dali express itself.

It is interesting that the irrationalism and hyperbole of Surrealism, and especially of Dali, are not very highly regarded in the art world today, while abstraction continues to grow and hold our attention. Even Freudian dream theory is now challenged; many neuroscientists and psychiatrists argue that dreams do not stem from unacceptable hidden desires and fears but actually are caused by spontaneous electrochemical signals in the brain which we cannot help investing with meaning.

But Dali continues to fascinate.

—Martin Ries

Bibliography—

Soby, James Thrall, *Salvador Dali*, New York 1946.
Morse, A. Reynolds, *Catalogue of Works by Salvador Dali*, Cleveland 1956.
Jean, Marcel, *The History of Surrealist Painting*, New York 1960.
Morse, A. Reynolds, *Dali: A Guide to His Works in Public Museums*, Cleveland 1974.
Picon, Gaetan, *Surrealists and Surrealism: 1919–1939*, New York 1978.
Ades, Dawn, *Dali and Surrealism*, New York 1982.

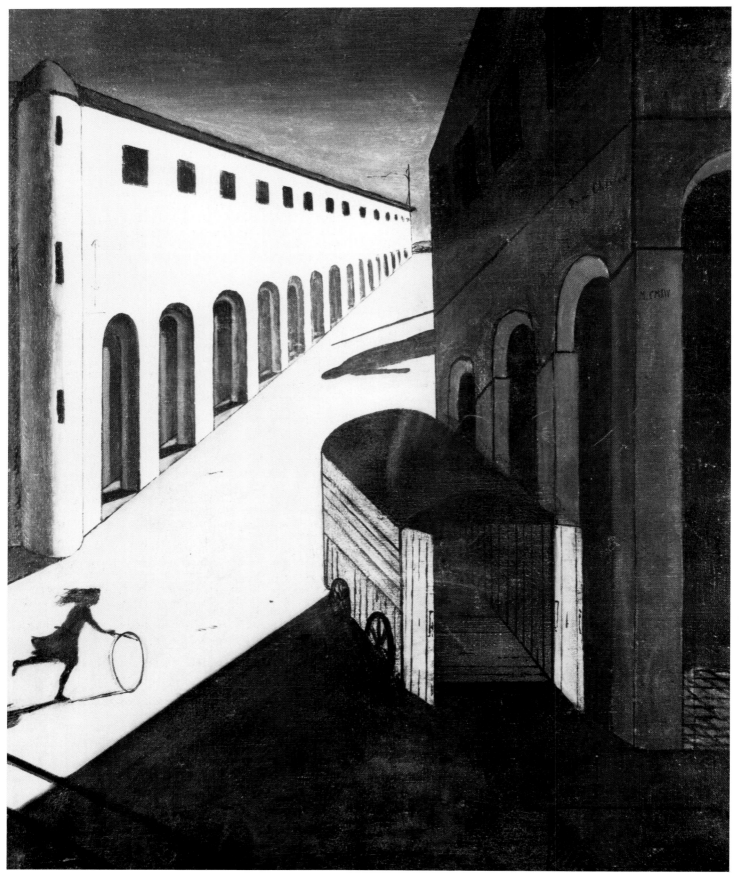

© DACS 1991

Giorgio De Chirico (1888–1978)
Mystere et Melancolie d'un rue, 1914
Oil on canvas; 87 × 71.5 cm.
New York, Private Collection

This picture is one of the series entitled *Places d'Italie* in which the setting is the city of Turin. In the course of the same year, Giorgio de Chirico executed several paintings based on the same urban space seen from differing vantage points. The most famous are *L'Enigme d'une journée* (in the MOMA in New York), *Nature morte: Turin au printemps* and *Le jour de fête*.

There is no doubt that 1914 was the most fertile year of the period during which the artist developed his "metaphysical" style. Between 1910 and 1919, Giorgio de Chirico created in his paintings an atmosphere that is both disturbing and enigmatic. Against a setting of deserted squares, unpopulated and sombre arcades, towers, factory chimneys, locomotives and long shadows, he invented a strange and unreal pictorial world. This anguished and melancholy space, which could already be termed "surreal," was to exert a powerful influence over the Surrealists of the 1920s, such as Salvador Dali, Max Ernst and René Magritte.

In the first decade of the century, Giorgio de Chirico can be seen as a highly unique artist in the context of those members of the avant-garde working in Paris and throughout Europe. Apollinaire, an assiduous and lucid witness of these times, wrote in 1913: "The art of this young painter is a cerebral and internal art which bears no relationship whatever to that of the painters who have emerged in recent years. He owes nothing to Matisse or Picasso, nor is he a descendant of the Impressionists."

This "metaphysical" painting is an expression of the mental landscape of a man haunted by memories of a childhood and adolescence spent between Greece, Germany and Italy. Giorgio de Chirico dwells upon his youth in Greece, dominated by instability and frequent moves due to the work of his father, who was building a railway line in Thessaly. He speaks of his general tendency to melancholy and the effect of the weather on his psychological state. His main themes, therefore, revolve around the enigma of departure and return (stations, the Argonauts, Hector and Andromache, the departure of the poet). Dehumanised figures (mutilated statues, dummies) are scattered around distorted perspectives, casting illogical shadows. The light is often that of the hottest part of the day, the early afternoon, when silent and empty streets are pervaded with what the artist called "the secret signs of a new melancholy."

In this painting, the arcades divide the scene into two distinct areas, one bathed with light, the other in the shade. These are the same arcades that can still be seen along the Via Po in Turin. The time is set in the heat of the afternoon. The trailer with its rear doors open is a removal vehicle, as seen in other paintings by Giorgio de Chirico of the same period. Here he is also dealing with the pain of departure intertwined with memories of a Grecian childhood, transposed here to a location in Turin linked to periods of his more recent life.

It is timeless meditation where past, present and future merge into the mental and cultural continuum created by the artist in each of his "metaphysical" paintings.

As he himself wrote in 1913: "Nevertheless, our spirits are haunted by visions which stay with us for all eternity. Strange irregular shadows are thrown across rectangular city squares; from behind walls emerge bizarre towers decked with little flags in thousands of colours. Everywhere we see the infinite, everywhere we find mystery."

Here, we see the shadow of what appears to be a statue cast menacingly on the ground. A little girl with a hoop runs towards it. The child is full of life and movement, which is rare in the "metaphysical" paintings where human figures are nearly always ambiguous (their bodies are both of flesh and stone). The girl is the element which breaks the tension of the space and the climatic heaviness of this enigmatic scene.

It is this unexpected freshness that makes this picture an exception among the rest of the "metaphysical" paintings, where nothing moves; where life, strictly speaking, is turned into statues; where time and movement, along with light and shadow, are the only protagonists in a universe of exceptional tension.

—Giovanni Joppolo

Bibliography—

de Chirico, Giorgio, *Memoria della mia vita*, Rome 1945.
Hedwig, Werner, *De Chirico: Periodo Metafisico*, Milan and Paris 1962.
Carriere, L., and Cavallo, L., *Giorgio de Chirico: l'Immagine dell'infinito*, Milan 1971.
de Chirico, Giorgio, *The Memoirs of Giorgio de Chirico*, London 1971.
Bruni, Claudio, ed., *Catalogo Generale: Giorgio de Chirico*, 6 vols., Venice 1971–76.
de Chirico, Giorgio, *De Chirico by de Chirico*, New York 1972.
Schmied, Wieland, and others, *De Chirico: Vita e opere*, Milan 1979, Munich 1980, Paris 1981.
Rubin, William, and others, *Giorgio de Chirico*, exhibition catalogue, Paris 1983.

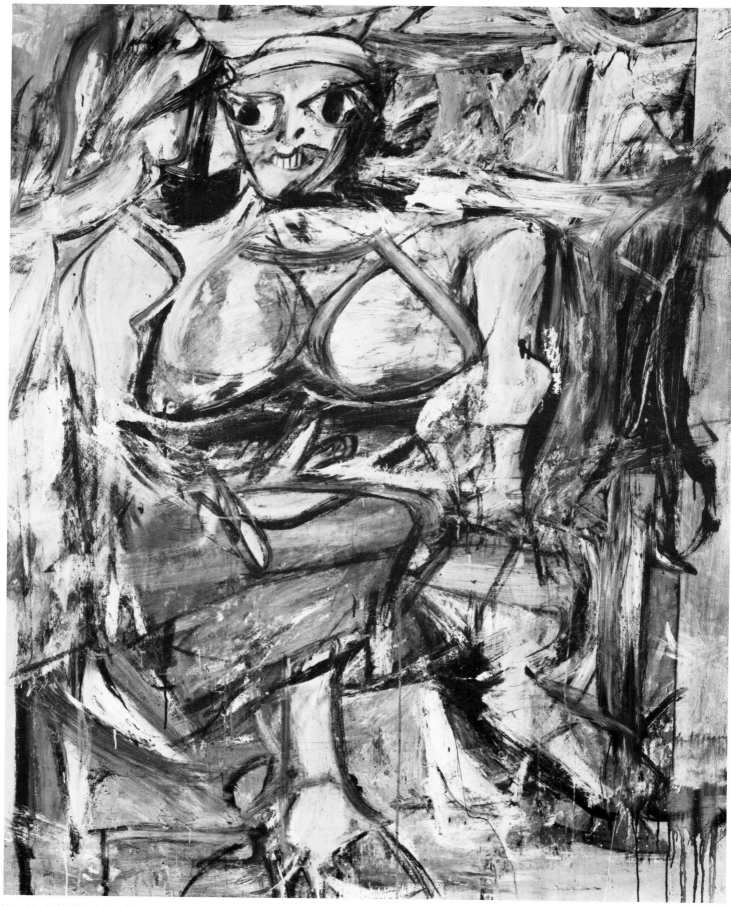

Copyright 1991 Willem de Kooning/A.R.S., New York

Willem De Kooning (1904–)
Woman I, 1950–52
Oil on canvas; 75 × 58in. (190.5 × 147.3cm.)
New York, Museum of Modern Art

When Willem Dekooning's, *Woman I*, was first shown, an artist acquaintance of his was heard to remark, "What has Bill got against the girls?" Actually, and despite an intervening accumulation of charges of being a macho icon of the degradation of women, it is neither misogynous nor particularly erotic. Granted that it is not flattering, it might better be called fierce, confrontational, energetic, even terrifying; others of the series (*Woman II, III, IV, V*, etc.) could be characterized as voluptuous, hilarious, inviting, glamorous, blowsy, predacious and the like. None of these aspects are dismissible in understanding the meaning of the work, but it would be a mistake to believe that any of the paintings are simply statements of such attitudes. Rather, the uncensoredness, the letting-it-all-hang-out, is ingredient to a far more consequential attitude toward images and their production, about consciousness and painting language and about how art and experience mediate each other. It is the fusion of form and meaning which makes this painting distinctive in the artist's development and in the art of our times.

Woman I is the culmination of a theme which the artist had stalked through a dozen years or more in numerous paintings of seated figures, both male and female. Its problem, which he did not know until he resolved it, was to make the presence of the figure and the painting coincide. Nothing defines humanness so much as our awareness of ourselves and others, in the relationship which is expressed as an "I and Thou." Just as we have this awareness of another like ourselves, confronting us and being confronted, complete with attitudes, intentions, character, expectation, summed up in our reading of the physiognomical, so the summing up of all the suggestions of the pictorial elements yields that condensation which led Dekooning to declare that, "Every painting has a face."

This condensation involved a long struggle of more than two years, and documented by a number of photographs of intervening stages by his friend and neighbor, Rudolph Burckhardt. Elaine Dekooning has estimated that there were more than two hundred different starts and erasures. As surprising as the aspects of woman represented was the fact of returning to representation itself, since he had been hugely successful in what were widely regarded as radically abstract paintings immediately previous to embarking on this project. In point of fact, he was never completely or programmatically non-representational, and vehemently disputed with contemporaries that the only valid or progressive art was abstract. As much of a surprise was his return to rich, sensuous, pervasive color after several years of working either completely in black and white or with relatively slight color.

More importantly, *Woman I* marks Dekooning's breakthrough to what was to be his his mature, highly personal language of paint manipulation and function, the slurred, fluidly blended and furiously slashed usage, with all the drips allowed to remain where they had fallen.

This celebrated facture fulfils several functions. The most obvious is that it conveys the speed of execution, which is not an end in itself, so much as a means of engaging the spectator in the intention of the forms, where one participates through the gesture in the feelings which the performance engendered. The intention is not prior to the act, but comes out of it, and is part of the method of automatism discovered by the surrealists as a means of releasing unconscious themes and associations. Here it is, in the words of Robert Motherwell, "a plastic automatism," where the pictorial forms themselves carry the emotions without any intervening iconography.

Besides incorporating action, the slurred, agitated paint conveys something of the sensuous continuity, not simply of flesh, but of carnateness which was accomplished earlier by the glazes and scumbles of late Titian and Rembrandt. This can only be done fully and freely by oil paint, wet in wet, so that there is an intimate relationship between the corporeality of expression and the spontaneity of intuitive projection. This also involves a structure of lost and found edges, of differentiated focus, equivalent in a formal way to the cubist use of "passage." The substance of the paint, dragged and skeined over the surface also constitutes a matrix of relations, not only to assert the literal flatness of the painting so much as the simultaneity in consciousness of all the readings of form and movement. It is this simultaneity, everything interacting with everything else, which requires that nothing be cleaned up, that all the strokes and smudges, emphases and elisions are presented as at the moment of their realization.

All of Dekooning's mature paintings are a continuation of the cubist tradition at the same time as they are attempts to get away from and supplant it. Like the major achievements of Braque and Picasso of 1910–11, they strive for an activation of the whole canvas as both a single entity and a set of mutually dependent internal relationships. The difference is in emotional connectedness as against dispassionate analysis and manipulation. In Burckhardt's photographs of the intermediate states we can see that formally the artist struggled against the separation of the figure from the background. But he was only able to overcome this when he had realized the psychological unity of the confronting personality. *Woman I* is distinctive in the way the confronting aspect, implicit in the frontal presentation of the shoulders and breasts, interacts with the torsion rendered by the placement of the feet, the separation of the knees and lap, the twisting of the pelvis to the right and the head to the left, all echoes of the contrapposto which Michelangelo innovated in the figures of the sybils, prophets and angelic youths on the Sistine ceiling to express the incarnation of the spirit. Classic cubism is not only restrained and detached; it is implicitly rationalistic and Utopian. Dekooning's cubism is anxious, doubting, existential.

The tortured paint, the incompleteness of some parts and the compulsive emphasis on others, mark a struggle, not only with painting, but with reality. The ferocity, destructiveness and questioning implicit in the endless revision involve a deeper sense of meaning than is visited on the subject alone. Many of the graphic elements of "*Woman I*" are prefigured in a pencil portrait of Elaine, done ten years earlier. Though the treatment and psychology are different it shows not only the same staring eyes and voluptuous bow of the lips, but also, in the details of hands and drapery, the same morphology of interlocking, hooked curves which make up the fabric of the present work and the "abstract" works which preceded it, as if the painter were carrying around, internally, a vocabulary of forms seeking to concretize their most emotional authentic and plastically complete meanings. The interdependence of the formal and the psychological is shown by the comparison of the photos of the intermediate stages with the final result where everything, character, gesture, spatial relations, even the meaning of the painting language are completely redefined.

This formal completeness was not for Dekooning simply an esthetic exercise; rather it was the means and authentication of the realization of meaning. Dekooning wanted it all: the completeness, self-definedness and evocativeness of abstract form, the multiple meanings of surrealism, the tawdriness and impact of actual life, the candor of self-revelation towards and within the human situation. For this integration the attitudinal themes of "*Woman I*" were the catalyst.

—Louis Finkelstein

Bibliography—

Greenberg, Clement, *De Kooning Retrospective*, exhibition catalogue, Boston 1953.
Janis, Harriet, and Blesh, Rudi, *De Kooning*, New York 1960.
Goodman, Merle, *"Woman" Drawings by Willem de Kooning*, exhibition catalogue, Buffalo, New York 1964.
Rosenberg, Harold, *De Kooning*, New York 1974.

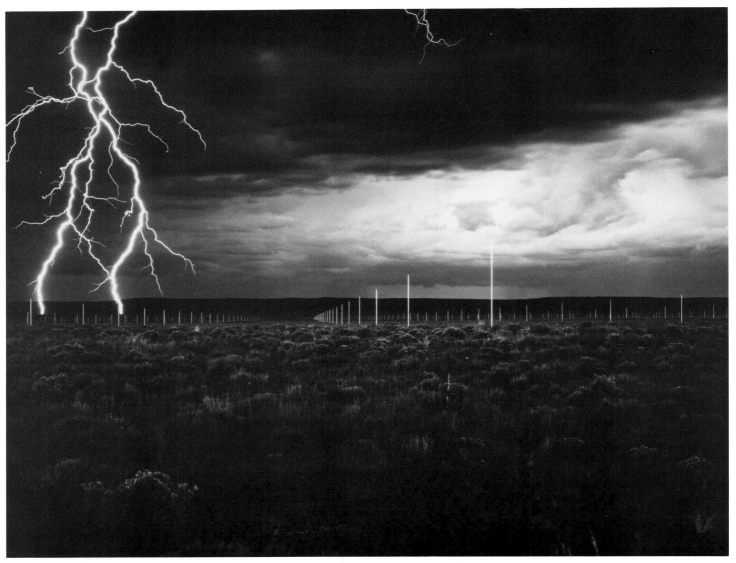

Photo John Cliett © Dia Art Foundation

Walter De Maria (1935–)
The Lightning Field, West Central New Mexico, 1969–77
400 stainless steel rods; 1609 × 1006m.
New York, Dia Art Foundation

When Walter De Maria presented his work *The Lightning Field* in the pages of *Artforum* (April 1980), he limited his exposition to five photographs and a page of facts about the piece. This emphasis upon impersonal photographic documentation and quantitative data rather than upon autobiographical anecdote or affective criticism makes two valuable points about *The Lightning Field*: it is, first of all, physical, and as mathematically correct as current technology will permit; secondly, its meaning is left up to the viewer.

Within a vast flat New Mexican plain ringed by distant mountains, an area of precisely one mile by one kilometer six meters has been occupied by 400 polished stainless steel poles with sharply pointed tips arranged in a rectangular grid (16 poles to the width and 25 to the length). The poles are spaced 220 feet apart. The mile-long rows, oriented east-west, each contain 25 poles, the kilometer-long rows, oriented north-south, 16. The poles were constructed of reinforced stainless steel tubing with an outside diameter of two inches, set into concrete foundations three feet deep and one foot in diameter, sunk into the earth one foot. The foundations are designed to hold the poles in a vertical position in winds of up to 110 miles per hour.

The height of these poles set into the naturally uneven terrain varies from 15 feet to 26 feet 9 inches. This is so that their stainless steel tips will attain an identical height above sea level: these tips could provide even support for a single sheet of glass one mile by one kilometer six meters in size. The placement and height of the poles were determined by an aerial survey combined with computer analysis (to work out the rectangular grid and the elevation of the terrain), and a land survey (to measure four elevation points around each pole to ensure perfect placement and the exact height of the pole). The surveys took five months to complete.

All this meticulous calculating, as well as the machine crafting that went into the turning of the steel tips and their welded, ground, and polished joining to the poles, are essential to the content as well as the visual effect of *The Lightning Field*. An ideal (Platonic) system of measure, as careful as technology can come up with, has been inflicted upon the chaos that is nature. "The invisible is real," says De Maria. Real poles mark the junctures of an ideal grid system, an invisible man-made system of measurement that we hold as universal (Plato and Augustine saw it as a divine ordering that we somehow discovered). The plane implied by the equal height of the 400 poles calls into question a plain that looked quite flat as one approached, but now is seen to undulate and to be covered with lumpy grasses and brushes. Even in this minimal landscape, nature is cluttered, accidental, anecdotal, compared to ideal, timeless (invisible) measurement, conceived by ancients, embodied successively in varying (and thus imperfect) forms in the most sacred architectural forms of changing cultures. Contemporary culture, with its computers and programmed high-tech machines which can fabricate seemingly perfect forms, has allowed Walter De Maria to demarcate more evenly (and more impersonally) the intersections of his grid—to puncture the earth with precisely placed needles, placed there as if by some aloof god. On the other hand, the universality of measurement is called into question by De Maria's simultaneous use of feet and meters in the same system.

De Maria's fascination for units of measurement is seen in previous pieces, such as *Vertical Earth Kilometer*, executed the same year (1977) for *Dokumenta 6* in Kassel, Germany. Here, a vertical shaft drilled into the ground exactly one kilometer deep sheathes a brass rod one kilometer in length. Except for the metal plate which marked its site, the piece, once installed, was invisible. Although Robert Hughes (*The Shock of the New*) dismissed it as an "extravagance" (it cost a third of a million dollars to execute),

and asserted that pieces like this "tend to trivialize the art experience by acting as epigrams of waste," it is instructive to consider its meaning for clues to important aspects of *The Lightning Field*'s content. *Vertical Kilometer* penetrates the earth deeply; it *rapes* the earth. For artists who, like De Maria, choose to work with the land, understand fully the mythic female connations of the earth: here culture, in the form of ideal measurement, has violated undifferentiated nature.

Yet, by the same token, nature swallows up culture in *Vertical Kilometer*: the wound is hidden from us. At the same time, nature is revealed to us, for the urban site would not be experienced as nature at all if one were not made aware that a rod had penetrated the ground to the depth of a kilometer.

Two years later, in *Broken Kilometer*, the artist laid brass rods of equal measure, whose total length added up to a kilometer, carefully parallel to each other in close intervals to form three parallel strips which took up most of the floor space in a gallery. In this format, units of linear measure had become areas, rectangular shapes, and had submitted to the ground plane asserted in *The Lightning Field*. Yet it would be erroneous to see nature winning out over culture in De Maria's work. *Broken Kilometer* was, after all, installed on a gallery floor. And, besides, as De Maria tells us in his *Artforum* presentation, the idea for *The Lightning Field* occurred to him upon completion of *The Bed of Spikes* (1969)—a painful, sadistic notion not conducive to thoughts of gentle nature.

Indeed, *The Lightning Field* is more contradictory than is usually thought. While it is about the lightning that the rods can attract to the earth in stormy weather (intercourse between sky and earth, mythically male and female), it is also about man-made measurement, inflicted upon the earth with impersonal needles. Yet "the light is as important as the lightning," says De Maria. When the sun is overhead, the needles become invisible in the landscape; in fact, they are clearly visible only at dawn and dusk. There is great tension in this piece: an area of the earth has been cruelly claimed, but it resists possession.

John Beardsley (in his *Earthworks and Beyond*) says that most contemporary works involving the landscape, including *The Lightning Field*, use reductive forms to convey metaphysical content, that they constitute a "contemporary expansion of the sublime," a concept dear to nineteenth-century Romanticism.

In order to see this remote piece, one must apply to the Dia Art Foundation, which owns and maintains it. The prospective pilgrim will be driven to *The Lightning Field* and abandoned in a log cabin on its edge to view 400 needles in a vast landscape (and perhaps lightning and other sensational displays of nature) for at least 24 hours—preferably alone, but with no more than five other people. Under these conditions, *The Lightning Field* may serve as a means of epiphany: nature, sadistically and ritualistically impaled by culture, is indifferent.

—Susan Havens Caldwell

Bibliography—

Baker, E. C., "Artworks on the Land," in *Art in America* (New York), January 1976.
Alloway, Lawrence, "Site Inspection," in *Artforum* (New York), October 1976.
Hughes, Robert, *The Shock of the New*, New York 1980.
De Maria, Walter, "The Lightning Field," in *Artforum* (New York), April 1980.
Wortz, Melinda, "De Maria's The Lightning Field," in *Arts* (New York), May 1980.
Lippard, Lucy R., *Overlay: Contemporary Art and the Art of Prehistory*, New York 1983.
Beardsley, John, *Earthworks and Beyond: Contemporary Art in the Landscape*, New York 1984.

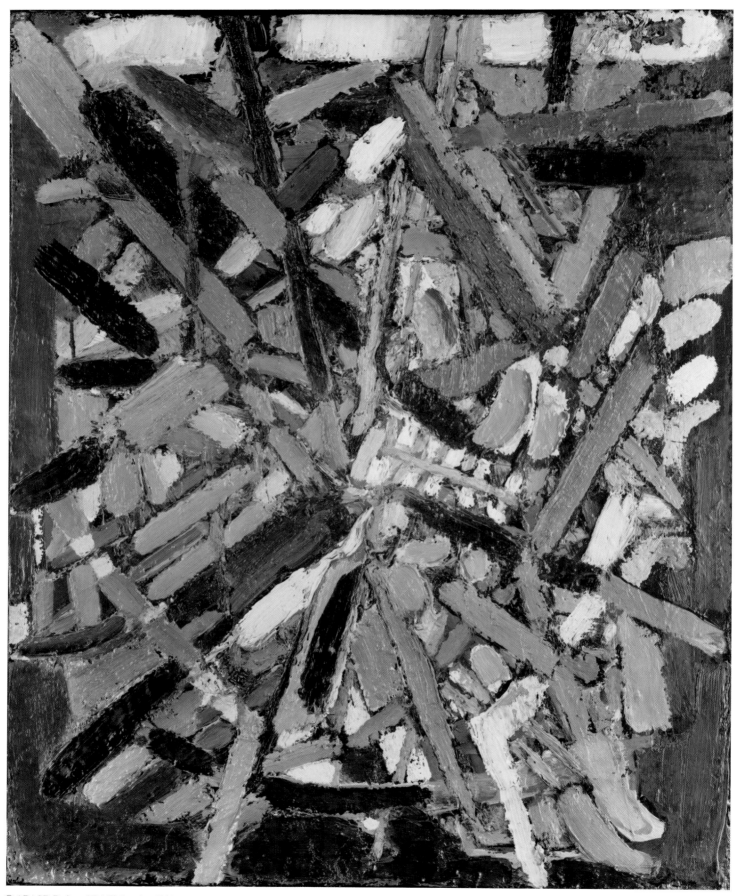

© ADAGP, Paris and DACS, London 1991

Nicolas de Stael (1914–55)
Marathon, 1948
Oil on canvas; 81 × 65cm.
London, Tate Gallery

Marathon is one of de Stael's best-known canvases and represents a central point in his career, both chronologically and aesthetically. In this work are combined the painter's interest in the texture and colour of paint within an overall design which contains the energy of the abstract composition. A permanent tension is in play between centrifugal and centripetal forces, between the matt surface of the background and the richly textured densities of the paint, achieved by using a palette knife to handle the heavy impasto.

In 1949 de Stael wrote, "you never paint what you see or think you see. You paint with a thousand vibrations the blow that struck you." After his death his champions praised his, "adoption of a monumental style, his use of impasto and his solid yet refined blocks of colour" (Denys Sutton, 1958). *Marathon* represents the artist's resolution of long-meditated ideas on colour and form. Twelve years before its composition, in 1936, he had written that, "one absolutely must know the laws of colour. Each colour has its reason." He was writing as a figurative painter, deriving example and stimulus from the masters of the past, including Titian, El Greco, Vermeer, Rembrandt, Chardin and Delacroix. A meeting with Georges Braque in 1944 encouraged him to move gradually from figuration to abstraction, Braque's own dedication to the exploration of space and perspective providing the inspiration for de Stael to develop the non-representational, architectonic painting of which *Marathon* is the exemplar. For de Stael painting was always a rigorous intellectual exercise and his life was dedicated to finding solutions to the pictorial challenges he perceived. His upbringing in a formal household in St Petersburg (in 1916 he was appointed page at the Imperial Court of Tsar Nicholas II) ended abruptly after the Russian Revolution. His family fled to Poland where both his parents died and he was brought up in Brussels before settling in Paris. Perhaps the turbulence of his early life contributed to his art; he indicated that painting involved the sum of his personal experiences: "I want to achieve a harmony; the material I use is painting. My painting is determined by my individuality and the individual that I am is made up of all the impressions received from the exterior world since and before my birth."

Herein lies the key to de Stael's art. Though *Marathon* is described as an abstract or non-representational painting it forms part of an oeuvre that began and ended with inspiration firmly rooted in the external world. His interest in the theoretical underpinnings of abstract art had to be reconciled to his belief that, "one does not begin with nothing: where Nature is not the starting point, the picture is inevitably bad." The abstract work of the 1940s (including *Marathon*) gave way to a series of still-life and landscape works in the early 1950s. This apparent betrayal of the avant-garde cause by one of its leading exponents created misunderstandings among fellow artists and critics alike. For example, at de Stael's first exhibition in England at the Matthiesen Gallery in 1952 several critics rejected the representational canvases depicting bottles and apples, regarding them as anachronistic and out of step with contemporary ideas. Such reactions may have contributed to the artist's suicide in 1956.

It should not be forgotten that the art establishment in Paris after the Second World War was sharply polarised. The figurative works of Matisse and Picasso found more favour with officialdom than did the abstract painters in their various groupings. "Exhibitions by Klee and Mondrain were actually closed by the authorities in the 1940s and as late as 1951 indigenous abstract artists had to file a petition to the French Government, asking for the right to be represented in exhibitions of French art abroad." (*Abstract Art*, Moszynska). However, the abstract painters, working in the style described loosely as "l'art informel," "tachisme," or "l'abstraction lyrique" were gaining ground in the 1950s at the moment when de Stael was questioning the validity of the abstract expressionist doctrine. Hence the loneliness of his position, isolated between the figurative painters of the establishment and the avant-garde, now dedicated to the pursuit of the unconscious, the imagination, calligraphy and automatism, in place of the geometric preoccupations of the previous decade. The professional circle of de Stael, Serge Poliakoff and Jean-Paul Riopelle dissolved as the latter painters pursued their own experiments in abstraction.

Since his premature death, de Stael's status as a major artist of the twentieth century has been confirmed and his integrity acknowledged where once he was criticised. Few painters have understood so completely the tactile and emotional properties of colour and line and have manipulated both paint itself and the planes and surfaces that blank canvas offers. In *Marathon* de Stael resolved colour and composition, energy and expression in a work that provided inspiration for painters of the next generation, notably Jackson Pollock and the American school whose reputations have often overshadowed that of the man from whose work they learnt a very great deal.

—Camilla Boodle

Bibliography—

Cooper, Douglas, "Nicolas de Stael: In Memoriam," in *Burlington Magazine* (London), May 1956.
Sutton, Denys, *Nicolas de Stael*, New York 1960.
Cooper, Douglas, *Nicolas de Stael*, London 1961.
Sutton, Denys, "Nicolas de Stael," in *Apollo* (London), November 1965.
Ashton, Dore, ed., *Twentieth Century Artists on Art*, New York 1985.
Moszynska, Ann, *Abstract Art*, London 1990.

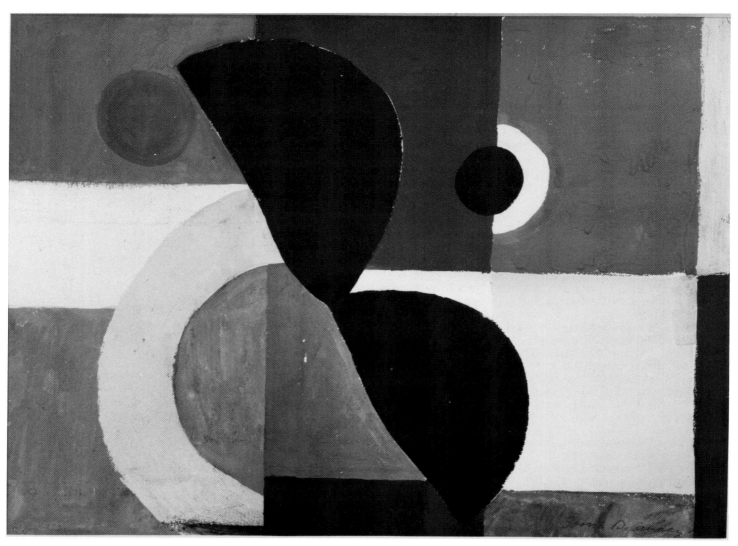

Photo M.N.A.M., Paris. © ADAGP, Paris and DACS, London 1991

Sonia Delaunay (1885–1979)
Colour Rhythm, 1953
Oil on canvas; 100 × 220cm.
Paris, Musée National d'Art Moderne

This is a painting typical of the "simultaneist" period of Sonia Delaunay-Terk who, since 1913, had proposed constructions of elementary colour-form with dynamic spatial connections. For this Ukrainian, who had moved to Paris in 1905 and became, together with Robert Delaunay, whom she had married in 1910, a leading figure of the "Orphist" movement, colour organises itself in *Les prismes electriques*, exhibited at the Salon des Independents in Paris in 1914, where they had great impact in non-figurative art circles, securing for the painter a complete independence from Robert Delaunay's research.

All of Sonia Delaunay's painting aims to free colour from any formal conditioning, assigning it the function of graduated optical disruption and visual interference. The "Simultaneous rhythms" were thus born. We find in them spirals and segments of circles which operate in perfect syntony with bright and shrill colours, applied in thin layers, which give the optical field expansive possibilities of pulsating dynamism.

Alternating with these are still-lifes which refer to Sonia Delaunay's sojourn in Spain and Portugal during the last years of World War I, which she spent at Vigo with her husband Robert, who was also engaged in innovative research on colour. Some visions of the *Market at Minho* refer to an expressionist figurative language, in which an extreme synthesis of objects and nature vibrates with intermittent lights like a popular folk-song. From the Vigo years, *Women at the market* is fundamental; their anatomies are used as a pretext for rhythmic dashes and optical torsions of concentric expansions, and wheels of solar colours distilled into graduated and half-stable glazes. The *Watermelon sellers* and the *Flamencos* of 1918, painted in Spain, are works of Slavic expressive feeling, structurally dynamic, where colour catches fire with intermittent explosions like a cosmic reference to hedonism and to syncopated music.

With these paintings Sonia Delaunay proposes a very personal "fauvisme" which owes nothing to Matisse, Herbin or Vlaminck for its sense of chromatic adventure. The dynamic tension of the anatomies which interpenetrate the objects and nature, through formal syntheses which are perceptively saturating, refer her narrative tale to an Oriental visual preciousness that combines the interiors of the palaces of her native Ukraine and the domes of the Orthodox churches of ancient Russia. With some gouaches made in the twenties (*Interferences chromatiques paralleles*, 1924; *Contrepoints en progression serielle*, 1925 and *Alternences des carres*, 1926), Sonia Delaunay anticipates the "kinetic art" of the 'fifties. Delaunay's research anticipates themes and problems which will become typical of European and North American "Op Art".

By means of the use of the most precise linear structures, parallel joints of segments with complementary chromatic connections, Delaunay anticipates also that minimalism that will become the expressive patrimony of constructed art, and of the chromoplastic unobjectivity of the 'sixties.

During the 'twenties Sonia's painting is fully independent from any influence suggested by Robert Delaunay's *Fenetres* or by his *Disques simultaneens*, still linked to a synthesis (although highly pure) of naturalism and the narrative event. On the contrary, Sonia creates optical situations which are totally unfigurative, perceptively aleatory, of a disconcerting formal elementarity, almost a reference to the spectacle of pure colour distributed in terms of a musical score. Some works dating from 1925–1928 could be associated with the *Parallel Flights* of Frantisek Kupka and the

"unism" of Wladislaw Strzeminskij, but at a closer look we can detect a substantial expressive difference, an optical-dynamic proposition which is completely autonomous and typical of the Ukrainian painter.

In these proto-kinetic paintings it is the colour which disposes itself in serialised neutral forms, like directionally synchronic signals, while the underlying rhythm of the composition becomes progressively undulating and radiant. This is all achieved instinctively by Sonia Delaunay, and doesn't stem from a scientific knowledge of optical physics. The phenomenic character of her paintings of the 'twenties, which reflect radiations of different wave-lengths, causes optical illusions in which the connections between colours is inverted and exalted. It is not a case of simple theoretical models, but of uniform zones that offer perceptible results according to different movements of depth and of perceptible fissions of colour. Every surface painted by Sonia Delaunay absorbs and reflects part of the light that reaches it, creating areas of contrast of a certain periodicity or spatial frequency in which simple lines cross a chromatically homogeneous area, creating a spaced and contrapuntal visual continuum. In a group of gouaches on paper, painted in Paris in 1924, Sonia Delaunay proposes a different intensity of contrasts of clarity in linear sequences of vertical and slanted lines, so as to allow the intermediate spatial frequencies to become as distinctive as possible. Thus, they are spatial variations of formal and chromatic symmetries, creating consecutive effects of contrasts of light and shadow.

When, in 1930, Robert Delaunay had started painting the *Rythmes sans fins*, Sonia Terk's painting had already revealed the new possibilities of unobjective perception and of virtually dynamic optical saturation. After 1945, the influence of Sonia Delaunay is detectable in the circle of artists gravitating towards the orbit of the Parisian Gallery of Denise Rene, while in the 'sixties the painter returns to painting rhythmic sequences of simultaneous colours without analogies with nature or reference to persons in everyday life. *Couleur Rythme* (1953) proposes again a total vision of the spatial event of curves in graduated tension in which she offers colour the role of vibrant song in the cosmic itinerary which is traversed by a renewed semiotic emotion. "Mes couleurs sont de la poesie sans mots . . .," Sonia Delaunay stated while painting the last gouaches for the great unfinished poem on which she had been engaged from 1919 until her death.

While remembering the importance of her painting, we should not forget her contribution to fashion, with her "tissus simultanées" (1922–1930), and to graphic design, with projects for posters and book and magazine covers, produced during a seventy year span of intense artistic creativity and continuous avant-garde inventiveness.

—Carlo Belloli

Bibliography—

Cendrars, Blaise, *Sonia Delaunay: composition, couleurs, idees*, Paris 1930.
Gilles de la Tourette, Francois, *Sonia Delaunay-Terk*, Paris 1950.
Bizardel, Yvon, *Sonia Delaunay, peintre de demain*, Paris 1952.
Belloli, Carlo, "L'opera grafica di Robert e Sonia Delaunay," in *Pagina* (Milan), no.3, 1962.
Hoog, Michel, *Situation de Sonia Delaunay*, Zurich 1965.
Damase, Jacques, *Sonia Delaunay: Rythmes et Couleurs*, Paris 1971.

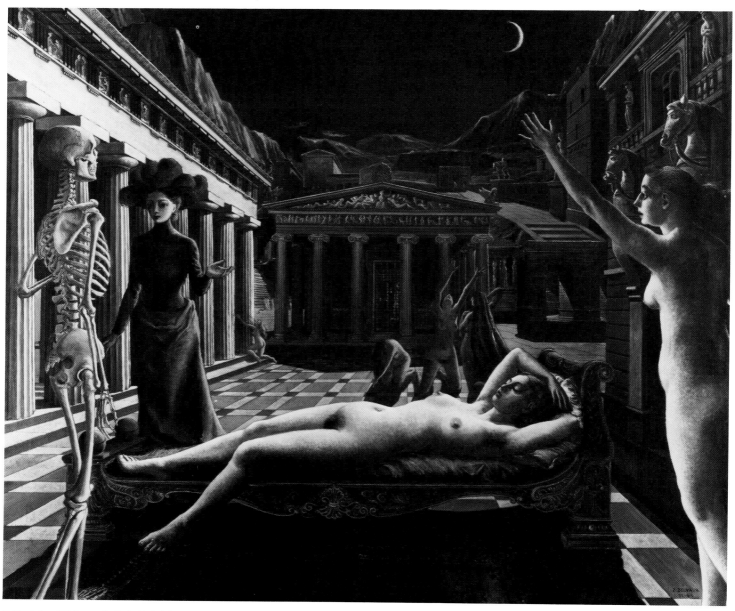

© Fondation P Delvaux, St Idesbald, Belgium/DACS, London 1991

Paul Delvaux (1897–)
La Venus Endormie, 1944
Oil on canvas; 68⅛ × 78¾in. (173 × 199cm.)
London, Tate Gallery

The Surrealist paintings of Paul Delvaux are characterised by their cool, grey-blue atmosphere, the precisely delineated architectural settings and the fair nude women who seem to accept passively the voyeuristic attentions of frock-coated savants, but in *La Venus Endormie* the chill surroundings are ominous, the women appear to be helpless victims of some malign fate and the mild professorial figures are replaced by the grim image of Death. It is, perhaps, his most disturbing work, evoking the "drama and anguish" of the time during which it was painted, 1944, in the city of Brussels during the attacks by flying bombs towards the end of the Second World War. Delvaux wrote of this painting, "It is my belief that, perhaps unconsciously, I have put into the subject of this picture a certain mysterious and intangible disquiet. . . . I tried in this picture for contrast and mystery." "I remember" he wrote, "that . . . I placed my picture each evening, when the painting session was over, perpendicularly to the window thinking naively that, if a bomb should fall it would be better protected in this position."

The strange mixture and the juxtapositions of source materials he has used in this work are truly Surrealist. He has taken the medieval legend of Death and the Maiden and placed it in a setting taken from Greek architecture, adding on the right a strange building with horses' heads which he had seen in the Royal Circle in Brussels. The despairing nudes in the background are reminiscent of Tintoretto's *Transfugamenti del Corpo San Marco*, while the figure of the Edwardian Madame is a dressmaker's dummy of the type familiar in fashion catalogues of 1910. Regarding the Sleeping Venus, Delvaux had already used this figure in previous paintings in 1932, 1943 and 1944, and depicted her in the smoothly articulated rhythms of the traditional Renaissance sleeping nudes found in Giogione and Titian. Here, however, he shocks the viewer with the inelegant sprawl of the young woman, her left leg sticking out over the edge of the couch, the sharp angle of her right elbow and the jutting angle of her chin. Precariously balanced on her narrow bed, her abandoned posture seems to invite the lecherous advances of the skeleton form of Death.

Delvaux has told how he discovered this Venus figure in a strange collection of curiosities called the Spitzner Museum. This so-called museum was a regular feature of the Brussels Fair and one which Delvaux visited several times in the early Thirties. He said that there was a shed at the entrance at which a woman cashier sat flanked on one side with the skeletons of a man and a monkey and on the other by a representation of Siamese twins. Inside, there was a horrifying and dramatic display of anatomical casts in wax representing the deformations and devastation caused by syphilis. In the centre of all this lay a waxen Sleeping Venus. This macabre scene amidst the artificial gaiety of the Fair made a powerful and lasting impression.

In nearly all his work, Delvaux used architectural settings to heighten the sensation of disquiet and unease. Sometimes he did this with very subtle distortions of perspective, camouflaging incompatible vanishing points with great skill; at other times, as in this instance, he does it by distortions of scale so deftly presented that it is not immediately evident that the foreground figures are gigantic by comparison with their surroundings. Greek architecture is, above all, one of volume and void and this spatial quality is here negated by the cliff face of the mountainous chasm into which it has been crammed, with the colonnade on the left appearing to front sheer rock. All the lines of the buildings converge on a single vanishing point in the middle of the facade in the centre background, where a golden figure is almost hidden behind the shadowy Ionic portico. Dimly seen through a grille, it can be made out to be a female figure. The question arises as to whether this is to be interpreted as a malign or a beneficent deity presiding over the drama in the piazza. The significance of the small figure of the lone horseman on the cold mountain side on the right also remains a mystery.

Psychologically, the painting also raises questions about the meaning of the Edwardian dressmaker's dummy. She is wearing the type of costume which would have been familiar to the artist from his childhood at the turn of the century—that worn by his mother and her friends—and which is the figure, who, by the gesture of her hands appears to be inviting Death, the skeleton, to make free with the vulnerable sleeping girl. In his account of his source material, Delvaux wrote that it was not a woman wearing these clothes but a dressmaker's dummy and he also emphasised that the Sleeping Venus was not based on a real girl, a human being, but a lay figure, a waxen model. So Delvaux has created strange layers of detachment, of distancing in this painting both for himself and for the viewer.

Surrealist art deliberately set out to probe the subconscious areas of the mind, and Surrealist painters evolved two very different approaches to the problem of representing Breton's "purely interior model." On the one hand, there are the painterly near-abstractions of Paul Klee, Andre Masson and Max Ernst, for example. In contrast is the straightforward, figurative style of Giorgio de Chirico which was to prove such an inspiration to Rene Magritte, Yves Tanguy Pierre Roy and many others, including Paul Delvaux. The latter academic, deadpan style which nineteenth-century painters had used to present reassuring bourgeois images is startlingly effective when subverted and used for the erotic and irrational purposes of Surrealism. It is one which Delvaux, with his architectural and Beaux-arts training at the Academy in Brussels handles in masterly fashion.

In an address delivered to the Museum of Modern Art, New York, in 1934, Salvador Dali spoke of the "three vital constants" which characterise Surrealist art. They were "sexual instinct," a "feeling of death," and "the physical notion of the enigma of space." Certainly all these three "constants" are to be found in the Sleeping Venus, Death himself, eroticism and enigmatic space.

Delvaux came late to Surrealism; he was in his late thirties when he produced his first Surrealist work, strongly influenced by his fellow Belgian, Rene Magritte. Coming in as he did on the "second wave" of Surrealist Art, Delvaux's work may lack the original impetus of the movement with its passionate and revolutionary political conviction, but the curious melancholy and the subliminal unease engendered by these carefully considered, carefully plotted and carefully executed works is his own original contribution.

—Mary Ellis

Bibliography—

Rubin, William S., *Dada, Surrealism and Their Heritage*, New York 1968.
Wilson, Simon, *Surrealism*, London 1971.
Butor, Michel, Clair, Jean, and Houbart-Wilkin, Suzanne, *Delvaux*, Brussels 1975.
Alley, Ronald, *Catalogue of the Tate Gallery's Collection of Modern Art Other Than Works by British Artists*, London 1981.

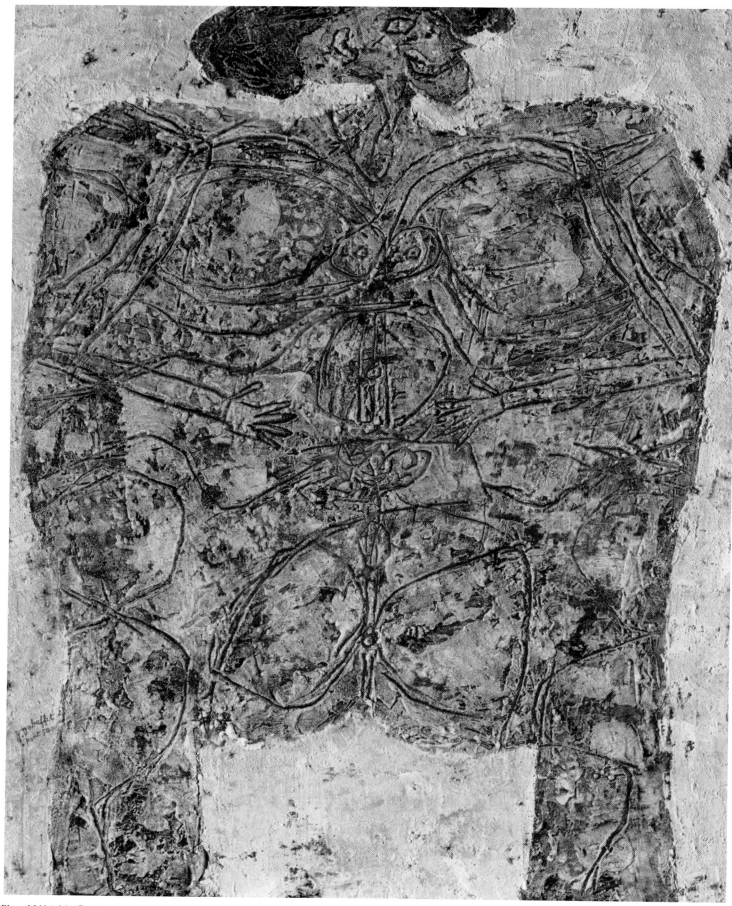

Photo M.N.A.M. / © ADAGP, Paris and DACS, London 1991

Jean Dubuffet (1901–85)
La Metafisyx, 1950
Oil on canvas; 116 × 89 cm.
Paris, Musee National d'Art Moderne Centre Georges Pompidou

Jean Dubuffet's main concern is to free his art from traditional conventions that have been valid for European Art since the Antique, and to replace them with a focus on cultural demands with elementary forms of expression that can unfold, regardless of conventions. In his search for purity and independence of tradition, his ideals were the artists who always, outside the artistic scene, developed their work from imaginary power alone. He coined the term *Art Brut* for this raw, unrefined form of art, which now has long been adopted as a term for the works of outsiders.

Dubuffet is obviously a highly intellectual artist who consciously takes a position to develop his concepts. His paintings, as well as his artistic manifestations in other media, display a different vision from the confrontation with an obligatory aesthetic framework. This becomes very clear in one of his central cycles, which includes *La métafisyx*. Dubuffet chose the title *Corps de dames* (with a provoking and ironic undertone) for a total of 36 paintings created in 1950, whose theme is the female nude. Thus he takes a decided opposition regarding representation of this subject of the female nude as the embodiment of aesthetic imagination.

Dubuffet had already violated conventional aesthetic values concerning the nude in several works on this theme before 1945, by representing childlike, naive contours in bright colours, reminiscent of marionettes, without any suggestion of volume. These paintings still seem rather conventional in the way they are painted in comparison with the *Corps de dames* of 1950. It was only after 1945 that the artist was to give priority to the action of painting and independence to the materials he used. The individual value of material and composition is demonstrated well in *Corps de dames*; *La métafisyx* is also a good example. The body of a naked woman is spread flat onto the picture surface as a whole, in compact figuration, defying all conventions of life painting. Only rudimentary legs attached to an almost rectangular body and head (the top which is cut off by the limitation of the canvas) stand out. This unusual presentation of a nude is in accordance with the unusual application of colour and the engraved linear articulation suggesting anatomical proportions, which are obviously not meant to coincide with an objective image of a person.

Dubuffet makes it quite clear that it is not his intention to portray the female nude in a traditional fashion, but to confront the observer with the painting as a process of construction. Thereby, the subject matter in its unusual conception is closely connected with the material and formal elements. This becomes apparent in the fact that the artist, in contrast to the expected flesh colour, chooses a rusty brown, and depicts the subject as a flattened form on a lighter background. The rough surface is striking, even more so because the artist treated the patchy, hard paint almost like a relief by engraving lines and removing parts of the substance after application. The material factors interacting with the rather unconventional formal aspects result in a significantly specific value. The observer almost relives, step by step, the process of creation. If he approaches the iconographic subject in that way—and Dubuffet forces him to—then this kind of portrayal no longer seems as strange or shocking as originally intended.

Dubuffet's aim is the revaluation or rather new understanding of traditional themes. His recourse to models outside the traditional academic standards is as important as it is influential for European and American painting after World War II. Dubuffet's influence spread not only over Paris but his pictoral manifestations and ideas were of considerable impulse for a group of artists named COBRA, and for the early representatives of Pop Art. Inspired and supported by Dubuffet in their search for new, aesthetically unprejudiced areas of work, many artists of the young generation in the '80s made use of his models.

The cycle *Corps de dames* marks the highlight of new figurative painting during the late '40s and early '50s. It is interesting that at about that time in New York William de Kooning was undertaking an equally intensive analysis of the subject of the female nude. Both artists independently arrived at new ways of painting the subject, whereby de Koonig created his best and most valid works at a time when Dubuffet had already moved on to new themes. Even more importantly, they had arrived at a new aesthetic based on the immediacy of expression, and renounced all recourse to tradition.

Dubuffet has himself described his intentions in the creation of a painting like *La métafisyx*: "In the *Corps de dames*, one should not look too carefully at the drawing, which is always rough and negligent, but the drawing aspect which encloses the body of the naked woman and makes the figures appear immensely voluminous and deformed. It was my intention not to produce a drawing which gives final shape to the body; rather to the contrary, the drawing should avoid taking defineable form; the body should remain as a generally valid concept, in a material state. I loved it . . . to brutally confront in those female bodies: the eternally valid and the specific, the subjective and the objective, the metaphysical and the trivial-grotesque."

—Andreas Franzke

Bibliography—

Loreau, Max, ed., *Catalogue des travaux de Jean Dubuffet, vol. VI*, Paris 1965.
Trucchi, Lorenza, *Jean Dubuffet*, Rome 1965.
Loreau, Max, *Jean Dubuffet: delits, deportements, lieux de haut jeu*, Lausanne 1971.
Franzke, Andreas, *Dubuffet*, New York 1981.
Thevoz, Michel, *Dubuffet*, Geneva 1986.
Franzke, Andreas, *Dubuffet*, Cologne 1990.

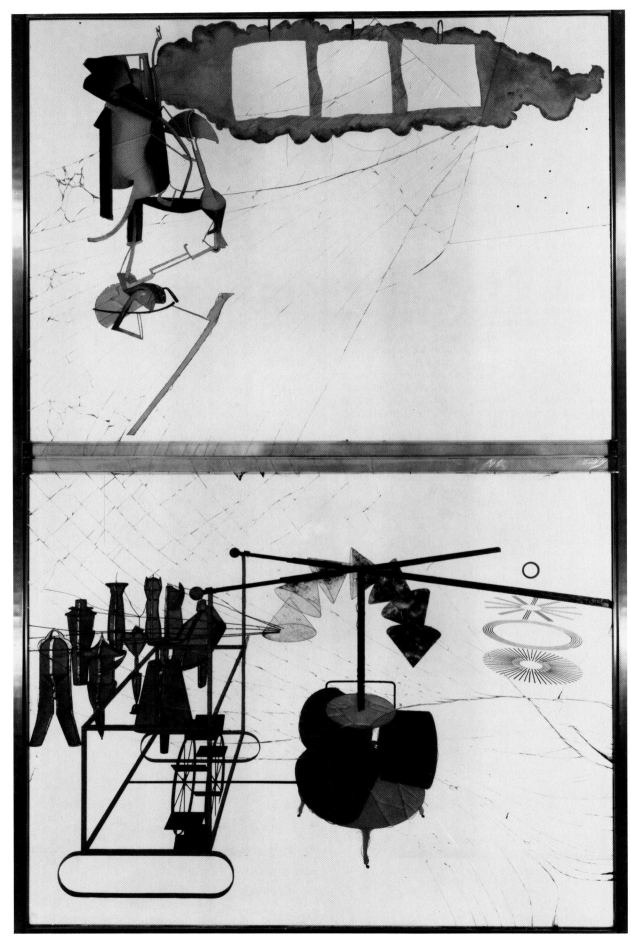

© ADAGP, Paris and DACS, London 1991

Marcel Duchamp (1887–1968)
The Bride Stripped Bare by Her Bachelors, Even (Large Glass), 1915–23
Oil and wire on glass; 109 × 69in. (277.6 × 175.6cm.)
Philadelphia Museum of Art

The Bride Stripped Bare by Her Bachelors, Even (*Large Glass*) by Marcel Duchamp has often been considered one of the turning points in twentieth-century art. Several critics have stated that Duchamp and Picasso are the two greatest innovators in the twentieth-century art world, and that in *Large Glass* Duchamp created a seminal work that has become famous beyond its individual artistic statement. The work was developed over a period of almost nine years from 1915 to 1923, yet it was deliberately left unfinished and accompanied by a complex set of notes known as *The Green Box*, as well as a number of scale drawings. Its importance lies in its moving away from the area of painting to an area in which visual matters are replaced by puns, intellectual commentary, and the inclusion in the final work of the actual artist's participatory action with all its accidents and changes. It is not sculpture, painting, or decorative art, yet it owes something to all of these.

Duchamp came to art in Paris following his two older brothers, Raymond Duchamp-Villon and Jacques Villon, during the early years of the twentieth century when Cubism had just swept the avant-garde world, while Futurism, with its interest in dynamism and the machine, was making a great impact in Italy. Duchamp's famous *Nude Descending a Staircase* (1912) caused a sensation in the art world because of its irreverence and seeming combination of the energy and movement of Futurism and the multiple, rearranged parts of Cubism. After this, Duchamp seemed to tire of painting and moved to the tongue-in-cheek selection of elements such as bicycle wheels and combs from everyday life as "Readymades," which became works of art by receiving his signature and being exhibited. During World War I, Duchamp was an influential figure in the Dadaist movement with its belief in accident, chance, and the mixture of everyday elements normally not seen together. Later Duchamp was also allied to Surrealism with its determination to depict inner states of mind through letting the artist's arm create an abstract inner reality through "automatic writing."

The Bride Stripped Bare By Her Bachelors, Even (*Large Glass*) is a work of process in which oil and wire forms are sandwiched between two sheets of glass. The whole is about nine by six feet, and is divided into two sections—the upper area or bride's domain and the bottom area of the bachelors' machine or apparatus. Duchamp, who may have had incestuous yearnings for his painter sister, Suzanne, sees the upper area as the domain of nudity and sensuality opposed by the mechanical apparatus of the bachelors, who through gravity, skill, and the will to strip bare, will plow and thresh the ground of the earth mother or nude above. In his notes, Duchamp labelled ten separate areas in the bride's domain and twenty-five separate areas in the bachelor apparatus. It is all meant to be a witty, intellectual, symbolic and whimsical exercise of all feminine myths down through history threatened by the machine world of the twentieth century. It is also the end of pictorial art and the beginning of art as a diagram of intellectual creation and the importance of chance. Even the name which originally omitted the "Even" at the end has a halting, disrupted, unfinished sound by the addition of this extra adverb.

The final fulfilment to this deliberately unfinished work came when it was returning from a Brooklyn exhibition in 1926 and the glass became cracked. This was the perfect finishing touch for Duchamp with his belief in chance, and he exclaimed "Finally!" Later in 1936 when he went back to the Large Glass to repair it, he commented, ". . . the more I look at it, the more I like the cracks, because they are not like shattered glass. They have a shape. There is a symmetry in the cracking, the two crackings are symmetrically disposed, and there is more; I see in it almost an intention, a curious intention that I am not responsible for, in other words a readymade intention that I respect and love."

Although the work and its creator were influential when the work was originally exhibited, the greatest influence came in the 1960s when Robert Rauschenberg, Jasper Johns, and other artists began to combine wit, chance, the idea of the readymade, and movement into the space of the viewer to create so called "Pop" art, while others were creating the theatrical "Happening" to involve the audience in chance, action, and physical experience. Also, the great ecological-environmental happenings created by Christo owed something to the earlier work of Duchamp. Certainly, from the perspective of the close of the twentieth century, one can say that Duchamp and his *Large Glass* have had a tremendous influence on most popular artistic movements and style developments.

—Douglas A. Russell

Bibliography—

Lebel, Robert, *Marcel Duchamp*, New York 1959.
Hamilton, Richard, *The Bride Stripped Bare by Her Bachelors Even*, London 1960.
Tomkins, Calvin, *The Bride and the Bachelors*, London 1965.
Hamilton, Richard, *The Bride Stripped Bare by Her Bachelors Even Again*, Newcastle-upon-Tyne 1966.
Golding, John, *Duchamp: The Bride Stripped Bare by Her Bachelors, Even*, London 1972, New York 1973.
Steefel, Lawrence D., *The Position of Duchamp's Glass in the Development of His Art*, New York 1977.
Paz, Octavio, *Marcel Duchamp: Appearance Stripped Bare*, New York 1978.
Adcock, Craig E., *Duchamp's Notes from the Large Glass: An N-Dimensional Analysis*, Frankfurt 1983.
D'Harnoncourt, Anne, and Hopps, Walter, *Etant Donnees: Reflections on a New Work by Marcel Duchamp*, Philadelphia 1987.

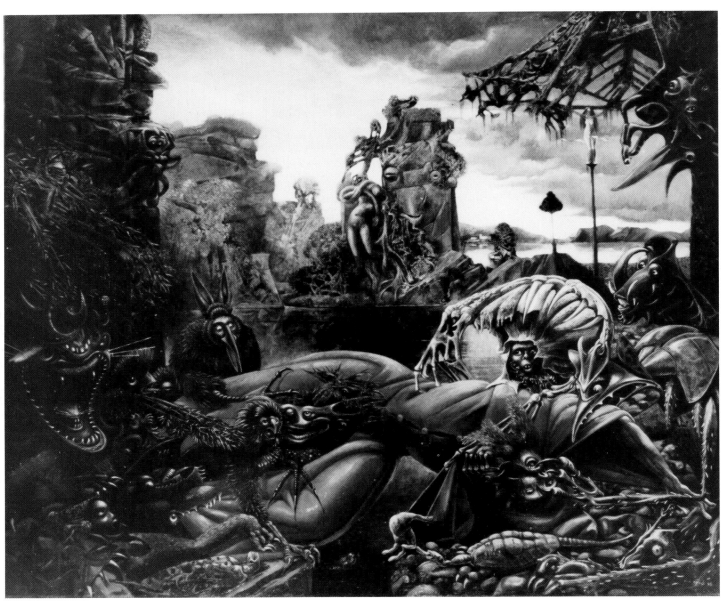

© ADAGP/SPADEM, Paris and DACS, London 1991

Max Ernst (1891–1976)
The Temptation of Saint Anthony, 1945
Oil on canvas; 108 × 128cm.
Duisburg, Wilhelm-Lehmbruck Museum

Saint Antony, called Abbot in order both to remind us that he was the first founder of a Christian religious community, and to distinguish him from the flock of other Saints Antony: (Fatati, Deynan, Neyrot de Patrizzi, of Amandola, of Stronconi etc., etc.) led a life of austerity, by present-day standards perhaps even of mortification. The details are disputed, but whether at the material time Antony was inhabiting a tomb, or was merely the sole occupant of a disused fort at Pispir in Egypt, the combination of any such location with a diet of bread and water, and that only after sunset, constituted a regime virtually certain to draw supernatural visitations upon him. That these were diabolical should be no surprise; such is par for the saintly course.

The variety and intensity of Antony's experiences may owe something to the competitive nature of religious immolations in third century Egypt; Antony certainly had rivals close at hand. However, their behaviour tended to be as spectacularly unpleasant as their visions, so that none was able to exert influence on the scale of Antony's, and down the years it is he who is remembered, and who has therefore provided the theme returned to again and again by all manner of artists.

Max Ernst was one of a group of eleven painters selected in 1945 by David L. Loew and Albert Lewin to compete for a prize they were offering for a painting on the Antony theme, which would be used in their film *The Private Affairs of Bel Ami*. [United Artists, 1947.] Of Ernst's then-distinguished fellows, some are almost forgotten, while others remain well in mind, though on the whole and sometimes unfortunately, their Antony paintings do not. Amongst them we find Stanley Spencer with Salvador Dali and Dorothea Tanning (then Ernst's companion) contributing visions of sexual temptation; while Leonora Carrington offers a touch of the migrainic malaise inherited from Bosch.

Ernst himself goes straight back to Grunewald for a model. There is no question of this Saint Antony being seduced from his vocation by processions of fleshly beauty: Antony is assailed by monsters breeding in his own stagnant universe. The intention is to drive him off with horrors, to tempt him, not to wallow in the rut, but simply to secure his own survival. Such female forms as Ernst allows to remain are isolated, marginalised or themselves in process of being consumed by malignant organisms. They arise in the part of the painting where Ernst has permitted the results of his practice of decalomania to remain visible, that is to say, of his creating random paint textures in which he could work up images as they are visualised in fires, clouds and so on. Their bodies flicker on the edge of being: it is the monsters who are fully formed, dominant, more prolific, more complex than the saint. May we suppose it is they who represent Ernst's certainties of that moment? What Ernst shows us is the final stage of enlightenment, a Christian equivalent of the Buddha's combat with Mara: the ultimate initiation.

There is indeed much of the Buddha in the historical St. Antony; perhaps this adds yet another layer to the ironies that surround the painting. The film for which it was made is based on Guy de Maupassant's novel *Bel-Ami*, that tells of an unscrupulous journalist, Georges Duroy, and his rise to wealth and influence not merely despite, but truly because he succumbs to each and every temptation placed in his way. So far as concerns the film,

The Temptation of St. Anthony therefore offers a splendid irony in its reminder that there is another, harder path to a different sort of triumph which in the case of the austere, self-denying St. Antony, has led to incomparably more long-lasting fame and influence than Duroy the sensualist could have wished for, or indeed dreamed of.

However, it is also worth noting that the painting De Maupassant writes of in his novel is entitled *Jesus Walking on the Waters*, "the kind of work which troubles the spirit and gives food for thought for many years" and that, as is the case for *The Temptation of St. Anthony* in the film, he shows the painting as being viewed by Duroy amongst a rich, morally worthless crowd in the house of the Jewish financier and newspaper proprietor, M. Walter. The contrast set up in the novel *Bel-Ami* is, for once, therefore simpler than that offered by the film because of the absolute difference in kind between the subject of the original painting and its viewers; the power of total virtue opposed to the corruption of the powerful. That becomes the more interesting when one discovers that the change of subject may well have been prompted by the Hays Office, concerned at possible breaches of the production code and accusations of blasphemy: we evidently have one of those occasions when the censors' contribution has been, however inadvertently, of great creative value to a project.

The organisational and motivational efforts of the sponsors to ensure the success of the competition included a fee of $500 for each painting and the $2,500 prize won by Max Ernst. The competition's notoriety produced a separate credit for *The Temptation* and Ernst in the lead titles of the film; and the first appearance of the painting there is as a very brief, surprising colour insert within the otherwise monochrome film. Later, it is seen surrounded by the vulgarity of electric light bulbs, acting as background to Mme. Walter's tirade against Duroy for taking her daughter Suzanne after having dallied with and rejected herself.

For all the efforts that went into *The Private Affairs of Bel Ami*, including the skilful adaptation of De Maupassant's novel and the (let us be honest) thoroughly hyped production of an outstanding painting, the critics were not disposed to kindness. For instance, the *New York Times*' critic writing on 16th June 1947 deplored the dullness of the film in general, and rounded on *The Temptation* as being "like a boiled lobster." Regrettably, such crass outbursts have been and remain par for the cinematic course. Perhaps they represent the medium's own demonic intrusions, reflecting its dualism as vulgar entertainment and serious art form? We are fortunate that both film and painting have survived for us to re-experience them and bring other forms of evaluation to bear.

—Philip Stokes

Bibliography—

Janis, Harriet, "Artists in Competition: eleven distinguished artists compete in a struggle with the temptations of St. Anthony," in *Arts and Architecture* (Los Angeles), April 1946.
Russell, John, *Max Ernst: Life and Work*, New York 1967.
Schneede, Uwe, *The Essential Max Ernst*, London and New York 1972.
Royal Academy, *German Art of the 20th Century*, exhibition catalogue, London 1989.
Lucie-Smith, Edward, *Art Today*, London 1989.

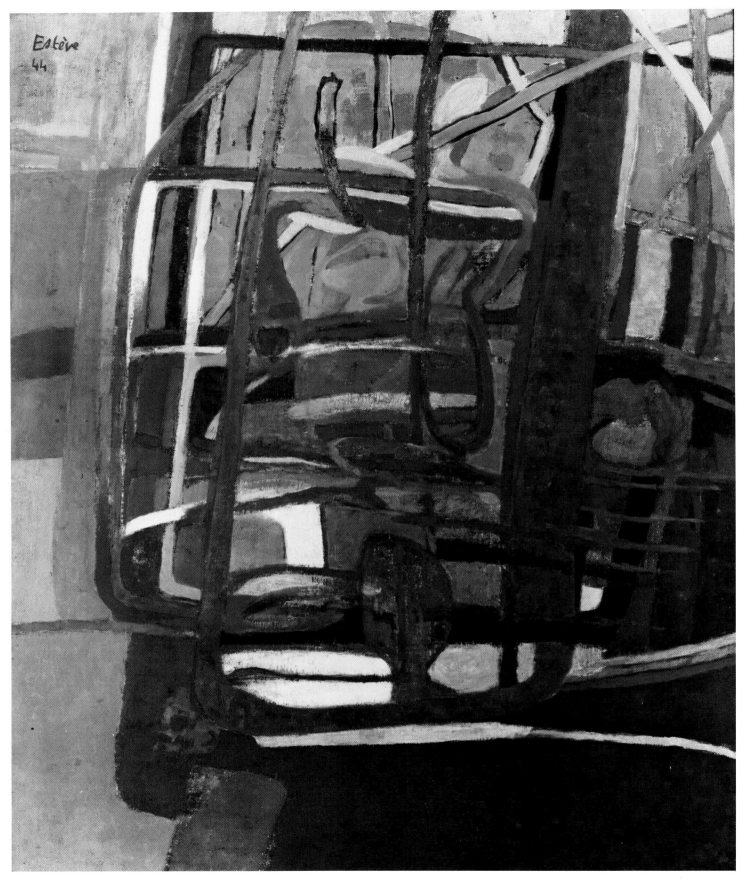

Photo M.N.A.M., Paris. © ADAGP, Paris and DACS, London 1991

Maurice Estève (1904–)
L'Aquarium, 1944
Oil on canvas; 81 × 65cm.
Paris, Musee National d'Art Moderne

Maurice Estève was forty when he painted *L'Aquarium* in 1944. With this picture he mastered pictorial space just through the use of colour. From the time that he began painting in 1915, frequenting the free schools in Montparnasse, his work showed the imprint of cubism which reigned over the avant-garde at the time. In particular, the influence of Léger and Braque can be perceived in his paintings of the Twenties, for example *La Liseuse* (1929). During the next decade he was influenced by the work of Bonnard and Matisse, as can be seen in *La Jeune Fille au Pichet* (1942). Estève, who was largely self taught, used to frequent the Louvre and was particularly drawn to Fouquet and Cézanne. He felt himself to have an essentially French temperament and recognized himself in them, but at the same time he did not ignore the contributions made by other artistic cultures. A lengthy stay in Barcelona in 1923 gave him the opportunity to become acquainted with Romanesque Catalan art.

From 1938, under Matisse's influence, Estève developed a method of "decoupage," or cutting out which transformed the outlines and shapes of things and beings into geometric figures. He had given up painting from nature in 1928, but he still had a tendency to relate his shapes, by now almost abstract, to reality. The network of spaces which goes through his work makes a clear statement about the structure of the deliberately non-figurative paintings, of which *L'Aquarium* is one of the first and most brilliant examples.

Estève's art stood out then because of his colourful invention and his attention to detail. Because of its chromatic intensity and its theme, *L'Aquarium* is close to Matisse's world, but does not look like one of his paintings. In Estève's work, by simply bending a blue and red line which crosses the pictorial field and disappears into a subtle latticework of yellows and greens, he summarized the space of an aquarium.

Without resorting to the use of any figurative elements, the artist suggested fountains and light: more exactly, light playing on the water. In this elemental painting, Estève established a taste, to which he remained faithful, for precise shapes and colours which were both clear and infinitely modulated. Later on, he even gave up stating the origin of the paintings in their titles. They were called simply *Là-haut*, *Ombre de Lune* or *Ballet de l'Aube*, names which only had poetic value, without reference to a given subject.

In *L'Aquarium*, as in practically all the later pictures, Estève avoided the use of pure white. He always covered the blank canvas with turpentine, in order to provide better and more immediate absorption of the colours over the whole surface. In Estève's work, the modulation of colours meant the exorcizing of whiteness (to quote the artist: "white is self sufficient").

Having observed an aquarium, Estève did not in fact work in front of one. He set himself to find a subtle compromise, unstable and unsettled, between the necessary credibility of his subject and the accuracy of his subjective vision. This dualism gave rise to a real "plastic drama": a sort of superimposition but at the same time a source of delight.

Estève never wanted to appear as a "professionnel de l'audace"—his words. He just wanted to organize, by bringing it into the light, a sensitive, coherent world which was a reflection of and a display for the riches which he acquired through a range of sensations. This painting goes way beyond Estève's cubist style and is achieved through a superimposition of planes made possible by the transparency of the colour.

One could say that *L'Aquarium* does not represent an aquarium, but rather Estève's thoughts about an aquarium. In the same way, when he painted *Padirac* in 1956, it certainly wasn't an image, even remote, of the famous chasm, but the plastic equivalent of the anguish he had experienced when he went there.

The function of Estève's abstraction was not to release the artist from an indifferent servitude in relation to reality: it was the means by which he revealed the reality of the world to himself. Neither purely spontaneous, nor purely introspective, *L'Aquarium* is a masterpiece of harmony between the two aspects of the painter's career. A great deal of work was necessary before the painting appeared to the artist—and also to us—as "a natural object enriched by man." This time lapse fitted into a natural, almost biological, rhythm: "a painting should ripen like a fruit," as Estève also said.

The critic Jean-Louis Ferrier remarked of *L'Arbre au Rivage* (1949), another painting from the same period as *L'Aquarium*, that it reconstituted the differential reality of a remote event experienced by the artist and sub-consciously repeated, which the painting had enabled him to externalize. He saw the visible world not so much as a model to be copied or interpreted than as a "solicitation" (*La Forme et le Sens*, Paris, Denoel, 1969).

L'Aquarium is thus a typical example of Estève's work; it is also representative of everything that was called, in the Forties and Fifties, "la Nouvelle Ecole de Paris", which was upheld at the time by the critics Pierre Courthon and Bernard Dorival. This school included among others Bazaine, Singier and Manessier.

Although essentially a painter, Estève made some stained-glass windows (Berlincourt church, 1957), cartoons for tapestries, collages (from 1969) and numerous lithographs. Since 1948, Estève had exhibited regularly at the Louis Carré gallery in Paris. In Bourges, the regional capital of Berry, where he was born, there is a *Musée Estève*.

—Jean-Luc Chalumeau

Bibliography—

Francastel, Pierre, *Estève*, Paris 1956.
"Hommage a Maurice Estève," special monograph issue of *XXe Siecle* (Paris), 1975.
"Maurice Estève," special monograph issue of *Zodiaque* (Yonne), no. 120, 1979.
Centre Georges Pompidou, *Paris-Paris 1937–1957*, exhibition catalogue, Paris 1981.

Luciano Fabro (1936–)
Attaccapanni, 1976
9 versions; bronze and canvas; 90 × 40 × 180cm.

Luciano Fabro created a series of works known as *Attaccapanni* at a time when, in the artist's own words, the logic of "black and white" prevailed in art. It was a moment at which art had caught up with style. Having researched the perception of space, with particular reference to the theories of Lucio Fontana, having made tautological statements and produced metaphorical and emblematic images, among them the famous *Italie* series, the artist created a series of pictorial-installational works. These were to initiate a discourse advocating the return of emotional and sensual values to the centre of the aesthetic activities. The main vehicle of these values is colour. With *Attaccapanni*, Fabro offers the spectator the experience of colour, painting technique and form. He presents a radically "new" work, never seen before in the formal repertory of art, but still somehow linked, even if at a distance, to a traditional kind of language which we define as pictorial. With *Attaccapanni*, the artist poses the question of colour as a means of evoking light, as the "classical" painters did. With the painting, we enjoy the experience of changing light, each example of which recalls a particular moment. They are the colours of sunset. As the artist says: *First that pink and blue light, then the light turns to fire, then comes the green, the blue, when it begins to get dark; then there is the violet stage and then, finally, night itself.*

This is, in a sense, a work which evokes two phenomena: a natural occurrence of great emotive power and, at the same time, the entire painting process carried out in order to represent it. Nature appears within the cultural environment that has dictated this particular interpretation of it. In other words, the relationship between nature and culture is brought up to date as a dialogue, which takes on a new meaning through the novel means used to express it. In fact Fabro does not limit himself here to merely making a statement; he does not try to revive a function which our culture has declared obsolete (he could do so if his intention was to provoke, which it is not), but he recalls and transforms that function and that relationship allowing us a concrete experience.

The materials and their support structure are in no way traditional. The canvas here takes the form of a cloth which hangs freely from a rigid structure; the stand which Fabro uses is his contribution to the "modernist" debate about the artist's materials and environment. The whole thing is based on a play on words. The title is simply the name of the thing from which the cloths are hung. The quasi-tautologous banality of the words shows the artist's ironic intention towards the avant garde and those who think they are conforming with the basic rules embraced by the notion of the "tradition of the new". Emotion is created by colour, combining perfectly with matter, designed to appeal to the senses. The painted cloth is modelled in sumptuous spirals recalling the magnificent marble of *Spirato*. It also serves to emphasise the essentially ambiguous nature of the work, which occupies a territory that hovers between real, plastic sculpture and painting, with its representation of potentiality. Here we have a kind of "abstract equivalent" of reality, without any point of reference but nonetheless appropriate and effective. The element to which the "cloth" is "hanging" is the crown, the garland of leaves, fashioned in bronze, Both the material and the concept are classical, stately and noble. Here its sinuous lines define the entire structure of the work.

Painting and sculpture are brought up to date avoiding both avant-gardism and outdated nostalgia. They are simply brought together here for the contribution each medium can make to this experience of reality. And so this is a work, the like of which was "never seen before", absolutely new and resolutely unclassifiable.

—Giorgio Verzotti

Bibliography—

Fabro, Luciano, and Izzo, Alberto, ed., *Attaccapanni*, Naples 1977, Turin 1978.
Risso, B., *Luciano Fabro*, Turin 1980.
Fabro, Luciano, *Regole d'Arte*, Milan 1980.
Felix, Zdenek, *Luciano Fabro*, exhibition catalogue, Essen and Rotterdam 1981.
De Sanna, Jole, *Fabro*, exhibition catalogue, Ravenna 1983.
"Domus Interview: Luciano Fabro," in *Domus* (Milan), December 1984.
Fruitmarket Gallery, *Luciano Fabro: Works 1963–1986*, exhibition catalogue, Edinburgh 1986.
Celant, Germano, "Luciano Fabro: the image that isn't there," in *Artforum* (New York), October 1988.
Gachnang, Johannes, and others, *Luciano Fabro*, Milan 1989.
Zevi, Adachiara, "Luciano Fabro: atto non d'intelletto ma di sense," in *L'Architettura* (Rome), May 1989.

on the right, a red blinker

le circus!!

smack

K47

and crew

they
leap
BARE-BACK
through
the
rainbow's

also

corks

nets

etc.

hoop

on the left, a green blinker

Ian Hamilton Finlay (1925–)
Poster Poem: Le Circus!, 1964
Letterpress on card; 44 × 57cm.
Carnwarth, Wild Hawthorn Press

Ian Hamilton Finlay's *Poster Poem: Le Circus!* (1964) is a classic example of both Finlay's early concrete poetry and of British concrete poetry in general. The first of Finlay's poem prints published by his Wild Hawthorn Press, it both looks back to the Modernist tradition of Pierre Albert-Birôt's "poèmes-pancartes" of the early nineteen-twenties, and forwards, from the pioneering concrete poems of Europeans like Eugen Gomringer and South Americans like the brothers Augusto and Haraldo de Campos, towards Finlay's own highly individualistic and innovative exploration of extra-linear "visual" poetry on the page, on posters, on glass, on metal, on wood, on stone, as neon reliefs, and latterly, as a part of complex three-dimensional environmental installations and garden projects.

Put another way, Finlay's *Poster Poem: Le Circus!* has the same sort of milestone status in the trajectory of his work and of visual poetry in general, that Picasso's *Les Demoiselles d'Avignon* (1907) might be said to embody, both in the context of his own painting and in the broader contexts of cubist and expressionist painting. It is a work marking a break with earlier poetic traditions and at the same time, a work annunciating and adumbrating new poetic possibilities combining formal innovation and thematic tradition, structural rigour and playful referentiality.

Significantly, Picasso's *Les Demoiselles d'Avignon* is not a "pure" cubist painting, although it is repeatedly cited as one of the first paintings to manifest Picasso's cubist aesthetic. Likewise, *Poster Poem: Le Circus!* lacks the austerity of the more "purist" concrete poems of Eugen Gomringer, and yet is also unequivocally one of the most memorable and enduring of Finlay's early concrete texts. Like Picasso's painting, it is a richly evocative early work, evincing both a sense of experimental vision and a sense of thematic audacity likely to over-reach the dogma of any particular movement, school or narrowly defined aesthetic.

As I have suggested, *Poster Poem: Le Circus!* can initially be read retrospectively, as Finlay's homage to such playful poster-poems as Albert-Birôt's *Paradise: This Way* (1922); itself an extra-linear, geometrical composition in the manner of Apollinaire's and Marinetti's typographic experiments. Viewed in its Post-Modern context—the nineteen-sixties—Finlay's text can also be seen as part of the widespread reaction in art, literature and theory against indulgent, expressionistic confessional rhetoric. Somewhat as the "concrete" artist Max Bill called for a painting which would eliminate "all naturalistic representation," and adopt a "non-individualistic approach" to the "fundamental elements of painting," Bill's sometime secretary, Gomringer, called in 1954 for a poetry constituting "a reality in itself and not a poem about something or other," or what he also termed "a play-area of fixed dimensions." Roland Barthes' advocacy of non-authorial literary analysis represents a similar structural impulse.

Writing to the French concrete poet, Pierre Garnier, in 1963, Finlay reasserted much the same point, arguing that "The new poetry will be a poetry without the word 'I'"; that it should be "a sign of peace and sanity"; and that "poets should bear the anguish of not writing anguish poems." All the same, Finlay admits that his early concrete poems *are* referential, in the sense that they fall into two kinds: one corresponding to fauve painting (in feeling) and one to "suprematism," rather than merely deploying "fundamental elements"—or "concrete" elements—of language.

At its most "fundamental," *Poster Poem: Le Circus!* parodies the typographic conventions of circus posters. But the poem is also an elaborate typographic metaphor, equating fishing boat K47 "and crew" and "also corks nets etc." with the members of a circus. More generally, it compares boat K47, with its red and green lights, with a red and green blinkered circus pony, leaping through the "hoop" of a rainbow reflected upon the sea.

While Finlay's text bears little trace of the amplified "anguish" in poems such as Ginsberg's *Howl* (1956), its allusion to culturally specific content (Scottish fishing boats and European circus poster conventions), its literary references (Albert-Birôt's poems), and its whimsical metaphorical humour (very much a trait of Finlay's poetry), inimitably identify it as an "individualistic" work about "something or other," rather than an orthodox, non-referential concrete poem. It is precisely this fusion of richly evocative and carefully structured semantic, semiotic and sonic textual energy which makes Finlay's poems such delightfully distinctive works.

Just as Picasso was both a great cubist, yet much more than a cubist, Finlay is both a great concrete poet, a celebrant of pastoral harmonies, and an astringent moralist, satirist and *agent provocateur* in the most positive sense of the term. Not surprisingly, his works of the 'seventies and the 'eighties combine ever more media, and successively address heroic, military, historical and revolutionary themes in a series of multi-media compositions castigating the poverty of prevalent secular values. *Poster-Poem: Le Circus!* marks the memorable first phase of Finlay's distinguished career.

—Nicholas Zurbrugg

Bibliography—

Houedard, Dom Sylvester, "Concrete Poetry and Ian Hamilton Finlay," in *Typographica* (London), December 1963.
Bann, Stephen, ed., *Concrete Poetry: An International Anthology*, London 1967.
Bann, Stephen, *Ian Hamilton Finlay: An Illustrated Essay*, Edinburgh 1972.
Bann, Stephen, *Ian Hamilton Finlay*, exhibition catalogue, London 1977.
Abrioux, Yves, *Ian Hamilton Finlay: A Visual Primer*, Edinburgh 1985.

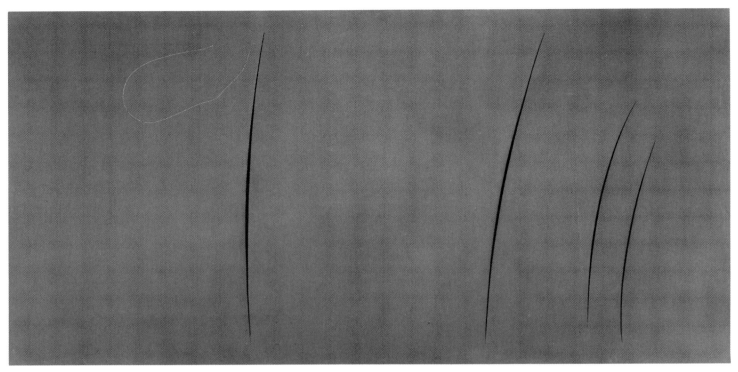

Photo Robert E. Mates

Lucio Fontana (1899–1968)
Concetto Spaziale, Attese, 1959
Watercolour on cloth; 126 × 251cm.
New York, Guggenheim Museum

Concetto Spaziale: Attese (1959) fits into the long series of 'concetti spaziali' which Lucio Fontana produced from 1947 until 1968, the year of his death. These represent the materialisation of theories formulated in the Manifesto Blanco, drawn up by him in 1946 in Buenos Aires, and of the consequences that it would have in Milan, to where he returned at the end of the war. Lucio Fontana is recognised as the initiator and founder of the "Movimento spaziale"; this can be read in the proposal for rules for the spatial movement, drawn up and signed by a group of artists that joined the movement in 1950. In fact, from 1947, Fontana's activity drew in artists, architects and intellectuals to the discussions linked to spatialism. The consequences and results are contained in the six manifestos which the spatialist group, composed of Joppolo, Dova, Tullier, and at a later date by Gino Morandi, Bacci, Deluigi, Crippa, Bergoli and Donati, publicised between 1948 and 1953.

Spatialism expresses the search for a new figurative space through the evolution of artistic means or a new concept of physical, phenomenalistic and artistic space. Fontana sought to renovate the traditional language of painting and sculpture, to bring it up to date through the achievements of technical and scientific progress. He wanted to overcome the collision between the supporters of Abstraction and of Realism, who from the end of the 'forties and for a large part of the following decade clashed culturally and idealogically.

The aims of Fontana and of the spatialist movement were to devise new instruments of communication, basing them on the discoveries of modern technology, such as television, radio etc.

This is one of reasons why a parallel has been made with Futurism, with its plan of renewing Italian culture, and with its myth of the machine, speed and space. Certainly, Fontana fits into the best tradition of the avant-garde; that which is linked to symbolist culture, in contrast to realism in all its forms. He has stated: "I believe in Van Gogh, colour, light. I believe in Boccioni, plastic dynamism. I believe in Kandinsky, concrete abstraction. I believe in spatialists, time-space."

To understand the deepest meaning of *Concetto Spaziale: Attese* and the series of "Concetti spaziali" it is necessary to retrace the path followed by Fontana, starting from the Manifesto Blanco and the creation of the "Ambienti Spaziali."

In 1949, in an exhibition at the Milanese gallery "Il Naviglio," Fontana exhibited neither ceramics nor paintings but created a spatial environment. Guido Ballo recalls it thus: "... forms recalled each other in a diffuse luminosity; one entered into these sculptures, one could not contemplate them from one viewpoint. Everything becomes instable and allusive. It could appear scenographic: it was a large ceramic, where the free forms subtly recalled each other with a suggestive effect, and space became almost palpable, clinging to the forms ...". Therefore, that which interests Fontana is space in all its manifestations. In fact, the best testimony is the fact that he has never given a definition to it. Perhaps because, as Giulio Carlo Argan has pointed out, his wish, even if not clearly stated, was to surpass the fourth dimension, the spatial one, in order to reach the fifth, that of indetermination, of absolute freedom.

In any case, on the level of artistic activity, this project had to move by degrees. It was necessary to deal with the organic material of informal painting. It was necessary to dry it and render it aseptic; it was necessary to liberate oneself from the material in order to aim for a spiritualisation of art. It is not by chance that a short time before he produced the first "attese" the artist had presented a series of canvases at the Biennale in Venice of 1958. These were barely veiled by a light stain, often monochrome, at other times created by the overlaying of two thicknesses of different canvas. As Gillo Dorfles has pointed out, these works neatly separated themselves from the works of almost all the other artists, which appeared to be incrusted with dense "impasti," hirsute with colours that have set to form layers of a material, both very physical and "antispatial."

Once the material has been rarified, and surfaces rendered spatial, the possibilities offered by the two-dimensional surface of the canvas stretched on the frame were minimal. The cuts and the holes are in some sense the straining of the pictorial surface, the testimony of a desire to search for the spatial depth, presumed or real; the desire to escape from the strict limits of the painting.

The cuts that Fontana creates are the result of a gesture, the testimony, revealed in a moment, of committed energy. In this sense his work presupposes, but at the same time overcomes, the gesturality of informal painting. It presupposes it, because the gesture of the brushstrokes is like that of cutting. It overcomes it, because the result of the brushstrokes is to put colour onto the canvas, whereas the cut, opening a slit, is like removing the material. If Fontana's gesture is indebted to informal culture for the possibility it offers of measuring the space which is before the canvas, spatial concepts are not the result of an existential introspection, but concepts which refer to the impalpable, to the immaterial consistency of an idea.

In the series of the *Concetti Spaziali: Attese* the slits open the surface to the space behind the canvas, magically revealing the rarified depth of the space. It is the trace left by the quick handgesture which has cut the canvas.

The cut no longer signifies itself, but according to the statement contained in the Manifesto dello Spazialismo (1948) it means yet more: "... it is not interesting that a gesture, completed, lives for a moment or a millennium, because we are really convinced that once completed it is really eternal ... ," and further on: "... it is impossible that man, from canvas, from bronze, from gesso, from plasticine, does not pass to pure aerial, universal, suspended image ..." It is the search for the pure conceptual expression, for the affirmation of thought over and above the confines of the material.

—Roberto Lambarelli

Bibliography—

Argan, Giulio Carlo, *Cinque scultori d'oggi: Moore, Mastroianni, Fontana, Mirko, Viani*, Turin 1960.
Dorfles, Gillo, *Lucio Fontana*, New York 1966.
Crispolti, Enrico, and van der Marck, Jan, eds., *Lucio Fontana: Catalogue Raisonne des Peintures, Sculptures et Environnements Spatiaux*, 2 vols., Brussels 1974.
Ballo, Guido, *Lucio Fontana*, exhibition catalogue, Rimini 1982.
Hegewisch, Katharina, *Lucio Fontana 1938–1966*, exhibition catalogue, Hamburg 1987.
Bony, Anne, ed., *Les Annees 50*, exhibition catalogue, Paris 1988.

Photo M.N.A.M., Paris. Copyright 1991 Sam Francis/A.R.S., New York

Sam Francis (1923–)
In Lovely Blueness, 1955–57
Oil on canvas; 118⅛ × 275⅝in. (300 × 700cm.)
Paris, Musee Nationale d'Art Moderne

In Lovely Blueness, an oil by the American painter Sam Francis, is in the collection of the Musée d'Art Moderne, Paris, an appropriate home for a work produced in France by an incomer who admired the work of Matisse, Bonnard and Monet. Monet's handling of colour and light, as displayed in his large-scale *Waterlilies* series particularly enthralled Francis and *In Lovely Blueness* is a wonderfully hedonistic evocation of sunlit days. The paint was applied very wet and thinly so that the separate blocks of colour (sometimes described as "kidney-shaped") overlap and merge in a soft radiance, shot through with patches of white light. The painting has no apparent narrative content and Francis's own commentary on his work tends towards the poetic and the mystical. "Do you still lie dreaming under that huge canvas? Complete vision abandons the three-times divided soul and its neighbours . . . you can't interpret the dream of the canvas, for this dream is at the end of the Hut on the Heavenly Mountain— where nothing remains but the Phoenix caught in the midst of lovely blueness."

Sam Francis studied painting in America at the University of California at Berkeley. He came to his profession (literally) by accident, having been forced to abandon studies in medicine following a serious back injury sustained whilst in action with the US Air Corps. Immobilized in hospital, he was given a box of paints to distract him from the frustrations of his confinement, and on his recovery entered graduate school in 1949. He arrived at a fortuituous time, the art scene in San Francisco being second only to New York in terms of excitement and vitality. Hans Hofmann (whose drip paintings had preceded by a decade those of Jackson Pollock) had exerted a profound influence as a teacher in the years before Francis's arrival and the San Francisco Museum of Art had several challenging avant-garde works of art on display, including important pieces by Jackson Pollock, Mark Rothko and Clyfford Still. From being influenced by Picasso and Miro, Francis adopted some of Pollock's technique though he left America for Paris in 1950. He attended the Atelier Fernand Leger and studied the French tradition at first hand. He found artistic and critical stimulus, befriending the critic Georges Duthuit and the sculptor Giacometti. His work (abstract in content and concerned to capture the effects of light) attracted the attention of dealers and critics, and he was included in the important 1952 show organized by Michel Tapie, *Un Art Autre*.

The American art establishment was quick to recognize and appropriate his talent following his first one-man show in New York in 1956. He and Grace Hartigan were the two "younger" painters selected for inclusion in the important *New American Painting* show, curated by the Director of MOMA, Alfred H. Barr, which was shown in eight European cities during 1958–59. Barr wrote that, "Francis was unique as the only expatriate in the show . . . the only painter whose reputation was made without benefit of New York." A German critic, William Grohmann, writing in a Berlin newspaper in 1958 saw Sam Francis as part of an American school that was in the ascendant: "For nearly ten years Pollock had exerted his influence on the avant-garde of all countries. The appearance of his paintings in Paris and in Venice was a sensation; and since the young Sam Francis lives in Paris, he too is in the centre of international interest. The unshakeable fortress of the French School is shaken."

But though Francis had loyalties and affinities to both America and France, a third major influence shaped his work. In 1957 he went on a long tour which included a stay in Japan, and thereafter his painting often invoked Oriental styles and moods, drawing in particular on the "haboku" or "flung-ink" works of 19th-century artists. He was not alone in his interest in Far Eastern Art; his American compatriot Mark Tobey, and the Europeans Soulages and Michaux had also looked to Oriental ideas and techniques.

As a result of his cosmopolitanism, Sam Francis is not easily categorized. The Americans claim him as their own, seeing him as one of the second generation of Abstract Expressionists, in the wake of Jackson Pollock, Clyfford Still and others. However, the relaxed anti-intellectual quality of much of the work has led to the work being dismissed as lightweight or merely decorative. The critic Hilton Kramer felt Francis's work to be "emotionally thin" and painted without a struggle compared to Barnett Newman's quest for the sublime or Rothko's insistence on spiritual values. The French felt he understood the dynamics of space and structure within painting and aligned him with the Tachiste painters whose work was lyrical, spontaneous and decorative. The British art critic Herbert Read responded to Francis's own mysticism, writing, "his awareness is directed . . . outwardly, towards a source from which proceeds the primary substances of light and colour, the formless forms of a sensuous reality in a state of becoming."

The truth is that Francis draws on many different sources and traditions to deal with the problems that confront him, notably the depiction of light and the phenomenon of gravity. "I am fascinated by gravity . . . Painting is a way in and out." Francis moved from the "all over" painterly approach of Pollock to the contrasts of colour and white where colour floats in white space. His "Mandala" paintings of the 1970s continued to pursue these themes. *In Lovely Blueness*, though much denser in content than this latter work, stands witness to his enduring interest in colour, beauty and the liberation of the emotions.

—Camilla Boodle

Bibliography—

Waddington, C. H., *Behind Appearance*, Edinburgh 1968.
Hunter, Sam, *American Art of the 20th Century*, London 1973.
Vogt, Paul, *Contemporary Painting*, New York 1981.
Selz, Peter, *Sam Francis*, New York 1982.
Moszynska, Anna, *Abstract Art*, London 1990.
Shapiro, David, and Shapiro, Cecile, eds., *Abstract Expressionism: A Critical Response*, Cambridge 1990.

Helen Frankenthaler (1928–)
Flood, 1967
Acrylic on canvas; 124 × 140in.
New York, Whitney Museum of American Art

Flood, painted in 1967, is a large canvas, described by the critic E.A. Carmean as, "one of the most atmospheric and dramatic works in Frankenthaler's oeuvre up to this point in her career." This monumental abstract with its surging bands of colour flowing horizontally to saturate the canvas was praised as "an ambitious and successful Turneresque performance" (James R. Mellow, *Art International*, May 1969). Though many critics chose to limit their interpretations of *Flood* to analysing its response to Nature, the artist herself explained the genesis of the title in different terms. "The studio floor was small and I wanted to work on a canvas as large as possible. Once the canvas was laid down, I had only about a foot of margin to stand on between the canvas edges and the wall. I recall that there was a lot of liquid paint on the floor. The studio was flooded with colour."

Helen Frankenthaler has always protested against too literal a reading of her paintings. In conversation with E. A. Carmean (organiser of the large-scale retrospective of her works, shown in 1898/90) she pointed out that her choice of subjects (including *Flood*) was as much dictated by metaphorical as actual considerations. "I'm not protesting the association, but the painting as a painting has no more to do with nature than the greatest Pollocks or the greatest Monets have to do with nature. Even the apples in Cezanne primarily have little to do with apples . . . Any successful picture—an abstract work or a landscape—has a place and rightness and an ability to last and grow. It is not merely a matter of painting a tree, but of making a picture that works."

Throughout her long career Frankenthaler's credo has remained consistent. She has always understood the lyric and emotional properties of colour and the technical demands of design and scale which were the necessary underpinnings of Abstraction. Though her sources were at first eclectic, she moulded them into a unified vision and her unique contribution to twentieth-century painting, through the innovation known as "colour stain" has been widely recognised.

Born in 1928, Frankenthaler studied painting at Bennington College and held her first solo exhibition in New York in 1951. Early influences included Arshile Gorky, Kandinsky and John Marin. Subsequently, her friendship with the critic Clement Greenberg brought her into contact with Hans Hofman, Jackson Pollock and other members of the artistic avant-garde. Pollock's experiments with flung and dripped oil paint stimulated her to explore new ways of applying paint to canvas. She diluted oil paint to a thin consistency which she was then able to pour onto canvas, eliminating the need for the brush. The first painting achieved using this new technique, *Mountain and Sea* (1952), has acquired mythic status, not least because it inspired Kenneth Noland and Morris Louis (via Clement Greenberg) to embark on their own incursions into "Stain painting." Both artists acknowledged their debt to Frankenthaler, Morris Louis saying that, "she was a bridge between Pollock and what was possible." According to critic E. C. Goossens, "this seminal painting draws on Gorky's line cutting across or defining stained areas of colour, Kandinsky's 1910–1911 improvisational emotion, John Marin's watercolour feeling and vignetted organisation. Pollock, of course, appears as the father of the spilled rather than the brushed colour."

The charcoal drawing which was the counterpart to the colour washes in *Mountain and Sea* was eliminated by the time of *Flood*. Another change was the transition from oil to acrylic paint which, thinner than oil, did not penetrate that canvas so deeply but rather floated on (or flooded) the surface of the cotton duck canvas. Hence, Frankenthaler was moving away from the dense surfaces of the Abstract Expressionists with their illusionistic devices and expressionistic techniques, to an exploration of two-dimensional space. Clement Greenberg, writing in *Art International* in 1962, understood the significance of this change. In an article entitled "After Abstract Expressionism," he opined that, "By now it has been established, it would seem, that the irreducible essence of pictorial art consists in but two constitutive conventions or norms: flatness and the delimitation of flatness; and the observance of merely these two forms is enough to create an object which can be experienced as a picture." In 1964 Greenberg's *Post-Painterly Abstraction* exhibition at the Los Angeles County Museum of Art included the work of Frankenthaler, Sam Francis, Louis, Noland and others. It was clear that the so-called "Sterile mannerism" of Abstract Expressionism was being challenged by the lyrical improvisations of the stain painters.

Flood has been succeeded by many canvases organised on a grand scale, dedicated to exploring the relationship between the formal requirements of painting and the descriptive relationship existing between painting and the perceived external world. For example, a work such as *Nature Abhors A Vacuum* (1973) consists of abstract colour used to explore the philosophical and conceptual challenges contingent upon the consideration of space and time. Thus the natural world offers both aesthetic opportunities and solutions to the creative artist.

Helen Frankenthaler is still painting and exhibiting worldwide. Her palette has changed and modified over the decades, and she has more recently painted what she calls "vertical landscapes" in addition to her horizontal canvases. However her concern remains to "get the pictorial image down to its simplest terms, to make it sensuously readable in an instant, and yet complex enough to last a lifetime." It is this unerring purpose that gives her work its validity and undoubted importance.

—Camilla Boodle

Bibliography—

Goossen, E. C., *Helen Frankenthaler*, New York 1969.
Fried, Michael, *Morris Louis*, New York 1970.
Elderfield, John, *Helen Frankenthaler*, New York 1987.
Carmean, E. A., Jr., *Helen Frankenthaler: A Paintings Retrospective*, Fort Worth and New York 1989.

Lucian Freud (1922–)
Large Interior W11 (after Watteau), 1981–82
Oil on canvas; 186 × 198cm.
London, Private Collection

Freud's most ambitious work of the 1980s, and one of the most significant works in his oeuvre, is *Large Interior W11 (after Watteau)*. Its genesis was occasioned by Freud's being presented with a catalogue which included a reproduction of a painting by Watteau of a music party. This particular work struck a responsive note in Freud, prompting him to rework the theme in his own way. It is interesting to compare briefly the qualities of these two artists. Watteau's works are tinged with a gentle melancholy, a pervasive musical air, an elegance of line and, above all, a certain dispassion and at the same time a deep sympathy for his subjects which at a rapid glance seem to look artificial.

By contrast Freud's work is marked by a trenchant line which captures the essential features of his subject. His colour is not so luxurious as Watteau's but is nevertheless vibrant and yet subtle. A common denominator of the two artists is their involvement with the sexual nature of human life, a quality clearly and unequivocally stated in Freud's paintings. While this feature is not nearly so overt in the works of Watteau, it is a significant and integral undercurrent in his work and contributes to the charm and attraction which his works hold for us today.

Freud based his large painting, over six feet square, on Watteau's *Pierrot Content* c.1712 (a section of which is seen in the background of Freud's painting of *Portrait of a Man* 1981/82). Watteau grouped four people, seated on a bench, while a fifth is seated on the ground. The background is heavily wooded and from this area two characters observe the scene of music making. In Freud's painting much of the compositional structure used by Watteau is freely adapted but it is in the detail that difference is clearly marked. In the Watteau the mise-en-scene is a cultivated woodland. The Freud painting is set in a rather typical and bare London flat. To the centre left of the painting is a hand basin with a collection of exposed water pipes running along the wall. Through a window, one has a glimpse of roof tops and a chimney. The wall of the room is a dirty grey colour and the wooden floor is bare. The sole piece of furniture in the room is a bed covered with a rug. On this are seated four characters who look rather dejected and introspective. While Watteau's subjects, drawn from the Comedies, are linked by a gentle amorous atmosphere, Freud has drawn his subjects from his models and family and has linked them physically by crowding them on the iron bedstead. Unlike Watteau's characters, they do not appear to relate to one another except that the act of making and listening to music has apparently drawn them together. Unlike Watteau's painting the atmosphere is strained and moodily introspective. No gaiety enlivens the room. Even the presence of a large and luxurious indoor plant cannot erase the drabness of the room. Nevertheless, Freud has achieved a great unity in the grouping and there is a curious interaction between the seated figures and the worried looking child who sprawls at an angle at their feet. The sensation of anxiety is heightened by the perspectival direction of the floor boards which compels one to focus on the figures, notably on the figure in the yellow track suit.

A feature of this painting is the treatment Freud has given to the hands and feet of his subjects, so giving them a greater importance than they receive in Watteau's painting. The inelegant way in which the feet are placed and the artisan-type hands and fingers project an air of an earthy life-style which adds to the barren surroundings in which his subjects are clustered. There is, above all, an oppressive air of resignation, almost pessimism, which dominates this painting. And in many ways this can be considered the source of its strength. Freud's draughtsmanship is pitilessly accurate and compelling, and he does not attempt to avoid the imperfections inherent in the subject matter. This reaction is reinforced by his choice of colour—it is restrained and a greyness permeates the colour range, all of which helps to unify the composition.

Just as Watteau's work was often a puzzle to his contemporaries as it may be to modern viewers, so does Freud's work pose curious qualities for contemporary society to consider. While both artists infuse their respective works with a feeling for remoteness distancing them from their subject matter it is clear that Freud is more involved with the analysis and recording of the innermost thoughts of each of his subjects. He scrutinises their features with infinite patience so that no nuance of expression or bodily gesture escapes him. Freud records his observations supremely well in his individual portraits, but in this large painting he has compounded the subtleties involved by showing how they relate to one another and to the group in general. One recognises some of the same models he has used previously but has recast them in such a way that they seem fresh and hitherto unrecorded. Freud's handling of the painted surface calls for special attention. He draws his brush across the surface repeatedly; at times it is loaded with colour. At others, it is used to introduce the most delicate glazes of colour, so carefully built up that a vibrant and mobile texture results. Like Watteau, he creates a shimmering surface when necessary to simulate living tissue. At other times, in a Rembrandtian manner, he builds up the texture of the pigment and at the exact moment leaves it to create a remarkable illusion.

Group studies are, perhaps, a supreme test of an artist's skill and technical competence. Although Freud has created an amazing range of paintings of the single figure, it is his triumph in this work that he has managed to convey the same unity of colour and interest as he does in the single portraits. This painting, however, has more to offer the viewer than mere technical virtuosity. It is Freud's insight enabling him to present a group whose gaze never meets that of the viewer, but whose posture and attitude present a state of mind which the viewer does not share or perhaps comprehend. He has demonstrated that he has the insight and technical skill to recognise and record the psychological state which animates this group. He is a master of detaching the individual from the group and revealing his innermost feelings and thoughts.

His subjects remain isolated and ultimately untouched except by the artist who is painting them. Freud emerges as one of the few artists of this century who possess the gift and genius to comment on and perceive the nature of much of contemporary society, with its social complexities, much unevenness of social justice, deep-seated insecurities and neuroses. Freud's vision is certainly disturbing. It is apocalyptic in quality and mercilessly honest in analysis. And yet it is a vision that is full of compassion for his subjects. One suspects that in these things is the quintessence of the artist himself.

—Melvin N. Day

Bibliography—

Brookner, Anita, *Watteau*, London 1967.
Sunderland, John, and Camsaca, Ettore, *Watteau: The Complete Paintings*, London 1971.
Gowing, Lawrence, *Lucian Freud*, London 1982.
Johnson, Robert Flynn, *Lucian Freud: Works on Paper; The Later Works 1961–87*, London 1988.

Naum Gabo (1890–1977)
Linear Construction no. 2, 1970–71
Perspex and nylon filament; $45\frac{1}{4} \times 32\frac{7}{8} \times 32\frac{7}{8}$in. ($115 \times 83.5 \times 83.5$cm.)
London, Tate Gallery

Linear Construction in Space No. 2 (1970/71) presents the viewer with an image of classic purity, harmony and order yet, together with these timeless qualities, it is instantly recognizable as a product of a particular era, clearly inspired by 20th-century scientific and engineering thought.

The artist, Naum Neemia Pevsner (later to take the name Gabo) did not train as a sculptor, but had instead taken an engineering degree at Munich University from 1910 to 1913. However, his wide ranging interests were evident from the start as he also dipped into medicine, philosophy and art history. In these years leading up to the outbreak of the First World War, the young Gabo was aware of the discoveries of physicists regarding the complex structure of the universe, the dematerialization of matter and the space-time continuum. Rutherford's model of the atom was published in 1909–11, and Bergson's theories of constant transition were well known by 1910. These new theories had discredited concepts of solid and static matter. Space was now recognized to invade and link all matter. From Gabo's engineering studies he was to bring to sculpture the structural vocabulary of open systems of beams, trusses and planes and its implication for sculpture's centuries old tradition of mass and volume.

At the outbreak of war in 1914 he joined his brother, Antoine Pevsner, also a sculptor in Norway and finally decided to become a sculptor himself. They both returned to Russia in 1917 to work with other young artists in support of the Revolution from which it was hoped a new, just and free society would arise. It was here that he developed the aesthetic of Constructivism which informed his work from that time onwards with a remarkable intensity and consistency.

In the Realistic Manifesto of 1920 Gabo and his brother promulgated certain principles of constructive technique. Central to these was the renunciation of "the descriptive value of the line; in real life there are no descriptive lines . . . descriptiveness is an element of graphic illustration and decoration. We affirm the line only as a direction of the static forces and their rhythm in objects. We renounce volume as a pictorial and plastic form of space. We renounce in sculpture the mass as a sculptural element." They also felt that the new constructive art should be made of materials appropriate to the 20th century—steel, glass and plastic—and they most fervently believed that this art should address a mass audience with a life affirming moral imperative. By 1922 the hopes of reaching this mass audience were curbed, and the authorities demanded "social realism." Gabo, unable to sacrifice his principles of art as an independent and spiritual activity, had to leave Russia for ever.

His work in this early part of his career, probably because of his preoccupation with the potentialities of the structural strengths of materials, had an architectonic quality, a somewhat angular conception of space in accordance with his theory of stereometry. Stereometric construction defines forms in terms of space rather than mass; the structures are comprised of the intersection of two or more planes to which subsidiary planes could be added, thus revealing the interior as a series of open volumes. He gradually abandoned this angular conception in favour of a spherical, continuously flowing space which was more in tune with his innate, poetic and sensuous perception of the world. He had always been absorbed with transparency—a desire to dematerialize the object—and had been frustrated with the brittleness (and the tendency to crack and yellow) of cellulose, which was the only available plastic immediately after the First World War. It was only in 1936, during his stay in England that he was introduced to a new and much improved form of plastic: perspex. Perspex was brilliant, clear and had a light emitting edge. Using this material and pure white nylon thread, Gabo was able to create what many consider to be the most beautiful of all his constructions. *Linear Construction No. 2* (1970/71) is an outstanding example. It is a structure of two flat elliptical planes set at right angles to each other, the alternate quarters becoming hollow curves. Then, within the plane, a negative ellipse has been cut out. The complex external surface is created by diagonal stringing. The planes are made of fine clear perspex and the stringing is of nylon filament. The forms of the plastic planes are defined by the white lines of their edges. The strings which define the weblike surface also appear to be luminous. The construction hangs a few millimetres from its base and the slightest draught causes it to turn slowly—an airy, ethereal image.

The first *Linear Construction in Space* was made in 1949 and was followed by seven other versions differing only slightly in height and all, with the exception of the first and the 1970/71 version, having a black cut-out shape of plastic in the centre. The 1970/71 version which hangs in the Tate Gallery was made in memory of his close friend and admirer, the poet and critic Herbert Read, who had always supported Gabo's work. Gabo said that he made this version without the black inlay because it kept the feeling of serenity as a memory of Read.

In an open letter to Herbert Read (*Horizon, Vol X. No. 56*) Gabo wrote, "I am repeatedly and annoyingly asked—where do I get my forms from? The artist as a rule is particularly sensitive to such intrusions in this jealously guarded depth of his mind—but I do not see any harm in breaking the rule. I could easily tell where I get the crude content of my forms from, provided my words be taken not metaphorically but literally. I find them everywhere around me, where and when I want to see them. I see them, if I put my mind to it, in a torn piece of cloud carried away by the wind. I see them in the green thicket of leaves and trees. I can find them in the naked stones on hills and roads . . . sometimes a falling star, cleaving the dark, traces the breath of night on my window glass, and in that instantaneous flash I might see the very line for which I searched in vain for months and months."

He was an artist who lived through and personally experienced some of the most distressful epochs of this century, knowing rejection and exile from his homeland; being largely unappreciated and misunderstood for decades; shifting from country to country until at last he came to rest in the United States in 1947. Here, at last, came recognition of his quality as an artist and commissions for large scale works in public spaces. But during all those years of tribulation he never lost faith in his aesthetic nor wavered in his essential optimism. In the same letter to Herbert Read in July 1944 he wrote of his work: "the image they evoke is the image of good—not of evil; the image of order—not of chaos; the image of life—not of death." He was writing at a time when Europe was at war, engaged in a mortal struggle, and he asked himself: should he carry this horror through into his art—and then was there anything, indeed he could tell people about death and destruction they did not know only too well. The answer was his ringing affirmation, "I am offering in my art what comfort I can to alleviate the pain and convulsions of our time. I try to keep our despair from assuming such proportions that nothing will remain in our devastated life to prompt us to live. I try to guard in my work the image of the morrow we left behind us in our memories and foregone aspirations and to remind us that the image of the world can be different."

—Mary Ellis

Bibliography—

Read, Herbert, and Martin, Leslie, *Gabo*, London 1957.
Read, Herbert, *The Philosophy of Modern Art*, London 1964.
Haftmann, Werner, and others, *Naum Gabo*, exhibition catalogue, Berlin 1971.
Newman, Teresa, *Naum Gabo—The Contructive Process*, London 1976.
Compton, Michael, *Naum Gabo: Sixty Years of Constructivism*, London 1987.

© ADAGP, Paris and DACS, London 1991

98

Alberto Giacometti (1901–66)
Landschaft bei Stampa, 1952
Oil on canvas; 55 × 73cm.
Chur, Bundner Kunstsammlung

No other artist from the Swiss canton Graubuenden, in the south-eastern part of the Alps, has achieved the world wide reputation of Alberto Giacometti. Neither his uncle Augusto, who belonged to the early expressionists, reached such recognition, nor his father Giovanni with his late-impressionist landscapes. After World War II, Alberto spent some years in Paris, where his talent was more and more recognised. His sculptures of human figures with almost skeleton-like bodies were enthusiastically adored by the French existentialists who thought him to be the artistic prophet of their philosophy. Jean-Paul Sartre and Simone de Beauvoir were amongst his friends at this time. However, it has been rightly pointed out that the character of Giacometti's art, seen in both his paintings and sculptures, is really supported by his outstanding drawing technique, which combines a sense of twitching and aggressive tension with sensitivity. These elements become more obvious as he overcomes his surrealist phase in the 1930s.

However, we have to take into account Giacometti's background; the landscape in the area where he was brought up, to understand his extraordinarily mature style. Each winter, he left the world-city of Paris to return to Graubuenden. His home was in the village of Borgonovo near Stampe, in the steep valley of the Bergell in the southern Alps. This valley falls approximately 30 kilometres from northeast to southwest, and begins in Maloja, still situated in the Upper Engadin, at a height of 1815 metres, and then leads across the Swiss-Italian border; Chiavenna ("key-city"), the next small Italian town, is only 330 metres above sea level. A little further on lies the seemingly mediterranean Lake Como, and from there the lombardic metropolis Milan is within easy reach. Ernst Bloch called this connection between the icy mountain-tops of the Bernina group and the insubric world of Upper Italy the Maloja-Chiavenna-Drift. In Bergell, the Val Bregaglia, Italian is spoken. Alberto has also learnt German and French. Just like the Engadin, Bergell is of Protestant belief. A certain puritan seriousness distinguishes its inhabitants from the neighbouring Catholic Italians. This is echoed in the character of the landscape of this narrow, steep valley, the heart of which in winter never sees the sun. High above, amongst the granite peaks of the three-thousanders, we find the thin, chiselled figures which had inspired Giacometti and thus became known throughout the world. Shades of grey dominate the mountain-sides, showered with a snowlike light of silver, ochre shimmers through, and a light yellow, high up where the sun manages to break through the sky. At the bottom of the valley black creates the contours.

These are the colours and nuances which also compose *Landschaft bei Stampa*: sparsity and exquisite elegance. An air of the untouchable from the north, and at the same time Italian sensitivity and sophistication. There is hardly another painting which reveals Alberto's double-character in such a way: icy rocks reminding you of the glance of Medusa, which is caught and conveyed by the pliable, nervous network of his strokes.

The *Landschaft bei Stampa* is an oil painting, but the ductus of a drawing dominates the painting. Not unlike an etching, or as if he had used crayon, Giacometti is able to capture the contours (or rather tries to question them, to find paraphrases) before he settles for a decision. As in his portait-work, he confronts the problem of discovering the essential. One can feel the questioning, doubting movement, and then the determination with which the structure is formed. Colours accompany and highlight the process. The images take on shape, at first tentatively, then more and more clearly.

The secret of the liveliness of Alberto's art lies in the fact that he shows the working process in his pictures. As we know, he often found it hard to define a work as finished and complete. The observer gets transported through the stages of development of the piece of art, realising the process of orientation along the way, just as it must have been for the artist himself. Giacometti has always tried to set dimensions and proportions carefully, often by using points of reference and a network of lines and grids. He was faced with a similar problem to the mountain-climber, who tries to find his way in the bleakness of high mountains, above the forests, where you can no longer find points of comparison, and where scales become next to absolute.

Such was Giacometti's aesthetic problem: How do I establish proportions, sizes for phenomena that could actually exist for themselves? This means that space has to be discussed with artistic means. Maurice Merleau-Ponty, the existentialist philosopher, has recognised the constitutive role of the perception of space to create our perception of reality: ". . . more urgent still than any other directions in space, depth forces us (. . . .) to rediscover primary experiences, with which the world overwhelms us; out of all directions in space, depth is therefore the most existential. It cannot be noticed on the object itself, but is rather part of the act of seeing, and not a separate entity. It proves that the objects and myself are linked to each other in a certain insoluble way . . ."

Giacometti must have formed structures of perception along these lines from early on in his childhood, developing and refining them while living at home in the mountain-valley, so that they could provide a matrix for his aesthetic perception and artistic expression in later life. He confirmed this quite clearly himself, when he said to Luigi Carluccio: "Each time I had to reconstruct space, I measure distances again that lie between me and the objects, and between the objects themselves."

So we look at artistic production following the pattern of existentialist strategies of survival in the depth of existence where things manifest themselves. This explanation might be the common denominator of the fundamental questions and doubts of orientation which divides on one hand the basis of aesthetic perception, and on the other the philosophical knowledge from existentialists as far as the analysis of existence by Martin Heidegger. The question of life/existence has become both artistically and philosophically the radical question of orientation in this world of time and space.

In *Landschaft bei Stampa* time is captured in the structure of the painting by simulating the ductus of the brush; space expands in the wide format of the painting in order to portray the basin of the valley, the retreating demicircle of the mountains: Alberto's beloved home, where he returned to each winter to draw and paint the numerous portraits of his mother, and only then to go back to his atelier in Paris in the springtime, to the cafés frequented by artists and intellectuals.

In the foreground are pillars, a portal, fragments; this leads into space beyond; houses on the right, colours of a grey pink, light ochre, cool and withdrawn; behind, the eye is directed towards the skies, and the cathedral of the mountain; a deep horizon beneath a sky that fills half of the painting and stands out, delicately and precisely broken only by the pointed tower of a small church. The painting achieves everything that is demure and of distinguished purity, of sibyllic transparence. It was near here, at the cemetery of Borgonovo, in the narrow valley, detached from the world, that the famous artist found his last place of rest in the winter of 1966.

—Gerolf Fritsch

Bibliography—

Giacometti, Alberto, *Begegnung mit der Vergangenheit*, Zurich n.d.
Jedlicka, Gotthard, *Alberto Giacometti als Zeichner*, Olten 1960.
Bloch, Ernst, *Verfremdungen II*, Frankfurt 1961.
Meyer, Franz, *Alberto Giacometti: Eine Kunst existentieller Wirklichkeit*, Frauenfeld 1968.
Hohl, Reinhold, *Alberto Giacometti*, Frankfurt 1971.
Bundner Kunstmuseum, *Alberto Giacometti: Ein Klassiker der Moderne*, exhibition catalogue, Chur 1978.
Fritsch, Gerolf, "Alberto Giacometti: Kunst zwischen Begehren und Willen zum Wissen," in *Das Kunstwerk* (Stuttgart), no.2, 1981.

Photo Riccardo Colella

100

Piero Gilardi (1942–)
Inverosimile, 1990
Polyurethane foam, steel and electronic components; 8 × 14 m.

Inverosimile in Italian means something that is at the same time improbable and incredible. This work of art by Piero Gilardi is an improbable synthetic vineyard where everything is an artificial copy of nature: namely, rows of vines, leaves, bunches of grapes. Forms of things are known, but the raw material is purely synthetic. *Inverosimile* is more than a sculpture, tending towards the concept of the total work of art, like Richard Wagner's *Gesamtkunstwerk*—a fusion of all the arts "for the unlimited, direct representation of the perfect nature of man."

Piero Gilardi, one of the crucial figures of the avant-garde in the 'sixties, is possibly less optimistic than Wagner as far as the nature of man is concerned. Men have to be involved and stimulated: *Inverosimile* is actually an environment where everybody can enter and walk, interacting with the elements of this unreal vineyard. It is a multimedia electronic installation symbolizing the Latin Saturnalia, re-proposed by means of environmental interactivity.

Inverosimile is based on a modular composition and each row of vines, as regards sound and kinetic animation, is self-sufficient. One thing to note: Gilardi's work is not a pure illusion of a lost nature. Among leaves and bunches of grapes, people will face a menhir and a primordial altar: through the openings of the rows of vines, the Solar myth is simulated in the deepness of its mystery.

These synthetic trees have sensors responding to the bodily movements of the visitors; music and light effects contribute to create an astonishing involvement in the audience. Interacting with all the different elements of the synthetic flora compounding *Inverosimile*, people attain a high degree of bodily and emotional participation. The latter is one of the aims of Gilardi who, in recent years, has investigated interactive technologies and the opportunities offered by the human-machine interface, from a creative point of view.

Piero Gilardi is not particularly interested in studying the human factors, that is to say the pure human-machine interaction, using his art works as an unusual laboratory for behaviour tests. When Gilardi started to plan *Inverosimile* with the collaboration of Riccardo Colella, who realized the original interactive software, the purpose was to develop an environment adequate to stimulate a ludic connection among men and machines.

This is what happened when *Inverosimile* has been exhibited for the first time in September 1990, in the old deconsecrated church of the Volpaia castle, in Tuscany.

Human myth and memory are today put into question by a mutable connection among arts, sciences and technology, a field where Gilardi is one of the leading international figures. In *Inverosimile*, as in a symbolic Saturnalia, the public cannot relax and remain passive. The performances programmed in *Inverosimile* last about twenty minutes each, and people play the role of co-actors. Each visitor not only interacts with a single row of vines, but can develop more complex synergy with other people acting inside the installation. Somebody touching a leaf of a tree starts a movement which can excite all the row of vines, producing spectacular effects in the whole virtual setting.

The artist acts like the poet in Shakespeare's *A Midsummer Night's Dream*: "The forms of things unknown, the poet's pen turns them to shapes, and gives to airy nothing, a local habitation and a name."

The *trompe l'oeil* effects of all the *Inverosimile* half-alive flora are not so far from the research into Artificial Intelligence, pertinent to human computer interaction. Gilardi's problem, of course, is not to design more human interfaces, but to suggest a creative use of technologies.

More than a sample of an artificial countryside, *Inverosimile* is a fragment of a virtual galaxy. It is both a work of art and a portion of a system where a star—the Sun—follows a very familiar life cycle. The performance starts by night, in the frightening darkness of a lunar eclipse. Fear and distress continue on the following day, because of stresses and strains of routine life. A catharsis happens at the worst point of the crisis, namely a liberating event that celebrates the recovered capacity of the human beings to socialize and communicate with each other. It is a choral human-machine interface where the artist has considered several levels of dialogue and abstraction.

In Gilardi's *Inverosimile*, virtual energies, light and sound effects, interactive devices, stimulate a real desire for social mutation. Gilardi's interactive rows of vines release energy by exploiting the symbolic memory of the visitors. The new relations between human beings and technologies suggested by the artist should help society to equalize its contrasts. The performance occurring among the rows of vines alludes to the Roman Saturnalia, the harvest festival during which moral codes were relaxed and freedom and equality took the place of oppression. Saturn, the Latin god of agriculture, is maybe distant from post-modern society, but the myth nevertheless preserves both a social function and the opportunity to be interpreted from the point of view of dreams.

In Saturnalia, masters and slaves exchanged positions. The symbolic Saturnian festival becomes the virtual stage where the complex social relations of our era are focused, using some of the most significant inventions of this century. Art, science and engineering, allow an art installation like *Inverosimile* to operate with an extraordinary flexibility and with extreme care for the human side of the partnership between men and machines.

Artists working with advanced technologies should benefit, likewise engineers, of some tolerances. As John Woodwark says in his essay in *The conquest of form*, a book consecrated to the amazing computer sculptures of William Latham, "Engineers would also like to be able to simulate many of the aspects of real life in their models: for instance (. . .) the springiness of structures, and the fact that real components are not made exactly to plan . . ." Gilardi's *Inverosimile* is neither a real vineyard, nor an entirely virtual one: tolerances must be allowed.

Piero Gilardi believes that new technologies as well as new media require new languages, new forms of script, new forms of involvement and communication. His work are neither pure entertainment, nor objects belonging to the so called *synthetischer Kitsch*: in the background of *Inverosimile*, visual arts merge with the history of vision, with sciences and technology.

—Elisabetta Tolosano

Bibliography—

"Piero Gilardi exhibit," in *Domus* (Milan), June 1985.
"Gilardi in Africa," in *Domus* (Milan), December 1985.
Trini, Tommaso, *Inverosimile*, San Casciano 1990.

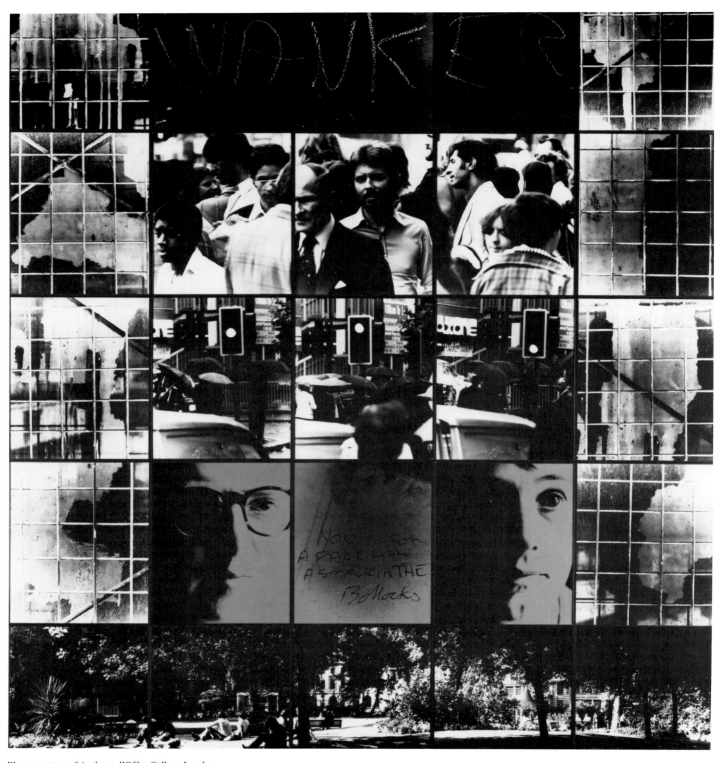

Photo courtesy of Anthony d'Offay Gallery, London

Gilbert and George (1943–/1942–)
Wanker, 1977
Photographs and collage; 300 × 250 cm.
London, Anthony D'Offay

Who are Gilbert and George? Why do these two men have no last names and exist as a corporate entity, a divine twinship? When Gilbert (born in the Dolomites, Italy in 1943) and George (born in Devon, England in 1942) met and studied at the St. Martin's School of art in 1967 the art world was in a state of flux. Art concepts and careers were under attack and redefinition. When they began their careers upon graduation, they practiced a new art discipline, that of performance art, a quasi-theatrical public display in which the art consists of the artist's actions which may or may not involve actions or words. George puts it simply: "On leaving college and being without a penny, we were just there. Just two physical presences, Gilbert and George." Gilbert recalls, "We put on metal make-up and became sculptures. Our whole life is one big sculpture."

Calling themselves "Living Sculptures" in 1969 they wore suits and bronzed their hands and feet to look and act like well-dressed mechanical men or robots. In one early performance, they stood on a pedestal and pantomimed to a scrathy 78 of the music hall song "Underneath the Arches" played on a tape recorder. When the song finished they took turns getting down, rewinding and restarting the tape before returning to their partner on the pedestal to continue the performance. In pieces like this they often would stay in character for eight hours.

One of the revolutions in the history of photography occurred in the late 'sixties and early 'seventies when artists began to use photography to document their ephemeral art works and performances. Ostensibly merely documentation, this use of photography had an aesthetic basis and came in time to change the nature of high art photography. Gilbert and George's earliest use of photography can be seen as an extension of their performances, at first documenting them and then becoming an art form in and of itself. Although two of the pioneers of this new, hybrid photography, Gilbert and George's stated goals have always been populist. They want to have a clear, recognizable subject matter that in their words, "speak(s) across the barriers of knowledge directly to people about their life and not about their knowledge of art." They challenge high art definitions of art or photography and often speak of their work as "pictures," much as we speak of snapshots processed at a drugstore as "pictures." George says, "We think of our art as just pictures, not as photographs. We are using photography, not being photographers . . ."

One of the outstanding characteristics of Gilbert and George's photographic work is their use of multiple images arranged in grids. Although initially interpreted as a Minimalist obsession with grids, they make it clear that their employment of grids was a technical necessity. At the time they began working, extremely large format photography, such as has developed in the last five years, was not available. To give their work the scale of large paintings, especially its power to envelop and move the viewer, they began to work in multiple photographs arranged in grids. Gilbert recounts, ". . . we like it very much when the pictures take over. When they're bigger than the viewer. We want to dominate the viewer with the force of art. Because art can change people." George concentrates on the mechanics of picture making saying, "the grids are a natural part of making large photo pieces. It is like a week has to be divided into days for convenience. A house has to made of bricks. You can't make a house of one big brick." Gilbert continues," You cannot have a sheet of photographic paper big enough to put it all together. Technically it is impossible." Yet, their use of multiple images goes beyond mere structural necessity and incorporates an often cinematic sense of the passage of time.

Beginning with their *Nature-Photo Pieces* of 1971, Gilbert and George's work is done in a series of panels developing the same general theme. The series build on and grow from each other. For example *Any Port in a Storm* of 1972 is followed by *New Decorative Work*, 1973, and *Modern Rubbish* of the same year. *Drinking*

Sculptures of 1974 are followed that year by *Human Bondage* and *Dark Shadow*. *Mental*, a 1976 series that dealt with their own feeling of perilous sanity, was followed by *Red Morning* and *Dirty Words*. In *Dirty Words*, which includes *Wanker*, as well as *Bent*, *Cock*, *Smash the Reds*, *Angry* and *Lick*, they photographed derogatory, often sexually explicit graffiti. They discovered most of the graffiti was found in the slightly hidden yet, easily accessible area of doorways. The montage/collages of this series are structured to echo the doorways where it was found. Unlike the original site where the graffiti was found, they emblazoned the word across the top of the photograph like a lintel. Gilbert says, "By putting the word along the top, then something vertical down both sides, it looked like a door." George adds explaining their choice of composition, "We found much of the graffiti in doorways. In every major city, you just found it immediately, the moment you look . . ."

In addition to the "dirty words" and the usual Gilbert and George self-portraits, this series features anonymous crowd scenes, one of the first introduction of strangers into their private world. George recounts, "The photos were taken very shyly out of the first floor window at Fournier street . . . after a time, we ventured out of the house with a camera, but only with a long lens so we could take people's pictures at bus stops and things."

In *Wanker*, the word forms a three part lintel across the top of the panel. It is flanked on either side by two "posts" made up of walls photographed through grids, giving the panel an air of incarceration. Immediately under the words is a three-panel anonymous crowd scene with the members of the crowd looking at the camera/viewer. Below it is a rainy day scene where the bodies become dark silhouettes and umbrellas hide faces in deep shadow. The slightly vulnerable-looking faces of Gilbert and George, like animate architectural ornament flank the words "you've got a face like a slap in the buttocks." Below, stretching the width of the panel is a peaceful garden scene. Reading this sequence from top to bottom is like looking at a transformation of hell or purgatory to the Garden of Eden. The majority of the work conveys a sense of imprisonment in societal values and structures. They acknowledge their homosexuality in this series and show themselves as both subjects and objects of prejudice and negative labeling. Yet, for all their bleak depiction of the coldness, alienation and prejudice of the modern urban environment, they find within its midst a vision of promise and redemption from both their own thoughts and those of society.

Often misunderstood and admired for qualities that are in their work but not at its heart, Gilbert and George have a noble if unusual ambition in the spectrum of contemporary art. They want to create work that rejects hermiticism and seeks to bridge the gap between high and low culture to make an art that speaks directly and unequivocally about personal and social concerns. They often make work that is decorative and partakes of a kitsch sensibility, but at the center lie two human beings, two artists who ask questions like: "what does it mean to be alive today?; What does it mean to be an artist?" They do this in a visual language that is innovative, technically exciting, visually engaging and emotionally rich. Who could ask for anything more?

—Ann-Sargent Wooster

Bibliography—

Gilbert and George, "Underneath the Arches," in *Interfunktionen* (Cologne), no. 4, 1970.
Ratcliff, Carter, *Gilbert and George 1968–1980*, exhibition catalogue, Eindhoven 1980.
Richardson, Brenda, *Gilbert and George*, exhibition catalogue, Baltimore 1984.
Jahn, Wolf, *Gilbert and George: The Paintings 1971*, Edinburgh 1986.
Ratcliff, Carter, *Gilbert and George: The Complete Pictures 1970–1985*, London and New York 1986.

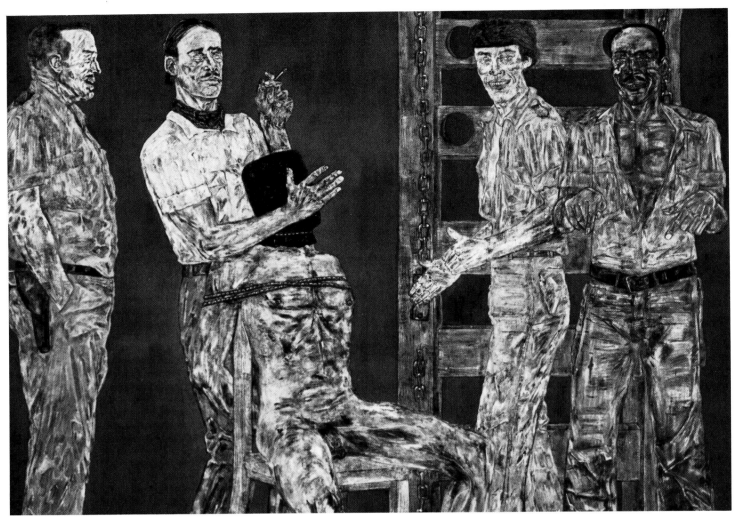

Photo courtesy Josh Baer Gallery, New York

Leon Golub (1922–)
Interrogation II, 1981
Acrylic on canvas; 120 × 168in.
Art Institute of Chicago

Independent of political ideologies, Leon Golub has dedicated his art to the ontological probing and exposure of repression and violence within contemporary power structures. In the tradition set by Goya, Orozco, Beckmann, and Heartfield, Golub gives persuasive expression to those blood-and-guts issues underlying the politics of our time—violence, power, and survival. With unsparing insights into the politics of violence, Golub holds firm his position of artist as humanist.

From its beginnings in Chicago, Golub's art has sought to define with increasing clarity our contemporary reality. By doing so within a vital expressionist style, in 1959, he and several other artists (including Nancy Spero, Cosmo Campoli, George Cohen, June Leaf, Seymour Rosofsky, and Ted Halkin) were dubbed the "Monster Roster" by Chicago critic Franz Schulze. Golub's paintings from that time reflect his interest in Dada, German Expressionism; *l'art brut* of those detached from social conformism; and the tribal arts before European acculturation. These interests were fresh, creative individualistic reactions to the prevailing dominance of Abstract-Expressionist style.

From 1976 to 1979, Golub painted more than 100 images of those members of the power elite who shape and interfere with the flow of human events called history—Chou En-Lai, Ho Chi Minh, Dulles, Franco, Brezhnev, and others whose decisions have affected the destinies of nations and the fates of millions. In this shift from ideal concept to more specific definition, the news photograph became the medium of reference, giving mordancy and contemporaneity to a cumulative awesome statement of political power. Struck by the impact which the head alone has as an image of political force, the portraits are small (life-size or up to one-half larger). They are painted with the blandness of political posters or the sardonicism of caricatures, but retaining a cool objectivity, lest the portrait degenerate into caricature and lose its power. Nothing would be gained from making them look like fools, for they are not fools. They are dangerous. For that true nature to be revealed, the artist must also be as cool and deliberate in his style as they are in their calculated acts.

Violence becomes concrete reality when placed within the context of contemporary events, as depicted by Golub in three thematic series: *Assassins* (1972–74), *Mercenaries* (1979–84), and *Interrogations* (1981). These large figure compositions are directly concerned with the war in Vietnam, covert operations in Central and South America, and other destructive situations of political upheaval. They are demonstrations of how power in the contemporary world is exerted politically. Whereas the *Gigantomachies* (1965–67) had dealt with mythical elemental power without judgement, these war paintings involve the amorality of violence in real situations. This shift from generalized form and content to the specifics of actuality demands a realism of particularized references. Images from television and news photography—the media whereby the war was made real to the folks back home—provide the visual means for presenting political violence on a more intensely personalized level, and with an even greater sense of urgency and pungency.

Interrogation II, 1981, presents a shocking image, even when seen here in photographic reproduction. Thrust into our own space is the repugnant, total violation of another human being. Four torturers make ready their dirty work on a male "suspect" stripped naked and lashed to an upright chair. Disoriented, blinded and stifled by a black sack pulled down over his head and tied around his throat, the victim sits tensely expectant—made into an object vulnerably exposed to the impending sadistic expertise of his leering captors.

The very character of the painted canvas surface bears its own configuration of inherent violence. After preliminary decisions, the raw linen canvas is nailed along its edges directly to the white brick wall of Golub's studio. When all the forms describing the subject are brushed onto the unstretched and unprimed linen canvas, the painting is taken down and placed face-up on the floor. The acrylic paints are dissolved with solvent and, then, are scraped down with a butcher's cleaver, until the surface becomes a sparse tortured skin. The figures are then reconstructed; adjustments are made of glances, gestures and their other interactions.

In contrast with their heroic, classicized victim, the four hired killers of fortune are sharply individualized in their roles. The uniformed one in strict profile at the far left—hands in his pockets, with a holstered pistol (for the coup de grace?), his mouth twisted by some gibe at the victim—is the one in charge, a mercenary. Hardly mercs, the others are hopped-up riff-raff without values, loyalties or cause. Their discordant gestures and shifty glances, as well as details of weapons, leather, and chains, charge the space with anticipated domination and the sick pleasures of torture. We are simultaneously fascinated and repulsed. The presumptuous intimacy of the two lumpens on the right identifies our curiosity and invites us as sharing participants. To share their responsibility? Or to await our turn? The red field around the larger-than-life figures, and the torture rack looming forward on the right, push this horrific event up to the surface of the canvas, making it part of the spectator's space, in the way a sideshow banner confirms the reality of misshapen freaks.

The shallow stage-like space intensifies the acts of cruelty and impending torture. It is as though we are part of all audience at a public execution, at which these clowning torturers are mocking the shock and uneasiness with which we watch their unsettling performance.

Such a performance can, interestingly, be viewed as an extreme perversion of European morality plays of the 15th and 16th centuries. Those public allegories had as their characters personifications of moral abstractions, such as Everyman, Vice, and Virtue, and they stressed the benefits of confession, shrift, and penance. Especially significant to the viewers was the hero Everyman, i.e., Mankind. For it was how the individual responded to the moral forces and to sinful temptations that would determine his salvation upon his inevitable death.

Perhaps there is a morality lesson in the Classical references in this Golub painting. The red ground of the paintings in the "Interrogation" series relates closely to the red backgrounds in Pompeian murals. The torture victim, restrained and idealized, also convincingly derives from our Classical legacy—on second thought perhaps even more so, because this particular image is directly lifted from a present-day photographic publication of sadomasochistic pornography. As we know, vicarious pleasure in viewing domination and control was a favorite arena sport among the ancient Romans, even with the barbarians at the very gates of their capital. By thus recycling into our culture its own pornography within the context of political brutality, Golub seems perhaps to be making a statement about our own destruction of those remnants of Classical thought and values in the face of our own deluge of barbarity.

—Edward Bryant

Bibliography—

Roberts, John, "Leon Golub's Mercenaries and Interrogations," in *Art Monthly* (London), September 1982.
Gumpert, Lynn, and Rifkin, Ned, *Leon Golub*, exhibition catalogue, New York 1984.
Kuspit, Donald, *Leon Golub: Existential/Activist Painter*, New Brunswick 1985.
Pincus-Witten, Robert, "The View from the Golub Heights," in *Artsmagazine* (New York), March 1986.
Kuspit, Donald, *Leon Golub*, exhibition catalogue, Lucerne and Hamburg 1987.
Brooks, Rosetta, "Leon Golub, undercover agent," in *Artforum* (New York), January 1990.

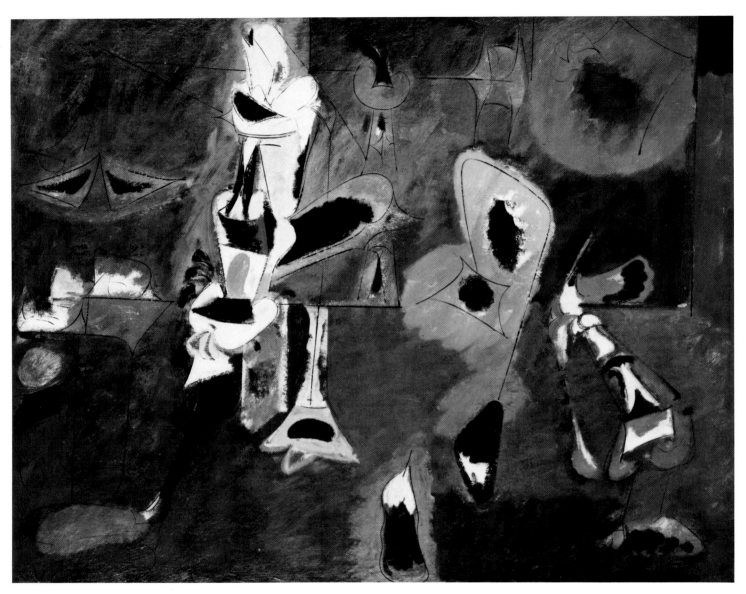

© ADAGP, Paris and DACS, London 1991

106

Arshile Gorky (1904–48)
Agony, 1947
Oil on canvas; 40 × 50½in (101.6 × 128.3cm.)
New York, Museum of Modern Art

As its title implies, *Agony* is a painting of enormous passion, psychological depth, and gestural complexity. Even when it was painted, in 1947, it was understood to challenge the limits of painting and to indicate the terrain that the new abstract expressionist painting in the United States would have to explore, and by the early 1950s it had achieved almost mythic status, containing and summarizing, it seemed, the emotional and aesthetic tenor of the post-War era. With this painting, and perhaps two or three others, Gorky's reputation as hero, saint, or tragic poet of modernist painting was established.

Agony offers something to almost every possible point of view or aesthetic taste, short of one that rejects abstraction altogether. Most obviously, it can be read autobiographically, as if it is the unmediated expression of the artist's own personal agony, presaging his suicide on July 21, 1948, only a few months after it was first exhibited at the Julien Levy Gallery in New York, February 29–March 20. Writing in the catalog to the Museum of Modern Art's 1962 retrospective of Gorky's work, Levy later detailed its autobiographical essence: "His tragedy was that he felt himself three times rejected: in his love, in his health, and in his art. Any two of the three rejections he might have resisted, but the three together were not endurable." At the time *Agony* was painted, Gorky's marriage was dissolving, at least in part under the pressure of other events. In February 1946, a fire had destroyed everything in his Sherman, Connecticut studio, including fifteen canvases painted in 1945 and twelve others on which he had been working for a number of years. Three weeks later, he was operated on for cancer. Tragedy appeared to be his destiny, and in retrospect *Agony* came to embody for many Gorky's recognition of his imminent fate. At the end of June 1948, he was hospitalized again, this time after an automobile accident in which his neck was broken and his painting arm paralyzed, though probably temporarily. He hanged himself in a woodshed near his home a few weeks later.

However powerful the personal and emotional content of *Agony*, it resonates at a formal level even more dramatically. From the beginning, Clement Greenberg viewed it as a sort of icon for his brand of modernist aesthetics. Reviewing the 1948 show at Julien Levy in *The Nation*, Greenberg called it one of Gorky's two best paintings. The other was *The Calendars*, which he had praised just a month before as "one of the best pictures ever done by an American." Both paintings displayed, he said, "the processes of painting for their own sake." Greenberg felt that Gorky had gone beyond any other painter—American or European—in "identifying his background . . . closely with the picture's surface, the immediate, non-fictive plane" upon which "spots," or isolated areas of color, are placed. Gorky seemed to weld these "spots" with their background, thus flattening the canvas, eliminating figure/ground relations, and forcing the viewer to experience the painting in what for Greenberg was its essential character, as a two-dimensional surface, pure and simple.

The brushwork of the painting—its insistence on the painterliness of its surface—is, in fact, one of its chief virtues. The rich fields of red, orange, and brown that compose its background wash freely over the hard edges that delineate the figures, or "spots," above them and do indeed draw figure and ground together. But it is probably better to see this as a "contest" between figure and ground rather than as a synthesis of the two in Greenbergian terms. In the insistence of their outline, as well as the relative brightness of their color, the figures and forms in the painting stand in opposition to the painterly field of the lower keyed ground. One can as easily read them as rising up out of the plane of the canvas as flattening themselves into it. In fact, Gorky's close friend Elaine de Kooning, in a 1951 review of his retrospective at the Whitney Museum of American Art, describes his forms as floating "upward with an extraordinary buoyancy." Most importantly, these forms *are* forms, consciously surrealist in their heritage, and they can be read in a variety of ways.

The painting can be seen, for instance, as an interior, not altogether different from Matisse's great painting *The Red Studio*. A wall defines itself behind the central figure. Two tables emerge, one in the middle, next to the tall central figure, and another on the left. A second figure enters from the right, bowing forward. Gorky had absorbed, especially, the figurative abstraction of Picasso and Miró, both Picasso's tendency in the 1930s to elongate, simplify, and distort anatomy to the point of making it unrecognizable, and Miró's interest in a more or less organic, amoeba-like figuration. These figurative tendencies coalesce in *Agony*. Still, the figures themselves remain ambiguous. Speaking of the central portion of the long figure on the left, Elaine de Kooning describes its forms as flowers and petals, a garden that suddenly changes, she says, "as you look, into a cruel and opulent sexual imagery." It is tempting, even, to see this figure as Gorky himself, perhaps even Gorky as the hanged man, consumed by fire, both literally and figuratively, the fire in his studio, the fire in his heart, his body discovered by some second figure stumbling in from the right in dismay.

Gorky's work situates itself between the space of three-dimensional illusion and the reality of two-dimensional space, between figurative representation and non-objective abstraction, and it enacts the passage between these poles. Each element of the painting is countered by its opposite number, and perhaps, for Gorky, the real "agony" here is the struggle to synthesize and resolve these conflicting forces. And yet, he seems to have in some measure succeeded. The painting seems to thrive in this field of opposition, as if Gorky has painted here a democracy of elements and techniques, each insisting on its own integrity even as it works with and against other elements within the space of the composition, give and take, to make a whole.

—Henry M. Sayre

Bibliography—

Greenberg, Clement, "Art," in *Nation* (New York), 20 March 1948.
de Kooning, Elaine, "Gorky: Painter of his own Legend," in *Art News* (New York), January 1951.
Rosenberg, Harold, *Arshile Gorky: The Man, the Time, the Idea*, New York 1962.
Seitz, William C., *Arshile Gorky: Paintings, Drawings, Studies*, New York 1962.
Rand, Harry, *Arshile Gorky: The Implications of Symbols*, London 1980.
Lader, Melvin P., *Gorky*, New York 1985.

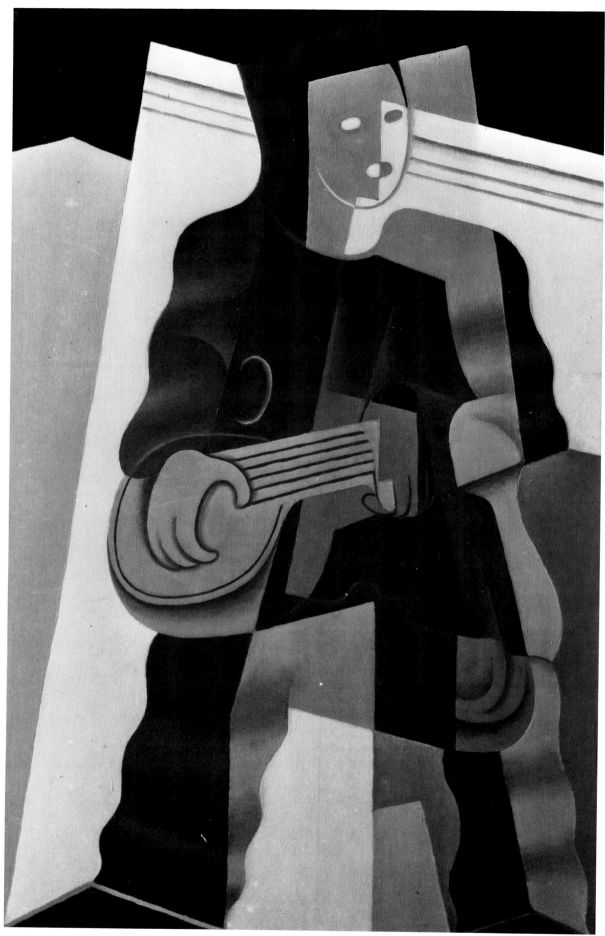

Photo courtesy Galerie Louise Leiris, Paris

Juan Gris (1887–1927)
The Pierrot, 1922
Oil on canvas; 92 × 60cm.
Paris, private collection

Not long after Georges Braque and Pablo Picasso developed analytical cubism with its austere technique of broken forms only vaguely related to reality and with a severe lack of color, a freer, more reality-based, more colorful form of cubism developed, known as synthetic cubism. It was at this point, about 1911, that the third member of the cubist triumvirate, a young man who had worked with Picasso and Braque, came into his own as the poet of the movement. His name was Juan Gris.

Juan Gris was the pseudonym for Jose Victoriano Gonzalez, who had given up academicism to come to Paris to find a full expression in more abstract terms for his poetic ideas about every-day objects and persons. He worked softly, and with a sense of ornamental effect, to produce a combination of forms and colors that could not have been achieved without the early experiments with analytical cubism. Compared to the cubist work of Braque and Picasso, his art is filled with gentle, quiet moods composed in simple shapes dominated by soft blues, grays, and whites.

To a novice all synthetic cubism may look somewhat alike, but with careful viewing Gris's poetic quality becomes apparent in the personal associations from real life that inhabit his work. He is sometimes called the Corot of cubism. Typically the color is gentler, the forms more placid, the combinations of form more serene than is the case with the other cubists. He was younger than either Braque or Picasso and rather isolated and alone since, except for Picasso, his fellow cubists were French. He thus began his early experiments with cubism in his own way, and this may account for the deepening solidity and mystery in his work between 1911 and 1913, when the quality of this work clearly equalled if not surpassed the efforts of Braque and Picasso.

He was born in Madrid, the son of a prosperous shopkeeper and the thirteenth of fourteen children. As a young boy, like many other future artists, he was very enthusiastic about drawing and was enrolled in the School of Arts and Industries at an early age. He also studied painting under the Malaga artist, Jose Moreno Carbanero, who also taught Picasso and Salvador Dali. It was in a bookplate, which he did for a Madrid publishing firm, that he first used the pseudonym, Juan Gris (the latter name being the color gray in both French and Spanish).

By 1906, he did plates and covers for a book of poems by a minor Peruvian poet, and in that same year he bought a ticket to Paris, leaving Spain to escape military service. He also left to find a freer atmosphere for both his art and his interest in women. He arrived with only sixteen francs, and a friend found him a position as an illustrator for an artistic journal. He soon came to know Picasso and his circle, but the older artist never fully accepted him or his work until after his death.

He soon was living with a woman named Belin, who gave him a son, Jorge, in 1909, all the while continuing to work as an illustrator in the art nouveau style. His transition to painting was gradual and influenced by the arrival of cubism on the artistic scene. Finally, in 1911, he made a modest start with two still lifes, *Still Life with Book* and *Still Life With Eggs and Bottle*. Each was simple and direct with an echo of the solitude and majesty of the seventeenth-century Spanish painter, Zurbaran. In 1912, he achieved one of his most famous works, *Portrait of Picasso*, which came to be considered a masterpiece of cubist art. In 1913, a young woman named Josette came to live with him and remained his helpmate and companion until his death. In that same year, he commenced a business relationship with the German art dealer, Daniel Henry Kahnweiler, that freed him forever from financial worry. From this date onward, his work began to demonstrate great sureness and control, and he also experimented with sculpture and collage.

With the coming of the war, he and Josette spent time at Ceret, near the Spanish border, where they were to return many times in the coming years. It was at this time that he met and was influenced by Matisse. By 1916, as the war dragged on, his work became more somber and reflected a true Spanish gravity. 1917 was the high water mark of his career in sales, acclaim, and number of works produced; but by 1920, due to a bout of pleurisy, his health was impaired, and he was to suffer greatly until his death seven year later. In 1922, he designed costumes and settings for the Diaghilev ballet, *Les Tentations de la Bergere*, but his forte was not theatrical design, and the results seemed unrelated to his true nature as an artist.

In 1922, he also produced one of his masterpieces, *The Pierrot*. It presents a simple, quiet figure with a guitar in colors dominated by blue, and dark and light brown against beige and tan. The forms are simple with curvilinear, wave-like outlines to the sides of the pierrot against the straight lines of the flat, architectural pieces behind. Forms overlap and interpenetrate one another, and colors divide down the middle of the pierrot figure. The painting is easy to read, simple, serene, quiet and rather subdued with no confusion or hidden agenda of meaning. Gris often painted this subject as did many other artists, and the theatricality and opposition between outward character and inward feeling as in *Pagliacci* appealed to Gris. The arrangement here is complete and self-contained, and involves rearranging the optical order of reality onto a flat surface according to the artist's sensibilities. Juan Gris said of his art: "My aim is to create new objects which cannot be compared to any object in actuality."

At one point in his life Gris set down fully the credo of his artistic mission in a lecture that he gave at The Group of Philosophic and Scientific Studies at the Sorbonne: "The only possibility for painting is the expression of certain affinities of the painter with the outside world, and the picture is the intimate association of these analogies among themselves and between them and the limited surface that contains them."

At another point in his career, Henry Daniel Kahnweiler quoted Gris as saying: "Cubism is not a style but an aesthetic, and even a mental state." Kahnweiler also quoted Gris as saying: "Cezanne turns a bottle into a cylinder, but I begin with a cylinder and create an individual of a special type: I make a bottle—a particular bottle—out of a cylinder. Cezanne tends toward architecture, I tend away from it. That is why I compose with abstractions (colors) and make my adjustments when these colors have assumed the form of objects."

—Douglas A. Russell

Bibliography—

George, Waldemar, *Juan Gris*, Paris 1931.
Kahnweiler, Daniel-Henry, *Juan Gris: His Life and Work*, London and New York 1947, 1969.
Cooper, Douglas, ed., *Letters of Juan Gris 1913–1927*, London 1956.
Cooper, Douglas, *Juan Gris: Catalogue Raisonnee*, Paris 1977.
Rosenthal, Marie, *Juan Gris*, New York 1983.

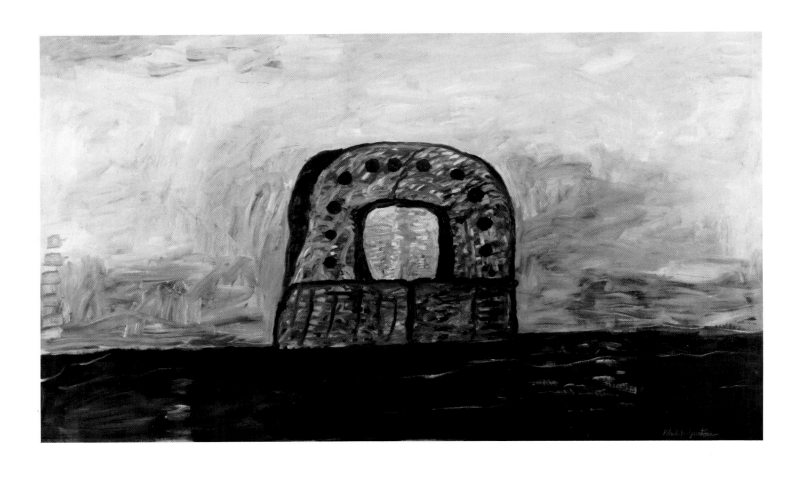

110

Philip Guston (1913–1980)
Black Sea, 1977
Oil on canvas; 173 × 297cm.
London, Tate Gallery

Black Sea by Philip Guston is one of the most sombre works of art produced by a painter whose oeuvre spanned a variety of styles, from the figurative narratives of his early years, and the lyricism of his "Abstract Impressionism" phase to the darker concerns of his last decade. *Black Sea*, with its menacing imagery and forbidding tones does not allow us to seek refuge from the ugliness of the world by means of aesthetic escapism. Rather, the painter was determined to confront what he considered the evils of contemporary life. He claimed that an artist living during such an age had unavoidable moral responsibilities. "Abstract art is a lie, a sham, a cover-up for a poverty of spirit," he said, abandoning a style which he derided as a "soothing lullaby." Many erstwhile admirers and patrons expressed revulsion at the harsh colors (black, white, grey and livid red) of the post 1970s work, but as Guston said to Ross Field, a friend visiting his studio, this was not a gratuitous exploration of evil. "People, you know, complain that it's horrifying. As if it's a picnic for me, who has to come in here every day and see them first thing. But what's the alternative?"

Although Guston baffled many of the art establishment with his rejection of Abstract Expressionism, it is clear in fact that certain common concerns informed his work from the outset, despite the various chronological shifts of style. His left-wing sympathies were forged in the 1930s, as was his belief that what drove art forward was not a preconceived scheme, but the stimulus of uncertainty and the need for the "subversion of finality." The roots of these convictions may have stemmed in part from his dislocated childhood. He was the son of Russian Jews who had settled first in Montreal and then in Los Angeles, where his father committed suicide in 1919. Due to Guston's impatience with formal schooling, he was largely self-taught, showing a voracious appetite for knowledge of history of art, philosophy and ideas. He was fascinated by artists as diverse as Piero della Francesca, Rembrandt and Giorgio de Chirico, and constantly questioned the rationale of art. He admired the "anxiety" he detected in Piero della Francesca and articulated his own vision: "In my experience a painting is not made with colours and paint at all . . . it might be things, thoughts, a memory, sensation which have nothing to do directly with painting itself. . . . It is an illusion, a piece of magic—so what you see is not what you see. I suppose the same was true in the Renaissance."

Philip Storr, author of a monograph on Guston, has pointed out that, "in many respects the story of his life is a chronicle of the ideas and events that transformed American painting this century." Guston's transition from the engagement of the 1930s when he worked as a muralist, to the fantasy figurative work of the 1940s, to the Abstraction of the 1950s was followed by the "apocalyptic vision" (which *Black Sea* represents) of the 1970s. At all times until the 1970s Guston enjoyed a large measure of critical success. As a mural painter he drew on sources including Uccello and the Cubists in designing a decorative scheme for the WPA Building at New York's World Fair. He was a teaching member of the Faculty of Art at the University of Iowa in the 1940s and had his first one-man exhibition in New York in 1945. Not only did he win the prestigious Carnegie Prize, but he was the subject of a major profile in *Life* magazine in 1946, and by 1948 he had been awarded the American Prix de Rome.

In the 1950s (partly influenced by Jackson Pollock who had been a friend since high school) Guston embarked on his own journey into Abstract Expressionism. Of the paintings produced during this phase he said, "The meaning of these paintings is contained less in the identity of the particular images hinted at in their titles than in the suspended state in which we encounter them and they continue to exist. Neither figurative nor fully abstract, the content of these images is in the elusiveness of their being." Critics including Harold Rosenberg and Dore Ashton responded warmly to these beautiful pictures which were compared both to the late landscapes of Monet and to the austere beauty of Mondrian. But Guston was not content to rest on his laurels and was unhappy at the artificiality of much of his contemporaries' work, especially considering the brutality of the world. "What kind of man am I, sitting at home, reading magazines, going into a frustrated fury about everything—and then going into my studio to *adjust a red to a blue*." He decided that "To paint, to write, to teach in the most dedicated sincere way is the most intimate affirmation of creative life we possess in these despairing years."

Hence he turned to painting emblems of menace and oppression, drawing on inspiration from sources as diverse as the paintings of Goya and Max Beckmann and the writers Gogol and Isaac Babel whom he described as "a moral and artistic brother." Large satirical paintings using cartoon techniques were narratives about the Klu Klux Klan, the Holocaust and the threat of impending Armageddon. Though few of the audience who were shocked by his exhibition at the Marlborough Gallery in 1970 were sympathetic to this radical departure from his earlier lyricism, Guston remained undeterred, preferring to "tell stories" to "all that purity." He felt that it was the duty of the artist to respond to change. "For if, as I believe, one is changed by what one does—what one paints—continuous creation can only be furthered in time. That is, to maintain the condition of continuity—or as we might put it, the subversion of finality."

Guston's achievement is still being debated. It is clear, however, that his intellectual and moral integrity were the driving force behind his late change of direction, or as Harold Rosenberg said, "Guston is the first to have risked a fully developed career on the possibility of engaging art in political reality."

—Camilla Boodle

Bibliography—

Ashton, Dore, ed., *Twentieth Century Artists on Art*, New York 1958.
Ashton, Dore, *Yes, But . . . , A Critical Study of Philip Guston*, New York 1976.
Lynton, Norbert, and Serota, Nicholas, *Philip Guston 1930–1980*, exhibition catalogue, Basel 1983.
Graham-Dixon, Andrew, "Laughing in the Dark," in *The Independent Magazine* (London), 23 February 1991.

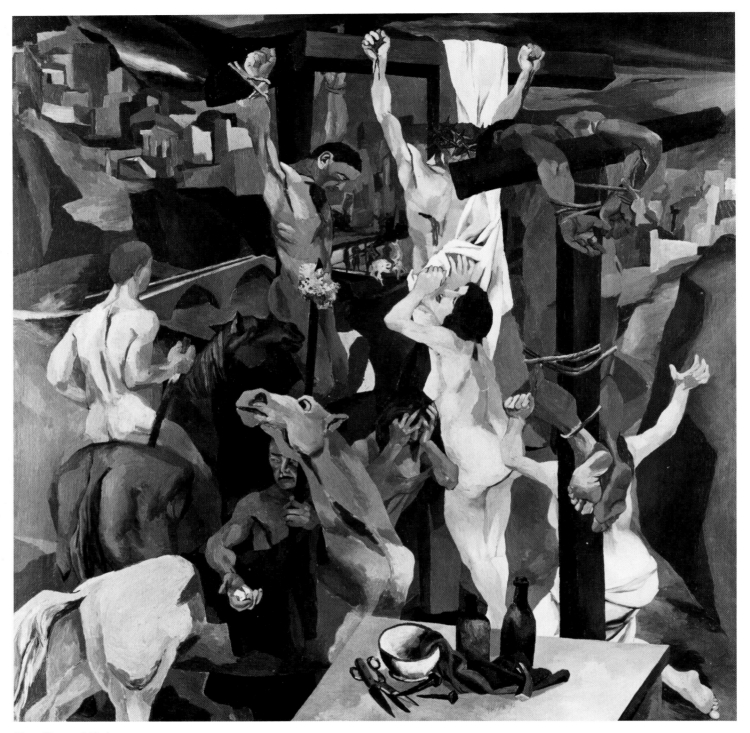

Photo Giuseppe Schiavinotto

112

Renato Guttuso (1912–87)
Crucifixion, 1940–41
Oil on canvas; 200 × 200 cm.
Rome, Galleria Nazionale d'Arte Moderna

Crucifixion (1940–41) represents a special event in the artistic journey of this Sicilian painter. It was shown in 1942 at the prestigious Bergamo Prize, where it won the second prize (the first prize went to Francesco Menzio, one of the Six Painters of Turin). This caused a great controversy: on the artistic level the composition was daring and unorthodox in its colour, and on the political level the theme was treated in such a sacrilegious manner that many people called for the intervention of the bishop. This, however, brought Guttuso a certain notoriety.

Guttuso was preparing himself to enter the great events of Italian painting. More than a decade had elapsed since he decided to give up his law studies in 1930 to dedicate himself to painting. In 1931 he exhibited at the First Roman Quadrennial, and in 1932 and 1934 he exhibited in two collective shows of Sicilian artists in Milan.

At the beginning of his career, Guttuso was strongly influenced by the painting of De Chirico and Carrà. As has been recently demonstrated, thanks to his strong personality he soon redeemed himself from the hindrance of the "return to order" which saw its moment of maximum influence in those years, and he accepted the aspirations of the painters of the Roman School. From 1933 he regularly visited Rome and settled there the following year, establishing a friendship with Cagli, Mafai, Fazzini and the other exponents of a painting styled along the lines of an expressionism of European origin. This was of paramount importance for the development of his style, which became more and more personal. The painting of these years is characterised by a direct observation of reality seen through eyes moved by and respectful of human values, in solidarity with mankind. Revealing in this respect is his comment about Mafai's work, *Women hanging the washing*: "There are two naked women in bright sunlight who hang out the washing on a warm morning: they are two women of Rome, from the suburbs, or from the top balcony of a council apartment block . . .".

In this painting Guttuso notes the use of colour and light, but he doesn't forget the subject: two women from the suburbs. If since the very beginning his interest in the painting of the Roman master is clear, very soon adjustments occur that better express his own personality. His successive works, reflecting his close friendship with Cagli, convey existentialist tensions, while on the pictorial level colour becomes more vibrant, wrapping the subjects in a twinkling and dense atmosphere.

In the second half of the 1930s, his spontaneous realist vein, together with a strong will to search into the depths for the meaning of painting, became more evident. For this reason he was attracted to Milan, where a group of artists, among them Birolli, Sassu and the art critic Edoardo Persico, had grouped themselves around "Corrente." There they were engaged in an intense debate about art, and significantly, Guttuso became the friend of Persico who, together with Lionello Venturi, was a convinced promoter of a European opening for Italian contemporary art.

What characterises Guttuso's pictorial personality is his capacity to capture cultural tensions at their inception. By the end of about ten years his style came close to "novecentism" and then to the Orphic Expressionism which was pursued in Rome at the beginning of the 'thirties. Later, shuttling between Rome and Milan, he reached his maturity with the realisation of a series of paintings which are still points of reference for all those who want to understand the artistic events of those years. Works such as *Execution in the country* and *Escape from Etna*, both from 1938, express all those tensions which allow Guttuso to be defined as a Romantic and pre-Cubist painter. In this sense, references to Courbet and Delacroix' *Liberty leading the people* have been noted. But these are not his only interests and he confirms this, stating his participation in the "Corrente" group: ". . . I was interested in the Mannerists, I liked Grünewald, and then, Van Gogh, the painfully earth-bound sense of Van Gogh (and therefore I compared him, in my love, to Picasso) . . .".

It is mainly with the *Crucifixion* that Guttuso expresses at his best his interests and his passions: "A painting of unusual dimensions and with an extraordinary formal tightness" was the comment made by Duilio Morosini, a passionate reporter who lived these years intensively. This prestigious work brings to a close a journey; that of a formalist painting made of still-lifes and decorations, opening a new phase linked to the human myths. *The Crucifixion* in this sense proposes itself as the rediscovery of man and his story.

The most impressive feature is the twisting of the classical iconography to favour an interpretation which has the tragedy of man as its focal point. Everything contributes to express the pathos. The composition: Christ is between the two robbers, but, in the foreground are the instruments of the sacrifice and a woman with her back to the scene so as to avoid more suffering; on the left are two horses and—high up—the village. That man and his passions are the centre of Guttuso's interests is reaffirmed by the two women: the nude of the Magdalen looking at Christ and almost clinging to his body, not as a redeemed sinner, but as a woman irresistibly attracted by a man . . . the third woman, raising her arms, repeating the gesture of love of the Magdalen (Morosini). The modelling, with its nervous jerk, and the use of colour, also contribute to reinforcing the drama here enacted, to underlining the suffering of man.

A complex work, full of citations from the history of painting which places itself between the introverted European tradition and the expression of human tragedy, almost as if Guttuso sensed the impending European events.

—Roberto Lambarelli

Bibliography—

Marchiori, Giuseppe, *Renato Guttuso*, Milan 1951.
Crispolti, Enrico, *La Crocefissione di Renato Guttuso*, Rome 1970.
Calvesi, Maurizio, and others, *Guttuso: Opere dal 1931–1981*, exhibition catalogue, Venice 1982.
Morosini, Duilio, *L'arte degli anni difficili (1928–1944)*, Rome 1985.
Cortenova, Giorgio, *Guttuso: 50 anni di pittura*, exhibition catalogue, Verona 1987.

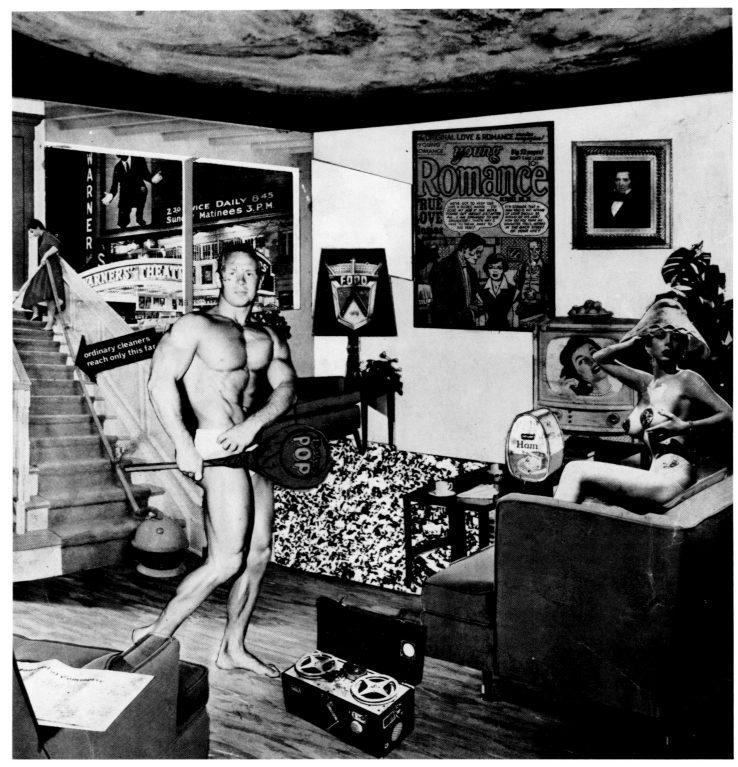

© Richard Hamilton 1991, all rights reserved DACS

114

Richard Hamilton (1922–)
Just What Is It That Makes Today's Homes So Different, So Appealing?, 1956
Collaged paper; 26 × 25 cm.
Tubingen, Kunsthalle

Avatar of the Pop sensibility, Richard Hamilton's *Just What Is It That Makes Today's Homes So Different, So Appealing?* (1956) is also an important sign of Pop Art's yearning for tangency with the historical past. Created for the *This is Tomorrow* exhibition in London, Hamilton's collage is precursor of such Pop tomorrows as consumer values, banal contemporary life, popular imagery, and their trenchant critique. The seeming iconoclasm of the Hamilton collage is betrayed by the collage's thorough and cognizant reconstitution of the Jan van Eyck *The Arnolfini Wedding Portrait* (1434). Hamilton described the Renaissance painting, avowedly his favorite in the National Gallery, London, "whenever I've looked at that picture, I've had this feeling that we're looking at something of momentous significance . . . the whole of life is suddenly crystallized in that moment when these two people face you not only across a void of space, but a void of time."

That same description obtains for *Just What Is It . . . ?*. In an environment of modern consumer culture, two principal figures confront us. The sportive, nearly nude male is a Schwarzenegger-*poseur* while the coquettish and passive semi-recumbent female figure reclines on the sofa. The Tootsie Roll Pop held by the man has traditionally been compared to a tennis or squash racquet, thus elevating the 1950s lower-class recreation of body building to a more respectable "Tennis, anyone?" invitation of the middle class. His solicitation is, however, patently more: the Tootsie Roll Pop just directly from the waist of the man as a phallic symbol, confirming the sexual dynamic of male and female in their modern environment.

Of course, we cannot ignore the distinction between Jan van Eyck's sacramental scene cast as ceremony and Richard Hamilton's secular work. The crucial religious symbol of matrimony uniting the Arnolfinis appears on the back wall of the room, demonstrating, as Erwin Panofsky perceived it, that the nuptial bond occurred within a religious sphere. Furthermore, Hamilton noted this mirror in comment on *The Arnolfini Wedding Portrait*, a clue to Hamilton's acuity to Panofsky's thesis. In lieu of this mirror, we have its direct reconstruction on the back wall, more or less equally between the two figures, in the Hamilton work. If the Passion of Christ afforded the circumstances of matrimonial covenant in the painting, *Young Romance* corroborates the secular context of the Hamilton figures. *Young Romance*, with its promise of "true love stories" and suburban values serves a function identical to that of the mirror in *The Arnolfini Wedding Portrait*. Connector to the two figures, it is likewise the index of conjugal and social values.

Above the Arnolfinis the single burning light symbolizes the all-seeing presence of God. This simple, domestic instance betokens a whole system of faith representing the transfigured reality of the nuptial moment. There is, of course, no candle in the Hamilton collage, but if we look to the corresponding ceiling level of the room we notice the cosmic presence of the twentieth century: not a symbol of deity, but instead the outer space of scientific exploration. That this room is enigmatically opened up to the heavens is akin to Jan van Eyck's ability to implicate the cosmos in domestic incident. The Ford-Lord lamp illuminates as well.

The two windows to the left in *The Arnolfini Wedding Portrait* afford access from the closed world of the domestic interior to the contiguous reality of a larger world. So, too, the double windows on the left of the Hamilton collage provide a view of a broader reality. Modern materialism is manifest in the room, including the Hoover vacuum cleaner and, of course, the canned ham, the 1950s image of a "new," "elite" food portrayed in conspicuous consumption on the coffee table. A canned ham signifies plenty and good taste. But as the Arnolfinis' domestic interior is not wholly isolated, so too this interior is not entirely closed. As we look out the window, we see Warner's Theatre and the movie playing there, *The Jazz Singer* with Al Jolson. On one level, despite its anachronism, *The Jazz Singer* reflects Hamilton's preoccupation with American movies and their promise of material wealth and

comfort not unlike that of *Just What Is It . . . ?*, but *The Jazz Singer* also *the* movie that transformed symbolic expression into realism through the increment of the spoken word. Hamilton's figures are not merely movie-goers; they view a benchmark American film, symbol of both the technological and materialist culture.

On the right side of the Hamilton collage we find one element displaced from its position in *The Arnolfini Wedding Portrait*: the bowl of fruit. Anomalous, perhaps, in the context of this modern household, the bowl of fruit on the television set reiterates the fruit on the window sill and table in *The Arnolfini Wedding Portrait*. As Jan van Eyck's signatory inscription appears on the back wall of the room in one, we see a secret love in *Young Romance* under the witness of the woman's father afraid that they will end up on the dreaded "back street of life." Yet another witness to their union appears in the traditional framed portrait on the back wall. The van Eyck witness in red is now the vacuum cleaner's woman on the left.

But what is the character of this union, if not traditional marriage? This is a marriage portrait in twentieth-century terms. Their union is founded in exactly the same bond in *The Arnolfini Wedding Portrait*. The Arnolfinis clasp hand in hand in ceremonial compact, but there is another bond as well. The dog, representing Fidelity, appears at the hem of Mrs. Arnolfini's garment while the dog's tail just touches the toe of Mr. Arnolfini. The ligature of Fidelity and the literal bridging of the dog confirms the nuptial exchange of the Arnolfinis. This crucial bridge is echoed in the Hamilton collage. Touching the edge of the sofa on which the female figure reclines is the tape recorder which, at the other end, just touches the toe of the male figure. The tape recorder—symbol of materialism—bonds these two figures as common property might afford a connubial bond. Common property and materialism thus play exactly the same role as the dog Fido and the symbol of Fidelity. What was for the Arnolfinis a vow of Fidelity becomes in Hamilton's work High Fidelity.

We know a great deal about Hamilton's particular sensibility toward the naked marriage as symbol in twentieth-century culture. After all, Hamilton provided the definitive English translation of Marcel Duchamp's notes in explanation of *The Bride Stripped Bare by Her Bachelors, Even*, offering to the English-speaking audience the full description and explication of the ideal nudity in Duchamp's cryptic work. In 1978, Hamilton's *The Artist's Eye* exhibition and catalog at the National Gallery, London, paid homage to *The Arnolfini Wedding Portrait*, an altered copy of which was the catalog cover. Hamilton interpolated himself in a faint image below the painting to signify his artistic intervention, a role he had secretly played in his 1956 collage. A collage of today's life, created for *This is Tomorrow*, is a transcendent revision of a masterpiece of yesterday. Hamilton realizes Eliot's recognition of memory as "liberation from the future as well as the past."

—Richard Martin

Bibliography—

Morphet, Richard, ed., *Richard Hamilton*, exhibition catalogue, London 1970.
Guggenheim Museum, *Richard Hamilton*, exhibition catalogue, New York 1973.
Martin, Richard, "Richard Hamilton," in *Arts Magazine* (New York), October 1980.
Hamilton, Richard, *Collected Words 1953–1982*, Stuttgart and London 1982.
Field, Richard S., *Richard Hamilton: Image and Process 1952–1982*, exhibition catalogue, Stuttgart and London 1983.
Livingstone, Marco, *Pop Art: A Continuing History*, New York 1990.
Robbins, David, ed., *The Independent Group: Postwar Britain and the Aesthetics of Plenty*, London and Cambridge, Massachusetts 1990.
Martin, Richard, "A Past as Palpable as the Present: Image and History in the Art of Richard Hamilton," in *Arts Magazine* (New York), October 1985.

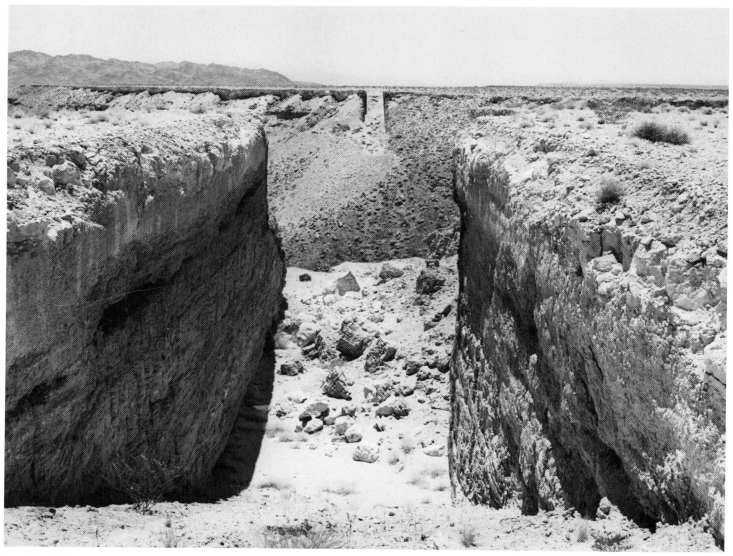

Photo Robert Miller

Michael Heizer (1944–)
Double Negative, Mormon Mesa, near Overton, Nevada, 1969–70
Rhyolite rock and sandstone; 1500 ft. long × 50 ft. deep × 30 ft. wide
Los Angeles, Museum of Contemporary Art

Double Negative is the most radically subversive of the earthworks (also referred to as land art) produced in the great spaces of the Western United States between 1966–76. Two immense excavations, precisely formed on three sides, cut into the rim of a giant mesa. They confront each other as mirror images across their formless fourth sides which merge with the sand and stone of the mesa's escarpment. To reach *Double Negative*, one proceeds from Las Vegas by car over fifty miles toward the Valley of Fire through limitless stretches of high desert called Mormon Mesa, near the Muddy River. Both the boundless spaces and the scale suggest notions of the Romantic sublime, be it the 19th-century American landscape paintings of Alfred Bierstadt, and Frederic Church, or 18th-century essays on the terrible and the sublime by English theoreticians Edmund Burke (1757) or Uvedale Price (1794).

The closest art historical roots of *Double Negative*, however, lie unexpectedly in European sources, in Picasso's subversive little scrap metal and wire *Guitar* of 1912, whose solid forms and negative spaces are simply reversed, confounding our expectations. For *Double Negative* is composed largely of volumes of space, not mass, and like Picasso's *Guitar*, this monumental earthwork reverses our conceptions of, and expectations for, sculpture. Like *Guitar* (and like most of the early pieces of earth art), *Double Negative* was created from a strongly Conceptual basis.

More importantly, the spectacular twin voids of *Double Negative*, its length more than the height of the Empire State Building in New York, is not sculpture to be walked around, but into. Like architecture or landscape design, this sculpture is meant to be experienced from within, like the colossal temple and complexes of Pre-Columbian America or the funerary complexes of the Valley of the Kings in Egypt, all of which Heizer's archaeologist father introduced him to early in his life. And, unlike Picasso's human scaled *Guitar*, *Double Negative*'s materials are not industrially made, but ecologically given.

In association with Robert Smithson, Walter De Maria, and Nancy Holt, Michael Heizer led the much publicized late 1960s artists' revolt against the art world as marketplace, against the art work as product or commodity object. Their revolt was out of the galleries and into domain of the natural world, where Nature itself provided their raw materials. Heizer said in 1969, "The position of art as malleable barter exchange item falters as the cumulative economic structure gluts. The museums and collections are stuffed, the floors are sagging, but the real space exists." Heizer also said, "In the Desert I can find that kind of un-raped peaceful religious space artists have always tried to put into their work." (Detractors' charges of Heizer's rape of the desert's fragile ecological systems began in 1970 when documentation of *Double Negative* was exhibited at the Dwan Gallery in New York, and continue. Heizer protests that his earth-moving practices are as skilful—he comes from a family of several geologists—and relatively inconsequential in the vastness of the landscapes involved.)

Earthworks in general and *Double Negative* in particular, then, have sought to reassert the transcendental nature of the experience of art over and against the economic system which, since the Renaissance, has become its basis. The power of this system was perceived by artists in the early 1960s as threatening to reduce art to mere objects of barter. Hence the de-materialization of art began; and avant-garde artists started working with concepts (as Duchamp admonished), with processes, and performance.

Along with Smithson's *Spiral Jetty* (Great Salt Lake, Utah, 1970), and De Maria's *Lightning Field* (near Quemado, New Mexico, 1974–77) *Double Negative* remains the quintessential earth work, for moving sculpture into what has been termed its "expanded field." These works provide the "classic" or seminal phase of earth art, from which all others continue to derive and/or depart. Each of these monumental works provide the genesis of a new conception of sculpture; each dramatizes the dialectic between the imaginative, organizing intelligence of the artist and Nature's processes. And, since Nature's processes (erosion and entropy) ultimately prevail, these pieces of land art are highly romantic gestures. Unwittingly or not, they become metaphors for humanity's tracings in the sands of time and space.

Paradoxically, these works utilize the perfect, geometric forms (circle, square, rectangle, etc.) of the Minimalist tradition (which dominated sculpture in the mid-1960s) in the virgin arena of the desert's enormous space. The Minimalist's concern with the relationships among simple forms and the spaces they occupy, and with the human body as perceiver of those ambiguous spaces, is also operative in earthworks. The desert is nonetheless an arena which cannot but diminish, as it did the pyramids of Egypt and Mezzo-America, the simple, monumental forms that earth art takes.

On another level, however, in a work like *Double Negative* (where, twenty-one years after its completion, erosion is as yet inconsequential against the sculpture's vastness), the desert itself becomes a metaphor for the vastness of the universe. And *Double Negative*'s transcendence may be that it can operate as a metaphorical image of the *relativity* of all space.

Michael Heizer's art is marked by an abiding concern with a synthesis of polarities, exploring a dialogue between nature and culture. His first temporary works in the desert: motorcycle drawings, dispersals of soil from moving vehicles, trenches, were self-financed. His *Nine Nevada Depressions* of 1969 were commissioned in part by the taxi-cab magnate Robert Scull, and New York gallery dealer Virginia Dwan came to his financial aid in the completion of *Double Negative*. Heizer's rejection of the gallery and museum systems was temporary, for therapeutic purposes. Reflecting a concern in *Double Negative*, he paints non-objective paintings wherein positive and negative spaces are reversible. He currently exhibits monumental sculptural objects at Knoedler and Company and the Whitney Museum of American Art. These can be described as allusions to Paleolithic hand tools. Transcending any reference to particular cultures, they investigate the structures of utilitarian forms as determined by function; and allude to art as technology.

Heizer's life's work, however, began with his concrete, granite and earth *Complex One/City* 110 × 140 × 23½ feet (1972–76) in south central Nevada; the first of six massive projected sculptures as architectural metaphor, the third of which is now under construction. *City* will ultimately be an enclosed precinct, the viewer surrounded by structural allusions to the ceremonial centers of the ancient world, a metaphorical space with visual connections to history and ritual.

Heizer's art provides a dialogue between the world of geological time and humanity's tracings in it. *Double Negative* is the initial statement in that dialogue of metamorphosis.

—Ann Glenn Crowe

Bibliography—

Heizer, Michael, "The Art of Michael Heizer," in *Artforum* (New York), December 1969.
Gruen, John, "Michael Heizer: You Might Say I'm in the Construction Business," in *Artnews* (New York), December 1977.
Felix, Zdenek, and Joosten, Ellen, *Michael Heizer*, exhibition catalogue, Essen and Otterlo 1979.
Massie, Sue, "Timeless Healing at Buffalo Rock," in *Landscape Architecture* (Washington, D.C.), May/June 1985.
Amaya, Mario, "Land Reform: Monuments by Michael Heizer," in *Studio International* (London), no.1009, 1985.
Kertess, Klaus, "Earth Angles," in *Artforum* (New York), February 1986.
Weisang, Myrian, "Unnatural Acts," in *High Performance* (Los Angeles), April 1987.
Beardsley, John, *Earthworks and Beyond*, New York 1989.
Hine, Hank, "Desert Song," in *Artforum* (New York), February 1990.

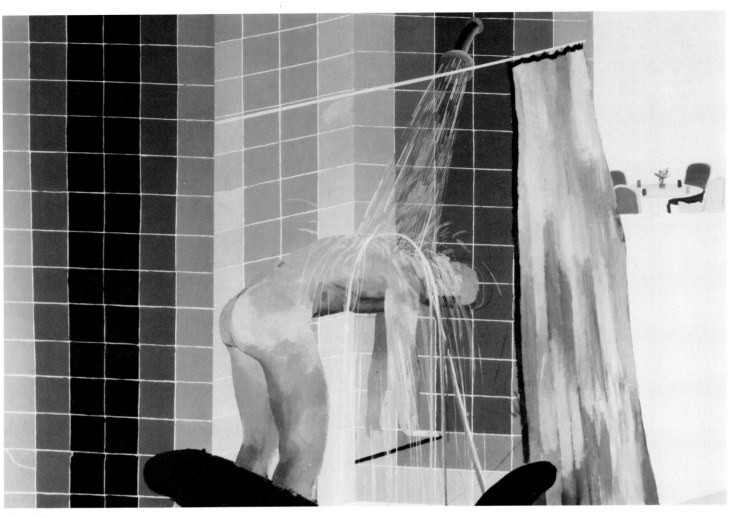

© David Hockney 1964

118

David Hockney (1937–)
Man in Shower in Beverly Hills, 1964
Acrylic on canvas; 167.3 × 167cm.
London, Tate Gallery

The Beverly Hills shower painting of 1964 embraces many of Hockney's passions at that time—the male nude, descending water with its impact on landing, curtains, tiles, patterns, combined with content and form and some narrative. The Renaissance influence frequently seen in his work is here, particularly that of Piero della Francesca.

Certain preconceptions on first viewing in 1981 had to be thrown to the winds. Here was the background figure of the disrobing Jesus in Piero's *Baptism*, but in his recorded conversations with Nikos Stangos in 1975 Hockney states that the figure and tiles in this painting were taken from a photograph supplied by a Los Angeles group specialising in studies of the male nude. However, many years later the Piero painting was one of four Old Masters selected by him at the request of the National Gallery for their exhibition in the series *The Artist's Eye* in 1981. He had previously painted his friend Henry Geldzahler *Looking at Pictures on a Screen* (1977) in which he had copied the chosen paintings in quite beautiful detail and in *My Parents*, of the same year, it appears reflected in a mirror. His irresistible attraction to this particular work is of long standing.

Hockney had little access to illustrated art books until he arrived at the Royal College of Art in 1959. At some point he purchased a postcard of Piero's *Baptism* from the National Gallery which he pinned on the wall of his room in New York and "constantly saw new things." He noticed that "the water being poured doesn't seem still" and wondered at "the marvellous suggestions of movement."

"I would think that anybody who likes painting at all would like a Piero della Francesca"—one of many references to Renaissance painters made by Hockney in 1975. Such strong visual and emotional impact can penetrate the mind and lie dormant for months, years, even decades; it can surface at any time, not always consciously, and, as Hockney has stated, used as "quotes." He speaks of notions borrowed from Fra. Angelico and Piero della Francesca and, later in the '70s, uses artists as various as Ucello and Carpaccio for period accuracy. He is not "lifting"; it is far more a didactic exercise. "I'm still a student, finding out things."

Hockney believes he only began to paint seriously in 1960 which makes the Beverly Hills painting an early work; he was 28. At that age Masaccio was dead; Raphael and Caravaggio each lived a further nine years.

The drawing-out of this painting was begun in Los Angeles early in 1964, but Hockney took it off the stretcher, rolled it up, put it in his car and drove to Iowa where he finished it during the Summer whilst teaching at the State University. The subject is straightforward. Here is a man taking a shower in Beverly Hills where "houses seemed to be full of showers" and "Americans are always taking showers."

The shower theme and all its accoutrement fascinated Hockney in the early '60s. He painted the subject again and again. Not only has he exhausted the subject on paper and canvas, he has written and spoken of it a great deal. In a shower, he says, "the whole body is in view and the variety of shower enclosures offers beautiful things to paint—different types of glass, curtains with drops of water."

A chalk and pencil study of 1963 shows a near nude partially obscured by a straight plain curtain. In *Two Men in a Shower*, there is a patterned curtain, with full and convincing gathers, dominating the centre of the composition, behind which is a distinct outline of a second man. The nude in profile is silhouetted against a pathlike sheet of white, crudely suggesting a flow of water—no hint, as yet, of the spray from the showerhead. This is introduced in *Domestic Scene, Los Angeles* with an attempt to show the power at which the water is ejected. This is a busier work with a beautifully painted floral armchair, a vase of exuberant flowers and a red telephone.

In 1964 Hockney returned to the same theme with a more sophisticated and tactile approach to the nude form. It becomes more sculptural and weighted and the rounded forms contrast to the straight lines of the tiles. The armchair has gone; in its place are austere dining, or office type, chairs and a simple round table; no luxuriant flowers—just a simple posy in a glass.

The Beverly Hills painting presents the nude in bending form thus giving a larger surface on to which the water can bounce. The composition is complex. From the left of the canvas a tiled wall stretches almost a quarter of the way across and two further walls at an angle near 180° form a recessed cubicle enabling the body, in the "wet" area, to be viewed in full, leaving space for additional interest in the "dry" area. The eye is directed, initially, to the buttocks of the sculptural nude and then to the outsize darkest black leaves of the plant lying flat to the canvas in the foreground. The feet, we imagine, to be partially standing in flowing water and Hockney cheats a bit and hides them behind these enormous leaves, but not so hidden that we cannot see, between the leaves, the narrowing of the calves. The luxurious carpet, in a soft lilac, has a distinct border pattern moving diagonally towards the right edge of the canvas; the neatly pleated edge of the curtain, despite slight billowing, falls exactly level with the carpet border. The curtain introduces a new colour, turquoise, and is unpatterned. Water descends from a phallic showerhead with some force, on to the flesh, bouncing off at different angles, dependant upon the skin surface; sharper at the muscular base of the neck, gentler on the flabbier back. In the mid-60's, Hockney made Leonardesque studies of the speed and directions at which water flows from pipes at various angles. The hoops that are formed by the bouncing water create a balance, and it is interesting to see that Hockney had made three outlines of the head, settling for the shorter length and crowning it with a mop of blond hair. There is the content and the form; the narrative is represented by a domestic scene, on a smaller scale, lying back from the central theme—a table and four chairs, each in a different bold colour, indicating that company can be expected after the solitariness of the shower.

Hockney, as most artists do, paints from his life and likes to tell a story. His California paintings tell us many tales. We seem to have come a long way from Piero, but have we? Piero also told us stories, narrative paintings were common in the Middle Ages when literacy was not the norm. In the *Baptism*, Piero gives us, in the background, the events leading up to the central theme; Hockney reverses the form and leaves us in some suspense as to whether anyone will turn up for breakfast.

—Muriel Emanuel

Bibliography—

Glazebrook, Mark, *David Hockney: Paintings, Prints and Drawings 1960–1970*, exhibition catalogue, London 1970.
Hockney, David, *David Hockney by David Hockney*, London 1976.
Geldzahler, Henry, *David Hockney*, London 1976.
Stangos, Nikos, *Pictures by David Hockney*, London 1979.
Livingstone, Marco, *David Hockney*, London and New York 1981.
Wilder, Nicholas, *David Hockney: Paintings of the Early 1960s*, exhibition catalogue, New York 1985.

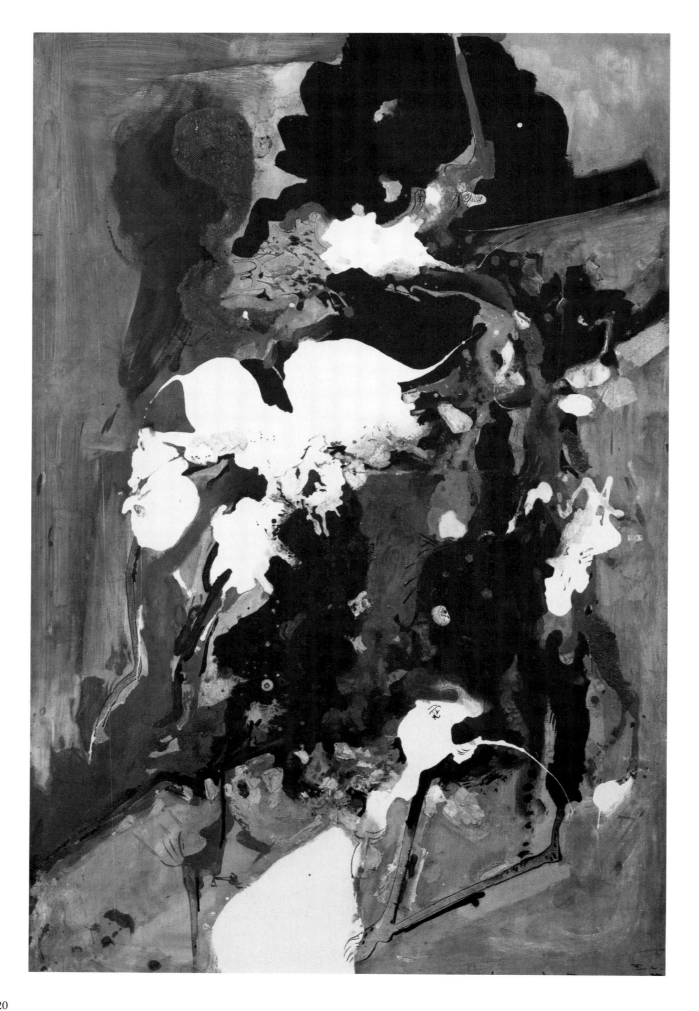

120

Hans Hofmann (1880–1966)
Effervescence, 1944
Oil, india ink, casein and enamel on plywood; 54¾ × 35⅞in. (138.4 × 91.1cm.)
Berkeley, University Art Museum, University of California

Effervescence seems like an uncontrolled explosion of color—red, yellow, green, excited by the closeness of black and white. The material substance of paint—a mixture of oil, india ink, casein and enamel—enhances this impression: the patches of color seem to be thick, intensive and glossy. The artist applied many techniques of painting in this picture. There are broadly impasted patches, paint smudges retaining the traces of brushwork, there are patches freely thrown on canvas as well as randomly formed splotches and spots.

The art of Hofmann, an artist who came to New York from Munich, was based on the experience of German Expressionism as well as French Fauvism and Cubism. Having settled in the United States (1930), Hofmann, however, went beyond that European experience, heading towards a modern conception of the surface: he treated it as a self-contained, autonomous area, in which the drama of paint, color and free movement of an artist's hand takes place. He wanted to attain a rapid visual impact of colors: he called it: "the simultaneous contrast." He applied broad brushwork, beside which random effects of a freely used pigment were arranged. In this way artistic creation was not an effect of a previously devised plan, but self-contained reality, driven by the energy of the very process of painting. Hofmann said: "Pictorial life is not imitated life, it is, on the contrary, a created reality based on the inherent life within every medium of expression. We have only to awaken it."

Effervescence is one of the best known works of the period, when Hofmann was crystallizing the idea of his painting. The picture was made seven years after the famous *Spring*, where the artist for the first time had applied the "dripping" technique. That was the beginning of paintings with very mobile forms, without any clear-cut dominant, made of the flows and bays of color, identified by the artist with his personal impressions. This procedure revolutionized the idea of painting at its very foundations. The painting ceased to refer to the order of the external world; it became a reality of its own.

Hofmann's ideas, promulgated also by the school he founded in New York (1933), exerted a considerable impact on young American painters, since they coincided with the intuitions and quests of the New York-based founders of Abstract Expressionism. They also claimed that creative expression was born in the process of transposing the condition of spirit into the pure, unfigurative form. They also sought the dynamics of movement, space and color. They wanted to create intuitively, putting emphasis on the physical freedom of movement and instinct as creative impulses of art. They saw themselves not "in front" of a canvas, but "within" the process of painting. They made an allowance for the risk of the emergence of random forms, not being an effect of a prior plan. In this way a picture was losing its traditional static and limitation in time; it was becoming a fragment of a broader, never ending process. Hans Hofmann's painting was at the outset of this new road.

The title of *Effervescence* as if matches the painting procedure introduced by Hofmann, signalling its stimulating energy and emotional excitement. However, the title, like many other Hofmann's titles, does have another, concealed connotation. It is associated with the idea, common to all the artists of the New York circle, of looking for an idiom, which would melt personal experience with the innermost, ancient spiritual heritage of the human community. Many theoreticians (Irving Sandler, Sam Hunter, Sidney Tillim, Alfred Neumeyer, Barbara Cavaliere, Dora Vallier and others) underline the presence of a symbolic layer in Abstract Expressionism. This layer surfaced also with Hofmann, in his early pictures, representing also figurative elements. It took shape in the atmosphere of fascination of New York artists with the contents of ancient myths as well as those currents of the philosophy of culture which postulated its unconscious presence in the mentality of contemporary man. Grasped was primarily that motif, which in all the myths and beliefs of the world speaks about elements and chaos as a precondition for the birth of life (form), about dying (that is chaos again) and rebirth. This dynamic and repeated cycle of life is depicted in myths and primitive art with symbolic signs, containing the most essential elements of the model of Genesis. Many of those symbols can be seen in Hofmann's pictures from the years 1940–47 (circle, moon, lightning, bird, woman, eye, hand). The abstract picture *Effervescence* was painted in 1944, that is as if in the middle of this cycle, and this is undoubtedly not without significance for this painting.

Chaos, conceived as "materia prima," is, at the same time, in the terms of the depth psychology (C. G. Jung), a dark, unconscious part of the mind, which until now has remained a store of archetypes, a real source of human behavior. It is at this juncture that the underlayer of myth meets with the ideology of Abstract Expressionism. That is why also abstract pictures of Hofmann's conceal significant meanings. Their form, like in *Effervescence*, as if succumbs to the dynamic contents of these meanings and at the same time creates them.

In this way, the contents deeply anchored in the history of human psyche are sublimated and combined with the personal expression of the individual. The picture appears to be the residuum of concealed meanings and at the same time an incident in the drama of an individual. All that is then melted by the energy of the painting process. All these factors feed each other and form a work of a great force of expression.

Effervescence does not represent the esthetics of a given current, but a melting pot of ideas and a personal attitude of the artist to the painting matter. It is among those works which pave the way for new possibilities, new options and openings of art.

—Alicja Kepinska

Bibliography—

Hofmann, Hans, "The Color Problem in Pure Painting: Its Active Origin," in Wight, Frederic S., *Hans Hofmann*, New York 1957.
Wight, Frederic S., *Hans Hofmann*, exhibition catalogue, Berkeley 1957.
Rosenberg, Harold, "Hans Hofmann: Nature Into Action," in *Art News* (New York), May 1957.
Hunter, Sam, *Hans Hofmann*, New York 1963.
Greenberg, Clement, "The Late Thirties in New York," in *Art and Culture*, Boston 1963.
Sandler, Irving, *The Triumph of American Painting: A History of Abstract Expressionism*, New York and Washington, D.C. 1970.

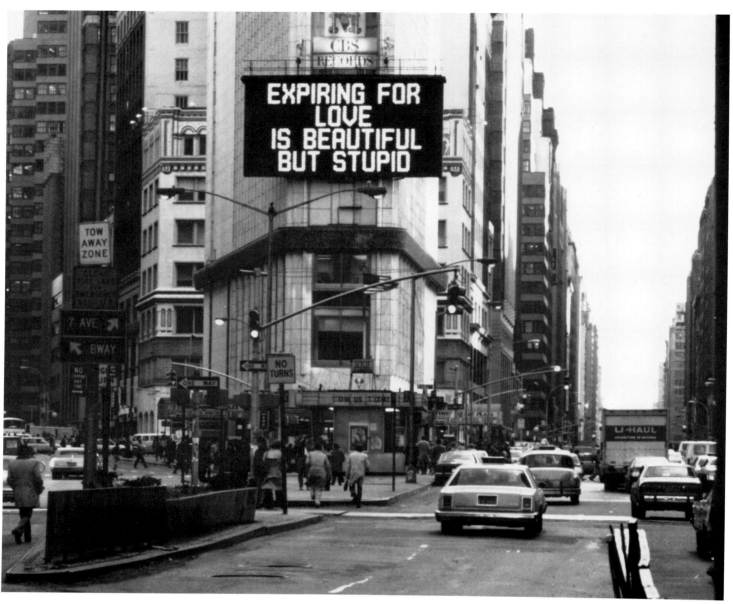

Photo Lisa Kahane, courtesy Barbara Gladstone Gallery, New York

122

Jenny Holzer (1950–)
Expiring for Love is Beautiful but Stupid, 1982
Electric sign board, Times Square, New York City

Jenny Holzer's electronic signboard text *Expiring for Love is Beautiful but Stupid* (1982) is at once both the synthesis of her own highly original language art, and the synthesis of a number of the more interesting impulses in the art of the 'sixties, 'seventies and 'eighties. Most obviously, perhaps, Holzer's use of giant electronic typography transports language art from the relatively restrained domestic dimensions of the page, the postcard, the poster and the print to the dynamic public scale of the advertising billboard. In this respect Holzer dramatically realizes the dreams of Modernists like Marinetti and of early Post-Modernists such as the concrete poets of the 'sixties: the wish to employ language with all the immediacy and impact of commercial and public sign systems.

To take another example, Apollinaire's poem *Zone* (1909), a classic celebration of Modernist Paris, eulogizes "the gracefulness" of a factory street in which Apollinaire identifies "this morning's poetry" in assorted handbills, catalogues and posters. While Apollinaire could sense the poetic energy and vitality of such texts, he never found ways to project his own writings beyond the page and through what one might think of as the "city barrier." At best, manifestos such as *The New Spirits and the Poets* (1918) record Apollinaire's prophetic conviction that poets should "mechanize poetry as the world has been mechanized." Holzer's most singular achievement is to have successfully pursued precisely this ideal and to have identified and popularized highly-charged modes of mechanized language art.

As I have suggested, Holzer's work not only revolutionizes the scale of language art but also synthesizes such contemporary artistic concerns as the wish to create an interactive "public" art outside the gallery system; the wish to deconstruct and deploy influential modes of public language; the wish to compete with the pace and patter of advertising in what one might think of as user-friendly anti-adverts; and the wish to employ new forms of feminist discourse. While Holzer's work resists strict definition in terms of any of these aims, her varied signs and installations frequently offer them extremely satisfying resolution.

Expiring for Love is Beautiful but Stupid is a supremely public work, at the core of the Big Apple. Competing with hedonistic hype for hard and soft drinks, hard and soft porn, and this or that "True Story Best Seller," Holzer's message infiltrates and irritates its surrounding textual context with an element of sound feminist common sense, refuting the romantic delusion of sensual and sentimental self-sacrifice.

Holzer's art might be seen as a kind of ironical ethical advertising. And as Holzer herself admits, the brevity of her messages, and of her readers' potential attention-span, present the "real danger" of oversimplification born of "the popular demand that anything be digestible in five-and-a-half-seconds." Nevertheless, Holzer's public pieces appear to resist this danger by virtue of the simple fact that they are part and parcel of an immense collage of other different texts. If one reads Holzer's signs for five-and-a-half-seconds, one probably does so before and after reading other public signs for similar intervals, and responds to their collective impact, implications and contradictions. In other words, Holzer's public texts function like the beard and moustache addended to the *Mona Lisa* in Marcel Duchamp's *LHOOQ* (1919). Seen in isolation, such signs and images have a limited, independent, meaning. Viewed in context, working in friction *against* their context, they generate a much more powerful, subversive impact.

The presence of internal or external context seems crucial for Holzer's work. Without elements of contextualization her words and phrases appear decorative rather than deconstructive, seductive rather than subversive, and forceless rather than forceful. Her early *Truisms* series (1977–79) derives safety from numbers. Alphabetically listing similar and dissimilar assertions (such as "Everyone's work is equally important" and "Most people are not fit to rule themselves"), Holzer's discrete statements throw one another into relief, as does their specific geographical placement on different New York walls, and such interactive graffiti as the comment "too much shit" scrawled upon a poster pasted up in New York in 1978.

Exibited as gallery installations, Holzer's truisms lack this sense of street-wise context and conflict, and tend to benefit materially—but to suffer conceptually—when left to their own devices. *Venice Installation* (1990), for example, stunningly re-orchestrated truisms upon palatial marble tiles, and as sequences of three-colour text racing down and across elaborate vertical and horizontal series of up to twelve rows of LED signs. All the same, avowals like "any surplus is immoral" appeared strangely out of place in a pavilion reeking of surplus funding from a nation eager to triumph at the Venice Biennale. More prize-wise than street-wise, this installation seemed partially neutralized by its gallery context, evincing more glitter than guts, and more competitiveness than compassion. Holzer's *Venice Installation* worked best where it re-established a sense of autonomous context in a long prosaic meditation upon motherhood, presented partially on a marble slab, and in its entirety, flickering over LED signs. Assimilable in whole and in part, at two speeds, this configuration seemed the most viable of Holzer's "gallery" projects.

—Nicholas Zurbrugg

Bibliography—

Holzer, Jenny, *Abuse of Power Comes as no Surprise: Truisms and Essays*, Halifax, Nova Scotia 1983.
Simon, Joan, ed., *Jenny Holzer: Signs*, Des Moines, Iowa 1986.
Auping, Michel, "Jenny Holzer," in *XLIV Esposizione Internazionale d'Arte: La Biennale di Venezia*, Venice 1990.

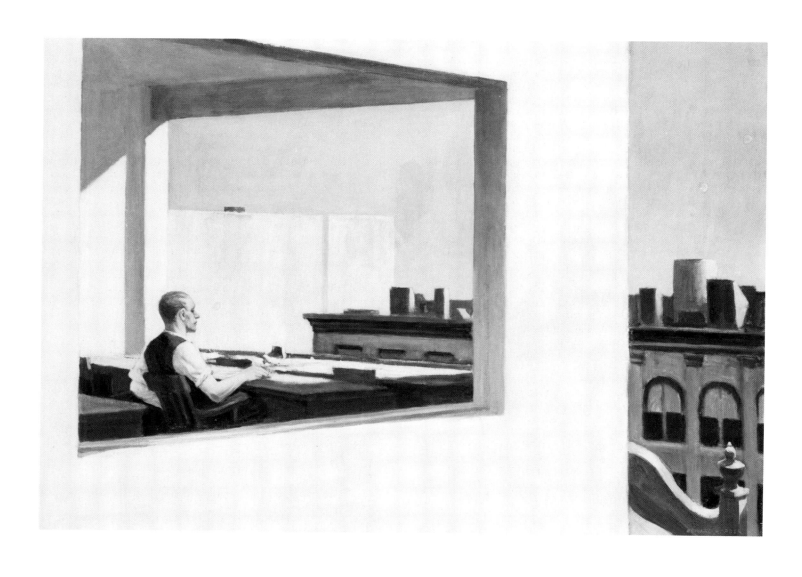

124

Edward Hopper (1882–1967)
Office in a Small City, 1953
Oil on canvas; 28 × 40 in.
New York, Metropolitan Museum of Art

After serving his apprenticeship in various European cities, including Paris, where the experienced the excitement of discovering French art, Edward Hopper became the greatest painter of American life and landscapes, both urban and rural, in the period between the 1920s and the 1950s.

What makes Hopper unique is his highly personal way, so different from that of the avant-gardists of the first half of the century, of depicting features of everyday life in the USA (streets, suburban villas, public places, domestic interiors and exteriors, offices, bars, trains, cinemas, theatres) with sympathy and the skilled application of the techniques of photography and cinema. In this sense, his urban landscapes provide an alternative to conventional American art, namely a fresh approach within the realist preoccupation of US artists in the first half of the century.

Thanks to his extremely sensitive manner of interpreting everyday reality, Hopper is recognised as the incomparable painter of anticipation.

Office in a Small City is one of a series of "offices," an unusual theme in the history of painting, a series which includes some of the most accomplished, original and representative of this great twentieth-century artist. The composition is seen from a vantage point outside the building which takes in the internal architecture of an office several floors up, surrounded by the architecture of nearby buildings. The spectator (and the painter) is suspended in mid-air, his eyes at the same level as those of the figure seated at the desk. Maybe we are in the apartment building opposite? In any case, our position is indeterminate. We might also be perched on scaffolding like a window cleaner.

The man is wearing a waistcoat and his shirtsleeves are rolled up. It is as if he were frozen in the typical attitude of the office worker. Through the large bay window in front of him, he can see the building opposite. But his view of the outside, like the window through which the spectator can see out (between his back and his profile) does not appear to have any opening mechanism. In fact he is in a glass cage, imprisoned in an air-conditioned universe. The sky is blue and sunlight falls on his face and on to the wide surface of desk.

It is the spectator's enigmatic standpoint that makes the painting so striking. Earlier canvases like *Apartment Houses*, painted in 1923, *Night Windows* (1928) and *August in the City* (1945) pose a similar question. Here too, the spectator is positioned "somewhere" mysterious and indefinite. By contrast, in *New York Office*, painted in 1962, the spectator obviously views the picture through a low-angle shot taken from the street.

Hopper operates like a film director who creates a space inhabited by objects and people waiting for something to happen. The artist controls each component of the scene he seeks to portray. Once the decor and the characters are placed, he moves around the set in search of the best way of centring the image.

At the same time, Hopper presents a pictorial method of exploring reality in which his apparent impartiality is counterbalanced by an underlying criticism and commitment. The artist's lucid and committed attitude does not strike the viewer at first glance. But closer examination of these paintings which demand prolonged and careful attention from the spectator, brings to light a hidden dimension, namely an intense social criticism. In each of his compositions, the choice of attitude and expression for each of his human figures, and the particular quality of the light are the main constituents which give rise to the remarkable result.

This observation balanced between distance and involvement, between indifference and emotion, make Hopper's work a vital landmark on the route pursued by international artists of the realist school during the 'thirties and 'forties.

Hopper's paintings are an object lesson in the compromise between the detachment and concern in the face of the loneliness of the human condition.

—Giovanni Joppolo

Bibliography—

Goodrich, Lloyd, *Edward Hopper*, London 1949.
Morse, John, "Edward Hopper: An Interview," in *Art in America* (New York), no. 1, 1960.
Mellow, J. R., *Painter of the City Dialogue*, New York 1971.
Levin, Gail, *Edward Hopper*, New York 1980.

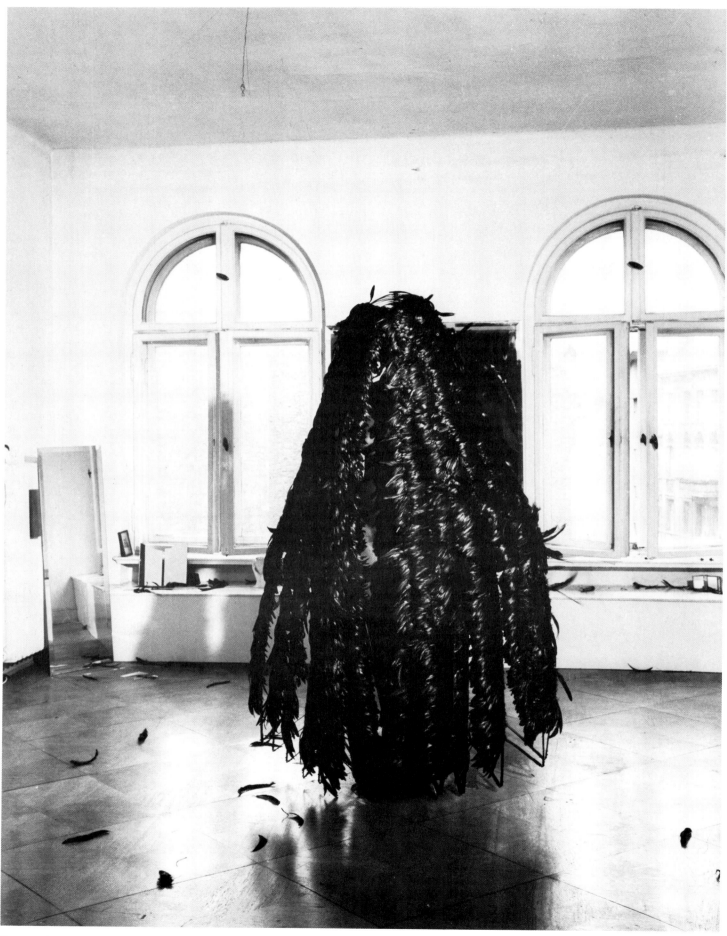

Photo Städtisches Kunstmuseum Bonn

126

Rebecca Horn (1944–)
Paradise Widow, 1975
Performance work and videotape; 30 mins.

Rebecca Horn's *Paradise Widow* is a work in which the artist translated the public nature of performance art into private ritual while using the documentary and potentially intrusive nature of the video camera as a means of private expression. The theme of *Paradise Widow* is the expression of personae through mythic images as internal awareness finds expression in external form. The work has also been referred to in the context of a work called *Widowhood, a Tender Instrument of Torture*.

Horn begins with her naked body in an extension of women's body art as the core of the work. Standing inside an iron framework covered with feathers, the performance is videotaped as it is enacted inside an empty room with no one else present. The videotape is the only means by which the observers, if so they may be termed, become aware of, and a participant in, the actual performance. In this way, the private transformational process of the creative act is made public.

Paradise Widow is constructed of layers of metaphor. At the core is the sense of self and the perception of one's identity, and how that identity is defined. The widow represents self defined as another: the wife who has social meaning in the context of husband and wife. Seen as part of a unit which transcends the individual, the identity ceases when the husband dies and the wife becomes widow.

This theme relates Horn's work with the artistic and literary theme of the transition from one stage of life to another, and the symbolic death and rebirth. The woman's body has been the locus of her social identity, as biological functions use the argument of design to define her social personae. Yet the real origin of her identity has been its use as locus of male desires. Body art thus has significance as the locus of personal and social identity, and it is with her body that Horn must begin as the point of self discovery.

Once the original source of identity is gone, the widow must undergo the pains of death and rebirth in redefining herself in relation to herself and the external world. The framework covered with feathers reflects the image of herself that arises from her new consciousness. The mythical bird replaces her skin as the defining condition of her being. She is no longer known by her body with its socially prescribed meanings. The world can now know her as *Paradise Widow*, a combination of widow signifying death, and paradise signifying a place of painless freedom. Horn becomes transformed into the bird she was within, and she can now see herself as an expression of her inner being, not as an image from someone else.

The publication of the woman's body that confronted society with its prejudices has been taken into privacy where the transformation and realization made possible by body art can take place within the intimacy of a protected environment.

The bird represents an important symbol for Horn. It exists within its multicultural context representing freedom through its ability to fly. One has only to recall the mythical phoenix and its reference to death and rebirth. The bird and its feathers signify the means by which one frees oneself from the limitations of earthly, material existence. While the transformation of the *Paradise Widow* is a totally personal experience, the images of woman's body and mythic bird have a social and cultural context that makes them universal.

This admixture of mythic and symbolic imagery and experience with the social was shared with Joseph Beuys. Both Horn and Beuys were represented by the same gallery in New York City, and Horn had begun her fascination with birds about the time that Beuys had lived with a coyote for several days.

The empty room in which Horn's performance takes place serves also as a metaphor of a cocoon, or egg. It is also analogous to the artist's studio where the ritual of artistic creation takes place. The room provides a safe place in which one can move freely, and act out one's fantasies while undergoing transformation. At the same time, it is like a cage that protects and defines the limits of existence.

Thus, the room itself is only one in the series of layers that enclose and define self, surrounding the self in material body contained in skin, the cage of feathers, and the room. What differentiates it from the artist's studio, and affirms its status as performance art, is that process is form and content. Like all transformations, change takes place internally. It is never directly observed.

The video camera records the performance, and we view the process after the fact. The camera plays a central role in the iconography of the work. The performance is recorded mechanically as the intrusive, voyeuristic eye of the camera stands in for the missing spectator, and electronic visual record replaces human memory. The performance itself is thus not subjected to the transformations effected by subjective memory. It has been documented, and can thus be reproduced endlessly without variation.

In this situation, an irony in the work becomes evident in the use of multiple layers, and the relationship between performance and record. Horn's performance remains personal and private. The metaphorical transformation of the *Paradise Widow* enters a public domain after being experienced privately. Thus the electronic eye becomes a means to protect privacy, at the same time that it makes it accessible to the world. The electronic machine image itself becomes a visual metaphor for experience, reflecting in part Horn's admiration for Marcel Duchamp and his machine esthetics as metaphor for the human body and his interest in psychosexual transformations.

Underlying Horn's *Paradise Widow* is an association with esoteric knowledge traditions of the western world. In Horn's performance work, one finds a synthesis of aspects of Beuys' shamanistic performances with its close ties to Rudolph Steiner's anthroposophical writings, and Duchamp's interests in science and alchemy. Horn's performance thus takes on the aspect of ritual shamanist practices as a way mediating one's existence with the world. And by making the ritual public, it becomes a means of socialization as well.

With the videotaped record, the illusion becomes real, and the metaphor becomes the reality. The layer of the room and camera that protects and makes possible are dissolved as performer and observer are brought into visual contact with each other through the medium of video.

—Karl F. Volkmar

Bibliography—

Horn, Rebecca, *Dialogo della Vedova Paradisiaca*, Genoa 1976.
Haberl, Horst Gerhard, *Rebecca Horn*, exhibition catalogue, Graz 1976.
Haenlein, Carl-Albrecht, ed., *Rebecca Horn: Der Eintanzer*, exhibition catalogue, Hannover 1978.

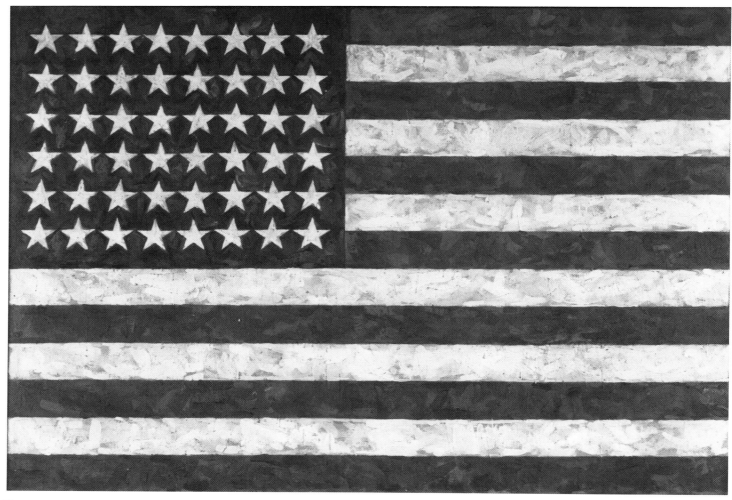

Photo courtesy Leo Castelli, New York © DACS 1991

Jasper Johns (1930–)
Flag, 1958
Encaustic on canvas; $41\frac{1}{2} \times 60\frac{3}{4}$in.
New York, Private Collection

Throughout his career Jasper Johns has used the image of the American flag in diverse media including drawing, printmaking, sculpture and, of course, painting. In his 1958 one-man exhibition at the Leo Castelli Gallery, Johns' portrayals of flags, targets and numbers astonished the New York art world by seeming to appear out of nowhere.

Particularly disturbing was *Flag* (1955) which Johns started in 1954 and completed the following year. At the time of his Castelli exhibition, *Flag* seemed an affront to the aesthetic status quo since it simulated a banal design that was not even invented by the artist. The superficial-looking composition also outraged many because the composition repeated in encaustic on canvas the impersonal appearance of an actual American flag whose design could easily be replicated by someone without first requiring any special skill or talent. Worse yet, or so it appeared at the time, this visual affront in an art gallery seemed no less than a "neo-Dada" gesture, inviting a pointless comparison with Duchamp's earlier "ready-mades," which included such commonplace objects as a urinal or snow shovel which similarly were presented as works of art. According to Johns, the inspiration for *Flag* (1955) came spontaneously when he dreamed that he was painting a large flag. Johns' enigmatic reference to a dream as the source for his *Flag* inspiration is consistent with much of his art which similarly obscures his intentions and leaves the viewer to confront this artist's often enigmatic creations as visual riddles.

Especially disturbing in 1958 was the imprecise role of Johns' encaustic picture which did not fit comfortably in either the category of "painting" or that of "flag." Also confusing was Johns' double emphasis on both the two-dimensional pattern and the three-dimensional object quality of the picture. The physicality of the painting was emphasized by Johns' dividing the composition into three distinct sections, each using a separate rectangular canvas. One panel depicted the stars and their blue background. The adjoining canvas to the right presented red and white parallel stripes. The longer canvas placed beneath the two smaller ones completed the stripes of the "flag."

No less jarring than the viewer's inability to precisely categorize *Flag* as either a painting or a flag was Johns' startling appropriation of a pre-existing composition. This act was regarded as an arrogant rejection of the validity of Abstract Expressionism, and caused a sensation in the art world. Indeed, the creation of *Flag* (1955) was regarded by many as a studied rejection of the Abstract Expressionists' belief that emotion and the very act of creation could be portrayed in an abstract painting. Whereas Abstract Expressionism invited the viewer to interpret its paintings in terms of the personality of their creators, Johns' *Flag* shifted the viewer's focus away from viewing a work of art as a record of an artist's singular genius. Instead, *Flag* required the observer to see this particular work of art as an object which appeared to be remarkably detached from the emotions of its creator.

To emphasize the impersonal appearance of the ready-made composition of *Flag* (1955), Johns covered the entire surface of the design with brushstrokes of equal intensity. This overall textural uniformity not only could be regarded as a backward glance at the paintings of Cezanne but additionally could be seen as an abandonment, and therefore a sharp criticism of, the earlier expressive brushwork of deKooning and other Abstract Expressionists. Instead of exploring the artist's subjectivity, Johns' aesthetically disruptive *Flag*, as well as his numbers and targets, abandoned the introspective qualities of Abstract Expressionism in favor of an extroverted, impersonal-looking imagery which seemed, at least in comparison with Abstract Expressionism, to be an uncompromisingly objective presentation of the most banal subject matter imaginable.

Evidently, Johns was not dissuaded from creating additional examples of what many considered to be a visual travesty. By 1975 Roberta Bernstein was able to refer to approximately twenty-five known *Flag* paintings created by Johns through 1974 including

five variations in the series: (1) red, white and blue single flags; (2) monochromatic single flags generally in white or gray; (3) single flags against expansive backgrounds and presented in compositions where the shape of the canvas differs from that of the flag; (4) multiple flags where a flag image is repeated two or three times and (5) backward and vertical flags.

Johns' red, white and blue *Flag* paintings have generally been smaller than the first *Flag* (1955) and subsequent versions have been executed in different materials. However, there is one notable exception, *Flag* (1958) which is the same size as the first *Flag*. Nevertheless, the 1958 version does differ significantly from the first version in a number of respects, not the least of which is its employing a single canvas rather than three joined together as in the 1955 version. In addition, while both versions of *Flag* are executed in encaustic, the 1958 version employs no collage, has a smoother texture, incorporates more regularly applied brushstrokes and presents more luminous color than does the 1955 example.

In the 1955 *Flag* painting the artist's employment of separate canvases in a single composition seemed to state, if somewhat ambiguously, that the three attached canvases depicting a flag comprised a painted construction which only feigned to be a flag, much like the illusionism of traditional painting which only simulates but does not actually replicate three-dimensionality. The identity of the later 1958 *Flag* is more problematical due to its having a single canvas, which results in its greater visual and physical resemblance to an actual flag. This enhanced verisimilitude further blurs the distinction between the function of *Flag* (1958) as a picture and its possible role as an actual flag. It is in this realm of mind-numbing aesthetic ambiguity that Johns has insistently chosen to explore throughout his *oeuvre*, explaining in 1969: "Most of my thoughts involve impurities. . . . I think it is a form of play, or a form of exercise, and it's in part mental and in part visual (and God knows what that is) but that's one of the things we like about the visual arts. The terms in which we are accustomed to thinking are adulterated or abused. Or, a term that we're not used to using or which we have not used in our experience becomes very clear. Or, what is explicit suddenly isn't. We like the novelty of giving up what we know, and we like the novelty of coming to know something we did not know. Otherwise, we would just hold on to what we have, and that's not very interesting."

Because of its almost perverse ambiguity, *Flag* (1958) may be regarded as providing the key to unlocking Jasper Johns' aesthetic, even when we consider his later works which, in relation to the impersonal, almost anonymous appearance of *Flag* (1958), explore more personal and subjective imagery. In addition to its exploration of ambiguity, *Flag* (1958) reflects powerfully the artist's intellect rather than his emotions by scrupulously avoiding any specific or subjective meaning, either of which would permit us to be distracted by the artist's individuality. Instead, as Johns stated in 1974, "I'm interested in things which suggest the world rather than suggest the [artist's] personality."

Rather than reminding us of its creator, *Flag* (1955) presents a ready-made, anonymous-looking composition whose aesthetic meaning is frustratingly equivocal, even in relation to its 1955 predecessor. Indeed, future generations may well regard Jasper Johns as the master of indeterminacy and detachment while his *Flag* paintings of 1955 and 1958 will no doubt be considered visual manifestos of aesthetic ambiguity.

—Joseph Young

Bibliography—

Solomon, Alan R., *Jasper Johns*, New York 1964.
Young, Joseph E., "Jasper Johns: An Appraisal," in *Art International* (Lugano), September 1969.
Sylvester, David, *Jasper Johns: Drawings*, London and New York 1974.
Bernstein, Roberta, *Jasper Johns' Paintings and Sculptures 1954–1974: The Changing Focus of the Eye*, Ann Arbor 1975, 1985.

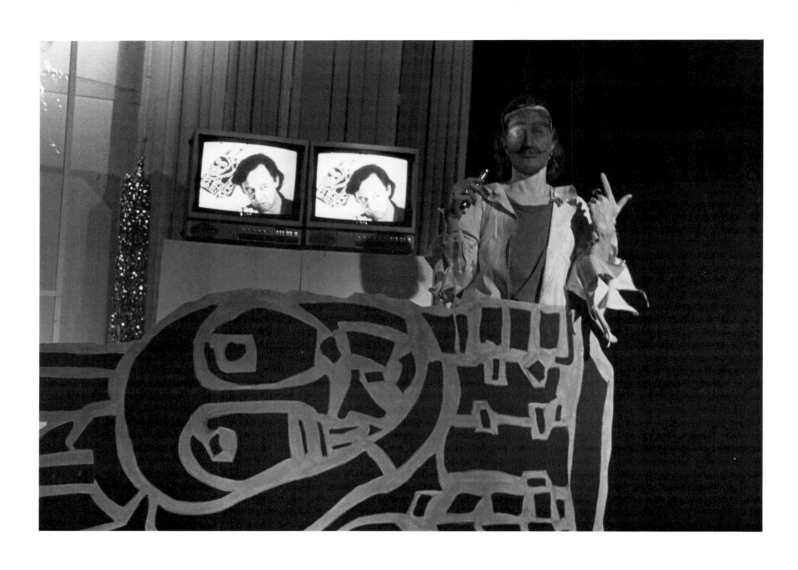

Joan Jonas (1936–)
He Saw Her Burning, 1982–83
performance work

Joan Jonas' *He Saw Her Burning* is a multi-media performance work that synthesizes many different trends in both her own work and performance art in general. Elements of painting, sculpture, dance, video, and music are combined with ideas borrowed from social rituals and the toys of children to create the work. In an animated collage of images and actions, the artist offers an experience that simulates her understanding of the world.

The general idea of performance begins with the Italian Futurists of the early twentieth century, and their interest in exploring the dynamics of artist-audience relationships. But a more direct connection can be drawn from Black Mountain College and the ideas of Joseph Albers, John Cage, and Merce Cunningham. Thus the ideas of the Bauhaus as translated by Albers became a search for an art about means rather than end products, and an emphasis on the performance or process that brings art into being.

The collage nature of Jonas' performance has roots in the early twentieth-century developments of Cubism, and the irrational juxtaposition of unrelated objects of Surrealism. This idea was shared in part with John Cage and his arrangements according to chance, structured, if ever, after the fact.

Jonas' selection of two contemporary news reports reflects the dominance of chance in events of everyday life. *He Saw Her Burning* is based on the stories of an American soldier who went berserk inside a stolen tank, and a report of spontaneous human combustion in which a woman seated in a car suddenly bursts into flame. These two accounts represent the irrationality and unpredictability of life. The seemingly meaningless and inexplicable is more common than one would like to admit, and life seems to be organized on the same principle of a Dada arrangement according to chance.

The appropriation of ideas and images from the public media owes some debt to Pop Art, but also was absorbed by Jonas through her experience with the Judson Dance Group, and its connections with Black Mountain College ideas and the efforts of Merce Cunningham. Incorporating movements and sounds from the everyday world of human actions was the significant concept. Jonas had not been a trained, or even skilled, singer or dancer, but that was not a deterrent. Technical perfection was not essential to expressive realization.

Interaction with the audience provided a cathartic and energizing experience greater than that realized through the traditional artistic training which Jonas had received. The audience was essential to the performance, and Jonas work is as much concerned with the relationship of artist to audience as she is with that between audience to artist. The vicarious pleasure resulting from her own desire to keep the audience at a distance was in conflict with the sense of pleasure derived from their attention and approval, and this emotional edge replaced the proscenium of traditional theater.

With the artist as performer, Jonas manipulates the media like a magician at a stage show, or a shaman performing a ritual. The performance emulates the healing power of the ritual, whose form may be meaningless to an observer. The apparent lack of meaning iterates the indeterminacy of chance arrangements, as well as the idea that meaning lies within the observer, rather than in the events themselves.

The performance is intertwined with two video presentations of an actress and actor reading the two stories of the soldier and the tank, and the spontaneous combustion of the woman, in an emotionless monotone. Like the profanation of human pain and suffering observed by Andy Warhol, the tapes provide a neutral backdrop of facts and descriptions. The depersonalization of the tragic by contemporary news media is another example of borrowing from the everyday world.

The cardboard car and truck rolled back and forth by Jonas and an assistant are like children's toys. Toys are a medium for the acting out of children's fantasies and anxieties. Jonas' appropriation of these images is also the adoption of their psycho-social function. The translation of cultural rituals into art signifies an awareness of the omnipresence of ritual activity, and its importance as a socializing activity.

The performance becomes a theater or laboratory for actions and symbols which mediate the artist's self with the external world. Jonas incorporates objects which are not usually regarded as having ritual significance or symbolic value. The two golf clubs with which she dances are recognized as the cultural emblems they are. Yet the effect on the observer can be startling because of the initial interpretation of them as superficial elements.

Selection of images such as these emphasizes the apparent nonexistence of an underlying narrative or literal content. The irrational combination of disparate objects and acts demands that the observer accept the performance as it is given. Or to give a meaning. The spectator thus becomes a participant in the completion of the work. One is never sure whether the meaning ascribed to it is the one the artist intended. Many of the objects take on a value because they seem to represent some previously-unknown collective cultural unconscious.

A linguistic analysis during the performance of the word "berserk" emphasizes the relativity of meaning. By attempting to reductively analyze the performance into its constituent elements in order to understand, one loses the whole sense of the word as word. Like Polyani's clock, once it has been totally described in scientific terms, one is still left with the question of how the idea of the clock arose. The idea of a clock exists for reasons representing a process different from its physical description.

He Saw Her Burning happened as idea, and was expressed in the form it was through the artist's unconscious selection process. Because the forms were developed through the subjective logic of feeling, the work can only be fully understood on a similar intuitive basis. The internal logical consistency of the work determines its effectiveness, and such subjective determinations of truth suggest that interpretations are personal.

The performance may be as inexplicable or unpredictable as the soldier going mad in a tank, or a woman bursting into fire because of spontaneous combustion. But it is just as real. The events occur. One only has to find the explanation, and the lack of resolution leads to more complete participation.

—Karl F. Volkmar

Bibliography—

Lippard, Lucy R., "Art and Politics: questions on a politicized performance art," in *Art in America* (New York), October 1984.
Wooster, Ann-Sargent, "Video and Ritual," in *Afterimage* (Rochester, New York), February 1985.
La Palma, Marina, "Video Verging on Television," in *Artweek* (Oakland), 6 April 1985.
Torphy, Will, "Complicating the Issues," in *Artweek* (Oakland), 29 March 1986.
Wooster, Ann-Sargent, "Video Art: Expanded Forms," in *High Performance* (Los Angeles), Fall 1988.

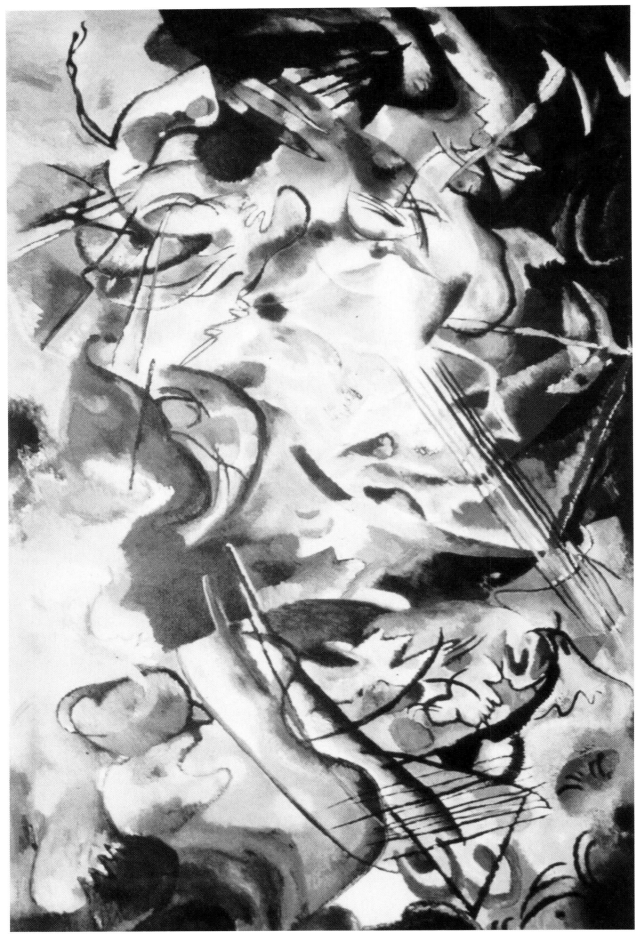

© ADAGP, Paris and DACS, London 1991

132

Vasily Kandinsky (1866–1944)
Composition VI, 1913
Oil on canvas; 195 × 300cm.
Leningrad, Hermitage Museum

Composition VI is a decisive stage in the abstract meditation undertaken by Kandinsky during the 1910s. Today it is possible to state that this painting, among all those produced by the artist during the second decade of the century, remains as the most intense moment of an abstract adventure in which forms evolve in an incomparable freedom.

The lynch-pin of Kandinsky's oeuvre is formed by the first abstract watercolour of 1910 until the artist returned to Germany at the request of the Bauhaus, and the most beautiful pictorial results are found in Soviet museums. This period lasting from 1910 until 1922 is without doubt the most singular, and anticipates all that was to become abstract expressionism, the painting of gesture in the post-war years. But during the years in which Kandinsky accomplished this fundamental break, international abstraction resolutely defined itself on the side of a geometric universe, constructed and cold, whilst the artist was evolving in a lyricism in which the plenitude of interior vibration triumphed. Kandinsky's first abstract period was therefore not influential and remained a dead letter throughout the whole of the first half of the century. In fact, this work was marginal even in its own time. It had no hold on the formal revolutions or the historic turmoils of this decade, which was nevertheless rich in artistic and political upheavals. The year 1913, during which Kandinsky produced his *Composition VI*, is indisputably an exceptional year for artistic events. It is the year of the *Manifesto of the Music Hall* by Filippo Tommaso Marinetti, the year of the first "ready-made" by Marcel Duchamp (the *Bicycle Wheel*), the year of the large exhibition in New York of the Armory Show, the year of the suprematist and constructivist premises in Russia, the year which precedes World War I.

The theme of the flood, which is the point of departure for Kandinsky in this *Composition VI*, might lead us to think that this work is a premonition of the world conflict; and yet, reading the commentary by the artist, the unrest of the war appears to be very distant. In a text of exemplary sharpness, in which he analyses his own painting and his "inner tension" at the moment of accomplishing the work, Kandinsky wrote in 1913: "Great destruction, through an objective effect, is also a song of praise, which lives fully in the isolation of the sonorousness, like a Hymn at the new creation which follows destruction." Elsewhere, Kandinsky precisely states that it is not a question of him arriving at the "exterior expression" of the flood, but rather at the expression of the *word* "flood" in as much as an "inner resonance." The artist takes absolutely no account of the appearance of exterior reality (that of the flood or the war). The shapes and colours engaged here express spiritual and emotive meanings which are at the very root of the creation of the work, and which the artist wishes to communicate to the spectator by a form of communication which is that of "inner resonance," that is, rising above the language of visual appearances and exterior representations.

In the very precise description which he has given us about the duration of the gestation of the work, Kandinsky tells us at length about the complexity of the means employed after the conception and then the realisation of the work. He declares that he carried this painting within himself for a year and a half before having started the first preparatory sketches. When he finally felt ready, animated, as he says himself, by "a peaceful inner tension," he proceeded to "throw large masses onto the canvas," in order to then balance the principal centres, the secondary centres and the four sides of the painting in order to end at "this infinite Living, this incommensurable Feeling of a well painted painting."

Kandinsky knew himself how to express this indefinable place of creation where the uncontrolled and the controlled parts skirt each other, without it being possible to know where one starts and the other ends in this infinitely complex process which is the gestation of a plastic work.

—Giovanni Joppolo

Bibliography—

Kandinsky, Vasily, *Uber das Geistige in der Kunst*, Munich 1912.
Groyhmann, Will, *Wassily Kandinsky: Life and Work*, New York 1958.
Read, Herbert, *Kandinsky, 1866–1944*, London 1959.
Overy Paul, *Kandinsky: The Language of the Eye*, London 1969.
Rothen, Hans K., and Benjamin, Jean K., *Kandinsky*, London 1979.
Bowlt, John E., and Washton Lane, Rose-Carol, eds., *The Life of Wassily Kandinsky in Russian Art*, Newtonville, Massachusetts 1980.
Derouet, Christian, and Boissel, Jessica, eds., *Kandinsky*, exhibition catalogue, Paris 1984.

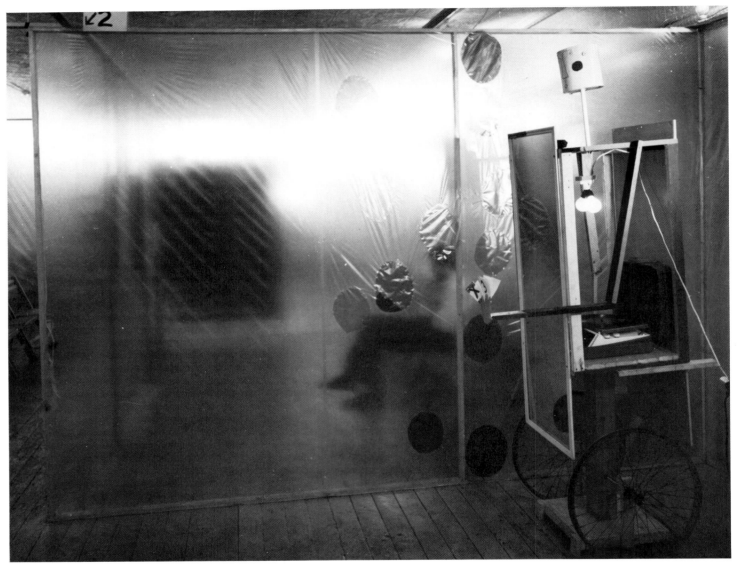

Photo Scott Hyde

Allan Kaprow (1927–)
18 Happenings in 6 Parts, Reuben Gallery, New York, 6–10 October 1959
Happening

In 1959, Allan Kaprow, a young art historian from Rutgers University, published an outline for an artistic event that he labelled a "happening"; and later in that same year he organized a public showing of *18 Happenings in 6 Parts* at the Reuben Gallery in New York. The term "happening" soon came to be the name given to an artistic event in which improvisation and chance played a major role. The idea was that participants, through sensuous, physical involvement, rather than through intellectual criticism and appreciation, would awaken in themselves a whole new dimension of nonintellectual nonverbal communication values—human values that were missing in contemporary society. This new kind of art was a mixture of theatre and collage art of the studio, and the artistic events included much literal reality organized and chosen from the realm of popular culture. Thus, a kind of environment was created into which participants were led, exposing them to sights, sounds, time duration, gestures, sensations, and smells that would awaken their sensibilities to the everyday world around them.

Earlier in the century, during the development of the Dadaist movement, the idea of the "readymade" had come into art, whereby objects and artifacts from daily life such as baby carriages, machine parts, crockery, and tools, when exhibited with a signature, suddenly became art. Marcel Duchamp (1887–1968) had been a leader in this movement which then merged with the many facets or realities of an object analysed by cubism. Thus real or "readymade" objects were cross-cut with paint, cut-out shapes, collage pieces, newsprint, photos, and textural shapes. These concepts culminated in the Pop Art phenomenon of the late 1950s and early 1960s with its sources in the advertising art of the urban scene. One movement within this Pop Art development was the concentration on impermanence and time duration, a concept that came from the Impressionists who had attempted in the late nineteenth century to capture a moment in nature rather than the permanent look of a scene. Thus the concept of the happening is that of the Pop Art assemblage or environment limited in time and involving participants, a situation in which the artist and the viewer both actively participate, and no-one is left outside just looking at the experience. In these events the line between art and life is kept fluid, and the themes of the experience are from life rather than from art. A happening usually takes place over fairly widely spaced areas with participants shifting from one locale to another; time should be variable and discontinuous; the event should be performed or presented only once; and there should be no audience other than the participants. Thus, a happening is akin to an assemblage, but is a collage of events rather than a static "thing" or environment.

Allan Kaprow was born in New Jersey, educated at New York University, did advanced work in painting at the Hans Hoffman School of Fine Arts, and took a Masters degree in art history at Columbia University. He worked with the avant-garde composer, John Cage, at the New School for Social Research, and in the late 1950s was a young professor of art history at Rutgers University. It was at this time, in his connection with the Reuben Gallery of New York City, that he first began his work on performances or artistic events that would come to be called "happenings." Such events had a certain physical crudeness and an amateur atmosphere due to financial limitations, the use of junk as a great part of the environment, and a strong desire for immediacy and spontaneity of effect. The character of the "scripts" was very nonverbal, with words used only for their associative and symbolic values.

18 Happenings in 6 Parts took place at the Reuben Gallery in New York on October 4, 6, 7, 8, and 9 of 1959 and consisted, as the title suggests, of 18 events divided into 6 parts, all taking place both sequentially and simultaneously in varied compartments. Kaprow has said he was indebted to the theatrical theorist, Antonin Artaud, who believed in physical action and language that were below the level of reason, acting upon the human psyche as half-gesture and half-sound. Kaprow also felt that his happening should occur on four levels: (1) a physical, tangible sense of being for the participants; (2) an involvement with fantasies based in real life; (3) an organized structure of events; and (4) meaning through symbols working on the senses.

In the October event, the floor of the gallery was divided into three transparent rooms with painted bands on the floor; participants were seated in fourteen groupings of chairs facing different ways; some were to be heavily dressed, some nude, and different actions were given to different people (for example, one painted, another lit matches, one jumped up and down). The participants changed seats according to the numbers on their tickets, there were slides and films projected on screens, groups of words were spoken by different groups at different times, and there was dissonant musical accompaniment and many light changes during the process of the event.

From the program one learns that "permanence" is divided into six parts, each part containing 3 happenings which occur at once in the three rooms. There were six participants from the gallery plus the visitors in the chairs. All actions were supposed to be carried out without emotion in a stiff, methodical movement, and the actions of the participants were carefully rehearsed.

Thus a new era was born in which the boundaries of art and theatre were blurred and disappeared, and out of the Pop Art development of the happening came an entire new mode of artistic-theatrical expression known as performance art.

—Douglas A. Russell

Bibliography—

Livingston, J. H., "Mr. Kaprow's 18 Happenings," in *Village Voice* (New York), 7 October 1959.
Meyer, A. J., "Happening at Reuben Gallery," in *Art News* (New York), November 1959.
Kirby, Michael, *Happenings*, New York 1965.
Hansen, Al, *A Primer of Happenings and Space/Time Art*, New York 1965.
Kaprow, Allan, *Assemblage, Environments and Happenings*, New York 1966.
Kostelanetz, Richard, *The Theatre of Mixed Means*, New York 1968, London 1970.

135

Ellsworth Kelly (1923–)
Red, Blue, Green, 1963–64
Oil on canvas; 73 × 100 in. (185.4 × 254 cm.)
New York, Whitney Museum of American Art

Among the artists identified with hard edge painting, Ellsworth Kelly was probably the first to discover both the power of pure undetailed color surface and the shaped canvas. In addressing the themes of "Fragmentation and the Single Form" in modern art in an exhibition Kelly curated on June 15–September 4, 1990 at the Museum of Modern Art New York Kelly constructed a highly personal artistic genealogy for his own work, including such seemingly logical choices as Kasimir Malevich, Piet Mondrian, Hans Arp, the Cubist work of Braque and Picasso and Matisse. His emphasis on planes floating in space has been present from his earliest work as have radically cropped and abstracted forms. But, when his career began in the early 'fifties only some of the precedents for his unique vision with its blend of the abstract and the real were known to him and the general public. Generally, he felt alone and out of step with the times. That aloneness would vanish as Kelly became one of the leaders of Minimal painting in the 'sixties.

Kelly was born in 1923 in Newburgh, New York. E. C. Goossens in his 1973 monograph on Kelly suggests that his earliest interest in the kind of color problems that became Kelly's signature style came from his early training as a bird-watcher saying, "It is worth speculating that close acquaintance with the black-throated blue warbler and the red start and other two- and three-colored birds is traceable in the two- and three-color painting Kelly is best known for . . ." After briefly studying art at Pratt, Kelly joined the Army's 603rd Engineer's Camouflage Battalion during World War II. The Battalion was composed mainly of artists from New York and Philadelphia. Kelly was put to work making silkscreen posters of a short visual course on concealment techniques teaching: Texture, Color, Blending, Shadow and Shape.

After the Army, Kelly studied at the Boston Museum School for two years and then returned to Paris, an art mecca he had encountered briefly during the war. The G.I. Bill let him enrol at the *Academie Des Beaux Arts*. Most of his study was outside the classroom, where he often went and sketched the art and architecture he had studied in art history classes. In 1949 a friend introduced him to Surrealist Automatism—drawing from the unconscious—and a year later he began to use chance. He began to make a record of the patterns of stains and shadows, openings in walls, doorways and windows, and chimneys on the outside of buildings. In 1950 he met Hans Arp, an early user of chance, and visited him in his studio in Meudon. His drawings began to change as he realized the profound implications of chance as a means of understanding our surrounding visual world. Chance was not just a device to construct a painting in the studio. More profoundly, he realized that the idea of understanding the world in terms of chance, how things fall, our shifting angle of vision as we walk through the world, opened up greater possibilities for images than traditional art. He began to make black and white brush-and-ink drawings of everything but people. He would cut them up and collage them together to create new linear patterns. Sometimes the collages became the basis of paintings or panel constructions. When he began painting in Sanary in the South of France, he was confronted by a landscape that forced him to use color. Again he focused on architectural details, but here the buildings were often white and the doors and window shutters were floating rectangles of color. Always interested by architecture, a visit to Le Corbusier's *Habitation* in Marseilles while it was still under construction reinforced his interest in multi-colored grids.

His six years in France gave him his basic visual vocabulary. In 1984 Kelly recalls, "It was in the period from 1949 to 1954, when I lived in Paris, that I first achieved the separation of form and ground in a series of joined-panel paintings. The canvas panels were painted solid colors with no incident, lines, marks, brushstrokes or depicted shapes; the joined panels became a form, and thereby transferred the ground from the surface of the canvas to

the wall. The result was a painting whose interest is not only in itself, but also in its relationship to the things outside it."

Kelly's decision to return to America in 1954 was partially the result of picking up a copy of *Art News* in the Rue de Rivoli that featured a review of Ad Reinhardt's work. The similarities he saw between Reinhardt's work and his own convinced him America would finally welcome his work but that was not to be the case. America was still in the spell of Abstract Expressionism. Although Barnett Newman, Mark Rothko and Ad Reinhardt were all using geometry in their work, Rothko was working with the softer, atmospheric color fields and Newman's "Zips" the straight lines that divided his canvases vertically at times had soft edges and were always a statement about a spiritual condition. Reinhardt's work with its often dark squares was laden with a brooding moodiness and complexity that contrasted sharply with the profound simplicity of Kelly's work. Kelly's work was "real" in a way none of the Abstract Expressionists were. At first, the shock of being in New York affected his ability to work, but gradually he began to draw specific things again—changing shadows on a book while he was riding a bus, a curving wire, the shifting effects of the world framed by his studio windows.

Many of Kelly's paintings juxtapose two or more panels in different colors. Kelly's paintings of multiple colors usually involve monochromatic equal-sized panels in which each panel is a single color. In *Red Blue Green* he does something unusual in several ways. Instead of basing his painting on a fragment, a distillation of a corner of the universe, it was made at a time when he more or less arbitrarily selected shapes. He had been concentrating on the square and the ovoid. The composition is the result of cropping overlays placed over these two shapes. An inverted apple green "T" uneasily holds a blue ovoid and a red square. But, the composition is never static. The "T" never remains a frame. The red and blue shapes war with it and try to escape. Alternatively, they can be read as behind, parallel or in front of the green shape. The blue shape seems to cut into the green one. Some of this instability is unexpected. Red and green are complementary colors, and the point where they touch might be expected to vibrate. Green is made of blue and should peacefully co-exist with green but it doesn't.

Throughout his career Kelly has favored complicated systems, streamlined and simplified into two or three colors. He then sets up a dialogue between contrasting and clashing colors. As he shows here, he creates harmony out of discord as he creates a union of opposites. Usually, Kelly's multiple color paintings involve equal-sized panels. This avoids the problem of creating an illusionistic landscape or figure space with a foreground, middleground and background. Here, he takes the risk of combining different colored shapes on the same surface. Scale contributes to the anti-illusionism of this potentially illusionistic painting. The painting is an immense seven feet by almost twelve feet and what might have been precious, jewel-like and ambiguous on a small scale takes on a greater directness when each piece of Kelly's puzzle is large enough to assure its own identity.

—Ann-Sargent Wooster

Bibliography—

Sidney Janis Gallery, *An Exhibition of Recent Paintings by Ellsworth Kelly*, catalogue, New York 1965.
Waldman, Diane, *Ellsworth Kelly: Drawings, Collages and Prints*, Greenwich, Connecticut 1971.
Coplans, John, *Ellsworth Kelly*, New York 1972.
Goossen, E. C., *Ellsworth Kelly*, New York 1973.
Baker, Elizabeth C., *Ellsworth Kelly: Recent Paintings and Sculptures*, exhibition catalogue, New York 1979.
Rose, Barbara, *Ellsworth Kelly: Paintings and Sculpture 1963–1979*, exhibition catalogue, Amsterdam 1979.
Axsom, Richard H., ed., *The Prints of Ellsworth Kelly: A Catalogue Raisonne, 1949–1985*, New York 1987.

Anselm Kiefer(1945–)
Father, Son and Holy Ghost, 1973
Oil on burlap; 288 × 189cm.
Eindhoven, Stedelijk Van Abbemuseum (permanent loan from Sanders Collection, Amsterdam)

In 1971 Anselm Kiefer moved to the remote village of Hornbach, in the region of Oden Forest, in what was then West Germany. The trees of the forest and the space of Kiefer's attic-studio began to appear in his work. Kiefer used, and continues to use, spaces symbolically and poetically rather than literally. The forest can be seen as a place of reflection and revelation; a place of solitude imbued with the companionship of living, breathing, ever-extending, ranks of trees. Within the context of Kiefer's oeuvre, in which he continually rakes over the ashes of Germany's history and cultural heritage, the forest can be seen as a reference to the German Romantics, for it was a place which they, too, colonised. It can even be seen as a reference to the German army which has been described as the forest on the march.

The attic-studio, like the forest, is a place of self-reflexivity. During the nineteenth century the attic or garret, separate from the day-to-day sphere of domestic life, became symbolic of artists' position on the margins of society. The attic-studio features in most of Kiefer's 1973 paintings. In each picture the space is adapted to the demands of composition and takes on a different character through the references and symbols placed within and layered over it. In the monumental *Germany's Spiritual Heroes* (1973) the attic becomes a mythological hall of the Gods; in the *Parsifal* series (1973 Tate Gallery collection) it becomes a theatrical setting for Wagnerian legends. Mark Rosenthal has described Kiefer's attic environment as, "a singular world where much may be considered. . . . Given the subjects depicted, one may understand the attic as the setting for the beginning of time, when religious and ethical values are created and tested. . . . It is a metaphysical place. . . . This place is the mind itself, at once malleable and steadfast, a filter through which concepts are pondered, invented, buried, or transformed." The attic, sometimes a storeroom, moreover, functions as a place where aspects of German history and culture, tainted, tarnished and bannished through association with, or appropriation by National Socialism, can be revisited and reconsidered.

An earlier version of *Father, Son and Holy Ghost* (1973) depicted the attic space alone, but this version juxtaposes the two self-reflexive worlds. The forest and the attic are linked conceptually, the living wood of the forest trees transformed, or even civilised by man, becomes the wood-grained floor, walls and beams of the attic space, and literally through the inscription of the words "Vater Sohn hl. Geist" (Father, Son and Holy Ghost). The verticals of the forest trees meet the horizontals of the floorboards which in turn are paralleled by the horizontal branches of the trees. In the attic space sit three chairs, and three fires burn on them or burn them. The three chairs echo the three trees in the foreground of the forest section of the painting. The inscription "Vater Sohn hl. Geist" suggests that the chairs, flames and trees may symbolise the explicitly invoked Christian Trinity. In Rosenthal's eyes, Kiefer "proposes in the painting that from the experience of the forest emerges thoughts about the existence of a divinity, which become words or symbols."

Fire, one of the four elements, recurs as an archetype throughout Kiefer's oeuvre. Mythical fire has a dual nature: it is both divine and demonic; it has the power to destroy and to regenerate. Within the world of the painting fire threatens the flammable wood of the studio and even that of the forest, two self-reflexive, conceptual spaces continually at risk. If the fires represent the three aspects of the Christian trinity, perhaps they also represent belief itself. Ideas, beliefs and religions, like wood, are vulnerable, but like fire, they too, have powers of destruction as well as creation.

During the 1950s West German art was dominated by various forms of Abstract Expressionism (sometimes known as Informel); during the 1960s Op, Pop and Minimalist styles prevailed. Kiefer belongs to a generation of German artists, such as Baselitz, Penck and Schonebeck, who began to work figuratively again. Nevertheless, Kiefer's roots lie in conceptual work, for he studied with Beuys, whom he has described as his teacher in the largest sense of the word. Kiefer's conceptual background is apparent in his choice of subject matter. His paintings can be seen as illustrations of ideas. But his intellectual concerns are combined with painterly concerns, for instance, startling compositions and seductively textured surfaces. It is through the process of painting that Kiefer's images are infused with redolent meaning and emotional impact. Beuys believed in art as a redemptive force, in art's potential to heal. Such notions resonate within Kiefer's work. He appears to embrace the position of the artist as the onlooker, the commentator and it is in the attic-studio, the domain of the artist, that grand and metaphorical themes are considered and depicted. In *Father Son and Holy Ghost*, Christianity, a system of thought concerned with redemption, is invoked. Yet there is in this painting, as in many of Kiefer's images, a touch of irony, for such grand themes could be considered out of place in the humble surroundings of the attic-studio.

Kiefer's work provoked a furore amongst German critics in the early 1980s. They were offended by its explicitly teutonic themes and Kiefer's insistent reviewing of the cultural heritage of Nazism. But Kiefer has stated that it is not his intention to shock, rather to expand the boundaries of art. For Kiefer, the redemptive powers of art and the artist can heal the wounds inflicted by Hitler and the Holocaust.

Father, Son and Holy Ghost, like so many of Kiefer's paintings, crosses the boundaries between traditional genres. It is something more than a history painting, an altarpiece, or a landscape painting. It comes closest to allegory yet meaning remains elusive and ambiguous.

—Claire Lofting

Bibliography—

Felix, Zdenek, *Anselm Kiefer*, exhibition catalogue, Essen and London 1981.
Rosenthal, Mark, *Anselm Kiefer*, exhibition catalogue, Chicago and Philadelphia 1987.
Kiefer, Anselm, and Zweite, Armin, *The High Priestess*, London 1989.

Photo Statens Konstmuseer

Edward Kienholz (1927–)
The State Hospital, 1966
Mixed media tableau
Stockholm, Nationalmuseum

Edward Kienholz is one among a select group of modern artists who has fully developed a genius for transforming commonplace events and situations into significant artistic experiences. In his work since the 1960s, he has developed the idea of the "assemblage" made of the odds and ends and the castoffs of our modern society into experiential works of art. The works are not abstract, but so real and immediate that they strike the viewer forcefully with the idea or theme behind the event depicted.

Kienholz began with portable assemblage art that was very popular in the early 1960s, and by the end of the decade he was involved in full-sized environments that are actually essays on living at the margins of society. He has a very strong social conscience and is very aware that in our society people are as expendable as the myriad products found in our garbage cans, pawn shops, secondhand stores, and city dumps. A quotation by Kienholz from the *Volksempfangers* catalog applies to all his work: "I really begin to understand any society by going through the junkstores and flea markets. It is a form of education and historical orientation for me. I can see the results of ideas in what is thrown away by a culture."

Edward Kienholz was born in Fairfield, Washington and grew up on a rural farm with strong roots in the Pacific Northwest. He briefly attended school at Eastern Washington State College and Whitworth College in Spokane before moving to Los Angeles in 1953 to practice his art. From the beginning, he was interested in the art of assemblage which owed its origins to the Dadists and Surrealists and very specifically to Marcel Duchamp and the idea of the "readymade," in which items from everyday society were exhibited under the artist's name.

While he was developing his art, Kienholz supported himself through odd jobs and creative entrepreneurship that was to have great influence on his later work and on his view of our society. He was an orderly in a state mental hospital, managed a dance band, sold used cars, ran a night club, managed a restaurant, did window displays, and even sold vacuum cleaners. He was heavily influenced by the unrest of the late 'sixties and the Vietnam War protests, and when a 1970 retrospective of his work received enthusiastic acceptance in Europe, he realized that Europeans, due to long association with socio-political art, were much more sympathetic to his artistic approach than was the United States. In 1973 he was awarded a grant by the West German government, and since then, in collaboration with his wife, Nancy Reddin Kienholz, he has divided his time between a studio in West Berlin and a studio in the small resort town of Hope, Idaho, very near his mother and his early roots.

Kienholz, in attempting to explain his relationship to his public, says that he is much more dependent on them than many other contemporary artists—that he is the trailblazer, and the viewer is the hunter. Kienholz describes it this way: "At one point I as the trail-maker disappear. The viewer is then confronted with a dilemma of ideas and direction. The possibilities are then to push on further by questions and answers to a new place that I can't even imagine or to turn back to an old, safe place. But even the decision is direction."

Kienholz does not believe it is his mission to instruct people, and does not want to teach a history or a sociology lesson. He wants to put the viewer on the right track using his theatrical showmanship, and fully acknowledges that he is as dependent on his viewers as a director or playwright is upon an audience. That is why his work is often as much theatre as it is art and why it is poorly served by photographic reproduction.

The art of Edward Kienholz has a number of themes, such as the might of the few and the powerlessness of the many, gender relationships between male and female, and the loneliness of old age. Subjects cover a great range of scenes from a bordello called Roxys in Las Vegas, to the emasculation of a black by whites in the glare of a car headlight; from subjects related to the television and broadcast news to the loneliness of down-and-outers living in a run-down hotel; from the poignancy of age in his own mother to the humorous critical view of the U.S. Supreme Court. His sources are the fairgrounds, carnivals, fundamentalist churches, and flea markets that are the meeting ground for the lower reaches of our society. His techniques are those of the theatrical set designer putting together an environment with carefully chosen real properties peopled by plaster casts of actual human figures, sometimes with carefully chosen symbolic properties instead of ordinary body parts.

One of his most famous works that has been most often reproduced is *The State Hospital*, which draws on his own experience as an orderly in a state mental institution. As one enters the gallery where it has been placed, the viewer is forced up to a large life-size box with a small barred window through which he or she peers into a ghastly room. From the catalog description one understands that the old man has been beaten on the "stomach with a bar of soap wrapped in a towel (to hide tell-tale bruises). His head is a lighted fish bowl with water that contains two live black fish." The old man is thinking about himself and sees a mirror image of himself on the bunk above. The only difference between the two images is that one is surrounded by a balloon, as in a cartoon or comic strip. The suggestion is that the inmate cannot think beyond the present. He is constantly constrained by other human beings, and so the present is frozen as both past and future in a continuous repetition of suffering. Everything in the scene is absolutely real, and when the piece was originally exhibited, a sickly hospital smell emanated from the scene. The shock of recognition is immense when the viewer takes in the full scene and finally brings his or her eyes to rest on the fishbowl head. The piece is deeply experiential and brilliantly represents the Kienholz approach to art.

This work by one of the leading contemporary artists of the postmodern shows how the tactile and experiential are used to make an actual, physical, instinctive, free commentary on modern life.

—Douglas A. Russell

Bibliography—

Kienholz, Edward, *Works from the 1960s*, exhibition catalogue, Washington, D.C. 1967.
Helm, Robert, and West, Harvey, *Edward Kienholz: Sculpture 1976–1979*, exhibition catalogue, Seattle 1979.
Kienholz, Nancy, *Edward Kienholz: Roxys and Other Works*, exhibition catalogue, Bremen 1982.
Kienholz, Edward and Nancy, *Human Scale*, exhibition catalogue, San Francisco 1984.
Kienholz, Edward and Nancy, *Kienholz in Context*, exhibition catalogue, Spokane 1984.
Harten, Jurgen, *Kienholz: 1980s*, exhibition catalogue, Dusseldorf 1989.

R. B. Kitaj (1932–)
Cecil Court, London W.C.2 (The Refugees), 1983–84
Oil on canvas; 72 × 72in. (183 × 183cm.)
London, Tate Gallery

After Ohio-born R. B. Kitaj had settled in London in 1959, one of his favourite hunting grounds as a self-confessed bibliomaniac was Cecil Court, the narrow alley near Leicester Square Underground Station linking Charing Cross Road and St. Martin's Lane. Surrounded by theatres and bookshops, it was a centre for antiquarian and second-hand books on the visual and performing arts, the occult, maps and other specialised subjects.

Here Kitaj found much source material. Early in his painting career, he wrote that, "Some books have pictures, and some pictures have books," thus rejecting one major premise of 20th-century modernism: that art is uniquely visual and has no reference outside itself. Whilst the purely visual qualities of Kitaj's work are sensuous and seductive in terms of colour, drawing and sheer painterliness, the figuration begs interpretation. For Kitaj, the written word is often an essential key to the painter's world of ideas. His is a highly complex world, full of allusions not only to social, political, historical, philosophical and intellectual aspects of 20th-century culture but also encompassing an astonishingly wide range of artistic, literary and autobiographical references. His painting is as multi-levelled and as difficult as the annotated poetry of T. S. Eliot or Ezra Pound, and similarly resonant. Kitaj quotes Horace: "*Ut pictura poesis.*"

Now in his late fifties, Kitaj has for years been deeply preoccupied with his own Jewishness and the trauma of the Holocaust, with the subsequent dispersal of his people. His concern has not only been for the Jews, but for all those in exile, the enforced loners and wanderers who "live outside."

From the beginning his art has been figurative. For him, "the illustration of human life . . . has been art's main province," particularly in this century, "one of the most terrible histories of bad faith ever." Echoing Balthus (an artist whose influence he readily acknowledges), who said that he would like "to do Realism after Surrealism," Kitaj wrote that he would "like to try, not only to do Cézanne and Degas after Surrealism, but after Auschwitz . . . Some of us need a post-Auschwitz art even more than a post-painterly art."

Cecil Court, London W.C.2 (The Refugees) is one of a group of paintings of the early 1980s which deals with the fate of Jews in the post-Auschwitz era. Recognising the obscurity of his personal iconography, Kitaj has written a series of Prefaces to some of his paintings, which have been published in Marco Livingstone's monograph. Kitaj draws attention to Franz Kafka's *Diaries*, in which the Austrian novelist writes of his passion for the Jewish Theatre, a wandering troupe of Central European actors and playwrights, characters "light as a feather (that) . . . haven't the slightest specific gravity but must bounce right back up in the air." Kitaj shares that passion.

Kitaj has captured the architectural spirit of Cecil Court with sharply receding yellow planes of brightly lit shop windows, creating a dream-like setting. It would seem to be night, though the street lights are omitted. The artist himself is shown close to the viewer, reclining across the lower section of the canvas in his own Le Corbusier chaise longue. He seems, characteristically, to be reading a book or paper, with another book lying on the floor/pavement beneath him. However, he is remote, in deep reverie. The ground between himself and the far end of the alley, where a girl in an apricot dress and black boots is hailing a taxi, is peopled with intriguing characters who seem to have whirled like thistledown along Cecil Court.

As the bracketed sub-title implies, this is not mere topography. Who are these people, blown hither and thither like so much flotsam to be swept up by the man with the broom? Who are the sentinels watching in the wings, the man on the left with head bowed and a bunch of white flowers, the other on the right erect in haughty contrapposto, a large green book under his arm? Who is the girl with pink knickers, disjointed like a Bellmer doll; the

squatting boy in a red V-necked sweater and blue trousers; the man in maroon jacket, white shirt and plum-coloured trousers, his braces stretched to breaking point as he is hurled across the canvas? Where are the children heading, sad eyes downcast, the girl's arm protectively round the boy, towards the fragment of a woman's profile? Was this their mother, now forever "off-stage"?

Why, despite the beautiful organization of sumptuously rich colour, does such a sense of sadness pervade the scene?

Kitaj has always believed in painting out of personal experience. In his Preface he writes: "I have a lot of experience of refugees from the Germans and that's how this painting came about. My dad and grandmother Kitaj and quite a few people dear to me just barely escaped."

The names on the shop-signs—Seligman(n), GORDIN, LÖWY, KALB, JOE S(INGER)—could all be Jewish names. Many of the shops in Cecil Court were run by refugees. Mr. Seligmann did exist and Kitaj bought many of his art books and prints from him. Though now dead, he is recorded as the figure standing on the left. Behind him, beneath the roller blind, an open book is displayed in his shop window with barely legible writing evoking lost names one can almost—but not quite—decipher. Gordin (a playwright) and Löwy (an actor) both appear in Kafka's *Diaries*, whilst Kalb may be in the title of a play.

Joe Singer has appeared as an imaginary character in a number of other paintings since 1980, an emblematic Jew with whom the artist identifies, as Kafka did with K in *The Trial*. Singer wears a hearing aid (the cord is just visible in this painting; Kitaj too is hard of hearing) and has many roles. In exile, he is listener, watcher, messenger and guardian of the pure oral tradition of Jewishness. On his left arm is wound the black leather prayer thong of the Tefillin, an outward sign of the Jewish faith binding man and God with prayer—not unlike a rosary. Did Singer have to watch in 1938 as the Jewish shopkeepers took their brooms to sweep up after Kristallnacht? Kitaj's stepfather, a Viennese refugee who had recently died, has his portrait, bespectacled and wearing a peaked cap, incorporated with that of Singer.

Whilst working on *Cecil Court*, in December 1983 Kitaj married a fellow-American painter, Sandra Fisher, at London's oldest synagogue in Bevis Marks. In the painting he is seen in his wedding outfit: red shirt, yellow tie and green trousers. During a brief honeymoon in Paris the couple visited the Balthus retrospective exhibition, looking closely at *La rue* (1933), which Kitaj knew well from New York's M.O.M.A. With its multi-coloured shopfronts and signs and strange static personages, the painting stimulated Kitaj's competitive spirit. That winter he also visited the R.A. exhibition *The Genius of Venice 1500–1600* many times. In his studio he pinned up two postcards: one of Titian's late great *The Flaying of Marsyas*, which Kitaj says "may be my favourite easel painting ever," the other Tintoretto's huge *The Washing of Feet*, now hanging in Shipley Art Gallery, Tyne and Wear.

Kitaj once said that he would tell who the other people in the painting are supposed to be, but not now. In any case, it is enough. *Cecil Court* finds its place on the map of great city street scenes of 20th-century art.

—Cecily Lowenthal

Bibliography—

Ashbery, J., Shannon, J., Hyman, T., *Kitaj: Paintings, Drawings, Pastels*, London 1983.
Livingstone, Marco, *R. B. Kitaj*, Oxford 1985.
Rosenthal, Norman, "Three Painters of this Time: Hodgkin, Kitaj and Morley," in *British Art in the 20th Century: The Modern Movement*, exhibition catalogue, London 1987.
Kitaj, R. B., *First Diasporist Manifesto*, London 1989.
Kampf, Avram, *Chagall to Kitaj: Jewish Experience in 20th Century Art*, exhibition catalogue, London 1990.

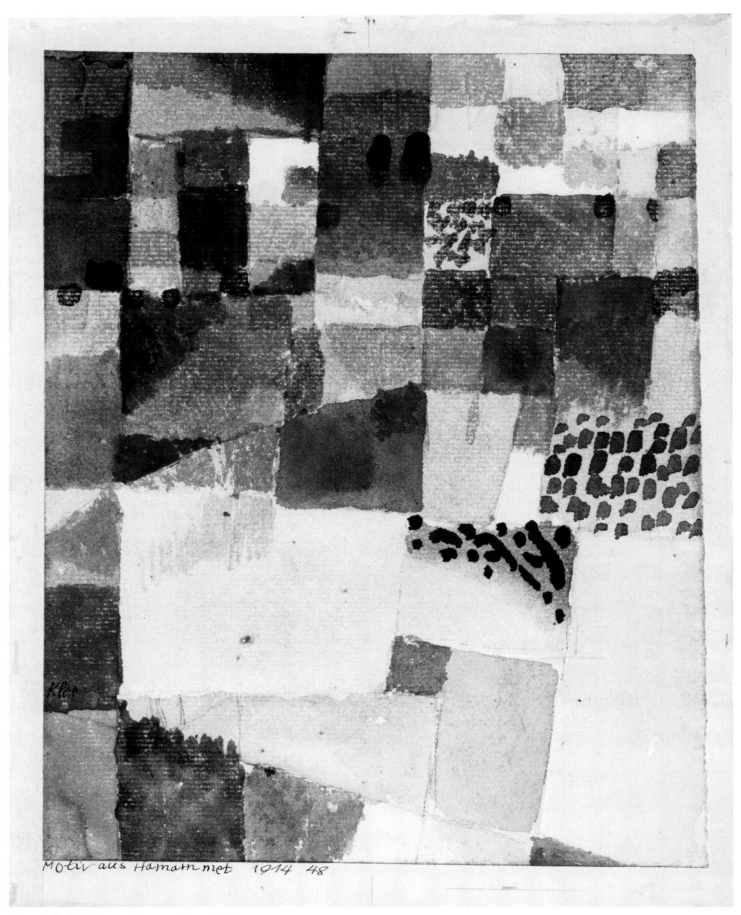

Motiv aus Hamamnet 1914 48

Photo: Oeffentliche Kunstsammlung, Basel © DACS 1991

Paul Klee (1879–1940)
Motiv aus Hamammet, 1914
Watercolour; 20.2 × 15.7cm.
Basel, Offentliche Kunstsammlung

In 1912 Klee translated Robert Delaunay's essay *Ueber das Licht*. There it says: "Nature is full of a diversity of rhythm which cannot be restrained. May art imitate her in order to declare such level of nobility, to rise to polyphon sounds, a harmony of colours that separate and join again to form a whole in the same action." This forms a set of guidelines. Klee reached their realisation during his journey with August Macke and Louis Moilliet to Tunisia in April 1914. His philosophy laid down in these guidelines includes three central factors: firstly the colour, its tonality and rhythm; secondly the compositional action of separation and conjunction; and thirdly the greater rules of nature.

The latter has for a long time had exceptional value in the occidental history of art, none more so than when one strives for classic ideas. This idea also applies to classic Modernism, where abstraction and deformation seemingly lead away from nature. On the contrary, classic modernists, at least those spearheading representative artists, manage to trace underneath the surface the organisational structure of things to achieve rhythm and configuration. It is then that the colour brings out the visual effect.

Added to this is an art-historical ingredient, the fragrance of the Orient. Ever since the crusades Europe has been intrigued by the arabic, and later by the osmanic world, against which Europe at times assumed a defensive attitude, and at other times willingly soaked up her influences, enchanted and mesmerised. The scents and moods of 1001 nights have spread from the Levante and Islamic Spain across the borders of the Occident long before the stories became known to Christian countries in the 18th century. Understandably so, the Orient has taken a prominent position in Venetian art; Serenissima clearly has cultural contact with the Orient. The fragrance of spices, the sensual magic, light and colour, all define it's life. In what other way could we understand the almost paradisian "Laendliches Konzert," be it Giorgione's or Tizian's work of art? The consciousness of Europe's cultural elites comprises from then on an almost pantheistic feeling for nature and a longing for paradise, for a fulfilled and satisfied life in Garden of Eden, which, believed to have been lost forever, reappears with images of the Orient. In William Turner's fleeting, translucent venetian watercolours, the Orient flares up in the distance, whereas in Paul Gauguin's visions we see it far removed, transposed into the Pacific, evoking colours and figures in Tahiti. Since the Algerian motives of Eugène Delacroix, the connection with the Occident has prompted increasing awareness of African cultures, and has become a constant in the development of European art. These cultures have achieved a distinguished place next to European civilisations, which are dominated by the enlightenment, science, technology, and industrialisation.

The so-called Orphism, a variation of cubism, concentrates on the organisational power of light and colour, and brings about a more radical artistic approach which celebrates anew the myth of nature and of Orphean songs from far away. Robert Delaunay's paintings from 1912 (*Les Disques, Les Formes circulaires cosmiques*) are in this respect "absolute paintings."

Each work of art grows out of a complex creative process that goes far beyond spontaneous creation. The artist can, at least in parts, be aware of the significance of this process within his perception and creation. Thus Paul Klee noted on his journey of study to Tunisia on April 16, 1914: "I belong to colour. I don't need to seize and run after it. I am hers forever, this I know. This is my contentment of this hour: Colour and I are one. I am a painter." It was at this moment of artistic reorientation, that the knowledge of Delaunay's ideas and that of the cubists caught up with him. He thought himself to be facing the "reality of the fairytale, not quite within reach, still far away, yet very clear." On his arrival in Kairouan he was very enthusiastic about being able to grasp "the essence," filtered through the traditions of the Orient: "No separations, only the whole! And what a whole! Tausendundeine Nacht as the essence with 99% truth in it. What aroma, how penetrating, intoxicating, how clarifying at the same time, food, most real food, and tantalizing drink. Composition and ecstasy. Sweet-scented wood burning. Home?" We notice unmistakably a transcultural, even mystical touch in the casual mention of "home." Could this be the home of the artist?

But, as always, Klee also displays a strong, precise rationality. How to bring together the perceptions of colour and light, of music, rhythm, and ornamental structures of islamic art, the "setting of delightful gardens," the "mountain-ridges, on which, strictly rhythmical, wise shapes of houses grow"? Thus we understand immediately the essential idea of structure and design, which is a synthesis of urban architecture and the architecture of the painting, where objects become obsolete in an orthogonal arrangement that is dominated by colour.

It is impossible to capture the swinging charm of these watercolours in black and white reproductions. Far from topographic realism, the *Motiv aus Hamammet* (a town south of Tunis) assimilates the lucid technique of aquarel-painting, transparent and flowing, nature and architecture in the deeper sense of harmony of colour and geometry. "Slightly scattered light, mild but clear at the same time" from Klee's notes brings life to the composition from the inside; it frees the seductive world of a foreign culture, captivating landscape and gives it an Orphean swinging motion, beyond space and time. In place of his drawn structures, Klee used assorted coloured squares, rectangles, and triangles, carried by shades of ocre, blues and greens to form the harmony of colours. "Reeds and bushes have a beautiful patchy rhythm," the painter writes (who also was an excellent violinist) in his diary in Hamammet. One can just see him, in the right half of the painting, whereas a little to the left, suggested only by a few dots, the picture expresses a delicate physicality. Do we find ourselves in one of the palace-gardens of 1001 nights? From the upper half of the painting, gaps in the wall look at us like eyes. What is the concept? Klee's words, which he wrote later in the Weimarer Bauhaus, explain, "To be abstract as a painter does not mean that natural objective references of comparison have to be abstracted, but rather to rely on the extraction of pure pictoral relationships, independent of these comparisons."

Some time ago Will Grohmann referred to Klee's "clear congeniality with the Orient." This congeniality, touching fairytales and myths, together with his novel abstract approach, becomes more and more important for the further development of the artist.

—Gerolf Fritsch

Bibliography—

Grohmann, Will, *Paul Klee*, Paris 1929, New York 1955.
Haftmann, Werner, *The Mind and Work of Paul Klee*, London 1954.
Klee, Paul, *Tagebucher*, Cologne 1957.
Geelhaar, Christian, *Klee-Zeichnungen*, Cologne 1975.
Guse, Ernst-Gerhard, ed., *Die Tunisreise: Klee, Macke, Moilliet*, Stuttgart 1982.
Fritsch, Gerolf, "Von der Weltmaschine zum Systembild: Klees Beitrag zur neuen Metaphysi," in *Kunst-Nachrichten* (Zurich), no. 2, 1984.

Photo Rheinisches Bildarchiv, Köln © ADAGP, Paris and DACS, London 1991

Yves Klein (1928–62)
Relief Eponge Bleu, 1958
Sponges, blue pigments, wooden support
Cologne, Wallraf-Richartz Museum

Yves Klein's *Blue Sponge Relief*, executed four years before his premature death at the age of 34 from a heart-attack, may be taken as epitomising the major direction of his once widely celebrated oeuvre. Its title is sufficiently self-descriptive of its formal or physical aspects—it is, after all, just an outsized monochrome panel-relief formed from sponges soaked in an intensely blue paint—if not of its masked inner content. In his mature works, usually monochromatic, colour is everything, and usually that colour is an intense and emblematic indigo blue. By the time of his demise, in 1962, Klein had become acknowledged as a major personality among the European "Neo-Dadaists." His spirit still informs much of the ethos of so-called "Performance Art." The anarchic artists of Klein's generation, like their WW 1 era proto-types, were responding to twin impulses, the shock of another cataclysmic war and a rampant materialism taken to have brought those murderous conflicts into being. Like the original Dadaists, the activities of the post-WW 1 generation were (and still are) considered more noteworthy for the largely symbolic value of what they did (or enacted) than for what they actually "made."

By 1958, the year of a "Blue Sponge Relief" neatly centered within a short but spectacularly notorious career, Klein had already moved from being a painter into the more ephemeral arena of performance art. Then, as now, the performance artist is treasured for his public "personality," and that often entertaining, usually highly publicised but largely dematerialised, concoction is seen, more often than not, as his one true and complete creation. Klein himself had announced that "the painter only has to create one masterpiece, himself, constantly." By 1957, at the Galerie Iris Clert in Paris, it was sufficient that a given exhibition space contained nothing but the announced, but wholly immaterial, "presence" of the artist; accordingly, the pseudo-event was just called *Le Vide*, "The Void." Artists like Klein wish to, as he once put it, "get away from the [traditional] idea of art," and, according to this French-Jewish international phenomenon, "The essential of painting is that something, that 'ethereal glue,' that intermediary product, which the artist secretes with all his creative being, and which he has the power to place, to encrust, to impregnate into the pictorial stuff of the painting."

Mystically-minded, yet working with largely unshaped physical realities, Klein typically employed untraditional means and rawly emblematic "modernist" materials. His major themes were, according to his own quirky terminology, "*anthropométries*" (the measure of man—meaning paintings made by "human brushes"), "*l'immatériel*" (immaterialism), and, above all, "*le vide*" (the Great Void). He used methods as unorthodox as a flamethrower or, conversely, the action of wind and rain, symbolising what he dubbed the "Cosmogonic" actions of nature, or, most in-famously, nude women smeared with indigo pigments. After their ritual anointments, the undraped and actually quite attractive models were dragged across expanses of blank canvases stretched upon the polished floors of eagerly-attended art galleries. These "anthro-pometric" activities—ceremoniously produced, solemnly presided, and often even accompanied by monotonously droning cello music—were called, blandly but rather fittingly, "*Imprints.*" But one could even dispense with the girls, the raindrops, and the flames; in Paris in 1958, Klein exhibited another exercise in sheer emptiness, "*Le Vide*": a vacant gallery painted pure white.

These kinds of non-events—*néo tableaux-vivants*—were, of course, eagerly "witnessed" by crowds of expensively dressed testators; in another age, they might have attended with equal fervour a High Mass in Nôtre Dame Cathedral. Klein and his followers were also wont to discuss endlessly the aspects of a future art. This utopian expression would be, so they said, wholly immaterial, free of all dependence upon images—or even tangible objects. The purpose was to stir unfettered spiritual mental activity, in which everyone, artists and (especially) non-artists alike, could join in a great and class-less brotherhood of heightened, wholly

modernist sensibility. The larger result is that the artist's role becomes broadly "social" rather than narrowly "aesthetic." In this emerging theatrical context, the New Realist would become *acteur* rather than *artiste*. An analogous idea was to offer to a properly reverent public what Klein called "zones of immaterial pictorial sensitivity."

Like his presently more celebrated colleague, Joseph Beuys, Ives Klein was an artist to whom the fluidly unconcretised and essentially spiritualised impulse was far more significant than the fixed and immutable artwork. Like Beuys', the character of Klein's philosophical *leit-motivs* was really "pseudo-philosophical," and specifically "occultist." Whereas Beuys' art was largely propelled by Anthroposophy, Klein's spiritual focus was unquestionably located in Rosicrucian mysticism. At the age of 20, in 1948, Klein took up a vegetarian lifestyle. At about the same time, he also became a practising Rosicrucian. For the rest of his life, by his own admission he spent four hours a day reading a bizarre theosophical work by Max Heindl, *The Rosicrucian Cosmo-Conception* (1909). It is Heindl's comments on the same strident shade of indigo—the one that Ives Klein was later to make famous as "International Klein Blue"—that best illuminate the real, entirely mystical impulse that impelled Klein's chromatic fantasies. The result is to show how the anti-formalist exercises of this activist artist were really more about spirituality than about "art," at least as this word was traditionally conceived, or even as it is still perceived by most art critics. According to Max Heindl's treatise, which we will recall was Klein's favoured spiritual guide, "We do not sin against the 'Oneness' of light because we [Rosicrucians] distinguish three primary colours into which it divides itself. The white light of the Sun contains the seven colours of the spectrum. The occultist sees even twelve colours, there being five between red and violet. . . . Four of these colors are quite indescribable, but the fifth—the middle one of the five—is similar to the tint of a new-blown peach blossom. It is, in fact, the colour of the vital body. Trained clairvoyants who describe it as 'bluish-grey,' or 'reddish-grey,' etc., are trying to describe a colour that has no equivalent in the physical world. . . . Colour alone will enable us to realise the Oneness of God with the [Rosicrucian] Seven Spirits before the Throne better than anything else . . . and one colour—*indigo*—contains the entire gamut of colours, making in all the seven colours of the spectrum. These colours [all synthesised in indigo] represent the Seven Spirits before the Throne."

From the eminent Rosicrucian's statement one draws two, both fairly obvious, conclusions: first, that the artist's much discussed "International Klein Blue" has a decided symbolic, versus merely "formalistic," significance; and, secondly, that all the art critics who have celebrated his heterodox antics ("funny, he didn't look bluish to me") had widely missed the mark of the largely spiritually centered, and specifically "occult" significance of his work overall. In fine, Klein's widely influential oeuvre—the last redolent bouquet from the School of Paris' *art informel*—must now be thoroughly re-evaluated by scholarly inclined art historians (specifically by iconologists) in the light of Klein's openly acknowledged Neo-Rosicrucian pursuits.

—John F. Moffitt

Bibliography—

Descargues, Pierre, ed., *Ives Klein*, exhibition catalogue, New York 1967.
Union Centrale des Arts Decoratifs, *Yves Klein*, Paris 1969.
Klein, Yves, *Selected Writings*, London 1974.
Henri, Adrian, *Total Art: Environments, Happenings and Perfor-mance*, London 1974.
McEvilley, Thomas, "Yves Klein, Conquistador of the Void," in *Yves Klein (1928–1962): A Retrospective*, exhibition catalogue, New York 1982.
Lucie-Smith, Edward, *Movements in Art Since 1945*, London 1985.
Moffitt, John F., *Occultism in Avant-Garde Art*, Ann Arbor 1988.

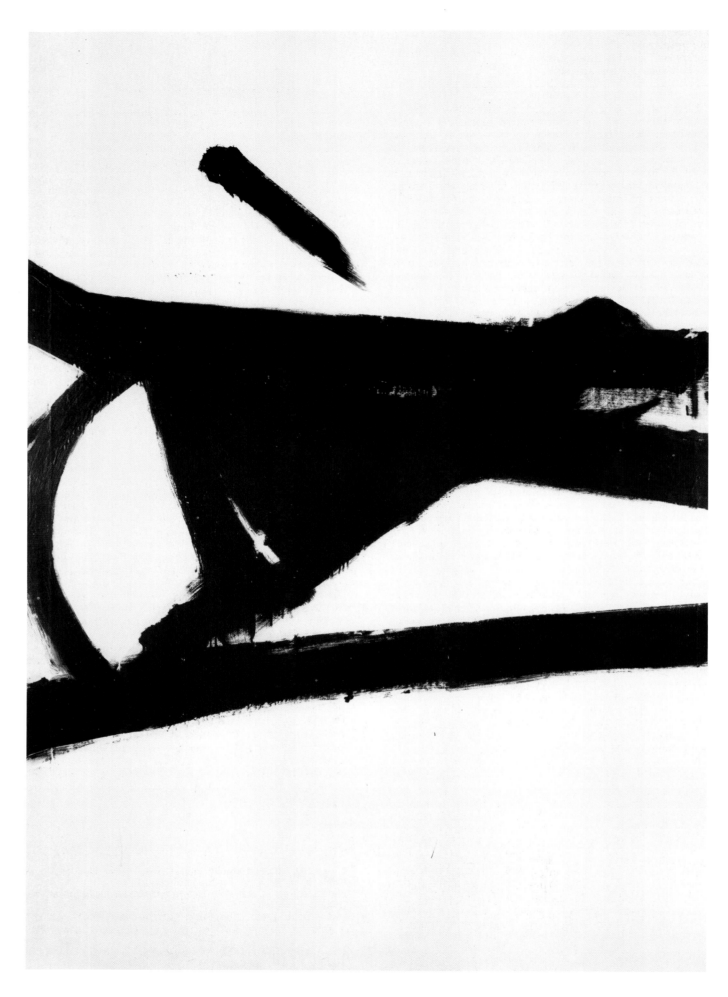

148

Franz Kline (1910–62)
Accent Grave, 1955
Oil on canvas; 75¼ × 51¾ in.
Ohio, Cleveland Museum of Art

Franz Kline was born in the dark hills of Wilkes-Barre, Pennsylvania, where he grew up marked by the region's black coal mines and railroads. The future artist was always fascinated by trains; later, at the height of his career, he titled several of his paintings after trains. A good student and athlete, he was also the cartoonist for his high school newspaper; eventually he studied academic drawing and painting at Boston University and the Art Students League before traveling to London where he attended Heatherly's Art School.

During the Great Depression of 1929, American artists were given stipends and kept alive by the Federal Art Project under President Roosevelt's Works Progress Administration. This allowed many artists, in their formative years, to experiment and develop during a time of bread lines, social protests, and political rallies. Meeting in dingy lofts and all-night bars and cafeterias in Greenwich Village, the more ambitious artists made an environment where they could emulate the cafe-studio life of Paris as they followed the latest European art movements in foreign publications. Reacting against the provincial American art styles at the time, the New York avant-garde artists were attempting to synthesize and go beyond the modern movements, Cubism, Surrealism, Abstraction, and Expressionism, which they knew primarily from black and white reproductions.

World War II forced many European critics, dealers, and museum directors, as well as artists, to flee to the United States, which helped create the ferment that developed into Abstract Expressionism, the first major original direction in American art. And the center of the art world shifted from Paris to New York.

In 1938 Franz Kline returned to America from London with a British wife and settled in New York City. In the early 1940s he won awards at the National Academy of Design, and, as a Greenwich Village sidewalk artist, produced traditional city scenes, studies of interiors and figures. Willem de Kooning is credited with introducing Kline to abstraction, and Kline began experimenting with small black and white brush drawings which he projected onto his studio wall with a Bell-optican, magnifying the brush strokes into enormous ideograms.

These gestural ideograms, like handwriting, the human voice or personality, vibrate differently with each individual artist and reflect different feelings, sensations, and emotions. Kline, perhaps more than any other Abstract Expressionist painter, demonstrated his experience of hand and arm gesture when his forceful line was placed on the canvas. His works suggest rapidly developed and spontaneous compositions almost independent of the space they generate in relation to those pictorial coefficients, black and white. His linear extensions enter and leave the edges of the canvas, continuing into space, beyond the painting.

Abstract artists feel instinctively that the order in nature cannot be justified by the mere observation of nature. Indeed, the spatial universe is a field of force and of incessant activity; the great powers of nature, such as gravity, the changes in motion and direction, are determined by configurations and movements of masses. Kline's abstractions are about force, about clashing energy, limitless mass, and planeless dimensions.

It was the startling vigor of his paintings, with their non-chromatic boldness, that stunned the art world when they saw Kline's first solo exhibition in New York in 1950. At first, viewers saw only a chaotic field of black lines against a white ground; eventually the more discerning realized that the black lines related to the white areas and combined into a single perceptual concept.

Accent Grave is one of Kline's most open compositions, with the white shapes deployed by black trajectories of force, dividing the picture in half. Elementary visual logic expects the principle form somewhere in the center, but here the form has the property of simple location in space. The tightly compacted black lines, which carry the eye horizontally out of the picture, encroach on the clear-cut whites above and below. But the white is not subordinate, it does not go behind the black as ground but comes to the edge of the black and forms its own field. *Accent Grave* is among the very few paintings by Kline which incorporates an arc or part of a circle. The long black incisions stretching horizontally across the surface seem at first to be straight, but, as large arcs, they play an important part in relating to the smaller, bracketing arc on the left. Like a logarithmic curve (any two segments of a curve are the same shape, merely different in size), the large curve at the bottom is countered by the arc above in a mirror image of the first. The small semi-circle at left, is almost in a state of rest as it directs our eye compulsively to the narrowing white area to the right. It is a duality of opposites—opposites usually cancel each other out, but here they squeeze the field of force into a compressed activity, and defy gravity.

A large black triangular form is suggested within the juncture of large arcs, but we cannot tell whether it is in front, or behind, or part of the overall dark form. However, these ambiguous forms dominate, if very subtly, the shape which is echoed in smaller white triangular forms, becoming progressively smaller and scattered within the central mass. This parenthetical arc outlines a triangular fan shape to its right; all these triangles act as a prelude to the triangular accent floating in the white space above as though flicked on spontaneously and as easily as one adds a diacritical mark to a foreign word. The artist worked back and forth, from black shapes to white shapes, modifying them, shaping them, developing their positions and their relationships to one another. He set up a conflict between black and white which eventually resolved itself into a final unity encompassing the rectangle of the picture, with all shapes equally controlled. He disliked the comparison of his work with calligraphy, which is a matter of writing on a white surface; Kline's own use of black and white was quite different since his intention was to create positive shapes with white as well as with black: "People sometimes think I take a white canvas and paint a black sign on it, but this is not true. I paint the white as well as the black, and the white is just as important."

Abstract Expressionism was not generally accepted for a long time, and it was denounced by dealers and critics as well as politicians and the public. One public official harangued modern art as an effort to "addle the brains of innocent Americans" so the Russians could conquer the United States without firing a shot, and that Abstract Expressionism was "shackled to Communism."

From its origins in the early 1940s until official recognition with the Museum of Modern Art exhibition, *Abstract Painting and Sculpture in America* of 1951, Abstract Expressionism developed into one of the most powerful and original movements in art. By the end of the 1950s, *The New American Painting*, organized by the Museum of Modern Art, was sent to eight European countries where it was admired and recognized as an astonishing break with traditional methods of seeing and making art.

Franz Kline was awarded the prize at the XXX Biennale, Venice, in 1960; two years later, in his prime and at the height of his career, he died of heart failure at age 51.

—Martin Ries

Bibliography—

Goodnough, Robert, "Kline Paints a Picture," in *Artnews* (New York), December 1952.
Kuh, Katherine, ed., *Artist's Voice: Talks with 17 Artists*, New York 1962.
Gordon, John, *Franz Kline 1910–1962*, New York 1969.
Gaugh, Harry, *The Vital Gesture: Franz Kline*, New York 1985.

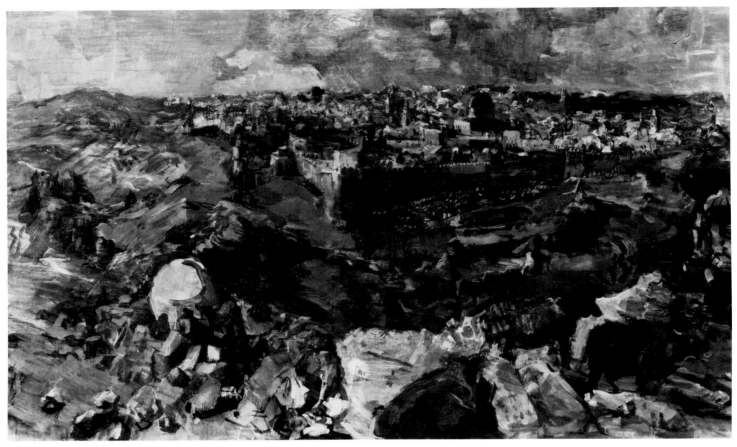

© COSMOPRESS, Geneva and DACS, London 1991

Oskar Kokoschka (1886–1980)
Jerusalem, 1929–30
Oil on canvas; 32 × 51in.
Detroit Institute of Arts

Oskar Kokoschka referred to his many views of cities, which include London, Prague, Cologne, Istanbul, Venice and New York, as portraits rather than cityscapes. While the latter term connotes a factual or impressionistic appearance at a particular place and time, "portrait" signifies the condensation of an inner essence, apprehended through personal feeling as in his earlier "psycho-analytical" portraits.

The inspiration for his extended production of grand panoramas conveying this essence derives besides, generally, from his deep identification with humanistic and historical strivings, from El Greco's *View of Toledo* and Altdorfer's *Victory of Alexander Over Darius*. For the Cretan artist, himself like Kokoschka, a wanderer, twice transplanted, the city of Toledo was a special manifestation of the divine presence by virtue of the concentration there of fervid Counter-Reformation religiosity. Altdorfer's *Victory*, on the other hand, is secular, a celebration of the vastness of the material world and the momentousness of purely human occasions. In contemplating this spectacle, Kokoschka was drawn to the extremity of the contrast between this vastness and the minute particularization of its human implications. Jerusalem, with its awesome antiquity and continued involvement in sacred and secular history was an ideal nexus of these two concerns.

At the time of the painting, the winter of 1929–30, the city was not yet the scene of agonized political conflict of the last half of this century, nor had it undergone the feverish spate of modern building which now surrounds it. It presented instead much more of its age old aspect, Jerusalem the golden, the awesome, a fortress, whose battlements and monuments extended in space over a bleak and rocky terrain and in time back to biblical times. The painting seems to take in the mass of the enclosed ancient city as a complete entity contrasted with the irregular hills which extend to a distant and luminous horizon. Within we see a clutter of towers and domes, alley, rooftops, gardens and arcades. Some of the structures are identifiable as monuments of historical significance; others are the accreted evidences of the city's antiquity. A multitude of details both within and without are picked out by means of glittering highlights and colorful shadows with great specificity. This has the effect, as we allow our focus to take in and decipher a variety of particulars, to expand the scale, so that, just as in other Northern paintings (Altdorfer, Van Eyck), a canvas of fairly modest size, in this case 32 by 51 inches, seems vast.

The innate grandeur of the subject is given a special drama by virtue of an approach to space composition, which while not unique, was distinctive of Kokoschka. This consisted of painting from the same motif from two separate locations. In his European city views, for example, he has explained how he would rent two widely separated rooms in a hotel for this purpose. This is geometrically analogous to the horizontal-beam optical range finders used in naval gun-laying before the advent of radar. This requires the artist to combine a multiplicity of views within the canvas, and differs from the snapshot or single view photograph which approximates Albertian Renaissance perspective, in the same way as the wide-angle, or fish-eye lens, or the traveling lens of certain panoramic cameras. The effect is actually more veridical to the experience of being in and moving through the space, as is demonstrated by the usual disappointingness of views taken with a snapshot camera. In *Jerusalem*, this results in the strongly marked diagonal thrusts from near the center of the foreground, asymmetrically to the horizon, which are countered by the diagonal protrusion forward of the city walls so the space seems both to open outwards and come toward us.

This is echoed by a host of small diagonal planes and brush-strokes throughout the picture, so that at each point our glance is directed to another interval in depth, and, as these accumulate, to shearing movements or vectors in space, almost perpendicular to the picture plane, as between the second nearest cow and the domed structure at the right hand side, or from the center cow to the corner of the city walls. Every part of the picture is caught up as in a musical fugue, darting, shifting, carrying our gaze in a continual counterpoint of description. This formal structure, which excites the sense of physical presence and connection, is the vehicle for the expressive import of the painting, where the presence of the Arab herdsmen in the foreground states the contrast between the overarching events of human history, wars, dynasties, veneration and awe, and the humble ongoingness of everyday life. By extension, in its meaning, this is the capturing of the sense of the individual soul posed against eternity.

Along with all this specification the painting is very loosely, even spontaneously executed, producing in its shimmer and informality of brushstroke a light-filled, enveloping atmosphere. Something must be said in this regard about the distinctive quality of Kokoschka's color, even though this does not show in the reproduction.

Kokoschka is part of the tradition of what Sir Kenneth Clark has called, "the northern lights," colorists including Altdorfer, Van Gogh, Turner and Friedrich, and undoubtedly affiliated to the tradition of expressing the spiritual through the sensuous. His color is always searchingly vibratory, pitching one hue against its opposite, as, in the present picture, the glowing red-browns against acid blues and greens and accents of cool white, the whole floating in a kind of atmospheric soup of neutral ochres and gray-greens. Besides giving a juiciness and vivacity descriptively, this participates in what can best be called, "color volume." It is in the nature of an intuition which unites the optical and the physical. In the case of Kokoschka, it was recounted to me by a friend who accompanied him when he visited museums in the United States, that artist would inspect each picture by standing quite close and moving his upraised hand across and within a few inches of its surface in small patting movements as if palpating the weight and elasticity and pressure of each patch of color. This pulsating, physical presence, pushing forward and thrusting back establishes a voluminosity, different from that given by the drawing elements of overlap and modelling and perspective which is both enveloping and specific. For Kokoschka, it is an ultimate means of plastic expression as modelling and gesture for Michelangelo, linear rhythm for Van Gogh or Soutine. It creates for him the integrity of the picture. So that, through it, he emerges not only an artist dominated by feeling, an expressionist, but also a great constructor of pictorial form, for which he is not always given his due. *Jerusalem*, by virtue of the particular physical aspects of the subject as well as its unique historical and spiritual associations, brings out the distinctive, and indeed, idiosyncratic duality of Kokoschka's expression.

—Louis Finkelstein

Bibliography—

Hoffmann, Edith, *Kokoschka: Life and Work*, London 1947.
Wingler, Hans Maria, *Oskar Kokoschka: The Work of the Painter*, London and Salzburg 1958.
Hodin, J. P., *Kokoschka: The Artist and His Time*, London 1966.
Kokoschka, Oskar, *My Life*, London 1974.

The following text appears in the artwork within the image:

chair, n hence v; chaise (longue) and chay; (ex) cathedra, cathedral (adj and n), cathedratic; element -hedral, -hedron, q.v. sep.

1. Gr *hedra*, a seat (cf Gr *hezesthai*, to sit, and, ult, E SIT), combines with *kata*, down (cf the prefix *cata*-), to form *kathedra*, a backed, four-legged, often two-armed seat, whence L *cathedra*, LL bishop's chair, ML professor's chair, hence dignity, as in 'to speak *ex cathedra*', as from—or as if from—a professor's chair, hence with authority. L *cathedra* has LL-ML adj *cathedrālis*—see sep CATHEDRAL; and the secondary ML adj *cathedrāticus*, whence E legal *cathedratic*.

Collection of the artist

152

Joseph Kosuth (1945–)
One and Three Chairs, 1965
Photographs and chair
New York, Museum of Modern Art

Joseph Kosuth's *One and Three Chairs* (1965) demarcates the self-referential and self-reflective project associated with conceptual art with precisely the same sense of authority with which Marcel Duchamp's *Fountain* (1917) incarnates the proposal that art should henceforth be a question of ideas and choice (as opposed to the literary or anecdotal conventions of "aesthetic delectation"). As Kosuth observes in *Art After Philosophy* (1969), "The function of art, as a question, was first raised by Duchamp.... With the unassisted Ready-made, art changed its focus from the form of language to what was being said ... from 'appearance' to 'conception'."

One and Three Chairs takes the Duchampian assertion that any object may function as art in an art context several steps further, by indicating the plurality of ways in which any particular concept—such as "chair"—may be represented. In this instance, Kosuth juxtaposes three variants of the concept "chair," successively presenting, from left to right, a photograph of a chair, a real three-dimensional chair, and a photographic blow-up of a dictionary definition of "chair." (Viewed in reproduction, in reduced "illustration" format, Kosuth's installation assumes yet another format: the page-size black and white photographic simulation).

What seems most significant in Kosuth's *One and Three Chairs* is not so much any expressive or aesthetic evocation, as Kosuth's problematization of three different modes of representation. Put very simply, we are asked to consider the different discursive qualities and functions of photography, literal presence, and textual definition (rather than to evaluate competing modes of beauty, like Paris, confronting the charms of The Three Graces).

One and Three Chairs typifies the deconstructive impulse in the art of the late 'sixties and offers quite striking parallels to what one might think of as the "conceptual theory" of "new philosophers" such as Jacques Derrida. Just as Kosuth juxtaposes conflicting variants of the concept *chair* in order to evoke the differences between photography, three-dimensionality and dictionary definition, Derrida's deconstructive writings deploy what he terms "the systematic play of differences" in order to identify or evoke concepts and contradictions overlooked by traditional semiotic systems and oppositions. In both instances, provocative play replaces the aspiration to attain definitive exegesis. So far as Kosuth is concerned, "It just isn't possible to make conclusions about the world in the way it once was.... The assumption of traditional philosophy and religion are unreal at this stage of man's intelligence." Accordingly, "art's viability" is associated primarily with "its ability to exist as a pure, self-conscious endeavor ... concerned with the special issues related only to art."

These statements from Kosuth's interview with Arthur Rose (in *Arts Magazine*, 43, No.4, February 1969), find frequent counterparts in the subsequent writing on the Post-Modern condition by Europeans such as Jean-François Lyotard, who similarly emphasizes the demise of traditional "master narratives." On the one hand, Kosuth's stance appears to offer a boldly pragmatic response to an era of philosophical uncertainty. If it is the case that traditional philosophical and religious enquiry appear "unreal," then art might just as well investigate its own functions and its own discursive conditions. On the other hand, Kosuth's refusal to look beyond "special issues related only to art" suggests that his practice might also be interpreted as a latter-day equivalent of Wilde's rather similar self-dedication to special issues related only to art, with the obvious difference that, whereas Wilde's approach to art is unashamedly hedonistic and aesthetic, Kosuth's premature fin-de-siècle retreat from questions of truth and religion is unashamedly functional, conceptual, and anti-aesthetic.

Considered retrospectively from the early 'nineties, Kosuth's art seems both distinguished and to some extent deprived by its rejection of existential, ethical and metaphysical problematics. Compared with "chair" pieces by artists such as Brecht, Warhol and Beuys, Kosuth's *One and Three Chairs* seems remarkably—and perhaps regrettably—scholarly and hermetic.

The Fluxus artist George Brecht's *Chair Events* (1960) humorously evoke the overlaps between art and life by exhibiting a series of chairs—covered with a glove, a shirt, a can of paint and a loaf of bread—in gallery space. As Brecht remarks, these pieces are intended both to be viewed and "to be used," rather than merely being placed on a pedestal, like Duchamp's objects. While Kosuth insists that his work is not made with either "home or museum" in mind, his pieces seem to lack both the user-friendly quality of Brecht's work and the more complex associations of Warhol's and Beuys' deconstructive "chair" pieces. Contemplating Warhol's *Electric Chair* silkscreens of the mid-sixties, one becomes aware of the considerable tension between the self-consciously neutralizing impact of their flat monochrome surfaces, and the potent, menacing quality of their subject. Joseph Beuys' fat sculpture, *Fat on Chair* (1982), similarly problematizes our conception of the chair's function by covering a chair with the literally repulsive and symbolically attractive bulk of a huge wedge of fat; a reminder perhaps, that material functionality may also be supplemented by the spiritual energy that Beuys associates with the life-preserving qualities of felt and fat. Perhaps art's capacity to look beyond the "functional" is not so obsolete as Kosuth supposes.

—Nicholas Zurbrugg

Bibliography—

Battcock, Gregory, ed., *Idea Art*, New York 1973.
Ramsden, Mel, and others, *Joseph Kosuth: Investigationen uber Kunst und Problemkreise seit 1965*, exhibition catalogue, Lucerne 1973.
Stangos, Nikos, ed., *Concepts of Modern Art*, London 1981.
Boiurriaud, Nicolas, "Joseph Kosuth entre les mots," in *Artstudio* (Paris), Winter 1989.

154

Jannis Kounellis (1936–)
Civil Tragedy (*Golden Wall*), 1975
Installation
Naples, Galleria Lucio Amelio

This work, completed in 1975 on the occasion of Jannis Kounellis' solo exhibition at the Modern Art Agency in Naples, Italy, was published as *Untitled*. Four years later it was published again in the catalogue of the one-man show at the Folkwang Museum at Essen, and in 1986 it was included in the catalogue of the exhibition at the Museum of Contemporary Art of Chicago, under the title *Civil Tragedy*. The composition consists of a wall covered with gold sheets; in front of the wall a coat hanger with a coat and hat, and an oil lamp in a corner. This is a disquieting work before which one experiences a variety of sensations. The gold surface makes the wall light, makes it magically vibrate under the glittering light. The coat and hat suggest the presence of a man who is about to return and whose return awaited. The burning lamp reinforces this idea, and underlines the passing of time through the burning of oil. Man, his existence, is the focus of interest in all Kounellis' work. Space being his field of action, the artist takes possession of it with all it contains, and inserts it as an active component of his artistic expression in order to reach a perspective problematic of the world.

After having recorded, during most of the 'sixties, the graphic poem of a city captured in the banal everyday life, Kounellis sensed the danger of becoming chained to a style which would have prevented him from reaching that perspective of the world for which he had been searching since his first works. After profound reflection, which enabled him to widen his artistic language, in 1967 he presented some works at the Attico Gallery, which, because of their vocation are a prelude to his following works, to *Civil Tragedy*. Among other works, he exhibited three white fabric roses applied by press-studs onto a large canvas, with twelve cages containing birds at the corners. The result is an absolute image, abstracted from any natural context.

On the occasion of the exhibition, Alberto Boatto wrote: "Among the different devices for dilating art beyond the boundaries of the picture in order to invade space, Jannis Kounellis has adapted some of the most subtle and ironically charming strategies among those I am aware of today: applying temporary roses in space. The innocent invasion is based on a very simple iconographic unity: a rose in its triple versions—closed, fully matured and withered—is repeated on large panels strategically placed close to each other, with the aim of creating an environment. . .". The painting, therefore, invades space, involves it totally. But it is not only artistic space which becomes involved, but rather the space of life itself; those cages with birds are the testimony of natural reality. Boatto continues: "in the chain of flowers some links become loose, the succession leads to a void, suggesting the intimate and immaterial image with which each of us has to fill that absence. The effect is that of entering a garden frozen by a dream, as if in an allegory, of stylisations and purism. . .". Here already we find a suggestion for the reading of *Civil Tragedy*; the idea of building an environment into which to enter, if not as in a dream, as if in a sublimated reality. The gold, spiritual colour of primitive painters, works effectively to that end, filling the void, one of the central themes of the existential malaise of man and Kounellis' work.

There is no doubt that each work, beginning from the latter half of the 'sixties, constitutes a fragment of a global project which aims to put the artist and reality in a close relationship. The aim expressed by the "roses" of 1967 is to include within the artistic process as many expressive energies as possible. Thus Kounellis' research aims to the widening of his linguistic repertoire. He wants to involve the space of art with elements taken from everyday life, or borrowed from the natural world.

In another exhibition held in the same year, also at the Attico Gallery, he exhibited some metal containers full of earth in which cacti were planted, and a canvas against which stood a parrot. As previously, he added those elements able to give references external to the painting itself, and the same theme is applied to sculpture; to free oneself from the limitations imposed by tradition in order to proceed towards a total identification of art and reality. If, with these works a further step is taken towards an ever wider involvement of space as the place of existence, and the foundations are laid for the successive phase linked to "performances," it is still true that Kounellis wishes to remain within the problematic of art. In other words, he does not want life to overtake art, but to realise an art which is able to express itself to the highest degree.

In some works, it is possible to recognise references to the materials or the poetics previously used by other artists. A sort of use of the citation that enables him to remain linked to artistic language. References can be recognised in Kounellis' work, which might have been taken from some of the foremost exponents of Italian artistic culture of the post-war period. In some cases he utilises sacks, already used by Burri; he leans them against the wall or stretches them in metallic structures. In others he uses some rough wool, which Manzoni had already used for his monochromes, and with it covers some poles or inserts it between taut ropes.

Kounellis is interested both in the signs of art and those of life, but prefers the second aspect, which he calls "of sensibility." In some works he uses fire and metallic bed-frames. In a work dating from 1969, a gas-ring with the flame fed by a gas cylinder is applied to a metallic bed-frame. The bed, as existential measure of man, is thus subjected to the transformations of fire. Other works are produced with metallic bed-frames: on one he puts a pile of cotton; on another he lays burning bricks of inflammable compounds. Two measures of the human condition: the first is a metaphor for birth, the second a metaphor for death.

Life and death are the terms within which our existence is consumed, and between presence and absence is everyday life. Kounellis defined his work as "the iconography of iconoclasm," that is, building a world of images through the sense of destruction. An apparently contradictory condition. How is it possible to construct and to destroy at the same time? Deleuze, one of the most famous French philosophers, has pointed to a possibility in the "paradox." They have, he writes: "the characteristic of going in two directions simultaneously, and to make an identification impossible, stressing sometimes one of the effects, sometimes the other." *Civil Tragedy* expresses itself in a double existential and social meaning. It is life which, facing death, gives it a reason for existing. But it is also contemporary artistic language, theatrical and all embracing, which measures itself against the past.

—Roberto Lambarelli

Bibliography—

Felix, Zdenek, and Cora, Bruno, *Jannis Kounellis*, exhibition catalogue, Essen 1979.
Jacob, Mary Jane, and McEvilley, Thomas, *Kounellis*, exhibition catalogue, Chicago 1986.
Fuchs, Rudi, *Jannis Kounellis*, exhibition catalogue, Turin 1988.
Cora, Bruno, Froment, Jean-Louis, and others, *Kounellis*, Barcelona 1989, New York 1990.
Kounellis, Jannis, *Odyssee Lagunarie*, Paris 1990.
Beeren, Wim, and Briganti, Giuliano, *Via del Mare: Jannis Kounellis*, exhibition catalogue, Amsterdam 1990.

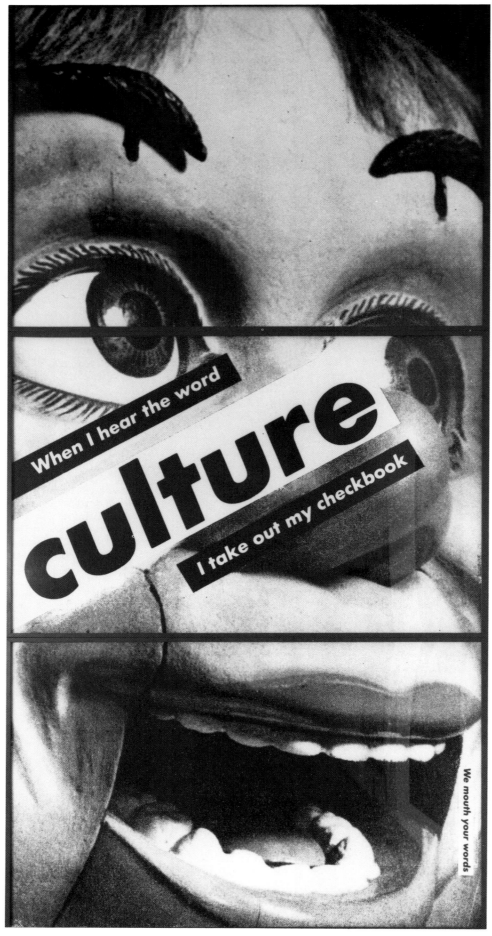

Courtesy of Mary Boone Gallery, New York

156

Barbara Kruger (1945–)
When I Hear The Word Culture I Take Out My Checkbook, 1985
Photo-collage; 138 × 60 in.
New York, private collection

A pluralist conception of visual culture emerged in postmodernist art in the 1980s engendering both social issues and hidden ideological agendas. Along with other artists, such as Cindy Sherman, Jenny Holzer and Sherrie Levine, Barbara Kruger explores media-conscious imagery as a way to address, question and initiate social change. By appropriating particular media images and language, Kruger's work functions as critical inquiry into feminist and other political agendas that address issues and provoke debate well beyond the gallery walls.

Untitled: When I Hear The Word Culture I Take Out My Checkbook, presents a critical discourse on 1980s consumerism. Since the 1950s in America, continuous economic growth has generated a new consumer culture. This increased affluence and resulting social mobility is manifest in an increasingly self-conscious construction of individual lifestyles. *Untitled* parodies American popular culture through its selection of 1950s media imagery. Specifically it employs an American children's television freckled-faced cowboy puppet to stimulate nostalgic reflection upon an assumed happier more carefree attitude of the 1950s. As a popular cultural icon, Howdy Doody's image stimulated the production of a variety of consumer goods, from the beginning of his television programme in 1947 until the last show aired in 1960. The diversity of 1950s lifestyles introduced a democratic notion of "choice" in the arena of consumer culture. In response, the Howdy Doody Show was able to market an entire range of goods from cowboy lunch boxes, clothing, masks and food stuffs. As specific meanings and values are associated with consumer goods a "whole way of life" is secured by their purchase. With respect to Howdy Doody, the myth lives on through the fetishism of new consumer products and the lifestyles they convey.

Trained as a graphic designer, Kruger is familiar with the immediacy of meaning that design techniques can construct. *Untitled* is produced as a poster—an accessible and recognizable format for the general public. *Untitled* also employs the recognizable forms of old display ads and newspaper headlines, collage with bold strips of text and coloured bands—a mediation ploy to sell particular forms of lifestyle to a consuming culture. While working at the publishing company Conde Nast, the process of design activity often meant that text and image were produced separately. In contrast, Kruger's career as an artist is focused on creating compositions where image and text are combined to produce a coherent, yet subversive, rhetoric. The juxtaposition of Kruger's photographs and texts visually support her probing into the authority of modern social and cultural hierarchies. The combined discourse is constituted with familiar media imagery found in mass circulation and results in an accessible and instant reading of the re-presented photo-text. The language is the common language of the street.

Kruger fragments her texts as if cut out from the magazines she once worked on. Her work also uses photographs drawn from television, film and photographic annuals. They are cropped and enlarged, thereby removing the printed matter from its original context and reinvesting the imagery with new meaning. The image of Howdy Doody is used in *Untitled* to initiate this process by inducing an immediate encounter with the puppet's face. Although Howdy Doody is re-presented, the image is part of the spectator's original vocabulary. In this way, photographs produce and document images from the spectator's own history.

Untitled is divided into three horizontal panels with text inserted into the middle panel and vertically along the bottom. The frame functions as an artistic device but also places the spectator linguistically within the frame as a "captive." Kruger's adoption of other vehicles of expression suggests an active participation in representation of contemporary cultural trends. Present culture is dominated by the output of mass media, and Kruger is not a passive observer or consumer of culture. Her text, "When I hear the word culture I take out my checkbook," suggests the expression and exercise of power in the purchase and acquisition of "culture." The legitimization of this process of commodification is made through Kruger's manipulation of "original" forms of mass media—television, advertising and film—whose cultural aesthetic and moral criteria has already been established in recognizable lifestyles. Kruger uses this popular imagery to produce a displaced language, thereby subverting accepted cultural signs. In effect, Howdy Doody also represents an unwitting accomplice controlled by advertisers to direct and regulate consumer desire and ultimately the purse-strings.

In contemporary western consumer culture the activity of shopping has often been associated with women's roles. The rise of the modern advertising industry was directed almost exclusively toward the female market. Within this historical context Kruger actively confronts the nature of female roles represented and circulated in the media. She promotes the view of female consumers as unwitting victims "caught within the structure of patriarchal language." The added text running vertically along the edge of the piece, "We mouth your words," reinforces the stereotypical image of women as puppets in the process of cultural commodification.

The narrative is multifold. The shift of gender-oriented pronominal referents in Kruger's text, from "I" to "we," emphasises the author's own shifting identity as well her definitions of the text. The observer's position likewise shifts. According to Kruger, the introduction of personal pronouns is used as a means of directly "greeting the viewer." Pronouns invite the spectator to participate as narrator or storyteller. But the use of pronouns also introduces ambiguity. The shifting "we" could be the narrator, Howdy Doody, women or indeed Kruger herself.

Untitled re-presents images and graphic techniques from posters, advertising and television, and questions the processes of forming cultural identities. The process criticised here most directly is the construction of personal identity through an affiliation with material goods that have been invested consciously with new and manipulated meanings. Ironically, the process is similar to the process engendered by Kruger's photo-texts themselves. These goods/images do not function necessarily as forms of original intent. They have progressed, as Baudrillard once suggested, from "use value to sign value," thus providing a lexicon of contemporary American consumer visual grammar.

—Teal Triggs

Bibliography—

Kruger, Barbara, and Owens, Craig, *We Won't Play Nature to Your Culture*, exhibition catalogue, London 1983.
Kruger, Barbara, "Virture and Vice on 65th Street," in *Artforum* (New York), January 1983.
Foster, Hal, "Subversive Signs," in *Art in America* (New York), November 1983.
Linker, Kate, "Barbara Kruger," in *Flash Art* (Milan), March 1985.
Kamimura, Masako, "Barbara Kruger: Art of Representation," in *Women's Art Journal* (New York), Spring/Summer 1987.
Kruger, Barbara, and Linker, Kate, *Love for Sale: The Words and Pictures of Barbara Kruger*, New York 1990.
Deitcher, David, "Barbara Kruger: Resisting Arrest," in *Artforum* (New York), February 1991.

Photo M.N.A.M., Paris. © ADAGP, Paris and DACS, London 1991

Frantisek Kupka (1871–1957)
Vertical Planes, 1912
Oil on canvas; 59 × 37in. (150 × 94cm.)
Paris, Musee National d'Art Moderne

Kupka's painted series of *Vertical Planes* are the first fully realised expressions by him of a theme of wholly abstract verticality. Even though this trait had begun to emerge in his paintings as early as 1906, previously the enframing compositional context was still unmistakably based on the painter's perceptual experiences. As a result, Kupka's paintings were then still generally figurative, and his painterly execution employed broad and impasted brushstrokes that underscored the tangibility of the material surface. To the contrary of the preceeding work, the soft-edged but rigidly structured rectangles deployed in *Vertical Planes I* of 1912 appear to be mysteriously suspended upon a thinly painted and nearly wholly atmospheric background. By 1912, Kupka's figuratively "dematerialised," or wholly unmodelled ground-planes begin to convey the idea of an infinite spatial continuum. The diagonally sliced tops and bottoms of the laterally placed planes produce an otherworldly effect of free-floating and slowly twirling objects, which now appear to represent a new kind of Cosmos, an alternative universe conforming to otherworldly principles of de-gravitation. The delicate colours characterising both figure and ground emphasise the essentially un-substantial quality of Kupka's weightlessly suspended geometrical shapes. In a private manuscript, now dated a few months after the execution of this canvas, the emigré Czech painter observed how: "A rectilinear order appears as the most energetic, abstract, elegant, absolute order. . . . The vertical line is like a man standing erect, where the above and the below, top and bottom are suspended and, since they stretch from one to the other, they are united, identical, one. . . . Profound and silent, a vertical plane helps the whole concept of space to emerge."

By the date, 1912, of his *Vertical Planes I*, Kupka had obviously become a wholly "abstract" painter—and that is a term as much applicable to the painter's thought as to his formal means. In fact, at that moment, Kupka's only real competitor in the initial creation of such completely *gegentstandlöse Malerei* was Wassily Kandinsky. Whereas Kandinsky's celebrated, self-entitled "Non-Objective Painting" tended towards contrasted and often strident colouration and curving, bio-morphic shapes, Kupka's cooly tinted, rectilinear forms represented what were probably the first purely, and purposely so, "geometrical abstractions" in modern avant-garde art. In the case of the much better-known Russian expatriot painter, who was then working in Munich, scholars now recognise that Kandinsky's fairly abrupt movement (ca. 1911) into completely abstracted figuration had largely been propelled by his commitment to the principles of Theosophy, a then-popular occultist sect. All this is well documented in Kandinsky's treatise *Über das Geistige in der Kunst* ("Concerning Spirituality in Art," 1912)—which Kupka only "discovered" in July 1913. But what was the impulse in Paris for Kupka's non-objective art, which, well before 1913, had been consummated, without any real knowledge of Kandinsky's work? As it turns out, very much the same thing . . .

Kupka's original involvement with the broadly mystical concerns—and, later, more specifically "occult" pursuits, when they became textually more focused—dated from his childhood in Bohemia. As a teenager, he was apprenticed to a saddler named Šiška who, in his leisure hours, regularly conducted spiritualist seances and headed a local secret society. Kupka was an apt pupil; later, in Prague, the future artist became a much appreciated, and often well paid, spiritual medium. From 1892 on, Kupka was enrolled as an art student at the Academy of Art in Vienna; at this time, he began to read avidly, generally in various kinds of occultist literature, particularly in Theosophical publications. As early as 1910, Kupka announced in writing that he was preparing to state publicly his beliefs in spiritualism in general—and in Theosophy in particular (his notes were later published as a book, *Tvoření v Umění Výtvarném* [Creation in Art], in 1923). As is common with many modernist occultist groups, and to Kupka as well, space is

viewed as infinite, colour acquires symbolic value, and everything—organic or inanimate—is taken to be in a constant state of flux. As may be allowed, Kupka's vertical-plane compositions deal with "sacred geometry." More specifically stated, the overall idea is broadly Theosophical, representing the idea of "Evolution," here metaphorically portrayed as an upward movement, leading from base "Matter" into the intangible realms of pure "Spirit."

For our purposes, among Kupka's known esoteric readings, most important were works by the Theosophists, and a typical example of these is an illustrated book—in which nearly all the brightly coloured plates are completely "abstract"—composed by Annie Besant and C. W. Leadbeatter in 1901. Called *Thought-Forms* (and translated into both German and French by 1908), this is, for instance, a provocative work that Kandinsky knew—and even extensively annotated.

Theosophical colour-symbolism also conveniently explains the "deeper" significance of the chromatic values in Kupka's *Vertical Planes*. For instance, according to Besant and Leadbeatter, "Affection expresses itself in all shades of crimson and rose [whereas] the different shades of blue all indicate religious feeling." These are only two of the many chromatic symbols described in much great detail by the Theosophists, and all these explanations are treated as dealing with the directly visual "expressionism" of many different kinds of emotional states.

As much for the Theosophists as for Kupka after 1912, the essence of Nature was manifested as a rhythmic, quasi-musical geometric force—to which various symbolic colours may be additionally attributed. After visting Kupka in Paris in 1912, a Czech poet, Richard Weiner, said that the synesthesiac artist "wants painting to sound like music." As Kupka told another interviewer a year later, "I believe I can find something between sight and hearing, and that I can produce a fugue in colours, just as Bach has done in music." Similarly, in a Theosophist publication like *Thought-Forms*, "Forms Built By Music" will be discussed at some length; as the Theosophists repeatedly affirmed, "sound produces form as well as colour, and every piece of music leaves behind it an impression of this nature, which persists for some considerable time, and is clearly visible and intelligible to those [the initiated] who have eyes to see [and] hundreds of volumes might be filled with [Theosophical] drawings of the forms built by different pieces of music."

That is just another largely Theosophical *leit-motiv* that Kupka shared—independently—with the "spiritual" recommendations similarly contained in Kandinsky's *Über das Geistige in der Kunst*. In short, the kind of radical abstraction pioneered in the work of many of the Early Modernists was scarcely a matter of empty formal exercises. Instead, as originally conceived and executed, those supposedly "meaningless patterns" were really meant to be read as pseudo-philosophical diagrams of cosmological forces and transcendental fates. The fact that these wholly pictorialised philosophical systems and statements still remain largely illegible, hence a "mystery," to an intelligent contemporary museum visitor must be reckoned the persistent fault of art historians—who have miserably failed for the most part of explicate properly the seminal works of the great pioneers of abstract art.

—John F. Moffitt

Bibliography—

Kupka, Frantisek, *Abstrakce Kreslil*, Prague 1948.
Fedit, Denise, *L'Oeuvre de Kupka*, Paris 1966.
Vachtova, Ludmila, *Frank Kupka: Pioneer of Abstract Art*, New York 1968.
Rowell, Margit, and Mladek, Meda, *Frantisek Kupka 1871–1957: A Retrospective*, exhibition catalogue, New York 1975.
Tuchman, Maurice, ed., *The Spiritual in Art: Abstract Painting 1890–1985*, exhibition catalogue, Los Angeles 1986.

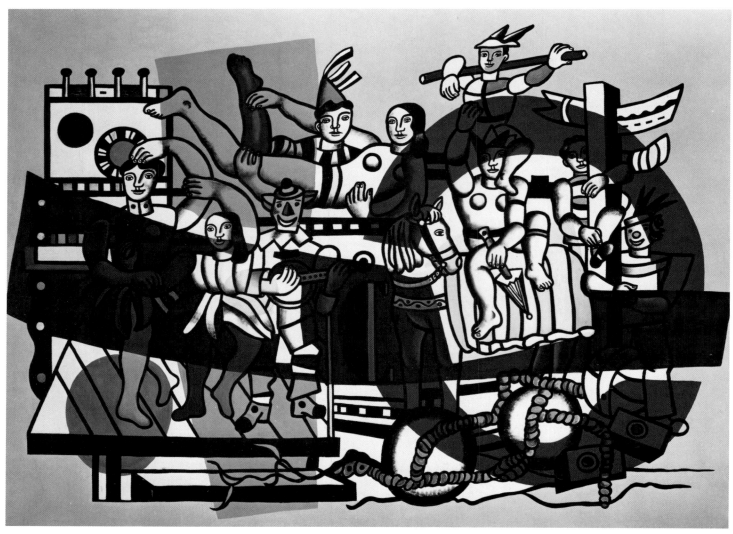

Photo Robert E. Mates © DACS 1991

Fernand Leger (1881–1955)
La Grande Parade, 1954
Oil on canvas; 299 × 400cm.
New York, Guggenheim Museum

Léger made a lot of preparatory drawings and gouaches for *La Grande parade*. After two years, in 1954, the painting was finished. It has become not only a representation of a circus finale but also the apotheosis of Légers own career.

"I am a classical artist," Fernand Léger could proudly announce after *La grande parade*. The picture has the dimensions of a wall painting. Nobody can overlook the vigorous, well-defined outlines by which the jugglers, acrobats, clowns and their attributes have been monumentalized. Léger has not given a sketchy, impressionist view of circus life, neither are the circus figures arrested in their movements or represented in their particular features as individual portraits. Here, circus life has been stylized beyond life, as in an Egyptian hieroglyph frieze. In a way, it is language and image at the same time.

Colour seemingly plays its own part. "First drawing, secondly colour," Léger once said. A circle of red, planes in blue, orange, green and yellow form together a second layer, now and then coinciding with the forms of the circus figures. First, *La grande parade* is figurative, secondly it is abstract. Yet there is a relation between the two qualities. Colour fulfils the role fanfare music plays in a real circus show. Besides, the broken circle in red alludes to the circus ring. Amidst the broad, blue strip that runs from left to right one can detect a big letter C—for *cirque*.

Léger finished his painted monument of circus life in 1954 when he was 73 years old. It was, however, not the first time he had handled the theme that already had a certain popularity in French art, as is shown in the works of Seurat, Rouault and Picasso. At several stages in his career Léger dealt with the subject. He published in 1950 a litho map entirely devoted to the circus. "I must tell you about the importance of the circus in provincial towns," he said shortly before his death in 1955. He recalled his childhood as a peasant's son in Normandy, and the big event when a circus arrived. The setting up of the tent, the spectacle of wild beasts, clowns and acrobats and the final "parade" must have been an unforgettable experience for young Léger. In *La grande parade* the souvenir has been recalled by an artist, who shortly before World War I, became one of the main protagonists of Parisian cubism. Afterwards, Léger developed this cubism into a more realist, classicist style. When he painted *La grande parade* he actually was influenced by Jacques-Louis David (1748–1825), the neo-classicist painter of the French Revolution.

In contrast with the far-reaching analytical experiments, around 1910, of his former artistic brothers-in-arms Picasso and Braque, Léger's brand of cubism was from the start firmly bound to reality. From Paul Cézanne, who had a tremendous impact on all three artists, Léger learned a new pictorial language. The elementary forms of Cézanne became in his hands the shapes of modern mechanized society—the cones were the shining grenades and gun barrels he saw as a soldier during the onslaught in World War I, the cylinders were the pipes and tubes of modern factory machines (jokingly his cubism was referred to as 'tubism'). In Léger's paintings the human figure received the same impersonal, machine-like appearance. Heads are streamlined, hair looks like undulating sheets of metal, limbs like spare parts of machines assembled for other purposes.

In his early years subject matter was for Léger not a neutral vehicle for pictorial experiments as it was in many of Picasso's and Braque's still lives. The importance Léger attached to the representation can already be observed in *Les nus dans la forêt* (1911), wherein the "nudes" actually are the cylindrical trees slain by wood cutters, or in *La partie des cartes* (1917) wherein Léger gave a striking image of his fellow soldiers in World War I during a pause in the battle in the trenches. After the war, Léger was influenced by the movement which then pervaded French art and which is called "Le retour à l'ordre"—the return to (classicist) order. Cubism became more realistic and became mixed with surrealist elements, for instance the principle of *montage*.

In *La grande parade* the world of objects, human figure included, has still been dealt with in the manner which derives from cubism. The figures have been reduced to essential forms. The principle of montage has been applied to those simplified forms, combined into a new ensemble. The painting is classical in as far it is monumental and unambiguous.

In his themes, Léger—a member of the French communist party—exploited the antique heroes of David have stepped from their socles and become working class people during leisure or, as in *Les constructeurs* (1950), working time.

Léger, whose physical appearance resembled a down-to-earth labourer and who called himself a *maçon* (brick layer) in paint, was not an intellectual. His goal was not to make art for art's own sake. Apart from some paintings in the 'twenties he never made abstract art. He tried to create, by new means, an art comprehensible to a large public. In this way, *La grande parade* is not only Léger's personal homage to circus entertainment but also he offers a lively alternative to the soulless clichés of socialist realism, for instance, as practised in the Soviet Union.

—Jan van Geest

Bibliography—

Leger, Fernand, *Selected Writings*, Paris 1959.
Francia, Peter de, *Leger's The Great Parade*, London 1969.
Leymarie, Jean, *Fernand Leger*, exhibition catalogue, Paris 1972.
Cassou, Jean, and Leymarie, Jean, *Fernand Leger: Drawings and Gouaches*, London 1973.
Schmalenbach, Wrerner, *Fernand Leger*, New York 1976.
Bauquier, Georges, *Fernand Leger: Vivre dans le vrai*, Paris 1987.
Whitechapel Art Gallery, *Fernand Leger: The Later Years*, exhibition catalogue, London 1987.
Serota, Nicholas, *Fernand Leger: Zeichnungen, Bilder, Zyklen 1930–1955*, Munich 1988.

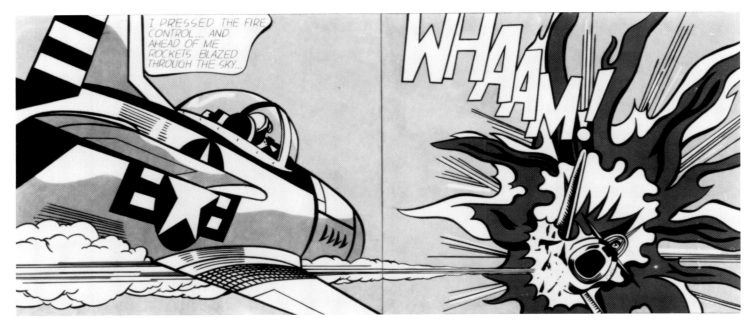

© DACS 1991

Roy Lichtenstein (1923–)
Whaam!, 1963
Magna on two canvas panels; 68 × 160in.
London, Tate Gallery

During the early 1960s when Abstract Expressionism was still widely accepted, London, New York, and Los Angeles simultaneously experienced the raucous aesthetic intrusion which we now call Pop Art. Among the forerunners of this explosive international art movement was Roy Lichtenstein, who from 1961 to 1965 based many of his compositions on pre-existing imagery found in actual comic strips, product catalogs, and advertisements.

For Lichtenstein, becoming a Pop Artist in 1961 meant turning to the comic strip and to anonymous-looking commercial art for the inspiration to create a new painting style which would parody the style of contemporary art and society: "What interests me," he stated in 1970, "are the symbols which come about in commercial art through labor-saving devices. In a cartoon, for instance, a lot of the way the image is drawn is for the expediency of the printer. This produces a kind of idealism as to what a pretty girl, or a handsome man, or a commercial product looks like." Ironically, the anonymous-looking execution of cartoons and commercial art was soon adopted and transformed by Roy Lichtenstein into a highly personal style with which he subtly made references to past styles. Commenting on his early predilection to draw inspiration from styles other than his own the artist explained, "I often transfer a cartoon style into an art style. For example, the Art Nouveau flames at the nozzle of the machine gun. It is a stylistic way of presenting the lights and darks. In the *Drowning Girl* the water is not only Art Nouveau, but it can also be seen as Hokusai. I don't do it just because it is another reference. Cartooning itself sometimes resembles other periods in art—perhaps unknowingly."

Lichtenstein's new Pop Art style was first introduced in February 1962 at the Leo Castelli gallery and included *Roto Broil* (1961) which was inspired by an illustration for a deep fat fryer, *Golf Ball* (1962) which as the title suggests was a large black and white enlargement of a stylized golf ball, and *Ice Cream Soda* (1962) which is a vertical composition in blue and white depicting a stylized, frothy soda in a three tiered glass. Lichtenstein's mass-media-inspired canvases seemed truly astonishing, particularly since the hard-edge flatness of the paint application was in considerable formal opposition to the visual illusionism and autographic qualities of Abstract Expressionism. And though Lichtenstein depicted recognizable mass-media imagery such as small appliances, a golf ball and an ice cream soda in his first show, such subjects were presented like twentieth-century icons against a neutral background. Describing these early compositions he stated that in each, ". . . there is an anti-Cubist composition. You pick an object and put it on a blank ground. I was interested in non-Cubist composition. The idea is contrary to the major direction of art since the early Renaissance which has more and more symbolized the integration of 'figure' with 'ground.'"

In addition to his non-traditional compositions in his early Pop Art paintings, Lichtenstein introduced a limited range of colors including a purplish-blue, lemon-yellow, green, red, black and white, the artist explaining in 1967, "I use color in the same way as line. I want it oversimplified—anything that could be vaguely red becomes red. It is mock insensitivity. Actual color adjustment is achieved through manipulation of size, shape, and juxtaposition."

For Roy Lichtenstein, the blatant aspects of commercial art and cartoons often contain a humorous quality which he chooses to explore and develop into major art: "I guess it doesn't look aggressive any more. I want it to be audacious. I like the audacity of the cartoon images. The early imagery looked as though it were understandable immediately, also detestable, also ludicrous. The idea of its being ludicrous isn't so different from Paul Klee or Picasso when they try to be humorous. I think that in the beginning I was interested in its being very funny too. Picasso, Klee, and Miro brought a kind of humor into art which was not a great part of nineteenth-century art. I wanted to make certain things very funny, because there was a new quality to explore. I don't think the humor I'm putting in is the same as Picasso, or Klee, or Miro, but I don't know how to say it's any different."

Particularly in his paintings inspired by romance comics and war comic books Lichtenstein often selected panels which employed text, thereby inviting the interpretation of his considerably larger compositions as scenes taken from visual narratives. Commenting on the literary aspect of his *oeuvre*, Lichtenstein related, "Well, at the beginning of the Pop Art movement my work was more literary. Then, people were so anti-representation that to me the idea seemed interesting to have figurative painting which would appear to be primarily involved in literary expression." Nevertheless, while Lichtenstein's "literary" comic-strip paintings may be inspired by an individual story panel within a comic book's pages, he transforms the original but not particularly memorable imagery and text so that the composition of his considerably larger painting more closely resembles the higher degree of stylization and visual authority of a comic book's cover. Also, in spite of the narrative possibility of comic strip compositions, Lichtenstein has never been particularly interested in a sequence of images as they are presented in comic strip narratives. *Whaam!* is one of the few linked-panel cartoon paintings which he has executed.

When asked by John Coplans in 1967 where he got the inspiration for his war imagery, he replied, "At that time I was interested in anything I could use as a subject that was emotionally strong—usually love, war, or something that was highly-charged and emotional subject matter. Also, I wanted the subject matter to be opposite to the removed and deliberate painting techniques. Cartooning itself usually consists of very highly charged subject matter carried out in standard, obvious and removed techniques."

In the left panel of *Whaam!*, in black letters against a yellow background placed above a diving war plane, we read, "I pressed the fire control . . . and ahead of me rockets blazed through the sky . . ." The right panel of this impressive diptych presents another plane exploding to bits in red, white and yellow stylized flames surmounted by enormous yellow letters spelling out, "whaam!"

Early in his Pop Art career, Roy Lichtenstein commented on the transitory nature of the literary content of Pop Art: "Pop Art has very immediate and of-the-moment meaning which will vanish—that kind of thing is ephemeral—and Pop takes advantage of this 'meaning' which is not supposed to last, to divert you from its formal content. I think the formal statement in my work will become clearer in time." In his use of certain qualities of commercial art and cartoons, such as the uniformity of line and color, dots to obtain tonal values, and the simplification of forms, Lichtenstein employs a highly individual style with which he obtains images of tremendous formal and aesthetic impact.

In 1982 Lichtenstein observed, "Almost everything I'm doing I did in the '60s." Indeed, in works such as *Whaam!* (1963), which at first glance seems no more than an enlargement of a comic strip, we find a superb example of Lichtenstein's fully developed Pop Art style that over the years he has employed to deal with a wide range of new subjects. In superb early works such as *Whaam!*, however, the artist first proclaims unequivocally his genius and stature as a major twentieth-century painter whose works rival those of Matisse in terms of their decorative power and aesthetic innovation.

—Joseph E. Young

Bibliography—

Coplans, John, *Roy Lichtenstein*, Pasadena 1967.
Waldman, Diane, *Roy Lichtenstein*, New York 1969.
Young, Joseph E., "Lichtenstein: Printmaker," in *Art and Artists* (London), March 1970.
Cowart, Jack, *Roy Lichtenstein 1970–1980*, St. Louis 1981.
Alloway, Lawrence, *Modern Masters: Lichtenstein*, New York 1983.

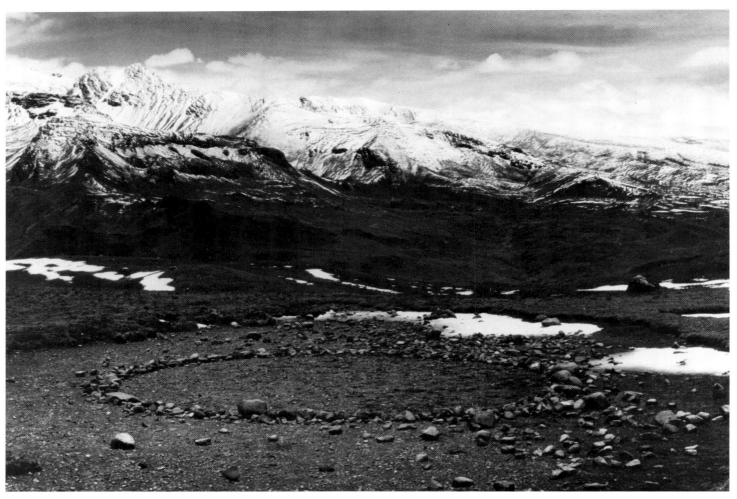

Courtesy Anthony d'Offay Gallery, London

Richard Long (1945–)
Circle in the Andes, 1972
Black-and-white photograph

When Richard Long was a student at St. Martin's College of Art on the "vocational" sculpture course (1966–68), Anthony Caro's presence since 1954 had made the sculpture department very well known amongst the public, critics and dealers. Some of the staff and students, influenced by Caro's work with metal and modern building techniques, were labelled the "New Generation" at an exhibition held at the Whitechapel Art Gallery in 1965. Inevitably a dissatisfaction was to arise with the minimalist constructions of these artists and it showed itself most dramatically in the work of students of Long's generation, such as Hamish Fulton, Gilbert and George and Long himself, amongst others.

"Conceptual" art was already on the move by the mid-1960s in response to Clement Greenberg's influence on the art of the 1950s and 1960s. Greenberg, an American art critic, argued that content should be inseparable from the form on the work itself. This gave automatic credence to painting movements such as *Abstract Expressionism*, *Hard-Edged Abstraction* and *Minimalism* (in both painting and sculpture). An unconcern with social responsibility and an avoidance of interpretation were some of the hallmarks of these artistic movements. These, allied with the massive increase in an investment-conscious art market to which this sort of art was manna from heaven, gave rise to dissatisfaction amongst certain artists to whom, in the social/political upheavals of the late 1960s, the avoidance of contact with "real life," as epitomised by the Greenbergian approach, was reprehensible.

In this climate, where artists were encouraging the breakdown of traditional forms in the interests of social responsibility, it was becoming possible to create art from any kind of activity. At St. Martin's, the students in the sculpture department were encouraged by teachers such as Roelof Louw to incorporate time into sculpture. Richard Long is considered to be St. Martin's most successful student in this approach.

Circle in the Andes (1972), like most of Richard Long's work, is the result of a journey—a long walk. (Long considers walking to be the most respectful way of entering and traversing the landscape.) Stones were arranged in a circle at a particular moment in this long hike and then photographed. From this seemingly simple action can be understood various aspects of Long's work. At the heart of Long's approach is a personal and direct relationship to landscape. He stands, and walks, *in* the landscape. The materials he uses are part of the landscape, and by arranging them as he does, he is not inflicting any harm on the countryside. (Sticks and stones are his most usual materials.) The forms he employs, in this case a circle, but he also uses lines and crosses, are metaphors for movement, distance markers and indicators of the passage of time. As part of his many walks he produces maps to mark where he has been and he gives indications of how long the walk has taken and how much distance he travelled. Photographs are taken to record the walk with captions to simply describe the temporary markers he has left in the landscape, such as the simple stone circle left in the Andes.

Long gave the following beautifully concise account of his work in the publication accompanying his 1980 exhibition at the Anthony d'Offay Gallery:

I like simple, practical, emotional,
quiet, vigorous art.

I like the simplicity of walking,
the simplicity of stones.

I like common materials, whatever is to hand,
but especially stones. I like the idea that stones
are what the world is made of.

My photographs are facts which bring the
right accessibility to remote, lonely
or otherwise unrecognisable works. Some sculptures
are seen by few people, but can be known about by many.

My outdoor sculptures and walking locations
are not subject to possession and ownership. I like the fact
that roads and mountains are common, public land.

I have tried to add something of my own view as an
artist to the wonderful and undisputed traditions
of walking, journeying and climbing...........

Circle in the Andes, with its simplicity, is therefore typical of much of Long's approach to nature and the landscape. It has the apparent simplicity of a stone circle, but without the desired-for longevity that seemingly possessed the creators of the stone circles. The photograph taken by Long will assure that the *Circle in the Andes* will be seen by those who cannot see it "in situ" and its longevity will remain in the photograph presumably long after the natural elements have shifted the stones about.

In *British Art Since 1900*, Frances Spalding refers to the "narrow, poetic vein, reviving the traditional concern with landscape in a new way" that Richard Long (and Hamish Fulton) had "tapped." This attitude, rather different from that of "Land Artists" such as Robert Smithson, takes a strongly ecological approach. It is important to Long that his sculpture is part of the landscape, but without making any long-term disturbance to it. His attempt is not to concentrate on the beauty or drama of a particular scene, but, by expressing his experience of being in and moving through a particular countryside and its constituent materials, to share with his audience something of his love and respect for the non-urban land, whatever part of the world it may be in.

—Victoria Keller

Bibliography—

Long, Richard, *Richard Long*, Eindhoven 1979.
Kettles Yard Gallery, *1965 to 1972: When Attitudes Became Form*, Cambridge 1984.
Fuchs, Rudi, *Richard Long*, London 1986.
Spalding, Frances, *British Art Since 1900*, London 1986.
Compton, Susan, ed., *British Art in the 20th Century*, London and Munich 1987.

EXPANDED ARTS DIAGRAM

INTRODUCTION TO DIAGRAM

The diagram on the right categorizes and describes planometrically the development of various "Expanded performing arts" movements. It describes movements rather than individuals and therefore should not be taken as a catalogue of names. Except for the Fluxus group, none others are complete. By the next edition it is hoped this diagram can be expanded to include more artists. Any comments, suggested additions and/or changes from readers will be welcome. The grouping of various artists was determined in most cases from statements of the artists themselves. When such statements were unobtainable, their work was studied to provide clues. Some controversial subjects such as sensationalism or pseudotechnology were based on careful observations of many performances rather than hearsay. Disrobing in public or lowering own pants to expose own bare bottom, or urinating in public, any such acts are considered by any dictionary definition exhibitionistic. Throwing oneself into water or covering self with cream etc., etc., can be considered as masochistic acts. Examples of preoccupation with sex and perversion are too numerous is to mention. All these stratagems are intended to arouse strong emotional response from the audience (and attention from the press of course), which may be a main motivation for such stratagems. Pseudotechnology or "engineering" (in quotes) has been derived from the fact that artists at best can acquire technical knowledge or understanding comparable to that of a technician (TV repairman or the like) rather than that of an engineer or scientist who spends many years studying his specialty (just like artists spending many years on producing art). Such knowledge among these artists at best represent understanding wiring diagrams, function of basic electronic components, mechanism of electric motors, simple engines, determinate structures and the like. Unfortunately the technology among most of the artists employing that term is of the radio shop variety. Collaboration with engineers can achieve only a level of sophistication comprehended by the artist since (1) artist's new ideas or concepts will be affected or rather limited by his own past and recent technical-scientific knowledge rather than the uncommunicated knowledge of the engineer.
(2) the collaborating engineer meanwhile, can't very well communicate a sophisticated technical and scientific knowledge to the artist without giving him a four year university course on related subjects.

Categories are ordered on the vertical scale to some degree within a spectrum of artificiality. Thus most "artistic" or cultural or serious are at the bottom and least so at the top ending with anti-art at the very top. The horizontal scale is chronological. Influences upon various movements is indicated by the source of influence and the strength of this influence (varying thicknesses of connecting links). Another vertical column indicates outlets, or major organizations, events, publications or institutions associated with the particular movement or group. Lines leading in and out of each persons name indicate various changes in the persons associations or chronological continuity of his work within any particular movement or group. Thus within Fluxus group there are 4 such categories: 1) individuals active in similar activities prior to formation of Fluxus collective, then becoming active within fluxus and still active up to the present day, (only George Brecht and Ben Vautier fill this category). 2) individuals active since the formation of Fluxus and still active within Fluxus. 3) individuals active independently of Fluxus but presently associated with Fluxus. 4) individuals active within Fluxus since the formation of the collective but having since then detached themselves. (Higgins, Patterson, Paik, Schmit, Williams, Flynt etc.) Some of them have even published own statements confirming their exodus.

George Maciunas

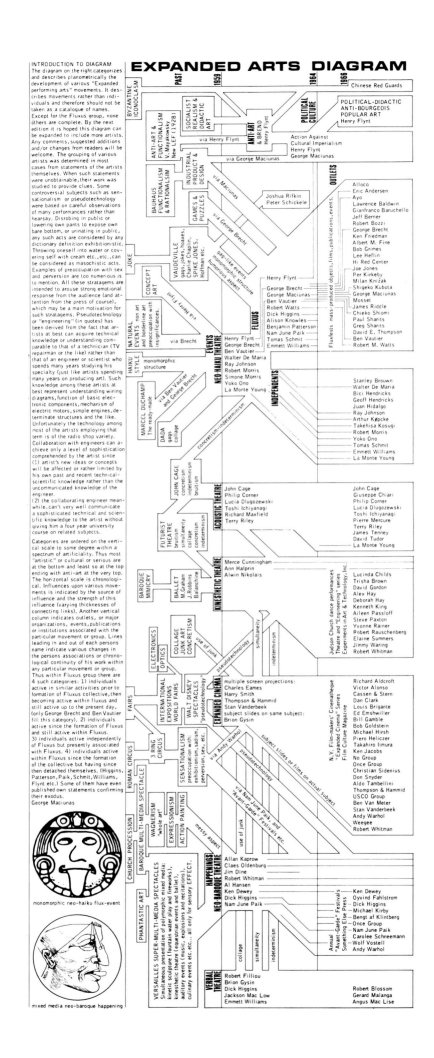

monomorphic neo-haiku flux-event

mixed media neo-baroque happening

166

George Maciunas (1931–78)
Expanded Arts Diagram, 1966

If George Maciunas was not a polymath, he was close to it; and polymathic individuals, ideas and movements fascinated him. Born in Lithuania, he moved to America where he studied architecture, design, art and art history. In his undergraduate and graduate days, he began creating the astonishing charts and diagrams of cultural evolution for which he was to become a legend. A passion for systems and a rage for order characterized everything that Maciunas did, and the crisp organization he sought had far more to do with the light, space and pristine clarity of Zen than with the Byzantine complexity some saw in his projects. The flow of ideas inspired him. He saw relationships between ideas, and connections between historical trends that shed light on the flow and meanings of culture.

Over the years, Maciunas attempted to chart a wide variety of phenomena. One series of notebooks and charts diagrammed the evolution of world architecture. Another followed the course of world music—a field he studied with as much passion and in as much depth as architecture, typography and design. In music, he leapt from visual charting to sonic charting: he undertook a massive series of tape recordings (now lost), in which he demonstrated the evolution and links between forms of music often separated by thousands of miles and hundreds of years. On a global basis, this was comparable to ethnomusicological triumphs such as the famous record, *Music on the Desert Road*, in which the influence of Arabic music is traced across Northern Africa, Southern Europe, the Middle East, and into Asia and India. Maciunas seems to have had the same thing in mind, beginning in ancient China and Pythagorean Greece, moving through European and American music up to John Cage and La Monte Young.

But the grand series of charts diagramming the historical antecedents, evolution and membership of Fluxus—the international colloquium of artists that Maciunas helped to create in 1962, and which Dutch critic Harry Ruhe characterized as "the most radical and experimental art movement of the 1960s"—are the charts for which Maciunas became best known.

To understand Maciunas' Fluxus charts, it is useful to know a bit about Fluxus, his relationship to it, and what it meant to him. Maciunas met many of the artists involved in Fluxus in New York after several of them had already worked together in the famous classes at the New School for Social Research, taught first by John Cage and later by Richard Maxfield. These artists and composers, including Dick Higgins, La Monte Young, Jonas Mekas, Alison Knowles, Toshi Ichiyanaga, Yoko Ono and others, fascinated Maciunas. In such projects as his AG Gallery or the landmark collection *An Anthology*, edited by Young and Jackson Mac Low, he saw relationships between the artists and their ideas, just as he did between converging histories of architecture. To Maciunas, these artists—however dissimilar they felt themselves to be—were a group, even a movement.

As Maciunas met and became acquainted with more and more artists worldwide, he saw them fitting together in an important, if complex, cultural phenomenon which became something he called Fluxus—though, often enough, the artists had a different view of things. The artists Eric Andersen believes that Fluxus was solely a meeting-place, a forum, and that the work of most Fluxus artists had nothing to do with the work of others. Joseph Beuys, another Fluxus artist, saw the movement as an influential philosophical proving-ground for ideas that he was to carry further in his own work. Dick Higgins wrote that, "Fluxus is not an art movement or a moment in art history; Fluxus is a philosophy, a way of life and death." But if Fluxus was not the movement that Maciunas felt it to be, it had undeniable aspects of what could be termed a group, a movement, and—at times—even a "school." The breadth of overlapping and differing interests, varying in fluid, subtle forms, made it all of these things and none.

Maciunas' notion of a movement or group was closer to Zen than to the orthodox Catholicism or Communist Internationalism with which it has been compared. Take, for example, the issue of anonymity. It is suggested that Maciunas believed in anonymity: this is not so. Like the Zen artists and poets, he believed that individual contribution takes place within a social and historical context. He rejected what he saw as the corrupt, market-driven notion of individual genius in favour of a more scientific model of genius emerging from a community of discourse. The care with which Maciunas credited innovation and artistic contribution disproves the notion that he believed in anonymity. He understood that ideas and their sources are part of a huge stream. He felt that by understanding where each idea begins we might understand our role in history and the part we ourselves play. Like the Zen priests, he believed that the personality was perhaps fluid (at least, in terms of work), so that ideas might flow from name to name.

More to the point is the musical model, in which one composer might borrow freely from the themes and work of another, or arrange and present the other's work, crediting the result to the original composer's name. This happened in Fluxus all the time, and no-one practised this method more keenly than George Maciunas. It was also one of the early sources of friction in the group: some artists felt that Maciunas took liberties with the work, interfering with what might be termed a "moral right" to control how work is presented. Maciunas felt he was honoring the work and, through it, the artist. He made his sense of respect clear by diligently presenting each project under the name of the artist. These issues and debates were central to the notions that gave birth to *events*, *concept art*, and *intermedia*, and to the use of the *short form*, or the *score* as a process in visual art.

If Maciunas was devoted to these artists and to their work, it was because he saw in them a line of action that could be traced to important historical roots. His 1966 *Expanded Arts Diagram* showed such sources as Byzantine Iconoclasm, Dada, Vaudeville, Natural Events, Marcel Duchamp, Baroque Mimicry, Futurist Theatre, Baroque Multi-media Spectacle, Sensationalism, World's Fairs, Walt Disney, and many more. He saw the artists fulfilling in their work a long evolution of ideas, fluid rather than rigid, part of a millennia-long human dialogue rather than a momentary succession of masterpieces sold for the profit of a dealer or bought for the delectation of a wealthy patron.

The last such chart Maciunas finished was the 1966 version. A later version, much larger, was under way at the time of his death, but the only extant version of this is an incomplete (and often incorrect) proof state that Maciunas had sent to artists and historians for their suggestions, contributions and corrections. Published in Sweden after Maciunas' death, this incomplete chart, still astonishing in its scope, has unfortunately been regarded by many people as a sort of "final version" gospel.

The 1966 chart reveals a designer with an eye for broad historical scope and a sense of visual humour. Maciunas uses an Aztec calendar motif to emblematize the monomorphic, neo-haiku Fluxus tradition, and a drawing from a mediaeval medical guide to symbolize the mixed-media tradition of happenings that he termed neo-Baroque. Maciunas' playful yet elegant use of emblems, symbols and type is visible thoughout all of the designs he created for Fluxus.

—Ken Friedman

Bibliography—

Ruhe, Harry, *Fluxus: The Most Radical and Experimental Art Movement of the 1960s*, Amsterdam 1979.
Hendricks, Jon, *Fluxus Codex*, New York 1988.
Philpott, Clive, and Hendricks, Jon, *Fluxus*, exhibition catalogue, New York 1988.
Milman, Estera, *Fluxus and Friends*, exhibition catalogue, Iowa City 1988.
Krinzinger, Ursula, ed., *Fluxus Subjektiv*, Vienna and Innsbruck 1990.

Photo M.N.A.M. Paris

Alberto Magnelli (1888–1971)
Equilibrio, 1958
Oil on canvas; 168 × 200 cm.
Paris, Musee National d'Art Moderne

The first "abstract" compositions by Alberto Magnelli were made in 1915 in Florence, when he was still associated with the Futurist group in the circle of the magazine *Lacerba*, edited by Giovanni Papini. They are extreme syntheses of objects and still-lifes that Magnelli submits to a slow process of formal dichotomy, while the colour has sharp and aggressive tones. But it was in the 'fifties that Magnelli's paintings became more elementary, fully non-figurative, engaged in weaving simple linear connections in itineraries of pure colour in which large backgrounds open wide bright lights of lyrical structural consonance. In these "compositions" the oneiric datum is always present, distributed in a fable-like and playful aura, and therefore not comparable to the formal rigours of orthodox Constructivism and Concretism. The large paintings in which Magnelli places imaginary surfaces in aleatory equilibrium, in search of the fascinations that rotate and are articulated around this geometric corporality, remain totally gestural and instinctive.

They are scripts which are taken out of the domain of practice and reflection about expressive synthesis, rather than unobjective constructions of the structural whole. They are paintings which constitute a staging of the shapes of imagery, of the ideology of passions, where rationality becomes a nostalgic melody, a transgression of the will to renounce artificial and obsolete nature. Renouncing a descriptive style, Magnelli organises unfigurative geometric metaphors as models of interpretation of a new reality, which are drawn through the constant, almost obsessive presence of elementary structural qualities, turned towards the search for a biology of the phenomena of history.

The major process of abstraction and structuralistic and semiological reconstruction is achieved by Magnelli by means of colour precisely charged with tensions, with wishes, the only recognisable centre of expropriated nature. In fact during his long career, Magnelli sometimes returned to highlighting nature, both as images of mighty rocks and as exaltation of everyday objects. During these adventures in expressiveness, within the framework of these returns to figurative work, Alberto Magnelli proposes the interweaving of many codes, like a "galaxy of significants" which is linked to the closed systemisations of Roland Barthes, sometimes affirming itself in provocative and controversial terms.

Magnelli was a friend of Jean Arp and Sonia Delaunay, and therefore felt himself to be part of the *ecole de Paris*, particularly having spent so many years living in Paris. The affectionate support given by Arp, who was already a well known personality in the international avant-garde movement, permitted him to exhibit from the 1930s in important French and European galleries, and his works began to be collected by museums and art foundations in North and Latin America. But it was his encounter with Cicillo Matarazzo, founder and first president of the Art Biennial in Sao Paulo in Brazil, which was decisive in Magnelli's success on the international art-collecting scene. In fact since the post-war years, his works have been bought by collectors like Nelson Rockefeller, Salomon Guggenheim, Hilla Rebay, Baby Pignatari and many other lovers of non-objective art and lyrical abstraction. Magnelli proposed to return painting to its origins with a precise wish to transgress the great rhetorical codes of the figurative tradition, in order to substantiate itself in undetectable balances of orphic surfaces and silent lines, which undulate rhythmically. During the 1940s, the use of tarred paper, displayed at right-angles, allowed Magnelli to produce a series of spectacular collages which, with the "blackboards" with their natural slate support, constitute a unique escape from oil and lean tempera techniques. In these works, Magnelli opts for lyrical abstractions where the slanted elements easily suggest perspective, and can be seen either as ensembles of lines laid on a flat background, or as structures immersed in a completely different tri-dimensional space.

By painting images in an altered orientation the painter achieves remarkable effects in the perception of form. The interlocking of planes and elementary forms are displayed in space with such clarity that they are striking for their corporeal presence, for their prominence, and for the presence of contrapuntal shadows. The perceptive experience produced by Magnelli's works results from the reception by the eye of the same amount of light emanating from every point of the stimulating field, which should be looked at as an area of homogeneous provocation. The impression gained is not that of a surface with various colours, but rather a coloured tri-dimensional space, with a depth in which one can wander infinitely. The forms favoured by Magnelli lead to an instinctively dynamic perception, which substitutes any structural unity, and where colour eventually becomes saturated, transforming itself into woven light, incidental illumination, a pulsating visual signal.

In this way *Equilibrium* (1958), is proof of Magnelli's new orientation towards a concretism which in Italy had been experimented with by Atanasio Soldati, and was practiced in France and Germany by Alfred Roth and Walter Dexel. Magnelli was no longer interested in using fragments of landscape, or sections of everyday objects to create chromatically sensational and formally neutral vast surfaces. In the 1950s he synthesises his structural repertoire with more rigour; he assigns the task of injecting dynamism into the painting to linear connections in elastic tension.

He is a painter torn between a symbolic totemism and a structural synthesism which sometimes aspires to monumentality by means of large canvases of clear visual comprehension. In the last period of his research expressive coherence becomes a fundamental component of minimalistic research, while colour presents itself as an uninterrupted polyphony of all signals.

In Grasse in the South of France during World War II, he made a peculiar experiment of "painting with four hands," together with Jean Arp, Sophie Tauber and Sonia Delaunay. This allowed him to collect in a curious portfolio of polychrome lithographs, the first results of a "collective abstract" art (as it was called), drawn simultaneously by the four "concrete" artists, and published in Paris in 1942 by the Aux Nourritures Terrestres publishers.

—Carlo Belloli

Bibliography—

Verdet, Andre, *Magnelli*, Paris 1961.
Argan, Giulio Carlo, and others, *Magnelli*, Rome 1964.
Belloli, Carlo, *44 Protagonisti della Visualita Struttura*, Milan 1964.
Huttinger, Eduard, *Alberto Magnelli*, St. Gallen 1965.
Valsecchi, Marco, *Magnelli*, Bergamo 1968.
Besset, Maurice, *Alberto Magnelli 1888–1971: Olbilder, Gouachen, Collagen, Skulpturen*, exhibition catalogue, Cologne 1973.
Maisonnier, Anne, *Catalogue Raisonne de l'Oeuvre Peint d'Alberto Magnelli*, Paris 1975.

© ADAGP, Paris and DACS, London 1991

Rene Magritte (1898–1967)
The Threatened Assassin, 1926–27
Oil on canvas; 59¼ × 77in. (150.5 × 195.5cm.)
New York, Museum of Modern Art

The image is as clear as a painted image can be. There is nothing to guess. An undressed woman is lying on a couch. A red stain—blood—emerges from her lips; a towel lies around her neck. On the floor stands a suitcase, and a coat and a hat have been thrown upon a chair. A man is standing before a gramophone. Behind his back, three identical heads are emerging above the railing in a window opening. Two identical men in black wearing bowler hats are posted at both sides of the large opening of the room, invisible to the first man. One has a club in his right hand, the other holds a net, as if they had to catch a monster alive. The title, *The Threatened Assassin*, seems to explain what remains unclear. What we apparently see is a murderer, who after his hideous crime is listening to music as if nothing has happened. The crook, however, is not aware of his impending arrest. We as onlookers know that one of the possible ways to freedom—the opening of the room—has been blocked by detectives and that the other—the window—by three eye-witnesses or voyeurs.

Confronted with this isolated picture from a comic-strip, we presume how the story will end. But we cannot be sure. Who knows, perhaps the murderer will miraculously escape from the hands of his waylayers. There are many possible outcomes. One concludes that this picture, that resembles one of the illustrations in the popular police magazines, is after all not as irrefutable as we thought.

In *The Threatened Assassin*, René Magritte undoubtedly got his inspiration from the popular crime magazines, wherein the illustrations gave vivid descriptions of murderers and other crooks, whether or not caught in the very act. In the years 1910–20 the adventures of *Fantômas*, first in print, afterwards on the film screen, were immensely popular in France. The criminal Fantômas, a master at disguising himself, continually outwitted his persecutors thus prolonging his existence for a next episode. In smaller, intellectual circles another hero was famous: Maldoror, a super-being also elusive for human law. Isidore Ducasse, who wrote under the pen name Comte de Lautréamont, created this amoral character in his prose poem *The Songs of Maldoror*. For the surrealists, who were fascinated by the boundlessness of imagination and by the Nietzschean belief in values beyond good and evil, *The Songs of Maldor* became a bible. In the same book, one can read the much quoted phrase: "as beautiful as . . . the fortuitous encounter upon an operating-table of a sewing machine and an umbrella." It became the motto for surrealist esthetics. Magritte, who later made illustrations for *The Songs of Maldoror*, would exploit the poetical procedure of estrangement. Objects were detached from their conventional context and meanings, and linked together in new combinations of a beauty which was unheard of.

Shortly after making *The Threatened Assassin*, Magritte moved from Brussels to Paris and became an official member of the surrealist movement. But before that time he came under the spell of this movement that represented more a manner of thinking than an artistic style in the narrow sense of the word. Surrealism that arose in Paris during the twenties was expressed in literature as well as in painting, in film, and even in politics.

Around 1925 Magritte, whose career as a painter first was influenced by the Flemish expressionists, by Léger and by the Italian futurists, became familiar with the paintings Giorgio de Chirico made in the period 1911–17. De Chirico's enigmatic images of hauntedly empty squares and strange combinations of objects were to influence many of the surrealist painters. Magritte, however, never became a firm believer in the surrealist creed as it was propagated by André Breton. So he was not interested in one of those other "forerunners" of surrealism—Sigmund Freud. Magritte tried to make images that were explanation-proof.

The Threatened Assassin belongs to Magritte's first series of surrealist works. At the same time, this painting presents a theme that would preoccupy Magritte until his death in 1967. This theme can be described as: the uncertainty of the representation. Formal or pure painterly problems are here not a stake. Except for the beginning of his career, Magritte seemed never to be interested in the finer technical details of his craft, i.e. in "Fine Art." *The Threatened Assassin* has been painted in the dry and slick manner of advertising images. For that matter a Magritte reproduction is as informative as the original painting.

The banal subject matter of *The Threatened Assassin* is, to begin with, incompatible with old representational art. Also, though the representation here looks still coherent, Magritte undermines the old ties between object and meaning. The content of *The Threatened Assassin* is quite alarming. Not only the murderer is threatened: the innocent onlooker is also in danger. His path to freedom in the mountains that are alluring in the distance is not blocked by detectives but by the awareness that the illusion in painting does not go beyond the thickness of paint. The painting itself has become a trap.

—Jan van Geest

Bibliography—

Soby, James Thrall, *Rene Magritte*, New York 1965.
Waldberg, Patrick, *Rene Magritte*, Brussels 1965.
Gablik, Suzi, *Magritte*, London 1970.
Torczyner, Harry, *Magritte*. London 1979.
Roque, Georges, *Ceci n'est pas un Magritte: Essai sur Magritte et la publicite*, Paris 1983.
Pierre, Jose, *Magritte*, Paris 1984.

Photo Giuseppe Schiavinotto

Giacomo Manzu (1908–91)
Christ and the General, 1942
Bronze panel; 72 × 51cm.
Rome, Galleria Nazionale d'Arte Moderna

Christ and the General is a panel, modelled in relief in clay and cast in bronze. It was made during the Second World War and is a comment, by a noted anti-Fascist, on the sufferings of war as well as the sufferings of Christ. Christ is not nailed to the Cross, as is traditional in Christian iconography, but is hanging suspended by the wrist and his tormentor is a modern, not an ancient Roman, complete with military helmet, though rendered absurd in his corpulent near-nakedness. Scenes of such brutality were commonplace throughout Italian towns and cities during the years of Mussolini's dictatorship and the political content of Manzù's work did not pass unnoticed. In 1941, the year preceding *Christ and the General*, he exhibited his series of reliefs on the theme of Christ's death in a gallery in Milan where they aroused a storm of indignation, not least because, by translating the Crucifixion into the modern day, the sculptor implicated representatives of the Church in Jesus's—and the people's—suffering.

It is misguided, however, to limit interpretation of *Christ and the General* to its immediate political context. To Manzù this is to diminish his aims and to distort his purpose, which is to explore several areas of man's humanity and experience, notably suffering, compassion and death as well as love, creativity and joy. In Manzù's work the religious and the secular, the sacred and the earthly are never far apart. His sensibility represents the pagan and classical married to the Christian and the Renaissance, with the result that all his work is endowed with a humanistic content and a sense of form learnt from his self-appointed masters, notably Aristide Maillol and Medardo Rosso. He has always been interesed in working on a multiplicity of sculptural challenges, including still-lifes, portraits and figurative studies (notably of his second wife, Inge, a dancer). His interest in depicting the Church and its power dates to a visit to Rome in 1934 when he observed in St. Peter's the Pope seated between two robed cardinals, this visual stimulus providing the starting point for many drawings and studies over the years. Similarly *Christ and the General*, though produced during the War, forms part of a much larger body of work, meditating on themes of suffering and brutality which have occupied Manzù throughout his working life.

In 1934, Manzù produced a study of suffering in his depiction of Saint Sebastian, and in 1938–39 he began work on his series of reliefs *Cristo nella nostra humanita*, the series which antagonized the Vatican in 1941. The ending of war did not see a cessation of this work. The break with the Vatican was healed when Manzù won the commission to decorate the portal of St. Peter's, Rome, with scenes depicting *The Triumph of the Saints and Martyrs of the Church*. It is significant that after the election of Pope John XXIII (an ally and a friend) Manzù sought and obtained permission to change the commission to *The Death of the Saints and Martyrs*. In their final form, the reliefs for the doors of St. Peter's are related very closely to the *Christ and the General* series, notably the panel entitled *Death Through Violence*. As soon as the Vatican commission was completed, Manzù reverted to working on the theme of *Cristo della nostra humanita*, a subject which had by then occupied his thoughts for over twenty-five years. In recognition of this particular achievement, he was awarded the International Lenin Peace Prize in 1966.

It must not be forgotten that, for Manzù, technique and form are as important as subject matter. Born into a poor family (his father was a cobbler) he had already learnt the skills of carving, gilding and stucco-work while still an adolescent. In 1927, he was sent to do his military service in Verona where he was able to study the reliefs on the bronze doors of the magnificent Romanesque church of San Zeno Maggiore. From then on, he dedicated himself to working in relief as well as in the round, since relief offered him some of the challenges of paintings, not least the problem of creating depth and space by means of illusion. John Rewald, Manzù's biographer, stresses the importance of relief modelling to the sculptor. "For Manzù, reliefs are not merely occasional works but a specific form of expression for his thoughts and feelings which interest him from a point of view of draughtsmanship and composition."

Within twentieth century art Manzù tends to stand alone, avowing traditional techniques and values in the face of the sculptural moderns. *Christ and the General* represents his work at its best, combining technical mastery and powerfully expressed emotion, testifying to the strength of his artistic and political beliefs.

—Camilla Boodle

Bibliography—

de Micheli, M., *Manzu*, Milan 1971.
Rewald, John, *Giacomo Manzu*, London 1973.
Velani, Livia, ed., *Manzu*, exhibition catalogue, Milan 1987.

Marino Marini (1901–80)
Horseman 1947
Bronze; 64½ × 61 × 26½in. (163.8 × 154.9 × 67.3cm.)
London, Tate Gallery

It is rare at any time in the history of art to find an artist as accomplished in both the fields of painting and sculpture as Marino Marini. Within these wide-ranging skills, he thoroughly explored a fairly limited range of mythic subject matter, the best known of which are the *Horse and Rider*, *Pomona* and *Harlequins*. Marini is probably best known for the Pomonas and the particularly for his horse and rider sculptures, which he began to develop in the early 1930s. The work reproduced here, *Horseman*, of 1947, is situated fairly early on in a series which extended into the 1960s.

The horseman holds a very distinguished place in the history of Italian sculpture. Marini was also an admitted devotee of Etruscan sculpture. He had grown up in the area of Italy best known for it, and Etruscan art was enjoying some popularity generally amongst artists in the mid-1930s due to interest in recent excavation work. Amongst the best known Etruscan sculptures are the winged horses of Tarquinia, while the Romans and later the Italian Renaissance made the horse and rider an important symbol of civic and national pride, with heroic statues such as the *Marcus Aurelius* in Rome, the *Colleoni* by Verocchio in Venice and the *Gattamelata* by Donatello in Padua.

Though he did not precisely deny the influence of these horsemen who were all specific people, Marini claimed that a trip to Germany in 1934, when he saw the equestrian monument in Bamberg, was of even greater significance. This piece of Gothic sculpture was more akin to a mythic rider, possible of carrying a wider emotional range than those "public hero" sculptures of the Romans and the Renaissance city states. It is, however, clear that Marini's interest in the idea of the horseman preceded the Bamberg trip and only needed that extra bit of inspiration and impetus provided by the German visit to launch one of his major life-long series of works. Marini produced a very low bronze relief in 1932, (entitled *Composition*, in a London collection), that shows a horse and rider looking as if they have been scratched into the surface, shepherding a group of figures before them. It looks almost like very elegant graffitti etched into a wall.

A full-blown *Rider*, made in 1936, (in a Milanese collection), is a sculpture whose "other worldly" feeling is quite powerful. The hands of the figure are lightly clenched as if the reins were being held, yet the faces of both horse and rider are removed to another plane of existence. The only powerful lines on the surface of the bronze look as if they belong to the casting process—an important point in view of Marini's later treatment of the bronze surface. In 1939, Marini produced an elegant, almost oriental, riderless *Horse*, (from the same Milanese collection), caught just as it is about to rear up. Again in 1939 came Marini's *Pilgrim*, (also from the Milanese collection), where the rider is gaunt and ascetic-looking. The Pilgrim's furrowed brow and the outline of his rib-cage give a sharpness and pain to the figures which they seem unwilling to elaborate on through movement.

It is tempting to see work from the late 1930s onwards in terms of wartime conditions and state of mind. Italian artists were not subject to the same kind of government restrictions as were German artists of the same period, and many were able to stay put and keep working, but it would be a rare artist whose work would not show in some fashion the suffering his fellow countrymen were undergoing.

In 1942 Marini made the *Quadriga*, a terracotta relief in the collection of the Kunstmuseum, Basel. Four crude horses emerge from the clay with details scratched onto them. With all the formal eloquence in bronze at Marini's command, he still felt at this time the need to revert to a deliberate exploration of his antique roots.

As time drew closer to the Tate Gallery's *Horseman*, Marini's work does not necessarily progress gently into a stylistic harmony between the *Pilgrim* of 1939 and the composed horseman of 1947. The *Small Rider* of 1946, in the Museum of Modern Art, Kyoto, is like a scream of anguish compared to the quiet pain of the *Pilgrim*. Crude by comparison with the prior and consequent works, the faces of both horse and rider are very roughly defined. The horse's rear legs look as if they are incapable of holding the weight of his rider. The most dramatic aspect of this work is the ferocity of the gouge and slash marks that appear all over the horse and rider, with vivid raw reds showing up beside the more neutral bronze. The sheer despair and pain in this work is brought out through the handling of the material rather than through actual facial expression. This use of material is brought into abeyance with the Tate Gallery's *Horseman*, or rather, a balance is sought between the two. In later horsemen, the material would take over again.

The *Horseman* of 1947 sits fairly relaxed on his animal, contemplating the sky, his hands loose in front of him. The horse is more on edge, with its neck at full stretch and its ears laid back, alert for something of which his rider seems unaware. When this sculpture was made, Marini had only been back in Italy for a year, after having been in a self-imposed exile in Switzerland for the last few years of the war. Perhaps he was in a more hopeful mood then, as this appears to be a calm rider, but the calmness doesn't last, as subsequent works were to show. The fragility of man and his despair tell greatly in his later work, and more consistently than even during the war. A horse and rider of 1949–50 shows the rider flinging his head back in pain—the horse's neck and the rider's penis in full extension. The effect is of overwrought tautness in every nerve. The horses and riders become ever more emotionally charged with the series of *Miracles*, where the figure is in the process of being thrown from a rearing horse—perhaps a modern day Saul on the road to Damascus, rather than a man being thrown into total despair.

In keeping with the development of his equestrian subject matter in painting, graphics and sculpture, Marini realised, within the so-called confines of sculpture, a number of ways of treating his subject. The horseman of 1947 is bronze and, therefore, was initially modelled before being cast. Marini was never content to let matters rest there. He worked over the bronze casts, chiselling or applying acid to create complex surface textures more in keeping with the subject matter.

Marini's achievement with his horese and riders over a roughly thirty year period owes something to Italian artistic tradition and a great deal to Marini's interest in antiquity, myth and the pain and suffering of his fellow man. Marini never allied himself with any particular Italian artistic movement, which has made it awkward for him to be assessed properly within exhibitions devoted to the sweeping embrace of 20th century Italian art history. He is, however, very much a product of Italian cultural history, finding room for his own modern artistic vision within that country's traditional subject matter without being a slave to its history.

—Victoria Keller

Bibliography—

Trier, Eduard, *Marino Marini*, New York 1961.
Read, Herbert, Waldberg, Patrick, and di San Lazzaro, G., *Marino Marini: Complete Works*, New York 1970.
Busignani, Alberto, *Twentieth Century Masters: Marini*, London 1971.

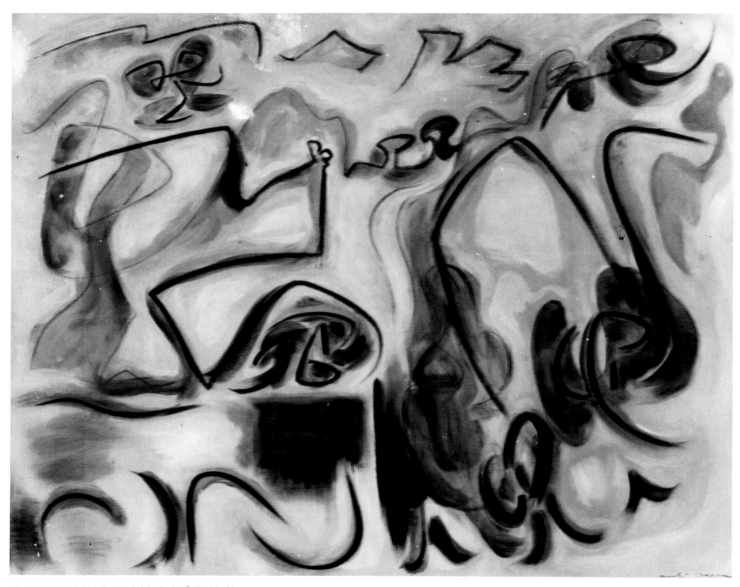

Photo courtesy Galerie Louise Leiris, Paris. © DACS 1991

176

Andre Masson (1896–1987)
Landscape with Precipices, 1948
Oil on canvas; 81 × 100 in. (206 × 254 cm.)
Paris, private collection

André Masson's large painting of a *Landscape with Precipices* (1948) may be taken as representative of his work as a whole. In this case, the key concept is "automatism."

Although the Depression years of the 1930s turned American art in upon itself for a salutary period of introspection, New York in particular had experienced a tradition of intermittent avant-gardism, beginning with the infamous "Armory Show" of 1913. American Abstract Expressionism, dramatically bursting upon the art scene after 1945, had its immediate roots in European Surrealism. One of the central performers was André Masson, and he, alongside André Breton (1896–1966), was also one of the most prominent Surrealist emigrés working in New York during the war years, 1941–45. This was the period that gave rise to a postwar, and near-imperialist, American domination over the visual arts worldwide and lasting up to the present day.

American exhibitions of Masson's freely painted and wholly "abstract" paintings are, for instance, known to have influenced, among others, Arshile Gorky, Jackson Pollock and Mark Rothko—whose works of ca. 1948 do all collectively look rather like Masson's *Landscape with Precipices*. The Americans particularly took to Surrealist principles, as emblematically represented in Masson's painting, largely for the sake of their supposedly "liberating" aspects, all summed up for them by the central Surrealist notion of "automatism." Masson's essentially gestural art, in turn, is definitely known to have been largely propelled by the otherworldly rhetoric of André Breton, whom he met in 1923, at which time he executed his first "automatic drawings." According to Breton, in his loquacious but widely studied (and often translated) *First Surrealist Manifesto* of 1924, Surrealism is a noun, standing wholly for: "Pure psychic automatism [*l'automatisme psychique*] in its pure state, by which one proposes to express—verbally, by means of the written word, or in any other manner—the actual functioning of thought. Dictated by thought, but in the absence of any control exercised by reason, Surrealism is exempt from any aesthetic or moral concern. Surrealism is based on the belief in the superior reality [*la surréalité*] of certain neglected forms of [free] association, in the omnipotence of dream, in the disinterested play of thought . . ."

As Masson himself remarked in 1941, "For us, the young Surrealists of 1924, the great prostitute was reason. . . . At that time, there was a great temptation to try to operate magically [*magiquement*] on things, and then on ourselves. The impulse was so great that we could not resist it and so, from the end of the winter of 1924, there was a frenzied abandon to automatism. This form of expression has survived until today . . ."

In a 1946 interview with Kurt Seligman, Masson was asked to define his understanding of *la magie* as it pertained to his art. The painter's riposte was that "its aim is to discover, to retain, relations invisible in nature, with the purpose of exerting by this *Knowledge* power upon the invisible world." Since the larger enframing notion, *l'automatisme psychique*, is probably *still* the foremost operating principle underlying avant-gardism today—and one knows that the aleatory principle is still "taught" actively to young artist-acolytes in many art schools—it behoves us to investigate the real matter of its historical roots. So doing, we begin finally to perceive its real significance. According to Breton in 1924, pure automatism, occurs when, "with a shudder, we cross what the occultists call dangerous territory." In fact, that specifically "occultist" terrain had been long since trampled upon in French letters.

As (presumably) Breton must have read in Éliphas Lévi's *L'Histoire de la Magie*, first published in 1860 and reprinted many times since, a certain Count d'Ourches had "been dominated by an *idée fixe*," namely, "the fear of being buried alive." In order to determine the real moment of death, this occultist aristocrat wrote a book with a ponderous title, *Practical Experimental Pneumatology, or the Reality of Spirits and the Marvellous Phenomenon of Their Direct Writing*. Among his other purposes, says Lévi, the Count d'Ourches meant generally "to introduce into France the findings of American Spiritualism" and, particularly, "the purely automatic writings of mediums." According to Lévi, truly "sensitive persons have acquired that most wonderful gift of mediumship, namely automatic writing [*l'écriture automatique*] Now, all such phenomena are proof positive of certain occult forces . . . and it is only this which offers irrefutable proof as to the reality of the supernatural world." As this statement makes apparent, not only was there an outburst of *l'écriture automatique* in France some sixty years *before* Breton got around to praising this same otherworldly gift, but additionally that, again according to Lévi, the phenomenon was entirely due to "the findings of American Spiritualism."

It is also well worth mentioning that this same kind of esoterism had also produced wholly "automatist" drawings and paintings, and that all this happened some three-score years before Masson bestirred himself to re-invent the process as an avant-garde mechanism. Although many written testimonies to the strictly 19th-century pseudo-artistic precedents exist, when they were commonly known as "Spirit Drawings," space only permits the citation of a single calligraphic epiphany from *au-delà*. One such otherworldly intervention in the creation of wholly automatic, and thus automatically "abstract," doodles happened (ca. 1875) to William Howitt. As the creative moment was described by his properly awestruck daughter, "My father had not sat many minutes, passive, holding a pencil in his hand upon a sheet of paper, ere something resembling an electric shock ran through his arm and hand; whereupon the pencil began to move in circles. The influence becoming stronger and ever stronger, it moved not only the hand, but the whole arm in a rotary motion, until the arm was at length raised, and rapidly—as if it had been the spoke of a wheel propelled by machinery—whirled irresistibly in a wide sweep, and with great speed, for some ten minutes through the air. The effect of this rapid rotation was felt by him in the muscles of the arm for some time afterwards. Then the arm, being again at rest, the pencil, in the passive fingers, began gently, but clearly and decidedly, to move."

As this quotation proves (and many others could be cited to the same ends), the strictly "automatist," or aleatory ("chance") art experience is not at all new. In short, Masson and his American followers were (and still are) in complete conformance to an already long-standing tradition of involuntary automatist abstraction. Regarding the truly antique origins of Andre Breton's Surrealist exaltation of *l'écriture automatique*, one need only read the Bible, namely, Ezekiel 2:9; I Chronicles 28:19; II Chronicles 21:12; Revelations 5:1; and, especially, Daniel 5:5 ff. Finally, it may be mentioned that Miss Howitt's picturesque description of her Spiritualist father's frantically automatist scribblings could as well have served as the scenario for the widely viewed film, shot some eighty years later, of Jackson Pollock's famous, balletic and dripping, avant-garde dance around a magical canvas emblematically stretched across his paint-splattered studio floor . . .

—John F. Moffitt

Bibliography—

Masson, Andre, *Le plaisir de peindre*, Paris 1950.
Masson, Andre, and Charbonnier, G., *Entretiens*, Paris 1963.
Clebert, Jean-Paul, *Mythologie d'Andre Masson*, Geneva 1971.
Masson, Andre, *Vagabond du Surrealisme*, Paris 1975.
Rubin, William, and Lanchner, Carolyn, *Andre Masson*, New York 1976.
Lucie-Smith, Edward, *Movements in Art Since 1945*, London 1985.

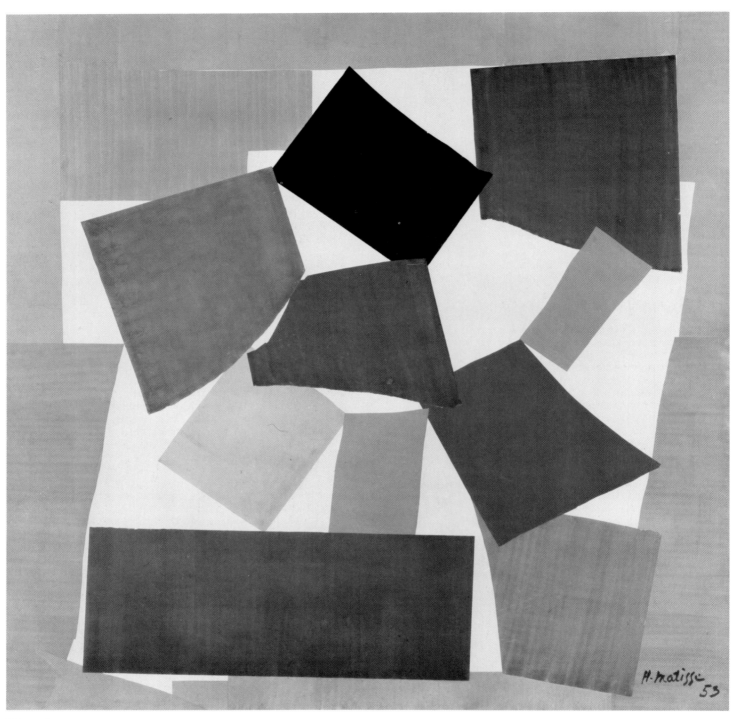

© Succession H. Matisse/DACS 1991

178

Henri Matisse (1869–1954)
The Snail, 1953
Gouache on cut and pasted paper; 113 × 113¾ in. (287 × 288 cm.)
London, Tate Gallery

The Snail is one of the great joys of decorative art in the Tate Gallery's collection. On sunny days it seems to reflect and reinforce the *joie de vivre* that fine weather brings. When the world is grey, whether with dull skies or metaphorically speaking, this huge kaleidoscope of colour can make it bright again. Contemplation of its carefully composed snail-like spiral can induce a slow, steady sense of calm and well-being. Its glow is life-enhancing. Henri Matisse always had great faith in the therapeutic powers of his art and spoke of the "beneficent radiation of his colours."

In 1908 he wrote that what he dreamt of was "an art of balance, of purity and serenity devoid of troubling or depressing subject matter, a soothing influence on the mind, something like a good armchair in which to relax." He wanted to create in his art a quality of quiet and tranquillity, "a kind of paradise."

Nearly fifty years on, *The Snail* seems to have fulfilled that aim. Despite its title it would indeed appear to be "devoid of troubling subject matter." Matisse gave the work an alternative title, *Chromatic Composition*, indicating the fundamental importance of colour to the artist, the belief that colour, quite independently of subject matter, can express the emotions of the artist and act directly upon the senses of the viewer. "Simple colours," he wrote, "can act upon the inner feelings with more force, the simpler they are. A blue, for example, accompanied by the brilliance of its complementaries, act upon the feelings like a sharp blow upon a gong. The same with red and yellow; and the artist must be able to sound them when he needs to."

After two operations for cancer in 1941 Matisse was never really to regain the stamina necessary for long periods of easel painting. Instead, living and working in his large apartment in the hills above Nice in the South of France, he developed the technique of gouache découpée, or painted paper cut-out, producing when he was in his eighties a magnificent coda of collages, of which *The Snail* is such a fine example.

Matisse has created a succession of large, almost rectangular, brilliantly hued patches of colour curling round like the spiral of a snail's shell, laid against a vast white ground within an irregular orange "frame." At the centre of the spiral an emerald green shape overlaps scarlet red, in turn overlapping an absinthe green. Orange butts up against a big block of deep cobalt blue, its upper corner linked with yellow. Fuchsia and lavender in the top left corner overlap and slide under the velvety black diagonal plane. Along the top edge of the lilac patch the silhouette of a small snail with its horns extended may just be perceived. Placed all together on this large canvas nearly 9½ feet square, these fragments of colour seem to float and slowly revolve, setting up a vibration of bright light in an open, unpainted, yet vital space, a shimmer that is stabilized by the horizontal rectangle of sea-blue at the base.

A reminder of basic colour principles may be helpful towards an appreciation of the artist's achievement. There are three primary paint colours: blue, red and yellow. Each primary colour is both opposed to and complemented by a secondary colour, i.e. a mixture of the remaining two primaries: blue/orange, red/green, yellow/purple. Placing complementary colours next to each other, because of the physical laws of colour perception, intensifies the colours, "completing" them and making them appear more vibrant. Warm colours come forward and cool colours recede from the picture plane or surface, so complementary colours also balance each other in terms of spatial tension depending on the area and intensity of the hues involved. Black and white, which Vincent van Gogh called the *fourth* complementaries, are in absolute contrast in terms of colour. White suggests the dimension of space, allowing the colours to breathe and expand, whilst black helps to keep the response to them alert, functioning like a tuning fork in maintaining an awareness of the true colour values which combine to create radiance.

Matisse stressed that even the most beautiful colours have no meaning in themselves. "What counts most with colours are relationships . . . When one composes with colours, like a musician with colours, like a musician with harmonies, it is simply a question of emphasizing the differences. Colour attains its full expression only when it is organized, when it corresponds to the emotional intensity of the artist."

He drew inspiration from the natural world for the simplified abstracted shapes that were to become the elements of his painted paper cut-outs. Studio assistants prepared a stock of sheets of cartridge paper painted with gouache, an opaque watercolour, to the exact nuances of all the colours Matisse required, producing a surface texture impossible to get in mechanically dyed paper. Leaves, flowers, parrots, dancers, fish, birds—and snails—were amongst his sources. Describing how he evolved a smaller cut-out of a snail in 1952, Matisse said that "First of all I drew a snail from nature, holding it between two fingers; drew it and redrew it. I became aware of an unrolling. An image formed in my mind purified of the shell. Then I took the scissors."

Cutting into the painted paper was like drawing directly into colour, simplifying drawing and painting into virtually one process, as a sculptor carves directly into stone. With long scissors open wide, slicing not clipping, coloured shapes came rapidly from his dextrous hands, the edges of the paper revealing the cutting or tearing action. These were the "forms filtered to their essentials." Then, sitting in his wheelchair or from his bed, Matisse would instruct his assistants as they pinned up patches of colour, arranging and rearranging them meticulously on paper hung on the wall. This part of the process might take months. Careful examination of *The Snail* will reveal many pinmarks indicating just how crucial the adjustments were in perfecting the relationships of the patches of colour. Only when the artist was completely satisfied that the shapes and colours harmonized absolutely would they be lightly stuck down and the whole composition sent to Paris, where it was finally fixed onto thin paper covering cleaned raw canvas.

In *The Snail*, colour is fundamental and supreme. Not the individual colour, but the colour built up through relationships. There is no one area of maximum intensity. Every part of the work ranks equally: the white atmospheric space, the spiral of colour, the uneven orange frame. Nothing is actually describing or imitating, yet Matisse's immaculate sense of decorative order has produced an arrangement of intense harmony that radiates happiness and well-being.

The spiral motif on which it is based is found in decorative art all over the world, echoing the direction of the earth's movement and of natural growth. Its ancient form was intended to induce a state of deep contemplation, like a mandala, to enable man to escape from the material world and enter the beyond. "One may demand from a painting a more profound emotion," Matisse wrote, "and one which touches the spirit as well as the senses." At one time he intended to use *The Snail* and *Memory of Oceania* (1953, 112 × 112 in., Museum of Modern Art, N.Y.), which are both the same square format and about the same size, as flanking panels forming a triptych with the vast *Large Decoration with Masks* (1953, 139¼ × 392½ in., National Gallery of Art, Washington). What a majestic environment for the spirit that would have been!

Above all, *The Snail* radiates light. Not the cold pale light of the north, but an ideal golden light that appears in so many of Matisse's paintings of the view framed by the artist's window of sunshine on blue waters and the lush greenery of pine trees and palms. It is the inner light in his mind's eye of his dream of paradise.

—Cecily Lowenthal

Bibliography—

Hunter, Sam, *Matisse*, New York 1956.
Russell, John, *The World of Matisse*, London 1969.
Flam, Jack D., *Matisse on Art*, Oxford 1973.
Elderfield, John, *The Cut-Outs of Henri Matisse*, London 1978.
Schneider, Pierre, *Matisse*, London 1984.

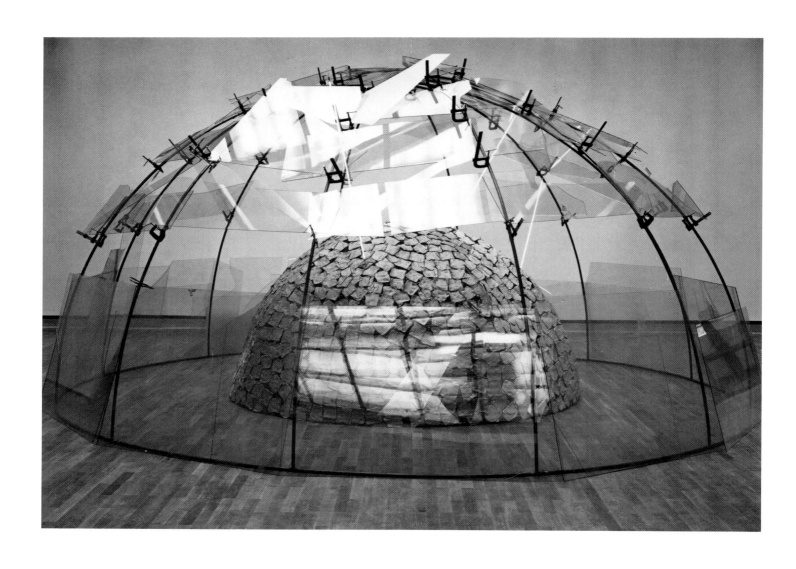

Mario Merz (1925–)
Double Igloo, 1969–81
Steel, glass and earth; 274 × 547cm.
Stuttgart, Staatsgalerie

The igloo is considered to be one of Mario Merz's signature motifs. This being so, this motif, as well as his other major symbols and metaphors, (for example, the table and his use of Fibonacci numbers) is the development of an artist who was forty-three when, in 1968, he produced his first igloo during a period of extreme political turmoil in Italy.

Initially a painter, his heavy impasto was used to create images linked to the natural world in a style not unrelated to the various artistic activities of the mid-1940s to early 1960s: European Informel, American Action Painting and Abstract Expressionism. The desire for his canvases to grow outwards, away from the wall, something he found difficult to manage using thick paint alone, caused him by 1964 to produce structures jutting forward that allowed shaped canvas cubes to be formed—halfway houses between pictures and sculptures. By 1967, neon tubes began to pierce the structures that frequently have wicker incorporated into them.

It is important for the understanding of Merz's development to know that the galleries in Turin, Merz's home town, were very active in the early to mid-1960s in presenting New York Pop and Minimal art. This was bound to influence an artistic generation such as Merz's, but the interest was tempered by their strong European, and particularly Italian, identity. This combination led to the development of Arte Povera, a term coined by the critic Germano Celant in 1966–67. The numerous artists who exhibited in Turin in these two years, Merz amongst them, were proceeding to answer the economic boom in industrial and consumer production with their own brand of minimal art, but using "poor" or recycled materials, down to Merz's use of his old raincoat. Merz also began, in 1966, the use of neon tubes in his work as a gestural element. Sometimes that gesture is metaphorical and turns into words and sometimes the gesture is literal and is a piercing of a surface. Always its use is symbolic.

Merz produced his first igloo in 1968 at a politically revolutionary time, which also dramatically affected the visual arts. It was a time when the visual arts could no longer be safely divided into painting and sculpture, as all adventures were now possible and called themselves by many names in many countries: Arte Povera, Land Art, Body Art, Conceptual Art. Merz's earliest igloo was a semi-circular structure covered by a net on which Merz placed lumps of clay that eventually dried, and on which neon script was written. These early scripts had bearing on the political situation of the time and they stood out from the enclosed hemisphere huddled on the ground.

For Merz the igloo shape is a form to be understood on several levels. It is a form understood within nature, yet it is also a symbol of support. In an interview of 1987 he is quoted as saying: ". . . We know that when a drop of water is struck by a far more powerful force, like perhaps that of a teaspoon, the drop escapes from the spoon, reforming as a hemisphere because of the surface tension . . . The surface tension of the molecule causes the drop to assume a specific form, rather than becoming a shapeless entity, and the ideal form is the spherical form . . . The human mind is very close to the form of the sphere. Man has an intuitive consciousness of the sphere—a piece of fruit, a ball. It is an age-old intuitive form . . . "

The mud igloo pierced by neon tubes from the late 1960s, which is the interior of the *Double Igloo* reproduced here, takes Merz's original intuitive form and combines it with his contemporaneous use of light energy connecting the enclosed world with the outside world.

As Merz began to exhibit more widely in the 1970s, the igloo as installation began to be developed according to the part of the world he found himself in. This emphasised Merz's belief in the transitory nature of art—its ability to change. The igloo is art or man, and as such, is earthbound, particularly to its local environment. Yet man, the artist, also wanders and is a nomad, as far as Merz is concerned, and as he shifts his ground, art changes as the local materials change. Germano Celant wrote of Merz's use of the igloo: "He used the igloo like the Navaho wigwam or the Mongolian yurta, as a cultural value that provides a support for living and surviving. Referring to the societies and cultures that Merz experienced—German or Swiss, British or Italian—the igloo was charged with moods and impressions induced by whatever the artist discovered in situ. Thus, in the isolation of his Berlin studio, Merz darkened his igloo, covering it with black tar and blocking its relationship to the outside world. However, this relationship was soon restored by the presence of transparent panes when the igloo was presented as a social mechanism . . . "

During the 1970s Merz developed a range of symbolism involving his painting, the use of the igloo, the neon tubes, another intuitive form—the table, and the use of what is called the Fibonacci formula of mathematical progression.

The 1970s was a decade within which Arte Povera, Land Art, Body Art and Conceptual Art flourished, fêted by the international gallery and museum system and the critics. But by the late 1970s, a reaction had set in and painting, to be hung on the walls, made its re-emergence in the 1980s at the top of the international art agenda. One of a number of reasons for this was that the art market was growing weary of the difficulties of promoting conceptual art.

In this climate, Merz's igloo was covered over, becoming the *Double Igloo* in 1981. Germano Celant saw this glassed-over igloo as a defense, as the mud igloo being captured for its own protection by the glass igloo, both of them being transfixed by rays of light: "One igloo captures the other, housing it and superimposing itself . . . The superimposition alludes to the geological theme of sediments, adding something that it did not have originally: it places it in perspective and historicizes it . . . the double igloo is a snail or spiral that carries inside and around its own soft body, in clay; its sap and sensory apparatuses, which, until 1979, were exposed, are now shielded by a second igloo."

Whether or not the double igloo can be seen as a response to a change in the artistic climate, Merz had undoubtedly redoubled his own painting energies by the late 1970s, while still working with his three-dimensional motifs and the Fibonacci sequence. He incorporated his rich iconography of abstracted beasts, amongst them lizards and bison, into his installations of igloos or tables.

By the 1980s his installations had become very complex, combining all his motifs as well as vegetables and stacks of newspapers. The late 1970s saw him increasingly given the opportunity to respond directly to the architectural setting within which his installations were placed, which has given an even greater richness of meaning to his views on the transitory nature of art and artist as nomad/snail who takes his igloo/shell with him and attempts to transform it in his travels.

—Victoria Keller

Bibliography—

Celant, Germano, *Arte Povera*, Milan 1969.
Felix, Zdenek, *Mario Merz*, exhibition catalogue, Essen 1982.
Celant, Germano, *Mario Merz*, New York and Milan 1989.
Braun, Emily, ed., *Italian Art in the 20th Century: Painting and Sculpture 1900–1988*, London and Munich 1989.

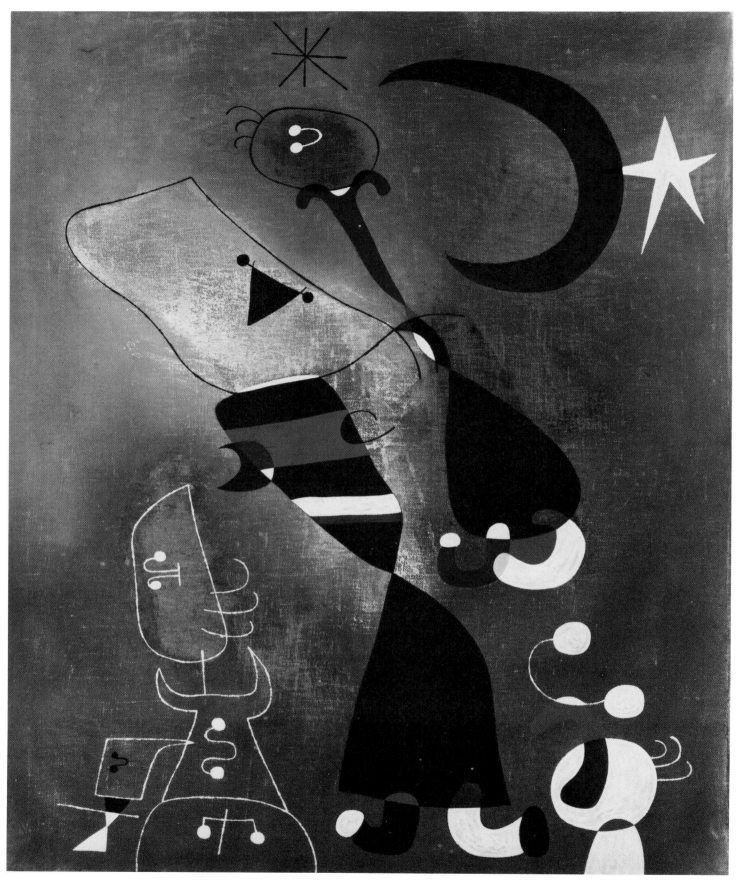

© ADAGP, Paris and DACS, London 1991

Joan Miro (1893–1983)
Femmes, Oiseau au Clair de Lune, 1949
Oil on canvas; 32 × 26in. (81.5 × 66cm.)
London, Tate Gallery

Miro's *Women and Bird in the Moonlight* is one of a series of works generally termed "slow paintings." Miro himself explained, in a letter to the Tate Gallery of 17th June 1974, "To the whole of this series of paintings, which was executed very slowly, I gave on completion a general title of "paintings," but later, to be more precise and give a more objective and concrete meaning, I entitled your picture *Femmes, Oiseau au Clair de Lune*."

The period from 1949 to 1950 was a hugely productive one in Miro's *oeuvre*. He had returned to Paris from his first visit to New York in 1948 after an absence of eight years spent in his native Spain. Miro's stay in New York had been an invigorating one. His work had achieved considerable status throughout the United States with the major retrospective exhibition at the Museum of Modern Art in 1941, and Miro renewed his friendship with such expatriate Surrealists as Marcel Duchamp and Yves Tanguy and made the acquaintance of the American sculptor Alexander Calder, whose "mobiles" and "stabiles" have much in common with Miro's own work.

On his return to Paris, Miro began work on two complementary yet contrasting series of paintings simultaneously. *Women and Bird in the Moonlight* is one of the so called "slow paintings," a canvas worked meticulously with great refinement of painstaking detail, as distinct from the so-called "spontaneous" paintings of the same period. The 1950 *Painting*, in the Stedelijk van Abbemuseum, Eindhoven serves to point the important contrast between the "slow" and "spontaneous" series. *Painting* is a mixed media work, of oil, casein and twisted and knotted cords. The mixture of brilliant and sombre colours and varied textures of *Painting* act as background to the precisely delineated shapes in primary colours and black which appear to float spontaneously over this tempestuous background. The gestural character of such a painting is in strictest contrast to *Women and Bird in the Moonlight*, which is meticulously rendered in a conventional oil medium with an impeccable, dead-pan surface texture.

Women and Bird in the Moonlight combines the use of brilliant primary colours such as red, blue and yellow with black to suggest the clothing of two of the women, against a mysterious colour-washed background with areas of the ground colour scraped down so that the canvas shows through, to signify the effect of moonlight. The precision of the forms of the figures is enhanced by the sharply delineated areas of brilliant white, which give the painting its quintessentially Miro qualities of wit and vivacity.

In this painting, Miro has abandoned any suggestion of the recession or illusion evident in his earlier work, while the graphic invention which is so marked a feature of his mature work is much in evidence, particularly in the bird form which, while bearing some resemblance to the genus hoopoe, still seems to inhabit an imaginary universe. Each of the forms at one and the same time seems related in some dimly remembered fashion to our own world and yet distant from it, except in the world of dreams.

As in a dream, the precisely focused and delineated forms appear to float in the picture space, with only the blue crescent moon and the huge star, which appears to be fixed to it, working as stable points in the composition. Forms related to the crescent moon are echoed in both bird and women, and all seem to gravitate towards the moon as a traditionally female symbol. In his book *Joan Mirō: la vie et l'oeuvre*, Jacques Dupin comments on the series of paintings of which *Women and Birds in the Moonlight* is part, "The subjects of the pictures become secondary, they are no more than a pretext, like the accompaniment that sustains the melody."

In an interview for the *Partisan Review* in 1948, the year before *Women and Bird in the Moonlight* was painted, Miro detailed his current process of work, explaining that he then rarely started his paintings, as he had done in the 'twenties, from "a hallucination . . . or, as later, from collages". He found "the form of the material I am working with . . . supplies the shock which suggests the form just as cracks in a wall suggested shapes to Leonardo . . . The form becomes a sign for a woman or a bird as I work."

From 1919 onwards, Miro had spent part of each year in Paris, where he became connected with Andre Bréton and the poet Paul Eluard, and such key figures of twentieth century art as Picasso and Max Ernst. From 1920 Miro's work had drawn on the world of dreams and the subconscious. André Breton had described Miro as early as 1927 in a well-known passage in *Le Surréalisme et la Peinture* in the following terms: "He may be considered the most surrealist among us." However, unlike Ernst, or his fellow Spaniards, Picasso and Dali, Miro creates a series of dynamic pictographic symbols which, while obviously related to the world of appearances, create a fantasy world of their own.

The creations of Miro's world, whether in painting, sculpture, ceramics or graphic design are instantly recognisable and *sui generis*. They exert a powerful fascination, as can be observed in any gallery containing a Miro work. *Women and Bird in the Moonlight*, with its evocative atmosphere that is both witty and dreamlike with more than a hint of menace, is essential Miro.

—Doreen Ehrlich

Bibliography—

Greenberg, Clement, *Joan Miro*, New York 1948, 1950.
Prevert, Jacques, and Ribemont-Dessaignes, Georges, *Jean Miro*, Paris 1956.
Dupin, Jacques, *Joan Miro: Life and Work*, Paris 1961, London 1962.
Penrose, Roland, *Miro*, London 1970.
Rowell, Margit, *Joan Miro: Selected Writings and Interviews*, Boston 1986, London 1987.

© DACS 1991

Piet Mondriaan (1872–1944)
Composition with Yellow Lines, 1933
Oil on canvas; 44½ × 44½in. (113 × 113cm.)
The Hague, Haags Gemeentemuseum

At a first glance—from the distance—Mondrian's *Composition with yellow lines* looks symmetrical. Four strokes of the same colour around a white void. Then, at a nearer standpoint, it becomes clear that not any of the yellow lines in this composition has the same thickness. So this painting, too, gives an example of Mondrian's efforts of demonstrating balance without taking his refuge to symmetry. Another characteristic of the painting is that the lines are not crossing or touching each other. And at last, perhaps the most remarkable treat of all, the painting is lozenge-shaped.

One could first also say: the painting is only hung like a lozenge and, turned a quarter, it will show diagonal lines. But that does not fit with the painter who allegedly saw the horizontal and vertical as two of the leading principles of cosmic order. That he should make a compromise with the principle of a diagonal is out of the question.

The composition obeys to the laws of *Neo-Plasticism*, the austere art movement of Mondrian's own invention. In his manifesto of Neo-Plasticism (published in 1920) Mondrian declared the horizontal, vertical and the right angle as the fundamental and "eternal" conditions for the statical balance upon which cosmic order was based. By being a lozenge, the painting gives only a casual glimpse of the diagonal. The cosmic order is, as it were, only observed through a diagonal "dynamic" form, while remaining itself untouched. Outside the boundaries of the canvas the static order can be presumed to be omnipresent, like all-pervading nature was outside the accidental outlines of a snapshot given by an Impressionist painting. It seems as if in Mondrian's painting the yellow lines are forming a perfect square outside the canvas. They only will fail to do so because of the different thicknesses of the lines involved.

Many have seen in Mondrian's use of the lozenge a comment on the art of Theo van Doesburg (1883–1931), and it began as such indeed. The story was as follows: Van Doesburg, the driving force of the so-called "De Stijl" movement, to which also Mondrian once belonged, was tired of the austerity of *Neo-plasticism* and proclaimed in his own *Elementarism* a more libertine approach of art: the diagonal was now admitted and even acclaimed. Mondrian considered it as a sort of offense against the "righteous creed."

The artistic clashes of the two principal painters of De Stijl have, indeed, something in common with theological disputes that traditionally were flourishing inside Dutch calvinism. Against this cultural background the art of Mondrian has often been seen.

Mondriaan—only when he later moved to Paris he dropped the second a of his name—was born in Amersfoort as the son of a strict calvinist school master. So when Piet Mondrian in a long, continuous development came to his abstract art, the link with the iconoclastic tendency of his calvinistic upbringing could easily be led. Another somewhat dubious parallel, by the way, has been drawn by some critics between his art and Dutch landscape. The flat rectangularly parcellated Dutch countryside should be reflected in Mondrian's compositions.

Actually Mondrian's art in the 'thirties, represented by his *Composition with yellow lines* from 1933, is above all a next step in his rigorous formal researches which gave at the same time an insight into a world still to come. Mondrian's art stood, after all, in the service of a utopia.

Paris cubism, rather than Dutch calvinism or for that matter Dutch landscape, was one of the starting points for his abstract art. After a modernist career—started nevertheless in an academic style—he discovered shortly before World War I the principles of cubism. With the help of theosophy, the modernist religion he adopted after his calvinist past, he gave a spiritual meaning to the elementary forms he found in cubism.

Formal purism was combined with a similar purism in the field of colour. Apart from black and white, Mondrian used the three primary colours red, yellow and blue. Also in this field Theo van Doesburg, who was not ashamed in using brown or violet, appeared to be more lenient.

In *Composition with yellow lines* Mondrian goes to the limits of his self imposed orthodoxy. The image is stripped of all accidental—or rather what was considered by Mondrian as accidental—elements. He goes even further. White and yellow are here the only colours left over of his already restricted gamma. The only variation in colour consists of the slightly perceptible differences in mass, one line being fuller than the other. In this subtleness, the painting has more of an experiment than of a fully accomplished master work. It appeared to be, however, a crucial experiment.

In the series of Mondrian's lozenge-shaped paintings the *Composition with yellow lines* was, in a way, his last statement as far as his dispute with Van Doesburg was concerned. From now on, the lozenge became for him a definite new means for his own artistic struggle. By avoiding here black lines Mondrian anticipated his last "diamond": *Victory Boogie-Woogie* of 1943/44. This unfinished painting, referring to music and dance like *Foxtrot A* (also a lozenge), was fully filled in with the three colours again.

While in the *tabula rasa* represented by *Composition with yellow lines* an old development came to a close, a new and final one in Mondrian's art was starting. He made the painting when he was still living in Paris. At the other side of the ocean, in New York, he started with his last lozenge, and died in 1944.

—Jan van Geest

Bibliography—

Seuphor, Michel, *Piet Mondrian: Life and Work*, New York and Paris 1956.
Jaffe, H. L. C., *Mondrian*, New York 1970.
Blok, Cor, *Piet Mondriaan*, Amsterdam 1974.
Ottolenghi, Maria Grazia, *L'Opera Completa di Mondrian*, Milan 1974, Paris 1976.
Carmean, E. A., *Mondrian: The Diamond Compositions*, Washington, D.C. 1979.
Champa, Kermit Swiler, *Mondrian Studies*, Chicago 1985.

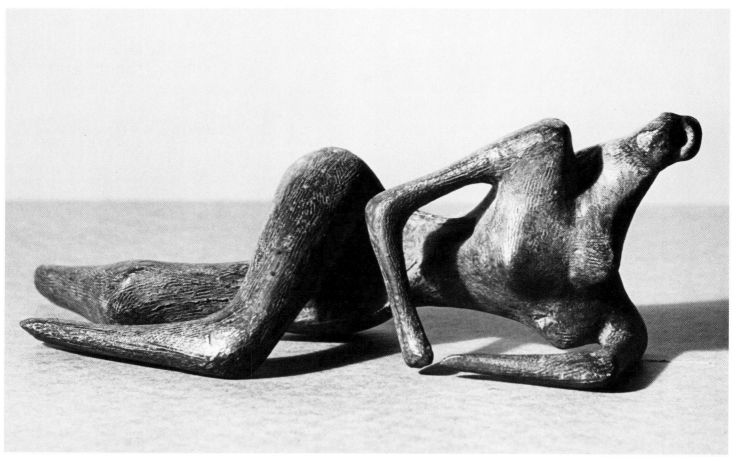

Maquette, 1955

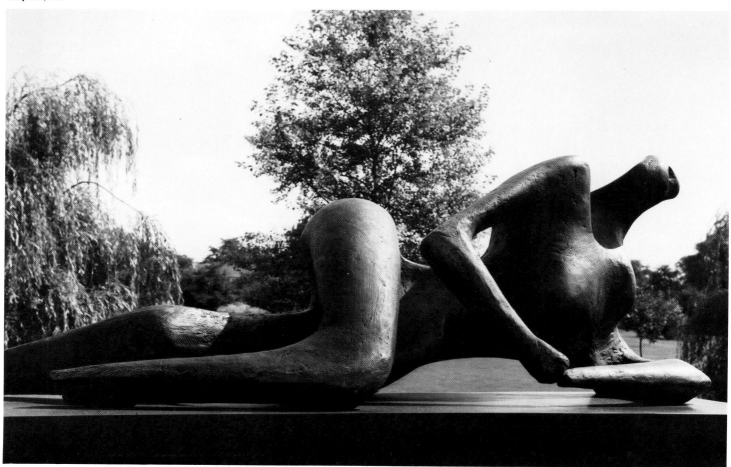

Photos reproduced by kind permission of the Henry Moore Foundation

Henry Moore (1898–1986)
Reclining Figure, 1956
Bronze; edition of 8; 96in. (244cm.) high
Berlin, Akademie der Kunst; Perth, Western Australia Art Gallery; Pasadena, Norton Simon Museum of Art; and private collections

Henry Moore's work is so familiar world wide that it is difficult to recall that he was always an experimental artist, taking many risks in his daring formal inventions. This has been very evident in his treatment of the reclining female figure which has been one of the most significant and important themes of his art throughout the whole of his long career, from the compact and chunky figures of his earliest work in the 'twenties to the great two- and three-piece, space-embracing sculptures of his later years in the 'sixties and 'seventies. It has always been noticeable that the figures, though lying down are never supine or languid. On the contrary, they are alert and vigilant with heads erect. Talking of his obsession with the reclining figure Moore said "sometimes an artist has a set theme that he takes over and over again . . . and the theme frees him to try out all sorts of things that he doesn't quite know or isn't quite sure of. With me, the reclining figure offers that kind of chance. The subject is settled for one, one knows it and likes it, and one's free to make a new form-idea within that subject that may be completely different from any other idea that one's ever had."

In the 1956 *Reclining Figure*, Henry Moore created one of the most expressive and disturbing of all the many variations and nuances of feelings he drew from this motif. It was in the early 1930s that his "hole" period began when, by piercing the sculpture, going right through from one side to the other, he started to make what he considered to be truly three dimensional forms rather than by just cutting in to the surface of the block. He wrote, "At one time, the holes in my sculpture were made for their own sakes. Because I was trying to become conscious of spaces in the sculpture, I made the hole have a shape in its own right . . . recently I have attempted to make the forms and the spaces (not holes) inseparable, neither being more important than the other."

It was not until the 1951 Festival of Britain *Reclining Figure* that he was able to say ". . . now the space and the form are so naturally fused that they are one."

This fusion is marvellously achieved in the 1956 bronze, where the holes are replaced by a continuous pulsating space that swells, narrows and flows out again throughout the entirety of this eight-foot-long sculpture. He has scooped out the torso to such an extent that the waist has become very slender, a fragile bridge between the upper and the lower parts of the body and it was not many years before he was to dispense with the bridging waist and develop the motif into great two- and three-piece reclining figures.

As ever with Moore, the image in the 1956 sculpture is powerful and vital, but it is presented here with a feeling of barely restrained violence that is rare in his oeuvre. Starting from the brutally chopped off ankles, it thrusts upwards under the arched right leg to the jutting right shoulder and the straining, phallic neck—at the end of which is a head with a vertical, woundlike gash. This neck and head bear an uncanny resemblance to one of Francis Bacon's screaming heads. The feelings it arouses are of pathos and pity for this figure, which appears to be not so much a reclining form as one struggling to rise from a prone position. In nearly all his other reclining forms there has been an air of plenitude and serene authority, the feminine principle displaying itself in all its indomitable strength and capacity to endure. The 1956 figure, seen from some aspects, appears mortally wounded. The left arm lies at an oddly dislocated angle to the body and is painfully flattened. The shoulders, the elbows and the right knee all set up a strongly right-angled rhythm, which is in complete contrast to the view of the figure from the back which is dominated by the unexpectedly sensuous and ripely rounded buttocks. In the majority of his reclining figures, Moore has shown them with their legs apart, their openness suggesting sexual responsiveness and also suggesting analogies with penetration and the birth passage, the channel through which new life is brought into the world. In contrast, in this figure the genital area is closed and almost hidden.

The form idea and its associations in this bronze seems to have had a particular fascination for Moore, because over the next four years he worked on an elmwood version (now in the Guggenheim Museum, New York) which is almost identical, but in which he placed the figure upright against a wall from which it seems to be struggling to detach itself. The air of a stress and poignancy that is not characteristic of his female reclining figures may be attributed to the other works on which he was engaged during this decade—most notably his two *Warrior* sculptures. Of the *Warrior with Shield* of 1953/4, the Jungian analyst Dr. Erich Neumann wrote, "it was the most devastating portrayal in all art of a suprapersonal castration complex," showing "complete capitulation before the forces of destruction," and his *Falling Warrior* of 1956 depicts the dying body in a last spasm of agony as it hits the ground. Moore has spoken of his "tough" and his "tender" sides and the necessity of tension and conflict in any art that can be considered great, and in these works strangeness and terror find expression. "Beauty in the late Greek or Renaissance sense is not my aim," he said. In much of the art of the 'fifties, the European work is haunted by the aftermath of the Second World War and the revelation of the extent that civilised restraints can break down. It is Moore's strength that, in his sensitive response to these chaotic and restless stirrings, he gave us images of, in John Russell's phrase "a meaningful ambiguity"; an awareness certainly of the destructive forces but also a very positive, stoical and affirmative attitude. He was a big enough artist to find ways of making new relations between man and his world.

—Mary Ellis

Bibliography—

Read, Herbert, *Henry Moore: A Study of his Life and Works*, London 1965.
Moore, Henry, and James, Philip, ed., *Henry Moore on Sculpture*, London 1966.
Russell, John, *Henry Moore*, London 1968.
Moore, Henry, and Hedgecoe, John, *Henry Moore*, London 1968.
Tate Gallery, *The Henry Moore Gift*, London 1978.
Rousen, Steven W., Garrould, Ann, and others, *Henry Moore: The Reclining Figure*, exhibition catalogue, Columbus, Ohio 1984.

Photo courtesy Leo Castelli Gallery, New York

Robert Morris (1931–)
Observatory, 1970–77
Earth and water construction; 230 feet diameter
Constructed at Arnheim, 1971, and at Oostelijk, 1977

After a series of small neo-Dada sculptures based on Duchamp, Robert Morris made his mark on the art scene in the early 'sixties as one of the founders of the Minimal Art movement. Although his early fame rested on sculpture based on simple, solid geometry such as three-dimensional right angles, beams, boxes and wheels, the origins of his sensibility lay not in simple structures but in complex ones compounded of equal parts theater, history and a celebration of art materials. In the late 'sixties Morris's work first changed from the crisp, hard contours of Minimalism to the drooping, heavy felt pieces tugged into elegant ceremonial contours by the effects of gravity.

By the late 'sixties, art and life in imitation of each other were rejecting the status quo and looking for new meaning and concepts of art in cultural roots and a renewed closeness to the land. For artists, this meant rejecting the gallery system as the primary locus of activity and making works of art that could not be easily bought and sold. Morris made his first earthwork, a pile of loose dirt laid on the gallery floor for the 1968 *Earthwork* exhibition at the Dwan gallery. By the late 'sixties, Morris and other artists under the influence of Robert Smithson began to explore new forms of sculpture outside the traditional gallery framework. Instead of "Putting a work of art on some land," as is traditional in a sculpture garden, Smithson said, "some land is put into a work of art." For artists like Morris it meant going back to pre-history and looking at primitive structures that used rocks, earth, ditches, embankments and walls to construct celestial clocks marking the passage of time. What for primitive man was a necessity became in the hands of Morris a jeweled luxury, like an ornamental wristwatch embodying what is the ultimate luxury in late twentieth-century society—space. In 1971 Robert Smithson's work of the decade culminated in the much publicized *Spiral Jetty*, an immense spiral earth ramp built in the great Salt Lake, Utah.

The following year Morris constructed his *Observatory*, an earthwork at the Sonsbeek International Outdoor Sculpture Exhibition organized by the town of Arnheim. The site lay on the border between cultivated lands and towns to the east and a wilderness area of dunes and low forest extending West about two miles to the sea. The *Observatory* had a total diameter of two hundred and thirty feet and consisted of two concentric, circular mounds of earth surrounded by a water filled canal. The inner circle was a 9-foot-high and 60-foot-wide wooden pallisade banked with earth. It had four slit openings that corresponded to visual markers in the outer area that marked the position of the sun on the equinoxes and solstices. On the far point of the East–West axis are two nine-foot-square steel plates arranged in an open chevron (roughly equivalent to the heel stone at Stonehenge). The two equinox sunrises occur immediately above the steel notch. Four seven-ton granite boulders in the notches of the outer embankment are oriented to form a sight line from the central enclosure to two points on the horizon. These sightlines, 37° 3′ to the Southwest and Northwest, mark the solstice sunrise positions for the Ijmuiden lattitude.

Morris said, "The Observatory is not a scientific instrument any more than it is an earthwork. Marking four major solar positions gives the work a temporal dimension or 'time frame' and also ties the body's experience of moving within the work to the sun's movement beyond the earth. Enclosures and openings; the uses of earth, sky and water; sightlines and walkways; changing levels—such things ally the work more to Neolithic and Oriental building complexes than to the sculptural properties of earthworks."

In constructing the observatory Morris is claiming a larger role for sculpture. Not only is sculpture now big enough to engulf the viewers, to become a theater where both viewer and nature performs the work of art. He is going back to prehistory and modeling his work on the relationship of architecture to a greater context than simply the individual artist's journey through their own minds. The obvious parallel and clearly the one that presented itself to Morris is Stonehenge, the English Neolithic monument that used concentric rings of massive stone boulders set in lintels to frame the summer solstice. He also was clearly aware of other forms of sun symbolism in architecture such as the axial alignment of the Parthenon and Christian churches with the rising sun. If, as Maurice Berger suggests, ". . . the search for a self lost in the morass of late industrial culture was a re-eminent goal of the work of the period." Morris's works of this period reflect not only his own but a general cultural guest at this time for reviving dead forms to put new meaning into the activity of making art.

While the construction of the *Observatory* coincided with the peak of Earthworks many of the issues involved in this sculpture were present both prior and subsequently to its construction in other works by Morris. The shape of the *Observatory* is in a pierced circle. Although the placement of the opening had astrological imperatives earlier and later sculptures by Morris also relied on the image of the broken or pierced centrifugal form which often has an aura of being a locked container like a prison or labyrinth. From his earliest work in dance and performance art, Morris has been concerned with the human presence. Here, the geometry of his minimal pieces is given greater meaning by its scale and its orientation to the sun. Here, he creates a theater, a sculpture that is experienced as architecture and landscape, destroying the neutrality and passivity of Minimalism in the process.

Morris's work has concentrated on the action of materials since his *Anti-Form* manifesto of 1968 in *Artforum* called for an art that made itself through an investigation of the properties of its materials. Here he works with both hard (granite and steel) and soft (wood, earth and water) materials. Although the process of construction was largely removed after completion Lucy Lippard points out in *Overlay* that the "two steel plates used for the equinoctal notches were dragged along the ground by bulldozers to their final resting place, leaving deep groves in the ground as a record of passage." This decision to leave the marks produced by the plates passage is meant to indicate that it is a man-made construction just as the marks of the stone malls on Stonehenge reveal that the shape of the stones has been created by man. Yet, there is a difference. The *Observatory* took relatively little effort to construct compared to the labor of building Stonehenge and that labor was performed more by man than machine.

In its initial phase, *Observatory* was constructed on an alluvial plain that had been frequently flooded in the past. Insufficient funds as well as the initial concept of the piece as a "temporary" work of art caused its eventual dissolution. When the piece was new, it looked as if it were a geological formation indigenous to the landscape, because of its shape and its use of local materials. After the close of the exhibition, it decomposed and gradually returned its materials to their source—the earth around it. Although earthworks, process and conceptual art were all designed to circumvent the commercialism of art by not creating a commodity that could be bought and sold, the practicalities of the art world have often caused these unownable pieces take on permanent forms. The *Observatory* was reconstructed on a larger scale in 1977 at Oostelijk, Flevoland, Holland and funds were allocated for its perpetual upkeep.

—Ann-Sargent Wooster

Bibliography—

Tucker, Marcia, *Robert Morris*, New York 1970.
Compton, Michael, and Sylvester, David, *Robert Morris*, exhibition catalogue, London 1971.
Morris, Robert, "Observatory," in *Avalanche* (New York), Fall 1971.
Sonfist, Alan, ed., *Art in the Land*, New York 1983.
Karmel, Pepe, and Berger, Maurice, *Robert Morris: The Felt Works*, exhibition catalogue, New York 1989.
Berger, Maurice, *Labyrinths: Robert Morris, Minimalism and the 1960s*, New York 1989.

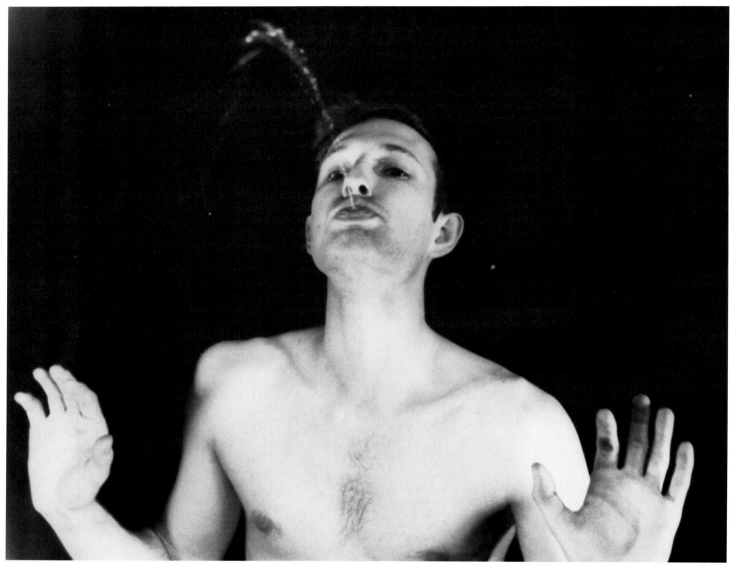

Photo courtesy Leo Castelli, New York

Bruce Nauman (1941–)
Self Portrait as a Fountain, 1966–67
Colour photograph; $18\frac{3}{4} \times 23\frac{1}{2}$ in.
New York, Whitney Museum of American Art

Bruce Nauman, a Californian artist, has been described as a process artist, body artist, sculptor, performance artist, behaviourist, phenomenologist and post-minimalist, but perhaps Nauman is best described by the more over-arching term, conceptualist. He has worked with many media including paper, film, video, photography, neon, plaster and fibreglass with which he has produced a diverse range of work including sculptures, installations, films and videos of private performance-like pieces, drawings and neon pieces.

Nauman's varied body of work is difficult to see as a whole; it appears open-ended, shifting, fragmentary. Some pieces literally resemble fragments, for instance *From Hand To Mouth* (1967), others, such as the untitled fibreglass pieces from 1965–66, appear unfinished. Yet there are recurrent concerns and threads which run through Nauman's work. He tends to work through an idea in several media, or revisit and reformulate earlier ideas in later works. His disparate activities form an elusive, complex series of investigations, paradoxically both private and public. His oeuvre could be described as an oblique, almost abstract, conversation with his materials, himself and his audience.

After studying mathematics and art at The University of Wisconsin, Madison, Nauman attended The University of California, Davis, graduating with an M.A. in 1966. At Davis, Nauman was largely left to his own devices and in 1965 he stopped painting and began making objects, films and performances. During this period, and subsequently in his San Francisco studio, Nauman developed the habit of setting himself game-like projects, and this sense of play is apparent in *Self-Portrait as a Fountain*. This work is one of a series of eleven photos, *Bound to Fail, Coffee Spilled Because the Cup Was Too Hot, Cold Coffee Thrown Away, Drill Team, Eating My Words, Finger Touch Number 1, Finger Touch with Mirrors, Feet of Clay, Untitled* and *Waxing Hot*, (1966–67, various sizes, approx. 19 × 24 in. Whitney Museum of American Art, New York). The works in this series can be described as visual puns, and Nauman has said of them, "I think that when I made the photographs I had been trying to [figure out] how to get those images out and I thought about making paintings but it had been such a long time since I'd done any painting that . . . I had no style of painting. If I had made paintings they would have been just very realistic paintings, and I don't know if I could even have done that at that point . . . And so it was just easier to use photographs."

Self Portrait as a Fountain makes a direct reference to Marcel Duchamp's *Fountain* (1917). Duchamp can be considered the "father" of conceptual art, for Duchamp recognised the linguistic basis of art and played upon it. Nauman has acknowledged his interest in Duchamp, "I wanted to put ideas into the works—mainly to put language into the work. I would say my interest in Duchamp has to do with his use of objects to stand for ideas." In 1917 Duchamp took a urinal, signed it "R. Mutt," and entered it as a piece of sculpture entitled *Fountain* for an exhibition in New York. In signing the urinal and placing it in an art context, Duchamp designated the urinal "art" and questioned the apparatus of the art world. In *Self Portrait as a Fountain*, the artist, Nauman, is photographed spurting water from his mouth, and so can be

seen as a Fountain, but the spurting arc of the water is also reminiscent of the act of urinating, hence the double reference to Duchamp's readymade. The metaphor of the fountain appears in other works from the same period, such as *Window Screen* (1967), a rectangular sheet of transparent rose coloured mylar with the words "The true artist is an amazing luminous fountain" inscribed around the edges.

The early fibreglass pieces were untitled, but from 1966 titles began to assume an important role in Nauman's work, for they allowed the open introduction of literary and verbal ideas. In some cases, words actually appeared in pieces. This is most apparent in the neons and window screens, but in two of the photo series words are integral to the visual puns. In *Eating My Words*, the word "words" is literally shaped out of bread, and Nauman is photographed about to spread jam on the bread, presumably about to eat the words. Similarly in *Waxing Hot* the artist is depicted literally waxing the word "Hot." It was at Davis that Nauman, through his tutor William Wiley, became interested in word play and punning. He was also influenced by the philosopher Wittgenstein's writings on language and language games. Individually, these visual puns have a certain straightforwardness, almost banality, for the words and images form closed, circular systems, but as a series they can be interpreted as "a kind of summing up for the artist of ideas about himself and the function of art."

In nine out of eleven of the photographs Nauman uses his own body as part of the image. He also used his own body and actions in many of his film and video pieces and as a template for body casts such as, *From Hand to Mouth*. Some critics have called such work narcissistic, but his distanced and impersonal use of his body in the photo series and other works belies the charge of narcissism. In 1971, *Self Portrait as a Fountain* was used for the cover of a German avant-garde art magazine, *Interfunktionen* where "it took on the character of a kind of seminal work in the context of the international body art movement" but "Nauman was never to actually become the 'body artist' his work so authoritatively presaged." (Livingston) Similarly, although punning recurs in Nauman's later work it never appears in such a literal and pictorial manner as in *Self Portrait as a Fountain* and its companion pieces.

—Claire Lofting

Bibliography—

Nauman, Bruce, *Pictures of Sculptures in a Room*, Davis, California 1966.
Whitney, David, *Bruce Nauman*, exhibition catalogue, New York 1968.
Pincus-Witten, Robert, "Bruce Nauman: Another Kind of Reasoning," in *Artforum* (New York), February 1972.
Livingston, Jane, and Tucker, Marcia, *Bruce Nauman: Work from 1965–1972*, exhibition catalogue, Los Angeles and New York 1973.
Schmidt, Katharina, *Bruce Nauman*, exhibition catalogue, Baden-Baden 1981.
Ammann, Jean-Christophe, and others, *Bruce Nauman: Werke von 1965 bis 1986*, exhibition catalogue, Basel 1986.
Van Bruggen, Coosje, *Bruce Nauman*, New York 1988.

Barnett Newman (1905–70)
Vir Heroicus Sublimis, 1950–51
Oil on canvas; 240 × 540 cm.
New York, Museum of Modern Art

Vir Heroicus Sublimis represents a huge field, saturated with bright red color, which seems to outflow the picture. This explosion of color and light is in several places cut by thin vertical strips (Newman called them "zips"). The strips have been pasted on canvas and painted. Three of them are darker than the background, one is white. In 1951, the artist added a last strip on the right-hand extreme of the picture; this one is brownish-yellow. The zips have been drawn intuitively and have nothing to do with geometrical division. What is more, they seem to come from space outside the picture; well, the whole picture seems to be a fragment of something even bigger, which does have neither the beginning nor the end.

Vir Heroicus Sublimis is a masterpiece of the mature period of Barnett Newman's art, which is characterized by such huge fields of color with vertical strips coming "from nowhere." At the same time, these strips appear to repeat the edge of the frame: the concrete, material framework becomes in this way an element of the composition. The frame disappears and the area of expansion becomes open on all sides.

Barnett Newman belonged to the heroic generation of Abstract Expressionism, the leading current in American art of the 1940s and early 1950s. He represented its specific variety, called *field painting*. The term *field* was for the first time used by Clement Greenberg in 1955. The word was borrowed from the terminology of *Gestalt psychology* (configurationism), which in turn had adopted it from physics ("electromagnetic field" or "field of force"). Newman's field of color acts according to this very principle—as an entity, which is primary to a part.

In the late 1940s, Newman introduced large scale in his pictures. Paradoxically, he wanted them to be watched at a close distance, the spectator standing not in front of them but as if being "within," alone vis-a-vis the world, to which those huge chromatic fields sent him.

Newman conceived that world as a transcendental one, the foundation of which was the oldest archetype of human existence, consisting of the eternal and recurrent cycle: nothingness as a precreational state—form (life)—nothingness again (chaos, death as a condition of rebirth). Thomas Hess called Newman a great celebrant of the creation of life and rebirth, the poet of Genesis. Newman himself claimed that the artist should start like the Lord—with chaos and emptiness. He did not comprehend chaos as the mixing or explosion of elements, but rather as an even more primary state, the state of magma and nothingness.

The symbolic layer of Newman's pictures took shape in the first stage of his painting, at the turn of the 1930s and 1940s, in the atmosphere of the artists of his circle: fascinated by the contents of ancient myths, primitive art as the residuum of myths, and those currents of the philosophy of culture that dealt with the phenomenon of myths, their contents and structure, and postulated their presence in the mentality of contemporary man. Those interests arose in the cultural climate prevailing at that time in the United States, which thrived on the spread of C. G. Jung's theory (concept of archetypes always present in so-called collective unconscious), development of ethnography, anthropology and comparative study of religion (revealing the common significative core of all myths and religions), as well as the American research of "symbolic imagination" in literature. Not without significance was also the impact of European surrealism, referring to the poetics of dreams, that is the subconscious of our psyche.

The effulgence of this field, in which attempts were made to formulate a new philosophy of man, served for reformulating the foundations of thinking about art, about the primary impulses and sources of creativity, about the mechanisms of the emergence of meanings.

It was chaos, disintegration, "death" as a precondition of new life became the key meaning (Newman calls it "subject matter"); it functions in all the myths of the humanity as a motif of God, who dies and is reborn again and again, embodying the eternal process of the transformations of nature. This motif is a basic link of the pattern of creation and as such was adopted in various forms by the artists representing Abstract Expressionism. Lawrence Alloway wrote that "the quest for myth" as an access to the contents of the unconscious reached its peak in the 1940s in New York; he called the situation "the appeal of myth." In their famous letter to *The New York Times* (June 13, 1943), Newman, Gottlieb and Rothko announced their conviction as to the weight of eternal symbols, the expressive force of myth, which provides a sense of linkage with the primitive man, as well as the crucial weight of the subject matter, which embodies what is "tragic and timeless."

Barnett Newman referred also to the attitude of the archaic artist, as the one who expressed primary meanings; he was particularly interested in the pre-Columbian art and the art of North American Indians. Thus, he made it his objective to express such values which would be universal and timeless, which would manifest whatever was elementary and inalienable in human experience, whatever linked personal feelings with collective experience. The artist considered the possibility of creating a new art, which might be "formless," and which would not suggest beauty, but rather the "mysterious sublime." He was looking for an ideograph, which would embody ungraspable emotions, an emblem, a possibly immaterial form, which would represent the principle of transcendence. He wanted a picture, which would have "a second self," whose potency would be similar to the potency of a ritual; for in its course a ritual is real, and at the same time refers to something beyond its reality.

Those huge expanses of canvas, in which monochromatic color, flatly spread and applied broadly, forms Newman's personal vision of "the sublime," became the embodiment of the sought emblem. Physicality of the painting matter was almost eliminated, since the enormous dimensions of those planes make it impossible to perceive them as a form. What remains is a sense of something infinitely great and primary, which reminds of the Freudian "oceanic feeling."

Narrow strips running across the fields of color play the role of signs signalling the transcendental function of the picture. They do not evoke concrete designations, but merely delimit the area of potential associations. It is to be remembered that the vertical functions in myths as the axis of the world ("axis mundi"), linking the heaven with the earth and the underground, and at the same time designating the basic sides of the world: left and right as well as up and down.

In this way, in the spaces he created Newman established a link with what goes beyond the visible. Feeding our eyes with the magnificence of his pictures, he offers us access to the ineffable areas.

Vir Heroicus Sublimis is as if a sum total, a concentration of the idea that the artist wanted to express. This idea is supported by the title of the picture, which evokes the dramatic act of transcendence towards the unknown, the act, which is strictly personal, at the same time being the eternal experience of the humanity.

—Alicja Kępińska

Bibliography—

Newman, Barnett, "The Sublime Is Now," in *The Tiger's Eye* (New York), 15 December 1948.
Newman, Barnett, "The Ideographic Picture," in *Six Peintres Americains*, exhibition catalogue, Paris 1967.
Hess, Thomas, *Barnett Newman*, New York 1969.
Sandler, Irving, *The Triumph of American Painting: A History of Abstract Expressionism*, New York 1970.
Rosenberg, Harold, *Barnett Newman*, New York 1978.

Reproduced courtesy of the Isamu Noguchi Foundation, Inc.

194

Isamu Noguchi (1904–88)
Even the Centipede, 1952
11 Kasama ware pieces, on wood pole; 168 in. (425 cm.) high
New York, Museum of Modern Art

As a Japanese-American, Isamu Noguchi was fed by the cultures of two worlds: the Eastern and the Western aesthetic; or, perhaps, he should be understood from the opposite viewpoint, in that he was born not in Japan but in the United States. According to one writer, Shazo Takiguchi, Noguchi's work was seen as possessing many Western elements foreign to the Oriental mind; but, from an American viewpoint, his work was possessed with a decidedly Oriental persuasion. The nature of this contradiction is a profound one; and thus, it becomes appropriate to contextualize the works of Noguchi in such a way as to reflect the visual and conceptual operation of these elements.

The year 1952 was a year of incredible fecundity in Noguchi's career. It was his fourth trip to Japan. His first visit had been in 1931 where he lived in Kyoto for five months and studied the uses of clay under the tutelage of Uno Jimmatsu. Noguchi has expressed that it was not a happy visit. When he returned to Japan, nearly twenty years later in 1950, also for the purpose of studying terra-cotta applications, it was much better. Because his work had achieved a certain degree of notoriety after the War, in Tokyo especially, Noguchi found a greater enthusiasm and friendliness towards him that had not been evident on the occasion of his earlier visit. He was asked to produce an exhibition before leaving the country. In responding to this request, he decided to go to the pottery center in Setto where he made thirteen terra-cotta sculptures making use of the traditional Japanese techniques. The exhibition of these works was a huge success. He returned again to Japan the following year for another four-month visit where he was asked to produce a memorial work for Keio University, the place where his father had taught for forty years. In addition, he began working on the design for a garden at the Readers Digest building in Tokyo. Returning to New York, his attention was being drawn to a different area entirely; namely, the design of outdoor playground space for the new complex of United Nations buildings. (Curiously, Noguchi was asked to design another garden for the new Lever House, recently built by Skidmore, Owings, and Merrill, but the project was never funded; hence, it was not realized despite the support given to it by the chief architect of the building, Gordon Bunshaft.)

It was upon Noguchi's visit to Japan in 1952 that several important projects and ideas came together. The artist decided that he would spend the entire year of 1952 working in Japan on the *Hiroshima Bridges* and the projected *Memorial to the Dead*. While the former project was completed, the latter never was. (The large model for this memorial was later moved to Long Island City where it is currently on display in the Noguchi Museum.) In addition to these projects, he was married to the actress Yoshiko Yamaguchi and built a studio in the hills of Kamakura adjacent to a crude house temporarily given to him by the potter, Rosanjin Kitaoji.

Noguchi described his elation with his living and working situation in Kamakura as follows: "I was filled with joy and energy. As soon as the studio was finished, I made all kinds of sculptures and other objects, using the clay Rosanjin san gave me. These were fired in his kiln. Also, I took a trip south to 'Imbe' with my patron to use the famous earth of Bizen in the workshop of Kaneshige Toyo. The results of these two firings constituted a large exhibition at the newly built Modern Museum in Kamakura. About two-thirds of the work was then packed and shipped to New York."

In this shipment of work to New York were the eleven elements that constituted *Even the Centipede*. Prior to the artist's return to New York again the following year, Noguchi also gave birth to the concept of the light-lantern known as *akari*. These are paper forms or sculptures stretched over a thin wire frame with a lit interior. Eventually he would develop *akari* as a series of prototypes to be made as multiples.

Even the Centipede remained in storage in Noguchi's New York studio for the entire year of 1953. There were legal problems with his wife's visa that required frequent travel to Washington. (This was during the communist scare, and many foreign actors and actresses were held under suspicion until they could prove themselves "clean.") Finally, in 1954, the matter was cleared up and Noguchi received an offer from the Stable Gallery in New York to exhibit the ceramic pieces that he had sent back from Japan a year and a half earlier. It was through this exhibition in November 1954 that a curator from the Museum of Modern Art saw *Even the Centipede* and acquired it for the permanent collection. It has remained in the collection ever since and is frequently exhibited for public view.

Shuzo Takiguchi believes that, "underlying his Japanese works there is the logic or the illogic of Western construction." He goes on to say that "Noguchi is firing his pottery as sculptures, or, at least, they are being fired in a manner that captivates the fancy of a sculptor." These comments, written shortly after the exhibition of the ceramic pieces in Kamakura, reveal the tension between Eastern and Western modes of aesthetics. Takiguchi further suggests that Noguchi has revived a primitive sense of working that goes back to an age before the separation between pottery and sculpture was so easily categorized. He acknowledges that "people will be, no doubt, at a loss as to what to call these objects, the totem-pole, like "Large Centipede" [presumably referring to *Even the Centipede*], the objects that resemble upright tiles, the flower vases that look like trays, the miniature sculptures that are akin to the miniature garden: Sculptures or pottery? Yet, for all that, we Japanese once created freely without drawing a line between sculpture and pottery."

The eleven elements in *Even the Centipede* are Kusama clay that is fired at a high temperature. Each shape explores the morphology of a sexual motif that could either resemble botanical forms or express permutations of the male and female organs. Each of the elements is attached to a vertical pole, so that there is a progressive sequence of movement going both up and down the totemic structure. The fact that these forms are so close in their resemblance gives them an immediate association; yet the variation of the parts in relation to each unit is quite remarkable. It would be difficult to discern these units of form on the basis of pottery alone. Their relationship to one another and to the core element upon which they are fastened suggests a semiotic and a cinematic context. One may read these units of form as permutable elements of the same essential idea; yet one might also read these units as going outside the framework of their own delimitations, thus suggesting an inherent intertextuality between the parts in relation to the whole.

One cannot disregard Noguchi's perennial concern for spatiality in his work; and this sense of space is quite relative; that is, composed as an ideographic concept of space/time. In this sense, his work captures the essence of Moholy-Nagy's Western idea that space in the twentieth century can no longer divorce itself from time. Noguchi himself once made the statement that he wanted his garden not to retain the picturesque quality of the traditional Japanese garden as much the an ambulatory sense of moving through the space. In *Even the Centipede* there is the concern not only for the interior attributes of the individual shapes as units in themselves but for their relational attributes; that is, just as the painter Barnett Newman strove to declare the space of the canvas as a holistic object, so the artist Noguchi brings to life *Even the Centipede* in terms of the whole, where each unit is essential to the relationship of the spatial intervals which, in fact, makes it function as a sculpture.

—Robert C. Morgan

Bibliography—

Takiguchi, Shuzo, and others, *Noguchi*, Tokyo 1953.
Noguchi, Isamu, *A Sculptor's World*, New York 1968.
Hunter, Sam, *Isamu Noguchi*, New York 1978.
Grove, Nancy, and Botuick, Diane, *The Sculpture of Isamu Noguchi 1924–1979*, New York 1980.
Hunter, Sam, *Isamu Noguchi: 75th Birthday Exhibition*, catalogue, New York 1980.
Noguchi, Isamu, *Space of Ikari and Stone*, San Francisco 1986.

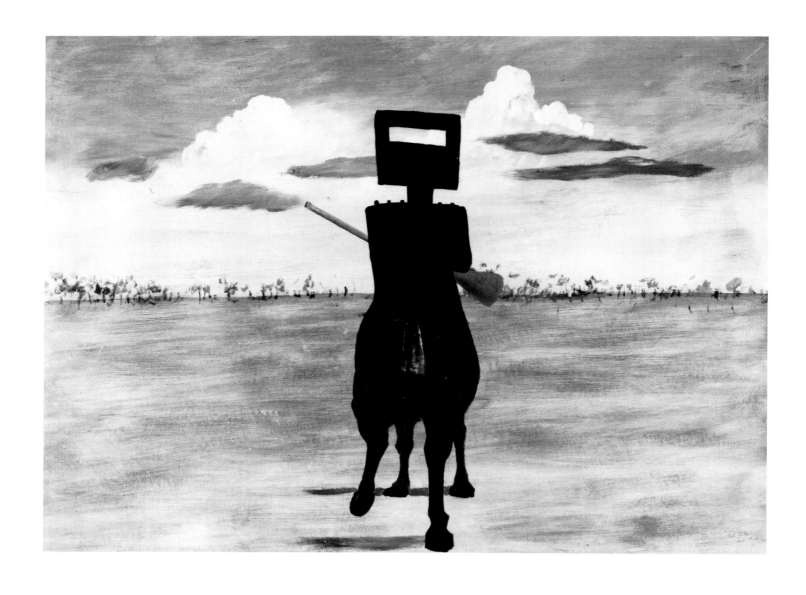

Sidney Nolan (1917–)
Ned Kelly, 1946
Ripolin enamel on board; 36 × 48 in.
Canberra, Australian National Gallery

Aspects of Australian nineteenth-century social history, the rise of Modernism in Australian Art and the career of one of Australia's most significant artists are all inextricably linked in the one key work: *Ned Kelly*.

Kelly, outcast and folk hero, stands four square and menacing in the various paintings of Nolan's Kelly cycle. In the central image of the series the iconic figure sits astride his horse, back to the viewer, assertively facing an uncertain future. His crudely armoured body is bisected by the unremittingly flat horizon line; the landscape is featureless and serves to emphasise Kelly's isolation. To understand why this outlaw from the rim of the world should have become so important to Australian cultural life, as well as to the career of the artist, it is necessary to examine the Kelly saga and the background of Australian Modernism.

As with most colonial cultures, the history of Australian institutions is the history of transportation and development of European models: in effect a variation upon the metropolitan/provincialist relationship. But, with the display of Australian Modernism by Nolan and a few contemporaries, a unique vision was revealed which, although not uninformed by European tendencies, remained largely independent of them. The *Ned Kelly* painting and its emblematic figure became a metaphor for Antipodean artistic and social radicalism. When painted in 1946–48, the myth of Edward (Ned) Kelly, bushranger, was well established and had been used as a source for radio plays, films, theatres, folk songs and literature. Its wartime revival came when Australian intellectuals were questioning issues of national identity. Kelly provided an image of a fearless but doomed challenger to the established order.

Nolan's near obsession with this archetypal figure has lasted for four decades. His Kelly can be seen as a manifestation of an uncertain national identity looking for recognition in an alien landscape.

The Kelly series portrays the brief, furiously burning candle of Kelly's rebellion. Like many of his police pursuers (and Nolan himself), Kelly was of Irish descent, possessing that Nation's humour and a grim free-booting belief in freedom. He began with adolescent larrikinism and ended in murder and execution. Nolan's Kelly is a hapless martyr who becomes transformed by local legend into national myth. With the Kelly series, Australian art is transformed from provincialist echo to an original internationalist voice. When shown in Paris (1949) the series was described by Jean Cassou of the Musée Nationale d'Art Moderne as "the work of a true painter and a striking contribution to Modern art."

To European and British commentators seeking clues to artistic revival in a tired post-war world, Nolan's Kelly series provided a new model. As a result of successful showings in Paris and Rome (1952), the Australian critics reversed their earlier unfavourable opinions of Nolan's work and, by the mid-Nineteen Fifties (Nolan was represented at the Venice Biennale of 1954) the artist became a role model for young Australian creative talent. At times his "Faux naif" style and Surrealist pictorial space resulted in him being seen as an Antipodean curiosity, regarded rather as kangaroos and wombats were by London's late 18th century society. But to the perceptive critics there was the recognition of a raw, creative energy to be found in contemporary Australian culture.

Ned Kelly is the key work in a first sequence of twenty seven. A second narrative series followed in 1954–1958, when the tube-bright colour range of the early series was ameliorated into greater subtlety. The second *Kelly* has its shadows cast from a different source and it seemed that, for Nolan, Australia could be best assimilated from a position of ex-patriation. The first series was painted at Heide, the home of Victorian art patrons John and Sunday Reed; the second series was completed in London. Nolan had by then commenced his regular travelling and conscious distancing from the sources of his art: this wandering also is redolent of Kelly's own outcast status.

Ned Kelly has its stylistic precursors in a 1938 almost Dadaist piece, *Head of Rimbaud*, and a mandallic yellow circle on a stalk-like neck, *Boy and the moon* (1940), this pedestal head pre-empting Kelly's helmet head. During a period of military service Nolan had experienced the flat, featureless landscape of North East Victoria—the Wimmera—harbinger of the great inland deserts of Central Australia. This is the landscape glimpsed through the slit in Kelly's helmet.

The Kelly of historical fact only wore his armour once at the final confrontation with the armed troopers, but the Kelly of Nolan's saga cycle is never parted from his plough share armour. To many commentators this armour is symbolic of the indestructable hero figures of many cultures. An alternative reading would be to see it as evidence of extreme vulnerability, as if some primeval carapace concealed a soft and easily damaged visceral creature. Nolan's Kelly is always awkwardly placed in front of rather than *in* the landscape. Like the European settler in the bush, he is a permanent trespasser with no hope of a symbiotic relationship with the land. The uncompromising horizon emphasises the desolation of rejection and isolation. The Kelly paintings were painted rapidly in a fast drying enamel, which is as demanding as the land itself: no errors are permissible.

In several of the series, eyes (or rather eyeballs) peer suspiciously through the helmet slit, but in *Ned Kelly* there is no indication of the bushranger's actual presence: the armour fixed firmly to the horse seems vacant. The painting illustrates a moment of passage of rebellious local hero to universal myth. The formal quality of the image often recalls wayside calvaries or reliquaries.

Nolan is a deeply literate artist, hugely well read; and his life-long odyssey through European literature is also marked by paintings which illustrate or feed on works of literature. Much of his later work developed through narrative series around such themes as doomed explorers and forgotten heroes as well as borrowings from classical sources. As the sources of the Kelly series the artist has quoted "Rousseau and sunlight."

The thorough-going Modernist Nolan early rejected the reactionary pre-war Melbourne art scene, and made it clear that he worshipped no European models. In this sense, the *Ned Kelly* paintings announce his attack on the cultural cringe with its concept that there could be no original Australian culture.

As a poet of inner loneliness the Kelly series struck a chord of universal appeal and, by strongly under-pinning his works with literary sources, Nolan also emphasises the continuity of the classical tradition. He is both inside the mainstream and yet not of it.

—Neville Weston

Bibliography—

Lynn, Elwyn, *Sidney Nolan: Myth and Imagery*, London 1967.
Melville, Robert, *Ned Kelly: 27 paintings by Sidney Nolan*, London 1974.
Haese, Richard, *Rebels and Precursors: The Revolutionary Years of Australian Art*, London 1981.
Clark, Jane, *Nolan, Landscapes and Legends*, Cambridge 1987.
Lynn, Elwyn, and others, *Sidney Nolan's Ned Kelly Paintings in the Australian National Gallery*, Canberra 1990.

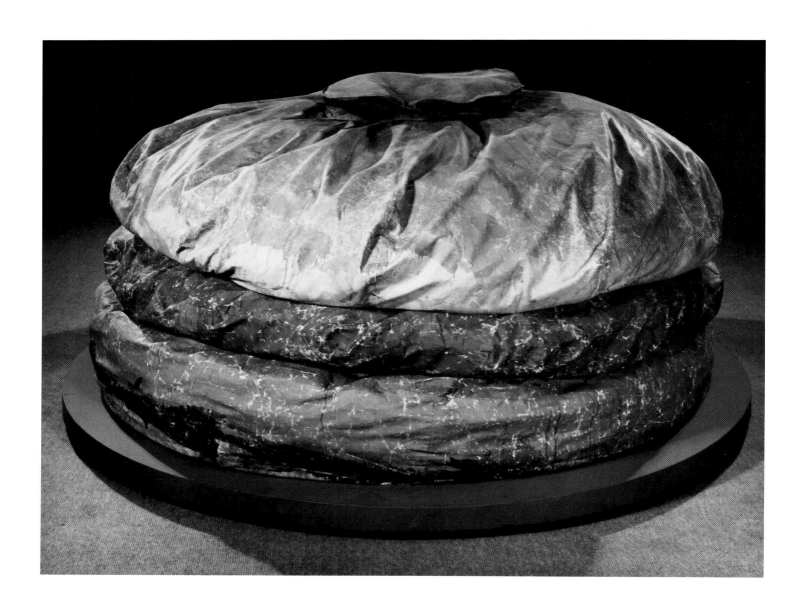

Claes Oldenburg (1929–)
Giant Hamburger, 1962
Painted canvas, foam rubber and paper; 52 × 84 in.
Toronto, Art Gallery of Ontario

In the summer of 1960 Claes Oldenburg wrote, "My position and that of others like me is one of the super-sensitive and super-intellectual in an insensitive and unintellectual society *who do not wish to escape* or who realize escape is impossible. We thus become clowns or wits or wise men." As Oldenburg's early masterpiece, *Giant Hamburger*, clearly reveals, he is a combination clown, wit and wise man.

Born in Sweden in 1929, Claes Oldenburg was brought to the United States as a young child when his father was on diplomatic service in New York. In 1936 his family moved to Chicago where he grew up, and for two years attended the Art Institute of Chicago. The first public exhibition of his work was at the Club St. Elmo restaurant on North State Street in March 1953 when he showed a group of satirical drawings in a joint exhibition with Robert Clark who later changed his name to Robert Indiana. In June, 1956 he moved to New York, two months before Jackson Pollock's fatal car crash. At the time, the dominant style in New York galleries was still Abstract Expressionism although Oldenburg continued to paint in a figurative manner that he had pursued earlier in Chicago, producing self-portraits and figure studies. Living on the Lower East Side of New York had an important influence on his developing art, inspiring him to shift his focus to American culture. "The streets, in particular, fascinated me," he stated. "They seemed to have an existence of their own where I discovered a whole world of objects that I had never known before. Ordinary packages became sculptures in my eye, and I saw street refuse as elaborate accidental compositions." The results of this inspiration were first shown in two exhibitions at the Judson Gallery in 1959 and 1960.

The second exhibition, called *The Street*, was the outgrowth of Oldenburg's attempt to formulate a figurative alternative to abstraction that would fully accept the conventions of modernism. *The Street* was in part inspired by the French artist Jean Dubuffet and his deliberatively primitive-looking *art brut*. Mainly flat, like huge drawings, Oldenburg's works consisted of figures, signs and objects constructed from discarded, often fragile materials including cardboard, paper, string, and burlap. In their nearly monochrome brown and black tonalities and textures the works reflected the decaying slums of New York which had been their inspiration.

The Street was shown in two versions. It was presented initially at the Judson Gallery from January 30 to March 17, 1960, as part of a two-man collaboration with Jim Dine whose environment was "the house" as opposed to Oldenburg's "street" scene. The second version of *The Street* was a one-man show at the Reuben Gallery the following May. Whereas in the Judson Gallery the figures had been tacked to boards against the walls, in the Reuben Gallery they hung freely in space, suspended from the ceiling. In his Summer review of the exhibition for *Art News*, Irving Sandler wrote, "Above all, it is the drawing that distinguishes these pieces. Line is direct and rough, in keeping with the content, but it is also precise and animate—like children's scribblings on tenement walls."

In the autumn of 1960, Oldenburg and Jim Dine were driving through Orchard Street in New York where Oldenburg noted that it was crowded with small stores. This observation inspired his next exhibition, *The Store*, which he conceived of as a complete environment that would transform into art the commodities of America's materialistic culture. In June 1961, he moved to a studio at 107 East Second Street, which became *The Store*, filled with sculptures of food, clothing and other objects made of chicken-wire and plaster-soaked muslin or sacking and then brightly painted. In September 1962, he expanded his exhibition concept for a second version of *The Store* which was shown at the Green Gallery.

In the fall of 1962 at the Green Gallery, Oldenburg's dramatic, large-scale works elicited a controversy typical of the first successful manifestations of Pop Art. Whereas earlier examples of Pop Art, including Claes Oldenburg's previous efforts, had often been formally related to the art of assemblage and elicited relatively little response, his new work became eagerly received by dealers, collectors and the mass-media. In fact, much of the critical controversy generated by Pop Art was inspired by Oldenburg's presentation in this exhibition of his first soft sculptures whose large scale and startling vulgarity made them impossible to ignore. The commercial success of his works was paralleled by the disapproval of Pop Art as a movement by major critics including Peter Selz who the following year wrote in *Partisan Review*, "A critical examination of ourselves and the world we inhabit is no longer hip: let us, rather, rejoice in the Great American Dream. The striking abundance of food offered us by this art is suggestive. Pies, ice cream sodas, coke, hamburgers . . .—often triple life size—would seem to cater to infantile personalities capable only of ingesting, not of digesting or interpreting. Moreover, the blatant Americanism of the subject matter . . . may be seen as a wilful regression to parochial sources just when American painting had at last entered the mainstream of world art . . ."

In his second *Store* exhibition at the Green Gallery, Oldenburg showed a number of sculptures which differed from those in the rest of the show, and from his earlier works, in two important ways: large scale and being soft and pliable, rather than hard and unyielding. These first soft sculptures by Oldenburg were intentionally crude and vulgar-looking, seeming only casually stitched together and perfunctorily painted. And rather than employing a traditional pedestal or base, large works such as *Giant Hamburger* were placed directly on the gallery floor.

Giant Hamburger (1962) is seven feet in diameter and four feet tall. It is made of canvas filled with foam and cardboard and then painted. The enormous scale of the hamburger draws the spectator's attention to the shape, color, texture and other sculptural qualities of the work. For Oldenburg, the pliability of his "soft" sculptures was a translation of painterly values into their sculptural equivalents. His concern for exaggerated size in his early soft sculptures culminated in his plans for giant monuments which he began in 1965.

Claes Oldenburg has tried to create an art which is universal in its significance. He has taken as his point of departure the specific and familiar in everyday life in order to create vulgar, representational art of formal significance. In his works such as *Giant Hamburger* (1962) he re-creates his subject in a generalized form which is intentionally exaggerated rather than an exact simulation of the original, and that in its awkward-looking execution simulates the style of a naive, self-taught artist. In such early works he has attempted to make sculptures which are metaphors for life as he stated in a manifesto that he published in 1961: "I am for an art that is political-erotical-mystical, that does something other than sit on its ass in a museum. . . . I am for an art that takes its forms from the lines of life itself, that twists and extends and accumulates and spits and drips and is heavy and coarse and blunt and sweet and stupid as life itself." With *Giant Hamburger*, Claes Oldenburg succeeds brilliantly.

—Joseph E. Young

Bibliography—

Oldenburg, Claes, and Williams, Emmett, *Store Days*, New York 1967.
Oldenburg, Claes, *Proposals for Monuments and Buildings 1965–1969*, Chicago 1969.
Russell, John, and Gablik, Suzi, *Pop Art Redefined*, New York and London 1969.
Rose, Barbara, *Claes Oldenburg*, New York 1970.
Haskell, Barbara, *Claes Oldenburg: Object into Monument*, exhibition catalogue, Pasadena 1971.
Wilson, Simon, *Pop*, London 1974.

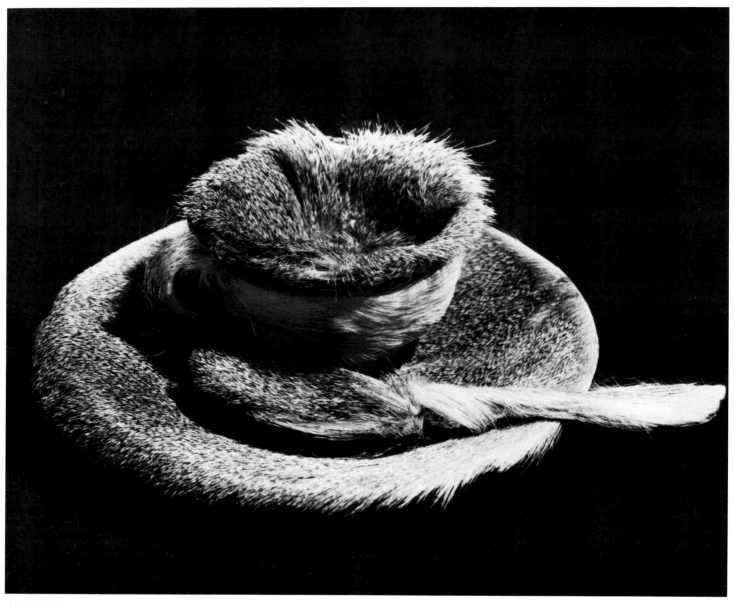

© DACS 1991

200

Meret Oppenheim (1913–85)
Le Dejeuner en Fourrure, 1936
Fur-covered cup, saucer and spoon; 2⅞ × 9⅜in. (7.3 × 23.7cm.)
New York, Museum of Modern Art

Almost everyone knows *The Fur-Lined Teacup* (1936, Museum of Modern Art, New York), and could identify it as Surrealist. Some (those who have passed art history exams) would know that its artist was Meret Oppenheim. At this point, for most people, knowledge runs out and sensation takes over. The object allures and repels at the same time. It is both all-too-familiar and alien.

Our oral intimacy with common household implements for tea-drinking is revolted by the fur covering. One cannot see these hairy utensils without experiencing the repulsive sensation of hair in one's mouth. In fact, seeing this piece arouses the other senses as well: touch, taste, smell—even hearing, if one thinks of picking up the cup and replacing it without that reassuring, familiar sound somewhere between a clack and a ting made by two pieces of china as they come together.

Because the fur-lined piece has been photographed repeatedly, and its image, or at least a verbal reference to it, appears in almost everything written about Surrealist objects, those who are familiar with twentieth-century art tend to *recognize* the piece rather than to *react* to it. And yet the same could be said of any work of art which has been seen as central to an historically important movement. The difference is that coming upon the *Fur-Lined Teacup* still jolts the viewer who visits the Museum of Modern Art. It is smaller and humbler than one remembers—after all, just a cup and saucer—but disconcertingly animate, clad in fur as it is. It sets up its own intimate little world, yet because its component parts are utensils handled every day, this world includes the viewer.

Oppenheim's *Fur-Lined Teacup* is an "object of symbolic function," as defined by Salvador Dalí (in his essay "Objects surréalistes," *Le Surréalisme au service de la révolution*, Paris, 1931). Chosen for their evocative powers, objects and fragments of objects from the real world are brought together, in collage fashion, to form the Surrealist object, which, ideally, would function in the course of ordinary life to subvert that minute-to-minute, communally-shared sense of lived reality, to jolt that person whom the object confronted into a "sur-reality," a reality which included the dream, sexuality, childish impulse. Such objects function poetically, not visually. They compete with ordinary objects in the real world and not with sculptures. Their aspirations are not aesthetic: the Surrealist object takes its form as a result of psychological necessity and not out of compositional concerns.

In a curious way, Surrealist objects function in the manner religious relics were said to function: they effect a passage from this world to another beyond experienced reality. The holy relic, a part of a saint or some object which had been in contact with a saint, was charged with divine grace, yet belonged to the realm of the material, in that it could be seen and touched. Belonging simultaneously to the material and the supernatural realms, the relic offered to the faithful the means to brush up against the supernatural. Surrealist objects, more material than sculpture and painting, were designed to be handled. Some of them have moving parts to be manipulated. Like the relic, these objects promise the means of contact with another world. But the Surrealist otherworld was *below* experienced reality rather than above it. The "underworld" of the Subconscious, first revealed by Freud, was of great interest to the Surrealists. Like Freud, the Surrealists were fascinated by the irrational nature of human sexuality. By evoking sexuality, their objects could divert a person from the light of everyday rationality to the darkness of the dream.

Meret Oppenheim's *Fur-Lined Teacup* is known by most viewers quite apart from her other works. In fact, that it lives a life very much on its own demonstrates its success as a "symbolically functioning object." It was the most highly-acclaimed piece in the first exhibition of Surrealist objects, held in 1936 in the establishment of Charles Ratton, a dealer in primitive art. In the same year, it enjoyed an even greater success in New York as part of the *Fantastic Art, Dada, Surrealism* exhibit at the Museum of Modern Art. A great part of its success is due to the simple means it employs to evoke tactile and oral associations.

To many viewers, it evokes female sexuality. Robert Hughes (in *The Shock of the New*, New York, 1980, p. 243) even characterized it as "the most intense and abrupt image of Lesbian sex in the history of art." The Freudian explanation of the object, then, prevails, quite apart from Oppenheim's own, more anecdotal account of its making. She claimed that, upon noticing a bracelet which she had made by wrapping fur around a wire, Picasso had remarked that there was practically nothing that could not be wrapped in fur. So, two weeks later, when André Breton asked her to make a piece for the forthcoming Surrealist exhibition, she bought a cup, saucer and spoon and proceeded to wrap them in fur. As Whitney Chadwick has pointed out (in "The Muse as Artist: Women in the Surrealist Movement," *Art in America*, July 1985): "To Breton, erotic desire was crucial to the surreal experience of the world . . . (But) while the men tended to treat woman as an image or agent of inspiration in an art of disruptive hallucination and erotic violence, the women sought to articulate a specifically female consciousness by recourse to a more composed, narrative, often autobiographical art of sensibility."

Oppenheim described the making of *Fur-Lined Teacup* autobiographically. If it evokes female sexuality, it is her own, or that of woman in general. She did not exploit another woman's sexuality as an erotic means to the irrational otherworld, as Hughes has contended.

Several of Oppenheim's works have in common that they serve things up as if to eat. The teacup is presented in the usual way on a saucer, while the spoon's function is to suggest that the objects are in use, rather than set on a shelf. *Ma gouvernante, my nurse, mein Kindermädchen* presents two white-linen high-heeled shoes, their heels capped with paper chef's "boots," bound together with twine and set on a folded linen napkin atop a serving tray. *Bon appetit, Marcel* (1966) serves up a white plaster chess queen on a plastic dish placed between knife and fork on chess squares. For the *X^e Exposition Internationale du Surréalisme* held in Paris in 1959, Oppenheim's assemblage *Spring Feast* consisted of a naked girl with a gilded face laid out on a long dinner table with food on and around her body. Although waxen male figures were seated at the table and the centerpiece nude was a dummy during the exhibition, Oppenheim had served an actual banquet on the opening night to real diners, who took their food from the body of an actual naked woman.

Born in Berlin in 1913, Meret Oppenheim arrived in Paris in 1932, and began exhibiting with the Surrealists. She was 22 when *The Fur-Lined Teacup* became the sensation of exhibitions in Paris and New York. She died in 1985, still a Surrealist.

—Susan Havens Caldwell

Bibliography—

Rubin, William S., *Dada and Surrealist Art*, New York 1968.
Alexandrian, Sarane, *Surrealist Art*, New York and Washington, D.C. 1970.
Calas, Nicolas, "Meret Oppenheim: Confrontations," in *Artforum* (New York), Summer 1978.
Hughes, Robert, *The Shock of the New*, New York 1980.
Musée d'Art Moderne de la Ville, *Meret Oppenheim*, exhibition catalogue, Paris 1984.
Krauss, Rosalind E., *Passages in Modern Sculpture*, London and Cambridge, Massachusetts 1985.
Chadwick, Whitney, "The Muse as Artist: Women in the Surrealist Movement," in *Art in America* (New York), July 1985.
Dehner, Dorothy, "Meret Oppenheim, Obituary," in *Art in America* (New York), January 1986.
Cotter, Holland, "Meret Oppenheim at Kent," in *Art in America* (New York), October 1988.

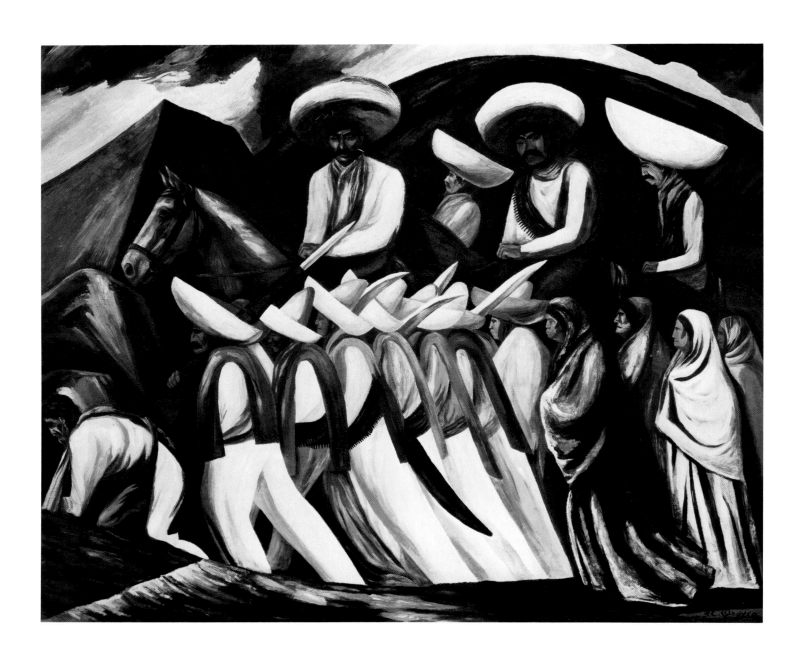

Jose Clemente Orozco (1883–1949)
Zapatistas, 1931
Oil on canvas; 45 × 55 in. (114.3 × 139.7 cm.)
New York, Museum of Modern Art

Zapatistas, José Clemente Orozco's stunning canvas of 1931, uses art to perpetuate a myth. Even if we happen to be equally ignorant of both the modern Mexican national myth and the cultural exigencies propelling its strident didacticism, the visceral effect of Orozco's art is itself undeniable. The artist's subject is a peasant army—"The People"—on the march, and Orozco's artistic means are skilfully employed to express the typically modernist idea of "popular militancy." The modelling of Orozco's figures is vigorous and his colours are earthen; accordingly, these determined "Zapatistas" are metaphorically taken to be both vital and earthy. The abstract patterns of Orozco's composition, owing much to his knowlege (largely second-hand) of earlier pictorial experiments by the German Expressionists, are similarly broadly symbolic. Repeated and overlapped diagonals create emphatic and staccato rhythms, moving from right to left, emblematically representing the inexorable forward progress of the *frente popular*. Set upon a slab-like foreground, a compressed and largely anonymous file of militant guerrillas—all "Indians," as all are dressed in the white cotton of a peasant class now armed with bayonetted rifles and sheathed machetes—grimly marches towards the coming battles of the People's Revolution. Men "lead" and their women—*sol-daderas*, wrapped in colourful *rebozos*—dutifully "follow" in their implacable footsteps. Higher up, a loosely arranged quartet of revolutionary "officers," with heads crowned by hugely brimmed *sombreros* enframed by the greater aureola of a distant mountain rim, look down placidly upon their anonymously massed irregular legions, all united by some dimly understood collective purpose.

Although Orozco's memorable *Zapatistas* is an easel painting, it is otherwise completely representative of the form and content his major work as a fresco-painter. The unique historical contribution of Mexican artists to 20th century art was (and still is) the so-called "*muralista*" movement, beginning around 1922. Besides Orozco, its guiding lights were "Dr Atl" (Gerardo Murillo, 1875–1964), Diego Rivera (1887–1957), and David Alfaro Siqueiros (1898–1978). They all once belonged to largely indigenous school of mural painting that was closely tied to a specific event on a titanic scale that was equally a social and a political phenomenon. The Mexican Revolution began in 1910 and was largely consummated, at least in the strictly military sense, by 1920. During that singularly horrific decade, the population of Mexico dropped from 15 to 12 million people. Underway well before a much better publicised cataclysm that destroyed Czarist Russia, this nearly unprecedented social upheaval represents the real parent of all the Third World Revolutions and guerrilla war episodes that so uniquely define 20th century political history. In Mexico, new social and political realities called for graphic expressions contrary to the naturalistic, "European," traditions identified with the hated regime of the grasping dictator, Porfirio Díaz, who was toppled by Francisco Madero's populist forces early in 1911. The quintessence of the native insurgent element was personified by the *zapatistas*, zealous and often rapacious followers of Emiliano Zapata.

A swarthy and pure-blooded, illiterate and quasi-*bandido*, Indian from the primitive southern state of Morelos, even today in Mexico Zapata remains the cherished emblem of largely mythologised, native-revolutionary foundations. Enthused by the militancy of his famous battle cry—"Men of the South, it is better to die on your feet than to live on your knees!"—unlettered and landless peasants in ragged thousands rushed to take up the heady cause of the Revolution. In less than ten years, until his assassination in April 1919, Zapata successively rose against Díaz and all the other, various and largely ephermeral, presidents and dicatorgenerals who succeeded him, including the saintly but wholly ineffectual Madero. An Englishwoman living in Cuernavaca, Mrs Rosa King, described a typical epiphany of the barefooted *zapatistas*: "A wild-looking body of men, undisciplined, half-clothed, mounted on half-starved, broken-down horses. Grotesque and

obsolete weapons, long hidden away or recently seized in pawnshops, were clasped in their hands. . . . They rode in as heroes and conquerors, and the pretty Indian girls met them with armfuls of bougainvillea . . ." Mrs King also mentioned the barbarous aspect of Zapata and his followers that Mexican hagiographers conveniently choose to forget: "The *Zapatistas* treated all alike—masonry, dumb animals and human beings; there was [at their hands] only devastation, desolation . . ."

For Latin Americans in general, a traditional belief in the superiority of European cultural and social systems was suddenly shattered by another massive, completely external, event: World War I. One had now to seek artistic and political Utopias on native soil. The Mexican Revolution provided the new ideal and, for the first time in Latin American culture, workers and peasants (both classes being mostly Indians) were deliberately brought into national culture as emblems of strictly "indigenous" social and political authenticity. The new values were, therefore, political in content and "*folklórico*" in iconography.

Particularly at the hands of Rivera, Siqueiros and Orozco, the new spirit identified the nation with the "common people," a symbolic entity identified by a new idealized iconography of earthy Indian peasants. Class struggle also often rose to the fore, and Whites were typically depicted by Rivera and Siqueiros as "un-Mexican," foreigners and oppressors. Orozco, arguably much the better artist, begged to differ, and later deplored the abuse of hackneyed folk-art motifs, namely, "the painting of Indian sandals and dirty clothes . . . to glorify them would be like glorifying illiteracy, drunkenness, or the mounds of garbage that 'beautify' our streets—and that I refuse to do." As in the Soviet Union during the 1920s, a newly-born and decidedly self-conscious Mexican culture became torn between the fascinations of international avant-garde experiment and the political demands of the homegrown Revolution, with its strident calls for "*nacionalista*" thematics. Orozco was caught in the middle, for the symptoms of the former was largely a matter of form and the latter one of content, patriotic subject matter. Orozco, however, managed to bridge these seemingly irreconcilable demands, and his painting of the *Zapatistas* brilliantly demonstrates the virtues of this unlikely marriage of diverse inclinations. Even though he was drawn to express revolutionary ideas in paint, it was also fortunate that Orozco, to the contrary of some of his *muralista* colleagues, was not aligned to a definite political ideology. Retrospectively viewed, his masterful attacks on oppression, inhumanity, and corruption were more broadly religious than narrowly secular and sectarian. Regardless of his specifically "Mexican Revolutionary" settings, Orozco's real subjects are human suffering, the result of conflicts spurred by timeless aspirations and grim determination. Like the best of Hispanic art, Orozco's powerful imagery really deals with universal archetypes: humanity in general, its struggles, its pain, and its ends: death. Regardless of the usually tragic consequences, the ultimate goal is "freedom," and Orozco's humanitarian means and mood represent single-minded commitment to that elusive chimera.

—John F. Moffitt

Bibliography—

Fernandez, Justino, *Arte moderno y contemporaneo de Mexico*, Mexico 1952.
Fernandez, Justino, ed., *Textos de Orozco*, Mexico City 1955.
Reed, Alma, *Orozco*, New York 1956.
Myers, Bernard S., *Mexican Painting in Our Time*, London 1956.
Charlot, Jean, *The Mexican Mural Renaissance 1920–1925*, New Haven, Connecticut 1963.
Frenco, Jean, *The Modern Culture of Latin America: Society and the Artist*, Harmondsworth, Middlesex 1970.
Atkin, Ronald, *Revolution! Mexico 1910–20*, London 1972.

Nam June Paik (1932–)
TV Bra for Living Sculpture, 1969
Performance work

The Korean video artist Nam June Paik's *TV Bra for Living Sculpture* (1969) is surely one of the most amusing, one of the most imaginative, and one of the most thought-provoking examples of early video art. At the same time, it is also a work which combines video art with live performance art; a work which bridges the seemingly separate domains of technology and theatre. Considered from these points of view, *TV Bra for Living Sculpture* is a quintessentially Post-Modern creation, born of the video-technology of the mid-sixties, and in turn, giving birth to a new form of partially live, partially technological performance revealing the positive potential of the supposedly "neutral" new media.

Visionary Modernist artists, such as the Italian Futurists, dreamt of a new technological art characterised by "man multiplied by the machine." Other more apocalyptic thinkers, such as Max Nordau, the author of *Degeneration* (1895), asserted that the "vertigo and whirl" of Modernist technology could only lead to confusion, "fatigue and exhaustion." In our own time, pessimistic cultural critics such as the American Marxist Fredric Jameson have once again denounced new forms of technology as a source of fatigue and exhaustion. Discussing the potential of video art, Jameson bluntly insists that video has no potential other than as "a structure or sign-flow which resists meaning." According to Jameson, it follows that all video art is pretty much the same, so that "What is quite out of the question is to look at a single 'video work' all by itself: in that sense, one would want to say, there are no video masterpieces, there can never be a video canon, even an auteur theory of video . . . becomes very problematic."

These lines from Jameson's essay *Reading without interpretation: postmodernism and the video-text* (1987) typify the conservative critical context in which—and against which—Paik's work struggles for recognition. Persuaded that *all* video art is inconsequential, Jameson insists that it would be bizarre to contemplate Paik's work seriously, or indeed to expect any serious implications to emerge from his work. More sensitive criticism, such as Marita Sturken's essay *Video in the United States* (1986), points to the ways in which Paik's early television and video works wittily restructure or redeploy aspects of the new technologies "to involve the viewers and to question their passive role." In other words, Paik's work, far from being typical of the worst aspects of mass communication, is very much "critical of the new role of television."

TV Bra for Living Sculpture requires the cellist, Charlotte Moorman, to play a cello which in turn activates images which she "wears" on the screens of her "*TV bra*." In this respect, as Gregory Battcock comments in his essay *Disaster in New York* (1976), "instead of 'being on television,' the televisions were, in fact, on Charlotte Moorman"; a conceptual shift from passive acceptance of the screen to active orchestration of the screen which Battcock hails as "a theoretical masterpiece." Discussing this piece in their co-authored notes entitled *TV Bra for Living Sculpture* (1969), Paik and Moorman comment: "By using TV as Bra . . . the most intimate belonging of human beings, we will demonstrate the

human use of technology, and also stimulate viewers *not* for something mean but stimulate their fantasy to look for the new, imaginative, and humanistic ways of using our technology." As Paik suggests elsewhere, *T.V. Bra for Living Sculpture* invokes "a new way of life," insofar as "The TV screen on her *body* is literally the *embody*ment of *live video art*."

While one rapidly becomes impatient before the simplistic ease with which critics like Jameson dismiss video artists like Paik, video art as a whole, and technological Post-Modern culture in general, one can certainly sympathise with Jameson's confusion before Paik's work of the last two decades. Discussing these multi-screen museum installations in his essay *Postmodernism and Utopia* (1988), Jameson fleetingly concedes their formal innovation, but again insists that they have almost no thematic or mimetic substance. Apparently, "only the most misguided museum visitor would look for 'art' in the content of the video images themselves".

It's worth asking what sort of "guidance" Jameson might recommend to the museum visitor. Complaining that Post-Modern culture is "decentered," Jameson measures its inadequacies against the "privileged language" and "'deep time'" of Modernist masterworks by writers like Proust or Mann. The problem here is that Jameson is attempting to evaluate the new currency of video in terms of the old currency of Modernist prose. As Paik remarks in his essay *Afterlude to the Exposition of Experimental Television 1963, March, Galerie Parnass*, his entire aesthetic is by very definition post-Joyce, and Post-Modern, insofar as "poor Joyce was compelled to write the parallely advancing stories in one book with one-way direction, because of the othology of the book." By contrast, by the early 'sixties, Paik was already attempting to juggle with "The simultaneous perception of the parallel flows of 13 independent TV movements."

Like it or not, video-works—particularly large-scale multi-screen installations—invite us to "think video," rather than to "think book" or "think picture." Considered carefully, Paik's best works gradually reveal major and minor motifs, and an art of—and *in*—new form and content, somewhat as complex restaurant menus gradually fall into focus, as one selects one (or more) main courses after patient contemplation. Paik tellingly comments, "if you see my TV, please, see it more than 30 minutes."

—Nicholas Zurbrugg

Bibliography—

Battcock, Gregory, ed., *New Artists' Video*, New York 1978.
Hanhardt, John G., ed., *Nam June Paik*, New York 1982.
Paik, Nam June, *An Anthology of Nam June Paik*, exhibition catalogue, Berlin 1984.
Hanhardt, John G., *Nam June Paik: Mostly Video*, exhibition catalogue, Tokyo 1984.
Payant, Rene, ed., *Video*, Montreal 1986.
Arts Council, *Nam June Paik: Video Works 1963–1988*, exhibition catalogue, London 1988.

Photo Sperone Westwater Gallery, New York

206

Mimmo Paladino (1948–)
Round Earth, Frugal Repast: The Wayfarer Waits in Distant Cities, 1986
Bronze; 217.2 × 105.4 × 47.6cm.
New York, Jane and Raphael Bernstein Collection

The complete title of this work tells all that is not depicted in it. The round earth is not depicted and there is no sign of the frugal repast; there are indications of the wayfarer, traces of him: the stick, a square and a blade (a plough?); in the top right-hand corner, almost hanging from the door there is a head, part of the vital body that perhaps represents the wayfarer himself. Walking around the sculpture we discover, behind the door, as if to seal it, a spindle-shaped head with long ears: goblin, satyr or devil?

There is no action in this work, it is suggested by the title: *the wayfarer waits in distant cities* . . . The fact that everything is symbolised in this work is confirmed by the fragmentary nature of the parts, which, reinterpreted, lead to a mythical narrative which talks of distant lands, of houses, of work and of a natural condition, now lost forever. This work, produced in 1986 with the ancient technique of bronze casting, lies in the very expressive heart of Mimmo Paladino's poetic world. The protagonist of this world is man. A natural man (one is tempted to say primitive) who lives from myths, fairy-tales, demons, ancestral fears, natural phenomena for which he has no explanation. A simple man expressed in his essential features. Again in 1986, Gian Enzo Sperone published a book written by Paladino entitled *Dens*. A passage reads: ". . . three oranges below the high window, vinegar and black olives. With the nuns beyond the wall, not in Palermo, we come back home . . .". The den where the animal takes refuge, the den where man makes refuge; and in the book the images become the symbols of that constellation. He expresses himself through painting, sculpture; everything takes part in that tale; it doesn't matter if it has an autobiographical flavour; everyone can recognize his own existential journey through these symbols. In the symbolic constellation which he uses, one can recognise most of the mythical tales: the wayfarer of *Round Earth/Frugal Repast* is man who ventures in the world; the wayfarer who, while preparing himself for his long journey, prepares his soul for the knowledge of reality. Beyond the narrative element, one can find in Paladino's work the implementation of a language that uses the traditional tools of painting and sculpture, merging them into a unified entity. His experience, moreover, exemplifies a transition which took place between the 'seventies and 'eighties. He belongs to that generation which has recast in painting/sculpture former conceptual and behavioural experiences. Following some milestones in his artistic development, we can grasp the deep meaning of his latest works. After a behavioural experience he reached painting.

In Milan in 1978 he exhibited two works representative of his new attitude. The first one is a large canvas, with a monochrome yellow layer crossed by a diagonal red-blue tongue that projects from a small head of clay in the top right-hand corner. The second work is composed of a series of irregular geometrical shapes, close to each other, in random order, painted directly onto the wall. In the same year he exhibited another work at Naples: again a large picture leaning against the wall, this time painted red, with fragments of clay on the canvas. In another room is a large wall painted blue, in the middle of which is a figurative insert. If in these works the narrative is kept to a minimum, to the few inserts on the canvas or on the wall, a primary role is performed by the canvas as support, a canvas painted with yellow, red, or in the case of the wall support, with blue, according to the primary colours, in a sort of alphabetisation of a work which once again deals with painting. But still strong is the symbolic mediation, in line with Duchamp's legacy which has characterised the 1970s. To use the wall as a support, or to lean the canvas diagonally against the wall, or even to break the rigid dimensions of the painting by overlapping some inserts which project from the edge, means to set as a further aim the involvement of the exhibition space in its role as privileged space where art is consumed.

To dilate the surface of the painting to the point of involving the space around it, was a device often used by the historical avant-garde, and (in the Italian tradition) by the Futurists, who aimed at the involvement of real space. Futurists wanted to paint the dynamism of everyday life, movement as life. They were looking for an identification between art and life, and that is what interested artists working in those problematic 1970s. When, towards the end of the 'seventies, faced with a profound change in the cultural conditions, Paladino engaged in the active tensions, turning his desire for expressive research towards a new artistic dimension; an object-based production turned to the inner core of the artistic tradition: painting and sculpture.

If we analyse Paladino's work, we must take into consideration his way of thinking about art in its widest sense, its complexity of references, inside and outside painting, inside and outside sculpture.

To understand the real impact of *Round Earth/Frugal Repast*, one must go beyond the interpretation of the various components of the work. It cannot be read according to the usual criteria—according to the theme represented, its composition or its technique: chiaroscuro, the modelling and so forth.

Because of its symbolic charge, the work should be read and interpreted for its aesthetic content. In other words, for its mythical and primordial contents. For example, to understand the meaning of the door in *Round Earth/Frugal Repast*, one should not forget Duchamp's door, especially its influence over so many experiences of the 1970s.

—Roberto Lambarelli

Bibliography—

Schwarz, Michael, *Mimmo Paladino*, exhibition catalogue, Karlsruhe 1980.
Paladino, Mimmo, *Tane*, Rome 1986.
Royal Academy, *Italian Art in the 20th Century*, exhibition catalogue, London 1989.

Giulio Paolini (1940–)
Giovane che guarda Lorenzo Lotto, 1967
Photographic print on canvas; 30 × 24cm.
Turin, collection of the artist

About eight years before Barthes' "Morte dell 'Autore", Giulio Paolini came to conclusions similar to those reached by the French semiologist. This despite the fact that his activities do not belong to the field of literature and even less to that of literary criticism. At the beginning of his essay Barthes says, *writing is that neutral oblique combination of facts, within which the personality is hidden, it is the black and white in which all identity is lost, including that of the writer* . . .

The evolution of visual art, from the end of the last century until the present day, has followed a similar course, a course in which the individual as the source which controls a hierarchy of the senses is displaced from his central position to a peripheral, neutral point. Conceptual art has perhaps marked the end of a similar course. The individual is no longer at the centre of the artistic procedure, that is to say he is no longer obliged to "express" (his thoughts, his passions). The tendency is for him to become an impartial instrument, whose sole role is to analyze the signs and symbols which have in the course of history become established within a particular field of activity.

Barthes and Paolini each declared a profound distrust of the language which urges the user to analyze all the methods of producing meaning. At the same time, both artists stated their deep faith in language, in that they acknowledge that no reality exists beyond language itself.

Linguistic analysis therefore traces the progress of identity in language from the very moment in which the statement is made. Likewise, written expression (including art, like any other system of "written expression") confirms a presence full of meaning and truth, and conveys the truth of the statement.

In a sort of dual movement, Giulio Paolini embarked on his own artistic task, while feeling the need to analyze his chosen working environment. He has defined himself not as an "author", that is as an individual, but as a mere user of his own language and therefore part of the "community of labour" (to use another Barthesian term) in this case the community of artists. He has placed himself as a "neutral point" within the structure which is itself considered as the point of departure of his imagination. Both artist and environment are revealed as heavily conditioned cultural rather than spontaneous and natural elements.

From the outset, Paolini's dual movement blends creation and critique itself with great attention to their historical influences. In this, the Italian artist has made a significant contribution to Conceptualism, of which he may be considered one of the leading exponents, despite the fact that he has approached it through autonomous and not always orthodox methods. For example, Paolini has never renounced the visual. Every artistic component, especially the pictorial, is brought into play: indeed these are emphasised in installations of clear theatrical value.

With *Disegno Geometrico* in 1960, Paolini already defined his working environment. The tools used by the artist (in this case canvas and pastel) are confirmed in their basic function. Hence every "act" is a metalinguistic proposition. This means that the subject of the statement is no longer the "persona", a historically determined role which the artist seeks to analyze in his *performance*.

Paolini's work is one of the most radical critiques of the assumptions surrounding the culture of artistic expression. In other words,

they denote a system, the system of art, while analyzing the functions of each element which conventionally operates within this system. His work is not limited to declining the grammatical elements of pictorial language, although this is his starting point. His early works are precisely designed to show the pure formative elements of painting, canvas, frame, colours. But it is clear from the earliest works onwards that the aim of the artist is to present art as the historical situation which generates "visible thought" as a specific way of expressing ideas, knowledge and experience of reality. This is based on visual perception, and all Paolini's art begins as a critique of the conventions that regulate the act of seeing. He explores its cultural dimensions, before shifting onto the more general existential plane with unusually attention to psychological detail. In this sense, *Giovane che guarda Lorenzo Lotto* remains one of the most meaningful artistic works of the 'sixties and 'seventies, those years of critical analysis and experimentation. The artist reconstructs with this little black and white photo-reportage the space where Lotto's painting was executed. The physical empirical space in which the painter himself worked is transformed into the space first occupied by Paolini and subsequently by the young visitor invited by him the view the work of the master. So the picture is focused on the environment in which it originated, on the artist's studio where the young man posed as model.

The photographic reportage not only represents an empirical environment but also a working environment, the one in which historically a particular cultural activity took place using a specific form of language—the language of pictures. It is the record of a cultural activity which also offers the viewer the opportunity to indulge in refections of a sociological kind. As painter and individual, Paolini is not present other than as the chronicler of the moment, as a function of a language which is presented for all to understand and reflect upon. We the viewers, the nameless group enriched by the encounter, are the ones who stand in the place of the painter. From the individual subject to the many who stand and admire the work there runs a line of communication, a rapport which is the whole purpose of every system of symbols.

—Giorgio Verzotti

Bibliography—

Celant, Germano, *Giulio Paolini*, New York and Paris 1972.
Celant, Germano, "Image of the Image: The Work of Giulio Paolini," in *Art and Artists* (London), May 1974.
Paolini, Giulio, and Calvino, Italo, *Idem*, Turin 1975.
Fagioli, Maurizio and Quintavalle, Arturo Carlo, *Giulio Paolini*, Parma 1976.
Paolini, Giulio, with others, *Hortus Clausus/Werke und Schriften 1960–1980*, Lucerne 1981.
Franz, E., *Giulio Paolini: De Bello Intelligibile*, exhibition catalogue, Bielefeld 1982.
Stadtische Galerie im Lenbachpalais, *Der Traum des Orpheus: Mythologie in der Italienischen Gegenwartkunst 1967 bis 1984*, Munich 1984.
Bandini, M., Coara, B., and Vertone, S., *Giulio Paolini: Tutto Qui*, Ravenna 1985.
Braun, Emily, ed., *Italian Art of the 20th Century*, exhibition catalogue, London and Munich 1989.
Poli, Francesco, *Giulio Paolini*, Turin 1990.

Photo Rheinisches Bildarchiv, Köln

Eduardo Paolozzi (1924–)
Last of the Idols, 1963–66
Aluminium painted with enamel; 244 × 61 × 11cm.
Cologne, Museum Ludwig

Dadaist. Surrealist. Constructivist. Pop. Collage. Any one—or all of these "isms"—describe *Last of the Idols* by Sir Eduardo Paolozzi. Indeed, these are descriptions which could apply to any of his sculpture in some way.

While still a student at the Slade, Eduardo Paolozzi became aware of Dadaism and surrealism, regularly visiting the London Gallery to see works by Picasso, Schwitters and deChirico. When he moved to Paris in 1947, access to the collections of Mary Reynolds and Tristan Tzara as well as meetings with Giacometti, Leger and Brancusi helped Paolozzi realise for the first time that his instinctive surrealist approach to his own art was legitimate and acceptable in some circles. He understood the intrinsic importance of the ready-made. He agreed with a "non-beautiful" approach to art. He revelled in the fascination with the machine and machine processes.

Since his childhood in the docklands area of Edinburgh, Eduardo Paolozzi had collected cigarette cards of aeroplanes and motor cars, had pasted cut-out images into scrapbooks, and had learned to use everything available to make toys (for the Paolozzi household did not have money for store-bought amusements). When he finally realised his ambition to go to art college, the semi-automatic processes of surrealism came naturally to him—although they were scorned by his tutors and fellow students. Scorned, too, was his interest in pulp magazines, comics, American magazine advertisements, science fiction films and scientific discoveries. In spite of that, the young student was more likely to be found in the Natural History Museum in London or the Musée de l'Homme in Paris than in the National Gallery or the Louvre. Yet he was to develop a thorough knowledge of art history while not neglecting the accumulation of knowledge of architecture, cinema, literature and engineering.

Ten years before he created *Last of the Idols*, Paolozzi gave a lecture entitled *Bunk* to the Independent Group at the ICA in which he showed seemingly random images related to his wide-ranging interests. Creative installations in the *This is Tomorrow* exhibition (Whitechapel, 1956) his brightly-coloured collages of the late 1940s, and his often-expressed interest in popular culture led him to be hailed as the Father of Pop Art. Paolozzi, however, sees himself as a surrealist delving deeply into his well-nourished, well-informed subconscious to create chance-influence collaged sculptures and graphics.

A taut, strong thread of recurring themes runs through Paolozzi's work, emerging in different manifestations through the decades. Art brut, abstraction, pop, representation and deconstruction have all been used to explore the idea of heroes, man and his relation to machine, heads and the human figure, surface texture. *Last of the Idols* is the culmination of a burst of creative energy and productivity which draws upon many of these approaches. It seems to have begun in Hamburg, where Paolozzi had gone to teach a master class at the Staatliche Hochschule fur Bildende Kunste from 1960 to 1962. He and his class made regular sorties from the school to the ship salvage yards, second-hand bookshops and scrap metal yards.

On his return to England, Paolozzi was introduced to a precision engineering works, C. W. Juby Ltd of Ipswich, within reasonable distance from his home. For 10 years he spent several days a week at Juby's working with the welder Len Smith who had been assigned to him. Here, for the first time, Paolozzi moved from working in bronze to working in non-corrosive aluminium such as that used in the aerocraft industry—a satisfying connection with his childhood interests. With W. L. Shepherd of London industrial pattern-makers, Paolozzi designed a series of shapes to be sand-cast. The sources for them sometimes came directly from standard catalogues for industrial machine parts, others were objets trouvés, and some were especially designed by Paolozzi himself in wax, plywood or in drawings. Paolozzi ordered a range of each of these shapes to make up his "vocabulary."

From 1962 to 1964 Paolozzi created a series of so-called "tower sculptures" from the vocabulary of elements sent to Juby's. Initially, they were based on drawings by the artist. The elements were tack-welded together before the arrangement was finalised by Paolozzi. As he and his welder became more confident and experienced, they were able to work without initial sketches. Just as Rodin created figures from a selection of pre-cast arms and legs, units were spread on the factory floor for selection by the artist, then pinned into place by the welder until a satisfactory "collage" emerged. Visible welds emphasised the process, making an aesthetic contrast between the precise finish of the machine-made forms and the rough finish of the hand-made weld. The lustrous grey finish of the aluminium gave an elegance and majesty to the completed works.

Perhaps for Paolozzi they were too elegant, for although a few of the towers remain in their natural colour, *The Last of the Idols* is one of many painted by Paolozzi in 1966. Belco paints were used—a kind of enamel used on cars. The paint was industrial and mass-produced, yet the name Belco evokes for the Italian-speaker "belle colore"—beautiful colour. Vibrant primary colouring of separate shapes of the sculpture transform it from a homogenous entity to an image emphasising individual units, showing the process used and calling to mind children's building blocks. Like fauve art, the colours excite the emotions; like pop art, bright industrial colours stimulate the imagination.

The majority of units in *Last of the Idols* are standard shapes ordered from catalogues, then cast in aluminium from patterns—taking them one step away from the position of being ready-mades. The emphasis is on classical geometric shapes—squares, rectangles, triangles and circles. The symmetry and solidity of the finished work gives it an architectural feel—labelled "post-modern" by architectural critic, Charles Jencks. Wheels in various forms often appear in Paolozzi's work with connotations of primary forms, basic geometry. One lost-wax art brut type figure from 1959 was even entitled *His Majesty the Wheel*. The particular wheel in *Last of the Idols* was cast from a workman's wheelbarrow bringing to mind not only movement but transportation, work and productivity. Topping the sculpture is a cast of a piece of a lorry's starter motor found by the artist in a skip at Juby's—a fitting "crown" for the figure-like shape.

Last of the Idols was the last of the architectonic towers. The same vocabulary of shapes was used for assemblages with a much freer look, more reminiscent of the *Laocoon* with spiralling snakes than the upright control of *Last of the Idols*. The end of that phase came in 1971 in his Tate Gallery retrospective, when Paolozzi cut up aluminium sculptures which he felt were unsatisfactory and tossed them into a specially-made aluminium skip together with some un-used elements and a double life-sized head of John F Kennedy. He called it *Waste*. The work was recreated at the Royal Academy the following year entitled *Thunder and Lightning with Flies and Jack Kennedy*. The ultimate farewell to the elements came in 1986 in Munich when a second aluminium skip was made for the Haus der Kunst into which all remaining aluminium shapes were placed. The final *Waste*.

In the sense that he ceased to dedicate works to heroes, *Last of the Idols* is a misnomer. *Hamlet in a Japanese Manner*, *Piscator*, *Homage a Bruckner* and *Leonardo* have followed over the years. Paolozzi is currently in the midst of a series of sculptures inspired by William Blake's graphic image of Sir Isaac Newton. Will *that* become the *Last of the Idols*?

—Marlee Robinson

Bibliography—

Middleton, Michael, *Eduardo Paolozzi*, London 1963.
Kirkpatrick, Diane, *Eduardo Paolozzi*, London 1970.
Schneede, Uwe, *Modern Artists: Paolozzi*, New York 1970.
Spencer, Robin, *Eduardo Paolozzi: Recurring Themes*, London 1984.
Konnertz, Winfried, *Eduardo Paolozzi*, Cologne 1984.

Mike Parr (1945–)
Language and Chaos II, 1990
12 prints; drypoint, grinder and aquatint on paper; 214 × 468 cm.
Melbourne, Viridian Press

Language and Chaos is a recent and especially important work in Mike Parr's Self-Portrait Project, an undertaking that has occupied him virtually exclusively for the past eight years. In the Self-Portrait Project, Parr has set himself the task of questioning the possibility of self-expression. Self-expression becomes problematical when one tries to explore the self that lies beyond the superficial ego—the social mask. The self beyond the ego is a self implicated in unconscious forces and the phenomenological experience of a being that changes in time. In the Self-Portrait Project Parr deconstructs traditional concepts of self as stable, rational identity through visual explorations of self as a multiplicity woven by memory and the motile forces of libido.

Since 1987 Parr has been experimenting with multiple self-portraits which enable him to portray a self that changes through the passage of time. The fact that these multiple self-portraits constitute a series, added to the fact that Parr has been producing self-portraits since 1982, suggests an endless series of self-portrayals, except, of course, for the inevitable conclusion of death—with which our deeper sense of being is inextricably entwined.

The multiple self-portraits that preceded *Language and Chaos* were composed of a grid of self-portrait drawings, but *Language and Chaos* is extraordinary in that it makes use of liftground etching and drypoint engraving. The application of printmaking in *Language and Chaos* makes it a very special member of the Self-Portrait Project in that its unorthodox and monumental use of the medium takes printmaking onto a heroic scale, one which becomes fully capable of expressing the profundity of the content.

Language and Chaos is in three parts of which part II is illustrated here. For the first part of the suite, *Language and Chaos I*, Parr confronted twelve large copper plates set out as a grid on a wall which he treated as one plate, working over the twelve plates simultaneously using a drypoint tool and an electric grinder. He did not use virgin plates, but the plates for a previous set of works entitled *Twelve Untitled Self-Portraits* (Bromfield, 1990). Parr then drew another set of self-portraits over the old self-portraits in order to suggest an obliteration of self by self.

This is a dynamic concept of self, a temporal notion of self that contradicts the static, spatialised, concept of self that dominates our culture. We like to think that self is an inviolable and integral whole, a masterful entity. This notion of self arises out of our fixation on presence. In Western culture we take the tiny moment where we exist in direct presence with reality to be the fundamental basis of being. We avoid the realisation that presence, the now, is merely a minute and discontinuous moment, like the frame of a cine film. The continuous thread that links our sense of being lies in memory not presence, which is to say it lies in the unconscious rather than in consciousness.

In the process of drawing over the previous self-portraits, Parr also tried to subvert notions of a static and overly delimited self-image by breaking the contours of the previous self-portraits through an exaggeration of the shapes and contours of "foul bite," the random scratches and marks on the copper plates caused by handling. In a letter to the master printer John Loane, with whom he collaborated in the production of *Language and Chaos*, Parr observed: ". . . I treasure inadvertent scourings and imperfections of the surface. This 'foul bite' or 'noise' seems to me to be the crucial 'other' of the image, one that collides with it and distances its residual self-regard and coherence."

While the drawing of self-portrait over self-portrait suggests the "erosion" of static identity by an overlaying of memory traces, the chaotic, automatic marks evoke another unconscious force, the powerful and overwhelming energies of libido.

For *Language and Chaos II* Parr printed another version of *Language and Chaos I* which he then overprinted with a second set of twelve etching plates. The image on this second set of plates was made with liftground which is an etching process, the highly technical aspects of which were taken care of by John Loane. Parr likes the technique because it allows direct drawing using a fluid blockout medium that produces flowing lines which in this case are quite heavy. Parr compares the subtlety, fluidity and directness of liftground with lithography.

The image on the second set of plates is evident in *Language and Chaos II* in the form of the enormous egg-shaped skein of dark, thick lines that stretches across the twelve self-portraits in the background, further overwriting and obliterating them. This egg-shape is in fact another "self-portrait," a disembodied head. But as much as it obliterates the self-portrait faces in the background, it is itself obliterated. It has become a web of forces rather than a representation.

The head-shape is also quite compressed and in this respect possesses a certain similarity to Parr's self-portraits of 1985, where he used the perspectival technique of anamorphosis to create a head which was horizontally compressed as if by the forceful attraction of the vanishing point. In *Language and Chaos II*, the large head seems to be sucked into the vanishing points formed by its two eyes which appear to form twin vortices of a gigantic whirlpool. The gaze of the giant face is directed inwards towards a profound psychological dimension that combines well with the "schizoid" imagery of the multiple-self portraits in the background.

In the third and final stage, *Language and Chaos III*, the original twelve plates were ground down then reprinted. The image was not entirely erased: there still remain obliterated mask-like shapes amidst a chaos of foul bite. Nevertheless, we have an almost total erasure of conventional identity. We are left with an expression of being without identity, pure being. Parr also said in his letter to John Loane, "I also regard the raw plate as a kind of image in its own right, as the essential ground of the Self-Portrait Project."

But *Language and Chaos III* was not left in this absolutely minimal condition. Over the erased series of self-portraits Parr used twelve new plates to reproduce a fragment of text from his diaries. The fragment was enlarged enormously to cover the whole format. We do not see the whole page of the diary; the sides are cut off. As such the text, like the self-portrait images, is not fully coherent. Which is to say it is an open as opposed to being a closed text. It is possible, however, to see that the text is about self-portrait drawing and one can read words and phrases such as "vortex," "censorship," "a whole process of editing."

Parr erases the boundaries of his own words in much the same way as he erases the boundaries of his own image, as a means of liberation. Language escapes the constraints of reason and enters into the freedom of chaos. Through the use of overdrawing, automatic drawing, and erasure Parr takes the notion of self-expression and self-portrayal beyond the conventional notion of representing a well-defined identity, or a rational meaning, towards an exploration of a deeper sense of being. This deeper sense of being is difficult, and perhaps even impossible, to grasp intellectually through language. It is certainly just as difficult, and perhaps even impossible, to represent as an image.

—Graham Coulter-Smith

Bibliography—

Fineberg, Jonathon, *An Australian Accent*, Sydney 1984.
DAAD-Galerie, *5/5: Funf vom Funften*, exhibition catalogue, Berlin 1985.
Coulter-Smith, Graham, and Morgan, Jane, "Mike Parr's Self Portraits: (Un)masking the Self," in *Eyeline* (Brisbane), June 1988.
Cramer, Susan, *Inhibodress 1970–72*, exhibition catalogue, Brisbane 1989.
Bromfield, David, *Mike Parr: Intaglio Prints in Collaboration with Viridian Press*, exhibition catalogue, Sydney 1990.

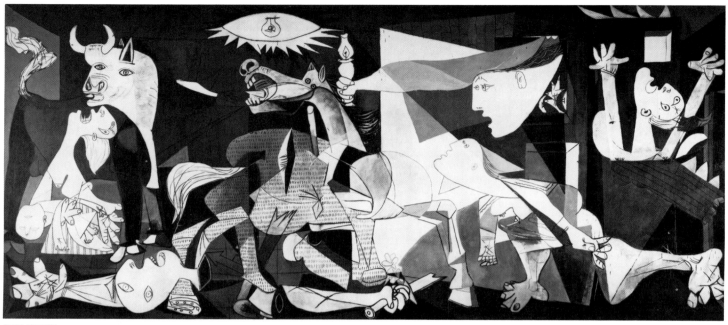

© DACS 1991

Pablo Picasso (1881–1973)
Guernica, 1937
Oil on canvas; 351 × 782 cm.
New York, Museum of Modern Art

"For almost a century, the mediterranean has shown a powerful countenance to those who try and listen to it from the outpost of anticipation. (. . .) From this stem the bleak architectures of Soulage, and the emblematic figures, distorted by pain, which gesticulate on Picasso's vast stage . . . Sun, yes,—but tragic. Celebrations, yes,—but those of the people. A mediterranean world—rough and intoxicating. The mediterranean of the poor." These short sentences written by Georges Duby, the great French historian, tell us more about the sources of Picasso's art than most experts' essays. Without a doubt the artist who was born in Malaga, Andalusia in 1881, produced his language of form and semantics from the mediterranean culture, its history, its living space, its geography and landscape, and its myths and customs. It is both his astounding artistic technique and the mastery with which he deals with the components of a four-thousand-year-old culture, which make him the most productive artist of the century. The semiotic layers seem almost tectonically blocked in this tryptich-like painting, which is named after the town Guernica in the north of Spain. The pyramid in the central area, where the action takes place, corresponds to triangular forms at the sides. The enormous size of the canvas is divided in a way which allows the overall compositional relationship to bring out the language of symbols at its best.

The colouring is of similar clarity, if not sparsity; basically black and white, with a range of the in-between shades of grey. This reduction of colour echoes the theme: a depiction of suffering that is beyond consolation, and of hopeless desperation. Stylistically, the painting would not exist without the bold innovations of Modernism, inspired by Cezanne, Gauguin, and van Gogh; and of Braque's and Picasso's own cubistic revolution which naturally influenced the forms. The displaced eyes, twisted limbs, the perspective of the horse in the centre; all convey these influences. In addition to this, the aforementioned geometrical elements inherent in the structure of the painting do not relate to the rudimentary perspective. Bearing this in mind, we see that this, together with his mastery of the range of dimensions, meant a radical turning away from the canon as a compositional form, a technique which has been valid since the Renaissance up until the end of the last century.

In January 1937, six months after the eruption of the Spanish civil war, Picasso had been commissioned by the Republican government to create a representative painting for the international exhibition in Paris. On April 26 in the same year, the fascist allies of General Franco bombed the small town of Guernica, displaying the brutality of modern means of mass-destruction. Exasperation, protest, and accusation were Picasso's motives for the concept of this painting. In parts of this painting, the reference to two etchings is clear. Both etchings he called *Franco's Dream and Lie*; each had nine parts, and depicted certain features that Picasso was to use, such as the dying horse, the bull's head, women and children savagely killed, and mouths wide open screaming grief. In comparison to these etchings *Guernica* clearly has a more impressive compositional flow and entity.

The painting parallels more than topical figurations of contemporary events; it reveals the semantics of a culture and tradition, making it both an artistic and historical form of expression.

The bull and horse, which are remembered in the context of arenas and references of the bullfight, the oldest surviving ritual of the mediterranean, both parallel the agony of the creature in the centre of the painting, and at the same time the animal seems, in a god-like way, untouched by human consciousness. Similarly, on the left side of the painting, raised above the mourning woman with a dead child—what else but a highly dramatised Pieta? The dying warrior clinging to his broken sword with his right hand assumes accordingly the position of the crucified, and from the right a domineering head carrying a light in his hand glides into

vision, suspended, reminiscent of an archangel. Towards the side of the painting a screaming head once again, the human arms stretched out in panic. One remembers the countless artists who interpreted the *Massacre of Children in Bethlehem* as depicting a superior force and bloodthirstiness which break the innocent and defenceless; and others up until Delacroix' *Slaughter on Chios*, an artist who Picasso had studied extensively. In his own painting, however, Picasso decided not to portray the power and brutality which caused misery, but instead he preferred to concentrate on the intensity of their effects, the misery itself.

A lamp is hovering above the centre of the picture, slightly to the left—why? Does it symbolize, like a monstrance, the eye of God? Since one could also read the painting as an estranged Doomsday, a fall to hell; relics of figures in the tradition of Luca Signorelli and Michelangelo strike the eye. Does not the stable-like interior on the right half of the picture seem a familiar feature of Christian art? Could it be a version of Mary who throws her arms to heaven in desperation after the death of her child? Doesn't the room snap shut like a torture chamber?

Clearly, we do not look directly for a religious meaning in the secular symbols of this work of art; they appear as a mythological arrangement on the stage of contemporary events. There still remains the question of the meaning of the lamp. If you imagine the bulb away, it appears as if on a darkened sky. Beneath is a bird hardly visible between the heads of the bull and horse. It is cut by the glaring disc of the light. Corresponding to the bird there is a little flower which seems almost to grow out of the fist of the dying warrior. Could it be heaven that can hear no more, obscured by dust, the sun substituted by electric light?

On the night of December 25, 1884, the south of Spain experienced a strong earthquake with an epicentre only 30 kilometres from Malaga, which shook the town six times over the period of two hours. Picasso was three years of age. He later told Jaime Sabartés: "My mother was wearing a scarf over her head, I had never seen her like that before. My father took his cape, threw it over his shoulders and wrapped me up to my head in the coat." The family abandoned their house to find safety with relatives. The streets were full of people in shock and despair. Two days later, in these difficult circumstances, Pablo's sister Lola (Dolores!) was born. Picasso wrote in 1936, one year before Guernica: "Children's screams, screams of women, birds' screams, flowers' screams, screams from the woodwork and from stones, screams from bricks, screams from furniture from beds from chairs from curtains (. . .) screams from bird-rain that swamps the sea which gnaws away the bone that breaks its own teeth . . ."

The psychoanalyst Alice Miller from Zurich may be correct in concluding that the experience of this double-shock way back in childhood during the Christmas of 1884 forms the matrix for the vision of Picasso's grand painting of *Guernica*, and moreover could be responsible for Picasso's theme of twisted, deformed bodies. This event relates directly to the topical destruction of Guernica, comparable to the earthquake, the screams of grieving mothers, mothers in labour, the fatal bombardment. Amidst all that are references of the ancient cultural roots, figures, gestures and signs, from the minotaur through to our civilisation. Pairs of eyes—displaced, rolling, and fixed—keep hold of this circle-dance of meanings.

—Gerolf Fritsch

Bibliography—

Schmidt, G., *Pablo Picasso*, Basel 1952.
Sabrates, Jaime, *Picasso*, Zurich 1956.
Penrose, Roland, *Picasso: His Life and Work*, London 1958.
Arnheim, Rudolf, *Picasso's Guernica*, London 1964.
Russell, Frank D., *Picasso's Guernica: The Labyrinth of Narrative and Vision*, London 1980.
Miller, Alice, *Der gemiedene Schlussel*, Frankfurt 1988.

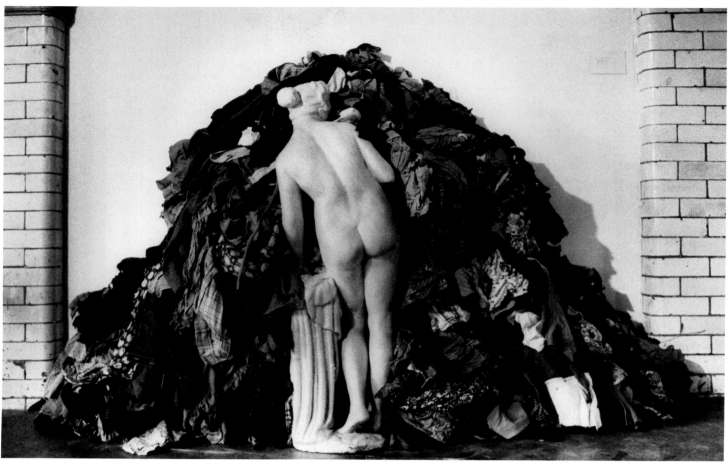

Photo Maria Mulas

216

Michelangelo Pistoletto (1933–)
Venere degli Stracci, 1967
Edition of 3; plaster, mica and rags; 130 × 100 × 100cm.
Naples, Di Bernardo Collection; Munich, Galerie Tanit; Milan, artist's collection

In 1967 in the early days of "Arte Povera," Michelangelo Pistoletto had already developed some of his main themes. At the end of the 'fifties, his self-portraits were a reaction to Bacon's expressionism, where desolate human figures are presented in total isolation against a monochrome background. These led Pistoletto to radically rethink the traditional relationship between figure and background. The dark-coloured background to the portraits was designed to have a reflecting quality, a property which he exploited in order to change the very function of the painting. By using a bright varnish, the artist achieved a surface which could reflect the space outside the work. This relationship between real and invented space became the dominant theme of his compositions executed from 1963 onwards. Pistoletto abandoned the usual artist's materials, replacing canvas with steel sheets. Painted images in turn gave way to enlarged photographs which were applied onto the steels sheets which also provided a frame. The entire linguistic system of painting underwent a kind of genetic mutation, marking the beginning of the great "mirror" stage, to which the artist was to return again and again (using real mirrors instead of steel sheets), and with which he was to achieve international fame. In his mirrors, the artist portrays ordinary people in a variety of everyday situations. These anonymous and static moments open a dialogue with real events. The invented world of the image is brought into direct confrontation with the empirical changing space of reality. The mirrors which form an essential part of the work reflect a space which completes the picture. The subject matter is transformed according to the surroundings in which it happens to be and which are reflected in it. The results are disturbing, since the work, transformed by the real environment, also has an alienating quality which directly affects the viewer's perception, through the interplay of reflections which multiply and "complicate" space. For his part, the viewer finds himself faced with a device which splits him in two and brings about simultaneous interaction between two realities—his own and that of the work of art. Pistoletto sees the mirror as allowing the spectator to "enter" the work, to "place himself in the centre of the picture" as the Futurists said. But this adaptation only takes place in the mind, it is a mental not a physical act. At the same time, according to Jacques Lacan's psychoanalytical theories, expounded in "Stadio dello Specchio," the act of seeing one's reflection is the beginning of self-acceptance. What the individual experiences is a pure image of the self as a split entity, as "the self and the other". As a contrast and a complement to this interplay between reality and potentiality, at the end of the 'seventies Pistoletto founded "Zoo," a street theatre group involved in collective activities and in the amalgamation of various artistic disciplines. In street theatre, where the boundaries between actors and audience are broken down, the artist gains first-hand experience of a reality which a mirror can only evoke as an extra dimension, presenting it as a possible alternative. Around the same time, Pistoletto began his exploration with ordinary objects and materials which made him one of the first exponents of "arte povera" in Italy.

Venere degli Stracci can be considered as the work that most clearly represents his whole philosophy. The copy of the *Venere Callipigia*, chosen to symbolize classical concepts of beauty and traditional artistic principles, stands with her back turned towards the viewer and the front of her body facing the wall. The statue is partially sunk in the pile of rags placed between it and the wall. The statue, which refuses to be seen, encapsulates the notion of the inadequacy of the traditional aesthetic canons in a changing society in search of new values, and in the face of a new artistic spirit which, especially in the 'sixties, was seeking a new identity by transcending the limits between art and life. The rags represent this concept of transformation of conventional languages and concepts which art has established. They are also a most explicit articulation of the will to create art which embraces different kinds of beauty that can be observed and enjoyed in everyday life. The rags are colourful and full of vitality. Above all they are objects which no longer have a use or function, they are material detached from the logic of consumerism. The artist has chosen them precisely because, in the world of art (this world that wants as far as possible to correspond to the real world), they can achieve a new vigour which has nothing to do with the consumer society. They serve as a vehicle for a discourse which advocates liberation and a return to natural instincts, a message implicit in all Pistoletto's work, from its beginnings until the present day.

—Giorgio Verzotti

Bibliography—

Friedman, M., *Michelangelo Pistoletto: A Reflected World*, Minneapolis 1966.
Martin, Henry, *Pistoletto*, exhibition catalogue, Rotterdam 1969.
Schmied, Wieland, *Michelangelo Pistoletto*, exhibition catalogue, Hannover 1973.
Celant, Germano, *Pistoletto*, Venice 1976.
Bandini, M., and others, *Michelangelo Pistoletto*, exhibition catalogue, Aalborg 1978.
Comi, R., *Pistoletto*, exhibition catalogue, Munich 1982.
Argan, Giulio Carlo, Celant, Germano, and others, *Michelangelo Pistoletto*, exhibition catalogue, Florence 1984.
Salvadori, Fulvio, *Michelangelo Pistoletto: Sculptures 1981–1983*, Geneva 1984.
Celant, Germano, ed., *Pistoletto*, Milan 1984.
Cora, Bruno, ed., *Michelangelo Pistoletto: lo spazio della riflessione nell'arte*, Ravenna 1986.
Celant, Germano, *Pistoletto: Gli Stracci*, exhibition catalogue, Berkeley 1986.
Staatliche Kunsthalle, *Michelangelo Pistoletto*, exhibition catalogue, Baden-Baden 1988.
Pistoletto, Michelangelo, *Un artista di meno*, Florence 1989.

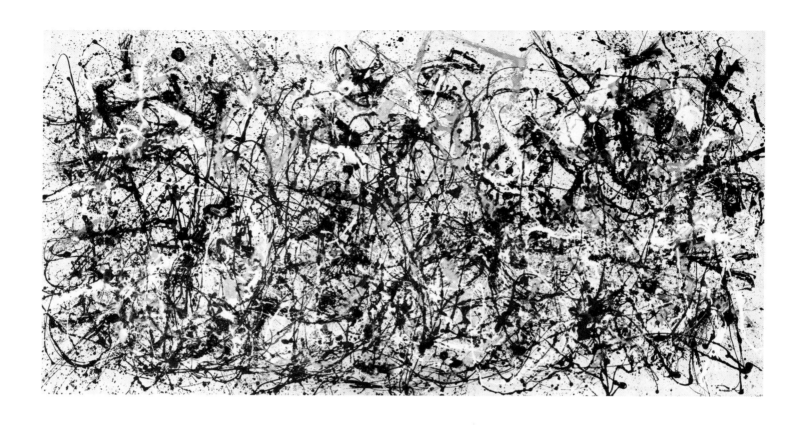

Jackson Pollock (1912–56)
Autumn Rhythm, 1950
Oil on canvas; 103 × 207 in. (262 × 527 cm.)
New York, Metropolitan Museum of Art

Jackson Pollock was one of the great innovators in American art of the twentieth century, developing the concept of free-form action-painting liberated from discernible subject matter to a high degree of controlled subconscious activity. As a means of visual discovery both for the painter and the viewer, Pollock sought to trap and record the transient human gesture in webs of dripped and spilled pigment to create a field of relationships between the movement of the human arm and body and the pigment on the canvas. Pollock, in his work from 1944 until his death, attempted to unite the intellect and emotion, flesh and spirit in a kind of archetypal, ritual form, or gesture, that created abstract patterns of paint that might be compared to the more real aspects of the theatrical, ritual mask.

As a man Pollock was taciturn and contemplative, yet drawn to violence, particularly the structure of its inner springs and tensions. If he had not had such a deep, emotional connection to the violence of the twentieth century, he might well have been an artificial mannerist rather than one of the great innovators of our time. Because of his alcoholism, he often plunged into violence just for the fun of it; in many ways, from the perspective of time, he is the essential romantic, compounded of those opposites of quiet sensitivity and physical violence that have marked the romantic spirit since Goethe wrote *The Sorrows of Young Werther* in the late eighteenth century.

Pollock was born in Cody, Wyoming in 1912 of Scots-Irish ancestry, and this may explain that part of him that was the dreamer and the visionary as well as the drinker. His parents appear to have been among life's losers—his father a failed farmer who kept moving the family around the country, his mother a worn-down helpmate who kept the family together. His father was finally reduced to the level of a day laborer, and yet of his five sons, three achieved some distinction as artists. Jackson, who was the youngest, was the most gifted and the most rebellious, often deliberately courting expulsion from normal society. He studied under Thomas Hart Benton at the Art Student's League in New York, and Benton and his wife, Rita, became substitute parents to his budding talent.

Pollock was uninterested in European art, and his major fascination was with the mural art of the Mexican painters, Jose Clemente Orozco and David Siqueiros. During the Depression, Pollock worked for the Federal Arts Project of the WPA, spending the years 1935 to 1943 doing mural work that he felt was totally unsympathetic to his nature. In 1938 he was hospitalized for six months for alcoholism, and after that he remained in some form of psychoanalysis for the remainder of his life. He was helped immensely in his personal life by his marriage to the painter, Lee Krasner, and by his meeting with the art patroness, Peggy Guggenheim, who became his mentor and sponsor after 1944.

By this time Pollock realized he wished to follow in the path of Miro and Picasso in exposing the realm of the subconscious through painting, and his best work was done during the years 1944 to 1954. By the latter date, he had lost confidence in himself, felt he had nothing further to say, and was frozen in depressed inactivity. He obtained a passport to travel in Europe, but it was never used. His wife departed without him, and on August 11, 1956, he was killed instantly in what may have been a self-induced car crash.

All his life he was afflicted by great mood swings, at one moment exalted by feverish activity, the next frozen in depression and inactivity. Despite this, he achieved heroic innovations in art through attempting to record the sensations of his subconscious in paint. Often, in looking at his mature work, one is tempted to see no structure or control, and yet Pollock insisted that he had an underlying sense of line and a visual field pattern in mind during all of his mature work, even though much was unconscious and dependent upon the artistry of accident.

His method of paint application resulted when he moved the canvas from the easel to the floor, and begin to drip and drizzle the paint onto it rather than using the brush. In 1947 Pollock described his method as follows: "My painting does not come from the easel. I hardly ever stretch my canvas before painting. I prefer to tack the unstretched canvas to the hard wall or floor. I need the resistance of a hard surface. On the floor I am more at ease. I feel nearer, more a part of the painting, since this way I can walk around it, work from the four sides and literally be 'in' the painting. This is akin to the method of the Indian sand painters of the West."

His drip technique may have owed something to the German expressionist, Max Ernst, but mostly grew from a personal desire to create long, flowing lines of pigment that were immediate and emanated from the subconscious—chance under control. Hans Namuth described Pollock at work on a large canvas this way: ". . . it was a great drama . . . the flame of explosion when the paint hit the canvas, the dance-like movement; the eyes tormented before knowing where to strike next; the tension; then the explosion again. . . . My hands were trembling."

Always he insisted that his work had graphic, linear-pattern underpinnings, and that, in his pouring of linear skeins and puddles of pigment, he was always in control of the basic pattern underlying the result. He described the process in this way: "Most of the paint is liquid, flowing . . . the brushes are used more as sticks and do not touch the surface . . . I'm able to be more free . . . and move about . . . with greater ease . . . it seems to be possible to control the flow of paint to a greater extent . . . I deny the accident . . . I have a general notion of what I'm about and what the results will be . . . I approach painting in the same sense one approaches drawing, that is, it's direct."

The most famous and often produced work of this mature period in Pollock's career is *Autumn Rhythm*, 1950, that now resides in New York's Metropolitan Museum of Art. In it, the pigment colors are related to those that Pollock saw in the pre-winter setting of his studio at East Hampton, Long Island. The bare trees, biscuit colored beach, and grey skies have been captured in the near monochrome pigment of the painting accented by the fragmentary whites that echo the foam at the edge of the beach. There is an all-pervading, tonal restraint that reflects the late fall, even though there are no formal analogies of any kind between the painting and the landscape. What is seen is a direct field of the artist's personal response to an autumn landscape.

This work is a culmination of a process that reached its peak about 1950 when Pollock had stopped drinking for two years, and it is a brilliant example of the painterly effects that were achieved through Pollock's action painting technique.

—Douglas A. Russell

Bibliography—

Alloway, Lawrence, ed., *Jackson Pollock*, London 1961.
O'Connor, Francis V., *Jackson Pollock*, New York 1967.
Tomassoni, Italo, *Pollock*, New York 1968.
O'Connor, Francis V., and Thaw, Eugene V., *Jackson Pollock: A Catalogue Raisonne of Paintings, Drawings and Other Works*, 4 vols., London and New Haven, Connecticut 1978.
Rose, Bernice, *Jackson Pollock: Drawings into Painting*, New York 1980.
Bowness, Alan, ed., *Jackson Pollock: Paintings and Drawings 1934 to 1952*, London 1989.

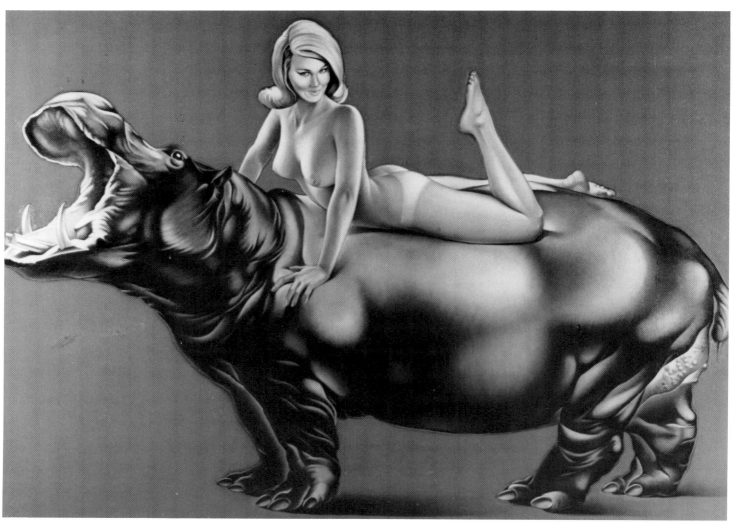

Photo courtesy Ludwig Forum for International Art, Aachen

Mel Ramos (1935–)
Hippopotamus, 1967
Oil on canvas; 70 × 96in. (170 × 246cm.)
Aachen, Ludwig Forum for International Art

By virtue of its focus on the image, Mel Ramos' *Hippopotamus* is rightly recorded in the annals of contemporary art as a Classic Pop painting. But, ideologically as well as idiomatically, the composition is about art and its history, one chapter in the artist's lifelong discourse on the history of art.

"One of the central issues of my work has been the notion that art grows from art," he wrote in *Mel Ramos: Watercolors*, "I have been fascinated by the myths, iconography and cliches that have perpetuated themselves throughout the history of art in various forms and idioms."

According to the artist, *Hippopotamus* and its companions in the *Animal Series* of the late '60s draw on the "grand tradition of beastiality in painting—" for example, medieval and Northern Renaissance religious imagery, the universal "beauty and the beast" theme and even the popular iconography of Japanese movies of the '60s and '70s.

"It's a common notion in the history of art that you see recurring over and over," Ramos explained, "and this series grew out of my interest in this particular motif—." An interest that continues to express itself in the form of gentle parodies of cultural icons.

Not that Ramos was making fun of anything—far from it. He was, then, as he's consistently been since, merely trying to dispel the notion of art as what he calls "a sacred cow." Comparing the History of Art to the Bible ("a great literary work, unfortunately made 'holy' by humankind)" he explains *Hippopotamus* and its sister paintings in terms of a continuum, likening artists throughout the ages to the anonymous "Egyptian sculptor sitting out in the desert 3,000 years ago," chiseling away at limestone to create what were to become masterpieces—prototypes studied by generations over the millenia.

"What I wanted to convey [with the *Animal Series*]," he elaborated, "was humor, but a humor laced with a very fine sort of virtuoso surface images."

Hippopotamus is a key painting in Ramos oeuvre in that it is representative of the artist's approach to art throughout his entire career. It is an "unbelievable image" that demonstrates a concern for duality and contradiction, reflected in the incongruous juxtaposition of the animal and female figures.

Like all Ramos' figurative works of the '60s, *Hippopotamus* stresses a single, artificially rendered nude, posed within a quasi-surreal setting—in this instance, an exotic jungle animal from Africa. It is a monumental compositon, nearly six-foot high by eight-foot wide, in which the subjects are "staged" and organized in a shallow pictorial space.

In the Introduction to the catalog of a 1968 traveling exhibition, Carl Belz had this to say about the *Animal Series* paintings: ". . . In each case, the abstract situation of the figure is stressed since [it] is pinned against an . . . indeterminant space that avoids the look of any believable environment. The same artificial touch, furthermore, is given to the figures as figures: they are illuminated with a harsh, neon type of light, and their flesh has the semblance of a plastic coating. Because of such insistent effects, Ramos' apparently academic illusionism is deceptive: it serves art more than it does the object of its starting point."

But, even if *Hippopotamus* is grouped within the realm of Classic Pop, it is far afield of the work of such other Pop heroes as Andy Warhol and Roy Lichtenstein. For one thing, the hand of Mel Ramos, the artist, is omnipresent throughout—in the blatant color, in the thick impasto paint, in the involvement with edges, in the contradiction between foreground and background space and, above all, in the modeling and three-dimensionality of the figures.

"Andy's and Roy's relationship to advertising has to do with the technical end of it," Ramos pointed out. "Roy with the Ben Day printing dots and Andy with the silk screen image. Lichtenstein once told me he works hard at removing his hand from the work to try to make it as mechanical as possible. I am at the other end of the spectrum, my paintings have a preoccupation with surface, with gestures—a physicality."

And it is this physicality, Ramos' successful integration of Pop canons of objectness within an art historical, painterly context that makes the artist's vision so singular.

Ramos' aesthetic may have turned to more complex, more ambitious compositions irrefutably stamped with the artist's identity. But in every painting of the '70s, '80s and early '90s, lurk echoes of *Hippopotamus*, a work which he said taught him so much about color, about surface, about problem solving.

"That's what it's all about for me," he concluded. "Without the stimulation of problems that needs solving, I would be bored to death."

—Andrée Marechal-Workman

Bibliography—

Beltz, Carl I., *Mel Ramos*, exhibition catalogue, Los Angeles 1968.
Skelto, Robin, "The Art of Mel Ramos," in *Malahat Review* (Victoria, British Columbia), October 1968.
Kahmen, Volker, *Erotic Art Today*, Greenwich, Connecticut 1971.
Ramos, Mel, and Tooker, Dan, "Interview with Mel Ramos," in *Art International* (Lugano), December 1973.
Claridge, Elizabeth, *Mel Ramos*, London 1975.
Ramos, Mel, *Mel Ramos: Watercolors*, Berkeley 1979.

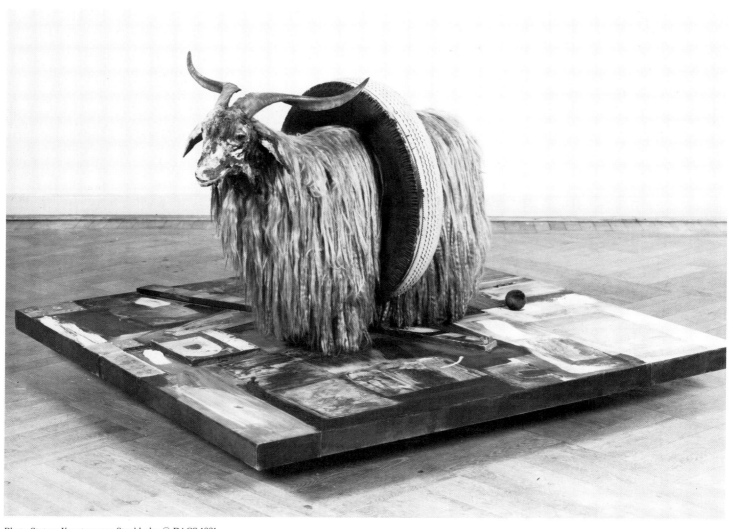

Photo Statens Konstmuseer, Stockholm © DACS 1991

Robert Rauschenberg (1925–)
Monogram, 1955–59
Mixed media construction; 48 × 72 × 72in.
Stockholm, Moderna Museet

For more than forty years Robert Rauschenberg has explored and advanced the aesthetic possibilities within the realms of painting, sculpting, drawing, printmaking, photography and dance—often abandoning ideas years before their being adopted by others. Pop Art, Happenings, Process Art, Performance Art, and contemporary printmaking all have been influenced by this artist's continually rejuvenating aesthetic.

Rather surprisingly, even this artist's early expressions seem contemporary today and are capable of inspiring a younger generation of artists. Such is the case of *Monogram* (1955–59) which incorporates a stuffed, long-haired angora goat standing on a mixed-media background that is placed on the floor. The aesthetic key to *Monogram*, and perhaps to all of Rauschenberg's *oeuvre*, may well be his intuitive approach to creation which the artist described in 1974, stating, "The only thing that supports me through one aesthetic disaster after another is the actual making of art. I usually joke about it, but I feel as though my brains are in my hands, which puts me at a great disadvantage on occasion because I like working 'blind'—where you can't really tell what's going to happen."

In New York during the early 1950s, Abstract Expressionism was not selling well and yet the struggling art movement faced an aesthetic crisis of major proportions. Both Jackson Pollock and Willem de Kooning, the two giants of the American branch of the international art movement, had returned to the depiction of the external, three-dimensional world in their pictures. Their departure from pure abstraction in order to return to depicting three-dimensionality seemed to place the once purely abstract visual illusionism of Abstract Expressionism into the service of a figurative mode of painting that to many critics, artists and other art world followers seemed aesthetically retrogressive. Inadvertently responding to the awesome challenge to rejuvenate American painting, Robert Rauschenberg became the first American painter to successfully incorporate three-dimensional imagery into Abstract Expressionism without aping traditional painting solutions. He accomplished this seemingly impossible feat in his paintings by fusing collaged photographic imagery, three dimensional objects, and abstract expressionist brushwork.

Rauschenberg's departure from Abstract Expressionism began as early as the fall of 1951 at Black Mountain College when he made a series of white paintings with virtually no imagery. Instead of creating either images or abstractions, he used a roller and evenly applied white house paint to his canvases. Some of these works consisted of identical white panels joined together to create larger paintings up to nine feet long. Then, during the summer of 1952, Rauschenberg began dipping torn strips of newspaper into black paint, gluing the fragments to canvases and paintings over the rough textured surfaces with additional black paint. When the black and white paintings were shown with abstractions by Cy Twombly at the Stable Gallery in 1952, Rauschenberg's black and white canvases were generally regarded as aggressively negative and ugly, most disconcertingly of all by fellow artists such as Barnett Newman, who responded to the white paintings, asking, "What's the matter with him? Does he think it's easy?" The black paintings elicited even more vitriolic responses including the apocryphal question, "If he hates paintings as much as that, why doesn't he quit and do something else?" For Rauschenberg, the misunderstood paintings were quite another matter. "I was interested in getting complexity without their revealing much," he has stated. "In the fact that there was much to see but not much showing. I wanted to show that a painting could have the dignity of not calling attention to itself, that it could only be seen if you really looked at it. I don't want a painting to be just an expression of my personality. I feel it ought to be much better than that."

Nevertheless, in response to the overwhelmingly negative responses to the black and white paintings, Rauschenberg began a new series of predominately red canvases. In several of these later works, he began by creating a background of pasted colored comic strips to the canvas. In these red paintings, Rauschenberg's brushwork and drips and splatters of wet paint were inspired by the works of de Kooning. In compositions such as *Charlene*, the largest of the series, bigger and more unusual collage elements than he had ever used before, included mirrors, fabrics, a woman's silk umbrella flattened and glued down in a circle, electric light bulbs that blinked on and off and a colored glass window. Such collaged articles allowed Rauschenberg to incorporate virtual reality into his art without imitating the external world, as had both Jackson Pollock and de Kooning when they simulated the human figure in their paintings of the early 1950s. Particularly jarring were deKooning's *Women* series which was represented by five examples at his third one-man exhibition at the Janis gallery in March, 1953. Clement Greenberg once told de Kooning, "It is impossible today to paint a face," to which de Kooning responded, "That's right, and it's impossible not to." Rauschenberg, on the other hand, has stated regarding the role of illusionism in his painting, "I don't want a picture to look like something it isn't. I want it to look like something it is. And I think a picture is more like the real world when it's made out of the real world."

As Rauschenberg's art rapidly emerged from Abstract Expressionism in the early 1950s, his persistent re-examination and questioning of accepted notions about art soon led him to invent a new term, "combine," to describe the mixed-media works which he presented in his January 1955 exhibition at the Egan Gallery in New York. In these works Rauschenberg incorporated various materials and objects into his painted surfaces including photographs, prints and newspaper clippings. Particularly noteworthy as a "combine" painting was his infamous *Bed* (1955) which hung on the wall as a vertical painting and incorporated the artist's pillow and quilt in a sea of abstract expressionist brushwork which only partially obscures the underlying bedding.

Unquestionably the most provocative of Rauschenberg's "combine" paintings is *Monogram* (1959) which presents a mixed-media composition on the gallery floor rather than on a wall. A stuffed angora goat wearing an automobile tire around his midriff stands in the midst of what otherwise might be regarded as but another mixed-media painting. But, presented on the floor, the two-dimensional collaged background becomes a "pedestal" for a bizarre, three-dimensional stuffed animal "sculpture" whose damaged face is smeared with various colors of paint.

As in all Rauschenberg's "combine" paintings *Monogram* (1959) presents three-dimensional imagery either as two-dimensional photographic pictures, which we see dispersed throughout the background, or as three-dimensional objects, which are not only collaged at various points in the background but include the strange looking stuffed goat which visually and physically dominates the composition.

Perhaps the key to Robert Rauschenberg's aesthetic success was summed up by him in 1974 when he stated, "Each time I start something new I try to forget what I already have done. And this self-discipline sustains the adventure too." Rather astonishingly, in his masterpieces such as *Monogram* we find that decades after their creation Robert Rauschenberg's initial aesthetic "adventure" still seems fresh and vital.

—Joseph E. Young

Bibliography—

Forge, Andrew, *Rauschenberg*, New York n.d.
Rosenberg, Harold, *The De-definition of Art*, New York 1973.
Young, Joseph E., "Pages and Fuses: An Extended View of Robert Rauschenberg," in *The Print Collector's Newsletter* (New York), May/June 1974.
Tomkins, Calvin, *Off the Wall: Robert Rauschenberg and the Art of Our Time*, New York 1980.

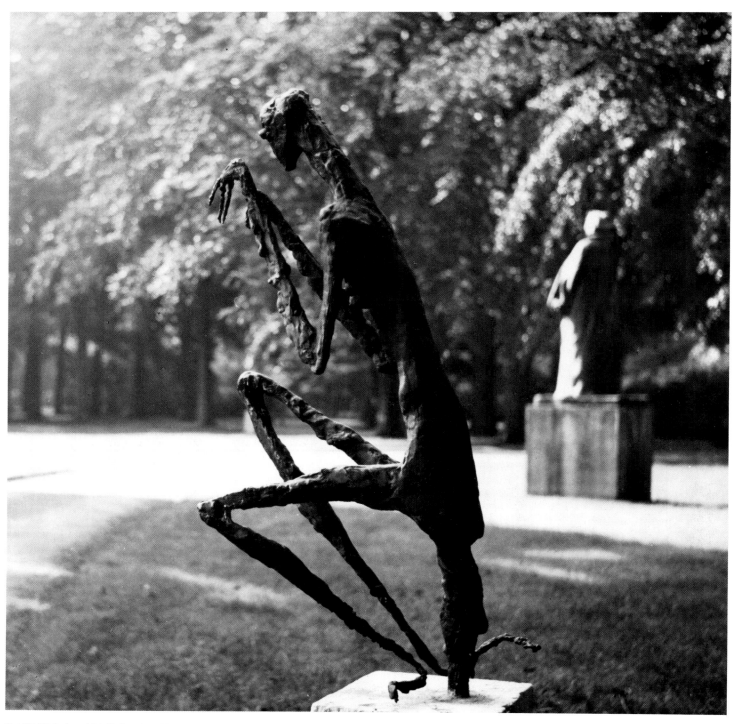

© ADAGP, Paris and DACS, London 1991

224

Germaine Richier (1904–59)
Praying Mantis, 1949
Bronze; 120 cm. high
Antwerp, Middelheim Sculpture Museum

It is perhaps significant that all of Germaine Richier's most important sculptures are today in important museums or in the hands of serious collectors. Little enough remains with dealers and a handful of art galleries, and what is still available is only so at a high price.

Germaine Richier was born in Grans, near Arles, in 1904. She underwent a rigorous course of instruction at the Montpelier Ecole des Beaux-Arts under Guiges, who has been a student of Rodin, and at the age of 21 moved to Paris where she began studying sculpture under Antoine Bourdelle, although at the time she felt closer to the work of Rodin. She married her first husband, the sculptor Otto Banninger, in 1929 and the rest of her career, broadly speaking, was devoted to her own sculpture, notable for its steady stream of professional success. Her grasp of techniques showed itself in the busts, torsos and figures of historical and classical characters that she first exhibited in Paris. Her first exhibition was at the Galerie Max Kaganovitch in Paris in 1934, and two years later she was awarded the Prix Blumenthal for her work. In 1947 she had her first London exhibition at Amedee Ozenfant's Anglo-French Art Centre, and began exhibiting at the Venice Biennale in the following year. She married the writer Rene de Solier in 1955, the year she shared an exhibition with Vieira da Silva at Amsterdam's Stedelijk Museum. The last two major exhibitions of Richier's work during her lifetime took place at the Stedelijk Museum and at the Galerie Creuzevalt in Paris.

Perhaps especially pertinent in respect of any appreciation of the large sculpture *Praying Mantis* is the praise lavished upon it by her second husband, Rene de Solier, who assessed it indeed as her masterpiece in the following words: "Germaine Richier undoubtedly reached one of the summits of her art with her blending of myth and reality, as early as the warlike and Mediterranean *par excellence* theme of *The Praying Mantis*—ready to attack on the edge and in the midst of the forest, in the very core of the mystery of the night."

If all that seems a long while ago now, and is far from dismissing what she achieved in the succeeding ten years leading up to her

death in 1959, there is no eluding the extraordinary dramatic power of this huge, rearing monster as it looms up in its place at the Middelheim Museum.

Because Germaine Richier was able to combine in *Praying Mantis* the near-human menace of a metallic creature while simultaneously imbuing it with all the determined lust of a devouring insect suddenly given a gaunt and exaggerated stature far in excess of its true diminutive dimensions, it demonstrates—as was often the case in her later works—her eccentrically valid ability to merge non-human species with humanity, as well as breaking down the barriers between the sexes when her inspirations called upon her to do so. Nor did male or female figures necessarily always retain routine facial features (sometimes veering towards animal or vegetable kingdoms; at other times, bursting into total non-figuration).

Although these observations may appear somewhat distant from the concept of the *Praying Mantis*, such a view may be rapidly dispelled. Adventures in sculpture that move into unreality are, in Richier's case, all kith and kin. The big *Mantis* exerts its magnetism not only by its overwhelming magnitude, but also through its particularly menacing gestures of clawing at space. It is a personification of aggression, a sinister reminder of the dark side of homo sapiens. For Germaine Richier, it is as if the frontiers separating the passions and behaviour patterns of mankind from those of other life-forms are, at best, wafer-thin, and often indistinguishable. If insects, seen at close quarters, can take on human characteristics, how much have we already absorbed from them over the millennia? The large *Praying Mantis*—besides its unquestionable artistic prowess—also offers a grim lesson, an hallucinogenic mix organically achieved.

Richier's childhood in the Midi had brought her into intimate contact with bizarre insect life which her own imagination extended with a sense of the macabre. Eccentric settings and the elaborate configuration of insects and animals combined in creating artifacts carrying their sinister air of disquiet. Situations became the central motifs of her sculptural groupings, far removed from the ideal monolithic unity of Greco-Roman archetypes characteristic of her early student work. Figures became personifications of disasters; ogres and brooding mythological presences became oppressively three-dimensional. Metamorphosis and strange juxtapositions invested her sculpture with an unnerving threat of surprise.

In the early 1950s, such artifacts as *The Bat*, and *Tauromachy* introduced what has been called "the geometry of fear" into Richier's strange and occult imagery. The surreal fantasies of Bosch and Grunewald present themselves in monochrome bronze. About 1951 she began her novel experiments of placing her sculptures against abstract backgrounds painted by Vieira da Silva, Hartung, and Zao-wou-ki. Her wish to introduce colour into her sculpture is also evident in those lead works incorporating pieces of coloured glass, and in the painted bronzes and large sculptures.

Richier is an important artist of the twentieth century for her combination, in a credible entity, of the generic separateness of the animal, mineral and the vegetable spheres of growth integrated in presences of real shock. Her work has affinities with Giacometti's wire-like illusion of mass, but is closer in the subconscious memory to the spawning bestiary of the myth-laden Mediterranean littoral where she was born.

—Sheldon Williams

Bibliography—

de Solier, Rene, *Germaine Richier*, Paris 1950.
Musee National d'Art Moderne, *Germaine Richier*, exhibition catalogue, Paris 1956.
Cassou, Jean, *Germaine Richier*, London 1961.
Richier, Germaine, "Fragments de lettres de Germaine Richier au sculpteur Banninger 1950–56," in Cassou, Jean, *Germaine Richier 1904–1959*, Paris 1966.

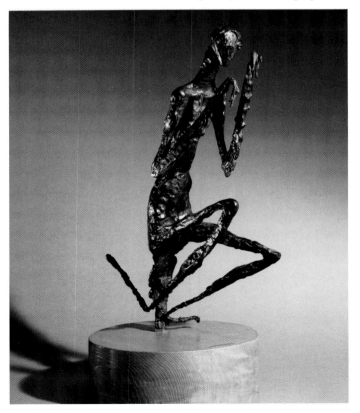

Praying Mantis, c. 1946 (Private collection). Photo courtesy Sotheby's, London.

225

Jugendbildnis / Youth portrait (Ulrike Meinhof)

Festnahme / Arrest

Erschossener / Shot man (Andreas Baader)

Gerhard Richter (1932–)
Oktober 18, 1977, 1988
15 paintings; oil on canvas; 35 × 40 cm. to 112 × 102 cm.
Frankfurt am Main, Museum fur Moderne Kunst

October 18, 1977 is a suite of paintings completed in autumn 1988. The subject matter of these paintings is quite remarkable in Richter's oeuvre in that he generally avoids any political content, "Nothing can be expected from politics because politics operates more with belief than with enlightenment." The subject of these paintings is the last days of the Baader-Meinhof Group, five of whom died in the Stammheim Prison in a high security wing built specially to house them. The deaths were presented as a collective suicide, but the suspicion remains that they might have been the victims of a state-ordered police assassination.

Certainly, as Benjamin Buchloh observes, there has been a remarkable silence in Germany surrounding the events of October 1977, a "collective repression." Buchloh also makes a comparison between the deadly repression of the Baader-Meinhof Group and the more liberal treatment offered to left-wing terrorists in Italy, where sentences were reduced, living conditions in prisons improved, and early releases granted. In Germany, on the other hand, the horror of young people driven to wage war on their own society was then outweighed by the overwhelmingly ruthless treatment afforded by the authorities.

Richter's *October 18, 1977* breaks the silence and, in spite of his avowedly apolitical stance, the work fits well into his oeuvre owing to his profoundly melancholic and even nihilistic outlook. For Richter, human beings are victims, victims of a largely futile and indifferent existence.

The paintings in *October 18, 1977* are made from police photographs and refer back to Richter's "Photopaintings" of the 'sixties. Richter is remarkable as a painter for establishing an inter-relationship between photography and painting that goes beyond Pop artists such as Lichtenstein or Warhol, who were strong influences on him. Whereas Lichtenstein and Warhol simply emphasise the photographic over the painterly, Richter uses photography to lend a certain negative poignancy to the expressive possibilities of painting.

In one Photopainting, *Eight Student Nurses* of 1966, Richter used newspaper photographs to paint a series of portraits of eight student nurses killed in the dormitory of a South Side Chicago hospital. ". . . because I didn't know them personally, I just wanted to paint anonymously, not in colour, from the photos, that is, to avoid painting, avoid direct involvement with life and, through it, subjectivity and still, despite the detour, produce an affect so that it touches your heart, indirectly, not in a conventional—sentimental—way."

Richter created other Photopaintings using images associated with victims such as his Aunt Marianne (1965) a victim of Nazi extermination, or Helga Matura (1966) a murdered Frankfurt prostitute. In another statement he said, "I would rather paint the victims than the killers. When Warhol painted the killers, I painted the victims." The reference is to Warhol's ten huge silkscreens of the FBI's "most wanted men" of 1964.

Richter also attempted to paint a series of works based on photographs of concentration camps, but destroyed them because they were so utterly without hope. In the late 'sixties and 'seventies he moved away from Photopaintings into abstraction, but his abstract work also reflected a profound sense of emptiness. We might think, for example, of his *Grey Paintings*, his empty *Windows*, his staring *Mirrors*, or the stark banality of his *Colour Chart* paintings. Indeed, he recently compared his attempt to paint concentration camps with his *Grey Paintings*, observing, "now when I see the grey monochrome paintings I realise that, perhaps, and surely not entirely consciously, that was the only way for me to paint concentration camps. It is impossible to paint the misery of life, except maybe in grey, to cover it."

October 18, 1977 is painted entirely in shades of grey, and the Baader-Meinhof Group are represented as victims, victims of extremist ideology and an overwhelming and unforgiving state apparatus. *October 18, 1977* poses the frightening question as to what is really the more terrifying, the fanaticism of the young urban guerillas or the mercilessness of the police and state apparatus they dared to challenge?

The suite consists of fifteen images, beginning with a portrait of Ulrike Meinhof as a young girl and ending with the funeral procession. The contrast between the sweetness of the portrait and the grimness of the funeral procession is stark. In between, we have a narrative of the arrest, imprisonment, and death of the group. Even within this appalling narrative we are given moments of beauty and humanity. For example, the series of three images entitled *Line Up* show a smiling young woman, and one of the images of a cell interior shows a close-up of a record player which must have belonged to one of the group. However, the rest of the images are implacably cruel. Such contrast between humanity and inhumanity only serves to increase the overall impact of the suite, intensifying one's sense of tragedy.

Another characteristic of the suite is that all of the paintings are blurred or streaked, as are the majority of Richter's Photopaintings. However, photography as a medium is not intrinsically blurred. On the contrary, its images are fundamentally sharp and clear, but this clarity assumes a mastery over reality which is not a part of Richter's vision of humanity. To represent the events of October 1977 with the same callous realism as the police photographs he worked from would be to suggest that we are capable of fully grasping their content. The blurring and streaking of the

Gegenüberstellung / Line Up (Gudrun Ensslin)

image indicates instead an inability to comprehend the ramifications of October 18, 1977, and a need to shroud the harshness of our world in a veil of silence.

—Graham Coulter-Smith

Bibliography—

Van Bruggen, Coosje, "Gerhard Richter: Painting as a Moral Act," in *Artforum* (New York), May 1985.
Harten, Jurgen, ed., *Gerhard Richter: Paintings 1962–1985*, Cologne 1986.
Nasgaard, Roald, Buchloh, Benjamin, and Danoff, Michael, *Gerhard Richter: Paintings*, London 1988.
Buchloh, Benjamin, and others, *Gerhard Richter: 18 Oktober 1977*, Cologne 1989.
Richter, Gerhard, and Schampers, Karel, eds., *Gerhard Richter 1988/89*, Rotterdam 1989.
Buchloh, Benjamin, "A Note on Gerhard Richter's *October 18, 1977*," in *October* (New York), Spring 1989.
Magnani, Gregorio, "Gerhard Richter," in *Flash Art* (Milan), May/June 1989.
Huther, Christian, "Gerhard Richter: 18 Oktober 1977," in *Kunstforum* (Mainz), July/August 1989.
Hall, James, "Richter's Baader-Meinhof Paintings," in *Art International* (Lugano), Winter 1989.

Zelle / Cell

Erhängte / Hanged woman (Gudrun Esslin)

Plattenspieler / Record player

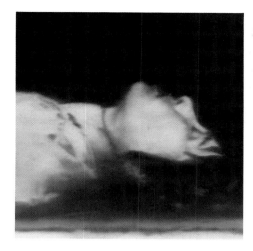

Tote / Dead woman

Beerdigung / Funeral

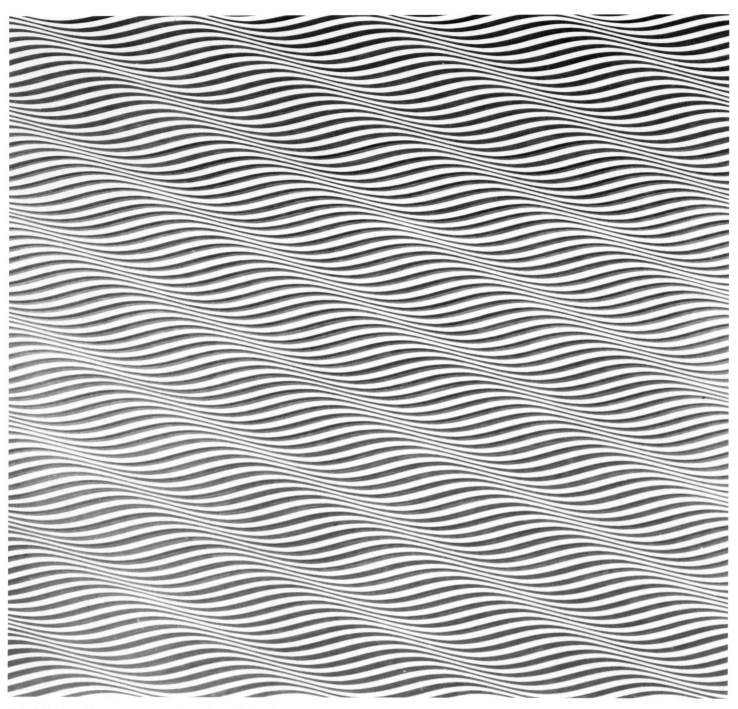

Photo British Council, reproduced courtesy Mayor Rowan Gallery, London

Bridget Riley (1931–)
Cataract, 1967
Oil on canvas; 86½ × 87in.
London, British Council

Cataract 3 is a huge painting, geometrically structured, and using a group of strong colours (white, black, grey, blue and red) and precise calculation to achieve a state of continuous movement. The picture is an exactly enlarged version of a preparatory drawing executed on graph paper by Riley and painted by a team of studio assistants. Paintings of the 1960s, such as *Cataract 3*, which borrow from geometry to create pattern and illusion tend to be characterised as "Op" (or "Optical") Art, though Riley has always stressed that "Op" art should not be understood too narrowly. "I have never studied optics and my use of mathematics is rudimentary". The point she makes is that "optical painting . . . has added to the language of formal art, to plastic understanding which cannot be ignored or eradicated."

"Op" art is assumed to be the product of a cerebral rather than an emotional temperament, "cool" rather than "warm" in its response to the world, scientifically rather than naturalistically ordered. However, Riley describes her own visual stimuli as coming from the external world, especially the Cornish landscapes of her childhood which "formed the basis of my visual life." She remembers "going up and down valleys . . . there was a constant interchange of horizon lines, cliff-tops and brows of hills—narrow slivers of colour rhythmically weaving and layering, edge against edge." Her art, whether the black-and-white studies of the early 1960s or her later (and continuing) essays in colour are designed to elicit sensual as well as intellectual responses. "My paintings are, of course concerned with generating visual sensations, but certainly not to the exclusion of emotion. One of my aims is that the two responses should be experienced as one and the same."

Bridget Riley's mature painting, of which *Cataract 3* is an example, is the result of enquiry and experiment, drawing on the work of artists as diverse as Ingres, Seurat, Balla and Mondrian. From Ingres she learnt of the beauty of balance, clarity and order, while Seurat's pointilliste technique provided the starting point for optical investigations. At the Venice Biennale in 1960 she saw the works of the Futurist Italian painter Giacomo Balla, while Mondrian's *Broadway Boogie-Woogie* demonstrated how space and surface could be combined to create permanent movement. "I tend to work with an open-space area . . . it had its origins in Mondrian. It demands a shallow push-pull situation and a fluctuating surface."

Riley was given her first one-man show at Gallery One in Soho in 1963. The noted Austrian pyschoanalyst, Anton Ehrenzweig, provided the catalogue introduction. He understood that Bridget Riley's optical experiments had their roots in the scientific enquiries of the nineteenth century and saw that her painting was capable of providing profound visual challenges. "One can distinguish two contrasting phases in the experience of Bridget Riley's paintings—the first phase can be called cold, hard, aggressive 'devouring,' the second, warm, expansive and reassuring. We sometimes speak of 'devouring' something with our eyes. In these paintings, the reverse thing happens, the eye is attacked and 'devoured' by the

paintings . . . this relentless attack on our lazy viewing habits will peel our eyes into a new crystal-clear sensibility." Ehrenzweig wished the critics to understand the fine judgement underlying Bridget Riley's work. "A perilous balance is achieved, as in a moving yet stable living organism. As we feel this balance, the whole experience can turn inward to a new invigorating awareness of the structure of our own body." John Russell, writing in the *Sunday Times*, did take the point: "A Riley is about the changes— progressive, sometimes abrupt, sometimes apparently disastrous— that can take place in a given situation . . . the paintings could be read as studies in dislocation; but their final statement is on the side of recovery and integration, and their effect for that reason is one of an intense and hard-won exhilaration."

Bridget Riley's use of colour evolved gradually, severe black and white giving way to graduated greys and pure colours in the mid-1960s. Her friend and colleague Maurice de Sausmaurez wrote that "any difference there may seem to be between the early works in black and white and the recent works in colour is more apparent than real." She herself wrote that "colour is the proper means for what I want to do . . . the colours are organized on the canvas so that the eye can travel over the surface in a way parallel to the way it moves over nature. It should feel caressed and soothed, experience frictions and ruptures, glide and drift." Since the painting of *Cataract 3*, Bridget Riley's palette has become lighter, brighter and more radiant, developed in response to travels in such exotic landscapes as Egypt and Bali. "My direction is continually conditioned by my responses to the particular work in progress at any given moment. I am articulating the potentialities latent in the premise I have selected to work from . . ."

The pleasures of a picture such as *Cataract 3* is that it is far more than an exciting visual joke or puzzle. It is based on deeply considered principles and thus is able, as the artist hoped, to "stealthily engage and disarm you." This is not a mechanistic process, but one in which the mind and eye of the discriminating artist is the deciding factor. "No matter what I do it will be subjective, and so to develop as much objectivity as I can, is simply counterbalancing this inevitable presence of myself in the work." It is this quality of the artist's vision that gives Op art its rightful place in the 20th century canon.

—Camilla Boodle

Bibliography—

Compton, Michael, *Optical and Kinetic Art*, London 1967.
Sausmarez, Maurice de, *Bridget Riley*, London 1970.
Kudielka, Robert, *Bridget Riley: Works 1959–1978*, exhibition catalogue, London 1978.
Cumming, Robert, *Working with Colour: Recent Paintings and Studies*, exhibition catalogue, London 1984.
Thompson, David, *Venice Biennale: Bridget Riley*, exhibition catalogue, London 1986.
Whitford, Frank, *Understanding Abstract Art*, London 1987.

© DACS 1991

Larry Rivers (1923–)
Washington Crossing the Delaware, 1953
Oil on canvas; 83 × 111in.
New York, Museum of Modern Art

Described in 1965, twelve years after its creation, as "the most important picture Larry Rivers ever painted," *Washington Crossing the Delaware* remains not only a milestone in Rivers' career but a pivotal piece in 20th-century American art history. Recognized today as both an early trumpet blast announcing the coming of Pop art and an ambiguous and prescient bow to tradition, the huge canvas was initially seen as a step backward by the Abstract Expressionists with whom Rivers had been associated; its reliance on natural form seemed a submission to a reactionary taste for realism, and its choice of thematic source—a 19th-century historical painting known and laughed at by every American schoolchild—mystified the general public and offended some.

Rivers' *Washington Crossing the Delaware* was based (loosely) on the even larger painting of the same name done in 1851 by the German-born Emanuel Leutze. Now in New York's Metropolitan Museum of Art, Leutze's 149 × 135-inch celebration of the General's historic Revolutionary War coup, the sneak attack on Christmas Eve, 1776, is a national icon. Generations of Americans have grown up with a mental image of Washington's heroic stance and based their understanding of Colonial history on this sentimentalized visualization of their country's past, even though the painting is generally known to be wrong in numerous historical details. Indeed, the anachronisms of Leutze's romantic tableau are among its most engaging elements.

Rivers' adaptation of Leutze's composition was taken by the avant-garde as a betrayal of principles, a deliberate assault on Abstract Expressionism. To traditionalists, the ambivalent spirit with which the painting addressed its source—the curious blend of nostalgic reverence and irony—was something of an insult to both the technique and the subject of the earlier painting. In an interview conducted some years later, Rivers recalled that people thought he was a wise guy. "Nobody got it," he observed ruefully.

Unlike Leutze's tightly organized, classically posed panorama, Rivers' *Washington* has distributed its human subjects across the canvas in a seemingly random pattern. Loosely sketched, they fade in and out of the hazy, undefined background in obvious rejection of the academic conventions of the original. If there was a tip of the artist's beret to the classical tradition in Rivers' painting, it was bewilderingly blended with a defiant gesture against authority.

Rivers has made clear the polemical character of his *Washington* in repeated statements rejecting Abstract Expressionism. Although his realism has remained strongly gestural—he has retained the loose, spontaneous brushstroke of the Action painter however traditional or ironic his subject matter—he has steadfastly declined to accept the classification. "They say action is painting," he noted in an article written in collaboration with poet Frank O'Hara in 1961. "Well, it isn't, and we all know that abstract expressionism and pop art have moved to the suburbs."

The attraction to the emotional ancestor-worship embodied in Leutze's painting lay for Rivers in his acknowledged yearning to identify himself with the "great" painters of the past. The very posturing of the 19th-century oil—the vulgar heroics, the historical inaccuracies, the cheap theatricality—drew him to it as a subject that would combine his guilty reverence for the past with a contemptuous gesture ridiculing the present. "Luckily for me, I didn't give a crap about what was going on at the time in New York painting," Rivers wrote in 1979. "In fact, I was energetic and egomaniacal . . . cocky and angry enough to want to do something

no-one in the New York art world could doubt was *disgusting*, *dead*, and *absurd*. So what could be dopier than a painting dedicated to a national cliché—*Washington Crossing the Delaware*."

That Rivers despised Leutze's corny painting of that cliché is clear not only from his words—he described the earlier artist as "a coarse German . . . academician"—but from the ironic use he made of it. Instead of a tendentious patriotic statement, Rivers' painting is a complex exploration of the interplay between form and color. Instead of a study in self-conscious heroics, it is a sensitive examination of human tension. "Leutze thought crossing a river on a late December night was just another excuse for a general to assume a heroic, slightly tragic pose," Rivers recalled. "What *I* saw in the crossing was quite different. I saw the moment as nerve-wracking and uncomfortable." The restraint of Rivers' muted palette—in striking contrast to Leutze's bold, dramatic colors—and the diffused modeling of the figures called up clear echoes of other artists than Leutze, and earned the painting Elaine de Kooning's suggestion that it be called *Pascin Crossing the Delaware*.

Contributed by an anonymous donor to New York's Museum of Modern Art in 1955, *Washington* was damaged by fire in 1958. It was discolored by smoke, and some charcoal drawing was washed away by water. The lower right-hand corner was charred and has been only partly restored. The Museum of Modern Art also owns 13 pencil sketches for *Washington Crossing the Delaware* and a study for a second version done in pencil on paper in 1960 and acquired as a gift from the artist the next year. Even sketchier in style, the second version's loose, spontaneous lines merely hint at elements of the human form. Although it shares the immediacy and the fluid draftsmanship of the original, the second *Washington* is clearly a separate work with little relation to its predecessor.

The depiction of a familiar visual image in a quasi-expressionist technique, the reduction of the human face by the omission of one or more features, the fusion of realism and Abstract Expressionism, the shifting uncertainty of shading, and the use of thin, almost transparent oil colors, all of which have become signature elements in Rivers' work, are apparent in *Washington*. Perhaps more important to its place in the history of American art is the painting's half-serious use of a consecrated but banal subject—the Leutze painting and the legendary crossing itself—foreshadowing both Pop Art's preoccupation with conventional iconography and Postmodernism's ironic use of historic tradition.

—Dennis Wepman

Bibliography—

Soby, James Thrall, *Modern Art and the New Past*, Norman, Oklahoma 1958.
Rivers, Larry, and O'Hara, Frank, "How to Proceed in the Arts," in *Evergreen Review* (New York), July/August 1961.
Nordness, Lee, and Weller, Allen S., *Art USA: Now*, New York 1963.
Hunter, Sam, *Larry Rivers*, New York 1969.
Bowling, Frank, and Rivers, Larry, "If You Can't Draw, Trace," in *Arts Magazine* (New York), February 1971.
Rivers, Larry, and Brightman, Carol, *Drawings and Digressions*, New York 1979.
Shapiro, David, "Larry Rivers: Maximalist in an Age of Minimalism," in *New York Arts Journal* (New York), 1981.
Harrison, Helen A., *Larry Rivers*, New York 1984.

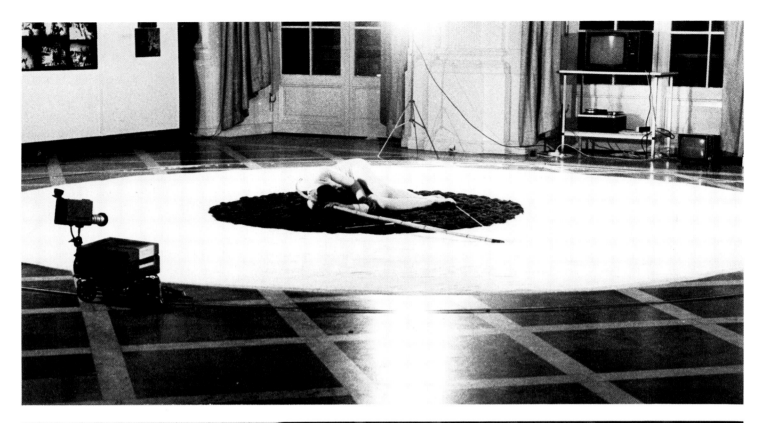

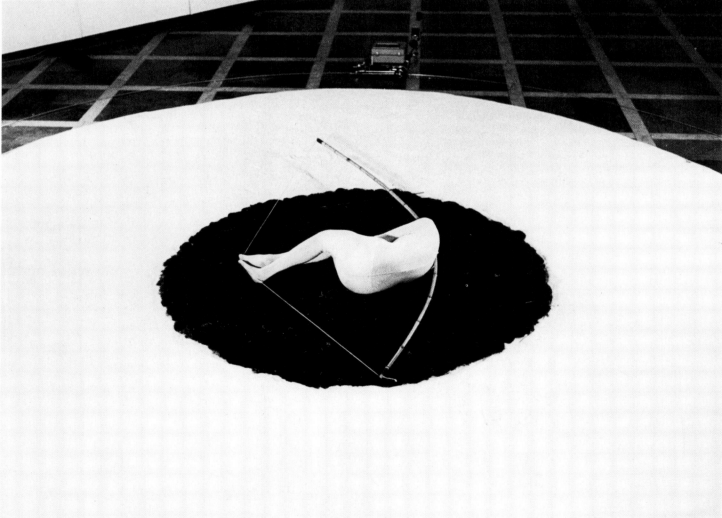

Photos Ludwig Forum for International Art, Aachen © DACS 1991

Ulrike Rosenbach (1943–)
Ten Thousand Years I've Been Sleeping, 1976
Performance work; 3 hours
Aachen, Neue Galerie

The work of Ulrike Rosenbach takes on a pioneering position in the development not only of women's performance art, but of the art development of the last two decades in general. This artist has been capable of creatively defining a situation, in which the most advanced electronic media and age-old forms of art are integrated into a new unity. No longer adhering to established and limited art forms such as theater, dance, painting or sculpture, she has overcome these borderlines, constituting a new medium of artistic expression. This newly-achieved synthesis created a freedom which is relevant for the content of the work. Mythology, nature, and humankind in contemporary social and political challenges are all part of this medium which has no precedents in earlier art developments, and which, even in its early phase, has found brilliant manifestations. One of Rosenbach's works, the three-hour performance *Tenthousand Years I've been Sleeping* of 1976 can be seen as the culmination of her early work.

The artist's work took place on a marble floor in the Neue Galerie in Aachen, in a circular environment of salt filled with fresh green moss. Salt has the function of purification, and moss is the age-old symbol of living organic matter. In the center of the moss the artist, dressed in white, lies in a sleeping position. Her body, representing the arrow, ready to be shot, is situated within a two-meter bow of bamboo.

The circular ensemble on the floor, with the artist in the center, is surrounded by a set of metal rails on which a moving video camera, like a controlling eye, records the event. As the video equipment moves around the tracks, the recorded images of the event are seen on a monitor documenting the three-hour action as it takes place.

The action is quiet and meditative, as most of the time the artist is sleeping, and only the electronic recording apparatus is in action. At the end of the performance, the artist rises from her bent and tense position, picks up a stick and turns off the electronic circuit, thereby stopping the camera. The artist then moves in slow motion around the circle and writes into the salt the sentence: "Ten thousand years I've been Sleeping and now I awake."

The inherent symbolism of the performance cannot be rationally deciphered. It has to do with moss and salt, life substance and purification; but salt is also important for the quality of the video-recording in terms of the accurate reflection of light. In contrast to these elements is the weapon from Prehistory, the bow and the bowstring, all set into action in order to give a complex and fascinating image of death and rebirth on a ritual level. The artist identifies herself with the forest and the clouds, and in this function she becomes the protector of life.

Woman is the medium of transforming nature into culture, and it is woman in the center of the cyclic rhythm of the world which is the symbol of all transformation. In an interview with Kiki Martins in 1981, the artist said: "Circle and spiral are in the language of symbolism, or, to say it in other words, in our cultural tradition, signs for the endlessness of time, for the return of life, for the reincarnation, for the endless time sequence of things, for matter itself—in this regard you could call my actions and performances rituals. They do have a strong ritual effect on human beings who see them." And in an attempt to define her work she continued: "For me, they are processes of change, which alter you. Often they are crossings of borderlines—lines into another world, the world of the psyche, the psychic situations."

The center of the action, as the main part of all her works, is the artist herself, who identifies with the arrow ready to be shot into a new dimension. The bow and the bowstring, which had been used by the artist in earlier works, taken—like in Homer's "*Odyssey*" and Wolfram von Eschenbach's "*Parzival*"—on the instrumental meaning of artistic creativity itself.

The focal point of the performance is the identity of woman today, within the cycle of cultural history, from the earliest times to present steps toward change. Sleep and awakening of woman take on a meaning far beyond the rational terms of feminist statements, they are articulations in a newly created medium of mysterious intensity and lasting beauty.

—Udo Kultermann

Bibliography—

Lippard, Lucy R., *From the Center*, New York 1976.
Gorsen, Peter, *Wegmarken und Stuetzpunkte der Feministischen Kunst: Zum Beispiel Ulrike Rosenbach*, Aachen 1977.
Rosenbach, Ulrike, *Videokunst, Foto, Aktion/Performance, Feministische Kunst*, Cologne and Frankfurt 1982.
Pohlen, Annelie, *Zeichen und Mythen*, Cologne 1982.
Rosenbach, Ulrike, *Spuren des Heiligen in der Kunst heute, II*, Aachen 1986.
Kultermann, Udo, "Zehntausend Jahre habe ich geschlafen," in *Du* (Zurich), December 1990.
Kultermann, Udo, "Woman Asleep and the Artist," in *Artibus et Historiae* (Vienna), 1990.

Photo courtesy Studio Marconi, Milan. © DACS 1991

Mimmo Rotella (1918–)
The Assault, 1962
Stuttgart, Staatsgalerie

At the beginning of the 'sixties Mimmo Rotella became known on the international artistic scene as the only Italian representative of a group of artists known as the New Realists (Nouveau Réalistes). Sam Hunter defined them as a disconcerting group of documentarists of the contemporary artistic and political scene.

Pierre Restany, who brought the artists together at the end of the 'fifties and the beginning of the following decade, recently talked about his encounter in 1957 with Rotella, introduced by the painter Giulio Turcato: "...I realised that the work he was carrying out was in total harmony with his Parisian colleagues, Hains, Villegle, Dufrene, whom he didn't know. This is how I became interested in Mimmo's work, and how I introduced him into the group of the New Realists at the beginning of the 'sixties". But what was the meaning of that grouping? According to its creator, all the personalities of the group had a common respect for the expressive autonomy of sociological datum. That means that the urban phenomenon, the city with all its social relationships, was at the centre of their interest. The poster, used by Rotella and the others, in this sense represents the means by which the city, as a social environment, expresses and communicates itself. Rotella was the first one to use advertising posters, tearing them off the walls of the city on which they were glued, and pasting them onto the canvas.

Before joining the group of the New Realists, Rotella's work was heading in an informal direction; in the second half of the 'fifties, abstract painting ruled unchallenged. Rotella's works did not represent anything, did not carry images that could bear an iconographical meaning. The materials and the technique he employed were the same as that used in *The Assault* and following works, but the formal result was different.

The first torn poster was exhibited at a Roman gallery in 1954. The following year he joined the group of the "Seven Painters on the Tiber at Ponte Sant'Angelo," introduced by Emilio Villa, who wrote about the "rejection of gnoseologic painting or crude geometry," pointing out afterwards the distance from "The whirlpool of the automatic epiphanies."

In fact, the results of Rotella's works in those years were far away from the geometry of the abstract-concrete painters, perhaps reminiscent of the Informal and Material painters. But he distanced himself from informal painting because of his use of those torn posters, with which, on the level of material impact the fat, dense and thick paintings so beloved by those painters, could not compete. The gesture of tearing the posters has been interpreted according to the gesturality linked to the tradition of Action Painting, which found a great following in Europe. But the process between the tearing and the creation was a void which permitted reflection, the rethinking of the result itself, so much so that Villa talks of a distancing from automatic creation.

It is again Villa who in 1955 dedicated a brief essay to Rotella's work of that period. The title itself already hints at a critical reading of the work: "Décollages by Rotella were an interpretation, because the works about which he was talking were simply called *Collage*." Rotella ripped posters off walls and transported them directly onto the canvas, either straight or back-to-front in order to tear them a second time. Villa states: "...the gesture of tearing the coloured paper and constructing the fragments can, generally speaking, recall Dada characteristics, the results obtained are so charged with virtue and intuition as to create an isolated and defining typology of pictorial intelligence."

Evidently, an exaggeration for making comprehensible to those who did not wish to understand, that in the last analysis Rotella's work was still painting. The interpretation that Restany gave a few years later was different. In fact, his work was gradually settling down. After having exhausted the existential meditations of informal experience, the artist opens up to a world beginning to be conscious of reality. Restany himself was one of the first critics to become aware of the exhaustion of informal research and to look at the beginning of the 'sixties in a different way.

What convinced Restany to invite Rotella to join the group, was therefore his artistic research which was not understood in Rome. His "décollages" were an absolute novelty. The technique was not shared by many, in spite of Villa's efforts, and was interpreted as coming too close to the Dada tradition. The materials employed were too obvious, and the torn posters carried within themselves the idea of the recycling of rejected material. The collages, thus characterised, could not find a place in a research based on the existential character of painting.

The solitary research of Rotella from 1954 went against prevailing currents until 1960, when Restany put him into contact with those Parisian artists who, without knowing it, held the same position. The remains of a generation imposed itself definitively. The encounter with Hains and the others in 1960, and changed cultural conditions, strongly influenced Rotella, who was able to express himself according to his natural expressive tendencies. He began, thus, that long series of décollages in which figurative images assert themselves.

Rotella had already entered this new dimension when he created *The Assault* (1962). Consistent with the general assumptions of the group (that is, a respect for sociological datum) Rotella ventured into the city streets with a new spirit. What interested him now was not only the material and colouristic qualities in an abstract sense, but rather the direct and epidermic expression of the modern city, whose symbol is consumerism to the bitter end. Rotella takes off the walls, like a skin, the advertising posters which are the most obvious signals of mercenary values.

Whether film posters, as in the case of *The Assault*, where an image of Elvis Presley publicises a film being shown in a city cinema, or advertising posters of commercial products, Nescafé, (rather than the omnipresent Coca Cola) or a poster for voluntary enrolment in the "Carabinieri," the substance does not change. But beyond this social denouncement of the consumerism of capitalism, beyond the nihilist will of "duchampian" and dadaist moulds of breaking with traditional values of art, hides a capacity to express and symbolise the forms of popular art. And now that the embattled impetus of the 'sixties has settled, it is possible to find in Rotella's works a suffused poetic will that can be caught in a moment, in the time it takes for his work to be observed and consumed.

—Roberto Lambarelli

Bibliography—

Restany, Pierre, *Rotella: dal Decollage alla Nuova Immagine*, Milan 1963.
Restany, Pierre, *Nuovo Realismo*, Milan 1973.
Trini, Tommaso, *Rotella*, Milan 1974.
Hunter, Sam, *Rotella: Decollages 1954–1964*, Milan 1986.
Royal Academy, *Italian Art of the 20th Century*, exhibition catalogue, London 1989.

Copyright 1991 Kate Rothko-Prizel & Christopher Rothko/A.R.S., New York

Mark Rothko (1903–70)
Green and Maroon, 1953
Oil on canvas; 91¼ × 54¾ in. (321.8 × 139.1 cm.)
Washington, D.C., Phillips Collection

Green and Maroon is a stunning example of a "classic" Rothko, a variation of the basic format he developed in the early 1950s and continued to work with until his death in 1970. Beautiful, imposing, and deliberately human in scale, this image displays an inherent tension. To bask in its glowing, sumptuous color is to also feel unease, as if confronted by an absolute. This dual disclosure comes as a shock: while we recognize that we are looking at a painting, we find ourselves emotionally engaged with a presence. Directive and elusive, the painting asks something of us.

Against *Green and Maroon's* blue background, a dark green rectangle hovers above a smaller, intensely red one. The edges of these shapes blur into the ground, giving the illusion that they are floating. Yet this sensation of weightlessness is countered by the unrelenting frontality of the total image. Infinite subtleties in the shimmering colors of *Green and Maroon* create movement. They recede, advance, and induce a reflective quality, but the anchoring reality of gravity is equally powerful. Rothko does not allow us to forget entirely our bodies or their attachment to the earth.

Rothko achieved his unique expression of a direct, ethereal quality through a tireless search. He explored materials and techniques that would allow him to portray the full range of life through a single pattern. In the late 1940s, Rothko, like other artists of his generation, began experimenting with newly developed synthetic paint mediums, anticipating by decades the work of color field painters such as Morris Louis and Jules Olitski. By staining glue size mixed with powdered pigments into the raw canvas, he obtained the ground, the unifying element. Over this, he layered numerous radically thinned films of paint, making the surface appear luminous. When Rothko's paintings are viewed in low light as he intended, this radiant effect intensifies, and the glowing canvases impart a distinct presence.

Rothko's singular passion was the depiction of human feeling. He desired above all to imbue his paintings with the poignancy of great music, with its ability to provoke deep emotion. His passion for the ethical and for the human element is well known: as Robert Motherwell has noted, the greatest compliment Rothko could pay anyone was to call them a "mensch"—a real human being. Rothko sought visual equivalents of the basic human experiences of tragedy, ecstasy, sorrow, joy and isolation, believing that sensitive viewers would grasp intuitively the meaning of his art. He was so concerned with viewers' responses that, during his 1961 retrospective at the Museum of Modern Art, he often walked about the galleries, listening to people's reactions to his paintings. Horrified at the possibility of his work's being misunderstood—seen strictly in terms of color relationships, or obscured by imposed meanings—he at first sought to educate viewers through his writings and numerous public statements. Eventually, however, he became convinced that crucial to the life of the work was the environment in which it was seen. And so, with an obsession that became legendary (he even supervised the hanging of his paintings for private collectors), he increasingly sought control over the conditions in which his work was shown.

Likening his paintings to dramas, and the shapes within them to actors, Rothko saw these conditions as crucial to the correct perception of their intrinsic meaning. His own studio was the first such ideal environment; silent, dimly lit and free of objects; it was a space for contemplation of his enterprise. Above all, he maintained that his paintings must be seen together in a group, hung not with concern for chronology, but rather according to the effect they had upon each other. He often hung the largest works in the smallest spaces, and only inches off the floor, for that, he said, was the way they were painted. Spurning traditional gallery-white walls, he experimented with colors that would not, as he put it, fight against the pictures. The lighting was by far the most important factor; indeed, strong light completely destroys the painstakingly achieved effects of his color. Installed in a setting as he specified, the meaning of Rothko's work lies open and apparent in his own perceptual values. An equilibrium exists between each painting and its diffusion into a field. Thus, as Rothko intended, is not merely a single painting that is remembered, but the *feeling of presence*, the totality of an *experience*.

Green and Maroon is one of the few Rothkos to be permanently installed in such a setting. It was the first of Rothko's works acquired by the collector Duncan Phillips. Subsequently, Phillips visited Rothko's studio on several occasions, and eventually purchased more paintings. When a new annex was added to the Phillips Collection in Washington, DC, one gallery was designated as the Rothko room. Phillips and his wife Marjorie planned in advance the arrangement of the paintings, the only things in the room besides a few colored chairs. Though the room was installed in 1960, Rothko did not see it until 1961, when he was in Washington for President Kennedy's inaugural celebration. It snowed heavily; he walked to the museum unannounced. Looking around the room, he made suggestions for rearranging the works, and they were changed then and there. He also recommended replacing the chairs with a simple wooden bench. A week later, when Duncan Phillips returned and saw Rothko's alterations, he noted that they were interesting, and had the room changed back to its original configuration.

Green and Maroon is an abstract expressionist work that, like Rothko himself, does not fit neatly under this rubric. Ultimately, such labels have little meaning, for as he himself believed, painting is not a question of being abstract or representational, but of shattering our encrusted vision of reality.

—Kimberly Davenport

Bibliography—

Rothko, Mark, "The Romantics Were Prompted," in *Possibilities 1* (New York), Winter 1947/48.
Waldman, Diane, *Mark Rothko*, New York and London 1978.
Schjeldahl, Peter, "Rothko and Belief," in *Art in America* (New York), March/April 1979.
Ashton, Dore, *About Rothko*, New York 1983.
Tate Gallery, *Mark Rothko*, London 1983.
Clearwater, Bonnie, "How Rothko Looked at Rothko," in *Art News* (New York), November 1985.

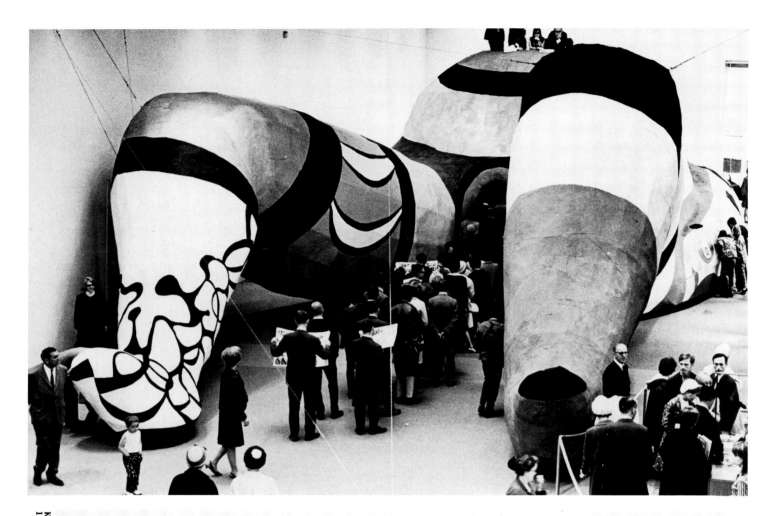

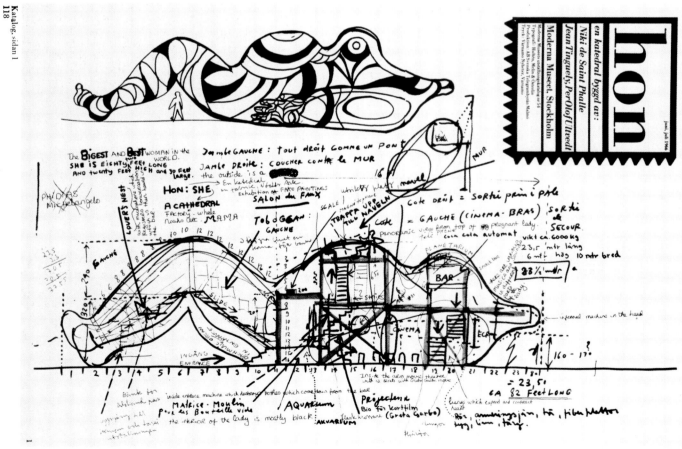

Photo Statens konstmuseer, Stockholm/© DACS 1991

240

Niki de Saint-Phalle (1930–)
Hon 1955–66
Mixed media sculptural environment; 20 × 82 × 30ft.
Stockholm, Moderna Museet (fragmentary remains)

There is a serious range of difficulties surrounding any assessment of *Hon*, a project that went through so many vicissitudes during its eleven years of gestation in the minds and at the hands of so many artists, technicians and others involved in one way or another as administrators.

It would be an error to imagine that the entire enormous supine female figure built in Stockholm's Moderna Museet during 1966 owed its total conception to the 36-year-old Niki de Saint-Phalle. But it would be true to say that the basic theory and the fervour in which it was brought about proceeded from Niki herself, albeit with a tremendous team of artists, technicians and administrators to aid her carry out her deepest wishes, whilst at the same time often incorporating their personal contributions to *Hon*'s final assembly. Although the weight of the recumbent frame of *Hon* was over six tons with a body that stretched nearly thirty yards, this immense Woman's three storeys did not quite fill Room No. 1 in the premises of the Moderna Museet.

Entry was obtained through the natural aperture between her outstretched legs, which led—to the strains of Bach music—into a plethora of different compartments interconnected by stairs, lifts, chutes or other easy access. At the base of the refuse chute descending from the dark but friendly bar—far below—was the bottle-crunching machine devised by Niki's friend and frequent collaborator, the mega-mechanical metal sculptor Jean Tinguely. This sophisticated destructor was situated in the excretion areas of *Hon*'s body.

Above the bar was a "planetarium," another invention by Jean Tinguely, a vast spread to remind the viewer that from ancient times destiny had been determined by the stars. Special rooms for the "lonely, yearning to be desired" were not far distant. Over all, a lookout tower could scan the whole extent of *Hon* from above, and below the bar was the silver aquarium pond full of goldfish, another archaic reminder of the spiritual supremacy of Pisces.

Peace or distress was provided in a number of facilities, such as the telephone, the Coca-Cola automat and the old mattresses (looted from the Strativagen's National Museum in the Court Stables) to give soft entry to the public on their way into *Hon*. Loudspeaker systems in *Hon*'s interior made it possible to hold conversation with the public outside, and they were also connected with the scarlet love-couch so as to relay lovers' conversations to a wider audience. Other visible symbols made their point, such as Per-Olof Ultvedt's *Man Sitting in a Chair*, watching a television screen that emitted scenes of poetic chaos, whilst he was stroked by hands he could not see—all located in the "sprained collarbone." In the upper reaches of *Hon* in the general area of the head was to be found the "Infernal Machine," with its stark black-and-white impression of a tangle of bones gnawed at by a rat (a reference to the mentally-torn brain).

Three huge cupolas comprised the Woman's belly and breasts. The bar was naturally to be found in one of the breasts. In the pit of the back was the Cinema showing the fragmented remains of Garbo's first film, *Luffar-Petter* (1922). Deliberately decrepit, the Cinema's emergency exit was built from the carcass of an obsolete (but authentic) old aircraft.

The Lovers' Nest displayed, on a suspended panel to the rear, a collection of picture postcard reproductions: Yve Klein's *Square*, Kandinsky's *Composition 1908*, Leger's *Staircase*, Bacon's *Double Portrait of Lucian Freud and Frank Auerbach*, and Uno Wallman's *Peasant Wedding*. These were flanked to one side by the strict contrast of the "fakes" painted by Ulf Linde, mock made-up imitation of works by Dubuffet, Fautrier, Klee, Pollock, Soulages and the rest—with their signatures mis-spelt. The actual "Love Tunnel" had all the trappings of a cheap fairground attraction, featuring lust.

It can be seen that for anyone to find their way about the interior of *Hon* required not only a map but a veritable chart. Signs and directions helped, but for the 70,000 visitors more than one day-trip was needed—if only for the slide down the right leg and the parquet-patterned staircase up the left leg.

The basic team of creators were Niki de Saint-Phalle, Jean Tinguely, Per-Olof Ultvedt, Ulf Linde and Pontus Hulten, the supreme co-ordinator of all the Moderna Museet's art activities and exhibitions. All of these persons contributed to Niki de Saint-Phalle's over-riding conception: "Woman Assumes Power"—which at one time even possessed particular visual connotation when it was given by Per-Olof Ultvedt the sculptural form of a tiny man sprawling under one of *Hon*'s enormous feet.

Nevertheless, the ultimate "personality" and the brightly-patterned exterior of *Hon*'s immensity stemmed from Niki de Saint-Phalle. Jean Tinguely was to handle the "animation," and Per-Olof Ultvedt to deal with the "power."

Although originally titled *Cathedral*, a name only partially relinquished, the final decision to call her *Hon* (the Swedish for "She") was eventually unanimously agreed. The early choice of "Cathedral" as a description came from Niki de Saint-Phalle's wish to identify the gigantic woman lying on her back, together with all aspects of her interior apparatus and intentions, with ancient and modern spirituality—a "cathedral" where men and women could foregather or come singly to experience, loneliness, love and happiness, guilt and virtue, and even have their faith, fears and playtime italicized by the surroundings they encountered, instant feelings and secrets swamped by confrontation.

For Niki, all people's passions and disappointments needed to be brought to the surface and "exorcised." Typically, she chose the mighty Mother, the Astarte, the Triple-Goddess to emphasise in so many guises the chances of ubiquitous fulfilment. *Hon* was supposed to encompass every appetite—whether erotic, purely sensual, saintly, loving, hating, sadistic, masochistic, motherly, playful, destructive, creative, and on and on—until all desires, open or secret, were sated.

In the Moderna Museet's three-month exhibition, world opinion—however diverse—largely confirmed that in many ways she had made her point. On Monday, 5 September 1966, demolition began. By September 8, *Hon* had disappeared. Only her head remainded as a permanent acquisition by the Museum.

—Sheldon Williams

Bibliography—

Sylwan, Barbro, ed., *Hon—en historia*, Stockholm 1967.
Descargues, Pierre, *Niki de Saint-Phalle: Les Nana au Pouvoir*, exhibition catalogue, Amsterdam 1967.
Saint-Phalle, Niki de, *Niki de Saint-Phalle*, London and Milan 1968.
Hulten, K. G. Pontus, and others, *Niki de Saint-Phalle*, exhibition catalogue, Paris 1980.

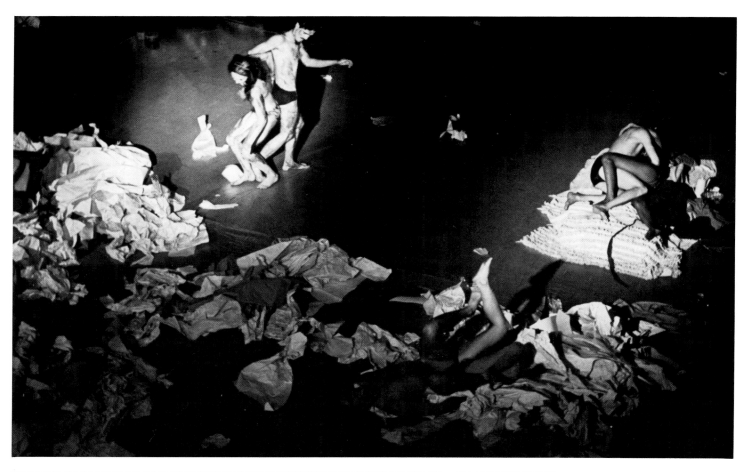

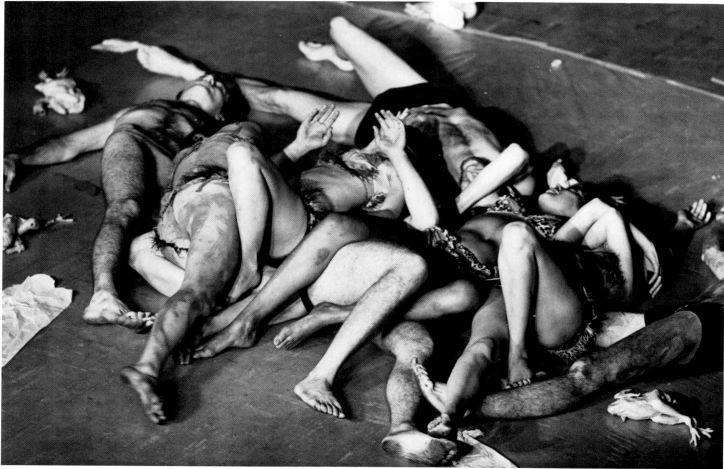

Photos © Peter Moore

Carolee Schneemann (1939–)

Meat Joy, Centre Americain des Artistes, Paris, 29 May 1964; Dennison Hall, London, 8 June 1964; Judson Memorial Church, New York, 16, 17, 18 November 1964
"Kinetic Eye Body Theatre" event

Carolee Schneemann has remarked that her fame as the author of *Meat Joy* can seem at times to be "rather like being buried in a very lovely coffin." *Meat Joy*, in fact, is but one of nearly sixty major entries in the overview of the artist's activities that was published in 1979, and which now is no more than partial. Even then, moreover, she felt the need for a title that would stress the scope of her work, and that monograph is known as *More than Meat Joy*. (Documentext, New Paltz, N.Y.) *Meat Joy* evolved out of earlier work, and continued to evolve into subsequent work; it had the quality of a liturgy or a ritual, exploring a series of intertwining themes, needs, and intuitions, and it declared a commitment to their further exploration. A ritual is necessarily repetitive, since its very function is to re-establish cohesion and connection among drives and principles that otherwise tend to fly apart. *Meat Joy* was a promise that the artist continues to keep.

The artist writes: "*Meat Joy* developed from dream sensation images gathered in journals stretching back to 1960. By February '64, more elaborate drawings and notes accumulated as scraps of paper, on the wall over my bed, in tablets. I'd been concentrating on the possibility of capturing interactions between physical/metabolic changes, dream content, and my sensory orientation upon and after waking: an attempt to view paths between conscious and unconscious organization of image, pun, double-entendre, masking, and the release of random memory fragments (often well-defined sounds, instructions, light, textures, weather, places from the past, solutions to problems). I found the transition between dream and waking, envisioning and practical function, became so attenuated that it was often difficult to leave the loft for my job or errands. My body streamed with currents of imagery; the interior directives varied from furtive to persistent: either veiling or so intensely illuminated ordinary situations that I continually felt dissolved, exploded, permeated by objects, events, persons outside the studio, the one place where my concentration could be complete.

"The drawings of movement, and notations on relations of color, light, sound, language fragments, demanded organization, enaction, and that I be able to sustain the connection to this imagery for an extended time—through the search for space, performers, funds, during painstaking rehearsals, the complexities of production down to the smallest details—all to achieve a fluid, unpredictable performance.

"*Meat Joy* has the character of an erotic rite: excessive, indulgent, a celebration of flesh as material: raw fish, chickens, sausages, wet paint, transparent plastic, ropes, brushes, paper scrap. Its propulsion is towards the ecstatic—shifting and turning between tenderness, wildness, precision, abandon: qualities which could at any moment be sensual, comic, joyous, repellent. Physical equivalences are enacted as a psychic and imagistic stream in which the layered elements mesh and gain intensity by the energy complement of the audience. (They were seated on the floor as close to the performance area as possible, encircling, resonating.) Our proximity heightened the sense of communality, transgressing the polarity between performer and audience."

Meat Joy was a sequence or progression of events for four men (a central man, two lateral men, one independent man) and four women (again a central woman, two lateral women, and one independent woman), plus a serving maid. As the audience entered and moved to its seats, Carolee Schneemann's preparatory notes for the piece, interspersed with scraps of beginners' grammar-book French, were read over a loudspeaker and the various performers,

dressed in street clothes and bath-robes, brought in a mirror and a table at which they sat, chatted, and drank while touching up their make-up and going through other casual back-stage business. The hall was flatly lit with its normal house lights. This might have been normal waking life, as opposed to the dream life soon to follow—a dream life where the words heard so abstractly in waking life were to rediscover their latent intensity, finding themselves transformed into action and image. The audience, during this prologue, was left to the boredom of an almost perfect but heightened normalcy, here redefined as a state of uneasy expectancy.

When the prologue finished and the lights blacked out, what then took place cannot really be described. Colored spotlights stabbled through the darkness and skeins of waste paper tumbled from above and collected into piles on the floor, themselves like pools of light, the performers reappeared and ever so slowly undressed one another, ending up in feathered bikinis; the independent woman set up a bed made of mattress and blankets at the edge of the performance area and provided herself with tea and cakes and oranges and a book to read; the serving maid in black uniform and white apron wandered through the area neatly reassembling discarded clothing; the couples approached one another, slowly, as though moving underwater or caught in a spell where physical proximity and psychic distance were totally at home with one another; various games and charades took place with the men stacking the women into figures that then fell apart or collapsed; bodies writhed in debris; couples ran towards one another and collided, bodies clustered with their backs against the floor and groups of legs waved back and forth in the air like the pistils and stamens of exotic flowers; bodies were slowly tied with ropes; the serving maid reappeared and distributed flashlights that the performers moved in arcs to cast sudden illumination on one another in an otherwise darkened room; dead fish and chickens and strings of hot dogs were cast through the air by the serving maid and reverently preferred by the men to the women and the women to the men; there were sheets of plastic and bowls of paint, bodies brushed and colored and wildly splashed, constant pop music, my guy, my boy lollipop, street sounds, baby love, live buttocks slapped with dead fish, breasts caressed with chickens, feathers in the air, scraps of plastic construed into outlandish hats, orgy, crescendo, descrescendo, staccato colored lights, rolling, embracing, darkness, writhing, paint, laughter, nudity, violence, wetness, tenderness and gore until the final call of the central woman, "Enough, enough," and the sudden closing black out.

Carolee Schneemann has referred to *Meat Joy* as "an erotic celebration to sensitize my guilty culture." It was an orgy, but as well was an orgy of exquisite control. Her point in creating this primal netherworld was to be able to move within it, not only with joy, but with joy as a form of impunity, or as proof and achievement of purified desire.

—Henry Martin

Bibliography—

Smith, M., "Theatre: Meat Joy," in *Village Voice* (New York), 26 November 1964.
Hansen, Al, *A Primer of Happenings and Space/Time Art*, New York 1965.
Lebel, Jean-Jacques, *Le Happening*, Paris 1966.
Schneemann, Carolee, *More Than Meat Joy*, New Paltz, New York 1979.
Castle, Ted, and Ballerini, Julia, *Carolee Schneemann: Early and Recent Work 1960–1982*, Kingston, New York 1983.

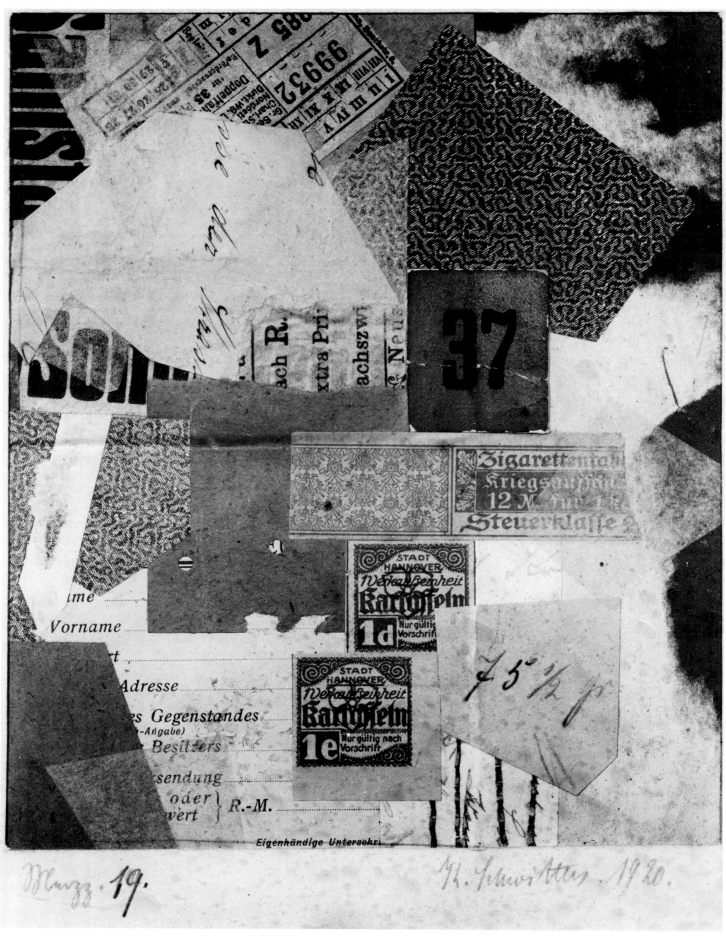

© COSMOPRESS, Geneva and DACS, London 1991

244

Kurt Schwitters (1887–1948)
Merz 19, 1920
Paper collage; $7\frac{1}{4} \times 5\frac{7}{8}$in.
New Haven, Yale University Art Gallery

Merz, from the word "Commerz," cut out one day and used to specify the genre of Schwitters' work, summarizes in sound and feeling everything the artist was ultimately trying to do with his collage, bricolage and assemblages. "I also evaluate material against material," he wrote, "wood against burlap, for example . . . Every artist should be permitted to put together a picture out of nothing more than, say, blotting paper—as long as he knows how to give it form."

So he pasted together whatever he found, and made pictures out of rubbish, constructing his objects like his house, out of scraps. As a consequence, they all have a lived-in quality, a lovable monsterdom: the monster Merz building, the *Kathedrale des erotischen Elends* (Cathedral of Erotic Misery), stretches over two storeys. There is room to play and work, live and die. The Merz spirit is one of interweaving towards a Gesamtkunstwerk.

Later, by the time of the 1926 Monstre-Merz-Munster-Messe (Monster Merz Sample Fair), Schwitters maintains that he is interested not in abstract form, but in precise form with an interior melody reaching through it: "It is the song that sounded within me while I was at work that I have poured into the form, that now makes itself heard by you, too, through the form."

It is this song of the Merz spirit that we still hear in in the Merz constructions of 1942: the interior finding itself in the exterior, as the exterior is founded in art. The spirit is really about building, with humour and lyricism, irony and conviction. It is like an environment in which the spirit can live. To be sure, it is constructed out of "rubbish"—but that is its own statement, both about business and life.

The works are not without a light and touching humour: take *Young Plan* (1929), featuring not only roses and curling, clown-like forms, but a headline reading "Unterberg"—under a mountain, as it were. Sometimes there is black humour—as in the construction entitled *Gallows of Desire* (1919), with a wagon wheel atop a pole, and a noose suspended from it, a wall concealing a future victim, a torn-off number, a scrap of burlap, and an entirely desolate atmosphere.

Each of these constructions is made up of found objects (similar to the Surrealist "objet trouve"), whose own loose ends are then combined—not merely taking advantage of what is around us in daily life or setting up a monument to garbage, but a statement about what the human mind can construct. Each makes a bold and colorful statement, a statement that speaks with increasing power to our current appreciation of that spirit.

Every part of Schwitters' monumental series of collages bespeaks a masterpiece. Take *Merzbild 14* (1921): it protrudes, via knobs of metal, into our space, playing with rounded and rectangular forms, reminiscent of a child's toy; in the lower left-hand corner, it is marked by a blob of sealing wax (the top of a wine bottle, or a seal on a letter) that circles above a leaf in the form of a pair of lips—an echo of Man Ray's painting of Lee Miller's lips. In this extraordinary universe, Merz resounds with overtones of Surrealism as well as of Dada.

Merz 19 (1920) manages to combine at least six kinds of print and italics, treating the textures of its typographic squiggles and intricate patterns as simple components of a world waiting to be combined. Here, they are. All the stuff of daily life is represented in a metapoetic meditation on the philosophy of the Merz constructions themselves—both humble and moving. The potatoes (Kartoffeln) that sustain us, priced according to size, are marked clearly as having their origin in Schwitter's own location: the City of Hannover. The cigarettes (Zigaretten) that we consume and which consume us are labelled and ticketed. We are in a specific time and place, with its own price—75 for half a gram. But it might be anything . . . What is the ticket at top left for? What would all that writing mean to us, were we to be allowed to see it complete? What are those cloud-like forms drifting behind the rectangles of material and paper? What are those shadowy numerals—like "37"—referring to?

The constructions of Schwitters send us back to philosophical investigations of their own (or our own) sort. What is our point of reference, when everything is encountered separately, torn off from its original context, then re-composed and framed? The artist is a philosopher and semiotician who, all these years after his death, seems a reader of contemporary theory. He has referred us to the very commerce from which the name of his work comes— an advertisement for the Commerz-und Privat-Bank—and has banked upon it the modest supply of potatoes and cigarettes, with their prices. He has left open the entire interpretation of his work, and signalled it as open: ready for reader-reception. Notably, in the lower left-hand corner, there is a space for our names— first and last names—our addresses, the things that concern us ("Gegenstand"), the objects of our desire and worry. He plays with the cancellation: the lines that run down to the lower right-hand corner, with their writing stroked through. There are holes in the fabrics of his construction, so that we can see our way through them. Upon it all, he has set his own private handmark, his own writing.

"I am a painter. I nail my pictures," he said to Raoul Hausmann. And it is not just objects that are nailed thereby, but the attention of the observer. "The great time will come at last," he claimed, "when we will influence an entire generation."

—Mary Ann Caws

Bibliography—

Janis, Harriet, and Blesch, Rudi, *Collage: Personalities, Concepts, Techniques*, Philadelphia 1962.
Steinitz, Kate Trauman, *Kurt Schwitters: A Portrait from Life*, Los Angeles 1968.
Schmalenbach, Werner, *Kurt Schwitters*, London 1970.
Lach, Friedhelm, *Der Merz Kunstler: Kurt Schwitters*, Cologne 1971.
Burkett, M. E., *Kurt Schwitters: Creator of Merz*, Kendal, Westmorland 1979.

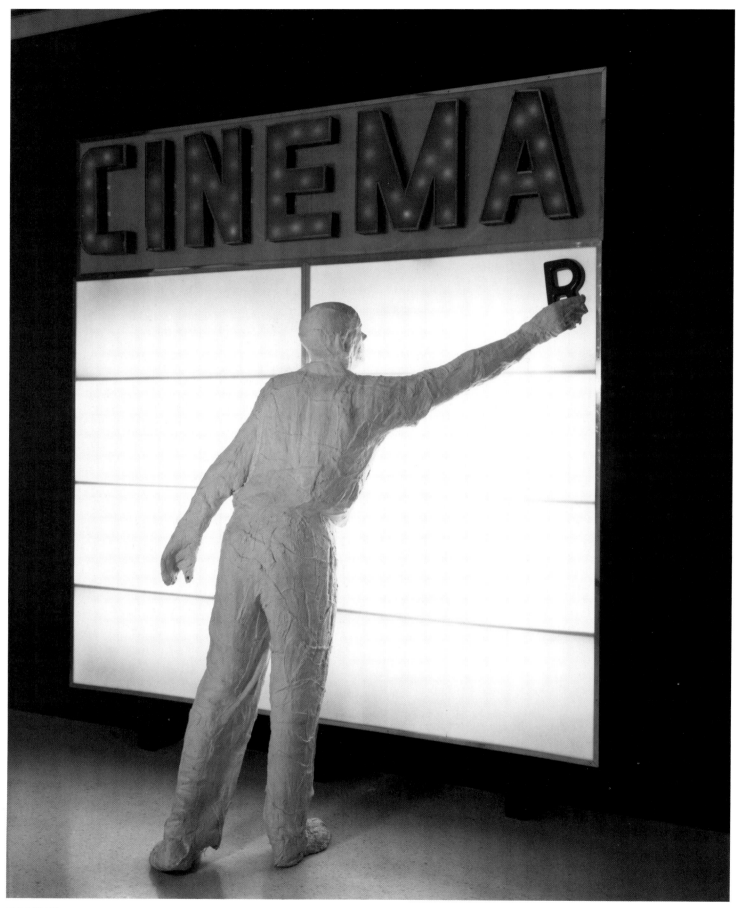

© DACS 1991

George Segal (1924–)
Cinema, 1963
Plaster figure with illuminated metal-and-plexiglass sign; 118 × 96 × 30in.
Buffalo, Albright-Knox Art Gallery

Segal's tabloid represents a banal, everyday scene, well known to urbanites and therefore easily recognizable: a man putting up the title of the next week's movie. However, the frozen movement of the life-size figure causes the trivial event to assume a hieratic quality, while the bright, artificial, bluish-green light emanating from the background and the shining red inscription *Cinema* make the scene dreamlike; its dramaturgy is complemented by an element of mystery: the man is placing the first letter of the title and we have no idea whatsoever what movie is in the offing.

Segal's installation consists of ready-made objects and a plaster cast of a human figure. The use of ready-made objects yields an irresistible effect of direct projection of the reality, whereas the character of the plaster cast is a mystery in itself. The same is to be found in every Segal work. In each, he uses such a white, real and at the same time unreal figure, placing it among "real" objects, e.g. at a genuine Coca-Cola fountain, on the bus conductor's seat, at a laundry counter, in a bathtub, in front of a mirror, etc. The contrast between real objects and quasi-real figure is one of the energy sources of those works: looking at them, enchanted, we find ourselves as if on two planes of existence at the same time. We are trapped between literal and coded reality.

Plaster casts are made from live models (usually patient friends of the artist), but made in such a way that any likeness to the original is illegible, since it remains inside the mould, forever inaccessible to the spectator's eyes. Outer surfaces of the plaster are, on the other hand, formed freely, patted by hand in the rapidly setting material. This procedure gives them a specific roughness as well as generality, being an effect of superficial and hasty handling. That is why all Segal's figures are alike. Deprived of any details of face and costume, they are frozen in their nameless existence. They are not defined by individual features, but rather by being placed in the realities of their occupation or home. They are thus elements of a series. Although the series has not been manufactured mechanically, the accompanying objects are industrially-made serial products, and as such lend something of their anonymity to the figures.

George Segal was associated with the Pop-Art movement, a dominating artistic current in the United States in the first half of the 1960s. That movement focused on the phenomenon of American popular culture, reaching to the core of its captivating mechanisms. It exposed its omnipresence, multiplicated by advertisements and the mass media. It revealed the typology of its patterns, its superficial though suggestive beauty. By blowing up and multiplying the patterns of this culture (the widespread models of work and entertainment, objects as well as popular sport and movie stars) the artists referred to the world of American everyman, to his everyday life and dreams being within the arm's reach, made available by the movies, TV and omnipresent advertisements.

This art makes us realize that popular culture has become something more than merely a platitude: it has become a mythology of its period, a new faith, new destiny, new power and subordination of the individual. This art revealed to us not only the artificiality of the consumer art, but also the artificiality of our vision, which—unified by the "manufactured" lifestyle and controlled by the media—has become, without our will and knowledge, "second-hand" vision. We no longer speak with our own voice; it is the objects we use or we want to have and the situations we are in that speak for us. Our thinking and our feelings are tinged with the omnipresent coolness of this model. We accept it

without resistance, neither happy nor unhappy. Every one is "in his place" and apparently everything is available for everybody. Everybody may enter the cinema, in front of which Segal's man is putting an advertisement. Where is the problem?—this art seems to ask and with this question opens up a field for fundamental reflection over human condition in such an efficiently programmed world.

Segal feels the drama of this condition and tries to save something human, something individualistic for his figures. He says that the task of an artist is to select from the multitude of human gestures and attitudes those which are most expressive, and that he himself tries to grasp the seriousness and dignity of the subject. He does this by monumentalizing his figures and contrasting their unnatural whiteness with the literalness and detail of the surroundings. But at the same time, these merely outlined figures, deprived of individual features, become but alienated specimens of the species, trapped in the mechanisms which eliminate their ability to decide about themselves. The monumentality of Segal's figures is not inherent in their form but in their destiny. The man in the *Cinema*, putting up the title of a movie, seems to be doomed to this single, elementary movement, which determines his condition in life. We are not prone to think about his other gestures; we tacitly assume that these other gestures are also stereotypes. Whereas the individual drama, which takes place during taking a cast from a concrete man, is hidden inside the mould and the spectator has no reason to think about it. All the more so as he sees how these figures are attached to the most impersonal places imaginable: they are placed on a bus, in a bar, in front of a cinema, on a stairway, in a gas station, that is not in heroic and exceptional but rather commonplace situations.

A question arises how does it happen that Segal, dealing with the area of sheer banality, manages to turn it into a real discovery for our eyes. "Frozen happenings" (as Lucy Lippard calls them), constructed by the artist, are like stilled film frames, waiting to be put in motion. This still movie, this fragment of narration makes the spectator wish to see "what's next," what are the following scenes. Segal makes us look at the reality he shows as if at the stage; he reveals to us that the "truth" of life is already represented by stage reality, that is artificially set up, in which all the roles have been already cast. Segal's figures are performers of these roles; their pattern is also the pattern of our fate.

The *Cinema* is one of the most suggestive works of George Segal. Having seen it once, even in a reproduction, one would never forget it. Just as we never forget a movie seen sometime in the past, whose message remained with us forever.

—Alicja Kępińska

Bibliography—

Gruen, John, "A Quiet Environment for Frozen Friends," in the *New York Herald Tribune*, 22 March 1964.
Lippard, Lucy, *Pop Art*, New York 1966.
Rose, Barbara, *American Art of the 20th Century*, Brussels 1969.
Russell, John, "Pop Reappraised," in *Art in America* (New York), July/August 1969.
Seitz, William C., *Segal*, Stuttgart and New York 1972.
Bario-Garay, Jose L., and Delehanty, Suzanne, *George Segal: Environments*, Philadelphia 1976.
Friedman, Martin, and Beal, Graham W., *George Segal: Sculpture*, exhibition catalogue, Minneapolis 1978.
Bario-Garay, Jose L., *George Segal*, Barcelona 1979.

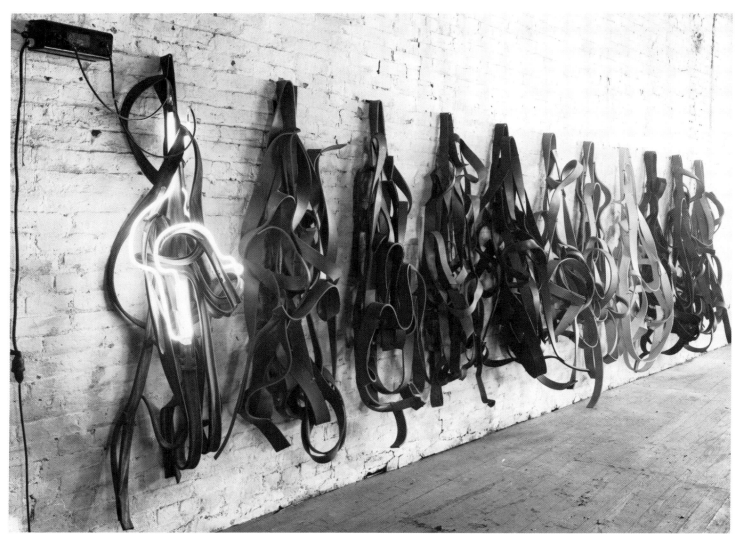

Copyright 1991 Richard Serra/A.R.S., New York. Photo © Peter Moore.

Richard Serra (1939–)
Untitled/Belt Piece, 1967
Rubber and neon, 9 units; 72 × 264in. (180 × 660cm.)
Milan, Count Panza di Biumo Collection

Richard Serra's soft, fleshy rubber *Belts* of 1966/67, merely hung from nails and threaded with neon, marked the emergence of Post-Minimalism or process art. They also heralded the presence of an important new talent. How could an affinity for industrial waste accomplish so much?

Serra was born in San Francisco and studied at the University of California, Berkeley and Santa Barbara, and at Yale. He came to New York City in the mid-sixties when the dominant art style was Minimalism and Pop Art. By 1967 Minimal art, with its primary structures and rigid industrial forms and materials, had reached the high point of its popularity when a backlash began to occur. Robert Morris began to attack the style he made popular that Summer by loosely stacking materials, beginning a new movement that came to be called Process art and later Post-Minimalism. Morris was the theoretician of this new movement and in his 1968 essay "Anti-Form" in *Artforum* he linked this new sculptural tendency to Jackson Pollock's allover drip paintings. In his essay, Morris called for the visibility of process in art work, something he remarked had previously only appeared in the sketches and unfinished work of the Renaissance and Rodin's "traces of touch" in his finished work. He asked for a "reconsideration of the use of tools in relation to materials," saying that sometimes works of art could be made by "a direct manipulation of the material without the use of any tool. . .In these cases considerations of gravity are as important as those of space. The focus on matter and gravity. . . results in forms that were not projected in advance. Considerations of ordering are necessarily casual and imprecise and unemphasized. Random piling, loose stacking, hanging give passing form to the material. Chance is accepted and indeterminacy is implied. . .disengagement from preconceived enduring forms and orders for this is a positive assertion."

That same Summer the younger, yet unknown artist Richard Serra began working with a flexible, drooping material—rubber—constructing a new kind of sculpture that almost programatically fulfilled Morris's ideas. . . Artists had begun to live in the light manufacturing district South of Houston street (SoHo) and the various industries in that area regularly discarded interesting garbage—i.e. strips of leather, plastic or rubber that artists recycled into a new kind of art material. Serra says, "In 1966 I happened to find tons of rubber. . . lying around Canal street, and found more in the rubber than anything else—a sort of private language going on—and I felt if you could only get that language you could reinforce your art by using it." Serra began to hang harness-shaped sloping circles of rubber in clusters from nails on a wall. Eventually, he threaded these soft, seemingly casual forms with neon tubing bent in linear configurations that echoes the rubber shapes. The neon, with its colored light and hard, cold, glass contours, counterpointed the more fleshy presence of the rubber. He said, "Gravity and drawing defined the work. The drawing was predicated on the joints and where the lines crossed."

This work fused painting and sculpture. He said, "I made a work with eleven units which was consciously influenced by Pollock's Iowa State Mural. . .The implication of Pollock's painting was a non-compositional overallness: open field. However, the implications of the open field remain bounded by the frame." Unlike Minimalist work, which often relies on a mechanistic grid made up of identical modular units, *Belts* is based on the idea of diversity within sameness. Although the sculpture is created of multiple units, each cluster is slightly different. Serra observed, "The *Belt* relief differs from Pollock in that it establishes a near reading of discrete units in succession. That is, each form being different prompts one to walk from form to form, comparing the inherent process that delineates the work. The only gestalt reading possible is from a far distance." Serra realized that, "the open field work had other potentials if it was not bound to the wall. The result of this consideration led me to open field scatter pieces, tear pieces, splash pieces and cut pieces. . ."

At this time Serra conceptualized the act of making sculpture as one not based on images or abstract shapes but one of artistic process, and he compiled a list of verbs that became his "tools" for making sculpture. This list of transitive verbs to be applied to an unspecified material includes, "To Roll, To Crease, To Fold, To Store, To Bend. . ." For the 1969 Whitney exhibition, *Anti-Illusion Procedures and Materials* he splashed lead against the wall. Each piece was pried and scraped loose and laid in parallel lines like the ridges on a sand bar. The process was repeated eight to twelve times in succession. The process of making the work was as important as its final appearance. In the same year, Serra's work focused on gravitational problems. Pieces of lead in different forms—sheets, rolls, etc.—were propped against each other or against the wall. Gravity was given the often deliberately frightening job of holding them up. Separating himself from David Smith and the Minimalists, no welding was used. If the massive plates fell down, (always a real possibility) they could potentially hurt the viewer.

Later work, such as his controversial, site specific sculpture of the eighties, *Tilted Arc* continued to develop these ideas. Here, a curving wall of Cor-ten steel bisected a public piazza forming a real and psychological barrier in front of the building. The steel was allowed to rust, forming a crumbling, scarred orange and brown patina that resembled abandoned industrial scrap. Experienced as a confrontational eyesore by the office workers who passed it daily it was eventually removed over Serra's protest.

Belts anticipated many of Serra's later concerns.

—Ann-Sargent Wooster

Bibliography—

Szeemann, Harald, and others, *When Attitudes Become Form*, exhibition catalogue, Bern 1969.
Burnham, Jack. *The Structure of Art*, New York 1971.
Muller, Gregoire, *The New Avant Garde*, London 1972.
Becker, W., "Richard Serra," in *Das Kunstwerk* (Baden-Baden), March 1972.
Amaya, Mario, and others, *Soft As Art*, exhibition catalogue, New York 1973.
Anderson, Wayne, *American Sculpture in Process: 1930/1970*, Boston 1975.
Weyergraf, Clara, ed., *Richard Serra: Interviews, etc. 1970–1980*, Yonkers 1980.
Bois, Yves-Alain, and Kraus, Rosalind E., *Richard Serra*, exhibition catalogue, Paris 1983.
Stockebrand, Marianne, *Richard Serra*, exhibition catalogue, Krefeld 1985.
Kraus, Rosalind E., *Richard Serra: Sculpture*, New York 1986.
Guse, Ernst-Gerhard, ed., *Richard Serra*, Stuttgart 1987.
Lucie-Smith, Edward, *Art Today*, London 1989.

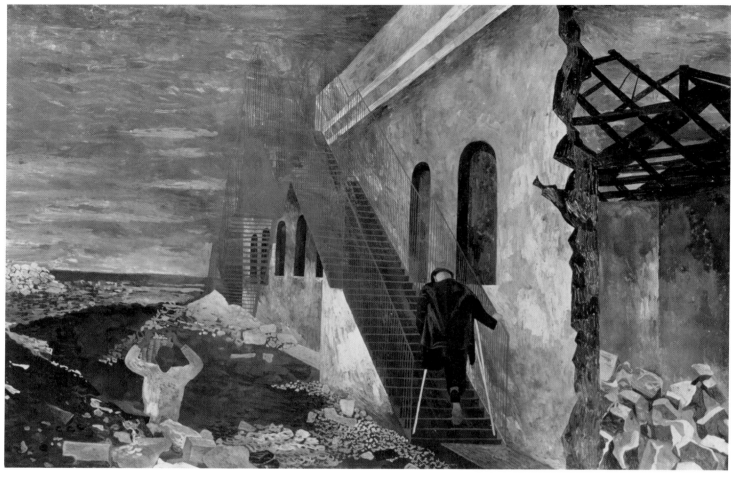

© DACS 1991

250

Ben Shahn (1898–1969)
Red Stairway, 1944
Tempera on canvas; 16 × 23½in.
St. Louis, City Art Museum

The Red Stairway is a witness to Ben Shahn's artistic credo, which he announced early in his career and which remained constant throughout his life. This was a belief in the importance of the individual human being in the modern world which threatened to overwhelm and de-humanize him. The date of the composition of *The Red Stairway* is significant for this is a war picture despite its lyrical and symbolic (rather than documentary and descriptive) content. As Shahn pointed out "a symbolism which I might once have considered cryptic now became the only means by which I could formulate the sense of loneliness and waste that war gave me and the sense of the littleness of people trying to live on through the enormity of war."

The Red Stairway is painted in tempera, a method of painting using powdered colour mixed with an agent such as egg or size (glue), used by pre-Renaissance painters. On a visit to Italy, Ben Shahn had admired the luminosity of early Italian frescoes and came to prefer the smooth uniformity of tempera to the dense impasto of the oil paint he had hitherto used. In a sense, his switch from oil to tempera marks a shift from the social realism of his pre-War paintings to the metaphysical detachment of *The Red Stairway* and associated paintings of the 1940s. In his paintings and murals of the 1930s Shahn employed satire and political commentary in paintings that were directly critical of the prevailing social and economic ills. This was a period artistically in revolt against the doctrine of art for art's sake, an American reaction to the aesthetic preoccupations of the Ecole de Paris, led in the USA by the generation preceding Shahn which included Edward Hopper, who painted oils showing the spiritual malaise endemic in urban and rural life and the muralist (with whom Ben Shahn worked on government commissions) Diego Riviera. However, the next decade saw Shahn's work shift from exploring public to private concerns, from a social realism to a "sort of personal realism." He wrote, "The universal experience is that private experience which illuminates the private and personal world in which each one of us lives the greater part of his life . . ."

Shahn's experience in the 1930s, as an artist first for the government's Public Works of Art project, and then as an artist and photographer for the Farm Security Administration caused him to meet people whose sufferings were endured with "a transcendent indifference to their lot in life." It was this private grief that he came to want to record rather than the political injustices which had earlier engaged his anger and sympathy. In 1934 Shahn was commissioned by the Federal Emergency Relief Aid Administration to submit sketches for murals for the penitentiary at Riker's Island, New York. His sketches were rejected as being "unsatisfactory and unsuitable," and this lesson, learnt sooner or later by all social realist painters that their paintings were suspected of having subversive connotations, may also have been one of the

motives for moving to a lyrical, less polemical style during the War years.

In *The Red Stairway*, we see Shahn drawing upon examples provided by Italian art, both old and new. He cited two major influences as Masaccio's *Expulsion from the Garden* (Adam and Eve expelled in disgrace from Paradise) as "so intensely personal that it leaves no person untouched" and described "a de Chirico, figure lonely in a human street, haunted by shadows; its loneliness speaks to all human loneliness." It is clear that Shahn was guided by the Metaphysical School of Carlo Carra and Giorgio de Chirico, who were looking to suggest a form of super-reality through the depiction of poetic figures set in mysterious surroundings. Shahn also looked for inspiration to the symbolically-charged paintings of Paul Klee, in particular imitating his luminous and translucent colour.

The Red Stairway, with its half-ruined classical building, one-legged pilgrim on crutches, archaic figure carrying a basket against the limpid blue sea and sky of a Mediterranean landscape, bisected by a blood-red stairway that takes the pilgrim nowhere, represents a change in emphasis for Shahn—not just in documentary terms from explicit to implicit comment, but in painterly terms from the dark tones of social realism to the clear colour washes for a mystery landscape that is forever elusive and tantalising. What remains unchanged is Shahn's graphic sense as draughtsman and designer, which he had learnt first in commercial lithography studios and which remained a hallmark of his work throughout his life.

It would be wrong, however, to interpret Shahn's withdrawal from social realism as a retreat into a personally-felt and self-regarding mysticism. He had no truck with Surrealism saying that "the subconscious cannot create art" and he saw the challenge "to see within reality a deeper reality." His profoundly moving paintings of the 1940s expressed a powerful comment upon the suffering resulting from War, and highlighted the plight of men aware that, for better or worse, their destiny is shaped by others whom they have no power to influence.

—Camilla Boodle

Bibliography—

Soby, James Thrall, *Penguin Modern Painters: Ben Shahn*, Harmondsworth, Middlesex 1947.
Rodman, Selden, *Portrait of the Artist as an American: Ben Shahn*, New York 1951.
Ashton, Dore, ed., *Twentieth Century Artists on Art*, New York 1958.
Lipman, Jean, ed., *What is American in American Art*, New York 1963.
Morse, John D., ed., *Ben Shahn*, London 1972.
Hunter, Sam, *American Art of the Twentieth Century*, London 1973.
Shahn, Bernarda Bryson, *Ben Shahn*, New York 1975.

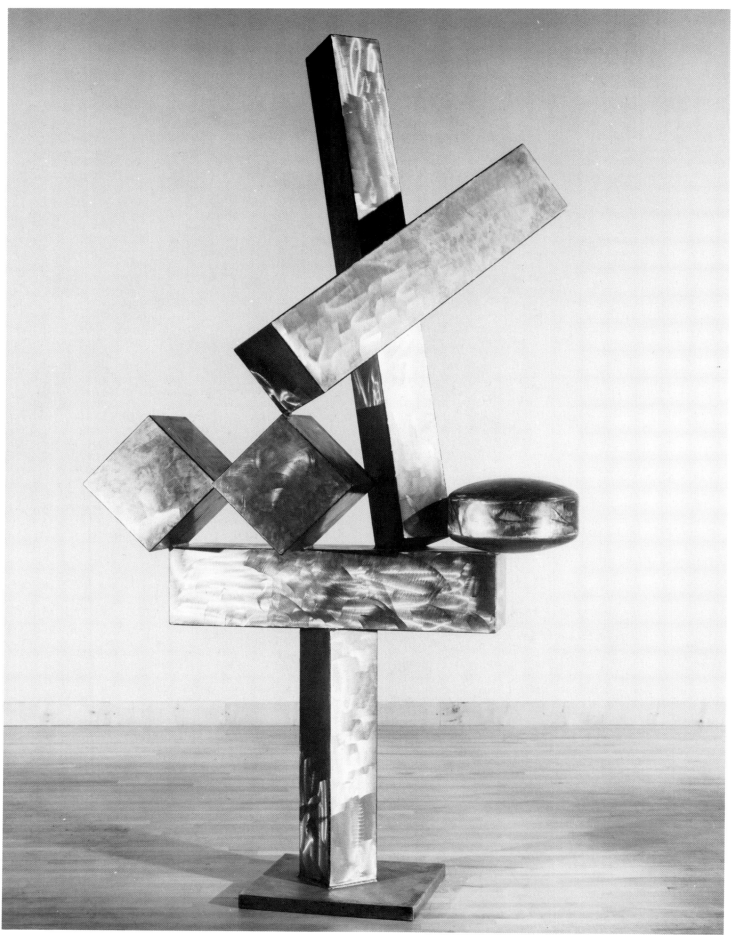

© DACS 1991

David Smith (1906–65)
Cubi XIX, 1964
Stainless steel; 287.5 × 55 × 52.5 cm.
London, Tate Gallery

Cubi XIX is one of a series of twenty-eight numbered sculptures constructed by David Smith from various combinations of stainless steel forms. The *Cubis* (ranging in height from ten to twenty feet) were on a larger scale than anything previously produced by Smith, and were his last completed works before his death in an automobile accident in 1965. Much has been written about the *Cubi*, which are regarded as the summation of David Smith's ideas and a testament to his profound originality. For the artist it was important that the *Cubis* should be viewed against the landscape: "I like outdoor sculpture and the most practical thing for outdoor sculpture is stainless steel, and I made them and polished them in such a way that on a dull day, they take on the dull blue or colour of the sky in the late afternoon sun, the glow, golden like the rays, the colour of nature, and in a particular sense, I have used atmosphere in a reflective way on the surfaces. They are coloured by the sky and surroundings, the green or blue of water. Some are down by the water and some are by the mountain. They reflect the colour. They are designed for outdoors." Smith believed that "stainless steel seems dead without light," and Hilton Kramer, the critic, writing in 1966 believed that Smith had achieved something of mysterious beauty: "at certain moments it seems as if these sculptures were actually constructions of light itself, not so much occupying but illuminating the space that contains them."

David Smith is one of the most important sculptors of the 20th century. Possessed of great technical skills matched by a fertile imagination he gave sculpture a new direction which he considered appropriate for the modern age. His early career, much mythologized, suggests an inevitability about his final choice of career. His father was a telephone engineer, and Smith claimed that as a child he had had a "high regard for machinery." As a student he took a casual job in the Steel Frame Assembly Department of the Studebaker Automotive Plant, Indiana, where he learnt various manual skills, including riveting, soldering, welding and using a lathe. Intending to be a painter, he took a particular interest in the work of the Cubists, led by Picasso. Although the examples of the welded metal sculptures of Picasso and Julio Gonzalez seen in the pages of the avant-garde magazine *Cahiers d'Art* in the late 1920s caused him to embark on his own experimental three-dimensional work, he never forgot the lessons of Cubism. At an address given at the University of Mississippi in 1955 he reiterated that "Cubism, essentially a sculptural concept orginated by painters, did more for sculpture than any other influence. It was Picasso, working with another Spaniard, Gonzalez, in 1929, who made the iron constructions utilizing "found" or collected objects. Cubism freed sculpture from monolithic and volumetric form, as Impressionism freed painting from chiaroscuro. The poetic vision in sculpture is fully as free as in painting."

Smith always maintained that there were no rules in sculpture and that art was "a paradox with no laws to bind it. It is created by man's imagination in relation to his time . . . when it is created, it represents a unity that did not exist before." He chose to work in iron and steel, as Rosalind Kraus points out, "because of its lack of association with high art and because it enabled him to explore the radical notion of surface disconnected from an underlying structure, grafting onto sculpture Cubism's break-up of the planes of a picture, confounding the viewer with a collapse of structural logic."

Smith's work evolved as he explored these ideas in various series or groups of works. The *Agricola* series consisted of seventeen pieces constructed mostly from pieces of discarded agricultural machinery, whereas the *Voltri* were a group of twenty-six sculptures made in Italy which drew on ideas from the archaic and classical past to produce icons for the modern age. Certain ideas remained constant throughout his career and are manifested in the *Cubis*, for example the notion of using "found" objects as the raw material for his work. The prefabricated shapes of the *Cubis* he considered "found," just as much as pieces of scrap metal. All of his work draws to some extent on the real world, for as he said in 1964, "There is no such thing as truly abstract art. Man always has to work from his life."

All of his constructions are dedicated to exploring and exploiting the ambiguity between perception and reality, between expectation and actuality. *Cubi XIX* exerts a powerful paradox by confusing the viewer with its juxtaposition of burnished flat surfaces and three-dimensional volume. As Rosalind Kraus concludes "Never before has the enforced frontality seemed so in conflict with the apparent bulk of the sculptures, or indeed with the nature of sculpture itself."

David Smith was held in high esteem by his contemporaries, in particular the painters Robert Motherwell, Helen Frankenthaler and Kenneth Noland, as well as by the young British sculptor Anthony Caro, who was profoundly influenced by his ideas and his example. It is no exaggeration to say that his work in general, but the *Cubis*, above all, changed the course of sculpture this century.

—Camilla Boodle

Bibliography—

Gray, Cleve, ed., *David Smith by David Smith*, London 1968, New York 1969.
Kraus, Rosalind E., *Terminal Iron Works: The Sculpture of David Smith*, London and Cambridge, Massachusetts 1971.
Kraus, Rosalind E., *The Sculpture of David Smith: A Catalogue Raisonne*, New York 1977.
Ashton, Dore, ed., *Twentieth Century Artists on Art*, New York 1985.
Merkert, Jorn, ed., *David Smith: Sculpture and Drawings*, Munich 1986.

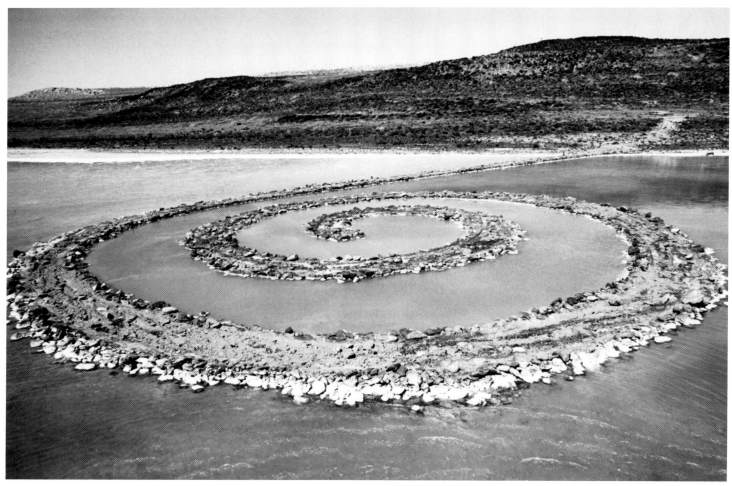

Photo Ace Contemporary Exhibitions, Los Angeles

254

Robert Smithson (1938–73)
Spiral Jetty, Rozel Point, Great Salt Lake, Utah, 1970
Mud, rocks, water and salt crystals; 1500 × 15ft.
Los Angeles, Ace Contemporary Exhibitions

Most people who have only known Robert Smithson as the creator of the earthwork, *Spiral Jetty*, will be unaware that, before his tragic death at the age of 35, he had made an astonishing leap from being an Abstract Expressionist painter to one of the major exponents of Conceptual Art. A look at his background, however, may make that leap seem more comprehensible. His paternal great-grandfather and grandfather were responsible for the ornamental plasterwork in the New York Subway System, the Metropolitan Museum of Art and in many churches—sculptural shapes were in his blood, so to speak. As a child, Smithson collected reptiles and fossils and was fascinated by paintings of dinosaurs at New York's Museum of Natural History. He was interested early on in crystals and natural geometry. As a child, he drew maps and plans for the family's annual vacation routes.

By the early 1960s, Smithson had begun to turn away from the paintings he had originally trained to make, and he started to make assemblages and then sculpture in the mid-1960s, when he became friendly with Minimal artists. The strength of his own approach was becoming apparent by 1965–66, with the publication of articles bearing on his ideas about what constituted his art. The decay of the suburban environment, which could easily be seen in the New Jersey of his childhood, sparked off several major strands in Smithson's approach. One he called the "dialectics of entropy." Entropy, as he saw it, was the gradual deterioration of a system with no chance of regeneration. The other strand was the massive amount of documentation that accompanied all his work from then on. The visits to urban and industrial areas, and disused quarries in New Jersey, were assiduously photographed and footnoted.

From these visits he developed his series of sites/non-sites. The sites were the areas where materials (such as rocks) came from, and these sites were photographed and notes taken. Then the results of the visits and the documentation came to be exhibited at non-sites, that is, the gallery space. Art, he and like-minded artists felt, should not be confined to fine art on the walls, but should be made of the materials of life, which included decay. Throughout the rest of his life and work, the documentation grew in importance. The *concept* of the projects grew in importance and, eventually, when the projects, such as major earthworks, grew to be so major that they required massive advance planning and then could not be made because of lack of funds, or, as is the case with the *Spiral Jetty*, disappeared due to natural causes, then the documentation became of paramount importance in order the preserve the concept.

The concept of the *Spiral Jetty* came about with Smithson's desire to find an accessible inland red salt lake. He heard that the Great Salt Lake in Utah had a reddish tinge due to microbacteria and, when he saw it, he initially wished to create an island. He wanted to place the island within, as he saw it, the symbolic blood-like, primordial surroundings of the lake. His interests in dinosaurs and the tar pits that had swallowed and embalmed them (his days in the Museum of Natural History never deserted him), were revived by the sight of the abandoned hulks of oil rigs on the edge of the lake, still seeping oil. The whole project was steeped in symbolism such as life's beginnings in saline solutions; blood as part of life's beginning; life's eventual decay/entropy as symbolised by the disused oil rigs. Other symbolism abounds in all the other aspects of the project, but particularly in the major symbol of the project—the spiral itself.

The spiral shape is a symbol with many ramifications such as: the evolution of the universe; a symbol for growth; serpents in myths and legends and, above all, it is an essential motif found in ornamental art all over the world. To add to that, with Smithson's life-long interest in crystallography and natural geometry, the lake was periodically encrusted with salt crystals, which have a spiralling shape, and crystalline forms are some of life's most basic shapes.

In his book on Smithson's sculpture, Robert Hobbs is at pains to point out that most people who know the *Spiral Jetty* only through its elaborate documentation (a 35-minute film, numerous photographs, drawings and essays), see it as only an artist's heroic gesture made of local elements, and an attempt at conquering the landscape with a magnificent, but meaningless, mark. With Hobbs' assistance, we can see that it certainly wasn't a meaningless mark. But it is only through having seen the film or reading descriptions of the building process that we can understand that Smithson is ambivalent about the heroics of the gesture. In the film, he compares the machinery made to create the work—the caterpillars and dump trucks—to huge dinosaurs. The viewer of the film and the reader of Smithson's essay is reminded again and again of the primitive nature of the whole undertaking, from the concept of the spiral to the construction itself—primitivism, rather than heroism. However, if the viewer's only access to the *Spiral Jetty* is through the beautiful still-photographs made of it on its completion (minus oil-rigs and caterpillars), then these notions of primitivism could understandably be missed in front of the sheer elegance of the construction.

The following is a direct quotation from Hobbs' book, detailing the construction of *Spiral Jetty*: ". . . 6,650 tons of material were moved and 292 truck-hours (taking 30 to 60 minutes per load) and 625 man-hours (adding up to more than 10 tons of material per hour) were expended in moving it. Approximately $9,000 (not including the many expenses incurred) was spent on construction of the Earthwork alone by Virginia Dwan of Dwan Gallery, New York, and another $9,000 was provided by Douglas Christmas of Ace Gallery, Vancouver, B.C. . . . for a film of the work . . ."

The *Spiral Jetty* has been under water since 1972. Apparently, according to the artist's wife, Nancy Holt, if he had realised that it was going to be submerged, he would have built it higher. Smithson obviously did not intend for "entropy" to go so far so quickly.

There appear to be conflicting opinions as to whether Smithson was really concerned with reclamation from an environmentalist's standpoint. Surely it cannot be doubted that an element of this concern existed in his work. It is indeed true that many of his late projects, completed and uncompleted, were sited in disused quarries, and, in the case of the *Broken Circle/Spiral Hill* in Emmen, Holland, proved very popular with the public, but it seems unlikely that environmentalism was at the forefront of his mind.

Smithson's art lay in his ideas and projects associated with his "dialectics of entropy," the gradual decay of natural things, whether they were dinosaurs, tar pits or Passaic, New Jersey. To create art out of this material was his achievement. Fortunately for those of us who came late to his work, Smithson was also in the vanguard of Conceptual Art, whereby his Earth Art could be kept alive through its prolific documentation.

—Victoria Keller

Bibliography—

Smithson, Robert, *The Spiral Jetty*, film, 16mm, 35 minutes, 1971.
Wheeler, Douglas, "The Spiral Jetty is a Verb!," in *Artscanada* (Toronto), April/May 1971.
Kepes, Gyorgy, ed., *Arts of the Environment*, New York 1972.
Holt, Nancy, ed., *The Writings of Robert Smithson*, New York 1979.
Hobbs, Robert, *Robert Smithson: A Retrospective View*, exhibition catalogue, Venice 1982.

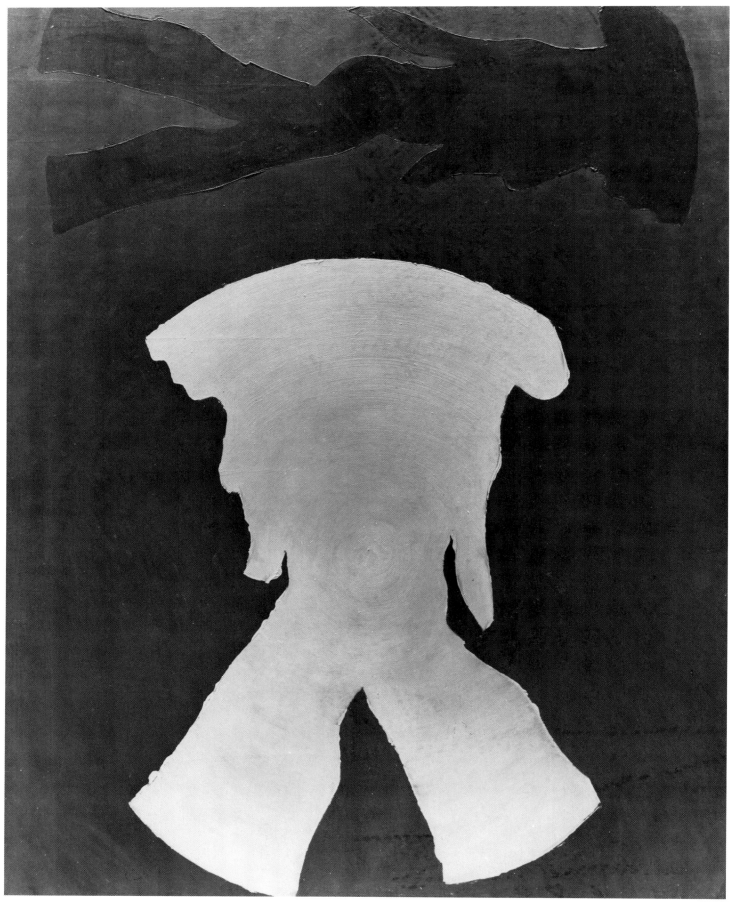

Turn, 1961

Michael Snow (1929–)
Turn: Turning in the Paint, 1961
Oil on canvas; 228.5 × 177.5cm.
Oshawa, The Robert McLaughlin Gallery

Michael Snow's *Turn* (1961) is a monument in the history of Canadian abstraction, of which Snow was a second generation practitioner. "The shape is made in a way similar to those angels made by lying in the snow and moving one's arms and legs," Snow said recently. Here the snow is dark brown and the figure which turns in the mud exposes the lime green of grass. (There is also a gentle pun on Snow's name.) Above, on her side in black, is Snow's *Walking Woman*, but the usual svelte, simplified cut-out in a tight skirt is squeezed slightly tighter than usual and rotated. The size of the work, its simplicity, and its offbeat colour make it one of the most impressive paintings in the *Walking Woman* series that dominated the middle period of Snow's career.

The *Walking Woman* image is an index, indeed a weathervane to much of Snow's art. It lasted roughly from 1960 to 1970, following a period of abstraction and during a time when Snow was involved in experimental film. The image was serial, like Jack Bush's *Sash* series painted at the same time. But the *Walking Woman* was figurative. She conveyed the sexual reference of the younger generation of painters with whom Snow was associated, especially two of the Isaacs Gallery group (Av Isaacs was his dealer in Toronto): Joyce Wieland and Dennis Burton. Painters of the 1960s used serial images like scorecards: we are able to recognize instantly the team/artist who was playing.

Like many artists, at least since the time of Mallarmé, Snow has always felt that art is a game. "I make up the rules of a game," he has said, "and then I attempt to play it." In choosing the *Walking Woman* he reacted against abstract expressionism and the works of his immediate past, which—no matter how austere and plain—were painterly. In *Theory of Love* (1961), for instance, Snow diagrammed the rudiments of sex: two half moons and, in between them, a space for a bar; below them was a red bar. In *Narcissus Theme*, the same year, he used similar simple geometric shapes.

The *Walking Woman* was a way of clarifying his material and developing a variety of ways to look at the same subject. By discovering the *Walking Woman* in many different media, he discovered himself. There was something commercial about her image, something raffish and casual. Snow wrote, "my subject is not women or a woman but the first cardboard cutout I made."

There's something charming to the *Walking Woman*, even wispy: she leaves the room in *Exit* (1961), appears in the subway in 1962 (he planted an image of her there). She can recall works by Paul Klee, Snow's early fascination before he fell in love with Marcel Duchamp. Sometimes he uses her in a more complex way, as in *Venus Simultaneous* (1962), where she appears in blue, black and red.

By 1963, she's more sexy, as in *Beach-Hcaeb*, where Snow plays with the application of paint; *Olympia*, where she appears nude along with five dressed images; or *Une nuit d'amour* (1963), where he has folded up pictures of her. (This mood would climax in 1970 when Snow showed himself having sex with the image in *Projection*). The *Walking Woman* walks into one side of a painting called *Estrus*. At the other end is her cut-out. In *Switch*, he plays on drawing her outline first on one side, then the other. She appears on her side on *Half-Strip*, and naked as a print in *Register*. In *Morningside-Heights*, we only see her face, and in 1965 he shows her through plexi-glass. In *Sleeve* (1965), she appears with twelve different parts, now self-consciously an art work. In *Gallery*, he showed her walking in front of a Mark Rothko painting. She becomes a collage, rolled and weathered. He's begun to have mixed feelings about her, like the painting of the same name. At *Expo* in 1967, she becomes a series of stainless steel sculptures.

"There isn't a single content to the *Walking Woman*," Snow said later. "Every work was of a different kind, generated a different content." Using the *Walking Woman* in his art was his jazz musician's way of enlarging the scope of his improvisation (Snow performs regularly with an experimental jazz band which has toured in Europe and issued several records). "'Swing' is generated by the relationships between the shifting accents of 'foreground' instruments and the relatively steady beat of the 'background' rhythm section," Snow once wrote about his music. The *Walking Woman* provided the background section to his improvisations as a painter. "Swing" is what her graceful image gave his work.

—Joan Murray

Bibliography—

Sitney, P. Adams, *Michael Snow: A Survey*, Toronto 1970.
Youngblood, Gare, "Icons and Ideas in the World of Michael Snow," in *Artscanada* (Toronto), February 1970.
Cornwall, Regina, *Snow Seen*, Toronto 1980.
Dompierre, Louise, *Walking Woman Works: Michael Snow 1961–67*, exhibition catalogue, Kingston, Ontario 1983.

Olympia, 1963

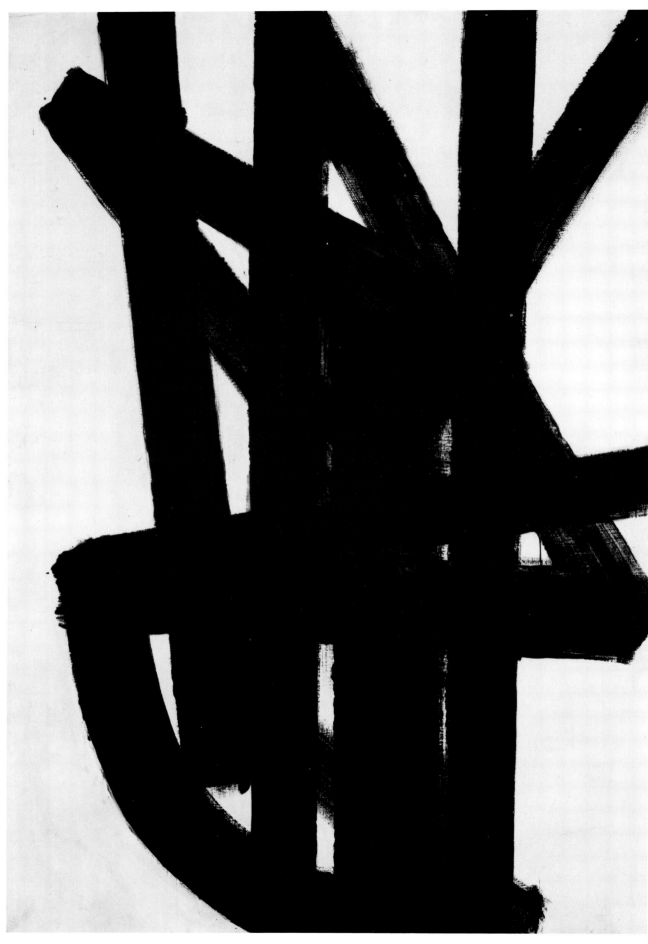

© ADAGP, Paris and DACS, London 1991

258

Pierre Soulages (1919–)
Painting 1948–49, 1949
Oil on canvas; 76¼ × 50⅞ in. (193.4 × 129.1cm.)
New York, Museum of Modern Art

Pierre Soulages had mastered the essence of his style by 1947 when he was only 28: a wide black line whose variations and transformations were unlimited throughout his career. The *Painting 1948–49* corresponded to a time in his life when he was asserting himself as a purely abstract artist, approaching the French lyrical abstraction of the period.

In 1949 he was invited to exhibit at the Betty Parson gallery in New York, together with Hartung and Schneider, two other young artists with similar leanings. From the art history point of view, this date in 1949 which saw the public exhibition of Soulages' paintings in Manhattan (including the one later acquired by MOMA) is extremely interesting. Franz Kline, whose work has often been compared to that of Soulages, was living in New York at the time. He was still a representational painter whose favourite subject was "rocking-chairs"; he did not give up representation until 1950, that is to say after the Frenchman's exhibition. Did Kline visit the exhibition? He certainly could not have failed to see the poster which featured one of Soulages' works. In fact, the critics were struck by the similarity between Kline's new paintings and Soulages' lines. It was noted that Kline's shapes were less energetic, less assertive than those of the Frenchman. There was still a certain softness about them, doubtless left over from his melancholy portraits and countless "studies of a woman seated at the corner of a table" which Kline did between 1940 and 1950. Soulages thus preceded Kline in the variant of abstract expressionism which was common to them both, although in appearance only, as their origins and motives behind their respective careers were completely different.

What did abstract painting mean to Soulages? The artist answered freely, remembering the effect on him of a reproduction of a wash drawing by Rembrandt, the *Femme à demi couchée*, published in a schools' radio magazine in 1938, when he was not yet 20. He described this wash drawing as "a series of very powerful, very beautiful, brush strokes. I was very interested by it. I liked the way it was done, the relationship between the strokes, the rhythm they generated. Then, if the head was covered, the drawing began to take on life as an abstract painting, that is to say just the actual appearance of the shapes and the space they created and their rhythm. When the head was visible, the sketch became representational. I have to say that, even today, I like to see this wash more as abstract than as representational." The important thing is the way one looks at it. Depending on this, Rembrandt's brush strokes can indeed be considered abstract, as are the streams of walnut stain from the years 1948–49 or the black paintings of the 'eighties, which began in 1979 with the exhibition at the Centre Pompidou.

As in all Soulages' paintings, in the *Painting 1948–49* there is no shadow, no "chiaroscuro," only differing degrees of tension between dark and light. This, then, is his abstraction, richer and more varied in its development than many representational painters. There is no subconscious projection, no pursuit of rapid execution: Soulages' action, while being spontaneous and free from any premeditation, once on the canvas, are facts which must be taken into consideration subsequently. What tells us about an artist's intelligence is the way in which a painting is done. Feeling is not absent from Soulages' work, but it is not pre-existent: it comes and goes on the canvas under the artist's penetrating eye and stops once the rhythm is achieved—for meaning in painting is rhythm.

Throughout his life as an artist, Soulages constantly changed rhythm. Whilst always keeping in touch with previous experience, he changed styles apparently effortlessly, guided by the demands of the painting currently under way. He pointed out that it was a non-linear journey: his painting had always been unrestricted and he sometimes went back on himself. Which brings us back to the importance of *Painting 1948–49*, which reappeared in the pictures of 1979 in particular. There is a permanence in Soulages' work, due to its fundamental nature, already apparent in 1948: the ability to take responsibility for the pictorial problem inherited from Europe. The art historian, Marcelin Pleynet appreciated this: he was able to take away what remained of "phenomenonological" anecdotism in shapes and restore them on the surface.

—Jean-Luc Chalumeau

Bibliography—

Sweeney, James Johnson, *Soulages*, Neuchatel 1972.
Ceysson, B., *Soulages*, Paris 1979.
Pacquement, Alfred, *Soulages: Peintures Recentes*, exhibition catalogue, Paris 1979.

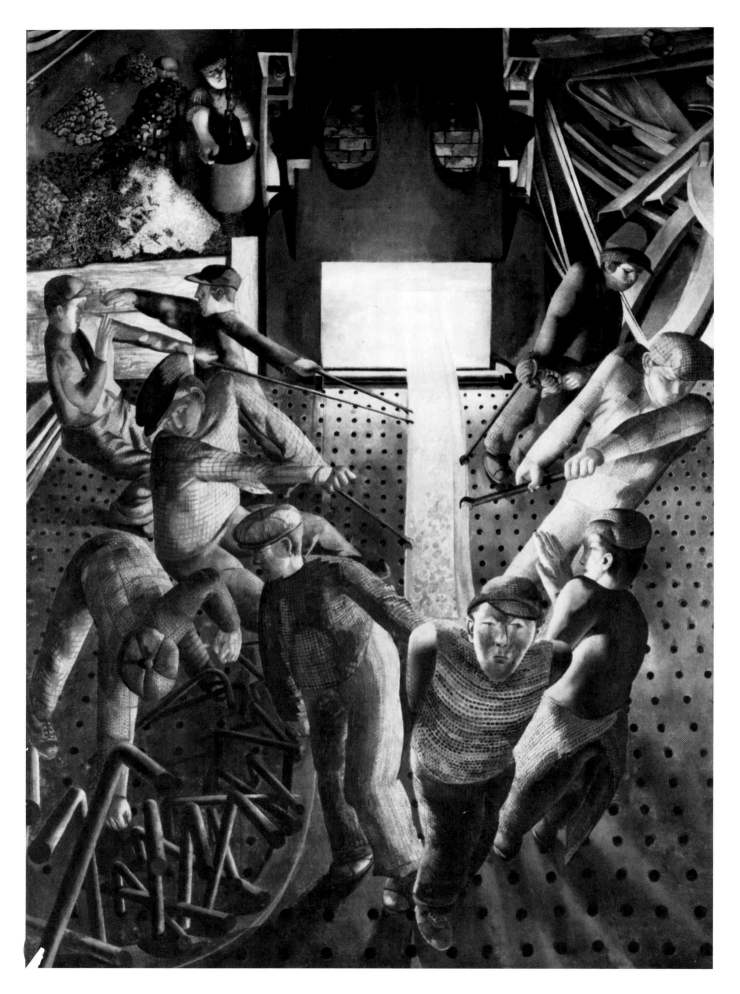

Stanley Spencer (1891–1959)
Shipbuilding on the Clyde: Blast Furnaces, 1946
Oil on canvas; 158 × 114cm.
London, Imperial War Museum

Blast Furnaces is a painting which forms part of a decorative scheme, *Shipbuilding on the Clyde*, comprising a series of paintings commissioned by the British War Artists Advisory Scheme from Stanley Spencer. He always recognised the importance of the series in his career and wrote that he was "very pleased that all the shipbuilding paintings are to be kept at the Imperial War Museum." He was particularly well chosen to undertake an official commission to record some aspect of the war effort, having gained similar experience during the First World War. He had been serving as a medical orderly in Macedonia in 1914 when he was informed that he was to be released from active service in order to paint a war subject of his choice. The completion of the picture *Travoys with Wounded Soldiers Arriving at a Dressing Station* acted as a spur to Spencer to record his response to war more fully and resulted in a commission from Mr. and Mrs. Behrend to decorate the memorial chapel which they had built to commemorate the memory of Mrs. Behrend's brother, Lieutenant Sandham. Sixteen panels depicting the various tasks and preoccupations of military life decorate the chapel's side walls while the end wall is filled by an immense *Resurrection* showing the surrendering of crosses, as men who have died lay aside their earthly burdens.

The completion of this large decorative scheme in 1933 left Spencer lamenting that he had perforce to return to painting landscapes which sold better than his visionary religious paintings and intimate portraits. Hence his delight when the dealer Dudley Tooth put his name forward to Kenneth Clark as a War Artist, resulting in a commission agreed in 1940 for a series of five paintings for which he was to be paid £3,000. Here was an opportunity to return to the figurative work he found so absorbing, moreover in an atmosphere he found wholly congenial. He wrote that, "Most of the places and corners of Lithgow's yard moved me in much the same way as I was moved by the scenes of my childhood," a significant statement from a painter whose work was so intensely bound up with memories and recollections of the landscapes of his childhood.

Lithgow's Yard, one of the Clyde Port Glasgow shipbuilders, worked to full capacity during the War, building merchant ships. Soon after his arrival, Spencer wrote of the "pleasure and privilege of being given the opportunity of making these drawings" and he produced dozens of pencil studies of the various groups of workers engaged in their specialist tasks: the Burners, Riveters, Welders, Plumbers, Riggers and those working on the Template and Keelplate and fashioning the hot metal from the Furnaces, all of which were depicted in the eight panels of the final scheme. Drawing was always the essential preliminary to painting, as Richard Carline, Spencer's nephew and biographer described: "After making a 'grill' on his preliminary drawing, he would similarly 'square-up' the canvas in order to transfer it accurately. He relied completely on this careful and detailed drawing. Painting was then begun on the top left-hand corner working steadily downwards and completing it as he went. He scarcely ever altered what he had painted or worked over it. This was his method all his life".

Furnaces was the last painting of the series to be completed, although the drawing on which it was based had already been made in 1940. Indeed, by the time of its completion the scheme had been modified with the five paintings becoming eight, each one paid for separately, since Spencer preferred to paint not on commission "but on the understanding that the Committee will probably buy them." It depicts the scene as a bar of white hot metal is pulled from the furnaces to be hammered and shaped. Technically, the picture represents Spencer's considerable skills as a mural painter. The lessons he had learnt on the Sandham Memorial Chapel about design of large-scale compositions stood him in good stead and his absorption with the subject matter gave the pictures a warmth and humanity which accounted for their great popularity. Spencer felt he was testifying to the human spirit present in the work place and wrote that "whatever may be thought about these shipbuilding pictures of mine, I am much moved by what I see up here, and experience joy in attempting to express the feeling I have about it all." There is an added poignancy unforeseen by Spencer in the fact that he was recording skills and processes that soon after vanished with the closure of the Clyde yards.

Spencer's stay in Glasgow was productive long after the commission was completed. Just as the Sandham Memorial Chapel decorations came to fruition some years after his war experiences, so his explorations of Port Glasgow provided stimulus for his subsequent *Resurrection* series, nine large paintings produced between 1945 and 1950, the central canvas of which depicts the cemetery of Port Glasgow transformed into Spencer's vision of the Hill of Zion. Glasgow lived on in his imagination long after he had returned to his native Berkshire, and away from "documentary" to more mystical paintings. Thus, the war commission contributed significantly to the artist's mature development as well as standing as one of the finest results of the Commission scheme itself.

—Camilla Boodle

Bibliography—

Newton, Eric, *Stanley Spencer*, Harmondsworth, Middlesex 1947.
Carline, Richard, *Stanley Spencer at War*, London 1978.
Rothenstein, John, ed., *Stanley Spencer, The Man: Correspondence and Reminiscences*, London 1979.
Carline, Richard, and others, *Stanley Spencer RA*, exhibition catalogue, London 1980.
Darracott, Joseph, *Spencer in the Shipyard*, exhibition catalogue, London 1981.

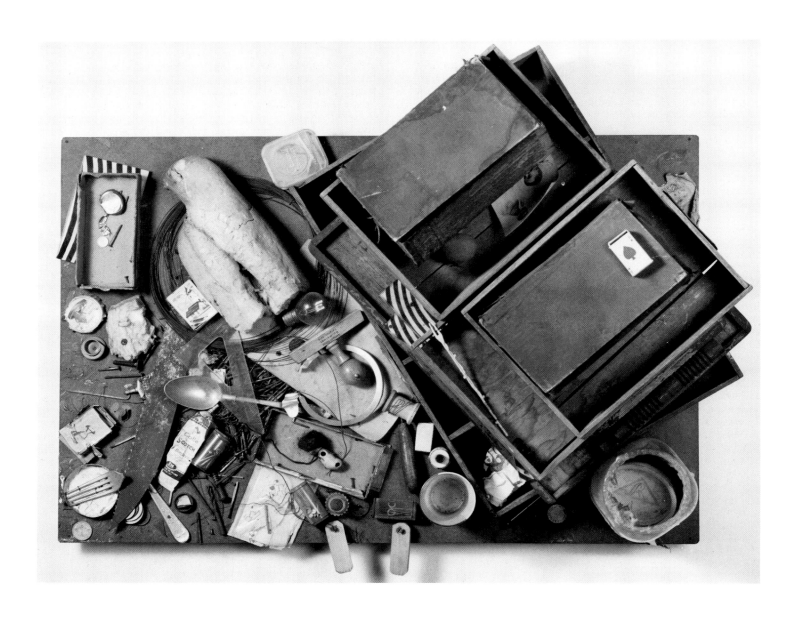

Daniel Spoerri (1930–)
Mr. Bitos, 1961
Mixed media assemblage; 60 × 75 × 30cm.
Winterthur, Kunstmuseum

A heap of objects of all kinds, thrown carelessly on a table, like the contents spilt out of a drawer or an odd suitcase, or maybe like a table on which, with all the profusion and preciseness of prehistoric geological stratification, the "objective correlative" of an individual's life has accumulated from day to day. Such is the outward appearance of *Mr Bitos* (1961), a classic and precocious example of tableau-piège by Daniel Spoerri.

The first idea of this radically new form of artistic expression, half way between sculpture, painting and theatre (defined by the artist himself as "the theatricalization of a real situation") came to Spoerri when he was wandering round the Paris rubbish-dumps with Tinguely in search of material for their kinetic sculpture. Spoerri, unlike his friend, was fascinated purely by the external appearance of the litter; his object was not to try to work out a new aesthetic or rational order from these materials, but simply to fix them just as they were, retaining in that way the unintelligible order they had been given. The process that followed was one of repeating a similar sort of operation, but using more banal material and situations, identified less expressionistically on an aesthetic level.

The first genuine tableau-piège was a glass case full of cemetery tablets used casually by the artist, who turned it over sideways like a dinner-table, fixing cutlery and the remains of a meal onto it and then hanging it on the wall, so that through a radical change of function and of viewpoint *Lieu de repos de la Famille Dellbeck* (1960)—the title was taken from the inscription on one of the tablets—was turned into a picture.

What is by definition insignificant (the everyday object, the leftovers from a meal deprived now of any value of taste or elegance, refuse) is restored through an operation of alienation to a higher level of significance, higher even than the aesthetic or symbolic values of traditional art.

The artist's confining himself to blocking, to entrapping, a given situation, abstaining from any voluntary intervention in the intrinsic process of the work's manufacture, is the most interesting aspect of the poetry of the tableau-piège. In this self-imposed discipline of withdrawal, common to a whole tradition of non-intervention which can be traced back to certain aspects of Dada (think of the aleatory methods of composition of Tzara and Arp) and to the theories of John Cage, lies essentially for Spoerri in the common denominator of neo-realist orthodoxy; absence of manifestos, accumulation, compression, empty space turn into simple acts or into elaborate processes aiming at the same appropriation of reality. As in concrete poetry (long practised and understood by Spoerri as a form of reference), the breaking down of the canonic and elaborate relations between the elements of language leads them back to their primary components, phonetic or graphic or semantic articulation, so in tableaux-pièges the freezing and over-turning of the object become metaphors of the inescapable urgency of reality. Spoerri rejects every possible symbolic approach. The difference, banal but critical, that lies between displaying an object for what it is and presenting an object that stands for something else clearly differentiates Spoerri's work and, more generally, New Realism from the culture derived from surrealism. "The mystery of Klein," writes Spoerri through the hand of Otto Hahn, "is in the ritual, not the work."

Particularly significant is the experiment always tried in the 1960s to make a monochrome tableau-piège by painting it white once it was finished; the excessive coldness, the apparent formal perfection, the elaboration and sophistication of every aspect of reality, in short, the withdrawal from the work of the crudity of its impact, also deprived it of all its intrinsic properties, making it into a sort of curious variation on the theme of collage and assemblage. Spoerri will refuse the proposal made to him later by Yves Klein to collaborate with him in making tableaux-pièges in blue, not merely from his confessed fear of being swallowed up in Klein's aura, but precisely for that same reason.

Spoerri's conviction that it was quite wrong (at least with regard to the initial phase, to which *Mr Bitos* belongs) to modify or in any way influence the work in question in a tableau-piège is well demonstrated by his contemptuous reaction to the attempt by Gherasim Luca, a real "outrage against the truth," to add a cigarette-lighter to the table before Spoerri began to fix the objects to it.

We have seen how an essential element in the transformation of reality into a tableau-piège lies in changing the viewpoint; what is lying on a flat surface—a cup, utensils, cutlery—is fastened to it and switched from a horizontal plane to the vertical dimension of the wall. The observer, disturbed by this perspective sideslip, is obliged by his quite new viewpoint to think again, to reassess his traditional perception of reality.

The Utopia of an art that completely rejects every value connected with the personality of the artist lies at the base of another of Spoerri's projects, begun in 1959 and later taken up several times in succession: the *Editions MAT (Multiplication d'Art Transformable)*. The concept of multiplication of a work is the reverse of reproduction; works exist for which multiplication, carried out outside the usual processes, becomes an operation that is not just quantitative, but qualitative, allowing the production of an object that in avoiding any personal touch escapes from the hand's emotion. Works by Mari, Soto, Vasarely, Duchamp, Tinguely and others have been treated in this way; all the examples were personally executed by Spoerri, with the artists' permission.

The artistic universe, now that its qualities of superiority and separateness have been given up, is coinciding more and more with real life. Duchamp had raised real life to the level of art when he had recourse to the distinctive signs that belong to art (the pedestal, the museum, or just the gaze of the observer), but the problem was still art and what really distinguishes it from everyday life. For Spoerri, life is the problem; art is important to the extent to which it frees itself from everything that restricts it, thus providing a solution that may be more emphatic or less, but which is none the less essential to life itself.

—Giorgio Zanchetti

Bibliography—

Spoerri, Daniel, *Topographie Anecdotee du Hasard*, Paris 1961, New York 1966, Neuwied 1968.
Restany, Pierre, *Daniel Spoerri*, exhibition catalogue, Milan 1963.
Restany, Pierre, *Nouveau Realisme*, Paris 1968.
Bremer, Claus, and Bloem, Marja, *Daniel Spoerri*, exhibition catalogue, Zurich 1972.
Martin, Henry, *Daniel Spoerri: Bronzi*, Verona 1986.
Centre Georges Pompidou, *Petit texte sentimental autour de Daniel Spoerri*, exhibition catalogue, Paris 1990.
Hahn, Otto, *Daniel Spoerri*, Paris 1990.

Photo Leo Castelli, New York. Copyright 1991 Frank Stella/A.R.S., New York

Frank Stella (193⬦)
Tahkt I-Sulayman I, 1967
Oil and acrylic on canvas; 120 × 240in.
Pasadena, private collection

Tahkt I-Sulayman I is a large-scale painting (10 feet by 20 feet) which forms part of the *Protractor* series, conceived by Frank Stella as ninety-three related paintings making up a vast coloured mosaic. The painting and much of the series is based on "protractor" (semi-circular) forms. The series as a whole consists of different shaped canvases described by Stella as "interlaces," "fans" and "rainbows." The series is painted in bright, hard colours, many of them mixed by the artist himself in order to achieve particular tonal relationships. Preceded by a sketch version in gouache on paper, the finished pictures consist of a single coat of paint applied thinly and evenly for overall saturation.

The *Protractor* series, painted when Stella was a young man (he was thirty-one), nonetheless represents the fruit of many years of deliberation and experimentation which began when he was a student at Princeton and was able to see the work of the first generation of Abstract Painters on show in exhibitions and galleries in New York. In particular, he admired the work of Jackson Pollock and Jasper Johns. "What I saw, what I liked, was the openness of the gesture, the directness of the attack." His academic studies in history and art history enabled him to appreciate Jackson Pollock's place in a tradition of picture-making current in Western Europe since the Renaissance. Lecturing at Harvard University in 1983–84, Stella compared the artistic situation in 20th-century America with that of 16th-century Italy, notably the challenge laid down to prevailing aesthetic conventions. In particular, Stella admired Caravaggio for sensing limitations in contemporary painting and for extending the possibilities of pictorial description. "Caravaggio said that painting in the sixteenth century, great as it may have been, was comprised by a spatial sensibility that was accommodating and artificial, rather than independent and real . . . Caravaggio liberated painting from its literal surface and made pictorial space the surface for his action, for his pigmented figuration."

According to Stella, the outstanding painters of the 20th century, confronted by an outmoded pictorial language, equally sought to "liberate" painting—and succeeded. "Painting desperately needed the literalness, immediacy, freedom and clarity of the drip paintings . . ." Subject matter, too, was confronted. Writing of Jasper Johns's first one-man exhibition, Stella approved of the "way he stuck to the motif . . . the idea of shapes—the rhythm and interval in the idea of repetition." The rhythms of Jasper Johns were of more practical interest to him than what he regarded as Pollock's updated painterly illusionism. The challenge for Stella was to break with a tradition embraced by both viewer and artist, and which, despite assaults from Cubism and Constructivism, proved resilient and enduring. "Certain conventions of hierarchical or relational structure were still maintained even in high Analytic Cubism, where the abstract fragments were arranged to left and right of the axis to achieve a balance that depended on compensatory 'relational' arrangements . . . in the case of Pollock and even of Rothko, there were vestiges of Analytic Cubist space. And beneath the expression of improvisational freedom and the meandering architectonic drawing which characterised the Pollock surface was a sense of structural coalescence."

After graduating from Princeton, Stella worked as a house painter, conducting his own experiments using cheaply bought decorators' paints. "I tried for something which, if it is like Pollock, is a kind of negative Pollockism." His first "black" paintings "tried for an evenness, a kind of all overness, where the intensity, saturation and density remained regular over the entire surface." But "I remember being infuriated by a . . . description of the space in my black stripe paintings when he (Leo Steinberg) cited the similarity of the spatial organisation to the recessional character of perspectival Italian Renaissance space. This was exactly the opposite of what I wanted; I wanted everything to be on the surface."

Determined not to allow the viewer to search for "humanistic values" in his work ("if you pin them down, they always end up asserting that there is something there beside the paint on the canvas") Stella abandoned "the chiaroscuro of black" for the hardness of metallic paints to create the *Aluminium* series. These were followed by the large *Copper Paintings* of 1960–61 whose flatness and clarity was to prove to the viewer that "my painting is based on the fact that only what can be seen is there . . ."

Having denied the viewer both the emotional consolations of graduated colour and the intellectual response to architectonically-ordered space, Stella subsequently reintroduced both in the *Protrator* series. He had "proved his structures viable," and had demonstrated his ability to make "the visual experience one of instantaneous apprehension." Moreover, his pictures were now no longer restricted by the conventions of easel painting. He had begun to experiment with irregularly shaped canvases, unrestricted by either border or frame. "The size of an abstract painting never has to account to our everyday sense of scale; there is no point in comparing an abstract image with an image from the real world." Hence "traditional" colour and design were now used by Stella to "non-traditional" ends. "The large picture, which displaces or identifies itself with the wall, imposes itself on the spectator in a more authoritative way."

The decorative qualities of the *Protractor* series are infused with an energy consequent upon their size. Most of the pictures are titled after the names of the ancient cities of Asia Minor and the whole series is held together by a linear rhythm that is derived from both Islamic and Gothic sources. The radiant pure colour harks back to the example of Delaunay and Matisse. Mondrian, too, provided inspiration. "Pure colour is the beginning of Mondrian's sensationalism." Stella admired Mondrian, in particular the painting *Broadway Boogie-Woogie*. "This surprising light, emanating from a background which has the ability to assert itself as foreground, is hard to pin down, but it does seem to suggest that colour travels as it radiates, which in turn suggests some graspable pictorial substance of its own. Finally Mondrian pulls it all together with rhythm, the painter's ultimate tool."

Tahkt I-Sulayman I, perhaps the most complicated of the *Protractor* series, demonstrates Stella's intellectual integrity and technical accomplishment. Colour and design triumph, showing us that painting still has a future, but the new aesthetic (defeating the tradition of depicting illusionistic space), based on a tightly-controlled overall rhythm, dominates. Although complicated, the interweavings within the paintings and across the series, never produce illusions of receding space. Thus the series demonstrates conclusively Stella's absolute commitment to, and justification for, abstract art. "I feel that abstraction became superior to representation as a mode of painting after 1945. This is obvious on the level of physical and visual excitement, on the level of pictorial substance and vitality. It also established its superiority on a theoretical level: abstraction has the best chance of any pictorial attitude to be inclusive about the expanding sum of our culture's knowledge." In the *Protractor* series Stella achieves his aim of creating a dynamic visual language for the second half of the 20th century.

—Camilla Boodle

Bibliography—

Seitz, William, *Recent Paintings by Frank Stella*, exhibition catalogue, Waltham, Massachusetts 1969.
Rubin, William S., *Frank Stella*, New York 1970.
Rosenblum, Robert, *Frank Stella*, London 1971.
Stella, Frank, *Working Spaces*, Cambridge, Massachusetts 1986.

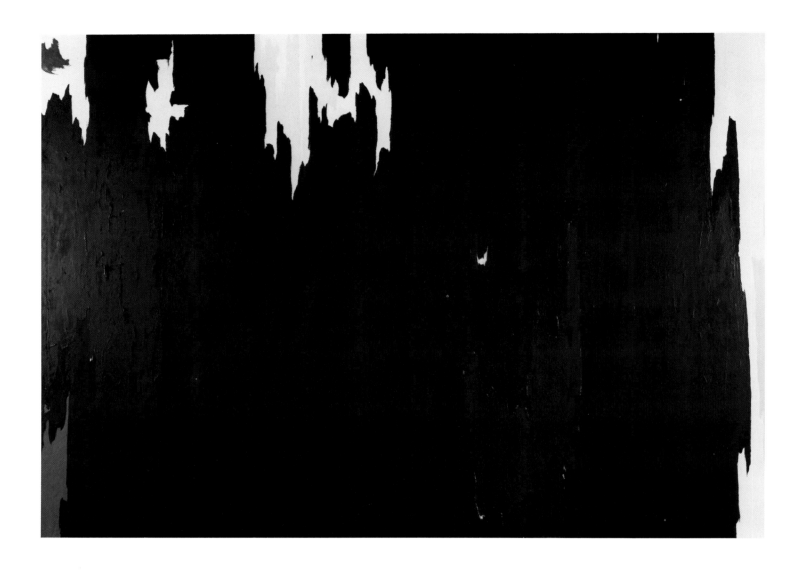

Clyfford Still (1904–80)
Untitled: 1957–K(PH-149), 1957
Oil on canvas; 112 × 154in. (284.5 × 391.2cm.)
New York, Whitney Museum of American Art

A thirteen-foot stretch of darks variegated in colour and texture stops just short of the righthand edge, but runs clear off the other sides. This lateral extension is counteracted by the up-and-down "drawing" of the jagged patches that read as within, suspended from, or flowing beyond (and often just about nosing into) the rectangle of the painting. The word "patch" is too positive for the way in which edges are drawn so that a settled perception of shape against ground is avoided, except that the word carries appropriate connotations of tearing and reconnecting. The surface is differentiated yet unified. Light areas "eat into" this unified ground at the right edge and top left. Different oranges at the bottom left and far right stretch one's perception across a whole vista, though we relate mainly to the large maroon and "suspended" yellow areas which edge the central ground bottom right and top left as if bracketing an area in which we can insert ourselves.

Some published diary notes written in the year prior to painting *1957–K* give some insight into Still's experience of painting: "A great joy surges through me when I work. Like Belmonte weaving the pattern of his being by twisting the powerful bulls around him, I seem to achieve a comparable ecstasy in bringing forth the flaming life through these large responsive areas of canvas. And as the [colours] leap and quiver in their tenuous ambiance or rise in austere thrusts to carry their power infinitely beyond the bounds of the limiting field, I move with them and find a resurrection from the moribund oppressions that held me only hours ago."

Experience of such painting on the spectator's part can be various. Our gaze sweeps across an abstract vista awesome in its dimensions, yet we also size ourselves up to the vertical stance of its forms. We confront a "face" where the facture and colour-plane resist visual penetration, yet our scan gets snagged on the jagged edges and their persistent figure-ground juggling. These passages of visual interlock provide major and minor compositional incidents (albeit around the centre of the dark plane), yet we sense potentially vast extensibility beyond its finite form. The grandeur of orthogonal layout is qualified by the frangibility of edges, the erosion of plane. While a solid darkness encompasses most of the canvas, it is disrupted by flashes of illumination. Emotional drama derives from this sense of form becoming vulnerable to change, colour-plane penetrated by shafts of light, edges suggesting a field expanding and contracting, pulsating according to the pressures of consciousness.

These qualities appear in his work a few years prior to his first New York exhibition at Art of this Century Gallery in 1946 which, in the words of a contemporary Peter Busa, "created the critical distance we needed . . . from Surrealism, from French painting." His early impact on that branch of Abstract Expressionism which has subsequently been dubbed "colourfield painting" is quite evident.

A 1959 statement by Still referred to outdated but still popular 19th-century evolutionist ideas about each modern individual's development repeating (psychically as well as physically) the evolution of the whole race. The suggestion of prairie landscape, growing forms and ancestral figure in his earliest surviving work can be understood in terms of this recapitulation theory in which each individual returns psychically to the start of life and works

through primitive consciousness again to a fully fledged modern consciousness. The ancestral figure is collapsed into pictorial space, and this fusion of figure and ground becomes the field of modern consciousness. Still wrote in 1963 that "space and the figure . . . had been resolved into a total psychic entity."

This emphasis on some rebirth of consciousness, this heroic aspiration beyond one's natural being and the plight of contemporary civilization, is found in the outlook of contemporaries such as Pollock, Rothko and Newman. Still refers to the "sublime" as "a paramount consideration." Such individualist transcendentalism is a staunchly utopian mode of cultural resistance within a field of ideological discourse dramatically narrowed by the collapse of 1930s political radicalism which had affected cultural circles deeply. This dramatic process of de-politicization can be related to the long-term effects of the New Deal, bureaucratization of labour organizations and absorption into the war production machine, conflicting leftist responses to such developments as well as to Stalinism, anti-union legislation, the rise of corporate capitalism, and the Cold War consensus.

When Still talks about the "collectivist rationale" of his culture, "authoritarian devices for social control" and ideology of "shouting about individualism," he is clearly adopting an extreme anarchist stance. He wants to "restore to man the freedom lost in twenty centuries of apology and devices for subjugation." This freedom is partly from the demands for communication with an audience, yet he wants the spectator to have a glimpse of his/her possibly free "self" and its exhilarating sublimity. We recognise the ultimate origin of such a programme as lying within the tradition of Romanticism. (Still talks about unfettered Imagination becoming "as one with Vision.") This assertion of freedom is on behalf of a "self" seen as in antagonistic relation to Society and History. Yet it is acted out in the culturally given domain of painting with an anxious concern for his place in art history, however much he kicks against art institutions and the notion of historical determination. Still presents himself in culturally conventional terms as the American frontiersman who quit New York finally in 1961 to live in Maryland. "It was as a journey that one must make, walking straight and alone," Still wrote in 1959, "until one had crossed the darkened and wasted valleys and come at last into clear air and could stand on a high and limitless plain." His sizeable bequests to Buffalo (1964) and San Francisco (1975) read like the frontiersman engaged in founding various Stillsvilles.

—Adrian Lewis

Bibliography—

McCaughey, Patrick, "Clyfford Still and the Gothic Imagination," in *Artforum* (New York), April 1970.
Kuspit, Donald, "Clyfford Still: The Ethics of Art," in *Artforum* (New York), May 1977.
Kuspit, Donald, "Symbolic Pregnance in Mark Rothko and Clyfford Still," in *Arts Magazine* (New York), March 1978.
O'Neill, John, *Clyfford Still*, New York 1979.
Polcarl, Stephen, "The Intellectual Roots of Abstract Expressionism: Clyfford Still," in *Art International* (Lugano), May/June 1982.
Anfam, David, *Abstract Expressionism*, London 1990.

Photo UNESCO / © DACS 1991

Rufino Tamayo (1899–1991)
Prometheus Bringing Fire to Mankind, 1958
Mural; 4.5 × 5m.
Paris, UNESCO Headquarters

The Mexican painter Rufino Tamayo was born in 1899. Revered in Latin America and admired throughout the world, he first became famous for his opposition to the Muralist movement. Led by José Clemente Orozco, Diego Rivera and David Alfaro Siqueiros, Muralism was a dominant force in Mexican painting for the three decades between 1920 and 1950.

Not that Tamayo had any objection to murals—he was also to paint them, as we shall see; indeed, one of them is reviewed here. What he was opposed to was the way in which muralists used them as a means of creating historical and ideological "revolutionary" art for the masses. Naturally, it was "antibourgeois" and was financed by the State. The immense size of the murals was a response to the fact that they were public property. It also created a distance between them and paintings executed on an easel. Their central theme was the emergence of the Mexican nation, starting with the revival of the country's magnificent Pre-colombian culture. But in the end they became no more than pedagogic caricatures, whose only intention was bureaucratic.

Tamayo did not believe in this kind of mural. He was as patriotic as the rest and was committed to political and social progress in Mexico. At the same time, he was convinced of the power of art and of the need for complete freedom to exercise that power for the good of mankind, without any of the restrictions imposed by the obligation to stick to any specific political ideology. Tamayo's first exhibition was held in 1926 in Mexico City, where after completing his studies at the Escuela Nacional de Bellas Artes he taught painting and drawing to pupils at the city's elementary schools.

The exhibition was staged later the same year in New York, opening the doors of the North American art world to Tamayo. His prestige was to grow during the years after he settled there in 1938. However, it was the exhibition of his work at Mexico City's Palacio de Bellas Artes in 1929 that established his reputation as an artist.

Twenty years later, in 1948, at the same museum, a retrospective of his work earned him the adulation of his compatriots. At a time when mural painting was in its death throes, he was recognised as the master of the new avant-garde who advocated experimentation and creative freedom and autonomy. Tamayo said "It is a mistake to claim that the value of painting is derived from other elements, in particular its ideological content, or to claim that this value has no direct relationship with the artistic content. This is a fallacy which can deceive the unwary."

In order to define the painting of Tamayo—the only internationally famous Mexican artist—we must refer to his very personal amalgam of the figurative and the abstract. But most important of all is his use of colour and the balance of his images. Without heavy-handed demagogy, we feel the vitality of Mexico and the Latin-American presence. Time and again Tamayo has repeated that a work of art should only be judged "bearing in mind that it is an independent entity, with a life and problems of its own."

In the twenty murals executed by Tamayo between 1933 and 1977, Mexico and her history play a leading role. However, their expressive and conceptual elegance, for which the only adequate description is "philosophical," places them diametrically opposite to traditional mural painting and among the most advanced artistic creations of all time. From Mexico, Tamayo turned his attention to Latin America and then to the whole of mankind. Nevertheless, his approach has never lost its basic "spirit of place," that vital regionalism which identifies him with his land and his people.

Prometheus bringing fire to mankind, painted in 1958 in the Conference Hall of the UNESCO headquarters opened that year in Paris, is Tamayo's twelfth mural and the second to have this mythical character as its subject. A year before, in 1957, he was commissioned by the University in Puerto Rico in Río Pedras to paint a mural entitled *Prometheus*. In *Brotherhood* (1968) which was finally installed in the UN headquarters in New York, he once more examines the theme of Prometheus.

It is easy to see why Tamayo preferred Prometheus—perhaps the outstanding figure in world mythology, far transcending his origins in Greek legend—to any of those from Mexico's Pre-colombian tradition. Tamayo sees him as the founder of human civilisation. Hence his threefold vision. In the Puerto Rico mural, Prometheus is the educator who taught mankind about medicine, navigation, the alphabet and how to measure time. In the Paris painting, Prometheus brings humanity the sacred fire stolen from Olympus, that is to say the means of self-perpetuation through culture and art. The theme of fire recurs in the New York mural. Here are presented its twin characteristics of violence and creation, the latter being a symbol of how culture endures within the human personality. It also shows how peace is essential for culture to exist and develop. According to the myth, Prometheus suffered for his defence of mortals against the hatred of the gods. At the same time fire is a source of light.

Tamayo was one of the great artists invited to decorate the building in the Place de Fontenoy and his work stands alongside those of Picasso, Henry Moore, Calder, Miró, Matta, Appel, Noguchi and Arp. This Paris mural is a celebration of the colour red in all its shades, a storm of red which blazes—more than metaphorically—amidst the white panelled walls of the huge Conference Hall, dominating its vast space. The windows covering 1,400 square metres accentuate it even more.

Fire is a living element which can only be understood through its modulations. So Tamayo spread over the plaster the variations of the first colour of the spectrum, from carmine to vermilion, and from scarlet to purple. But there is nothing haphazard about Tamayo's conflagration. Underlying it is a substructure of elemental shapes, like the parts of a machine. This arrangement is in itself a proclamation of freedom. It is the essence of the mural. Its substance is the colour itself, not only in terms of material but also what it represents.

Tamayo's reds have a life of their own, an autonomy as creative as that of the artist who defiantly ignited them on the plaster wall. For Tamayo, mural painting is not a matter of putting paint on the façades of buildings. It is rather to enhance the work of the architect. "Every mural depends on the conditions provided for the painting by the architecture. One should not insist on such conditions, but use what is available to the best advantage," he added, pointing out that "architecture should not be sacrificed to exhibitionist murals." The Place de Fontenoy fresco is not only one of the most accomplished examples of Tamayo's theories and one of his masterpieces, it also shows how murals—and although Tamayo has not said it in so many words, it can be deduced from his work—should not be sacrificed to the whims of the architect.

—Jorge Glusberg

Bibliography—

Ponce, Juan Garcia, *Tamayo*, Mexico City 1967.
Rodriguez, Antonio, *A History of Mexican Mural Painting*, New York 1969.
Genauer, Emily, *Rufino Tamayo*, New York 1974.
Lynch, James G., *Rufino Tamayo: 50 Years of His Painting*, Washington, D.C. 1979.

© ADAGP, Paris and DACS, London 1991

Antoni Tapies (1923–)
Grey with Red Streak at Base, 1957
Mixed media on canvas; 81 × 65cm.
Paris, Galerie Stadler

After World War II, Antoni Tapies emerged as a prominent personality in the art circles of Barcelona. In addition to his well attested talents as a draughtsman, his work reflected the influences of his exposure to such international art movements as Dadaism, Surrealism and Tachism, to name but a few of those readily discernible. Such eclecticism is not unexpected and is the way Tapies chose to follow in order to come to terms with the many strands of art which crowded in on artists of his generation. In so doing, Tapies developed a large vocabulary of forms and ideas and consequently laid the foundations for a style and approach which was highly individual. By the early 1950s, his work demonstrated he had been successful in understanding the nature of the diverse artistic strands he had employed in earlier work, and from now onwards he would draw on them, when appropriate, thus enabling him to establish more convincingly his personal vision.

By the mid 1950s, a highly idiosyncratic approach is clear. It lay in his preoccupation with walls. In his earlier writings, Tapies explained that he had been attracted to walls for many years. The ancient walls in his native Barcelona with their scars, time-worn textures and the generations of graffiti presented Tapies with a motif that proved to be highly stimulating. Allied to this visual inspiration, Tapies was able to draw on his extensive readings and studies of mediaeval Catalan mystics and writers, some philosophers of the 19th and 20th centuries and, perhaps of greater importance, the writings of Oriental philosophers, with special interest in Zen with its many ambiguities and seeming irrelevancies. Many years previously an artist of an earlier generation, Mark Tobey, had pioneered the relationship of Zen to his paintings and had been drawn to the uniqueness of man's vision, postulating a "oneness" between form and means. Whether Tapies derived anything from Tobey's paintings is not clear, but the parallel between the works of the two painters is highly interesting. In a like way, Tapies sensed the "oneness" or universality of form and presented it so directly that his work reflects great authority. One should not infer, however, that his painting was recondite or obscure, despite the fact that it relies often on allusion and, at times, ambiguity. Indeed at times his painting has a pellucid quality, at times very literal, but Tapies's ability to transmute the forms he selects makes for work that is both compelling and visionary.

The work under consideration, *Grey with Red Streak at Base* (1957) shows Tapies approaching the problem of both revealing and commenting on a subject which makes simple analysis deceptive. In this painting, he transcends the difficulties implicit in the subject matter confidently and magisterially. The image is direct and forceful. From this concept he creates a "oneness" which is both of the moment and again, timeless. For immediate antecedents, one is drawn to consider the art forms of ancient Egypt, especially the structural form of tomb doorways. In this work, Tapies presents the viewer with the allusion to the wall/doorway which is inevitable. In its original purpose, the doorway sealed up the tomb of the ruler and in so doing became an integral part of the wall in which it was placed. Consequently there is something forbidding about the tomb doorway—it created an air of finality. There is an ambiguity about this interpretation, for the door may be regarded as the entrance to eternal paradise. More referential interpretations come to mind, such as the sculptures of ancient Mesopotamia with annotations reinforcing both meaning and form which move across the surface of the work in a strangely incantatory, almost hallucinatory way. In a like way, Tapies uses the mutilated and partially destroyed forms to explain his wall which results in a form suggestive of an ancient stele commemorating an event long lost in time. In such a manner, Tapies has evolved a

timelessness enabling the viewer to select the time frame from which the work may best be contemplated. He creates his world which, whilst evocative, is never simply literal, and to enter this world one must identify absolutely and unreservedly with the artist.

One cannot escape the parallel between this work and the raked stone gardens in Zen monasteries. Tapies creates the same feelings of tranquillity and reflection that is the quintessence of that philosophy. The viewer must allow his eye to follow the intaglios on the picture plane and reflect on the positive and negative forms which grave their way across the surface in much the manner of a glacier which scours and polishes and redefines the land forms over which it moves. Likewise, Tapies, with great sensitivity, shapes and directs the material towards an irreducible and cogent whole.

Of great importance is Tapies's method of working. The materials he uses are reminiscent of the substances of the wall: sand, plaster, pebbles and simple natural objects, and these are fused to create the allusion. By these means he identifies with the artisan class, working with simple materials like a manual labourer. And, by working with such materials not usually associated with fine art, Tapies moves his work into the mainstream of art of the mid 20th century. He identifies closely with the earth from which we spring and moves close to the world of the potter. Thus, by using simple materials readily available, he makes his art universal in its demands and responses. His art informs us of the direction art was inevitably taking in the 1950s and '60s. It is not unexpected to find that his colour is often restrained and in this way contributes to the force of the form of the work. With prescience, he observes that "in an insignificant piece of clay one may see the whole universe" which does not imply that the chance happening of natural events will produce a work of art; rather its suggests that the artist senses the genesis of a work of art may lie to hand in some insignificant form. The "piece of clay" must be directed and guided and forced to take the form the artist knows it must take. In this work, the seemingly irrational way in which the forms are carved into the surface is perhaps the most significant feature, because it underscores Tapies's carefully controlled elements of chance and transmutes them into a well-considered direction. This ambiguity is the key to understanding much of Tapies's art— indeed the art of this century. In the hands of Tapies, however, this direction is resolved in a way hitherto not seen in the art of our times.

When all this has been stated, it is clear that Tapies is, above all else, a painter emerging from a long line of Catalonian cultural tradition. Upon this secure basis, he structures the many other influences so that his work reflects a highly sensitive amalgam of ideas and examples. It is an organic growth nurtured by intellect and intuition. Consequently, Tapies has the power, like a seer, to reveal truths which lie well hidden below the surface of consciousness. In this work he guides the viewer confronting him with an experience in which he must participate actively—to establish a dialogue between perceiver and percept. It is Tapies's greatness as an artist that establishes this structure. He becomes both a spiritual leader and visionary revealing in a flash the inexplicable, and in so doing has rightly assumed a place as one of the most potent image makers of the second half of this century.

—Melvin N. Day

Bibliography—

Penrose, Roland, *Tapies*, New York 1978.
Gimferrer, Pere, *Tapies and the Catalan Spirit*, Barcelona 1986.
Agusti, Anna, Raillard, Georges, and Tapies, Miquel, *Antoni Tapies: Works 1989*, New York 1989.
Dexeus, Victoria Combalia, *Tapies*, New York 1990.

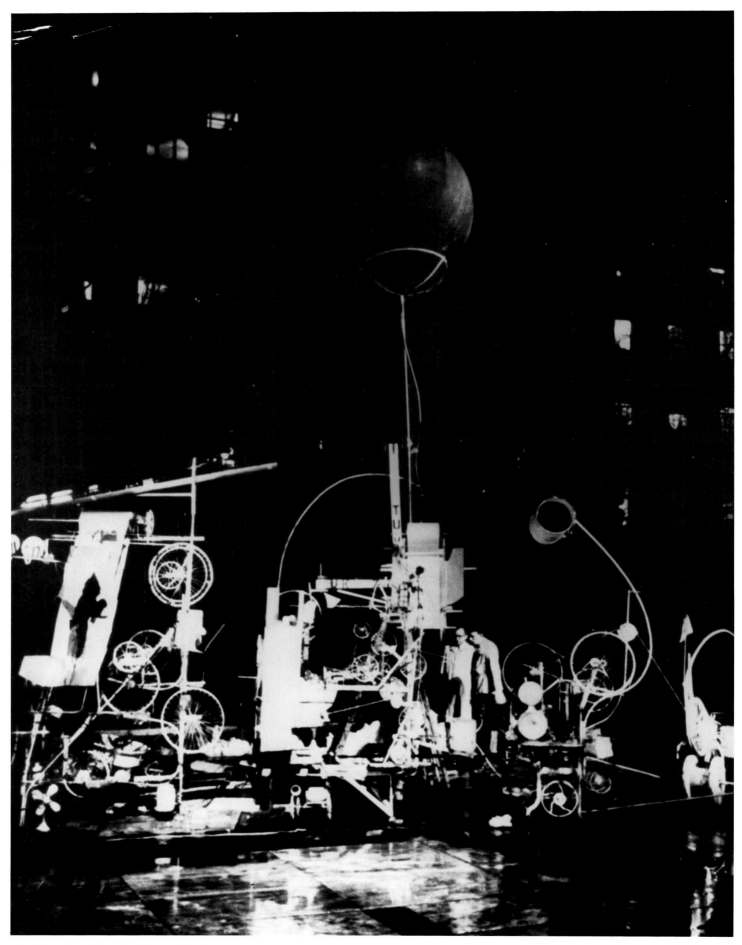

Photo Tinguely Archives, Galerie Bruno Bischofberger, Zurich

272

Jean Tinguely (1925–)
Hommage to New York, Museum of Modern Art garden, New York, 17 March 1960
Multi-media kinetic sculpture event; 23 minutes
New York, Museum of Modern Art (fragmentary remains)

On March 17, 1960 Tinguely constructed *Hommage to New York*, a self-destroying work of art made of scrap metal, motors etc. that he was able to join together as easily as glue using a new electric welding device. He incorporated gunpowder, explosives, "wood-metal," smoke bombs and fireworks in the construction, and painted it white all over. On the 17th of March at 7:30 in the evening, the sculpture was set on fire and within the space of twenty-three minutes destroyed itself. The next day, Tinguely removed the remains of the sculpture and took them back to the refuse dump. The Museum of Modern Art kept a fragment consisting of a long curving wire, bicycle and baby carriage wheels, a flag and a large white can. The fragment was kept by the Museum without Tingely's knowledge and is not recognized by him as a sculpture.

A sculptural environment that destroys itself in twenty-three minutes in the garden of the Museum of Modern art attacks both our notions of sculpture and the role of the museum. Instead of preserving art, the museum becomes a Roman arena where a series of machine/sculptures made of scrap metal destroy themselves in an experience that is like watching gladiators fight to the death. Tinguely's sculpture re-defined the noun "art" and used the museum's authority to do it. Yet, the presence of the audience is an essential component of the sculpture because it would never have come into existence without the audience's presence participating in its destruction as witnesses.

Tinguely's sculpture exists as a fulcrum, a balancing point; a moment of transition between two eras. His sculptures developed against the post World War II landscape of Europe with its shattered landscapes and bombed-out cities. They also developed against the new material landscape of the Post-war era where plenty ultimately produced the excess called junk. By the late 'fifties, a group of artists had begun to make additive sculpture out of flotsam and jetsam. This type of sculpture with its Neo-Dada overtones of challenging the status quo and traditional values through the use of non-art materials was called assemblage, the three-dimensional version of Cubist collage. Dada experiments such as Marcel Duchamp's *Large Glass* often likened human organisms to machines, saying, "a beautiful woman is like a motor." Tinguely took this idea one step further, and constructed machines out of human discards.

To some people at this time a self-destructing machine was a metaphor for the human condition. Peter Selz in the announcement inviting spectators to the event said: "We know that emotion can not be petrified, that love can not be bound and time can not be held. Jean Tinguely's experiments are works of art in which time, movement and gesture are demonstrated—not merely evoked. Tinguely accepts the Heraclitian change inherent in life. His is a world in constant flux and self-transformation. Being very much part of his time, Tinguely uses machines to show movement, but he is fully aware that machines are no more permanent than life itself. Their time runs out, they destroy themselves . . ."

Selz found the idea of this sculpture descriptive of life in New York saying, "In New York, Tinguely finds a maximum concentration of life and energy, a virility which accelerates its own dissolution . . . Its dynamic energy as well as its final self-destruction—are they not artistic equivalents for our own culture?"

Tinguely's machines would not have existed without the precedents of earlier Kinetic experiments such as Mohly-Nagy's *Light-Space-Modulator* and Alexander Calder's mobiles and other works. Tinguely's audience saw his concept of sculpture as both unique and as a logical development of a living tradition in twentieth century art. In the exhibition announcement Alfred Barr, director of the Museum of Modern Art, constructed a family tree for the work that included all artists' use of machines going back to the Renaissance: "Forty years ago Tinguely's grand DADAs thumbed their noses at the Mona Lisa and Cezanne. Recently Tinguely himself has devised machines which shatter the placid shells of Arp's immaculate eggs, machines which at the drop of a coin scribble a mustache the automatistic muse of Abstract Expressionism, and (wipe that smile off your face) an apocalyptic far-out break through which, it is said, clinks and clanks, tingles and tangles, whirrs and buzzes, grinds and creaks, whistles and pops itself into a Katabolic Gotterdammerung of junk and scrap. Oh Great brotherhood of Paul Klee, Sandy Calder, Leonardo da Vinci, Rube Goldberg, Marcel Duchamp, Piranesi, Man Ray, Picabia . . ."

What Barr didn't know (because it was yet to come in the future) was Tinguely's profound influence on the development of Kinetic art in the 'sixties and other artistic experiments with technology such as video and laser environments.

Abstract Expressionism was the strongest international art movement of the 'fifties. Beginning in 1959, Tinguely's art actively engaged the myths of the movement. That was the year he first began constructing robotic drawing machines he called *Métamatics*. On the one hand his work embraced the allover, informal properties of Jackson Pollock's drip paintings, what is called tachism in Europe. Yet, Tinguely's use of robots to perform his work attacked the romanticism attached to the use of automaticism (letting the line produced by the unconscious when the mind and hand are allowed to wander freely) in Abstract Expressionist compositions. Part of the "myth" of Abstract Expressionism lay in the idea of the artist performing the work of art in his own private existential theater—the blank canvas. After a decade of hearing about the action in action painting but only getting to see a stilled image, Tinguely's sculpture, especially *Hommage to New York*, seemed to offer the experience of watching an Abstract Expressionist work being made. Dore Ashton thought that Tinguely offered, "—an art of artlessness and imperfections—more human than machine. . . . —an art of destruction enacted—not concealed and held captive as they are in 'ordinary painting.'"

As Richard Hulensack pointed out at the time (little realizing how prophetic his words were) the sculpture's urge toward self-immolation reflected the contemporary condition, a harbinger of things to come: "There are times in human history when the things men have been accustomed to doing and have long accepted as part of the established order erupt in their faces. This is the situation right now—the universal crisis is forcing us to redefine our cultural values. We are like the man who is astonished to discover that the suit he has on does not fit him any longer. Religion, ethics and art have all transcended themselves, especially art, which instead of being art as we know it, has come to demonstrate man's attitudes towards his basic problems. So it is senseless to ask whether or not Tinguely's machines are art. What they show in a significant way is man's struggle for survival in a scientific world."

The destructive impulse of Tinguely's sculpture anticipated the major social and artistic revolutions of the next decade—the civil rights movements, the decomposition of the family, changing gender roles, the evolution of new values and the de-materialization of the art object. Nobody knew at the time the full dimensions of these sweeping changes but, artists are often bell weathers of change, and Tinguely's exploding *Hommage to New York* symbolically reflected the temper of the times.

—Ann-Sargent Wooster

Bibliography—

Ashton, Dore, "Die seltsame Maschine des Monsieur Tinguely," in *Baukunst und Werkform* (Nuremberg), February 1961.

Hunter, Sam, and Pontus Hulten, K. G., *Two Kinetic Sculptors: Nicolas Schoffer and Jean Tinguely*, exhibition catalogue, New York 1965.

Sweeney, James Johnson, *Jean Tinguely: Sculpture*, exhibition catalogue, Houston 1965.

Althaus, Peter F., and others, *Machines de Tinguely*, exhibition catalogue, Basel 1972.

Bezzola, Leonardo, *Jean Tinguely: 166 Fotos*, Zurich 1974.

Bischofberger, Christina, ed., *Jean Tinguely: Catalogue Raisonne—Sculpture and Reliefs 1954–1968*, Zurich and New York 1982.

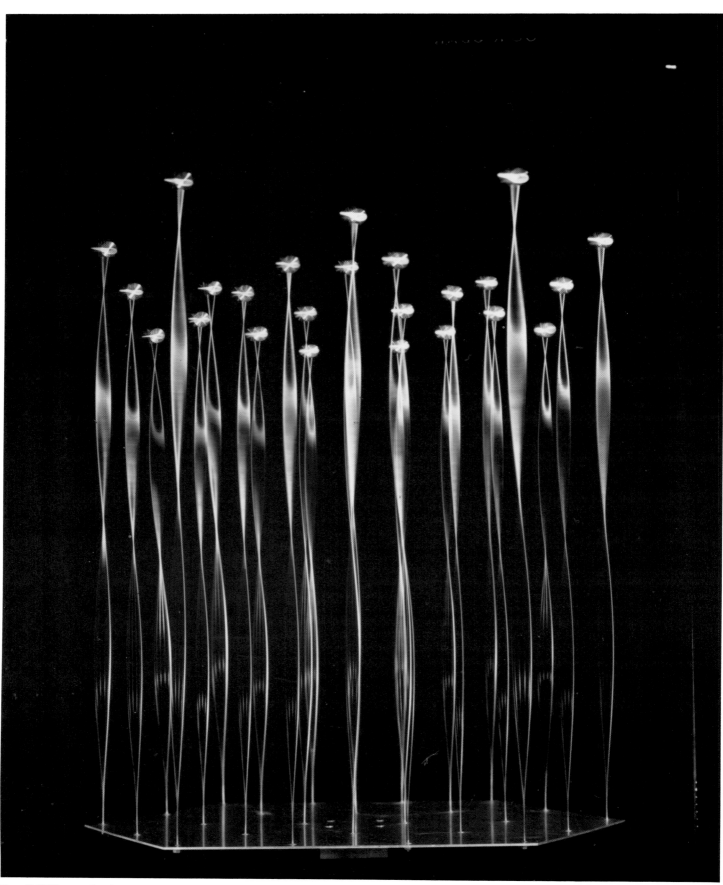

Photo Si-Chi Ko, reproduced courtesy TSAI

Wen-Ying Tsai (1928–)
Dancing Rods: Double Diffraction, 1971–80
Stainless steel rods with vibrator, stroboscope and electronic feedback control; 123 × 75 × 56cm.
New York, Tsai Collection

Wen-Ying Tsai, commonly known only by his family name, came to America early in 1950 to attend William Penn College in Oskaloosa, Iowa. His father, a businessman in pre-Communist China, advised the sixth of his eight children to study science and technology; an uncle, a theologian already residing in America, advised doing so in "the heartland of America." Uncomfortable in such a small rural school, Tsai, by birth a city boy, followed another Chinese student's advice and transferred to the University of Michigan, where he earned his B.S. in mechanical engineering in 1953. For the following decade he worked in New York City as a consulting engineer and project manager on various architectural projects, most of them industrial; by 1962 he had taken American citizenship.

Interested in visual art from childhood, he painted in his spare time until 1963, the year he received a John Hay Whitney Opportunity Fellowship. Quitting engineering work, he wandered through Europe for three months and, upon his return to New York, began to work not in two dimensions but three. Within a few years, his reliefs were included in *The Responsive Eye* ("Op Art") (1965) exhibition at the Museum of Modern Art; his sculptures gained international renown. In the heady 1960s, he deduced that he could combine his engineering training with his artistic interests, producing sterling examples of avant-garde technological art. "I wasn't satisfied with something static," he told me recently. In an USCO exhibition in the mid-1960s, he rediscovered the flickering strobe light that was to become an essential element in displaying his work. "In engineering school, it was used in laboratory tests of material—modular elasticities, waveform amplitudes. I never thought the strobe could be part of artistic expression."

More than two decades later, I can still remember walking into the Howard Wise Gallery in 1968 and being knocked over by examples of his most famous sort of work—shiny, flexible rods with tops the size of bottle caps. Thanks to a motorized base, these rods could shake at variable speeds before a physically separate strobe light that, rapidly flickering at a slightly different frequency, caught these vibrating rods in a succession of striking postures that created the anthropomorphic illusion of dancing. Firm material, steel, was transformed to look as though it had lost its rigidity. At the time, I responded to such work as an excellent example of *kinetic* or moving sculpture in the tradition of Naum Gabo and Moholy-Nagy. It was scarcely surprising that Tsai's work won second prize in a 1967 international competition sponsored by E.A.T.—Experiments in Art and Technology—and was later included in *The Machine*, a monumental 1968 exhibition at the Museum of Modern Art.

It should be mentioned that these cybernetic sculptures come in various sizes, some with spines over ten feet tall, others the height of shrubs. Some have squares on top of their rods; others, circles. In some, two rods emerge from a single base, resembling tuning forks. One historical improvement was that the flickering speed could be changed in response to either sounds in the surrounding space or the spectator's proximity to a sensing device in the sculptures themselves, making them a pioneering example of responsive or cybernetic art (that I take to be more advanced than artistic machines that move autonomously). Another later development was substituting fibreglass for stainless steel in the upright rods, and he has more recently been considering the use of carbon fibres and radar. Though no two are identical, they resemble one another much like siblings in a family that, at last count, is still growing.

With several sculptures operating in the same space, Tsai is able to get different responses from each. To show how the speed of the strobe light can be changed, he generally claps his hands before admiring "the dancing rods," as he calls them.

These "Dancing Rods" are so memorable that other Tsai works have been slighted; and since these are not as widely exhibited as they should be, it would be appropriate to mention a few of them here. Perhaps the best example of his early painting is *Random*

Field (1963), in which a plane of unmodulated fluorescent red is mounted $\frac{1}{2}''$ in front of a field colored only with fluorescent green. Circular holes cut into the front board reveal the green background. Seen under ultraviolet light, the green appears to shimmer above the red. In *Multi-Kinetic Wall* (1965), motors make circles suspended within other circles spin in various directions. When all thirty-two elements are assembled together, the work measures eight feet high by sixteen feet across and twenty inches deep. *Multi-chromics* (1971) is a sort of painting three feet square, in which he embedded reflective circles, called defraction gratings, that appear to change color as you move from side to side. (Tsai speaks of them as technically having "color without pigment.")

Computer Column (1980) has a vertical row of flippers, much like those in a train station. The plates in this piece have various colors, and the speeds of the various flippings, from one color to another, can be controlled from an early Radio Shack computer. To my senses, such sculptures are more theatrical than painterly—they function in time as well as space; that explains why most of us can spend a generous amount of time looking at them. Tsai reveals his engineering training not only in neat workmanship but in his sense of how elements might interact together.

Upwards-Falling Fountain (1979) creates an illusion that must be seen to be believed. As the water falling from a vibrating shower head is illuminated by a strobe, the droplets dance up and down in response to sound; at certain strobe speeds, the droplets appear to be moving upwards, violating all rules of gravity. *Living Fountain* (1980–88) is a yet larger water sculpture with a shower head three feet in diameter plus three concentric circles of water jets all installed above a basin twelve feet by sixteen. Here the strobe is designed to respond to combinations of changes in audible music, random sensors, audio feedback controls and a computer program. For the traveling *Computers and Art* exhibition (1987) Tsai chose G. F. Handel's *Water Music*. In my opinion, this set of related cybernetic sculptures constitutes the second indisputable masterpiece in the Tsaibernetic oeuvre.

What his best sculptures are fundamentally about, in my opinion, is the esthetics of electricity, which is to say possible artistic properties that depend upon electricity. Beyond that, Tsai is also interested in ideal kinds of person-machine experiences. As he wrote in 1971, responsive sculptures have "been created to effectuate an instantaneous interaction of Man with his art, his environment, using scientific instruments as a tool. By virtue of this interaction, the cybernetic sculpture evokes a spontaneous vigor and response in the participant, thereby awakening in him the inner curiosity and sensitivity toward the poetic unfathomable wonder of the universe."

Though he had obtained patents for the technology behind these last illusions, Tsai's works are fundamentally inimitable. "Technological art can be easily copied," he once told me, "unless the technique is so profound it is difficult. You can make it so complicated or so subtle that nobody else would have the combination of artistic sensitivity and patience to do it. In my case, people who try to copy can't do it, so I retain my uniqueness." Copy? hell. Their mystery comes from the sense that most of us can hardly deduce how they might work.

—Richard Kostelanetz

Bibliography—

Pontus-Hulten, K. G., *The Machine as Seen at the End of the Mechnical Age*, New York 1968.
Benthall, Jonathan, "Cybernetic Sculpture of Wen-Ying Tsai," in *Art International* (Lugano), March 1974.
Popper, Frank, *Art-Action and Participation*, London and New York 1975.
Kostelanetz, Richard, "Artistic Machines," in *Metamorphosis in the Arts*, New York 1981.
Kostelanetz, Richard, "Tsaibernetics" in *On Innovative Art(ist)s*, Jefferson, North Carolina 1991.

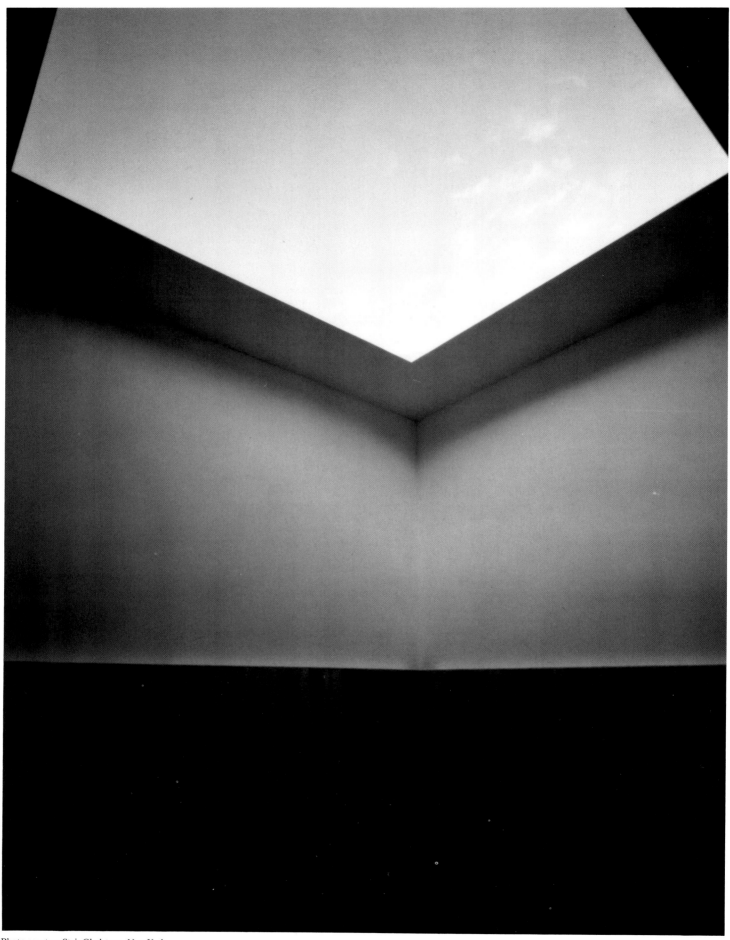

Photo courtesy SteinGladstone, New York

James Turrell (1943–)
Meeting, 1980–86
219 × 236 × 270in.
Long Island City, New York, PS 1

The most remarkable thing about James Turrell's career, when you look back on a quarter century of it, was that he knew from the beginning that his medium would be light. He didn't discover light after a career of exhibiting objects or a period of theorizing. His first exhibition, in 1967, just two years after his graduation from college, consisted entirely of projections within a museum space. The best sense that we can get of his earliest works now is to read between the lines of the chapter about them in Turrell's single book, *Occluded Front* (1986), which began as the catalogue of a retrospective exhibition in Los Angeles. He then created in his own Southern California studio a series of light-based installations by cutting slits into the walls and ceiling to let sunlight sweep through his space in various experimental ways; he used lenses to refract it strategically. What he never did was make objects.

The first Turrell I saw was *Laar* at a 1980 exhibition at the Whitney Museum of American Art. On the other side of a darkened room, opposite the elevator and stairway, appeared to be a large gray monochromic painting. As you moved closer, it retained that identity, its surface shimmering, much as good monochromic painting sometimes does. Only when you were literally on top of the work, close enough to bump your head into it, did you discover that, surprise, the monochromic rectangle is really a hole in the wall—or, to be more precise, a window onto a three-dimensional space painted gray. If only to accentuate the illusion of entering a palpably different world, you could feel that the air behind the aperture had a perceptually different weight—heavier to my senses. According to Adam Gopnik in *The New Yorker*, "What Turrell had done was to define 'the approach space' with direct light from four seventy-watt tungsten bulbs mounted and pointed at the side walls, while lighting the rectangular aperture entirely by indirect, 'ambient' light." In a later variation, *Daygo* (1990), shown at the SteinGladstone Gallery in New York in 1990, I stuck my head through the rectangle and noticed purplish light fixtures. In either case, the effect was not only magical, it was unlike anything else anyone had ever seen.

For over a decade now, Turrell has been working in remote Arizona on remaking a volcanic crater into a celestial observatory. The *Roden Crater Project*, as he calls it, should be a masterpiece; but until it is complete, as well as more popularly accessible, my Turrell nomination for the contemporary canon would be *Meeting*, as installed in 1986 at PS 1 in Long Island City. You are asked to come no earlier than an hour before sunset and to stay no later than an hour after sunset. You're ushered into a former classroom, approximately twenty feet square, most of whose ceiling has been cut away into a smaller rectangle, 49 inches less on each side, leaving the sky exposed. (It looked like very clean glass to me until I felt the temperature change.) Benches are carved out of the walls, but it is perhaps more comfortable to lie on the rug floor, looking skyward. Along the top of the benches runs a track behind which is a low level of orange light, emerging from tungsten filaments of thin, clear, metre-long, 150 watt "Osram" bulbs. (Having no visible function at first, these lamps later contribute crucially to an illusion.)

What Turrell has done is framed the sunsetting sky, making its silence audible, its slow metamorphosis visible, in an unprecedented kind of theater that proceeds apart from human intervention. You see clouds move across the aperture; at times, an airplane, a helicopter, or some birds. It all looks familiar until the sky begins to turn dark. Lying in the middle of the floor, I saw the sky pass through a blue reminiscent of Yves Klein. Above me developed, literally out of nowhere, the shape of a pyramid, extending into the sky; and as the sky got darker, the apex of the navy blue pyramid descended down into the space.

Eventually it disappeared, as the square became a flat dark gray expanse, looking like nothing else as much as a James Turrell wall "painting," before turning a deep uninflected black that looked less like the open sky than a solid ceiling. Now, I know as well as the next New Yorker that the sky here is never black; there is too much ambient light. What made it seem black was the low level of internal illumination mentioned before. (You can see the same illusion at the open-air baseball stadium where, because of all the lights shining down onto the field, the sky likewise looks black.) I returned on another day, cloudier than before, to see textures different from those I recalled. On both occasions I remembered the epithet of a European art official who, getting up from two hours on the floor, exclaimed, ironically, "This Turrell is a great painter."

On the simplest level, what Turrell had done was manipulate the natural changing colors of the sky, first through the frame that required you to look only upwards and then with the internal illumination that redefined its hues. How he discovered this I do not know, as he is reticent about his working processes; I can imagine him setting up experiments with light and *then patiently sitting with them long enough to see what happens.* Otherwise, remembering my own skepticism about reading about Turrell before seeing, I would be remiss if I did not say that no less than experiencing *Meeting* in time is believing; descriptions always sound insufficient.

What is also remarkable is how much intellectual resonance the work carries to a wealth of contemporary esthetic issues, such as illusion/anti-illusion, painting/theater, unprecedentedly subtle perception, the use of "found objects" (in this case, natural light), and conceptualism (bestowing meaning on apparent nothing), all while transcending all of them. I personally thought of John Cage's *4'33"*, his notorious silent piece, in which he purportedly put a frame around all the miscellaneous accidental sounds happening to be in concert hall for that duration, much as Turrell frames unintentional developments in the sky. *Meeting* is *theatrical* in that it must be experienced over a requisite amount of time; no passing glance, as well as no single photograph, would be appropriate. Indeed, though *Meeting* could have been realized technically prior to the 1950s, there was no esthetic foundation for it prior to then. It is indicative that though most artists agree Turrell is "doing something special," he has no well-known imitators; what he does must be hard to do.

—Richard Kostelanetz

Bibliography—

Turrell, James, and others, *Occluded Front*, New York 1986.
Adcock, Craig, Ammann, Jean-Christophe, and others, *James Turrell: Mapping Spaces*, New York and Basel 1987.
Hapgood, Fred, "Roden's Eye," in *Atlantic Monthly* (New York), August 1987.
Adcock, Craig, *James Turrell: The Art of Light and Space*, Berkeley 1990.
Gopnik, Adam, "Blue Skies," in *The New Yorker* (New York), 30 July 1990.

Cy Twombly (1929–)
Untitled Grey Painting (Bolsena), 1969
Oil and crayon on canvas; 78¾ × 98½in.
London, Saatchi Collection

Line dominates the visual field of Cy Twombly's *Untitled Grey Painting*. At first view, there seems to be little else to it: two not quite parallel horizontal lines bisect the canvas. Neither is quite "whole": the lower one seems to be overpainted toward its left side, and the top one is simply broken in the middle, at a point marked "B." Neither line quite reaches to the right side; only the top one extends as far as the lateral edge on the left. The two lines are each drawn twice, once as a thin scratch on the surface of the grey, and a second time in a thicker crayon stroke that loosely follows the original line, not quite overlapping it.

The ends of five other parallel lines emerge in the lower left quadrant of the composition, descending in a diagonal from the left side of the two horizontal lines. But these five lines have been painted out, covered by the same field of somewhat lighter grey paint that extends over the lower horizontal line, a wash added sometime late in the composition, as the series of drips, just to the left of center, indicates.

Other more subtle lines appear: great sweeps or veils of paint fold across the surface like drapery, slightly different in value, broad lines that move mostly left to right or right to left, occasionally falling into a curve or taking off at a diagonal. Long linear drips establish the vertical dimension of the painting, defining the top and bottom of the composition.

In addition to the lines, letters and numbers become apparent: not just the "B" at the painting's center, but something like the number "14" on the left (though other marks confuse it); possibly the number "12" or "120" to the right of that; then, above the line on the right, so lightly drawn it almost disappears in the grey paint, a "4"; and below, perhaps another letter—is it "r" or "π," or is it both, and is it squared, so that taken altogether, we discover the intimation, if not quite the articulation, of the formula for the volume of a circle, πr^2?

Such are the small pleasures of Twombly's work-small pleasures that offer great rewards. *Untitled Grey Painting* is one of a number of "blackboard" paintings that date from the late 1960s, paintings that sometimes seem to imitate penmanship lessons, as if Twombly is practicing his cursive letterforms in large. This painting has, in relation to the others, something of the flavor of the aftermath, as if the blackboard has been erased with a sponge, and two lines new drawn upon it. This sense of erasure, of the canvas as a sort of reusable gestural field, has been called by Demosthenes Davvetas Twombly's "erography"—an erotic, errant, erratic writing of errors and erasures. Errors in Twombly's work are never errors, never mistakes. Erasures become veils of paint, part and parcel of the composition. Twombly's painting is never about perfection, beauty, or truth. It is about the reality of seeing, the ways that in seeing we construct space, however illusory or real.

Twombly's surface is a repository, waiting to be filled, then erased, then filled again. To be in a Twombly painting is always to be *in media res*, in the middle of things, just like the letter "B" and the lines themselves are spatially in the middle of this painting.

But it is also to *begin* in middle of things *temporally*, as if the line here is a time-line, and we are at point "B," somewhere near the beginning but nowhere near the end. This relationship between time and space is for Twombly the heart of the painting. The surface is archeological. It intimates that something came before it—some history—and that there is always more to come. Probably more than any other American painter of his generation, and surely because unlike anyone else he left New York in 1957 and moved to Rome, where he has lived since, Twombly's work has always been informed by its links to Western culture, from the epic and pastoral traditions of Roman civilization to the art and literature of the Renaissance. This painting seems to come "after" the Renaissance, capturing, in fact, the very essence of a landscape tradition that originated in the late eighteenth century. Its two central lines form a double edge, horizon and shore. We stand at the edge of a great dark space, like Caspar David Friedrich's *Two Men by the Sea at Moonrise* (ca. 1817), a painting structurally almost identical to Twombly's.

Untitled Grey Painting, of course, comes *after* landscape painting as well, even as it enacts landscape's essence. The notational ease of Twombly's gesture emphasizes the "presence" of the painter's hand, the immediacy of his marks in the here and now. The innocence of these marks, their "doodling" quality, embodies the sense of his *going on*, the hand always filling up space, doing more. Roland Barthes has spoken of Twombly's painting as "producings" rather than "products." That is, they never seem to end, they are always *becoming*, spatially and temporally. Just as we find ourselves in the middle of a time-line, the lateral edges of this work likewise seem arbitrary, as if the panorama before us goes on and on beyond the frame, beyond the limits of vision.

Into the flat space of the blackboard, Twombly has intimated not just a landscape but a world, as the horizontal line becomes part and parcel of the larger circle that is the globe. And he has intimated even more, a sense of the infinite, a time-line that stretches far enough into the future to swing circularly back on itself and begin again, an horizontal line stretching far enough left and right to reach, one can imagine, the very edge of space itself.

—Henry M. Sayre

Bibliography—

Delehanty, Suzanne, *Cy Twombly: Painting, Drawings, Constructions 1951–1974*, Philadelphia 1975.
Sheffield, Margaret, "Cy Twombly: Major Changes in Space, Idea, Line," in *Artforum* (New York), May 1979.
Art of Our Time: The Saatchi Collection, London 1984.
Barthes, Roland, *The Responsibility of Forms*, New York 1985.
Szeemann, Harald, *Cy Twombly: Paintings, Works on Paper, Sculpture*, Munich 1987.
Devvfetas, Demosthenes, "The Erography of Cy Twombly," in *Artforum* (New York), April 1989.

© DACS 1991

Victor Vasarely (1908–)
Orion MC, 1964
Oil on canvas; 82 × 78in. (210.1 × 199.9cm.)
Gordes, Fondation Vasarely

Victor Vasarely was the founder of the kinetic tendency in the plastic arts which, from the middle of the 'fifties became very popular in the USA under the name of "Op Art," in Italy with the emerging of "Cinevisualism," in Germany with the title of "Programmed Art," and in other countries with the more generic term "Hard Edge." In 1928 Vasarely had attended the "Hungarian Muhely/Bauhaus" in Budapest, directed by the constructivist painter Sandor Bortynik. Subsequently, in 1930 he moved to Paris from Pecs, where he was born in 1908. The first proto-kinetic paintings by Vasarely date from 1931 and take their inspiration from animals with striped furs, like the skin of a zebra. From the relation of parallel black and white stripes, Vasarely extracts the possibility of optical disruption and perspective inversion that create a virtual dynamism of the field of perception which is totally new.

Many of Vasarley's paintings are examples of the psychology of form which would have interested Wolfgang Kohler, and often refer to crystallographic principles of transformation. Other paintings by Vasarely are based on apparent changes in the perception of depth, from concave to convex, in relation to different directions of light. The result is enigmatic or ambiguous figures which present an inversion of depth and an altered spatial orientation. The perceptive results of these works, where the illusions of reversible perspectives underline the ambiguity of the elementary volumes, affirm the concept of multi-stability and the condition of virtual dynamism of the optic field. During these years (1955–65) Vasarely plays with the ambiguity of the volumes arranged on the flat surface of the composition, suggesting illusory perceptions of new optical incidences and high visual pregnancy. Some of Vasarely's paintings appear as perceptive enigmas, which prompt the hypothesis that the formation of the anomalous surfaces is caused by the contrast of brightness in which a white surface adjacent to one or more black surfaces looks whiter or vice versa. By means of consecutive effects of linear inclination that make lines which are objectively vertical look slanted in the opposite direction, Vasarely leads us into a virtually dynamic optical world. Also by overlapping transparent "rodoid" screens to the same compositional structure of the background painted in oil, tempera or acrylic on canvas or panel, Vasarely invites the public to operate the transparent surface by means of a lateral shift, to create optical interferences of particularly visual saturation and complex spectacularity. Thus the painting is transformed into a chromatically unstable effect that inaugurates a new condition of interformal perception.

Vasarley's painting introduces the spectator to an unobjective world of optical psychological disruption, where some geometrical shapes, if observed fixedly for some time, change aspect, intervening directly in the physical organisation of the system of perception. Images and elementary geometric figures which continuously change shape have a certain fascination. Perception is not simply sensation, but rather, an effect determined by the sensorial stimulation in the system of representation. The reversible figures painted by Vasarely communicate to the spectator a stimulus to which they correspond, according to the criteria used in the perceptive system: two or more possible representations which are completely different from each other and almost equally valid.

When the representations or alternative descriptions of stimuli are determinant to the same degree, the perspective system accepts either one, or the other, and in this way perception becomes multi-stable. There are many multi-stable physical systems, and a comparison of multi-stability in perceptive physical situations offers a useful guide to understanding the elementary mechanisms of perception within which Vasarely's painting operates. Thus, the inversion between figure and background that so often recurs in Vasarely's works of the 'sixties leads us to the reading of enigmatic structures with several solutions of stability. Structural fields formed by repetitive elements point to ambiguities of groupings, where fairly stable perceptions of even complex figures can be achieved, while in Vasarely's work the figures most quickly perceived tend to be simple, compact and symmetrical.

Orion MC, painted in Paris in 1964, belongs to that group of works dedicated by Vasarely to the "études profondes cinétiques" which inaugurates an ambiguous and illusory visual system made of planes and progressively saturated linear intersections.

Since the end of the 'fifties, Vasarely's painting has become more and more committed to promoting visual spectacles about the perception of unobjective chromolinear depths. Vasarely's world attributes to the virtual movement of positive-negative structures, or of chromatic extensions of different optical-saturating incidence, values of stereoscopic visual stimulation. The cinevisualism inaugurated by Vasarely's painting allows us to overcome the idea of a painting with the new concept of a chromoplastic object. Therefore, the programmed sequences of the linear segments of Victor Vasarely's paintings manage to condition the space that contains them, like a constant optical provocation and as a permanent signal of perceptive interference. In some ambiguous constructions of the most recent paintings, we can clearly understand the nature of the mechanism which allows the stabilisation of both aspects of the image at every moment. Visual ambiguity, in the sense of optical depth, characterises a large number of multistable structures created by Vasarely. Applying Virginia Brook's criteria of complexity, we must take into account the number of continuous lines within the structures painted by Vasarely; the number of internal angles and the number of different angles that allow us to forecast, with great precision, in what proportion of time the image is perceived as a solid instead of as a flat figure. Vasarely's way of painting confirms the fact that the mechanism of perception is a teleological system aiming to depict the external world in the most economical way possible within the limits of received signals and of its capacity for coding.

Vasarely's work has influenced more than two generations of chromoplastic artists in France, Italy, Switzerland, Germany, Holland and the USA, while the most recent paintings by the Franco-Hungarian master propose ambiguous segmentations of overlaid and half-stable elementary structures.

—Carlo Belloli

Bibliography—

Belloli, Carlo, *Telespazialita di Vasarely*, Milan 1961.
Vasarely, Victor, *The Notebook of Vasarely*, Oxford 1964.
Joray, Marcel, *Victor Vasarely*, Nuechatel 1965.
Spies, Werner, *Victor Vasarely*, Paris and New York 1971.
Hallain, Marc, *Ateliers Aujourd'hui: Vasarely*, Paris 1973.
Hahn, Otto, *Le Musee Imaginaire de Vasarely*, Paris 1978.
Dahhan, Bernard, *Vasarely: Connaissance d'un Art Moleculaire*, Paris 1979.

Photos © Peter Moore

Wolf Vostell (1932–)
You de-coll/age happening, Bob and Rhett Brown residence, Kings Point, New York, 19 April 1964
Happening

Looking at a brief list of the events that make up the Happening (or rather, as we shall see, the Dé-coll/age Happening) *You*, by Vostell (1964), they seem at once to be associated with situations of violence, of oppression, expressed through metaphorical and symbolic references or, more explicitly, through real acts of destruction; the spectators, caught walking or shuffling along a winding path to the swimming-pool, receive toy pistols containing coloured paints and are invited to decide whether or not to shoot at the performers to be found in a confused bunch at the end, and at the other spectators; three television sets are placed on hospital beds, the picture transmitted by them has been appropriately distorted; at the side of the swimming-pool three ladies (one of them is Letty Eisenhauer) are performing simulated sex with the carcases and entrails of animals, and with a vacuum-cleaner; five hundred mourning candles are burning on the surrounding trees; on reaching the tennis-court the spectators, fenced in like prisoners and putting on gas-masks, are invited to spray some of the performers with yellow as they roll in the mud; scattered all round are four hundred pounds of beef bones; the Happening ends with the combustion and explosion of the television sets.

The representation, or rather the simple presentation, of violence as a constituent element of existence is perhaps the central theme of Vostell's work. The idea of development, of the changing of everything as a natural law that leads to a condition of uniformity man, natural phenomena, the products of technology and of culture, makes Vostell focus on the double slogan life-death. On one side is the creative impulse, self-preservation, the sexual urge; on the other, every phenomenon of destruction, disintegration and violence, the perception of chaos, of the nonexistence of structure and rules.

The object of it all is explained by Vostell in the introductory words to the full score: "The public is brought face to face, in a satire, with the unreasonable demands of life in a form of chaos, and is confronted by the most absurd and repugnant scenes of horror in order to awaken consciousness."

Since the start of his work, Vostell, following a line that has its most obvious precedents in the Dada of Berlin, has interested himself in the possibility of subversion of the mechanisms acquired by artistic activity (generically identifiable with the refined and reticent introspection of abstract impressionism). Working out since 1954 the theory of Dé-coll/age, he insists precisely (distancing himself from a whole tradition of "affichistes" like Hains, Rotella and Villeglé) on the analysis in his development of a natural process of degradation or on the spontaneity of the destructive, separative, act carried out by the artist as a metaphor of the human condition ("life and conscience are torn up, not just the manifesto").

The conception of dé-coll/age from the withdrawal of manifestos is then applied more widely to all Vostell's work: the subtitle of *You* is actually *A Dé-coll/age Happening for Bob and Rhett Brown*. Dick Higgins in *Against Movements* (1967) describes Vostell as an artist "working in a Happening format using the dé-coll/age principle." Besides the Berlin Dada mentioned above, another precedent that cannot pass unobserved is that of Artaud's theories on the theatre: cruelty as a means of undermining the confidence of an audience, the need for an artistic discourse to become a viral phenomenon, with the aim of permeating the public at a level lower and thus more profound than the rational, these are fundamental points for Vostell, who, not by chance, gives to some of his Happenings and Environments titles like *Berlin-Fever*, *Auto-Fever* and *Mania*.

A point common to the whole theory of the Happening, from Cage to Kaprow to Higgins, consists of intending the work as a mere perceptive stimulus. Corresponding to the artist's non-intentionality is a more creative role on the part of the spectator. Vostell, while partly accepting this principle, gives room in *You* to the effort to reawaken the consciousness of those present: the

accent, whether through the specific argument (meditation on the horror of violence) or through the 'moral' aims of provocation—contempt, repugnance, rebellion—falls on the social significance of the Happening. As a result of the passage quoted above, the didactic-cathartic intention is explicitly declared. Achille Benito Oliva has spoken, talking of Vostell, of violence as an "objet trouvé." But, if Duchamp's objective estrangement was aimed at subverting the linguistic machinery and the rules of the work of art, the shock effect created by Vostell aims rather at laying bare the total lack of feeling, the cruelty, the brutality of psychological and social machinery, individual and collective. We are looking at a crisis that finds its beginning and its end in the rejection of political and social conventions found in a great number of neo-avant-garde artists.

It is important not to ignore the effective division of roles between public and performers revealed in *You* by the spectator, if indeed not foreseen or intended by Vostell. The performers function, as they do in a great proportion of Happenings, as a stimulus to the public, which, through its own perception and, as in this case, its own actions, become performers themselves, co-authors of the event. What is special about *You* lies precisely in the fact that the spectator, faced with scenes of violence, is not, as for example in some futuristic or Dada productions, attacked by the pictures or the action represented or simply by the actors themselves; the spectator is on the contrary impelled, or rather psychologically constrained, to assume the role of persecutor himself. The material is constructed, from a language point of view, on a pronouncement based on direct interpolation by the public. That is the point of the advertisements taken from magazines and scattered on the path, of the loudspeakers that shout "You! You! You!" as every spectator passes, of Tomas Schmit's gesture of accusation, writing the word "You" obsessively on the bottom of the swimming-pool on a variety of typewriters, and, finally, of the leaflets distributed to the public at the end of the Happening bearing messages like 'How long has it been?,' 'Consider China,' 'Are you a Nazi?,' aimed at disturbing logical thought processes and involving the individual conscience in the first person.

This is the profound significance of the Happening, clearly expressed by the whole of its structure and even its title: the author of all violence, the sole bearer of all historical and social responsibility, is always, in every case, the individual. The only possibility of redemption, of collective catharsis, lies in making every individual conscience aware of its total and irrepressible participation, in the role at once of executioner and martyr, in the tragedy of history. The cathartic intention appears, as we have seen, definite; but what is proposed cannot obviously be a traditional catharsis, aimed at the reorganization and the security of a pre-existent moral and social code regarded as superior and unquestionable. Vostell also carries out a dismantling operation (an operation of dé-coll/age or 'effaçage', to be precise) of the linguistic and psychological mechanism of the catharsis; perception of the horror, reawakening of individual consciousness, resting on no logical system of values, are deliberately blocked at the level of a stroke of conscience that admits no moralistic or illusory evasion.

—Giorgio Zanchetti

Bibliography—

Higgins, Dick, *Postface/Jefferson's Birthday*, New York 1964.
Hansen, Al, *A Primer of Happenings and Time/Space Art*, New York 1965.
Kaprow, Allan, *Assemblage, Environments and Happenings*, New York 1965.
Higgins, Dick, *Against Movements*, New York 1967.
Vostell, Wolf, and Simon, Sidney, *Vostell: Eine Dokumentation 1954–69*, Berlin 1969.
Page, Suzanne, *Wolf Vostell: Environments/Happenings 1958–1974*, exhibition catalogue, Paris 1975.

Andy Warhol (1928–87)
Gold Marilyn Monroe, 1962
Synthetic polymer, silkscreen and oil on canvas; 83½ × 57in. (212.1 × 114.8cm.)
New York, Museum of Modern Art

Of the artists who became prominent during the international Pop Art movement of the 1960s, Andy Warhol is probably the best known and the least understood. While Warhol's considerable aesthetic contributions rank him as one of the major American painters of the 1960s, his artistic innovations have largely been ignored by the general public and inadequately appreciated by the art world.

Included among Warhol's once startling contemporary "icons" is *Gold Marilyn Monroe* (1962). Seeming to "float" in the center of this expansive canvas is a garishly-hued photographic image of the film star Marilyn Monroe. Her bright yellow hair, pink flesh, bright red lips and blue eye-liner are silkscreened off-register against a black "key" image of the actor's face. In his 1962 New York exhibition at the Stable Gallery, Warhol included *Gold Marilyn* as well as several additional paintings based on the same Marilyn Monroe image. Among the latter Marilyn Monroe paintings one canvas presented five rows of the star's face, a diptych repeated the former composition in color in one panel and in black and white on the adjoining canvas, and another diptych on each panel presented eighty-four disembodied images of the movie star's broad smile.

In contrast to Warhol's paintings of Elvis Presley which are silkscreened on a silver background, the latter suggesting a motion picture screen, the photographic image in *Gold Marilyn Monroe* (1962) is silkscreened over a gold-painted canvas background. In this ironic setting the "hovering" photographic "icon" of a movie star seems a witty parody of Medieval and Renaissance religious panel paintings which often portrayed meticulously hand-painted saints against gold-leafed backgrounds.

In spite of powerful opposition from many in the art establishment in the 1960s, the international Pop Art movement swelled to tidal wave proportions. Works such as Warhol's *Gold Marilyn Monroe* enraptured a mass audience which knew little or nothing about contemporary art but was familiar with such ubiquitous mass media images as Coca Cola bottles, Campbell soup cans and photographs of movie stars. This large, unsophisticated audience was thrilled with the new Pop Art movement that presented familiar imagery from everyday experience and, best of all, did not require specialized training to appreciate.

In the early 1960s serious American contemporary art collectors had only recently emerged from a profound state of cultural provincialism and had began acquiring American avant-garde works, particularly after Europeans began acquiring American Abstract Expressionism. Consequently, with imagery taken from popular culture and its astonishingly rapid popularity with the general public and *nouveau riche* collectors, Warhol's silkscreen paintings were at first regarded by some observers as an affront directed at the sophisticated art world's widespread notion that art and culture were by definition high above the plebeian concerns and mediocre tastes of the masses. Such snobbishness was perpetuated by those who adopted the intriguing, but far from unassailable, intellectual dogma of cultural elitism advocated by such American art critics as Clement Greenberg, an early champion of American Abstract Expressionism.

Presented in art galleries, Warhol's startling Pop Art images including *Gold Marilyn Monroe* (1962) implied a brazen acceptance of the banality of urban culture and its ubiquitous visual demands that previously "serious" fine art and the art establishment scrupulously sought to avoid. Greenberg's unrelenting and militant advocacy of "high art" aimed to preserve "culture" which, from his perspective, was threatened with inundation by ubiquitous "kitsch" artifacts, including Pop Art works. In contrast to the somewhat egalitarian philosophy of the new Pop Art art movement, Greenberg's theories of modernism as a process of reductionism and personal taste as "objective" aesthetic evaluation were based greatly on aristocratic, 18th-century points of view.

While the formal appeal of Abstract Expressionism was designed to appeal to the viewer's intellect, Pop Art was considered from this point of view to have snubbed the very notion of "high art" by incorporating into a fine art context vulgar, mass-media imagery that bombarded everyone, privileged or not, on a daily basis. Worse yet, Andy Warhol had the audacity to turn his back on employing subjectivity and personal expression to create works of fine art advocated by the preceding abstract expressionists. Instead of carefully hand painting subjectively-derived abstract compositions, Warhol not only selected mass-media imagery such as photographs of movie stars or other celebrities, he also sent the pictures to commercial silkscreen makers to make the screens the sizes he desired. In theory, Warhol's "mechanically" created compositions could be replicated indefinitely through the silkscreen process, thereby sabotaging even the traditional hallmark of uniqueness as a necessary criterion for a painting to be considered a contemporary "masterpiece."

In his imagery produced from photographic silkscreens, Andy Warhol has employed subjects that can be grouped into several broad categories including *consumer articles* (Campbell's soup cans, Coca-Cola bottles, dollar bills), *commissioned portraits* (Ethel Scull, Governor Rockefeller), *documentary images* (car crashes, electric chairs, race riot, atomic bomb), and *famous personalities* (Elvis Presley, Troy Donahue, Marilyn Monroe, Liz Taylor, Jacqueline Kennedy). The last category includes numerous portraits of Warhol himself, thereby pictorially documenting the artist of the 1960s as a "superstar."

When *Gold Marilyn* was painted in the early 1960s, many of the cultural elite misunderstood the significance of Warhol's silkscreen paintings and sought to reject his contributions as being essentially subversive culturally. With the passage of time, other critics chose to see Warhol's impersonal and detached-looking art as a social commentary portraying the spiritual decay of society. From this perspective, Warhol was regarded as a painter who used the devices of commercial art to expose the mediocrity and exploitiveness of a manipulative society whose primary goal was to transform everyone into a consumer. Ironically, in reaching out to an audience which encompassed members from both the general public and the art establishment, Andy Warhol's art seemed destined to be misunderstood by the majority of both audiences. Perhaps his art is best understood as presenting glamorous and seductive art for a powerful and rich, but highly manipulative and corrupt, society who see mirrored in Warhol's paintings their glamor but not their shallowness and spiritual bankruptcy.

Andy Warhol has proven himself to be an astonishing innovator. Among his contributions should be included eliminating paintings as unique objects, introducing commercial photographic silkscreen imagery into a fine art context and elevating silkscreen printing to a "high" art status by printing on canvas large-scale prints that have competed with paintings for both historical importance and social prestige. In addition, Warhol's serial imagery has successfully abandoned the traditional concept of the masterpiece as a consummate example of inspired skill compressed into a single work. When several centuries have passed and the meaning of Marilyn Monroe has to be explained in a footnote, Warhol's formidable aesthetic innovations will no doubt overshadow the cult of personality that still partially blinds our full appreciation of *Gold Marilyn* as a 20th-century icon of materialistic culture.

—Joseph E. Young

Bibliography—

Coplans, John, *Andy Warhol*, New York 1970.
Crone, Rainer, *Andy Warhol*, New York and Washington, D.C. 1970.
Young, Joseph E., "Serial Prints," in *The Print Collector's Newsletter* (New York), September/October 1975.
Ratcliff, Carter, *Andy Warhol*, New York 1983.

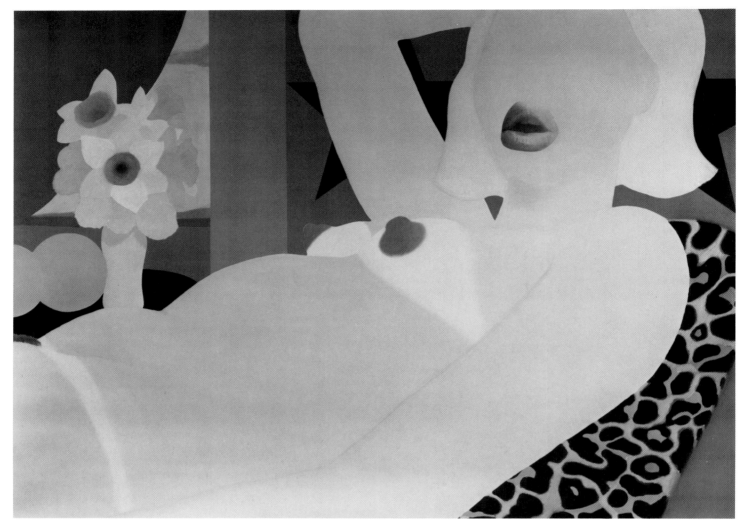

© DACS 1991

Tom Wesselmann (1931–)
Great American Nude no. 57, 1964
Synthetic polymer on board; 48 × 65in. (121.9 × 165.1cm.)
New York, Whitney Museum of American Art

Before he became a painter and a maker of collages, assemblages and reliefs, Tom Wesselmann was a cartoonist, drawing for *1000 Jokes* and *True*, and for Bigelow Rug advertisements which appeared in the *New Yorker*; in his own words, mediated by "Slim Stealingworth," by 1956 "he sold cartoons at a slowly increasing rate, until he was making almost as much money as he would if he were on unemployment." And just as Renoir the painter of crockery and Rouault the designer of stained glass never entirely disappeared from their subsequent work, so Wesselmann the cartoonist is discernible in the work that succeeded his artistic training at Cooper Union in 1956–59. Cartoons make their point directly, unequivocally, using simplified outlines to focus the viewer's attention on those elements in which the point of the cartoon resides and eliminating all extraneous detail that might distract this attention—styles of cartoons may vary but this imperative remains constant, and is also something identifiable in all Wesselmann's work.

The Great American Dream and The Great American Novel were (and are) mythic constructs of an idealistic, platonic nature whose very ubiquity in the popular consciousness of America militated against their ever being realised, and their only real existence in the latter part of this century has been as parodic myths, to be mocked and satirised in cartoons and elsewhere. To these two Wesselmann added a third, The Great American Nude, echoing and mocking the two existing paradigms while at the same time finding a trope which could be developed and extended through a hundred variations over a twenty-year period, in a variety of media, in a variety of sizes and shapes. Applied to any individual work, the title carries resonances of national symbolism, however satirical, and the serial element emphasises links with numerous other such works by the artist.

Wesselmann/Stealingworth describes the genesis of the series thus, referring to his earlier unconcern with colour itself: "This particular problem was solved late in 1959 or early in 1960 when he had a dream about the three colors: red, white and blue. It was not a color dream: it was just about these words. Almost immediately on awaking, he decided to do the nudes around that theme, under the unifying title of *The Great American Nude*. (This was directly a result of his having been a gag cartoonist—The Great American Novel, Dream, etc. were standard humor topics). The title was arbitrary and capricious, as was the resulting selection of colors and symbols. In this period he confined himself to the colors red, white, and blue, and because of fringe on flags, gold or yellow." Four years later, when *Great American Nude No. 57* was painted, Wesselmann had broadened his tonal range, but the restriction to the colours of the Stars and Stripes (plus fringe) and the use of elements from the flag itself still underlies the work. Two five-pointed stars, dark blue on pale, appear behind the head in the painting.

The scale of the painting is not excessive, but the cropped half-figure fills most of the surface of the painting and is projected forwards by both the background detail and the strong colouring of this detail. The pose is languid but still alluring, the raised arm and turning erect head contrasting with the relaxed position of the body, the flaccid curves of the shoulder and abdomen. The figure is reduced to a completely flat shape, with only faint shadow indicated beneath the chin, along the left arm and on the hip. The face is a blank, apart from the fully-realised mouth: Wesselmann/Stealingworth writes, "The figures dealt primarily with their presence. Almost all faces were left off because the nudes were not intended to be portraits in any sense. Personality would interfere with the bluntness of the *fact* of the nude. When body features were included, they were those important to erotic simplification, like lips and nipples. There was no modelling, no hint at dimension." This elimination of face and individuality in order to concentrate entirely on the sexual features is of course the rationale behind much pornographic representation. Wesselmann, however,

denies the connection: "It is pertinent to remember that in the early 'sixties nudity in American media was still rare and demure. There were not yet magazines publicly available that showed women openly displaying their genitals. Such magazines were, in fact, illegal; and it wasn't until around 1965 or 1966 that Wesselmann ever saw one. Wesselmann took his spread leg nudes as an aggressive image and also as an expression of his joy at rediscovering sex, following the breakup of his first marriage. He was irritated with critics who spoke of the nudes as girly magazine material. The nudes were an expression of his delight at realising that his girlfriend would make such gestures and poses naturally, as a part of sexual pleasure and communication."

Wesselmann drew from the figure and enlarged these drawings onto the board, but the sense of an individual was eliminated at some point in the process; he wrote, "Nearly all of these large nude collages grew out of drawing sessions, in which Wesselmann nearly always used Claire [later his second wife], but occasionally one or two other friends. His way of working now was to select one small figure drawing, enlarge it by grid onto a board surface, and arrive at the rest of the collage by trial and error manipulations." The same applied to the painted works as to the collages.

The painting includes a vase of daffodils, two oranges, a curtain and part of a cushion covered by a synthetic imitation of leopard-skin. Wesselmann writes, "The compositions with nudes at this time generally included still life elements—some logical such as a bowl of fruit, others bizarre, including sundaes or a bowling ball. It didn't matter at that time what the objects were, it mattered only how they worked visually in the painting." In the present case, the curtain and the stamen of the central flower echo the nude's mouth tonally, while the oranges more remotely echo the breasts—oranges appear in many of the Great American Nude series, including Nos. 40 (1962), 51 (1963), 53 (1964), 58 (1965), 91 (1967) and 99 (1968); Nos. 51 and 53 also incorporate vases of flowers into the composition, while No. 99 also includes the same synthetic leopard-skin material (which also appears in No. 55 (1964)). In defining the figure, Wesselmann emphasises the pale, untanned skin of the breasts and the pubic area and hips, and the stylised forms of the nipples and areolae, which are frequently depicted in profile; writing of his later *Seascape* cutouts, Wesselmann says, "It is in these standing cutout still lifes that one becomes most aware of Wesselmann's reliance on profiles. Nearly everything he has painted is in profile. This, he feels, is the strongest and most direct way to keep the painting from getting too bogged down in the peculiarities of its objects; and profiles offer blunter confrontations."

That latter phrase sums up the effect Wesselmann aims for in his work, and the effect it achieves—a simplification of form, a reduction of the figure to its erotic elements, surrounded by strongly-realised objects executed in flat primary colours as on a billboard, on an enlarged scale—the artist writes, "Wesselmann became excited about scaling up his nudes to the same size as the billboard collages. Historically, the nude as a subject has a somewhat intimate and personal relationship to the viewer, even if only in terms of scale. By their larger scale, Wesselmann's nudes now transcended these characteristics. They abandoned human relationships and as a presence became more blunt and aggressive. Wesselmann was aware of a relationship between scale and eroticism."

—Krzysztof Cieszkowski

Bibliography—

Abramson, J. A., "Tom Wesselmann and the Gates of Horn," in *Arts Magazine* (New York), May 1966.
Stealingworth, Slim, *Tom Wesselmann*, New York 1980.
McEwen, John, *Tom Wesselmann: Paintings 1962–1986*, exhibition catalogue, London 1988.
Livingstone, Marco, *Pop Art: A Continuing History*, London 1990.

ARCHITECTURE

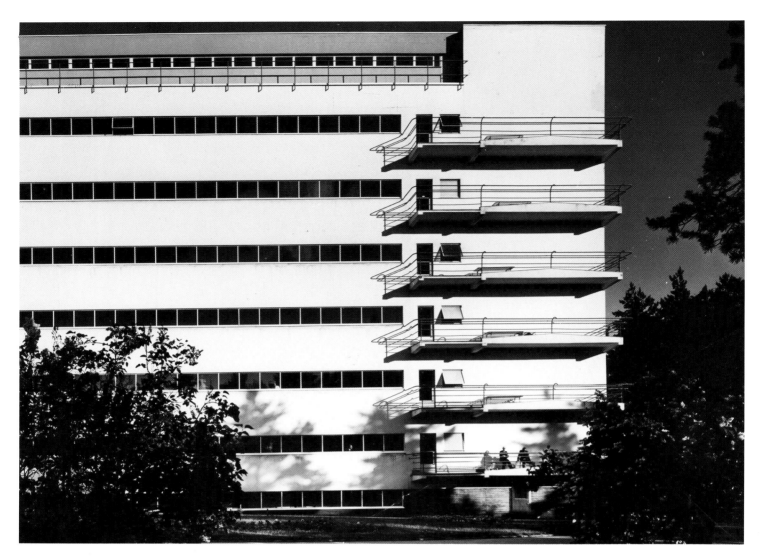

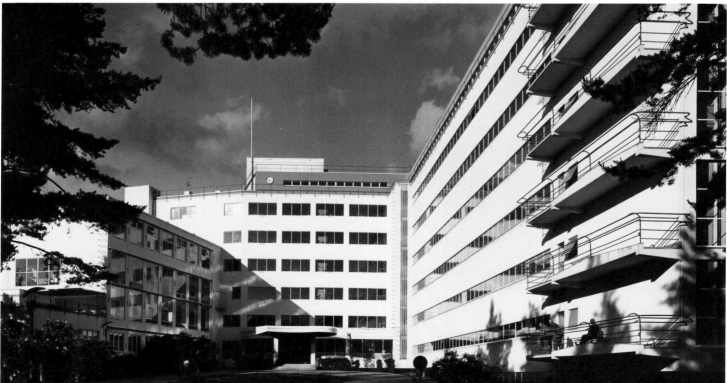

Photos Kari Hakli/Museum of Finnish Architecture

Alvar Aalto (1898–1976)
Paimio Tuberculosis Sanatorium, Finland, 1929–33

In November 1928 the Finnish architectural magazine *Arkkitehti* announced a competition for the design of a tuberculosis sanatorium to be built at Paimio, which lies in the countryside about 30 kilometers from the west-coast town of Turku, just off the main road from Turku to Helsinki. Entrants were given only two months to submit their proposals, which were due in January 1929. Aalto was at that time aged 30, and rapidly establishing a reputation as an architect and designer of furniture. His entry won the prize of 20,000 marks and the building was erected to his design in 1930–33, albeit with numerous modifications in the course of completion. The project was the most important in Aalto's career to that date, and was instrumental in establishing his reputation as an architect of international significance. The Paimio Tuberculosis Sanatorium has been described as a fine example of the heroic age of modern architecture and is worthy of some detailed consideration.

During the first quarter of the century the clinical treatment of tuberculosis favoured removal of patients from the smoke and pollution of cities to the countryside. It was believed that patients benefited from fresh, clean air, and the maximum exposure to solar radiation, supported by suitable diet and exercise. Tuberculosis was still very widespread and, prior to the development of effective drugs, often fatal. The principles of treatment accorded well with the emerging spirit of modern architecture, emphasizing light, open structures with the maximum use of glass to admit light and sun. Sanatoria of this kind were being erected in numerous locations, one of the most famous being that at Davos in Switzerland.

Aalto was certainly aware of what was then the most advanced method of managing tuberculosis. He was even more aware of one project in particular, the Zonnestraal Tuberculosis Sanatorium at Hilversum by the Dutch architect Jan Duiker, which he visited and studied in 1928, the year of the competition, as part of an international tour. It has been suggested that Aalto's building at Paimio was closely modelled on Zonnestraal in regard to its overall layout, structural principles, and much of its detail. However, Aalto's development of the theme at Paimio was more ambitious in scale and conception, and passed a threshold in imaginative innovation which explains why it is the more famous of the two projects.

The practice of tuberculosis management accorded well with the direction of modern architecture in the 1920s. The patients' wing was to be a kind of massive window composed of numerous modules, each consisting of a patient's room with a large window and a balcony. Aalto adopted as his motto for the project "Piirretty ikkuna", or "Window drawing". This was realized by means of a massive structure in reinforced concrete consisting of six tapering piers rising six storeys and buried half a storey in the ground. On these piers the patient's rooms were hung, with balconies cantilevered out on the south side. The result was the largest monolithic concrete project in Finland to that date, a feat of both architecture and engineering designed not only to support its own weight, but to resist the very considerable stresses which the strong winds and weather of the region could place on such a tall, flat structure.

The striking modernity of Paimio, which is evident from every angle, must also be appreciated in terms of its renunciation of the main trends of architectural practice in the first quarter of the century. In Finland, as in many other countries, the architecture of Aalto's youth was dominated by two historicist influences. The first was National Romanticism. In Finland's case, this entailed the conspicuous use of traditional materials such as stone and timber, often in massive proportions. Revivalist architects favoured an organic and rough-hewn asymmetry, with an extensive use of decorative and symbolic motifs. Visually exciting as many of these buildings were, they were often dark, badly ventilated and impossibly inconvenient. The other major tradition was that

of Neoclassicism, which featured the classical language of colonnades, capitals and elegantly proportioned walls of stucco. Aalto himself made effective use of the Neoclassical idiom, for example in his Workers' Club at Jyvaskyla (1923–4).

At Paimio he renounced any stylistic preconceptions as to how the building should look. His starting point and paramount concern were the needs and expectations of the building's future intended users, the patients and the doctors, nurses and ancillary staff who would care for them. He made a thorough study of the nature of tubercular illness, assisted, as he was to claim, by observing himself during a brief period of ill health which he suffered shortly before the project. Tuberculosis is a chronic and debilitating disease. Many patients would spend long periods in a prone position, too weak to move easily and experiencing frequent fevers. He designed lighting systems which would not glare in the faces of patients in a prone position. Ventilation and air circulation was devised which minimised draughts. Plumbing was designed and located to reduce noise to a minimum. The sanatorium would receive frequent new patients and visitors who would not know its layout, so he colour-coded linoleum tiles to provide pathways around the building.

In some respects the building may be seen as a triumph of functionalism. However, this was functionalism with a human face, and a motivating spirit which was essentially humanistic in the most fundamental meaning of the word. Although to some extent a fulfilment of Le Corbusier's dictum of a "machine for living in", Paimio is life-enhancing rather than mechanical in the impression it makes on visitors, even today.

In order to head-off the risk that such a scientifically conceived building could look mechanistic and forbidding to the new patient or visitor, Aalto introduced a number of organic asymmetries, such as the design of the entrance balcony, which remind one of the human consciousness driving the total conception. In doing this he attempted to get the best of both worlds. In its striking modernity the sanatorium inspired the patient and the visitor that here was a plce which offered hope in the form of the best treatment which was available; at the same time one never loses the feeling that there is a caring, loving human intelligence which informs the building at every level, creating a place in which people can live harmoniously in the pursuit of good health.

Not surprisingly, Aalto's design for Paimio proved to be highly controversial, leading to a heated debate in architectural circles and requiring much defence and explanation during construction and afterwards. Nor can it be claimed that the building was a complete success in technical terms. It embraced so many innovations that it was inevitable that something would go wrong. In the first winter the down-pipes, which Aalto had buried in the walls, froze and split the walls open.

It is perhaps ironic that the purpose for which the sanatorium was constructed lasted only two decades from its erection, before tuberculosis was finally conquered by effective drug treatment combined with improved public hygiene. On the other hand, perhaps the finest thing one can say of such a building is that it helped to conquer the problem it was created to counter. Today Paimio is used for more general medical purposes, but it remains a thrilling building to visit, as fresh and exciting as it was when it was opened in 1933.

—Clive Ashwin

Bibliography:—

Neuenschwander, E. and C., *Alvar Aalto and Finnish Architecture*, London and New York 1954.
Fleig, Karl, ed., *Alvar Aalto*, London 1975, Zurich 1979.
Pearson, David, *Alvar Aalto and the International Style*, New York 1978.
Schildt, Goran, ed., *Alvar Aalto*, London and Cambridge, Massachusetts 1978.
Quantrill, Malcolm, *Alvar Aalto: A Critical Study*, London 1983.

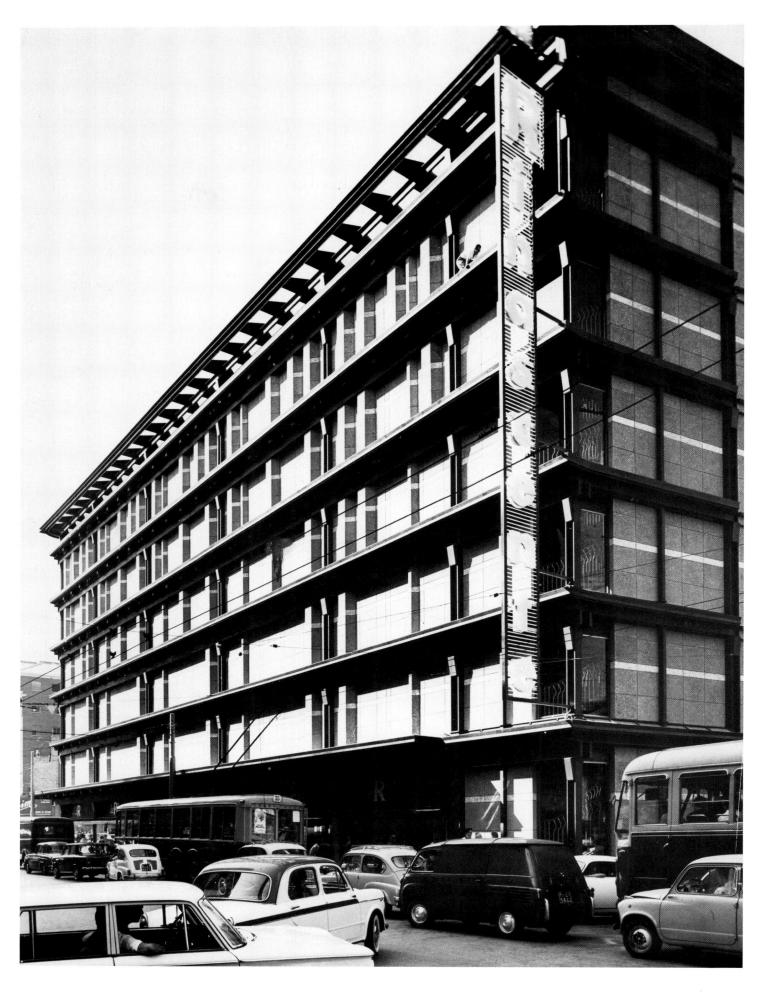

292

Franco Albini (1905–77) **Franca Helg** (1920–)
La Rinascente department store, Piazza Fiume, Rome, 1957–61

The eager anticipation which preceded the *La Rinascente*'s completion has been justified neither by the building type nor its location. Italy was not new to department stores, since the first *La Rinascente* had opened in Milan in 1919. The site in Rome is undistinguished, being one of those densely developed areas which expanded the city beyond the Aurelian Walls after the Reunification of Italy, at the end of last century. The store type itself does not have any peculiar features; it is essentially a big box with open selling areas without partitions and windows as they are incompatible with shelving. At the time the choice of Albini and Helg was regarded as unusual. Although they were well respected, their fame had been mainly achieved through interior and exhibition design work and their last building, the I.N.A. pavilion, dating from 1935.

The roots of the two architects might provide the key to understanding this anticipation. People not aware of how strong Italian parochialism is might find it difficult to realize how important it was to have Lombardian architects working in Rome again. Apart from a few exceptions, mostly in suburban areas, you have to go back to the golden age of Baroque to find buildings by architects from the North in Rome. *La Rinascente*, generally regarded as an intrusion, was nonetheless keenly awaited.

The building's charisma is mostly due to the fact that it blends into the urban environment thus avoiding the need for camouflage or absurd disguise. *La Rinascente* was one of the first projects with a design which took into consideration the impact of a building on the environment. The fact is even more notable if we consider that in Italy, at that time, the concept of environmental evaluation was not widely known. Its chief qualities are its design coherence and a strong identity. In other words, it does not try to hide its real function: a box for selling goods. Nevertheless this determination does not intrude on its surroundings. This discretion is probably due to the complex design process, made up of several variants, which has brought *La Rinascente* to lose "some of its objective severity . . . of its conceptual clarity, but gaining greater wealth of vibration," as Ernesto Roger wrote about this building. In fact, the actual building is the result of a complete revision of the first project; this was never realized for economic reasons and violations of town planning decrees which determined the volume, shape and dimensions of buildings in Rome. However, we need to refer to the first project, which is regarded as a lost opportunity in Italian architecture, to see how, by simplifying and to a certain extent softening the shape, the architects have succeeded in designing a highly technological building within an historic environment.

In the original proposal, the structure plays an important role, as Albini and Helg decided to use different materials for each of the three separate functions of the building. The service tower and the three underground floors have a concrete structure, while the seven-storey building's retailing area has a steel portal frame without any internal columns. Clearly visible from outside the building, this structure was accentuated by travertine limestone and concrete windowless curtain walls. The building is a composition of different elements, each of them with a specific role: the large parallelepiped containing the selling spaces, the external stairs diagonally cutting across the facade, and the service tower for storage areas and lifts. The distinctive function and design of each space makes it extremely easy to understand how the building

works. In keeping with the rest of the building, the car-parking is not hidden away but sits on top of *La Rinascente*'s roof like the much-admired Turin Fiat factory.

In comparison with this proposal, the actual building might be regarded as traditional, starting with the abandonment of using the roof as a car park. The structure still uses different materials for each function, but it is simpler in some parts: for example, in the steel frame which is now more traditional with internal columns. The elements which constitute the building are no longer clearly differentiated and therefore they are less easy to comprehend. The parallelepiped appears to have absorbed some of the elements for the vertical distribution. The irregular shape of the site is filled with regular geometric forms. Once again nothing is hidden: the stairs are visible through the big windows which, rather than letting the light in, reveal to the passing pedestrians an amusing show of escalators and the elegant helical outline of the stairs. The metallic frame is still exposed, while the curtain walls are made up of pre-cast concrete. These panels have been folded to create room for the service ducts. The apparently irregular corrugation also avoids the feeling of blankness which could be created by the lack of windows. The edifice remains the coherent building it was in the first project, but is more respectful to the surrounding environment from which it also seems to have borrowed some features. The red bricks of the Aurelian walls find a slight resemblance in the reddish concrete panels; the projecting metallic roof-frame brings to mind the cornice of a typical Roman Palazzo. However, everything is justifiable: for instance, the metallic frame holds up the rail of the facade maintenance system.

Although maybe unintentionally, the strict design does not lack irony. The choice of hiding the service ducts might be an example. In contrast with the contemporary tendency, services such as air-trunking and pipe-runs are hidden behind the concrete panels. However, the positions of the pipes are clearly indicated by the corrugations on the panels. One might play with the facade guessing where the ducts are and which floor they serve. Maybe an even sharper irony is that although Albini and Helg were well renowned interior designers: they did not participate directly in the design of the *La Rinascente*'s interior, apart from the service areas and the staircases. In any case, its simplicity and maybe its anonymous appearance, respects the need for adaptable retailing areas.

—Enzostefano Manola

Bibliography—

Rogers, Ernesto Nathan, "Un grande magazzino a Roma," in *Casabella/Continuita* (Milan), no. 257, 1961.
"Das Warenhaus La Rinascente in Rom," in *Baukust und Werkform* (Nuremberg), no. 4, 1962.
"Warenhaus la Rinascente in Rom," in *Werk* (Zurich), no. 8, 1962.
Portoghesi, Paolo, "La Rinascente in Piazza Fiume a Roma," in *L'Architettura* (Rome), no. 75, 1962.
Ponti, Gio, "La nuova sede de La Rinascente a Roma," in *Domus* (Milan), no. 389, 1962.
Atkinson, F., "La Rinascente Store, Rome," in *Architectural Review* (London), no. 788, 1962.
Banham, Reyner, *The Architecture of the Well-Tempered Environment*, London 1969.
Helg, Franca, ed., *Franco Albini, 1930–1970*, London 1979.

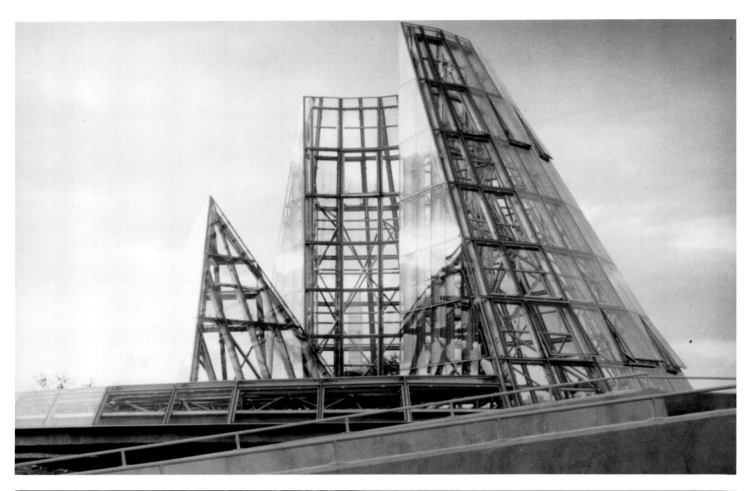

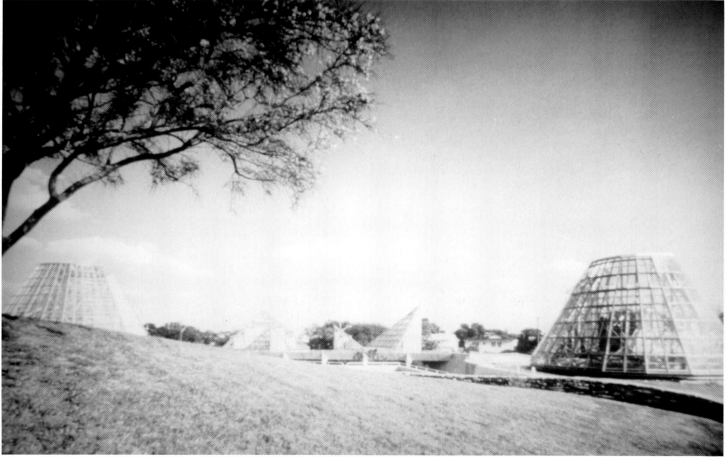

Photos courtesy Emilio Ambasz

294

Emilio Ambasz (1943–)
Lucile Halsell Conservatory, San Antonio Botanical Gardens, Texas, 1982–87

"My architecture may be seen as a kind of man-made nature," says Emilio Ambasz, an Argentine architect who graduated at Princeton and established in New York in 1969, where he was the curator of design at the Museum of Modern Art from 1969 to 1976. But it is an architectural as well as a humanistic, socially oriented definition.

Among today's architects, Ambasz is frequently referred to as a poet and a magician; on the opposite side, there are some who have severe reservations about his works, because they consider them anti-urban. Usually, there is little or nothing in the way of façades or any other conventionally civic or rhetorical elements in his buildings. Instead they tend to bury themselves below bermed earth and planting. But if the buildings have disappeared, the resulting schemes suffer no lack of key urban ingredients like presence and sense of place. Both are powerfully elicited: the landscapes that swallow and smother his buildings blend primordial and poetic presences with mythic and magical evocations and enchantments.

Such is the case with the Lucile Halsell Conservatory, at the San Antonio Botanical Gardens. Gilbert Denman, president of the Ewing Halsell Foundation, which provided $5 million of the $7 million involved in the project, had seen an exhibition of Ambasz's work at the Leo Castelli Gallery in New York City, which included several bermed and earth-sheltered designs. Although impressed, Denman also knew of Ambasz's reputation as an uncompromising idealist, who had designed furniture, kitchen utensils, and diesel engines. The following anecdote is worth telling. Ambasz was asked if he thought of himself as an engineer or an architect. He said he thought of himself as a poet. Now it is clear that it is precisely the union of poetry and innovative technology that makes the Lucile Halsell Conservatory a unique piece of architecture.

Traditional conservatories—London's Kew Gardens, New York Botanical Garden—are essentially gigantic glass sheds designed to admit as much sunlight as possible. But Ambasz recognized immediately that such a design would never work in San Antonio, where summer temperatures often exceed 100 degrees. So he buried most of the plant rooms, designing them as discrete boxes that can move independently in San Antonio's unstable clay soil.

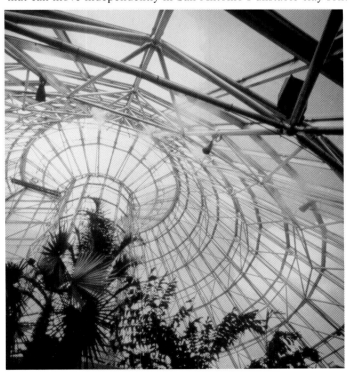

Light enters through the glass cones and triangles, which are equipped with operable windows and computerized sun screens that can be raised and lowered as light levels change. A special fogging machine keeps the tropical plants moist by atomizing a stream of water into tiny droplets that remain suspended in the air. In summer, the droplets lower the temperature of the room through evaporation; in winter, they keep it warm by retarding plant heat loss.

If there are "design metaphors" in architecture, Ambasz has really built one. The idea of a passage from earth to sky, from darkness to light, from man to nature, drives the design of the Lucile Halsell Conservatory, pushing it beyond mere utility toward some kind of lyrical ritual.

As in several other of Ambasz designs (Frankfurt's zoological garden, Nichii Sanda sports and cultural centre in Japan), the underground quality of the Lucile Halsell Conservatory is an illusion: the structure is actually built at ground level, and soil is bermed up around it to heighten the sense of connection to the earth. So, the Conservatory is not set upon the landscape—it *is* the landscape, and the visitor feels that its elements, obviously man-made and geometric as they are, have a harmonic relation to the plants they contain.

The tunnel-like entry of the San Antonio Conservatory bring us symbolically down into the earth, not above it, and it leads to a further symbol: a small round courtyard, its wall of concrete and its top open to the sky, that is to contain a single plant, a Mediterranean fan palm, in the center. Another tunnel-like corridor leads to the first true conservatory, an apsidal room capped by semi-circular and triangular rooflights. Here, seasonal flowers and shrubs bloom while doors on axis open to a porch that overlooks an elongated central court, a roofles trapezoidal cloister surrounded by an arcade of concrete columns, which might be seen as a Regionalist reference to the *patios* of local, Spanish-vintage tradition.

In the centre is a free-form lily pond and around this a lawn, flowers and palms. Jutting into the arcade on one side are a pair of square rooms, one for the tropical, the other for desert plants. Stretched along the opposite arm of the arcade is an orangerie and hidden behind that is a circular fern room, set entirely into the ground.

At the head of the court is a climax to the composition and to the processional route through it: the tall semi-circular conical palm house (110 feet in diameter at ground level, 55 feet above the top of the cloister), in which cycads and palms step up in tiers, their heads rising to fill the lofty space. A ramp circles up around the perimeter and then climbs to a central platform. From here, it is possible to look back and for the first time really comprehend the relationship of crystalline roofs and courtyard and see them in another relationship—to the city beyond. On the hill behind the fern room can be seen the final romantic touch—a mist shrouded tempietto.

Ambasz once expressed a hope that "if a parent brings a child, the two could walk and have a feeling, without using words, that they have entered a symbolic place. It will be a place with a deep feeling of silence." The Lucile Halsell Conservatory fulfils those expectations. Not only satisfies practical needs but also taps something deeper and more elemental, perhaps a memory of Eden recuperated for ever.

—Jorge Glusberg.

Bibliography—

Ambasz, Emilio, *Emilio Ambasz 1984: Arquitectura, Diseño Grafico e Industrial*, exhibition catalogue, Madrid 1984.
Tironi, Giordano, *Emilio Ambasz*, exhibition catalogue, Geneva 1988.
Bellini, Mario, and others, *Emilio Ambasz: The Poetics of the Pragmatic*, New York 1989.

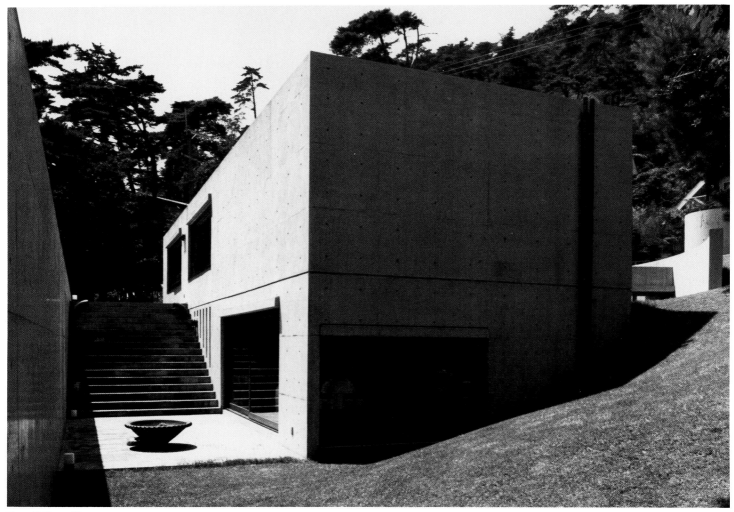

Photo © Botond Bognar

Photo Hiroshi Kobayashi

Plan courtesy Tadao Ando & Associates

Tadao Ando (1941–)
Koshino Residence, Ashiya, 1981–84

Completed in the beginning of the 1980s, the Koshino Residence represents a transition between two modes of design in Ando's overall work. On the one hand, the building reflects as well as summarizes the attributes of his previously evolved "defensive" architecture of the 1970s; on the other, it points toward a more open architectural model Ando was to fully elaborate and follow from the second half of the 1980s on. In this sense, the Residence combines the best of both modes exemplified by two such outstanding projects as his Row House in Sumiyoshi, Osaka (1976) and the Church on the Water in Hokkaido (1989). Moreover, the building is the most successful early example of Ando's mastery in articulating light-and-shadow effects as part of his persistent efforts to introduce natural phenomena in the domain of architecture. Also, by this time Ando had developed a highly sophisticated technique in applying unfinished concrete structures, notably walls with surprisingly delicate surfaces, which have greatly enhanced both the geometric configuration and the poetic qualities of spaces in his uniquely minimalist architecture.

Ando launched his career with a powerful new design paradigm which, as part of the New Wave of Japanese architecture in the 1970s, sharply rejected the increasingly hazardous, chaotic and uncontrollably volatile urban developments in Japan. Such developments were reinforced with the simultaneous commercialization of architecture and practically the whole built environment which, altogether, began to intrude even the private domain of the human habitat. Thus, Ando's first projects, epitomized by his famous paradigmatic Row House in Sumiyoshi or Azuma Residence (1976), manifested a two-prong stratagem. While the largely enclosed concrete shell structure of his box-like residences, within their run-down and tightly built industrial, suburban settings in Osaka, was meant to protect the inhabitants from the rampant intrusions of the megalopolis, the primitive simplicity of their design was to provide resistance and a meaningful alternative to the hodgepodge of proliferating fashions, hedonistic lifestyles and garish architecture in the city.

Using the layers of walls as the means of territorial articulation, the goal of each of Ando's designs was to create an internal world, a kind of "hermetic microcosm" which centered around a small courtyard in order to reintroduce the evocative as well as provocative aspects of nature. His domiciles were shaped as protective retreats, capable of recreating the weary human mind, body and spirit; Ando was determined to establish "new relations between the person and the space." Yet, in so doing, he was able not only to express radical opposition to the present course of urbanism, but also, while using contemporary materials and structures, to reinterpret the courtyard arrangement of traditional urban residences (*machiya*) and the calm spirit of *sukiya* or teahouse architecture without mimicking their formal attributes.

The Koshino Residence has been shaped along similar design intentions, yet it manifests additional concerns of Ando altering his previously closed architectural model. The most important aspect is the site which, as opposed to the cramped urban locations of most of his projects, is on a sloping, wooded hillside in Ashiya— with an assortment of loosely-built residences—inside the Seto Inland Sea National Park. This setting necessitated a design which could assure the building a "selective engagement" with its environment in addition to maintaining a protected, yet poetically inspired interior realm.

The Residence was designed and built in two stages; the first, completed in 1981, consists of two rectangular concrete boxes, with a small courtyard in between them; the second, added in 1984, forms a flat curving volume defined by the circular concrete wall of a quarter cylinder; all partially sunk into the sloping site. Facing south, the one-storey, longer rectilinear block houses six bedrooms for children and two *tatami* rooms, all in a row, and a bathroom. The higher yet shorter block features the kitchen, the dining area and the two-storey high living room on the first level, and the entrance with an adjoining study and master bedroom on the upper level. These spaces face the courtyard also to the south. The third one-storey circular volume of the addition includes an atelier and a washroom plus a grassy outside area partially enclosed by the extension of the curving wall. The three "detached" sections of the Residence are connected on the first floor with a passage which, between the rectangular volumes and beneath the outdoor stairway, forms an underground tunnel, while between the old and new sections, becomes a short, glass walled corridor.

The courtyard arrangement of the first phase is derivative of Ando's earliest and often implemented design axiom wherein a building is composed of two "independent" yet interconnected units. Like in every case of his "architecture of duality," here too, the courtyard is an outdoor extension of the living area and a place of direct interface with natural elements, wind, rain, sky, etc. Yet, in the Koshino Residence, the courtyard has an additional role; it recreates the surrounding landscape, insofar as this autonomous exterior space along with the wide stairway within recollects as well as internalizes the qualities of the site on and in which the house is located.

Ando's "architecturalization of nature" continues inside the Residence as well. The outside stairs and, by extension, the topography of the hilly terrain are echoed in another stairway which leads from the second level entrance to the lower level of the house. Moreover, the carefully shaped and located openings through the walls selectively frame and focus upon vistas to achieve a mosaic-like fragmentation yet a heightened awareness of the landscape, while filtering out the disturbing visual aspects of the immediate neighborhood. Simultaneously, the limited number and relatively low profile openings increase the intensity and significance of darkness, especially in the high-ceilinged living room, rendering its space perceptually akin to both some ancient cave dwellings and traditional residences.

Against the prevailing dimness of the interior, Ando captures the changing phenomena of the outside world and the passing of time by modulating the gradations and shifting spectrum of light. Skylights, shaped as long and narrow incisions in the roofs, let the sun pierce through and sweep across the delicately uneven, exposed surfaces of the flat and curving concrete walls of the living room and the atelier respectively. At the same time, a short structural beam of the roof crossing the skylight over each space casts a sharp, elongated and slowly moving shadow which, like a curious sun-dial, emerges and fades according to the passages of the sun, the day and the season.

This way the tectonic exactitude and substantiality of Ando's concrete walls and structures are both affirmed and challenged or negated; they are rendered, even if temporarily, perceptually dematerialized bordering on the ephemeral. Ultimately, the "primitive" simplicity yet poetic richness of his design allude to a unique phenomenology of architecture which, as in traditional Japanese architecture, is evocative of a profound sense of the void, emptiness and/or no-thingness (*mujō*), the quintessential attributes of Oriental cultures. Although Ando has since that time completed a remarkable number of outstanding works, the Koshino Residence remains one of the best examples of his impressively powerful architecture.

—Botond Bognar

Bibliography—

Frampton, Kenneth (ed.) *Tadao Ando: Buildings Project Writings*, New York, 1984.
Bognar, Botond *Contemporary Japanese Architecture: Its Development and Challenge*, New York, 1985.
Futagawa, Yukio (ed.) *Tadao Ando*, Tokyo, 1987.
Bognar, Botond *The New Japanese Architecture*, New York, 1990.

Model of *Irene Hixon Whitney Bridge,* basswood and birch, 1985
(Collection Walker Art Center, Minneapolis)

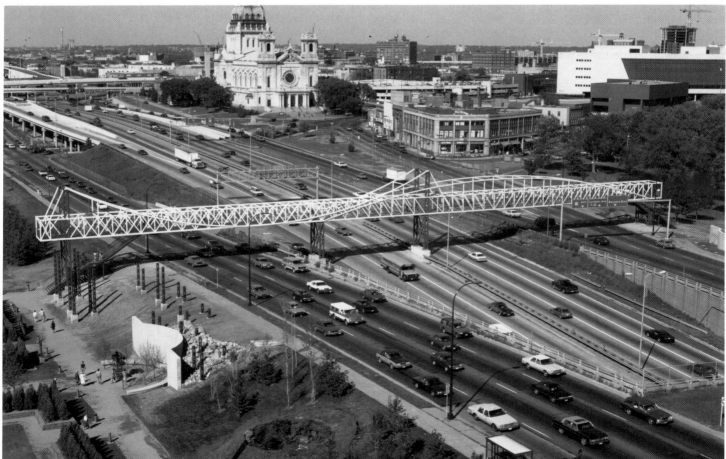

Model of *Irene Hixon Whitney Bridge,* basswood and birch, 1985

Photos courtesy Walker Art Center, Minneapolis

Siah Armajani (1939–)
Irene Hixon Whitney pedestrian bridge, Loring Park and Walker Art Center Sculpture Garden, Minneapolis, 1988
375 ft. long

"It did not become a bridge until the first person walked across it," Armajani said, soon after the *Irene Hixon Whitney Bridge* opened in Minneapolis in 1988. His statement reveals important philosophical and egalitarian concerns that underlie all of Armajani's art, whether public or private. Iranian by birth but Middle Western by adoption (he became a naturalized citizen in 1967), his art is conceptually complex and seriously humanitarian.

The *Whitney Bridge* typifies one aspect of the utilitarian art currently being made by many contemporary sculptors (Mary Miss, Richard Artschwager, George Trakas, Ned Smyth, Athena Tacha, the late Scott Burton among others) who create art projects with social concerns for public spaces. As Scott Burton pointed out, an early twentieth-century prototype for this sculpture lies in Brancusi's war memorial park complex, his *Gate of the Kiss*, *Endless Column* and *Table of Silence* at Tirgu-Jiu, Rumania; in what Burton referred to as Brancusi's "invention for our century of sculpture as *place*." Like the sculptures in Brancusi's park, and the utopian social ideals of the Russian Constructivists Armajani so much admires, the recent public sculptures of the artists cited above are works of art for a non-art audience. These sculptors share an attempt to engage the viewer, elicit his/her response, involvement, participation. A primary concern in Armajani's art is revealed in his statement, "It is always through the idea of the usefulness of an object that I become acquainted with it; this usefulness can be functional, or perceptual, or spiritual." In the case of the Whitney Bridge, Armajani's concept of usefulness works on all three levels.

Reconnecting two areas of Minneapolis separated twenty years ago by Interstate Highway 94, Armajani's graceful footbridge for Irene Hixon Whitney spans 375 feet: sixteen lanes of traffic. It is constructed of two great catenary arches, one concave, the other convex, which overlap at the center in a clasped hands or sine-wave configuration. The interlocking arches symbolically unite the two distinct areas the bridge connects: the Minneapolis Sculpture Garden of the Walker Art Center with Loring Park and the city's urban center. An open gate at the center of the Bridge reinforces the sense of passage from one side to the other, as do the Bridge's colors. Though the Bridge has a wooden deck, the steel arches of the superstructure are painted pale yellow on the Walker Art Center side, pale blue on the side leading to the greensward of Loring Park.

Reflecting his abiding dedication to eighteenth-century American architectural discourse (primarily its vernacular), Armajani finds the two sides of the bridge are like the passage from one pleasant room to another. "The yellow is from Monticello," he has said, "Jefferson called it the color of wheat, of the harvest." The blue is the color of the sky, an optimistic counterpoint to the long gray winters of Minneapolis. Benches, in the same spare style as the Bridge, are placed where the walkway widens, so pedestrians can enjoy views of the Sculpture Garden designed by Edward Larrabee Barnes, architect of the Walker Art Gallery, on one side, or the city on the other. Both sides of the Whitney Bridge are accessible to persons with disabilities by means of ramps, and the bridge is very popular with the public. Even in the dead of the Minneapolis winter the walkway is rarely deserted.

A poem by John Ashbery, commissioned by Armajani for the bridge, is inset in bronze letters on the superstructure. It reveals itself in short strophes as one progresses,

It is not a conduit (confluence?) but a place.
The place of movement and an order.
The place of old order.
But the tail end of movement is new.
Driving us to say what we are thinking.

Poetry (a major artistic expression in the Islamic Sufism which forms a major part of Armajani's cultural heritage) and philosophic texts: Walt Whitman, Frank O'Hara, Herman Melville and John Dewey are almost always worked into the fabric of Armajani's public art.

The architectural vocabulary of early American bridges and houses are the recurring themes in Armajani's sculpture, public and private alike; and "bridge" as a verb may be a symbol for what he hopes his public art will accomplish. Paradoxically, his first bridges were non-utilitarian investigations into conceptual/perceptual experience. His *First Bridge* (1968), constructed when Armajani taught with Barry Le Va at the Minneapolis College of Art, was a covered wooden bridge 125 feet long which diminished from ten feet at one end to four feet at the other. Another conceptually inspired sculpture was Armajani's *Covered Foot Bridge* (1970), eighty-five feet long, temporarily installed in a field near the Walker Art Center. It is remembered by its more accurate description, *Bridge Over a Tree*. Like the more hermetic, seemingly incongruous sculptural ideas that Armajani continues to investigate in his more private art—most recently the components for theatrical stage sets titled *Elements* (1989)—Armajani's deconstructed vernacular forms, both early and late in his career, are always in the service of plumbing the depths of their meaning.

With architect Cesar Pelli (with whom he and Scott Burton collaborated on North Cove for Battery Park City, NYC, completed in 1989) Armajani has designed two other elevated walkways in Minneapolis. Fittingly enough, bridges also have a special resonance for the Wheelock Whitney family, who, with supplemental gifts from federal, state and city government agencies, funded the Whitney Bridge in memory of the woman whose name it bears. Mr. Whitney said of his wife, "throughout her life she saw the necessity for bridges, between ideas, between generations, between people."

Armajani's public art, then, stands in marked contrast with the outdoor sculpture of the past twenty years: (1) with earth art, (2) with "plop-art" (essentially self-referential studio art, monumentalized and made public by being "plopped" into the plazas of urban offices towers in an effort to humanize the anonymous space), and (3) with "site-specific" art, all three of which can be seen in retrospect as only marginally, quasi-public in intention. Armajani's art is understated, self-effacing, explicitly populist and essentially democratic, yet it re-emphasizes the ancient role of the artist as integrally connected to society. "There is no room for a focus on the ego," he has said. "You have to get lost in the context of the work."

Scott Burton believed that Armajani has brought about a significant mutation in what art is; that the work is profoundly American, and that it probably could not have been done had Armajani been born in the United States. Birthdays are not celebrated in Iran, where there is very little use of the pronoun "I". Underlying Armajani's sculpture is the presence of Islamic Sufism, with its high ideals and strong sense of moral obligation to others. In Armajani's art, Sufism found a fortuitous kinship in its unlikely merger with the populism of Mid-Western America.

—Ann Glenn Crowe

Bibliography—

"Siah Armajani," in *Design Quarterly* (Minneapolis), no. 74/75, 1969.
Princenthal, Nancy, "Master Builder," in *Art in America* (New York), March 1986.
Kunsthalle Basel, *Siah Armajani*, exhibition catalogue, Basel 1987.
Shermeta, Margo, "An American Dictionary in the Vernacular: The Sculpture of Siah Armajani," in *Arts Magazine* (New York), January 1987.
Friedman, Martin, "Growing the Garden," in *Design Quarterly* (Minneapolis), no.141, 1988.
Antonelli, Paola, "Armajani: Opere pubbliche e private dal 1968 al 1989," in *Domus* (Milan), February 1990.

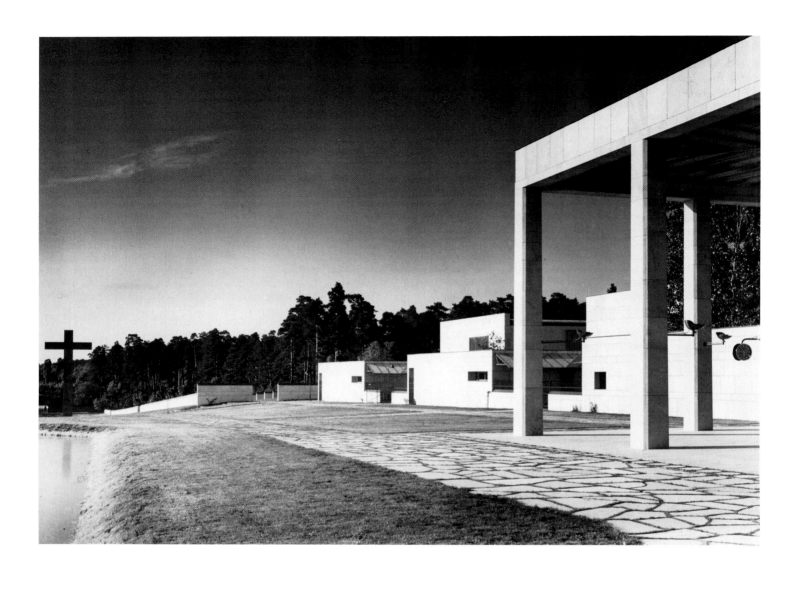

Gunnar Asplund (1885–1940)
Woodland Crematorium, South Cemetery, Stockholm, 1935–40

The Woodland Crematorium (Skoggskrematoriet) is located in the southern cemetery of Stockholm. Being an example of the perfect synthesis of landscape and modern architecture it is considered to be Asplund's most important work. As early as 1915 Asplund's career as an inspired architect began at the same location.

In 1915 an international competition was organized that invited designs for the extension of the southern cemetery of Stockholm. Asplund, in co-operation with his colleague Sigurd Lewerentz won this competition. As a result of this success, Asplund was able to build there the Woodland Chapel (1918–20). The chapel is situated in a woody environment. It has a classical plan-layout and includes a double row of colums on the frontside of the building. The columns, though, do not support an entablature and tympanum: a pyramidal roof sits right on top of the row of columns. The chapel proper has a rectangular plan, yet the visual experience of the space inside is determined by the inscribed circle of the dome. Even though Asplund allowed himself to deviate from the classical canon, both the exterior and the interior of the Woodland Chapel are neo-classical with respect to their simplicity and purity.

The liberal and often mannerist interpretation of the classical rules is characteristic not only for Asplund but for Swedish architecture of the 'twenties in general. At the time, this was called "The Swedish Grace" in Great Britain. Rather unexpectedly, Asplund's work changed between 1928 and 1930. This became visible at the Stockholm Exhibition of 1930. The exhibition turned out to be a built manifest of functionalism in Sweden in which Asplund had played a large part. Asplund did not stick to radical functionalist for a long time: already after 1933 he tried to incorporate the principles of Modern architecture into the Swedish situation and to adjust Modern architecture to Swedish circumstances. Just as in the Woodland Chapel, Asplund was searching for a personal interpretation, a new balance. In the Woodland Crematorium he struck the balance.

Although Asplund designed the crematorium on his own from 1935, a few of the design solutions of the cemetery-extension can be traced back to the period in which he worked on the design together with Sigurd Lewerentz. Already during this collaboration that started in 1915 a few concepts were developed that ultimately contributed to the executed result. In the autumn of 1933, they submitted the site plan for the crematorium complex. In it, the location of the entry and the chapel were already determined. The building committee of the crematorium eventually commissioned only Asplund, which caused a rupture between the two architects.

The Woodland Crematorium is situated in a wooded area. The entry road to the precinct is bordered by trees. At the end of this road the landscape suddenly opens up and allows the visitor a grand view. To the left, against the forest, the crematorium is situated. Opposite the crematorium there is a lawn that is bounded by the "meditation grove" to the right. The main chapel can be recognized in the distance by its protruding portico and a cross. The road that leads to this chapel runs along the columbaria and two smaller chapels. The terrain slopes up very gently, because of which the road visually seems longer. Asplund has opted for a linear lay-out along the entrance road. First of all, one comes across the two small chapels, the one after the other. They both have the same front court, waiting room and open interior court. Then one reaches the main chapel that, like the Woodland Chapel, also has a portico. This one is much bigger, though, and has an atrium in the middle. In front of this portico is a pond that reflects the building like a mirror. Service rooms are located on the backside of the complex. The difference between "front" and "back" not only is expressed in function but also in material. The front is finished with unpolished marble, the back has a yellow plaster all over.

The architecture of the crematorium is abstract without any ornament. The flat roofs accentuate this. The separate elements of the entire complex are arranged in such a way that it results in a composition whereby not only high and low but also open and closed spaces succeed each other. The entire composition evolves around the frugal and the objective portico of the main chapel; in fact, the portico is a separate entity that stands on its own. It is not attached physically to the chapel. The main chapel itself is a closed rectangular block. Its side walls and corners are slightly curved. The low roof also curves slightly, which is in contrast to the roofs of the other buildings. Similarly to the Woodland Chapel the interior space is not determined by the outside walls of the building in the first place, but rather by the row of columns and the line that is formed by the beam these columns support.

With the Woodland Crematorium, Asplund succeeded in striking an almost classical balance while making use of the vocabulary and language of Modern architecture. The intertwinement of Asplund's architecture with the landscape makes the Woodland Crematorium a unique project.

—Otakar Máčel

Bibliography—

Ahlberg, Hakon, "The Crematorium in Stockholm," in *Byggmastaren* (Stockholm), no.19, 1940.
de Mare, Eric, *Gunnar Asplund: A Great Modern Architect*, London 1955.
Wrede, Stuart, *The Architecture of Erik Gunnar Asplund*, Cambridge, Massachusetts 1980.
Wrede, Stuart, *Global Architecture 62: Erik Gunnar Asplund*, Tokyo 1982.

Gae Aulenti (1927–)
Musee d'Orsay interiors, Paris, 1986

The Hotel d'Orsay and the Gare d'Orsay (railway station) were inaugurated in 1900, coinciding with the World Fair held in Paris that year. Both were the work of architect Victor Laloux. In 1978, the station was handed over to the Direction de Musées de France to provide a home for a museum of nineteenth-century French art and culture which, together with the Louvre and the Pompidou Centre would form a trilogy covering the entire history of French art.

After a series of controversies over the appointment of architects to carry out the conversion of the Gare d'Orsay, the final choice was ACT Architecture for the overall design and Gae Aulenti for the interior architecture. Italian-born Aulenti is best described as a theatrical designer. Apart from this project, she was also responsible for the Palazzo Grassi and made a major contribution to Luca Ronconi's *I Festivi Rustiniani*, becoming a close collaborator of this great theatre director. She made good use of this experience in her work on the Museum.

The Musée d'Orsay is one of the buildings which form part of the *Paris of François Mitterand*, the most ambitious examples of which include l'Institut du Monde Arabe, La Villette, the Louvre extension, the Finance Ministry, l'Opera de la Bastille and l'Arc de la Communication. Together, they represent an elaborate and highly visible cultural plan whose size and significance will earn it its place in history.

The building's dimensions are exceptional for Paris: the facade occupies 200 metres of the Avenue Anatole France; it is 75 metres wide and the great interior hall is 138 metres long by 40 metres wide by 32 metres high. It is a vast container whose metal and glass structure provides the basis for the design of exhibition areas on three main levels.

The overall organisation of the spacious interior respects the structural features of the former station, providing a longitudinal route along a wide aisle topped by six existing domes. The various levels are laid out making use of this enormous space: the pivotal points of the design and the rhythm of the joinery, both conceived by Laloux in his original plans, are the elements taken into account in organising the different areas of the Museum.

The Musée d'Orsay houses more than 4,000 works, including paintings, sculptures, drawings and furniture, as well as a collection of 3,000 photographs. There are also exhibition areas, an auditorium seating 350, a cafeteria, restaurant and a cultural service, which aims to encourage greater public interest in art.

The latter suggests the purpose of museum architecture is to provide a place where visitors can share a collective experience, adopting an approach rather different to the traditional idea of the museum as somewhere where the solitary spectator acquires information in the silent, almost inhibited, atmosphere so beloved of academic culture. At the same time, the layout of the Musée d'Orsay breaks with tradition in that the visitor is free to *choose* his own route through the different levels.

Aulenti's designs—particularly the case in point—have produced a new architectural concept: integration in the management of interiors. The problem of moving actors around a stage has its parallel in a question of particular interest to futurists: that of mobility within space. Space is no longer static and figurative; at the Musée d'Orsay it goes beyond a strictly architectural concept and leads to a critical consideration of the *idea* of what a museum should be. The very way in which its spaces are organised offers information on possible itineraries.

Aulenti is to be congratuled on having achieved her aim of "presenting the works under the best possible conditions," despite having to "*design on the basis of what had already been designed*" (the existing context). The Musée d'Orsay differs from other museums in that it presents a collection of all the visual arts: town planning, architecture, painting, sculpture, photography. From the outset, this made the project more complicated.

The aim is not to recreate—as we might assume an architect intent on historical authenticity might have done—the uniquely triumphal mood of 1900 exhibition, or the scale and character of the original station. We consider this to be a wise decision. Another important virtue is the interpretation of the space as a whole. We have an architecture *which can be seen* within the great hall and which has reduced its monumental scale through the incorporation of other, skilfully-placed structures. The *visual* reduction of the hall nevertheless preserves the original impression. The enormous range of perspectives and viewpoints offered by this central space make it a real photographer's paradise. Throughout most of the museum, lighting is very well worked out, making good use of the natural light which penetrates through the original windows. Artificial lighting, both direct and indirect, provides ideal conditions for viewing the exhibits.

The result, a milestone in museum development, is the *happy ending* of a complicated story of conflict and confrontation in which politics played their part. It is important to outline, albeit briefly, what happened during the quarter-century between 1961—when the State acquired the station from the Paris-Orleans railway company—and the time when the Museum was inaugurated. It is useful, even if only to appreciate the difficulties surrounding the task of the architect, in this case Gae Aulenti, when a work assumes the character of *a matter of public interest* and hence attracts a whole range of pressures and concerns, which take the designer's obligations beyond the purely professional.

In 1961 a competition was organised for the redesign of the area surrounding the Gare d'Orsay. It was a failure and, two years later, a second competition also ended in disaster. The entries in both contests were severely criticised by the press. In 1971, permission to build in the Gare d'Orsay area was revoked at the request of the Ministry of Cultural Affairs. It was the year of the demolition of Les Halles and of the controversy over whether historic monuments should be preserved. Five years later, it was handed over to the Direction de Musées de France, as previously mentioned.

In 1973 building began on the Pompidou Centre and it became necessary to find a home, other than the Pompidou Centre, for the many Second Empire, Art Nouveau and other works of art scattered all over France. Here begins the story to which we referred. It is uncertain who can be credited with the original idea of taking these works of art to the Gare d'Orsay. But soon after Giscard d'Estaing became President of the Republic in 1974, work on the Gare d'Orsay project was speeded up.

In 1977, it was officially announced that Laloux's former station, now restored, would be the "museum of nineteenth-century French art and civilisation" and an autonomous administrative body would be set up to oversee its creation. The administrators organised a competition in which there were two finalists: ACT Architecture (Pierre Colboc and his associates) and Yves Boiret. The President of the Republic chose ACT and work was scheduled to start the following year, to be completed in the summer of 1983.

Cooperation between the architects and the official experts—the museum curators—was far from friendly, since the competition winners' proposals for the use of space and form clashed with the museum experts' demands. Meanwhile, the President had revealed his expectations in a newspaper interview. These were based on the idea of "a beautiful museum . . . which avoids the banality of fashionable sizes and shapes."

The public debate was between two opposing schools of thought, the *traditional* (academic, defended by Giscard) and the *modern*, and even went so far as to discuss the artistic content of the Museum: Romantic art, the second half of the nineteenth century. . . . When the governing body asked for specifications as to the internal layout, the architects' reply was not thought satisfactory, since it went against the principles laid down at the time of the competition. It was agreed that ACT collaborate with an expert in *interior architecture* and governors proposed that, in addition to French *decorators*, they should invite the collaboration

of Gae Aulenti, who enjoyed considerable prestige in her native Italy but was less well-known in France.

In fact, the basic problem of the Musée d'Orsay was its internal layout. So *battle* began for Aulenti, who finally succeeded in being accepted as something more than an *interior decorator* and imposing her point of view, which obviously conflicted with that of the Colboc group. As a result of this, a great deal of time was wasted and it became impossible to meet the proposed deadlines.

Another actor entered on the scene: François Mitterand, who as President of the Republic dictated the terms of the debate by launching the scheme to extend the Louvre in 1981 and assigning specific functions and areas of activity to the Musée d'Orsay. ACT were unhappy with the interior design but, in the midst of so much controversy at so many levels, Gae Aulenti's ideas emerged triumphant. Work began in the summer of 1983 with a budget three times as large as that originally approved by parliament.

All in all, despite the extremely difficult conditions under which it was created, the Musée d'Orsay has proved to be one of the most significant achievements of its kind this century. It is exceptional for its size and its historical value, for its aim to be a comprehensive museum of the visual art of the nineteenth century in France and for the quality of its exhibits, which represent one of the most dazzling periods in French culture. Above all, it is outstanding for its achievement of harmony between the artistic and the architectural.

—Jorge Glusberg

Bibliography—

Gregotti, Vittorio, and others, *Gae Aulenti*, exhibition catalogue, Milan 1979.

"The conversion of the Gare d'Orsay," in *Architecture Interieure Cree* (Paris), July/August 1982.

Vernes, Michel, and others, "Musee d'Orsay," special monograph issue of *Architecture Interieure Cree* (Paris), December 1986.

Ergmann, Raoul, and others, "Orsay," special monograph issue of *Connaissance des Arts* (Paris), December 1986.

Zardini, Mirko, ed., *Gae Aulenti e il Museo d'Orsay*, Milan 1987.

House, John, "Orsay Observed," in *Burlington Magazine* (London), February 1987.

Montaner, Josep Maria, *New Museums*, London 1990.

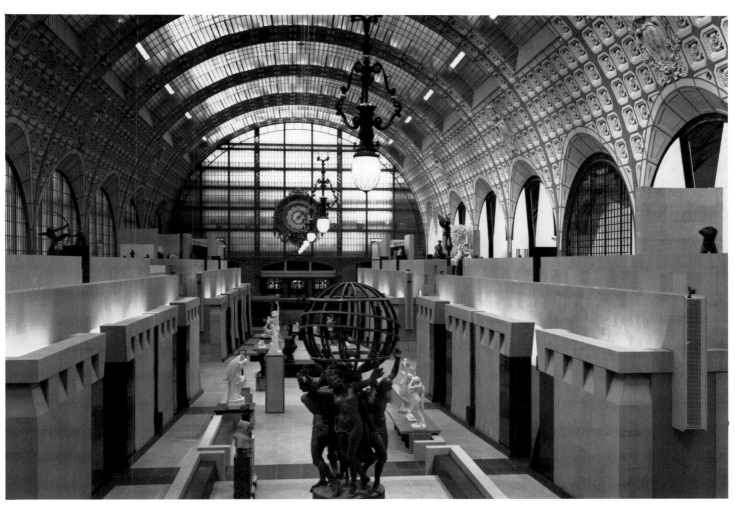

Photo © R.M.N., Paris

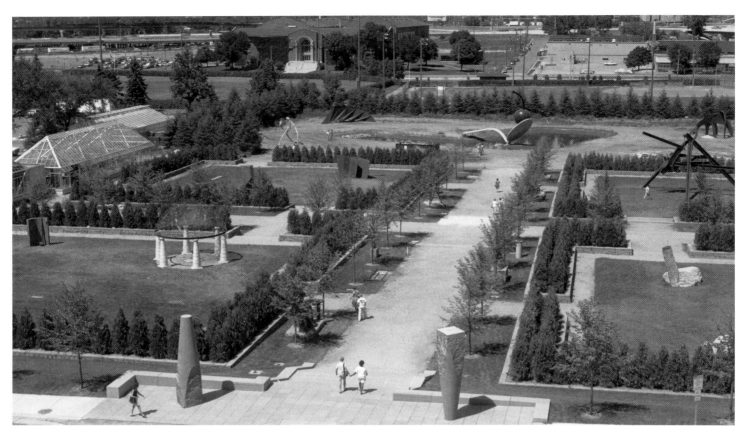

Photos Walker Art Center, Minneapolis

Edward Larrabee Barnes (1915–)
Minneapolis Sculpture Garden, Minnesota, 1988
7.5 acres site
Walker Art Center, Minneapolis

The Minneapolis Sculpture Garden, one of the largest urban sculpture parks in the U.S., resulted from the collaboration of the Director of the Walker Art Center, Martin Friedman, with the municipal parks and recreation board in Minneapolis. Completed in 1988, the sculpture garden comprises 7.5 acres of city park land lying directly north of the museum building. The garden plan is composed of grandly-scaled outdoor display spaces for contemporary sculpture designed by architect Edward Larrabee Barnes that complement his acclaimed 1971 design of the Walker Art Center museum building.

The garden plan is classically simple, symmetrical, and commodious as a setting for sculpture. The central *parti* is a cross-axis that establishes four equal courts. These are balanced to the south by the blocks of the Walker and the Guthrie Theater and to the north by an open, rectangular meadow. A conservatory designed by Barnes's partner Alistair Bevington defines the western edge of the garden and forms a transparent backdrop to the spaces for sculpture installations. The Cowles Conservatory features year-round horticultural displays and its central house contains Frank Gehry's *Standing Glass Fish* sculpture, framed within a classic palm court.

Barnes's garden design is notable both for his translation of historical precedents into a modern idiom, and for his integration of the garden into an urban plan. The strong north–south axis of the garden forms a needed connection across the street separating the garden's site from the Walker Art Center. This axis aligns with the lobby entrance shared by the Walker and the Guthrie Theater, and is reinforced by a crosswalk designed by artist Sol Lewitt. The axial plan, riveted to the museum entrance, draws the envelopes of space within the Walker out into the garden and creates a dramatic foreground for the museum. The axes are wide allées of compacted crushed limestone, lined with linden trees. Long, unimpeded vistas are the signature of the design, unifying the heroic scale of the site.

The axial division serves as a point of reference on the large site, so that visitors can transverse installations in some kind of logical sequence. On such a large site, there is an obvious need for an architectonic framework to function as a foil to the modern sculpture. Many of the sculptures in the original installation were not large because they were not conceived as outdoor pieces and their placement within the smaller courts and along the allées gives them a sense of scale. A strong analogy between Barnes's museum and the garden is formed as the minimal character of his all-white museum spaces is reiterated in green grass floors and green hedge walls. Openings in the walls provide glimpses of sculptures in other courts, just as Barnes's design for the Walker offers views of artwork in adjacent rooms.

The garden site was further isolated by Interstate 94, which severed it from Loring Park to the east. Artist Siah Armajani was commissioned to design a footbridge to span the yawning 16-lane chasm. Composed of inverted catenary arches, the footbridge re-integrates the sculpture garden into the verdant chain of parkland threaded through Minneapolis.

The heart of the sculpture garden plan is the four 100-foot-square grass courtyards, each framed by double-walled stone planters containing arborvitae. The courtyard enclosures that subdivide the garden spaces serve as a buffer against the noise of nearby freeway traffic. Once the arborvitae plantings mature they will be clipped to resemble the crisp box hedges that outline traditional European parterre gardens. Barnes cites the tall hedge walls of the Boboli gardens in Florence as inspiring the outdoor "rooms" of the Minneapolis garden. Seventeenth-century illustrations of the gardens of the Villa Medici present a striking parallel to the Walker's garden plan, particularly in its combination of box parterres with long rows of trees along the allées. Yet Barnes transformed historical precedent in a manner that supports the priority function of the garden as a space to display artworks. While European gardens often contain decorative plantings within the parterres, Barnes approached the design with characteristic clarity, reducing the forms to their elemental essence. Museum officials also stipulated that there would be no seasonal displays in garden to distract from the sculpture.

One area that seems too sparingly planted is the large meadow that contains as its focal point Claes Oldenburg's and Coosje van Bruggen's *Spoonbridge and Cherry* sculpture. This site-commissioned work is dramatically positioned at the end of the long north–south axis, and is sited over an elongated pond that assumes the role of the traditional *isolotto* in Italian gardens. The artist team's objections to the landscaping plan developed by Peter Rothchild led to the removal of informal tree plantings surrounding the pond, leaving its organic form isolated within the formal enclosure of the meadow. Considering the expansive garden setting, it is surprising that there were not more site-specific sculptures commissioned. The other commissioned works are Martin Puryear's totemic endposts which frame south entrance to garden.

The Minneapolis Sculpture Garden opened to almost unanimous critical approval, even though Barnes's formal garden plan deviates from the Olmsted-style naturalism of other Minneapolis gardens. Unlike many sculpture parks around the country, which have been developed as amorphous spaces containing randomly scattered trees and sculptures, both client and architect made a deliberate decision to develop clearly defined outdoor museum spaces. In the April 1989 issue of *Landscape Architecture*, Jean Feinberg praised Barnes's "courageous plan," observing that the romance of informal garden settings does not necessarily support the aesthetics of modern sculpture.

In spite of the critical success of the sculpture garden, Walker museum officials vacillated when planning a 2.5 acre expansion to the north. The planned expansion will increase the size of the garden to ten acres when completed in 1992. Rather than continuing the unification of the overall garden plan with a logical extension, the competing hand of another landscape architect vies for attention with the initial plan. Michael Van Valkenburgh, who collaborated with Barbara Stauffacher Solomon in the design of the Regis Gardens in the Cowles Conservatory, designed the expansion. His informal addition appears as an addendum intended to polarize the two basic approaches to sculpture park design, and the transition is abrupt from one space to another.

The wide variety of contemporary sculpture in the Walker's collection could certainly be shown to advantage in a similar variety of settings. The expansion to the Minneapolis Sculpture Garden may pose a question regarding the appropriate outdoor setting for the display of modern art, but its failing is that it assumes that there is a right and wrong answer.

—Barbara L. Koerble

Bibliography—

Viladas, Pilar, "Minneapolis Sculpture Garden," in *Progressive Architecture* (New York), January 1988.
Relyea, Lane, "Lawn and Order," in *Artpaper* (New York), September 1988.
Taylor, Sue, "Garden City," in *Art in America* (New York), December 1988.
Riddle, M., "A Modernist Museum without Walls," in *New Art Examiner* (Chicago), January 1989.
Goldeberger, Paul, "Sculptural Links in the Chain of Urban Events," in the *New York Times*, 29 January 1989.
Koerble, Barbara, "Design Clarity and Urban Synthesis," in *Architecture* (Washington, D.C.), February 1989.
Feinberg, Jean E., "The Museum as Garden," in *Landscape Architecture* (Washington, D.C.), April 1989.
Martin, Mary Abbe, "Splendor in the Grass," in *ArtNews* (New York), October 1989.

Luis Barragan (1902–)
San Cristobal: house, stables, and pools, Los Clubes, Mexico City, 1967–68
Mr. and Mrs. Folke Egerstrom

Although Luis Barragán, the Mexican master architect, has been justly admired and internationally known, the first book devoted to his work was published by Emilio Ambasz only in 1976, on the occasion of the Barragán exhibition at the Museum of Modern Art in New York, organised by Ambasz in his capacity as curator of design.

Both the exhibition and the book were more than necessary diffusion channels—a paramount hommage to a creator defined by Ambasz as "one of landscape architecture's most refined and poetic practitioners." "His magnificent fountains and carefully constructed plazas seem to stand as great architectural stages for the promenade of mythological beings," he said, adding that while his design approach is classical and atemporal, the elements of his architecture are deeply rooted in his country's cultural and religious traditions.

Barragán himself, an engineer by training and an autodidactic architect who learned the profession by direct experience, summed up his production in 1981, saying: "My architecture is autobiographical. It is the memory of the ranch my family owned near the village of Mazamitla, where I lived my childhood and adolescence." Barragán's description of Mazamitla, located in his native State of Jalisco, is more or less tantamount to a description of his architectural spirit and vision.

"It was a *pueblo* with hills, formed by houses with tile roofs and immense eaves to shield passers-by from the heavy rains which fall in that area," he recalled. "Even the earth's color was interesting because it was red earth. In this village, the water distribution system consisted of great gutted logs, in the form of troughs, which ran on a support structure of tree forks, five meters high, above the roofs. This aqueduct crossed over the town, reaching the *patios*, where there were great stone fountains to receive the water. The *patios* housed the stables, with cows and chickens all together. Outside, in the street, there were iron rings to tie the horses. The channeled logs, covered with moss, dripped water all over town, of course. It gave this village the ambience of a fairy tale."

Barragán, who began practising around 1927 in his native Guadalajara, the capital of Jalisco, and settled in Mexico City in 1936, said once that he believed in "emotional architecture." "It is very important for humankind that architecture should move by its

beauty," he argued. "If there are many equally valid technical solutions to a problem, the one which offers the user a message of beauty and emotion, that one is architecture." For Barragán, "any work of architecture which does not express serenity is a mistake. That is why it has been an error to replace the protection of walls with today's intemperate use of enormous glass windows."

Emotion, beauty, serenity, walls, water dripping, troughs, patios, fountains, gardens, color, horses, trees—the inventory of Barragán's architecture fits in those values and elements, and creates an architectural language capable of expressing man's eternal longings in the context of modern Mexico's natural and cultural conditions, "*a program of metaphysical imperatives*," as Ambasz called it.

San Cristóbal is one of his outstanding works, and completes what may be seen as Barragán's equestrian trilogy, after the residential subdivision of Las Arboledas (1958–61) and that of Los Clubes (1963–64), both in Mexico City's suburbs.

Once a ranch, Las Arboledas was conceived for residents devoted to horsemanship. Barragán designed the streets, established building norms and created all public gardens and fountains, as well as special paths for horses, gathering places for riders, walled enclosures, watering troughs and pools, all around and through a majestic avenue of eucalyptus trees.

As a symbol of the equestrian character he wanted to give the residential subdivision of Los Clubes, Barragán designed a heroically scaled fountain for horses, the Fuente de Los Clubes (or Fuente de los Amantes, Lovers' Fountain, as the two derelict horse troughs became known). San Cristóbal was erected precisely inside Los Clubes.

Mr. and Mrs. Folke Egerstrom, the owners of this stable, breed thoroughbreds they train as racehorses. Before being taken in an adjoining field, the horses are excercised within an enclosure defined by box stalls, pink and red-rust colored walls, and a great flat water pool. The walls are designed to the scale of a horse. Two masterful openings cut in a long pink wall serve for the horses leaving and entering, while riders enter directly from the house and grooms filter in between a double layer of purple walls.

The stone paving in front of the box stalls ramps down to create the pool's basin, fed by water gushing through an edge of the red-rust colored wall, which also shields visually the stable wing from one of the entrance doors. This wall is in fact a double plane with water running in between, although only at one of its ends. The second pink wall, higher, seems to suggest a fortification but it hides the haystack.

The Egerstrom house, Barragán's "most complex creation," according to Ambasz, is conceived as a multi-layered series of planes of different height defining a volume, one of its most accomplished features being the double wall which shields a long open corridor leading toward one of the entrances.

San Cristóbal is for all that a miniature of the old *pueblos* like Mazamitla—the house, the plaza, the patio, the fountain, the friendly trees, the water coming from away. A memory of other voices and other rooms but of the same men.

—Jorge Glusberg

Bibliography—

Smith, Clive Bamford, *Builders in the Sun: Five Mexican Architects*, New York 1967.
"I Muri di Luis Barragan," in *Domus* (Milan), November 1968.
McCoy, Esther, "Designing for a Dry Climate," in *Progressive Architecture* (New York), August 1971.
Ambasz, Emilio, *The Architecture of Luis Barragan*, New York 1976.
"The Works and Background of Luis Barragan," in *Architecture + Urbanism* (Tokyo), August 1980.

Photos Wolfgang Pehnt

Gunter Behnisch (1922–)
Hyosolar-Institute, University of Stuttgart, Stuttgart-Vaihingen, 1987–88

Following the previous works designed by the Stuttgart firm of Behnisch & Partner, the Hysolar-Institut came as a surprise. The Stuttgart architects had certainly demonstrated a characteristic effortlessness in the majority of their buildings, had valued relaxed designs and had left room for the interplay of the parts with the whole. They had kept a distance from any labelling of style as much as possible—so much so that their buildings were described by commentators sometimes as organic buildings, sometimes as developed Modern and were sometimes even placed (thoughts turning to Hans Scharoun) in an Expressionist tradition. One of the team's great successes was the Olympic Games site of 1972 in Munich, which had existed in varying forms since 1966, a successful experiment in combining state representation with the cheerfulness of an informal tent landscape.

The institute on the edge of the Stuttgart-Vaihingen technology college's campus is, by contrast, the product of contemporary collision architecture, a German contribution to international deconstructivism. Two two-storey rows of containers, the research laboratories, stick out like railway carriages in a train crash that have been pushed against and into each other at slanting angles. The approximate triangle of the roof which covers the collage of stairways and gangways splinters into glass and corrugated iron surfaces. Steel supports and beams, as well as the rungs of the glass curtain, stand and lie around like Mikado sticks which have just fallen from the player's hand. Here and there a steel beam protrudes out of the glass cover. A red, chord-like, twisted steel tube goes through and over this out-of-joint complex without fulfilling any more important, static tasks. Outside, scaffolding with solar panels has been set up which, by comparison with the apparent chaos of the institute building, stands apart as the guardian of law and order.

The Hysolar-Institute is a research project for German and Saudi Arabian institutions. Its purpose is to explore and test the generation and uses of solar hydrogen with the help of the latest technology. The building had to be constructed at low cost and rapidly. These two requirements, according to the architects, determined the design and the materials to be used—chiefly industrially produced goods from the catalogue. But, above all, the novelty of the commission must have given rise to the desire to translate it into an innovative appearance. That these architectonic collisions also suggest catastrophes does not seem to have entered into the semantic calculation; or are they to be seen as playing on the destructive power inherent in technology?

Günter Behnisch has always liked to describe his team's architecture as democratic building. The argumentation extends to several different levels of the design. In actual fact, the Stuttgart architects were unusually often involved in buildings for the social needs of the community: kindergartens, schools, sports centres and old people's homes. Formulations that could be interpreted as architecture of authority, an "architecture of the powerful," were avoided—there are no great axes, there is no obtrusive symmetry, no gestures of authority, with glass, transparency and lightness as metaphors. A division into many parts, often also into small parts, prevails. Unity is not sought in the uncompromising binding and rigorous formula, but in the variety of the differentiated.

Taking this into account, the order of events in the planning is organized in such a manner that the course of the design can be modified to make changes, additions and corrections for as long as possible. In Stuttgart-Vaihingen, as well, a series of design decisions was only taken on the construction site. Behnisch's hope is that a greater multilayered complexity and a greater composure will grow from these open processes. It is also part of his philosophy of planning to give freedom to things. Their resistance, their wishes, should not be sacrificed to a superficial perfection. The architect is assigned a role which resembles more that of a gardener. Behnisch views the architect as a mediator in the conflict between different demands, different types of form, different materials, different participants; he lets things happen rather than making them happen. Behnisch attributes the architect with the capacity to create "freedom and room to move for everyone and everything . . . and the opportunity for everyone and everything—even little things—to find their own form and place in the overall structure of society."

The executioners are particularly called into this planning mythology. "If you have to look a craftsman in the eye, you will also reflect on whether a job can be done under humane conditions." Behnisch's office for its part is federally managed so that hierarchical constraints are given little importance. The project architects (in this case Frank Stepper and Arnold Ehrhardt) and the firm's partners responsible in each project (in this one, Erhard Tränkner) share the responsibility.

Seen from this way of thinking, such a provocatively anarchic building as the Hysolar-Institut becomes more comprehensible. Behnisch has already spoken a long time ago about the original power which resides in the seeming disorder and chaos. "Everyone and everything" *wanted* the architecture here to appear especially wild. Just as with Behnisch things are left more free movement, so are those employed on the projects—one person dealing with the project, Frank Stepper, came from the respected Vienna deconstructivist team, the Coop Himmelblau. Meanwhile, other Behnisch architects have produced further examples of topical catastrophe-architecture, as in the university library in Eichstätt (1987)—admittedly tamer in appearance from the exterior—and a kindergarten in Stuttgart-Luginsland (1987–1989).

—Wolfgang Pehnt

Bibliography—

Behnisch and Partners, *Architekten Behnisch und Partner: Arbeiten aus den Jahren 1952–87*, Stuttgart 1987.
Bachmann, Wolfgang, "Hyosolar Forschungs- und Institutsgenbaude der Universitat Stuttgart," in *Bauwelt* (Berlin), 8 January 1988.
Wortmann, Michael, *Lichtblick in der Gewerbesteppe*, Dortmund 1990.
Bohning, Ingo, "Behnisch und die Dekonstruktivisten," in Wyss, Beate, ed., *Bildfalle, Adolf Max Vogt zum 70. Geburtstag*, Zurich and Munich 1990.

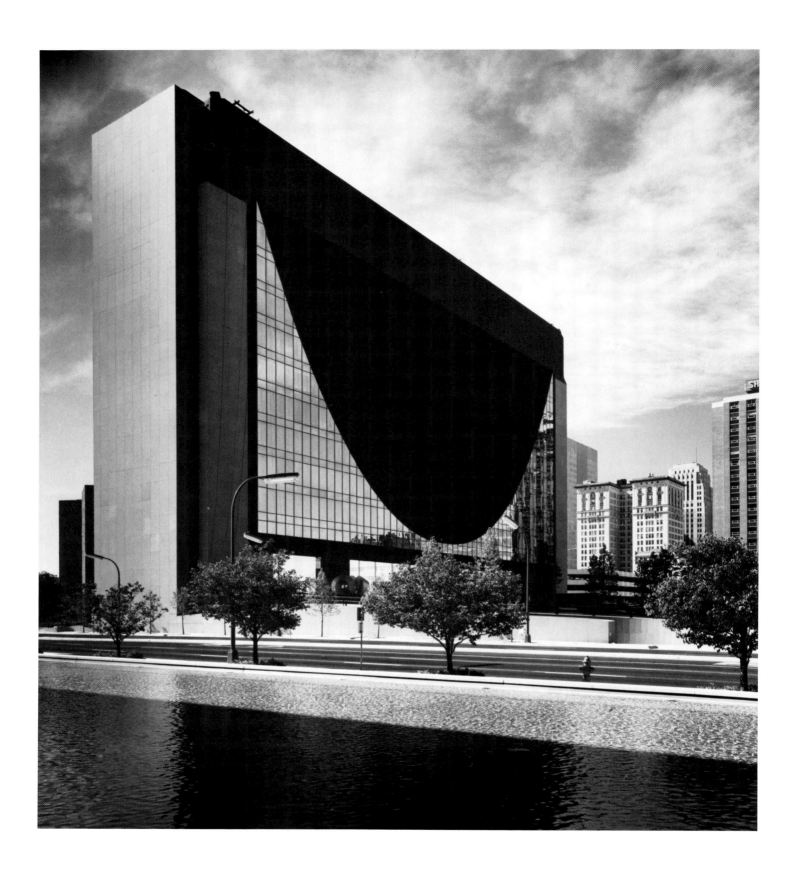

310

Gunnar Birkerts (1925–)
Federal Reserve Bank, Minneapolis, 1967

America is the home of many fine modern buildings. One thinks of Frank Lloyd Wright's constructions; of Le Corbusier's projects; and closer to our own time, of the work of I. M. Pei and Richard Meier. Few of these buildings, however, are as strikingly original as the Federal Reserve Bank in Minneapolis—indeed, it is one of the most eyecatching edifices in the United States.

The Bank's beginnings go back to the mid-1960s, when the Federal Reserve decided to rehouse its Minneapolis operation. After considering proposals from 14 firms the authorities resolved to adopt the plan put forward by Gunnar Birkerts, the Latvian-born emigré architect who had made a name in America with his unusual buildings. Hitherto, Federal Reserve banks had been constructed in a reassuringly classical style, the security they needed for their work being provided by massive stone walls. In Birkerts' plan, however, something very different was envisaged—something so original, in fact, that nothing like it had ever been built before.

Birkerts is a Modernist. By his own admission he grew up with the Bauhaus and is fully conversant with its history and tenets. That said, he strongly abjures rigid ideology—for him, architecture is primarily a matter of intuition, a question, that is, of creativity in the deepest sense. "Not theories, but life lived is at the base of all good architecture" he has written. In the Federal Reserve Bank in Minneapolis this is clearly apparent: while completely "Modernist," the building is at the same time completely original.

Birkerts' design was planned, first and foremost, around the need all Federal Reserve banks have for security. Eschewing the traditional classical edifice surrounded by high walls, he chose instead to separate the bullion vaults and truck ramps from the administrative offices, burying the former in a massive granite plaza while suspending the latter from a huge bridge-like structure overhead. The effect is to remove administrative staff from any possible danger zones, at the same time leaving the high-security sectors of the Bank free to carry out their work unimpeded. The plaza-and-bridge design has other advantages, too: the absence of interior columns and walls means trucks can flow freely beneath the ground, while above, in the suspended offices, employees can enjoy a pleasant, light-filled environment with uninterrupted views across their city. (Like other architects from northern latitudes, Birkerts is highly conscious of the importance of light.) In addition, finally, the bridge design will enable future architects to build a further six storeys on top of the existing 11, should the need arise (Federal guidelines require the possibility of a 50 per cent expansion in office space).

Birkerts' design is more, however, than merely practical. So striking is it that the Bank has become not just widely known but almost emblematic. For some its towering shape, linked internally by the huge looping catenary, is a giant gateway leading to the Mississippi and the great plains beyond; for others it is vast "M" for Minneapolis, a symbol of the city's pride and importance. Even the plaza beneath has its own significance: besides fulfilling a civic plan that called for an open space in this spot, it serves as a reminder of the vast, harsh land surrounding the building (Birkerts has written that he wanted it to resemble the eroded base of a mountain). The whole design of the Bank, in fact, displays great sensitivity towards its mid-Western environment; it can be no accident that its architect is proud to have become a mid-Westerner himself.

There are, inevitably, a few problems. Perhaps chief of these is the fact that the plaza—like the plazas of so many modern buildings—has not lived up to expectation, being unpleasantly hot in summer and dangerously icy in winter (rope-holds have had to be installed to avoid lawsuits). In general, though, the Federal Reserve Bank in Minneapolis has turned out to be hugely successful: proof, in Birkerts' own words, that the modern architect can "shoot for the moon and have the wisdom to bring it back down to earth."

—John Terence O'Leary

Bibliography—

"Federal Reserve Bank in Suspense," in *Architectural Forum* (New York), January/February 1969.
"Eine Bruecke fur die Federal Reserve Bank in Minneapolis," in *Werk* (Zurich), no. 4, 1970.
"Bridge for a Bank," in *Architectural Forum* (New York), June 1971.
"Gunnar Birkerts," special monograph issue of *Architecture + Urbanism* (Tokyo), July 1972.
"A Minneapolis, La Banca," in *Domus* (Milan), January 1975.
"Aktualitat: Federal Reserve Bank of Minneapolis," in *Bauen und Wohnen* (Zurich), April 1975.
Futagawa, Yukio, ed., *GA 2: Gunnar Birkerts and Associates*, Tokyo 1982.
Benson, Robert, "Gunnar Birkerts and the Domino Theory," in *Inland Architect* (Chicago), January/February 1986.
Kaiser, Kay, *The Architecture of Gunnar Birkerts*, Florence 1989.

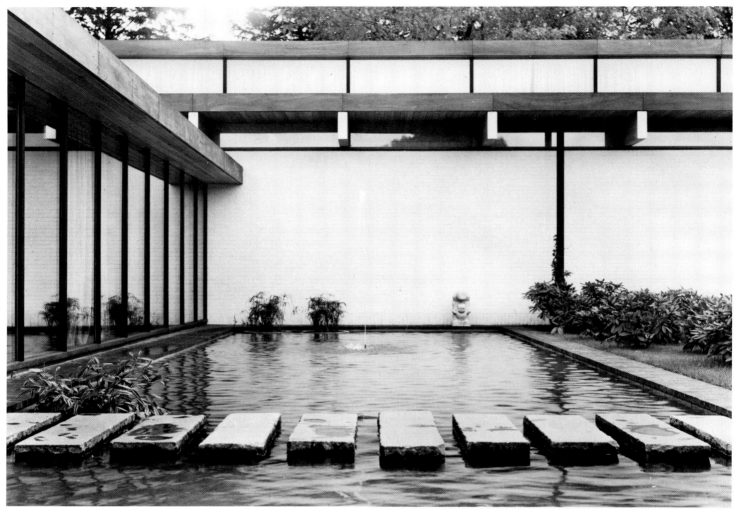

Photo courtesy Jorgen Bo Associates

Jorgen Bo (1919–)/**Wilhelm Wohlert** (1920–)
Louisiana Museum of Modern Art, Humlebaek, 1958–62

Frequently the impression projected by art galleries is of an elite approach to culture. At Louisiana a setting is provided which allows art, music, landscape design and architecture to be appreciated in an accessible way. The entrance to the galleries and the only significant facade presented on approaching the building is that of an existing mid-nineteenth century villa. Visitors are allowed to feel that they are guests at Louisiana.

From this villa the design allows the guests to meander through a series of galleries and corridors which are set in a landscaped garden. The layout of the design is controlled by the position of natural features such as a small lake and the location of mature trees which are a characteristic of the site. A gallery which is both of double height and well proportioned overlooks the lake which is surrounded by trees. Eventually the visitor is led to the café that has access to a terrace with a view of the sound between Denmark and Sweden. Art works may be observed at a leisurely pace which in a way is implied by the closeness to nature. The architectural expression is reticent with a delicate effect upon the senses.

There is a timeless feeling to be found in the complex of pavilions, corridors and galleries of the Louisiana Museum. It is discovered in the rhetoric that exists between art and nature. The architectural setting complements the enjoyment of works of art. Clearly the subtleties in design produced by the architectural interpretation of the brief have not only come to terms with the impressive site provided for the Museum, but the designers have been inspired by the possibilities available. This is reflected in the use of natural materials as well as in the informal composition.

Jorgen Bo and Vilhelm Wohlert, the architects for the Museum, originally conceived the design whilst staying at the Villa Louisiana for two "wonderful" weeks in 1956. The language of the architectural style they developed at that time has been flexible, so that the additions and modifications that have occurred over the years have been accommodated by that approach to design. One of the delights of visiting the Museum is to experience the natural, arguably organic, quality created by the addition of new galleries and of corridors forming paths through the landscaped garden. An auditorium where music is regularly performed has been designed as an extension of the café. The new facilities have grown naturally from the original design concept over three decades, and the reliance of the architects upon the use of natural materials allied to a modern approach to design is reflected in the human scale of the spaces.

Materials are used in a natural way to express their tactile qualities. Externally, the whitewashed brickwork is enlivened by recessed jointing to form a plainer base to the timber frame of the clerestory lighting. Smooth red brickwork is used as an internal floor finish, which is set against the timber windowsills and mullions that echo the natural setting. The timberwork at clerestory level is of redwood, pinewood and Bangkok teak which is given a natural finish. The joists are exposed and become a feature of the architectural expression. Textural qualities of the materials are apparent throughout the building, but harsh surfaces are toned down. Perhaps it would be fair to say that the detailing is deceptively simple.

Frequently, the way art galleries are lit appears contrived but fortunately the domestic scale of Louisiana has implied that particular lighting affects are used. Seldom is direct lighting from above provided in the smaller galleries. Sometimes a top lit formal device is situated to create a specific effect but it is more usual to find clerestory lighting, curtained to avoid direct sunlight. Other galleries rely upon side lighting. Good quality industrial design is found in the copper lanterns which direct light onto the walls to illuminate and enhance the natural textures. An awareness of the appearance of surfaces is integral to the conceptual approach of Bo and Wohlert. Larger galleries have been included in the recent additions, but the control of the visual qualities of these spaces is less successful. Louisiana is really a design best suited to the human scale.

The essence of the design is that the scale is appropriate both in plan and as a characteristic of the formal appearance. The planning is controlled by a modular unit which results from the spacing of window mullions in the corridors. Yet, the rhythm which results from the mullions and the precision of detailing is not obtrusive; rather a natural texture is provided for the spaces which alternate between open and enclosed forms. A balance is achieved between vertical and horizontal elements that creates a sense of harmony. This quality of scale and harmony unifies both interior and exterior so that the timber joists exposed internally are allowed to overhang the whitewashed brick walls, on which they are set, to provide a delightful formal rhythm with consumable ease.

To an extent, the design is reminiscent of the planning concepts of traditional Japanese architecture, particularly in the way in which people move through the building and in the manner in which the formal elements of the design are placed. At one point, stepping stones lead one across a small pond to a sculpture garden. Sliding glazed doors open from the corridors into the garden and are evocative of the affect of Japanese screens. The total impression created is that of a contemplative and spiritual dimension.

The design reflects the intrinsic quality of Danish craftsmanship not only in the detailing of the building but also in the choice of furnishing and fittings. There is an economy of means, a purity of conception and care in finishing in both the industrial design and architecture. Jurgen Bo and Vilhelm Wohlert's chair that was specifically designed for Louisiana is a particularly elegant piece. The skill in design restraint is to be discovered in the design of the open fireplace of the cafeteria and of the pergolas in the garden.

Whilst Bo and Wohlert have other works to their credit, including the sensitive rehabilitation of existing buildings, none is as successful nor as influential as Louisiana which can be spoken of, in the context of Danish architectural design, in the same breath as the better works of both Arne Jacobsen and Jorn Utzon.

—E.S. Brierley

Bibliography—

"The Louisiana Museum," in *Arkitektur* (Copenhagen), nos.3, 4, 1959.
Faber, Tobias, *Dansk Arkitektur*, Copenhagen 1963, 1976.
"Extension to the Louisiana Museum," in *Arkitektur* (Copenhagen), no.6, 1973.
"Louisiana—extensions 1971–82," in *Arkitekten* (Copenhagen), no.7, 1982.
Louisiana Museum, *Louisiana: The Collection and Buildings*, Vaerlose 1986.

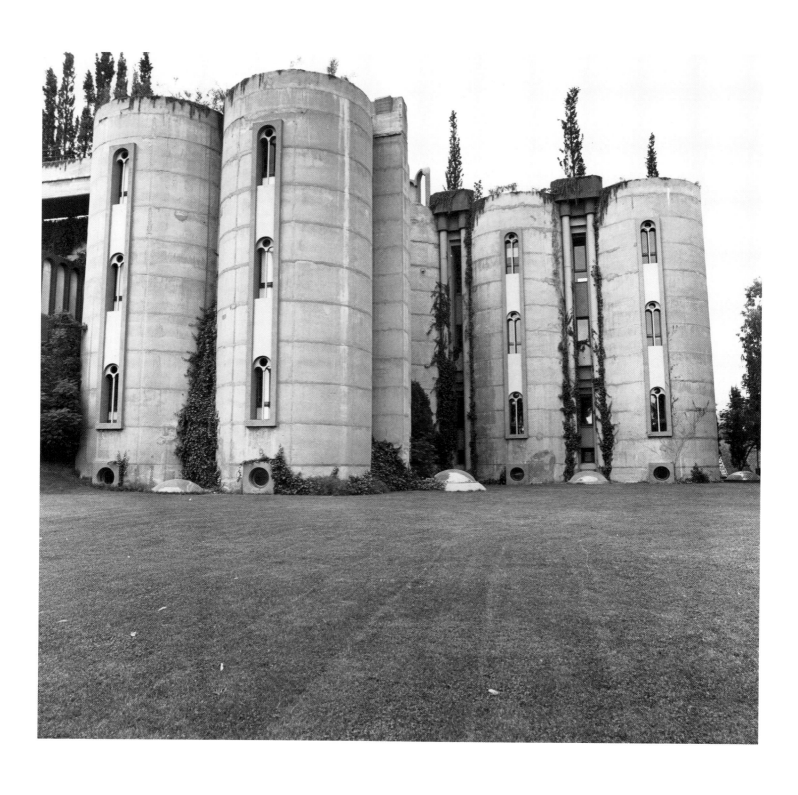

Ricardo Bofill (1939–)
La Fabrica cement factory/Taller de Arquitectura conversion, Sant Just Desvern, Barcelona, 1973–76

When Ricardo Bofill first saw the concrete silos, chimney, machine-rooms, and immense underground galleries of the disused factory he was later to convert, he observed in the complex an embodiment of an aesthetic that had been developed since the War of 1914–18. Those memorable images of grain silos, hoppers, and vast industrial structures that had served Erich Mendelsohn so well in his visions of a new architecture which he created when serving in the German Army during the catastrophe of the First World War, struck chords in Bofill, who saw paradoxes in the making of stairways which led nowhere, in spaces that were full of emotional and visual power, yet were useless, and in the strange proportions that became full of wonder through the tensions they set up in the eye of the beholder. Not only that, but the stereometrically pure forms had independent visual existences, reduced to basic shapes, and sometimes were broken, so they suggested something of the chilly stripped Neoclassicism of the end of the eighteenth century. The empty factory shell thus possessed primitive elements, abrupt, tough, and sculpturally violent, with the rough material fully exposed.

What was so interesting was that the factory had been expanded and added to as demands were made to increase production, so the result was that not only was there a stratification of volumes, but various powerful objects were set in space, and not particularly related to each other in any architectural way, rather like a complex of vernacular buildings that had been extended and altered as needs arose.

Bofill was bowled over by the ambiguities of the factory, and he decided to retain much of the fabric, adding to it, sculpting it, and moulding it into a coherent composition. Using explosives and hammers, the buildings were altered, changed, partially demolished, and stripped to the bare bones, so that concealed forms were revealed, and the potential power of the spaces was made plain. The next step was to clean out all débris and dust, and then a platform or plinth was created and planted which gave a marvellous green base from which vegetation would climb the walls. At the same time the tops of the platforms and silo towers were planted so that the roofs were covered with greenery, including tall evergreen trees, giving the character of a ruined series of mausolea, a broken hill-town, or even allusions to Arnold Böcklin's celebrated *Toteninsel*: from the roofs planting would also be encouraged to descend towards the ground.

Then came what Bofill has described as the annulment of functionalism. By this he meant the complete change of use, and also that spaces and use can be dissociated; for a beautiful, well-conceived space can hold a variety of functions, if the architect approaches his task with verve, sensitivity, and competence. So much for 'from follows function' and other manifestations of feeble thinking.

Slowly, the factory was transformed. Bofill turned, not to the machine-aesthetic of the humourless dogmatists of C.I.A.M., Constructivism, and Functionalism, but to the despised craft traditions which are an essential ingredient of great architecture: and in his Catalan craftsmen he found the ideal responses to his intentions. As the work proceeded, the various parts of the ensemble began to suggest memories of cathedrals, fortifications, earthly paradises, silos of intelligence (that is, reservoirs of motifs and themes), catacombs, and even Classical ruins. Next, Bofill began to introduce a vocabulary into the scheme based firmly on historical precedents, but the vocabulary was that of high architecture rather than of the vernacular. There are references to Venetian arches, to false perspectives from the Renaissance masters, and to a

long tradition stretching back to Roman Antiquity. In this "free-thinking lay monastery," Bofill set up his studio and living quarters. It is as though themes of association, sparking off new ideas, grow from this extraordinary place, a fortress of feeling, craftsmanship, and intellect, defended by a remarkable architect against the forces of utilitarianism and poverty of spirit.

Undoubtedly the most dominant forms in the complex are the cylindrical towers, some of which have acquired Venetian arches arranged in tall loopholes, but there is an L-shaped concrete wall pierced by large rectangular openings which plays a very important part in holding the composition together. Massive bridges from which cypresses grow up towards the skies, concrete beams that leap out of walls, and a marvellous counterpoint of great complexity add up to a stunning ensemble. Repetitive motifs such as tall semi-circular-headed openings recall some of the stripped Neoclassicism of the 1930s and 1940s, and the scale, in parts, of a Roman aqueduct.

Bofill has added to the stripped core of the factory, but he always intended that the transformation should remain unfinished to suggest the ambiguity of a ruin and a rehabilitated building with a change of use. He finds that he has been able to live and work there more satisfactorily than anywhere else, and this is not surprising, for the complex is a *tour-de-force* of imagination worthy of genius itself. As well as Bofill's studio, office, and home, this marvellous place also contains several apartments. Details allude to ruined, incomplete Classical porticoes, but the sophistication and sheer beauty of the interiors is undeniable. While ruins, Classical Antiquity, industrial silos, Expressionist drawings, Renaissance complexities, fortifications, and much else can be found in Bofill's work here, there is another theme of complicated geometries that crops us again and again: this is an allusion to spatial inter-relationships derived from Baroque precedents and (dare one say it?) from the extraordinary legacy of Catalan architecture and designs, not least the work of Gaudí. Bofill believes that daily life should not be banal, but should be exalted, to enrich Mankind, and that the creative architect should be the agent of this change.

In his great work described above, the essence of Catalonia can be found, for that country is a place where many cultures mix: northern and southern, Mediterranean, Classical, and even North African elements merge, to produce a violent, startling, and yet uplifting architecture of immense emotional power. Quite clearly the dreary leftist Calvinistic ethos of so much of the Modern Movement, with its desiccated austere aesthetic, and its moralistic and materialist pretensions, is absent. In this work of Bofill the spiritual, historical, and craft-orientated aspects are gloriously, triumphantly, wonderfully evident. Here is life, joy, spiritual uplift, and much else in a building that represents the reservoirs of the springs of creative invention. It is a building with a vocabulary and a language undreamed of by tight-lipped Northern dullards. It is a great achievement.

—James Stevens Curl

Bibliography—

Goytisolo, Jose Agustin, *Taller de Arquitectura*, Barcelona 1977.
Bofill, Anna, "Taller de Arquitectura," in *Wonen-TA/BK*(Heerlen), April 1979.
Futagawa, Yukio, ed., *GA 19: Taller de Arquitectura,* Tokyo 1980.
Bofill, Ricardo, "La Cimenterie," in *l'Architecture d'aujourd'hui* (Paris), no.213, 1981.
Bofill, Ricardo, *Taller de Arquitectura: city design, industry and classicism*, Barcelona 1984.

Photos courtesy of Architekturbüro Böhm

316

Gottfried Bohm (1920–)
Town Hall, Bergisch Gladbach-Bensberg, 1962–71

In 1962, the year in which Gottfried Böhm designed Bensberg town hall, the debacle over German post-war architecture—in fact not just German post-war architecture—was already coming to the fore. A spiritual vacuum, squandered opportunities, the destruction of the countryside and inhospitable environments—such phrases were already common currency. Resistance by the individual was required to combat the general levelling down in such a situation. Originality acquired renewed value. In the attempt to be different from the much maligned commonplace architecture, religious and cultural buildings often stood out as bizarre exceptions to the routine, replacing old disasters with fresh ones.

Böhm's works are themselves not without such tendencies. But in the Bensberg town hall, the Cologne architect succeeded in creating a building that shunned the dialectic of the banal and the bizarre. Böhm offered something that had never been seen before, but that seemed natural. He did not treat history primly or without respect. Original to the point of foolhardiness, the building took its place in the townscape as though it had always stood there.

Bensberg, at that time an independent town of barely 40,000 inhabitants, lies on the easterly ridge of the Cologne basin. The skyline was, and is, as exceptional as it is vulnerable. The new castle, a summer residence built for the electoral prince of the palatinate, crowns the spur of a hill, a miniature Versailles with four amusing little towers topped with domes and a sturdier central tower. The old castle, once the home of the Counts of Berg, descends the slope; it was built looking inwards on itself and prepared to defend itself, not stretching out expansively like the Baroque structure on the heights. Only the foundations, the wall surrounding the palace, the external fortifications, the large keep and the smaller tower on the ramparts have survived of the Romanesque site. Once the new castle had been constructed, the well-fortified round castle quickly fell into disrepair. In the 19th century, a religious hospital was established in the ruins, but it was finally abandoned as it was uneconomic to run. Just a little before the beginning of planning, the town acquired the piece of land.

The building location was not uncontroversial. Many people favoured a site at the foot of the hill where new residential quarters were advancing towards the Cologne metropolis. But the town councillors showed self-confidence in their plan to make the seat of the former sovereign of the town the chosen centre of the community, and courageously awarded the commission to the competition winner Böhm. What the son of the great builder of churches, Dominikus Böhm (1880–1955) had suggested surpassed any visions that his father had ever cherished in the period when Expressionism was at its zenith—just as Hans Scharoun with his design for the Berlin Philharmonic building, only now was Böhm able to realise the boldest ideas from his youth.

Böhm placed his town hall next to and on the vestiges of the medieval feudal architecture. New parts were added to the palace and the keep in an irregular oval shape which corresponded quite closely to the old circular castle. The paved courtyard leads up to the entrance following the natural rise in the land, making a grand and beautiful gesture of welcoming and embracing. The new part is reached through a massive tower with its stair-case which leads to a fantastical point, a free sculpture in concrete. The architect had envisaged this modern counterpart to the keep and its irregular slate tower projecting even higher into the sky. But the design was trimmed down, not to its detriment. Timidity was not one of Böhm's characteristics. On the east side the mass of the building is eight storeys high, but it is given rhythm and made acceptable by projecting triangular bays.

The palace wall that was retained was used by Böhm to create the council chamber. The old masonry at the back of the auditorium preserves the element of shelter and protection, but, looking in towards the courtyard, the chamber has been ripped right open and panneled with glass to give one the impression that one is sitting in the open. Like this, the architect wanted his fellow citizens settled between the massive and the light, between protectiveness and openness. Walled-up windows with two or three arches, attributed to the Cologne atelier of St. Gereon and dating back to the 13th century, were uncovered during the building work. The sills of the later, now blocked-up Renaissance windows were also left in the wall. The idea was that the history of the place was to remain decipherable while the new building was to appear as the last, if also tremendously dominating, link in the chain of the centuries. It was only to the relics of the 19th century that Böhm's tolerance did not stretch.

A phobia towards visible concrete has developed in recent years as has a great cautiousness in dealing with original material handed down through the centuries. More conformity is shown, and fewer scruples when it is a matter of fictitious re-inventions of alleged history. Böhm was not cautious and he has not conjured up any tricks of illusion for his public. Far more, he found a strong answer to a difficult challenge, used coarse-grained visible concrete next to the rough quarried stone of the historical part of the building and trusted in the power of self-assertion of the old just as of the new.

Its self-assurance cast in concrete did not help the client, the town of Bensberg, much. In 1975 it was merged with the neighbouring town of Bergisch Gladbach and furthermore lost its place name in the process. Böhm's proud town symbol now only houses half of the town hall, specifically the technical departments. The council sometimes sits here, sometimes in the other part of the new town. At least the changes meant the building was given the opportunity to demonstrate its adaptability. The heavy concrete construction contains more possibilities of adaptability than its exterior would leave one to suppose. The walls inside can easily be moved and the rooms correspondingly reduced or enlarged, although the building is anything but an example of neutral container-architecture.

Unfortunately, the townscape has changed very much for the worse. Speculators were allowed to erect housing and offices in the neighbourhood, whose boorish bulkiness detracts from Böhm's achievement. The desired jump in scale from the small typical local half-timbered houses to the imposing citizens' castle has become the vulgar rule. Town planning proposals which Böhm himself submitted for a cultural centre and a market were not realized.

—Wolfgang Pehnt

Bibliography—

Pehnt, Wolfgang, *New German Architecture 3*, New York 1970.
Nestler, Paolo, and Bode, Peter M., *Deutsche Kunst seit 1960: Architektur*, Munich 1976.
Raev, Svetlozar, ed., *Gottfried Bohm: Bauten und Projekte 1950–1980*, Cologne 1982.
Weisner, Ulrich, Pehnt, Wolfgang, and Sack, Manfred, *Zusammenhange: Der Architekt Gottfried Bohm*, exhibition catalogue, Bielefeld 1984.
Raev, Svetlozar, ed., *Gottfried Bohm: Vortrage, Bauten, Projekte*, Stuttgart and Zurich 1988.

Photo courtesy of Mario Botta

Mario Botta (1943–)
Casa Rotonda, Stabio, 1981

The antecedents for Mario Botta's designs, of which the Casa Medici, better known as the Casa Rotonda, at Stabio is generally accepted to be a significant example, can be found to a large extent in the influence of his tutor at Venice, Carlo Scarpa, and to the work of Louis Kahn and Le Corbusier both of whom designed projects for Venice during the time when Botta was a student.

An essential feature of a building by Botta is the way in which geometry is used to reveal the overall formal content of the design. This is the central theme of the Casa Rotonda for, unlike other houses by Botta which are built on magnificent, often steeply sloping sites, the Casa Rotonda is built on the perimeter of the Ticino village of Stabio. The landscape of the site, which is one of several plots for single family houses, is enlivened by a hill to the north. Normally Botta places the emphasis upon the frontality of his houses; however, the almost featureless site at Stabio has suggested that the design should be circular in plan form with subtleties of expression giving emphasis to parts of the elevation.

A distinguishing feature of the house is that provided by the semi-circular expression of the staircase which forms a strong focus to the elevation and denotes the entrance to the house. The drum like form of the staircase, built in concrete block, reads as a column perhaps evocative of Ancient Roman forms. The mass of the "column" is revealed by the spatial penetration of the circular concrete block form of the house on either side of the "column." The use of the metaphor of defining the staircase as column is enhanced by a "capital" motif of blockwork which links the semi-circular column to the circle form of the house. Technically, this proves to be a very adept solution to reconciling the contrasting formal expression. Another feature used by Botta which is reminiscent of Roman design is that of a string course of blockwork placed at forty-five degrees to the wall surface to read as a dog tooth pattern and to terminate the vertical emphasis of the elevation below a block on edge parapet. The affect of this angle to the block course is particularly intriguing on a sunny day when the changing shadow effects create a stimulating shimmering pattern. It is a perceptual effect that Botta has used for other designs, in particular the house at Morbio Superiore.

It is usual for evaluations of dwellings to be based, to a large extent, upon the formal disposition of rooms; yet the starting point to understand a house designed by Botta is the way in which space is controlled. The functional use of space is subsidiary to the dramatic events contained in the plan. The feature which provides the spatial character of the interior of the Casa Rotonda is aligned on a north-south axis with the staircase to the north and a segmental balcony at first floor level to the south. This axis is defined by a narrow roof light formed by a strip of pitched glazing to the otherwise flat roof. Natural light is thus provided to the second floor circulation space of the bedrooms and by means of a void in the structure to the first floor living space. The device of a linear central lightwell is a feature of Botta's architectural language. That feature is often accompanied by a narrow vertical slit in the elevation which terminates in a small window. At the Casa Rotonda, this slit symmetrically divides the segmental balcony, and the small window provides light to the entrance hall.

One explanation offered for the emphasis placed upon the vertical feature, and indeed upon the sense of enclosure or privacy given to the interior spaces, is a need to acknowledge the mountainous scale and geography of the Ticino. Perhaps the architecture of Botta illustrated by the Ticino houses, including the Casa Rotonda, may be termed regional. To an extent this is true both in the way detailing and materials provide appropriate formal devices for the variable Ticino climate. Although Botta's designs for single family houses in the Ticino invariably have intriguing plan forms, a skilful use of symmetry and spatial penetration of form, the Casa Rotonda at Stabio has the additional quality of formal entity. The skylight that reflects the organisation of the internal spaces is also used as a formal device to terminate the composition of the south aspect which contrasts with the massing of the "column" device to the north.

The circular plan of the house which results in the formal envelope of the building and the linear light well which cuts through two floors determines the quality of internal spaces. This works well at the first floor open plan living spaces but less well at the bedroom level where uncomfortable shapes are found. In other houses by Botta such as the family houses at Origlio and Pregassona he shows that he is a past master at the art of defining internal spaces on the basis of geometrical rules.

The lighting effects provided by the rooflight, allowing shafts of sunlight to enliven the interior spaces, to an extent acts as a relief to the monotone colour scheme of grey blockwork, white walls and black ironwork for the door and window frames. There are, however, two circular concrete columns in the living space which are painted a delicate shade of blue.

The work of Botta is significant in assessments of developments in Swiss architecture. He has been influenced by both the Atelier 5 office, whose work owes a considerable debt to Le Corbusier in the use of materials and forms, and by his fellow Ticino architect Snozzi with whom he has been associated. Yet, a clear indication of formal influences is given by the name Casa Rotonda, for Botta continually draws upon the forms and detailing of Ancient Rome. He often uses constantly repeated decorative geometric patterns in a similar manner to Scarpa. However, the flair contained within designs by Botta such as the Casa Rotonda reveal a mature integration of architectural style both in detail and overall composition, and that skill is indicated in the way the building is used to give identity to a place.

—E.S. Brierley

Bibliography—

Sanguineti, Eduardo, Nicolin, Pierluigi, and others, *Mario Botta: La Casa Rotonda*, Milan 1982.
Botta, Mario, "Casa a Stabio," in *Rivista Tecnica* (Bellinzona), no. 2, 1982.
Futagawa, Yukio, ed., *GA Architect 3: Mario Botta*, Tokyo 1984.
"Mario Botta," special monograph issue of *Space Design* (Tokyo), August 1984.
Dal Co, Francesco, *Mario Botta: Architecture 1960–1985*, London 1987.

Photo British Architectural Library/RIBA

Johannes Andreas Brinkman (1902–49)
Van Nelle tobacco factory, Rotterdam, 1926–29

The most celebrated product of the Rotterdam partnership (1925–36) of Johannes Andreas Brinkman and Leendert Cornelius van der Vlugt was the Van Nelle Tobacco Factory near Rotterdam (to the design of which Martinus Adrianus Stam also contributed). This large building, begun in 1926, and completed in 1929, is one of the most significant and influential twentieth-century industrial buildings for reasons more complex than its undoubted photogenic character and unquestionable elegance.

In terms of its composition the Van Nelle Factory consists of a large, eight-storey slab-block with attics, the staircases and vertical circulation areas being expressed as towers attached to the long slab of the factory proper which is clad with a curtain-wall, the windows arranged as long strips with solid bands between them. The staircase towers are clad with fully glazed curtain-walls, but the emphasis of the tower fenestration is vertical. Curved wings of three storeys over basements and with attics, the tall chimneys, and the freely expressed ramped corridor-connections, with lower buildings, complete the ensemble. The cladding, indeed, is one of the best of the earliest examples of a fully developed curtain-wall system, while the treatment of the massing of blocks, the relationships of solids to voids, and the disposition of elements and masses is extraordinarily sophisticated, memorable, and bold. In can be said that the Van Nelle Factory combines some of the main architectural concerns of the Modernist camp of the 1920s in the one building, but we are here concerned not only with motifs and themes, but with dogma.

Constructivism is a term that is rather vague and ill-defined, but its devotees strove to eliminate the distinctions separating art from life by devaluing art in favour of technology, which was then elevated as an "art" form. Constructivism seems to mean a movement concerned mainly with expression by means of constructions, but its main thrust was essentially anti-aesthetic, anti-craft, and utilitarian: it was embraced by those with left-wing pretensions, but its manifestations were so extreme that its practitioners, and indeed the movement, were denounced for decadent bourgeois tendencies in the Soviet Union, so that Constructivist ideas fell on more fertile ground in Western Europe and America. Constructivism tended to produce an architectural theory that created buildings which were little more than expressed structural frames clad with transparent envelopes, and with the systems of access and circulation clearly expressed, and even exaggerated. In many respects the Van Nelle Factory is a manifestation of Constructivist principles of the 1920s, and is actually very close in its themes and motifs to the entry by Hannes Meyer and Hans Wittwer for the League of Nations Competition of 1926–27. Even today, the factory provides a good example of reinforced concrete construction with "mushroom" columns and curtain-walls. The Constructivist elements are clear, especially in the moving conveyor-belts that cross backwards and forwards in the elevated glazed ramped corridor-connections between the slab-block of the Factory proper and the warehouse by the canal.

Something of the fanaticism of the time can also be detected in the Van Nelle Factory, for in the building the complete devaluation of architecture as an art is apparent, as is the attempt to impose an "exact science" based entirely on function and technology. The breach with traditional formal demands of architecture is startlingly obvious in this building, as is the reduction of architecture to the resolution of problems of organisation. Indeed the attitudes and dogmatic stances that are so clearly stated in the Van Nelle Factory were to permeate the 1928 C.I.A.M. Declaration in which organisation of function was elevated over any aesthetic considerations. The architects of the Van Nelle Factory had a pronouncedly idealistic faith in the "new" building techniques, holding that "functional" architecture would herald a bright new future. The *expression* of structure, curtain-wall, and conveyors therefore was perceived as profoundly moral, and the Factory was not just a work of modern architecture, but an icon of 'Functionalism'. These attitudes, of course, sounded the death-knell of traditional craftsmanship, and elevated the prefabricated factory-made artefact to an almost mystical status.

Yet how "honest" is this "Functionalism?" As with many other designs of the period, the image of the ocean-going liner is evoked. Portholes, horizontal bands of windows, and handrails like those of the decks of ships, were *de rigueur* in Modern-Movement architecture of the 1920s and 1930s, and they recur in plenty in the Van Nelle Factory. The curved glazed walls of the attic-storeys over the staircase towers owe something to maritime design, and also to airport towers, while the ubiquitous horizontal strip-windows, wrapped round the ends of the main slab-block, recur in thousands of buildings from the 1920s to the present.

Now the point is that these motifs actually help to establish a set of *stylistic* themes, and therefore, by the fact that they are derivative images, are not as "rational" or as "functional" as the architects who favoured them claimed. The "technological" and "machine-made" aesthetic provided a series of clichés that were actually rather more limited than the vast vocabulary and rich language which the despised Classicism could offer, and which gave the craftsman no place in the creation of new buildings at all. All the limited range of clichés did was to *suggest* functionalism, because they were associated with the *claims* to modernity.

The Van Nelle Building is therefore rather more than an apparently elegant industrial structure of its time displaying many fashionable clichés favoured by "progressive" architects. It is, in fact, an important landmark in the links between Constructivism, Functionalism, the Bauhaus, and the various architectural and political trends that eventually joined and became restrictive chains, stifling architectural development of our cities and towns. The anti-aesthetic concerns expressed in the Factory have their roots in Calvinism and in the iconoclasm of the Dutch Reformation: they were to surface in the antagonism between the traditionalists (who included many Roman Catholics) led by Granpré Molière of Delft and those who favoured industrialised, non-craft techniques of design, such as Mart Stam and others who were associated in one way or another with Brinkman's office. Subsequently, in the 1940s, Brinkman's partner from 1936, Johannes Hendrik van den Broek, teamed up with Jacob Berend Bakema, rallied support from the survivors of the De Stijl movement, and further attacked the traditionalists, who were all but routed in the political climate of a post-War Europe in which left-wing ideas flourished. Subsequently, the chain that lead from early Modernism, through Constructivism, and C.I.A.M., bound architecture in a doctrinaire approach that was to give rise to developments such as the Lijnbaan Shopping Centre in Rotterdam of 1953, a scheme that has not aged gracefully. The Lijnbaan was therefore designed by architects who were closely associated with the firm which produced the Van Nelle Factory: the latter cannot really be viewed as an isolated phenomenon, but as an important building marking a significant step on the road that led to the architectural disasters of the post-War era.

—James Stevens Curl.

Bibliography—

"Usines de Tabac, Rotterdam," in *Cahiers d'Art*(Paris), no.4, 1929.
"Brinkman, Brinkman, van der Vlugt, van den Broek, Bakema," special issue of *Architectural Association Journal*(London), December 1960.
"Van Nelle Factory in Rotterdam," in *Architecture*(Paris), April 1975.
Beeren, Wim, and others, *Het Nieuwe Bouwen in Rotterdam 1920–1960*, Delft 1982.

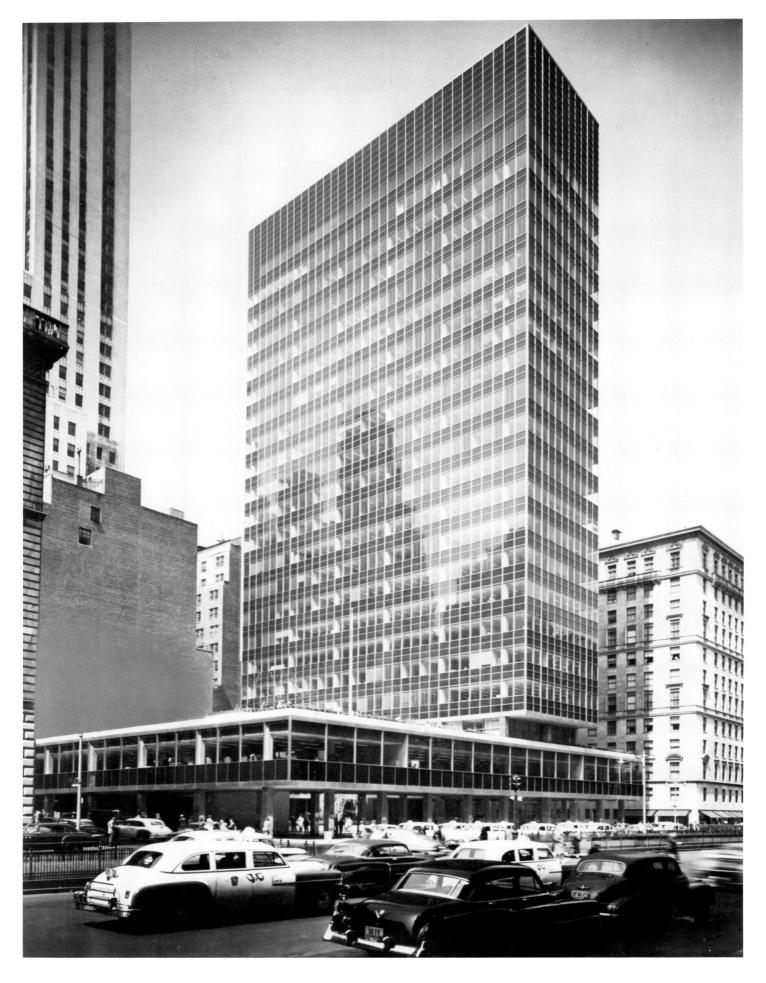

322

Gordon Bunshaft (1909–90)
Lever House, 390 Park Avenue, New York, 1950–52

When Gordon Bunshaft's Lever House was unveiled on April 29, 1952, four months after its completion, it was hailed by the Mayor of New York (Vincent Impellitteri) as a "new type of office building [that] would have far-reaching effects on city planning all over the world." This 24-storey building, which occupied in its tower only 25% of the designated air space available, would soon revolutionize the appearance of office architecture throughout the world. It was immediately given an award by the American Institute of Architects as the "outstanding office building of the year." Subsequently, over the next twenty-five years, Lever House would be the recipient of twelve major awards. It was considered a model of comfort, cleanliness, efficiency, and economy. According to the critic Lewis Mumford, writing in 1952, it was a perfect blend of both visual and utilitarian functions. In contrast to his rather negative position toward the United Nations Secretariat building, completed within a year of Lever House, Mumford had only adulation: "Lever House is a building of outstanding qualities, mechanical, esthetic, human, and it breaks with traditional office buildings in two remarkable respects—it has been designed not for maximum rentability but for maximum efficiency in the dispatch of business, and it has used to the full all the means now available for making a building comfortable, gracious, and handsome."

At the time Lever House was being designed, the location on Park Avenue between 53rd and 54th Street was lined with brownstone apartment houses, stores, and a movie theatre. Bunshaft's architectural concept was to allow maximum light and airiness to exist within the lot where the building was to be situated. He was also concerned with the neighborhood context of the building—that people walking by Lever House would feel that the space was a democratic one and that they could enter into it. The lower plaza with his elevated garden was able to accomplish this ideal. Instead of creating a sense of foreboding isolation, Bunschaft was able to conceive of a transitional space in which the passer-by might feel the connection between the sidewalk and the tower rising above it. Perhaps, the most striking feature of Bunschaft's design from a purely visual standpoint was the curtainwall glass that rose up in a rectangular grid twenty-four storeys.

Influenced by the two leaders of the International Style, Mies van der Rohe and Le Corbusier, Bunshaft was interested in creating a non-abrasive lightness through an economy of spatial means. Another primary influence on Bunshaft was the work of the founding Bauhaus Director, Walter Gropius, who inspired the basis of his organizational principle that architecture should function as a total art—with efficiency. In an interview for *Architectural Review* (May 1977), on the 25th anniversary of Lever House, Bunshaft made the following observation: "To a much greater degree than any other country, the United States is a steel and production-line economy. It follows logically that its architecture has become industrialized: the basic materials in which it works, steel, aluminum, glass, plastics, all come from the production line . . . It is to Skidmore, Owings and Merrill's credit that we have taken prefabrication and made a design asset of it."

Clearly Bunshaft was committed to the use of these new materials in that they afforded great advantages in accomplishing "more with less." The architect chose to make the tower only 53 feet wide with a single masonry wall on the western side of the building, serving as the elevator and service core, and appearing nearly invisible from the north, south or eastern views of Lever House. Taking a cue from Louis Sullivan's Wainwright Building (built in Saint Louis, Missouri over sixty years earlier), Bunshaft elected to use the upper three storeys for maintenance systems. Rather than the obsolete industrial hardware for the operation of Sullivan's early building, Bunshaft located modern heating, air conditioning, and telephone equipment, necessary for his building to function. Given that the curtainwall glass, set in mullions, is an airtight structure, the flow of air in the Lever House is contingent on the operation of these systems.

One of the brilliant innovations used to keep the exterior glass walls of Lever House clean was the invention of a gondola that could be stored out-of-sight on the roof and lowered on a system of tracks that would allow a team of two workers to wash the entire surface of the building in six days. This was considered a spectacle for New Yorkers.

A standardized steel frame provided support for the reinforced concrete floors in the office tower. This was not an original innovation, but it was the way to exploit the use of the steel frame to its fullest without resorting to masonry at the lower levels. Bunshaft, who considered himself within the modernist tradition, was attentive to the overall steel structure as a standardized support, and wanted this overall look to be apparent in terms of how the building appeared and how it functioned. Although 24-storeys in height, only nineteen of the floors in the towers are operable as office space, given the three storeys at the top used for repair and maintenance and the first two floors consisting of the lobby, conference room, and a medical service center.

The air-tight glass curtainwalls on Lever House were designed with a heat-resistant blue-green glass that filtered 35% of the sunlight entering the building. This helped to stabilize the temperature throughout the building. Each office floor was designed in such a way so as to allow desks to have some reasonable proximity to the windows. This would allow for the benefits of natural light and thus create a healthy ambience among the office personnel. At the time Lever House was completed there were over 1,000 employees who worked in the building.

In 1982 there was some threat that a real estate developer would buy out the leasing rights of the Lever Brothers and remove the building in order to build a new higher-rise office building. The following year, after considerable litigation, Lever House was given landmark status in the City of New York which, in turn, prevented its demolition. The fact is that the modernity associated with the building in 1952 changed its character in respect to the changing neighborhood around the building. With newer high-rise office building up and down Park Avenue, the Lever House was beginning to look time-worn by comparison. Many of the exterior glass windows had to be replaced over the years. As a result many of the newer panels did not exactly match the look of the original ones. Also, there were problems developing with the air conditioning system and some leakages around the spandrels that would be costly to repair. Given the six-million-dollar price tag on Lever House in 1952, it would cost considerably more to upgrade the structural and electrical systems of the building in order to get them to code. With the approval of the landmark status, however, it was possible to make the necessary reparations, but at considerable cost. One would hope that the longevity of this important and historic architectural monument of high Modernism will be preserved. The claim once made by Olindo Grossi, Chairman of the Department of Architecture at Pratt Institute, would seem appropriate in giving Lever House this insured status: "Lever House is the essence of modern architecture. It excels in order, clarity, simplicity, serenity, and denies the trivial."

—Robert C. Morgan

Bibliography—

Scully, Vincent, *Modern Architecture*, New York 1961.
Abercrombie, Stanley, "25-Year Award Goes to Lever House," in *AIA Journal* (Washington, D.C.), March 1980.
Herrera, Alex, *Report Prepared for the Landmarks Preservation Commission*, New York 1982.
Wolfe, Tom, *From Bauhaus to Our House*, New York 1981.
Goldeberger, Paul, *On the Rise: Architecture and Design in a Postmodern Age*, New York 1983.
Krinsky, Carol Herselle, *Gordon Bunshaft of Skidmore Owings & Merrill*, Cambridge, Massachusetts 1988.

John Burgee(1933–)/**Philip Johnson**(1906–)
AT&T Corporate Headquarters, New York, 1984

Dark, sombre and solid, the A T & T Headquarters stands apart from its glassy neighbours along Madison Avenue, New York. Designed in the late 1970s and completed in 1984, it is one of the most controversial buildings of the twentieth century, representing the crux of the conflict between Modernism and Post Modernism. John Burgee Architects with Philip Johnson designed the A T & T Headquarters at the very time that their Pennzoil Place, Houston, (1976), was receiving accolades and awards for its elegance and cleverness, and for its demonstration of the continuing vitality of Modernism.

The design of the A T & T with its allusions to historical styles and "witty" architectural jokes caused complete uproar and instant polarisation among architectural circles: the Modernists ironically becoming the conservatives, and the Post Modernists the irreverent delinquents. In 1990 the feud continued, Modernist outrage is unabated, the debate bitter and unforgiving. Architectural design, however, seems to be hybridising elements of Modernism, Late Modernism and Post Modernism, along with smaller impulses such as Deconstructivism, into something else, the character of which will become clearer in time.

Philip Johnson, more vocal and more public than his partner, John Burgee, clearly enjoyed the notoriety and lost no opportunity to stir things along. To Modernists the "defection" of so significant a figure as Johnson—who had worked with Mies van der Rohe on the Seagram Building, New York, 1958, the epitome of Modernism—was unforgivable. Perhaps it should not have been so severe a shock for as early as December, 1961, (see *Architectural Record*, July, 1962), Johnson had said: "There are no rules, surely no certainties in any of the arts. There is only the feeling of a wonderful freedom of endless possibilities to investigate, of endless past years of historically great buildings to enjoy."

In 1984, with the opening of the A T & T Headquarters, Johnson's words took on a profoundly different reality from what they may have had twenty three years earlier when functionalist International Modernism seemed supreme and unchallengeable in its right to reform the world of architecture and, indeed, the world *in toto*. Johnson was always something of an *enfant terrible*, so that the *Architectural Review* in its October, 1964, issue had already found it possible to write: "Still swimming briskly against every available current of architectural opinion, Philip Johnson continues to confound his critics, dismay his supporters and contribute generally to the present confusion of standards of critical judgement." The accuracy of these statements was vindicated by later events, in particular the publication of plans for the A T & T Headquarters in the late 1970s.

What is it that made this rather austere building so contentious, so remarkable and so divisive? Why did Paul Goldberger (*New York Times*, 31 March, 1978) proclaim it, "the most provocative and daring skyscraper proposed for New York since the Chrysler Building?" Why did Michael Sorkin of the *Village Voice* call it, "the architecture of applique . . . the Seagram with ears?"

It is in some ways a rather lumpish building of thirty seven storeys, a mere six hundred and forty eight feet tall (one hundred and ninety eight metres)—not very impressive in New York City. Its construction is a conventional steel frame with granite facing, grey anodised aluminium window frames and it contains a gross area of 855,000 square feet of office space. Nothing unusual for its Madison Avenue location.

For a building completed in 1984 it appears to have greater visual affinity with the New York towers of fifty years earlier. Its main facade treatment is, in fact, strongly reflective of the buildings of Raymond Hood and the style of the 1920s and 1930s, dubbed Manhattanism, with recessed windows, overtly declared, gathered columns and strong play of light and shadow. The walls look solid and deceptively suggest, in the Art Deco manner, that they are loadbearing unlike the glass skins of Modernism which proclaim their nonstructural nature out loud.

At the top of the building there is a change in the facade pattern signified by a simplification of the column pattern, and this is surmounted by a pediment with a broken key. It looks like an abstracted, shaved down classical temple, and it is this device which promoted the scathing references to "Chippendale highboys" and "Eighteenth century grandfather's clocks."

The tower sits atop an entrance block that bears an uncanny resemblance to Brunelleschi's Pazzi Chapel of 1461 in Florence, except that its dimensions are huge. Behind the loggia-style facade is the lobby of the office tower, though the lobby is more an enclosed plaza than a simple vestibule. Round windows or *oculi* occur throughout the lobby and echo the rounded key of the pediment. The central arch of the entrance is high and curved, the other arches are narrow and square topped. Inside the lofty lobby round arches, oculi and vaults give a feeling more of Romanesque churches and monasteries than a late twentieth century office building. The pattern of the pavement and the beautifully detailed stonework of the walls and columns create an atmosphere of almost spiritual austerity, so that the revelation of the gleaming gilt of the Golden Boy statue, crouched like Atlas, and the four part vault above him, comes as a startling shock. The impact verges on the vulgar and the theatrical in the best Baroque manner and is typical of Johnson's predilection for the clever effect. It may not be expected and it may be of questionable taste, but there is no denying its force.

Put together the three major elements, entry block, tower and cap, and you have a building which is more important for what it represents rather than for what it is. It uses the technology of the late twentieth century but clothes it in the imagery of the past both recent and distant, and it is the latter, the eclectic references to historical styles combined with the irreverent gameplaying that so affront the Modernists.

Modernism sought to eschew all decoration, to reduce all to pure functionalism, to seek truth to material, like it were the Holy Grail. Consequently this betrayal, this reversion to the dishonesty and falsity of the past, was complete anathema to them. That broken pediment, that Pazzi pastiche are to Modernists like Satan in the sepulchre, which is why tempers ran high, epithets and insults were flung into print and why the A T & T Headquarters is so significant a building in recent architecture: it is the focal point which both identified the problem of what seemed to be a declining Modernism, and galvanised the forces into action. For some it was—and is—*jihad*; for others an amusing game.

Johnson, apparently unabashed and unperturbed, has continued, in association with John Burgee, to design buildings in a variety of styles and a variety of combinations of styles, across the world from Houston to London to Brisbane. Perhaps, after the splendid achievement of Pennzoil Place, he concluded that architecture and architects took themselves much too seriously and suffered from an almost terminal lack of humour. He had become disenchanted with Modernism which had resulted, not in splendid monuments to the International Style, but "a bunch of cheap towers." He set about restoring some of the fun and joy to the art, and, A T & T Headquarters was his first one-liner shot.

Now, ten years down the track, the A T & T Headquarters does not seem as outrageous as it once did, but it has certainly established its reputation, for better or for worse, as a key building in Twentieth Century architecture.

—Brian Phipps

Bibliography—

Miller, Nory, *Johnson/Burgee Architects*, New York and London 1980.
"Johnson/Burgee," special issue of *Progressive Architecture*(New York), February 1984.

Photo Philip Drew

326

Santiago Calatrava (1951–)
Felip II/Bach de Roda bridge, Barcelona, 1988

Santiago Calatrava y Valls (b. 1951—in Valencia) is unusual even for Spain, a country which has produced some of this century's most inspired engineers, inasmuch as his structures adumbrate the unity between architecture and engineering outside the realm of the technically inventive and the innovative, structures that display a sculptural expressiveness which is decidedly organic if not actually zoomorphic. Calatrava is a structural artist, a sculptor who designs large urban structures such as bridges and railway stations with an eye to their beauty, efficiency and appropriateness to their urban settings.

The Barcelona bridge connects the Carrer Felip II in the north with the Carrer Bach de Roda to the south spanning the tracks of the Northern Railway which previously separated the districts of Sant Andreu and Poble Nou. The bridge, which carries four lanes of traffic and has pedestrian sidewalks, is 128 metres long comprising a centre span of 45 metres with two approach spans of 25 metres. It is more than a wonderful piece of large scale urban sculpture to be appreciated for its own sake, inasmuch as it contributes to the urban design of the city by splicing the two disjointed districts together, and also, by providing urban balconies for pedestrians, small attenuated places where pedestrians can go for a stroll in the evenings which look out across the city. It is this special ability on the part of Calatrava to make what are basic engineering functions respond to other dimensions and concerns while developing forms that are at once evocative of their setting and seductive in their peculiarly bone like skeletal formations which sets his works apart and which typifies Calatrava's achievement generally, which is best illustrated by the Barcelona bridge.

The bridge deck is suspended from two sets of arches by means of steel rod hangers, an inner vertical arch and a second tilted arch which leans inwards towards the axis of the bridge to touch the vertical arch at the middle. The cantilevered pedestrian sidewalks contained between the spreading twin arches continue on down to the ground as four stairways to link the bridge with the surrounding park. A delicate network of suspension rods surrounds the pedestrian in a space that is open yet defined, one which expands and contracts visibly as the individual moves across the walkways.

Calatrava's reputation as an architect-engineer is based on his design of landmark bridges for such historic urban centres as Paris,

Florence, Seville, Basel, which because of their location, could not be thought of in exclusively engineering terms, but rather, as focal monuments seen from various parts of the city and from above that contribute to and enrich the city. Calatrava's position is an unusual one. He is undoubtedly influenced by Antoni Gaudí in his preference for organic shapes and passion for models to verify his complex structural forms. Felix Candela, and Eduardo Torroja stimulated an interest in thin shells whose strength is dependent on their shape.

Calatrava completed his engineering studies at ETH in Zurich (1979–81) and Robert Maillart's influence in the early work is apparent. This is readily discernible in the Barcelona bridge. Calatrava was impressed by Maillart's simplification of his forms into a curved concrete slab for the arch and a horizontal slab in the 51 metre Tavanasa Bridge over the Rhine (1905), but in practice Calatrava builds composite structures.

On closer inspection it is observed that the road deck is composed of closely spaced transverse steel I-beams held between longitudinal beams, a light steel and concrete composite instead of Maillart's monolithic construction integrating arch and roadway into a structural unit. The Barcelona bridge is a steel arch which looks as if it were made of reinforced concrete.

Calatrava is a structural expressionist. He uses modern technology to produce expressive sculptural forms, forms which, because they are simultaneously strong and beautiful, are associated with zoomorphic or biological structures. This is in part a legacy of Gaudí, but if Gaudí's mode is to represent nature in the Art Nouveau manner with complex curvilinear decorative schemes, Calatrava is more abstract, the relationship between his structures and nature is covert, so that instead of an explicit natural model there is an underlying affinity with nature. By drawing on nature, Calatrava provides a much needed foil to the city and some relief from its pervasive rectilinear order.

There is about Calatrava's work a consistency founded on a preference for asymmetry, for bringing together a number of different materials in the same work. The angled alignment of the Barcelona bridge axis results in the arches being offset, and this causes an interesting trapezoidal asymmetry. Unlike Candela or Maillart with their devotion to reinforced concrete, Calatrava uses steel, aluminium, reinforced concrete, wood and even stone. Sometimes on their own, but more often than not in the same work. Thus, the Barcelona bridge consists of a concrete road deck and abutments with steel arches and hangers. The lateral edge beams supporting the pedestrian walkways are also steel.

Calatrava is an anomaly in architecture: he is neither a Postmodernist nor a practitioner of High-tech. While he might be compared with Foster, Rogers, Piano and others, he rejects the exhibitionism implicit in their use of complicated cages, and exposure on the outside of their buildings of wind bracing services and over-sized joints. From Calatrava's standpoint such works are pseudo-machines rather than the result of real invention. Calatrava should be seen as an artist in structure, an artist who has learned from the great constructors of the twentieth century who is also Spanish, and therefore, understands that structure, properly organised, can provide a profound expressive link with natural forms.

—Philip Drew

Bibliography—

"Bridges and Canopies: projects by Santiago Calatrava," in *Lotus* (Venice), no. 47, 1985.
Barcelona: Spaces and Sculptures (1982–1986), Barcelona 1987.
Ranzani, Ermanno, "Ponte di connessione viaria, Barcellona," in *Domus* (Milan), July/August 1988.
Peters, Tom F., "Crossing Boundaries," in *Progressive Architecture* (New York), April 1989.
"Santiago Calatrava," in *Architecture + Urbanism* (Tokyo), May 1989.
"Spanish Contemporary Architecture," special issue of *Space Design* (Tokyo), May 1990.

Photo Paolo Rosselli

Illustrations by kind permission of Felix Candela

328

Felix Candela (1910–)
Church of the Miraculous Virgin, Navarte, Mexico City, 1953

Felix Candela's *Church of the Miraculous Virgin* (1953) is one of those rare contemporary architectural works which successfully integrates form, structure, and materials into a conceptual whole. Candela achieved this synthesis with greatest economy and speed in a booming post-Word War II Mexico City, confirming the thin concrete shell as his trademark and establishing his international reputation as a brilliant poet of form and engineering genius.

As religious architecture, the *Church of the Miraculous Virgin* embodies a special attitude toward space and the form which encloses it. A profoundly moving spirit is expressed in simple, clearly readable geometry. Triangles predominate throughout the building. They are visually stable yet aspirational. Iconographically they suggest a clear reference to the trinity. A large plain triangle forms the church's facade, while the entrance to the side chapel off the small rectangular entrance plaza is composed of an open vault with four triangular sides. The eastern wall of the church abuts residential buildings, but the western wall which faces a quiet street continues the geometric theme with four smaller triangular roof sections which enclose the confessionals of the interior side aisle. The west transept terminates in still another large triangle. Each of these great openings peaks to frame the inclined, curving planes of the roof. Its profile climbs from a forty-six foot height at the tip of the southern facade to a height of sixty-seven feet above the altar at the north end.

The interior space is unfolded in a series of forty by twenty-two foot bays which spring ten feet above the floor from complex triangular-section piers. The soaring vaults span an unpretentious rectangular plan. The chapel is also rectangular in plan and is covered by a folded slab roof whose rhythm is more measured than that of the nave vaults. It is the structure of the nave bays which is the glory of both the church's design and construction. The enclosing form consists of a series of amazingly thin (37 mm or 1½ in.) reinforced concrete shells. The thin-shell vaults are made structurally sound and aesthetically appealing by the design of the doubly curved surfaces of hyperbolic paraboloids.

In the *Church of the Miraculous Virgin*, Candela uses the hyperbolic paraboloid expressively, warping, twisting, and bending the form to achieve a graceful interior volume and a vigorous exterior silhouette. The enclosed space sweeps forward to the altar and soars upward along the bulging and turning vault surfaces. The structural properties of this form produce superior acoustics, making additional acoustical treatment unnecessary. The interior volume is expressed on the exterior roof line by sharp vertical angles, inclines and scooped-out voids suggesting the crown of the Virgin, or even more characteristically, the cut of melons found in the stalls of Mexican fruit vendors.

Candela has said that he often prefers his structures in their unfinished concrete state, before the "architectural" materials are added. However, his use of materials in the *Church of the Miraculous Virgin* is typical of architectural surface treatment throughout Latin America. The combination of modern industrial materials like concrete and steel with ancient traditions of indigenous brick, mosaic and wood, as well as with European colonial introductions like stained glass and wrought iron creates a complementary layer of texture, color, and decoration in the church.

The reinforced, board-marked concrete structure which forms the vaults and defines the space is painted light gray. It expresses the dominant texture of the interior space as well as the exterior mass. The interior walls below the concrete vaults are of mellow red-orange handmade brick, contrasting warm color, rougher texture, and smaller pattern rhythm to the overall concrete theme. Accents of geometrically patterned stained glass carrying images of angels, Virgin, and her miraculous ribboned medallion punctuate the brick narthex and transept walls. Unpainted wooden sculptures whose iconography concerns the Virgin and St. Vincent de Paul adorn the other brick faced interior walls. The four confessionals which line the west wall are framed and enclosed with warm polished wood. The floor of the nave is concrete. The altar space is defined and distinguished by a light, warm, tan-colored stone on the altar and pulpit. The open triangles of the east wall which connect the nave to the side chapel are spanned with metal geometric grill work.

The variety of textures and subtle patterns complement and humanize the powerful vaults overhead. The tones of these earthly materials are bathed by light which unifies materials with form and space. The nave glows with natural light which enters through the large triangular stained glass windows of the facade, transepts, and along the side aisles. A small, high, triangular opening punctuates the wall behind the altar adding its light to the daylight streaming from hidden openings between the brick wall and the concrete vault. In the eastern aisle chapel light slants through the folded slab roof from clerestory windows of undecorated stained glass. The clerestories run the width of the folded slab in long narrow rectangles, echoing the overall rectangular plan of the chapel, its walls and altar. Just as in the great Gothic cathedrals, the natural light which filters into this small parish church illuminates the miraculous forms of its structure and glorifies the sacred space.

Though praised for the poetry of his concrete forms, Candela has objected to the sensationalism with which his structures are imitated. The hyperbolic paraboloid is one of the easiest and most practical shell forms to build, and in countries where labor costs are traditionally low, as in Mexico, it is also one of the cheapest to construct. More importantly, in Candela's view, is the fact that, though visually the hyperbolic paraboloid is complex and stunning, its structural stresses can be calculated in plain, elementary mathematics. It is the logic and clarity of the structural design which creates the beauty of the visual form.

Candela's insistence upon the integrity of structural design is a mark of his architectural character. In 1939 he emigrated from Spain in search of the opportunity to build thin shell concrete vaults. He had acquired superior engineering skills from the example of Eduardo Torroja whose Zarzuela racetrack grandstand of the 1930s was one of the first masterpieces of thin shell concrete vaulting. In Mexico, Candela found the conditions necessary for the realization of his concepts. There was a need for new buildings such as warehouses, factories and churches which enclose large open spaces cheaply. Concrete was cheap, readily available and easy to manipulate by unskilled labor. Often functioning as engineer and construction foreman for his own designs, Candela even evolved simplified concrete formwork for his curving shells which consisted entirely of straight boards.

As a builder, Candela has constructed practical, well-crafted buildings. As an engineer, he has pioneered the development of one of the richest, yet simplest geometric structural systems known—the hyperbolic paraboloid. As an architect, he has designed buildings of enduring poetic strength and beauty. As a 20th-century artist, Candela deserves the honorable title of "master builder" and his *Church of the Miraculous Virgin*, the apellation, "masterpiece."

—Lynn Gipson

Bibliography—

"The Work of Felix Candela," in *Progressive Architecture* (New York), July 1955.
"Folded-Slab Church," in *Architectural Review* (London), January 1956.
"Understanding the Hyperbolic Paraboloids," in *Architectural Record* (New York), July 1958.
"Deux Eglises au Mexique," in *Architecture d'Aujourd'hui* (Paris), September/November 1960.
Faber, Colin, *Candela: The Shell Builder*, New York and London 1967.
Smith, Clive B., *Builder in the Sun: Five Mexican Architects*, New York 1967.

Photos Gerald Zugmann, courtesy Coop Himmelblau, Vienna

Coop Himmelblau (1968–)
Rooftop Office remodelling, Falkestrasse 6, Vienna, 1983–89
Schuppisch, Sporn, Winischofer law firm, Vienna

In 1983 the law firm of Schuppich, Sporn, Winischhofer commissioned the celebrated Viennese architectural firm, Coop Himmelblau, to renovate their office which was located in the historical first district in the city of Vienna. The law firm wished to extend their first floor office all the way up to the attic. Thus the Rooftop Remodeling Project was launched.

The major design issue that confronted the architects was the question of the "corner problem." Located at the intersection of Falkestrasse (Falcon Street) and Biberstrasse, it was typical of many structures in Vienna. In their preliminary design of 1983, Coop Himmelblau depicted their solution: a visualized line of energy which, coming from the street, spans the project, thus breaking the existing roof and thereby opening it. There are no alcoves or turrents on the roof, no context of proportions, materials or colors; but what distinguishes the project is its space-creating taut arc, an element of Coop Himmelblau architecture since 1980. The arc is the steel backbone of the project and its posture.

The open, glazed surfaces and the closed, folded or linear surfaces of the outer shell, control the light and the view. Both directions of view, the one from the outside and the one from within, which are captured in early drawings, define the complexity of the construction's spatial relations. The differentiated and differentiating construction system, which, according to the architects, is a cross between a bridge and airplane, becomes a medium to translate the spatial energy into the constructed reality. The main truss forms the visual and structural spine of the construction. The spatially slanted and laterally supported prestressed "Greber Cantilever" truss transgresses the existing roof lines and encloses the conference room by spanning the roof top. The side trusses define and differentiate the glazed canopy spatially and structurally. Structural glazing of clear thermal glass is specially curved to form the main glass plane. Louvered blinds control sunlight. Folding and sliding windows regulate ventilation. The spatially arranged light fixture-halogen spot, neon lines, indirect light fields and constructed light arrows intensify the spatial quality at night. A system of reinforced concrete and steel is arranged to allow the distribution of structural loads into the existing building while circumventing the transfer of concentrated and lateral loads into the unreinforced chimney and walls.

The project which constitutes two storeys is 7.80 meters high, with an area of 400 meters square. The Spatial layout consists of 90 meters square meeting room, three office units including a secretariat, a reception area and adjacent rooms. It took one year to plan it and one year to construct it. The project was completed on December 23, 1988.

Coop Himmelblau, which means "Blue Sky Cooperative," was founded in 1968 by the Viennese architect Wolf D. Prix, Helmut Swiczinsky and Rainer Michael Holzer, who left the group in 1971. Among many avantgarde groups formed in Vienna since 1968, Coop Himmelblau has emerged as the most radical and aggressive group. They are now gaining recognition at the international level. Their uncompromised fame was affirmed when they were included in the 1988 exhibition of *Deconstructivist Architecture* at the Museum of Modern Art in New York.

The key to understanding the rooftop modeling project, and their other projects, is to address Coop Himmelblau's radical position in the context of the current consumer-oriented historicism and commercial post-modernism. In this context, Coop Himmelblau's architecture defies any stylistic categorization or any tendency to form a movement. Their own manifesto-like statements attest to their unique position which holds the key to judge their vision for contemporary architecture. The themes of the "body

analogy" and dissipation of that bleeding body in the city, the "poetics of desolation," and the angelic messages of their building with wide wings flying over the city characterize their uncanny architecture.

Moreover, as opposed to the "heaviness" of the humanist "body" of the classical post-modernism, Coop Himmelblau suggests the "lightness" of the post-humanist body. The tortured, fragmented and broken body of the Rooftop Modeling Project is, in essence, a statement of the post-humanist body in pain, superimposed on a typical classical humanist Viennese apartment building. Transgressing the existence of this humanist body is the projection of the curved line of the corner on the face of the existing building. The metaphorical allusion of lightness of the outline of the Rooftop body and its resemblance to a bird, desiring to fly in lightness, is unmistakable. This characteristic projection in Coop Himmelblau is already present in the exhibit *Architecture is Now*, installed at Stuttgart in 1982. Ironically, the bodily projection of the Rooftop and its analogy to a bird reminds us of Alberti's benign vision of a "building like a horse." In this context, the tilted truss of the Rooftop Project serves as a spine for irregular ribs framing a glass roof. Thus, it should be perceived as a bodily projection. Set at a slightly diagonal, the truss alights on a balcony where it arches, taut as a bow.

It is germane to contrast the Coop Himmelblau Rooftop Project with Le Corbusier's surrealistic project of the Beistegui penthouse apartment of 1931 on the Champs-Elysees. Le Corbusier opens one room to blue sky, yet walled around, to block the view to the city below. Such a gesture manifested the *Flaneur* character of an architecture which is reluctant to touch but eager to gaze the city by hovering above it. In contrast, the Coop Himmelblau's Baroque type dome of the Rooftop, gazing from atop, touches everything below it and desires to extend to the street.

The openness of the Rooftop Project to the blue sky of Vienna is the metaphor of the architects by naming themselves "Blue Sky Cooperative," desiring an angelic architecture and its flight in the high to the blue sky. Within the current architectural culture we are experiencing a weight of "heaviness" under the return of the classical body. It is refreshing to be able to liberate our body from this heaviness and take a flight. Coop Himmelblau is the image of an architecture for the lightness of being, albeit fragmented in the city.

—Nadir Lahiji

Bibliography—

Coop Himmelblau, *Architecture Is Now*, New York 1983.
Werner, Frank, "Designing (Ent-Wurf) as an Existential Rejection," in *Site* (New York), no. 14, 1985.
Johnson, Philip, and Wigley, Mark, *Deconstructivist Architecture*, New York 1988.
Architectural Association, *Coop Himmelblau: Wolf D. Prix, H. Swiczinsky*, exhibition catalogue, London 1988.
"Coop Himmelblau," special monograph issue of *Croquis* (Madrid), June/September 1989.
Werner, Frank, "The Dissipation of our Body in the City," in special monograph issue of *Architecture + Urbanism* (Tokyo), July 1989.
Stein, Karen D., "Over the Edge," in *Architectural Record* (New York), August 1989.
Giovanni, Joseph, "Vienna Vanguard," in *House and Garden* (New York), September 1989.
"Eclats sur ciel d'azur: Coop Himmelblau," in *Architecture d'Aujourd'hui* (Paris), September 1989.
"Projects by Coop Himmelblau," in *AA Files* (London), Spring 1990.

Giancarlo De Carlo (1919–)
Faculty of Education, Free University of Urbino, 1968–76

If one were looking for a definition of the dream of the architect, one could not avoid the reference to a real event and one in which are involved one of the most committed and versatile Italian architects and the city, where he, as if by magic, found himself working.

Urbino represents "The Ideal City," which became famous for having been one of the most important cradles of the Renaissance and for having favoured a continuous and measured urban development, such as to confer onto the fabric of the city a homogeneous architectural character, without breaks or trauma, which has been passed down to our period. Intact within her walls, the city contains a glorious Free University, founded in 1506 as the College of Doctors for the administration of justice. The major authors of the Renaissance architectural arrangement were Luciano Laurana and principally Francesco di Giorgio Martini, who succeeded in integrating the walled city with the stupendous countryside which surrounds it, creating those insurpassable attributes such as the Ducal Palace, and the Mausoleum of S. Bernardino, that harmonious stronghold situated in the immediate rural "vicinity" of the urban structures and defined by De Carlo as, "a magical counterpoint between external domestic tenderness and internal magnificence." Urbino is so saturated with spirituality and creative stimuli that in 1951 De Carlo, summoned by Carlo Bo, rector of the University of Urbino, was soon conquered by it, with the consequent engagement of the whole of his complex personality in an effort to penetrate the most recondite areas of the "genius loci."

In Urbino his professional attitude, which was always very committed, became total since he was conscious of finding himself unique and fortunate, with a commitment for a project of exceptional import. No architect in Italy has had the fortune of occupying himself with an historical city with such intensity as De Carlo. Only a great personality such as his was capable of assuming weighty and courageous responsibilities which led him to operate in a environment of coexistence between the past and the present, in the spirit of the evolutionary process that has always characterised Federico da Montefeltro's city. Giancarlo De Carlo was strongly stimulated by the subterranean architecture of the Rocca Paolina at Perugia, rare and suggestive realisation of Piranesean utopias, whose spaces, created by Francesco di Giorgio, contribute to the development of his "endogenous" conception of architecture.

His concept of history is rigorous: to operate in a historical contest, conceived as an "excavated" slab, means to intelligently go back over the genetic process in order to understand the meanings which have determined forms which will generate the future projections towards which the present project is directed. History and nature are integrated in a correlation of perfect balance: "a building which is added to has value only if it participates in this balance by introducing innovations in traditions," Henry A. Millon states in his essay *Time and architecture*, stressing the discovery, rather than the origins of a building. This is a key concept, which substantiates and gives determining strength to the problem of the modern restoration conceived by De Carlo.

After the recuperation of the ancient Renaissance seat of the atheneum and the installation of the Faculty of Law in the convent of S. Agostino, De Carlo tackled the most delicate and difficult intervention undertaken in the urban fabric: the Faculty of Education. The mimesis here practised is the fruit of a perfect symbiosis, both on the urban as well as the architectural scale, which Norberg-Schulz defined as "a geometrically organised interior in a topological shell of continuous development." The harmonic gradation of geometric forms between the old adjacent fabric and the new buildings could only be possible with the use of bricks, excellent modular elements which characterise the architectural face of Urbino.

From a distance, you glimpse behind the great wall the hemicycle which accommodates beneath its glazed slanted layers four levels of lecture halls, of which the two lowest can be used either separately, subdivided into semi-circles in four segments by temporary mobile sound-proofed walls, or singly forming a vast auditorium. The character of gradual extroversion increases in intensity towards the top where the edifice assumes the typical visual height of Greek theatres, where the sets and landscape are ideally integrated. This semi-circular element is found again as a key element of the new college of the Tridente.

This strongly graduated plastic element is contrasted with an invention which appears to have been inspired by Francesco di Giorgio Martini's ramp which leads up to the Ducal Palace at Mercatale. The circular patio above which lean four floors of auxiliary spaces of the Institutes of the Faculty, together with the small helicoidal staircase and the hemicycle discussed above, seem to constitute a delicate watch mechanism, whose winder projects externally adjacent to the narrowest wall of the quadrangle. Only the church of S. Girolamo remains of the old convent, which has been substantially and masterfully substituted by new buildings. In its interior a cinema hall has been placed in the basement, and in the old church is the library, characterised by attics with wooden balconies, supported on transversal metal girders. These allow one to glimpse the stuccoes of the ceiling and to take advantage of the light coming through the church windows. The excavated "slab" is covered with terraces cultivated as gardens, which become part of the urban vegetation.

For almost twenty years in Urbino, De Carlo has been bringing to maturity an experience which, beginning with the central seat of the University, has been consolidated with the Collegio del Colle. Here the communal spaces reach an articulation which constitutes a circuit of peripheral "sensors" of the new type of university which is exploding out of traditional boundaries towards new forms of interrelation. The new Faculty of Education expresses the firm wish to maintain the presence of university institutions in the historical nucleus, and the Mercatale operation has become a fitting example of methods of intervention. External and internal functions are linked by the key element constituted by Francesco di Giorgio Martini's staircase, restored and reinserted in the urban circuit by De Carlo.

The university colleges of the Capuchins, other than satisfying their requirements as residences, constitute articulated series of peripheral institutes revolving around the ancient convent which becomes the hinge between the periphery and the centre of the city. We see in the complex development of the university during the thirty years of De Carlo's activity in Urbino, the gradual realisation of a multipolar concept which after its first trial at the University of Dublin in 1964, found full realisation in the project for the University of Pavia.

—Giuliano Chelazzi

Bibliography—

Van Eyck, Aldo, "University College, Urbino," in *Zodiac* (Milan), July 1966.
De Carlo, Giancarlo, *Proposal for a University Structure*, Venice 1965.
De Carlo, Giancarlo, *Urbino: La Storia di una Citta*, Padua 1966, Cambridge, Massachusetts 1970.
De Carlo, Giancarlo, *Pianificazione e Disegno della Univerita*, Venice 1968.
Loach, Judy, "Giancarlo de Carlo in Urbino," in *Architectural Review* (London), no. 986, 1979.
"Faculty of Education, Urbino," in special monograph issue of *GA Document* (Tokyo), Summer 1980.
Brunetti, Fabrizio, and Gesi, Fabrizio, *Giancarlo de Carlo*, Florence 1981.
De Carlo, Giancarlo, *Architettura, citta, universita*, Florence 1982.
McKean, J. M., "Giancarlo de Carlo in Urbino," in *Building Design* (London), 24 February, 2 March 1984.
Rossi, Lamberto, *Giancarlo De Carlo: Architetture*, Milan 1988.

Photo British Architectural Library/RIBA

334

Charles Eames (1907–78)
Eames House, Pacific Palisades, California, 1945–49

Working in conjunction with Eero Saarinen (1910–1961), the Eames Office, under Charles (1907–1978) and Ray Eames (1912–1988), produced a steel house of enduring architectural value and conceptual importance, the *Arts & Architecture* magazine Case Study House #8. The preliminary design (1945) was strongly reminiscent of Mies van der Rohe's (1886–1969) Glass House on a Hillside (1934) and his design for the Resor house, Jackson Hole, Wyoming (1937–1938). The *Bridge House* consisted of two rectangular volumes, the studio separate from the living space, at right angles to one another. The bridge-like living space spanned a meadow and was cantilevered from two steel supports. (The structure was engineered by Edgardo Contini.) Situated on a cliff one-hundred and fifty feet above the Pacific ocean, the three-acre site in the city of Pacific Palisades was part of a five-acre parcel of land purchased by the magazine especially for the Case Study House program.

Conceptually, the *Bridge House* was to have been constructed from prefabricated parts, essentially off-the-shelf. After these parts had been delivered to the site, the proposed house underwent a radical and profound transformation. Perhaps influenced by his visit to the Museum of Modern Art's exhibit of Mies's work on 1947 and the realization that the *Bridge House* employed the largest amount of steel to enclose the smallest amount of space, Charles Eames worked on a new plan for the house. In contrast with the first, the second plan enclosed a significantly greater volume of space while still utilizing only those parts already delivered to the site; only one additional beam was required. As published in *Arts & Architecture* (1949), the house and studio are aligned in a straight line along a retaining wall 175 feet long and 8 feet high constructed along the base of the hill from which the earlier scheme had projected. Again, there are two volumes, the living space separated from the studio by an open court. Uniform bays, seven and one-half feet by twenty feet modulate both interior and exterior spaces. The living space consists of eight such modules plus the addition of an overhang; the court has four modules, the studio five. Within the living space is a two-storey living room; kitchen, dining, and utility spaces are also on the ground floor. The second floor, overlooking the living room, has two baths and a bedroom that can be subdivided for additional sleeping space by using sliding panels. The studio also contains a two-storey space, with a balcony containing storage and another sleeping space. Below the balcony, on the ground floor, is a darkroom and a third bathroom.

Despite their obvious sophistication, the two buildings were constructed using only off-the-shelf parts available in the immediate post-war period. The structural frame consists of four-inch steel H-columns and twelve-inch steel open-web bar joists; tension rods and turnbuckles provide the necessary diagonal bracing; and steel decking forms the ceiling which, like the open-web joists, is left uncovered throughout. By exposing as much of the structure as possible, Eames sought to emphasize both the industrial nature of the two structures as well as the lightness and openness made possible by the use of industrial materials, an idea that owed as much to war-time design experience as well as Eames's earlier work as a laborer in a steel mill when he was a teenager.

Floor, roof, and walls rest lightly against each other; and there is a visual thinness about these planes that is enhanced by the choice of colors. In the color scheme designed by Ray Eames, all steel sections, including metal sash and flashing, were painted a warm, dark gray to unify the structural elements. Infill panels of stucco, cemesto, asbestos, and plywood were painted white, dark blue, bright red, black, or a medium gray. Clear, translucent, or wire glass was used to enclose the window sections. The resultant ensemble owes as much to the paintings and color studies of Piet Mondrian as it does to the visual lightness and translucency of Japanese architecture, similarities which did not pass unnoted by contemporary critics.

The Eameses moved into their house on Christmas Eve, 1949. Until Ray's death in 1988, the house was lived in continuously for nearly four decades and visited by hundreds of students, teachers, architects, and assorted interested guests who made what amounted to a pilgrimage to see the house. As architectural critic and historian Reyner Banham observed: "The Eames House had a profound effect on many of my generation in Britain and Europe.... For most of two decades, it has shared with Rodia's towers in Watts the distinction of being the best-known and most-illustrated building in Los Angeles." Later, as architect A. Quincy Jones wrote in the American Institute of Architects citation recognizing the contribution the Eameses made to American architecture (1978), "Designed by its owners, [the house] is at once an intensely personal statement and a pioneering adventure in merging technology and art. Despite its spareness and economy, it provides a subtle richness of pattern, color, and texture, and a sense of unity of nature which have successfully withstood the test of time."

In terms of individual expression and innovation in domestic architecture, the *Eames House* is well within an American tradition of designing and building one's own home, that can be said to have started with Thomas Jefferson and Monticello. However, as a demonstration of their innovative approach to problem solving, the house The Eameses designed is not unique in their *oeuvre*. They approached every problem with refreshing openness; their only preconceptions were visual economy and material elegance.

Filled with things they collected and furniture designed by Charles, the house functioned as a living laboratory. However, and here the similarity with Jefferson and Monticello ends, once completed, the fabric of the Eames house was not altered. Objects could be rearranged, furniture replaced, or other, minor, changes take place, but the house remained unchanged, a timeless background, a rationalist's exercise in self-control. In many ways and at various levels, the *Eames House* is a more accessible work of modern architecture than other Modern Movement houses because of its clear and understated unity with Nature. This accessibility is all the more surprising when we consider its unconventional (for 1949) use of exposed steel in residential construction, its openness, and its conceptual framework.

In an effort to preserve it as it was during their life times, shortly before Ray's death, the house was nominated for protection as part of Southern California's cultural heritage by the Los Angeles Conservancy (1986). It remains a private residence today. Its importance, as Eames observed, lies "In the structural system that evolved.... The structural approach became an expansive one in that it encouraged use of space, as such, beyond the optimum requirements of living... it is interesting to consider how the rigidity of the system was responsible for the free use of space and to see how the most matter-of-fact structure resulted in pattern and texture."

—David Spaeth

Bibliography—

"Case Study House no.8," in *Arts and Architecture* (Los Angeles), December 1945, May 1949.
Banham, Reyner, *Los Angeles: The Architecture of Four Ecologies*, London 1971.
Drexler, Arthur, *Charles Eames: Furniture from the Design Collection*, New York 1973.
McCoy, Esther, *Case Study Houses 1945–1962*, Los Angeles 1977.
Newhart, John, Newhart, Marilyn, and Eames, Ray, *Eames Design: The Work of the Office of Charles and Ray Eames*, New York 1989.

Egon Eiermann (1904–70)
Olivetti German Headquarters building,
Frankfurt am Main-Niederrad, 1967–72

In the 1950s and 1960s Egon Eiermann was a leading authority on the West German architectural scene. His faculty at the Karlsruhe Technical University was regarded as a place where talent was forged. His participation on countless adjudicating panels, where he was often made chairman, helped him gain considerable influence. His wit and repartee also led him to be listened to by a wider public.

The effect he created would not have been possible if the work that he executed had not met the wishes of the times, or at least the wishes of his forward-looking contemporaries. Opening out to bright light and the fresh air, unpretentious, trim, transparent and light, continuing in the fine tradition of the 1920s, modern and worldly—that was how West Germany tried to appear and how buildings by Eiermann presented it: in housing and factories, in State-commissioned buildings such as the German embassy in Washington (1959–1964), the skyscraper building for Members of Parliament in Bonn (1965–1969) or, in direct competition with the buildings of other countries, the pavilion-landscape at the World's Fair in Brussels in 1958. Eiermann also challenged church buildings, with his aesthetic favouring steel scaffolding and in which colourful, glazed Formsteine [shaped stones?] were used to create the sacral atmosphere.

In the field of German post-war architecture, Eiermann's architecture stood in direct opposition to Hans Scharoun's "organic building." Eiermann started out from the construction, not from the processes of living that were to go on within the building. For him, the cool, clear order of the exterior views and its harmony with the skyline were qualities of value in themselves. Architecture, for him, meant "making evident the order of urban development down to the smallest building."

The less important uses had to be subordinated to this view and were not to lay claim, as they did in Scharoun's work, to their own parts of a building or their own use of form. Instead, Eiermann loved to superimpose elegant layers, maybe of balconies, of cleaning walkways, of balustrades, wind shields and sun awnings onto the facades of his buildings. Lightness, brightness, colorfulness and adaptability were entrusted to these secondary, but also necessarily technically precise elements. The world of the future should be characterized by a controlled, sensitized technology. "With the help of new technology mankind is on the point of developing a new culture on a higher level," Eiermann hoped in 1953. His vision of the future was correspondingly cosmopolitan: "The way will be opened to a unique, worldwide manifestation of our architecture."

The symptoms of fatigue in modernism that were so conspicuous in the 1960s also led Eiermann to clash with new figures in the architectural world. Unlike his brutalistic contemporaries, he did not attempt to find graphicness in the adaptability of cement, a medium that he disliked; unlike his American colleagues Philip Johnson, Edward Durell Stone or Minoru Yamasaki, he spurned the comforts of history. With the Olivetti center in Frankfurt-Niederrad, his last work, completed posthumously, the building's unusual appearance arose from a forced interpretation of the building programme and the restrictions of the site.

Niederrad, next to Frankfurt, is one of those suburbs that was singled out in the 1960s as a place to build offices, which would otherwise have been crammed into the city, and so reduce the pressure on the services trade in the center. An administrative ghetto consequently grew up which was marketed by the town of Frankfurt as an "office town in the country." Eiermann had to submit to these constraints, but helped the suburban agglomeration by giving it its finest examples of skyscrapers. At the same time, he satisfied the requirements of a client that was more aware than other companies about employing design to cultivate its image. Olivetti awarded the prominent German architect the commission without opening it to competition.

The constraints of the brief consisted in a restricted plot of land, not more than half of which was to be built on and the diverse purposes of the rooms which were to include sales offices, exhibition spaces, training rooms, workshops, storerooms, data processing installations, guest rooms and canteens. Eiermann decided on a low, two-storey building divided into two parts, with two reasonably tall towers flanking the flat building. One tower was taken up by hotel rooms, the other by administrative offices.

It is these two towers that give the complex its distinctiveness. White reinforced concrete shafts that widen out like chalices support the steel floor. They are furnished on each corner with a narrow prism which contains the emergency staircase. Originally, Eiermann had wanted these to be varied, with alternating ones as a hanging construction with a hooded roof whose form would correspond to the chalice-like base, only being upside down. Because of the cost involved, that idea turned out not to be feasible. The architect justified the elevation of the floor of the towers—they only begin on the fifth storey—functionally, having as he did to join the skyscrapers to a wide, flat base. But the impressive silhouette was more than a happy by-product of the design; it must have been the very impulse behind it.

Eiermann's decision to develop the two sections of the low body of the building as a hall with steel girders into which the floor levels (made out of reinforced concrete) were independently incorporated proved to be less successful. The work areas were only divided up by medium-height wall units. This was following Mies van der Rohe's principle of a "single space". But as with Mies's projects, this created problems for the user in terms of the noise and visual distractions, while the efforts to resolve the problems with further installations disturbed the large-scale concept of the appearance. The teaching rooms were located in the centre of the hall, cut off from any daylight.

The visual details of Eiermann's facades are added to by details such as the entrance awnings suspended by steel cables and which demonstrate Eiermann's constructive bravura. An "aesthetic of detachment" is striking in this late phase of classicist modernism. Each part is detached from the next, the sun-screen awnings from their supports, the stair-well from the body of the towers, the skyscrapers from the low buildings, the flat buildings—connected by bridges—from each other.

—Wolfgang Pehnt

Bibliography—

"Headquarters of Olivetti-Germany," in *Architecture + Urbanism* (Tokyo), June 1974.
Nestler, Paolo, and Bode, Peter M., *Deutsche Kunst seit 1960: Architektur*, Munich 1976.
"Headquarters of Olivetti Germany, Frankfurt am Main," in Futagawa, Yukio, ed., *Global Architecture Document: 1970–1980*, Tokyo 1980.
Schirmer, Wulf, ed., *Egon Eiermann 1904–1970*, Stuttgart 1984.
Schreiber, Mathias, ed., *Deutsche Architektur nach 1945*, Stuttgart 1986.

Peter Eisenman (1932–)
Wexner Center, Ohio State University, Columbus 1983–89
108,750 sq.ft.

The fragmented, fragmenting Wexner Center both signalled and symbolized Deconstructivism in architecture. When the design won a major competition in 1983, the heyday of post-modernism in America, Deconstruction was seen as a literary phenomenon. By the time the building was completed in the fall of 1989, Deconstructivist architecture had been canonized at the Museum of Modern Art, debated, disclaimed, dismissed as non-existent or overpromoted, and lionized as the fashion of the hour. The lionization reached its apogee as the opening of the Wexner Center was acclaimed in *Time, Newsweek, The New York Times* and its Sunday magazine, whole issues of *Inland Architect* and *Progressive Architecture*.

The architect, Peter Eisenman described the structure not as a building but as "a scaffolding." Indeed, the bold white three-dimensional grid that runs between two characterless existing auditoria, uniting and obliterating them, does form a framework on which glass walls, cubic galleries and other spaces are hung. Most of the Center's theaters and studios are underground and covered with sloping lawns or boxed gardens of wild plants. An old, Medieval-looking armory, demolished after a fire in 1958, has been resurrected near the entrance, with its tall brick towers pulled apart like a ruin and filled with gridded modern walls. This whole strange non-building occupies an area that was not identifiable as a building site when the competition took place.

The architects were allowed to locate their Centers on any open space—or spaces—near the main Fifteenth Avenue entrance to the campus and the gigantic central Oval which the original university buildings surround. The other architects—Arthur Erickson, Michael Graves, Cesar Pelli and the firms of Kallmann, McKinnell & Wood and Lyndon/Buchanan Associates working together—all chose open areas at the western end of the Oval, in front of or behind the performance halls.

Eisenman's Visual Arts Center (named the Wexner later after benefactor Leslie A. Wexner) occupied approximately the same area in front of and behind the Brutalist Weigel Hall and Art Moderne Mershon Auditorium as Graves's museum design. But because Eisenman's slid between the existing buildings at an angle, nestled almost imperceptibly into their back yards, and extended into the formal vehicular entrance to the campus, substituting a gridded grove of trees for the driveway, it seemed to occupy ground that was non-existent or unavailable.

Eisenman, who was associated on this project with Trott & Bean of Columbus, interpreted quite literally the program's mandate to make the art center central to the campus. The building's spine asserts itself as a pedestrian passageway, virtually forcing anyone entering the campus at that point to experience the visual arts. The plaza in front, planted with trees, draws pedestrians inside or directs them westward towards the Oval.

The Wexner Center is highly visible from within the campus and without. On the corner of the site, at the edge of the Oval, tall brick fragments of the castellated towers pierce the sky forming a powerful but not-quite comprehensible image. Inside, the firmness of the ground gives way to sloping floors and walls, disjointed corridors and windowless subterranean chambers.

The Wexner Center ties the Ohio State campus to the city beyond its gates by imposing the urban grid of the city streets on the campus grid, which is $12\frac{1}{4}$ degrees askew. The gridded scaffolding is aligned with the city streets, not the campus building grid which it intersects, violates and integrates. Imperceptibly but conceptually, the scaffolding is also aligned with the Ohio State football stadium, the flight path of the Columbus airport and the historic grids used to survey and subdivide Ohio which, like the Wexner and the rest of the campus, failed to mesh in some areas. The brick armory towers, rebuilt near where they once stood but literally fragmented, straddle both grid systems and blur the line between past, present and future. They provide a visualizable, memorable image in a way that is frankly and noticeably reconstructed—real and false at the same time.

The Wexner Center is neither modern nor post-modern, but it reflects and undermines both movements. Its crowning towers pay homage to the power of imagery and the importance of history, as a post-modern monument might, but they call the possibility of the preservation of the past into question. The design expands the post-modern notion architectural context, extending it to the whole campus, city and state, but it acknowledges its neighbors by swallowing them up. Its abstract white grid resembles the structurally expressive, functionally versatile, neutral look of International Style modernism, but this cool, regular, mechanistic imagery is used here symbolically and ironically. The scaffolding, which looks like a giant early Sol LeWitt sculpture, is neither simply nor singly a means of support.

The grid was the hallmark and organizing principle of Eisenman's earlier work—a series of boxy white houses in which he investigated and articulated a variety of theoretical ideas. In these very complex, "post functionalist" aesthetic exercises, the architect made structure not only the basis but also the essence of the house. Like a sculptor, he designed the structure in order to explore specific structural principles, then put the rooms, furniture and mechanical equipment in wherever they would fit, instead of making their arrangement the starting point, as a functionalist architect would have. At the Wexner Center he placed grids within grids to accommodate functions and extended the idea of the grid as an organizational principle onto the site, uniting the idea of the "grid" of the cityscape with the idea of the "grid" in modern art and the "grid" of architectural structure. But here the grids interconnect with irregular architectural forms of existing buildings, intersect and overlay one another in ambiguous ways, undermining certainty instead of clarifying it. The whole process is infinitely more complex and ambiguous.

Before he won the Wexner Center competition, Peter Eisenman functioned primarily as a critic, educator and theorist of architecture. A graduate of Cornell (B.Arch. 1955), Columbia (M.S.Arch. 1960) and Cambridge University (Ph.D. 1963), he taught at Princeton, Yale, Harvard, Cooper Union and the Institute of Architecture and Urban Studies in New York which he founded in 1967 and where he published the journal, *Oppositions*, 1975–82. In 1980 he formed a partnership with Jaquelin Robertson of the University of Virginia (disbanded 1988) and began to seek major commissions. Eisenman's contribution to architecture had always been that of an intellectual intermediary. He adapted methodologies or conceptual schemes from other disciplines and collaborated with people from other fields like William Gass and Jacques Derrida. In the houses of the 1970s, which are numbered with Roman numerals rather than named for their owners, he investigated Structuralist ideas about logical processes and "deep structures," and explored pure structure, progression and perception like a Minimal artist. At the Wexner Center, he made the Deconstructivist concept of a decentered, fragmented reality real—and, appropriately, apparently unreal.

—Jayne Merkel

Bibliography—

Frampton, Kenneth, and Rowe, Colin, *Five Architects*, New York 1972.
Gubitosi, Camillo, and Izzo, Alberto, *Five Architects, New York*, Rome 1976.
"Eisenmanamnesie," special monograph issue of *Architecture + Urbanism* (Tokyo), August 1988.
Moneo, Rafael, and others, *Wexner Center for the Visual Arts*, New York 1989.
"AD Profile 82: Wexner Center for the Visual Arts," in *Architectural Design* (London), November/December 1989.
Somol, R. E., "Wexner Center for the Visual Arts," in *Domus* (Milan), January 1990.

Photos by Simon Scott, courtesy of Arthur Erickson Architects Inc.

Arthur Erickson (1924–)
Museum of Anthropology, University of British Columbia, Vancouver, 1971–77

Arthur Erickson believes that all buildings are a response to specific requirements, the most fundamental being locale. He has said that architects "should be listeners, since architecture is the art of relating a building to its environment, and this requires listening to what the environment has to say—listening to its total context. For architecture is not so much a process of creation as it is a discovery, and a building is not so much designed as it is decreed by its context—by the fact of where and when and for whom the building exists." Erickson's Museum of Anthropology at the University of British Columbia exemplifies this approach to architecture. Commissioned in 1972 primarily to house the Northwest Coast Indian collections of Audrey and Harry Hawthorn, the museum occupies a promontory on the northwestern edge of the university's campus looking out to the Strait of Georgia and the Tantalus Mountains.

Designed before the international flurry of innovative museum buildings which followed in the late 1970s and 1980s, Erickson's building was one of the boldest structures to house a museum at that time. Yet its boldness is not derived from the desire to simply make an architectural statement, but rather from a careful attention to the site and the cultural expressions of the peoples whose work would be contained within. The materials used are simple: grey concrete, acrylic skylights, and large expanses of glass. The detailing is equally simple. Glass panels are held in place by a system of fasteners that eliminates mullions, thereby opening views to the landscape. Grey carpet throughout the building, combined with the lightly sandblasted concrete surfaces, provides a subtle backdrop for the collections, merging the structure with the often grey skies of Vancouver.

The building follows the slope of the site with a succession of ramped, skylit galleries which carry the visitor from the entrance down the slope to the Great Hall. Moving from these dimly lit galleries one enters a spectacular space which appears almost to lack enclosure. Typical of Erickson's work, the Great Hall's form is simple and evocative of the post and beam construction used by the Northwest native peoples whose cultures are represented in the museum's collections. Channelled beams move from wide and low spans near the entrance galleries to narrower and taller spans until the north wall, made entirely of glass, rises 45 feet above the floor. Because of the sloping site, however, visitors have no indication from the entrance side of the museum that they will encounter such an inspiring space. Much of the building is actually buried in the hillside and from the campus road above the museum is almost entirely concealed, preserving pedestrians' views out to the Strait.

In contrast to the museum's other galleries, in the Great Hall the exhibition of works which have been exposed to natural light for decades permits the use of more extensive glazing than seen in most museums. Although galleries are climated-controlled, this use of glass, combined with the often dilute natural sunlight of the Pacific Northwest, results in an exhibition space that places the exhibited works back in the landscape at the same time that it protects them from the natural elements that have destroyed so much of the material culture of the Northwest's native peoples.

Unquestionably the most innovative aspect of the museum is the visible storage area for the collections, designed by Erickson to place all of the museum's holdings at the immediate disposal of visitors. Describing museums today as "icebergs, with only one-tenth of their collections visible," he devised a system which houses large pieces in glass cases backed with peg board to ease rearrangement, and smaller pieces in cabinets with glass-topped drawers which can be opened at will. Collections are housed by indigenous groups with no hierarchical arrangement within drawers or cases to influence the perceptions of visitors. Notebooks containing descriptive information on each item are adjacent to the cases, reducing the need for curators to serve as intermediaries for individuals' interpretation of the works.

Erickson's desire to build with all details suppressed so that what he has built appears to have just happened, "as if there was nothing studied, no labour or art involved," has succeeded in the Museum of Anthropology. His plans for the museum's site to also accommodate a collection of buildings forming two native villages have been left incomplete. The original design called for the area between the museum and the cliffs to be flooded, creating the illusion that the museum and its totem poles sit at the edge of the sea in the same way that houses and totem poles do in Haida and Kwakiutl villages. The flooded area instead is laid with grey pebbles, a sort of surrogate inlet. Likewise, Erickson's plan to flood the roof above the visible storage area has not been carried out, perhaps to the relief of curators charged with the welfare of the collections. Although some totem poles and several reconstructed Haida buildings have been installed south of the pebbled "inlet," his plans for the rest of the museum grounds to become an ethnobotanical garden have similarly been left incomplete. Nevertheless, the museum is a part of its site in a way that few public buildings are. It does not so much occupy the site as it grows from it.

Erickson's career has not followed a logical stylistic progression. The Museum of Anthropology does not relate stylistically to any of his other buildings, but rather strives to respond to a unique need. Likewise, one finds no direct evidence of any other museum structures influencing his design for this commission. Unconcerned with style or trends, Erickson has gained prominence for his success in approaching every project as a singular challenge of intention and site which must be merged in the resulting building. His lifelong study of the built environment in all parts of the world began with a two and one-half year travel scholarship after completing his degree at McGill University, and it continues to this day. Subtle references to a Persian mosque, houses in Bali, or Japanese gardens are as likely to shape his response to a site as is the use of innovative materials or technologies. Erickson refuses to tolerate the approach to architecture espoused by the majority of clients and architects in the Western world. As a consequence, his built designs occupy the cutting edge of architecture and have largely been commissioned by clients who are nearly as unconventional as he in their response to the contemporary built environment. The Museum of Anthropology is an outstanding example of the innovative work of an architect who often designs the landscape before the building, who says he is "not involved in the aesthetics of architecture or interested in design as such," who expresses his contempt for the architectural establishment and traditional architectural education, and who believes that there are not many new types of buildings, just different ways of expressing what are, essentially, a few archetypes.

—Sheila Klos

Bibliography—

Erickson, Arthur, *The Architecture of Arthur Erickson*, Montreal 1975.
Vastokas, Joan, "Architecture as Cultural Expression: Arthur Erickson and the New Museum of Anthropology, University of British Columbia," in *Artscanada* (Toronto), November 1976.
Lehrman, Jonas, "Museum of Anthropology: An Appraisal," in *Canadian Architect* (Toronto), May 1977.
Schmertz, Mildred F., "Spaces for Anthropological Art," in *Architectural Record* (New York), May 1977.
"Museum of Anthropology, Vancouver," in *Canadian Architect* (Toronto), May 1977.
Iglauer, Edith, *Seven Stones: A Portrait of Arthur Erickson, Architect*, Seattle 1981.
Shapiro, Barbara, *Arthur Erickson: Selected Projects 1971–1985*, New York 1985.
Erickson, Arthur, *The Architecture of Arthur Erickson*, New York 1988.

Photo British Architectural Library/RIBA

Ralph Erskine (1914–)
Byker Wall housing development, Newcastle-upon-Tyne, 1969–81

The redevelopment of a residential area always presents special problems: not only must the architect rehouse the local inhabitants in better buildings than before, but he must also do it with minimum disturbance and disruption to their lives. Seldom was this truer than with the Byker redevelopment in Newcastle-upon-Tyne; and seldom have these problems been better solved than by Ralph Erskine.

Byker was an old working-class suburb about one-and-a-half kilometres from the city centre. Built over with cramped two-storey terrace housing in the last century, by the mid 1960s it had become impossibly congested. The local Council decided to redevelop it, and to this end hired Ralph Erskine, the British-born architect who has made his professional life in Sweden. It was an inspired choice: Erskine, by nature and training sympathetic to the ideals of the welfare state, was predisposed to fulfil the Council's aim of rehousing the local population as economically and humanely as possible. Setting up office in a former funeral parlour, Erskine and his team began a process of informal consultation with the future residents which, combined with his own very distinctive ideas about community housing, resulted in a uniquely successful and popular redevelopment.

Conscious of the disruptive effects of demolition, Erskine was careful, initially, to preserve certain well-known local buildings, eg. a church and public baths. Around these, in phased stages, was then erected the new Byker. This, basically, can be divided into two parts: to the north a massive curvilinear wall ("the Byker Wall"), and in its lee, on a gentle slope, a spread of two-storey timber and brick housing. Of the two elements, the Wall is undoubtedly the more spectacular: rising some seven storeys high and stretching some two kilometres, it dominates its section of the Newcastle skyline. Precedents for such a wall can be found throughout Erskine's work, and indeed architectural preoccupation with the idea goes back to the 1930s, with Le Corbusier's plans for Algiers Bay. It was no abstract ideology, however, that prompted Erskine to build the Wall; rather it was the need to protect Byker residents from cold north winds and nearby road noise. Nor is the Wall oppressively monumental—on the road side its own curves, and the careful use of coloured bricks, disguise its scale, while on the south side brightly painted balconies and walkways offer a friendly, human aspect. The total effect, as one critic has observed, is less of a fortress than a comforting bulwark.

Not too much, however, should be made of the Wall. Over 80 per cent of the housing in the redevelopment is on the slope in its lee, and in the opinion of many critics it is here that Erskine has best succeeded. Not only were the houses here economical to build (a special large brick was employed for the cladding, to reduce costs) but each has a unique outlook and character. Individuality is further enhanced by the presence nearby of small piazzas, steps, archways and the like; the result is an intimate, villagey atmosphere rare in council estates. Sometimes Erskine's designs proved too popular, indeed: a bedroom in an archway was found to be uninhabitable because of people standing underneath and talking about it!

Successful as the new Byker has been, it does, however, have its critics. A few object to the "folksey detail" of the housing; more wonder if the flimsy balconies and walkways will continue to look as attractive as they did when new. Much of the woodwork, it is generally admitted, is poor (a fault partly excused by the absence of wood in the local building tradition), while the areas of paint need a certain amount of maintenance. Such cavils, though, are more than balanced by the genuine popularity of the redevelopment: few of the old Byker's inhabitants have chosen to move away, surely the acid test of a scheme like this. Erskine's Byker, indeed, proves that housing "for the masses" need not be horrible; that the modern architect, in fact, can build economically and rationally and yet still (in Erskine's own words) be "a bit of a poet."

—John Terence O'Leary

Bibliography—

Amery, Colin, "Byker by Erskine," in *Architectural Review* (London), December 1974.
Erskine, Ralph, "Byker," in *Arkitektur* (Stockholm), February 1977.
"In Newcastle—Byker," in *Abitare* (Milan), December 1978.
Futagawa, Yukio, ed., *GA 55: The Byker Redevelopment*, Tokyo 1980.
"Ralph Erskine," special monograph issue of *Arkitektur* (Stockholm), September 1981.
Collymore, Peter, *The Architecture of Ralph Erskine*, London 1982.
"Ralph Erskine," special monograph issue of *Deutsche Bauzeitung* (Stuttgart), no. 3, 1983.
Benton, Charlotte, "Erskine's Evolution," in *Building Design* (London), November 1984.

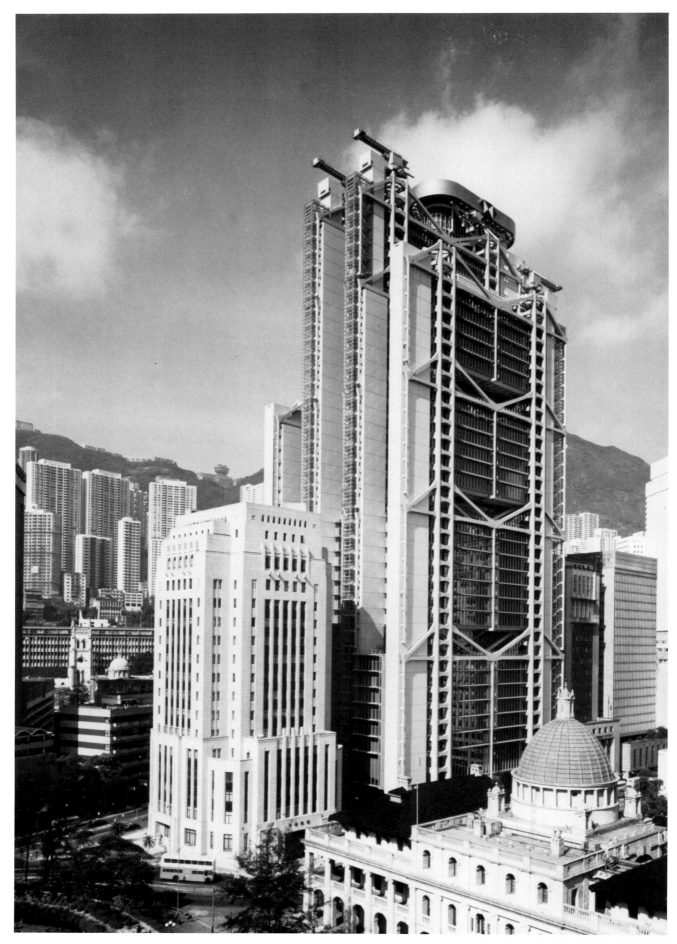

Photo Ian Lambot, courtesy of Foster Associates

Norman Foster (1935–)
Hongkong and Shanghai Bank Headquarters, Hong Kong, 1979–85

People love it, or hate it, but find it impossible to ignore it. Like any major building in the heart of a big city the headquarters for the Hongkong and Shanghai Bank, designed by British architect Norman Foster, was born of controversy. Not only did it replace a beloved and potent landmark (the Bank's headquarters which appears on the reverse of the colony's banknotes has long been a symbol of Hong Kong's good fortune), but with a price tag of well over £600 million at the time of its construction, it was fabulously expensive.

Today, it is an utterly compelling building. Bafflingly, it appears to bear closer relation to an oil rig or a stack of steel bridges than any conventional office tower. Yet its finish is infinitely superior to either. In spite of its unorthodox structure and the originality of its design, the clarity of its form and the elegance of its symmetry are timelessly classical. The Hongkong and Shanghai Bank is a machine of a building, superbly crafted, a masterpiece of precision engineering, and an architectural tour de force.

It is also [Sir] Norman Foster's personal masterpiece, by far his most interesting and significant building, and one that marked a turning point in a career of doing modest buildings for individualistic British companies, to major international projects. In 1979, Foster was 45, an unknown architect who had built nothing over four storeys. The Hongkong and Shanghai Banking Corporation, then among the world's top twenty banks, required a new headquarters—one that would make an unquestionable architectural statement. Seven well-known firms from around the world were invited to compete for the commission; against all the odds, Foster won.

The Bank's brief to the architects contained one significant challenge. It required a new building which would incorporate its original, much-loved banking hall, a feature which covered much of the site. Foster applied the approach which had served him well on his earlier buildings for Willis Faber in Ipswich and the Sainsbury Centre for the Arts at the University of East Anglia: a detailed critical analysis of the client's requirements coupled with an obsession to create a building that could be used as flexibly as possible.

His solution was characteristically simple: bridge the banking hall, and build above it. Thus was born the concept for erecting four great steel masts on either side of the site to support a series of suspension bridges from which floors could be hung. The Bank could either retain its old banking hall beneath the new structure, or have a new one, at any time.

What had appealed to the Bank was Foster's ingenuity, and his emphasis on flexibility. In the event, the plan to retain the old banking hall was dropped. But flexibility, together with a stress on what the building would "cost-in-use" became by-words for any merits in the subsequent design. For example, to encourage more efficient use of the building (while keeping staff from tying up the lifts with journeys between one or two floors) escalators were to be installed right up the building. The floors of the new building were to be completely open, uninterrupted by columns, loaded throughout for computer installation and suspended above a void through which all electrical wiring, telephone cabling, and air-conditioning ducting would be run, to pop up at frequent intervals all across the floor. Liftshafts, staircases, plant rooms, kitchens and lavatories—supplied in the form of prefabricated modules

which were hoisted up the building and locked into the steel frame—were pushed to the sides of the building so as not to interfere with the infinitely variable range of uses to which the floors were to be put.

The result is a building—so rationally conceived, so mechanically built—that is rare in its inspiration. The diversity of its spaces, the rich complexity of its facades, and the quality of its finishes continuously surprise and exhilarate. It is a tower that is full of movement: people, glass lifts, escalators, and changing light and shade. In no other building does the mood change so dramatically with the weather. On a June day in damp and low cloud it is like an alien battleship, brooding, hostile and grey. Yet in bright sun, and blue sky it becomes a jewel, sparkling with the reflections of greenery and sky. It is at once cool, anonymous, metallic and richly baroque.

There is a strange pleasure in walking down quite a substantial slope *underneath* a building which you can look up into and catch a blinding glimpse of sunshine, reflected off the "sunscoop" (an application of the ancient idea of bouncing light off mirrors from the outside to the inside of a building) high above the atrium of the banking hall overhead. Gliding up the great entrance escalator into the vast cavern of the banking hall you feel like a swimmer surfacing in a pool. Stand on the edge of the atrium, say at the seventh floor, and observe the workings, like some industrialised hive, of a late twentieth century bank. The scale is such that you feel like you are in an outsized dolls house.

You travel by escalator in this building, not by lift. Higher up the building the same open floors which gave glorious views out over the harbour from around the atrium, are left open-plan, or subdivided into glass boxes of individual offices, or are sealed off for computer use. It is as you reach the highest floors of the building, reduced in area because of set-backs required by the building regulations, that the stupendous scale of the steel masts and gigantic trusses is dramatically revealed and you enter the boardroom beneath a colossal cross brace worthy of the pharaohs.

It is dubbed "high-tech." In fact, the Hongkong and Shanghai Bank defies expectations. It will endure as one of the finest, and most remarkable buildings of the late twentieth century.

—Stephanie Williams

Bibliography—

Foster, Norman, "Foster Associates: Hongkong and Shanghai Banking Corporation Headquarters," in *Architectural Design* (London), March/April 1981.
"Foster Associates: The Architecture of the Near Future," special monograph issue of *Space Design* (Tokyo), March 1982.
King, Frank, ed., *Eastern Banking: Essays in the History of the Hongkong and Shanghai Banking Corporation*, London 1983.
Goldberger, Paul, "Three Distinct Approaches to Skyscraper Design," in the *New York Times*, 30 January 1983.
Dodwell, C. R., *Norman Foster, Architect: Selected Works 1962/84*, exhibition catalogue, Manchester 1984.
Lambot, Ian, *The New Headquarters for the Hongkong and Shanghai Banking Corporation*, Hong Kong 1986.
"Hongkong and Shanghai Bank," special monograph issue of *Architectural Review* (London), April 1986.
Williams, Stephanie, *Hongkong Bank: The Building of Norman Foster's Masterpiece*, London and Boston 1989.

Photo © Botond Bognar

Hiromi Fujii (1935–)
International Arts Festival Center, Ushimado, 1985

Architecture of Hiromi Fujii is, in its thinking and realization, undeniably related to the perplexing urban condition of the Japanese metropolis. Discontent with the urban impasse of architecture—which in the context of the commercial nihilism of the metropolis faces ultimate flattening of its perspectives and impossibility of signification—is an attitude which Fujii has in common with other Japanese architects like Kazuo Shinohara, Hiroshi Hara, and Tadao Ando. At the same time, the mode of recognition of that impasse condition and its influence on the architectural design conceptualization delineates the point of difference between this architect and his contemporaries mentioned above. While, for instance, Ando acts from the position of uncompromising ideological clarity confronting the metropolis with a sense of immediacy and urge to physically resist and subvert its "will to formlessness" (whereby he conceives of and uses architecture as a most concrete instrument for the recovery of meaning), Fujii relates to the same phenomenon in a less tangible and concrete way, regarding it mainly as a sign of a general cultural condition which is itself the actual locus and cause of the fundamental controversy of architectural production. Consequently, his buildings immersed in their Carthesian world suggest enigmatic detachment from the chaotic matter of the metropolis which has been reduced to an abstract point of reference against which a "science" of geometric dissection (and reintegration) of architecture takes place.

Ushimado International Art Festival Center is by its location and site condition a somewhat uncommon example of Fujii's architecture, usually associated with the dense urban contexts. The Center, whose design inception has been predetermined by the requirement to incorporate an existing storehouse into the new whole, appears as a structure affixed in the rural landscape in an idealized manner that connotes a sense of static universality. The difference, relative to his earlier urban projects, is striking. The enigmatic autism of the machine-like concrete boxes of Todoroki House and Manutake building—which, planted in the city as clockwork devices, stand in defiance of its reality threatening to detonate themselves and set free a different world they contain within—has been superseded by a mute monumentality of Ushimedo's (de)composed structure. That structure, analogous to Fujii's urban projects, belongs to the internal world of his architecture which, in this instance, has ceased to be physically contained. Its externalization is, however, paradoxical. It conveys a sense of a stillborn entity that betrays the premonitory anticipation of its existential dimensions present in his earlier projects. Externalization in this case has become a means of concealment, since the revealed architectural condition remains as enigmatic and inaccessible to the outside thought as the one which preceded it. The enigma of Fujii's architecture in Ushimado Center has become merely relegated from the realm of content to the realm of form. The building, as a "constructed ruin" unintelligible in its geometrical abstraction, inhabits the landscape outside of time, leaving the question of its raison d'etre—the actual subject of monumentalization—infinitely obscure.

As previously suggested, for Fujii, the Japanese metropolis embodies problematic reality (meaning) "which has arisen as a result of architecture's degeneration into a false vision, exclusively determined by utility and universality." Accordingly, the only resolution of that situation can be sought in the reductive reconstruction of architecture's "false vision"; namely, arriving at a condition where meaning is solely sustained in the existential experience of space and form. Such an approach embodies dual intention. On one hand, it attempts to create an architecture defiant of the mechanisms of its own subversion and exploitation in the metropolis; and, on the other, seeks an elementary condition in which architecture approximates its own indivisible essence. Attainment of such an elementary condition, according to Fuji, can only be achieved through the deconstruction of the outside world (metropolis); that is the deconstruction of the parameters of its problematic reality. Consequently, he uses geometry as an autonomous scientific instrument (set of logical principles) by way of which he dissolves the form and the meaning of the outside world and simultaneously constructs rectilinear landscapes of an interstitial universe in which he traces the original condition of architecture. However, the actual subject of Fujii's architecture is not eventual spatial resolution of that condition but the process of its generation—the design method, the iterative and repetitive mechanism of planar and graphic translations, which, derived from set geometric rules, imposes itself as antithetical materialization of space and form.

Ushimado Center embodies thus far the most elaborate pursuit of this subject in Fujii's architecture, and conversely delineates a point of its eventual closure. The whole building is a rather literal explication of the design genesis and its manipulation through the imposition of geometric rules and principles. The method that Fujii calls metamorphology (a series of geometric operations devised to transform spatial and formal codes of architecture which "if repeated, cause forms and spaces to lose their coding and to become eventually traces of their originals") has been employed to deconstruct the space and form of the original storehouse and physically record that process as a matrix and the substance of the annexed structure.

Indeed, in his writing about Ushimado Center, Fujii briefly refers to it as a ruin. The formal analogy, if unintended, is nevertheless obvious. The ossified intersections and superimpositions of the traces of transformational iterations and abstract graphic codes form building fragments whose physical regression dissolves the original object (storehouse) into a non-recognizable state. The implied signification of this condition remains unclear. It eventually embodies a distant presentiment of a Piranesian flavor, suggesting loss and unattainability: the realization of the impossibility of architecture to form a whole and sustain meaning. Fragment (artificial ruin) is a fetish object, argues Georges Teyssot in his essay subtitled *Architecture as a Work of Mourning*, quoting Giorgio Agamben: "it continually refers beyond itself towards something that can never be truly possessed, something unreal. The fetish object is both negation and a sign of an absence." Hence Ushimado Center as a "ruin" denies the reality of the world to which it physically belongs by pointing towards and signifying something which is non-existent (or no longer existent) and thus unattainable: an authentic condition of architecture. Consequently time is brought to a halt. By opposing two dialectical points of origin; the physical one which is subsequently deconstructed and denied and the hypothetical one which seeks its improbable validation in the autonomy of the geometrical principle; Fujii has subverted linear progression of time rendering past and future interchangeable. The resulting suspension of reality invalidates any temporal perspective since the possibility of resolution remains always equally distant and unattainable. Accordingly in spite of the claims to the contrary, Ushimado's fragmented world is imbued with the stillness of an archaeological finding which marks the closed space of indifference and impossibility. In this respect its arcadian frame of reference cannot be understood as merely circumstantial but rather premediated revealing monumental intentions to commemorate the loss of architecture.

—Vladimir Krstic

Bibliography—

Frampton, Kenneth, *New Wave of Japanese Architecture*, exhibition catalogue, New York 1978.
Fujii, Hiromi, "Deconstruction Through Differentiation—Metamorphology, Desemiotization, Traces and Deconstruction," in *The Japan Architect* (Tokyo), November/December 1980.
Bognar, Botond, *Contemporary Japanese Architecture*, New York 1985.
Watanabe, Hiroshi, "Amazing Grace," in *The Japan Architect* (Tokyo), June 1986.
Bognar, Botond, ed., *The New Japanese Architecture*, New York 1991.

Photos Otakar Macel

Frank O. Gehry (1929–)
Vitra Design Museum, Weil am Rhein, 1987–89

Those who want to see the first building in Europe by the American architect Frank O. Gehry, have to set out for the German province. Close to the border, in a corner of the Baden-Württemberg area, at Weil-am-Rhein, a production hall and a museum designed by Gehry were completed in 1989. Both buildings are situated on the premises of the Vitra Company, a furniture manufacturer. They contrast sharply against the rural environment.

How did Frank Gehry get a commission in the German province? It is the company's policy to combine its commercial success with an active form of support for the modern arts. In line with that policy the Vitra Company once wanted an object by Claes Oldenburg on its premises. Gehry, a friend of the artist, was consulted with respect to the architectural aspects of that project. This is how Gehry's relationship with Vitra got established. Gehry's direct collaboration with Vitra started with the design of his cardboard furniture.

The program Gehry had to accommodate consisted of three elements: a siteplan for the entire precincts, the design of a factory extension and the design of a museum, that could be operated independently. At this point in time, with only the production hall and museum completed, the overall design concept doesn't show yet. A new entrance to the factory grounds still needs to be built, as well as a porter's lodge, a building that can facilitate the spatial consequences of an increase in production and a parking lot, including the necessary provisions. Only when these plans are realised, the complex will acquire a campus-like character, similar to earlier Gehry projects. So far, not much can be detected of this future situation.

The production hall is bordering the existing company buildings and comprises not only the production space proper, but also a showroom, offices and a restaurant/canteen. Looking at the rectangular plan configuration, the concrete skeleton construction, the large fenestration and the rooftop skylight, the building is not setting itself apart from other examples of utilitarian buildings. But, looking at the east facade opposite the museum, Gehry's particular approach to design is clearly visible: the taut geometry of the hall here is affected by the plastic forms of the entrance and by the curve of the ramp connecting the ground- and first floor. The morphology of this facade allows for a better formal connection of the hall with the museum: seen from the main entrance towards the precincts, the east facade of the new hall serves as a backdrop with respect to the new museum building.

The Design Museum itself resembles a dynamic sculpture, located in the middle of a green. The sculptural effect stems from the building being composed of stereometric bodies; cylindrical shapes (staircases) and sloping planes—the effect being reinforced by the absence of windows and by the walls being made out of white stucco. Only the constituent parts of the roof (when discussing Gehry's rooftops one can hardly speak of one single rooftop) are made out of sheets of zinc or glass. The museum is not large (740m²). The larger part of the three dimensional space serves the spatial composition. The ground floor holds three exhibition rooms, the library and services rooms. The second floor is organized around a void, that itself also gives an opportunity, though limited, for exhibitions. Characteristic for the white stucco interior is its spaciousness; from the building lobby the visitor is able to get an impression of all three exhibition rooms. The larger two of the exhibition spaces have various floor levels and are connected with each other by means of openings in the walls. Another aspect that connects these two largest spaces is the penetration of daylight in both rooms. The light enters through a cross-shaped extension on the roof that itself penetrates under an angle into the exhibition space. This contributes to the possibility to read from the interior the composition of stereometric bodies and sloping planes.

In comparison to earlier work by Frank Gehry this museum could be a first step in a new direction. So far, the breaking up of a building into separate volumes that are connected with each other by transparent intermediate spaces has been a characteristic feature of his architecture. Although the constituent parts of the Vitra Designmuseum are stereometric volumes as well, this time the heterogeneous parts are linked together into one spatial composition. The building materials *stress* this sense of unity. Gehry is known for the application of heterogeneous building materials. With respect to the museum, though, only the white stucco and the grey-ish zinc sheeting used on the exterior of the building are contrasting. Inside, there is no contrast of this kind whatsoever. The architect attributes this to his conformation to "local tradition." You might say he has a wide interpretation of the concept "local tradition"—all over the middle of Europe buildings get plastered. Moreover, the final result is too eye-catching to be explained by a reference to "local tradition" only. The white stucco gives the museum the character of a sculpture, a freestanding object in space. Gehry once has stated that he rather thinks as a sculptor than as an architect who hides spaces behind a closed facade.

Is the Vitra Design Museum an example of deconstructivist architecture?

It is doubtful. In comparison to the oeuvre of Zaha Hadid or Daniel Liebeskind, Gehry's museum is much less fragmentary. Here, we are not dealing with the analysis of a building down to its elementary fragments. Rather the museum is about the composition of stereometric volumes, together forming a spatial unity. Within the contemporary post-modern discourse, the deconstructivists and the Gehry Museum have a relationship at a more conceptual level: both display an anti-classicist attitude. Taking the plastic quality of the museum in consideration, one could speak of "expressionistic architecture." Whether a "neo" predicate should be added or not is not important here. Maybe it isn't a coincidence that it is possible to discern morphological resemblances between Gehry's museum and early expressionism as embodied in the work of, for instance, Ladovsky and Krinsky of 1919.

—Otakar Máčel

Bibliography—

Haag Bleytter, R., van Bruggen, C., and Friedman, M., *The Architecture of Frank Gehry*, New York 1986.
Aedes Galerie, *Frank O. Gehry: Design Museum Vitra*, exhibition catalogue, Berlin 1989.
Sudjic, Deyan, "One Man and His Museum," in *Blueprint* (London), November 1989.
Boissiere, Olivier, and Filler, Martin, *Frank Gehry: Vitra Design Museum*, London 1990.
"Vitra International furniture manufacturing facility and design museum," in *GA Document* (Tokyo), no.27, 1990.

Giorgio Grassi (1935–)
Student Housing, Chieti 1976–80

Over the last decade, few projects have been as widely publicized in the European and the American press as Giorgio Grassi's and Antonio Monestiroli's Student Housing in Chieti; yet few have also received such scant critical attention. It is as if the project's message needed to be exorcized through its endless repetition and reduction to a consumable image. Such a fate is especially ironic in the case of Grassi's work, since its stated objective from the start was to counteract the commodification of architecture by a design strategy based strictly on use-value and necessity. But, if such a fate may to some extent be ascribed to the whole experience of the Italian neo-rationalist movement in the 'eighties, one is not thereby entitled to ignore the group's programmatic intentions, the civic and political ideals which formed the theoretical core of the Italian "Tendenza" movement.

Grassi's rise to prominence in the early 'seventies was chiefly due to his book *La costruzione logica dell'architettura* (1967), which set out the theoretical basis for all of his subsequent work. This idiosyncratic essay, which still awaits an English translation, established the principles of the neo-rationalist movement in the somewhat anachronistic form of a logical treatise (the title was a paraphrase of Rudolph Carnap's *The Logical Structure of the World*). In it, Grassi articulated a view of architecture based on the notion of design as a rational, analytic, and verifiable process, proceeding through syntactic "propositions." In practice, this approach entailed a search for a universal vocabulary of primary and self-evident forms, elements established by repeated use, stripped of their occasional meanings, and assumed to constitute the substance of architecture as a historical discipline. Such a neutral and objective stance, presented under the guise of an a-historic classicism, was also related to Conceptualism's attempt to replace the object by a linguistic definition. Grassi's earliest works, including his remarkable project for the Monument to the Resistance in Brescia (1965), would seem to confirm this link.

In any case, the student housing project in Chieti was certainly the most succinct and compelling expression of these theoretical concerns. The stark simplicity of the scheme—two comb-like buildings containing the student residences and two service blocks arranged symmetrically along a central street—made it one of the most representative and influential among the few executed works of the group. At the same time, its uncompromisingly civic character reflected the group's commitment to Modernism's collective and political ideals.

The building stands at the outskirts of the town of Chieti, in a sparsely populated agricultural area designated to be the site of the new university. Its most striking feature is undoubtedly the pedestrian street, which is raised upon a three-foot high concrete base accessed by a short flight of steps and bounded on either side by giant arcades. Behind the arcades at ground level are the dining hall, the meeting rooms, and several small shops. Such a primary scheme, in its deliberate avoidance of individualist whimsy, has the simple and compelling force of a collective archetype; in his presentation, Grassi stressed the need for an architecture "founded above all on the principle of non-contradiction" and in which "a door is a door and a window a window, and where that which gives form to each element is a principle of clarity and persuasion." This search for the self-evident and inconspicuous solution is the informing principle of the entire scheme. It may be seen in the dense staccato rhythm of the arcade, enlivened only by the Schinkelesque open staircases linking the public space to the students quarters, as well as in the rigid and formalized fenestration. Such a "tautological" architecture, in which each element refers only to its own condition within a formal syntax, aims to provoke the viewer through its flaunted ordinariness. As Grassi writes in an article significantly entitled "The licence of the obvious," the project abides by "a very broad and general idea of 'function' with the capacity to embrace not only different uses but also changing significations."

Typologically, the scheme may be linked to any number of precedents: Friedrich Weinbrenner's proposal for Karlsruhe (1820) and Henrich Tessenov's School at Hellerau (1925) are the two most frequently cited sources, but it may just as easily be related to the main arcaded street in the old town of Chieti (Corso Maruccino), or to the anonymous farmhouses of Northern Italy, many of which have similar covered galleries and loggias. The combination of urban and rural prototypes acknowledges the building's own peripheral condition at the edge of the city and overlooking the cultivated fields of Chieti's hinterland. Indeed, its very location helps to strengthen the relationship between public and private spaces: thus while the students' bedrooms are all oriented sideways towards the open fields, the communal areas, including the spaces for study and recreation, face the public street.

Grassi's crisp renderings in ink and Pantone on mylar manage to convey the sense of neoclassical order permeating the entire scheme. His perspective view of the public street offers a hushed scene whose stillness recalls Renaissance perspectives of ideal cities, with their juxtaposition of architecture against the distant countryside, as well as the more aggressive though no less idealizing schemes of the fascist period. The dramatic play of light and shade disturbs the symmetry of the composition and underscores the metaphysical quality of the whole. As Henrich Klotz has observed, it is an architecture that "almost drowns in silence." Indeed, this timeless character, combined with the scene's emptiness and uncanny sense of disquieting expectation, differentiates Grassi's work from the quaint superficiality and the nostalgic character of so many other neo-rationalist projects.

The building is thus a testimony to Grassi's belief in architecture as a social artifact, the "silent scene of human events," as his mentor, Aldo Rossi, called it. Its uncompromising clarity is both a statement of intellectual rigor and a selfconscious homage to the disappearing remnants of a collective vision.

—Libero Andreotti

Bibliography—

Grassi, Giorgio, *La Costruzione Logica dell'Architettura*, Padua 1967.
Monestiroli, Antonio, "Teoria e Progetto: considerazioni sull'architettura di Giorgio Grassi," in *Controspazio* (Bari), October 1974.
Grassi, Giorgio, "The Licence of Obviousness: Students' Hostel at Chieti," in *Lotus* (Venice), June 1977.
"Giorgio Grassi," special monograph issue of *2C Construccion de la Ciudad* (Barcelona), December 1977.
Grassi, Giorgio, and Monestiroli, Antonio, "Casa dello studente, Chieti, Italy, 1976–1980," in *Architectural Design* (London), May/June 1980.
Klotz, Heinrich, *The History of Postmodern Architecture*, London and Cambridge, Massachusetts 1988.

Photo courtesy of Gregotti Associati

Vittorio Gregotti (1927–)
IACP Zen Housing Development, Cardillo, Palermo, 1969–73

Once again in Italy we are faced with an unfinished project, compelled to discuss the architect's intentions rather than the reality. The lengthy design process, carried out during a period of deep debate on the social role of architecture, has produced many alterations which have slowed down, and sometimes even stopped, the completion of this project. Even though incomplete, today the *Zen* is the object of ferocious criticisms, wrongly accused of being directly responsible for the social problems of its inhabitants. Nevertheless, this quarter demands our interest, as it is the Gregotti Group's solution to the question of state housing.

At the time of the competition which was for a new development in Palermo, the biggest town in Sicily, the issue of state housing had once more gained the interest of all concerned. The possibility that this type of development could have an urban role was less uncertain, especially after some changes in the legislation and a growing interest from the architects. In this atmosphere the Gregotti Group was one of the few equipped to respond to the problems posed by changing cities and territories. The ability with which, during the preceding decades, he had faced the demands of landscape enabled him to re-create disciplinary functions capable of coping with the complexity of the new issues. According to his experience, an environment's design suggests its own distinctness: firstly the materials used by urban design, then the time taken to complete the whole project from start to finish, and finally the particular use which it is necessary to make of geometry and measurements. The analysis of the theme given, based on these three subjects, leads to the solution.

Gregotti with the *Zen* puts into practice his way of approaching a project by using urban design which he considers the only method sufficiently specific and articulate to work on this scale. Avoiding provocative answers, Gregotti decides that the only possible solution for the *Zen* is to adhere exactly to the competition's requirements. And his plan for Palermo's housing estate is outlined in a very lucid diagram of the requirements. The architect intends the *Zen* to be the embodiment of the new town, capable of improving the quality of Palermo's expansion. The link with the pre-existing town is strengthened by the location of the development. The area is in fact located on the borderland between an urban zone and the countryside, bridgehead of the development of Palermo along the axis of Via Maquida/Via Libertà.

The first proposal for the development is composed of three rows of six "insulae" (blocks) formed by four buildings arranged on three different levels, taking advantage of a natural slope of the ground. The buildings are linked together by towers at the furthest ends. Two parallel strips hold the collective services, creating a variation in the regularity of the grid. In a way, the desire for consolidation with the town itself is contradicted by the choice of the grid, which means that the quarter is closed on itself. This compactness seems designed to defend the *Zen* from being too oppressed by its pre-existence, and it also endows the quarter itself with an identity as a structured system. The apparent uniformity of the rigid grid, determined by the apartment blocks, is interrupted, in the spaces for the service buildings, by using a design which is suggestive of the Arab town with no squares, and which is frequently found in that part of Italy. Nevertheless, the buildings clearly have a Central European origin.

The interest aroused by state housing was here greatly increased due to the change of policy in the relationship between the architects and the clients, in this particular case the I.A.C.P. (State Housing Body). The complexity of the project prompted the Gregotti Group to work with I.A.C.P. in mutual collaboration while maintaining a more indirect relationship with the building contractor. The Group therefore attempts to avoid any kind of misunderstanding by carefully designing everything down to the last detail. However, the relationship began to deteriorate due to the rivalry which arose during the executive design stage. The differing attitudes to the design eventually led to an uncontrollable project, and this is clearly visible in the *Zen* as it is today. Between the architecture of the original project and the realised version there are substantial differences which are not limited to small details, but compromise important technological, functional and morphological choices. The renouncing of some of the duplex apartments and a number of "insulae," the fact that concrete was used rather than steel for the structure, and the framed structure itself which in some cases is substituted by load-bearing walls, are just some examples which help understand all the difficulties encountered in the realization of this development.

The *Zen* development is also Gregotti's contribution to the debate about the revision of the Modern Movement's heritage and more generally on architecture. Gregotti takes his decisive stand using numerous references to projects from the Rationalist movement of German, Dutch and Italian origin, although these are partially contradicted by the presence of the design of the Sicilian walled town. But his emphatic confidence in urban analysis is the key to comprehend Gregotti's approach to architecture. As he wrote in an essay about the *Zen*, "Urban analysis is the fundamental critical instrument for knowledge and for the constitution of a doctrinal body in architecture. It permits . . . a form of rational control of every piece of architecture either designed or built." Today we know that such a clear vision has not been completely realized, but to a certain extent we are satisfied that this partial failure was essentially due to unprepared clients and strong political interference in the management of I.A.C.P., rather than to a totally misguided approach to the issue of state housing from the Gregotti group.

—Enzostefano Manola

Bibliography—

Italian Architecture 1965–1970, exhibition catalogue, Rome 1973.
Tafuri, Manfredo, *Vittorio Gregotti: Buildings and Projects*, Milan and New York 1982.
de Seta, Cesare, *Architetti Italiani del Novecento*, Bari 1982.
Lovero, Pasquale, "The Zen Generation," in *Lotus International* (Venice), no. 36, 1982.
Tafuri, Manfredo, *History of Italian Architecture: 1944–1985*, Cambridge, Massachusetts 1989.
Crotti, Sergio, ed., *Vittorio Gregotti*, Bologna 1990.

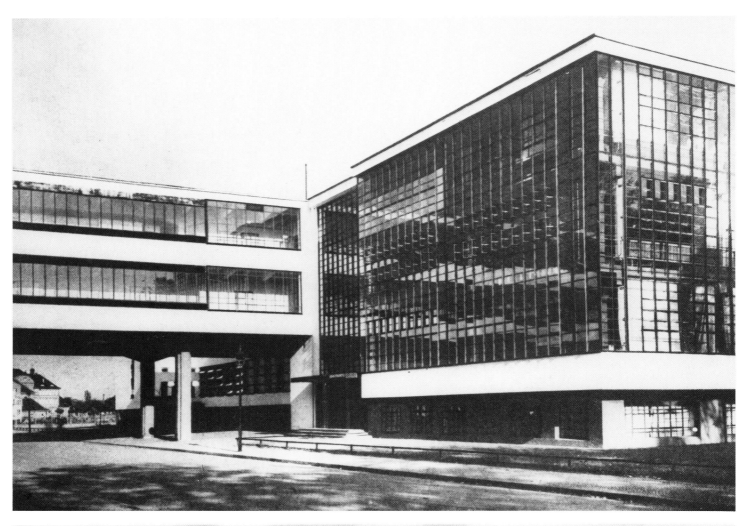

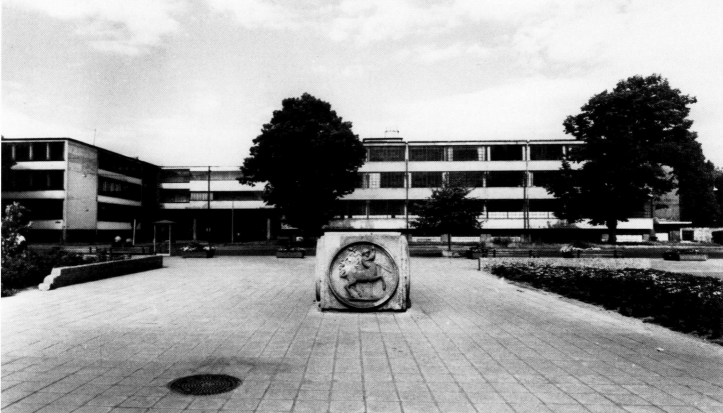

Photos Bildarchiv Foto Marburg

354

Walter Gropius (1883–1969)
Staatliche Bauhaus building, Dessau, 1926

In 1915 Walter Gropius was appointed by the Grand Duke of Saxe-Weimar to succeed Henry van de Velde as Director of the Grossherzöglich-Sächsische Kunstgewerbeschule and also as Director of the Grossherzöglich-Sächsische Hochschule für Bildende Kunst at Weimar. In 1919 Gropius merged the two institutions under his overall direction, and renamed the conglomerate Das Staatliche Bauhaus Weimar: he was to remain Director at Weimar until 1925. Thus came into existence the Bauhaus, in which were embraced notions that had derived from the English Arts-and-Crafts movement: the objectives were to combine disciplines that had become isolated from each other, to unify craft skills with industrial method, to educate in cultural matters, and to remove the idea of High Art from the curriculum. The unity of art and craft was central to Gropius's theory. Contrary to widespread and popular belief, there was no School of Architecture at Weimar, and none at Dessau either until the last years: the Bauhaus was, in effect, a revolutionary Utopian Art School, and there was a course in "architectural delineation" established in 1927 under the direction of Hannes Meyer, who succeeded Gropius as director in 1928.

By 1924 the association of the Bauhaus with the Socialist Government (and indeed some of the left-wing pretensions of the institution itself) brought it into conflict with the Thuringian authorities, and the Weimar Bauhaus was closed in 1925. Several cities and towns sought the re-establishment of the Bauhaus, and in due course the Mayor of Dessau secured the transfer of the organisation to that town, and set aside seven houses for the use of the Bauhaus pending the erection of a purpose-made building. At the request of the Town Council, Gropius himself designed the new structure, which was completed by the end of 1926. It consisted of three main wings containing the School of Design, the workshops, and the hostel. The first two were joined by a bridge over the road leading to the centre of Dessau, and this bridge contained the administration rooms, other facilities, and a private studio for the Herr Professor Gropius, who was to remain Director at Dessau until 1928, in which year he resigned in order to practise architecture.

The rectilinear forms of the wings were laid in three different directions and were linked by lobbies and staircases. In form the plan resembles Frank Lloyd Wright's so-called "windmill" designs, or a distorted Swastika with one of its arms missing. Thus the design and layout of the building attempted to express the different functions, which were yet merged in the whole.

A six-storey block contained the students' hostel, consisting of twenty-eight studio-dormitory rooms with balconies, and was partly constructed of reinforced concrete. The four-storey workshop block had reinforced concrete floor-slabs supported on "mushroom"-headed columns set well back to permit a large metal-and-glass curtain-wall to be placed on the façade of the upper three floors, and this was one of the first instances in which a fully glazed wall was employed on an industrial building. The classroom block was also of four storeys.

The bridge unit was intended to suggest the bridge of a ship from which the vessel was controlled (the Modern Movement often sought allusions to ocean-going liners), and expressed the link between leadership, administration, the School, the craft workshops, the town, and the greater world outside, a somewhat hoary concept that was indicative of much of the tone of the place. A lower element connected the hostel with the workshop block, and contained the School Hall, the dining-room, and a small theatre.

In the workshop wing tendencies present in Gropius's earlier Fagus Factory (1911–13) were developed further, for the structural system was almost entirely internal, allowing the curtain-wall to extend to the top of the building, and even return at the corners. This arrangement was subsequently altered, and the glazing rearranged as horizontal strips with solid bands between them, but in 1976 the original design of the curtain-wall was reinstated, and the entire building restored under the Communist authorities of the former German Democratic Republic.

Smooth-rendered walls and absence of mouldings created an aesthetic that was widely copied, but which required regular and expensive maintenance as the fabric deteriorated rapidly. The large amounts of glass also created problems of insulation and condensation, yet again were widely copied. Furthermore, the Bauhaus was perceived as an ideal by many persons of "progressive" opinions, and the obscure utterances emanating from members of the institution's staff were believed to contain profound truths.

An analysis of the building (rather than a reliance on carefully composed photographs which conceal more than they show) reveals that the junctions between the various elements of the total composition are extremely clumsy and ungainly, while much of the detail (notably the undersides of the bridge and the treatment of the ground-floor façade of the workshop block) is unsightly and ham-fisted. The Bauhaus gained enormously in importance, of course, when the institution was obliged to remove itself from Dessau in 1932 to Berlin when the National Socialist German Workers' Party took over the Government of Sachsen-Anhalt. Meyer remained director until 1930, when he was replaced by Ludwig Mies van der Rohe. In April 1933, however, the Berlin Bauhaus was closed and many members of staff moved to the United States of America. The fact that the National Socialists disapproved of the Bauhaus was sufficient to place it, its buildings, and its teaching firmly in the category of Revealed Truth among the uncritical. The influence of the Bauhaus probably became very much greater after it was closed, for many Schools of Art adopted its tenets after 1933. Similarly, Adolf Hitler's admiration for Classical architecture was enough to damn it throughout the world, while his opposition to the Bauhaus and its theories has been sufficient to make a prophet of Gropius and Holy Writ of his teachings.

The confused and obfuscatory writings and theories that originated under the aegis of the Bauhaus and its professors did nothing for the craftsmen and workers, of course, for not only were they alienated: the belief that a building should be the result of collective effort, and should contain contributions from each artist-craftsman who would be fully cognisant with the purpose of his work in relation to the whole, shows no sign of expression in the finished Bauhaus building. The aesthetic, in fact, helped to divorce the artist-craftsman even further from being able to play any real part in design and the creative process, with the result that by the time sub-Gropius buildings were *de rigueur* in Europe and America in the 1950s and 1960s, it was not unusual for a provisional sum to be set aside for some "art" or "sculpture" which would be stuck on afterwards. Rarely can intentions have produced realities so different from what was hoped, and the place of the artist-craftsman in society so fatally weakened as was the case after the Bauhaus.

—James Stevens Curl

Bibliography—

Gropius, Walter, *Bauhausbauten*, Munich and Dessau 1928.
Gropius, Walter, *The New Architecture and the Bauhaus*, London 1935, New York 1936.
Argan, Giulio Carlo, *Walter Gropius e la Bauhaus*, Milan 1951, Paris 1979.
Gropius, Walter, *Architecture and Design in the Age of Science*, New York 1952.
Gropius, Walter, *The Scope of Total Architecture*, New York and London 1955.
Fitch, James Marston, *Walter Gropius: Buildings, Plans, Projects 1906–1969*, exhibition catalogue, Washington, D.C. 1973.
"Bauhaus, Dessau," in *Architecture + Urbanism* (Tokyo), October 1982.
"Walter Gropius and the Bauhaus," special monograph issue of *Architektur der DDR* (Berlin), April 1983.

East elevation

Axonometric view

Illustrations courtesy of Gwathmey Siegel & Associates

356

Gwathmey/Siegel and Associates (1971–)
Busch-Reisinger Museum, Harvard University, Cambridge, Massachusetts, 1991

One of the most intelligent architectural firms currently working in the United States is Gwathmey Siegel & Associates, whose founding partners, Charles Gwathmey and Robert Siegel, third generation modernists, design with total command of the International Style idiom and with full comprehension of their modernist lineage. In Harvard University's Werner Otto Hall of the Busch-Reisinger Museum, Gwathmey Siegel pays homage to modern predecessors, integrating Le Corbusier's grand stroke site planning, Gropius' Bauhaus "new objectivity," and Louis Kahn's light and spatial processional, into their own contemporary synthesis.

This encompassing vision is effected within an exceptionally diverse programme, calling for a very small but multi-functional building to house gallery space, print study space, and an art library. The site is particularly constricted, facing to the rear of the Harvard University Art Museums complex, contiguous with the Fogg Art Museum, Le Corbusier's Carpenter Center, and James Stirling's Sackler Museum. The former buildings are not only stylistically inconsistent, ranging from Georgian to Brutalist to Post-Modern, but are unrelated in massing, materials and silhouette, strung along a street at the edge of Harvard Yard with little concern for ensemble or integration with the campus/urban site. Considering these site conditions, aesthetic problems, and programmatic restrictions, the commission for the Busch-Reisinger Museum would seem so constrained that many an architect would despair; Gwathmey Siegel, however, accepting the complicated premises, viewed the complex commission as artistic impetus to the creation of a difficult but functional work of art for art.

A tremendous cultural and aesthetic burden falls on the designer of a museum, and certainly such is the case in the Busch-Reisinger commission, for a museum building is surely to be the largest acquisition ever to made by an institution: as the building itself becomes a work of art in the museum's collection, it will be judged by a higher artistic standard than other contemporary buildings. Thus in the museum commission, bricks and stone and steel come to connoisseurship. Museum buildings of the 1980s and '90s, like the corporate headquarters of the '50s, will be the points of reference for architectural historians of the future, the works that will define the aesthetics of this age.

Gwathmey Siegel & Associates will then be noted not only for the Busch-Reisinger Museum, but for the controversial plan for the addition to Frank Lloyd Wright's Guggenheim Museum in New York City. Both the Busch-Reisinger and the Guggenheim addition are significant not only as works in themselves, but also because they represent case studies for the architectural problems of the late 20th century: like these works, other important buildings will increasingly be built on constricted and reworked sites, in high-density locations, often within the shadow of architecturally significant predecessors. As the Busch-Reisinger and the Guggenheim addition must respond to the powerful landmark modern images of the Carpenter Center and the Guggenheim Museum, so too must Gwathmey Siegel, descendants of the early modernists, respond to the mythic figures of Le Corbusier and Wright. Whereas first generation modernists had the privilege of sweeping aesthetic gestures, contemporary architects such as Gwathmey Seigel have found that the grand gesture must, by necessity, give way to the considered contextual solution.

Gwathmey Siegel's Busch-Reisinger Museum, true to contemporary contextual standards, is a quiet, urbane building. Consisting of two interlocking masses, with inset entrance and courtyard, the building attempts, in Gwathmey's words, "to mediate the dual context" of the Fogg and the Carpenter, achieved through palette, materials and flat pattern. The primary facades are faced in clay-colored metal and porcelain panels, planar and sleek, arranged in a smooth grid. As the grid is sympathetic to the brick and mortar pattern of the Fogg, the neutral clay palette responds to the cast concrete of the Carpenter.

The neutral front elevation is dominated by wrap-around, glass-block windows and cubic glass voids cut into the gridded, factory-metaphor skin, incorporating fenestration and natural light as design elements both externally and internally. The galleries are lit both by the irregularly placed open cubes of light seen on the elevation, and by a series of skylights, creating dramatically upper-lit, compressed darkened spaces with unexpected light shafts scattered among the artworks. The processional spaces and lighting of the galleries are clearly reminiscent of the work of Louis Kahn, modernist of the second generation, and a figure influential in the work of Charles Gwathmey.

Modern historical references are ever present in the Busch-Reisinger in industrial detailing such as the glass block, streamlined windows and factory-like staircase. The resultant "objective" modernist aesthetic appropriately speaks to the art housed within, the University's 20th-century collection of Germanic painting and sculpture, as well as to the Bauhaus archives located there. The historical presence of architect and Bauhaus founder Walter Gropius haunts the new Busch-Reisinger.

The great Corbusian conundrum of the Harvard University Art Museums confronted Gwathmey Siegel in this commission: whereas the Fogg and the Sackler lie on one grid, flush with the street edge, the Carpenter is oddly turned 45 degrees from the grid within its own "orthogonal site framework," its major design statement being the overwhelming diagonal of the ramp. In Gwathmey's words, his "solution also resolves Le Corbusier's compelling site circulation idea." What this means today is that, though Le Corbusier created the Carpenter Center, as early modernism would wish to, as an isolated, sculptural work in opposition to the streetscape of Cambridge, the ramp cutting through the building ostensibly to move the observer processionally through architectural space, the building's design and siting must now be reconciled within the Harvard University Art Museums complex. The early vision of the Carpenter Center and its processional ramp, however, had been left compromised and unfinished, the site plan a grand gesture without meaning. At last with Gwathmey Siegel's plan, the processional through the Carpenter, which for decades had climaxed at a dumpster, is now completed for the pedestrian at the new Busch-Reisinger's courtyard. It was left to Gwathmey Siegel to give form to Corbu's concept of the university campus.

Gwathmey Siegel & Associates, previous to their work at Harvard University, had established their credentials as academic architects, both as university professors, and in built works. In one of their earliest and most creative works, Whig Hall at Princeton University (1970), Gwathmey Siegel demonstrated a sensitivity for the concept of academic enclave, with its historical, social and aesthetic associations.

Important commissions, particularly those for the contemplative environments of the campus and the museum, call equally for intellect and inspiration. Breadth of architectural thought, as Gwathmey Siegel & Associates has demonstrated, spanning the "pervasive principles" from ancient Greece to modern America, is crucial to the aesthetics of the campus and the museum. As Charles Gwathmey has stated, "history is a continuous exchange between old and new . . . profoundly enriched through interpretation."

—Leslie Humm Cormier

Bibliography—

Arnell, Peter, and Bickford, Ted, eds., *Charles Gwathmey and Robert Siegel: Buildings and Projects 1964–1984*, New York 1984.
Harvard University, *The New Building for the Busch-Reisinger Museum, the Design for the Werner Otto Hall by Gwathmey, Siegel and Associates*, prospectus, Cambridge, Massachusetts 1989.
"Museum on the Move," in *Harvard Magazine* (Cambridge, Massachusetts), May/June 1989.

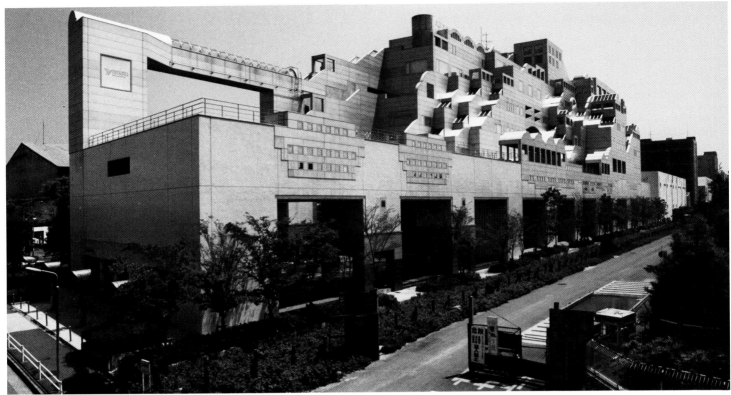

© Botond Bognar

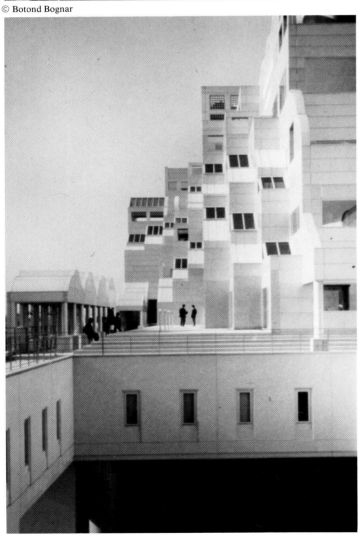

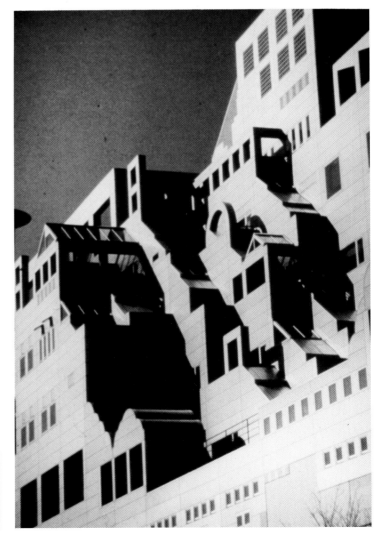

Photos Tomio Ohashi

Hiroshi Hara (1936–)
Yamato International Building, Tokyo, 1987

Since the mid-1980s Hara's architecture has been unfolding along his new interest in and reinterpretation of the concept of modality. According to Hara, in our age of super technology and information, more than any time before, the appropriate state of things, including architecture and the city, cannot be assessed and/or achieved merely by being concerned about their physical attributes: size, color, form, etc. More sensitive understanding and projecting the qualities of the environment, suggests Hara, can only be done by mobilizing and involving other faculties of the mind: memory, illusion, imagination, etc. Admittedly influenced by such avant-garde artists and thinkers as Magritte, Dali, De Chirico, but especially Marcel Duchamp, whose proverbial saying he borrows, Hara intends his designs as modes of revealing, or rather, "peeping into consciousness." Yet, human consciousness, as opposed to the body, does not have precise definition and clear boundaries; as it engages reality and overlaps with the worlds of others as collective consciousness, it is free from rigid delimitations while inducing a "vague atmosphere."

Accordingly, Hara in his new architecture of modality aims at creating buildings whose shapes, spaces and meanings are defined as ambiguously as possible, with boundaries that cannot be deciphered, in principle at least, with absolute certainty. In this regard, he often refers to such amorphous and elusive phenomena as clouds, mist, fog, rainbow, mirage, etc. In his patterns of thinking, however, one is prompted to discover not only the imprints of Duchamp and his contemporaries, but also the basic tenets of Oriental philosophy, especially Buddhism. Indeed, Hara's recent design enterprise is taking shape at the crossroads of various influences, between East and West, past and present, archaic, elemental and futuristic, high-tech, etc.

The Yamato International, headquarters of a Japanese fashion clothing company, is the most successful and spectacular demonstration of Hara's intentions to merge the realm of architecture with those of urbanism and nature in a way that also reflects equally well both society's consciousness of the present and memory of the past. The building is located on recently reclaimed land near Tokyo bay. The area, although now replete with commercial and residential developments, still carries the remnants of its previous industrial buildup. Occupying almost completely its 150 metre long yet narrow site, the longitudinal structure is perpendicular to the adjacent elevated highway and is in between an attractive green park and an urban road, with densely built and chaotic but relatively low profile urban areas around.

In response to these conditions, the large complex has been designed with an elevated platform and elevations that are more open toward the park in the west while higher and more closed on the other side. The extensive, three-storey substructure, featuring storage facilities and loading ramps inside, matches the elevated highway in both height and regularity; it also acts as an infill of the urban fabric and, more importantly, as an artificial urban topos raised above the noise and confusion of the semi-industrial environment. Built upon this new layer of "land," the section of offices, studios, reception, conference and showrooms emerges in a curious way not so much as an ordinary building, but in fact as a small "hilltown" where a multitude of individual houses and other structures, denoted by their various roofs and even volumes, are layered in rows behind and above one another as they are piled up several storeys high. Sculpted and clad extensively in highly polished aluminum panels of slightly different colors, this upper region of the Yamato gives the impression of a surrealistic vision of a fairy tale village and at the same time embodies the idea of the "city within city," or the "building as a small city."

To provide further justification to this interpretation, Hara has arranged the rooftop terraces as plazas lined with small gazebos and connected with walkways and stairs which, inlaid among the fragmented volumes and facades, add up to an urban promenade. Visitors can use this outside public realm and experience the built sceneries without disturbing the activity of the offices inside. The pedestrian path, that also includes a long, glass vault covered bridge flying high over the elevated plaza, begins in the partially enclosed entrance courtyard whose space, through the large openings of the platform, is directly linked to the park and the surrounding residential area nearby.

Blurring even further the boundaries between inside and out, Hara designed the interiors with polished and inlaid granite walls of various textures, with layered, translucent glass partitions and window panes, all etched with consistently altered surface patterns. By way of their visual overlappings and interpenetrations, exterior and interior as well as in-between spaces or vistas are fragmented, scattered and superimposed to create perpetually shifting "scenes" wherein reality and fiction are inseparably intertwined. Absorbing as well as reflecting both light and vistas, the building also responds to its environment by changing its mood with the change of the day, the seasons and nature. "Contrary to an immutable edifice," as Hara explains, the Yamato International is meant to represent "in Japanese traditional aesthetics, the value of *mujo*" that is the world of mutability and transience.

If Hara's purpose in his earlier projects envisioned the reconstitution of the city within the realm of architecture, then this intention can be seen continued with renewed impetus in his recent works: the Tasaki Museum (1986), the Iida City Museum (1989) and, most especially, in the Yamato building. Yet, the original model, now eschewing symmetry, is less rigidly arranged and, more importantly, it is reversed or turned inside out. In other words, the new urban order is taking shape in the exterior, rather than remaining hidden or buried inside the building. In both versions, however, the prototype for the "new" order can be traced back to indigenous examples, insofar as Hara, influenced by his earlier extensive anthropological and architectural investigations of third world—mainly African and Asian, including Japanese—vernacular villages, implemented much of his findings in terms of formal articulation and, more so, topological disposition of space. Traits of primitivism or of returning to the origins can be discerned both in his houses and recent larger public buildings. In case of the Yamato International, the imagery of ancient hilltown communities is unmistakable yet without necessarily being identifiable.

On the other hand, the building also displays similarities with another, more futuristic and utopian urban model, the "city in the air" that first emerged in Arata Isozaki's visionary projects of the early 1960s and has since then surfaced as a latent idea, if not really an explicit form, in the work of several Japanese architects, Riken Yamamoto, Kazuo Shinohara, etc. Despite, or perhaps exactly because of, having been shaped along a broad spectrum of ideas, theories and often contradictory influences, the Yamato International provides a superb architectural as well as human experience, particularly with regard to its urban environment; on the one hand, it is capable of continuing the densely built and ambiguously collaged fabric of the existing city around, yet at the same time as an elusive mirage of a "high-tech Shangri-la," in and of the air, it manages to transform the very city into an altogether different one.

—Botond Bognar

Bibliography—

Bognar, Botond, *Contemporary Japanese Architecture: Its Development and Challenge*, New York 1985.
Hara, Hiroshi, "Modality—Central Concept of Contemporary Architecture," in *The Japan Architect* (Tokyo), November/December 1986.
Hara, Hiroshi, "Yamato International," in *The Japan Architect* (Tokyo), August 1987.
Bognar, Botond, *The New Japanese Architecture*, New York 1990.

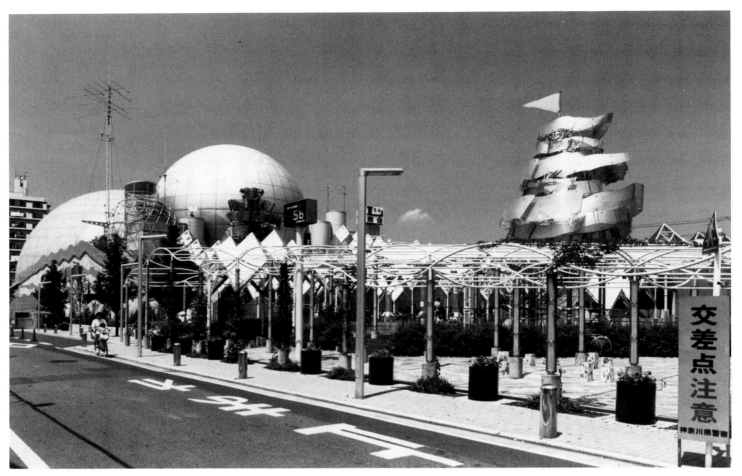

Photos © Botond Bognar

Itsuko Hasegawa (1941–)
Shonandai Cultural Center, Fujisawa City, 1989

The recently completed Shonandai Cultural Center (1989) signals not only a new highpoint in Hasegawa's career, but perhaps also a turning point in the course of Japanese architecture. The Center, occupying two city blocks in downtown Fujisawa, is the largest work to date by this outstanding designer; it is also one of the first really urban-scale public complexes completed by a new generation of Japanese avantgarde architects—the so called New Wave—who emerged in the '70s and have been coming to age since the mid '80s. Considering the fact that in Japan the commission of large, public or governmental projects is customarily awarded to equally large corporate design offices and/or construction companies that turn out "safe" or reliable, but predominantly conservative, works reinforcing rather than questioning the status quo of a prevailing rigid modern urbanism, the mere existence of the Center is already remarkable.

Furthermore, the Shonandai, the result of a winning entry in a nationwide competition, had been designed by one of the handful, and indeed the only really active woman architect in Japan. Hasegawa, with her work, thus has infused a "feminine voice" in the contemporary Japanese architectural discourse, shaped almost solely by the representatives of the other gender. Nevertheless, while this "feminine voice" manifests a unique poetic quality, it bypasses any nostalgic reinterpretation of architecture, the architectural past and the "lost center," so common in today's historicist and trivial postmodernism.

In the Shonandai, Hasegawa has created an urban "park" by way of redefining "architecture as second nature." She has done this so that, while mobilizing the "translucent world of emotions" devoid of the spirit of rationalism, the overall design eschews the sentimental attributes of nature. She introduces nature into her design on two levels: the first, the actual nature through the careful yet extensive utilization of ever changing natural phenomena and the reliance on the evocative, but also provocative power of nature; the second, analogical nature, a man-made, industrial/technological and so, even futuristic construct.

The overall scheme of Hasegawa, quite obviously then, is not an ordinary building that wants to appeal with its overwhelmingly monumental form, as this is usual in case of large public facilities; rather, it is an accumulation of various elements: several spherical volumes of different size, light, punched aluminum screens, canopies, series of small prismatic glass and metallic roofs over an extensive open plaza that includes an amphitheater, walkways and stairways. The plaza also features devices activated by light, wind and sound, a "tower of wind and light" and a "tree" with a built-in clock. This man-made high-tech park, contiguous with the surrounding pedestrian areas, yet also extended on top of the stepped roofs, is inlaid with green zones of trees, bushes, etc., which interweave with the whole complex in and out. Since the majority of this first level is devoted to outside leisure activities: playing, gathering, strolling for the citizens at large, the more specific functions of the center are arranged in either the spherical structures or are set underground. The globes house theaters and/or auditoria, while the first basement level accommodates offices, lounges, practice rooms, an exhibition hall, etc., that all face small sunken gardens; parking and additional machinery rooms are on the second basement level.

Since the early '80s Hasegawa has been choreographing "natural landscapes" with and within her architecture. She has developed a design sensibility toward light, flexible, scattered, and ambiguous realms, similar to the ones experienced in nature. To achieve this, she, like many other contemporary Japanese designers, such as Toyo Ito, Kazunari Sakamoto, Riken Yamamoto, etc., began to extensively employ lightweight industrial materials and products: layered, perforated aluminum screens; slim, ferrous elements; synthetic fabric; etc. She configures these so that while the dispersed and collaged architectural elements are exposed to and activated by light, wind and sound, they also allude to natural formations; they become analogous to some fictive or symbolic landscapes buried in the collective Japanese memory.

These fictive, almost utopian, sceneries in Hasegawa's design for the Shonandai Cultural Center, however, suggest not only rolling fields, hills and mountains, trees and woods, but also some small vernacular settlements, villages, and farming communities that have by necessity maintained a close affinity with nature and the natural.

In the '70s, Hasegawa both studied and worked in Kazuo Shinohara's studio at Tokyo Institute of Technology. Her career was thus launched under the influence of her mentor's highly "art oriented" work. They shared a common interest in an architecture of minimalist/primitive simplicity yet, whereas Shinohara tended toward an abstract, conceptual approach in his efforts to redefine Japanese space, Hasegawa was gradually drawn toward a kind of intuitive or poetic *realism*. Her small residences were arranged as an almost direct response to the clients' needs, lifestyles, the usually cramped and irregular site conditions, etc., rather than prefigured by some *a priori* conceptual model. Consequently, her works have been, from the very beginning, free from the fetish of form or formalism, and have also had little to do with defining "architecture as language" either; they all have a matter-of-fact quality, revealing the chaotic and paradoxical urban conditions in which they have been invariably conceived as well as eventually set. The fragmentary nature of Hasegawa's designs thus continue the heterogeneous, collage-like texture of the Japanese city, yet the projects also provide, by way of both primitivism and the application of technology, a sharp contrast to the same environment; they result from a process of dissimilation. In other words, her "analogical (land)scapes" profoundly challenge the actual, surrounding land- and urbanscape that inspired them. Hasegawa's architectural realism thus is at odds with its American counterpart, the contextualism advocated by Venturi, Stern, and others.

Simultaneously, the prevailing feeling for the primitive was complemented by a sense for nature/vernacular mediated by the vestiges of high-tech. Thus such projects as the Bizan Hall (1984), the House in Nerima (1986), and especially the Shonandai, beyond recollecting images of primal landscapes, old villages, and a primitive living, also allude to a new technological landscape and futuristic modes of urban lifestyles. Like many recent works by Toyo Ito, much of the Cultural Center suggests a kind of "high-tech camping," something temporary and hence suitable for Japan's new "urban nomads." Yet these qualities here, as Hajime Yatsuka observed, can also evoke scenes as naive as a "fairy tale village on the moon out of a children's book."

In this sense, Hasegawa's Shonandai Center reveals some new aspects of her design, that both broaden the horizon of its possibilities and increase the risks involved. The combination of contemporary technology with a "primitive" simplicity, in addition to continue producing a new industrial vernacular, also yields a cosmic dimension (note the large spherical elements, in fact globes), and bears a certain affinity with the simulated world of Disney. The future success of Hasegawa's "architecture as second nature" will ultimately depend upon how far she is able to avoid succumbing to, while flirting with or utilizing, the tempting world of simulations in order to shift the course of recent, consumerist urban developments toward new realities.

—Botond Bognar

Bibliography—

Bognar, Botond, *Contemporary Japanese Architecture: Its Development and Challenge*, New York 1985.
"Itsuko Hasegawa," special monograph issue of *Space Design* (Tokyo), April 1985.
Hasegawa, Itsuko, "Shonandai Cultural Center," in *The Japan Architect* (Tokyo), November/December 1989.
Bognar, Botond, *The New Japanese Architecture*, New York 1990.

Photo by W. Diepraam

Herman Hertzberger (1932–)
Central Beheer office complex, Apeldoorn, 1969–73

The way we identify a building and the way in which we perceive a structure is often determined by preconceived ideas. In addition, spaces provided for the use of people often allow little opportunity for them to control or modify their environment. Probably, Herman Hertzberger's design of an office complex at Apeldoorn has indicated how these problems may be answered. The scale of the Central Beheer offices can be appreciated at a domestic rather than institutional level. This is a result of the basic structural geometry of the design which is planned as a series of squares that are expressed as components of a low-rise building.

Hertzberger had developed the concept applied at Apeldoorn in the mid-1960s in two unbuilt competition proposals for town halls at Valkenswaard and Amsterdam. The design approach is in essence that of the Dutch Forum group in which Van Eyck and Bakema were influential and Hertzberger was a member. Their concern was that the public realm should be formed so that the design of spaces for use was flexible and adaptable, and that the scale did not dominate the people who would occupy them. The Forum group believed in a social attitude to design. Some critics have observed that the Central Beheer office complex has the formal characteristics of a Casbah. Certainly, the traditional hierarchy of spaces associated with office design is not in evidence.

Although there is an identifiable central space to the scheme, the character of the formal expression suggests several perimeter points of access rather than one main line of approach, which is of symbolic rather than social significance. The basic structural grid of the design which acts as a continuous reference system evolved from ideas discussed in the architectural milieu of Holland during the 1960s. One feature of that approach was that of a contrast between a structurally defined support system, in the case of Central Beheer this is provided by a concrete framework to the square blocks, and of a flexible infill system. The use of the infill units at Central Beheer is of various functions such as toilets, coffee bars, reception spaces as well as the multitude of office arrangements.

Both internally and externally, the materials expressed are concrete structural forms with concrete block and glass block infill panels. Externally, the cubic massing of the building and elegant rhythm of the window mullions contrast with landscape features to relieve the overall grey appearance. Internally, the spatial structure facilitates a lively environment. The central space forms a dramatic focus to the circulation. Balconies from the upper levels penetrate into this space; escalators provide almost sculptural features aligned diagonally across the space; the liftshafts are glazed and the lifts have brightly coloured panels; throughout the circulation spaces, plants provide greenery to soften the concrete block surface. In the office spaces, the blockwork provides a background for the decoration and personalisation of the spaces by the occupiers.

An understanding of the basic structural system provides insights into the conceptual approach. At basement level there is a car park from which massive stub columns and capitals support the lighter framework structure of the office spaces. The office modules are based upon a nine square Palladian grid each unit being of three metres square. Between each module a transitory space of three metres width is formed. The central squares of adjacent modules may then be linked by bridges in the transitory spaces

to form the idea of "streets" which criss-cross the basic structural system. Office spaces of a wide range of layout can then occupy the corner squares of the Palladian grid. To further enhance the concept of public "street" and private office, the office spaces are defined by carpets.

One of the delights of the building is the way in which the top-lit transitory spaces act as light wells for internal office units, which are expressed as corner balconies overlooking the spaces. Nowhere does the building exceed four storeys in height so that pedestrian movement through the complex is comparatively unrestricted. The perimeter blocks are of two or three storeys in height and the block form is higher at the centre of the plan. This effectively provides the characteristic massing of Central Beheer. Hertzberger's notion of "usable form" results in the roofs of the lower blocks being used as roof gardens. The total effect of this approach to design has led some critics to suggest that buildings of this type have resulted in Dutch "Structuralist" style or language of architecture.

A building complex of this scale clearly has implications for the way in which Hertzberger views urbanity. Perhaps the use of the Casbah as an urban metaphor for the design may be too evocative but the formal character of the building and openness of the planning do suggest values associated with tightly knit and thus interactive communities. The use of photographic images of ethnic communities and their habitats was frequently used by the *Forum* magazine. Also, it would be fair to suggest that Hertzberger had in mind an urban quarter of Apeldoorn, rather than an isolated block, when he conceived the design. Indeed it was originally intended that a pedestrian route from the town centre to railway station would cross the Central Beheer site. Further evidence of the urban notion contained in the design is discovered in the position of the restaurant which would have been adjacent to the pedestrian route. The restaurant is also planned on the basis of the structural grid with lantern rooflights to central spaces. Hertzberger appears to imply that buildings and urban form should be of an appreciable scale and that grandeur and civic design are values ill-suited to social need, democratic values and communal interaction.

Hertzberger's design for Central Beheer may be considered in the same context as Van Eyck's Orphanage built ten years earlier. Both designs were consistent to the modern movement but not to the concept of analytical functionalism. To an extent, the social notion inherent in their designs was one with a cultural basis in which the spaces provided, particularly by Hertzberger's work, have been defined as "polyvalent" capable of adaptation and usable in a variety of ways. The process of architecture developed by Hertzberger at Central Beheer is not a hermetic one, but results in open ended solutions with organic implications.

—E.S. Brierley

Bibliography—

van Dijk, Hans, "Herman Hertzberger," in *Dutch Art + Architecture Today* (The Hague), December 1979.
"Insurance Company Offices in Apeldoorn," in *l'Architecture d'Aujourd'hui* (Paris), February 1981.
Luchinger, Arnulf, *Herman Hertzberger: Buildings and Projects 1959–86*, The Hague 1987.

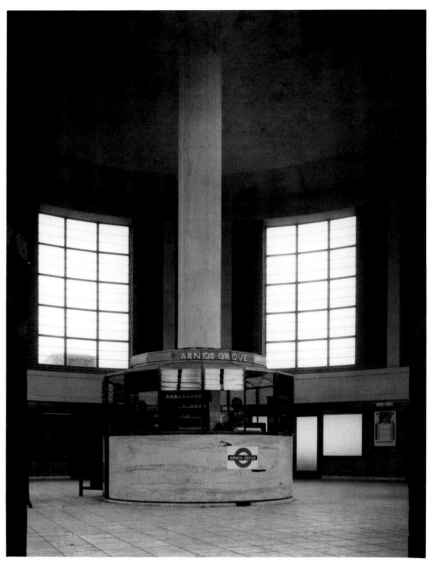

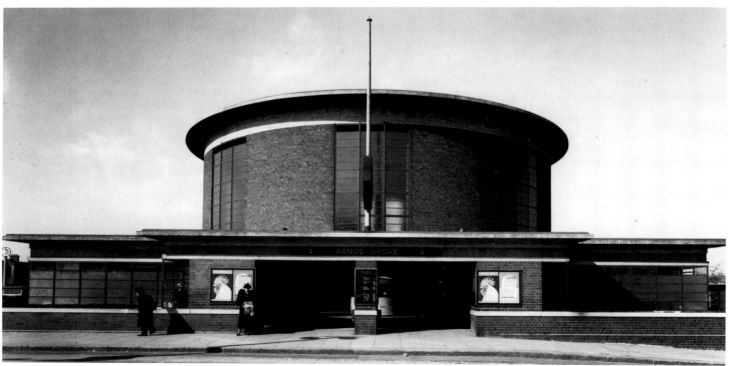

Photos London Transport Museum

Charles Holden (1875–1960)
Arnos Grove underground station, London, 1932–33

The house style of the London Underground developed as a result of the meeting of Frank Pick and Charles Holden at a Design and Industry Association exhibition sometime during the years of the First World War. Holden was to describe this style, later applied to many London Underground station buildings, as "a concrete lid on a brick box" and indeed, a better description would be hard to find.

The first station to be built in this manner was at Sudbury Town in 1931. The extension of the Picadilly Line to Arnos Grove provided the perfect opportunity for the generation and testing of an architecture which was intended to reflect the modernity and the corporate image of the largest underground passenger railway in the world.

The London Underground Railway had been formed through the amalgamation of several smaller companies and, as a result, the new corporation had inherited station buildings in a mish-mash of architectural styles. Under the tutelage of Frank Pick, who had realised the value of a strong corporate image, new-built stations were to define in a form of architecture which could be immediately recognised as belonging to the London Underground Railway. Holden was committed to developing an architectural language which had both civic and corporate resonances.

Arnos Grove Station uses such a language. It follows the pattern set by the Sudbury Town building, using concrete, glass and brick in its construction. In so doing, Arnos Grove can be seen as the precursor to the civic/corporate style adopted for the station buildings on the Cockfosters line after the New Works Programme of 1935–40 came into effect.

Although this building is ostensibly just a railway ticket hall, it should be viewed in the context of modern architecture in Europe between the wars. Not least because of the research undertaken by the architect and other interested parties before work on the project began.

Pick, Holden and W.P.N. Edwards travelled to Europe the year before Arnos Grove was built with the express purpose of visiting some examples of the new architecture which was springing up on the continent. They visited Germany and Denmark, but it was in Holland and Sweden that they found the clues to the built expression of modernity which were to inform the designs for the Underground Railway.

The new architecture in Germany was considered to be too boldly revolutionary for the tastes of Pick and Holden, but in Holland the work of De Klerk and Dudok in Amsterdam and Hilversum struck a chord. The combination of a peculiarly Dutch civic sense, together with the use of brick as the predominant material lent itself to Holden's vision. Furthermore, Gunnar Asplund's City Library in Stockholm also made an impression upon the architect during this visit. Arnos Grove and the other subsequent stations bear a striking formal resemblance to Asplund's cylindrical civic building.

With its careful geometry, massing the cylinder with the rectilinearity of the base, the building at Arnos Grove reflects the influence of, and places itself within a certain strand of modern, European architecture.

It is undoubtedly a modern building; it relies on a concrete frame for its structural integrity, but rejects the brutal modernism of the "functionalists" of the European mainland. The concrete frame is only exposed internally; from the outside the viewer is presented with a brick drum on a brick base, punctuated by horizontally dynamic fenestration. Unusually, the glass in the windows sits almost flush with the outside of the frame, creating an exterior in which the curve of the wall is accentuated and not broken by the windows.

The panels which form the infill to the concrete frame are of Buckinghamshire brick, a choice which reflects the attention to detail brought to the design by Holden and his team. Buckinghamshire brick is of a characteristically reddish-brown colour, as is the dust which was thrown off by the brakes of the trains. The choice of this material was designed to prevent the inevitable staining from the dust being visible to the passengers.

The lofty interior space of the ticket hall is a study in restrained "good design." With concrete frame exposed to the interior, the crisp formwork on the structural members can be seen. The seating of the circular, concrete roof made the inclusion of the central column necessary. The column, therefore, has a definite structural purpose, but it also serves to create the hub around which the human traffic of the station is encouraged to move.

The treatment of the column where it joins the pre-cast roof is typical of Holden's aesthetic approach to the rendering of architectural detail. Holden understood modern architecture, certainly, but it was not in his nature to reveal structural details for the sake of an architectural ideology to which he did not fully subscribe. Instead, the elegant solution is applied as the column is joined to the ceiling by means of a stepped rose.

Holden was also aware of the impact and importance of fashionable styles in design on the general public in the buildings they were required to use. Consequently, the ventilation panels in the walls are evidence of Holden's deference to popular trends in art and design. Executed in a style bordering on a bastardised "decomoderne," the panels are the work of Harold Stabler.

Original detailing in the interior is in bronze and, during the 1930s, the house style of the London Underground was in the process of being so well-defined, that instructions were issued to maintenance staff to the effect that the bronze should not be polished, but instead left to acquire its natural patination.

Arnos Grove Station represents the essence of the drive towards good design coupled with the exercising of a peculiarly English reserve which so characterises the work of Holden and the ideas of Pick. It lacks the flashiness of Southgate Station, adorned as it is by the equivalent of a "geometric kebab," but it avoids the façadism of Holden's earlier work for the London Underground.

Holden's belief was that architectural style should arise out of the solutions to particular problems and that it was the architect's job to give visual and aesthetic qualities to those solutions. Arnos Grove follows that philosophy, in that it is a building born of the application of common sense and a version of modern architectural theory to a range of design problems.

Although small in scale by Holden's standards, Arnos Grove Tube Station manages to achieve a rare quality of good architecture in the most mundane of settings by combining personal architectural expression with design solutions executed in impeccable good taste.

—Michael Horsham

Bibliography—

Austin, D. F., *Charles Holden*, thesis, Royal Institute of British Architects, London 1964.
Mayer, Martin, "Underground Architect," in *Building Design* (London), 11 April 1975.
Hanson, B., "Singing the Body Electric with Charles Holden," in *Architectural Review* (London), December 1975.
Middleton, G., "Charles Holden," in *Architectural Association Quarterly* (London), no. 2, 1976.
Hitchcock, Henry-Russell, *Architecture: 19th and 20th Centuries*, London 1977.
Adler, Gerald, *Charles Holden: Underground Architect*, thesis, University of Sheffield 1978.

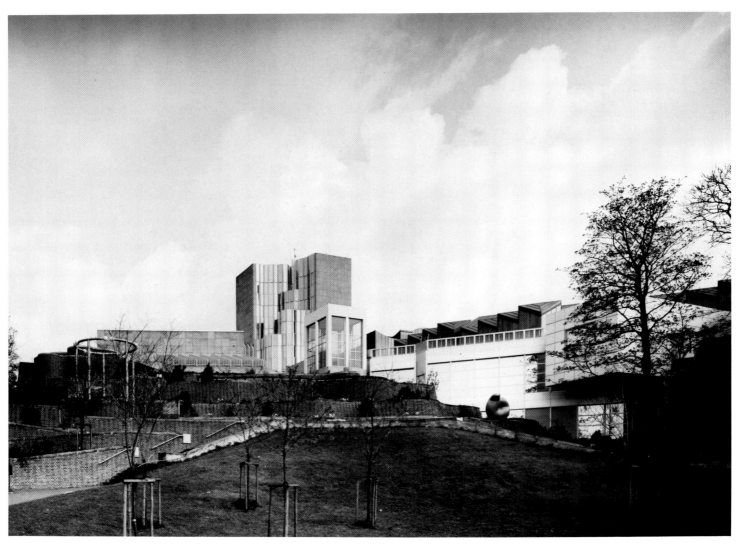

Photo Marliese Darsow

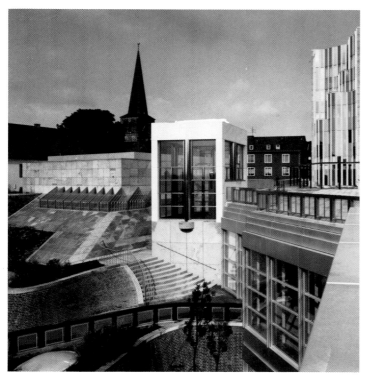

Photo Ruth Kaiser

Hans Hollein (1934–)
Stadtisches Museum, Monchengladbach, 1972–82

Painting as a form which is tied to its locus was still being practiced in the application of frescoes to wall surfaces during the Italian Renaissance. Painting has often had a direct relation to the environment and to architecture. The division between painting and architecture has progressed since the Renaissance, as if image and form are constantly displaced from each other. The director of the Stadtisches Museum, Johannes Cladders, proposed the creation of a painterly museum to Hans Hollein. His interest was to create a museum where image and form could be sensed through the perceptual intentionality of the viewer and the artist. The proposal was also for a museum where the relation of painting to architecture would be portrayed within a collection of works focused on conceptual art. The result is a building which is decentralized in its overall structure, and which introduces a "viewer-based" phenomenological center. The viewer aestheticizes the collection, and the relation of the works of art to the architectural structure, within his or her movement throughout the building.

Many architects have understood structure as a form of expressivity, particularly as reconciled in Eric Mendelsohn's Einstein Tower. Hollein, instead, has created a museum that is uncovered through a series of phenomenological operations. The entrance itself is not pivotal to the museum—there are in fact several architectural entrances. The building is both attenuated and maze-like. It is hidden, yet molded, onto a series of levels, which never dominate the hill on which it is placed. It is impossible to ever see the whole structure which can be perceived only in segments. There is no back, front or side to the building. From the interior the collection is approached by the art viewer through a series of rooms of varying sizes. Some rooms are cul-de-sacs, such as the small personal gallery with curved walls which houses one work of art, Paolini's *Mimesis*. Other rooms open upon views of larger galleries, or of the gardens. Each room, and every detail has been carefully crafted, down to the latticework of the windows, asymmetrical ceilings, geometric, skylights, curvilinear stairways, and an audiovisual theater which resembles a Jules Verne submarine.

The viewer finds works of art through descending and ascending plateaus and rooms. The collection itself mimes the progression of the viewer throughout the museum. While a number of works are by Pop artists, even these works are conceptually affiliated. The collection is dominated by conceptual works, which at times are indistinguishable from the conceptual form of the museum's architecture. Thus, sculptural floor works direct the viewer to the structure of the building itself. The geometrical neon lighting of one gallery ceiling mimes the sculptural lighting work of Dan Flavin. The museum structure is dominated by ideas of covering, and uncovering, discovery and disappearances. The exterior movement within the architectural structure, again a reference to Mendelsohn, though more geometrical, also displays the movement of the viewer inside and throughout the galleries.

The structure of Hollein's museum is not only concerned with enclosure and disclosure, hidden and open areas, but exhibits as well the layering of images and form. The gradated garden adjoining the museum has a similarity to fields of Asian rice paddies. Several windows function as alcoves on an otherwise modernist sleek facade. A series of spinnaker-like skylights are set above a pedestrian balcony, and near the central tower which caps Hollein's work. In another section of the structure the facade appears as a reference to a movie screen, with a window in the center, projecting itself out of the building and into the garden. The city of Monchengladbach adjoins the museum, so that as visual form, the city is appended to the form of the museum. No viewing of the museum is related. The aerial view has no relation to an interior or exterior view, or to a frontal or side view. The museum as corporate whole cannot be visibly found, but can be experientially sensed.

But what is uncovered as the viewer wanders throughout the museum or in the sculpture gardens? The metaphor for a museum here is not about works of art as studied objects. The approach to artistic revelation, and the cognition and persistence of artistic form and image is meshed in the movement of the viewer throughout the museum. The Stadtisches Museum is about the activity of viewing: how to create what is aesthetic. The viewing of the art work and of the architecture is aestheticized in this encounter. The Stadtisches Museum brings to mind two other museums which are kinetic in structure: The National Gallery in Washington, D.C. and the Neue Staatsgalerie in Stuttgart. These three museums are works of art which are unsettled as structures. They suggest that the function of a building is one of motive force. A theatrical-performative activity is present within the structure, rather than the proposition of structure as a stabilizing or functional force. These museums are works of art which deny the separation between painting and architecture, image and form.

In the Stadtisches Museum, the works of art are installed in such a manner that the structure of the building becomes an installation. The subject, the "viewer" is always in the position of recontextualizing image and form. Hollein, as architect, has used imagery, structure and concept compositely. He thus produces a museum within the lineage of conceptual art on the one hand, and architecture as concept on the other. The museum collection is conceptual; the building is a concept. Malraux' theory of a museum without walls exists here as a museum with walls.

—John Robinson

Bibliography—

Makler, Christoph, *Hans Hollein*, booklet, Aachen 1978.
"Projects of Hans Hollein," in *Werk, Bauen und Wohnen* (Zurich), January/February 1982.
"Hollein Fragmenta 1972–82," in *Domus* (Milan), October 1982.
"Hans Hollein—portrait," in *Architecture Interieure* (Paris), April/ May 1983.

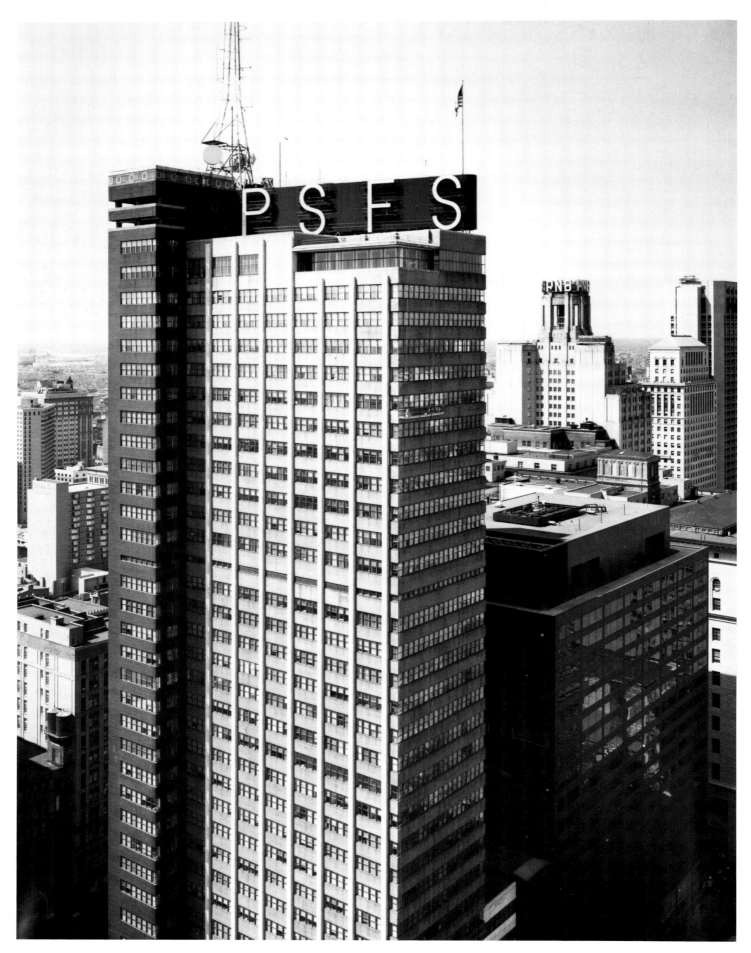

Photo Library of Congress

George Howe (1886–1955)/**William Lescaze** (1896–1969)
Philadelphia Saving Fund Society Building, Philadelphia, 1931–32

The Philadelphia Saving Fund Society Building stands as a primary monument to early Modernist architecture in the urban core. Though it has been criticized for compromising the aesthetic purity of the European International Style, these compromises have also made an enduring contribution to the appropriate relationship of highrise architecture to the central city.

The "PSFS," as its red neon rooftop letters proclaim, was conceived during that brief window of time between the late 1920s and the Great Depression when the visions of European Modernists began to gain currency among American architects. The American response to pressures for a new architecture was at the time largely confined to "Modernistic" treatments of traditionally decorated buildings, later called the Art Deco style, until European architects themselves transported Modernism to America. The architect William Lescaze, George Howe's junior design partner in creating the PSFS, was a dedicated Modernist when he arrived in the United States from Switzerland in 1920. The story of his collaboration with the prominent Beaux-arts architect Howe, revealing their originally awkward design attempts and their breakthrough to the breathtaking clarity of the final PSFS design, has been elaborated in detail by William H. Jordy in the May 1962 *Society of Architectural Historians Journal.* Suffice it to say here that this precise combination of the two architects with widely contrasting backgrounds, along with PSFS president James Wilcox's demand for an "ultra-practical" building, forged a design solution nearly without precedent and, in some ways, hardly equalled since.

When the PSFS was completed in 1932, critics were hard-pressed to define this unusual 32-storey skyscraper of horizontal ribbon windows held in place by protruding limestone-covered piers set atop a curved base of polished charcoal granite. While Douglas Haskell derided its machine-age character by complaining about the "filing-cabinet building," appearing as "a stack of trays, held at the side by the vertical sticks of the rack," the journal *London Studio* proclaimed that, in PSFS, the skyscraper had reached maturity. To be sure, this building was outrageous—especially in conservative Philadelphia—in its starkly trabeated sheathing devoid of applied ornament. It must be remembered that even in Europe only a relative handful of assertively Modernist buildings had been constructed by 1932, and those built in the United States—such as Neutra's Lovell House in Los Angeles—were much smaller and fairly secluded. Indeed, PSFS was the first truly Modernist skyscraper actually to be constructed anywhere in the world, and the dominance it exerted over the Philadelphia skyline made it anything but secluded. Raymond Hood's McGraw-Hill Building, the one other contemporaneous skyscraper flirting with the International Style, was much more orderly in its composition and traditional in its massing, the latter required in compliance with New York City's rigid setback laws.

PSFS was particularly unsettling in the center of Philadelphia partly because it was such a non-tactile building within a sea of tactile architecture. The glazed tower without cornice, the mirror-smooth granite face of the gently curving base, and the shining stainless steel of the storefronts stood in jarring juxtaposition to the architectural tradition of brick, cast stone, concrete and terra cotta associated with central cities. Viewed from afar, it represented a Cubist anomaly, without frontal orientation. The "drawers" of the office tower jutted forward asymmetrically from the black brick elevator spine at the rear. Viewed from Market Street, the cantilevered north face floated over the dark base in an apparent defiance of structural laws that would fascinate designers of corporate highrises twenty-five years later.

Yet despite its aesthetic, the PSFS retained the trappings of tall buildings of its period, when the apex of American skyscrapers was assumed to carry special functions. The mandatory observation deck was present at the highest point of the spine, as was a penthouse with inset balcony at the corner of the office tower, each of which offered a small flourish to the otherwise flat roof. The red roof sign indeed celebrated the building's asymmetry, when most tall buildings of the period sought order in symmetry.

Not only on the exterior did PSFS express the authority of machine-age Modernism. Patrons ascended to the banking room through a huge escalator lobby imbued with the same mirror-finish quality as found on the base exterior, to emerge into a vast hall punctured by the building's interior piers and surrounded by the sweeping yellow marble fronts of the mezzanine balconies. To enhance the experience of building-as-machine, the entire space was air-conditioned. PSFS was indeed the second skyscraper in the United States to be completely air-conditioned; the roof sign actually shielded the cooling towers.

The assumption that a financial institution's principal public space, the banking room, would be placed at the most prominent location on the site—on the street corner at ground level—was daringly violated by this lifting of the banking hall to the second floor, releasing the street corner to retail establishments that would generate shopping traffic essential to the prosperity of an urban center such as Philadelphia's Market Street. Indeed, the importance of retail trade at the ground level, even for a building of 32 storeys, is suggested by the bank entrance placement at the far corner of the plan on Market Street and the office tower entrance at the farthest opposite corner on 12th Street, under the tall elevator spine, thereby leaving a magnificent sweep of stainless steel retail storefront to wrap around the corner between the two.

Aesthetically engaging as PSFS's early Modernist skyscraper form may have remained to succeeding generations, it is here at the street level where perhaps the building's greater, more enduring contribution to the city may be found. While the public spaces of much post-World-War-II highrise architecture retreated from the street, leaving only elevator lobbies or voluminous but generally empty spaces such as bank lobbies at the ground level, the PSFS expressed a harmony between urban building and urban life by incorporating intense, street-level retail use into its design in a way that was rediscovered only after the Miesian hegemony of postwar corporate architecture had passed.

Given its construction during the Great Depression, the Philadelphia Saving Fund Society was a threshold building to an era that never arrived. Almost nothing of such architectural scale was to follow for nearly two decades, Rockefeller Center being a salient exception. The adoption of more narrowly bounded Miesian forms in the 1950s precluded further architectural explorations of equal daring, leaving PSFS hauntingly to provoke the question of how Modernism may have transformed large cities, absent the depression and war which wrenched architecture into a far different future.

—Paul Gleye

Bibliography—

"The Saving Fund Society Building," in *Architectural Forum* (New York), January 1932.
Haskell, Douglas, "The Filing-Cabinet Building," in *Creative Art* (New York?), June 1932.
"A New Shelter for Savings," in *Architectural Forum* (New York), December 1932.
"Skyscraper Reaches Maturity," in *The Studio* (London), June 1933.
Gutheim, Frederick, "The Philadelphia Saving Fund Society Building: A Reappraisal," in *Architectural Record* (New York), October 1949.
Jordy, William H., "PSFS: Its Development and Its Significance in Modern Architecture," in *Society of Architectural Historians Journal* (Philadelphia), no. 2, 1962.
Stern, Robert A. M., "PSFS: Beaux-Arts Theory and Rational Expressionism," in *Society of Architectrual Historians Journal* (Philadelphia), no. 2, 1962.

Arata Isozaki (1931–)
Civic Center, Tsukuba City, 1978–83

The difference between architecture and industrial design is that architecture has an established position, while industrial design has none. Of course, if architecture could get up and walk, the situation would be quite different; but in terms of value scale, far broader discrimination is demanded in terms of value in the case of industrial design, while architecture is required to have a far stronger relationship to the area where it stands and has a much deeper individual value. In other words, it can be said that architecture has a more symbolic aspect while industrial design has a more ideographic aspect.

In the context of the history of *dogu* (tools), industrial design which constantly searches after original *dogu*, making it basically different from architecture, particularly in the production process. And industrial design is also constantly striving for requests and approval from the public in daily life terms. The foundation of industrial design in Japan is found in the plea for democratization of things in the face of the post-war shortages, and as a result, the basic mission of industrial design has come to be generally a design of the people.

The reason I am beginning my comments on Arata Isozaki's Civic Center with industrial design is because the internationality sought after by industrial design has a great deal in common with the architectural design stance of Arata Isozaki. In other words, everybody believes industrial design to be of value, and that it is an important element in the formulation of life culture. Isozaki's architecture touches upon this same element, in an attempt to steep itself in the most advanced aspects of the times. This could be referred to as the work of image repetition. Today, in this information-intensive age, even though architecture dominates a set space, it is possible to view it through connected media. The significance of architecture is definitely not frozen in a set area. Thus it can be said that if architecture is taken as a medium of self-expression, the object of the significance propounded by the one expressing himself is quite definitely the public. In the past, it was not the public but individual persons. It was for the pleasure of the individual and of those in power. It can be said that both the tearing down of the Berlin wall and the dissolution of the eastern establishment are the results of the freeing of information and the advent of a borderless society. Particularly, if architecture is related to the public and the nation, the working of information is even more indispensable. It has come to the point that architecture cannot be established through the unilateral expression of power by the nation and those in authority. Rather, now there must be sufficient power to satisfy the hearts and minds of the people and there must be an expression of the mutual simultaneous understanding of the people. All of this exists in the Civic Center. It is a brilliant expression of the breakthrough of the dissatisfaction of the people toward the times. There are two aspects of Arata Isozaki's wisdom.

One is the fact that he is basically of the international faction. The advantage of the international faction can be said to lie in the excellence of its sense of proportion. Since the time Isozaki was a student of Professor Tange, it can be said that he was already the main successor to Professor Tange's sense of proportion. In other words, this is something that is found in traditional Japanese architecture where a well-balanced totality is the first priority. The unique features of architecture are the attempt to achieve its stated purposes and the total balancing of the nature and drama of its space. Thus, when beginning architectural planning, the concept must be one to which all people can relate. Le Corbusier, who gave birth to Pilotis architecture, was truly one of the greatest exponents of the international faction. And another superior member of the international faction was the German functionalist philosopher Mies van de Rohe. All of Arata Isozaki's designs are extremely clear when viewed through an X-ray. He never designs bedrooms that are difficult to sleep in, nor does he design toilets where it is difficult to urinate. Every aspect of his works are firmly and unmistakenly based upon the lineage of modern architecture, and are extremely well organized.

His second level wisdom is to make architecture entertaining. Architecture has a long history of superior expression of authority. And it is true that tourists enjoy the remains of ancient architecture long after it has lost its practical function. But such artifacts are not truly entertaining. Anyone would readily agree that Isozaki has, if nothing else, introduced the concept of aspiration into post-modern architecture. It is certain that the works of the post-modernist architects were good news to the modernism that had lost its spiritual tensions. They have an outstanding ability to entertain. Even if this was only the joy of a single night, they effected a great movement in the world of plastic form. It seems to me that that Isozaki's earnestness led him to take post-modernism as a simple but effective entrance way by which he broke through the boring international modernism to carve out a new spiritual tension. To Isozaki, architecture must be capable of entertaining the public above all else. In other words, the ability to attract the public on both the psychological and physical levels is an absolute necessity today, whether on the public or on the private level. Architecture that makes people happy, architecture that people can enjoy—today architecture plays a leading role in the popular theater that creates the trends of the times. Isozaki literally lives to entertain people and this is one of his strongest virtues. He can be said to have an entertainer's heart. He is not interested in entertaining special individuals only. Rather he insists on entertaining the unspecified masses. Herein we find a point of reference between Isozaki and industrial design that enjoyed a honeymoon with post-modernism. If we look at Isozaki's works in terms of those before Tsukuba and those subsequent to Tsukuba, we find a sense of speed in those after Tsukuba. To begin with, we see an extreme model change. And each model holds expectations of the next model to come. His new models have the power to rock the very soul. He pays close attention to every detail of space creation in his brilliant works. He never does anything that people would reject. Thus his forms have a certain persuasiveness. This appears to be an ability that he nurtured during his time as a student of Professor Tange. It is for this reason that it is said that his post-modernism will continue for some time to come. But, it would be more accurate to say that he is not a member of the post-modern movement. One could almost go so far as to say that he is of the lineage of Sen no Rikyu who originated the Tea Ceremony. His spirit of service in every corner of his forms is very near to that of Rikyu. It is said that Rikyu continued to take an anarchic attitude toward authority, and that his forms constantly entertained the masses with their new values. The same is true of Isozaki's architecture. There is no sense of insecurity in his response to reality. At the same time, they have a total freedom of formal expression that makes them worthy of praise no matter where they are placed. For example, if the Civic Center were transported to some Italian city, it would undoubtedly take on a different atmosphere. Isozaki's anarchism lies in his architectural expression that no one can judge. This is the kingdom where he alone rules. The Civic Center-Tukuba city, is the beginning of Isozaki's kingdom.

—Kenji Ekuan

Bibliography—

Drew, Philip, *The Architecture of Arata Isozaki*, New York and London 1982.
Barattucci, Brunilde, and Di Russo, Bianca, *Arata Isozaki: Architecture 1959–1982*, Rome 1983.
"Arata Isozaki 1976–1984," special monograph issue of *Space Design* (Tokyo), January 1984.

Photo © Botond Bognar

Toyo Ito (1941–)
"Silver Hut" Ito Residence, Tokyo, 1984

The Silver Hut was built on a site adjacent to another previous and well-known work of Ito, the U House in Nakano (1976), designed for his sister some eight years earlier. These two residences, while located by a unique coincidence side by side in a cramped suburban area of Tokyo, are also the best representatives of two and sharply different phases in Ito's architecture. The contrast between these designs aptly reveals a fundamental shift in his architectural paradigm, his understanding of, and response to the urban developments of the Japanese city.

The U House, as many of its contemporary counterparts within the residential architecture of the 1970s, was shaped as a radically inward oriented, reinforced concrete shell that rejected the disturbingly congested and uncontrollably intrusive attributes of megalopolitan Tokyo. Indeed, Ito's early architecture was explicitly defensive and anti-urban, and as such, represented a design attitude that was shared by many new generation architects within the so-called New Wave, including Itsuko Hasegawa, Kazunari Sakamoto, Hiroshi Hara, Hiromi Fujii, Kazuo Shinohara, etc., and most especially Tadao Ando, at this time.

In reaction to the deteriorating urban conditions, the U House was designed with two protectively solid and parallel curving walls centered around a small, completely enclosed grassy and empty courtyard. Openings were reduced to the minimum and appeared only toward the court or took the form of skylights. On the other hand, Ito, influenced by the highly art-oriented and conceptual architecture of Shinohara, focused upon the autonomous quality of the dim and cave-like interior that, while rendered as a poetically evocative realm, suspended the rationality of spatial reality. The goal, somewhat utopian in anticipation, was to achieve a new perception and awareness of both architectural and human reality.

In the 1980s, however, Japanese urban developments, bolstered by a more progressive and stronger economy, took a turn for the better, prompting many designers to reinterpret the nature of the city and reconsider their previously strongly oppositional strategies toward it. Ito began to change course as early as the late 1970s. As a result, his works, starting with the PMT Building in Nagoya (1978), became gradually more sympathetic to the flux and dynamic processes of the fast developing urban culture and environment. His new designs received inspiration from the heterogeneous semantic charge plus the collage-like and ephemeral quality of the Japanese city, yet without yielding to a commercialized and trivial postmodernist architectural representation. Therefore, Ito's design enterprise, unfolding since the early 1980s, could be termed an architectural realism with a critical edge that distinguishes it from the populist work of Robert Venturi, Charles Moore, etc. This mode of design reaches its first epitome in his own house, the Silver Hut, that opened the road to the realization of several other outstanding projects thereafter.

The Silver Hut is laid out along a simple rectangular, geometrical plan in modular arrangement that surrounds, yet again, a small courtyard/atrium to the south. The basis of the arrangement is a nine-square unit—3 × 3.6 metres on each side—with four of its squares assigned to the atrium. The other five, in an L-shape, accommodate the living/dining room, kitchen, bathroom, and on two levels a pair of bedrooms. This initial *parti* is then extended by additional units which, although adjoining the atrium, are not connected directly to the rest of the house. As a consequence of such loose or "scattered" disposition, the tatami room and the study are separated and can only be approached from the outside space of the courtyard.

While the incorporation of the court in the scheme is akin to the U House, its articulation and role are vastly different. Here the courtyard connecting between outside and inside is an active place and an integral part of the residence, not merely an empty or negative center. Moreover, rather than using solid walls, the

Silver Hut is designed with a structural framework of concrete posts and lightweight steel elements that simultaneously recollect the essence of traditional timber constructions and utilize the building methods as well as iconography of contemporary industrialized architecture.

This latter is evidenced by the infill elements between the supporting posts and by the roof structure over them. Walls are made of thin layers: corrugated metal sheets, perforated aluminum screens and large, sliding glass doors facing the stonepaved courtyard. Even more importantly, the roof is comprised of a series of prefabricated and locally assembled thin steel spaceframe vaults with various spans. The six smaller vaults above the rooms are covered with industrially-produced composite roofing, while the seventh, the largest one above the court, is partially wrapped in stretched canvas, leaving most of the steel framework still open to the sky. Yet, the outdoor space of the court is further protected from sunshine by an additional layer of pleated and moveable canvas blind.

Shaped as it is primarily with thin and, more often than not, semi-transparent layers of material insubstantiality which filter light and privacy, Ito's residence acquires an almost unsurpassable lightness with a feeling for the ephemeral. In so doing, the design approximates the qualities of such temporary and primitive structures as yurtas, tents or, indeed, huts. And, since the scheme features a multiplicity of vaulted roofs with a potential of denoting individual shelters, it can also signify not simply one, but in fact a whole cluster of such huts. Yet, Ito's return to the "primitive" is not a "sentimental journey" back to the past, a flight from the often harsh realities of the present. Utilizing late twentieth-century modes of production, readily available ordinary materials and technology in a straightforward manner, the Silver Hut is a significant step toward a new "industrial vernacular" which, like its ancient predecessor rooted in the contemporary conditions of life, could eschew the process of commodification within recent consumerist urbanism.

Ito deciphers the contemporary city along new sensibilities. He observes the fast-changing urban realm in Japan as a locus where human life is in a constant flux, and where physical, spatial and formal permanency of the built environment loses its meaning.

Ito has conceived the Silver Hut as an elusively fluid and "flexible" realm attunable to the unpredictable future events of human action and to the manifestations of natural phenomena; responding to, and thus, formed as well as "deformed" by such elements as wind, light and shadows, sound, etc., it aspires to a unique, non-rational order while approaching an almost "immaterial evocation of building." The Silver Hut as well as such subsequent projects as his House in Magomezawa (1985), the Nomad Pub (1986), the Guest House for Sapporo Breweries (1989), etc., while disguised in austerity and the attributes of the primitive are significant departures from the city-as-is, representing a truly visionary architecture. Ito has written: "Imagine a town where clothes, furniture, pans and houses are all fluttering in the wind like sinuous clothes. . . . The entire town, awaying and glowing, would inspire people and liberate [them] from their hard shells that bind their bodies. I want to fill this town with many more flags, pans and floating houses."

—Botond Bognar

Bibliography—

Bognar, Botond, *Contemporary Japanese Architecture: Its Development and Challenge*, New York 1985.
Ito, Toyo, "Silver Hut," in *The Japan Architect* (Tokyo), May 1985.
Friedman, Mildred, ed., *Tokyo: Form and Spirit*, Minneapolis and New York 1986.
"Toyo Ito," special monograph issue of *Space Design* (Tokyo), September 1986.
Bognar, Botond, *The New Japanese Architecture*, New York 1990.

Helmut Jahn (1940–)
Terminal of Tomorrow, O'Hare International Airport, Chicago, 1987–88
United Airlines, Chicago

Helmut Jahn's $500 million United Airlines *Terminal of Tomorrow* (1987–88) at O'Hare International Airport brightens and dazzles travelers that walk through it. Awarded the A.I.A. Design Award of 1988 and the Reynolds Award to the Best Building in the Country in 1989, the building is an architectural echo of yesterday—perhaps a deliberate suggestion of the iron and glass pavilions of the great Victorian railway stations. It is as much technological progress as a nostalgic dream. One speeds through physically on people—walkers as mentally transported through time in another era.

In comparing it to Joseph Paxton's *Crystal Palace* (1851) (with or without the palm trees), we see the elevated prefabricated metal and glass construction to the scale of civic architecture. Like the Palace, Jahn's United Terminal and its companion "satellite" building are axial structures. (United Airlines each 1600 feet long to Paxton's 1800 feet). They are metal framed, glass paneled, capped with soaring barrel vaults and drenched with natural light. Yet Jahn's high-tech update of nineteenth-century engineering is a far cry from explicitly historicist buildings. He has issued no statements against the functional aesthetic of Modernism, nor renounced the ideal of social progress that aesthetic once expressed. The cruel-kind treatment of the future as past reflects a more complex state of perplexity. The problem is how modernity can be visually represented at a time when the correlation between the aesthetic and the ideal has collapsed.

The course of Helmut Jahn's development as an architect recapitulates the breakdown of the Modern faith. Like the Victorian Railway Station Jahn's work is split into two contradictory parts, though arranged in a sequence that reverses the logic of the Modern breakthrough.

Born in Nuremburg, Germany, the son of a Bavarian schoolmaster, Jahn emigrated in 1966 to Chicago on account of his admiration for Mies van der Rohe, then at the peak of his prestige as the father of the modern office tower. Jahn's earliest buildings proclaimed his faithfulness to the great master of structural expression, and earned him a place in the "Second Chicago School" that had sprung up around Mies during his tenure as director of architecture at the Illinois Institute of Technology. A year after joining Chicago's C. F. Murphy Associates, Jahn prospered almost immediately on the strength of his prolific new design ideas and lightning-fast ability to sketch them. At the age of 33, he became Executive Vice-President and Director of Planning and Design.

Today the same firm, now named Murphy/Jahn, employs 80 architects. His peers have referred to him as Baron von High Tech—but, by far, Jahn is the most flamboyant and commercially successful architect of his generation. He says, "As an architect, you have to be an optimist, always trying to relate to an exuberance and an excitement in your buildings that will make our cities a better place to live." He melds a Space Age look with traditional skyscraper lines, exploiting their contrasts so few could miss them. A typical Jahn touch: folding glass and stone curtain walls into octagons, rotundas, diamonds and spirals.

The Terminal of Tomorrow, was a key component of O'Hare's $1.6 billion redevelopment program and promised to speed passengers to and from planes. There is a 42-plane gate system. A $38 million dollar baggage-handling system capable of handling 480 suitcases a minute with laser scanners and bar coded tags far surpasses the old 75 bag system. A high-tech underground passageway with moving sidewalks connects the twin 1600 foot concourses. As passengers whisk along, they can admire the world's largest neon sculpture pulsating to music. The fascination of the terminal at O'Hare lies in how successfully it stimulates through an architecture that arose from profound philosophical conviction. This time, Jahn actually buried his customary flamboyance. Only through the underground concourse connecting the main building to the "satellite" terminal does his flashy trademark erupt: "rainbow neon pulsating to New Age music." Above ground, Jahn plays it straight and sleek in a monochrome display of structural muscle. It's a very handsome display. Passengers are grateful for the abundant natural light, the no-wait ticket counters, and the efficient organization of passenger circulation.

What is significant about the terminal is not about how it mimics the rational principles of Modern design, but how it subverts them. Modernists acclaimed the old railway terminals because, unlike the historical romance embodied in the facade, the building spoke honestly of the industrial age. Jahn by contrast has selected this image because it is fiction. He wanted to embody a certain romance, a feeling of fantasy that one associates with travel.

What distinguishes Jahn from the post-modern historicists is that his work has moved progressively toward the embodiment of a new paradigm. He understands better than any architect of his generation that the cultural authority of industrial production has been supplanted by the authority of marketing. His work represents a recognition that this development holds aesthetic as well as socioeconomic implications. What Jahn has accomplished is an architectural equivalent of a TV spot for "The Friendly Skies." As we step out onto the people-mover and glide down the concourse, we lift our eyes to perfect white clouds in a blue sky as seen through the glazed barrel vault. We can forget about hijacking, microwave airline food and holes in the ozone layer.

The paradox is that Jahn's architectural fictions give us a factual representation of values in the post-industrial age of the service economy. In this sense, John is a true heir of the Mies who once defined architecture as the "will of an epoch translated into space."

—Andrea Kalish Arsenault

Bibliography—

"High Tech Expansion: United Airlines Terminal," in *Architectural Record* (New York), May 1985.
Dumaine, Brian, "The New Generation of American Architects: Architects for the 1990s," in *Fortune Magazine* (New York), June 1987.
Muscamp, Herbert, "Architecture: The Temple of Marketing," in *The New Republic* (Washington, DC), October 1987.
"The Best of 1987: Architecture," in *Business Week* (New York), January 1988.
Filler, Martin, "Going for the Glitz: Helmut Jahn's Flamboyant Designs," in *House and Garden* (New York), March 1988.

Axonometric view of roof
Illustrations courtesy Murphy Jahn

Photo Balthazar Korab

Photo courtesy of John M Johansen

John M. Johansen (1916–)
Mummers Theater, Oklahoma City, 1968–70

For many architects, John M. Johansen's Mummers Theater in Oklahoma City (1966–71) has been a compelling and influential source occupying a special niche in the history of 1960s design. Johansen's design, at once emblematic of the 'sixties and of his own wilful personality, challenged accepted modernist practices with its confrontational assemblage of industrial components. It was a building that shocked the public and delighted many architects who applauded Johansen's foray into the exploitation of new materials and compositional methods. The Mummers Theater is an achievement all the more striking when contrasted with the classical modernity espoused during that period by Philip Johnson, Edward Durrell Stone, Minoru Yamasaki, or Skidmore Owings and Merrill.

The genesis of this remarkably novel design resulted from the pairing of the talents of progressive Oklahoma City theater director Mack Scism with the support of a Ford Foundation challenge grant. Scism recruited stage designer David Hays, and the two men selected Johansen, who had previously designed Clowes Memorial Hall in Indianapolis, Indiana (1963), and the Mechanic Theater in Baltimore, Maryland (1966), as the architect of the Mummers. The Ford Foundation grant did much to permit the full flowering of this design, as Ford officials fully backed Johansen by threatening to withdraw financial support if the architectural integrity of the design was compromised by a skeptical board in Oklahoma City.

With the Mummers design, Johansen broke with his previous neo-brutalist work, such as the Mechanic Theater, and developed a more expressive approach in which light spanning elements and heavy structural parts were delineated through the use of contrasting materials and eye-popping primary colors. Johansen's local sources were grain elevators, quarrying lifts, and brightly-painted junked automobiles. As Johansen explained to Robert Hughes in an interview for *Time*, he was looking for "a kind of slang . . . I want my things to look brash and incisive and immediate. They should respond to what people actually need, the way slang and jargon respond to quick needs in communication."

Formally derived from the organization of electronic circuitry, the Mummers represented the culmination of his exploration of the prototype in the Goddard Library at Clark University in Worchester, Massachusetts (1968), and was the capstone of his career. The basic program components included a 600-seat thrust theater, a children's school and a 240-seat arena theater, which surrounded a central court and cooling tower. The original design concept was tailored to the experimental theater productions favored by Scism, and the thrust stage was planned by Hays as an island floating in space surrounded by a open moat.

Johansen's explanation of the seemingly eccentric assembly of the building's components appeared in his 1968 article "The Mummers Theater: a Fragment Not a Building," published in *Architectural Forum*. "The design process, if the term can be used at all, is not one of composing but of rigging or assemblage. Each element, whether enclosed functional space, conveyor tube, or structural member, goes about its work directly and independently; sometimes with utter disregard for the other elements, or for occupants it is not required to accommodate at that place or moment. The way of dealing with functional elements then might be to 'position' them, i.e., to satisfy functional relationships; to 'prop' them, i.e., to support with structure; to 'connect' them, i.e., to provide circulation and distribution."

The stylistic evolution that led Johansen to this ground-breaking design is an interesting saga; Johansen's explorations in the 1960s certainly paralleled those of the Metabolists and he admired the work of Archigram. Johansen also drew from the writing of Marshall McLuhan, who, in *Understanding Media*, wrote of an analogy between electronic communication and the human central nervous system, an analogy that compelled Johansen to compare the people tubes of the Mummers to arteries in a body.

Johansen's trip to the Gulf of Mexico in the 1960s to study the prefabricated Grand Isle island mine might have further inspired him to exploit industrialized building techniques. Johansen's subsequent 1966 "Leapfrog City" proposal for interconnecting towers and bridges that appeared in his article "New Town" (*Architectural Forum*, September 1967) relates directly to the Mummers' ramped conveyor tubes for people.

The design quickly brought Johansen acclaim in the architectural press, and he subsequently received a 1972 AIA Honor Award for the Mummers. Yet Johansen's critical success was tempered by a lack of local acceptance, and the building was viewed as an affront to community sensibilities, even though it played a pivotal role in urban renewal plans for downtown Oklahoma City. The fate of the Mummers Theater provides a case study of what happens when a progressive design is interjected into a community that is completely unprepared and uncomprehending of the architect's intent. Local antagonism has dogged the theater since its opening, leading to calls for its demolition, and attempts to obscure the structure with vines and trees. As a performing facility, the Mummers has experienced a checkered history, following the political ouster of its founding director within two years of its opening. Subsequently, closures of one resident theatrical company after another occurred, all unable to support the overhead of operating the facility with the modest local appetite for theater. The innovative thrust stage was soon replaced by more conventional proscenium staging favored for amateur productions.

Concern over the building's current dilapidated condition has recently arisen, and nearly $2 million has been raised from state and local sources to refit and remodel the Mummers Theater. These plans do not include a resident theatrical company, but instead the building will become a multi-use facility, used primarily for performing arts but also for meetings and lectures. The renovation plans by Elliot & Associates, an Oklahoma City firm, will include functional improvements, but also propose a transformation of interior spaces to make the building more palatable to the general public. The question remains whether this radical and confrontational building can be made more mannerly, and whether a polite Mummers will still evoke the vanguard design of the experimental 1960s.

—Barbara L. Koerble

Bibliography—

Johansen, John M., "An Architecture for the Electronic Age," in *American Scholar* (Washington, D.C.), no. 1, 1966.
Johansen, John M., "New Town," in *Architectural Forum* (New York), September 1967.
Johansen, John M., "The Mummers Theater: A Fragment, Not a Building," in *Architectural Forum* (New York), May 1958.
Blake, Peter, "The Mummers Theater," in *Architectural Forum* (New York), March 1971.
Pastier, John, "Something Else Altogether in Oklahoma City," in *AIA Journal* (Washington, D.C.), August 1981.
"Imperativi di John Johansen," in *Architettura* (Rome), October 1984.
Johansen, John M., "The New Modernity," in *Architecture + Urbanism* (Tokyo), September 1989.
Koerble, Barbara, "A Mummers' Tale," in *Cite* (Houston), Fall 1990.

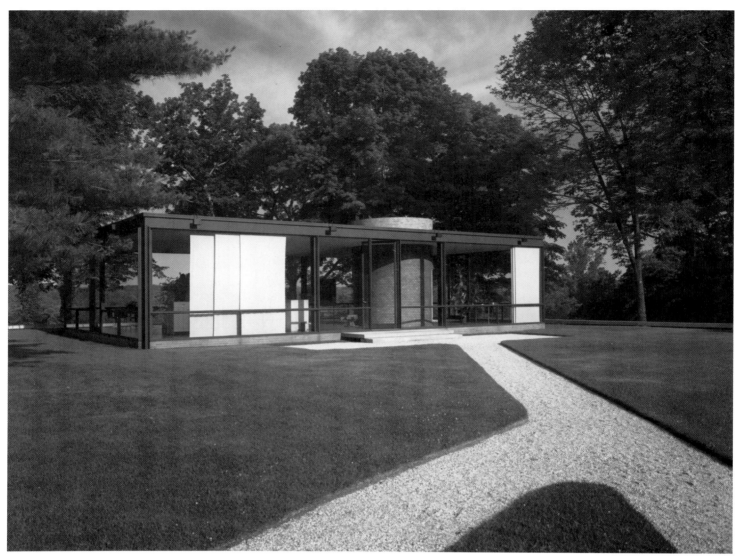

Photo Ezra Stoller © Esto

Philip Johnson (1906–)
Johnson "Glass" House, New Canaan, Connecticut, 1949

It is likely that Philip Johnson will be written about in future architectural histories as one of the most influential architects of twentieth-century America. His long career actually consists of three careers. In his early years, he was the first director of architecture at the Museum of Modern Art in New York, a position he held with interruptions until 1954. During that period he published together with Henry Russell Hitchcock the influential book on the *International Style* (1932) and also went back to Harvard during those years for a degree in architecture. When he started to practice architecture he became one of the leaders of American international style, heavily influenced by Mies van der Rohe (with whom he collaborated as designer of the Seagram Building). The third part of his career was started in the late 1970s when he became the most powerful figure of American Second Modernism and a leading figure in postmodern design. Many of Johnson's buildings continue to have lasting influence on architecture; none more than his own glass house designed in 1949.

The house comes just about 100 years after Paxton's Crystal Palace and follows in a tradition and obsession of western architecture with glass, yet it is also a house that embraces nature as an integral aspect of design. The house is sited on a grassy plateau which drops off towards a very large and beautiful property without any neighbors. On its front, it is provided privacy through a rising piece of land towards the main road. Johnson's glass house is a weekend house only, and Philip Johnson is a bachelor. It is important to keep that in mind since an evaluation of the house as a standard residence would not make sense. Sometimes the house has been criticized as a plaything for a wealthy person. Again, this is not a fair comment. Johnson spent three years on the design of the house and the influence of the house on contemporary residential architecture of the 1950s and 1960s has been enormous. In fact, it is remarkable that for over forty years the house has remained more than a milestone in modern architecture; it is still, after four decades, a leading example of modern design and will permanently remain a significant contribution to twentieth-century architecture.

The house is all one open space, most likely influenced in that respect by Mies van der Rohe. The only solid element in this open and transparent space is a ten-foot cylinder, placed off center. This powerful geometric solid contains the bathroom, which by the way is a most luxurious one with leather tiles covering the walls. The sleeping area is defined by free-standing storage cabinets which do not reach the ceiling. The food preparation area (it is decidedly not a kitchen) consists of another free-standing storage element which is a buffet-bar near the entrance. The seating area is a pristine arrangement of Mies van der Rohe furniture originally designed for the Barcelona pavilion. The seating area is held together by a white rug on brick floors and is further defined by a renaissance painting placed on an easel. The glass house represents a total integration of exterior and interior design in the most elegant manner and with meticulous and precise detailing. Unfortunately the house—or rather partial aspects of the house—have been imitated by many builders, but never achieved. It is for that reason that the very unique program of the building must be kept in mind at all times. Not only the detailing of the structural frame, but all mechanical engineering aspects have been carefully solved.

There is a radiant heating system from both floor and ceiling. The spaciousness of the house measuring 56 by 32 feet ($10\frac{1}{2}$ feet ceiling height) provides significant acoustical privacy for its users.

An integral part of the design of the glass house was a guest cottage erected at the same time. It is connected to the main house by a heated walk, and could function as the sleeping quarter of a family—if indeed the house were meant to be a paradigm for housing. Here, it was simply designed as a very enclosed and private elongated structure containing two guestrooms, a bathroom and a small study. Interestingly enough, the original interior was designed in a rather theatrical manner, with a vaulted roof and a canopied bed—in some ways the opposite design statement to the crisply pure epitome of international style represented by the interior of the main house. The Johnson property had an older house near the entrance. It was given over to a couple who lived there as caretakers of the estate—another aspect which made the glass house atypical of family housing.

Over the period of about twenty years, Philip Johnson continued to use his weekend retreat as an experiment for architectural ideas. An underground museum was added to house Johnson's extensive private collection of twentieth-century art. Also a half-scale pavilion near a pond was added. It could best be classified as an architectural folly, but added visual delight to the view from the house.

The significance of the house is in part its date. Clearly the design of the house in 1949 was an outstanding event in architecture. Johnson was already an important enough figure to have been assured of national and international recognition. The seminal nature of the open plan and glass enclosure came at the time when the United States was about to embark on its largest development of one-family homes ever—the period after World War II. There is also a more poetic and elusive function in the glass house. It points to the ultimate domestication of nature or the total integration of built structures with nature. Philosophically, the glass house implies a trust in security more so than a solidly built structure. Perhaps that ideal could only be achieved by somebody endowed with a great deal of wealth and a large and protected property. The glass house is representative of almost excessive perfection—yet the epitome that has been reached in its design is so far reaching and so permanent that it compensates for some of the excesses that Philip Johnson has been criticized for in his later years' design of postmodern buildings.

—Arnold Friedmann

Bibliography—

"Glass House in New Canaan," in *Architectural Forum* (New York), November 1949.
Hitchcock, Henry-Russell, *Philip Johnson: Architecture 1949–1965*, New York and London 1966.
Futagawa, Yukio, and Robertson, Bryan, *Johnson House, New Canaan*, Tokyo 1972.
Hunt, William Dudley, *Encyclopedia of American Architecture*, New York 1980.
Raeburn, Michael, ed., *Architecture of the Western World*, New York 1980.
Trachtenberg, Marvin, and Hyman, Isabella, *Architecture: From Prehistory to Post-Modernism*, New York 1986.

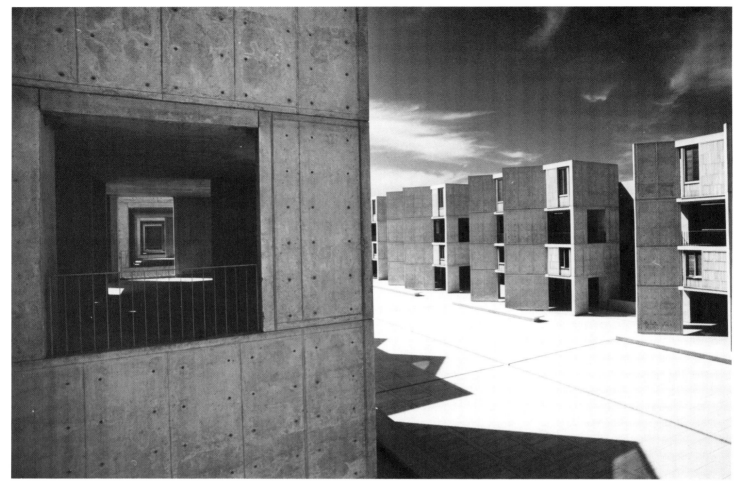
Photo courtesy The Salk Institute

380

Louis I. Kahn (1901–74)
Salk Institute Laboratories, La Jolla, California, 1965

The continuing status of Louis Kahn's Salk Institute Laboratories as a masterpiece or indeed a monument of contemporary art is not in question. The question that remains may now, with thirty years hindsight be framed as: of art as what? a monument to what? With this thirty years' hindsight we can begin to take a new look at the Salk Institute for *what it now says* about ourselves, our idea of art, our sense of the monumental.

The concept of science and of scientists which I see enshrined in The Salk Institute is "separate, anonymous, coordinated individual effort." The Salk presents itself as a biomedical research equivalent of the Rand or of the Hudson Institute: an inheritor of the concept of scientific fragmentation. The cold-war story about this type of science is based on The Legend of the Development of the Atomic Bomb. It is told that the scientific research for that weapon was broken into pieces so tiny that each given investigator not only had no knowledge of what aspect of the development of the bomb he was working on, but that he did not even know that he was working on The Bomb at all. The entire concept of the Salk Institute is a monument to medical biology interpreted as *that sort* of science. What I am calling the Legend of cold-war science served as a cover story for the general and silent complicity of the scientific community in the perversion of the idea and ideal of progress to the ends of "mutually assured annihilation."

Visually, the architecture of The Salk Institute is cold-war art: the art of *abstract expressionism*. No other oxymoron could better express the despair of the cold war artist than the analytically futile effort of visually, plastically, presentationally, "self-expressing" pure abstraction. As mute about its own true mission as was the fragmented, anonymous and dislocated scientist, the cold-war artist searched for and found his version of "pure art"—art which purported to represent absolutely nothing at all. The Legend of pure art served as a cover story for the general and silent complicity of the artistic community in the perversion of the idea and ideal of "beauty" to the ends of the destruction of "the individual."

In Kahn's Masterpiece House of Research, cold-war art and cold-war science came together as cold-war architecture. This synthesis was as perfect as it was complete.

In this sense the Salk Institute can be viewed as a masterpiece of the art and science of artifice, of self-deception and a monument to our own guilty conscience. More accurately perhaps, as a masterpiece monumentalizing the power of the art and science of architecture to serve as a vehicle for and as a container of self-deception and as the material manifestation of a collective guilty conscience.

In the Salk Institute one may perceive Architecture's last and desperate attempt to articulate a language which might escape or at least evade the fate of all art to represent. "Abstract-expressionism": reference to nothing concrete, reference to what Kahn called the "idea": the want, the desire, disembodied of its "form" and finally bereft of the actual physical design, the construction, the program. In The Salk, "form" is but the imperfect "footprint" of the "idea" "behind" it.

With The Salk Institute we witness the worship of an institution as "idea" in the absence or perhaps in contradiction to the humans who work on or possibly even "benefit" from this asset: we witness the veneration of the disembodied stock, the spiritualized asset itself, the signal, the icon, the underlying idea, the percept, the appearance, the act of perception. With The Salk, Kahn turned toward a "formalism" in which Idea, pure Form, transcended mere design and became an end in itself—*POE, purity of essence*. This is a cold masterpiece: an art of iciness and frigidity, of flatness and thinness, of the tenebrous and spectral, the spirituous esterification of the American grain. In terms of Kahn's own words about his architecture, with the completion of The Salk, he learned to address "desire" instead of mere "need." Kahn inserted the seed of desire into an architecture of need, inserted the idea and Form into an architecture of "designing for human needs." Ironically indeed—this act begot an architecture of deadly, diseased, viral,

genetically engineered, sardonic and tortured spectral shades: but an architecture of purity that surpassed Mies van der Rohe's most dustfree fantasies.

The physical representation of The Institution can perhaps most readily be seen in the rigid interplay of concrete slab shadow-casters: in the Salk Institute's massing and fenestration. The oblique wood-inserts into the concrete grid which constitute the frames for the windows have transformed Kahn's enduring quest for "natural" light to a cave dweller's hunger for the transitional, cool, monochromatic murky and shadowy refraction of the sun. The Pacific shorelight is filtered into a directionless and achromatic diffuse moon-lit Californian on-location "night" Western movie chase-set.

Futagawa's powerful photography has become the classic "representation" of the Salk. In these timeless pictures the project is shown with the contrast and the visual intensity of the "moonlit" desert chase-scenes of high-Fifties Saturday-matinee Hoppie Westerns. Father Sun as presence has been veiled and erased as have all traces of humans (save for the occasional carefully placed, unoccupied director-chair as a kind of empty mold for the shades of post-holocaust human bodies).

As we penetrate into the Salk's office complexes, we have entered an internalized City of Perpetual Mist. Here, at the edge of the deep Pacific Ocean live and work these fog-bound Cimmerian biomedical researchers; in their move to California, the wide-open windows of Kahn's earlier Richardson Research Building have become deeply lidded and socketlike receptacles gouged into the concrete skeleton of The Institute: foreshadowing the vaulted daylight-illuminators of the Kimbell Art Museum.

Finally, the Salk presents itself as a *monument* to the progressive irrelevance, abstraction and anonymity of the human being: a planned obsolescence that can Now be Shown and Proclaimed. The *art* of creating a dream-world: a dream world turned into reality, a reality in which the past is preserved and frozen into immobility. In this dream world it is as if the two periods of "waking" that bracket the night's "events" are frame and door where reality is on the shady-side of the windows. The barred steel gates afore each courtyard of the Salk Institute seem designed to keep the shady inmates in more than the fleshy plebs out: to confine that which may perhaps prove to be a source of pollution after all.

The world of the Salk is truly a dream-world both inside and out. With each foray into the place of shades a turn of the spiral around a nodal point: the pivot, the pin of the hinge, the shaft of the joint. The gates of this last resort turn on the hinges of sleep. The sleeping self burrows into the depths of its own experience, foresees the post-nuclear, biochemical morrow and thus prepares for it. This architectural morrow is finally the two-dimensionalization, the flattening, and the erasure of the subject of architecture itself.

—Joseph B. Juhasz

Bibliography—

Giurgola, Romaldo, and Mehta, Jaimini, *Louis I. Kahn*, Urich and Boulder, Colorado 1975.
Kommendant, August, *Eighteen Years with Architect Louis I. Kahn*, Englewood, New Jersey 1975.
Futagawa, Yukio, ed., *GA 5: Louis I. Kahn—Richards Medical Research Building Pennsylvania; Salk Institute for Biological Studies, California*, Tokyo 1977.
Ronner, Heinz, and others, *Louis I. Kahn: The Complete Works 1935–1974*, Basel, Stuttgart and Boulder, Colorado 1977.
Lobel, John, *Between Silence and Light: Spirit in the Architecture of Louis I. Kahn*, Boulder, Colorado 1979.
Norberg-Schulz, Christian, *Louis I. Kahn: idea e immagine*, Rome 1980.

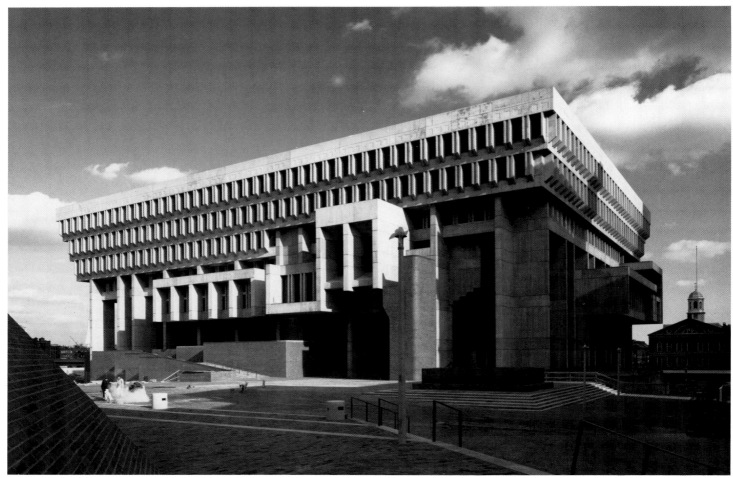

Photo Ezra Stoller © Esto

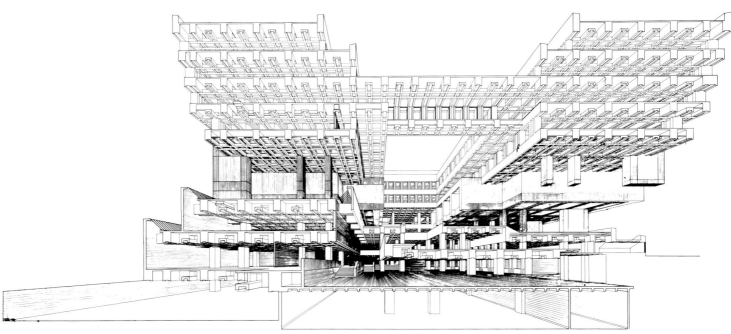

Drawing courtesy Kallmann, McKinnell & Wood Architects Inc

Kallmann/McKinnell/Knowles (1963–)
City Hall, Boston, Massachusetts, 1969

This striking and innovative city hall was designed by Gerhard Kallman, Noel McKinnell, and Edward Knowles as a result of a competition won in 1962. The project was controversial during the years of development and building and is still subject to debate by many conservative Bostonians who have never quite accepted the uncompromising modern design of their new city hall. The building is the centerpiece of a major downtown redevelopment plan conceived by I. M. Pel in 1960. It must be assessed as a part of that total civic center as well as a city hall representing historical continuity in contemporary terms. The Boston City Hall contains many architectural analogs—from buildings based on mediterranean city plazas to the scale and modulation exemplified in Le Corbusier's buildings—whose influence together with that of Louis Kahn is very much in evidence. Some of the earlier commericial buildings, created as part of the redevelopment of what had become a dilapidated area in the center of Boston, were dull and mediocre buildings at best. It was the new City Hall that managed to bring to fruition the efforts of planning and architecture together—which is indeed the way cities need to be designed.

The City Hall's building area is 513,000 sq. ft. and was built at a cost of $21,000,000. Consulting engineers were LeMessuerier Associates, Inc., and there were consultants for mechanical, lighting, electrical, plumbing, acoustical, space planning, furniture and graphics. The style of the building is extreme articulation which in the 1960s was widely practiced. The reinforced concrete structure is, however, sensitive to its neighbors in Boston's North End and is a public building with many appropriate symbolic features. There are a number of historic views from within the building, which are carefully and dramatically framed to provide glimpses of the past by focusing on neighborhood historic buildings and to set the building into proper context. The plaza, which can appear stark at times, is a ceremonial outdoor space whose purpose is initiation into the City Hall spaces rather than just an outdoor space providing amenities for the public. Yet, at times, the plaza is used as a setting for performances and public events and works equally well for both purposes. Flat terraced steps, unfolding like a fan, connect the lower plaza and third floor levels of the City Hall with a stepped approach to the subway station, which was also designed by the same architects and is an unusually attractive station.

The building's heavy superstructure is supported by "pilotis" which turn into columns extending to the full height of the structure and which form a rhythm of solid and void at the same time, relating the exterior to the interior spaces. There are three major zones corresponding to the exterior: the north lobby and plaza level, the middle section of the building which is the formal and ceremonial part, and the office floors which form the three top floors. The north lobby is conceived as the main public entrance as well as a gateway through the City Hall, encouraging people to make the concourse a passage through the building in their downtown activities as well as in specific visits to conduct business at the City Hall. At one-and-a-half floor level, ramps lead into those departments most frequently used by the public, and then connect to the third and upper floor by escalators and steps and elevators. The center of the building contains the ceremonial spaces. They focus on the mayor's office, the councilmen's offices, and the council chamber. The architects have used a monumental staircase from the south lobby to create the symbolism of important public spaces through visual and spatial experience. There is a conscious monumentality in most of the public spaces of the building. The architects have said that making the process of government meaningful needs to be monumental in order to involve everybody. Of course, one could also state that the process becomes monumental because it is meaningful.

The offices on the upper three floors are orderly and simple. Long corridors, typical of municipal buildings, have been avoided. The offices are light and spacious and even have recessed terrace spaces accessible to them. The lighting throughout the building is in a mixture of excellent daylight filtered through glazed entrances, combined with fluorescent and incandescent fixtures throughout. Many have been recessed into the precast trusses with an overall pleasant, yet dramatic, effect. The offices' interiors were carefully planned by Becker and Becker Associates, and furniture and graphics were handled by I.S.D., Inc. This becomes particularly important since it softens the monumentality of the building and counteracts its concrete surfaces. Boston City Hall thus became not only a strong and serviceable building, but one that offers pleasant amenities to its users.

The area adjoining City Hall is dominated by Faneuil Hall and Quincy Market—one of Boston's, and probably the country's, most successful urban market and eating places. The continuation of the flower and food market, which had been there before the new master plan was put into effect, together with nearby residential developments, has created a paradigm of successful urban design, with lively crowds at all times of the day and evening in evidence. Thus the Boston City Hall has imparted a new visual dimension to the area, and has become the focal point of the government center and the newly revitalized downtown area, which was indeed the intent of the architects.

—Arnold Friedmann

Bibliography—

A Competition to Select an Architect for the New City Hall in the Government Center of the City of Boston, Boston 1961.
Spreiregen, Paul, "The Boston Government Center," in *Arts and Architecture* (Los Angeles), October 1965.
Moholy-Nagy, Sibyl, "Boston's City Hall: It Binds the Past to Its Future," in *Architectural Forum* (New York), January/February 1969.
"An Airy Fortess," in *Time* (New York), 21 February 1969.
Raeburn, Michael, ed., *Architecture of the Western World*, New York 1980.
Hunt, William Dudley, *Encyclopedia of American Architecture*, New York 1980.
Jencks, Charles, *Architecture Today*, New York 1982.

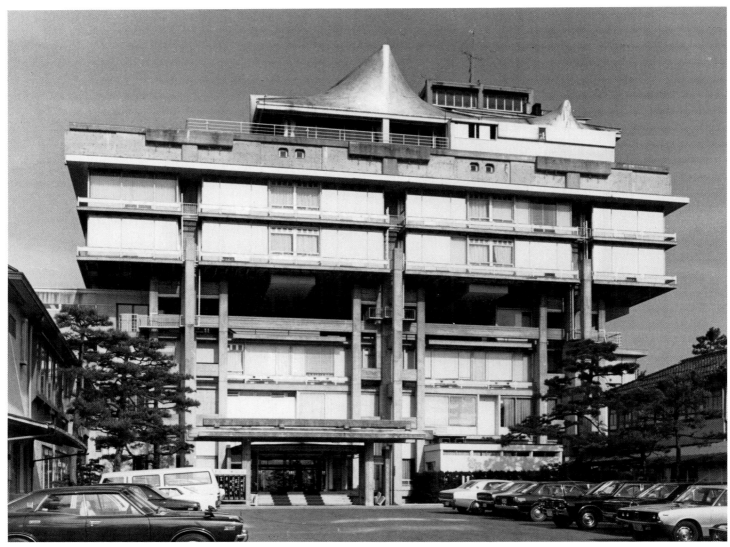

© Botond Bognar

384

Kiyonori Kikutake (1928–)
Hotel Tokoen, Yonago City, 1964

The Hotel Tokoen was designed and completed in between two equally significant, and perhaps even better known, works by Kikutake—the Izumo Grand Shrine Office Building (1963) and the Miyakonojo Civic Center (1966). Yet, while these two projects may manifest designs of more unified architectural form, the Hotel surpasses them with its dynamic but balanced composition, and complex structural solution that best exemplify Kikutake's efforts to combine contemporary advanced technology with certain traits of traditional design and construction. Also, the building better represents his longstanding preoccupation with, and expertise in, the issues of residential architecture within urban settings. The Hotel is an integral part of a series of projects which, more than the others, are directly related to the wide-ranging theoretical investigations Kikutake pursued from the very beginning of his career both as an architect and urbanist.

In the late '50s, Kikutake became an influential leading figure of the movement known as the metabolist architecture of Japan. His aim, along with the similar intentions of the Metabolism group, was to elaborate proposals for new types of urban communities that could alleviate the increasing congestion and other problems of rapid urbanization. The extraordinary technological progress in Japan seemed to offer the solution with flexibility and change; urban growth and, by extension, the function of architecture, were seen as analogous with the metabolic processes of living organisms. Kikutake's visionary and often utopian schemes, such as the Marine City (1958), Tower City (1959), and many others, were conceived with the application of megastructures which, as permanent frameworks, supported extensive systems of industrially-prefabricated and ready-made residential units, all with the potential of interchangeability. These clusters of highrise structures, while effectively dissolving the boundaries between architecture and the city, appeared as both huge buildings and "small" urban enclaves. As such, they foreshadowed both Kenzo Tange's famous Tokyo Plan (1960) and Arata Isozaki's "Cities in the Air" (1962).

Although significantly smaller than any of these unrealized urban projects, much of the Hotel Tokoen can be described, understood, and appreciated along the designer's similar intentions, that is Kikutake's continued efforts as background, to realize and test his novel theories in actual projects. The eight-storey Hotel features a massive, reinforced concrete post-and-beam structure which, manifesting itself as an "independent" system, articulates the overall formal and spatial disposition in a significant way.

While the slabs of the first three floors are supported by the combined primary and secondary systems, the ones of the fifth and sixth floors are actually suspended from a pair of storey-high roof-beams running between the higher, primary pillars only. Partially due to this unusual solution, Kikutake was able to leave the space of the fourth level open, providing both extra means of ventilation as well as a new kind of architectural aesthetics. The void spaces, in conjunction with the various other "gaps" and concavities in the structural fabric, render the entire complex as a porous spatial matrix that fosters, on the one hand, a profound sense for perceptual depth; on the other, a unique, unfinished quality. Moreover, the suspended upper floors could allude to the idea and image of a small "city in the air." Kikutake's design thus emphasizes the individuality of both the "independent" supporting skeleton and the "dependent" elements, or the spatial units, while revealing the mode of the building's own making. The Hotel appears to be assembled from a set of parts rather than built in the usual way, as a monolithic entity.

Much of these intentions and attributes, including the emphasis on systematic design, structural systems, the primacy of a technological approach, and even the derivative aesthetics of the "unfinished," can also be found in numerous works by other metabolist architects, such as Tange's Yamanashi Communications Center in Kofu (1966), for instance. Nevertheless, there are several features that distinguish Kikutake's Hotel Tokoen from most others and also from Tange's somewhat similar scheme for the Center. Whereas Tange has created an impressive, but overwhelmingly powerful and monumental representation, and a clear diagram of an idea, the metabolist megastructural methodology, Kikutake, by way of his particular application of advanced technology and modern design, was able to reinterpret not only the heavy constructural traditions, but also to reuse and redefine the heritage of the lightweight and delicate wooden vernacular of Japanese architecture within an exceptionally attractive complex.

The Hotel, despite its extensive exposed concrete structure, does not appear overly heavy or volumetric. This is attributable, first of all, to the frame construction, and beyond, to the large number of elegant details: the applied forms and materials. Again, they all represent elements of both contemporary and traditional architecture and design. There are large glass walls in wooden frames with sliding shutters in front recalling the old-fashioned *amado* that protected the interior of the Japanese house from rain; the majority of the guest rooms feature *tatami* matting as their floor cover, and are partitioned within by way of paper covered sliding screens or *shoji*. On top of the building, and above the restaurant and bar, one comes across specially shaped roof elements that Kikutake has often used, starting with his first well-noted innovative work, the Sky House in Tokyo (1958). The curving form of these shell structures makes reference to both Le Corbusier's novel Philips Pavilion in Brussels (1958)—that influenced numerous Japanese designs including Tange's Olympic Stadia (1964) and St. Mary's Cathedral (1965) in Tokyo—as well as recollects the gracefully curving lines of ancient Buddhist temple roofs, whereby softening the predominantly rectangular design of the Hotel.

More significant, however, is the mode in which Kikutake has reinterpreted the intimate relationship between the building and its surrounding environment, a capacity which had always characterized traditional architecture in Japan. The designs of the first floor lobby, lounge, and terrace, in addition to the hotel rooms, is done so as to establish a meaningful dialogue between the building and both the small Japanese garden behind and the urban fabric of Yonago. There is only one aspect in which the Hotel, similar to most metabolist works, falls short of the ideals of the movement and Kikutake's original intentions; this is so, insofar as no major element or unit is interchangeable or easily replaceable within the overall framework making the idea of mobility, that is the actual, mechanical changeability of spaces and function, a largely elusive issue. Yet, in the last analysis, this does not prove to be a serious shortcoming at all; therefore despite, or perhaps also because of, the implicit contradiction, the Hotel Tokoen remains one of the outstanding representatives of an architecture that characterized Japan in the 1960s and early '70s.

—Botond Bognar

Bibliography—

"Hotel Tokoen, Yonago, Japan," in *Baumeister* (Munich), February 1966.
Boyd, Robin, *New Directions in Japanese Architecture*, New York 1968.
Kikutake, Kiyonori, *Works and Methods 1956–1970*, Tokyo 1973.
Ross, Michael Franklin, *Beyond Metabolism: The New Japanese Architecture*, New York 1978.
"Metabolist Kiyonori Kikutake," special monograph issue of *Space Design* (Tokyo), October 1980.
Bognar, Botond, *Contemporary Japanese Architecture: Its Development and Challenge*, New York 1985.

Photos courtesy Josef Paul Kleihues

Josef Paul Kleihues (1933–)
Berlin Municipal Refuse Collection Depot, Berlin-Tempelhof, 1969–78

The relationship between classicism and rationalist technique is greater than might be supposed at first glance. Logical planning lies at the root of both styles. They both make use of a clear and practical ordering, of modular designs, of well-ordered supporting frameworks, of economy of means, of technical and functional mastery. In Berlin, the industrial buildings designed by Peter Behrens in the first and second decades of the century for the Allgemeine Elektricitäts-Gesellschaft (AEG General Electricity Co.) are the closest example of such a symbiosis of classicism and rationalism, and Behrens's great model was the classicist work of Karl Friedrich Schinkel and his school. With his design for the principal workshops of the Berlin Municipal Refuse Collection Depot, Josef Paul Kleihues has added a new, contemporary link in this chain.

The land that the town refuse collection manages counts among the least attractive areas on the edge of the city. It is an elongated piece of land close to the circular suburban railway that gave the impetus, what with its convenient railway sidings, to the development of an industrial zone there at the end of the 19th century and the beginning of the 20th century. In addition, the extended motorway-like south circular came along in the 1970s. From here, one can get a first fleeting view of the whole plant. Only a strongly defined construction could assert itself in the chaos of the town's edge.

The clients' restrictions were clear. A large works hall was required in which the refuse collection and street-cleaning lorries could be serviced and repaired. The town cleaning authorities had imagined this hall set in the middle with the workshops on the side. Kleihues, when participating in an invitational competition, turned the project round. He suggested two parallel halls for the servicing areas, which he positioned on the periphery of the construction. By contrast he brought together the workshops, the storerooms, the changing rooms and social rooms in an inner ribbon-like and mostly two-storey kernel, the backbone of the building. A three-bay ground-plan emerged, which made possible smaller measurements for the spans of the halls and which shortened the distances to the different work areas and allowed for a decentralised arrival of the lorries—each vehicle drives through its own gate to its place in the hall.

On the outer wall, double supports and girder-heads made out of prefabricated cement blocks appear like memories of the classical order of columns. They have a kind of base, suggested by the emergency exits between the bollards and a kind of capital, the ventilation slits next to the spotlights. It is an arrangement that has an almost ritual solemnity to it; the other installations and the superstructure of the roof are likewise designed with the solemnity of liturgical paraphernalia. In the spaces between the columns are the portals which open upwards. The clerestory above, breaking off in a diagonal slope at the top, is covered over by a milky insulting glass. By contrast, the gates have been given clear glass panes at eye level, maintaining the contact with the outside world. Furthermore, they are kept open most of the day at the warmer times of year. Inside, slanting bands of skylights run along the length of the building, directing daylight into the depths of the workplace.

The elongated building finished on the westerly end with a hemicycle, which continues the firm elegance of the bays of the facade onto the volume as a whole. A further stage of the construction is supposed to have completed the easterly end of the plant with an administrative section ending in a kind of apse in answer to the roundedness at the western end—a promontory of a pulpit with a view. Memories of Berlin are brought into play once again, with associations with the Luckhardt brothers and Erich Mendelssohn, who in the 1920s and early 1930s found similarly brilliant solutions—in their case conditioned by the sites of their buildings within their urban fabric.

Architects often defend themselves from being labelled with a certain style. Kleihues, quite to the contrary, delivered a description of the style with his work. Since the 1970s he has laid claim to a "poetic rationalism" in his work. Since the old rationalism of the modern has surrendered itself to the constraints of economic factors and building technology, a new rationalism could only arise if it exposed itself to the risk of poetry. Architecture, which Kleihues—like many of his contemporary colleagues—would like to be understood as the art of building, had to free itself from the dictates of the requirements of function and gain complexity through undetermined, open behaviour. He sees its patron saints in Alberti, Palladio and Schinkel. He does not regard the debate with history—in this respect close to Oswald Mathias Ungers's principles—as a licence to steal quotations, but tries to bring it together with discipline and logic, with the Prussian feeling for duty and with Westphalian stubbornness.

The Berlin municipal refuse collection works serve as the illustration of this position. The construction does not neglect any of the tasks which a utilitarian building has to fulfil, but makes them into a sophisticated composition which is concerned with recapitulation. Kleihues has invented a building for the machines which have to deal with the filthiest business of the city which belongs to the highest level of design, a temple to cleaning—as though it were a question of a ritual bathing, not just the cleaning and repairing of dust-carts.

—Wolfgang Pehnt

Bibliography—

"Hauptwerkstatt der Berliner Stadtreinigugn," in *Bauwelt* (Berlin), 28 October 1977.
"Architettura Berlinese," in *Domus* (Milan), May 1978.
Clelland, Doug, "Main Workshops of the Municipal Refuse Collection Depot, Berlin," in *AD* (New York), no. 11/12, 1982.
Galerie Aedes, *Josef Paul Kleihues: Vier Projekte 1969 bis 1980*, exhibition catalogue, Berlin 1983.
O'Regan, John, ed., *Josef Paul Kleihues*, Dublin 1983.
Schreiber, Mathias, ed., *Deutsche Architektur nach 1945*, Stuttgart 1986.
"Josef Paul Kleihues," special monograph issue of *Architecture + Urbanism* (Tokyo), October 1986.
Kleihues, Josef Paul, *The Museum Projects*, New York 1989.

Lucien Kroll (1927–)
Medical Faculty Housing, University of Louvain, Woluwe, 1970–77

Lucien Kroll had enjoyed a reasonably successful career as a designer of sensitive, generally low-budget domestic and ecclesiastical projects when this astounding creation on the outskirts of Brussels launched him into international prominence. Frequently published, the outline history of the project became quickly familiar. The commission arose in the event of constructing a new campus for the Medical Faculty of the French section of the Catholic University of Louvain (split off, along with a Flemish section, from an historically unitary university in the late 1960s).

In the heady atmosphere of 1968, students protested the numbing dullness of the modern architecture planned for the campus by the administration's architect, Henri Montois. As a concession to their concerns, the students were allowed more or less free rein in determining the form of their living environment (their own housing proper, club rooms, dining hall, child-care facilities, etc.). The students elected to work with Kroll, in the expectation that his well-known predilection for, and previously successful experiences in, participatory design efforts held the greatest promise for creating living situations acceptable to the greatest number of a very diverse student population. The result was a structure designed to accommodate an extremely wide variation in size and configuration of living quarters, as well as easy variability of these quarters through the displacement of non-bearing partitions between gridded floor slabs. The variation and variability were expressed both inside and out through the use, in violent juxtaposition, of almost every imaginable building material and construction technique available.

While there is much genuine beauty in many of its details, Kroll's Medical Faculty Housing may be criticized in two respects: (1) the participatory design process as a generator of viable built form in this particular case; and (2) the formal qualities of the housing complex's particular form in its particular urban context.

The Medical Faculty Housing is by no means a unique experiment, either in Kroll's own work, or in that of earlier, contemporary, or later twentieth-century architects. It is, nevertheless, one of the most conspicuous instances of a participatory design resulting in actual construction because of the large scale of the project, the prominence of the university that built it, and the striking form that it eventually took. There is no doubt that the process initiated and led by Kroll, which involved the formation of student committees and the exhaustive debate of design alternatives by committee members, resulted in the choice of a structural system of remarkable flexibility. If the building's appearance has been more or less frozen since its "completion" (as originally conceived, the housing would never have been completed but rather would have existed perpetually in a state of becoming), it is not due a design failure but rather to the fact that the inhabitants have chosen not to introduce major modifications and indeed have been discouraged by the university administrative from doing so. Unfortunately but inevitably, the students who helped design the housing complex originally are not the ones who have occupied it since its construction. Since the tastes and social values of later students are seldom congruent with those of their predecessors, this building shaped by hardly any considerations other than the preferences and values of students of the late 1960s (and little modified since that time) not only looks increasingly dated but actually stands as something of an anachronistic annoyance. There is some evidence that the complex is shunned by students with easy access to several housing alternatives (i.e., relatively affluent Belgian students) and left largely to those of lesser means (i.e., poorer and foreign students). Viewed in a socio-historical perspective, Kroll's Medical Faculty Housing suggests that to be successful, participatory design can never be a process that ends with construction but (as Kroll himself grasped) must continue to affect the use and modification of the building throughout its existence.

This housing complex was brought more or less to its definitive form before its neighbourhood had been entirely urbanized. Its jagged silhouette and its variegated surfaces looked especially odd, even insolent, rising on an almost barren site between a lovely, quiet garden-city housing estate on one side and Montois's Brutalist hospital and teaching blocks on the other. Detractors thought it monstrous, and their opinion was not entirely unjustified. But over the years, the silhouette has been softened by the rise of many other large (and infinitely less distinguished) apartment buildings in the vicinity, with whose own silhouettes it blends nicely. The variegated facades look much less conspicuous, but indeed camouflaged, among the facades of those later structures. At the ground level, a delightful "anarchist garden" planted over and around heaps of construction debris ties the complex firmly to the earth. The Medical Faculty Housing, once a shocking novelty, increasingly looks like a piece of the cityscape that has always been there. To that extent, it is unquestionably a masterpiece of urban design. Its position among the greatest monuments of Belgian architecture and city planning is secure.

—Alfred Willis

Bibliography—

Kroll, Lucien, "Why I Could Build Woluwe," in *Wonen TA/BK* (Heerlen), June 1977.
Gassel, Ita, "Anarchitecture of Lucien Kroll," in *Architecture + Urbanism* (Tokyo), November 1979.
Kroll, Lucien, "Architecture and Bureaucracy," in Mikellides, Byron, ed., *Architecture for People*, New York 1980.
Kroll, Lucien, *An Architecture of Complexity*, Cambridge, Massachusetts 1987.
Pehnt, Wolfgang, *Lucien Kroll: Buildings and Projects*, New York 1987.

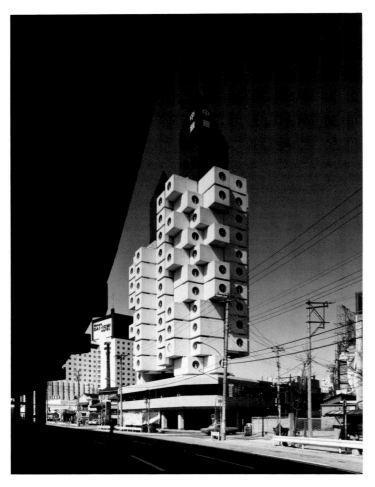

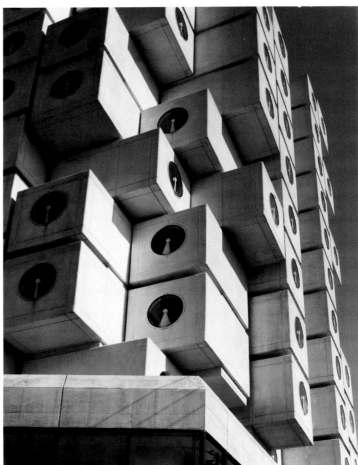

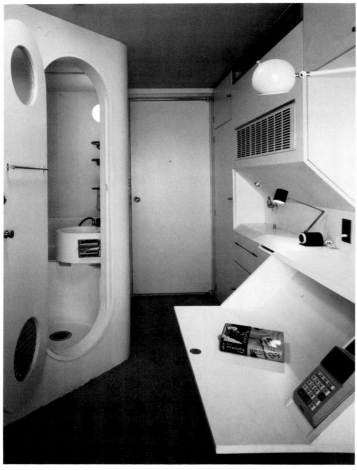

Photos courtesy Kisho Kurokawa & Associates

Kisho Kurokawa (1934–)
Nagakin Capsule Tower Building, Tokyo, 1972

The 1960s in Japanese architecture are known as the age of Metabolism. The Metabolist movement began with a new approach to urbanism, questioning the principles and dogmas of modernist urban design. Aiming at a high degree of functional flexibility in the city, in order to better cope with the demands of rapid urban growth and increasing congestion, plus the fast-changing lifestyles of the citizens, Metabolist architects offered a wide variety of solutions with proposals for large scale urban projects; they all relied heavily on advanced industrial technology that was readily available in Japan by this time.

These visionary, and often utopian, urban schemes included Kiyonori Kikutake's several variations of Marine cities over the water, tower cities above the land; Kisho Kurokawa's Helix city, a series of projects by Arata Isozaki for a "City in the Air" and, of course, Kenzo Tange's famous Tokyo Plan (1960). In all of them, the sharp distinctions between architecture and urbanism, or between building and the city were effectively dissolved. They could be interpreted equally as large buildings or small cities. Moreover, these urban schemes were all conceived with industrially-produced megastructures that comprised both the physical (loadbearing, tectonic) and operative (generative/functional) systems of their quasi-structuralist designs.

These architects in the Metabolism group—which beyond the ones mentioned above, included also Fumihiko Maki and Masato Otaka—in their designs made distinction between a largely permanent system of infrastructures and various systems of spatial/functional elements that were regarded as rapidly obsolescing components of the urban organization; as such, these component elements were intended to be interchangeable. In order to facilitate interchangeability in a highly effective way, two things were necessary: first, standardized connections between the spatial elements and their supporting megastructures; second, the designing of the interchangeable elements as industrially ready-made or pre-fabricated units, often in the form of various capsules.

It goes without saying that these utopian, urban-scale projects could not, and were not realized. Nevertheless, many of their inherent ideas were eventually channeled into various architectural complexes as this was exemplified by such buildings as Tange's Yamanashi Communications Center in Kofu (1966) and Kikutake's Hotel Tokoen in Yonago (1964) or his Hotel Pacific in Chigasaki (1966). None of these, or any other Metabolist buildings had, however, any easily replaceable "plug in" parts. This task awaited Kisho Kurokawa, the youngest member of the original group.

In the 1960s, Kurokawa built relatively little. Yet, even during these early years of his career, he became increasingly interested in the elaboration and actual application of capsule architecture. For the 1970 Expo in Osaka, he designed several pavilions with various, quasi-capsule units, including the experimental Capsule House suspended in the huge space frame of the Theme Pavilion. The first real capsule architecture, nevertheless, debuted in his widely acclaimed Nakagin Capsule Tower in Tokyo, which until today best represents the principles of Metabolist architecture, especially that of actual interchangeability.

The Nakagin Building, a residential complex for businessmen while on temporary assignment in Tokyo, consists of 144 studio apartments. Each of these apartments is arranged as an individual capsule made of welded steel frames covered with galvanized rib-reinforced steel panels. These capsules, both in terms of their structures, size as well as the idea behind them, are derivatives of shipping containers. They are stacked on two ferroconcrete communications and service shafts. These shafts, just like the ones in Tange's Yamanashi Communications Center in Kofu, work both as the sole structural support of the building, and also as the means of vertical circulation; each includes an elevator and stairway, in addition to all the service ducts for electricity, utilities, telephone, drainage, waste disposal, etc.

The capsule unit, with an interior size of about 2.4 × 3.6 metres, like its counterpart know from space exploration, is a high quality, ready-made industrial product which is fully equipped with a large variety of installations; these include a double bed with storage underneath, a built-in cabinet system with a folding desk, a stereo, TV, phone, and a kitchenette. A small bathroom, air conditioning, and heating add to the comfort of the owner/resident while utilizing the small space in a most efficient way. The window with a permanent glass surface and a rotating fan-like blind system, is circular in shape. The Nakagin building also provides services similar to a hotel: room service, joint facilities like lobby, restaurant, lounge, etc.

The factory-finished units, as well as the vertical shafts, are equipped with highly mechanized and standardized connections for both utilities and structural support. Thus, when the capsule unit is clipped on to its "docking" structure by means of four large bolts, the built-in facilities and equipment are simultaneously and simply plugged into the vertical central supply of electricity, water, etc., within the service shafts.

The idea in Kurokawa's design was that the capsules, produced inexpensively by industrial methods, could be easily replaced upon the wish of the owner, with new ones that incorporated the latest technological achievements of the time. These living units could be ordered and purchased like an automobile with a variety of options and luxuries, and indeed, at the time of the building's completion, one capsule cost about as much as a mid-size Toyota car. Also, the system foreshadowed a potential future situation, wherein, with numerous receiving or "docking" structures in various parts of the city or the country, owners of standardized capsule homes could change residence with ease by transporting their units like a shipping container on trailer trucks.

As a matter of consequence of such a flexible system, the appearance of the Nakagin building (in fact a small "vertical city") would depend on how many units and in what configuration are attached to the concrete service shafts. Kurokawa referred to this perpetually unfinished look as the "aesthetics of time," or the aesthetics of Metabolism. Kurokawa's design thus effectively elaborated a new architectural paradigm, implied in the principles of Metabolism, which was to challenge the prevailing notion of a more or less stable built environment and urbanscape. Then it is only paradoxical that, ever since the building was completed in 1972, there have been no changes in its composition, neither in terms of rearrangement nor in adding extra units. Nevertheless, Kurokawa's Nakagin Capsule Tower remains an outstanding piece of architecture, a "sculpture" dedicated to the idea of interchangeability of its architectural parts, and as such, the best representative of a unique period of Japanese contemporary architecture.

—Botond Bognar

Bibliography—

Kurokawa, Kisho, *The World of Kisho Kurokawa*, Tokyo 1975.
Kurokawa, Kisho, *Metabolism in Architecture*, London 1977.
Kurokawa, Kisho, *Kisho Kurokawa: A Contemporary Japanese Architect*, Tokyo 1979.
Kurokawa, Kisho, *Kisho Kurokawa: Architecture and Design*, Paris 1982.
Papa, Lia, and Manocchio, Vincenzo, *Kisho Kurokawa: Il Futuro nella Tradizione*, Naples 1984.
Bognar, Botond, *Contemporary Japanese Architecture: Its Development and Challenge*, New York 1985.
Suzuki, H., and Banham, R., *Contemporary Architecture of Japan 1958–1984*, New York 1985.
Stewart, D., *The Making of a Modern Japanese Architecture*, Tokyo and New York 1987.
"Kisho Kurokawa 1978–1989," special monograph issue of *Space Design* (Tokyo), June 1989.

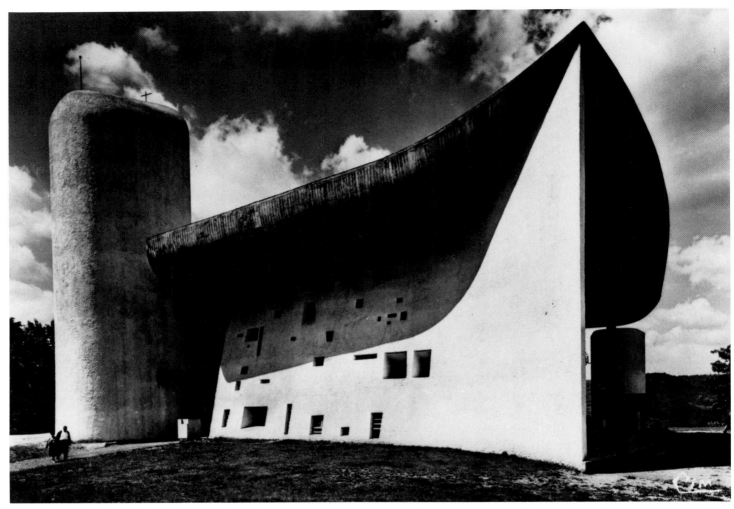

Photo British Architectural Library/RIBA

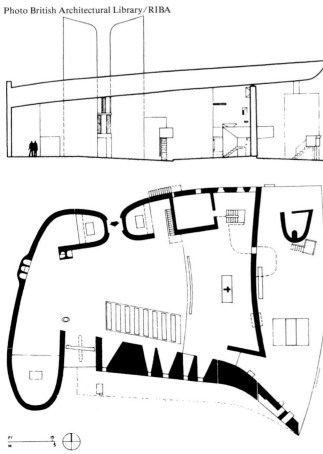

Le Corbusier (Charles-Edouard Jeanneret) (1887–1965)
Chapel of Notre-Dame-du-Haut, Ronchamp, 1950–55

Great architecture is rare in history. The mark of real distinction in form, volume, space, colour and acoustics is that exceptional quality which moves and uplifts the human spirit. Such is the destiny of Notre-Dame-du-Haut. It is an experience of silence, peace and inner sweetness. Ronchamp is never easy to understand or explain because, ultimately, Le Corbusier's late work defies rational explanation. At best, we can only experience Ronchamp and be grateful that this miracle of the imagination was built at all. For great works of architecture which speak of the human spirit are an uncommon excellence in any age. Ronchamp is Le Corbusier's jewel. It is a very real part of his inner journey as a spiritual person.

Notre-Dame-du-Haut is situated on the southern foothills of the Vosges, 33 kilometres from Belfort. Its completion and dedication in June 1955 was certainly a creative shock to the village of Ronchamp, to the clergy, and to a whole generation that followed World War 2. Revulsion from militarism, from hatred, oppression, from the tyranny of the right angle is marked high and heroically on this ancient building site of Bourlémont. Yet this plastic work is in deep harmony with Nature and the four horizons. We need to remember architects of genius can never be understood as predictable creatures. Ronchamp is Le Corbusier's most enigmatic building where he liberated himself irrevocably from the logic of straight lines. Like a true composer he was also indifferent to worldly applause. As he exclaimed:

"This pilgrim's chapel is no baroque pennon.
May Ronchamp bear witness
five years of work isolated on a hill.
I have never in my life explained a work,
The work may be liked or disliked,
understood or not,
What difference does that make to me."

This chapel can be seen from a long way off, like a white light house, set in the middle of a huge landscape of earth and sky. It, too, sees a long way. To the south, the last outposts of the Vosges, to the West, the plain of the river Soane, to the North a valley and a village, to the East d'Alsace. This landscape, these four horizons were the deciding factors. They are nature's hosts—they are always present. It is to them that the chapel speaks.

Ronchamp is contact with a place. A situation in a place. A word spoken to this place. Ronchamp is freedom. It is totally unrestricted. There is no functional programme other that the Mass—one of the oldest rites in Christendom. Ronchamp is a place of pilgrimage. A source of consolation to the lonely. But Ronchamp speaks of inner joy. As Le Corbusier understood it: "inside alone with yourself, outside 10,000 pilgrims in front of the altar."

Le Corbusier's disciplined plan cherished this compelling dream. He used the east wall as a cyclorama against which the public and more private altars were set, incorporating a swivelling virgin in the reredos wall. This was a stroke of genius. Not only did it give due honour to the Virgin: Notre-Dame-du Haut, but this detail shows us how Le Corbusier approached the notion of the spiritual. For to deny this link between the interior and exterior, would have been a direct contradiction of his approach to the spiritual. On this point it is vital to realize Le Corbusier's spirituality came not through the catholic mass but direct from Nature.

To celebrate pilgrimage mass outdoors before nature was in great sympathy with Le Corbusier's approach to the spiritual. He was supremely receptive to the world of nature, and before nature he was himself. Nature in fact reveals Le Corbusier in all his Rousseauist glory. At Ronchamp, nature becomes the loudspeaker for Le Corbusier's architecture. The manner in which the concrete shell roof, thick walls, and vertical towers define this chamber of silence is pure poetry. Such a controlled space is alive in light. Light is the key, and this space carries a rich variety of meanings woven into its cave-like synthesis. It is this experience which produces amazing and varying responses in pilgrims.

Without a doubt, this Chapel is Le Corbusier's most available and popular building. It captured the imagination of a whole architectural generation and historians have been writing about it ever since. It has entered the popular mythology of stamps and posters, and finds a place on the front cover of many books which deal with twentieth-century civilization.

Why, one might ask? Simply because in an era of deep spiritual poverty, the architectural language of Ronchamp is incredibly rich. At Ronchamp Le Corbusier gave living form to dead matter—his curving forms are alive in spirit. At Ronchamp Le Corbusier sought to express the ineffable, and the inner voice of the artist. For this very reason, Ronchamp was, and still is, a masterpiece. But it is a poetic masterpiece that has to be creatively experienced. It is also a help to the understanding, if the visitor has personally experienced the Mediterranean. For here the seal was set on Le Corbusier's sensibility.

To answer the question whether or not Le Corbusier's vision as an architect changed fundamentally between his purist and mature periods, the answer must be categorically No, but it must be realised that until he built the Chapel of Ronchamp, his nature mysticism was not fully visible to the world. It was this deep experience in nature which provided the visual force behind all his work. Le Corbusier's work was never dull. At Ronchamp, Le Corbusier created architecture that was not only original to the post World War 2 period in which he worked, but also within his own Oeuvre. Above the village of Ronchamp he followed his own path, he was master of his own fate. At the end of the day, for those who seek to climb the hill of Bourlémont, Ronchamp is a unique moment in a unique landscape, by a spiritual person who moved his generation in a heroic way.

—Russell Walden

Bibliography—

Petit, Jean, *Le Corbusier: The Chapel at Ronchamp*, London 1957.
Petit, Jean, *Le Livre de Ronchamp*, Paris 1961.
Walden, Russell, *Le Corbusier: Ideals and Realities*, PhD dissertation, Birmingham 1978.
Pauly, Daniele, *Ronchamp, lecture d'une architecture*, Paris 1983.
Pauly, Daniele, "The Chapel of Ronchamp as an example of Le Corbusier's creative process," in Brooks, H. Allen, ed., *Le Corbusier Archive*, vol. XX, New York and Paris 1983.
Walden, Russell, *Bon Anniversaire Le Corbusier 1887–1987: The Joy of Ronchamp*, Auckland 1987.

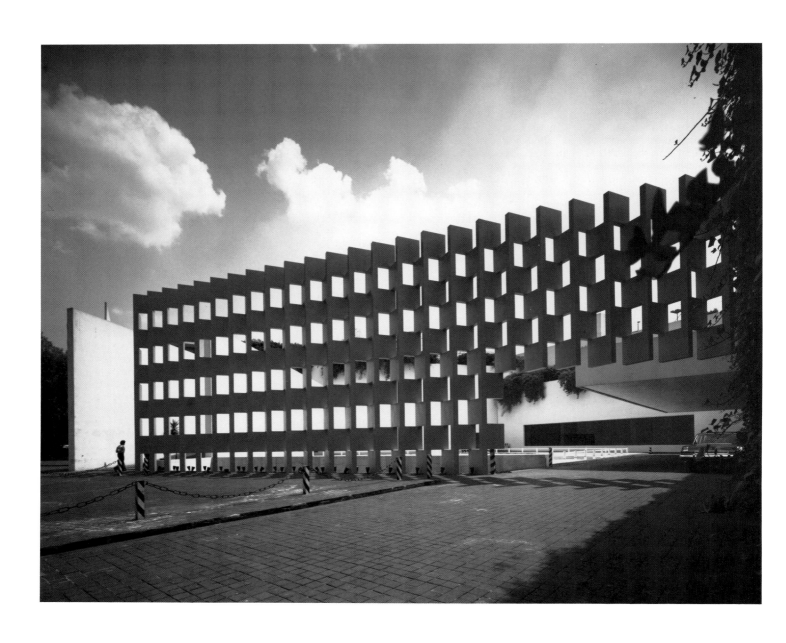

Ricardo Legorreta (1931–)
Camino Real Hotel, Mexico City, 1968

Camino Real, Mexico City, is among the finest expressions of contemporary Mexican architecture and at the same time points the way toward a new international architecture in response to the decline of the Modern movement.

On a 30,000 square-meter site opposite Chapultapec Park, the hotel was commissioned early in the 1960s to be ready for the 1968 Olympic Games in Mexico City. Time and feasibility studies precluded a high-rise structure. What was proposed instead was a new type of urban hotel—one distinctly Mexican, a popular meeting spot for city residents of many classes and at the same time a comfortable home for sophisticated international travelers. By blending outer and inner spaces, by mixing native with luxury materials, by introducing a palette of vernacular Mexican colors and by bold use of walls, architect Ricardo Legorreta created in Camino Real a strong regional architecture that also has lessons for architecture beyond Mexico.

When Legoretta was given the commission for Camino Real, Luis Barragan was made the landscape consultant. And, especially for North Americans unaccustomed to Mexico's patio and pool tradition, it is the landscaping of plants, pools and water-walls that gives the hotel guest a feeling of heaven on earth. Sitting in a guest room, one experiences the room as part of the garden and the gardens as outdoor rooms. Even for those staying in rooms on the second and third floor of the hotel, the visual connection to pools and gardens is intimate. Because the hotel is so large—with some 700 rooms—Legoretta provided many separate patios and courtyards around which sleeping rooms, located away from the public rooms, could be organized, much as rooms in a convent or monastery might be. The street on which the hotel fronts has been landscaped with trees so that the hotel also seems to extend across the avenue to Chapultapec Park, the breathing green heart of Mexico City. Luxury restaurants are located on the highest storey of the hotel.

The plan for Camino Real includes a generous forecourt for arriving cabs and cars, a low entrance, a sunken lobby and reception from which one gains a first impression of gardens and pools to the right. Shops, carrying Mexican crafts, clothing and art, are located behind the reception area. A popular coffee shop and a cantina open out to a rear lobby and street behind the hotel. Along the south-facing side of Camino Real, Legorreta specified monumental decorative white cylinders that screen out city traffic.

One drives into the hotel through a huge magenta sun-screen to be surprised by a large, circular pool, whose water is agitated with wave-like motion. "I wanted a discreet and mysterious entrance sequence for the hotel, something to be discovered little-by-little as you penetrate the building," Legorreta has said. From the open-air entrance adjacent to the pool and secluded from street traffic by the pierced-wall, stucco sun-screen, one steps down into a spacious low-ceilinged lobby. Moving past a Mathias Goeritz mural in brilliant gold leaf, one descends a broad carpeted stair to reach the marble reception desk. Here the experience of space is both luxurious and as mysterious as the center of a vast pyramid. Proceeding toward the assigned guest room, one sees not only the pools and gardens beyond but also walls of water connecting to pools above the reception level to upper public lounges. Rooms include luxurious marble baths which contrast with simple stucco walls and bright Mexican fabrics of ochre, orange, magenta and blue. The same colors appear on walls enclosing the garden courtyards.

Wayne Attoe, who edited *The Architecture of Ricardo Legorreta*

(1990), has said that in Legorreta's work there is a coincidence of the vernacular and modern and that the resulting hybrid is remarkable for its vitality. Hybrid elements—including pre-colonial, Hispanic baroque and Hispano-Mexican vernacular—contribute to the success of Legorreta's later work, including notably the Camino Real, Ixtapa, completed in 1981. If the challenge at Camino Real, Mexico City, was to create a garden paradise in an urban setting, the task in Ixtapa was to respect the mountainside site by making majestic views of the Pacific Ocean available from every room in the hotel. As a contrast to ocean and sand beach, Legorreta also designed as focal point to the entire hotel, Las Fuentes, a complex of fountains, pools, aqueducts and water-stairs all served with restaurants and showers.

The success of Legorreta's hybrid approach to architecture was confirmed on an international scale when he was invited by IBM to provide a marketing center at Solana, Westlake/Southlake, Texas. The project, with a hacienda configuration and a yellow, magenta, blue, red and white color scheme, was financed by premier Los Angeles developers Maguire Thomas and completed in 1986. In the 1990s Legorreta continues to work for Maguire Thomas on such projects as Playa Vista, a pedestrian-oriented new town, adjacent to auto-choked Los Angeles airport.

The concerns that would be reflected in future work are all encountered in the Camino Real, Mexico City. Here the wall is both monumental and facilitator of intimate space. "Part of the magic of walls is how they are opened, how they give us a glimpse to a secret garden, or hide from us the view of a place beyond," Legorreta has said. At Camino Real, Mexico City, and at subsequent projects, these walls are brought to life by vibrant ochre, magenta and blue. Light, both natural and artificial, is then manipulated by the architect in such a way that one's experience of the walls changes—hour by hour and season by season.

In a recent essay, the American architect Charles Moore has suggested that the qualities in Legorreta's work describe a desirable architecture for the future. Among these characteristics are 1) a capacity for intimacy, hand in hand with elegance; 2) a freedom from rules, which shows up especially in use of color; 3) a sense of mystery; 4) a sense of humor, seldom encountered in traditional modern architecture. These qualities, which are manifest in the works of Legoretta that have followed the Camino Real, Mexico City, are what makes Legoretta's architecture among the most significant today being produced in the Americas and, indeed, in the world beyond.

—Ann Ferebee

Bibliography—

Smith, Clive Bamford, *Builders in the Sun: Five Mexican Architects*, New York 1967.
Legoretta, Ricardo, *Los Muros de Mexico*, Mexico City 1978.
Bayon, Damian, and Gasparini, Paolo, *The Changing Shape of Latin American Architecture: Conversations with Ten Leading Architects*, New York 1979.
Kappe, Shelly, ed., *Modern Architecture: Mexico*, Santa Monica 1981.
Pratt Institute, *Contemporary Third World Architecture: Search for an Identity*, exhibition catalogue, New York 1983.
Museo Rufino Tamayo, *Luis Barragan: Ensayos y apuntes para un bosquejo critico*, Mexico City 1985.
Attoe, Wayne, ed., *The Architecture of Ricardo Legorreta*, Austin, Texas 1990.

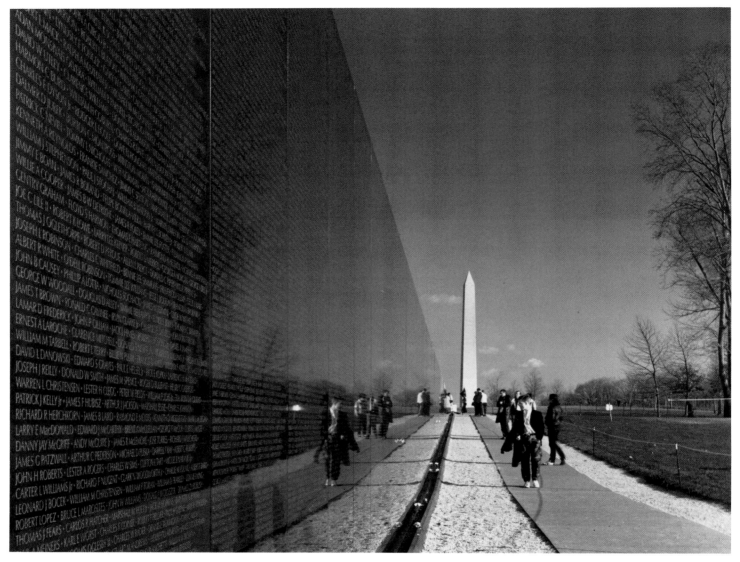

Photo © Peter Aaron/Esto

Maya Ying Lin (1960–)
Vietnam Veterans' Memorial, Washington, D.C., 1982

A concept as brilliant in its geometry as it is dark in its eloquent symbolism; a monument as appropriate to its site as it is disquieting to the spirit; a monument as healing of the soul as it is a scar on communal memory; a monument as representative of its subject as it is severely abstract in its execution: Maya Lin's Vietnam Veterans Memorial is a deeply moving, evocative, profound, magic and sacred place.

A student asked me this morning: could I cite an architectural project which has made the world a better place? Without hesitation I replied: The Vietnam Veterans Memorial.

Monumental Washington is a place of abstruse and complex geometry: the geometry of place, of power, of memory, of celebration and repression; the geometry of the seeming and of the secret; the geometry of secular esoterism and material utility; overlapping and interconnecting multi-level geometries. Maya Lin's design reduces geometry to its essentials: a three-dimensional angle, dug into the earth; an arc of a great circle, a composition of two triangular slabs meeting in a vertical line.

The sight line from the bottom of the apex, looking East by South East, leads through the vertical obelisk of the Washington Monument to the Cupola of the US Capitol beyond it; but if one follows by implication its undug implicit extension West by North West, the line would intersect with the American flag of the Marine Corps War Memorial in Arlington. Congress, George Washington, Vietnam, [The Marine Corps, The Flag]—one leg of the **V**.

Turning one's eye along the other wall, looking South West, the plane cuts diagonally through the heart of the Lincoln Memorial and continues across the Potomac to the Tomb of the Unknown Soldier. If one follows this slab implicity in the other (North East) direction, this undrawn, unstated, but implied line points directly to The White House. The other leg of the **V** then: Tomb of the Unknown Soldier (Planted in Robert E. Lee's garden), Abraham Lincoln, Vietnam, [the present Commander in Chief]. In a city of brilliant geometries a direct, straightforward, understated, powerful, brilliant act of placemaking by geometry.

· · ·— Dot Dot Dot Dash. Ready, set, go! Morse code for V. Da, Da, Da, Dah. Deaf and syphilitic Beethoven. Edward R. Murrow. The BBC. Occupied Europe. The battle against fascist tyranny and against genocide. The Battle of Britain. The Empire's Last Stand, on borrowed time, on borrowed money, in the hock . . .

For at all hours of the day a line of mourners, as if by instinct, following a scent that will take them underground from Washington to Lincoln, pass through this vale; grown men crying, carrying half-breed children on their back, leaving flowers in a crack, buttons, mementoes, pieces of torn uniform, quiet as at a wake, cameras not clicking, in awed silence they pass, kneel, blush and weep crossing over and under, always East to West and across and back around the Globe following the course of inscribed name-time from the crack of the V, 1959, around the globe and back again to the crack in 1975. Veterans telling it as it was, unembellished but unashamed to their children; a Purple Heart, left behind; wheelchairs and baby carriages, babes and crones, families and lonely men, the pilgrims, the feeling in my own heart as it broke unbidden and undramatically right at the vertical line of the V. It seems almost sacrilegious but determinedly right for me to tell you some of the things that I have seen there, the words and sounds that I heard, the feelings that I felt.

"Appropriate to the site": sacred to the memory of those who died; and as you gaze at the names, you gaze beyond them, just out of focus, at your self: a dematerialized image of your self is on the other side of the black polished granite, a nameless, unknown dead veteran of that War. Appropriate indeed, and because appropriate to its site, profoundly disquieting to the spirit—for this is no shallow grave nor empty pro- or anti-war rhetoric, for this memorial grazes deep into the inner contradictions of the Spirit of America and indeed of the Human Spirit itself.

This monument is as healing of the soul as it is a scar on communal memory. Six feet under there is no scar; when your head is below the sward of the Mall you know: you too bit the dust, you too have bought the farm, the death rattle has ended, your dog tag is in your rigidified jaw, between your clenched teeth, like a Greek coin, a latter-day fare for the ferryman; from dust to dust, from ashes to ashes, the great conflagrations of this world heal over in time, not in the spirit but in the soul; forming a scar is a method of healing—not a cosmetic one, a functional one. A healing wound that has scarred, scar tissue, a scar on the soul as an act of healing; a scar on the community for all the living that have untimely died; so long a war, so long a deadlock, so sudden a retreat, so Orange an Agent, so cold a war, so fiery the napalm . . .

We have seen that Maya Lin's adherence to The Program was technically perfect but profoundly evasive. Technically the monument "make[s] no political statement regarding the war or its conduct." It is above such commentary. But, such commentary is below it. For while making absolutely no political statement, it is a political statement, for it is a statement of power as it is about power. This is a political statement that has power in Washington, power in America, power in the World. This is an utterance, an act of memory, a statement, as directly meaningful as it is abstract, as apolitical as it is deeply moral, as unpartisan as it is deeply committed, a monument as representative of its subject as it is severely abstract in its execution.

In a positive sense, the program asked that the memorial should "become a symbol of national unity, a focal point for remembering the war's dead, the veterans and the lessons learned through tragic experience." After the immediate controversy and turmoil that surrounded this design, how profoundly and unexpectedly but how thoroughly it has fulfilled this part of its contract with society and its commission with the client! There are traveling and still replicas of it (sans flag, sans Frederick Hart's "realistic" and "representative" sculpture, sans fanfare); there is a reverence for it; there is a non-trivial unity around, behind, below, and above it; the people have voted with their hearts and found this to be one of the great pilgrimage-goals of this earth; a kind of American sacred black stone, a Kaaba; a small stone in a Great Mosque; a point toward which we can turn when we pray.

As we walked to the Library this morning, the student, young enough to be my daughter, said: What is architecture? To be architecture rather than building, it should be designed by an architect, it should make a place, and it has to have aesthetic merit, I said. Does that make the world a better place, she asked. Not necessarily, not if we see the human race as a plague upon the earth and its aesthetic one of defilement, I said. Has any piece of architecture made the world a better place, she asked. Well at least one place does, the Vietnam Veterans Memorial does, I said. And I stand by that.

—Joseph B. Juhasz

Bibliography—

"Vietnam Memorial," in *Artnews* (New York), January 1983.

Kelly, J., "Vietnam Veterans' Memorial," in *Artforum* (New York), April 1983.

Hess, E., "Tale of Two Memorials," in *Art in America* (New York), April 1983.

Blum, S. N., "The National Vietnam War Memorial," in *Art Magazine* (New York), December 1984.

Howett, C. M., "The Vietnam Veterans Memorial," in *Landscape* (Berkeley, California), no.2, 1985.

Springer, P., "Rhetorik der Standhaftigkeit," in *Wallraf-Richartz-Jahrbuch* (Cologne), vo. 48/49, 1987/88.

Kunze, D., "Architecture as Coding," in *Journal of Architectural Education* (Washington, D.C.), Summer 1988.

"The Vietnam Memorial," in *Abitare* (Milan), July/August 1988.

Beardsley, J. "Like a Mighty Stream," in *Landscape Architecture* (Louisville, Kentucky), January 1990.

Stein, K. D., "Touch Stone," in *Architectural Record* (New York), February 1990.

Highpoint One

Highpoint Two

Photos British Architectural Library/RIBA

Berthold Lubetkin (1901–90)
Highpoint One and Two apartment blocks, Highgate, London, 1935–38

Highpoint One and Two stand at the summit of North Hill in north London, offering the interested passerby one of the better comparative illustrations of the languages and execution of architectural modernism in Britain between the wars. Although only three years separate the completion of each block of flats—Highpoint One in 1935, Two in 1938—there are sufficient differences and similarities between the buildings to confirm a shift in emphasis in the role of modern architecture as interpreted by the architects: Berthold Lubetkin and Tecton at that time.

In 1931, Lubetkin settled in Great Britain. Although he had built in Paris, studied concrete construction techniques in Warsaw and been taught by the renowned art historian Willhelm Worringer in Berlin, it was not until he had recruited the members of his practice from the Architectural Association in London that Lubetkin was able to embark on any major architectural projects. Highpoint One was the largest commission yet to be won by the young members of Tecton, with Lubetkin building on the relationship he had established with Zigismund Gestetner, the industrialist entrepreneur who was to provide the backing for the project.

Upon completion, Highpoint One stood at the vanguard of European modern architecture. Praised by Le Corbusier and vilified by traditionalists, the block became a focus for advocates of a new, white-painted architectural order. As Lubetkin said: "it was a sort of symbol . . . creating a backstage for all sorts of things." Highpoint's success as a symbol came as much from Lubetkin and Tecton's vision and attention to detail as Ove Arup's skill in engineering the structure.

For these reasons, the block is something of a masterpiece of planning and execution, successfully combining architectural conceits with engineering solutions. Arup's contribution to the construction of both blocks cannot be underestimated. His mastery of the techniques of concrete construction meant that Lubetkin and Tecton could feel relatively free to pursue the realisation of a modernist morphology at a time when the expression of rationalism and functionalism in the design of new buildings was the dominant feature of the newer and increasingly fashionable architectural philosophies.

This is how Highpoint One appears to the viewer. Expressions of modernist-inspired rationalism pervade the building. The windows are of a design first used at the Wiessenhof Siedlung, the Deutscher Werkbund's "modernist village" built in Stuttgart in 1927. Instead of simply swinging outwards on a hinge, the centre section of the living room window "concertinas" upon itself to create a long slit in the wall, so destroying the confining solidity of conventional fenestration and bringing the occupants into contact with light, sun and air. Highpoint One benefits from the application of careful thought to the problems of design throughout. Because of the double cruciform plan of the block, all 60-odd flats are cross-ventilated and, originally, central heating was provided through a system of concealed pipes above ceilings. The built-in refrigerators in the kitchens were fed from a cooling plant in the basement.

The construction of the building was made both speedy and cheap by Arup's system of climbing shuttering, previously unused in the construction of domestic dwellings, which made the concrete walls the load-bearing elements of the structure, allowing for a freedom in the design of the facade which would not have been possible otherwise. The characteristic, cyma-curved balconies are a further product of Arup's ability to provide structural solutions for expressions of tectonic flair. As they seem to float gracefully from the facade, tethered only by thin metal rails at either end, these balconies provide a recognisable signature and add a compositional richness to the play of light upon the surface of this graceful, white-painted building. Yet there is no hint on the outside of the building of the structural contortions which had to be mastered to allow the balconies to feature as they do.

Highpoint Two represents a somewhat different approach to the planning and building of a modern block of flats in the late 1930s.

Lubetkin and Tecton had originally planned to replicate Highpoint One, intending to consolidate an architectural vocabulary for the modern block of flats. But owing to a bye-law, which gave local councils aesthetic jurisdiction over new building in their area, permission for another huge, white building was flatly refused. Instead, Lubetkin and Tecton, again with Gestetner as the client, gained permission for a different type of building which, nevertheless, expressed modernity in its architecture whilst departing from the form of Highpoint One.

Highpoint Two also differs in intention from Highpoint One: it houses just thirteen apartments, with those in the centre block featuring double-height living rooms with windows measuring 16×10 feet providing views over Hampstead Heath and London beyond. In many ways, Highpoint Two is unashamedly luxurious. Nevertheless, Lubetkin and Tecton's approach to the architecture is characteristically inventive and rigourous.

In combining the method of construction used in Highpoint One with a concrete frame and infill technique, Highpoint Two presents a greater textural variation to the viewer's eye. Dark brick infill panels are bounded by the exposed concrete frame in the centre block, whilst the end sections are clad in smooth, glazed tiles. The fenestration is boldly orthogonal and helps to divide the street frontage into what appears to be several overlaid grids. Continuity with Highpoint One is achieved, however, in the alignment of the buildings and their predominant features.

The garden facade of Highpoint Two includes long balconies which echo the positioning of the balconies in Highpoint One. Hence, all the geometric relationships that are set up between the two blocks are horizontally linear.

Other relationships between the two buildings also exist in the materials used—concrete, glass, steel and brick—but it is the way in which the materials are brought together in each of the buildings which differentiates the one from the other. By the time Lubetkin and Tecton had completed Highpoint Two, the architectural language which they had striven to perfect in Highpoint One was rapidly descending to the status of a much-diluted style. Highpoint Two, in eschewing the white garment of what had become the so-called international style, served to offer an approach to modern architecture which relied not on the expression of a style for its own sake, but rather on the visible integrity of a well designed building.

The integrity of Lubetkin's architecture is not compromised by what is perhaps the most jocund of his architectural conceits. Rather, the inclusion of concrete replicas of the Erechtheum Caryatids as supports for the large "wing" of the *porte cochere* in Highpoint Two simply confirms the spry, wry intellectualism brought by Lubetkin to architectural practice. Their presence seems to underline an idea first expressed by Lubetkin's old teacher, Willhelm Worringer; that utilitarian purposes and materials are only factors with which higher ideas are expressed.

—Michael Horsham

Bibliography—

Furneaux, R., "Lubetkin: A Critical Appreciation," in *Architectural Review* (London), July 1955.
Whittick, Arnold, *European Architecture in the 20th Century*, London 1974.
"High Point Flats, Camden," in *Design* (London), December 1974.
Curtis, William, "Lubetkin," in *Architectural Association Quarterly* (London), no.3, 1976.
Allan, John S., *Lubetkin and Tecton: The Modern Architecture of Classicism*, London 1981.
Coe, Peter, and Reading, Malcolm, *Lubetkin and Tecton: Architecture and Social Comment*, London and Bristol 1981.
Diehl, Tom, *Lubetkin: Theory and Practice in Highpoint I and II*, thesis, Architectural Association, London 1982.
Tatton-Brown, W., "Tecton Remembered," in *Architects Journal* (London), January 1982.

Fumihiko Maki (1928–)
Municipal Gymnasium, Fujisawa, 1984

Located in an extensive suburban park, Maki's Gymnasium is the main facility of a recently developed cultural and sports center in Fujisawa, a residential, leisure and industrial town some thirty kilometers to the west of Tokyo. The large complex is comprised of two distinct yet interconnected volumes, one accommodating the two-thousand-seat main arena, the other housing a small gym on the top floor, judo and kendo practice halls plus a restaurant on the second floor, and a training court, conference room and administrative spaces on the first floor. In between these two volumes, a two-storey entrance hall, foyer, and gallery section—accessible through a wide, outdoor stairway for spectators—provides a common, public space and indoor connection.

The Fujisawa Gymnasium displays numerous unusual features and qualities which are not only new in Maki's overall work, but also unparalleled in contemporary Japanese architecture until very recently. Most obviously, it is the highly reflective stainless steel sheet cover over the all-around curving surfaces of the roofs that needs to be pointed out first. These thin but extensive metallic surfaces, textured by the seam-lines of the sheets, lend the uniquely shaped volumes a high-tech, futuristic, and indeed a space-age appearance, which is then properly matched by the display of engineering bravura of the structural design inside the arenas.

Supporting the roof structure of the large arena, two giant arches span its space longitudinally. These 80-metre long spaceframe arches, composed of H profile steel elements, are triangular in section with a height of 3.5 metres. Above, they are adjoined by the continuous and similarly triangular prismatic bands of glass skylights which, like the arches inside the space beneath, although in a reversed configuration, form two sharp-edged ribs over the roofs, dramatizing further the curvilinear forms of the structure. The two large, crescent-shaped concrete podia of the spectators' seats are cantilevered on both sides of the court. Connecting the podia with the arches are steel girders at 6-metre intervals whose pin joints at the edges of the podia are designed so as to allow for long, continuous stripe windows which altogether make the roof seem to float over its substructure.

On the other hand, the smaller arena is constructed of a reinforced concrete rib structure that, over the top floor gymnasium, converge in a series of 12-metre high pointed arches. While the sequence of these ribs is abruptly discontinued at the west side, resulting in a flat elevation, at the east side, the ribs form a rounded, semi-circular "cage" with the continued solid surfaces of the stainless steel finish outside. This east section of the smaller volume shelters the impressively high, multi-storey space of the restaurant that has an additional gallery level inside. Natural light is provided through a narrow vertical slit and a low-profile curving glass wall with access to a small rooftop terrace in front. The carefully positioned openings not only reveal the thin, membranous quality of the enclosing, helmet-like shell but again also make its structure seem to float above the terrace, and the base walls around.

Size and structure, nevertheless, are not the only differences between the two wings. Their formal articulation, too, shows dissimilarities, constituting the basis of the impressively dynamic yet apparently "discontinuous" and, in many respects, fragmentary architectural composition. Indeed, although defined primarily by curving surfaces, the two forms could not be more different. The smaller one is higher and elongated, the larger is flattened, and shell-like, both with a wide range of possible formal references of their own. Additional aspects of disparity become evident only slowly, almost by stealth, as the observer moves around the vast and monumental complex.

Similar disruptions of form occur in the case of the large arena as well. The north side of the structure accommodates a stage for performances both inside and out. Above this area, in order to connect exterior with interior, the down slope of the roof is suddenly interrupted by another irregular shape superimposed on the one behind. The south side of the arena is also opened up, yet again in a different way to provide connection with the entrance/foyer section. As a result of the so-folded surfaces, seams on the roof seem to go every which way. All these operations on the surfaces, forms, and structures result in the creation of additional spatial crevices, as well as, the deviation from a well-defined unity of interior spaces.

To demonstrate further the discontinuous, fragmentary quality of the Fujisawa Gym, one only needs to compare it with another outstanding sports facility of twenty years before, Kenzo Tange's Tokyo Olympic Gymnasia (1964), by which Maki seems to have been partially influenced. Tange's design for the two arenas—also defined solely by structurally shaped curving surfaces—aimed at, and has achieved, as all modernist buildings did, a synthesis of form, that is a highly integrated composition, wherein every element is subordinate of, and determined by the preconceived and unified whole. Maki's work puts this modernist design paradigm into question while, like Tange's buildings, relying on the vocabulary and structural predisposition of modern architecture.

Parallel with his increasingly detailed and sophisticated designs and responding more intensively to the layered, collage-like quality of the heterogeneous Japanese city, Maki began to pay more attention to the sequential layers of space created by the intricate manipulation of surfaces, a feature also known from traditional architecture and gardens. Building envelopes in Maki's designs have become gradually more detached and, acquiring a certain sign quality, freely manipulated. This is seen best in his Spiral Building (1985) and Tepia Science Pavilion (1989) both in densely built areas of Tokyo.

The Fujisawa Gymnasium on the other hand has no urban areas around to respond to. Therefore Maki here has opted for a design that, while sympathetic with the fragmentary nature of the city, appeals more to the imaginary or primary landscape of the Japanese with references to both contemporary, even futuristic, but at the same time, also traditional images of Japanese culture. The collaged surfaces and forms, in conjunction with the structural configuration, like an elusive surrealist vision, can equally remind one of an ancient samurai warrior helmet, a mask, the wooden gong in Buddhist temples, a giant reptile, a spaceship or UFO, and many others, yet never diminishing the stature and overall magnificence of the design. Only two recent projects of Maki, the Nippon Convention Center (1989) and the Tokyo Metropolitan Gymnasium (1990), reach if not surpass the Fujisawa Gym in this respect. Ultimately, Maki's exceptional achievement lies in the fact, that he has been able to evoke and juxtapose a broad spectrum of experiences and images, while not sacrificing the material substance and tectonic importance of building for mere scenography. And yet, as Maki observed, when seen against the clear sky, with the glittering stainless steel skyline acquiring "an aura like that of the sun during an eclipse, . . . [the] roof loses all material presence," even if temporarily.

—Botond Bognar

Bibliography—

Bognar, Botond, *Contemporary Japanese Architecture: Its Development and Challenge*, New York 1985.
"Fumihiko Maki," special monograph issue of *Space Design* (Tokyo), January 1986.
Woodbridge, Sally, "Urban Helix," in *Progressive Architecture* (New York), April 1986.
"Fumihiko Maki," special monograph issue of *The Japan Architect* (Tokyo), March 1987.
"Maki's Spiral Art Center Wins R. S. Reynolds Award," in *Architecture* (Washington, D.C.), June 1987.
Maki, Fumihiko, *An Aesthetic of Fragmentation*, New York 1988.
Bognar, Botond, *The New Japanese Architecture*, New York 1990.
"Fumihiko Maki," special monograph issue of *The Japan Architect* (Tokyo), August/September 1990.

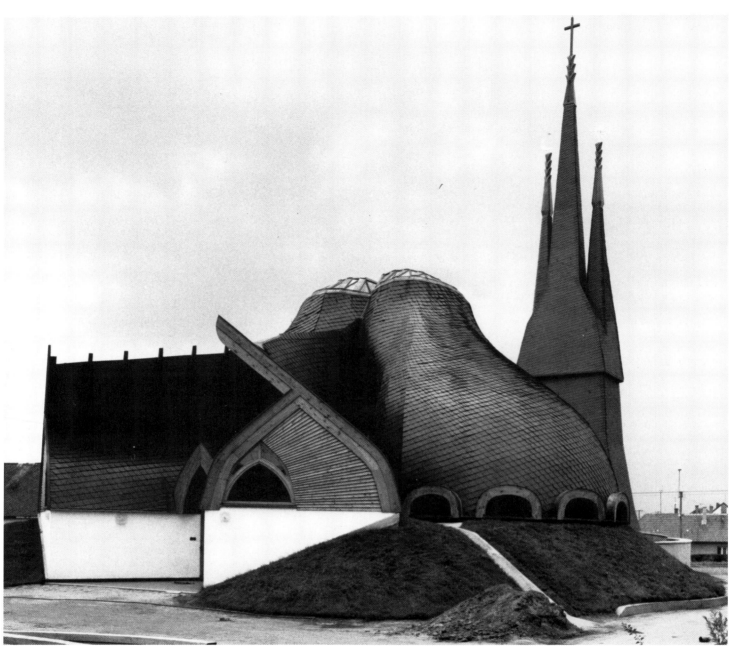

Photos © Botond Bognar

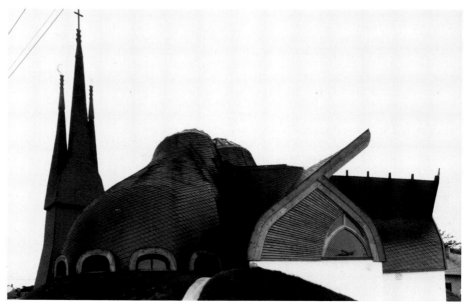

Imre Makovecz (1935–)
Catholic Church, Paks, 1990

In an interview with the Finnish architect Reima Pietila, Makovecz stated: "I would like to create architecture relating human beings to the sky. If we accept that geometry falls between spirit and material, it can also be accepted that architecture can be realized between the heavens and the earth." Such intentions for poetic and spiritual qualities are evidenced in a uniquely powerful way in every work of Makovecz, yet nowhere more appropriately and profoundly than in his two recent buildings, the first churches in his almost three-decade-long career. Both the Protestant Church in Siofok and the Catholic Church in Paks, completed in 1990, were designed for relatively small but basically different towns in the country. Siofok is a popular resort area near Lake Balaton, while Paks is a new industrial town along the Danube and the site of Hungary's first and only nuclear power plant. Considering their diverse circumstances, the designs of the churches, even if sharing Makovecz's unmistakable architectural trademarks, are also significantly different in terms of size, spatial and formal configuration and, perhaps, symbolic qualities as well.

The church in Paks is much larger, more complex and, with regard to its location in the given urban context, is definitely more striking than its counterpart. The building occupies the frontal area of a long, triangular site, in fact an island, sandwiched in between two bifurcating roads, in the outskirts of Paks. The city itself, one of the "new-towns" planned and built during the 1950s and 1960s, displays the typical soulless monotony of such urban developments: the rows after rows of identical concrete blocks of prefabricated housing and other industrially-produced buildings. Although dotted by an assortment of smaller residences, the sururb in question is equally generic, or nondescript at best, lacking any kind of cohesion. Makovecz's design creates a dramatic contrast to and sharp protest against its shallow and trivial environment.

The entire, fully symmetrical complex is defined by softly curving, slate-covered roof surfaces reminiscent of his first highly acclaimed project, the camping facilities in Visegrad (1979). In case of the sanctuary, these roofs form an elongated helmet-like or "twin" dome structure; in case of the belfry, they converge into three spires on top of an elegantly tapered high tower. This belfry, like its Transylvanian predecessors, stands apart and in front of the building, thus also forming a separate ceremonial gateway. Displaying the symbols of the sun and moon in addition to the cross on the steeple, the design reveals a multiplicity of symbolism that harkens back not only to the Christian past, but beyond, also to the pre-Christian, pagan origin of Hungarian culture and civilization. This ancient religious culture, sharing much in common with its Oriental counterparts, was rooted in animism and so extremely rich in mythology. It is therefore not a coincidence that Makovecz's buildings, more often than not, are conceived as some mythical living beings, and the Catholic Church in Paks is no exception. The shaping of the sanctuary with rounded forms, arched windows, elongated spine and opened birdtail-like rear section (or wings?), has plenty of references in this regard.

On the other hand, the plan of the sanctuary and the churchyard behind are designed with the mirrored and repetitive use of the runic sign borrowed from another pre-Christian culture, the Celtic, which flourished in northern and western Europe. The two bifurcating and truncated small wings at the back of the church are, in fact, the beginning of another pair of the curving signs which are then to be continued, according to the plan, in the shapes of the fence around the yard. Also rather conspicuous is the earth work bermed up along the perimeter of the building—another recurring theme in Makovecz's designs—which manifests the unity of the land and architecture; the building like a tree grows out of the living "mother earth."

This metaphor is all the more appropriate, since Makovecz designs and builds primarily in and of wood, and his special feel for this material inscribes much of the fantastic qualities of his work. For him, wood, even in the form of lumber, is always living,

hence so are the buildings; he calls them "building beings." To underscore his interpretation, frequently the structure of the building—wooden columns, branching diagonal braces, etc.—are actually trees in their "original" form. In this church, there are several tree-trunk columns, two also with branches, that support the large and cavernous roofwork with a heart-shaped skylight over the altar.

As the space gradually widens from the narrow main entrance toward the altar area, along and under the spherically curving walls/roofs on both sides, Makovecz has included two separate spaces defined by their own domed roofs and circular rooflights. The incorporation of these additional twin structures of the chapels within the large womb-like space alludes to the idea of "architecture within architecture," or perhaps also of the "conception and birth of architecture." In either case, the dimly-lit interior is suggestive of the inner realm of a living being, approximating the feelings dramatically expressed within his earlier Farkasret Mortuary Chapel in Budapest (1977). The converging wooden "rib-cage" of the roof shell appears to reinforce this impression. The roof here, as always with Makovecz, is shaped along unique but patently tectonic considerations that, in addition, are capable of endowing it with a mythical power. In so doing, the roof-like building stands, both figuratively and symbolically, for a protective shelter.

Makovecz's interpretation of architecture as an organic, living entity, nevertheless, is derived not only from his sympathy for Hungarian mythology and vernacular, or from his background, love and high skill in carpentry; it is also significantly influenced by the American organic architectural movement best represented by Frank Lloyd Wright, Herbert Green, Bruce Goff, etc., and, very importantly, by the philosophies of Karl Jung, Martin Heidegger, as well as the anthroposophy and anthropomorphic architecture of Rudolf Steiner. In turn, Makovecz's unique architecture has, over the years, become very influential in Hungary, forming what is generally known as the Makovecz school of organic architecture.

Nevertheless, despite the excellent work by many of his followers and others with similar intentions, the intensity and depth of his designs have rarely been surpassed, if at all. He, both as an architect and thinker, continues to draw from various sources and combine apparently contrasting thoughts in the most highly original way to shape his own philosophy of nonduality. His holistic architecture reconciles the opposites and aims at holding the world, the earth and the sky, together within and around us. Through his designs he strives, first of all, for initiating and cultivating human communities. While his work has nothing to do with either a cheap and superficial post-modernism, or a simply technologically oriented modernism, as Jonathan Glancey observed, "Makovecz has been able to develop a language of architecture that is at once [mystical or esoteric and so] intensely personal, and yet populist and likeable." The Catholic Church in Paks is a superb "living" testimony to both Makovecz's commitment and success in this regard.

—Botond Bognar

Bibliography—

Glancey, Jonathan, "Imre Makovecz and Corvina Muterem," in *Architectural Review* (London), March 1981.
Bognar, Botond, "The Architecture of Anatomy or the Anatomy of Architecture? Imre Makovecz and the New Wave of Hungarian Architecture," in *Architecture + Urbanism* (Tokyo), March 1984.
Glancey, Jonathan, "Makovecz Embrace," in *Architectural Review* (London), October 1984.
Glancey, Jonathan, "Imre Makovecz," in *World Architecture* (London), no.2, 1989.
"Contemporary Hungarian Architecture," special issue of *Architecture + Urbanism* (Tokyo), March 1990.

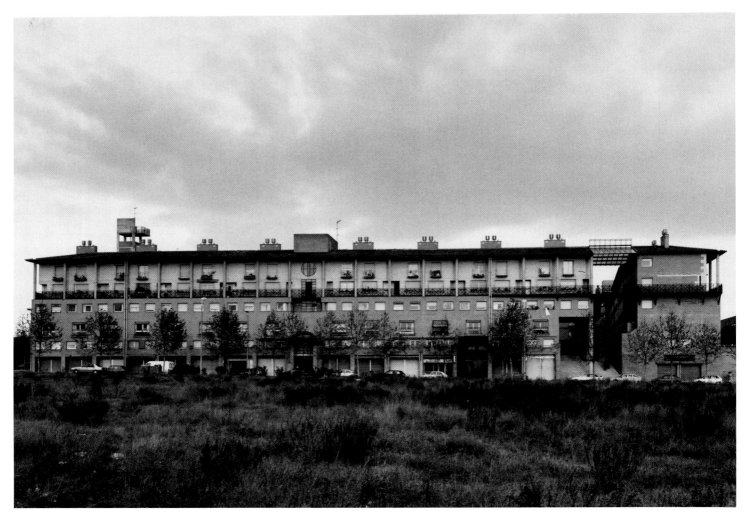

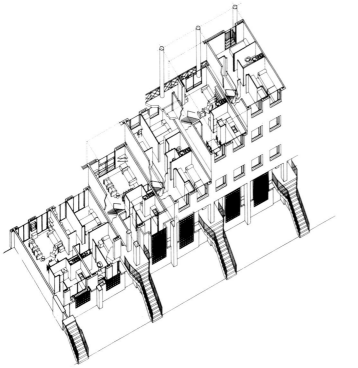

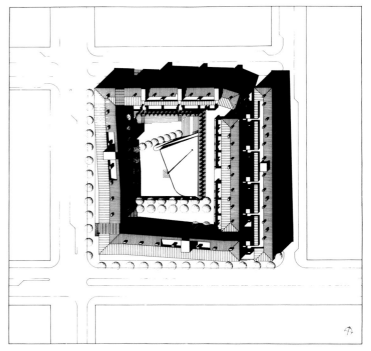

Illustrations courtesy Martorell/Bohigas/Mackay

Martorell/Bohigas/Mackay (1962–)
Housing at Mollet, Barcelona, 1983–87

It is in the field of housing, notably multiple unit group housing that the Barcelona firm Martorell/Bohigas/Mackay (MBM) has made its most substantive contribution to date. From the beginning, with the Manzana Pallars housing of 1959, the essential lines of the firm's approach were apparent. The housing at Mollet, a new centre on the periphery of Barcelona, is a climactic work coming at the height of a series of essays in urban group housing, the most notable being the Manzana Marti l'huma at Sabadell (1979), Sarria (1979), La Manquista (1989), and the Friedrichstadt Housing Unit, Berlin (1981), for the IBA.

Two factors are important in understanding MBM's approach. The first is the traditional pati or patio, which was borrowed from Naples in the 15th century, and Ildefons Cerda's 1859 conception of a city composed of diagonally aligned 133-metre square octagonal blocks having two parallel walls of building on opposite sides, separated by a garden in the centre, this being interlaced by a network of pedestrian pathways.

The pattern of the Mollet housing is ultimately derived from this model. The housing is comprised of four connected blocks on a 100×100 metres base rising five storeys on a sloping site, with openings at each corner for access to the interior multi-level courtyard. The entrances have been given a strong formal presence. On the southeast there are two lines of units back-to-back, bridged by vertical circulation. The Mollet housing consists of 200 units of five types (65–113 square metres) with a double-height unit, with balcony reached by an external gallery capping the southwest facade.

The courtyard is a strong communal space articulated by a pergola and formal rows of ornamental trees. Steps and a diagonal pedestrian ramp lead down to a lower level where cars are allowed limited access. A supermarket was proposed for here, but this is currently used for residents' parking.

The choice of a soft orange brick, tiled roofs, light steel balcony screens, the quiet precision of the window openings, allied with the subtle inward movement of several street facades, is indicative of a more human responsiveness absent from Le Corbusier's Unite d'Habitation, Marseilles. Spanish architects, from Jose Luis Sert on, were quick to adapt Modernism to Catalan necessities. The general appearance of the Mollet housing is Italian more than anything else. In this, it betrays the formative influence on Bohigas of neo-realist Italian cinema. Neo-realism's demonstration of the aesthetic consequences of employing local materials (non-professional actors and shooting on location) was an important lesson at a time when the machine mythology of Modernist ideology was increasingly being questioned.

MBM occupies a critical position among the various competing views on urban design. Consequently, realised works such as the Mollet housing provide a valuable illustration of the implementation of their theory. The architects reject the call for a return to historical building typologies proposed by Aldo Rossi, and insist instead on a city composed of contemporary building types which have been matched to the morphology of the existing city. In the case of the Mollet housing block, this represents an extension of that morphology to new centres outside the existing city. While MBM show a degree of sympathy for Robert Krier's aims they have no desire to return to a typology of strongly defined urban spaces derived from historical prototypes; rather, they seek a return to the city block as the fundamental unit of city form.

The Mollet housing illustrates what happens when Modern architecture is reformed by the incorporation of the kind of human concerns exemplified by Alvar Aalto, who was a leading influence on Grup R, established with the support of Bohigas and Martorell in the early 1950s. Aalto's influence was tempered by MBM's acceptance of Realism as a guiding principle, which meant for them picking up where 'thirties Modernism had left off, expressing the reality of construction details, and, where appropriate, adopting or adapting—depending on the circumstance—traditional methods or structuring spaces.

—Philip Drew

Bibliography—

"Housing Development in Barcelona," in *Bauwelt* (Berlin), 30 April 1982.
Frampton, Kenneth, *Martorell, Bohigas, Mackay: 30 Years of Architecture 1954–1984*, Barcelona 1985.
"Martorell/Bohigas/Mackay," in *El Croquis* (Madrid), July 1988.
"Martorell/Bohigas/Mackay," in *Architecture + Urbanism* (Tokyo), June 1989.

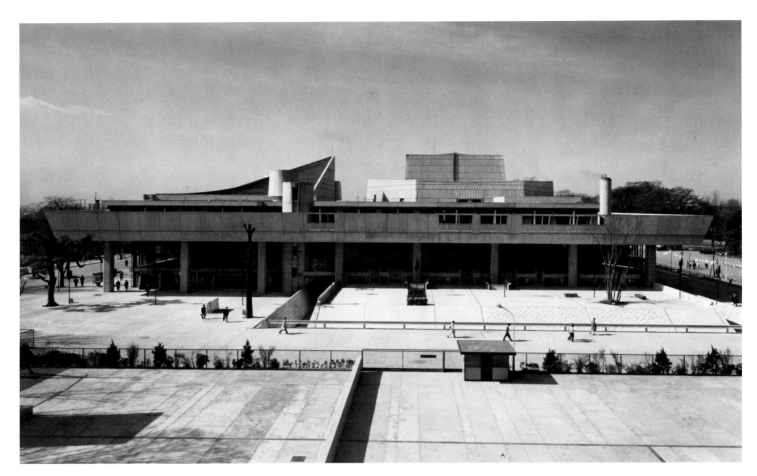

Photo © Botond Bognar

Kunio Mayekawa (1905–86)
Metropolitan Festival Hall, Tokyo, 1960–61

Mayekawa, whose career began in the difficult and controversial times before World War II when a variety of architectural styles and ideologies clashed, was always an advocate of modernism. He worked with Le Corbusier in Paris between 1928 and 1930 before continuing for five years in the Tokyo office of Antonin Raymond, another admirer of the Swiss master's architecture. Although Mayekawa completed a few works of his own before 1945, his architecture began to flourish with the reconstruction of the country and the democratization of the nation that also assured the unobstructed spread and wide acceptance of international modern architecture in Japan.

In the latter part of the 1950s, reinforced concrete structures became very popular in Japan. This still continuing trend owed as much to Le Corbusier's influence on Japanese architects, as to the suitability of such structures to the local conditions of Japan where frequent earthquakes and fires are part of everyday life. Mayekawa, similar to many of his contemporaries, like Kenzo Tange for example, began to use concrete in a unique way, contributing thereby to the evolution of the "New Japan Style" that, by the late 1950s, early 1960s, began to yield such masterpieces as Tange's Kagawa Prefectural Offices in Takamatsu (1958), Junzo Sakakura's Hajima City Hall (1959), Mayekawa's Kyoto Hall (1960), and, especially the Tokyo Metropolitan Festival Hall.

All of these, and many other outstanding architectural pieces of the time, were the direct results of various government programs that intended to foster the civic and cultural infrastructure of the country which, after its reconstruction from war damages, was on its way to economic prosperity. Along with this trend, a sense of national pride was on the rise that also demanded proper expressions; there was a need for new city halls, civic and cultural centers, museums, and so on. As part of this feverish activity, even Le Corbusier, the much admired architect himself, was invited to design the new National Museum of Western Art (1959) in Ueno Park, Tokyo. More significant, however, was the completion of Mayekawa's Metropolitan Festival Hall; it was the first really large scale cultural complex in Tokyo, as well as in Japan, that was designed by a Japanese architect after the war. And Mayekawa deserves all the credit for the lasting success of the building, which is clearly a masterpiece.

The merits of Mayekawa's design is attributable to the fact that he was able to give a new direction and enriched meaning to the prevailing New Japan Style. Previous representatives of this architecture adhered to strictly regulated, rectangular, overly rational and often rather austere designs largely for offices and apartment blocks. The Festival Hall in Tokyo still incorporates a system of post-and-beam structure, notably in the extensive public spaces, lobby, foyer, exhibition hall, etc., but this system here is successfully combined with, and challenged by the high, hexagonal volume of the large auditorium/concert hall, the sloping roof of the small theater, and particularly the large, impressively curving and cantilevered surfaces of the eaves over their supporting trabeated structural skeleton, all shaped in sturdy and unfinished reinforced concrete. With such an articulation and monumental disposition, the huge complex created a bold contrast to Le Corbusier's small and relatively undistinguished Museum nearby.

Owing to the skilfully-applied structural system, various materials, expansive glazing in steel sash, concrete louvers, patterned ceramic tiles on the floor, and the elegantly decorated auditoriums, the interior of the building is as impressive as the exterior dramatic. Yet, shaped with a Japanese sensitivity to details, the overall dynamic composition reveals a sense of balance that has influenced many generations of architects thereafter. The Tokyo Metropolitan Festival Hall remains a magnificent landmark in the course of contemporary Japanese architecture.

—Botond Bognar

Bibliography—

"The Tokyo Metropolitan Festival Hall," in *Progressive Architecture* (New York), April 1965.
Altherr, Alfred, *Three Japanese Architects: Mayekawa, Tange, Sakakura*, Teufen 1968.
Boyd, Robin, *New Directions in Japanese Architecture*, New York 1968.
"Kunio Mayekawa: Sources of Modern Japanese Architecture," special monograph issue of *Process: Architecture* (Tokyo), no. 43, 1984.
Bognar, Botond, *Contemporary Japanese Architecture: Its Development and Challenge*, New York 1985.
Suzuki, H., and Banham, R., *Contemporary Architecture of Japan 1958–1984*, New York 1985.
Stewart, D. B., *The Making of a Modern Japanese Architecture*, Tokyo and New York 1987.

Illustrations courtesy Richard Meier & Partners

Richard Meier (1934–)
Museum fur Kunsthandwerk, Frankfurt-am-Main, 1984

In the past decade many cities in Germany have embarked on a major programme of museum and gallery building. One thinks of Stirling's Staatsgallerie in Stuttgart, of Hollein's Art Gallery in Mönchengladbach, and of other new edifices in Berlin and Munich. This reflects, partly, the wealth of the Bundesrepublik—modern Germany can afford to spend more on such projects than other countries—but it suggests also a deeper desire to revive Germany's standing in world culture, a need to present a new image of the nation. If such a wish exists, then nowhere is it better fulfilled than in Richard Meier's Museum für Kunsthandwerk in Frankfurt, for in its airy harmony and grace this building seems to proclaim a new and enlightened German spirit.

The city's collection of decorative arts was originally housed in the Villa Metzler, an old patrician mansion on the banks of the river Main. The Villa was much liked, but in time it proved too small, and accordingly the Frankfurt authorities invited architects to submit their plans for extending the museum. Most—including prestigious names such as Robert Venturi—envisaged enlarging the Villa Metzler itself, but one, the American Richard Meier, proposed leaving the old building intact and erecting nearby three new pavilions, or villas, linked by geometry and proportion, but otherwise distinct. It was this plan that was adopted and, with a few alterations, built.

Meier is a conscious Modernist who sees himself in the line of Le Corbusier and Mies van der Rohe. Beginning with private houses, and moving on to public buildings, he has developed a highly individual style that combines flat white surfaces, vertical lines and large areas of glass to produce structures unique in their precision and grace. "Fundamentally" he has written, "my meditations are on space, form, light and how to make them." In the Museum für Kunsthandwerk in Frankfurt these meditations have reached a new level of complexity and perfection.

Meier's design is basically L-shaped, with the Villa Metzler forming the fourth element of a square. Within this square there are two tree-filled courtyards; it is through the larger of these that visitors enter the museum. First, they encounter a glazed vestibule; from here wide ramps entice them upwards to the galleries, which are connected to one another by glass-sided walkways. Everywhere there is light and air—the total effect is one of a radiant serenity, an ideal environment for contemplating the museum's collections. Nor are such pleasant conditions confined to the interior of the building: looking through the many windows, or stepping out onto the many balconies, visitors can catch various views of Frankfurt, while around the museum there extends a wooded park where visitors can walk on paths carefully laid out to replicate the geometry of the complex. From the park, too, the subtlety of Meier's design becomes more and more apparent: far from being a simple monolithic white, the exterior surfaces of his building are revealed to be of various textures and planes that catch the light in different ways, so avoiding monotony and glare. As one critic put it, from the outside the Museum für Kunsthandwerk looks—at least in summer—like "a villa immersed in greenery"; few modern public edifices, surely, can have earned such an attractive tribute.

Meier's building does, however, have its drawbacks. Perhaps chief of these is the fact that it needs good weather to appear its best; under the grey skies of Germany it tends to look flat and uninteresting. A lack of light, moreover, in the galleries (it is usual for these to be dimmed, in accordance with modern museum practice) deprives them of much of their elegance, as indeed does the clutter of humidifiers, alarms etc. deemed necessary by today's curators. A preoccupation with light, in other words, can become a liability in northern climes, or in particular environments where illumination must be minimized. It will be interesting to see if and how Meier adjusts his designs to cope with this problem.

Such difficulties, however, do not detract from the overall success of the Museum für Kunsthandwerk. For an architect who is self-confessedly still taken by the poetics of Modernism, by the beauty and utility of technology, Meier has succeeded in creating a uniquely pleasant and graceful building. Would that more architects had his skill and humanity.

—John Terence O'Leary

Bibliography—

Huse, Norbert, *Richard Meier: Museum fur Kunsthandwerk, Frankfurt am Main*, Berlin 1985.
Irace, Fulvio, "Radiant Museum," in *Domus* (Milan), June 1985.
Stephens, Susan, "Frame by Frame," in *Progressive Architecture* (New York), June 1985.
Murray, Peter, "Frankfurt's Carbuncle," in *RIBA Journal* (London), June 1985.
Zardini, Mirko, "Richard Meier and Partners: Museum of Decorative Arts," in *Casabella* (Milan), July/August 1985.
"Richard Meier and Partners: Museum fur Kunsthandwerk," in special monograph issue of *Architecture + Urbanism* (Tokyo), September 1985.
Cook, Peter, "Meier Handwerk," in *Architectural Review* (London), November 1985.
Enomoto, Hiroyuki, "Crafts Museum, Frankfurt," in *Space Design* (Tokyo), February 1986.

Museum für Kunsthandwerk, Frankfurt

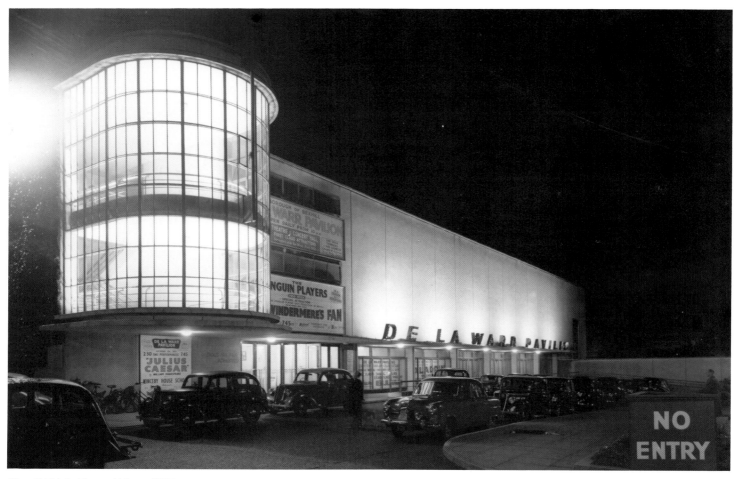

Photo British Architectural Library/RIBA

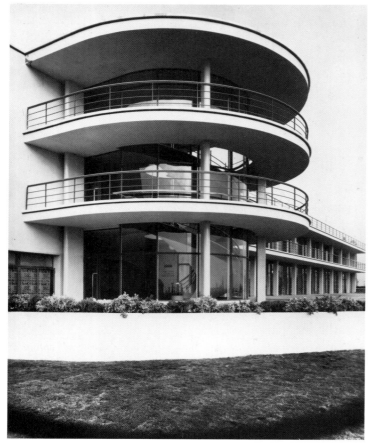

Photos Royal Commission on The Historic Monuments of England

Eric Mendelsohn (1887–1953)/**Serge Chermayeff** (1900–)
De La Warr Pavilion, Bexhill-on-Sea, Sussex, 1935

The De La Warr Pavilion was built in 1935 after the design by architects Erich Mendelsohn and Serge Chermayeff won an open competition run by the Bexhill Town Council in 1934. Upon laying the foundation stone, the Earl De La Warr was heard to proclaim that, "great people leave behind them great memorials to themselves which they have erected in brick and stone." For several reasons this was a particularly inappropriate phrase to employ. Although the pavilion bears the name of the Earl De La Warr it was never intended to stand purely as a memorial to the great and the good; it is, first and foremost, a public building designed to function as such. Furthermore, it is not constructed from stone and brick, but from steel, concrete and glass.

The De La Warr Pavilion was born of a period which saw an enormous growth in the popularity of the seaside among holiday-makers and day-trippers alike. Municipal responsibility for the provision of entertainment and recreational facilities was given priority in many resorts, as the mania for a supposedly healthy indulgence in sun, sea and air took hold on the national conciousness.

When first conceived, the De La Warr Pavilion was to have been part of a greater plan. It was designed as the centrepiece of a development including a cinema and a hotel, an apartment building and a large lido and pier. Although these additions to Bexhill's purpose-built resort facilities were never constructed, the decision to use Mendelsohn and Chermayeff's design was the first move in a plan to turn Bexhill-on-Sea into something other than a sleepy retirement town on the south coast of England.

The project caused controversy before construction had even begun. When the news was announced that the contract for the design of the pavilion was to be awarded to Mendelsohn and Chermayeff, parts of the architectural establishment in Britain were up in arms: not only were the architects not British, they were also prime movers in the generation of a new architectural language on the continent.

On a more positive note, others received the building as "a notable step toward eliminating the usual tawdry Edwardianism of the average English seaside resort." The combination of new materials and construction techniques, together with a complete absence of historical reference points in the form of the building, meant that the design of the Pavilion was held to be radically modern by the standards of Britain in 1935.

Although Chermayeff was Russian and Mendelsohn German, they were not unknown to the world of architecture and design in Britain. Chermayeff had contributed to the interior design of the new headquarters of the BBC in London and to exhibition work for the Design and Industries Association. Mendelsohn, having fled his native Germany upon Hitler's rise to power, arrived in Britain to find his reputation as a modernist preceding him through his design for the Schocken department store in the Chemnitz district of Berlin.

So, whilst not of the reactionary architectural establishment, Mendelsohn and Chermayeff had, nevertheless, garnered a reputation which would allow them to exercise their skills without pandering to notions of architectural style. Instead, their building was to evolve under the impetus of an approach informed by a direct experience of, and involvement in, the construction of modern buildings in Europe.

The Pavilion is, therefore, replete with many of the features which characterise a building derived from the rationalist precepts of the European modernist school of thought the 1930s.

It is the first building in Britain to have been constructed using a frame entirely of welded steel. The engineering skill of Felix Samuely in executing this fundamental element of the structure meant that Mendelsohn and Chermayeff could achieve an open quality in the interior spaces, taking advantage of the absence of clumsy bracing members to create rooms defined by a sparse geometry in keeping with the rational precepts of modernist design.

This open quality is further enhanced by the creation of a free façade within the shelter of the boundaries defined by the sun decks and walkways.

Felix Samuely's welded frame bears the weight of the structure, allowing large areas of glass to be used in the parts of the building which are south-facing. The windows of the restaurant on the ground floor and those of the lounge on the first floor can be slid back to remove the division between interior and exterior and so create an extended and sheltered sun deck and a "continental style pavement café."

The de La Warr Pavilion is a well-designed and well-planned building. In its original configuration the ground floor housed a large auditorium, a restaurant with dance floor which opened onto a terrace, and utilities such as telephones and toilets.

The second floor had a conference hall, library, bar, lounge and sun parlour. Each of the last four amenities gave onto the sun decks and walkways. The interiors also feature well defined spaces and architectural solutions to the problems of use by large numbers of people. In particular, the auditorium caters well for the audience, featuring a sloping floor which is skilfully bordered by raised walkways, ensuring untroubled access to amenities and good, uninterrupted visibility of the stage for all.

Although the building is characterised throughout by a quintessentially modernist approach in plan and execution the Pavilion is not without its own dramatic, architectural flourishes.

The main staircase is one such feature; a gravity-defying helix of steel and concrete, it spirals upward within its thin, glass housing at the centre of the sea-facing façade like a vast, uncoiled spring. It is a dramatic illustration of the freedom from conventional architectural restraints afforded by the modern techniques employed in the construction of the Pavilion.

Mendelsohn and Chermayeff together, brought a particularly European sensibility to the job of designing the building; creating a modernist building of the European mainland on British soil. Like their expatriate European contemporaries, Lubetkin and Gropius, Mendelsohn and Chermayeff created mature modernist architecture in Britain which served as a model for the home grown efforts of, among others, Emberton, Fry, Gibberd and Harding.

As such, the De La Warr pavilion remains an important building. It is as much a testament to an anti-historicist architectural philosophy as a useful and appropriate building which continues to serve many of the purposes for which it was built.

—Michael Horsham

Bibliography—

Kubetkin, Berthold, "Modern Architecture in England," in *American Architect and Architecture* (New York), February 1937.
Behrendt, W. C., *Modern Building*, London 1938.
Yorke, F. R. S., and Penn, C., *A Key to Modern Architecture*, London 1939.
Whittick, Arnold, *Eric Mendelsohn*, London 1940, 1965.
Von Eckhardt, Wolf, *Eric Mendelsohn*, New York and London 1960.
Zevi, Bruno, *Eric Mendelsohn: Opera Completa*, Milan 1970.

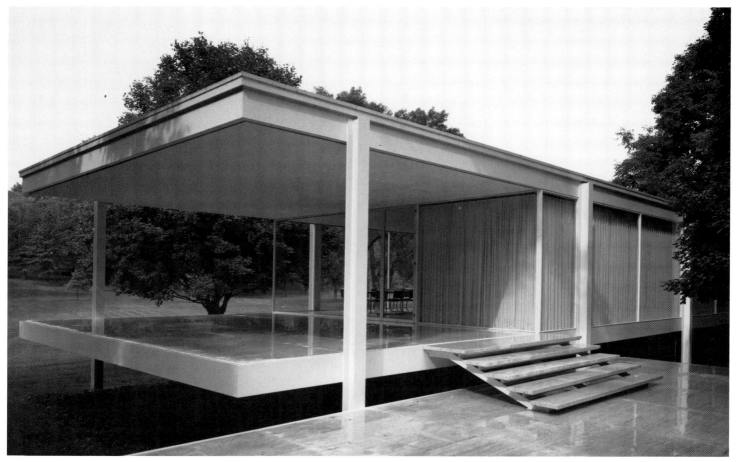

Photo © Scott Frances/Esto

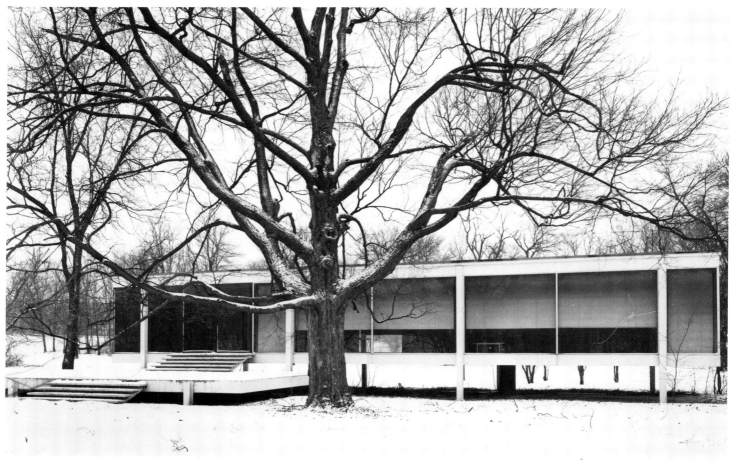

Photo Library of Congress

412

Ludwig Mies van der Rohe (1886–1969)
Farnsworth House, Plano, Illinois, 1945–50

While preparing for an exhibition of his work at the Museum of Modern Art, Mies van der Rohe accepted a commission for a small house which was destined to be the clearest expression of his ideas about space and structure. This was The Farnsworth House (1945–50), which proved to be his most controversial building. The Farnsworth House is a classical design with romantic implications, a work of art that architecturally mediates between nature and man. He came closer to the dematerialization of architecture leading to the expression of a fixed and super-sensible order than in any of his other buildings. As the Barcelona Pavilion was to his European period—so is the Farnsworth House to his American Period: the apotheosis of a world view. He changed from the conditionality of his early years to the objective finality for which he strove as he grew older. The house was unlike any ever conceived before it. It was a totally glassed-in rectangular box, consisting of roof slab and floor slab. The long walls faced north to a gentle grassy rise, south to the wooded riverbank and a patio as wide as the house extended the length of one bay from the west end. The interior was a single space, one room whose major subdivision was provided by a freestanding longitudinal, assymetrically placed core containing kitchen to the north, bathrooms east and west—separated by a utility space and fireplace to the south. The roof and floor slab was cantilevered at both ends so that the vitreous corners of the room were virtually transparent. The minimalism of all aspects of Mies' design can be gathered from this description: his American attitude reflected the treatment of structure and space. His European attitude remained in symmetry and use of materials.

The Farnsworth House at the edge of the Fox River in Plano, Illinois, was planned as a weekend retreat. The house consists of a roof and floor plane supported on eight exposed steel H-columns. It is enclosed by sheets of plate glass which extended from floor to ceiling and from column to columns. Into this enclosed space (55 feet long by 28 feet deep) were placed only two fixed elements. The larger core, the service core, contains the kitchen, two bathrooms, a space for mechanical equipment and a fireplace. By its asymmetrical placement in the space, this core defines areas for dining, living and sleeping; the smaller core, with the wardrobe unit, screens the living room from the sleeping area and vice-versa. Because the site is subjected to periodic flooding, Mies built the house five feet three inches above grade. With this, we realize two results: one that is protection of the living volume from inundation; the second, the poetic effect is a lightness and a sense of space surrounding the house. The space flows under and over as well as through. Our awareness is heightened by the existence of architectural space by cantilevering the roof and floor planes beyond the columns at either end. There is no air conditioning. Cross-ventilation could be encouraged by opening the portal and two windows, located at the base of the east wall and at the other end of the house.

The floor whose surface was laid out in a geometric grid was deep enough to accommodate a coil system for heating as well as all the pipes that served the kitchen, baths and utility space. An element extending upward from the core exhausted the kitchen. Roman travertine was used for all deck and floor areas, and the primavera core was created by German craftsman Karl Freurd in teak. The steel frame, once completed, was sandblasted to guarantee the smoothest surface, then painted white.

The placement of furniture in the Farnsworth House was of architectural significance and importance. Functional and aesthetic requirements were carefully balanced. With sophistication and subtlety, beds, chairs and tables served as counterpoints to the fixed elements, animating the total composition and enhancing the total spatial experience.

Proportions, construction details, finishes and colors were carefully considered. No formula forms the basis for the proportions: they were a response to the materials and methods of fabrication and assembly as they were satisfying to the eye and intellect. The finishes are simple and muted throughout. Everywhere the sensitive and discerning eye of a master craftsman has seen that no element, no detail distracts from the house as an artifact which is integral within its environment.

Dr. Edith Farnsworth (1904–77), a physician and member of Northwestern University's Medical School faculty, purchased a property along the Fox River about 60 minutes west of Chicago near Plano, Illinois. Her ambition to build a weekend country house for herself prompted her to ask the Museum of Modern Art to recommend an architect. It is said her choice of Mies was more than just geographic proximity: her relationship with him was something other than purely professional. The two of them got on at once and famously, and his germinal idea for the design early in 1946 suggested he recognized the commission was as nearly ideal as any he could have hoped for. Intended as a rural retreat for a single woman, it was to be built on a 9.6 acre tract. If Mies arrived rapidly at the concept of the house, he dawdled at its actual construction. Fully two years after the model house was shown in 1947 at the Museum of Modern Art exhibit, the concrete footings were prepared. It was completed in 1951.

The Farnsworth House is unmistakably modern in its abstract geometry. The building reminds some of an eighteenth century pavilion, others of a Shinto shrine. There is obviously an inclination to history and classicism. Certainly the house is more nearly a temple than a dwelling and it rewards aesthetic contemplation before it fulfills domestic problems. Its beauty is immensely persuasive. The chaste geometry of the house and impeccable proportions of its parts are expressive of a human presence held in counterpoint with nature. From within and seen in 360 degrees through transparent walls, nature especially in changes of light and the seasons becomes an integral part of the experience of any and all time spent there.

In the Farnsworth House, Mies was able to liberate the structure as never before. It has stood the test of time and the judgement of history. Its beauty has come to be appreciated because it appeals to the senses, to the intellect and to the spirit. In 1981 as the Farnsworth House received the American Institute of Architects' prestigious "25 Year Award," Reyner Banham, architectural critic and historian, said, "The building has all the virtues . . . of a particular concept of architecture driven to its extreme limits, and therefore, a kind of landmark demonstration of what architecture could do. Like many extreme statements, it was made at the beginning rather than at the end of the period it represents, and it left other architects little to do except to try to make even more perfect that which was already perfected."

—Andrea Kalish Arsenault

Bibliography—

"Farnsworth House," in *Architectural Forum* (New York), October 1951.
Speyer, A. James, and Koeper, Frederick, *Mies van der Rohe*, exhibition catalogue, Chicago 1968.
"Mies' Farnsworth House Wins 25-Year Award," in *AIA Journal* (Washington, DC), March 1981.
Spaeth, David, *Mies van der Rohe*, New York 1985.
Schulze, Franz, *Mies van der Rohe: A Critical Biography*, Chicago 1985.

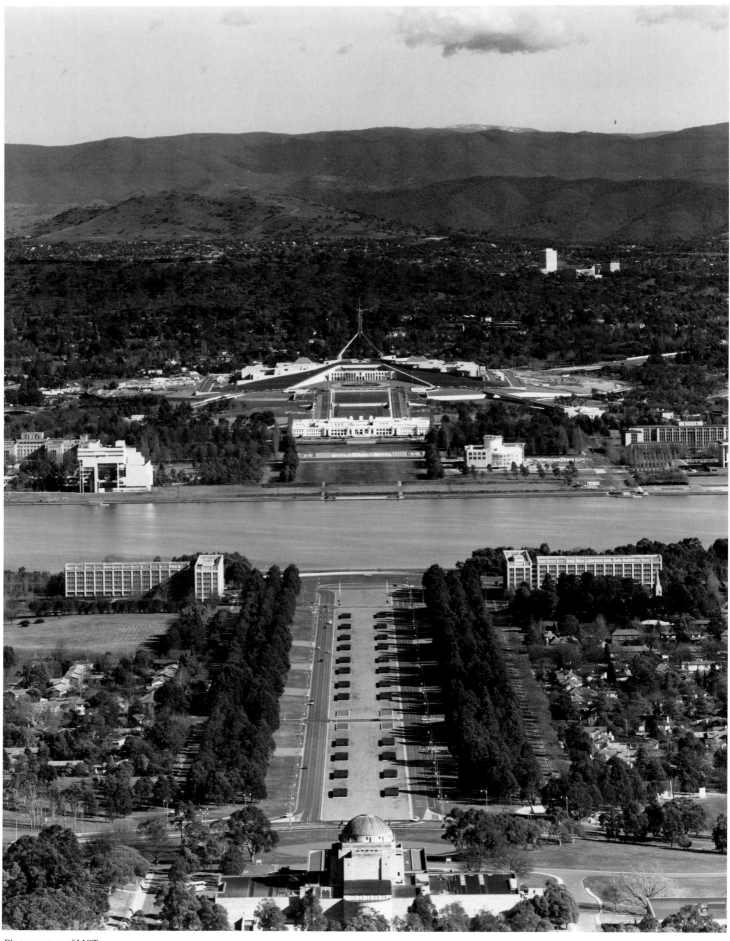

Photo courtesy of MGT

414

Mitchell/Giurgola & Thorp (1958–)
New Parliament House, Canberra, 1980–88

The New Parliament House, Canberra is many things. Not all of them are compatible, and some even conflict. It is foremost a symbol of the Australian nation, but it is also, importantly, a work place for parliamentarians and seat of the Federal Parliament of Australia. It is also a leading tourist attraction.

Any attempt to evaluate its significance and relationship to comparable contemporary architecture must take into account this degree of complexity and apparently mixed messages. The most striking first impression is that of an anti-monumental monument. Part of the Parliament disappears inside a hill, and an 81 metre high stainless steel flag pole and huge flag was added on top of the hill to establish its presence in the Canberra landscape.

The essence of the design, and its most successful aspect, is the subordination of the complex to the landscape. A portion of the building group was covered by a reconstructed hill to recall the original Capitol Hill. This was carried out before building work commenced allowing work to proceed on a level site.

The buildings composing the group together form an imposing Baroque scheme around two opposed axes with two strong super-imposed arcs in the form of thick grey granite-clad walls, serving as references that separate the exposed working sections of the two houses and the members' offices from the hidden symbolic spaces devoted to the public ceremonial areas and to the cabinet areas Prime Minister's suite on the southern terminus of the main axis. The rigidity of this bi-axial scheme is so strongly identified historically with Baroque absolutism that it is difficult to reconcile it with the intention of an open democratic institution devoted to the ideals of representative government. Yet, in an unexpected way, the *parti* resolved the underlying functional relationships of a complex brief by isolating and localising the basic working parts of a bicameral parliamentary institution while giving it a memorable form.

Built at a cost of 1.2 billion Australian dollars and housing 3,500 people when parliament is sitting, the New Parliament House is a veritable city within a city. The capital, Canberra, was the result of

an international competition, and, in both instances, the successful designs came from Americans. Walter Burley Griffin, whose ambitious 1911 scheme for Canberra was never properly implemented, nevertheless, provided the principal urban features and arrangement of a land and water axis related to prominent nearby hills along with a series of round points with radiating streets: rather like L'Enfant's Washington, which Romaldo Giurgola judiciously affirmed in his Parliament House scheme. The two arcs which are such important compositional devices in Giurgola's Parliament first appear on Griffin's competition drawing.

In addition to isolating the ceremonial and public areas from the offices and meeting rooms of the parliamentarians, the monumental curved walls provide a focus for the two parliamentary chambers on either side of the central axis. Throughout the complex, Giurgola placed great emphasis on the design of skylights to filter and redirect sunlight into important spaces such as the Great Hall, Members Hall, and the House of Representatives and Senate chambers. This reveals Giurgola's admiration for Louis Kahn. Giurgola belongs to the Kahnian Philadelphia School, but such things as the northern portico screen facing the Forecourt and Ceremonial Pool, the pop-art symbolism of the flag, belong more to Robert Venturi.

Inside the Parliament, the mood is predominantly one of Scandinavian restraint affected possibly by the Volvo commission with the intrusion of vaguely Art-deco touches in places. Throughout, the emphasis on Australian materials and crafts meant that the decoration has an Australian content and employs Australian materials.

This is a building which could only have been designed by someone who had grown up in Rome and was comfortable with its grandiose scale and magnificent orchestrations of urban space. There is a degree of historical referencing which one has come to expect in the 1980s, yet Giurgola is not a Post-modern designer as such, and his use of the past is respectful and intelligent. Nevertheless, such borrowings as the staircase to the Doge's Palace, Venice, for the Foyer are immediately recognisable, as are Giurgola's repeated allusions to Kahn. Beneath its reconstructed Australian hill, the Parliament building has preserved some the essence of the Roman Baroque, but these elements of the Baroque have been reworked to meet the needs of the late 20th century corporate interior in the U.S.A.

Giurgola has remained an Italian-American architect, as can be seen from the New Australian Parliament House. He is an architect with a sense of history who has never forgotten his roots or the great Roman Baroque traditions. This makes for a strange conjunction of themes in a building which speaks so powerfully and eloquently in its forms of a country emerging into nationhood which has yet to give a final shape to its identity. The metaphor of the partly buried monument, surely a *grottesche* concept, expresses the confusing stage of the half-formed, a liminal stage between two worlds. In this instance, the grotesque form of the Parliament building expresses the condition of Australian identity struggling to be given a final shape. Perhaps there is no better way of picturing Australia than that.

—Philip Drew

Bibliography—

Beck, Haig, *Parliament House Canberra: A Building for the Nation*, Sydney 1988.
"The New Parliament House," in *Architectural Review* (London), October 1988.
"Mitchell Giurgola Architects," special monograph issue of *Process: Architecture* (Tokyo), March 1989.
"Parliament House in Canberra," in *Architecture + Urbanism* (Tokyo), May 1989.
Drew, Philip, "Giurgola in Canberra: Quiet Colossus," in Dean, A. O., ed., *American Architecture of the 1980s*, Washington, D.C. 1990.

Interior of foyer photo John Gollings

416

Jose Rafael Moneo (1937–)
Bankinter bank office building, Madrid, 1972–76

The Bankinter Building in the city of Madrid has influenced a new generation of Spanish architects. They were searching for a language of Modernism after discarding the classical and eclectic vocabulary of the post War era. That earlier vocabulary had continued through the '50s and '60s in Spain. Jose Rafael Moneo, in collaboration with Rameo Bescos, established himself in Madrid and influenced its "school" with the Bankinter design. Moneo's deep understanding of the art and craft of building manifests itself first in the Bankinter and culminates with the design of National Museum of the Roman Art in Merida in 1984.

The Bankinter is situated on Madrid's Paseo de la Castellana, next door to the small nineteenth-century town house of Marques de Tudela which was designed by Alvarez Capra. From its conception, the Bankinter was conditioned by its setting and its specific context. Its restricted size as a low block pays an absolute respect in its planning to the proportion of Capra's existing building. The new building was the first part of the redevelopment process of the Castellana which was achieved without demolishing the existing building. The sharp geometry of the tall wedge-shaped tower, slotted into the lower block, is shaped rather like an arrow. It points toward the entrance shared by both buildings on Calle del Marques del Riscal. The horizontal plane is covered by granite paving slabs. It underlines the distance between the two buildings so that both of them appear on the grid as autonomous objects. The classical role of architecture, which serves as the foundation to integrate other arts, is realized in the Bankinter by incorporating the work of both a sculptor and a painter. Francisco Lopez Hernandez created of the relief on the facade and the painter, Pablo Palazuelo, executed the plaster work in the entrance hall. In the words of the architect himself, this collaborative attempt with other artists along with the eagerness to achieve correct proportion—an attribute of the classic architecture—arises from the desire for perfection.

In the context of the mid-seventies, the elements of the Bankinter design was judged as the beginning of the emergence of post-modernism on the architectural scene in Spain. Considering the dominant and reductive historicist quotations in the so-called postmodern buildings, the Bankinter, in its deeper rapport with the dialectical relation between history and tradition, manifests sensibilities other than historicism. The Bankinter should be seen as a reaction to the eclecticism, neoclassicism, and the reactionary nostalgia of the Franco's era.

Rafael Moneo was a pupil of the most influential master and professor of architecture, Francisco Javier Saenz de Oiza, who was the mentor of many younger generations of architects active on the architectural scene today in Spain. Having learned from the master and his cultural concern with Zeitgeist, Moneo goes further than his mentor. From his conception of historical consciousness and his ability to abstract from tradition the motifs that arose from different sources and precedents, he created buildings which are modern and historicist at the same time. Moneo's skill arises from his deep understanding and research on the question of typology and architecture as both an artifact and an autonomous discipline. This study enables him to critically distance himself from the naive and reductive imitation of the ready-made historical form. Nevertheless, Moneo places no importance on architectural typological studies when working out the ideas for a given design. He believes that all of the hypotheses that are derived from the forms of modern architecture are, in fact, forms of nostalgia. A Spanish architect, he wants to solve the problems of each individual work by developing its own original expression. He decides to lay bricks densely in the exterior walls of the Bankinter building in order to express the deep structure of the idea of a wall in the act of being built.

In both the town hall in Logrono, on which he worked between 1973 and 1981, and in Bankinter building, Moneo develops his technique of assemblage. His technique aims to incorporate, if not integrate, contradictories: standard forms and exceptions, non-geometrical and geometrical forms clearly interrelated in the over-all structures. At the Bankinter Building, an unfocused wall covered in red bricks is used in the dried, high, elegant architectural volume. The wall articulates the structure which is arranged quite freely throughout the entire site. He carries the same technique to the wall of Merida Museum in order to express the true continuity and metaphorical relationship to the remaining structure of the ancient Agusta Emerica Theatre. The special identity of the various works of the Madrid architect Rafael Moneo is established by the joy in the application of the images arising from the diverse results of modern architecture. Walls, vivid with the texture of brick, expansive and finished in stone, have openings with silent expressions, but these all seem to be subordinated to the main aim of clarifying the thickness and the delicacy of the wall structures. These wall surfaces are produced by an ascetic expressive technique which suggest an architectural presence that aims to open up an original historical development. Moreover, he incorporates architectural techniques similar to those of many classical monuments which characterize the special qualities of traditional Spanish architecture. Thus, his work suggests the vibrant cultural qualities which are the result of the typological studies in the dialectical relationship between history and tradition. This gives a unique quality to Moneo's buildings: they are modern and traditional at the same time. They are powerful because they evoke in the observers the sense of memory and recollection of the traces of the culture of the forgotten past.

Moneo developes both architectural images and the system of architectural structures rooted in the craft of building which constitute the essence of his work. This essence is supported by that special wisdom rooted in the rich culture of the architectural traditions of the Iberian Peninsula along with the principles of modern architecture. Moneo himself poetically called this essence as "The solitude of the building."

—Nadir Lahiji

Bibliography—

Capitel, Anton, and others, "The Work of Rafael Moneo," in special monograph issue of *Arquitectura* (Madrid), May/June 1982.
Ruiz Muniz, Baudillo A., "Notes on Spanish Architecture of the 20th Century," in *Process: Architecture* (Pittsburgh), April 1985.
Buchanan, Peter, "Spain: Poetics of Modernism," in *Architectural Review* (London), May 1986.
"Rafael Moneo," in *Progressive Architecture* (New York), June 1986.
"Bankinter, Madrid (1975–77)," in *Abitare* (Milan), July/August 1986.
Moneo, Rafael, "The Solitude of Building," in *Architecture + Urbanism* (Tokyo), August 1989.

Photo © Norman McGrath 1978

418

Charles Moore (1925–)
Piazza d'Italia, New Orleans, 1975–79

"The manner in which the world of appearances imposes itself upon us, and the manner in which we try to impose on the outside world our own interpretation—that is the drama of our lives." Charles Moore's masterpiece, the Piazza d'Italia in New Orleans is the quintessential stage for this post-Gidean play. The idea behind the Piazza d'Italia, as the idea behind Gide's *The Counterfeiters*, is based upon the premise that people are the sum total of their social roles.

The idea of social role itself, as the psychologist Sarbin has pointed out, is ambiguous and contradictory. There is embedded in it the notion or role playing, something to be taken on or off as the circumstances and context seem to demand. There is also embedded in the concept of social role the idea of role taking, where the self, an entity which transcends social role, becomes involved in the actor's performances. The Piazza d'Italia, like Gide's, Wilde's, Mann's, Eliot's or Conrad's anti-heroes, is a stranger to the idea of an authentic self, to the concept of role taking. There is only play at the Piazza d'Italia, there is no self, the self has been bombed to oblivion, annihilated, incinerated, incarcerated, *vernichtet*. This stage is a post-existentialist, soft-core post-punk composition; on it are played out the random scraps of ancient plays. The texts and sets of these plays were exhumed after the psychological cataclysm of the annihilation of the Idea of a Fixed Human Personality.

If the boot fits, put it on: if this is not the Piazza d'Italia's motto, it ought to be. The boot of Italy is outlined as the "Island" of the fountain. Moore's name is inscribed on "Sicily" (approximately at Palermo). The ghosts of dead Italian architectures *bricolaged* into a mask of the *Fontana di Trevi*—Three Coins in the Fountain.

Although in the Piazza d'Italia Moore takes the architecture of the satirical put-on perhaps further than any contemporary architect, shamelessly insulting The Italians, Italian Culture, New Orleans Italians, the Client, user, architectural critic, historian, and the profession of architecture in turn—it has at least to be admitted that he has been and remains his own primary client, user, historian, critic, and *connoisseur* audience. After all, it is two copies of his own personal mask that adorn the frieze above this transitional and ambiguous form between sculpture and architecture, fountain and square, monument and charade.

There is a special ambiguity in the staged self-revelation of these masks: an *ambiguity* that *is not inertly suggestive but actively insinuating*, but nevertheless still delicious, voluptuous fun. It is after all, of course, "mere play," role playing, playful, a hoax. There is no self: only a mask, a name, a role.

Thus, the truly black humor of this stage-set is always first and foremost directed at Moore himself. If the mask is earnest, it is because the satirical put-on hurts, and if he fears to smile at his own jokes, it is because it is his own lips that are chapped. It is the courage to laugh at himself that makes his work both redemptive and artistic. As we gaze on the staged publicity photos of the "perfect" not-yet-decayed Piazza d'Italia, "as designed," we confront, we witness, we are confronted by a mis-en-scène for an allegory, a masque, with the theme: "The courage of self-destruction."

I have put my genius into my life; I have only put my talent into my works. It is as if this external "work" were but Bunburying, but putting on the Johns, a preparatory exercise to the really serious put-on of his only truly worthy opponent: himself. But Piazza d'Italia rises above the merely vulgar in that both the confidence man and the John know and enjoy the masque, the charade. One can certainly not accuse Moore of the public scandal of washing his clean linen in public.

But, as Mishima showed, self destruction is redemptive and artistic only as a public act. The Piazza d'Italia is a self-narrative, a "novel" of "self expression" staged unto a physical public theater.

In the Piazza d'Italia, Moore's work reaches if not its culmination then its catharsis in a supreme moment of autoerotic suicide in a carefully staged, lit, produced and rehearsed, a superbly put on auto-da-fé.

Piazza d'Italia: New Orleans at the boot of Italy, Moore at the above-ground burial, among the ragazzi of the Italian internment-clubs of New Orleans. Moore, after the careful study of faux-marble, of historicist farce-façade, of paint and makeup, sets the stage for the tragedy of the Man Without Qualities: the man who is bereft of self and for whom only role remains. The self revealed as make-up, as so much face powder, as a Garbo-Camille with a heart of gold. In creating the Piazza d'Italia Moore had the courage and the talent to show us our own forbidden colors and thereby to bring The Moment to its crisis.

The Piazza d'Italia turns out to have been an instant monument: it decayed and became a compost-pile of itself the very instant that it was "finished." The "Mediterranean Sea" is now a pale-yellow marsh-water puddle. The boot of italy is shattered into marble shards, little pieces. The Mississippi groundwater is seeping up and reclaiming The Plaza; Death in Venice. The neon lights are broken. The fountains spew no more. One can debate endlessly about the "intention" to create a ruin; nevertheless the justice behind the end of the Piazza is as poetic as it is playful.

In justice, Moore's ironic, cynical and satirical "self-revelation" is elevated into high art through this willing submission to the reality of decay. Here, in his supreme moment as public architect, Moore dared to be less: he touched The City lightly, and like a delicate banana blossom it was touched, and having materialized, and having been touched, the bloom is now quite gone. But a mask remains. As he touched The City, he touched us at the center of our role-determined social reality: he showed with a special puckish playfulness that, in truth, we live in an age of surfaces.

We walk about the ruins of the Piazza d'Italia, and we realize that The Bomb has already gone off. We are but spirits inhabiting a barren land wiped clean and free by a plague of our own making, by a past no longer available for redemption: He reveals "the truth of masks."

When I was last at the Piazza d'Italia I watched: as the architectural students set up their medium format cameras on the tripods, a schizophrenic vagrant, a burnt-out case, carefully wadded up some newspapers and set a fire under himself. Was this Moore, bereft of the funerary mask of himself, gazing over his left shoulder?

The special power of a swift satirical put-on like this is that it is able to expose the underside of reality by holding a mirror firmly and brutally to our feet. Though in these liberated times the home does seem to be the proper sphere for the man, the mock-epic of the Piazza d'Italia liberates the long-buried and chained Father long enough to give him space to pick his head above the muck for the moment, and scarf just one or two of the remaining, though contaminated, cucumber sandwiches. Finding a boot that fits: that is the stage for the drama of *our* lives.

—Joseph B. Juhasz

Bibliography—

Allen, Gerald, *Charles Moore*, New York 1980, St. Albans, Hertfordshire 1981.
Futagawa, Yukio, "Charles W. Moore," in *Architecture + Urbanism* (Tokyo), January 1978.
"The Work of Charles W. Moore," special monograph issue of *Architecture + Urbanism* (Tokyo), May 1978.
"Charles Moore: Recent Projects," in *Architectural Review* (London), August 1981.

Photo British Architectural Library/RIBA

Pier Luigi Nervi (1891–1979)/ **Marcello Piacentini** (1881–1960)
Palazzo dello Sport, Rome, 1958–60

In preparing for the great sporting festival of the Olympic Games of 1960, in Rome, the city authorities turned to Pier Luigi Nervi to create three of its most important venues. Crucial among these was the Palazzo dello Sport, a multi-purpose, indoor sports arena, to seat up to 16,000 people.

Built between 1958 and 1960, the Palazzo was the last of the three Nervi buildings to be completed, the other two being the Palazzetto dello Sport, a smaller, and structurally-simpler companion to the Palazzo, and the Stadio Flaminio, the major outdoor venue for the Games. Interestingly enough, Nervi worked with a different collaborator on each of the buildings. In the case of the Palazzo, Nervi was solely responsible for the civil engineering design, but worked with his fellow-Italian, Piacentini, on the planning elements of the work.

Any architect, at least any architect possessed of sensitivity and imagination, commissioned to design buildings in the Eternal City, must feel the weight of history on his or her shoulders. How much more so for the architects involved in the preparations for the Olympic Games, with their conscious foundation in the cultural traditions of the classical era. The Palazzo dello Sport, then, had both to meet the practical requirements of its immediate and future users (more than simple utilitarianism, a suitable housing for the grandiloquence of Olympic ceremony would be required), and also to stand within the unique architectural and cultural context of Rome itself.

Here we encounter perhaps the prime dichotomy in understanding the Palazzo as an architectural showpiece. Nervi's whole career and practice stands by his stated philosophy: "In examining the designs . . . or in selecting and adapting the technically best conception, I have never allowed my objectivity and clarity of judgement to be clouded by any preconceived aesthetic or cultural thesis or by recollection of the solution of similar problems found by others or by myself." (From Nervi's introduction to his autobiography.) Taken at face value, this statement asks us to believe that Nervi was able to stand in the full face of history, and indeed of the forceful ideological pressures exerted by his peers, and to create buildings solely in answer to the structural and utilitarian requirements of each commission.

Can we accept this without qualification? Perhaps we must not. Nervi, in the Palazzo dello Sport, created a building which slips, hand into glove, into the historical context of Roman architecture.

Nonetheless, it would be wrong to dwell overlong on the links between the Palazzo and its historical context. Nervi indeed created a building with a sense of place, an adornment for an already rich architectural environment. However, it is more important, by far, to consider the context within which Nervi worked in the twentieth century. Gregotti, influential editor of *Casabella*, in his book *New Directions in Italian Architecture* (1968) was able to say of Nervi: "The rigorous continuity of his buildings seems to evade history." Nervi, first and foremost, was a Structuralist, and a powerful innovator. The Palazzo dello Sport is an assured, practical and elegant answer to the needs of the site, and the requirements of the commission. The use of concrete and steel, which is characteristic of Nervi's style, transmutes mundane engineering into high art.

As an indoor sporting venue, the Palazzo had clearly identifiable requirements: ease of ingress and egress for many people in short periods, good pedestrian traffic flow within the building, clear lines of sight to the event floor from all seats, with good sound transmission, practical provision of the necessary services, and overall, especially internally, a sense of place appropriate to the building's role as a focus for the attention of the world. All these things Nervi succeeded in providing: wide, open concourses; plentiful entranceways; excellent lines of sight. Still more was achieved, since by use of his innovative structural and building techniques, the Palazzo was created as an economically efficient entity, with admirable speed of construction. The building was completed in 13 months (10 weeks for the dome) at the cost, for the structural elements, of £350,000 (1960s value).

Nervi's influence and ideas are seen most purely in the structural solution for the building. The domed roof of the building is its most striking feature, externally and internally. Constructed using a series of 144 pre-cast radial concrete ribs, joined by the pouring of concrete in situ to form secondary ribs between each of the pre-cast sections, the dome has a diameter of 100 metres. The static strength of the ribs gives resistance to external forces, in addition to the provision of a roof membrane in the same structure. Whereas in the Palazzetto dello Sport the structural elements bearing the thrust of the dome are externally expressed, those for the Palazzo are hidden within the galleries forming the concourses outside the main arena. Some critics have seen this as a weakness in the overall composition of the design, since the structural purity of the building is to some extent compromised by the external "dressing up" of galleries and colonnade forming a drum to the striking dome of the roof. For all its invisibility to the outside observer, the supporting structure to the dome is nonetheless a masterful effect, and the full force of this is apparent inside the building. Fan-shaped buttresses carry the thrust of the dome outwards to meet inclined pillars, which transmit the thrust on down to the foundations, passing through the concourse galleries around the arena. The inclined pillars form a magnificent effect, their tapering and twisting shape establishing a marvellous rhythm through the gallery area.

The arena itself is formed of three tiers of seats, the topmost of which also offers a striking example of Nervi's structural creativeness. This tier is supported on a sort of dome-turned-inside-out: a circular half-vault, constituted of pre-cast concrete sections, again joined by concrete poured in place, to form a base for the seating, a partial roofing for the main gallery, and a floor for the upper gallery. Seen from the main gallery, the honeycomb-like undersurface of the structure is one of the most impressive features of the building.

All this then provides clear illustration of the assessment of Huxtable, who in her 1960 work on the career of Nervi wrote: "His work is concerned primarily with the search for correct structural solutions for utilitarian problems . . . His best buildings are directly functional, and achieve their decorative and sculptural qualities as a natural by-product of their techniques."

Some critics regard the building as less than Nervi's masterpiece, since the external treatment covers the purity of the structure. Gregotti would have us look right back to the hangar which Nervi designed at Orbetello in 1936 for a quintessential oeuvre. However, on balance, the Palazzo dello Sport is exemplary of Nervi at his best; an engineering and architectural solution to a unique set of requirements, which achieves elegance and beauty through clarity of form and fitness for purpose. The interior arena space, under its stunning dome, is quite simply a tour-de-force. One reviewer at the time of construction provides us with a bold statement to consider in conclusion: "In a country of great and inspired designers the greatest is undoubtedly Pier Luigi Nervi," and, speaking of the Palazzo dello Sport: ". . . perhaps Nervi's greatest building to date . . ."

—Andrew Parker

Bibliography—

Huxtable, Ada Louise, *Pier Luigi Nervi*, New York 1960.
Nervi, Pier Luigi, *New Structures*, Milan and London 1963.
Nervi, Pier Luigi, *Aesthetics and Technology in Building*, London and Cambridge, Massachusetts 1966.
Major, Mate, *Pier Luigi Nervi*, Budapest 1966, Berlin 1970.
Gregotti, Vittorio, *New Directions in Italian Architecture*, London 1968, New York 1969.
Pica, Agnoldomenico, *Pier Luigi Nervi*, Rome 1969.
Tafuri, Manfredo, *History of Italian Architecture 1944–1985*, Cambridge, Massachusetts 1989.

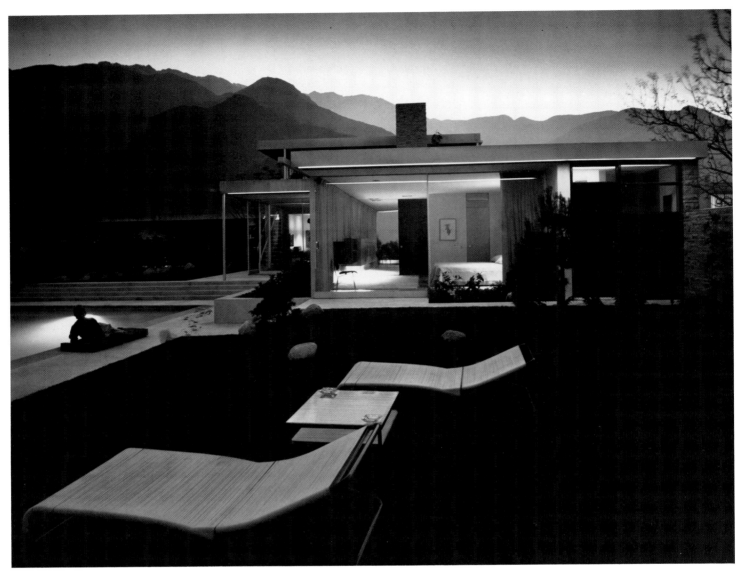

Photo © Julius Shulman

Richard Neutra (1892–1970)
Kaufmann House ("Desert House"), Palm Springs, California, 1946

Like a Bedouin tent, Richard Neutra's 1946 house for Edgar Kaufmann becomes a piece of its surroundings even as it sits apart from them. With his design for this thoroughly modern vacation home, Neutra charted his own course between the two prevailing winds of contemporary architecture, helping to create a new regional identity at the same time. Rather than follow in the footsteps of his one-time mentor, Frank Lloyd Wright (who designed his masterpiece Falling Water for the same client), Neutra made little attempt to blend this residence into its stark desert setting. However, neither did he opt for the strict International Style approach that he had favored earlier in his career. Instead, Neutra blended the sleek, reflective materials of the internationalists with a vigorous, Wrightian plan to create, in the words of his biographer Thomas Hines, "a manmade pavillion for encountering, inhabiting, and observing the desert."

Born and raised in Vienna, Neutra learned his modernist lessons from the buildings of Otto Wagner and Adolf Loos, in whose studio he had trained. Loos's arguments against the use of ornament clearly found a receptive student in Neutra, who later termed ornamentation a waste of money dictated by the whims of fashion. He emigrated to the United States in 1923 and, following an apprenticeship under Wright at his Wisconsin studio and school, Taliesin, made his way to Southern California, where he soon made his mark. His 1929 "Health" house for fitness enthusiast Philip Lovell was not only the first completely steel-framed residence in the country, but also—after his Jardinette apartment house—the first mature example of the International Style in the U.S.

Over the years, Neutra's approach shifted from pure internationalism to an adaptation that became known as "California modern." Though not organic in the Frank Lloyd Wright sense of the term, practitioners of this school did try to reach out to their temperate surroundings through the use of expansive wings, decks and overhangs. They were conversant with the "less is more" doctrine, but prefered a more humanistic approach to domestic architecture than that of such purists as Philip Johnson, whose 1949 glass house in New Canaan, Conn., became a touchstone of the International Style's cool aesthetic.

The 3,800-square-foot plan of the Kaufmann house illustrates the hybrid nature of the California school. Its pinwheel design incorporates four wings which spin out from a central core into the desert, in much the same way as Wright's Robie House reached out to the prairie. Neutra combined this dynamic scheme with a limited palette of materials (glass, steel, aluminum, stucco, and sandstone) to create light-filled interiors with no apparent boundaries. Indeed, glass walls retract in the living room and master bedroom leaving only their floor and ceiling tracks to define these rooms' perimeters. The flat slabs of the roofline accentuate this ambiguity between the definitions of "inside" and "outside" as they reach beyond the outline of the interior floorplan to meet supporting steel columns at their corners.

In the back of the house, where the dining area and gallery overlook a patio connecting the main building to guest quarters, crisp International Style attention to material takes precedence.

Here, fixed floor-to-ceiling glass panels are evenly spaced with thin vertical aluminum framing members. The resulting arcade-like rhythm underlines the building's horizontal emphasis and adds a classical restraint to the design as a whole.

Indeed, love of materials and technology remained one of the major links between Neutra and other internationalists. Material becomes the ornament in the Kaufmann house, providing the contrast and definition for which earlier architects turned to the ancients' orders. White stucco outlines the plane at which building meets sky. Slender steel supports and aluminum framing members create a wall out of glass and air. As a counterpoint, a monumental chimney of rough-textured sandstone rises above a semi-enclosed roof deck, becoming the tack which holds this airy structure to the roof, and the house itself to the desert.

This roof-deck, which Neutra termed a "gloriette," is a sort of minimalist version of a French "folie." Local building codes forbade two-storey houses, so Neutra only partially enclosed the structure using louvered aluminum panels. However, the inclusion of ceiling fans and a fireplace makes this a comfortable entertaining space and a wonderful vantage point for appreciating the spectacular desert landscape. The adjustable louvers of the gloriette and the radiant heating and cooling systems employed by Neutra throughout his design for the Kaufmanns represented a state-of-the-art approach to climate control at the time. Not only a demonstration of the architect's familiarity with contemporary technology, these amenities were also expressions of his attention to client comfort, another area the internationalists often overlooked.

Neither truly Wrightian nor truly internationalist, the Kaufmann house combines aspects of these two most influential schools of contemporary architectural thought. This dualism creates a unique relationship between house and site: the manmade materials obviously separate the structure from the desert setting, but once there, they do react to that setting's changes. Neutra himself noted the two roles of the Kaufmann house, as both observer and participant in its unique surroundings, writing "While not grown or rooted there, the building nevertheless fuses with its setting, partakes in its events, emphasizes its character." In addition, although Neutra never attempted to create a program for affordable housing, as did Wright with his Usonian projects, the success of the former Austrian in meeting the singularly American needs of Southern California homeowners went on to become a model for developers throughout that region.

—Charles Ross

Bibliography—

Boesiger, Willy, ed., *Richard Neutra: Buildings and Projects*, 3 vols., Zurich, London and New York 1951–66.
Spade, Rupert, *Richard Neutra*, London 1971.
Drexler, Arthur, and Hines, Thomas, *The Architecture of Richard Neutra: From International Style to California Modern*, New York 1982.
Hines, Thomas, *Richard Neutra and the Search for Modern Architecture*, Oxford 1982.

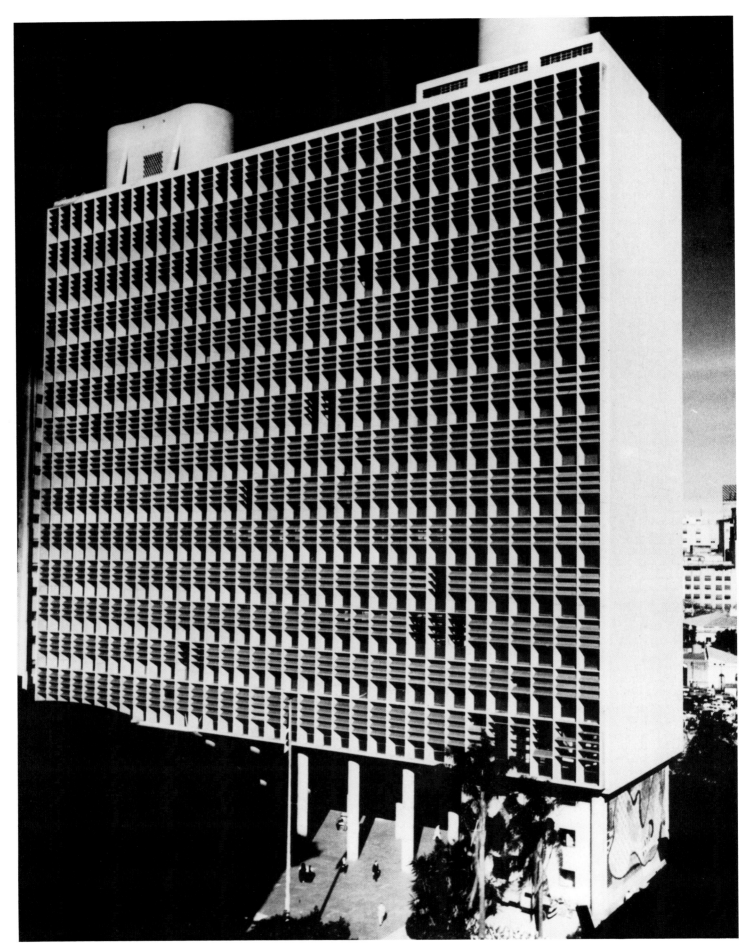

Photo British Architectural Library/RIBA

424

Oscar Niemeyer (1907)/**Lucio Costa** (1902–)
Ministry of Education and Health Building, Rio de Janeiro, 1937–43

The *Ministry of Education and Health Building* in Rio de Janeiro (1936–1943) was the first monumental public structure in the style of Corbusian modernism to be officially sanctioned and erected in Brazil.

Commissioned by the reform-minded Minister of Education, Gustavo Capanema, the building is the complex product of a fruitful artistic and technical collaboration between Le Corbusier and a talented team of young Brazilian architects and artists headed by Lúcio Costa and Oscar Niemeyer. Dissatisfied with the academic- and historicist-style entries selected in a design competition sponsored in 1935, Capanema, who presided over the jury, paid the winners their cash prizes and called on Costa (who had submitted a disqualified project) to come up with a new, more modernist solution that would move Brazil forward into the mainstream of modern European architecture. Capanema's arbitrary action, though initially creating an outrage, was gradually accepted in part because of the increasing public recognition that Costa, who had initiated the curricular reform of Rio's Escola de Belas Artes in 1930–31, was the undisputed leader of the new generation of Brazilian architects. In an apparent effort to minimize the perception of the arbitrariness of his decisions and to "democratize" the design process, Capanema called on three other architects who had submitted disqualified modernist projects— Carlos Leão, Affonso Reidy, and Jorge Moreira—to participate with Costa in elaborating a new design. A team composed of the best young Brazilian architects, it was felt, would result in a better, more broadly-based Brazilian work. To this group of four would be added two others: Ernani Vasconcellos, whose inclusion was insisted upon by his usual collaborator Moreira, and the energetic and ambitious Oscar Niemeyer who, determined not to be left out, imposed his own participation on his colleagues by calling attention to his work as Costa's chief draftsman. This definitive design team, formed in early 1936, was a highly homogeneous group: all were students of the reformed fine arts academy, and all were committed to the functionalist principles of Le Corbusier.

The team's commitment to Corbusian doctrine was reinforced by the intimate personal contact with the European master that occurred during his six-week stay in Rio beginning in July 1936. Invited to consult on the Ministry project and a plan for a *Cidade Universitária*, Corb delivered a series of conferences and soon assumed leadership over the initial planning for the Ministry. The evolution of the design and the form of the building as it was executed, however, illustrate that the Brazilian team went well beyond Corb's tutelage to create their own richer, more characteristically Brazilian masterpiece, one that would advertise the progress of Brazilian modernism internationally.

Le Corbusier's contribution, most strongly felt in the early stages of the design, consisted in moving the Brazilians away from certain academic tendencies that characterized early Brazilian functionalism. Rejecting their preference for symmetrical dispositions and absolute regularity of masses, Corb proposed a more plastic solution that called for a sweeping, horizontal mono-block instead of the beaux-arts U-form composition they preferred. Building upon Corb's innovation but rejecting his suggestion of a waterfront site for the building, the Brazilian team elaborated their design from Corb's second project, one with an asymmetrical disposition of masses that was nonetheless sensitive to the surrounding street pattern of the chosen center-city lot. From this, the team worked out a number of important adaptations that resulted most importantly in an emphasis on the vertical character of the building and its adaptability to the local climate. The Brazilian variant of Corb's "fixed" *brise-soleil* (sun-breaker), a concrete grid proposed for the facades of a 1933 Algiers project, was the horizontal *quebra-sol*, a system of moveable louvers that could be adjusted for increased luminosity in accordance with the changing angle of the sun. The application of the *quebra sol* system across the entire facade resulted in greater balance between horizontal elements and the verticality of the block and, more importantly, in an increased plastic effect, and greater unity, proportion, and formal purity.

Corb's original proposal for a composition of three distinct volumes—the principal office block, the exposition block (perpendicular to the main block), and the conference salon (across from the exposition salon)—was carefully modified by the Brazilian design team into two continuous perpendicular volumes. This new arrangement, achieved by placing the exposition and conference salons on the same axis, resulted in a more unified composition. The main block and exposition wing thus intersect at the conference salon, which was not constructed on pilotis but directly on the ground floor. The height of the conference chamber demanded that the pilotis of the main block be increased in height from the original four meters to ten if the intersection of the two wings was to be visually and volumetrically congruous. The team's handling of the height and structural details of their own, more slender pilotis led to an effect very different from that intended by Corb. In the exposition wing, the pilotis were moved outward from the body of the structure and conceived as columns that supported their superstructure with small consoles or brackets of reinforced concrete. The result was the new sense of daring structural lightness that is often associated with the work of Oscar Niemeyer, who was probably also behind the suggestion that the pilotis of the main block be heightened. In 1940, Costa left the direction of the team to Niemeyer, whose impact on the plastic conception of the ensemble was by that time the preponderant force in the evolution of the design.

The overall impact of the Brazilian modifications to Corb's ideas was the creation of a work that was at once more monumental and more dynamic. To this must be added the typically Brazilian interest in formal lyricism and decorative exuberance manifest in the colorful *azulejo* (ceramic tile) wall panels of Cândido Portinari. The inclusion of the *azulejos* by Portinari, the works of the sculptors Bruno Giorgi, Antônio Celso, and Jacques Lipchitz, and the landscape gardening of Roberto Burle Marx signals the Ministry building as a milestone in Brazilian artistic collaboration and the first major example of Brazilian modernism's valorization of architecture as a *tour de force* showcase of a multi-media ensemble of great plastic richness and formal unity.

—David K. Underwood

Bibliography—

Papadaki, Stamo, *The Work of Oscar Niemeyer*, Tokyo and New York 1950.
Gazenco, J. O., and Scarone, M. M., *Lucio Costa*, Buenos Aires 1959.
Evenson, N., *Two Brazilian Capitals: Architecture and Urbanism in Rio de Janeiro and Brasilia*, New Haven 1973.
Bruand, Y., *Arquitetura Contemporanea no Brasil*, Sao Paulo 1981.
Fils, Alexander, ed., *Oscar Niemeyer: Selbstdarstellung, Kritiken, Oeuvre*, Berlin 1982.

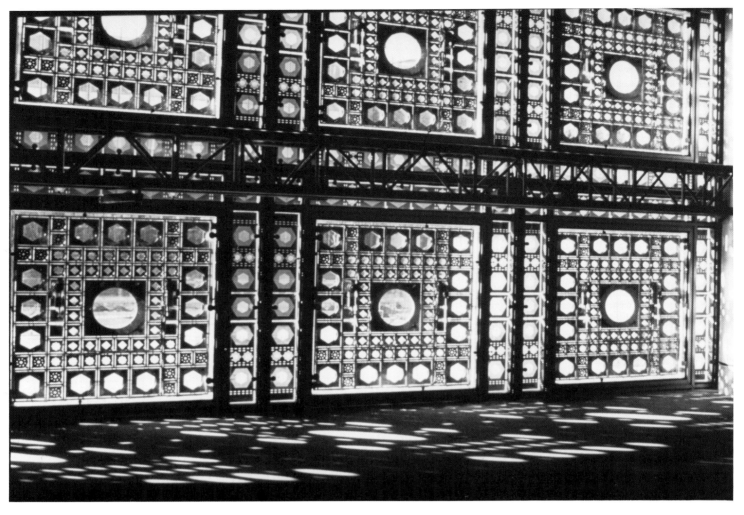

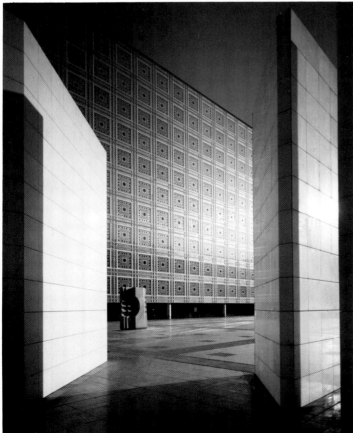

Photos courtesy Institut du Monde Arabe

Jean Nouvel (1945–)
World Arab Institute, Paris, 1988

The seat of the Arab World Institute is one of the so-called "Presidential Projects," which helped to transform Paris and French architecture in the '80s, and as such a remarkable one, an imposing masterwork.

The "Presidential Projects" were initiated by President Georges Pompidou (1969–74) with the National Center for Art and Culture by Piano and Rogers, that went to bear his name. But the main impulse is due to his two successors, Valéry Giscard d'Estaing (1974–81) and above all François Mitterrand (1981).

The Musée d'Orsay and the Science and Industry City at La Villette were Giscard's proposals carried out according to original plans. Mitterrand—the inspirer of the Grand Louvre, the Bastille Opera, the Ministry of Finances, the Music City and the Park of La Villette, the Library of France and the Center for International Meetings—also resumed two of his predecessor's ideas, but giving both a new spirit and a new orientation: one is the Grand Arch of La Défense, the other the Arab World Institute, by Jean Nouvel.

Professor and critic Wojciech Lesnikowski, an expert in French architecture, said that, of all the Presidential Projects, the design of the AWI, "although the most modest in dimension, is the most interesting architecturally." In fact, its extraordinary sophistication is connected to several factors—its exceptionally good fit on a difficult, demanding and constraining site at the Quai Saint Bernard, on the Seine river opposite the Île Saint-Louis; its elegant volumetric massing; and its attractive use of metal to express traditional Islamic architectural and ornamental themes.

Nouvel's name has become synonymous with the AWI, for which he received the Grand Prix of French architecture in 1987. The design of this masterpiece reveals four concerns which have been essential for Nouvel—contextuality, urbanism, cultural imagery, and technology. Nouvel and his associates (Gilbert Lezénes, Pierre Soria and Architecture Studio: Martin Robain, Jean-François Galmiche, Rodo Tisualdo, Jean-François Bonne) demonstrated a quality that was unique at that time—the ability to achieve the formal integration of an ultramodern object into a site consisting of many historical features.

The decision to create the Arab World Institute in Paris dates back to 1980, as a joint venture of France and 20 Arab states. Jean Nouvel and his associates won the national competition for the design of the building on the Quai Saint Bernard, a place selected by President Mitterrand himself. The headquarters offer a museum of Arab-Islamic art and civilization, 2,800 square metres on five levels with works of art—including contemporary art; a mediatheque with access to books, magazines, sound archives, an image bank, films and a cinema directory; a documentation service; an auditorium; a temporary exhibition space; a TV room, offices and other facilities.

According to Nouvel, the major element in the greatest Arab architecture is the use of light as a material; thus, he decided "that light should be the most important material in our project." He also played with the decorative themes which occur in Arab architecture—particularly at the Alhambra—, such as the square, the circle, the star, the polygone. As the decorative figures are often generated through rotation, the idea of diaphragms came naturally. As the site is located on the boundary between two types of urban fabric—one of which is traditional and continuous while the other is more modern and discontinuous—a dialogue between both was in order.

The eastern end of the Boulevard Saint-Germain constitutes one of the most important vantage points of the site. The AWI's visual impact upon this renowned avenue makes it a major reference in the Paris urban landscape. The western end of the building, visible from the boulevard, includes a tall white cylinder behind a transparent façade—the Books Tower, a library conceived for a collection of 40,000 volumes. The glazed portion of the façade is slightly behind the plane of the structure to accentuate the transparency, thus permitting the observer to clearly perceive the interior of the building, especially the southern façade. The tower's ascending movement, that clearly suggests the presence of the books which line it, is cut off at the roof-garden level in order to leave only the glazing outlined against the sky at the top of the building.

The northern façade design establishes the building's relationship with historic Paris. The curtain wall incorporates a rhythm which suggests the courses of a stone wall; the upper part of the façade uses silk-screened designs to evoke on the glass the reflections of the silhouette of Parisian buildings of the Île Saint-Louis and the Marais district opposite.

At the southern façade the problem of admission of natural light is solved by using an entire wall of diaphragms (a reference to the noble geometric elements of Arab architecture), activated by photo-electric cells which register changes in external natural lighting conditions. It consists of 27,000 aluminum diaphragms placed in 240 panels. The wall thus resembles a curtain in constant movement.

The technological geometry becomes a contemporary expression of the importance of geometric openings in traditional Arab architecture. A reference to the introversion typical of Arab architecture lies in the division of the building in two volumes through the use of a narrow opening which terminates in a central courtyard deep within the building. This opening accentuates the visiting dignitaries' entrance—accessible by car—leading directly into the Institute and to the High Council meeting room. The view of Nôtre-Dame through this opening is a reminder of the link between Arab and Western cultures.

"Architecture is that which is built," says Nouvel. "An architect must first resolve all the problems related to the building's use and offer precise answers to its objectives, and only then can he begin to 'create.' I don't think that he can or should invoke artistic values to alter the building's activities." The Arab World Institute headquarters is the conscious, imaginative achievement of these guidelines.

—Jorge Glusberg

Bibliography—

Goulet, Patrice, *Jean Nouvel*, Paris 1987.
Salam, Sami, "Istituto del Mondo Arabo," in *Abacus* (Milan), April 1987.
Ellis, Charlotte, "Split on the Seine," in *Architectural Review* (London), October 1987.
Ellis, Charlotte, "Nouvel Masterpiece," in *Blueprint* (London), October 1987.
Loach, Judi, "Parisian Arabesque," in *Building Design* (London), 17 June 1988.
"Jean Nouvel," special monograph issue of *Architecture + Urbanism* (Tokyo), July 1988.
Ellis, Charlotte, "Self-effacing IMA," in *The Architectural Journal* (London), January 1989.

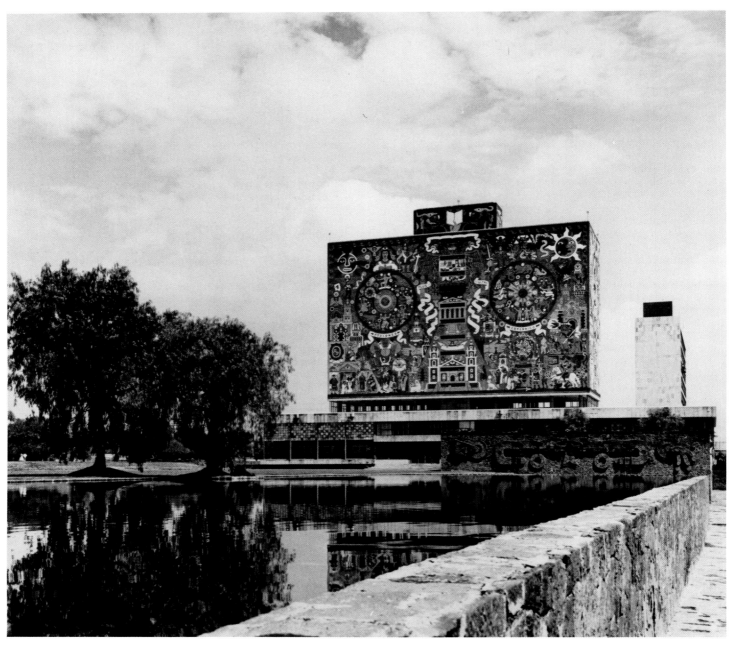

Photo British Architectural Library/RIBA

428

Juan O'Gorman (1905–82)
National Library, State University of Mexico, Mexico City, 1952–53

Juan O'Gorman, who was one of a handful of twentieth-century Mexican architects of international stature, did not regard the library at the University of Mexico as his masterpiece: that distinction he reserved for his own house (built 1953–56; destroyed 1970). The library is not even, strictly speaking, a work of O'Gorman. It was designed by in collaboration with Gustavo Saavedra and Juan Martínez de Velasco, and O'Gorman's contribution was limited largely to the design and execution of the exterior mosaics. Nevertheless, through repeated publication the building has become the best known building in Mexico. Meanwhile, its frequent attribution to O'Gorman alone (he being the most famous of the designers associated with it) has resulted in an indelible popular impression of his sole responsibility for this remarkable monument.

The National Library is the major center of interest on a vast campus planned in the early 1950s to bring together on one site the previously scattered facilities of a great university founded some four centuries earlier. When the new campus was planned and built, the university was conceived not simply as a teaching and research institution among others, but as a national center for the preservation and advancement of Mexican culture. Its central library was one of many libraries on the campus, and by no means the only one whose scope of service may be correctly described as national.

The National Library building, as constructed, exemplifies one of several classic library configurations: the tower type. It is often cited in discussions of this type, even in preference to many historically more significant examples (including Henry Van de Velde's early tower library for the University of Ghent). In the Mexico City building, an almost windowless tower contains the bookstacks, while a broader, low, and generously glazed substructure contains searching rooms, reading rooms, and accommodations for technical services. This design—little more than a functionalist cliché—was certainly not O'Gorman's choice. O'Gorman, although one of the chief proponents of International Style functionalism in Mexican architecture in the 1920s and 1930s, had by World War II become so thoroughly disenchanted with both its aesthetics and its theoretical underpinnings that for several years he utterly abandoned the practice of architecture and devoted himself to painting and the construction of mosaics. When he again took up architecture in the early 1950s, it was as an advocate of a nationalist Mexican style based on certain ideas of Frank Lloyd Wright, the monuments of the Mayan and Aztec civilisations, and undoubtedly also the Mayan revival tendency whose strength had varied but never completely dissipated since the triumph of the Mexican Pavilion at the 1889 exposition in Paris. To house the National Library, and to symbolize its significance as a national institution of a hybrid nation comprised of native American as well as European populations, O'Gorman reportedly had proposed a low masonry pyramid explicitly reminiscent of the monumental religious structures of ancient Meso-America. Too daring, too inevitably controversial, this alternative was rejected in favour of a functionalist solution—precisely the sort of solution which O'Gorman had come to reject out of hand as inappropriate to virtually any modern Mexican architectural programme because inherently devoid of any appreciably Mexican content.

O'Gorman's mosaics, with which the library's tower were completely clothed, were the only viable options for erasing the visual significance of that mass within the overall campus design. They were viable in part because of a strong tradition of mural decoration in modern Mexico; in part because of O'Gorman's reputation as an artist of considerable reknown. They were also a stroke of subversive genius in at least two respects. In the first place, these surface embellishments demonstrated the triumph of appearance over substance, and in doing so pointed up the vacuousness of International Style architecture (however solid) in comparison with nationalist cultural expressions (however thin). Secondly, their quality as a communicative medium (with iconography legible almost as a rebus) pointed up the distinctive function of the library shelved within the mosaic-coated tower as a collection of cultural communications of all sorts, with a clarity of which the form of the building alone (however functional) was quite incapable. O'Gorman's mosaics told the story of the history of Mexican culture, of the promise that amalgamated native and European ideas held for the intellectual development and scientific advancement of twentieth-century Mexico. The library building does indeed disappear beneath their fascinating and colourful surfaces. They make O'Gorman's a building which was not his at all. Merely a skin, they express what O'Gorman would have preferred the entire structure to have expressed throughout and by means of its whole substance, and in doing so the mosaics reduce the contributions of the associated architects to a nullity.

One of the most fascinating aspects of the building, as has been pointed out by Esther McCoy, is its siting with respect to O'Gorman's fantastic, troglodytic house not far away. O'Gorman's house, nearly contemporaneous with the building for the National Library on the campus of the University of Mexico, was the great built manifesto of his later career. This house was so arranged that one of its windows perfectly framed the tower of the National Library between two volcanos. Thus, from his real masterpiece O'Gorman could view doubly pictorialized (first, because obscured by pictures; second, because framed in a window) an edifice that might have been a greater masterpiece, with the satisfaction of seeing how, with the meagre means of a painter—mosaicist—he had gotten the better of a team of architects and builders in concrete, steel, and stone who had rejected his *parti* by dematerializing their achievement.

—Alfred Willis

Bibliography—

Myers, I. E., *Mexico's Modern Architecture*, New York 1952.
Hitchcock, Henry-Russell, *Latin American Architecture since 1945*, New York 1955.
Reed Alma M., *The National University of Mexico*, Mexico City 1957.
Damaz, Paul F., *Art in Latin American Architecture*, New York 1963.
Smith, Clive Bamford, *Builders in the Sun: Five Mexican Architects*, New York 1967.
Bullrich, Francisco, *New Directions in Latin American Architecture*, New York 1969.
McCoy, Esther, "Death of Juan O'Gorman," in *Arts and Architecture* (Los Angeles), August 1982.

Tent for Cologne Garden Show, *Tanzbrunnen,* **1957**

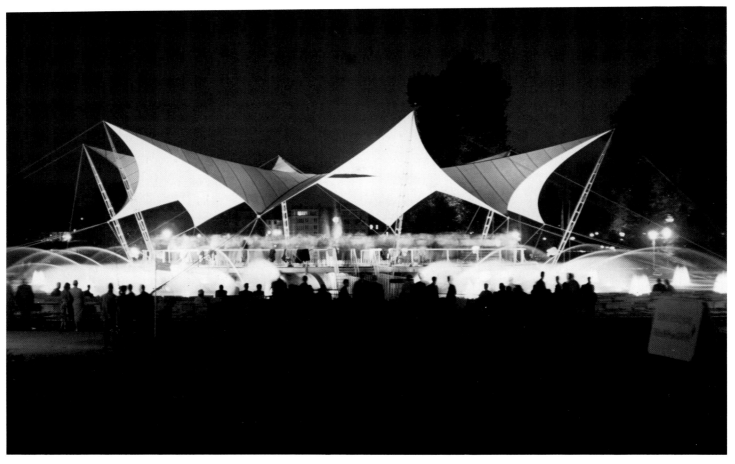

Detail of tent structure, Cologne, 1971

Photos courtesy of Atelier Frei Otto

Frei Otto (1925–)
Tent-structure pavilions, Rheinpark, Cologne, 1957, 1971

To achieve the maximum effect with the minimum of means—that is the path to follow for the engineer and the inventor who, in contrast to the architect, accepts the notion of progress in their work. The solution that achieves the greatest possible effect with the least amount of material and energy will take the place of solutions which achieve this aim less successfully. Frei Otto drew this conclusion early on. It has led him to a life-long use of light constructions, of tents, cablenet structures, wooden grid shells and pneumatic membranes (that is to say layers supported by air). In an institute founded specially for him in 1964, the Institute of Light Surface Structures, he was able, with his employees, to pursue relevant research for decades to come.

Otto's predominantly tensile constructions follow the ideal of weightless utility as laid down from the very beginning of his biography. The son and grandson of stonemasons, therefore of artists who deal with heavy, arduous material, as a boy he was engrossed by the aerodynamics of bird feathers, the building of model airplanes and by gliding; in the war, he became a fighter pilot. Frei Otto's light architecture therefore differentiates itself from traditional "heavy" architecture through the apparatus of his inventions, through the readiness of its creator to see it as a stage on the way to other, better variants through its adaptability and easy dismantling. The former pilot succeeded in building "flying buildings." "Houses should not take over time and space, but should be a part of space and time." The beauty of such constructions serves as an indication in this aesthetic of the correctness and intelligence of the solution found.

When Frei Otto was able to raise his first tent structures at the *Bundesgartenschau* (the Federal Garden Show) in Kassel in 1955, the thirty-year-old had already been able to draw on the experience of varied theoretical and practical experiments. During his studies at the Technical University of Berlin, he had formed ties with Walter Gropius, Mies van der Rohe, Frank Lloyd Wright and Eero Saarinen. In Fred Severud's studio, the partner of Matthew Nowicki, who had recently died in a crash, he saw the model for the successful arena in Raleigh, North Carolina, a cablenet construction spanned between two parabolic arches. At that time Frei Otto was working on his dissertation, *The Suspended Roof* in which he defines the notion of the classical. In his view, it is reached "once simplifications are no longer possible." Otto's book itself became a classic, influential just as the buildings he executed. No works of German post-war architecture made a greater impact on the international scene than Otto's tensile structures.

With the tents at the Cologne Garden Show two years after Kassel, Otto repeated and extended his initial success. At the main entrance he spanned a piece of fabric (originally a piece of glass-fiber) over an arch made of steel tubing and secured it at four points so as to create saddle-shaped surfaces on either side of the arch. The formula that Otto found for the dance fountain (*Tanzbrunnen*) was captivating. The circular dance platform is surrounded by the ring-shaped pool of the fountain and reached by connecting bridges. It is covered by a "wave of stars," a radial arrangement of saddle-shaped surfaces which are alternately suspended from low anchor points and from steel trellis masts—the construction itself dances. In the center of the membrane, a ring takes up the tension. In 1971, Otto completed the tents of the 1950s with a row of large umbrellas which protect around 800 seats from the elements. These canopies are made up from steel frames covered with membranes made out of polyester fabric and their spokes are moved by a lifting tube located in the mast.

The Cologne solutions are in keeping with their time but also anticipate future developments. On the one hand, the cheerful sails in their playful, swaying lightness corresponded to the spirit of the 1950s, a period when German society finally tried to detach itself from the careworn post-war austerity. On the other hand, they were the starting point for substantially larger tensile roofs, of which the most famous examples are the German Pavilion at the World's Fair in Montreal (with Rolf Gutbrod, 1965–67), the tent landscape for the Munich Olympic Games for Behnisch & Partner (1968–72) and a string of commissions in Saudi Arabia. Frei Otto's practice also executed numerous movable, dismountable and retractable tented roofs, for example in Wunsiedel for the open-air theatre (1963), in Cannes (1965) and in Bad Hersfeld (1967–68).

It is no accident that Frei Otto's first works were connected with garden shows. However much these occasions, so typical of West Germany, were always in danger of becoming events for reports for the horticultural trade and for parishes attempting to gain prestige through their beautification, they were nonetheless founded on the old utopian ideal behind every garden, of reconciling the realms of man and nature. Ecological arguments are given value in Frei Otto's works. That there might be an "architecture of nature and of love", architecture that could be experienced sensorially and that had a closeness and associations with the objects of our world is a hope that his work has espoused. Otto's utopia is a temporary architecture which does not put a burden on the earth and its creatures, which does not unfold more material than is necessary for the fulfilment of its purposes and which, once it has fulfilled its tasks, can be taken away again.

"Natural constructions" are not, in Frei Otto's eyes, structures culled from nature's way of building. Certainly there are close parallels: between the cablenet and the spider's web; between the branching frameworks and vegetal forms or mineral structures; between halls supported by air and soap bubbles or the sound bubbles of acquatic frogs. But the realization that man's work may be natural, or even perhaps heightened nature, does not mean that the creations of nature have to serve as the only models in one's own work. Otto views the relationship between his products (and those of like-minded colleagues) on the one hand and those of nature on the other not as dependent but as analogous. It is not just insights into the activities of architects that are to be gained from such correspondence, but also into the research of biologists, palaeontologists, physicists, chemists and behaviourists. Frei Otto's movable architecture is commensurate with a mobile way of thinking which is not limited to one single discipline.

—Wolfgang Pehnt

Bibliography—

Otto, Frei, *Das hangende Dach: Gestalt und Struktur*, Berlin 1954, Stuttgart 1990.
Roland, Conrad, *Frei Otto—Spannweiten*, Berlin, Frankfurt and Vienna 1965, New York 1970.
Drew, Philip, *Frei Otto: Form und Konstruktion*, Stuttgart 1976.
Glaeser, Ludwig, *IL Publications 17: The Work of Frei Otto and his Teams 1955–1976*, Stuttgart 1978.
Otto, Frei, and others, *Naturliche Konstruktionen*, Stuttgart 1982.
Burkhardt, Berthold, ed., *Frei Otto: Schriften und Reden 1951–1983*, Braunschweig and Wiesbaden 1984.
Wilhelm, Karin, and others, *Architekten heute 2: Portrait Frei Otto*, Berlin 1985.

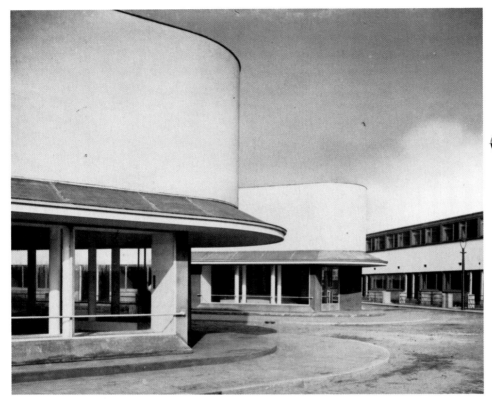

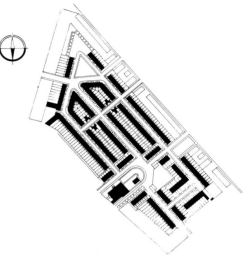

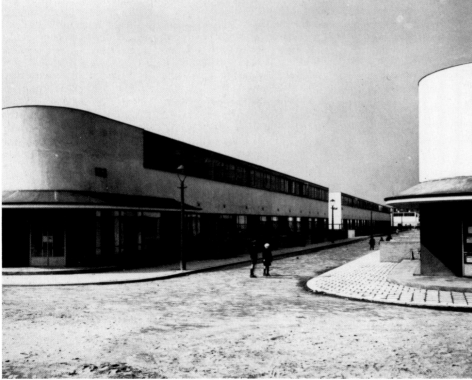

Dwelling unit ground and first floor plan

Photos Gemeentelijke Archiefdienst Rotterdam

432

J.J.P. Oud (1890–1963)
Kiefhoek Workers' Village, Rotterdam, 1925–30

At the time Oud set out with his design for the Rotterdam residential quarter "Kiefhoek" in 1925, he was employed for seven years already by the Rotterdam Housing department. In that period, he had realized four large housing projects for the city: Spangen, Tusschendijken, Oud-Mathenesse, and working-class housing at Hoek van Holland. His work was esteemed highly by modern architects and critics alike. H.-R. Hitchcock, for example, valued Oud's housing project at Hoek van Holland as being "probably the finest monument of the new architecture." The invitation to participate in the "Weissenhofsiedlung" exhibition in Stuttgart Oud owed to the appraisal of this project. He was seen as someone who was capable of making the connection between modern architecture and the social problem that had to be solved. Moreover, it was appreciated that he had chosen to practise not as a private architect, but rather as a municipal employee. He was one of the first architects to operate under such conditions—in Germany Martin Wagner only took up his post with the city of Berlin in 1924, whereas Ernst May joined the city of Frankfurt in 1925. Only in Vienna the development of municipal housing projects started at an equally early date (1918), but the products of these endeavours were not very much liked by modern architects.

The program of "Kiefhoek" consisted of 291 dwellings, 2 shops and workshops and a "waterstokerij" (hot water shop) plus dwelling. A "waterstokerij" was a typical Dutch shop: hot water was sold there by the bucket which cost people less than when they would boil their own water at home. The dwellings were meant to be occupied by the financially disadvantaged. Therefore they had to be small in size, yet large enough to house a family of eight (parents and six children). The dwelling was only to number two floors. Later, in 1929, a church of Oud's design was built for "Kiefhoek." Because of financial problems, building activity only started in 1928, not until certain economies were effected: a cheaper foundation solution was chosen, prefabrication of building parts was discarded, and the shower facility was cancelled as being a superfluous luxury. The building site, located on the left bank of the river Maas, already was surrounded by existing buildings. Oud's urban concept corresponds with the existing linear street pattern; side streets also correspond with the pattern in the new development but sometimes were bent. The strips of the housing blocks do not dominate because Oud saved space for a small centre that interrupts the regularity of the urban structure. At the south end of the project, he suddenly closes off the housing blocks obliquely. In the space that is left over, he planned a playground for children. Despite its adaptations to the existing street pattern, the quarter contrast with the surroundings because of its striking white architecture.

Oud took one dwelling type as a starting point for his design of the entire project; a dwelling of two layers, 4.10 metres wide and 7.5 metres in depth each. The net area for living was 48.5 square metres. This seems to be a very small area but given the fact that the gross floor-area was only 61 square metres, one can understand that Oud had to design the plan very rationally in order to accommodate the "model-family" of 2 parents, 3 boys and 3 girls. The ground floor was designated for living (living room, kitchen), the first floor for sleeping (3 bedrooms). The stairs were placed at the rear end of the dwellings. This had to do with the orientation of the dwellings towards the street; in most cases, the garden sides could not be seen from the street, as they were located on the

inside of the housing blocks. It was presumed that in the end the gardens would become messy, anyway.

Oud once termed these dwellings the "Residential-Ford." This reference to the successful Ford model-T is no coincidence. This car was seen as a product that offered functional comfort through moderate means, just as Oud's rational solution of the housing plan does. Moreover, the car symbolizes efficient serial production that is at the heart of prefabrication. Indeed, Oud hoped it would become possible during the execution of the "Kiefhoek" project to prefabricate some of the building components: after all, he had worked with standardized measures and only one housing type. It did not get that far due partly to economies, partly to the contractor's unfamiliarity with such a building process.

The analogy with the American car therefore was restricted to the inventive solution of the plan and to the appearance of the project. The smooth surface of the façades and the continuing window sills indeed suggest forms of industrial production even though—in fact—the construction method was a traditional one.

This modern design was indebted to Oud's experiences as a member of the "De Stijl" group, as is witnessed by the composition and (use of) colors: at groundfloor level a strip (1) of yellow bricks and of grey windows, interrupted by red front doors; at firstfloor level a strip (2) of white stucco that reminds one of concrete underneath yellow stripwindows (3). These three layers jump compared to one another, because of which Oud attained a façade with relief. The dwellings are attached to each other in a mirrored fashion. Consequently, in the façade a rhythm arises of two doors each time. A balcony protruding from the white stucco strip marks every occasional single door in order to end the block in a compositionally responsible way. These single doors occur at the end of housing blocks that consist of an odd number of dwellings.

Considering the housing projects of Oud and concerning the "Kiefhoek" project in particular, one cannot speak of individual houses. Already in 1917, Oud expressed his ideas about the image of the city in an article in *De Stijl*. The modern urban space would not consist of individual houses but of housing blocks. In the "Kiefhoek" project, the housing blocks are at once an architectural object and a compositional element; an architectural object because of the overall treatment of the design and a compositional element because of the spatial effect the configuration of the blocks has. To Oud, the rules that have to do with the positioning of a dwelling in relation to the sun were of less importance for the quality of living than was the sensation of spatiality. It is in this respect that the "Kiefhoek" project distinguishes itself from the functionalist strip-building of the time. It is not until his (not executed) housing design at Blijdorp (Rotterdam, 1931) that Oud applies this strip-building type for once in his career.

—Otakar Máčel

Bibliography—

Hitchcock, Henry-Russell, *J. J. P. Oud*, Paris 1931.
Veronesi, Giuliana, *J. J. P. Oud*, Milan 1953.
Wiekart, K., *J. J. P. Oud*, Amsterdam 1965.
Stamm, G., *J. J. P. Oud: Bauten und Projekten 1906 bis 1964*, Mainz 1984.
Cusvelier, S., ed., *De Kiefhoek, een woonwijk in Rotterdam*, Laren 1990.

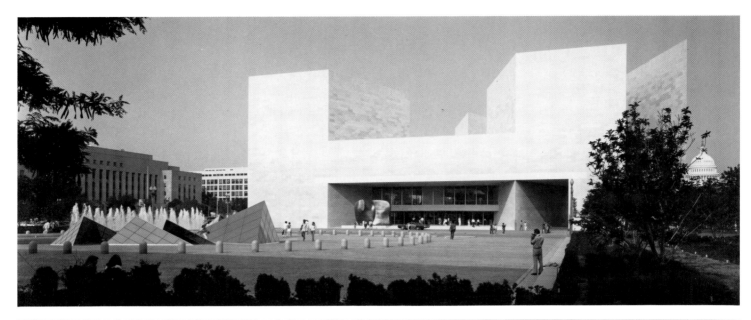

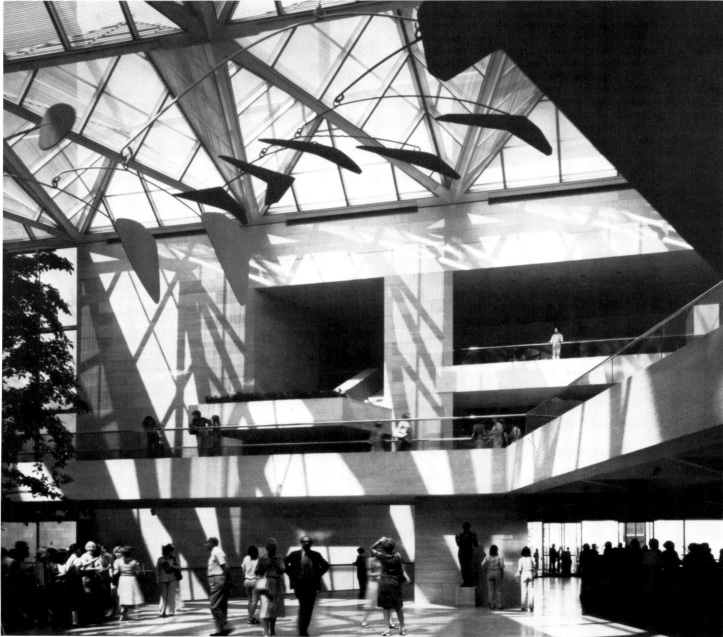

434

I. M. Pei (1917–)
National Gallery of Art East Building, Washington, D.C., 1978

While it has become fashionable of late in some quarters to decry the work of I. M. Pei, he continues to create buildings of sculptural abstraction and geometric elegance. One of the most refined of these buildings is the 1978 East Building of the National Gallery of Art in Washington. It contains not only the gallery extensions, but also the Center for Advanced Study in Visual Arts.

It is situated on a complex and difficult site between Pennsylvania Avenue and The Mall, derived from L'Enfant's eighteenth century plan for Washington. Both streets are of national significance and each required a different scale. On one side, the gallery is connected to John Russell Pope's original neo-classical National Gallery and on the other side, further along Pennsylvania Avenue, is the Capitol Building, dominating, vast and heavily classical. To complicate the design even more, the site is trapezoidal.

Such an important location required a building of suitable scale and stature, one that not only served its function well but could hold its own on its site between such imposing neighbours.

From the air, the East Building looks like a giant Rubic puzzle, but in plan it is two triangles, one isosceles, (the gallery), the other right-angled, (the study centre). The two triangles fit together to form a trapezium, reflecting the shape of the site. The exterior treatment of each element reflects the differing functions within. The gallery is enclosed, with sheer, smooth, solid walls, while the Center for Advanced Study has more diverse façades.

The three "towers" of the gallery rise at each point of the gallery triangle and contain the main exhibition spaces over five levels. These spaces are of room-like scale and are in the form of a parallelogram. The interior areas can be altered to suit the needs of different exhibitions. The top galleries are lit from skylights.

The main gallery entrance is a long, low, horizontal slot facing the original building. With its towers and low entrance; the new gallery, for all its twentieth century abstract geometry, has the feeling of a Norman fortress. The Center for Advanced Study is less monolithic in appearance, with more broken façades, including a glass curtain wall.

The exterior cladding of the East Building is the same brown-to-pink marble from the same quarry as was used for the original, or West Building, of the National Gallery in 1941. Pei has also acknowledged the grading of tone from darkest at the bottom to lightest at the top by using similar grading in the new building.

There is no ornament or decoration. The East Building, however, is not a marble building; it is a concrete building with three inch thick marble cladding, each 5 by 2 foot piece being perfectly set. The areas of exposed concrete were tinted with a hint of powdered marble and given a compatible texture to maintain a close harmony with the marble-clad surfaces. Any other reference to the older building is cerebral rather than actual.

The West Building is dominated by its dome, the East Building by a huge skylight over its central room. Pei wanted this central space to work on many levels, and it does indeed dominate the interior. It is suffused with light, crossed by overhead bridges and surrounded by side galleries. It contains only a few works of art.

The central space of the gallery is both its strength and its weakness. It does provide a fine and grand space with lots of movement, many levels and plenty of light, but the architecture tends to overwhelm the artworks. Instead of being a place to display art, it is a huge environmental sculpture starring as the main art attraction itself. While visually impressive in its own right, it is functionally questionable.

The movement of people was clearly a major concern, with a plethora of crossbridges, escalators and stairs. Movement is guided upwards in "a procession to nowhere," as Robert A. M. Stern put it. The intention was to achieve clarity of circulation, but the complexity of the means, although visually very strong, confounds that intention.

The East Building is connected underground to the West Building beneath Fourth Street. This basement is substantial in size and contains, as well as the direct circulation link, an auditorium, bookstacks and various service areas.

The Center for Advanced Study of Visual Arts also has its entrance off Fourth Street, but it is discreetly to the side, avoiding any confusion with the entrance to the gallery. Inside, a wall of bookstacks and offices rises six storeys and seventy feet around a reading and reference hall. In its austerity, its feeling is similar to the medieval quality of the building's exterior.

While criticised for its less than successful handling of function as a gallery for the display of artworks, I. M. Pei's East Building is, nonetheless, a major work of art in itself, and, for some, the most interesting sculptural exhibit on show at the gallery.

—Brian Phipps

Bibliography—

McLanathan, Richard, *East Building, National Gallery of Art: A Profile*, Washington, D.C. 1978.
Pei, I. M., *Drawings for the East Building, National Gallery of Art*, exhibition catalogue, Washington, D.C. 1978.
"I. M. Pei," special feature of *AIA Journal* (Washington, D.C.), June 1979.
Diamonstein, Barbaralee, *American Architecture Now*, New York 1980.

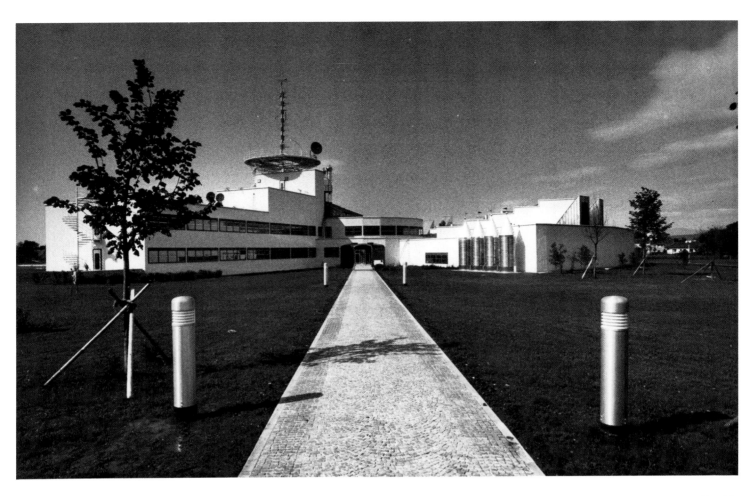

Gustav Peichl (1928–)
ORF Radio Stations, Austria, 1968–81
Oesterreichisches Rundfunk, Vienna

The ten year decentralization programme of the Osterreichisches Rundfunk (the Austrian Broadcasting Service) led to the construction of the first four ORF Radio Stations at Dorbirn, Innsbruck, Linz and Salzburg between 1968 and 1972. Two additional stations were later built at Graz and Eisenstadt (1979–81). Designed by the architect and political cartoonist Gustav Peichl, these buildings are amongst the finest examples of Austrian modern architecture.

Peichl and a team of twelve assistants were awarded the commission for the Radio Stations in a 1968 design competition. The client, ORF, specified that each building should have efficient connections, maximum flexibility and be capable of expansion. The six buildings built between 1968–81 are based largely on these principles. Each installation houses planning, technical and transmission services on the same site as the administrative offices. Five segmental studio buildings radiate from a central nucleus and double-height circular vestibule. The three-storey office wing is surmounted by a platform with an antenna and forms a right angled quadrant in the central hall. The aerial view of the studios fanned around the central core with its projecting antenna make inevitable comments on its resemblance to a snail. The different studio spaces vary in size from the large public concert area of 274 meters square to the small broadcast studios of 31 meters square. They occupy several floors and are situated radially around the remaining 270 degrees of the circle.

Gleaming walls of exposed aluminium ductwork flank the staircase in the central lobby and occasionally burst through the glazed roof. Extractor vents and silencers protrude through the exterior walls of the large public studio like battleship guns, giving the stations a militaristic feel. These partly express the technological nature of the building and facilitate subsequent technical modifications, but they are also a deliberate feature of the architectural design. Peichl emphasizes the importance of the aesthetic. He never lets structure or service concerns impose a rationale on his buildings. This explains the prefabricated construction, the seemingly mass-produced precast concrete panels and the often meccano-type design that exist for graphic rather than practical purposes.

The organic planning of this project reinforces the architectural design in such a way that the character of the stations remains unchanged when additional buildings are constructed or existing ones reformed. This flexibility facilitated the introduction of television installations in the first four ORF stations seven years after their construction, with no apparent effect on their architectural configuration. The strong organizational concept found in each of the installations has brought many analogies, the most common of which are the Snail's Shell, the Nautilus (Peichl's own metaphor), and Duchamp's Anemic Cinema. For mechanical expressionism the Stations have been compared to Piano and Rogers' Centre Pompidou and Stirling and Wilford's 1968 Cambridge building. It is impossible to find, however, a single image which captures the amazing unity that exists in these buildings in spite of the many eccentricities found in Peichl's work.

ORF-Eisenstadt is both criticised and admired for its nautical detail. The ocean-liner metaphor most often applied to the Station is apt as much for its aesthetic expression as for its mechanistic implications. The exterior of the radio station has been compared to a section of a large ship, stranded in a forest. The aerial tower resembles the mast of a dreadnought and the entrance to the building is like a covered gangplank. The extractor ducts of the main ventilation system end in a series of silver tents, headed by small tin flags that are purely decorative. The interior of the structure also has nautical inspiration. The studios are arranged in wedge-shaped spaces which fan towards the hall (this forms the hub of the whole building). These increase in size, like the segments of the shell of a nautilus. The design is incredibly economical; the hub allows most of the circulation to concentrate at the centre and makes these seemingly complex buildings convenient to use. Only a master architect such as Gustav Peichl could mould such diverse architectural forms into the sophistication found in the ORF Radio Stations. The buildings are marked by their professional artistry; the combination of building and art.

In addition to the six ORF buildings, Peichl designed the archives for the ORF building in Argentinierstrasse, Vienna (1982–83). The new extension to the original 1930s' structure was built to meet the managerial and technical stipulations of the Austrian Radio team. It attempts to blend the new forms and functions of the archive with the existing construction and the connection between the two is simple and convenient. It is obvious that the architecture of fellow architect and former tutor, Clemens Holzmeister, has influenced the design of this building, although Peichl uses more contemporary forms and materials.

The ORF Radio Stations are beautifully crafted and inspirational pieces of architecture. Their High Tech character, as defined by the use of silver protective coating, precast concrete panels and exposed aluminium ventilation ducts and the attention given to fine details such as the railway carriage windows and nautical handrails, enable the ORF stations to be appreciated from both an aesthetic and functional viewpoint. This has led one critic to comment that Peichl is an artist who uses the forms of advanced technology much as the Cubists and Constructivists used them in their day.

—Aruna Vasudevan

Bibliography—

"ORF Studios," in *Architecture d'Aujourd'hui* (Paris), December/January 1972/73.
"ORF Radio Stations," in *Architectural Design* (London), January 1973.
Best, Alistair, "Radio Four," in *Design* (London), June 1973.
Peichl, Gustav, *Gustav Peichl: Bauten, Projekte, Meisterschule*, Vienna 1981.
Samitz, August, ed., *Three Viennese Architects: W. Holzbauer, G. Peichl and R. Rainer*, Vienna 1984.
Doubilet, Susan, "Relay Station," in *Progressive Architecture* (New York), March 1984.
Royal institute of British Architects, *The Architecture of Gustav Peichl*, exhibition catalogue, London 1989.
Davies, Colin, *Hi Tech Architecture*, London 1991.

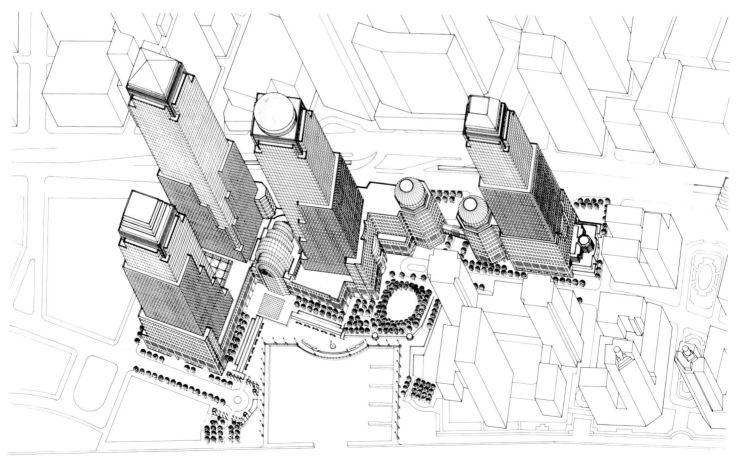

Illustrations courtesy Cesar Pelli & Associates

438

Cesar Pelli (1926–)
World Financial Center, Battery Park City, New York, 1982–88

César Pelli had expressed the hope that the World Financial Center would be "a complex of our time." It is, indeed. But for that reason, it is obviously one of the major pieces of international contemporary architecture and up till now the paramount work of its author.

An Argentine (b. 1926) graduated at the University of Tucumán, Pelli transferred in 1952 to the United States, where he was a collaborator of Eero Saarinen for ten years; he established himself later in Los Angeles and finally in New Haven, with his own studio. During this third of a century, Pelli's reputation had grown incessantly inside and outside the USA, and he is now one of the foremost practitioners of his generation.

Pelli won the competition for the World Financial Center in 1981. His design met, of course, the brief's demands but—perhaps more valuable also the original views Pelli had developed about architecture, the "mother of arts, because it is deeply rooted on reality," as he says.

According to Pelli, in designing a building in a city it is necessary to resolve the different requirements of the building and the city, which are far from being the same. As architecture is understood today, a building has its own autonomous logic, which is often in conflict with the needs of the larger urban whole. It is obvious for him that the whole is more important than the part. Accepting this, it follows that decisions of form and character should first serve to make a better city, and only secondarily be guided by aesthetic consistency with the works of the same architect. Summing up his ideas, Pelli remarks: "The city is more important than the building and the building is more important than the architect."

The World Financial Center is just West of the World Trade Center on a site on Battery Park City, at the southern tip of Manhattan. It includes 6 million square feet of offices, 300,000 square feet of retail space, and 250,000 square feet of lobby and public spaces on 13.5 acres of landfill. There are four office towers ranging in height from 34 to 51 storeys, a winter garden, and a 3.5 acre landscaped public plaza.

Pelli departed from three guidelines. Firstly, his design should connect with "the beautiful, crowded, romantic skyscrapers of the 1920s and 1930s that created that urban form." Secondly, the design also had to mediate with the sheer bulk and presence of the two towers of the World Trade Center and last, the design had to incorporate all that had been learned about architecture since those "romantic" skyscrapers were built. In Pelli's own words, "my intention was to add to the concerns of the Modern tradition some attitudes, necessary to make our buildings more responsive and responsible to the needs of our cities."

Thus the plan for WFC creates major public forms that both celebrate and pursue the historic skyline of Manhattan. The four reflective glass and granite towers rise from a continuous granite-sheathed base. The proportion of granite to glass is greater at the base of each tower and gradually lightens into completely reflective glass skins. At various intervals corresponding to the heights of surrounding buildings, the towers are set back and ascend visually towards distinctively shaped tops made of copper, a classic material chosen for its noble character and association with many of the world's major public buildings.

It was in an effort to reduce the massive towers' bulk that Pelli peeled the granite and glass cladding back a notch at each of four setbacks and made the buildings look increasingly inmaterial as the rise, by changing the relationship of glazing to stone from base to crown. He enlarged and elongated the windows at each setback, finally overlaying them with fine drawn mullions and tautly stretching them against a granite grid of similar color value. As Pelli said, "at the base these are skins of stone with windows in them; at the top they are skins of glass with a tracery of stone marking the modular system."

The four skyscrapers surround and define a public plaza that is the heart of the waterfront edge of Battery Park City, over the Hudson River. Pelli and his collaborators in the planning of the square—artists Scott Burton and Siah Armajani, landscape architect Paul Friedberg—discarded anything that "smacked of an art statement and wasn't responsive to public use, and our different attitudes added vitality to the design."

The two nine-storey octagonal building wings on either side of Liberty Street and between the first and the second towers (looking North to South), have been conceived to create a gateway from the city to the river. Each of these domed atriums is an airy, beautifully modulated space ringed by two balconies, capped by a stencilled ceiling, and terminated at ground level by two semi-circular stairs flanking an escalator. Both buildings are connected by a bridge. Two second-storey enclosed bridges crossing West Street serve for pedestrian entry and exit to the four towers, and resemble airport corridors.

Finally, the winter garden, adjacent to the plaza, creates a great open hall enclosed in an arched steel and glass vault of 125 feet in height, 120 feet in breadth and 200 feet of length. This major public room was Pelli's initiative and part of his competition proposal. The winter garden telescopes from the East in increasing diameter, then bumps back down "to contain the space" (Pelli's own words), before ending in a sheer wall at plaza's edge.

Its grand half-circle stair, with an hourglass-like tuck at its middle, leads in from one of the two bridges and is a processional entryway, the only one in the complex. The winter garden (by the way, a popular name for what is an enclosed skylit courtyard) "is today the heart of the project and the main public living room of downtown Manhattan," as Pelli says. But that project is also the heart of a brilliant, exclusive and above all liveable architectonic production.

—Jorge Glusberg

Bibliography—

Pastier, John, *Monographs on Contemporary Architecture: Cesar Pelli*, New York 1980.
"A New Phase of Cesar Pelli," in special monograph issue of *Space Design* (Tokyo), September 1980.
"Pelli Unveils Battery Park City Plan," in *Building Design* (London), 5 June 1981.
"New Layers of Meaning: Works in Progress of Cesar Pelli," in *Architectural Record* (New York), July 1983.
Dean, Andrea, and Freeman, Allen, "The Rockefeller Center of the '80?," in *Architecture* (Washington, D.C.), December 1986.
Truppin, Andrea, and Tetlow, Karin, "Trading Up," in *Interiors* (New York), March 1988.
Pelli, Cesar, and Macrae-Gibson, Gavin, "Recent Works by Cesar Pelli," in *Architecture + Urbanism* (Tokyo), February 1991.

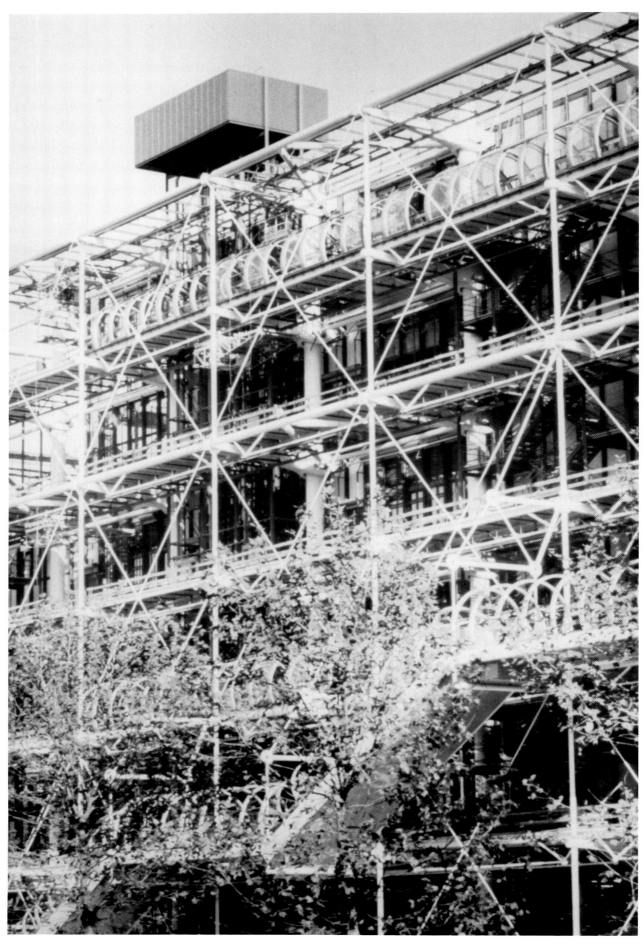

Photo Renzo Piano Building Workshop

Renzo Piano (1937–) **Richard Rogers** (1933–)
Centre Culturel Georges Pompidou, Paris, 1976

The Centre Pompidou needs to be looked at from several points of view: a significant piece of high-tech/constructivist architecture, a French cultural center in the tradition of French "grands projets" such as the Eiffel Tower, and a background of activities referred to by Richard Rogers as "a setting for things to happen." The building was controversial from its inception, and is still being debated by Parisians as well as by architects and critics. Some feel that, in spite of its innovative structural approach, it is a museum space in the nineteenth-century tradition—a flexible, open exhibition space pioneered by Paxton in his Crystal Palace, rather than a truly twentieth-century museum. Others are critical of the insertion of this highly unusual modern structure into the Beaubourg section of Paris, clearly clashing with its traditional neighbors. Yet, whatever criticism one might have, the center has obviously succeeded on most levels. It attracts approximately 8 million visitors per year and beats out the Eiffel Tower with only about 4 million visitors, and is probably the most visited museum in the world.

The design of the Centre National d'Art et de Culture Georges Pompidou was awarded to Piano and Rogers through a competition which attracted 490 entries. Renzo Piano from Italy, and Richard Rogers from Great Britain worked with the British engineering firm of Ove Arup on the design of this highly complex structure. Its cage-like, tinkertoy structure consists of thirteen bays made from trusses fabricated in Germany by Krupp. The clear span of the truss is 156 feet with a spacing of 42 feet apart. The main circulation up to each floor is by a tube of cantilevered escalators which are seen as a dynamic diagonal from the front of the building. The escalators connect on each floor to horizontal tubes running the length of the building. All of the mechanical duct-work is also exposed. Together with the circulation components, the façade of the building forms a network of vertical and horizontal struts, diagonal cross bars, and the main bridge-like structural members connected with cast steel joints. There has been much debate about the highly complex mechanical image of the building. The colors of the mechanicals are a conscious part of the design: red for circulation (elevators and escalators), blue for air conditioning and heating, green for water, and yellow for electricity. Many felt that the mechanical systems had been exaggerated for the sake of ornamentation, but Richard Rogers and Peter Rice, the engineer in charge for Ove Arup, claim that nothing superfluous has been added.

The one million square foot building was designed to house a museum of modern art, a public library, an industrial design center, a cinematheque, and a center for music and acoustic research. The latter is housed underground and the plaza above it is used for outdoor musical and theatrical performances. The center also contains cafés and restaurants. The building quickly became a magnet for tourists and Parisians with as many activities taking place on the sloping piazza in front of it as inside the structure. There are always performers, jugglers, fire-eaters, acrobats and musicians, and during the summer months young people in particular seem to fluctuate there with backpacks and guitars. The celebrations of public life have made the Centre Pompidou a true monument for Paris and for the twentieth century, with the principal façade forming the stage for performers and the spectators becoming a supporting cast of characters. The building is 138 feet high, somewhat taller than the adjoining buildings. Yet its huge scale makes it loom larger than life as one comes upon it, and it clearly becomes the focal point of the area. Since 1977 the whole surrounding area has seen enormous building activity from new buildings to restorations. Many shops, restaurants and bou-

tiques abound nearby. Two blocks from the Centre Pompidou on the site of the old Les Halles, a new shopping mall and other public buildings have been created. Thus the Centre, which has been questioned and attacked by many Parisians in its early days, has quickly become one of the important landmarks of Paris and can, in its obvious success, be compared with the Eiffel tower and more recently with the new entrance to the Louvre—all three innovative structures questioned at first, but soon becoming accepted as important parts of the very fiber of the city.

The Centre Pompidou remains as the most important expression of the late modernist high-tech direction in architecture. It has the extreme articulation and responsiveness to a machine aesthetic which at the same time becomes a part of an important sculptural form. There have been similar ideas before this building, particularly those projected by Archigram in 1963. There have been a number of high-tech buildings since 1977, and one of the most famous is the Lloyds' building in London by Richard Rogers. Yet high-tech as a stylistic architectural direction has not become a predominant movement, and the chances are that the Centre Pompidou will remain as one of the few and most significant examples of the style.

Historically, one also needs to look at the building as one of the earliest new museums being built in the second half of the twentieth century, preceded only by the Mies van der Rohe museum in Berlin. Since that time, new museums have proliferated in Europe as well as in the United States. As a museum, the Centre Pompidou did not develop new ideas. The museum as a building type became fully developed in the 19th century at the same time as the exhibit hall came into its own. The Centre did not take advantage of its programmatic potential as a new museum in spite of its futuristic architecture. In fact, the part devoted to the museum of modern art has been completely redesigned in the 1980s, and functions much better as a museum at this time. To some Parisians, the Centre Pompidou appeared to be a kind of cultural supermarket. With the opening of the D'Orsay museum in the 1980s the perspective of Parisians and critics has somewhat changed. The center's importance is now more as a multicultural building since modern art has been given a very important new repository of its own. The fact that the sense of place at the Centre Pompidou has been kept outside the museum—in the plaza around it—has underlined the fact that the building is less about art and more about events, spectacles and sightseeing. It is remarkable that the center, more than any cultural institution anywhere in the world, has pioneered the involvement of the general populace in the arts. Whether this was Piano and Rogers' intent is doubtful, but clearly one should not quarrel with success. The Centre Pompidou inserted amongst 17th to 19th century buildings in Paris much like a visitor from outer space remains as a great architectural, symbolic and cultural monument, one that contributes to joy and delight more than any other building in Paris.

—Arnold Friedmann

Bibliography—

"Centre du Plateau Beaubourg," special issue of *Techniques et Architecture* (Paris), February 1972.
Piano, Renzo, and Rogers, Richard, *The Building of Beaubourg*, London 1978.
Fils, A., *Das Centre Pompidou in Paris*, Munich 1980.
Raeburn, Michael, ed., *Architecture of the Western World*, New York 1980.
Jencks, Charles, *Architecture Today*, New York 1982.
Trachtenberg, Marvin, and Hyman, Isabella, *Architecture—From Prehistory to Post-Modernism*, New York 1986.

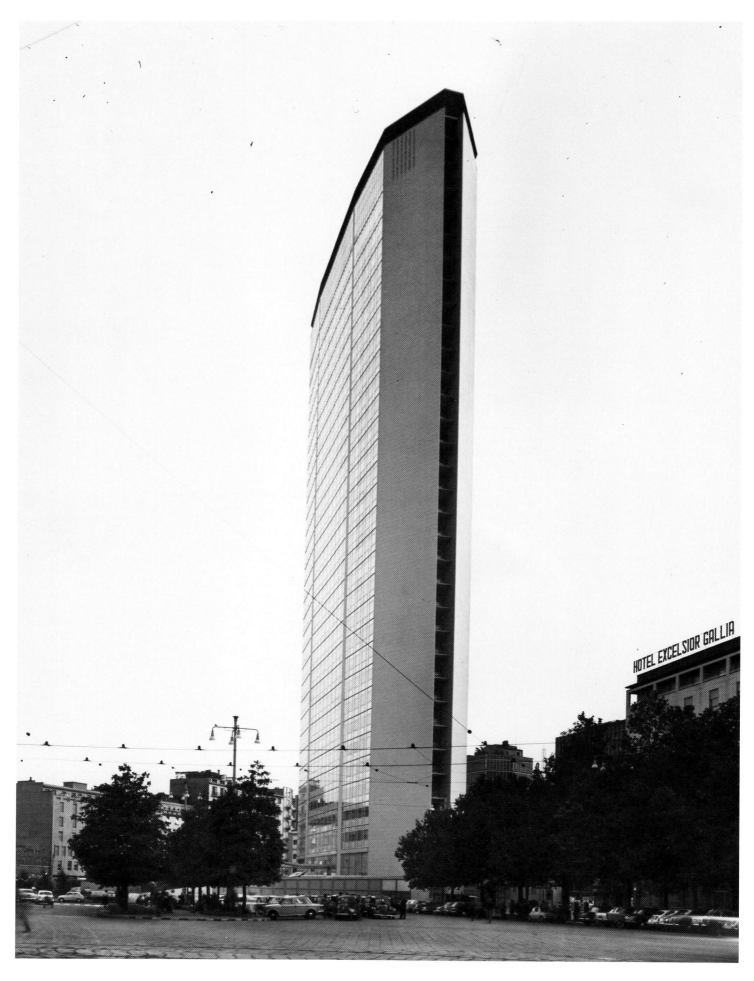

442

Gio Ponti (1891–1979)/**Pier Luigi Nervi** (1891–1979)
Pirelli Tower, Milan, 1955–58

"A superbly polished diamond"; "one of the most exciting buildings in Europe"; "a perfect collaboration of architect and engineer"—these are a few of the superlatives that have been showered on the Pirelli tower in Milan. More than three decades after its construction this extraordinary building still dominates the city, by virtue of its size, its elegance, its daring; indeed, it is one of the handful of modern edifices which even those uninterested in contemporary architecture can name. Where, one asks, did it come from? And what makes it so special?

The answer to these questions lies partly in Italy's post-war history. With its cities devastated and its civic life disrupted, the country needed, in this period, to rebuild quickly and efficiently. As a result of these pressures a school of civil engineering arose that was unusually innovative and original: for a whole generation Italian engineers led the world in skill and daring. At the same time the nation's architects, freed from the shackles of Fascist ideology, were able once more to build with their characteristic flair: the result was a flurry of construction projects whose imagination and stylishness were unsurpassed in the rest of Europe. The two schools came together most spectacularly, perhaps, in the Pirelli tower—specifically in the team of architects and engineers headed by Gio Ponti and Pier Luigi Nervi.

At the time of the tower's construction Gio Ponti was one of Italy's foremost architects. A committed Modernist, his speciality was the "forma finita," or closed form, whereby the lines of a building, if extended, ultimately converge. Such closed forms, he felt, were characteristic of art—opposed to them were the open forms of industry and technology, whose lines, no matter how far lengthened, will never meet. For Ponti this was not merely a question of geometry: between the two forms, he believed, there was a decisive moral and spiritual chasm. In his meditations on closed form, indeed, Ponti reveals himself to be a humanist as well as a Modernist—a very Italian combination, maybe, and one he shared with his exact contemporary and colleague Pier Luigi Nervi.

Like Ponti, Nervi at the time of the tower's construction was at the forefront of his art. A pioneer in the use of ferro-concrete, he had been responsible for some of Italy's most eyecatching and successful modern buildings. A Modernist like his friend (he once wrote that "today's is a new architecture, which has no real connection with the past") he nevertheless insisted on the necessity of synthesizing in a deep and thoughtful way the new materials and theories of the twentieth century. It was perhaps inevitable that the two men should work together, given the congruence of many of their ideas—inevitable, too, that the building they created should be both daringly original and hugely successful.

Viewed straight on, the Pirelli tower looks, at first glance, like a standard office block. Such a cursory inspection, however, fails to reveal the subtlety of the design; in particular the way the sides of the building are angled toward each other, thus creating the closed form that so preoccupied Ponti. Nor is this closed form confined to the horizontal aspect—between the topmost storey and the roof there is a slight gap which similarly limits the tower's vertical thrust. Closed as its form may be, the building is, however, far from earthbound: rising thirty-six floors from its podium at ground level, it seems to advance toward the viewer with something like a flourish, an effect enhanced by the relative isolation in which it stands. (Such isolation was, of course, carefully planned. Buildings that would normally have clustered at its base—eg. auditoria and service rooms—were placed underground out of sight, or else styled differently so as to separate them from the tower.) The whole building, in fact, functions rather like a giant billboard; even at night, it is lit in such a way as to emphasize its singularity. Ponti, indeed, was so conscious of its advertising role that even before it was complete he released to the press certain key architectural diagrams ("slogans") as a means of raising public awareness of the tower and, by extension, of Pirelli. The strategy was by all accounts very successful—for months the building was the most talked-about construction project in Italy.

The interior of the tower is no less original than the outside. While there is no central entrance hall or vestibule—the visitor moves more or less straight into offices—there are on each floor long open aisles that run across the building and end at glazed windows. These aisles permit the circulation of light and air; combined with the large amounts of glass in the exterior walls, they help create a pleasant, sunny ambience. Nowhere, indeed, not even in the underground areas, is there the sense of constriction and claustrophobia common to so many modern office blocks; for all its size and mass, the tower gives the impression not of weight but of lightness.

There will always be those for whom any modern building is an unsightly monstrosity, and these critics would, no doubt, dismiss even the Pirelli tower. But for those who are prepared to accept the Modernist canons of rigour, austerity and innovation it remains a stylish symbol of what modern architecture can—with skill and daring—achieve.

—John Terence O'Leary

Bibliography—

Kidder-Smith, G. E., *Italy Builds*, London and Milan 1955.
Ponti, Gio, "Espressione dell' edificio in costurzione a Milan," in *Domus* (Milan), March 1956.
Nervi, Pier Luigi, "The Place of Structure in Architecture," in *Architectural Record* (New York), July 1956.
Labo, Mario, *Ponti: Summing Up*, Milan 1958.
Banham, Reyner, "Pirelli Building, Milan," in *Architectural Review* (London), March 1961.
Shapira, Nathan H., ed., *The Expression of Gio Ponti*, Minneapolis 1967.
"Gio Ponti," special monograph issue of *Space Design* (Tokyo), May 1981.

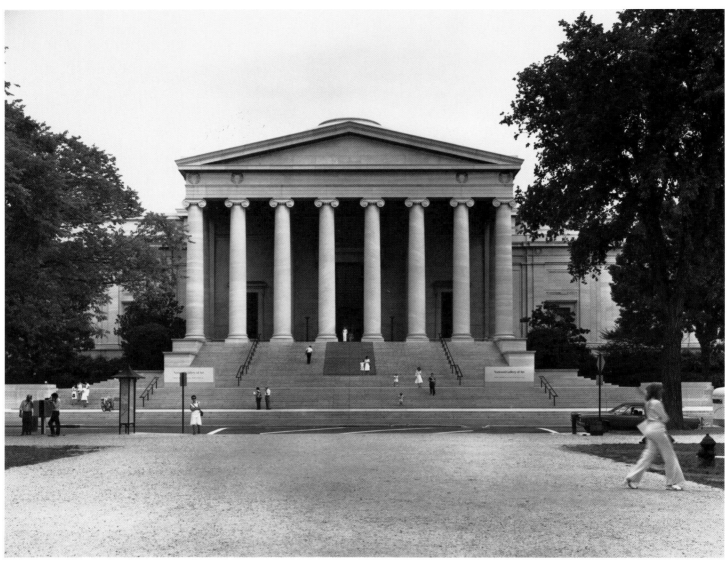

Photo © Wayne Andrews/Esto

John Russell Pope (1874–1937)
National Gallery of Art (West Building), 6th and Constitution Avenue, N.W., Washington, D.C., 1937–41

The National Gallery of Art in Washington (1937–41) is the last in a series of neo-classical governmental buildings that began with Latrobe's design for the U.S. Capitol (1803–17). The Gallery is the fulfillment of the vision of Andrew W. Mellon, who founded the institution by giving the building, an endowment, and a collection of old master paintings. Although contemporary critics lamented the traditional design of the National Gallery when it opened in 1941, the style of the structure was, in some ways, preordained; it is unlikely that a rich financier, intent on establishing an institution to preserve the Western heritage in the nation's capital, would have chosen a style other than neo-classicism.

Andrew Mellon (1855–1937) had served as Ambassador to Great Britain and as Secretary to the Treasury under Presidents Harding, Coolidge, and Hoover. As early as 1928 he was discussing with his family the idea of establishing a national art museum; by 1935 he had selected John Russell Pope (1874–1937) as his architect. His letter to President Franklin D. Roosevelt offering to build a building and donate his collection is dated to 1936.

The widely-respected Pope had graduated from Columbia University in 1894 and won the American Rome Prize; he spent two years in Italy and Greece studying Classical architecture and working with Charles McKim and then two more years at the Ecole des Beaux-Arts in Paris. Mellon and Pope had worked together on the Federal Triangle, for which Pope designed the most symbolic structure, the National Archives (completed 1935). Pope had other Washington structures to his credit, including the Temple of the Scottish Rite (1910–15) and the Thomas Jefferson Memorial (1934–43). At the same time that Mellon was considering building a national museum, Pope was designing museum buildings and additions, including the Baltimore Museum (1926–35), the Duveen Gallery for the Elgin Marbles at the British Museum in London (c. 1931), a sculpture gallery for the National Gallery, Millbank (now the Tate Gallery) in London (1932), the museum for Washington's Headquarters in Morristown, New Jersey (c. 1935), and projects for the Metropolitan Museum of Art, the Frick Collection, the Art Institute of Chicago, the Walters Art Gallery, and the Cloisters (c. 1930).

By the early twentieth century the basic neo-classical design for a museum building had been established: a porticoed entrance, often domed, was flanked by wings, as seen in the National Gallery in London (William Wilkins, 1832–38), the Fine Arts Building of the Columbian Exposition (Charles B. Atwood, 1893), and the Brooklyn Institute of Arts and Sciences (now the Brooklyn Museum; McKim, Mead and White, 1893–1915). Such structures expressed the ideals of the Western cultural tradition through their references to ancient Greece and Rome. In addition, the rotunda and the temple facade had been appropriated as popular expressions of American democracy through their use by Thomas Jefferson and other American architects.

In Pope's design, the Pantheon centerpiece with its grand staircase and smooth Ionic columns gives an emphatic focus to the 782-foot-long structure. Facing the mall, it guarantees that the main facade of the building is in a favorable relationship to the Capitol. The long and relatively low wings, completely windowless, emphasize the interior as an enclosure, a container for culture.

Mellon played an important role in the evolution of the building. His choice of a site on the mall, at the foot of the hill below the Capitol, fulfilled the goals of the McMillan Commission, which in 1901 had urged the construction of "City Beautiful" groupings of neo-classical buildings along a mall between the Capitol and the Washington Monument. Mellon and his associate David Finley, who later became the Gallery's first Director, advised Pope as he planned the building; on their advice Pope eliminated the porticoes he had planned for the ends of the building.

The building is completely sheathed in smooth marble to suggest wealth, refinement, and permanence. The stone chosen was a Tennessee marble that looks almost snow-white in full sunshine but has a pronounced rose hue after rain. Pope envisioned figural sculpture in the pediments, but it was eventually decided to leave them plain.

Despite the neo-classical basis for the design and decorative motifs, the building is not a strict revival of any classical or earlier neo-classical structure, and it is unlikely that a connoisseur of architecture would mistake it for a nineteenth-or early twentieth-century structure. The building is simply too plain and severe. The broad planar surfaces of marble, the smooth columns, and the razor-sharp lines of the moldings produce an austere, undecorated effect that can even be related to the "Moderne," the Art Deco style prominent in architecture and decorative arts in the 1920s and '30s. The building becomes a minimal statement of the classical ideal in which each form is reduced to its essentials and then expressed in precisely-milled stone.

The modernity of the National Gallery is also expressed in its steel construction and technical sophistication. It was one of the first museums in the world to be completely air-conditioned and humidity-controlled; the original efficient system is still in use. The galleries use natural light from broad expanses of skylights, which is supplemented by artifical light depending on weather conditions.

The interior is dominated by a grand rotunda with a highly polished stone floor, stone walls, a fountain, and dark green Italian marble columns supporting a coffered dome; the effect is of awed grandeur, a mood once considered appropriate for a visitor about to approach works of art. Flanking sculpture halls lead the visitor to garden courts with more fountains; clustered around the sculpture halls and garden courts are small rooms to showcase the works of art. These were designed as a series of rather neutral period rooms that would provide appropriate, if restrained, settings for the works of each particular period. Comfortable couches urge the visitor to enjoy the cultural experience.

The National Gallery was among Pope's last works; he died in 1937, only hours after Andrew Mellon. The completion of the structure was undertaken by his assistants, Otto R. Eggers (1886–1953) and Daniel P. Higgins (1886–1953), who were loyal to the original designs; Eggers is responsible for the design of such unfinished elements as the neo-classical marble benches and fountain in the rotunda.

On March 17, 1941, President Franklin D. Roosevelt dedicated the National Gallery before 8000 guests, including Paul Mellon, the son of the donor; the service was broadcast nationwide. The collections of the National Gallery have continued to grow, and the institution that Andrew Mellon established now attracts approximately six million visitors a year. After the opening of I. M. Pei's addition to the National Gallery in 1978, Pope's structure became known as the "West Building." Pei's East Building, which was built with funds given largely by Paul Mellon, was designed to complement the original National Gallery, as is evident in the materials; the surface of the new building is the same smooth pink marble and it is finished to an equivalent sharpness of edge. By 1968, however, when Pei's design was conceived, the commitment to modernism demanded a building that would avoid any reference to earlier architectural styles.

—David G. Wilkins

Bibliography—

Hudnut, Joseph, "The Last of the Romans: Comment on the Building of the National Gallery of Art," in *Magazine of Art* (New York), no. 34, 1941.

National Gallery of Art, *John Russell Pope and the Building of the National Gallery of Art*, exhibition brochure, Washington, D.C. 1991.

Bedford, Steven, "Museums Designed by John Russell Pope," in *Antiques* (New York), no. 139, 1991.

Williams, William James, "John Russell Pope: The Building of the National Gallery of Art, Washington," in *Apollo* (London), March 1991.

Photos © Lucien Hervé

446

Jean Prouve (1901–84)
School in Villejuif, Val-de-Marne, 1957

When the municipality of Villejuif (east of Paris in Dept. Val-de-Marne), in the beginning of the 'fifties, decided to order a school that could be taken apart, they took their commission to someone who was very well suited for the job: Jean Prouvé. It is not known if the council of Villejuif was also satisfied with the result. If the school had been made two or three decades later it would perhaps be called "high tech." Erronously, for Prouvé's design has nothing to do with architecture that gives only the image of being a product of sophisticated steel industry or being the industry itself—a refinery, for instance. The School of Villejuif simply *is* a product of industry.

In the 'fifties that specific industry, however, was not much used for buildings. Bricks, stone, concrete, glass and wood—they are, roughly speaking, the materials a conventional architect preferred (and still prefers) and the usual building industry produced (and still produces). The industry that Prouvé tried to use for buildings was usually reserved for cars and aircraft.

The result of Jean Prouvé's activity for Villejuif's municipality gives an airy impression. The school has become a sort of tended skin, at two sides consisting of transparent glass. The school could be taken apart like a tent . . . or like a machine.

The oblique form of the glass walls at one side and the curved roof do not fit into the esthetics and the style one generally associates with "classical" modern architecture. It has more to do with the dynamic forms which were emerging in the postwar period and which are sometimes called "organic." However, named organic or not, form with Prouvé was always an outcome, it was never a starting point or an end in itself.

Most of Jean Prouvé's sophisticated architectural constructions are based upon one leading constructive principle. For the school of Villejuif it is the so-called *béquille*, a crutch. This T-shaped crutch, performing as a column and a roof beam at the same time, is made from sheet steel. For the vertical part, the sheet has been folded into a closed rectangular section, for the horizontal part into an open U-form. The horizontal beam has been divided in two parts—the longer part bridges a part of the classroom, the shorter one the total width of the school corridor. Here Prouvé's technical solutions did not stop.

The crutches have been erected at a distance of 1.75 centimeters each. They are connected and stabilized by the roof construction that consists of long transversal beams and sheets of plywood. Both ends of the horizontal part of the crutch are pulling the roof downwards, so it is slightly curved. At one side (over the classrooms) the roof runs through in order to form a canopy above the glass wall, protecting the glass wall from rain and the school children from too much sun. In the vertical V-shaped metal posts of the glass "curtain" Prouvé has incorporated another of his inventions—openings are providing for air circulation.

Jean Prouvé grew up in the last years of the so-called Ecole de Nancy, an Art Nouveau movement centered in and around a city that was always famous because of its glass and iron industry. Jean Prouvé's father, Victor Prouvé, was one of the leading figures in the Ecole de Nancy. Jean was trained as a "decorative" smith in a time when ornament was still considered necessary. Quickly, he adopted modern methods and techniques. Before World War II he had opened a work shop that gradually developed into a real factory.

Some years before he designed the School of Villejuif, Prouvé was still director-owner of a metal processing factory in Maxéville, in the outskirts of Nancy. His factory produced furniture, building parts and complete buildings. Prouvé never became a director secluded in his office; his workers were always convinced that he surpassed them in their crafts. Their boss continuously demonstrated how to hammer, to bend and to weld metal. By foregoing an assembly line (that presupposes specialization), his factory gave ample scope for improvisation. If there were not enough orders for buildings or building parts, one changed simply to furniture making.

Prouvé's products were aimed at a market—of architecture and furniture—that was not very familiar with the materials and production methods which were used in his factory. Apart from furniture, he tried to develop houses that could be taken apart, that could be moved from one place to the other or that could be delivered in parcels on the spot. French architects—Prouvé always had to engage an official architect when it came to real building on a site—and the French building industry were not amused by his endeavours in "their" disciplines. Still, he managed to receive some important orders, especially in the years directly after World War II, when there was a shortage in housing and other buildings. In 1953, unwilling to bend to the wish of the majority-stockholder of his factory—Aluminium Française—that there should be a greater uniformity of the factory products, he left as a director and became, as he was with the School of Villejuif, a consultant engineer whose constructive ideas, nevertheless, were still far reaching for architecture.

The School of Villejuif functioned as was foreseen. After having been a school for some years it was dismantled. The parts were moved and reassembled on another spot. Later, it became an architect's office. Now it is a showroom. As long as the spare parts are available or remade, it can be used. It only wears out, like the coachwork of a car does.

—Jan Van Geest

Bibliography—

Musee des Arts Decoratifs, *Jean Prouve*, exhibition catalogue, Paris 1964.
Huber, Benedikt, and Steinegger, Jean-Claude, *Jean Prouve: une architecture par l'industrie*, Zurich 1971.
Beeren, Wim, van Geest, Jan, and others, *Jean Prouve, Constructeur*, exhibition catalogue, Rotterdam 1981.
Clayssen, Dominique, *Jean Prouve: l'idee constructive*, Paris 1983.
Cohen, Jean-Louise, "Jean Prouve 1901–84," in *Casabella* (Milan), July/August 1984.
"Jean Prouve et Serge Mouille," in *L'Oeil* (Paris), May 1985.
Centre Georges Pompidou, *Jean Prouve, constructeur*, exhibition catalogue, Paris 1990.

Bruno Reichlin (1941–)/**Fabio Reinhart** (1942–)
Casa Tonini, Torricella, Switzerland, 1972–74

The Casa Tonini is a precisely shaped, regularly formed building. Its plan is a perfect square and its cubical volume is covered by a pyramidal roof. This is topped by a lantern replicating this shape on a smaller scale. The Casa Tonini is built of a reinforced concrete skeleton with stuccoed and glazed panels.

The design follows both the rational and the historicizing developments of post-modern architecture. Its creation resulted from the encounter of Aldo Rossi's and Robert Venturi's theories. The main idea was that the new must be created through manipulation of traditional orders. The primary historical source of the design lies in the Renaissance style, which is transformed through typological and contextual investigation.

The Renaissance elements refer to Andrea Palladio's typical solutions for country villas. The cubical volume of the Casa Tonini, the plan, and the emphasis on the central bay were taken from this source. The Casa Tonini plan is a nine-square grid, symmetrical on all four sides. This is exactly Palladio's scheme as distilled by Rudolf Wittkower. Reichlin/Reinhart used this systematized plan and arranged for a central hall, secondary spaces on either side, and small spaces in between. Public spaces are located on the ground floor, private ones above. This plan solution may have been chosen because the Casa Tonini was built for a mathematician. Following the Renaissance belief that the dignity of architecture resulted from its foundation on numbers and geometry, Reichlin/Reinhart made their building an expression of a discipline that comprised art and philosophy. Consequently, the post-modern house of a mathematician became a celebration of the essence of the Palladian villa.

The historical references are quoted in an abstract manner, thus increasing ironically their distance from the original. The recovery of history proceeds through the dismantling of previously united elements. Palladio's frontispiece is placed behind the building, in the form of an arch that refers also to the Renaissance theme of the "view through an arch," and simultaneously increases the spatial depth of the interior.

These motifs are presented in a dignified manner. A practical use is found behind most of them. The posts of the arch contain chimney flues, and the cornices serve as rain gutters. The historical motifs are used to give this modest house an allure of grandeur. Here, they are combined with the formal rigor of the International Style, as seen in the abstract details and the use of modern materials. The look of the building is formalized Palladian, modernized through the use of a hard-edge reinforced concrete skeleton and eroded corners. The Casa Tonini emphasizes normative design with a relationship to Classicism.

Reichlin/Reinhart's design is based on the logic of an inherently architectural system. Its subjects are living in the country and a discourse of architecture in terms of types and rules. Among the themes used is that of the house within the house. The central hall, containing the dining area on the ground floor, continues into the lantern on top. Through this vertical interpenetration of space, the central bay becomes the focus of the house. Allowing light to penetrate into the center of the building transforms Palladio's villa into a modern experience. Moreover, this changes the central bay into a public square within the building. The four cross arms extend the central volume to the exterior. This axis of the house is emphasized through pediments lining the bays adjacent to the central core. Also dealing with the house theme, they pick up on Palladio's belief that the temple front originated in the private house. The steel grids enclosing the central bay on the upper floor further enhance its transparent quality. The whole building is an outstanding example of craftsmanship.

Another theme found in the building is that of centrality. Already noted in both plan and spatial articulation, it is also noticed on the entrance platform. Similarly, the Josef Hoffmann dining room set occupies the center, announcing this motif with its round table.

The elegance of the interior is in contrast to the brutalist exterior. Inside, the historical quotations are more openly acknowledged. On the whole, the historicism of the Casa Tonini is not meant as a joke, but demonstrates a stolid approach to history. Most historical allusions are slightly distorted and built with contemporary materials. One finds an array of Venturi's complexities and contradictions. These include the above contrast between inside and outside, as well as a modernist-versus-an-historical vocabulary.

The Casa Tonini postulates strongly that architecture has the right to its own autonomous language. This is revealed in the typological foundations of its design. While priority was given to the typologically fixed total form, this was merged with the individual traits of the architects. Reichlin/Reinhart produced their own piece of "ecriture architecturale." They combined an architectural symbolism with the pleasures offered by this text. They established stable connections between various existing types of houses, interiors, and the eternal language of architecture, and demonstrated their dialectic relationships. A quote constitutes the basis of the architectural solution.

In its broader cultural and geographical contexts, the basis of the Casa Tonini is a conceptual understanding of the traditions of the Ticino region. The architects searched for elements which are repeatedly used in vernacular architecture. This confirmed that architecture results from construction and materials.

The house thus tries to continue the existing traditions by extending the tendencies of the past. The array of particular sources alluded to by Reichlin/Reinhart points to their additional intention to address precisely the surrounding topography and geography. Their design presents a form that integrates all the substances, forms and relationships of buildings meant for living in the country. The final solution resulted from a sensitive approach to the surrounding landscape with its villages. As the Ticino region is a borderland between different cultures, Reichlin/Reinhart chose a realistic approach that subordinated techniques, materials and formal inventions. Through a clear pattern, they reformulated the context to establish the mutual relationship of history, environment and architecture. The geometric precision of the individual details ties the Casa Tonini to the surrounding mountain landscape. The building attempts to interweave modern culture with the local tradition, by combining modern materials with historical typology. The arch on the garden side is an appeal to the beautiful Ticino landscape. Reichlin/Reinhart integrated their house into the continuous evolution of an esthetic formal language and a dialogue with the needs of the user. In this respect—in addition to the strong historical allusions—the Casa Tonini by Reichlin/Reinhart joins with the mythical topography of the region.

—Hans Rudolf Morgenthaler

Bibliography—

Tendenzen—Neuere Architektur im Tessin, Zurich 1975.
"Residences: Twenty Works in Ticino," in *Architecture + Urbanism* (Tokyo), no. 9, 1976.
"La tendenza dans le Tessin," in *l'Architecture d'Aujourd' hui* (Paris), no. 190, 1977.
Nicolin, Pierluigi, "Intrinsic Architecture: Works by Bruno Reichlin and Fabio Reinhart," in *Lotus International* (Venice), no. 22, 1979.
Architecture 1980: The Presence of the Past, Venice Biennale, New York 1980.
Werner, Frank, "Lieder die man nicht erwartet—neue Architektur im Tessin," in *Bauwelt* (Berlin), no. 71, 1980.
Blaser, Werner, *Architecture 70/80 in Switzerland*, Basel 1981.
Muller-Dietrich, Ingeborg, "Vergangenheit und Gegenwart in der Architektur: Reiseeindruecke aus dem Tessin und der Toskana," in *Deutsches Architektenblatt* (Stuttgart), no. 18, 1986.
Richardson, Sara S., *Bruno Reichlin and Fabio Reinhart: A Bibliography*, Monticello 1988.
Brown-Manrique, Gerardo, *The Ticino Guide*, Princeton 1989.

Gerrit Thomas Rietveld (1888–1964)
Schroder House, Utrecht, 1924

When Rietveld designed the house for Mrs. Schröder in Utrecht, it was for the first time he was working independently on a design that was going to be executed. He began his career as a cabinet-maker. He acquired architectural know-how through attending evening-classes. Up until 1924 he did not progress beyond the conversion and furnishing of stores. Yet ever since 1918 Rietveld's furniture designs set a precedent for the Schröderhouse.

In 1918 Rietveld got acquainted with some of the members of the "De Stijl" group, such as Van Doesburg and Oud. He appeared to be receptive to the new aesthetics of the group. Shortly after, he produced his Red and Blue chair. This chair already embodies certain principles that are essential for the Schröder house as well. The chair is made out of a number of equivalent elements that are not concealed, in contradistinction to current armchair practice at the time. Hence the construction of Rietveld's chair is transparent. The meaning of the material out of which the chair is made (wood) is negated. The painted finish makes the wooden surface-structure invisible. Moreover the separate elements are slender because of which they seem to be reduced optically to lines and surfaces that together form an abstract composition. Rietveld himself remarked that ". . . most of all, the whole is a free-standing and clear object in space and form overcomes material."

Concerning the Schröder house, spatiality also comes first and form overcomes material. Just like the Red and Blue chair the house is spatial. The space is defined by surfaces and lines. As opposed to the traditional dwelling of the time that makes a clear distinction between inside and outside, Rietveld in the Schröder house aims at the continuity of inner- and outer space. Comparable with the Red and Blue chair, the surfaces and lines of the Schröder house are covered with plaster and paint which makes the structure of the building materials invisible. Colored surfaces are an important compositional device for Rietveld, both on the interior and the exterior. Rietveld's working method sometimes led to hilarious misunderstandings—Walter Gropius and Jean Badovici commended the Schröder house amongst others for the use that was made of modern technology (use of concrete) while most of the house was erected using traditional brick technique. The use of concrete is limited to 7 pillars that carry the first floor and the roof and to the slabs that constitute the roof and the balconies. The steel I-profiles that are visible on the exterior only serve to support the cantilevering balconies and the roof.

The resemblances between the chair and the house above all are conceptual. As far as related to the architectural elaboration of his ideas, Rietveld was inspired by some of the projects of his "De Stijl" colleagues. These precedent projects did not get built, however. Especially the "Maison particuliere" and the "Maison d'artiste" by Van Doesburg and Van Eesteren (1923)—designed for the Parisian art dealer Leonce Rosenberg—are based on the same aesthetic concepts. Rietveld made a model of one of the designs for the exhibition at Rosenberg's Galerie de l'effort moderne.

The Schröder house is not only a formal manifest of the "De Stijl" principles in architecture. It also puts "dwelling" in another perspective. The house has only two floors. The ground floor is partly occupied by service rooms (kitchen, maid, storage, study), the first floor accommodates the living and sleeping activities. The stairs are located in the middle of the house and are toplit. The first floor is rather unconventional. It is possible to divide the space by means of sliding doors, varying from a situation with four separate rooms or any combination of two or three rooms (for instance for sleeping during the nighttime) to a situation with only one large space. The spatial effect, even today, is impressive. Small details enhance the spatial effect. The side-hung casement window opening, for instance, is placed away from the corner with no corner mullion which makes the ceiling seem to float. The flexibility of the walls has yet other consequences: the use of the living room as bedrooms during the night implies the disappearance of daytime-furniture during the night, and in turn the disappearance of beds and the like during daytime. Therefore Rietveld designed tables and wall-beds that could be folded back. One had to live in an active and conscious way in order to take full advantage of the opportunities that the house had to offer. Yet, the living conditions were far from spartan. The house was equipped with electricity, central heating and running hot and cold water. Commodities like these were not at all self-evident in 1924. It must be said that the design and the furnishing of the house came into being in close collaboration with Mrs. Schröder who shared Rietveld's ideas. This made it possible to design even the smallest details of the house and to comply with the wishes of the client at the same time.

The tradition of the creation of enclosed interior spaces for a dwelling was broken first of all by Frank Lloyd Wright. His architectural ideas inspired architects in the Netherlands—shortly after his return from the United States of America Robert van 't Hoff put into practise the lessons he had learned from studying Wright when designing his villa at Huis ter Heide (1914–16). Rietveld's solution went even further. The traditional enclosing walls totally dissolved under his hands. The Schröder house is the climax of the "De Stijl" architecture. In the years that follow Rietveld's interest and ideas shifted towards issues related to the functionality of architecture, even though he never became a pronounced functionalist. Already four years after the Schröder house, in 1928, Rietveld writes that color and form can have a negative impact on the perception of space.

—Otakar Máčel

Bibliography—

Brown, Theodore M., *The Work of Gerrit Rietveld, Architect*, Cambridge and Utrecht 1958.
Rietveld, Gerrit, *Schroder Huis*, Amsterdam 1963.
de Rook, Gerrit Jan, and Blotkamp, Carel, *Rietveld Schroderhuis 1925–1975*, exhibition catalogue, Utrecht 1975.
Bless, Frits, *Gerrit Rietveld, 1888–1964: een biografie*, Amsterdam 1982.
Overy, Paul, *Rietveld Schroder House*, Houten 1988.
Casciato, Maristella, "Casa unifamiliare, Utrecht," in *Domus* (Milan), September 1987.
Lenneke B'uller, Frank den, "Schroder House: A Work by Gerrit Rietveld," in *Lotus International* (Milan), no.60, 1988.

Miguel Angel Roca (1936–)
Central area pedestrianization, Cordoba City, Argentina, 1979–80

Argentine architect Miguel Angel Roca is also a painter, a writer and a professor. But he is essentially a polemicist. For Roca, graduated at the University of Córdoba, one of the oldest in America, and a disciple of Louis I. Kahn (1966–68), good architecture is to make places and to build, a fundamentally cultural operation.

The architect should be, for him, a professional of thought, that is to say an intellectual. According to Roca, "philosophy is not valid, but paradoxically we can do nothing without it."

Innumerable projects have poured out of his studio for over two decades. Dozens of works have sprung up all over Argentina, in places ranging from the tentacular Buenos Aires to towns in the outlying provinces, and also in foreign countries. These obviously differ according to the nature of the brief—residential blocks, community centres, low rise housing developments, office blocks, shopping centres, banks and churches. Nonetheless, all these works are integrated in a distinctive building rhetoric on the basis of a process that involves a direct relationship with the future users.

Secretary of Public Works of the Córdoba City Council for twenty months in 1979–81, Roca changed his native city at a dizzying pace. Roca's role as a questioner and challenger outweigh his administrative work, his programme or the performance of his official duties. He has stimulated and excited his fellow citizens, but he has also exasperated and confused them. He has forced them above all to engage in heated discussions on the fundamental themes of their society, their culture and the nature of their day-by-day lives.

This controversial approach has led to a number of broadly shared conclusions, first of all Roca's view of public space as the essential raw material and basic setting of all events in the life of the inhabitants of the city. This is the way his projects identify with urban reality—the city accepts his work and through this act constitutes itself in space and time. Roca's architecture activates people's minds and logical processes; it prepares them to embrace new values, meanings and modes of use, *i.e.* new modes of living.

Departing from Kahn's remarks about the street as "the first being of the city, a gift of the neighbours, whose facades are its own face, having the sky as roof," Roca planned and executed the pedestrianization of the central area of 16th-century Córdoba City, capital of the ancient province of the same name, and the second highest-populated in Argentina, after Buenos Aires. The pedestrianization is nothing but the acknowledgment, in the case of Córdoba, that the above mentioned pedestrian area has the

extended character of a main square which the central square had at the turn of the century.

Between Plaza San Martín (a green 19th-century "building" which occupies a square whose centre is honoured by San Martín monument) and the Cathedral and the former Cabildo (Municipal Council) building, last testimonies of the Spanish colonial Plaza Mayor, there was a space occupied by a parking lot.

Its transformation into the Plaza de Armas (or Parade Ground) was the starting point of two simultaneous cultural projects—the pedestrianization of the central area and the re-significance given to historical monuments. The main idea was conveyed by paving the space in stone and its unique characterization due to the subtle introduction of mirrored façades, or marble shadows, of the monuments on the soil, a new representation of buildings which thus acquired a new reading dimension.

Adjoining this new Plaza de Armas is the Pasaje Santa Catalina, unique in its kind, defined by the lateral façades of the Cathedral and the former Municipal Council building and terminating in front of Santa Catalina church, at Obispo Trejo Street. It has been provided with stone paving in a pattern of concentric, adjacent, aligned circles reminiscent of the circular church's dome.

Now at Obispo Trejo Street, a propyleum or shady marquee composed of twelve *palo borracho* trees, whose tubs have been designed as stony seats, creates the covered gate of a promenade which extends from a small planted square behind the Cathedral. An arch, threshold of the historical centre and the remnant of a virtual wall, is transformed into a gate, located at the middle of the axis formed by Obispo Trejo Street and its continuation Rivera Indarte Street.

A row of *palo borracho* trees closes the space and opens another one to the North in front of the provincial Legislature and the Ministry of Economy. Floor plans, not façades, of both buildings are represented in white marble on the soil. South of the arch, the pedestrian mall extends for two more blocks involving the buildings of the University (founded 1614) and the Colegio de Monserrat, their façades reflected in marble on the paved soil.

To West and East of the northern end of the axis Trejo-Rivera Indarte are located the pedestrian zone habilitated in the 1970s. The treatment followed in this area—five blocks in length and cruciform in shape—is one of vaulted pergolas of metallic arches covered with climbing deciduous plants, completed with a floor made of granite, grey slate and white marble slabs that mark the structural rhythm and the positioning of the flower beds and seats. But as Roca said, the pedestrianization of these significant areas are a simulacrum of a more ambitious cultural project—a model of a pedestrian city, a figurative city which abjures functionalist cities with exclusive zonings, activities aseptically juxtaposed and motor vehicles as unique means of transport.

A city, after all, which retrieves man's priorities, the habitable condition of the built product, that is the human condition.

—Jorge Glusberg

Bibliography—

Glusberg, Jorge, *Miguel Angel Roca*, London 1981.
Wagner, Walter F., "The Historic Core and Two Neighborhood Centres, Cordoba, Argentina," in *Architectural Record* (New York), July 1984.
"Projects for the City of Cordoba, Argentina," in *Architectural Design* (London), no.11/12, 1984.
"Profile: Miguel Angel Roca," special monograph issue of *Mimar* (Cambridge, Massachusetts), September 1988.
Roca, Miguel Angel, "Il Progetto Cordoba," in *Domus* (Milan), January 1989.

Photos courtesy Roche Dinkeloo & Associates

454

Kevin Roche (1922–)/**John Dinkeloo** (1918–)
General Foods Corporation Headquarters, Rye, New York, 1982

As elegant and grand as any château, palazzo or manor house, General Foods Corporation Headquarters sits astride a lake surrounded by a great park of sweeping lawn and woods near Rye, in New York State.

Completed in 1982, it is a building which has a strong sense of Palladio about it, yet it solves the functional problems of a large office building with on-site parking in a rural setting with consummate ease. Its gleaming white presence, surrounded by the green of nature, successfully achieves the corporation's desire for a visual symbol to validate it as an endeavour of substance. Image is all-important, even to a firm which produces such ordinary breakfast fare as "Post Toasties" and "Alpha Bits."

Kevin Roche has created just the right building in both functional and symbolic terms and, as a bonus, he has also designed one of the most sophisticated and aesthetically pleasing buildings of the 1980s.

General Foods Headquarters is reminiscent of the grand country houses of Europe, not only in its setting, but in its form as well. The central structure is a huge, curved rotunda, and the wings, stretching to either side, have attached pavilions, which extend forward, the whole ensemble resembling an enormous letter E embracing the lake. The dome-like form atop the central rotunda, extends to a simple, almost windowless structure at the rear. Its shape is somewhat suggestive of the blind, simple, blocky forms of grain silos, not entirely inappropriate in its symbolism for a company involved in breakfast foods.

Roche has solved the problem of the necessary and necessarily vast carpark required by the rural setting, by placing it beneath the office building. Indeed, it creates an imposing three-level podium for the five levels of offices and provides a visual contrast for them with its blind, aluminium-clad, strongly horizontal massing. The offices are also clad in aluminium alternating with long strips of reflective blue-green glass. The effect is lighter,

busier, but still retains overall a feeling of classically cool elegance. The reference to the great country house is evident but general rather than specific; it is a matter of allusion rather than direct statement.

Roche states: "My interest . . . was in the principles of classical composition. I did not want to get into mimicking any of the other aspects of classical architecture."

The classicism of General Foods is sensed rather than seen—there are no corinthian columns, no pediments and no cornices. On a fifty-four acre site, the seven storey (above ground) building contains 560,000 square feet of offices and 500,000 square feet of parking for 1250 cars. This is not a small building.

The lake is necessary to control flood waters as twenty-four acres of the site is flood plain, seven acres of which is the pond. The lake also provides the splendid setting to the main building. Main access to the building is from directly in front with a causeway crossing the lake onto a small island, continuing underneath a set of stairs—typical of eighteenth-century entrances but extended forward from the main façade—into the carpark.

The visitors' lobby is surmounted by a mirrored, top lit cone that fits into the dome form seen in the principal façade. It creates a dazzling, glittering space and an effect more to be expected in a ritzy hotel than in a country office building. It is the result of Roche's search for interior surfaces that have "life." Light, lights and reflection are used throughout the building adding "sparkle" to its suavely elegant white and beige, glass and metal surfaces.

The General Foods Headquarters won the Twenty-ninth Annual R.S. Reynolds Memorial Award for distinguished architecture using aluminium in 1985. The jury's report called it a "magnificent solution for a corporate headquarters. The complex forms are bold in their shape yet simple in their execution."

In General Foods Headquarters, Roche solved aesthetic and functional requirements, balanced vast bulk with fine detail and created a structure of great visual impact, a building rather more refined and elegant, and richer in symbolism, than you might ordinarily expect for so mundane a concern as a food processor.

—Brian Phipps

Bibliography—

Futagawa, Yukio, *Kevin Roche John Dinkeloo and Associates 1962–1975*, Tokyo and Fribourg 1975.
O'Regan, John, and O'Toole, Shane, eds., *Kevin Roche, Architect*, Dublin 1983.
Futagawa, Yukio, ed., *GA 9: Kevin Roche John Dinkeloo and Associates*, Tokyo 1984.

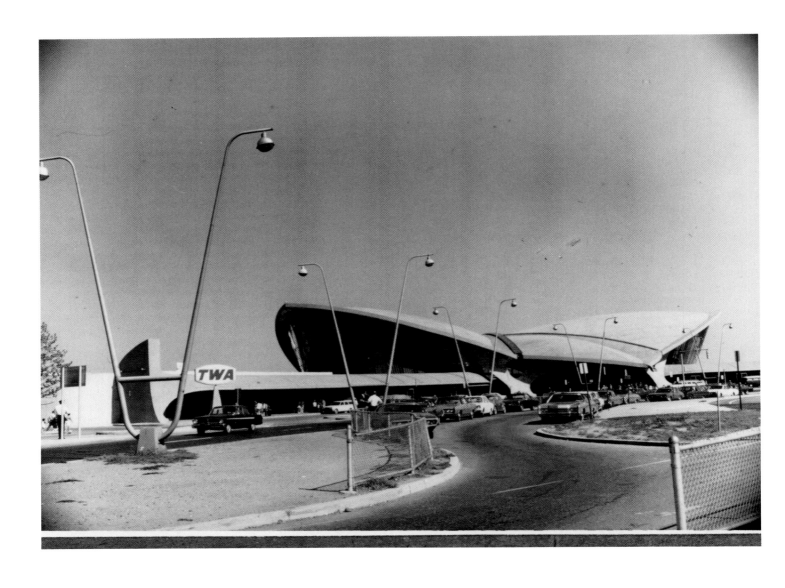

Eero Saarinen (1910–61)
TWA Terminal, John F. Kennedy International Airport, New York, 1962

At a time when the International Style reigned supreme, Eero Saarinen's TWA terminal became instantaneously famous and was probably one of the best known contemporary buildings in the world. The dynamic and sculptural form of the building was only possible in reinforced concrete. The rather spectacular shape of a soaring cross-vaulted roof suggested flight or, to many, a bird in flight. The building's imagery is flight in all of its aspects, from the powerful exterior forms to its fluid interiors. Perhaps the shape of a building as a metaphor is questionable: it certainly was questioned by many critics and architects when it was built. Yet the success of the structure as a transition from the world of terra firma, the automobile, the congestions of New York City—to the experience of flight and travel as another dimension was carried out with great success.

There is possibly some kind of structural exhibitionism in the TWA terminal. It was a form of experimentation that Saarinen more than most of his contemporaries engaged in consciously and with varying degrees of success in several important commissions. But in an era when many architects were constrained by a rigid Miesian approach it was also refreshing, and probably ahead of his time to see the powerful forms created by Saarinen—forms that became instant landmarks. Saarinen, unlike most of his contemporaries, did not appear interested in developing a style recognizable as his own. Each new project was approached as if there were no precedents for its solution. His work was always fresh and exciting; his early death put a halt to the development of a talent that would clearly have left an even greater impact on twentieth-century architecture and design than any of his peers. Certainly the TWA terminal will continue to be ranked amongst the major accomplishments of the latter half of the twentieth century.

The TWA terminal represents total design at its best. Saarinen designed the interiors of the building as an integral and necessary component of the whole. He designed the details of seating, the counters, the baggage retrieval area (which never worked very well) and even the large annunciator sign giving the listing of arrivals and departures on an oval-shaped surface that was sculpture as much as a functional component of the building. Even the tiles, which were used as flooring and which covered the rising surfaces of seating enclosures as well as the horizontal surfaces used as tables, were especially developed for the building. Small round white ceramic tiles were bent over many flat and sculptured surfaces; in the latter case, they were ground down around the edges and this formed a permanent and practical surfacing material. The only color used other than the white of the tiles and the grey concrete was the TWA red which appeared in carpeting and upholstery.

The main terminal building was never large enough for the masses of people during peak travel periods. The main seating area in the center of the terminal is a sunken area with perhaps fewer than fifty seats. In addition to the main terminal building, there are "fingers" which are gate areas with lounges and which provide spaces for several aircraft at the same time. One of the great experiences for the traveller was the tunnel connecting the main terminal to the departure areas. An elliptical shape in cross section, the tunnel was illuminated with indirect lighting and provided an almost mysterious environment—a kind of transition from the real world to the world of travel and flight. The main terminal provides the usual amenities needed in an air terminal.

From public facilities to news stands, and from gift shops to a rather elegant restaurant on the upper level. Bridges connecting the various areas on the upper level and the shape of the bridges are very much in keeping with the sculptural form of the building; they also offer additional visual stimulation as well as physical experiences to the users.

The most serious fault of the building is its limited size. It was completed just prior to the introduction of large jets. Undoubtedly, the program given to Saarinen by TWA was met, yet compared to other airline terminals—in fact Saarinen's own later design of the Dulles airport facility in Washington, D.C.—it did not have any flexibility, nor any provision for expansion. The 1960s and 1970s saw ongoing building and expansion at every major airport in the world due to increasing volume of air travel and the ever larger jet aircraft. Appraising the TWA terminal in historic, social as well as purely design criteria, the architect cannot be faulted for designing a building which meets program and criteria given by the clients.

Most certainly, the terminal was a huge success for TWA. It was used internationally in advertising and it has become a recognizable symbol for TWA. Thus Saarinen achieved two symbolic goals: one to symbolize flight, and the other to symbolize TWA.

In the context of the architecture of the period, the TWA terminal can be classified as part of the Neo-Expressionist school, and it is probably Saarinen's most expressive work. It is also a piece of architecture which started to break with the content-denying attitude of the International Style. Saarinen always remained a kind of enigma to the public as well as to his peers. Yet the TWA terminal establishes him once again as a designer, architect, and artist not unlike some of his famous Renaissance predecessors. Even those who have been critical of the symbolism as dominant design expression have been full of admiration for the way the problems of the building were solved once the "parti" had been established. The sculptural forms of the thin shell-reinforced construction are enormously sophisticated and actually were at their best before the necessary glazing was installed. The flowing shapes of the interiors are handled with consistent elegance and functional clarity. No detail from surface materials to signage, and from toilets to waiting areas was left without the deft hand of the master.

At times, the TWA terminal has been compared to Jorn Utzon's Sydney Opera House which established the latter's reputation as a world class architect. Had Saarinen never designed another building, the TWA terminal alone would have made him a significant figure in twentieth-century architecture.

—Arnold Friedmann

Bibliography—

Temko, Allan, *Eero Saarinen*, New York 1962.
Saarinen, Aline B., ed., *Eero Saarinen on His Work*, New Haven, Connecticut 1968.
Spade, Rupert, *Eero Saarinen*, New York and London 1971.
Hunt, William Dudley, Jr., *Encyclopedia of American Architecture*, New York 1980.
Freeman, Allen, "The World's Most Beautiful Airport?," in *AIA Journal* (Washington, D.C.), November 1980.
Friedmann, Arnold, and others, *Interior Design: An Introduction to Architectural Interiors*, New York 1982.
Kostof, Spiro, *A History of Architecture*, New York 1985.

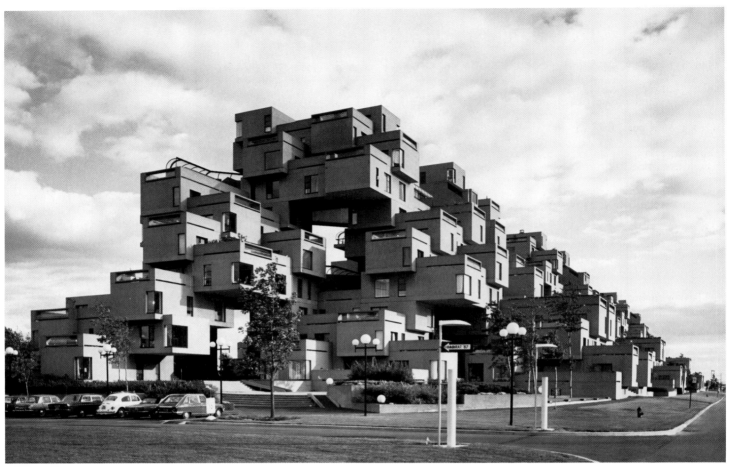

Photo Jerry Spearman, courtesy Moshe Safdie & Associates

Moshe Safdie (1938–)
Habitat '67, Montreal, 1967

Throughout history, world fairs, international exhibitions and the Olympic Games have acted as a catalyst for exciting architectural and engineering feats. Paxton's *Crystal Palace*, Eiffel's *Tower*, Behnisch's Munich *Olympic Stadia* and even Ferris's audacious *Wheel* are distinctive examples. *Expo '67*, the 1967 World's Fair held in Montreal, Canada, was no exception.

This fair commissioned a young architect, Moshe Safdie, to build *Habitat '67*, and he finished the final plans for the project during the six month period between November 1964 and May 1965. Safdie's original idea for the project was envisioned as a complex of one thousand units; however, Montreal had only enough money to fund a modest 160 rectangular modular apartments, stacked twelve high. The resulting pyramid shaped complex was the first major prefabricated housing complex in the world, and it was the hit of the fair, with upwards of thirty thousand visitors queuing up each day.

Many world leaders took a tour of the structure searching for a modern day solution to an age old problem: how to efficiently house a densely concentrated population. A solution to this problem had been attempted as early as the neolithic *Catal Hüyük* in Anatolia.

After completing his early education in Israel, Safdie moved to Montreal, Canada, where he completed a Bachelor of Architecture Degree from McGill University in 1961. He then worked for a year with Louis I. Kahn, a well known American architect, whom Safdie considered to be one of the great teachers of our times. With Kahn he worked on a planetarium, a synagogue and a college facility in India.

Safdie's first major commission was *Habitat '67*. He did not conceive the complex as a simple warehousing project, as many architects of the International Modern Style would have done. Instead, he designed an apartment complex—nestled in a city milieux, convenient to transportation, shopping, cultural centers and schools—that offered what every city dweller wants and needs. These universal desires, often unsatisfied in the contemporary city, are a longing for a private, safe, pleasant space to live and raise a family—ideally with a view and a touch of greenery.

Safdie chose concrete as the principle building material, not only because it is relatively inexpensive, durable and fire resistant, but also because it lent itself to fabrication in separate modules. These steel reinforced modules (exterior dimensions are $17\frac{1}{2}$ by $38\frac{1}{2}$ feet) rendered an interior floor space of 640 square feet. The bathrooms and kitchens were all prefabricated; the modules were cast separately and were eighty-five percent completed off-site before being transported and lifted into place by cranes. The plumbing and wiring was enclosed in separate vertical cylindrical shafts, while the elevators and stairs were located in towers adjacent to the modules. The square-foot cost of approximately $112.00 was expensive by 1960 standards, a point often mentioned by critics of the time. But this first attempt was highly experimental and too small to be cost efficient: larger versions, like *Habitat Puerto Rico* (1968–72), were later built at a small fraction of the cost of *Habitat '67*.

The actual placement of the modules necessitated a careful analysis and integration of three separate structural elements: the boxes themselves, which were load bearing; the pedestrian streets, which acted as beams carrying loads in both horizontal and vertical directions (in addition to earthquake and wind loads); and the integration of the service towers. Loads were thus transmitted in a complex totality, technically known as an "indeterminate structure." Furthermore, Safdie wanted to design a plan that was aesthetically pleasing and allowed occupants an unobstructed view; thus, each of the units opens to a view in three or four directions.

Some of the ideas that most influenced the concept of *Habitat '67* were the Bauhaus/modernist viewpoint that had permeated Safdie's early training, and a visit to Le Corbusier's *Chandigarh* in India (1958–62), which allowed him to examine the sculptural and practical utilization of concrete. Furthermore, he was certainly familiar with Le Corbusier's seminal concrete modular *Unité d'Habitation* (1947–52). Safdie himself writes that he had visited Frank Lloyd Wright's American masterpiece, *Fallingwater* (1936), built in the rolling Pennsylvania countryside. *Habitat '67* displays important influences from Wright's design—not just the obvious stacking of rectangular boxes to form an aesthetic sculptural form, but also its long interlaced horizontal members, carefully and irregularly balanced above the stream bed. And, more importantly, *Fallingwater* provides multileveled unobstructed views from several very private spaces.

Safdie also recounts a visit to Taos, New Mexico, where he saw the pueblos—continuously occupied since the eighteenth century— built of adobe, which is visually much like concrete. The pueblos themselves have antecedents in the cliff dwellings of the Southwest United States, dating from the twelfth century. *Habitat '67* clearly echoes these pueblos (as well as *Çatal Hüyük*) and, had the native Americans understood and used the cantilever, the similarities would be striking indeed.

Despite the fact that Safdie was trained in the modern Bauhaus method and *Habitat '67*— with its simple rectangular boxes— appears at first glance to be an obvious example of modern architecture, the apartment complex exhibits many less obvious characteristics that are more typical of the postmodern style. The boxes are arranged complexly to create what Safdie himself calls a "building system." Many structuralist critics maintain that such postmodern building complexes are "hyperreal" in that they aspire to being, in John C. Gilmour's words (*Fire on the Earth*, Philadelphia 1990), "a total space, a complete world, a kind of miniature city." This is almost identical to what Safdie writes, in *Beyond Habitat*, that he wanted to accomplish in *Habitat '67*. The overall design was shaped by political considerations: Safdie wrote that his political mentor was Buckminster Fuller. Of even more importance, Safdie's concept of structure differs substantially from the modern idea that structure is simply what holds the building up. Safdie insists: "[structure] is also the structure of light, the structure of air, the structure of the distribution of services through it, the structure of movement, the psychic structure of human response to location, identity, and privacy. All these are *structure*." This more complex Saussurean definition of structure is an important aspect of structuralism and postmodernism.

All these characteristics—the complexity, the concern with "systems," the hyperreal, the concern with politics and the Saussurean definition of structure—tend to make Moshe Safdie's *Habitat '67* function as an important transition between modern and postmodern architecture.

—Quentin Fitzgerald and William Dunning

Bibliography—

Safdie, Moshe, *Habitat '67*, Ottawa 1967.
Safdie, Moshe, "On from Habitat," in *Design* (London), October 1967.
Safdie, Moshe, "Post Mortem on Habitat: Anatomy of a System," in *RIBA Journal* (London), November 1967.
Jacobs, David, "Habitat '67," in *Horizon* (New York), Winter 1967.
Safdie, Moshe, *Beyond Habitat*, Cambridge, Massachusetts 1970.
"Seven Years After Habitat," in *Time* (Montreal), 15 July 1974.
"Habitat Lives," in *Newsweek* (New York), 9 February 1976.

Photos Lawrence Scarpa

Carlo Scarpa (1906–78)
Querini Stampalia Foundation Library, Venice, 1961–63

In several ways, the Querini Stampalia Foundation Library typifies the many small renovation projects that dominated the first thirty years of Carlo Scarpa's career. It may not be considered among the most important works during his professional practice, which spanned over fifty years, yet the significance of this project cannot be ignored.

Despite thorough documentation, the Querini Stampalia Library is often overlooked in favor of a few larger projects such as the Brion Family Cemetery near Asolo, and the Banca Popolare and Castelvecchio museum in Verona. The relatively small scale of intervention and over-simplistic program make the Library difficult to assess in artistic value. Nonetheless, this project brought to fruition a foundation of ideas that would preoccupy the architect and reoccur in many projects throughout the remainder of his career. To dismiss this work as inconsequential would be to misunderstand the architect himself.

Carlo Scarpa's influence on architecture was and is widely recognized. Although he was a professor of architecture and, late in his career, the director of the Istituto Universitario di Architettura di Venezia (IUAV), he never received a formal education or training in architecture, nor was he ever licensed as an architect. His distance from the theories and ideological debates of the time made him either enthusiastically supported or coldly rejected. What Scarpa ignored, either deliberately or instinctively, was the design strategy inherent in the philosophy of the rationalist movement that dominated Italian architecture at the time.

Despite his isolation, Scarpa knew the work of the masters of his era. He possessed the capacity to understand and transform into architecture the lessons of others he greatly admired. His memory included many—Mondrian, Miro, Braque, Leger to whom he made constant visual reference, and the works of Frank Lloyd Wright, Le Corbusier, and the Viennese Secessionists. A man living in his own Venetian heritage and tradition, he sought a delicate balance between objects and memory, art and craft and most importantly, tradition and culture. He considered himself a man of Byzantium by way of Greece.

The Querini Stampalia Library was the first project which brought to realization the true embodiment of many of these ideas. Certainly Scarpa's own personal understanding and further obsession. In previous projects, which included the well-publicized Olivetti Showroom in nearby Piazza San Marco, he concerned himself with little more than a complex dialogue between the craft of building and how a project is constructed. This is not to say that the work was anything less than evocative, yet the Querini Stampalia Library gave birth to a new understanding about the dialectics between preexistent conditions and new intervention. This is evident in Scarpa's willingness to allow his design to co-exist with the sixteenth-century palace.

The first indication occurs immediately upon entry into the ground floor lobby. The new floor added adjacent to the canal at Campo Santa Maria Formosa is prevented from touching the walls of the existing palace. The in-between space is left free to allow the high tide and flood waters to enter the building, creating a floating pavilion within the ancient palazzo. This discovery is quite extraordinary, considering that the Venetians have typically gone to great lengths to prevent this from occurring, yet Scarpa instinctively accepts the water as integral to both old and new and would often refer to its psychological and historical importance in Venice.

Scarpa would further argue the importance for this delicate balance and fragmentary synthesis by forcing the viewer to take part in the process that leads to the final object. Instead of annulling the differences between old and new, he displayed them. The building is both old and new, past and present in a dialogue between objects and memory. Visual logic, as he termed it, would occupy Scarpa throughout the remainder of his career.

The earliest realized indication of this idea occurred in the main stair leading to the second floor library. Scarpa opted to retain the ancient stair irrespective of its poor physical condition. New marble was partially superimposed over the existing risers and treads. Like a revelation, the stair was renewed without destroying its history. Paradoxically balanced, the tension is heightened by the union of different parts.

The Querini Stampalia Library might be considered a modern work, even though the building is abundant with historical reference. The roots of the work pass through the strata of tradition without being persuaded by it. The work should be viewed as modern architecture, because the principle to evolve a total composition through architectural volumes and corresponding parts has been abandoned. No classic harmony or symmetry exists in the project. It asks that we the viewer recognize a direct autobiographical relationship between a man and his culture founded on a highly developed appreciation for objects beyond his time.

Carlo Scarpa was an enigmatic character. He believed that a building was no more than a drawing at full scale. What evolved was his own concept, which brought forth the process of how a work was conceived as well as constructed. He possessed the ability to selectively choose and reconstruct, based on an exceptional mastery of appreciation for many things. Susanne Langer stated in her book *Feeling and Form*, "the fundamental technique of expression is something we all have to learn by example and practice by conscious or unconscious training." Whatever criticism the Querini Stampalia Library might receive, it will always remain a testament to a figure who purposefully explored tradition for new expressive opportunities instead of resigning to the accepted polemic.

—Lawrence Scarpa

Bibliography—

Mazzariol, Giuseppe, "Un'opera di Carlo Scarpa: il riordino di un antico palazzo veneziano," in *Zodiac* (Milan), no. 13, 1964.
"Nuova sistemazione della Galleria Querini-Stampalia a Venezia," in *Edilizia Moderna* (Rome), no. 82/83, 1964.
Ardinghi, M. P. Mortillaro, *L'Architetto Carlo Scarpa*, Padua 1968.
Pozza, Neri, *Carlo Scarpa*, Padua 1978.
Mazzariol, Giuseppe, "Historia i genesi de la intervencio a la Fundacio Querini Stampalia," in *Quaderns* (Barcelona), no. 158, 1983.
Dal Co, Francesco, and Mazzariol, Giuseppe, eds., *Carlo Scarpa 1906–1978*, Milan 1984.
Amodeo, Fabio, *Scarpa: L'Idea e la Materia*, Trieste 1984.

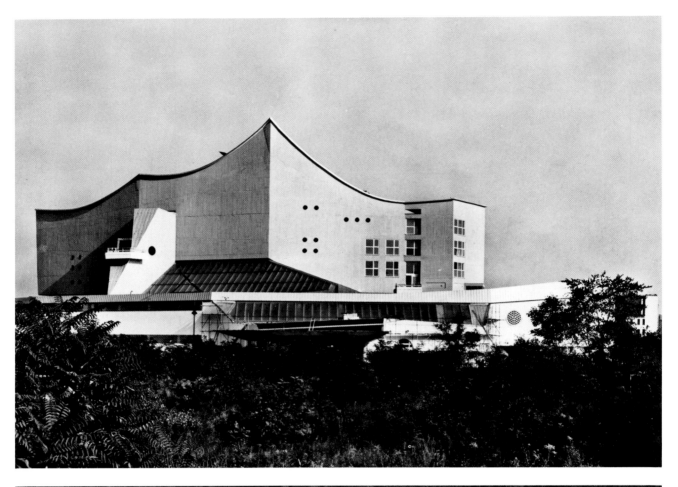

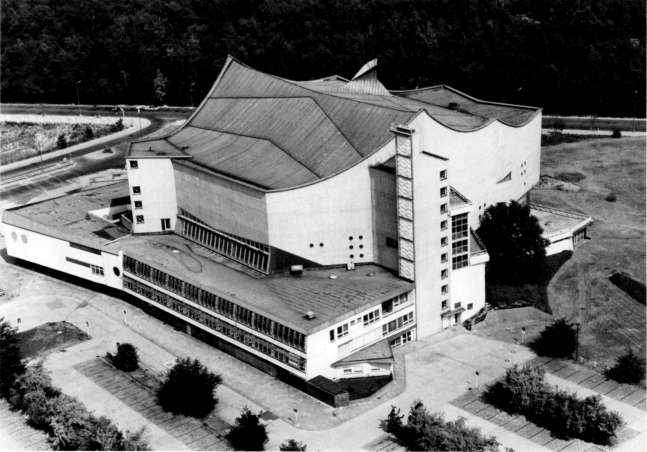

Photos Landesbildstelle, Berlin

462

Hans Scharoun (1893–1972)
Philharmonie concert hall, Kemperplatz, Berlin, 1956, 1960–63

Scharoun's concert hall houses the Berlin Philharmonic Orchestra, the ensemble of Hans von Bülow, Artur Nikisch, Wilhelm Furtwängler and Herbert von Karajan. It created a public sensation when it was opened on 15 October 1963. The approval was, to a degree, of a political nature. As the first building sited on the new "cultural forum" on the southern edge of the *Tiergarten* in the western quarter of the frontier town that Berlin had become at that time, it was seen as a symbol of cultural self-assertion. In the territory in front of the Berlin wall, it demonstrated openness to the world, a marked cultural awareness and certainty in the future. "It would be unthinkable to build something here as though it were nothing but a question of an architectonic exercise," was a statement of those years. It was also seen as "a unification in the face of the enemy."

The concert hall itself met these expectations in full. Architecture was put on as a festive production, it freed itself from the utilitarianism of the frugal post-war period and won back the poetic metaphor in building. The gradation of the groups of seats was compared by Scharoun to hillside vineyards. He christened the ceiling, which is suspended from prestressed transverse trusses made from reinforced concrete and studded with sound absorbers and sound-proofing sails, with spotlights, lamps and microphones, as a "skyscape," answering the landscape of the terraced plateau below.

Scharoun took his own maxim of "music at the centre of attention" literally. The orchestra no longer plays from a podium in confrontation with the stalls or rows, but in the hollow approximately in the centre of the assembled audience. The discreet ordering of the terraces with the help of an east–west axis of symmetry is only obvious in a few perspectives. This ground-plan was at the same time seen to be an expression of the democratic creed. The *formierte Gesellschaft* (structured society)—a catchphrase of the times—distanced itself very deliberately from the strong axes of the neo-classicism of the National Socialist past, just as it did from the regulated models of the socialist state on the other side of the wall of that time. In this community-in-the-round it is granted very distinct individuality. It renounces any visible hierarchy of an ordering of rows, but interacts in a so-to-speak voluntary agreement along the "common line" of the axis of the ground-plan.

Under the rising parts of the floor space, the main body of the hall is supported by a throng of pillars, some slanting, some joined together in pairs. Here and there in the adjoining annexes, the entrance passageways and foyers unfold, linked to the hall by a cascade of stairs, galleries, bridges and soundproofing locks. The ways through the passage, especially to the eastern half of the hall, which is situated opposite the main entrance, demand a concentrated search on the visitors' part. The impression is labyrinthine, with light falling in surprising ways, unconventional perspectives, confusing overlapping elements, a mass of the most varied and, individually, also ugly details . . . a magic mountain of music. Only once one reaches the expanse of the hall, large enough to hold 2,200 people, is the puzzle of finding the way in solved. Purification through art, both that of the musician and that of the architect, is the aim of this "architectural promenade," which owes nothing to Le Corbusier's serene latinism, but stems from an expressive "furor teutonicus."

The exterior is a mould of the spaces within, in Scharoun's words a "body" to contain the inner workings. Of course, the sequence of the interiors is too complicated to be discernible from the outer form. In the south and north perspectives, the tent-like roof extends in the form of a saddle. In the east and west perspectives, the silhouette runs in a threefold momentum. The entrance hall, the choir hall, the administrative offices and the chimney-stack protrude like limbs from a body. Groups of window openings and

of slanting fanlights pierce the reinforced concrete building in seemingly arbitrary manner.

The Berlin Philharmonic building marked a high-point in the architect's career. It seemed as though the whole life-work of the then seventy year-old had been directed into this building. In the days of Expressionism, Scharoun had already drawn and painted in watercolours centrally-organised festival and ceremonial buildings. In the 1920s such artists as Oskar Strnad, the painter Fidus, Erwin Piscator, Walter Gropius and Andreas Weininger had applied themselves to the concept of a new ordering of stage and audience which was to create a totality in the experiences of the theatre and of concerts. When building activity was put paid to during World War II, Scharoun referred back to these concepts in utopian sketches he prepared. His designs for a theatre in Kassel (1952–1954), in Mannheim (1953) and in Gelsenkirchen (1954) were to remain on paper. Even the Philharmonic building was not executed on the site behind the Joachimsthalschen grammar school, as had been laid down in the competition of 1956. Scharoun, though, remained the architect when the project was moved to the *Tiergarten* and he was able to put his theory (and that of his friend Hugo Häring) of "organic building" into practice with this spectacular and imposing building.

At one time the lone pioneering building on the ruined prairie of the Kemper Platz, the Philharmonic building has now been joined by a row of neighbours. Directly adjoining stand the low tract of the Museum of Musical Instruments and a similarly centralized Chamber Music Hall, both by Scharoun's collaborator Edgar Wisniewski, and designed according to ideas of the master's developed to differing degrees. The second new hall, in fact made to seat 1,150 people, has taken on unexpectedly large proportions.

Scharoun was also the architect, in collaboration with Wisniewski, of the state library which closes off the cultural forum to the east like a great piece of cliff. Mies van der Rohe's steel temple to house the New National Gallery and the unfortunate museum buildings by Rolf Gutbrod enlarge the collection of solitary cultural buildings, but could not liberate the forum from its isolation and monoculture. The connection to the centre of the city, once more freely accessible from the West, will take all the imagination the town planners can muster to execute successfully.

Scharoun's own overall concept for the development of the cultural forum remained unrealized; he was able to pursue his town-planning, with squares, paths and bridges *within* his building. At first painted in ochre colours, the Philharmonic building received a new coat of glittering gold synthetic laminated aluminium panels, similar to those Scharoun purportedly wished for. The impending renovation of the building, especially of the suspended ceiling will have to take into account above all the exquisite acoustics of the hall.

—Wolfgang Pehnt

Bibliography—

Jacobus, John, *Twentieth Century Architecture: The Middle Years 1940–65*, London and New York 1966.
Pehnt, Wolfgang, *New German Architecture 3*, London and New York 1970.
Pfankuch, Peter, ed., *Hans Scharoun: Bauten, Entwurfe, Texte*, Berlin 1974.
Blundell Jones, Peter, *Hans Scharoun*, London 1978.
Sassu, Alessandro, *La Philharmonie di Hans Scharoun*, Bari 1980.
Janofske, Eckehard, *Architectur-Raume: Idee und Gestalt bei Hans Scharoun*, Braunschweig and Wiesbaden 1984.
Burkle, J. Christoph, *Hans Scharoun und die Moderne: Idee, Projekte, Theaterbau*, Frankfurt 1986.
Schreiber, Mathias, ed., *Deutsche Architektur nach 1945*, Stuttgart 1986.

Photo © Botond Bognar

Kazuo Shinohara (1925–)
Tokyo Institute of Technology Centennial Hall, Tokyo, 1987

As Shinohara's architecture has been extending since the early 1980s to include within its scope larger public buildings after concentrating primarily on residential design for more than two decades, he has begun to pay more attention to the peculiar qualities of Japanese urban environment. He has come to observe that in Tokyo, "there exists . . . a complete antithesis of the beautiful and orderly urban compositions found in the West." By recognizing, yet not necessarily endorsing the chaotic nature of the built environment in the city, he has launched his new concept of "progressive anarchy" as the focus of his design. The pursuit of this concept, which runs parallel with his intention to create "zero-degree machine[s]," characterizes his recent works—such as his own House in Yokohama (1984)—exceptionally well, but none more so than the TIT Centennial Hall in Tokyo.

While contemporary Japanese architecture is not short of unusual buildings, the Centennial Hall is certainly among the most extraordinary structures today. Shinohara's design is the outcome, almost literally, of a collision dramatized by the intensity of juxtapositions of incongruous forms, shifting angles, broken axes, etc. The effect is heightened by the meticulous precision of metallic parts and finish within the machine-like structure, which demonstrates well Shinohara's admitted fascination with the performance and image of such products as an F-14 fighter plane or the Apollo Lunar module, the fearsome achievements of late-twentieth-century super-technology. Underscoring the airplane analogy, here the flying half-cylindrical volume can appear as a crash-landed fuselage piercing through the top of the rectangular, though irregular, substructure.

By boldly combining the horizontal, solid form of the cylinder with the cubic and largely translucent prism of the structure below, Shinohara established the basic image for the building as "a machine floating in the air." Yet, this image is achieved not by way of some orderly or strictly preconceived overall arrangement; each element of the building is treated as one part of a machine where they fulfil, as efficiently as possible, a specific role in the mechanism, like in the lunar module, without the necessity to synthesize them into an attractively unified aesthetic entity. The Centennial Hall is the assemblage of formally autonomous parts with diverse linkages constituting the essence of Shinohara's new design attitude of *Sachlichkeit*, that is a certain objectivity in building, as opposed to his more emotionally-charged previous phases of architecture. He calls the machine "a physical system in which objects are simply joined together in a *sachlich* manner."

Describing his architecture of fragmentary parts, Shinohara refers to the phenomenon of "random noise" by which he means not chaos or disorder *per se*, but a perceptual realm never filtered clean of interference. It is this realm, the urban realm of the Japanese city, wherein his "zero-degree machine," the reinterpretation of Roland Barthe's *Writing Degree Zero*, can be properly understood. It is an urban structure that performs various functions—just like early modern functionalist architecture did—but whose parts have only zero-degree symbolic meaning. Meaning, however, is not altogether given up since, as Shinohara has discovered in the Japanese context, "a relative value can be achieved from elements that have lost meaning and have been reduced to the zero degree." This is why Shinohara's buildings, unlike their monumental Western counterparts, could not be appreciated in spacious surroundings, a property they invariably lack anyway; they have to be, and can only be viewed within their cluttered, everyday environments wherein they begin to make sense, if only gradually.

Another example from Shinohara's architecture can explain better the process. His House Under High-Voltage Lines in Tokyo (1981) was shaped in direct response to the conditions of the site crossed by a couple of high-voltage lines. To keep the necessary distance from them, the concrete shell of the house was indented along two curving surfaces in a highly unusual and seemingly illogical way. Yet, as Mark Treib pointed out, the design of the so

distorted forms and spaces can be read as both an "act of obeisance in which the roof plane has bowed to the invisible powers of public utilities . . . [and also] as an act of defiance in which architecture does not retreat, but presses its face against the unseen force—though deformed by it in the process."

In the same manner, the Centennial Hall reveals a two-prong strategem; on the one hand, it draws from the city's life pulse, chaotic energy, ways and means of perception as well as the alogic of its urban nexus; on the other hand, it opposes its uncontrolled excesses, especially the trivializing modes of signification and representation, by refusing to harmonize with the all-too-chaotic urban conditions. And in so doing, the building, in fact, prefigures a new vision of the city as an information-fuelled "technopolis" of the future. Understood this way, the flying cylinder of the Centennial Hall makes one, almost involuntarily, recall not only the image of a "machine in the air," but also Arata Isozaki's numerous visionary projects for a City in the Air (1960–62), in which the future city, as a system of tubular spaceframes cantilevered from gigantic vertical shafts, is elevated high above the layers of the existing city, and often, over the fragmented ruins of the old, historic city.

This landmark work of Shinohara, built to commemorate the one-hundredth anniversary of Tokyo Institute of Technology, is a faculty center and alumni hall, with exhibition spaces on the underground level and first floor for a museum of technology; conference rooms, offices and a lounge on the second and third floors, and a restaurant and bar on the fourth floor within the space of the inverted semi-cylinder. Meant to be also as a center for information exchange, technology and the city became the major themes of the Centennial Hall.

Ferrous materials, stainless steel plates, perforated aluminum screens, glass surfaces and steel structures shape the exterior, while inside the industrial/technological character of the building become even more pronounced; interlocking structures and spaces, catwalks and bridges, numerous ducts and pipes induce a factory-like interior that is as dynamic as it is exciting. On the upper levels, the mood becomes calmer. Although the spaces of the third floor conference room and lounge are invaded by the dramatic thrust of the cylindrical volume above, inside the cylinder on the fourth floor, only the smoothly curving walls, the flat ceiling with circular skylights and the carpeted floor dominate the uniquely long and bent space.

With this building Shinohara, one of the most influential Japanese designers since the late 1960s, has yet again epitomized the essence of his architecture that had evolved through several distinct phases, yet with a consistent orientation away from the past. The Centennial Hall outlines a new mode of design, a contemporary form of "urban technology" and reaffirms his conviction that architecture must always raise issues regarding the present. As he said: "tradition can be the starting point for creativity, but it must not be the point to which it returns."

The Centennial Hall is a powerful testimony to Shinohara's quest for "the conditions of space that will characterize architecture and cities in the future."

—Botond Bognar

Bibliography—

Institute for Architecture and Urban Studies, *Catalogue 17: Kazuo Shinohara*, New York 1982.
Bognar, Botond, *Contemporary Japanese Architecture: Its Development and Challenge*, New York 1985.
"Recent Works of Kazuo Shinohara," in *The Japan Architect* (Tokyo), September 1986.
Stewart, David B., *The Making of a Modern Japanese Architecture*, Tokyo 1987.
Shinohara, Kazuo, "Tokyo Institute of Technology Centennial Hall," in *The Japan Architect* (Tokyo), May 1988.
Bognar, Botond, *The New Japanese Architecture*, New York 1990.

Photos courtesy of SITE

466

SITE Projects Inc. (1969–)
Indeterminate Facade Showroom, Almeda-Genoa Shopping Center, Houston, 1975
65,279 sq.ft.
Best Products Company Inc., Richmond, Virginia

SITE's Best Indeterminate Facade Showroom (BIFS) survives as a major icon of contemporary architecture's frustrating and frustrated quest for a place among The Arts. Although SITE is an acronym for *Sculpture* in the Environment, since the completion of the series of Best Products Co. Inc. catalogue showrooms, it is generally regarded as an architectural firm, headed by James Wines.

As a plastic manifesto, BIFS may signify equally the erosion of sculpture for sculpture's sake and the erosion of architecture for architecture's sake. BIFS points a finger at a Line which is meant to separate the realm of sculpture from the realm of architecture, places the façade of a catalog-showroom on the line, and then spills a pile of waste bricks over the top of the pedestrian canopy, over the entrance-door, toward the parking lot. Here, it says with an unmistakable gesture of kinship to Duchamp's 1917 ready-made "fountain," "may this cascade of ready-made cubes of oven-baked clay be the pile against which future acts of building are measured." Although it may not be The Pile, it is an element in the matrix of piles that have led to a re-examination not only of architecture but of sculpture, and indeed of art.

As Wines drew the line, he "lost control" over his façade, over his materials, over the redundant and ever-repeating elements and opened "the abyss of uncontrollable destiny": he performed the archetypal act of rebellion, of making a mess, in fact attempting to break "the last taboo." Such loss of control can be accompanied by the joy of release, it can be the grounds for the formation of a new gestalt, it can offer a cipher toward unsuspected meanings, it can lead to a revelation of unsuspected new relationships. At its Best, BIFS is capable of doing all of these things.

To let it all hang out, like this pile of spilled bricks, leads to a release of joyous liquid limpid laughter when the burden of solemn social roles and obligations becomes unbearably heavy. For architecture as well as for sculpture: indeed for their boundary, the burden of social, ethical and aesthetic responsibility had become unbearable by the mid 'seventies. Nothing could prove this more graphically than the staged "collapse" of BIFS front façade and the instant notorious infamy it brought upon its designers—instant transformation of a succès de scandale to a succès d'estime. Conditions were ripe, the energy had been stored and too-long confined, the line had to be drawn as it was breached; a smirk, a smile, a giggle, a laugh, a release, a golden shower of indistinguishable yet Best, ready-made consumer goods . . .

Often, the sudden release of joyous, manic liquid laughter is accompanied by a sudden and dramatic reconfiguration of the perceptual field. One has been rude; one has offended custom and the norms of public decency; and suddenly in the rubble of the old rules, in the echo of the release of energy the perceptual field reconfigures. It is like an exercise for the imagination: to identify a specific arrangement of familiar objects which lifts blinders from existing categories of perception. Suddenly concepts like Wall, Façade, False Front, Show Room, Spill, Consumer, Parking Lot, Construction, Demolition . . . conflate and implode, and in an act of defiant inversion "architecture becomes the subject matter of art."

Thus, the accumulated burdens of sculpture and architecture that BIFS released helped to reconfigure the boundary between the two: when architecture becomes proper subject matter for Art, hitherto unsuspected meanings emerge from the simplest ready-made architectural forms. This is not so much an act of Learning from Las Vegas as of Listening to Kleckley Street (the thoroughfare that BIFS faces) with the Third Ear. The third ear, itself, is opened by the very same released cascade of bricks, by the selfsame manic laughter, by the selfsame reconfiguration of the perceptual field

that allowed and brought about the initial "loss of control." What, through Wines' agency and mediation, *we* hear is a true story about our own innermost and unsuspected needs, wants, longings, neuroses, passions, motives, addictions, protrusions, dreams, images and illusions. As he bedazzles us with the visual anomaly of artistic and technical collapse, he whispers in our third ear: here, I have entombed all those false ideals which fed and were fed by the modern movement, by modern American architecture. Instant ruin; instant archeology; stop, look, and listen with The Third Ear.

The legerdemain, the light, quick deft subliminal sound, the sudden manic raucous laughter by which BIFS enables the ear to be faster than the eye points to new relationships. The line that BIFS falls over can be thought to contain such diverse points as Michael Graves' "Architecture as logotype" exercises (e.g. the Dolphin and Swan Hotels in Walt Disney World, Florida or the Copa Banana Lounge tabletop). Yet again, we are reminded of Venturi's Bill-Ding Board for the National Football Hall of Fame. Or again, Noguchi's Pyramidal Memorial to be Visible from Mars . . . or perhaps something far more rude and fetishistic, something far more Freudian and dream-like, well, something more like a "fountain" perhaps, a severed ear, or rather something out of the ordinary discourse of either art or architecture and more in the American submerged colloquial, like a SNAFU or a FUBAR.

The circle closes upon itself. For in dragging up a submerged image, the act of Letting Go, of Losing Control, becomes, paradoxically, a prototype for gaining control: once the image is retrieved from the unconscious, the conscious mind attacks it, voraciously digesting and analyzing it, just as I am doing now; and what has hitherto been forbidden and taboo enters the polite world through the newly forged door on the line between Art and Architecture. As soon as the image materializes, words attack it. These words cast a net over the wild, crazy and uncontrollable Dionysian frenzy of manic laughter; the satyr play becomes an interlude between two acts of a Classic Tragedy.

BIFS survives Best's bankruptcy. As a major icon of contemporary architecture's frustrating and frustrated quest for a place among The Arts, it spilled its seed unto the parking lots of our minds. Although we may no longer think of SITE as an acronym for Sculpture in the Environment, since the completion BIFS we can no longer simply think of public art as the handmade one-of-a-kind "collectors' item" that typically "adorns" a building. BIFS' stake in the controversy about the object of architecture is a spillway from which the subject of architecture may yet draw inspiration and renew itself. Admittedly, it does not provide a "satisfactory answer" to the question of the relation between the "custom made" and the "ready made." So, although it may not be The Pile, perhaps BIFS *was sent* to bear witness of that Pile not yet seen.

—Joseph B. Juhasz

Bibliography—

Nakamura, Toshio, "Indeterminate Facade," in *Architecture + Urbanism* (Tokyo), July 1975.
Davis, Douglas, "Houston Falling," in *Newsweek* (New York), 22 December 1975.
Restany, Pierre, and Zevi, Bruno, *SITE: Architecture as Art*, London and New York 1980.
Wines, James, "Best: SITE and the psychological effects," in *Architecture Interieure/Cree* (Paris), March, May 1980.
Wines, James, "La Facade Indeterminate, Magasin Best," in *l'Architecture d'Aujourd'hui* (Paris), February 1981.
"SITE: Architecture and Environmental Architecture," special monograph issue of *Space Design* (Tokyo), August 1981.

Photos courtesy Alvaro Siza Arquitecto

Alvaro Siza (1933–)
Banco Borges e Irmao, Succursal de Vila do Conde, Portugal, 1982–86

Architecture is not invention but the transformation of reality. This is the modest but decisive attitude of Alvaro Siza Vieira (b. 1933). But this transformation, initiated and directed by the architect, is completed by the community, by the inhabitant; without the presence of the individual and his day to day activities, there is no architecture worthy of the name. A graduate of the University of Oporto where he studied painting and sculpture, Siza began practising as an architect in 1954. His fame has spread beyond his native Portugal. Today, he is one of the world's most celebrated creative artists. Exhibitions devoted to his work have been staged in Milan (1979), Helsinki (1982) and Paris (1990) and other major cities. He has received international awards, been appointed to professorships in Europe and the USA and designed and constructed buildings in Portugal, Germany, Italy and Holland. Siza's work can be summed up in four basic principles: the relationship of the buildings with their urban or rural environment; respect for regional characteristics; the absence of theory and consideration of the user and/or sensitivity in the management of the project. The intentions of Siza's work are revealed in his designs and the laconic poetry of his sketches is fascinating. The presence of human figures in these sketches suggests not so much a sense of scale but essentially a connection, both tangible and intimate, between the human body and the architecture. This connection is also evident in the refreshing use of materials which link architectural form with human experience.

Although houses are central to his output and throw a great deal of light on his larger-scale work, it is the latter that displays considerable urban charm. Even when building work is at an end, the building itself is not complete. According to Siza, it is the occupants who create the finished works. Nevertheless, it is the architect who must initiate the process. His role should not be to mediate so much as to stimulate discussion. "What I do, what an architect does, cannot bend to the whims and fancies of A or B", he says. "It must be the outcome of A's ability to discuss things with B. It is not a matter of manipulation but of what can be done within the terms of what an architect sets out to do, what he believes he should do. What he has created is still not a building, nor does it yet have the atmosphere of a building. My responsibility, in consultation with the users, has to be fundamental precisely in order to achieve openness. If you want to create an open space, this space has to be very basic in its structure, because if it is not it will not even provide a stimulus for anyone who may have a contribution to make."

The relationship that Alvaro Siza's architecture establishes with the city or the countryside—a dichotomy between the demands of planning and architectural style—is rigorously defined and affirmed, both theoretically and practically in the case of the Banco Borges e Irmao's Vila do Conde office building. From the formal point of view the building is an artistic gesture, the culmination of a long series of analytical experiments in which the possibilities of traditional rationalism were taken to the extreme and independently reworked and updated.

If, on the one hand, Siza has brought this protracted process of development to a conclusion, he has, on the other hand, opened the way for new means of expression. The Vila do Conde Bank building is the crystallisation of a concept whose clear and logical intention is to respect what already exists, and to conform to a structural discipline which denies any break with tradition. So this work is a milestone in Siza's career: a conclusion and at the same time a beginning, which will allow the creator to surpass himself while perfecting a distinctive personal style. Siza himself said in 1986 that the Bank in Vila do Conde provided a contrast to and stood out from its surroundings. But the architecture of this work "fulfils its basic function in defining a fabric which there is no justifiable reason to change. Any work which respects the context or which goes no further than to carry out the necessary transformation should be seen as something new."

The building stands in the historic centre of Vila do Conde—a town situated to the north of Oporto—dominated by granite and stucco buildings such as the Church and Monastery of Santa Clara. The Bank is built on a rectangular site on the Rua 25 de Abril. A master plan drawn up before Siza's project substantially changed the area, creating a square, with access via a new thoroughfare, between the gardens of the neighbouring houses. The Bank stands on a corner, demolition of the existing building having given the architect a completely unencumbered space.

While the Bank differs in shape from the nearby buildings, it also bears a relationship to the town's monuments. With its prismatic purism and its white colour, it stands out from its context but its volume and size harmonise with the other buildings in the street. It mingles comfortably with the other buildings and monuments, while at the same time keeping its distance from them.

The white main block is surrounded by an architecture of ramps, staircases and entrances. Two of the corners are curved, giving the impression of two continuous facades instead of four. The frontages differ from one another: the north-west facade is polished, with the windows and the marble facings mounted on white plaster; the south-west frontage is highlighted by a ramp; a staircase; an area of glazed wall; a corner, also glazed, on the upper floor and a long, narrow space. The marble facing dominates the exterior, while the interior of the building is visible from the outside, emphasising its lack of privacy.

The building unfolds on four levels: the ground floor opening onto the garden, the mezzanine, the first floor and the terrace. Each level has its own entrance, the ground floor is reached from the street, the mezzanine from the corner, and the first floor by the ramp from the street and by the staircase from the garden.

The design is a kind of anthology of references to Siza's earlier work while at the same time heralding aspects of his more recent creations. The complexity of the building was achieved through an unusual accumulation of different spacial and figurative themes, combining elementary mass and unadorned surfaces. The result has formidable impact. Despite its smaller scale, it rivals the religious and civic monuments of the old town, without any detriment to them.

—Jorge Glusberg

Bibliography—

Huet, Bernard, and Nicolin, Pierluigi, *Alvaro Siza, architetto 1954–1979*, exhibition catalogue, Milan 1979.
"Alvaro Siza," special issue of *Architecture + Urbanism* (Tokyo), December 1980.
"Siza i Vieira: Banca a Vila do Conde," in *Domus* (Milan), November 1984.

SITUATION

FASSADENENTWICKLUNG REGIERUNGSVIERTEL

Illustrations courtesy Luigi Snozzi Architetto

470

Luigi Snozzi (1932–)
Parliament Building, Vaduz, Liechtenstein, 1987–91

The New Parliament of Liechtenstein represents for Luigi Snozzi his first opportunity to design a large public building. His ability to work on projects by establishing a particular relationship between the surroundings and the new building presents here totally different problems from those met in more modest edifices. His "dream to build a house which is hardly seen at all, reducing everything to the indispensable," as he recently said in an interview, is partially impeded by the bureaucratic slowness and the political indecisions which are typical elements of the public operators. The characteristics of representativeness of building for a parliament are decidedly in contrast with that wish of invisibility. And the tiny Parliament of a Sovereign State with less than 30,000 inhabitants seems to make it more difficult to communicate the highly symbolic nature of a monument, in a building of about 850 square meters.

Snozzi's approach to a project is supported by an accurate historic research on the site, recognising the great importance of the existing buildings and deciding which deserve to be considered in the new project. With design based on a volumetric simplicity, Snozzi is able to establish a kind of dialogue between the new architecture and the complex and irregular urban surroundings. Although apparently incompatible with the public buildings, this methodology has permitted Snozzi to find a solution, which acquires more value if we consider that famous architects have resolved the need for representativeness in their Parliament mainly by working on a bigger scale. For example, without any criticism or comparison, Le Corbusier in India with The Palace of Assembly in Chandigarh, or Niemeyer in Brazil with the House of Representatives and the Senate in Brasilia.

Even if Vaduz is essentially a large village without any real urban architecture, Snozzi solves the requirement of representativeness by working on the totality of the urban context, rather than on the building itself. During the historic analysis of the site, he found an old map with the trace of an ancient path that led from the Castle of the Prince to the location of the New Parliament. This link, which corresponds to a real relationship between the reigning Prince and the political authorities, is cleverly used by the architect to increase the historic value of the place of the development. The location almost becomes an "holy place" and assures the building which will stand on it a character of monumentality, appropriate to its functions. Snozzi strengthens the symbolic value of the site by designing a square that encloses the old and the new public buildings. In this way he suggests the idea of the classic town where the square plays the role of Agora, and the Castle, up on the hill, is the Acropolis. Snozzi has often been considered an architect who pays more attention to the territorial design rather than to the details of the building. With this project, it appears clear that he has given attention to details which, though not on the building itself, are on its synergism with the territory and cosmic agents such as sun, wind and light. In Vaduz the new buildings are precisely located, their position is determined by the accurate analysis both of the site—in the historic and geological aspects— and the pre-existing architecture. The big square of the Parliament is demarcated by a long sinuous building, essentially for office use, which connects the facing buildings of the Landesmuseum and the School of Music and ends where the path that leads to the Castle starts. The space limited by this building, which follows the curve of the hill slope, contains the new and the old Parliament side by side. By connecting all the new and old buildings, this edifice seems to develop the function of homogenizing the different types of architecture.

Once having solved the problem of the monumentality of the building, helped by the "holiness of the place," the architect proceeds more freely with the design of the Parliament, using his usual approach of volumetric simplicity. Snozzi strongly believes that a simple geometry provides the means to reach that integration between a new building and the existing ones. However some references to the work of Asplund and Aalto bring to his architectural language something new; this is probably also due to a recent journey during which he studied the work of those architects.

The extreme physical closeness between the new building and the old Parliament creates a striking contrast which is cleverly solved by Snozzi by paying a tribute to the latter. His edifice is forced to the same height as the cornice, to the alignment of the elevation facing the square and to the same axial symmetry of the floor plan as the old Parliament, but it strongly denies any stylistic continuity, and it clearly differs by emphasizing the presence of the Council Hall above the tall portico. The organization of the space is given by superimposing the two semicylindric volumes of the entrance hall—on which the office's corridors open like an amphitheatre—and of the Council Hall surrounded by the foyer and the gallery for the general public. Inside the building Snozzi uses the light in a continued effort to find a different quality of illumination according to the characteristics of the spaces. People are able to find the way by being attracted by the light. In this growing enthusiasm created by the light while climbing towards the heart of the building—the Council Hall—it is easy to find some references to the concept of the City Library of Stockholm by Asplund. By using the light and the transparency of the windows, Snozzi also gives a symbolic understanding of the edifice. The exhortation to enter through the big portico and then the desire to climb from the entrance hall to the Council Hall, attracted by the light, is after all like a metaphor in which the citizen is invited to participate to the democratic process enacted in the building.

—Enzostefano Manola

Bibliography—

von Moos, S., *New Directions in Swiss Architecture*, New York 1969.
Frampton, Kenneth, and others, *Luigi Snozzi: Progetti e Architetture 1957–1984*, Milan 1984.
Buchanan, Peter, "Ticino: constructing order," in *Architectural Review* (London), May 1988.
"Luigi Snozzi und das Politische in der Architektur," special issue of *Du* (Zurich), November 1989.
Croset, Pierre-Alain, "Architetture di Luigi Snozzi," in *Casabella* (Milan), April 1990.

WEST ELEVATION

SECTION

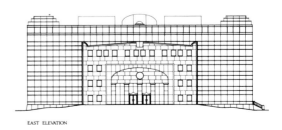

EAST ELEVATION

Robert A. M. Stern (1939–)
Point West Place Office Building, 111 Speen Street, Framingham, Massachusetts, 1983–85
10,000 sq.ft.
Hines Industrial Corporation

Designed by a leading proponent of Post-modern architecture, Point West Place is among the most vivid icons of Post-modernism, a highly visible building that boldly draws from tenets that shaped the movement. Its design applies elements of a pseudo-Classical temple front to a jazzy glass box, and attempts to impose the order of a French garden on an arbitrarily defined suburban site. Controversial among both architects and the public for its staginess, details, and seeming parody, Point West Place nevertheless demands attention.

The location's prominence adjacent to the heavily-travelled Massachusetts Turnpike sixteen miles from Boston inspired the developer, a Gerald Hines affiliate, to seek a high-profile architect for this speculative office building. Robert A. M. Stern, who previously had designed a summer residence for Hines, got the nod despite having never done a structure of this size or type. His visibility as an architect and writer surely contributed to his selection, in addition to his sympathy, following Venturi and Scott Brown, for the suburban context. With its pink, grey and black glass striping, illuminated rooftop ziggurats, and "collage" of Boullée-esque pink granite façade and portico, this building shows Stern playing to the passing motorist and exploring "the value of symbolism and allusion in an architecture of vast space and speed," to quote *Learning from Las Vegas* (1972), one of his sources. The design's highway orientation appears literally in the building's alignment: the structure parallels the turnpike access ramp behind it so that its monumental rear loggia overlooks the toll booths.

Stern's architectural "collage" juxtaposes Classicism with modernism, masonry and glass, axial with non-hierarchical planning, solidity and transparency, symbolism and abstraction. Collage was a clever way to provide a "proper" entrance to an unarticulated glass volume, and it enabled Stern to give his client such an economical, efficient building mass that his budget could include higher quality finishes and better-than-average public spaces. Wittily bringing together two such divergent vocabularies in so polemical a fashion evokes the "both-and" of Venturi's famous quotation that Stern drew from to popularize the "battle" of the "Grays" versus the "Whites": "I prefer 'both-and' to 'either-or,' black and white and sometimes gray, to black or white." (Stern was among Venturi's early ardent supporters, beginning with his preview of Venturi's forthcoming book in the landmark issue of the Yale Architectural Journal that he edited in 1965, *Perspecta 9/10*.)

While collage as an architectural technique has sometimes been seen as a post-modern phenomenon, it is, of course, a modernist artistic method, developed by Picasso and Braque. Rowe and Koetter addressed it as architectural technique and philosophy in *Collage City* (1978), where they noted modern architects' insertion of industrial elements into residences and the juxtapositions found in LeCorbusier's Nestlé pavilion and Ozenfant studio, among other examples.

Point West Place also draws inspiration from buildings that literally combine structures from different eras, perhaps most evocative in the historic façades on the walls of the Castello Sforzesca in Milan. The rear loggia set into Stern's commercial palazzo recalls the image of the new oversized loggia that Michelangelo superimposed on the back of the Palazzo Farnese, illustrated by Venturi as an example of "contradiction juxtaposed." Recent precedents include Mitchell-Giurgola's Penn Mutual Life Insurance Building in Philadelphia (1975) where the glass façade of the new tower rises behind John Haviland's 1835 masonry façade, and the less fortunate ZCMI Department Store in Salt Lake City by Victor Gruen Associates (1976), with an 1878 cast iron front affixed to a banal brick box.

While Stern's collage evokes such precedents, the character of the two basic elements being brought together becomes an issue in an appraisal of the building. Is the ungainliness of the new "Classical" pieces a reference to the awkwardness of post-war vernacular Classicism in all its untutored maladroitness, a phenomenon that might be called "commercial mannerism" in deference to what Summerson identified in an earlier period as "artisan mannerism?" Or is it, like "commercial mannerism" itself, born of unfamiliarity with the language and too little time spent on design? Point West Place's solecisms may, in part, express Stern's concern that this new granite façade not be mistaken for a historical artifact. However, they demonstrate the difficulty of "reinterpreting" the Classical vocabulary, for the odd proportions, awkward shapes, and unexplained window spacing are unsatisfying, unlike the inventive mannerism of Giulio Romano or Michelangelo. (Such design stands in sharp contrast to the more literal approach that more generally typifies Stern's historicist work, or to the freedom of design of the Lang (1974) and Westchester County (1975) houses.)

Although the stepped pyramid ziggurats at the four corners of this building "jazz it up" with Art Moderne recall, and present the conceit of a masonry form rendered in planes of glass, these corner structures conflict with the non-hierarchical nature of the continuous ribbon windows and with the planar characteristic of such a wrapper. This building's dialectic belongs to the collage of granite and glass, not to glass towers that seem to be vestiges of preliminary design studies. The memorable Ledoux-like pavilion finds clever justification for its contrary "pentastyle" portico with center column in the entry drive's two-way automobile circulation: no one ever approaches on center in a car. Nevertheless, this denial of the center weakens the grand sense of entry that justifies the inserted portico in the first place, and contradicts the openness implied by the oculus and the "broken pediment" above. The massive portico also intrudes upon the triple-height exedra of the finely detailed entrance hall to interrupt its expansive concave gesture. Finally, given its ambitious site plan alluding to formal French landscape, this building suffers even more than the typical suburban office block from inadequate planting of trees.

In 1977 Stern wrote that Post-modernism "prefers hybrids to pure forms; it encourages multiple and simultaneous readings in its effort to heighten expressive content. Borrowing from forms and strategies of both modernism and the architecture that preceded it, post-modernism declares that past-ness of both." Point West Place stands as the built illustration of this declaration. It is inventive and polemical, while it draws from a wide range of previous buildings and ideas. Although less resolved than the architect's more comfortable historicist work, Point West Place is both more speculative and provocative.

—Gary Wolf

Bibliography—

Stern, Robert A. M., *New Directions in American Architecture*, New York 1977.
Arnell, Peter, and Bickford, Ted, *Robert A. M. Stern: Buildings and Projects 1965–1980*, New York 1981.
Dunster, David, ed., *Robert Stern*, London 1981.
Scully, Vincent, "Architecture: Robert Stern," in *Architectural Digest* (Los Angeles), June 1984.
Papadakis, Andreas, "Robert A. M. Stern: Point West Place, Framingham, Massachusetts," in *Architectural Design* (London), January/February 1985.
Smith, Herbert L., "Turnpike Plazzo," in *Architectural Record* (New York), February 1986.
Rueda, L. F., *Robert A. M. Stern: Buildings and Projects 1981–1986*, New York 1987.
Jencks, Charles, *Post-Modernism: The New Classicism in Art and Architecture*, New York 1987.
Klotz, Heinrich, *The History of Postmodern Architecture*, Cambridge, Massachusetts 1988.
Funari, Lucia: *Robert A. M. Stern: Modernita e Tradizione*, Rome 1990.

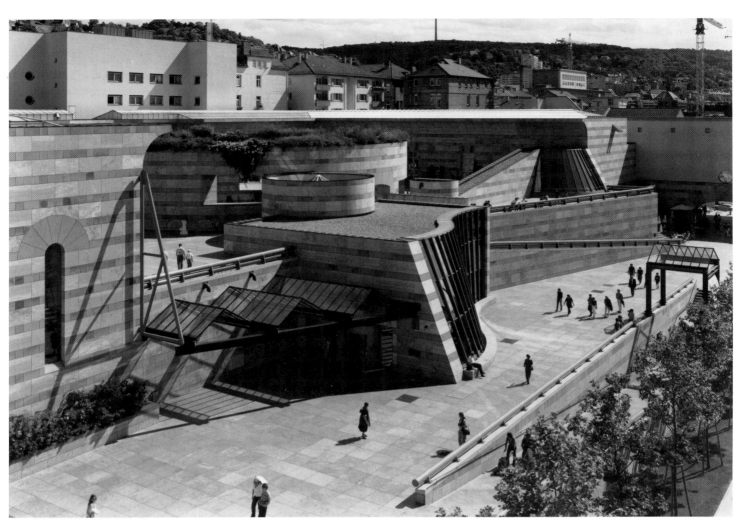

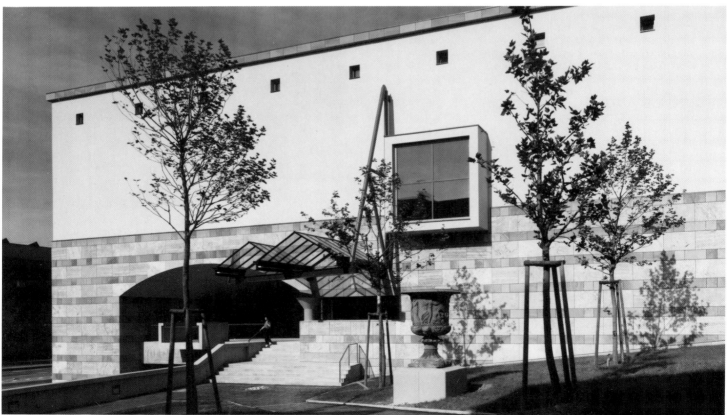

Photos courtesy James Stirling and Michael Wilford & Associates

James Stirling (1926–)
Neue Staatsgalerie, Stuttgart, 1977–84

The Neoclassical Staatsgalerie was erected to designs by Barth in 1842 in the heart of the cultural centre of Stuttgart. Today, a massive urban motorway severs the Staatsgalerie from that centre. The Neue Staatsgalerie is built to the south-west of the older museum, and is linked to it by means of a bridge. Thus the site, which rises steeply to the rear on the south-east, has its main frontage facing the older cultural centre of the city across the road.

The new building is basically a series of platforms which step up the site and overlap each other, with parking in the lowest storey. The terrace over gives access to the entrance and circulation-space, while the galleries are placed on the floor above and distributed in a U-shaped block forming the three sides of a court in the centre of which is an open drum. Behind the galleries are the administration-block, storage for archives, and a music-school. There is a small theatre with its own entrance to the south-west of the main galleries.

First impressions of the Neue Staatsgalerie are of ramps leading up to the two levels, with the drum and other blocks behind, the layered effect enhanced by horizontal bands of brown-yellow and russet-coloured stone, and enlivened by brightly coloured elements such as hand-rails, glazing-bars, and light structures (such as canopies) applied to the apparently weightier masonry behind. In the context of urban design, the building is most successful, and its massing, ramps, and platforms contribute greatly to a sense of place.

The brief demanded a path across the site, and this added to already difficult problems. Stirling's solution, in which he fragmented the parts of the building, responded to that demand. Clearly the core of the complex derives from Le Corbusier's Parliament Building at Chandigarh, and from Stirling's own project for a museum in Düsseldorf of 1975. The circular motif of the drum on plan might suggest Schinkel's Altes Museum, but the differences in three dimensions are too great: Schinkel's building is completely symmetrical, and the central rotunda, with its Pantheon-like dome, is based soundly on Antiquity; Stirling's drum is open to the sky, and has breaks in its perimeter that are almost random, while a ramp further compromises the axiality of the plan. Within the drum and sunk into the floor is a primitivist unfluted pair of Doric columns supporting plain blocky lintels, suggesting the work of Ehrensvård and other Doricists. Stirling's drum is also pierced by a series of segmental-headed openings that rise to accommodate the ramp behind: this has been equated with the interior of the Befreiungshalle by von Klenze, but the relationship is tenuous at best. Indeed, within the drum can be glimpsed an essence of what this building is about, for it is at close hand that we realise the stonework is merely an applied skin, and the fact that it is only a skin is made clear, for sound masonry practice is parodied at junctions and joints, and the stone is treated like wallpaper. There are, in this skin, references to *Rundbogenstil* windows, but done tongue-in-cheek, while the massive Egyptianising coved cornice of the gallery wings simply stops, "sawn off" at the ends. Parts of the building are carefully contrived "ruins," with blocks of stone apparently dropped from the wall, and lying on the ground, another jest in the direction of Mannerism, perhaps.

But the Neue Staatsgalerie, while undoubtedly a collage, is not a collage of historical details, but one of jokey references to them. The dominant influence is Le Corbusier in the plan form and in the disposition of elements, so it is a collage horizontally as well as vertically. The guitar-shapes on parts of the plan, too, come from Cubism and Le Corbusier. There is even a reference to a pithead gear in the lift-shaft. Stirling emerges as a kind of Modernist Mannerist, delighting in the effects of collage, creating clashing juxtapositions of form, image, and materials, and verging dangerously near vulgarity.

The stripey covering of stone recalls Victorian concerns with "structural polychromy," but the polychromatic stonework at Stuttgart is anything but structural, and is showing signs of distress.

This cladding sometimes partially disguises the clumsiest of junctions and the most uncomfortable of proportions in the fenestration, but more often, when seen close at hand, betrays what appears to be ignorance of masonry detail, as in the joins of strips and ramps, and in the bodged alignments and changes of plane: these points cannot be dismissed as intentionally "witty." The applied ornaments of metal porticoes, curving metal-and-glass wall, and tubular railings are therefore set, not against solids, but against a skin, creating a temporary and stagey environment. The curved glazed wall is perhaps a distorted echo of La Tourette or of some of Aalto's work.

Ambiguity, in fact, rules supreme throughout this collagist building. In spite of the apparent promise of the plan, the complex in reality has no sense of seriousness about it at all: it is overwhelmingly whimsy. The use of funnels reminiscent of the ocean-liners beloved by Corbusier via the Centre Pompidou on the rear façade overdoes the "historical quotation" joke collage, while the library and administrative wing stuck on clumsy *piloti* are suggestive of Le Corbusier's work at the *Weissenhofsiedlung* development not far away. The office block also has a clash of stucco and masonry.

From the main platform, access is gained to a foyer from which a ramp, stairs, and a lift lead to the galleries above, but attention is distracted by the green of the floor, while the white-painted walls betray a lack of appreciation of the grubby habits of people as well as of the appropriateness of finishes, for a tide-mark of dirt has to be kept at bay at hand level. Matters are made worse by the circulation spaces which are oddly indeterminate, confused, and have no sense of direction. Admittedly, the lift in its cage draws the eye to the ramp by its side, but, like many Modernist buildings, the absence of signals and of formal geometry creates uncertainty, and the visitor needs a notice to tell him where to go, and there is too much circulation and Stirling tricks before the galleries are gained at all. The "free" plan of the entrance is in contrast to the gallery level above, with its traditional *enfilade* system. These gallery rooms are undistinguished spaces, entirely lacking in personality, a fact that some persons might applaud, but if the gallery rooms were intended to be neutral, that intention is contradicted by the ferocious lime-green that runs through the interiors. Furthermore, virtually nowhere does the "free" plan merge satisfactorily with the more rigid gallery arrangement.

All in all, the Neue Staatsgalerie gives the impression of having very many quotations, ideas, and jokes put together in a collage: yet the breaking up of the building, quite deliberately, using collage techniques, tends to create problems of perception. While the drum and the wings combine reasonably satisfactorily, the "free" plan and the wings of the gallery do not: in addition, there is a sense of having the gimmickry of Post-Modernism jokingly served up all at once against a stage-set of tongue-in-cheek sub-historical images. The building's interiors are not really convincingly related to the powerful themes presented by the exterior, and the detailing, especially of junctions and apertures, is uncertain and looks wrong.

The complex appealed entirely to the instant visual impact, to short-term sensation, and to an aesthetic that lies uncomfortably between Modernism and half-baked historical allusion. The Neue Staatsgalerie also has a curious aura of spiritual emptiness: time will tell if this judgement is too harsh.

—James Stevens Curl

Bibliography—

"Stuttgart National Gallery Extension and Workshop Theatre," in *Architectural Design* (London), no. 8/9, 1979.
Stirling, James, and Maxwell, Robert, *James Stirling*, New York 1983.
Arnell, Peter, and Bickford, Ted, *James Stirling: Buildings and Projects 1950–1980*, New York 1984.
Goldberger, Paul, "New Museums Harmonize with Art," in the *New York Times*, 14 April 1985.

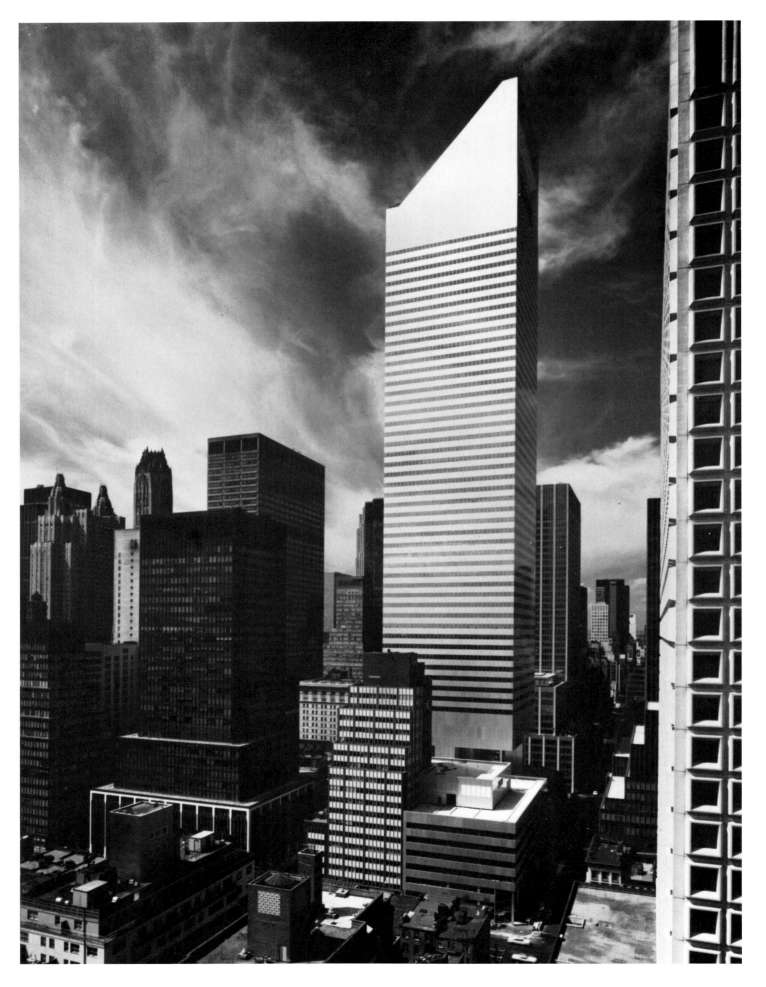

Hugh Stubbins (1912–)
Citicorp Center, New York, 1978

Citicorp Center is a distinctive addition to the many powerful skyscrapers of midtown Manhattan. It is also one of the best of the second generation of New York's skyscrapers.

The building is an important corporate symbol, largely due to the unusual crown of the building, a slanted surface which in earlier design stages was to be a solar collector. This turned out not to be practical, but other innovative features, such as a technologically highly sophisticated tuned mass damper to reduce the sway of the building was included. The building is clad in a curtain wall of smooth aluminum spandrels. In spite of this high technology look created by the smooth skin and the slanted roof, the building provides on the lower floors many amenities to the public and to its tenants. There is a church, a chapel (designed by Louise Nevelson, essentially providing a small space surrounded by her wonderful constructions) a plaza, and a galleria. This very humane space invites people, offers places to sit, a variety of food and places to eat food in a skylit atrium. Ever since the building opened it became a popular place for people from all walks of life, and is still the most successful atrium project in New York City. Its location in one of Manhattan's most popular and fashionable neighborhoods, close to Bloomingdale's and other fine stores, helped make it a natural center for people living and working in that area. The negotiations for the building took many years. The site contained a Saint Peter's Church which was sold to Citibank with the agreement that the congregation would have a new church built on the same site. The new sanctuary is a lovely space, clearly visible to passersby somewhat below ground level. Many activities from services to jazz festivals take place in the interior designed by Vignelli Associates.

The creation of Citicorp Center represented a social and urban planning achievement far superior to the prevalent mode of building inhospitable, slick slab buildings with a token of public spaces at best. The executives of Citibank/Citicorp, together with the Mayor of New York and the architect, Hugh Stubbins, collaborated in an enlightened manner on a building which has a definite sense of public responsibility. Hugh Stubbins, a highly respected architect with a considerable body of distinguished work over a period of twenty-five years, has achieved his most notable success with Citicorp Center. He was assisted by the project architect, W. Easley Hammer, and the production architect, Howard E. Goldstein, as well as by the associated architects, Emery Roth and Sons.

The center is a mixed-use complex consisting of a 65-storey office tower, a seven storey low-rise building containing shops, restaurants and other retail establishments surrounding a covered atrium. It also contains the church and chapel. The design development of Citicorp Center was exemplary. Hugh Stubbins went through a series of six or seven studies; many of his preliminary drawings as well as subsequent working drawings represent a significant example of excellent architectural design. Originally, the top of the building was to contain apartments in the slanted portion of the roof, but that, like the solar collector scheme was not found practical. One of the important aspect of a critical evaluation of any building or space is its use and the reaction of various groups of users. In this project the amenities and the excitement that once were considered the norm in central cores of cities have been reborn. The atrium has become an urban oasis filled with people from early morning until late at night. People go there to eat, to sit in the atrium, to shop, to listen to music, or just to look at other people.

The structural system was designed by the engineer William Lemessurier. It is a handsome frame which some critics would have liked to be exposed—similar to what has been done at the Hancock Building in Chicago. But the glass, flush with aluminum spandrels make for a sleek, clean look; it is indeed a clean building where the automatic washing machinery treats both materials as one surface. The building appears slender and elegant in spite of its mass. Most of the load is brought down the trussed frame on the outside of the tower. The remaining load—about half—is supported by the core. The core, even though it appears to support its massive load in a graceful column-like structure, is heavier than the actual steel. So is the spandrel on top of the columns. It does not contain the massive beams that it suggests, but is much like the column designed on aesthetic grounds. A building as large as Citicorp Center seems to require a look of solidity in order to feel right. Certainly this seems to have been a conscious design decision by Hugh Stubbins.

The trussed frame structure carries wind load as well as about half of the gravity. A very special feature has been introduced to counteract swaying motion in high winds. Located at the base of the building's slanted crown is a 400-ton concrete block. It is designed to move out of phase with the tower's motion. The block is fastened on rails and is controlled by a series of pistons and spring mounts which secure the block to the building. When there is motion in the building the block remains at first stationary, and then moves in the opposite direction. This dampening effect reduces the building's sway by about 40 percent.

Citicorp Center has firmly taken its place as one of New York's most important skyscrapers. In a decade since its creation it has become a much admired landmark. This was the result of excellent urban planning, enlightened clients, and above all outstanding architectural design.

—Arnold Friedmann

Bibliography—

"Seventh Heaven: Citicorp," in *Building Design* (London), September 1977.
"At the Core of the Apple," in *Progressive Architecture* (New York), December 1978.
"Hugh Stubbins: Architecture in the Spirit of the Times," special monograph issue of *Process: Architecture* (Tokyo), no. 10, 1979.
Hunt, William Dudley, Jr., *Encyclopedia of American Architecture*, New York 1980.
Goldberger, Paul, *The Skyscraper*, New York 1981.
"Skyscrapers in New York," in *Bouw* (Rotterdam), 28 May 1983.
Ludman, Dianne, *Stubbins Associates—Exhibitions*, Cambridge, Massachusetts 1986.

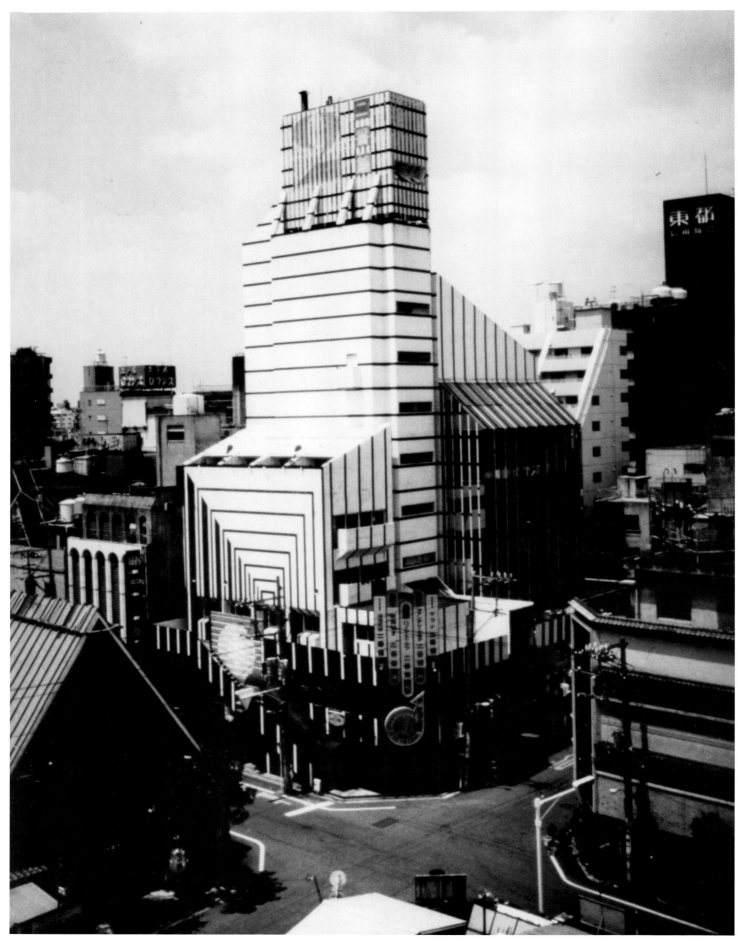

Photo © Botond Bognar

Minoru Takeyama (1934–)
Ichiban-Kan multi-use building, Tokyo, 1968–70

There is an easy and quite obvious way of relating to Minoru Takeyama's Ichiban-kan building by recognizing it as a rather radical and curious piece of pop-architecture which is, architecturally speaking, taking the original pop idea out on the limb. Looking at it from the time perspective of twenty years later, one would expect to see in it a monument to a passé ideology and style. However, the expectation remains unfulfilled—the building appears to be strikingly alive and still very relevant in the chaotic urban context to which it belongs. Consequently, one could suspect that Ichiban-kan's pop-face is a deceptive mask hiding a more profound set of conceptual ideas and explorations.

This suspicion can be further argued by realizing Takeyama's continuous involvement with building designs in the frantic urban context of Tokyo downtown areas. At the time when Ichiban-kan was conceived, no Japanese architect of considerable reputation and self-esteem would have committed himself to a design work in such uncontrollable circumstances, where frequent and unpredictable changes in the form of urban context were threatening to reduce any stylized piece of architecture into a meaningless object. Seen in this light, Takeyama's designs for Ichiban-kan, Niban-kan, and later 109 building, trace his exploration of the annihilating forces of the city and subsequent attempts at reconfiguration of architecture into a more meaningful (truthful) urban state—a process seemingly doomed to result either in self-abnegation of the architect or self-destruction of architecture.

The most provocative aspect of the Ichiban-kan's design is that it accepts the madness and the absurdity of the Japanese city as undeniable reality in which its own condition, and eventual resolution, is embedded. Its architecture relinquishes any attempt to revise or critique the city from the standpoint of an ideological principle which seeks and recognizes reality only in an ordered condition and desires its eventual reinstatement. Conversely, the expended question of reality and the imaginative stretches of its conceptual boundaries (surreality), inherent in the propensity for formal fragmentation and physical incoherence of the city, constitute underlining framework for the construction of the idea of the building. The whole building is built around contradicting realities of its external and internal worlds. Its site borders on the line of the surreal in the midst of the red light and night life district, where the commercialized and trivialized version of the traditional Japanese "floating world" perpetually exchanges elusive nocturnal glory with the sobering misery of the day light. Ichiban-kan is thus virtually located and exists in two different, parallel and dialectically opposed worlds, neither of which has a capacity to prevail and assert itself as ultimately real. Consequently, the abstractness and unintelligibility of the building's form denotes the architect's desire to resist committing himself to either of the realities by leaving his architecture to float as a dematerialized object (sign) whose meaning (reality) is not performed and can only be circumstantially inscribed.

The paradoxical reality of the Ichiban-kan's architecture is further perpetuated by the fact that it was originally designed and built without a concrete use program, which has been left open-ended as a vague call for a series of rental spaces for unspecified tenants. In the absence of the known use of building, the design process had to be conceptually and formally resolved by eventual centering on the only definable function: the vertical circulation system. The stairs and elevator shafts have thus assumed the role of the front elevation, becoming the main expressive and form-giving element. Through such a design focus, Takeyama has purposefully intensified the manifestation of the absurdity of the architectural condition he was confronted with, where marking of the void—the signification of the absence of the programmatic content—has become the ultimate subject of the articulation of the building form. Simultaneously, with the elimination of the internal content of architecture, glazed stairwells and elevator shafts of Ichiban-kan's black body have, in reverse effect, become

independent objects signifying and mirroring the outside world—the city—which is analogously revealed as a real subject of their form. Accordingly, the building exterior comes to serve as a surface that transmits the miracle of the city, a physical environment with no constants and no certainties, where everything seems to be equally possible, and reality is contained in the transcience of things and acts.

In case of the Ichiban-kan, the city is realized through the working of architecture, or conversely, architecture is put to use as an instrument for the manifestation of demeaning and subversive forces which act upon it in the context of the city. Such a use of architecture denotes the final realization of the loss of its capacity to, within the visual chaos of the Japanese city, constitute an independent reality and sustain meaning predicated on the correspondence between architectural form and its content. With no internal reality of its own, the body of architecture has become hollowed and permissive to the transfigurative processes, by way of which it formally references the multiplicity of the external world in an attempt to actualize itself. The fragmentation of Ichiban-kan's form—arbitrarily slanted and sawed-off building surfaces and white markings of the towering elements—is not design-induced condition, but a literal expression of applicable building and air safety regulation codes by way of which Takeyama has transgressed standard language of architecture in order to signify one of the particular realities of the building.

In this respect, it is important to clarify the extent to which Ichiban-kan is a piece of pop-architecture. It could be argued that Takeyama is a pop architect only as far as he recognizes the inevitability of the commercialized condition of the city and accepts working within it. However, his architecture escapes the triviality of the "decorated shed" philosophy by being devoid of any representational and associative meaning. The abstractness of the Ichiban-kan's form defuses communicative immediacy of the billboard architecture through the inconclusive nature of its physical composition, accessible to understanding only through the interactive interpretation.

In decomposing architecture through the Ichiban-kan's "composite body" Takeyama has succeeded in creating a building whose formal and physical texture continues to elude anchoring in time and space. It incessantly retraces and grafts its multiple shapes over the shifting background of the surrounding city, always actual but never definite, blurring the invisible line that separates real from surreal. Takeyama's recognition of the composite reality of the city, judged by hindsight, approximates through the working of architecture realization of Jean Baudrillard's argument about the "hyperreality of simulation," according to which the post-modern environment constitutes the "absolute space of simulation" where metaphorical reality and lived reality cannot be distinguished anymore. In that respect, the Ichiban-kan's simulative existence marks the elimination of the possibility to create the distance with the hyperreality of the city which, then, by the necessity becomes the new ground for reconstituting conceptual constructs of architecture. Consequently this building can be best understood as a precursor to the most current developments in the Japanese experimental architecture.

—Vladimir Krstic

Bibliography—

Minoru Takeyama: Ichiban-kan," in *The Japan Architect* (Tokyo), August 1970.
Takeyama, Minoru, *Autobiography of an Architect*, Tokyo 1973.
Ross, Michael Franklin, *Beyond Metabolism: The New Japanese Architecture*, New York 1978.
Frampton, Kenneth, *A New Wave of Japanese Architecture*, New York 1978.
Matsunaga, Yasumiba, "Against Regionalism: Minoru Takeyama," in *The Japan Architect* (Tokyo), September 1984.
Bognar, Botond, *Contemporary Japanese Architecture*, New York 1985.

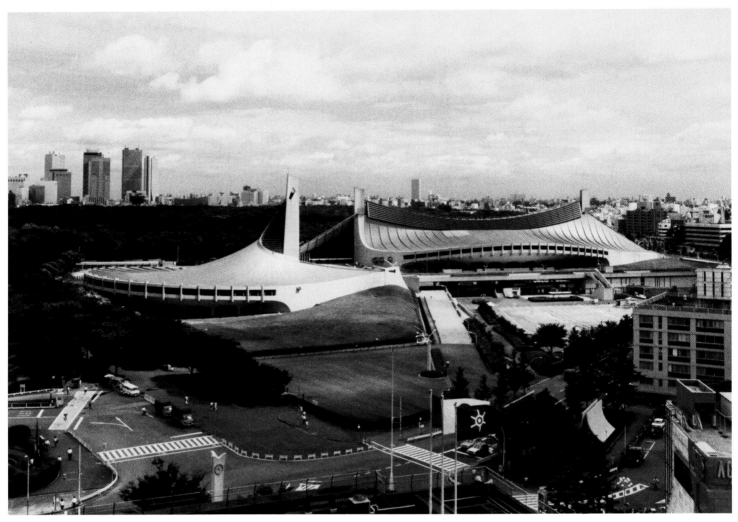

Photo © Botond Bognar

Kenzo Tange (1913–)
National Gymnasium for the 1964 Olympic Games, Tokyo, 1961–64

The Olympic gymnasium represents the epitome of Tange's most productive and most successful period in his architectural career. The early 1960s witnessed the coincidence of some three different design approaches in Tange's works. This was the time when he had just concluded the early stage of his architecture that had investigated the possibilities of combining some of the features of traditional Japanese structures with the demands of a rational and functionalist modernism. Buildings such as the Tokyo City Hall (1957), Kurashiki City Hall (1960) and, most especially, the Kagawa Prefectural Government Office Building in Takamatsu (1958) reinterpreted in a highly elegant and convincing manner the Japanese wooden post-and-beam construction system with the language of modern architecture. These buildings, molded in expressive, unfinished reinforced concrete, were all laid out along a rectangular system with modular dimensioning, comprising what became known as the "new Japan style."

1960 also signalled the beginning of Tange's new interest in a structuralist urban design methodology, based on the application of extensive megastructures. His Tokyo Plan (1960) elaborated the most important principles for his structuralist architecture that was to unfold thereafter, resulting in such remarkable works as the Yamanashi Communications Center in Kofu (1966), the Shizuoka Press and Broadcasting Office Building in Tokyo (1967), and many others later on, like the designs for the Osaka Expo in 1970.

Nevertheless, the early '60s were also the years when Tange accomplished his most mature works that were highly symbolic in nature and sculptural in form. Influenced by new developments both in Japan and in world architecture in general, and especially by Le Corbusier's design for the Notre Dame du Haut chapel in Ronchamp (1955), these works by Tange which, in addition to the Olympic Stadia in Tokyo, included the St. Mary's Cathedral, also in Tokyo (1965) and the Kagawa Prefectural Gymnasium in Takamatsu (1965), were all extensively and expressively shaped by curvilinear surfaces, lines, structures, lending to the building's dynamic but well-balanced appearance and a unique plasticity.

The Olympic Gymnasium has been the outcome of many factors, and signifies much in Japan and Japanese architecture. The country, by this time, having been rebuilt from the devastation inflicted by the war, was well on its way toward the economic boom, the so-called "Japanese miracle." Along with tremendous industrial and technological progress, a growing optimism about the future helped the new democratic country to regain its self-confidence and national pride. The hosting of the forthcoming 1964 Olympic games in Tokyo both benefited from, as well as fostered, the rapid developments in Japan. There was a need for a new infrastructure that could provide the basis for not only the games and related events, but also for the urban explosion that paralleled the economic upturn. Among others, new expressways, the bullet train, and, of course, new architectural facilities had to be, and were built in a short period of time.

Tange, who was by then the most well-known and celebrated Japanese architect, received the commission for the National Gymnasium which consisted of two separate yet interconnected structures. The larger one, accommodating the indoor swimming pools, seats 15,000 spectators; the smaller one, a multi-purpose sports hall, 4,000 spectators. Connecting the two is a low, rectilinear, largely subterranean podium with its roof used for an urban promenade. Inside this podium, Tange arranged all the service facilities: offices, training rooms, dining places, etc.

Taking advantage of the necessarily large, uninterrupted spaces of the two gymnasia, Tange designed their structures in a uniquely imaginative way. Aided by both an advanced construction industry and his talented structural engineer, Yoshikatsu Tsuboi, Tange employed a suspension cable structure as the basis for the roofs over the halls. These suspended roofs are supported by massive reinforced concrete pylons that adjoin the equally reinforced concrete compression ring structures around the spectator grand-

stands. In the large arena there are two such pylons, while in the small one, only one.

The large arena, in addition, features two clusters of cables (33 centimetres in diameter) that run not only in between the pylons, but also beyond them, and are anchored underground on both sides of the structure. Attached to these cables are delicately curving steel ties that connect at their other end to the compression rings of the concrete substructure delineating the humped seating galleries. The steel ties pull apart the two cables between the pylons, forming this way a cigar-shaped opening inbetween the cables. Tange used this area of the roof to provide skylights over the pools.

The case with the smaller arena is somewhat different, insofar as it has only one concrete pylon to support the single cluster of cable which runs down from the top in a spiraling line before it is anchored by a low profile concrete structure set in the ground. In both the large and small arenas, the edge of the grandstands (where the steel ties are connected) is curvilinear in shape. Yet, while these shapes in the large arena form two, shifted hyperboles which face each other, in the small arena the one and only line is a spiral one. In both cases, however, the structural forms yield excellent locations for the entrances, under the overrunning and largely diagonal cables. Due to the individual solutions, there are two entrances to the swimming pool building and one to the multi-purpose hall. Outside, the steel platecovered roofs are painted gray, which color is counterbalanced by the whitish texture of the unfinished concrete and the plush green grassy surface of the surrounding landscape. The overall effect, both inside and out, is striking and unsurpassable.

In Tange's design, which represents the highpoint in Japanese *modern* architecture, every detail and element supports the plastic, singularly dramatic and monumental forms of the composition; it results in a powerfully unified whole. Yet, despite the monumentality, the huge structures do not seem to be overwhelming or oppressive. The softly curving arches—somewhat reminiscent of the roof forms observed in traditional architecture—incline close to the ground, allowing the buildings to remain within human scale. Moreover, due to the fact that every part of the design is generated by curvilinear shapes, the whole complex gives the impression of merry-go-rounds in revolving motion.

In the history of modern architecture there have been numerous examples—notably works of Frei Otto, Eero Saarinen, Jorn Utzon, and many others—where tension structures and their sculptural forms have been exploited imaginatively, indeed. But, as Robin Boyd has aptly remarked, "it is fairly safe to say, that no one before or since the 1964 Olympics has built a tensile structure with such confidence and conviction and sensitivity to the sculptural and monumental potentialities of the principle."

—Botond Bognar

Bibliography—

Boyd, Robin, *Kenzo Tange*, New York and London 1962.
Riani, Paolo, *Kenzo Tange*, Florence and London 1968.
Kurita, Isamu, *Kenzo Tange*, Tokyo 1970.
Naka, M., *Philosophy of Contemporary Architects: Kenzo Tange*, Tokyo 1970.
Kultermann, Udo, *Kenzo Tange 1946–1969: Architecture and Urban Design*, Zurich and London 1970.
Kawazoe, Noboru, *Kenzo Tange*, Tokyo 1976.
Von der Muhll, H. R., *Kenzo Tange*, Zurich 1978.
"Kenzo Tange and URTEC," special monograph issue of *Space Design* (Tokyo), September 1983.
Bognar, Botond, *Contemporary Japanese Architecture: Its Development and Challenge*, New York 1985.
Suzuki, Hiroyuki, and Banham, Reyner, *Contemporary Architecture of Japan 1958–1984*, New York 1985.
Stewart, David B., *The Making of a Modern Japanese Architecture*, Tokyo and New York 1987.

482

Clorindo Testa (1923–)
Bank of London and South America (now Lloyds Bank), Buenos Aires, 1959–66

The building was erected following a limited design competition, which was won in 1960 by Clorindo Testa (b. 1923) and SEPRA Studio (Santiago Sánchez Elía, Federico Peralta Ramos and Alfredo Agostini), founded in the late 1930s.

Any account of the history of the SEPRA Studio would be tantamount to an account of the history of Argentine architecture over the past fifty years. From its earliest days, SEPRA has taken on a very wide range of architectural work, designing housing, offices, hotels and industrial complexes (more than two and a quarter million square metres).

Testa, whose architectural production began in 1952, is the author of an impressive body of architecture and has also created as an artist an equally valuable painting world. Testa has designed buildings which are something more than consumer objects; through such buildings, he demonstrates his potentiality as a creator of forms. His more decisive works reflects the importance that he attaches to the existing urban structure as, above all, a socio-cultural fact.

Several basic ideas predominated in the making of the design of the Bank of London and South America (now the Lloyds Bank). These ideas naturally answered the fundamental requirements of the brief. However, their materialization in no way signified the adoption of conventional or typified forms.

In the first place, the building as a whole suggests a *covered public square*. It is located on a corner side fronting two narrow streets approximately ten metres wide, and is surrounded by a number of other banks realized in neo-classical languages.

The public square actually exists in the sense that real limits of the large internal space of the building are defined by its frontages, which virtually allow the streets to enter this huge public space. In spatial terms, there is no division between interior and exterior. When one walks through the building, the walls that limit it disappear. One sees—as a boundary—the frontages of the buildings situated across the street. In other words, the building suggests a covered square because it involves a space limited by the urban framework.

As there is no division between interior and exterior, the frontage of the bank does not have an imposing presence. Strictly speaking, the huge columns serve to form a great *loggia* in which all the bank's activities are carried out. Furthermore, the frontages of the building are never seen in their totality, owing to a lack of perspective, and for this reason they have been drawn in sections but never completely.

In consonance with the idea of a public square, that is *an absence* within the urban fabric, on the scale of the man who uses it, the building does not depend on conditions imposed by the surrounding environment, namely the styles of the adjacent constructions.

From the functional point of view as well, the internal space has something of a public square about it, seeing that the distribution of the different elements—the counters, for example—does not follow the usual criteria where staff and public zones are kept well apart. Rather, the public moves between the elements: the designers created interior walkways which are extensions of the streets outside.

The building has three basements and six working levels. An overall area of almost 25,000 square metres is enveloped to a height of 26 metres. This answers the basic requirement that the building should function within an enclosing envelope and that different zones should be created for use by bank staff and customers.

Within this enclosed volume, the six working levels are linked by a pair of vertical circulation groups, one for the bank staff, the other for the consumers. The first two working levels are banking areas, and the remaining four are office space. This design feature permits the freedom of spatial creation which characterizes the entire work.

The enclosing envelope is demarcated by the main roof grid and the two party walls. The volume is completed by the system utilized on the two frontages: a glass inner structure and a perimetral concrete structure. The roof is partly supported by these columns which serve as a brise-soleil and have particular relevance as an architectural statement. Thus, the outstanding features of the work are created by its structure.

The main entrance to the building is established at the corner of the site. It forms a transition area and is emphasized by an enormous reinforced concrete screen which limits the space and the views from the inside. The exposed concrete, a distinctive feature of the building, is treated with exceptional care throughout. The module employed for the roof grid served to order the outer column spacing. In the three basements, extending to a depth of 14 metres, there is a conventional structure of columns and beams, also of reinforced concrete.

It is only possible to refer to the "hall" in terms of a spatial continuum which is materialized through the use of concrete to form the elements that occupy the hall with an incredible imaginative formal repertoire. The imagination is also manifested in the apparent boundary of the building, the curtain wall, which inevitably suggests a kind of complex grid that serves to support the wall of glass and aluminium.

The structure, which defines the free internal space and provides the flexibility required by the original brief, dominates the visual treatment of the work as a whole. The malleability of the concrete enabled structural details to became sculptural objects. With other material as well, a sculptural effect tends to be created throughout the building.

A unique piece of architecture, it has served, by its sheer presence, as a catalyst for subsequent generations of Argentine and other Latin-American architects.

—Jorge Glusberg

Bibliography—

Llimas, Julio, *Clorindo Testa*, Buenos Aires 1962.
Bullrich, Francisco, *New Directions in Latin American Architecture*, New York 1969.
Bayon, D., and Gasparini, P., *The Changing Shape of Latin American Architecture*, Chichester, Sussex 1979.
Kultermann, Udo, *Architekten der dritten Welt*, Cologne 1980.
Biblioteca U.I.A., *Clorindo Testa, pintor y arquitecto*, Buenos Aires 1983.
"Clorindo Testa: The Work of an Artist," special monograph issue of *Summa* (Bueos Aires), January/February 1983.
Glusberg, Jorge, *GA 65: SEPRA and Clorindo Testa—Banco de Londres y America del Sud*, Tokyo 1984.

Photo Howard N. Kaplan, HNK Architectural Photography

Plan and drawing courtesy of Stanley Tigerman

484

Stanley Tigerman (1930–)
Anti-Cruelty Society Building addition, Chicago, 1977–78
Aluminium façade with white trim

Chicago is both a city of lofty towers and a city of little clapboard cottages. Chicago's towers are concentrated in the Loop and northward along the Lake Michigan shore, while tens of thousands of low-rise commercial buildings and freestanding houses stretch westward and southward for miles toward the Prairie. Stanley Tigerman's Anti-Cruelty Society Building stands on the western fringe of the city of towers, where immensely tall, steel or stone skyscrapers stand cheek by jowl against little brick or clapboard buildings. This striking juxtaposition of the visionary and the workaday not only makes Chicago perhaps the most livable city in the United States but also accounts for its quintessentially American urban image. At once tall and low, sophisticated and simple, grandiose and merely efficient, the architecture of Chicago represents in microcosm the built environment of all America. Tigerman's Anti-Cruelty Society Building epitomizes the complex built culture of all Chicagoland.

This building is itself part and parcel of a small urban complex. Tigerman's design is actually an addition to, and partial remodeling of, two earlier and adjacent structures owned by the Anti-Cruelty Society. (The society encourages the euthanization of abandoned domestic animals or—better—their adoption by responsible owners, and educates the public concerning the plight of abandoned or mistreated pets.) This third and latest element in the complex brought its extent up to that of one full half of a city block. As it filled in a portion of Chicago's street grid, it also defined an inner court.

In plan, Tigerman's two-storey addition is simple almost to the point of being diagrammatic. Just ahead of the centrally positioned entrance lobby visitors encounter a reception desk, from whence they may be directed to animal-receiving rooms behind, a feline adoption area to the left, and a canine adoption area to the right. Opposite the entrance, the wall of the double-height reception room is glazed to provide visual linkage with the courtyard. (Architectonic and graphic treatments of this outdoor space gave it the potential of being a delightful focal point for the building, but procedural requirements of the society have unfortunately precluded its use as anything other than a rather cluttered service yard.) A staircase winds back over the small lobby to provide access from the reception room to administrative offices on the upper floor. Only the simplest, most economical, and most easily maintained materials are used throughout. If there is any decoration at all, it is only to be found in the exposed ductwork and in Tigerman's characteristic cyma curves evident in the floor pattern and tall front windows of the main hall. In the feline and canine adoption rooms, the extreme simplicity of the construction and a total absence of ornamentation not only make for very functional spaces but also ones in which the adoptable animals are always the only possible object of visitors' attention. In summary, the simply arranged, ascetically finished yet spatially interesting interior succeeds perfectly in directing visitors to the crucial loci of action in the building—the animal adoption rooms—and, once they are there, in focusing their attention on the very objects of the Anti-Cruelty Society's humane efforts: the animals themselves as individual creatures in need of compassion and as reminders of the precarious existence of all abandoned or mistreated domestic animals in a large city.

The exterior is equally subtle, both in respect to its insertion into its immediate and larger urban context as well as in its expression of the building's function. The mass of Tigerman's addition is low; its height is identical to that of the adjacent 1953 annex to the original Anti-Cruelty Society headquarters. The side elevation is treated as a glazed curtain wall closely resembling the façade of the 1953 annex and generally recalling the exterior treatment of many Miesian buildings in Chicago's downtown and other neighbourhoods. Around the corner, the entrance façade is treated in a wholly different idiom. This façade is sheathed entirely in imitation-clapboard aluminium siding (a material which extends around the corner in thin International-Style bands of the curtain-wall elevation). The shape and the fenestration of this façade make it an intentionally ambiguous evocation of two Chicago vernacular building types. On the one hand, the facts that the horizontal line of the façade is broken in the middle by a high triangular pediment, and that the upper level is pierced by rows of small, double-hung windows, suggest that the entrance façade is to be read as a Cubist unfolding of the front and side elevations of a typical clapboard Chicago cottage. On the other hand, the fact that the street level is glazed for practically its entire length, excepting only the fancy entrance under the pediment, allows the façade to be read simultaneously as one of the low storefront buildings that ubiquitously line Chicago's commercial thoroughfares. The function of the building is conveyed vividly by the adoptable animals visible in their cages behind the "storefront" windows. It is also emphasized by the inscriptions ("kittens kittens kittens . . ." and "puppies puppies puppies . . .") running just above those windows. A larger inscription, placed upon an oval signboard floating in a semicircular void in the pediment, reads "for animals," and thus suggests with ingenious economy both the higher purpose of the Anti-Cruelty Society (which exists "for [the protection of] animals") and the fact that visitors should come to the building "for [the purpose of adopting] animals." Surely this prosaic façade is, architecturally and epigraphically, also one of the most poetic ever created in a Post-Modern idiom. Seldom has Tigerman produced designs so rich in meaning, so evocative of their cultural context, so likeable despite their trademark hard-edged quality, as this one.

—Alfred Willis

Bibliography—

"Stanley Tigerman: Recent Projects," in *Architecture + Urbanism* (Tokyo), November 1979.
Tigerman, Stanley, *Versus: An American Architect's Alternatives*, New York 1982.

Ground floor plan

485

Courtesy of Susana Torre and Associates

Susana Torre (1944–)
Fire Station no. 5, Tipton Lakes, Columbus, Indiana, 1985–87

Born in Argentina (1944), educated in architecture and urban planning at the Universities of La Plata and Buenos Aires, Susana Torre is a resident of New York City since 1968, when she arrived on a fellowship to study at Columbia University. Later she became a United States citizen.

Associated with the Museum of Modern Art and the Institute for Architecture and Urban Studies in New York during the 1970s, researching the history of Modern architecture and the planning of new towns, Torre began her independent practice in 1978, combined since the early '80s with teaching.

Her architectural language, employed on institutional and residential buildings and renovations, but also from furniture to proposals for the future American city, relies on checkerboard or matrix-like plans and compositional oppositions between bold cylindrical and horizontal forms, mass and skeleton, metal and stone or wood. The visual variety in her designs can be attributed to her avowed commitment to regional expression in the use of local building materials and techniques. Her Fire Station No. 5 in Columbus, Indiana, is a kind of summing up of her work and her architectural and urban way of thinking.

Unlike the other free-standing buildings in the area—the houses, barns and other farm buildings—the Fire Station No. 5 stands at a corner of its site, where the two major roads between the new development of Tipton Lakes and the city of Columbus intersect. This urban vocation in the suburban context is counterpointed by the outdoor space bound between the two building wings, a type of space neither residual nor decisively figural, that is loosely defined by silos and barns in rural farmsteads. The juxtaposition of the diverse scales of the "house" and "garage" components is mediated by the two towers, the metal one housing the stair and sliding brass pole and the brick one used to dry hanging hose. These massive unbroken cylinders are powerfully abstract, introducing the eerily surreal quality that is a signature of Torre's work.

Because fire stations are, in Torre's words, "machine-like organizations for the protection of life and property," their spatial type is strictly controlled by the need for rapid response between the receipt of the alarm and the fire-fighter's presence at the fire. The path of exit must include the storage of protective clothing and personal equipment, forcing an unyielding spatial relationship of functions. This determinism of time and space has resulted in three typical combinations of the apparatus, service, public and domestic quarters of suburban fire stations.

While leaving the safety assumptions of the type intact, Torre's building has created a typological invention through her challenge of program assumptions based on gender. The integration of women suggested to Torre that dormitories and lockers—spaces where the women would feel excluded and inadequate—should be replaced with individual bedrooms, shared only by different shifts. It also suggested that male and female territories could be differentiated in order to promote the kind of intimate personal bonding that is essential for the coordinated performance of a fire-fighting team.

Divided on its long axis, the two-storey, U-shaped station is nearly symmetrical, a fact disguised as one approaches the entry on its long façade by way of an angled road. Nearing it, the building appears to rotate into a frontal position, an illusion achieved by means of one of the above-mentioned cylinders that acts almost as a hinge on which the building seems to turn.

Divided laterally, the station is composed of two interlocking squares, the intersection of which forms the main axis of the building, and probably the most important part of the composition. In the square to one side of the axis is the "machine" portion of the structure where the fire engines and some weight-lifting equipment for the firemen/women are kept; on the other side, distributed over two floors, are the "human" facilities, the sleeping quarters, the kitchen, living room, conference room, office, and the courtyard—a void carved out of the larger square. This lateral axis is the cross-circulation spine that ties the two functions of the building formally and physically. Its importance as the center is emphasized by the placement of two major elements on the building's cross axis: the stair that descends around the fireman's pole, both wrapped by the second cylinder in the courtyard; and a "house" containing the exercise room located in the machine shed.

The structure of Fire Station No. 5 is a combination of concrete block walls and steel frame on the exterior, concrete-block walls are clad with a beige-colored brick while the steel—painted gray—is left exposed. Gray-painted metal panels are used to knit together the geometry of the metal-clad cylindrical stair and triangular gable over the machine shed. This treatment serves to highlight these elements as special features.

But the most elegant details are in the courtyard, where a steel column acts as a positive against the negative of the I-beam's indentation running just beneath the roofline. The juncture of the two is further articulated by a square reveal. By putting fire insulation on the interior walls, the actual steel frame—not some simulation of it—could be exposed on the exterior. Inside, all the walls are of concrete block painted white. To provide contrast, the "house" inside the shed has been painted gray. Lightweight joists that frame the vast shed were also painted white, and add a delicate, lacy effect. Oak was used for the kitchen cabinets and to frame the doors and windows in the "human" side of the building. The color scheme provides a neutral background for the red fire engines.

—Jorge Glusberg

Bibliography—

"The Woman Behind the T-Square," in *Progressive Architecture* (New York), March 1977.
Diamonstein, Barbaralee, ed., *Collaboration: Artists and Architects*, New York 1981.
"USA Made by Argentines," in *Summarios* (Buenos Aires), January 1987.
Gusevich, Miriam, "Fire Station no. 5, Columbus, Indiana," in *Inland Architect* (Chicago), September/October 1987.
Smith, Herbert L., Jr., "A Festival of Firehouses," in *Architectural Record* (New York), March 1988.

Illustrations courtesy of Bernard Tschumi Architects

Bernard Tschumi (1944–)
Parc de La Villette, Paris, 1982–91

A 125-acre site with 70 acres of landscape (covered walkways, sunken gardens, a canal) and 30 "follies" containing cultural and recreational facilities (cinema, a video workshop, visitor information center, health club, day care center, bars and restaurants) totalling 186,000 square feet were built during the first two phases. The follies, which establish a 400 square foot grid throughout the park, are cut away from 36 foot cubes and made of prefabricated concrete, porcelain-coated steel, painted steel, aluminum and granite.

Probably the most radical work of late 20th-century architecture anywhere in the world, Bernard Tschumi's first built work, the Parc de la Villette, is neither a park nor a building in the conventional sense. It is an architectural open space more like a gigantic work of environmental sculpture than a natural landscape or traditional cityscape. Instead of building masses interrupted by openings for streets and plazas, it consists of an expansive plane punctuated by volumetric building masses, the little red "follies," which are placed not randomly but regularly on a grid plan—like city blocks turned inside out.

The $200 million park is one of the Francois Mitterand administration's ambitious, Grand Projects, along with the addition to the Grand Louvre, the Bastille Opera, the Great Arch of La Defense, the Ministry of Finances, the d'Orsay Museum, the Arab World Institute, and the City of Music and the Center of Science and Industry, both of which are located at La Villette. Like the Grand Arch and Bastille Opera, the Parc was designed as the result of a major international competition. The architects of some of the 470 entries for "An Urban Park for the 21st century" were later invited to design buildings and gardens within the park.

The Parc de la Villette or "little city" is intended to provide breathing space for the working class neighborhoods in the northeast quadrant of Paris the way the larger, grander, naturalistic, 19th century Bois de Boulogne does for the more prosperous residents of the west side. The Villette site became available in the 1970s when the slaughterhouses that used to occupy it were relocated. A few of the old buildings in the area were preserved, including the 1870 metal and glass Grand Halle, which was converted to exposition space. The project is important partly because it suggests a new way to approach a large parcel of land in a built up metropolitan area.

The treatment of the site is unprecedented. Other architects associated with the Deconstructivist movement have employed similar strategies but with vastly different effect. Rem Koolhaas's submission to the Parc de la Villette competition divided the land evenly into bands and scattered abstract elements throughout the site randomly, but in that complicated and whimsical scheme large independent buildings and layered circulation systems compete with the regulating devices. Peter Eisenman imposed a grid of fragmented cubes on the Canareggio Town Square in Venice, a project of 1980, and in a sunken garden, "Choral Works," he designed with Jacques Derrida in 1986 for La Villette, but in both of these schemes, the fragmented cubes vary in size and are partially submerged, so they appear and reappear mysteriously and irregularly.

Tschumi's follies, spread out evenly over the site, determine its character—open, flat, syncopated and civilized. They are immediately visible, clearly memorable and similar enough to one another to read as variations on a theme in the landscape. Their bright red color and smooth shiny surfaces make them easy to see, and their crisply cut, complex geometric shapes can be grasped from a distance. The format has the potential for almost infinite variation, intrigues enough to invite investigation and allows the architect flexibility in adapting the follies to different purposes, though they are all theoretically interchangeable. Like most late 20th-century architects, Tschumi rejects the functionalist mandate of early modern architecture. He wants to separate form from function and meaning, yet the follies are not just follies. They are designed to serve specific purposes (dining, day care, exercise, exhibition) and their materials and methods of construction are directly revealed in their appearance—a natural if ironic result of the attempt to create a park

that provides urban (as opposed to bucolic) experiences and looks it. Like the other Deconstructivists, Tschumi disapproves of the post-modernists' historicism and yet draws on early modern sources boldly.

The follies resurrect the imagery of Russian Constructivism, the one early modern style that remains fresh and pure, uncompromised by necessity and not yet exhausted by overuse. Its agenda remains unfulfilled because the Russian political revolution it was intended to serve ossified before the aesthetic revolution that accompanied it could bear fruit—at least before most of the architectural projects it had inspired could be realized. Russian Constructivism's connection with the Revolution, its intention to transform society and the fact that it was almost able to do so give it a power and integrity—and a romantic appeal—that none of the other early modern styles have. Its rebirth in "follies"—little playthings in a park, the 20th century equivalent of manufactured "ruins"—is tinged with irony as Tschumi must be aware. Nothing is sacred in a Deconstructed world. The architect's nostalgic reclamation of this machine-inspired style in the post-industrial era is as romantic as the nature worship of the Bois de Boulogne was in the industrial age.

The follies also allow Tschumi to articulate his theory of points, line and surfaces—a theory that allows him to adapt the modernist idea of the open plan to open land. The follies are little, light and bright, and delicate enough to read as points. They help the land become surface. And they are visually powerful enough to contain the rhythmic movement of the paths and walkways through the park—to make them read as wavy lines. These sinuous paths create irregular but identifiable shapes in the landscape—surfaces, some of which are carved out of the actual surface of the land to create sunken gardens.

Along with the grid of follies, which one day will extend in bits and pieces beyond the boundaries of the park, tying it ambiguously into the cityscape, Tschumi established strong north-south and east-west axes (aligned with the grid), much as a Roman general might have laid out a cardo and decamus. The east-west path along the Orocq Canal, which runs between Ledoux's recently restored Customs House (another product of government patronage) and the eastern suburbs, connects a row of follies on two levels. This pathway is sheltered in some areas by undulating, corrugated metal canopies. The walkway on the main north-south axis, which intersects the east-west one in the northwest corner of the Parc, is covered with concrete canopies of similar shape. The structural systems of both walkways, designed in collaboration with the daring British engineer Peter Rice, very much in the spirit of the rest of La Villette, "demystifies technology" by revealing the tilted supports and hung structures in tension that hold them up, seeming to defy gravity at the same time.

Bernard Tschumi was born in 1944 of French and Swiss parentage. He is a French citizen and lives in New York where he serves as Dean of the Graduate School of Architecture at Columbia University. Educated in Paris and at the Federal Polytechnic, Zurich, he taught the Architectural Association in London in the 1970s, Princeton University and the Cooper Union in the 1980s. He won second place in the Tokyo Opera International Design Competition in 1986.

—Jayne Merkel

Bibliography—

Tschumi, Bernard, *Architectural Manifestoes*, London 1979.
Tschumi, Bernard, *The Manhattan Transcripts*, London 1981.
Pizzetti, Ippolito, "A park is a park is a park," in *Spazio e Societa* (Milan), March 1984.
Derrida, Jacques, and others, *La Case Vide: La Villette 1985*, exhibition catalogue, London 1986.
Tschumi, Bernard, *Cinegramme folie: le Parc de La Villette*, Paris and London 1987.
Architectures capitales: Paris 1979–1989, Paris 1987.
"Travaux de Bernard Tschumi," in *Architecture-Mouvement-Continuite* (Paris), October 1987.

Photo Ingrid Voth-Amslinger

490

Oswald Mathias Ungers (1926–)
Deutsches Architekturmuseum, Frankfurt am Main, 1979, 1981–84

According to one of Oswald Mathias Ungers's beliefs, there is a strong metaphysical need in every human being to create a reality that is structured through images. A way of thinking in pictures and ideas helps to unite the disordered abundance of sensory impressions and thereby enables understanding—it is first of all the constellations of the Great Bear, of Orion and of Andromeda that make the configurations of the celestial bodies in the firmament experienceable.

Ungers's practical application for design rises to the challenge of bringing together the different given facts through the use of images, fantasy, metaphors, analogies, models, signs, symbols and allegories. He works with a store of potential thoughts and ideas which can be lent endless new applications through endless new combinations. "The problems for the future are these: not the invention of a new system, but the improvement of the existing one; not the discovery of new orders but the rediscovery of tried and tested principles; not the construction of new towns but the construction of the old ones."

Elements of architecture that never disappear, such as the atrium, the colonnade, the passage, the four-columned room, etc. are subjected to morphological transformations: to enlargement, to reduction, to doubling; to multiplication, fragmentation, variation, contrasting with other forms, etc.

With an architect who supports the most varied of methods for seeking forms and who in his own publications has pursued numerous themes of architecture in the natural as well as in the man-made world, one would not be surprised to find a colourful and confusing variety of handwritings. But Ungers is a masterbuilder who does not take his "thematisation of architecture" lightly. That is to say, it goes hand in hand with an almost ascetic restriction of means. The right angle, the square, the circle and the stereometric shapes derived from these represent, as it were, the basic material with which he works on the models already found in history. Discipline and strength have been qualities evident in this architect since the late 1960s, who provocatively regards himself as an artist. The ground-plan of the German Architecture Museum in Frankfurt am Main is rigorously defined by the module of the square, a theme continued in the elevation and even in the furnishing. Ornamentation and applied elements are, however, excluded from Ungers's work. He refuses any concessions to Populism.

The German Architecture Museum is marked by the theme that Ungers set himself of a "house within a house." It suggested itself strongly to him through the programme for Frankfurt's museums river bank. This projected the use of existing town houses and their conversion into a string of museums stretching along the Main and at the same time was to include the construction of thirteen new buildings or extensions on both sides of the river. In the case of the Architecture Museum, a pair of houses behind a single façade dating from 1912–13 was chosen to which the original architect Fritz Geldmacher had added Michelangelesque features. Since the old ceilings could no longer be supported, the building had to be entirely gutted. Ungers surrounded the shell of the villa's masonry with a lower layer of rooms, giving the shell itself the appearance of an exhibition piece—a principle that had already been used once in West Germany with the encasing of the Kestner Museum in Hanover (1961).

In Frankfurt, this enclosing of the building was limited to a single storey. It consists of a colonnade on the riverfront containing the entrance area, of ambulatories on the sides, and a hall at the back. The hall was given a vaulted ceiling made out of glass, reminiscent of Otto Wagner's post-counter hall in the Vienna Post Office Savings Building (1904–06). Space was left in the middle of the hall for an open courtyard taken up by an old chestnut tree—an encasement within an encasement. Along one of the long sides of the hall is a row of small, partly-covered cells given over to exhibition space on prominent architects, and which form a sequence of chapels devoted to the fame of the profession.

The higher floors of the old building rise above the annexes. In the original structure, Ungers placed a concrete scaffolding and within this a core which becomes more and more compressed from a four-pillar baldachino in the basement to the wholly enclosed tower under the ceiling with new sky-lights. With saddle roof and white-washed supports and walls, this house within a house seems quite simply the abstraction of the human dwelling, encapsulating the idea of the house *per se*. The sequence of changes from scaffolding to wall, from filigree to enclosed space, from reddish Main sandstone to cement and steel, from inner to outer to inner again, works as though the idea here is to show what architecture is capable of—a fitting demonstration for an Architecture Museum.

The cool, didactic nature that marks many of Ungers's buildings is avoided thanks to the conflict with the historicising architecture of the town house. The old building has clearly had to be sacrificed in certain ways. The proportions of its façade have been changed, to its detriment, due to the additions; the already small open spaces which once helped impart a certain amount of dignity are now missing. In an earlier version of the plans, Ungers had even wanted to pierce through the hipped roof with the core building.

The old-new building is not without problems in its practical applications. The exhibition spaces are limited and divided on several storeys, only connected by narrow staircases. Vestiges of the old building emerge between the old façade and the new additions showing clearly the violence of the intervention. With this introverted building, virtually no use is made of the lovely location on the riverside. It is wholly preoccupied with itself, with architecture as the theme of architecture.

—Wolfgang Pehnt

Bibliography—

Klotz, Heinrich, ed., *Jahrbuch fur Architektur: Neues Bauen 1980, 1981*, Braunschweig and Wiesbaden 1980.
Ungers, Oswald Mathias, *Morphologie: City Metaphors*, Cologne 1982.
Ungers, Oswald Mathias, *Die Thematisierung der Architektur/ Architecture comme theme*, Stuttgart and Paris 1982, 1983.
Deutsches Architekturmuseum, Frankfurt am Main, Frankfurt 1984.
Klotz, Heinrich, ed., *Revision der Moderne: Postmoderne Architektur 1960–1980*, exhibition catalogue, Frankfurt and Munich 1984.
Klotz, Heinrich, ed., *Oswald Mathias Ungers: Bauten und Projekte 1951–1984*, Braunschweig and Wiesbaden 1985.
Klotz, Heinrich, and Krase, Waltraud, *Neue Museumsbauten in der Bundesrepublik Deutschland*, exhibition catalogue, Frankfurt 1985.
Schubert, Hannelore, *Moderne Museumsbau: Deutschland, Osterreich, Schweiz*, Stuttgart 1986.
Lampugnani, Vittorio Magnago, ed., *Museumsarchitektur in Frankfurt 1980–1990*, exhibition catalogue, Frankfurt and Munich 1990.

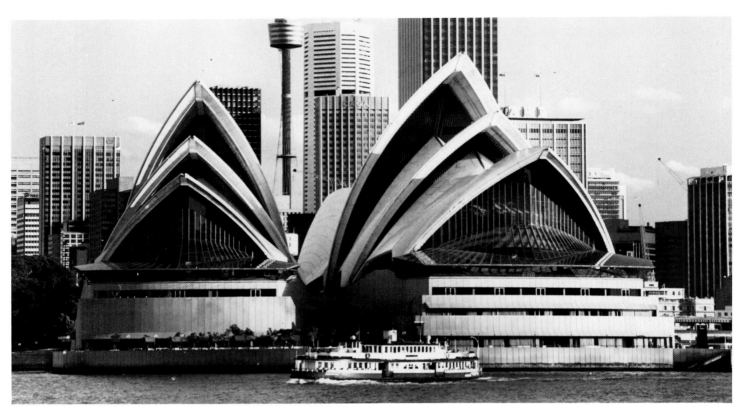

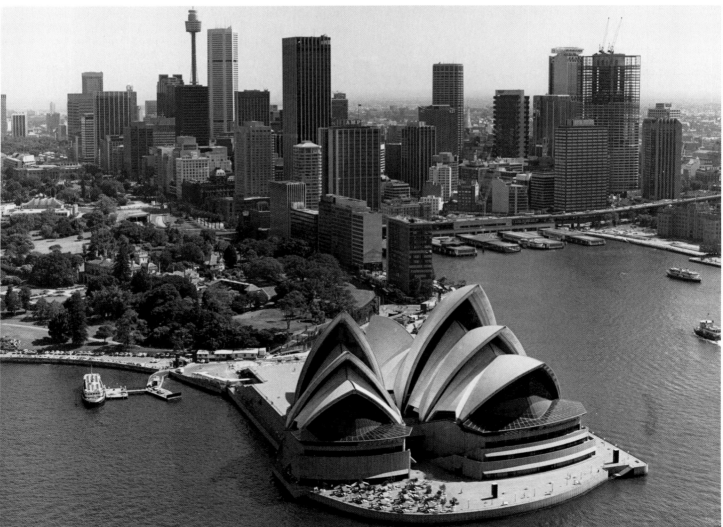

Photos Australian Overseas Information Service, London

Jorn Utzon (1918–)/**Ove Arup** (1895–1988)
Sydney Opera House, Port Jackson, Sydney, 1965–73

Whether glimpsed down narrow streets or gazed upon from city towers, whether seen framed through trees from the Botanic Gardens or in Cinemascope from across the Harbour, whether viewed from the distance of Rose Bay hill or from a descending jet, Sydney Opera House, jutting into the waters of Port Jackson, is a magical and awesome sight.

Now, nearly twenty years old, it is still unique and still beautiful. Different light alters its character so that it can sometimes be white and shining on a hot day, soft and pearly in the morning, or pink and dramatic at sunset. At night it is lit up brightly and glitters. While the events taking place inside do not always match its glamour and brilliance, the building itself is clearly one of the stars of Twentieth Century architecture. It is a fitting building for one of the world's most splendid sites.

Chosen as the winner of an international competition in 1956, Jorn Utzon's original design stood out, even as a mere sketch, from an array of pedestrian, gussied-up boxes which largely ignored the splendours of the site which projects out from Sydney's central business district, surrounded by water on three sides and framed by the familiar arch of Sydney's Harbour Bridge.

Construction began almost immediately in 1957, under political pressure—a state government election loomed—and so began fifteen years of construction beset by design and building difficulties and the very worst sort of cheap, opportunistic political interference. The architect became the convenient scapegoat for the politicians and he left in disgust before the building was finished, and has never seen his masterpiece completed.

The major design problem was that of the famous shells; as originally envisaged they proved too shallow. It took several years to solve the problem of the arches. Between them, Utzon and Arup devised a simple and clever solution based on arches, or spherical triangles, of varying sizes but made up of segments derived from one ovoid form.

Each shell is made from a series of concrete ribs which radiate from the podium, becoming wider up the shell, with successive ribs becoming either longer or shorter as needed. The shells are clad in patterns of two types of tile, one glazed, the other matt, both off-white. This combination gives the shells a softened glow rather than a blinding dazzle in Sydney's summer sunshine.

The shell roof structures which rise to 67 metres (221 feet), cover the two main halls of the complex, the smaller opera theatre beneath the eastern set of sails, and the concert hall beneath the western set. In line with the concert hall there is a small set of shells sheltering the Benelong Restaurant.

Within the pink granite covered concrete podium there is also a drama theatre, a small cinema and exhibition space as well as a multitude of service areas for costume, sets, artists Green Room, lobbies and bars. Despite its name, the Opera House is, in fact, more of a centre for culture and entertainment.

The entire building is surrounded by a broadwalk which on any sunny day is busy with tourists, school children on excursion, strolling couples, the occasional artist at work and plenty of locals gazing in wonder at the soaring, plump sails, taking in the rhythm of the harbour and its traffic or posing for snaps on the ceremonial staircase which rises like a vast Aztec temple.

The interior was completed by a consortium of local architects after Utzon's unhappy departure. The result, while adequate, lacks the genius of the building itself. From the lobbies at either end of both the concert hall and the opera theatre, there are dramatic views, day and night, either across the harbour, or to the towers of the city: sunset can be breathtakingly spectacular. Access to each of the major venues is via interior stairways which rise beneath the arching exposed ribs of the shells and have the feeling of Twentieth Century gothic.

Despite the difficulties of construction, despite the inadequacies of some of the facilities, despite being completed by lesser architects, and despite being bedevilled by political shenanigans, the Sydney Opera House is a monument to the originality of Utzon and the cleverness of Arup. It is hard not to wax rhapsodic over a building which was extraordinary in its conception and is awesome in its reality.

—Brian Phipps

Bibliography—

"The Sydney Opera House," in *Architecture in Australia* (Sydney), September 1960.
Utzon, Jorn, *Sydney Opera House*, Sydney 1962.
Arup, Ove, "Problems and Progress in the Construction of the Sydney Opera House," in *Civil Engineering and Public Works Review* (London), no.703, 1965.
Keys, Peter, and Brewer, Colin, "The Sydney Opera House," in *Architecture in Australia* (Sydney), December 1965.
Arup, Ove, and Zunz, Jack, *Sydney Opera House: A Paper on its Design and Construction*, London 1971.
Arup, Ove, and Zunz, G. Z., "Sydney Opera House," in *Civil Engineering* (New York), no.12, 1971.
Drew, Philip, *Third Generation: The Changing Meaning of Architecture*, London and Stuttgart 1972.
Bradley, Anthony, and Smith, Terry, eds., *Australian Art and Architecture*, Melbourne 1980.

Gino Valle (1923–)
Zanussi Electrical Appliances Factory, Pordenone, 1956–61

The partnership between Gino Valle and the Zanussi electric household appliances firm began in 1956, when the company, recognizing the need to establish their image and increase their production in the light of the new sales possibilities arising from the creation of the EEC in 1957, which would soon see them become the biggest producer of electrical household appliances in Europe, decided to seek the collaboration of an architect of known quality and definite personality.

Valle, endowed with an innate critical attitude, sometimes indeed self-critical, went through an important process of maturation during his time in the United States, where besides getting to know Mies, Gropius and Wright he chanced to read Sir Patrick Abercrombie's monograph on the Chinese Fung-Shui, according to whom the building had to be conceived as growing from the site and to generate a series of archetypes of the "primitive hut." On his return to Udine, he concentrated on trying to reconcile his American experience with the traditional values of rural architecture in Friuli: he developed the concept of a sort of "rhythmic structure of pylons in the façade between which the open space of the deep porticos is condensed" (F. Tentori). In G. Valle's conception of architecture, which K. Frampton defines as Critical Regionalism, different elements overlap, from Stirling's neo-plastic brutalism to the excavated stereometries of Kahn, the luminous transparencies of Neutra, and the organic fluidity of the municipal complex of Säynätsälo by Aalto—who to Valle, together with Mies, represented the role of the beloved master.

Valle displays an obstinately critical attitude in his confrontations with Rogers and Semerini, who sent no messages of real appreciation from the pages of *Casabella-continuità* of his ideas of the relationship between modern architecture and the existing surroundings. It is a question of the incompatibility arising from cultural motivations as different as they determined: Valle is against servile and indiscriminate accommodation with the environment, the falsity of the vernacular and historicist approaches. The Tower at Trieste is contrasted with the Tower of the BBPR, defined by him as "a cultural falsehood, a travesty of the facts of enquiry with Filarete."

His criticism refers to the immobilism of post-war Italian architects, who were unable to meet the urgent needs of architectural speculation. The theme of the tall building, faced by architects moving in the widest orbit of an organic-tectonic conception of architecture, assumes a special attraction because the shock of detachment from the site implies the creation of elements capable in part of enhancing and poising the object.

That is how Wright devised the Price Tower, A. Aalto the plastic lateral frontages of Paimio Sanatorium, Michelucci the skyscraper on Piazza Matteotti in Leghorn, which closely recalls the Tower at Trieste. The analogous relationship between some of Valle's and Michelucci's works is impressive, given their contemporary collocation in the field of "critical regionalism."

After a first approach by Zanussi, for whom he designed digital clocks and gas cookers, he submitted in 1957 a first plan for the new offices at Pordenone, conceived as a closed, inward-looking form developed round a square courtyard.

In 1959 the design was completely changed, while retaining the longitudinal development that formed, at the overhang of the workshops, a material and optical barrier towards Pontebbana street, along the Venice road, just out of Pordenone.

Set against the rectilineal length of the building is a series of highly varied sections, so positioned as to suggest continual movement of the masses, an effect of staggering that gives to the surroundings a dynamic characteristic of this phase of the architect's full maturity.

He was here endeavouring to synthesize the experience already gained in the projects for the municipality of Pordenone and the Savings Bank at Gorizia, in which the background and the existing buildings impose the opening of little interior spaces as courtyards or squares, which the differently projecting sections fill with movement. The process of opening up the parallelepiped, which Breuer used later to great effect in the Whitney Museum, New York, is planned so as to form a kind of wall; against the inside of it the sloping sections of the offices maintain visual contact with the workshops and at the same time, passing under the structure of the wall, appear on a storey at street level to end laterally in the double block of the showroom. The structural rhythm of the double reinforced concrete girders makes a contrast with the metal network which allows the roof levels to paint the background with lightness.

The gallery like a bridge over the whole length of the building conceals behind continuous panelling the long corridor from which the stairs descend to create those inclined planes on the lower storey that seem to provide support for the "bridge on piles," from which this falls to form the way into the industrial complex at street level and rest on the pier that ends where the reception rooms will be built, conceived like a village in the shadow of a mediaeval fort.

The creative process that generated "tectonic levitation," that he used in building the offices, which to anyone going down the main street nowadays make a great contrast with the proliferation of little houses and shops along the sides of the road, drawing attention to the Zanussi building's character of pre-existence and self-defence, was bound to become exhausted.

In fact his next project, for the municipality of Jesolo, offered nothing novel and reproduced the Pordenone idea with manneristic accents, and Valle felt himself in a deep planning crisis: "I recognized that I had nothing up my sleeve; I knew nothing, and had to start all over again."

He then began a period of regeneration that led him to the "rhythms of cosmic life" that he found in the philosophy of Fung-Shui, who in a process of continual decomposition and recomposition of the elements, earth, water, air and fire, succeeded in producing a slow catharsis. This launched him into an obsessive search of the foundations of architecture, capable of mixing abstractism and tradition in a continual exploration of the figurative dimensions that emerge from the bowels of the earth, from which they are extracted by "scratching like a truffle-hound."

Meanwhile, the evolution of the "design product" induced Valle to put forward a new idiom in the process of producing new buildings, given that the great expansion of the Zanussi business called for short time and great flexibility in the construction of stores and distribution centres all over Italy.

Valle thought up a series of prefabricated buildings that were so elementary that it could produce those buildings, defined by him as "non-architecture," which would be put up on the sides of all the most important thoroughfares—prototypes of that proliferation of manufactures that in a variety of shapes and colours will constitute the typical products of Italian industrial architecture of the seventies.

Although Valle claims to have arrived at an architectonic expression "as autonomous as possible," the conception—plastic and of restrained elegance—of blocks closed in on themselves but defined by a wholly pure geometrical form, with a highly studied and refined outer covering, seems to contain evident signs of the scrupulous planning that lies at the base of industrial design.

—Giuliano Chelazzi

Bibliography—

Giudicci, Roberto, "Presente e futuro della architettura industriale in Italia," in *Zodiac* (Milan), January 1962.
"The Look of Industry," in *Architectural Forum* (New York), April 1962.
Rykwert, Joseph, "Gino Valle: Edifici Industriali," in *Domus* (Milan), November 1970.
Fumagalli, P., "The Architecture of Gino Valle," in *Werk, Bauen und Wohnen* (Zurich), July/August 1983.

Aldo van Eyck (1918–)
Hubertus House single-parent family housing, Amsterdam, 1975–79

The art of the unexpected is never far from the surface in the work of Aldo van Eyck. That is one reason why Van Eyck has the ability to humanise institutional buildings. At the Hubertus House, which is designed for single mothers and their children, in a similar manner to the Orphanage that he designed in 1959, Van Eyck creates a framework for a social attitude to design in which people can live their lives in an environment which is stimulating. The design problem presented by the Hubertus foundation was to rehabilitate an existing building and to form a new one. In Van Eyck's solution, he manipulates the connection between old and new so that both designs are enhanced by their adjacency.

Central to Van Eyck's approach is a belief in modernism, but not in a dogmatic sense, for his work is always complemented by an artistic content. The concrete columns that rise from a plinth to support the superstructure of glass and steel, and the façade panels which are painted blue are modern in concept. There is art, too, in the connection between old and new, for a recess is formed in plan that comprises entrance and staircase. At this recess there is a display of colours, of green panels, and of yellow, red and orange window frames. The entrance at mezzanine level is approached by a curving staircase, and for those passing the building at pavement level there are multi-coloured tile panels surrounded by small mirrors. Throughout the building, the colour scheme used is that of the rainbow which at times produces a kaleidoscopic effect.

Van Eyck's accommodation for the infant children probably is less a design but more an invention. The rooms are arranged at ground floor level and at mezzanine. From the entrance a corridor at mezzanine level, which may be thought of as a "street," gives access to the children's wing. At regular intervals stairs lead down from the corridor, which is top-lit, to five "houses" arranged at ground level. The stairs lead into delightfully formed living and dining spaces that are articulated by convex and concave shapes. To the rear are the children's bedrooms, which are in effect "secret" rooms. Natural lighting to these rooms is provided from the glazed corridor, or "street" above and also from a dome ceiling light, covered by a sliding panel at night. The sectional form provides privacy for the children but allows the parents to see their children from the glazed access "street."

Ideas on the use of colour are further developed in the children's bathroom, where a narrow strip of multi-coloured tiles surrounds the room. Inventive detail abounds throughout the building. The bath tub is a timber one specially made by a shipbuilder and large enough for several children to bathe together. Each of the living spaces leads out to a communal courtyard from where a staircase leads people to the roof of the living spaces and, by means of an open trellice device, connects to the mezzanine entrance hall. Each bedroom and living space is identified by a particular colour scheme in which bright colours are dominant. Those colours are set against naturally finished timber panels that are used in all parts of the design. Subtleties in details are found in both the design of the range of doors and in the form of window frames. The transoms to the canteen windows which overlook the street are segmental so that, in theory, both a child and an adult may have unobstructed views at a scale which they understand.

Fortunately, the conceptual approach of Van Eyck to the design can be related to theoretical ideas which he has developed over the years. The notion of "street" observed in the children's quarters results from the metaphorical comparison of a house to a town. Van Eyck has stated that he likes the ambiguity which is created by the idea that a house may be considered a tiny city, and the city a huge house. He has identified a form of clarity which results from the ambiguity of what may be termed an in-between realm. This clarity he refers to as "labyrinthian clarity." Van Eyck considers that each individual personality is special, and that to think of space and of time is to think of abstract concepts. To Van Eyck "space in the image of man is place and time in the image of man is occasion." Where can we find theoretical notions for those "secret" bedroom spaces for the infants? Possibly in Van Eyck's appreciation of the contrasting conditions of day and night or in mythological allusions to Ariel and Caliban.

Arguably, the Orphanage by Van Eyck built in 1959 was a more significant design in its time than was the Mothers' Home. That is probably due to wider architectural issues, for the Orphanage was considered to reflect the discussions of both Team Ten and the Dutch Forum group. On the other hand, the Mothers' Home may be considered to have heralded a late flowering in the work of Van Eyck. Since when he has completed a group of richly creative buildings of which the ESTEC building for the European Space Research Centre on the Dutch North coast is the most significant. However, it would be unfair to underestimate the architectural value of the Mothers' Home, for although Dutch design has had a more solid base in modern architecture than that of other countries, Van Eyck's design reiterated a strong belief in modernism in the midst of a confusion of architectural styles. He did so in a way in which enjoyment is found in all aspects of the design.

Van Eyck's design of the Mothers' Home has reconciled divergent aspects of present day culture, for the complex social issues presented by the brief have been solved by an artistic spirit. A further challenge was that of building in juxtaposition with a building of some architectural value. This has been answered in a positive way, so that both old and new gain from the contrast in style. The design solution is a reflection of Van Eyck's idiosyncratic approach to architecture, which is one based upon both personal experience of wide ranging cultural influences and of an appreciation of the debt to the artistic founders of the modern movement.

—E. S. Brierley

Bibliography—

Hertzberger, Herman, *Aldo van Eyck: Hubertus House*, Amsterdam 1982.
Doubliet, Susan, "Weaving Chaos into Order: Home for Single-parent families, Amsterdam," in *Progressive Architecture* (New York), March 1982.
Buchanan, Peter, "Street Urchin, Mother's House, Amsterdam," in *Architectural Review* (London), March 1982.
Strauven, Francis, ed., *Aldo van Eyck*, Antwerp 1985.

Photo Rollin R. LaFrance

498

Robert Venturi (1925–)
Vanna Venturi House, Chestnut Hill, Pennsylvania, 1961–63
Painted stucco over concrete block; 27,000 sq. ft.

The house Robert Venturi built for his mother in a Philadelphia suburb looks like a child's drawing of a house. Flat fronted, clearly outlined and almost symmetrical, it has a big embracing gable, sheltered central entrance and prominent chimney post. It seems almost innocent, but it was anything but innocent when it was built. Venturi made the house a spirited critique of everything modern architecture had come to represent and he deplored—modernism's single-minded concern with function, rationality, and the present, with no regard for the history of architecture or the conventions of mainstream American culture.

The house may look simple, but it is loaded with historic references and complicated by elements that are not what they initially appear to be. Unlike most modern houses, it looks like a house. Its basic shapes and materials resemble those of older houses nearby. But its overarching gable is split down the middle. The chimney spout, which seems designed to fill that slit, is slightly off center. The symmetrically placed windows are balanced rather than paired. The front door is prominently centered but hidden in shadow. The smooth, thinly decorated, symmetrical façade, which meets the street blankly, refers to Michelangelo's Porta Pia. The embracing gable comes from McKim, Mead & White's Low House and Alessandro Vittoria's nymphaeum behind Palladio's Villa Barbaro. The cut in the middle echoes fissures in numerous Baroque churches, the Villa Aldobrandini and a modern apartment house by Luigi Moretti in Rome. The blind staircase inside recalls Frank Furness's "nowhere stair" in the old University of Pennsylvania Library. And every one of these details and others furthers the architect's theory.

While Venturi was designing the house, he was writing *Complexity and Contradiction in Architecture*, a statement of his architectural ideology which directly opposed the prevailing one of the time. "This building (the house) recognizes complexities and contradictions," Venturi wrote, "it is both complex and simple, open and closed, big and little . . . by which I mean that it is a little house with a big scale. Inside the elements are big: the fireplace is 'too big' and the mantle 'too high' for the size of the room; doors are wide, the chair rail high . . . Outside the manifestations of big scale are the main elements, which are big and few in number and central or symmetrical in position . . . The main reason for the big scale is to balance the complexity . . . the big scale in the small building achieves tension rather than nervousness."

Venturi's main idea was to avoid the oversimplification that an excessive concern for function created in most modern architecture. He believed in acknowledging ambiguity, the phenomenon of "Both-And" in architecture, "Double-Functioning" elements, and in embracing the conventional, pointing out that conventions, like clichés, became conventions for good reasons. Real invention could come from using the conventional unconventionally, he said.

In the introduction to a collection of the Venturis's writings, *A View from the Campidoglio, Selected Essays 1953–1984, Robert Venturi and Denise Scott Brown*, Scott Brown described the firm's working process: "Writing was important to us as younger architects before we had the opportunity to express ideas through building. However, as our practice has grown, we have continued to pen essays . . . for the same reasons we . . . sketch while designing: to clarify ideas about architecture. It seems that mixed media—opera, words with pictures, buildings with writing—is our medium."

The writings were particularly important because, until the 1980s, the Venturis (first Venturi and Short; then Venturi and Rauch; Venturi, Rauch and Scott Brown; finally Venturi and Scott Brown) had very few major commissions. Ironically, when the commissions came, they came from established cultural institutions. Although the Venturis had made popular culture respectable in avant garde circles with books like *Learning from Las Vegas* and had designed impressive projects for clients like the National Football Hall of Fame (1967), the old Blenheim Hotel in

Atlantic City (1977) and Miami Beach (1978), these were never realized. The popular culture was not ready for the Venturis. They are most likely to be remembered for the Vanna Venturi House, Franklin Court (a Ben Franklin memorial in Philadelphia of 1972), an addition to the Allen Art Museum at Oberlin College in Ohio (1973), a series of academic and residential buildings at Princeton University in New Jersey (1980s) and the National Gallery annex, London (1991). The firm's work is surveyed in Stanislaus von Moos's *Venturi, Rauch & Scott Brown, Buildings and Projects*, which traces the architects' intellectual and artistic roots from David Hume to Gyorgy Kepes and from Sebastiano Serlio to Jasper Johns, stopping to explain the connections to William Empson, Melvin Webber, Herbert Gans, Eugene Chevreul, Le Corbusier, Frank Furness, Louis Kahn, Alvar Aalto, Sir Edwin Lutyens, the Smithsons, Walker Evans, Robert Rauschenberg and Edward Ruscha.

From Empson, Venturi took the idea of ambiguity and pointed out that the most interesting works of historic architecture did not clearly fulfil a single, identifiable purpose, the way modern architecture was supposed to do. From the pop artists, he derived a respect for American culture of the masses which most modern architects despised. The architects he admired most defied easy classification, so Venturi tried to create an architecture that met psychic, social and personal needs uncanonically. His mother's house, though very quirky, is recognizable as a house. It is almost generic. The rather open, symmetrical plan is distorted here and there to provide for the owner's requirements. It is composed of irregular, overlapping shapes, surrounding two symbolical vertical elements, a staircase and hearth, which compete for the central position. In the house, Venturi used standard windows and doorways as modern architects rarely did. And he added purely decorative details, as historic architects always had.

Venturi's most radical idea, in terms of modern architectural theory which banished all applied ornament, was that of "the decorated shed." It called for a complete separation of the ornamental from the structural and functional, a position tantamount to a request for the separation of form and content in art. In practice, Venturi never designed a "duck," a pure sign building like the duck-shaped duckling stand on Long Island which he repeatedly tongue-in-cheekly praised. But he did apply ornament like the strips of standard moulding on the outside and interior walls of his mother's house which was intended purely to make it look more attractive and house-like. That was something, of course, that every unthinking, uneducated home builder automatically did, but it was scandalously tabu in the world of highly educated, intellectual modern architects—until Venturi.

—Jayne Merkel

Bibliography—

Venturi, Robert, *Complexity and Contradiction in Architecture*, New York 1966.
Scully, Vincent, *The Work of Venturi and Rauch*, exhibition catalogue, New York 1971.
Venturi, Robert, Scott Brown, Denise, and Izenour, Steven, *Learning from Las Vegas*, Cambridge, Massachusetts 1972, 1977.
Goldberger, Paul, and Futagawa, Yukio, eds., *GA 39: Venturi and Rauch*, Tokyo 1976.
Dunster, David, ed., *Architectural Monographs 1: Venturi and Rauch*, London 1978.
Pettena, Gianni, and Vogliazzo, Maurizio, eds., *Venturi, Rauch and Scott Brown*, Milan 1981.
Arnell, Peter, and Bickford, Ted, eds., *A View from the Campidoglio: Selected Essays, 1953–1984—Robert Venturi and Denise Scott Brown*, New York 1984.
Haag Bletter, Rosemarie, *Venturi, Rauch and Scott Brown: A Generation of Architecture*, exhibition catalogue, Urbana, Illinois 1984.
Von Moos, Stanislaus, *Venturi, Rauch & Scott Brown: Buildings and Projects*, New York 1987.

Photo Aéroports de Paris, Direction de l'Architecture

Johan Otto von Spreckelsen (1929–87)
Grande Arche de La Defense, Paris, 1981–89

In a technically demanding and financially complex field such as architecture, it is rare for an unknown designer to win a major international competition and actually see his work executed. One such case occurred in the 1960s, with Jorn Utzon's controversial Opera House in Sydney, Australia. A similar event took place in 1981 when an international competition called by the French government was won by another Dane, Johan Otto von Spreckelsen, a professor at the Academy of Art in Copenhagen who was practically unknown outside his own country. In both cases, moreover, economic difficulties and political intrigue in the host country led to the architect's quitting the job half-way through construction and to his disowning any artistic paternity for the work. But while Utzon lived to see his work completed eventually, Spreckelsen was not so fortunate. He died in 1987, shortly before his master-work was unveiled for the 200th anniversary of the French Revolution.

The Grande Arche de la Defense lies on one of the greatest historical urban axes in the world: Le Notre's grand projection from the Louvre through the Tuileries and the Champs Elysées. This magnificent westward vista runs in a straight line through the Arc du Carrousel, the obelisk in Place de la Concorde, and the Arc de Triomphe at L'Etoile. At one end of it lies I. M. Pei's much-debated glass pyramid, which takes up the center of the Cour Caree of the Louvre. Spreckelsen's great cube marks the other end with a "temporary Grande Finale" that terminates without closing the axis, which will be prolonged, presumably, as the city continues its westward expansion. The two monuments are thus complementary, each embodying a primary architectural form; yet Spreckelsen's work is the more successful and powerful, a "great window to the future . . . celebrating the triumph of mankind," as the architect described it.

In contrast to Pei's glass pyramid, the Grande Arche stands at the heart of the modern business district outside the historic center. It faces a great rectangular esplanade bounded on two sides by an assemblage of tall and, for the most part uninteresting, office and residential towers. The whole structure is twisted 6.5 degrees with respect to the axis, thus echoing the inflection of the Cour Caree. While the twist introduces a welcome element of uncertainty in an otherwise optimistic and somewhat technocratic set of ideological associations, it also serves to link it visually with that other great symbol of Paris, the Eiffel tower. In its dual relationship to its immediate surroundings and to the city as a whole, the building makes a striking new addition to the urban landscape of Paris.

The beauty of the scheme lies in its utter simplicity and awesome scale. A great hollow cube of more than 100 meters to one side, clad in sparkling white Carrara marble, this "modern Arc de Triomphe" is nothing if not spectacular. Its assertive profile may be seen rising above the skyline of La Defense from as far as the Arc de Triomphe. The hole itself is as wide as the Champs Elysées and tall enough to contain the façade of Notre Dame. In contrast with the smooth exterior surfaces, the inner sides present a coffered appearance, with square paned windows set in a splayed grid frame. The two sides are occupied by offices, while the top is bridged by a great landscaped roof terrace incorporating conference rooms and gardens (the roof is presently used for the Foundation for the Rights of Man and Human Sciences, set up by the French government to celebrate the bicentennial of the revolution). The bottom houses a vast exhibition space whose roof serves as a podium for the cube. Visitors reach the top of the structure through a glass column of lifts from which they can enjoy the dramatic view down the almost eight-kilometer long axis—a visual experience analogous to that other great government project of the '70s, the Centre Georges Pompidou, with its caterpillar-like escalators climbing up one side of the building.

The Grande Arche is as bold formally as it is technically innovative. Developers say that if a giant King Kong came to Paris he could pick up the cube and carry it away. Indeed, the cube is not anchored to the ground but rests on a series of neoprene cushions supported on two rows of six piles. The whole building is a single post-tensioned concrete structure consisting of four enormous square frames for the base, the two sides, and the roof. The sides are stiffened horizontally by seven concrete slabs set at regular intervals. The roof is supported by giant concrete beams set at right angles to the frames.

During the final phase of construction, the Grande Arche underwent several major revisions which deviated from the architect's initial intentions. At first it was intended that the whole structure be occupied by an international communications center, the so-called Carrefour International de Communication (CICOM), but in 1986 the conservative administration of Jacques Chirac decided to cut the funds and auction off part of the building and the land surrounding it for commercial use. Further changes were made to the exterior cladding, which went from smooth transparent glass in Spreckelsen's scheme to a rather ungainly grid of semi-reflective panels framed in dark grey marble. The worst change, perhaps, was in the suspended canopy hovering over the podium. Designed by Peter Rice after the architect's death, this unfortunate intrusion bears only the faintest resemblance to the glass "clouds" envisioned by Spreckelsen and makes a jarring contrast with the linear purity of the whole. Yet even with these alterations, the completed structure is reasonably close to the architect's intentions, as expressed in his remarkable series of sketches submitted in 1981.

Of all the "grand projects" commissioned by the French Government in the last decade, the Grande Arche is certainly the most compelling both visually and symbolically. As William Curtis observes, the arch tries to do for its time what the Eiffel tower did for the age of steam and steel: it is a grandiose assertion of confidence in a new age of communications technology. At the same time, the idea of an open cube—a huge shelter under which the people of the world may meet in a spirit of enlightened cooperation—manages to convey a sense of civic identity and timeless monumentality, which is only slightly marred by the sometime mundane materials and detailing. In its formal purity the Grande Arche is both a testimony to the historical ambitions of the French socialist government and a vital new addition to the history of modern monuments.

—Libero Andreotti

Bibliography—

Loriers, Marie Christine, "Building a new Paris: La Defense," in *Progressive Architecture* (New York), September 1983.
Tete Defense: concours international d'architecture 1983, Paris 1984.
Architectures capitales: Paris 1979–1989, Paris, 1987.
Mangin, David, and others, "La Grande Arche de La Defense," in *Architecture d'Aujourd'hui* (Paris), September 1987.
Monnier, Genevieve, "Hommage a l'architecte de la Grande Arche," in *Techniques et Architecture* (Paris), February/March 1988.
Andreu, Paul, *La Grande Arche, Tete Defense, Paris-La Defense*, Paris 1989.
"Johan Otto von Spreckelsen," special monograph issue of *Arkitektur DK* (Copenhagen), no. 1/2, 1990.

Photo British Architectural Library/RIBA

Photo Boots Company plc

Evan Owen Williams (1890–1969)
Boots Wet Goods Factory (D10), Beeston, Nottingham, 1930–32

Evan Owen Williams was an engineer who also practised architecture, and although he is rumoured to have despised talk of functionalism he is often cited as the progenitor of British modernism.

With buildings such as the Boots Factory at Beeston, Nottinghamshire and the Pioneer Health Centre in South London, Owen Williams displayed an ability to cater to the brief set by the client and produce works of structural clarity and architectural integrity. Both projects demonstrate how buildings owing their appearance and performance to the skill of the engineer can come to be regarded as functional architecture.

Although the factory building appears radical when viewed against the backdrop of contemporary British architecture, the Boots Factory was not without precedent when it appeared, either in construction techniques or in materials used. Brinkman and van der Vlugt's huge factory complex for Van Nelle at Rotterdam, built in 1927, has certain similar features, such as mushroom-post construction and extensive use of concrete and glass to provide a well-lit, functionally derived working space. Owen Williams could be said to have been working well within the accepted boundaries of engineering-cum-architecture when the Boots factory was erected; nevertheless, the building is well realised and, within the context of modern British architecture, deeply innovative.

The Boots Wet Goods Factory, or D-10, was designed to house the manufacture, packaging and distribution operations for "wet" goods, such as lotions, linctuses, shampoos and other liquid pharmaceuticals. The interior design of the factory is determined by the necessary movements of these goods and the people handling them. Large, ground-floor working areas are toplit by "glasscrete" ceilings which form the girder-supported, slightly hipped roof. In turn, these spaces are bounded in the vertical by four stories of galleries upon which goods and packaging materials can be stored. With a view to minimising the effort needed to move goods around, the shop floor was designed to be largely gravity-fed, with a system of gantries, shutes and pulleys connecting the galleries to the working areas below.

The interior is made remarkable by the absence of any solid interior walls. The reasons for their omission are two-fold. Firstly, the lack of interior divisions means that all of the galleries can connect with the shop floor, so allowing longitudinal and vertical links throughout the building creating one, large interactive and interdependent space instead of several smaller ones. Secondly, the intentions of both Boots and Owen Williams were reputedly to provide the employees with something approaching the ideal factory space in which to work. The eradication of enclosing and confining walls was designed to create a large, airy and well-lit environment in which the mainly boring and repetitive work could be carried out with the minimum of discomfort.

Although the interior of the building is spartan, with exposed pipework, rattling gantry cranes, conveyor belts and all of the equipment and echoing noise associated with a working building, there is openess and light and a sense of organised space which no doubt contribute to the fact that the factory is still in use in the role for which it was built some sixty years after its construction. Although the predominance of gantries and galleries, lined with utilitarian railings have prompted some workers to compare the interior to certain high-security prisons, there is no doubt that the building functions well in the capacities for which it was designed.

The quasi-utopian ideas, which brought about the suffusion of light and space into the industrial interior were in keeping with some of the thrust of European modernist philosophies, rooted as they were in the polemical search for an architectural order in keeping with the perceived modernity of the 20th century. In addition, the likes of Le Corbusier, Mart Stam and others were looking to the heritage of buildings designed by engineers for a heroic, functionally-derived architectural language in which to build.

Significantly, at least in the history of British modernist building, the Boots factory brings together these twin ideas of social concern and functionalism in architecture in the one building. Many of the building techniques propounded by leading European modernist architects are to be found in some form in D-10, not as a result of Owen Williams latching onto a new architectural style, but because the employment of these techniques allowed for the best possible resolution of the problems presented in the design of such a building.

For example, the use of pre-cast mushroom-posts as the predominant structural member allows for a system of cantilevering where the exterior fenestration can be rendered relatively unbroken. In Britain at least, the use of glass curtain walling on such a scale was a radical innovation. This free façade, executed in glass, avoids the potential pitfalls of monumentalism, whilst allowing light to flood the interior spaces.

The benefits of cantilevered construction continue on the inside of the building too, as it is the use of this technique which obviates the need for interior structural supporting walls.

The ubiquitous mushroom-posts, supposedly based on the shapes of palm trees, appear outside the building, too. Here, they act "pilotis," raising one wing of the building from the ground, originally allowing a railway to pass underneath.

The Boots factory exhibits several of the hallmarks of a quintessentially modernist building: clarity of structure, the employment of modern, eminently suitable materials, a free interior plan, a free façade and even pilotis, although never employed in the Corbusian manner. The Boots factory is a successful modernist building because it was never conceived or built with anything but its function in mind. There is a submission to efficiency in the design of the structure which eschews stylistic posturing in favour of a soberly expressed rationalism.

Nevertheless, there is a delicacy and control about the definition, enclosure and planning of such a large working space which lifts what could be a mundane building out of the ordinary and turns it into something of an architectural and engineering *tour de force*.

—Michael Horsham

Bibliography—

Cottam, D., *The Law of Least Action: Sir Owen Williams' Career 1922–1939*, thesis, Liverpool University 1980.
Rosenberg, Stephen and others, "Sir Owen Williams," in *Architectural Design* (London), July 1969.

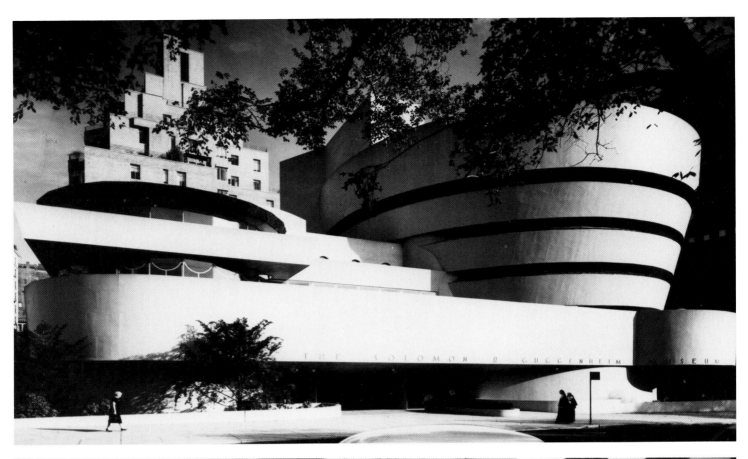

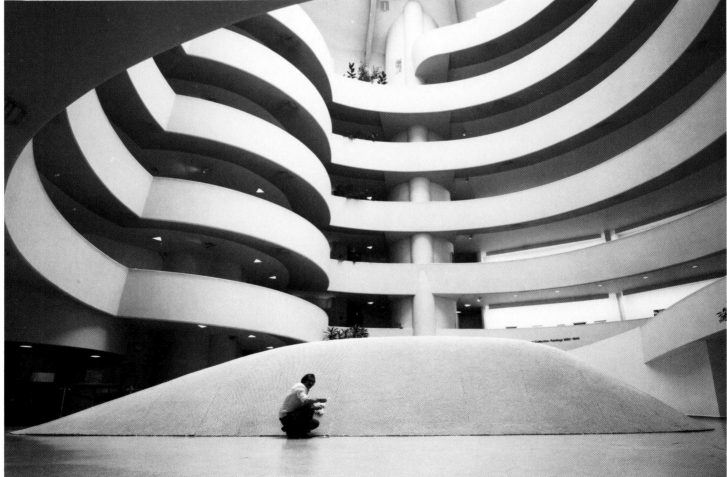

Photo British Architectural Library/RIBA

Frank Lloyd Wright (1867–1959)
Solomon R. Guggenheim Museum, New York, 1959

For more than sixty years up until his death in 1959, just a few months before the opening of the Guggenheim, Frank Lloyd Wright designed a long series of buildings that were eccentric and innovative, individual and revolutionary. There is no mistaking his hand despite the vast number of and the considerable variation of styles within his work.

Significantly, those who tried to follow in his footsteps were unable to match the genius; even though they emulated all the forms, they ended up with nothing much more than derivative superficiality and pastiche.

Most of Wright's later works were basically Modernist but he never fully immersed himself in European Modernism, preferring to follow the beat of his own somewhat different drum. During his later years Wright shifted in some ways from his adherence to organic design and explored more geometric forms. The Solomon R. Guggenheim Museum of Art is based on a spiral that is set into a podium. Included in the design were a small, round pavilion and an abbreviated, rectangular tower. The tower was not built until later and then only in reduced form.

The gallery space is contained in two areas, the permanent collection in traditional spaces within the podium and within the spiral, temporary exhibition areas. The spiral gallery is unusual in a number of ways. It is usual to take an elevator to the top of the spiral tower and then descend on foot taking in the display on the way down. Hardier souls have been known to walk up as well as down. The concept of a continuous gallery space within a spiral is a novel one, though not one that has gained universal approval.

Some find the spaces too confined and too constricted to properly display works of art to full advantage. The continuing slope of the floor and the ceiling can be disconcerting, especially the conflict between the edges of paintings and the out-of-alignment ceiling. Standing, despite the gentleness of the decline, is never fully vertical and some find this off-putting. "The mildly irritating fact that one foot is always lower than the other when viewing a picture is negligible beside the sheer drama of the interior space," is the opposing view stated by Peel, Powell and Garrett in their biography of *Frank Lloyd Wright*. Others find the experience so exciting that they have not noticed there is a problem.

As the spiral ascends, the ramp becomes broader, creating an open central well that is one of the great interior spaces of the twentieth century. The ramp is suspended from huge pylons while the light well is covered by a glass, ribbed "dome" and is flooded with natural light. Additional lighting is given by continuous strip lighting around the ramp. The area at the bottom of the well is often used for the display of sculpture.

The exhibition space along the ramp is divided into equal bays grouping works into threes and fours to gain a greater sense of intimacy. The gallery-goer can turn at any time, however, and look across the building, savouring both the memory of what has been seen and anticipating what is to come.

It is an idea that has not been emulated, yet, as a solution of the problem of circulation, it is a very clever one.

The circulation pattern and spaces of the permanent exhibition gallery are conventional in the general sense, but like all the interior areas and even the exterior of the building, the feeling is more that of 1920s Moderne rather than of mid-twentieth-century Modernism.

The exterior is smooth concrete totally without decoration other than the shape of the building itself, and that shape is both sculptural and dramatic. Sitting on its corner site, the Guggenheim is as unusual and flamboyant as its architect. The building deliberately contrasts with its environment, contrary to Wright's usual practice of relating his architecture to its surroundings in a very definite and "organic" way. The windows are a continuous strip set back from the façade to create a strong play of shadow against the smooth, light surface of the spiral tower.

While the Guggenheim is certainly one of Wright's best known works, whether it is his best is a moot point. He had a stock response whenever someone foolishly asked which he thought was his greatest achievement: "The next one, always the next one."

—Brian Phipps

Bibliography—

Scully, Vincent, *Frank Lloyd Wright*, New York and London 1960.
Lloyd Wright, Olgivanna, ed., *Frank Lloyd Wright: His Life, His Work, His Words*, New York 1966.
Pawley, Martin, *Frank Lloyd Wright: Public Buildings*, Tokyo 1967, London 1970.
Storrer, William Allin, *The Architecture of Frank Lloyd Wright: A Complete Catalog*, Cambridge, Massachusetts 1974, 1978.
Muschamp, Herbert, *Man About Town: Frank Lloyd Wright in New York City*, London and Cambridge, Massachusetts 1983.

PHOTOGRAPHY

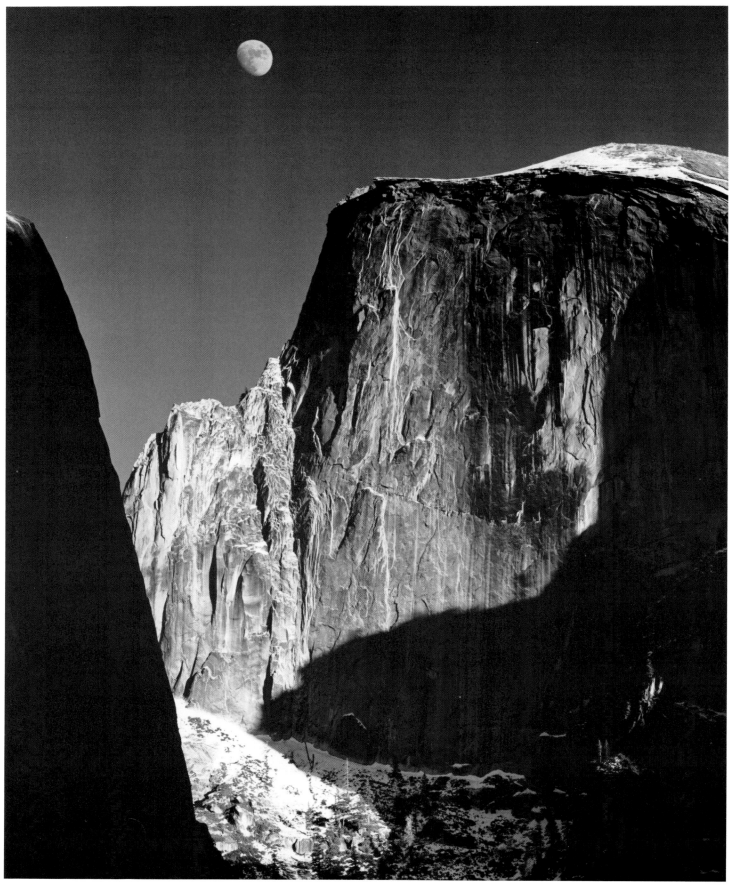

Copyright © 1991 by the Trustees of The Ansel Adams Publishing Rights Trust.
All Rights Reserved.

Ansel Adams (1902–84)
Moon and Half Dome, Yosemite National Park, California, 1960
Black-and-white photograph

The work of Ansel Adams, ranking among the classics of world photography, compels a new perception of the world and a rediscovery of nature. The artistic conviction that makes this photography great is contained in Adams' way of perceiving and registering reality. Adams sees with an absolute perfection that is idiosyncratically and characteristically his own. Conscious of the distinctiveness and individual character of photography, he tends to look for ways of creating a new aesthetic that is specific to it. Accordingly, he rejects the so-called beautiful, painted images that are based on bland geometric perspective. The photography he practises neither describes nor imitates reality—it experiences the world and nature. What Adams sees, he feels deeply and he admires his world and his country in all its power, variety and changeability.

The life and work of Adams are inextricably bound with the history of photography. His first photographs were taken in 1916 when he was a boy of 14. Photography, which originally supplemented his musical education, rapidly became his life's passion. The turning-point came in 1930, in Taos (New Mexico), when he saw some of Paul Strand's negatives and encountered "...forms of lighting and expression inaccessible to the ordinary camera...." As a mature artist, two years later, along with Edward Weston and Imogen Cunningham, he became a founder member of the f/64 Group whose short period of activity marked a huge step forward in the evolution of photography as an independent art form. In 1933, Adams met Alfred Stieglitz, a meeting which was to be totally decisive in determining his further creative output. Fascinated by Stieglitz's art and philosophy (...to look on the beauty of the world, and to express and interpret it through photographic means...), Adams was to remain faithful to him thereafter. His first one-man show in 1936 was not only a great example of photography as art but also a full acknowledgement of the Stieglitzian doctrine "...art as affirmation of life...."

Adams is extremely prolific in his output—interested in Hawaii and New England, the South-West and California, Alaska and the Rocky Mountains. The subjects of his observations and studies are people and architectural details, road signs, open spaces and rocks—anything and everything that the lens and eye of the artist can transmute to beauty and endow with meaning. Above all, however, Adams is a photographer of "Great Nature," of the "magnificence of his country" that fascinated him so much from childhood. For Adams, nature is perfection and, in it, he finds a consummate beauty capable of creating its own autonomous, poetical-mystical existence. "I know of nothing," he once said, "in painting, sculpture or music that could be more enchanting than precipitous coasts or domed rocks, that could be more beautiful than the soft light on the slopes of hills and on woods, or more powerful than the splendour of thunder..." Bewitched by nature, he subordinates almost all of his creativity to it and is passionate in his discoveries of mountain chains, rocky rubble, branches of trees and clouds—all the things that form the scenery to the spectacle we know as nature. Adams is an excellent guide to this spectacle—in sharing the reality of these unreal places with the spectator, he facilitates their recognition and fosters a dawning understanding of discovered greatness.

For him, nature is insurmountable—pure and virginal. For that reason, with a few exceptions, landscapes in which people are present are lacking in his work. Adams attains greatness, dimension and expression in ways that are actually very simple. His basic problem lies in composing his picture or, more accurately, in organising the flat surface of the photograph in relation to the space registered. Through long years of arduous studies, Adams came to the conclusion that the basic issue hinges on finding a way to illuminate the centre of the picture while leaving the borders dark. His "zonal lighting system" is nothing more than a perfectly mastered harmony of contrasting whites, blacks and shadows. Each element of the composition has its own carefully chosen and considered place, each subject is in some sense and to some degree

a collection of light. This lighting, low or high, is usually very complex. Regardless of what sort it is, for Adams, it is always something more than the ordinary light of a tree, rock or water. According to him, the distance that stretches between black and white separates the real world and its representations and encompasses the whole shape of the world. All this can be seen in his famous work—*The Moon and Half Dome Peak in the Yosemite Valley in California* (1960). Notable for its careful composition, deliberation and balance, it is built up of elements each of which has its own role to fulfil and in the absence of which the picture would be incomplete. The composition of the picture is inextricably interwoven with its aesthetic.

Not many artists in the history of photography have managed to combine artistic vision and extraordinary technical mastery in equal measure as Adams has done. The most surprising thing, however, is that such wonderfully mastered technical skill can be reduced, in essence, to a seemingly trivial operation—the ability to seize the appropriate moment.

"...Of all types of photography," Adams claimed, "landscape provides the best test of a photographer's skill. The photographer must almost physically seize that combination of land, sky and cloud that is accessible to him; he cannot compose these elements or arrange them to his own satisfaction, displacing the camera by a few inches will not help him to grasp this combination...In order to catch the moment when the landscape is revealed at its most vital, the photographer must hold his responsiveness in readiness like the hunter his gun. And just like the hunter he also needs to practise unremitting patience and constant vigilance...." Photography, for Adams, is the art of seizing miraculous moments, recording rare seconds filled with expression and real harmony—of composition, light and action. It is the art of grasping and consolidating something fragmentary, something that often disintegrates in the very process of being observed. Adams is the unsurpassable master of representations of short-lived beauty and perfection.

The whole of Adams' work aims to free photography from the influence of painting and to invest it with the autonomy and authority of art. Paradoxically, however, it is in painting that it finds its closest analogy. One glance at Adams' photographs is enough for an understanding of their close relationship to Cezanne. They have much in common—in their rejection of the past, of the subordination of art to the discipline of order and composition, in their appeal to nature. In endeavouring to realise his new perspective, Cezanne did not hesitate to distort and radically simplify, Adams resorts to registering non-recurring, rare—one wants to say impossible—events. Both have been criticised for practising a static art, soullessly beautiful and inhuman.

"...Art," said Stieglitz, "bears testimony to life, life in its turn, or what we understand as life, is encountered everywhere..." Deeply faithful to this idea, Adams encounters it in forests, cliffs and clouds, in the storms of desert landscapes—in nature. His photography not only reflects enchantment with a warning world but also belief and confidence in enduring and timeless values.

—Ryszard Bobrowski

Bibliography—

Adams, Ansel and Virginia, *Illustrated Guide to Yosemite Valley*, San Francisco 1940, 1963.
Adams, Ansel and Virginia, *Michael and Anne in Yosemite Valley*, New York and London 1941.
Adams, Ansel, *Yosemite and the High Sierra*, Boston 1948.
Adams, Ansel, *My Camera in Yosemite Valley*, Boston 1949.
Adams, Ansel, *Yosemite Valley*, San Francisco 1959.
Adams, Ansel, *Yosemite and the Range of Light*, Boston 1979.
Adams, Ansel, and Alinder, Mary Street, *Ansel Adams: An Autobiography*, Boston 1986.

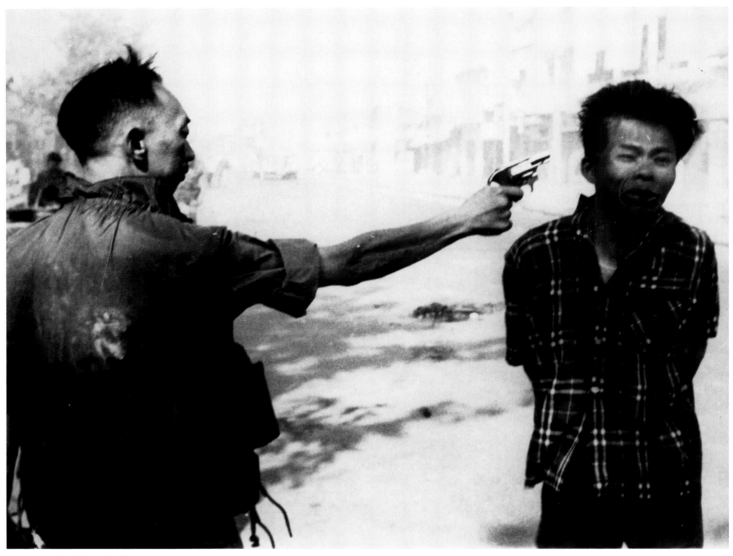

Photo Associated Press, London

510

Eddie Adams (1933–)
Vietnamese General Executing Vietcong, 1968
Black-and-white photograph

Perhaps the most profound image of the Vietnam War, this photograph is credited with firing up American objection to the war and tooling Pentagon officials with the "need" to censor journalistic reportage, with being too confrontational, e.g. too cold-blooded and with encouraging that cold-bloodedness with the camera. It has been accused of violating moral, aesthetic, and security standards; essentially for having, in large or small ways, upset American values and directions. For the most part, the charges are true, mainly because it roiled up American sensibilities of that time, and because it was a photograph, not any other visual instrument.

Eddie Adams, the AP photographer who took it, was in Saigon as the Vietcong Tet offensive opened to mark the Vietnamese lunar New Year, January 30th, 1968. All over the peninsula, Vietcong troops blasted into South Vietnam's provincial cities, even into the capital, Saigon. The US Embassy had been taken in the middle of the night—and recaptured—while Vietcong burst down streets, into homes and offices, drinking and celebrating, shooting Vietnamese and Americans, sometimes randomly sometimes purposefully. At the height of battle, near one of the city's major pagodas, a civilian-clad Vietcong prisoner wearing a coded arm-band was brought to General Nguyen Ngoc Loan, a local police chief heading the battle at the pagoda. Frustrated at not getting the prisoner to talk, he took out his pistol and shot him in the head.

The word "aesthetics" carries a soft armor, as if it should only be used in controlled and comfortable surroundings. Not so. It's perfect here. Adams, in what had to be an instinctive aesthetic response, chose to see the event head-on, a composition that inevitably conveys the greatest sense of power while bringing the viewer close to into the scene. Matching the image's shape and form to its subject while closing the viewer into its explosion, he has indelibly fastened the scene, conveying the fury and tangles not only of war, but of that war. The picture shot across newspapers, weekly magazines, TV screens and has appeared and re-appeared. The force of its aesthetics has continued to provoke the controversy the photograph initially created.

That is because it is a photograph, and a photograph, just by virtue of being a photograph, takes a cut of the real world, frames it, and then with varying impact and intensity, depending on both photograph and viewer, carries on a dialogue with the viewer. Viewers work themselves into a photograph. Not simply because they see what they perceive to be the real and true world. But because, as a visual, it speaks to the emotional part of our make-up. It gets under the skin, doing away with any distrust we may have about photographs. As a visual, it appeals, by definition, to the feeling part of the brain. But in doing so while abstacting a very real segment of the world, it becomes armed as no other visual form of expression does. It appeals to the known and unknown, the rational and the emotional. This photograph made viewers grimace and turn away. And it stuck.

This photograph mobilized, in many ways, the country's still-amorphous but negative feelings about the war: The US was not winning and that bothered Americans. Moreover, the act seemed particularly chilling because it was done by "our" side. But, perhaps, the most troubling of all: it wasn't right that Americans, the "civilized" force, was not defeating the "less-than-civilized" guerrilla warfare. Coming at the time of the civil rights movement in America, that racism fed simmering emotions—about civil rights and about Vietnam.

Chaotic and contradictory feelings ran through the country: The US was losing, but losing to the Vietcong's less-than-civilized fighting, and that ate away at Americans more than the simple act of losing; images of war-time violence unbelievably evoked violent feelings toward the civil rights movement, evoking, at the same time, images of violence running through the streets—of democratic America; and what to do about the growing duplicity of American Army officers telling of wins when it was clear the war was being lost. Americans tried to put it all together. And this picture came along. It summed up everything: the cold-blooded uncivilized nature of our side as well as the other side; the feeling of a curse on all their houses; the impossibility of winning in such a lawless environment. The war seemed both interminable and its losing inevitable. Once this photograph appeared, the cry to "get out of Vietnam" began to grow. It provided the spark; Americans provided the context in which it was to explode.

Each war produces its symbolic pictures—Robert Capa's loyalist soldier in the Spanish Civil War flung upon a knoll with his rifle flying through the air, a devastated crying baby left on Nanking's bombed rail tracks in the Sino-Japanese War. This one epitomizes the Vietnam War.

There is one question, however, that has only provoked greater controversy since this photograph was taken, one that is tied to the increasing place that photographs—not only this photograph—have come to occupy. Was the ubiquitous camera part of the reason for the killing? Did General Loan shoot his victim because a camera was on hand? People around the world, press officers for armies, and governments engaged in war have thought it has, and have since used this image as an example of what the camera can do—and what the controlling medium wants and does not want done. For example: The United Kingdom held the press in check at the Falklands, President Reagan choked off reportage in Grenada, the Pentagon not only censored reportage in the Gulf War but controlled the initial dispersal of all information not even related to the war. Contrariwise, Biafran public relations officers encouraged pictures of starvation; and warring African units maneuvered British TV cameramen into an actual staged "killing" scene.

Eddie Adams, who seldom speaks about this photograph, later discovered that the Vietcong victim had just murdered one of the General's friends and knifed his entire family. That context, however, has had little to do with the dialogue this photograph has established with Americans about that war and about their society. And it is that dialogue that has made this photograph so powerful.

In the twenty-five years since this photograph was taken, this photograph (and photographs in general) has increasingly gained the power to conduct a dialogue, to engage viewers and draw them not into its thick often verbal context, but into the sharp torments or ecstatic perceptions that symbolize that context. It's not only that this photograph did that then. And not only that it continues to do that now, but in continuing to do that it (and all others so ably conducting dialogues) intensifies its power and place in our lives.

—Judith Mara Gutman

Bibliography—

"Vietnam," in *Newsweek* (New York), 12 February 1968.
Lewinski, Jorge, *The Camera at War: War Photography from 1848 to the Present Day*, London 1978.
Leekley, Sheryle, *Moments: The Pulitzer Prize Photographs*, New York 1978.
Fulton, Marianne, "Making a Difference," in *Image* (Rochester, New York), December 1989.

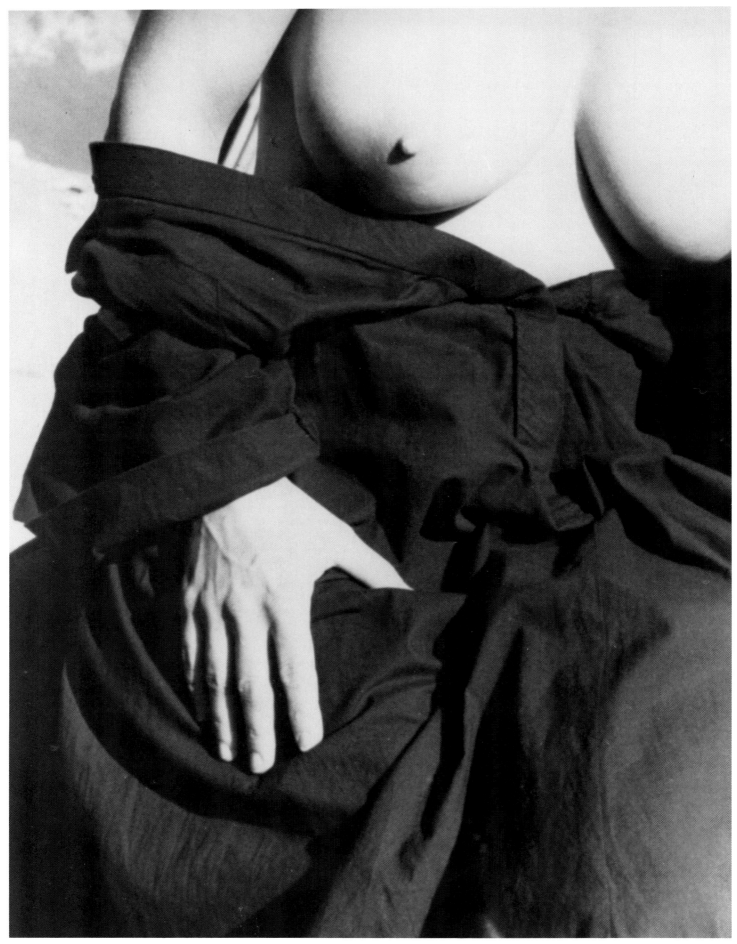

© Manuel Alvarez Bravo

512

Manuel Alvarez Bravo (1902–)
El Trapo Negro, 1986
Black-and-white photograph

Manuel Alvarez Bravo is one of those photographers whose work has entered so much into general awareness that it is hard to know by what degree one's experience of a new photograph from him is purely the result of that encounter, or how far it arises from the accumulated body of previous experiences.

Thus, is there something in the construction of *El Trapo Negro* that leads one to feel that although this is a very segmental image in relation to the original subject, it is yet very complete and sufficient in itself? Account must be taken of photographers like Edward Weston, who from time to time has shown us partial photographs of women, where the sense is of the photographer having held back from a complete description of the person before him, or else made the face illegible by inversion, in order deliberately to depersonalise the sitter in a way that renders her an object rather than an integrated human being. Perhaps on this occasion so much is curtailed by the frame and by the robe, that virtually no personal cues remain, and so there are no hints to be got from them towards an individual identity. Perhaps what we have here is not an object, produced by depriving the image of a woman of the individuality necessary for her to be perceived as a fully realised person, but a type, autonomous and general. A type which subdivides its aspects formally, between the arrangement within the frame, the balance of line, the contrast of light against dark, deep against shallow, and so on; and the type of fecundity and nurture. Does it make sense indeed to refer back to the *Caritas Romana* theme in art, in which the man starving in prison is saved by his daughter's visit to suckle him at her breast?

Perhaps it does, and perhaps, however coincidentally, such a linkage reminds us to look towards Alvarez Bravo's cultural roots. For he is of course Mexican, and thus the inheritor of a powerful Spanish-American tradition. In the relatively recent past, that has given rise to the concept, however cynically it might be voiced nowadays, of continuing revolution. Some of Alvarez Bravo's images reflect this. More remotely, the collision and fusion of Catholic Spain and the Indian cultures produced an art; or rather a world—and that is a crucial differentiation—in which the spiritual obtrudes physically into the temporal, the supernatural into the mundane.

For Alvarez Bravo, as an artist and a friend of artists, including the leading Muralists, Rivera, Orozco and Siqueiros, to have grown up in that environment was to accept the culture's forms and the peculiarly Mexican opportunities that accompanied them. If visitors such as Sergei Eisenstein and Malcolm Lowry should in their work have matched the native grown Mexican qualities, many (as for example, Paul Strand and Edward Weston) produced work which was for the most part dominated by the preconceptions they brought with them. The influence of these latter artists might be supposed to explain a good part of what is to be seen in the photography of Alvarez Bravo, not least because he was by some years their junior. Examples supporting this notion might be adduced from the posed figures of peasants who display a Strandian nobility in their gestures and attitudes, or from the close-framed segments of figures such as the one shown in *El Trapo Negro* with the superficially Westonian connotations discussed above. Such

suggestions are amplified by Alvarez Bravo's following of Weston's tendency, shared to an extent by Strand, to isolate his subjects within the frame even when not necessarily cutting them by its edges.

In the end, it is the titles which provide us with the essential clue to turn our looking away and beyond the confines of a safe modern aesthetic. For it is they, as a group, that have within them that very Mexican feeling that even survives translation. It is a feeling residing in the briefest phrase, of completeness and authority, and utter detachment: *Absent portrait*, *The crouched ones*, *Set trap*, *The big fish eats the little one*. The titles read like the sudden disconnected utterances heard in dreams, as sound bites of the imagination, or indeed as lines in a screenplay for Sigmund Freud.

They read too, in exact consonance with the titles given by Goya to the individual items in his series of etchings, *Caprices* or *Disasters of War*. The link for Alvarez Bravo is, in the end, back to his roots in the Iberian peninsula and the darkness of the past events which have continued to haunt its living consciousness. *El trapo negro* is transformed; no longer is it enough to think about merely formal questions, about suggestions of male chauvinism or even on the civilised aspect in which the *Caritas Romana* legend is usually manifested to us in paintings. Under all of that is the dark sunlight of the elemental things. In this case, the presence is certainly female, but whether as empowered, or victim of disaster, or somehow both, is never shown. The hand presses into the cloth, against the body. Has it dragged the robe down, or does it seek to prevent its further fall? What emotions and intentions are we to adduce as inhabiting the bosom so dramatically revealed: is this the chapter from a legend, or a moment in some incident?

The only certainty is that Manuel Alvarez Bravo is not giving us an item of tamely self-referential gallery art, but adding another, significant piece to a body of work which although centred in the Mexican tradition, is also an important offering as a commentary on the universals of human experience. He ranges from the primitive high drama seen here, to tiny items of gentle wit, and maintains his consistency the whole way, because he remembers that humanity encompasses all these things and everything between them. Photographers should feel encouraged that Alvarez Bravo has chosen their medium for his task, and, seeing the results of his work, understand the respect they owe him for having succeeded in such a difficult accomplishment.

—Philip Stokes

Bibliography—

Cardoz y Aragon, Luiz, *Manuel Alvarez Bravo*, Mexico City 1935.
Parker, Fred R., *Manuel Alvarez Bravo*, Pasadena 1971.
Coleman, A. D., "The Indigenous Vision of Manuel Alvarez Bravo," in *Artforum* (New York), April 1976.
Livingstone, Jane, Castro, Alex, and Fralin, Frances, *Manuel Alvarez Bravo*, Boston 1978.
Verdugo, Rene, and Pitts, Terence, *Contemporary Photography in Mexico*, exhibition catalogue, Tucson 1978.
Hill, Paul, and Cooper, Thomas, *Dialogue with Photography*, London 1979.

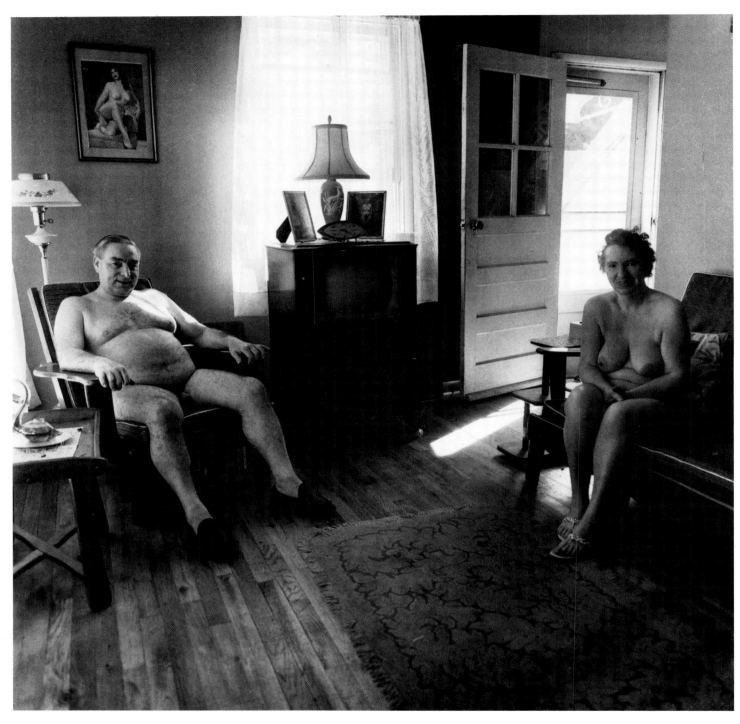

Museum of Modern Art, New York. Copyright © Estate of Diane Arbus, 1972

Diane Arbus (1923–71)
Retired Man and Wife in a Nudist Camp One Morning, New Jersey, 1963
Black-and-white photograph

"Nudist camp was a terrific subject for me. I've been to three of them over a period of years. The first time I went was in 1963 when I stayed a whole week and that was really thrilling. It was the seediest camp and for that reason it was also the most terrific. It was really falling apart. The place was mouldy and the grass wasn't growing."

When Diane Arbus went to the New Jersey nudist camp in 1963 she had yet to produce many of the photographs of midgets and giants, Siamese twins, transvestites and mental defectives for which she is best known. The New Jersey experience of walking around in the nude, her camera slung around her neck, clearly highlighted the less theatrical but more substantial aspects of her work: the relationship and the boundaries between revelation and concealment, between the permissible and the prohibited, between normal and abnormal, between the individual and society.

Nudity is a symbol of innocence, of existence in the state of purity before original sin. We are born naked, and we use clothing to conceal ourselves from the eyes of others and to conform to the demands of society. But in modern society the return to nature and to nudity is fraught with compromise and contradictions. While casting off one's clothes is an expression of freedom regained, this symbolic gesture can only be made in a particular environment, namely in a "camp". At the same time, is stripping off really all it takes to return to a state of freedom and innocence? *Retired man and his wife in a nudist camp one morning* gives some idea of Diane Arbus's response. The middle-aged Adam and Eve are completely naked, apart from their shoes. But their whole environment, starting with their own bodies, speaks the language of social pretence. The bodies are fat and flabby, typical of those accustomed to a sedentary life. The couple do not live in a cave but in an ordinary middle class house with carpets and the inevitable television set. The sunny morning light is the only purely natural element on the scene. The picture on the TV set of the couple's more youthful selves—again in the nude—lends an inadvertent touch of irony, as does the pin-up hanging on the wall. The myth of nature in all its innocence is shattered with a smile of sardonic commiseration: "It gets to seem as if way back in the Garden of Eden after the Fall, Adam and Eve had begged the Lord to forgive them and He, in his boundless exasperation, had said: 'All right, then. Stay. Stay in the Garden. Get civilized. Procreate. Muck it up.' And they did."

So this attempt to throw off the mask ends in failure. To the eyes of the observer, this defeat has all the more impact because Arbus makes no comment, keeping her emotional distance as she records the moment. The models cooperate; they are very conscious of the fact that they are being photographed and they assume the position in which they are most comfortable and which they believe will show them to the best advantage. This lack of subterfuge in Arbus's photography, the communication between subject and viewer in which she acts as a kind of mediator, is the strength which makes her images especially convincing as investigative and illustrative documents. The result is a straightforward frontal shot. The focal point is the TV set, the great homogenizer of 'sixties morality and deadly rival of photojournalism and its main vehicle, the illustrated magazine. She still uses available light. Later, she was to adopt the flash in order to shoot both in daylight and in poorly lit locations, in which subjects would emerge as ghostly figures, frozen in space. The square format gives no room for trickery in the interpretation of vertical or horizontal lines, as it would if a rectangular format were used. Arbus was then to move on to break new ground: the world of deformity and abnormality, the grotesque, the bizarre and the insane. This fascination for things that deviated from the norm was her way of defying convention. She went in search of bearded ladies, Siamese twins, lunatics, fat girls, midgets, giants and living skeletons. She also sought out those who made their own differences like tattooed men, trans-sexuals and reprieved criminals, and took candid camera shots of film stars. People who were scared by abnormality could enjoy these pictures of an alien and spectacular world as if they were a fairground sideshow. But Arbus felt a romantic attachment to these triumphant misfits: "Most people go through life dreading they'll have a traumatic experience. Freaks were born with their trauma. They've already passed their test in life. They're aristocrats." She was certainly aware of art director Alexey Brodovitch, who said: "If you see something you never saw before don't be shocked." Her respect for her subjects is clear from the way she makes no attempt to control or patronize them. They are aware that they are being photographed and they go along with it, looking us straight in the eye and choosing for themselves the pose which shows both their humanity and their singularity. Photography, with its raw and detached form of expression, is an ideal medium through which to indulge our curiosity and morbid interest in deviations far removed from normality. Through Arbus's camera, the viewer gains an insight that is undiluted and exciting, but which does not attempt to moralize.

When she checked into the nudist camp in New Jersey, Diane Arbus knew that she was venturing into forbidden territory, a place that was hidden from view as if it were indecent. Exposing things that public opinion chose to ignore was nothing unusual for her. But she still needed to ask the all-important question about naturism: is it possible to get back to nature, to return to a state of grace and innocence simply by being naked? The answer, as we have seen, is no. We are imprisoned not only by the clothes we wear but also by the mental trappings that go along with them. But, in photographing those who at once attract and repel, she no longer makes comparisons or tries to understand. It may be that every photograph will always be a tacit enquiry into the enigma of differences. While the precision of the nudist camp photograph contributes to the interplay of likenesses, however outrageous, it also confirms and underlines those differences about which nothing can be done. This is also the conclusion reached by Diane Arbus: "a photograph is a secret about a secret. The more it tells the less you know."

—Daniela Palazzoli

Bibliography—

Arbus, Doon, and Israel, Marvin, eds., *Diane Arbus*, Millerton, New York 1972.
Southall, Thomas W., *Diane Arbus: Magazine Work*, Millerton, New York 1984.
Bosworth, Patricia, *Diane Arbus: a biography*, New York 1984.
Tucker, Anne W., "Arbus Through the Looking Glass," in *Afterimage* (Rochester, New York), March 1985.
Jordan, Jim, "The Naked and the Masked," in *Artweek* (Oakland, California), 31 January 1987.

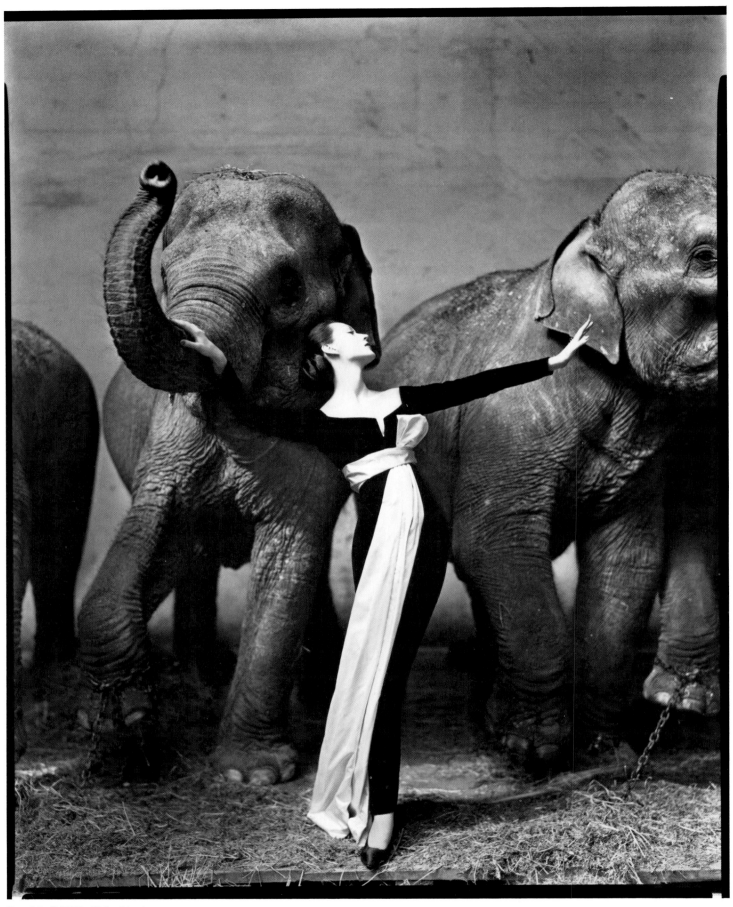

Copyright © 1955 by Richard Avedon

Richard Avedon (1923–)
Untitled (Dovima with Elephants, Evening Dress by Dior, Cirque d'Hivers, Paris), August 1955
Black-and-white photograph

Beauty and the beast has seldom had a more succinct and distinct recounting than in the Richard Avedon photograph *Untitled [Dovima with Elephants]*, 1955 appearing in "Carmel Snow's Paris Report" in *Harper's Bazaar* (September). The photographer's view of fashion for fall 1955 taken at the Cirque d'Hiver in Paris epitomizes Avedon's acute sense of primed motion, dance poise, and an elegant kinesis akin to that of paintings, as well as his propensity for the ordinary and extraordinary in unexpected juxtaposition. Like much of Avedon's so-called fashion photography, its kinetic energy comes not merely from the potential of animation, but from the humanistic attribution to personalities and circumstance. In 1948, Avedon had posed Elise Daniels in the streets of the Marais surrounded by a bodybuilder and a contortionist; almost ironically, spectators seem more spellbound by the street performers than by the elegant women of New Look exaggeration and contorted fashion pose. Likewise, the sweeping soft drapery of Dior evening dress in 1955 vies for the viewer's attention with the flanking pachyderms. By such real, but not quite quotidian, placement does Avedon achieve the integration of fashion into the world and, at the same time, sustain style's role to be outstanding.

Like Daniel in the lions' den, beauty stretches out to reconcile and tame the beasts. The chained, but high-stepping elephants, might seem formidable consort to fashion, but Avedon demonstrates an interest in fashion's accommodation to dramatic setting. Inspired by Martin Munkacsi, the fashion photographer who adored active movement, Avedon realized both the integrity of the garment seen with a certain stillness and the vibrancy of setting. Thus, while Dovima remains relatively traditional in her melodramatic fashion pose, the photograph's vivacity and dramatic originality come from the peculiar context of the circus animals. Fashion is a civilized form; the animal nature of the elephants is a sinister contrast. The high sophistication of the human gesture opposes the troublesome grace of the animals. The circus is not, however, bereft of elegance as proved by George Balanchine's *Circus Polka* (1942) with music by Igor Stravinsky, balletic elephants by Ringling Brothers Circus at Madison Square Garden, and pachyderm tutus by Norman Bel Geddes. Likewise, couturiere Elsa Schiaparelli had presented a "circus collection" with prancing elephant embroideries in 1938. After all, the circus is the sumptuous manipulation of perilous skills, menacing and performing animals, and slapstick comedy for spectator gratification. Its raw edge to glitter and pageantry is Avedon's human circus with fashion in the center ring.

Untitled [Dovima with Elephants] is, however, beyond a few historical references, an unexpected and unprecedented fashion image. Earlier fashion illustration sketched a setting, but did not take on the movie-like verisimilitude of Avedon's shoots on location. Even early fashion photography was unwilling and unable to venture out of doors where the control of light might be lost and the garment would have to fight for attention. Photographers such as Willy Maywald and Avedon moved decisively outside in the 1940s and 1950s in their quest for authenticity and the Paris streets and sites became vista for post-World War II fashions. Avedon served as visual consultant to the Fred Astaire-Audrey Hepburn movie *Funny Face* (1957) based on Avedon's career: the photographer's triumph there is as the model is snapped, as by a fillip of imagination, as she releases a bunch of balloons at the Arc de Triomphe. Thus, Avedon assumed Paris as his theatre for fashion photography, a vivacious place for new styles. Furthermore, Avedon's work at *Harper's Bazaar* (1946–65) was made even more spontaneous, with an often reflexive exuberance, by his association with Alexey Brodovitch (1898–1971), the *Harper's Bazaar* art director (1934–58) who encouraged novelty, éclat, unexpected images, and startling motion. That the image is black and white may heighten the viewer's awareness of the familiar and the viewer's discernment of the image as other than wholly real. At the time of this photograph, the Cirque d'Hiver was the site of shooting for the film *Trapeze* (1956) with Burt Lancaster, Tony Curtis, and Gina Lollobrigida: in Technicolor, the film's story of lust and rivalry in the straw and sawdust world of the circus is a picturesque narrative, whereas Avedon's black-and-white moment in time seems to stand for eternity.

The dynamic of the image is, in part, its implied sexual tension. The softness of the dress and the ever-present association of Dior with intensely clarified femininity realize an elegant female beauty standing in the midst of ponderous animals. Andy Grundberg describes, "The incongruity of the model's stately beauty and the elephants' earthy nonchalance gives the picture the kind of subliminal jolt that [art director] Brodovitch loved." That subliminal jab is as erotic as it is aesthetic.

No damsel in distress, but instead a woman in charge, the model possesses an important attribute for the second half of the century. Not only has she stepped into reality, but she is able to take care of herself in an otherwise hazardous circumstance. Avedon vests in her a symbolic self-confidence and mythic victory. That victory is of special and extended importance as the Empire dress from the House of Dior was, in fact, one of the first garments designed by Yves Saint Laurent, still a teenager, but one who would inherit the Dior mantle in 1957 upon the designer's death and subsequently create his own house and name.

Similarly, this photograph anticipates trends in fashion photography that follow. If there is a tepid risk and the *frisson* of courting danger in the Avedon image, that touch of peril becomes fierce threat for many fashion photographers of the 1960s and after. Fashion photography's *nostalgie de la boue* becomes significant in the 1960s as fashion is frequently placed in the rawest of settings, much indebted to the straw of the Cirque d'Hiver. Avedon demonstrates, of course, that refinement is even more distilled when set within coarse circumstances.

An abidingly provocative image, *Untitled [Dovima with Elephants]* demonstrates the power of the fashion photograph to command enduring attention. The accompanying text in *Harper's Bazaar* ends with the style coda that the model wears the fragrance Diorama, a scent apparently brave enough to accompany beauty triumphant over beast.

—Richard Martin

Bibliography—

Avedon, Richard, and Capote, Truman, *Observations*, New York and London 1959.
Avedon, Richard, *Photographs 1947–1977*, New York 1978.
Michener, Charles, "The Avedon Look," in *Newsweek* (New York), 16 October 1978.
Hall-Duncan, Nancy, *The History of Fashion Photography*, New York 1979.
Ross, David, *Avedon: Retrospective 1946–1980*, exhibition catalogue, Berkeley 1980.
Harrison, Martin, ed., *Shots of Style*, London 1985.

Courtesy Castelli Graphics, New York

Lewis Baltz (1945–)
The New Industrial Parks near Irvine, California, 1974
Gelatin silver print photographs; 20.3 × 25.5 cm.

Although Lewis Baltz has within a period of nearly twenty years published many notable books and portfolios, it is his 1975 *The New Industrial Parks near Irvine, California* that occupies a distinct position. This body of work marked a visual field that substantially brought to bear on photographic practice a new kind of ideological position. A pluralistic approach with emphasis on descriptive content, the emerging "New Topographics" exploited photography's paradoxical relationship between veracity of information and the allusiveness of style. Baltz, along with colleagues Robert Adams, Joe Deal, Bernard and Hilla Becher, Frank Gohlke, among others, asserted a contemporary affinity to 19th-century documentary works. With antecedents in the surveys of industrial progress and the spirituality of "Nature" or the land, "New Topographics" grafted a course of visually mapping the environment in terms of expansionism. This view, often site-specific, commented critically on urban development, ecology and social ethics. It utilized a restrained aesthetic that relied on ideas generated by Minimal Art, detachment from the emotional and the picturesque, and sought self-referential approbation of the photographic medium itself.

For Baltz, the single image stood secluded from the power and cogency of an extended series or sequences of images. *The New Industrial Parks near Irvine, California* should then be viewed as the genesis of a larger visual epic that concluded in *San Quentin Point* (1986). Baltz, illuminating on photographic practice has said that, "Among the most subversive qualities of the still photograph is that, at its best, it so often confronts us with a world wholly alien to our aspirations, a world, or its parts, that we would prefer to disregard altogether." Such an underlying disturbance is apparent throughout his *New Industrial Parks*; sites of sprawling man-made structures, a landscape where economic expansion has been indifferent to human concerns, and where the intrusion upon the land by exploitive development has been the most expedient. Yet, Baltz sets up an ironic reading of his subjects; the tug between nature and industrial culture and the uncovering of socio-economic values singularly revealing one aspect of its material conditions, and the transformation of this territory into brilliant formal photographic statements.

The unadorned banal structure of Baltz' *New Industrial Parks* represent a hard, concrete and metal world in which stillness pervades: each image gathering progressive evidence of this with a cool intensity. Baltz fills his frame with surface textures and details of man-made objects: doors, windows, lights, ladders, instruments, pumps, and pipes, pose as parts of an environmental installation, and culminating in a view of a landscape analogous to construction as an artistic form. The bold dark and light exteriors contrast with the discreet light and dark interior spaces; the incomplete, the disregarded, and often the fragmentary, however, directly confronted, diverts the sense of representation. Baltz' conceptual and the self-contained viewpoint of the subject brings vitality and life to the architectonic forms which in context of the tensions created ultimately negate Baltz' landscape as mere objective documents. Rather, the ambiguous mechanized world of rectangular shapes and linear divisions of verticals and horizontals become a surrogate for nature; the industrial structures and their environment assume the qualities of a strange monumental landscape, which holds at its centre a disquieting fascination. No matter how, still, dry and parched the subject appears, Baltz' use of the photographic medium creates a visual sheen out of ordinary facts which in reality we would otherwise prefer, as Baltz stated, to disregard or to remain hidden.

At first look, Baltz' images suggest an unsullied belief in the primacy of photographic information, but a closer reading reveals his clear understanding of the ironic properties created between the photograph and the photographed. In an article (*Art in America*, April 1975) Baltz expressed that, "The ideal photographic document would appear to be without author or art. Yet, photographs despite their verisimilitude are abstractions; their information is selective and incomplete." The conflict seized upon in *The New Industrial Parks*, the collision between the erosion of nature and the power of urban fill are stated with optical clarity, yet paradoxically, and as Baltz himself noted, no matter how skilful the photographer is at leaving no trace of a personal vision, or no matter how uninflected the image, the absence itself has a characteristic that shapes the individuality of the photographer and his work.

Since the impact of the *The New Industrial Park near Irvine, California*, Baltz' presentation of complex issues has sustained both the intellectual strength and visual assertiveness evident in this important early work.

—Maia-Mari Sutnik

Bibliography—

Baltz, Lewis, *The New Industrial Parks Near Irvine, California*, New York 1975.
Baltz, Lewis, ed., *Contemporary American Photographic Works*, Houston 1977.
Baltz, Lewis, and Blaisdell, Guy, *Park City*, New York 1980.
Baltz, Lewis, "Konsumerterror: Late-Industrial Alienation," in *Camera Austria* (Graz), no. 18, 1985.
Baltz, Lewis, and Haworth-Booth, Mark, *San Quentin Point*, New York and Berlin 1986.
Kelley, Jeff, *Nevada: Lewis Baltz and Anthony Hernandez*, Arlington, Texas 1988.
Baltz, Lewis, *Rule Without Exception*, Des Moines, Illinois 1990.

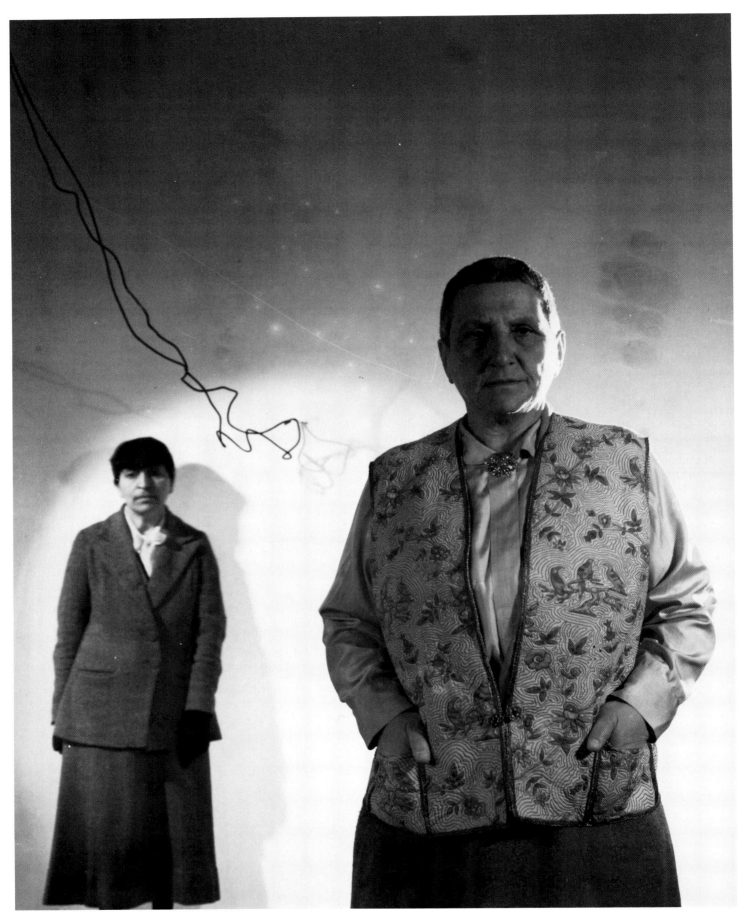

Photography courtesy of Sotheby's London

Cecil Beaton (1904–80)
Portrait of Gertrude Stein and Alice B. Toklas, c.1936
Silver print photograph

Writing in Cecil Beaton's photo-anthology *Time Exposure* in 1941, Peter Quennel remembered Paris of the 'thirties as: "oddly provincial . . . a place of incessant and spiteful gossip, furious snobbery, savage artistic feuds and fierce personal animosities." For Beaton himself, then in his early thirties, and at the height of his career as *Vogue* photographer and illustrator, it became a place of opportunity and enchantment.

Beaton was introduced to the American writer Gertrude Stein and her partner Alice B. Toklas by Edith Sitwell in Paris in 1933. It was a momentous year for Beaton; he met and grew close to Jean Cocteau (who christened him *Malice in Wonderland*), and to the painters Bebe Berard and Pavel Tchelitchew who assumed immense importance as allies and mentors throughout the Thirties.

During the early 'twenties, Beaton's iconography had been formed chiefly by twinned ideals of celebrity and elegance. His rococo imaginings had led him to photograph his sisters draped in silver and reflected in polished table tops. By the end of the decade, he had travelled to Hollywood to photograph (for the American magazine *Vanity Fair*,) the rising elite of the American film industry, producing portraits which combined drama and sumptuousness.

By the beginning of the 'thirties, he had achieved many ambitions—independent, wealthy, celebrated, but was yet to achieve the photographs for which he is now regarded as an innovator and a pioneer within the medium. But Beaton attached little value to his skills as a photographer. To an aspiring aesthete drawing, painting and theatre design had much more potential for glamour. But an important turning point came when Beaton met Edith Sitwell and her brothers, Osbert and Sacheverell and photographed them in high gothic poses. Edith recited Gertrude Stein's poetry during her portrait sitting and was astonished and delighted by the photographs which Beaton took. She introduced him to Stein and Toklas in the early 'thirties and the interest shown by these High Bohemians in his photo-portraits, which caused him to re-assess the validity of his photographic endeavours.

By the time Cecil Beaton met Gertrude Stein, she was a literary celebrity. Her *Autobiography of Alice B. Toklas* had been published in the summer of 1933 to great critical success. Beaton went to visit her in her new apartment on the rue Christine and relished its taste and dignity: "Here now was the expression of a *gout impeccable*. Tall ceilings, panelled walls and high windows delighted the eye. Each piece of furniture seemed solid and beautiful in design. There was no chichi or vulgarity anywhere. The Misses Stein live like Biblical royalty: simply, yet in complete luxury."

For Beaton, Gertrude Stein was "a kind of Biblical prophetess crossed with American businessman"; she and Toklas became distinguished additions to the new schema of seriousness which he began to construct as the 'thirties progressed. In 1938, he confided to his diary: "I am very conscious of my own limitations and all the time seem to be dragged down into my own sink of froth and scum." Stein was an effective antidote to the frivolity which Beaton had come to despise in himself by the late 'thirties; conversing with her, he felt that "a note of reverence marks one's every sentence." Exhausted by the unhappiness of his long affair with Peter Watson, his contract with *Vogue* lost, accused in New York of anti-semitism, Gertrude's company calmed and reassured. Dispensing "wisdom from a rocking chair," she impressed upon the debilitated Beaton "Your balance is what is important. The balance between fantasy and reality."

Beaton was commissioned by Conde Nast to photograph Stein and Toklas in the mid 'thirties during their visit to London to see Stein's new ballet *The Wedding Bouquet*. He invited the two women to sit for him. When they arrived at his London studio, "they at once displayed enormous delight in all the effects I had planned as properties and backgrounds for their special sitting."

Beaton had remembered the blue and white wallpaper with its motif of pigeons from his visit to the apartment in the rue Christine, and envisaged it as a possible backcloth. But the final portrait, in which no backgrounds were used, has a starkness and a potency which made such decorative effects unnecessary. Abandoning the fanciful, Beaton hung "twists of electric wire" (which reminded Stein and Toklas of a mobile which Picasso had constructed for them) from the ceiling. He delighted in their looks and their costume: "they were a startling-looking couple: Gertrude with her closely-cropped iron-grey hair, in her flowered waistcoat and tweed skirt; Alice in a large, black felt hat and grey flannel suit."

Standing in close proximity, but divided by the tangled lengths of wire, the portrait described the relationship with succinctness—Alice indispensable, but subordinate, Gertrude stately and brimming with power. In all the extant images from this sitting, Stein stands closer to the camera than Toklas and in one negative Beaton used a double image of Stein, removing Toklas (and the convoluted wire) entirely from the photograph. But above all, it was a portrait of enormous affection, Gertrude's "magnanimity shone through her trusting brown eyes"—she had become, and remained, a friend for life.

When the photographs were printed, Beaton was pleased with the results. In their making, he had dispensed with flattery, and had no need of the glitter and gauze which he had so often used in earlier work. He included a portrait from the sitting in *Cecil Beaton's Scrapbook* (1937), and again in *Time Exposure*. Years later, it was one of the works which he selected for his major 1968 retrospective *Beaton Portraits: 1928–68*, shown at London's National Portrait Gallery, and subsequently toured to the United States. When the show opened at the Museum of the City of New York (in 1969), critic Hilton Kramer, though dismissing Beaton as "a prisoner of the superficial" picked out the Stein and Toklas portrait as "something infinitely more fundamental."

For Beaton, a young man in 'thirties Paris, Gertrude Stein was "monumental". He photographed her many times over the years of their friendship, and thought her "the best sitter I ever had." Visiting Stein and Toklas in Paris after the war, he was relieved to find them unscathed by the German occupation and besieged by enthusiastic GIs. In 1946, he took more portraits of Gertrude leaning thoughtfully from her window. A few weeks later, she died. For Beaton, it was the end of an era.

Over the last two decades, critics and historians have reassessed Cecil Beaton's achievements in photography. They have seen him not as the camp flatterer so derided in Kramer's *New York Times* review, but rather as the maker of a cogent and compelling documentary of a fascinating Bohemia.

—Val Williams

Bibliography—

Beaton, Cecil, *Cecil Beaton's Scrapbook*, London 1937.
Beaton, Cecil, and Quennell, Peter, *Time Exposure*, London 1941.
Beaton, Cecil, *The Face of the World*, London 1957.
Beaton, Cecil, *Diaries: The Wandering Years*, London 1961.
Beaton Portraits, exhibition catalogue, London 1968.
Beaton, Cecil, and Buckle, Richard, ed., *Self Portrait with Friends*, London 1979.
Vickers, Hugo, *Cecil Beaton*, London 1985.

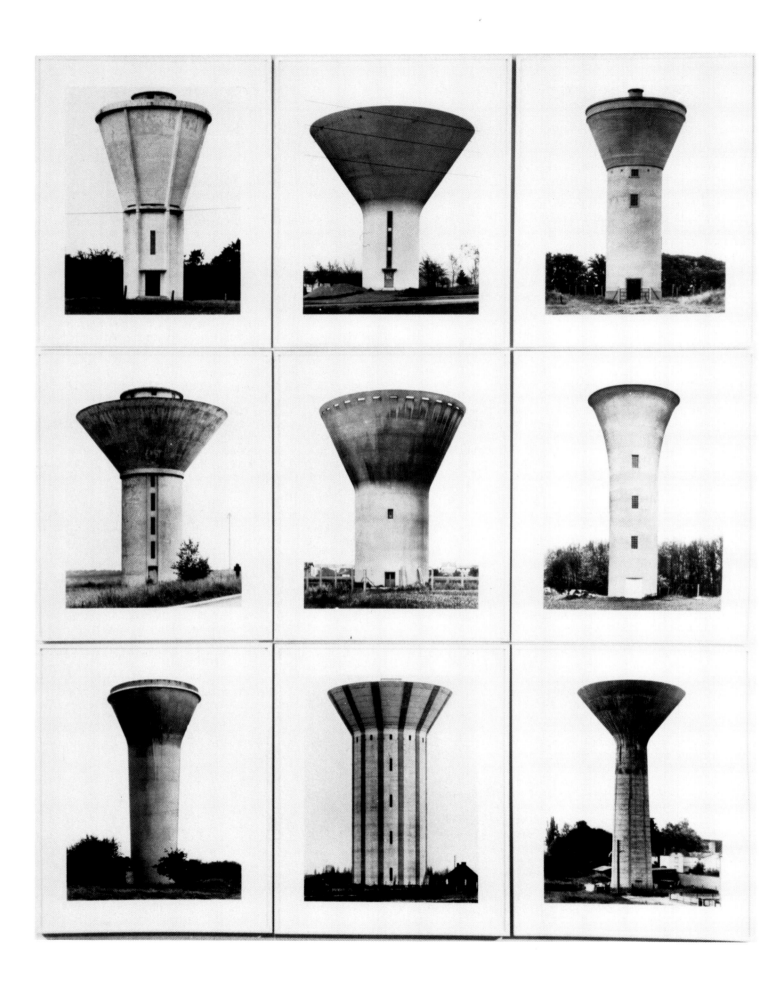

522

Bernd Becher (1931–)/**Hilla Becher** (1934–)
Water Towers—France, 1982
Nine gelatin silver photographs; 61¾ × 50 in.
New York, Mr. and Mrs. Arthur Goldberg Collection

Bernd Becher began to photograph industrial structures in 1957 after studies in painting and drawing at the Staatlichen Kunstakademie Stuttgart and while he was studying typography at the Staatlichen Kunstakademie Dusseldorf, where he met Hilla Wobeser while she was training in photography. In 1959 an artistic partnership was established to which Bernd added the painter's eye, while Hilla brought a purely photographic vision and the refined skills of a professional photographer. Over a period of almost thirty years they have evolved a body of work that is at the same time obvious and riddlesome. The work is obvious because its principal subjects are large scale industrial structures of a type familiar to anyone who has been to any medium sized manufacturing city. The work is riddlesome because it is documentary of the subjects represented, and yet at the same time it is full of the art spirit.

Bernd and Hilla Becher pursue their work, as all photographers who rely on external reality must, by first locating a prospective subject; then making a few negatives of it from several points of view; and finally, in the case of round water towers which can be described in a single image, choosing from the results of the session the one exposure which best meets their visual priorities. Compressed into a sentence this process seems simple, but when telescoped to actuality we see it requires the time-consuming step of travelling from city to city and country to country to prospect for subjects. In the early years (1961–1968) the Bechers travelled together and worked as a team to make the exposures; however, by 1978 their method had evolved to allow long periods of working independently making the negatives, with Bernd based in Dusseldorf and Hilla in New York. The separate campaigns were then followed by several months of joint editing and printing together in Dusseldorf.

The work first exists as individual images that can be displayed independently; however, the unique power of their vision is realized when groupings of the photographs are created by the highly collaborative editing process that advances with extreme deliberation in the quest of perfectly harmonious and totally revealing juxtapositions. The rules for grouping are rigidly defined: 1) several views of the same structure, 2) several views of the same type of structure in the same country, 3) several views of the same type of structure in different countries, *et cetera*.

Objectivity is achieved by conscientiously photographing each of their subjects under as close to the same conditions as possible. The exposure is made at a distance from the subject so as to retain the same proportion of sky and foreground in each image and thus establishing a relative (but not absolute) consistency of scale. They only photograph on days when cloud cover diffuses the sunlight and helps to eliminate the play of light and shadow that could cause undesired decorative patterns and a consequent flattening of the space into surface relief rather than dimensional substance. The camera is usually elevated above ground level on scaffolds or ladders, and the tilts and swings of the view camera are used to create the illusion that the subject is photographed at a height midway up. Since water towers are usually round, just one view is required in order to comprehend its shape and, by inference, we perceive through the photographs the form, structure and ornament of the unseen sides. If there are doors, windows or ornaments that establish a "front" to the structure the exposure is made so as to center those elements in the elevation. Exaggerated perspectives such as looking up, looking down and oblique angles are studiously avoided. The variables within the artists' control are kept to a minimum with the purpose of achieving absolute comparability between the subjects represented and to realize an untinted window through which to observe the industrial object.

The process of placing *Water Towers—France* in a traditional art historical context fails because the work does not fit the well-tested formulas of experimental modernism, since objectivity is their foremost concern and objectivity is often believed to be the antithesis of art or poetry. Moreover, if art is the manifestation of total ego and to achieve objectivity requires the annihilation of the self, then *Water Towers—France* would also appear to be artless because the annihilation of the self would seem to deprive the work of private meanings that are often deemed to be an essential component of serious art created in the traditional materials of pencil, paint, stone or metal.

The Bechers' work shares with experimental, idiosyncratic, and non-academic art an impetus that springs exclusively from their own imaginations. They have never been hired by the owners of the structures or their agents to photograph water towers or any other type of industrial structure, nor have their travel expenses or the cost of materials ever been underwritten by the communities in which the structures are located, by the trades and industries represented by the structures or by the trade organizations of these trades or industries. The work is totally self-assigned and therefore reflects exclusively their choices.

One litmus test of a work of art is whether the object or the body of work from which it is drawn incorporate private meanings that are under the skin of the work rather than on its surface. The most significant of the private meanings here is that industrial structures are not exclusively objects for clinical dissection, but rather elicit inside of the artists and in the viewer powerful emotional responses of liking and disliking. Bernd Becher's favorite water tower is located in Nancy, France (*Wassertürme*, p. 26) and Hilla's favorite is located in Akron, Ohio (*Wassertürme*, p. 23). Conversely they both loathe the design of the tower located in Kwadmechelen, Belgium (*Wassertürme*, p. 211). The strongest emotional ingredient is, however, the intelligence and truthfulness with which they understand and chronicle the emotion of seriousness. Theirs is work full of gravity; it is the manifestation of certainty rather than the joy of novelty. Accordingly, the Becher work inspires in its audience responses of affection or loathing. For all of its seriousness *Water Towers—France* also evokes humor in the folly of certain whimsical designs and in the cases where historical precedent has been invoked by the designer to disguise the function of the structure, or two endow it with multiple and sometimes contradictory purposes.

—Weston J. Naef

Bibliography—

Becher, Bernd and Hilla, *Die Architektur der Forder- und Wasser-Turme*, Munich 1971.
Naef, Weston J., *Counterparts: Form and Emotion in Photographs*, New York 1982.
Grundberg, Andy, and Gauss, Kathleen, *Photography and Art 1946–1986*, exhibition catalogue, Los Angeles 1987.
Becher, Bernd and Hilla, *Wasserturme/Water Towers*, Munich and Cambridge, Massachusetts 1988.
Becher, Bernd and Hilla, *Tipologie, Typologien, Typologies*, exhibition catalogue, Venice 1990.

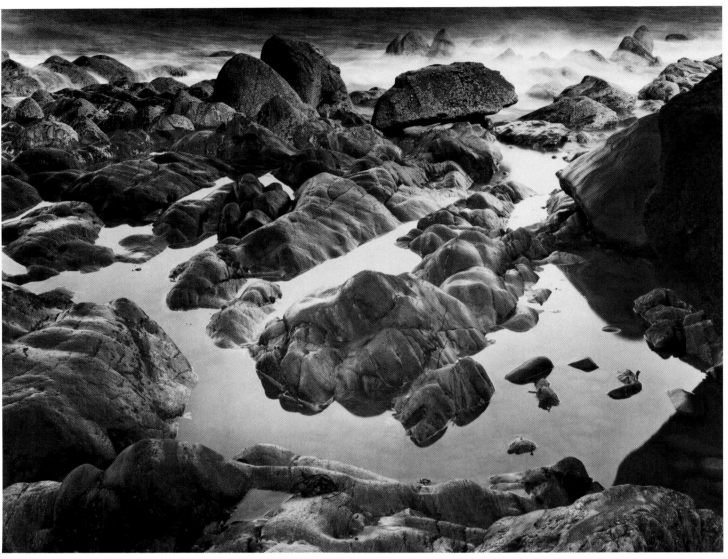

© John Blakemore

John Blakemore (1936–)
Rock Pool, Friog, North Wales, 1975
Black-and-white photograph

It is significant that John Blakemore's first engagement with the Welsh landscape was therapeutic, a panacea for emotional wounding, and an opportunity to consider a radical change in photographic direction. In 1968, after ten years as a commercial studio photographer and social documentarist, he made a temporary move to the Mawdach estuary in North Wales: "The decision to winter in Wales was an arbitrary one, generated by the need to escape the pressures of London. It was a time of change; I had decided not to continue working as a commercial photographer; I was uncertain of what to do, was seeking a new direction, a new impulse. It was a time of personal crisis following the break up of my first marriage. The landscape of Wales was different to any I had previously known."

Blakemore's "discovery" of the land, and its emergent symbolism, became a potent source of healing, of energy and rebirth. It presaged a new way of seeing, a religious, spiritualised and transcendental way of perceiving the physical world. Abandoning his interest in social documentary, he became part of a vibrant, articulate and fundamentalist grouping of new landscapists (other members included Paul Hill, Thomas Joshua Cooper, John Davies and John Charity) centred around the revitalised photography department at Trent Polytechnic in the North Midlands.

Adapting the high mysticism of American landscapists Aaron Siskind and Minor White (themselves informed by Steiglitz's arresting theory of *equivalence*) to a British terrain, the group became dynamic within photography during the Seventies. By the time that John Blakemore was making his *Friog* pieces, the resurgence of interest in landscape photography in Britain was at its height. The *Land* exhibition, selected by Bill Brandt (and shown at the Victoria and Albert Museum in 1975) accelerated an incipient process of removing landscape photography from its mordant pictorialist niche and establishing it as contemporary British photography's prime intellectual force.

Blakemore was perhaps the most articulate member of the Trent grouping—his concept of an artist/photographer who combined strength and sensitivity, whose aesthetic direction reinforced or paralleled his emotional drives was in itself a bold political statement within a British photographic community unused to such propositions. At the height of the feminist revival, it was also a trenchant defence of maleness, a re-assertion of male sensitivity and finesse. To this, he added his fears of an approaching ecological crisis as the land became increasingly damaged by industrial processes. With the new generation of social documentary photographers increasingly nostalgic for an eccentric British past, the landscapists insisted on confronting the present, and saw their photographs as vital documents, chronicles of a disappearing English countryside. Though not overtly concerned with topography, history, or rural documentary, and insistent on creating what Blakemore himself called "an intensity of relationship, an obsessive fascination with subject, with the attempt to see more deeply," the Trent grouping became stern defenders of Britain's remaining wildernesses.

Describing his work, and the experiences which informed it, Blakemore makes continuous use of language which emphasises the power of nature, its inherent struggle, the confrontation between man and the elements. During his first stay in North Wales he wrote in his journal that it was: "A land of paradox, harsh lunar landscapes, running with gurgling water, and supporting everywhere a riotous life. From the very rocks, trees thrust upwards, life at its most tenacious, gripping convulsively at the unyielding rock, and raising twisted arms into the unrelenting wind."

John Blakemore's *Rock Pool, Friog* (1975) is part of his major Seventies' photo-sequence *Sound of the Sea*. It was originally shown in his one-man show *Stand Before the World* (Arnolfini Gallery, 1976) and formed the endpiece of his 1977 monograph *(John Blakemore: British Image 3)*. He had been photographing the Welsh landscape since the early Seventies, using it as not only as a way of expressing aesthetic and ecological concerns, but also as a process of self-discovery: Interviewed for the magazine *10:8* in 1976, he concluded that: "To make images can become a process of renewing connection. Photography can serve to break down the barriers between self and other; the camera is a link, a means of concentration, a channel for both communion and communication."

Important, too, in the *Sound of the Sea* was the constant interconnection between the disparate elements of the natural world. *Rock Pool, Friog* is an apt example of Blakemore's own mystical and religious conviction that all nature is as one. Reinforcing this view, the contemporary critic Gerry Badger noted in 1977: "the natural world of John Blakemore is a paean of metamorphosis—solid becomes void and void becomes solid, viscous becomes fluid and fluid becomes viscous; inanimate becomes animate and animate becomes inanimate."

By his use of the large format camera with its ultra-sharp definition, Blakemore creates an image, which, in its exceptional clarity, becomes super-real. In 1979, he considered that: "it allows an intensity of description, a richness of detail, of tone which, in the photograph may produce for the viewer, an experience of revelation, a feeling of never having really 'seen' before."

In *Rock Pool, Friog*, he concentrates his gaze on a circumscribed area of sea and stone. The combination of sharply etched detail and intensity of gaze (focused on a carefully delineated space) creates what at first appears to be still-life. The centre of the image is tranquil, with the veined, rounded rocks marooned in a mirror-smooth pool. But at the far perimeter of the image, calm disappears, interrupted by a sea which foams and sprays. The anarchy of the waves in this Welsh seascape acknowledges the water's energy and the photograph conveys with precision what Blakemore regards as, "the dynamic of the landscape, its spiritual and physical energy, its livingness, its essential mystery."

By the end of the Seventies, Blakemore had begun to consider changes in emphasis in his photo-works: "I began to feel that the photographs were over-dramatic, that the drama was a product of my use of the medium, and that this drama overemphasised the negative forces in nature, the process of death and decay." *Rock Pool, Friog* remains a seminal centrepiece of that Seventies' aesthetic drama which so markedly changed the course of British landscape photography.

—Val Williams.

Bibliography—

Haworth-Booth, Mark, ed., *The Land*, London 1975.
Arts Council, *British Image 3: John Blakemore*, London 1977.
Gaskins, Bill, ed., *British Image 5: Perspectives on Landscape*, London 1978.
Sheild, Helen, and Siegieda, Jan, "Interview with John Blakemore," in *10:8* (Birmingham), Autumn 1979.
Campbell, Bryn, ed., *World Photography*, London 1981.
Bondi, Inge, "Interview with John Blakemore," in *Printletter* (Zurich), January/February 1981.

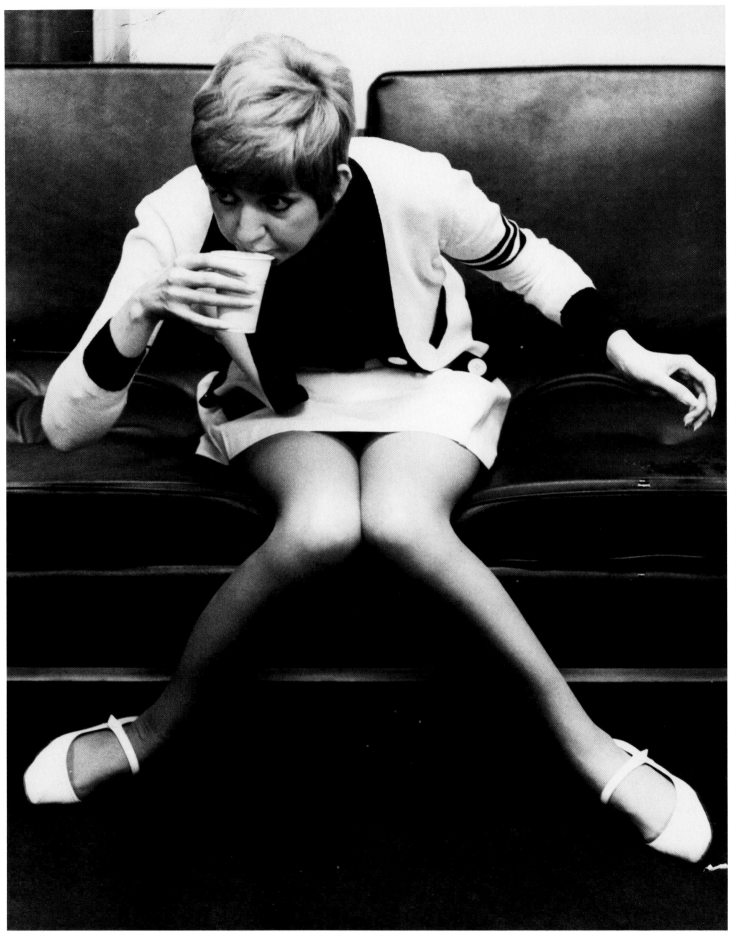

© Jane Bown

526

Jane Bown (1925–)
Cilla Black, 1967
Black-and-white photograph

This photograph has an intriguing double appeal and its twin subjects are both presented with admirable simplicity, Cilla Black, British singer and TV personality and the "Sixties Look," when the first really brief short skirts pioneered by Mary Quant stalked the high streets.

Natural lighting unboosted by spots or flash gives a reality to the picture. It is easy to believe that the girl is oblivious of the photographer, half concentrating on a plastic cup full of coffee, half worrying about the recording session to come. Cilla Black started her singing career with such a heart-rending hit that she had to struggle to avoid slipping into oblivion thereafter. Perhaps that is why she was sporting the eye-catching Sixties look, from the Vidal Sassoon bob with big dark eyes peeping out beneath a heavy fringe to the slender one bar shoes complimenting beautiful legs. She could not have dreamed that in the early 1990s, by the time short skirts became fashionable again, she would be offered a two million pound contract for three years' work with commercial television.

Jane Bown's charming and amusing evocation of a girl and her period is one of the many memorable photographs she has taken for the *Observer*. In 1950, scarcely out of photography school, she started taking pictures of people to illustrate the newspaper's regular profile feature and into the 1990's she continued to do this. If ever anyone was thrown in at the deep end, it was quiet, unassuming Jane Bown. She had to capture the great, the good and the frankly terrifying, such as Dame Edith Sitwell. Even nowadays she admits to a mild attack of panic at every fresh assignment.

Cilla Black, 1967 illustrates that Jane Bown is not really a portrait photographer, she is rather a skilled protagonist of photo-reportage. Furthermore, she does not need a set of pictures to tell her story, she can encapsulate a personality and an ambience in one sure shot. Jane Bown finds a multitude of lenses and accessories confusing and counter productive. She likes to be ready when, as in this photograph, the telling moment presents itself.

Jane started taking pictures with a £50 second-hand Rolleiflex, given to her by an aunt when she went to Guildford School of Art. Her famous close-up of a cow's eye was taken with a pair of proxars on the twin lenses and the courage to get very close to a large animal. Ifor Thomas, maverick principal of the photographic section of the college, decided there might be something in the small, shy, almost speechless pupil and his wife Joy, who presided over the dark room, took merciless trouble to teach her how to develop and print. To this day Jane is considered to be one of the best technicians in the *Observer* darkrooms. Since she works only with available light outdoors and in, meticulous negative processing is essential. By the time she photographed Cilla, Jane had graduated to a 35 mm Pentax and her standard exposure was usually a 60th at f 2.8. Nowadays she uses an Olympus OM1, with just two lenses, a 50 mm and an 85 mm.

In 1981, Jane Bown had a solo exhibition at the National Portrait Gallery, the first photographer to be so honoured, and over 120,000 saw the exhibition. *The Gentle Eye* was an inspired title for the collection of 120 pictures, ranging from Bertrand Russell and Nannies by the Serpentine to Noel Coward, Elizabeth Taylor and Richard Burton at a Society wedding.

The photograph of Cilla Black inspires in the beholder a small secret smile as do so many of Jane Bown's pictures, but the humour is never cruel. She is not in the business of snatching candid shots at awkward moments when the unfortunate subjects have their mouths open. Neither does she favour the wide angle lens which can distort faces and limbs. The Cilla Black picture could have appeared monstrous with a wide-angle and it is indeed earnest of Jane Bown's subtle skill that she got a potentially difficult pose just right.

Jane Bown came to the fore at the right time for her especial talent. The public was becoming bored with the formal portrait, overlit and heavily retouched, the business tycoon behind an improbably imposing desk, the "beauty," tactfully diffused to hide all imperfections.

The unthinking might dismiss the Cilla Black type of photograph as only a snapshot, but like so many of Jane Bown's pictures, it has a warm reality that makes its own particular contribution to our complex society.

—Anne Bolt

Bibliography—

Bown, Jane, and O'Donovan, Patrick, *The Gentle Eye: 120 Photographs*, exhibition catalogue, London 1980.
Bown, Jane, and Lowry, Suzanne, *Women of Consequence*, London 1986.
Bown, Jane, *Men of Consequence*, London 1988.
Bown, Jane, *Portraits*, London 1990.

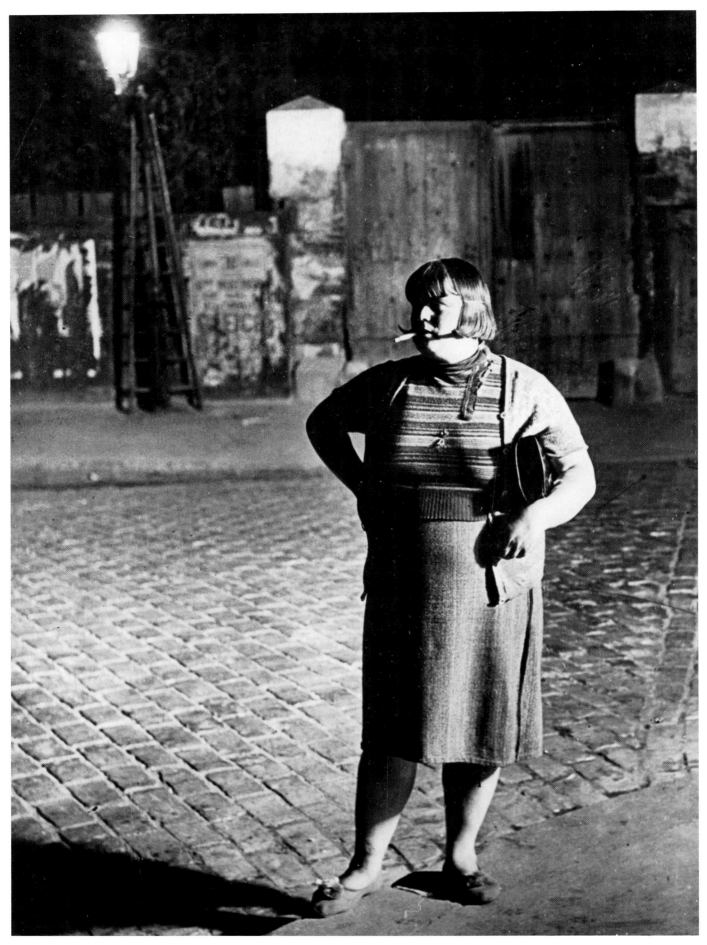

© Madame Gilberte Brassai/Photo Museum of Modern Art, New York

Brassai (Gyula Halasz) (1899–1984)
La belle de nuit, Place d'Italie, Paris, 1933
Silver gelatin print photograph

Brassai's *La belle de nuit* first appeared to a modern public in his 1976 photo-compilation *Les Paris Secret des Annees 30*. Taken in Paris during the interwar years, the photo series (when published in the 1970s) acted as an immediate catalyst for an emerging generation of European and American photodocumentarists. For Brassai's dark, mysterious photographs of city life not only served to illuminate an obscured history of urban mores, but also to reinvigorate emergent notions of a photographic cityscape.

"During my first years in Paris," wrote Brassai (in the introduction to *Secret Paris of the 30s*) "I lived at night, going to bed at sunrise, getting up at sunset, wandering through the city from Montparnasse to Montmartre." For Brassai, a young Hungarian sculptor, who studied at the Ecole des Beaux Arts in Budapest and at the Akademische Hochschule Berlin-Charlottenburg before arriving in Paris in 1924, the city at night became a coda for voluptuousness, for revelations, for the visual re-making of an experienced desire.

Like his near contemporaries Man Ray, Robert Capa and Berenice Abbott, Brassai experienced Paris as an emigré's city. He was guided by fellow expatriates (like the American eroticist Henry Miller), and by French companions like Leon-Paul Fargue (the "Pedestrian of Paris"), Raymond Queneau and Jacques Prevert (with whom Brassai "revelled in the beauty of sinister things"). The sights and events and people whom he observed became not only *illustrations* of city life, but also clues to enlarge an outsider's understanding. If Brassai revelled in exotica rather than real life, it was because exotica so perfectly codified his outsiderism.

Brassai's *Secret Paris* was Brassai's reading of the city, romantic, effervescent, enthralled. He recollected that in his nocturnal odyssey: "Sometimes, impelled by an inexplicable desire, I would even enter some dilapidated house, climb to the top of its dark staircase, knock on a door and startle strangers awake, just to find what unsuspected face Paris might show me from its window."

For Brassai, the underworld became an expression of voluptuousness, peopled by those who: "Live at night not out of necessity, but because they want to. They belong to the world of pleasure, of love, vice, crime, drugs. A secret suspicious world, closed to the uninitiated. . . . Drawn by the beauty of evil, the magic of the lower depths, having taken pictures for my 'voyage to the end of the night' from the outside, I wanted to know what went on inside, behind the walls, behind the facades, in the wings: bars, dives, night clubs, one-night hotels, bordellos, opium dens. I was eager to penetrate this other world, this fringe world, the secret, sinister world, of mobsters, outcasts, toughs, pimps, whores, addicts, inverts."

The underworld became too an anthropological oddity imbued with notions of preciousness, of heritage an expression of the city: "at its most authentic . . . preserved, from age to age, almost without alteration, the folklore of its most remote past."

Central to Brassai's perception of city life, his insistence on the veracity of the demi-monde lay his absorption with prostitution. If the city at night represented an emigré's identification with otherness, then its street women became mythical and fabulous creatures of the urban phantasmagoria. De-personified, made into both objects of desire and victims, the prostitutes became major characters in an alarming yet titillating carnival. "To the present generation," he wrote in 1976, "these pictures will seem as exotic as if they were of pygmies or Zulus."

The photograph *Belle de nuit* 1933 was made on the rue Quincampoix in the Les Halles district of Paris where Brassai had become intrigued by the "fat girls," "floozies," who were called "Nanas," "punaises," "morues" ("bedbugs" and "codfish"). Their stance caught Brassai's particular attention and he remembered how they: "waited, immobile and placid, along the sidewalk like a row of caryatids for the butchers and tripe-sellers from Les Halles, men who were accustomed to dealing with huge masses of flesh. One day I took a room in a hotel across the street and watched from my window these odalisques and the men would stroll past them ten or more times, back and forth, cigarettes dangling from their lips, before stopping in front of their choice."

Photographing *Belle de nuit*, Brassai also stood behind his subject, achieving a near-silhouette, emphasising shape and largeness. The woman's slippered feet rest flatly on the cobbled street, her arm held akimbo incises into a patterned surface of stones seen in chiaroscuro. The woman seems monumentally alone on the deserted pavement, disassociated (in exact accordance with Brassai's fantasy of city) from a real and daytime world. Like many of his photographed prostitutes, she is an obscured figure, shadowed by the mysteries of tribalistic rites and ancient practices. Distancing them from the "real" world, Brassai was able to invest even his most solid characters with a romanticism so insistent that he abandons his stance as witness and fictionalises from his documentary material, making out of it an elaborate system of signs. For the American critic Ben Lifson, photographers like Brassai "responded to a rapidly changing and disorienting world. Their photographs gather and display large amounts of facts within single frames without resolving their visual, psychological or social contradictions . . . these photographs discover worlds with laws of their own. They create the worlds that they report upon; their generalisations are poetic responses."

Making this "poetic response" to the Paris underworld of the 'thirties, Brassai contributed enormously to a post-war imaginative reconstruction of the European demi-monde of the inter-war years, and most especially to our received idea of its exotic deviance.

"Thievery for them, photography for me. What they did was in character. To each his own," wrote Brassai in *Secret Paris of the 30s*. Such positioning of the photographer, as underworld artisan working within an alternative system, placed, by his practice, apart from accepted modes of occupation and behaviour became, during the post-war years, an increasingly alluring stance for documentary photographers to adopt. New York photographer Diane Arbus (whose confrontational street portraits shocked and captivated a new post-war audience) was much affected by his gaze: "Brassai taught me something about obscurity, because for years I had been hipped on clarity. Lately it's been striking me how I really love what I can't see in a photograph. In Brassai, in Bill Brandt, there is the element of actual physical darkness, and its very thrilling to see darkness again."

Belle de Nuit, made in the 'thirties, but not brought to public attention until the 'seventies, became a modern ikon. Combining nostalgia with threat, romance with social comment, it emerged as a set piece, the acceptable voyeurism of the new avant garde.

—Val Williams

Bibliography—

Brassai, *Paris de Nuit*, Paris 1933.
Beaton, Cecil, and Buckland, Gail, *The Magic Image*, London 1975.
Brassai, and Miller, Richard, *The Secret Paris of the 30s*, Paris, London and New York 1976.
Lifson, Ben, *The Art of Photography*, New Haven, Connecticut 1983.
Mrazkova, Daniela, *Masters of Photography*, London 1987.
Grenier, Roland, *Photofile: Brassai*, Paris and London 1987, New York 1988.

© Adam Bujak

Adam Bujak (1942–)
The Funeral of Our Lady, 1962
Black-and-white photo series

Photojournalism forms one of the chief strands of contemporary Polish photography. Despite the fact that the most important post-war publication of this kind, the weekly *Świat*, is no longer published, there are still many illustrated periodicals on the market that, as a rule, allocate a great deal of space to press photography. However, while a forum for ambitious photojournalism certainly exists, there is also a lack of the sort of originality that might break through current editorial demands and impose its own subject matter, interests or enthusiasms on the journals. Adam Bujak, who was not associated with any particular illustrated publication, was one of the first and few exceptions to this.

The young Bujak showed no clear leanings towards any particular sphere of interest and, constantly changing professions, did not really know whether he was to become a businessman, dancer or priest. He became a photographer. "Photography," Bujak remembers, "did not come into my life by chance but was conditional on its association with events that fascinated me. My photography was born of the need to fix events that I had witnessed by chance and whose occurrence I had not predicted. When I first encountered remnants of past epochs, I felt I had to inform society of facts about which the average twentieth century man knows nothing. I am convinced that the things I have witnessed should not remain solely between myself and the few people concerned, that the information carried in my photographs is, in fact, a necessary complement to our knowledge of contemporary man."

The events that fascinated Bujak were mystery plays. Interwoven with Christian cults, these plays fascinated him with the authenticity with which they merged the theatre of the sacred with the theatre of the profane. Time and time again, these plays erase the boundaries between sacred rites and their common interpretation by ordinary people. This exceptional fusion of belief, mysticism and liturgy provides the opportunity for a public display of religious cult and of collective spiritual experience. Religion and folklore are indivisible here.

The first of the events to which Bujak refers was the glorious Passion of Christ enacted at the Zebrzydowska Calvary near Kraków. There, for over 280 years, local actors, mostly workers and peasants, enact the Passion Play every year during the last week of Lent, traditionally beginning with Christ's journey to Jerusalem and ending with Pontius Pilate's judgement and the Crucifixion. Another event, with an equally long history, depicts the Assumption of Our Lady and is celebrated at the Przecławska Calvary. These Calvarys were modelled on the original Way of the Cross. The events held there take place in the open air. The wayside shrines of the Way of the Cross depict the most important scenes from the Passion of Christ.

The Assumption of Our Lady at the Przecławska Calvary is celebrated in unique surroundings and attracts thousands of pilgrims from the whole of south-east Poland. Groups of pilgrims come first—each carrying a cross decorated with flowers and the name of the locality they represent. Monks in black habits, sashed with white cord and rosaries, make their way with difficulty through this crowd of pilgrims. They stop to pray by the shrines to Mary and Jesus that are scattered over the hills. From here, there is a view of the neighbouring hill across the Cedron valley where the tomb of Our Lady is located. High above the tomb, as soon as they catch sight of the monastery on the horizon, the pilgrims fall to the ground and pray with outstretched arms. In this way they greet their Mother and her Son.

This very moment is caught in Bujak's photograph. The pilgrims have stopped for a moment under a clouded sky. Their banners and streamers flutter in the wind. The crosses are held high and straight. People are lying in the shape of the cross on the grassy hillside. Were it possible to see their faces, they would show great rapture and love of their Creator. We are conscious of being included in a sublime religious rite which we probably do not understand and with which, in all probability, we do not identify, but which is laden with faith and greatly honours the Mother of God.

The decidedly religious character of these mystery plays and other events, their spectacle, folklore and mysticism, led Bujak to go on pilgrimages with followers of other religions, of which there is no shortage in Poland. In the years that followed, he accompanied members of the Orthodox faith, Protestants and Moslems, Adventists and others. At times, his pilgrimages also took him out of Poland. ". . . Religion," Bujak admits, "is the subject closest to me. Without it I probably would not be who I am. My relationship with this subject is not only photographical but also spiritual. Besides, in all of this only rarely am I, first and foremost, a photographer. I live with these people, share their experiences, and, sometimes, almost as an unthinking reflex action, I take a photograph. Even then I feel a dreadful intruder. . . ."

It must be emphasised that it is this attitude that distinguishes Bujak from other photographers interested in these issues. What makes Bujak so different from his contemporaries is not only his exceptional personal commitment, his fascination with the subject and his reverence for those singular phenomena in human lives that, in many cases, are already vanishing. ". . . I staunchly stand by the Catholic faith," he emphasises, "but have emerged out of Orthodoxy, Judaism and even Islamism. I consider these to be colossal topics . . . I have twenty years of work behind me but that is not enough. I believe this is only the beginning of some great endeavour. A time may come at last, perhaps towards the end of my life, when I will summarise it all with a publication on the world's religions."

It seems as if the foundations of Bujak's photography lie in a need to disclose and portray those of man's desires and dreams that never wholly come to fruition, as well as man's aspiration towards something more than is offered by everyday life and work. There is also that which, for Bujak, is probably the most important—his personal conviction that, despite disparity and even hostility, all the great religions of the world are parts of one enormous whole, branching from the common trunk of human destiny, and that, regardless of the differing roads taken and obstacles in their way, they all strive to reach a common goal—the light, the Creator.

—Ryszard Bobrowski

Bibliography—

Bujak, Adam, *Misteria kalwaryjskie*, Kalwaria Zebrzydowska 1973.
Bujak, Adam, *Journeys to Glory*, New York 1976.
Bujak, Adam, *Ojciec Swiety, Pielgrzym kalwaryjski*, Kalwaria Zebrzydowska 1982.
Bobrowski, Ryszard, and others, *Fotografia Polska 1945–1985*, Gorzow Wielkopolski 1985.
Bobrowski, Ryszard, *Masters of Polish Photography*, Geneva 1986.
Bujak, Adam, *Misteria*, Warsaw 1989.

Courtesy The Art Institure of Chicago

532

Wynn Bullock (1902–75)
Black Tree and Mountain, 1956
Black-and-white photograph

We see a photograph close in its design to the equivalents being produced by Alfred Stieglitz at least thirty years earlier. A sun disc in a dark sky allows us—indeed, could we stop ourselves from so doing?—to establish a balance of tensions between it and the four sides of the frame. Our eyes run back and forth in that process, and move in other patterns as we scan, identify and relate the objects represented there. The tonal modulations we encounter, the rhythms, the echoes and contrasts of forms produce the physical experiences that Stieglitz and his successors have in their different days and ways, identified as musical.

If Stieglitz sought to emulate the composer Bloch, and Ansel Adams, the pianist, was able to speak of the negative as the score, and the print as the performance; where does that leave the singer, Wynn Bullock? On the basis of the photograph alone, the answer would be that he placed himself in much the same position as his predecessors and contemporaries, was the elegant reinforcer of proposals made by them in respect of the photographic medium; they in turn, aware of it or not, having followed on the distant, painterly heels of James McNeill Whistler.

Only by knowing the ways in which Bullock was articulating his thoughts is it possible to extend our discovery towards the photographic ideas that were specifically his own, and be reminded in the process, that of all images, the photograph is the least able to be read accurately or comprehensively as a free-standing object, independent of the context of its making. Fortunately for our understanding, Wynn Bullock communicated freely, especially with his elder daughter Barbara, who as a writer has interpreted and published on her father's photographic work. To read Barbara Bullock's interpretations is to be introduced by her to a fertile mind possessing a great sense of curiosity, and which was neither stifled by the necessity to abandon a career in music for legal studies, and earn a living in real estate; nor eventually numbed, over some years of practicing commercial photography. Yet despite the many aspects of his learning and experience, the account of Wynn Bullock's aesthetic explorations shows us a man handcrafting concepts which he could have picked up readymade from his local bookstore: reinventing his own philosophical wheel; even a set of philosophical wheels, for he ended up well able to propel his photographic practice towards the goals which he discerned for it. These are to be seen in various sorts of representations where the subject matter is mediated through the highly Bergsonian notion that objects in the world are most appropriately perceived as dynamic events in space/time, and understood in terms of hier-archical oppositions to other object/events. Thus, as Barbara Bullock explains, the photograph of a decaying typewriter on a rotting redwood trunk may show a man-made/natural opposition in terms of process, at the same time as, on another level, it proposes the opposition, relatedness/uniqueness.

Black Tree and Mountain was made at a time when, by his daughter's account, Wynn Bullock was on the whole concentrating on the representation of man's relationships to nature. In photo-graphs of that kind, the opposing of the human body to vegetation and the land draws sharp attention to the difference in time scales of change for the various components of the depicted event. Human maturation plays against seasonal plant growth, and both are underlain by a sense of the slow course of geological change.

By contrast, in the smaller group of photographs from the same period which deal with unpopulated nature, and especially where, as in this image, humanity is not even alluded to, there is a first impression of monumental stillness. And stillness there most likely was, during the taking of the photographs, given the evidence of the extreme depth of sharp focus combined with the lack of movement blur, despite what must have been long exposures.

But in the light of Bullock's preoccupation with the flux of things, and the context of this photograph within his work, we have to see it as another proposal for his scheme of oppositions; setting the fixity of the separated photographic moment against all the movement which had determined the presence of that tree on those hills, and would as surely change it. Our knowledge of Bullock's thought sensitises our perceptions of the evanescence of the mist, the passage of the clouds, the movement of the sun which will change viewers' experience—by all their senses—of that scene in the course of a day; not to mention the seasonal flush and fall of leaves and the hardly perceptible growth and disappearance of the trees themselves.

We debate amongst ourselves about the wider significance of *Black Tree and Mountain*. A lyric for the nature-lover, certainly; an elegy for the environmentally conscious, no doubt; but an irony? Could that be so?

Less obviously here than in those photographs where Bullock exposes long, to represent the tide as an insubstantial mist lapping the solidity of the rocks which it will eventually erode, and so makes irony manifest in the content of the image, it is the very strategy of dealing with change and the flow of time through the fixity of the photographic moment that is profoundly ironical. There is none of the blurring of the wind blown forest, no hint of the time lapse natural history sequence, no literal expression of Bullock's aesthetic concerns. He shows us only the objects before him in the minutest detail and the greatest information density that the photographic process can offer, while doing all he may to ensure that his viewers use this determinate singularity of space and time to achieve a sense of the mobility and transience of all things.

It is in the nature of oppositions to generate ironies; it is Bullock's achievement to have employed them in an investigation of the natural world that does not depend upon its opposition to the industrialised world. They constitute the sharpness that enlivens the lyricism and confers the distinctiveness of this area of Wynn Bullock's photographic production. *Black Tree and Mountain* is one of a group of photographs where the ironic aspect is far from obvious; and its edge is a special one, for being quiet.

—Philip Stokes

Bibliography—

Herz, Nat, "Wynn Bullock: A Critical Appreciation," in *Infinity*(New York), November 1961.
Bullock-Wilson, Barbara, and de Cock, Liliane, eds., *Wynn Bullock, Photography: A Way of Life*, New York 1973.
Fuess, David, *Wynn Bullock*, Millerton and London 1976.
Sembach, Klaus-Jurgen, *Amerikanische Landschaftsphotographie*, exhibition catalogue, Munich 1978.
Hill, Paul, and Cooper, Thomas, *Dialogue with Photography*, London 1979.

© Rene Burri/MAGNUM

534

Rene Burri (1933–)
Men on Rooftop, Sao Paulo, 1960
Black-and-white photograph

The four men striding through the sun on top of a skyscraper in Sao Paulo appear closer to heaven. They wear business suits and ties and apparently hold top positions in the firm. From the roof of the skyscraper, they risk a glance below, from a safe distance. Above, the light is harder, the air thinner than down below. Down there, a wide street shines in strong contrasting light through the gorge of houses, with cars, trams, and people as extras. The smog of the industrial city drifts over their heads, such as the noise of movements whose meaning is both self-evident and mysterious.

The picture by René Burri appears cold and analytical, but the photographic transposition precisely represents what has been seen. Burri succeeded in capturing the social differences, so extremely obvious in South America, by means of his camera and a powerful teleobjectif. Planes and verticals, high and low, light and shade, hard and softer contrasts together form a brilliant image. The journalist Burri explores much more than his job requires. These people up there are not only above matters; they have lost the ground they were standing on, they are only shadows in the light. These few are not just lonely but also trapped in their small, protective terrain. The others in the distance below are subjected to different mechanisms which do not seem to allow them more freedom of movement. Hasty motion between premeditated points seems to dictate both the lives of the small people and the powerful.

Since the very beginning of his photographic work the balance of power was one of René Burri's favourite themes, though he never treated it in a spectacular way. Unlike many of his colleagues he never submitted himself to sheer sensationalism. There is no great bloodshed. Without ever losing the context of history and politics, the focus of his work is always human beings, even if they can only be recognized through their deeds or their conditions of life. We perceive them in changing clothes and disguises, in their modest prosperity and happiness, looking for comfort in consumption, religion, and social life. We see them in their impenetrable loneliness as well as protected by the masses, resigning and fighting at the same time. In Burri's destilled perception we are faced with an essence that could be the testament of mankind.

"In my youth I did a lot of mountain climbing. I used to start to run 50 meters or so from the peak, without really knowing why. I could not control the curiosity about what I could possibly see behind the peak—and discovered new mountain tops. This thirst to always try and meet the horizon! I never got dizzy. But I remember years later arriving in the Libyan desert at night. As I opened the door of the military camp in the morning there was infinite void in front of me. The telephone cables disappeared with the curvature of the horizon. It was there that I got dizzy, and I screamed out loud; I was facing the absolute."

In the late '50s as a member of Magnum, the agency for photographers, Burri had at last ample opportunity to satisfy this thirst. But at that time, electronic picture transmission had made its triumphant entry into the media. News no longer needs to make the detour via films and prints; live broadcast was not far off. Even the most manic reporter was no longer a serious rival in this contest if he remained loyal to the camera. He had to look for other priorities. Burri hardly needed to make any adaptations. His essayistic observations give sensitive insights into events of the day, which clarify interrelations and offer an understanding that is based on more than the mere knowledge of facts. Big magazines all over the world published his exemplary reports, amongst them a dozen issues of the Swiss paper *Du*, which entrusted several blocks to Burri's signature. There the static image wins over the fleeting pictures of television; it invites more intense contemplation and reflection. The impressions transmitted by film and television get blurred; pictures get superimposed and end to cover each other. At best, the spectator is left puzzled. A committed photograph demands a conscious analysis, a passive spectator becomes an active observer, a participator. *One World* is the title of Burri's monograph, an excellent choice.

The great masters of Fine Art have always been "models" for Burri. Their work has demonstrated to the photo-journalist the possibility of creating as well as the creative boundaries. Burri tries to break through the formal barriers of his photography by making films on cultural topics, putting together artistic collages made from banal bits and pieces, leftovers from his travels; he maintained his awareness, however, that the continuous search for the purpose of things was to lead back to the starting point like an infinite loop. In a photograph taken in the same year as *Sao Paulo* we see Alberto Giacometti working on a human figure. He forms the wet clay with his eyes closed, as if to be able to see more clearly inside himself. A cleft, uncouth form emerges from his hands. An idea takes shape, very slowly, as if under great pain. It becomes apparent that the world is still being created. With his photographs, René Burri brings this lost understanding back into our consciousness.

—Ralph Hinterkeuser

Bibliography—

"Rene Burri," in *Glasherz* (Munich), no. 6, 1981.
Burri, Rene: *One World*, Bern 1984.
Loetscher, Hugo, *Swiss Photography from 1840 until Today*, exhibition catalogue, Zurich 1984.
Goldberg, Vicki, "Rene Burri: An American Dream," in *American Photographer* (New York), May 1987.

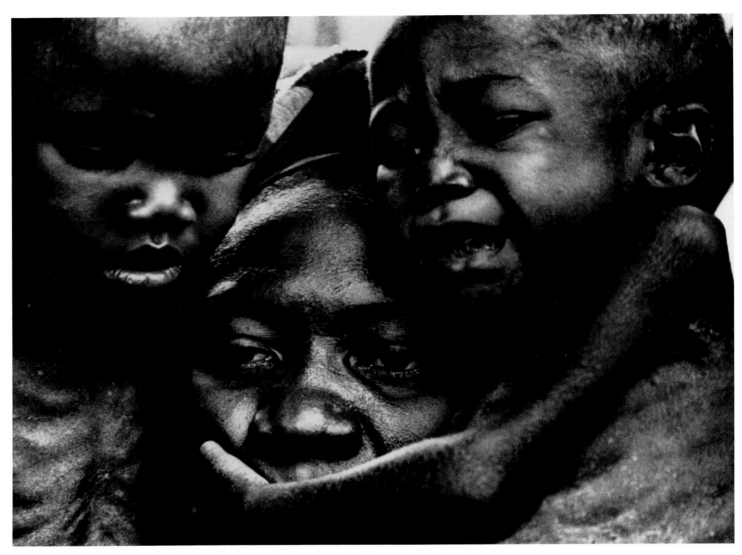
© Romano Cagnoni

536

Romano Cagnoni (1935–)
Biafran Mother and Children, 1968
Black-and-white photograph

Romano Cagnoni has to be considered as a British photographer, despite the fact that he was born in Italy (Pietrasanta, Lucca, 1935) and lived and studied there until 1957, at which date he left for London where he washed plates in clubs and restaurants. In 1954 he had begun to occupy himself with photography with the enthusiasm of an amateur, photographing country folk and some artist-sculptors who had come to the area to select marble for their work, in the quarries and the workshops for which Pietrasanta has been the capital since the time of Michelangelo. In London in 1958, Cagnoni increased his activity as a photographer, collaborating also on Italian weekly magazines as a correspondent, and in particular for *L'Espresso*, which at this time was the most important and progressive magazine published in Italy, from a political point of view as well.

A couple of years after this debut in photojournalism, Romano Cagnoni began travelling in various regions, on a sort of "journey round the world," during which he collaborated on various European and American magazines, among others *The Observer*, *Paris Match*, *Stern* and *Life*, with images of noteworthy drama, revolving around themes and situations emerging in the social context of the time. War and its consequences, in Biafra, in particular, in the aftermath of the war in New Guinea, and in Vietnam, where he qualified as an international photographer, was to be the territory of his sociological research, which more than any other characterised his work, with images of extraordinary drama.

In Biafra, much as in other "hot" places in the world, Cagnoni from that date "was interested above all in people," writes Attilio Colombo in a work on the photographer (*I grandi fotografi—Romano Cagnoni*, Milan, 1983), like in Vietnam, "where his images succeed in restoring the sense of extreme serenity of the North Vietnamese, even under bombing and, together, the tragedy of a life spent under constant threat."

In the line of great war photographers, which begins with Roger Fenton, Felix Beato or James Robertson, Romano Cagnoni also confronts the inevitable dangers with the enthusiasm of a witness, and intends to tell—in this case with an agile camera—the events upon which he casts his eye: this is both intelligent and ideologically sensitive to social contrasts, to the paradoxes of power, which often lead unaware populations, if anything innocent victims, into terrible conflicts, such as those, for example, in Biafra, where Cagnoni produced perhaps his most important reportage.

In Biafra he photographed the war and the famine, compiling what is considered—after the unmistakable, intense accounts by Robert Capa and Eugene Smith which stand out in the history of contemporary photography—as one of the photographic frescoes of our era. This is for the pathos that these authors have assigned to the images, not only as witnesses, but as authors capable of specifying in their photographs both the information and the ideological message, which in Cagnoni's case also has the sign of a new romanticism.

"The first western photographer to have discovered Biafra," again writes Attilio Colombo in his essay, "Cagnoni was also the last to leave it" (1970), with precisely the attempt to recount a complete event, not in fragments, as often happens with reporters, hurried and hastened by the editorial commissioner, who look for the persuasive political effect, even if superficial, rather than the necessity of an ethically correct message. The images of the famine in Biafra by Cagnoni, for example, were effective also on account of their completeness, and arouse interest and world emotion, especially regarding the starving children which his images have depicted with a potency which is not only promotional, but persuasive from a human point of view; and therefore quite outside any iconic speculation, as often occurs in these dramatically photogenic situations.

Cagnoni's photographs express this force especially through the energy of the symbols, structured by an energetic "chiaroscuro," often in counter-light and even in silhouette, but always in a low tone, which distinguishes him, for example, from photographers such as Cartier-Bresson, aiming instead towards a greater apparent "objectivity," which the conventional balance of chiaroscuro in a photographic print, which is never too dark or dense, should permit, according to an insistent ideology of traditional documentary photojournalism. With a pitch black tone, Romano Cagnoni expresses his impassioned participation in the event, directing the message with clarity, and at the same time reminding one of the "presence" of the author of the image. This is achieved without mystification and hypocritically documentary pretences, which lie only in the ideology of the photographer, in his capacity to synthesise, but which presume a sociological analysis, which follows from an indispensable talent for visualisation, and a cultural profile which in banal terms can be described as a trade.

The image of *Biafran Mother and Children* is an emblematic example of Cagnoni's photography, of his way of describing reality, of de-contextualising the "necessary and sufficient" elements for describing a situation, and in this case, to symbolically express a drama. This photograph is an effective metaphor for the biblical event seen by the Biafran citizens during the last years of the 'seventies, suddenly stricken by a "famine" which has become proverbial, also on account of Cagnoni's moving images shot in those years. While at the same date people discovering a continent, Africa, with its contradictions and primitive conflicts, fervently aiming at a progress that Europe and America were at that time initiating in this area of extreme poverty.

Two children, undernourished and terrorised, hug their mother, who is at the centre of the image, and seems to represent *primordial nature*, both physiologically and emblematically, and to which Cagnoni gives a potent visual sense.

The photograph of the *Mother*, is linked iconically (and it is not by coincidence if you recall the sociological vocation which is encountered in all his reportages) to another famous image with the same meaning (*Migrant Mother*, Nipomo, California, 1936) executed by Dorothea Lange during the exploration started with the *New Deal* for the Farm Security Administration. This is an ancient idea of the image of the *Mother* (the *Madonna* in the Catholic world), whose iconography has undergone few variations in time, but which Cagnoni has succeeded in expressing a memorable photographic model, which has now become historical.

—Italo Zannier

Bibliography—

"Biafra," in *Life* (New York), August 1968.
"Biafra", in *The Times* (London), 12 March 1969.
"Romano Cagnoni: Biafra," in *Schweizerische Rundschau* (Visp), August 1971.
Cagnoni, Romano, and de St. Jorre, John, *The Brother's War*, Boston 1972.
Segre, Bruno, *Romano Cagnoni, Presented by Olivetti*, exhibition catalogue, Milan 1975.
"Romano Cagnoni,", monograph issue of *Progresso Fotografico* (Milan), November 1976.
I Grandi Fotografi: Romano Cagnoni, Milan 1983.

KODAK—SAFETY TST

Harry Callahan (1912–)
Eleanor, 1947
Black-and-white photograph

This image—of his wife Eleanor Knapp whom Callahan had married in 1936—embodies the full resonance of his art. It appears utterly sophisticated as if self-consciously referential to the histories of both art and photography. Frame-filled, with its high-valued light scale eliminating depth, the photograph would appear a nod to Cubism and collage layering; and further, the seductive, armpit-revealing posture, might allude—in another direction—to painted representations of, e.g. Old Testament heroines, the Esther of Chasseriau, or Ingres' women of myth and harem. More to the point, Weston may be recalled in Callahan's seeming modernist up-date, a close-up of the naked female figure made abstract; and there is a very similar pose in the 1936 portrait of Dora Maar, by Man Ray.

But the full tension and mystery of this early high moment in Callahan's art comes about through the infusion of a casual artlessness into the historic allusions emmanating from the photograph. The facial character and its expression, in their human particularity and charm—their immediacy reflected in the snapshot intensity of the portrayal—somehow all deflate historic reference. And yet the elegance of the linear play given off by the shadow patterns, the tactile force and interplay of the flattened volumes, all speak to Callahan's intuitive grasp and perhaps sly and individualizing absorption of tradition.

It is not as if this different, and even non-verbal person, still uneasy about teaching after more than three decades, cannot be tied to the major modernist streams and aesthetic positions. After all, his first teaching position was given to him at the Chicago Institute of Design, by none less than Moholy-Nagy who interviewed him in 1946. And it was a personal lecture appearance by Ansel Adams in Detroit, invited there in 1941 by Callahan's hometown friend Arthur Siegel, that not only convinced Callahan that he was to be a photographer, but also offered him a model of technical assurance and tempered spirituality, devoid of exotic influence. As John Szarkowski remarks (*Callahan*, Museum of Modern Art, New York, 1976), "No art historian hunting for persuasive connection could hope for a more useful recollection..." since Callahan clearly recalled that Adams showed the group, among other pictures, a five-print series *Surf Sequence* (1940). In these works, very unlike the typical anthology presenting Adams' lush Western landscape, the play of surf upon beach sand is seen from above, reminiscent of the Stieglitz *Equivalents*, but here with an incisive linearity, and patterning.

From the start, Callahan eschewed most such Romantic inclination and moved towards spare and purist quietude. So that our image of Eleanor is prepared during the '40s decade by photographs tending towards Minimalism—partially the influence of Moholy-Nagy's work; at times with formalism the prime creative inclination as in the calligraphic markings against a whitened rearground seen in the frequently anthologized *Weed Against Sky, Detroit* (1948); at other times, the mundane surroundings and bland posture, the family-album quality, likewise attains the sense of the artless—as Eleanor, nude, standing against a steam radiator, or with overcoat and scarfed-head, on a drab street.

The central European fotoform group has been offered as a parallel tendency, while the stance of an hermetic subjectivity—perhaps a means to reject the War's horrific aura—formed as well at this time in the New York painting world: Guston, Newman. Such practitioners of quietude formed as alternative to the more outwardly emotive and gestural abstract-expressionist school, represented by major artists such as DeKooning and Pollock, with Minor White as photographer in a similar vein. During the years of World War II, Aaron Siskind, a photographer-friend of these artists, had practiced an abstracting photographic idiom which featured a flattened and complex rendition of wall surfaces with their built-up markings. While then close to the New York group, his aesthetic sense was distant from that of Callahan and his drive to suppress intellect. But no doubt index to the profound security and also compelling personal significance that Callahan found in his photo-activities, he himself invited Siskind to join the Institute of Design faculty in 1951. During the next decade, their teaching team strongly influenced the look of American "artistic" photography.

In our image, Eleanor's posture has been similarly offered, as such a typical Callahan example of his ability to handle a dense confluence of theme and form in his art. His wide-ranging visual repertoire is further felt in other earlier images from the *Eleanor* series—which was continued for about two decades. For there exist photographs of his prime model with arms similarly above her head, but with some little space between head and arms, and seen tiny against a distant sandy horizon, *Eleanor, Indiana* (1948); and in yet another variant, what is almost like a negative reversal of our photograph, as the figure is pulled back to torso-length with details of the face obliterated in shadow. (As well, in an effort to effect a sense of Callahan's aesthetic outlook as inherently Puritan and American, his more Romantic and specifically Surrealist-like images might be overlooked: His experimental attitude, from the opening decade of his creativity, allowed him to contradict his dominating aesthetic for clarity and produce both collage and montaged double-exposures. Several of the most well-known of the photographs from the *Eleanor* series, from the early '50s, show her body transparent and juxtaposed against landscape.)

So that just as two other important American modernists, Lachaise and Stieglitz, Callahan chose his wife as foremost model. The seemingly obsessive move would seem to reveal publicly some sense of their intimate lives—perhaps as well and more covertly, their search for some unattainable androgynous repose—and yet such utter subjectivity is marked here, and everywhere else in the works of Callahan by an acceptance of formal self-consciousness. Ironical then, modernist structure while relieving a personal and human unease, may have made it possible to explore such existential strain.

—Joshua Kind

Bibliography—

Callahan, Harry, *Multiple Images*, Chicago 1961.
Callahan, Harry, and Weber, Hugo, *Photographs: Harry Callahan*, Santa Barbara 1964.
Szarkowski, John, ed., *Callahan*, Millerton, New York 1976.
Callahan, Harry, *Eleanor*, New York and Carmel, California 1984.
Artner, Alan G., "Romance Without Pain or Anxiety," in the *Chicago Tribune*, 22 January 1984.
Grundberg, Andy, "When Woman is Idealized Without Resorting to Cliche," in the *New York Times*, 1 July 1984.

© Harry Callahan, courtesy of Pace/MacGill Gallery, New York

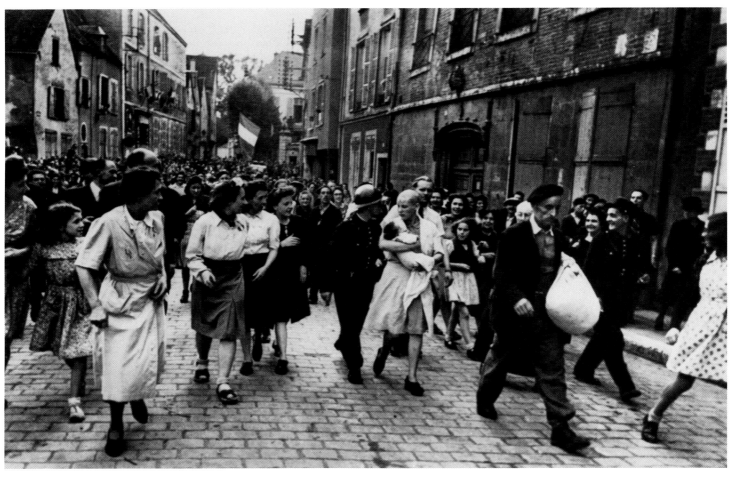

© Robert Capa/MAGNUM

540

Robert Capa (1913–54)
Collaborator, Chartres, 1944
Silver gelatin print photograph

In July 1944, Robert Capa travelled through Brittany with the troops of the liberating US Army. Everywhere he went, he noticed the reactions of the French population to the ending of war: "I joined Patton's fast-moving Fourth Armoured Division as it drove towards Brittany along the coastal road. On both sides of the road, the happy French were shouting "Bonne Chance!" And the happy signposts read, *90 kilometers 80 kilometers . . . to Paris* The Germans were on the run, and the good campaign began. Here the French were full happy. The food was good, and the first glass of wine was free in the bars."

France was Capa's adopted homeland, and, until the outbreak of war, Paris had been the centre of his personal and professional life. But he retained an outsider's curiosity about the French, observing and quizzically recording the paradoxes and peculiarities of a nation. Post-liberation events proved to be a carnival of mendacity described well by Capa's terse and concise camerawork.

By the time he crossed France with the US Army, Capa was an experienced war correspondent. In the late 'thirties, he had travelled to Spain to photograph the Civil War for magazines like *Vu* and *Regards*. The recording of the Spanish Civil War marked the beginning of a new photojournalism, typified by the work of Capa, Gerda Taro and the young German photojournalists Hans Namuth and George Reisner. Idealistic, politicised, pragmatic and opportunistic, they eschewed the old ethics of press photography and looked for the human stories provoked by the maelstrom of the military.

Travelling through northern France on the way to Paris, Capa used the same methods. As well as photographing advancing troops and captured soldiers, he studied closely the small dramas of post-war revenge and cruelty, acted out by a provincial population. When he saw collaborators being punished, he observed with irony that they were not the profiteers, the anti-semites or the corrupt bureaucrats but rather the dispossessed, the poor, the desperate, single women with their illegitimate children, prostitutes—society's customary scapegoats. In his major post-war photographs, Capa adopted an exceptionally precise moral coding.

When Capa arrived in Chartres on August 18th, 1944, he chanced upon a bizarre ceremony taking place at the Prefecture of Police. Here, Resistance members were shaving the heads of women who they had suspected of co-operating with the occupying enemy. For Capa, an emigré who had fled from a punitive Hungarian society and was, above all, a self-governing individualist, the right to punish was a questionable act.

Capa's photograph, *Collaborator, Chartres, 1944* becomes a distillation of all of his earlier war photography. A wide, crowded, almost panoramic image, it looks like a scene from a Hollywood epic, some awful saga of biblical wrath writ large by the media. The message of the image can be read immediately. The sheared woman, clutching her tiny infant is surrounded by a jeering, laughing crowd. Children in their best dresses, policemen in uniform, respectable bourgeois in tidy dresses and suits. Capa has no pity for them, gives no credence for their war-time suffering and dwells with irony on their lack of distress, their physical health, their jaunty gait. Before his lens, they become the cavorting mob at a medieval hanging, contemporary casters of a first symbolic stone. Considering these accusers, the photograph itself accuses. Thrown out, disfigured, humiliated, the scorned woman becomes a martyr, a striding heroine, a problematic Joan of Arc in her stained factory overall. Arms around her baby, surrounded by hostile, howling people, she makes the public journey from fallen woman to madonna.

Collaborator, Chartres, 1944, has become one of the emblematic photographs of the liberation, standing beside Lee Miller's cool, furious portrayal of the death camps and Margaret Bourke White's eerie tableaux of post war-Nazi interiors, with their suicide families. It illustrates society's bizarre idiosyncrasies, points to the duplicity of propaganda, illuminates cruelty and hysteria.

Capa left Chartres during the last week of August, 1944. Paris was to be liberated, and he was anxious to join up with the French 2nd Armoured Division who were to form the advance guard into the capital. With *Time* journalist Charles Wertenbaker, he inveigled his way into the French advance guard. Later, he recalled: "I felt that this entry to Paris had been made especially for me. On a tank made by the Americans who had accepted me, riding with the Spanish Republicans with whom I had fought against Fascism long years ago, I was returning to Paris—the beautiful city where I first learned to eat, drink and love."

It was a day charged with emotion: "The thousands of faces in the finder of my camera became more and more blurred." Journalists flocked into the city, congregating at the Hotel Scribe, and Capa looked for new opportunities. He had little interest in the aftermath of conflict, the "shooting war" had held far more appeal than the "looting war," and he viewed with horror any prospect of joining other photojournalists documenting the concentration camps and the ruination of Germany. He went into Germany for *Life* magazine (for whom he worked as a staff photographer until early in 1946), but in the autumn of 1945, he left for the United States, working in New York and later in Hollywood. Though Capa was to regard Paris as his home for the rest of his life, an important tie with Europe had been broken. He had emerged from the chaos of war-time Europe as a hero photographer, an intrepid chancer. At the height of the conflict he reflected: "I would say that the war correspondent gets more drinks, more girls, better pay, and greater freedom than the soldier; but that at this stage of the game, having the freedom to choose his spot and being allowed to be a coward and not executed for it is his torture. The war correspondent has his stake—his life—in his own hands, and he can put it on this horse or that horse, or he can put it back in his pocket at the very last minute."

In 1947 he founded the Magnum agency with Cartier Bresson, George Rodger and Chim Seymour. For Capa, the experience of war had formed a personal aesthetic. His early death in Indochina in 1954, sanctified his history, made a life story into a legend.

Collaborator, Chartres, 1944 is a photograph which stands centrally and seminally at the core of the western European humanist mode of photoreportage. Decades after it was taken, it remains one of photojournalism's most compelling observations. Sparse and dramatic in its message, but expansive and complex in its composition, it is an enduring and exciting moral tale.

—Val Williams

Bibliography—

Capa, Robert, Taro, Gerda, and Seymour, David, *Death in the Making*, New York 1938.
Capa, Robert, *Slightly Out of Focus*, New York 1947.
Capa, Robert, *Images of War*, London 1964.
Farova, Anna, ed., *Robert Capa*, New York 1968.
Capa, Cornell, ed., *Robert Capa 1913–1954*, New York 1974.
Martinez, Romeo, *Robert Capa*, Milan 1979.
Whelan, Robert, *Robert Capa: A Biography*, London and New York 1985.

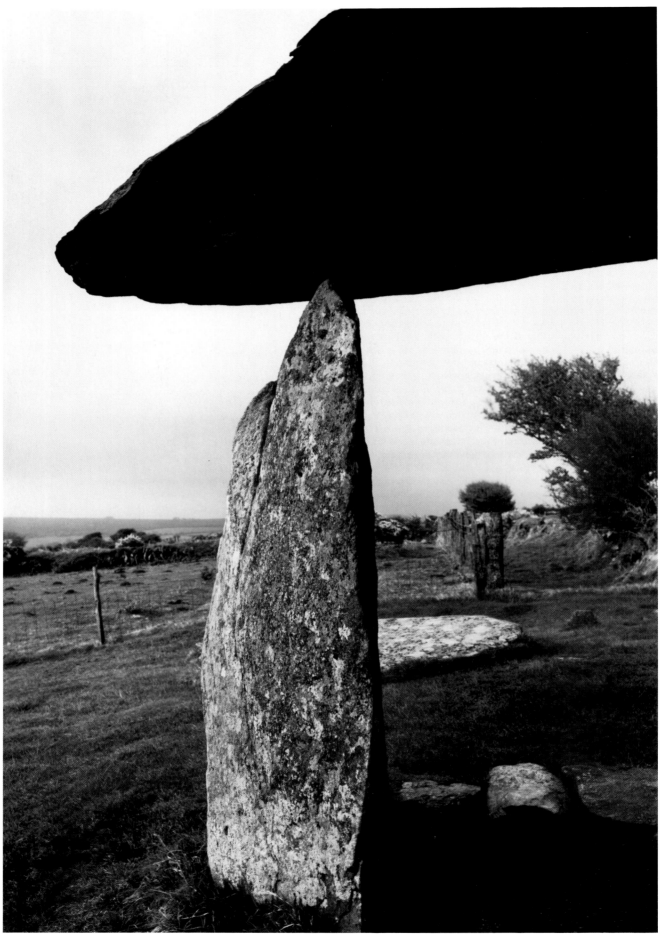

© Paul Caponigro

542

Paul Caponigro (1932–)
Pentre-Ifan Dolmen, Pembrokeshire, Wales, 1972
Toned gelatin silver photograph; 47 × 30.5 cm.
Santa Fe, Museum of New Mexico

Details of human existence have preoccupied photographers since the announcements of the invention of photography in 1839. Masters in this century, such as Edward Weston and Paul Strand, concentrated on the fundamental beauty of form in their subjects. Their vision for essentials brought the world to the viewer with a literal directness. Their contributions established a strong modern foundation for photography as a vital art form.

Paul Caponigro's search for nature's universal order and mystery establishes further achievements. The distinguishing mark of his vision and craft invites further introspective exploration. In his subjects, the viewer discovers a special sense of life's riddles and hidden power. Here, the photographer articulates the hidden dimensions of primal mystery that fosters our involvement. Our venture follows through what is seen and uncovered. A new landscape emerges in our passage, with its own scale and meaning.

The monumental ancient stones arranged throughout various parts of the British Isles and Ireland are a chronicle of the lives of many cultures over the centuries. They offer uncommon studies in human sensibility. Theory suggests that the imagination of the prehistoric mind was rich in cognizance. The people of early civilizations sought an extensive understanding of universal order and meaning that has stood the test of time. In recent years, technology such as carbon dating and computer analysis have started to answer the secrets of cultural histories. Through science, we are learning not only about their societal context but further clues to the position and function of the megaliths.

These massive stones played several roles. Functions include the rites of passage, religious ceremonies, scientific correlations with the seasonal calendar, and measurable correlations with the earth and the heavens and other forms of systematic measurement. However, in many ways, they remain the untold stories of deep human understanding and aspirations.

By 1966, Paul Caponigro became interested in the ancient monuments of Egypt. Because of the country's strained relationship with the United States, he began travelling to Ireland at the encouragement of his wife, Eleanor. There, he considered the historic churches and other sites. But it was the stones of prehistory, their character and position in the landscape, that prompted further inquiry. He spent the next two decades extensively researching and photographing their various arrangements.

The subsequent body of work around the megaliths became as inventive as the diversity of subjects. This included many manifestations of the stones, from the tumulus (passage grave) and smaller cairns, to the stone circles of Avebury and Callanish and Stonehenge, to the alignments of Kermario at Carnac, Brittany, to the standing stones and dolmens ("stone tables"). All convey engineering feats and a visual innovation often on a larger-than-life scale.

The numerous dolmens provide no exception. They are described as a giant's grave, soothsayer's altar or burial chamber that suggests the fantasy of legends and fables. In this photograph, the full scale of the Pentre-Ifan Dolmen is confirmed by other parts of the surrounding land. Yet this view hints at other allusions.

The artist has always been a precursor of knowledge that is not bound by calculation. Art offers a resolution of the past which is not determined by scientific models. Caponigro uses photography as a medium to uncover the seeds of prehistoric vision to seek the immeasurable aspects of understanding.

In the megaliths, he links the mutual sensibility of two very different forms of expression. The sculptural nature of these monuments is joined with modern photographic terms. As a kind of visual archaeologist, he discovers with the camera a parallel between the intuitions of antiquity and the contemporary experience of looking.

This is not the art of the metaphor or the reductive abstraction of Alfred Stieglitz. Nor is it a simple message of geometric propensity. The photographer reunites the relationship between nature and culture critically. In our looking, he reestablishes this lost alliance in the most explicit terms. What these ancient artists saw in excavating stones, the process of selection for quarrying, and the arranging of their positions in the land, became a visual archetype for the photographer. He describes the undertaking as an "emotional archaeology." "Most often," he continues, "mind and matter are used as the tools for discovery. . . . Emotions can also excavate."

Lucy Lippard wrote about these early forms and other contemporary works of art. They are a form of communication not relegated to language models: "I hoped to understand better the original connections between art, religion and politics, the ways in which culture contributes to and functions in social life. Conflicts between nature and culture, between historical awareness and the supposed universality of art, clearly did not exist in prehistory. . . . Many artists today are trying to overcome such false dichotomies by resurrecting lost connections within a contemporary framework. I, in turn, hope to use their discoveries to suggest some new models for the communicative function of art."

Paul Caponigro helps uncover the lost unions of prehistory. By connecting them with the present, the photograph joins a feeling of life's forces with human desires through the eyes of the past.

This facility found in photographs like the *Pentre-Ifan Dolmen,* opens new territory within the imagination. The photographer unveils further associations of the mind and matter with what he terms "the voice of the print." His love of craft upholds the highest standard of printing in the tradition of Weston and Strand. Through the refined skill and intensive labors of the darkroom, the final quality of timbre found in the photograph communicates for itself. Interactions follow beyond the literal renderings of light.

Throughout the intricate tonal scale of this print, there is a sense of density without gravity. The opacity of things is generated into a translucent interplay of light and values that opens the essence of the stones to vital interpretations.

The positions of these two stones appear unconnected. They do not seem to touch. Each part of this dolmen is suspended. The shape above becomes a floating element. The finger-like profile below points to the heavens. The large black form is weightless and flat in dimension. It is as impenetrable as the vertical rock. Such an attribute can be found in Strand's early prints where the tonality of black is neither void nor substance. It becomes something intangible, added to the viewer's personal experience. This is not the color found in the pigment of the painter or the printed ink of the printmaker. The black silhouette is at once liberating and entirely photographic.

This appropriation of prehistoric acumen is rare by any standard. It represents a kind of abstraction that invokes further introspection. As a part of the cultural landscape, this is a remarkably humanized view by the artist's achievement in vision and craft. We are silently reminded of our place in the universe, temporarily retained among its other secrets.

—Steven Yates

Bibliography—

Caponigro, Paul, *Landscape: Photographs by Paul Caponigro,* New York 1975.
Mellor, D. W., ed., *Paul Caponigro Photography: 25 Years,* exhibition catalogue, Philadelphia 1981.
Lippard, Lucy, *Overlay,* New York 1983.
Caponigro, Paul, *Megaliths,* Boston 1986.
Caponigro, Paul, *The Voice of the Print,* New York 1990.

© Henri Cartier-Bresson/MAGNUM

Henri Cartier-Bresson (1908–)
The Banks of the Marne, 1936–37
Gelatin silver print photograph; 23.3 × 34.8 cm.
New York, Museum of Modern Art

The Banks of the Marne is a splendid illustration of Henri Cartier-Bresson's concept of the "decisive moment," the climatic second in which he captured his subject in its most expressive form. Although this is a photograph by the man who pioneered a candid and immediate photojournalism made possible by the 35mm. Leica, paradoxically it is difficult to look at it without thinking of such precedents in painting as Monet's *Luncheon on the Grass* (1869) or Seurat's *Sunday on the Island of La Grand Jatte* (1884). Indeed, Cartier-Bresson began his career as a painter. As a child he was introduced to painting by his uncle, an artist, and was encouraged to pursue the arts by the headmaster of his school. By the time he was 18—in 1927—when he enrolled in the atelier of the cubist artist Andre Lhote, Cartier-Bresson had been steeped in the visual culture of late nineteenth-century art and early modernism. As with *The Banks of the Marne*, his work in general frequently merits comparison with French painting.

Cartier-Bresson's photograph breathes new life and some subtle humor into the venerable tradition of the luncheon on the grass as he captures the moment when the riverside picnickers are finishing their meal. The man at the left pours a glass of wine, his nearly empty salad bowl set to the right of the glass. Its distance from him and the two forks crossed one atop the other bespeak the completion of this almost final course. The corpulent woman at the far right manipulates a piece of food, perhaps a chicken bone, in order to extract every last morsel of meat from it. Her gesture and her large form suggest the obvious pleasure she derives from eating. Even though the picnickers remain anonymous—we see all but one man from the back—their forms suggest a general sense of satiety and well-being.

Actually this bucolic ambience was totally at odds with the miasma spreading over Europe and, indeed, the entire world. The picture was taken in 1936–37, when Europe was in turmoil and the spectre of war was imminent. By 1936, Hitler, Mussolini, and Franco had come to power. This socio-political context lends greater poignancy to the ephemeral quality of this peaceful pastoral interlude. Perhaps the picture's ultimate meaning may be found in the tension between the momentary oasis of this riverside picnic and the reality of war, although it is in no way visually apparent. (In 1939 Cartier-Bresson would enter the French army as a member of its photo unit and within a year become a prisoner of war.)

On first glance, it appears as though the photographer snapped the scene spontaneously, a characteristic which was the mark of Cartier-Bresson's "decisive moment," a concept he articulated in his essay of the same title. In his first exhibition at the Julien Levy gallery in New York in 1933, critics saw his apparently spontaneous work as "accidental," and failed to appreciate the order underlying his compositions. *The Banks of the Marne*, in particular, illustrates classical and precise compositional organization. The man on the left and the woman on the right frame the scene, recalling the compositions of Poussin and Cezanne. The curved back of the second woman, set in mid ground, echoes the curved back of the man at the left. When one stops to analyze each element in the photograph, one discovers that it contributes to a unified, integrated composition, in spite of the appearance of the haphazard and the casualness of Cartier-Bresson's candid photographic technique. It is this quality that has inspired Carter-Bresson's comparison with Edgar Degas.

In addition to its debt to French painting, this subject matter may also have been inspired by Cartier-Bresson's work with the filmmaker Jean Renoir at this time. He was the second assistant director in Renoir's *A Day in the Country* (*Une partie de campagne*) in 1936, a film that pokes fun at the city dweller's delights in the countryside—especially eating on the grass and fishing—as well as the country dweller's perceptions of cityfolk's "sophistication." The photograph, however, lacks the satire of the movie and suggests a respect for the cherished ritual of the rural picnic. Cartier-Bresson worked on one more film with Renoir, after which he committed himself to photojournalism. It is difficult to believe that when Cartier-Bresson photographed his now famous *The Banks of the Marne* he was not yet certain of the direction his career would take. Nevertheless, his work of this period has a resolution and maturity about it although he was still in his twenties.

Cartier-Bresson earned a reputation as a photographer with a very human and humane vision which his hand-held Leica enabled him to express fully; because he was able to move unencumbered by a tripod and without attracting the attention of his subject, he could be free to follow it as need dictated. With such mobility and flexibility, he redefined the photographer's relation to his subject and extended exponentially not only the wealth of formal possibilities in terms of composition and gesture, but also the human drama in its myriad nuances. Cartier-Bresson wrote that the photographer must "place [himself] and his camera in the right relationship with the subject," and that he must "hover around [an event] while it develops." In a picture such as *The Banks of the Marne*, he infuses the scene with humanity through a variety of details uniquely combined into a split second. He plays with the grand tradition of a luncheon on the grass to capture a world that is at one and the same time personal and timeless.

—Bonnie L. Grad

Bibliography—

Kirstein, Lincoln, and Newhall, Beaumont, *The Photographs of Henri Cartier-Bresson*, New York 1947, 1963, London 1964.
Cartier-Bresson, Henri, *Images a la sauvette/The Decisive Moment*, Paris and New York 1952.
Cartier-Bresson, Henri, *The World of Henri Cartier-Bresson*, Paris, London and New York 1968.
Cartier-Bresson, Henri, *Cartier-Bresson's France*, Paris, London and New York 1970.
Clair, Jean, *Henri Cartier-Bresson: photographies*, Paris 1982.
Galassi, Peter, ed., *Henri Cartier-Bresson: The Early Work*, New York 1987.
Livingston, Kathryn E., "Henri Cartier-Bresson: The Early Work," in *American Photographer* (New York), December 1987.

© Larry Clark, courtesy of Luhring Augustine, New York

Larry Clark (1943–)
Tulsa—Pregnant Woman, c.1969
Black-and-white photograph

The line and the bulk of the heavily pregnant belly, the ready breasts; maybe seven months of life are there, taking on form in the struggle for continuance. Everything about the woman's body is striving for perfection so that she may perfect the other, which now imposes itself over every aspect of her being.

The photographer does all a photographer should to make this a classic image. The setting is simple in the extreme, in a room with plain, even-toned walls, and a window at the top left that makes a perfect rectilinear foil to the woman's opulent, awe-inspiring curves. The tonal range in the print is elegantly rich, with the peak highlights on the woman's body and arms halating just enough to suggest the sentimentalised view of pregnancy peddled by certain magazines.

Except for the needle, and higher up her right arm, the tourniquet.

This woman is no more a happy rider on consumerism's moving pavement than she is an incarnation of the Willendorf Venus, that fearsome vessel of an ancient race. Who she is, as a person, Larry Clark never intends us to find out. It is enough for him to have strung this image together with a number of other moments from her life, so that we may add her into the brutal typology which his book *Tulsa* invites us to construct.

The first of these moments has her standing in a bathroom, seemingly defending herself against accusations driven by the pointing finger of a man, silhouetted in the foreground. In the gap between them, partly obscured by her knee and his free hand, is a small, ill-defined, embryonic-seeming child, one worried eye visible to the viewer. The next shows the woman in a kitchen, food pack in one hand and using the other to fend off a man, half hard and naked except for his underpants, who is squaring up to her in a boxing attitude which might or might not be playful.

It is nearly a hundred percent certain that it is she in the next photograph, kneeling on a bed, across the same man (his identity confirmed by the crudely tattooed heart on his arm, hers hinted at by the cut of the woman's hair), who is shooting her up with dope. Then we are shown the photograph seen here, of the woman alone, doing the injection to herself.

The next image, of an older woman bringing flowers to a funeral, and the next, of a baby about to be closed up in its coffin, are clearly expected to evoke the sense of destruction and loss presaged by the previous photographs.

Then we are treated to a double-page spread of a police informer being beaten up, followed by a photograph of two young men probably at a dope session; followed by the final photograph of the woman, sitting on a bed, naked, biting on a gag, injecting herself, the tourniquet held for her by a naked man; and another naked man is sitting by her to watch the proceedings as he approximates a state of erection.

We have followed up just one thread of the protracted cry of youthful *anomie* which pervades *Tulsa*. The book's ethos seems to propose for its characters an ineluctable and hence tragic progression from teenage fun, via boredom and ordinary delinquency, to extremes of violence leading ultimately to death. As Larry Clark says: "when i was sixteen i started shooting amphetamine. i shot with my friends everyday for three years and then left town but i've gone back through the years. once the needle goes in it never comes out." And, "death is more perfect than life."

It is a restatement of the Romantic's stance. The same, or similar positions are found throughout the histories of art, the annals of crime and the confessions of sinners. A sense of exclusion, a state of isolation, opposition, persecution, for some people at certain times grow way beyond the normal adolescent flowers of evil, into horrific jungles of vice, or alternatively, the sublimities of heroism. Indeed, just how do we differentiate these two extremes? Where would we site Verlaine as the author of his erotic poems? Would we eliminate all aspects of heroism from Rimbaud's gun-running? May we separate our judgment of a work from the acts that precede it? History suggests that we do tend to opt for the exclusive position, and experience suggests that if we want to continue to create recognisable categories of heroes and sinners, we had better go on doing so. But it is becoming an increasingly familiar characteristic of our culture that at a certain level of interpretation, categorical oppositions and boundaries are persistently called into question.

Tulsa is a nearly ideal vehicle for such questioning. Larry Clark pictured his friends with so great an intensity, despite the dreadfulness which we know must be the dominant note of the lives we see there; that is essential to the woundings, the batterings, the dope; they come across in the photographs as a kind of warrior elect, isolates proud of their chosen way along the remotest, most jagged experiential edge. Decadence raised to the level of virtue, the distilled essence of waste. Who can truly say that they have never felt even the merest tinge of envy for the knowledge so hardly gained? Who in their right mind would deny that any life so spent negates every aspiration for human love and betterment? Most people will have some kind of firmly articulated position on the life encapsulated by the photograph: I would guess that relatively few are prepared to bring out and examine publicly the paradoxes suppressed on the way to achieving it.

So far as Clark himself is concerned, *Tulsa* seems to be the single piece in which he achieves a resonance of peak intensity with his subject. The distance in time of Clark from his subjects in *Teenage Lust*, its elaborated and more diffuse structure, both conspire towards a set of images which still disturb his viewers, but also protect them by means of a veil of artifice, from having to deal with the uncomfortable matters that cannot be avoided in the earlier *Tulsa*.

—Philip Stokes

Bibliography—

Clark, Larry, *Tulsa*, New York 1971.
Zannier, Italo, "Larry Clark: Tulsa," in *Fotografia Italiana* (Milan), April 1973.
Dugan, Thomas, *Photography Between Covers*, Rochester, New York 1979.
"Larry Clark: Adieu Junkies," in *Photo* (Paris), September 1980.
Clark, Larry, *Teenage Lust*, Millerton, New York 1982.

Courtesy of the artist and Andrew Smith Gallery, New Mexico

548

(Frank) Van Deren Coke (1921–)
The Dentist's Office, 1958–66
Solarized and toned gelatin silver photograph
Santa Fe, Andrew Smith Gallery

The infinite relationships that artists establish *between* artforms remains an increasingly central story in twentieth century art. The influence of ideas from outside sources—in art, life and culture—continues to enlighten the viewer. In the use of photography, meaning can stem beyond the camera's literal rendering of the world. Ideas from painting, printmaking, sculpture and inner worlds are as useful to today's artist, as representational strategies of tangible reality were to the artisans of the Renaissance.

In his research and teaching of modern art at the University of Florida in 1958, Van Deren Coke began to look into the work of Norwegian artist Edvard Munch for a firmer understanding. During the summer, he came in contact with Harvard Professor Frederick Deknatel, America's modern authority on the artist. With the knowledge gained from Deknatel and publications held at the Fogg Museum's Library, Coke began to see similar potentials in subjects he was photographing. He returned to Gainesville to resume his teaching and work as a photographer.

While searching for studio space with a visiting faculty member the following fall, they discovered a vacated dentist's office with equipment still in place. The juxtaposition of the apparatus and the artist brought images of Munch's art back to mind. Coke set up the scene, made an exposure with his camera, and processed the negative which was then left for future interpretation.

A few years later, the he spent sometime with Man Ray in Paris. In viewing the artist's surreal photographs, the photographer was encouraged to re-explore earlier negatives and make prints that surpassed conventional darkroom practices. Man Ray exposed his negatives to be solarized to bursts of light during their development, then made prints through the normal darkroom methods. The nineteenth century process, discovered by French doctor and scientist Armand Sabbatier, was originally used for making positives by reversal with wet collodion plates. Man Ray exploited the *Sabbatier effect* with modern materials for its dimensions of chance, as well as to evoke ideas that transcended reality.

The results were partially reversed images. This was especially the case in the shadow areas. Depending on the amount of re-exposure to light, they turned positive while edges and contours complete a similar inversion from the inside to outside forms. Often, subjects in the picture are rendered with strange silvery hues that extended the normal grey scale of the black and white photographic print. An intensification in the surfaces of things represented carries a sense of incorporeal dimensions.

Coke took a cue from Man Ray, but instead of re-exposing the negative, he used flashes of light over the photographic paper in the solution. Some areas of the picture would reverse into negative forms from the positive, while other parts gained a new sense of tone and pattern. Too much light would entirely fog an image still developing, so a print was quickly submerged into the fixer to sustain the negative and positive quality. Chance becomes a factor in this process through the chemical variations of each final unique print.

In *The Dentist's Office*, the original associations the photographer evoked when he made the negative years before were further extended by the one-time printing method of solarization. Chemistry and light are used to redefine and enter another domain. As a consequence, the tangible world of this room borders on the transparency of a dream like one might experience in an apparition. The office window and wall begin to lose their physical properties in a fluid-like abstraction. Light not only renders form but becomes a reality of dematerialization.

Edvard Munch heightened reality through the use of ambiguous space and ominous relationships between people and their environment to convey his feelings. Similarly in Van Deren Coke's work, the polemic of Expressionism is reinstated in photographic terms. Everyday objects become signs rather than just details of concrete reality. In his use of human fear of certain types of machines, there resides universal symbols. Pictures are a catalyst to human references and emotion. The disquieting feeling of dentistry is evoked with a shiver, based on our personal experiences.

The constant cross-influences of art movements in the first decades of this century are also revitalized here. The doors of photography are opened to international aesthetic currents. In the solarization of this print made years later from the original negative, Coke heightened his Expressionist aims. Moving outside ordinary experience, he steps towards an exploration of the terrors of the unknown. The rational and scientific is conveyed with overtures outside reason. A Surrealist preference for the absurd is also implied through his partially controlled orchestration in the darkroom. In so doing, he introduces the possibility of other potentials for photography, unbound by the conventional methods of producing photographic prints.

Van Deren Coke not only grasped the affinity of art and the dream through photography, but suggested that the creation of the image relies less on the camera itself, than with the aspirations of the artist. Rather than an end, the photograph becomes a means towards something else. Reality is necessary only for working off of and into other directions. Furthermore, the notion of "vintage" print is redefined. The original negative was created in the spirit of Munch's example. To the final print, made almost a decade later, other ideas were added totally unrelated to the original conception.

Van Deren Coke's envisioning of photography's expressive promise through the course of modern art history has proven fertile ground. As a factor in the development of nontraditional approaches in the use of photography since the Second World War, this concept has been a panacea. While serious artists still work with the traditions of Weston and Stieglitz in mind, there are increasingly generations who are abandoning the historical parameters of the medium and striking out to explore new terrain.

If, as Coke has written, photography is the "quintessential" modern medium in its own terms, it is also being used in combination with other media by artists who have abandoned traditional directions. Such a spirit of exploration continues to resonate more and more as photographic ideas expand. Photographic imagery has become central to the pluralistic course of mainstream art without question as we complete the twentieth century.

—Steve Yates

Bibliography—

Smith, Henry Holmes, and Nordland, Gerald, *Van Deren Coke: Photographs 1956–1973*, Albuquerque 1973.
Neususs, Floris M., *Fotogramme—die lichtreichen Schatten*, exhibition catalogue, Kassel 1983.
Lufkin, Liz, "Van Deren Coke: Pied Piper of the Avant-Garde," in *American Photographer* (New York), June 1985.

Courtesy Arts Council Collection

Thomas Joshua Cooper (1946–)
Ceremonial Veil, Nesscliffe, Shropshire, c.1974
Black-and-white photograph

Thomas Joshua Cooper is in a great tradition when he turns to photography for the realisation of his own meditations, and to provide the means for others to apprehend them. Yet it is ironic and paradoxical that meditational objects of such evident power and lasting quality as his photographs should have been created out of a process nowadays more than ever experienced ephemerally, flickering across the field of vision and in and out of mind; that has become the perfect fodder, one might suppose, for the poetaster and the dilettante picture collector.

Even more curious is the fact that Cooper's works, from a distance visible as those dark, seemingly similar rectangles so familiar to readers of casually written reviews, are from time to time exhibited together in significant numbers; apparently the worst conditions to induce viewers to engage, image by image, with an intensity appropriate to the fulfilment of the artist's purposes. The conventions of both medium and chosen context have seemed to militate against him, but the audience has not walked away. His photographs have what it takes even in a line on the wall; the isolation as we are given it here, of the page in a book, approaches the ideal.

The photograph, *Ceremonial Veil*, is one of a number made at Nesscliffe. They are woodland subjects, and share the overall darkness combined with full tonality for which Cooper has become known, and at a superficial level is seen as the characteristic which best sums up his work. The other fundamentally photographic aspect of Cooper's images is the great density of the information contained in them.

Whereas the production of an image which seeks to maximise the mimetic connection with its subject should, on the face of it, point to the perfections of a materialist heaven, this photograph has, in common with the rest of Cooper's work, quite other significances. As a viewer moves into a study of detail, the realisation soon dawns that there are effectively no limits to the depths of reading; there is a point at which the eye has so much to deal with that the organisation of materiality dissolves, or rather, alternatives appear. The minutiae of rock surface, the infinite texturings, the sharp and rounded-edged cracks, the tones so painstakingly discriminated for each fraction of an inch across the rock wall take us through and beyond anything we might be able to say in description of the disused Nesscliffe quarry, but not as it might be said of a blurred photograph, that it could be a person or a rock, in loose careless ambiguity: for there is not the slightest ambiguity here. That is a certain, specific quarry face, those are the trees that were there before it on a certain day; everything a photographic representation could give is shown there.

Yet the descriptive journey beyond the limits of the commonly available photographic world acts upon the viewer as a release from crudely denotative bonds, and encourages the perception of another presence, or to follow in the Stieglitz-Minor White tradition, the understanding that the photograph may function as an equivalent; that it may offer a certain sort of poetic metaphor to its interrogator. Or, as White found out in the course of his 1950's researches, a metaphor of which a viewer is so uncertain of its sort as to be in danger of drifting off into regions of oceanic formlessness.

It is part of Cooper's strength that he is able to persuade his viewers of the certainty of their presences; not in any desiccatingly specific material sense, but in the belief that they are being invited to share in Cooper's acute sensitivity, which those who know him would happily call an ancestral sensitivity; to the pre-industrial, even pre-agricultural connections between humanity and the land. The titles make it clear. Whether Cooper speaks of a Ceremonial Veil, a Ritual Forest, a Ritual Indication or a Ceremonial Movement; as he does in the cases of four photographs taken at Nesscliffe, he links the idea of priestly activity with specific places, and by implication, with the ancient traditions of all cultures that have in their centres the need for harmony between the activities of humanity and the energies of the earth itself. Whether Cooper thought of his roots in China, in America or in the pre-Celtic inhabitants of Britain does not matter. It would have been the same had his mind been on Gaia; these things are a constant in our ground of being. To tease out the notions implied in naming such seemingly different locations as, say, the birthplace of the goddess, the energy node on the leyline, or Cooper's ritual locations, is to confirm their near identity.

The title offers a path, not a constraint. Through *Ceremonial Veil*, we are liberated to admit to the metaphysical translucency of the physically solid rock, which by the tension of the paradox thus takes on a spiritual dimension; and whether we confess it or not, as a consequence to allow ourselves a sidelong glance at our memory of the appearance of the Turin Shroud.

Even without the title, we would certainly have recognised the proportions established by the verticality of the trees against the primarily horizontal texture of the rock face, and it would be well within the established traditions of formalist analysis to note the harmonious relationships between the thicknesses and the spacing of the trunks; and to regard what might be called the counterpoint of the bark markings, and the intervening accents given by twigs and leaves, as having become as it were, the notes in some complex musical score, or diagrammatic poem.

But here, the fact of recognition of Cooper's intended context relegates any formalist account to a rôle supporting his primal theme: for work of this power it could hardly be otherwise. Yet only the final working-through of the less amiable, exclusive tendencies of Modernism has disabled the critical fashions which would once have sought to question the mythic importance or the lyricism of the poetry found there by viewers of Thomas Cooper's work. That this material, of which *Ceremonial Veil, Nesscliffe* forms a part, continues to find such favour, is surely a pointer to the wide survival of the ancient human connections to the land; and this must be a hopeful indication for the future, as well as being confirmation that there is a significant public for a visual poetic so profound as Cooper's.

—Philip Stokes

Bibliography—

Cooper, Thomas Joshua, and Hill, Paul, *Remnants and Prenotations: the photographs of Thomas Joshua Cooper and Paul Hill*, Bristol 1975.
Gaskins, Bill, ed., *British Image 5: Perspectives on Landscape*, London 1978.
Hill, Paul, *Three Perspectives on Photography*, exhibition catalogue, London 1979.
Cooper, Thomas Joshua, *Between Dark and Dark*, Edinburgh 1985.
Cooper, Thomas Joshua, *Dreaming the Gokstadt*, Edinburgh 1988.

© Bruce Davidson/MAGNUM

Bruce Davidson (1933–)
East 100th Street, 5: Mother and Child, c.1968
Black-and-white photograph

From 1967 to 1968, Bruce Davidson spent two years photographing one block in East Harlem or Spanish Harlem, as it is known, in New York City. He used a deliberated technique to record these images which resulted in the book *East 100th Street*. This untitled photograph of a mother and child was made, as were the other prints in this series, using a tripod mounted 4 × 5 camera and a strobe. Such technology enabled the photographer to stop action as well as to create a high contrast work in which darkness predominates over light to become a statement about the difficulties his subjects encounter in their daily lives.

The prints in the book are presented as untitled pieces which exist on facing pages. Except for a brief introduction, there is no text, and parallels are established between images on facing pages throughout the volume. This exposure of a mother and child exists opposite a photograph of a rubbish heap on which a mattress has been tossed. Thus, a relationship is established between the woman's bed and her room and the discarded mattress in the picture opposite. An analogy is established between her exterior environment and her private poverty. Both images are ambivalently connected as worlds she must contend with, for they mirror each other in their mutual disarray.

Although the photograph was originally intended to be seen within the context of a book, it also forms a strong statement on its own and contains many characteristics of Davidson's work as a whole. The poverty of the environment is open to view, for the camera's large negative and strobe light leave nothing hidden. We see evidence of the room's former elegance in the detailing of the walls, while at the same time that we are apprised of the cheapness and wear that characterizes the room's current furniture. The pilled blanket, the pinned curtains, the patch of dirty worn linoleum floor, are all evidence of a lifestyle that is constantly being eroded through the literal attrition of a daily struggle to survive.

The intimacy with which Davidson was able to record that struggle is shown by the bedroom setting. Although not all the people on the block were willing to be photographed, those that were often chose their bedrooms, as did this woman. The privacy of the bedroom thus becomes a metaphor for the intimacy Davidson achieved with his subjects. The bedroom highlights the vulnerability of the mother and child, for it is not only a private space but literally a room that normally functions as a refuge and a place for dreams. Yet it is evident from the objects in the picture that no refuge or place for dreaming exists here. Instead there is a sense of cramped disorder, created in part through the introduction of objects that are normally foreign to this space as well as by the fact that every available surface is covered with objects. Specifically, on the left of the image we find a nearly finished bowl of popcorn, while a baby buggy blocks access to one of the windows. In an unsuccessful attempt to introduce order, clothes and other items also spill out of closets and out of boxes.

The windows let little outside light in, and the outside world as revealed through one of them is rendered almost without detail by the dirt encrusted glass. Thus, the photograph reveals a world where the exterior is separated from the interior. A separation of worlds is characteristic of this series as a whole, for people are either inside in curtained or windowless rooms or they exist in the street. This dichotomy becomes a metaphor for people that lack certain connections between the interior lives they lead and their abilities to actualize them in the daily world. Instead, the objects that surround them serve to both define and circumscribe their existence.

Typically, Davidson draws our attention to these telling objects in the photograph by placing them near the edge of the frame, or by selectively revealing their highlights through the use of the strobe. More importantly, the objects are seen in terms of darkness or light in relationship to the skin color of the subjects, rather than an attempt being made to illuminate the whole picture with all its details. As a result, the putative mother and daughter in this print become themselves the measure of their world. The girl's self absorption is complete; she plays a lonely game in the corner of the room. On the other hand, the woman looks dully in the direction of the photographer, the line of her arm echoing the girl's arm in reverse. Otherwise, the two appear uninvolved, becoming a metaphor for a family group whose bounds are sundered through the difficult circumstances of their existence. Like many of Davidson's subjects in this *East 100th Street* series, his subjects here are both emotionally preoccupied and unsmiling.

Yet there is a curious beauty here as well. The woman's delicate torso and graceful position contrast with her gleaming enlarged thumb which focusses our attention on the center of the bed. Her skin glows softly in contrast to the shiny upright chrome of the baby buggy, its expensive presence a now unused symbol of all she had hoped for her child. This loss of purpose is emphasized by the general composition of the image. Although there is a stress on framing devices to structure the picture, these frames also become icons of constriction and control. The window frames the child, just as the open wardrobe and the bed frames the mother. The baby buggy's handle frames a window we cannot see out of, while the child turns away from the limited view that frames her. In general, the furniture and architecture of the room serve to frame the living people in it. Most importantly, however, the frames provide us with a metaphor for the entropy that informs these lives. For neither the woman nor the girl are at the center of the image; rather it is dominated by a blank wall created by the space between the window and a boxlike chest of drawers. Thus, it is objective reality of manufactured goods and their marketplace which controls these two humans, rather than the introspective lives they so evidently possess.

—Diana Emery Hulick

Bibliography—

Davidson, Bruce, *The Negro American*, New York 1966.
"Bruce Davidson: New York, East 100th Street," in *Du* (Zurich), March 1969.
Davidson, Bruce, *East 100th Street*, Cambridge, Massachusetts 1970.
Green, Jonathan, "East 100th Street: A Review," in *Aperture* (Rochester), no. 16, 1971.
Davidson, Bruce, *Bruce Davidson: Photographs*, New York and London 1979.
"Bruce Davidson: A Guided Tour," in *Exposure* (New York), Spring 1979.
Davidson, Bruce, *New York Subway*, Millerton, New York 1986.

© Paul De Nooijer

Paul De Nooijer (1943–)
Warmtebronnen/Heatsources, 1986
Monochrome photograph; 23 × 20in. (59 × 51cm.)

In the past, many a critic has introduced his evaluation of Paul de Nooijer's work with the observation that his photography is not to be easily defined in words. In random order, the following terms have been used by the critics to describe De Nooijer's art: surrealistic, fantastic, magical-realistic, conceptual, analytic, staged or monumental.

At any rate, this Babylon of characterisations reveals that he is not at work in the spheres of social-documentary or reporting photography. De Nooijer creates his own world. His photographs possess the excitement of a circus tent, full to the rim, in which the public, fully aware that it is all an illusion, still experiences the tension of the moment when the orphan girl is about to be sawn in half. You can almost hear the audience's applause in De Nooijer's photographs.

Thus De Nooijer is an illusionist who, by his deft deployment of a wide range of attributes, knows how to fascinate his public by treading the borders of reality and illusion. Dating from the 'seventies, his earlier works are often baroque scenes that deliberately lean towards the kitsch. The mainly domestic scenes are taken against a backdrop of fussy floral wallpaper, a door plastered over with old newspapers, a luxurious Persian carpet on the floor and a sofa draped with a panther skin. As a source of light, a fluorescent lamp emitting a greenish glow is hung against a wall. In a corner of the room stands an old radio which, to the horror of the onlooker, is churning out whipped cream instead of music. It is as if the curtain is going up and the beholder suddenly realises that he finds himself in the middle of a bizarre audience that will allow itself to undergo the torment of a fantastic dreamworld with pleasure. Once the actors make an entry it appears the male players are wearing threepiece suits, but minus their trousers and underpants. Their suits and hats are whitened as if they have just emerged from a flour mill. One of the players holds a bunch of flowers in one hand while, with the other, rubbergloved, he picks an extra flower out of the wallpaper to complete his bouquet. The piquantly clothed female players lie indifferently on the pantherskin draped couch. To heighten the effect, their buttocks are turned towards the public, as if to say "take a good look, it won't hurt me." As the door opens, a violinist enters, covered in dust. He takes a little run and subsequently disappears into thin air, violin and all. The players utter not a word and, as they gravely regard the audience, the feeling steals over you of being caught in the act of looking on at some queer play.

Overwhelmed by the anxious feeling that you absolutely don't belong here in the midst of an audience so intensely enjoying itself, you would like to escape. But, to your horror, you find yourself riveted to your chair. You are forced to sit through the whole performance.

The above paragraph describes an experience you could undergo when looking at Paul de Nooijer's early 'seventies work. Indeed, his photographs lure you to voyeurism. At the same time they contain a mixture of strangeness and suspense, which produces an atmosphere of oppression as fear in some cases, while others seem hilarious.

The domestic scenes are not staged in a studio that he turns his back on after completing the photograph. He has transformed his own living room with the greatest care into a decor for the needs of his exposure. De Nooijer loves his home with all its details. He lives in the middle of all his decors, which have become an inseparable part of him. As of old, the family plays a major role in the living room. Hence it is obvious that his wife Francoise, his son Menno and, in some instances, the dog are the most important actors in his shots.

By the way, do not think that if you were to ring at De Nooijer's door you would be received by a gentleman in a threepiece suit from which the trousers are missing or that, on greeting the visitor, he would take off his hat out of which the obligatory rabbit would escape.

Paul de Nooijer is, essentially, a serious photographer who composes his stages with the greatest thought and care. This devotion to detail protects him from using the easily achieved comic effects that would all too rapidly deteriorate into the vulgar and trivial. De Nooijer has always preferred working in isolation as a photographer. The outside world has never been allowed to intrude upon him and his family. He has remained untouched by fashionable trends in staged photography. The isolation of Home Sweet Home is his guiding principle and his inspiration.

The sketch given above of Paul de Nooijer's method of working is necessary if we are to understand the photograph *Heatsources*. In contrast to the earlier 'seventies photographs that comprised mostly baroque scenes in which the story is built up out of a large number of elements, Paul's work has become quieter in the last few years. His photographs have become simpler and quieter (Ingeborg Leijerzapf, *Losing One's Head*, 1978). *Heatsources* is an excellent example of his search for tranquillity and simplicity. De Nooijer used an SLR with a 15mm wide-angle lens for his earlier work. The 'seventies photographs show a noticeable but expertly constructed granular effect, achieved by using a custom-made point-source enlarger. A second typical trademark of De Nooijer's work, dating from this period, is the use of many grey tints in the photograph with no black or white contrast. Whites remained light greys, and greys never become black so that a graphic effect is produced. This apparent alienation and distancing from the usual photographic print was strengthened by completely colouring them in with ink-ish tints that further accentuate the theatrical aspects of the photographs. Paul de Nooijer has thrown such characteristic trademarks overboard in his work *Heatsources*. Gone are the grey tones in the photograph to be replaced by deep blacks, so that the serious content of the picture is reinforced. Here, the alienating effect of the wide-angle lens has made way for the pure registration of the larger format of a 6 × 6 camera. The composition of *Heatsources* lends itself admirably to this format. Paul de Nooijer's outstretched pose in this photograph reminds one of the Lamentation scenes in early Netherlands painting, such as those seen in the paintings of, for example, Rogier van de Weyden. Although some earlier stagings of De Nooijer's pastiches are of well known themes from art history such as *Leda and the Swan* (1977) and the *Birth of Venus* (1978) there is no iconographic scheme to be detected in *Heatsources*, nor is it an allegorical image that directs us to the history of art. However, this does not detract in any way from the quality of the photograph's contents which once more, albeit in an entirely different manner from his earlier work, represents a domestic scene. Nota bene, the livingroom stove forms the main theme. It is not a hilarious scene, although Francoise de Nooijer is posing in an abnormal situation. The black, threatening drapery and the bare decor partly contribute to a sober scene conveying an almost sacred mood. But here, too, the onlooker becomes conscious of voyeurism. It seems as if De Nooijer has recorded the viewer's gaze by pressing the cable release he holds in his hand. If, on seeing this scene, the onlooker is aware of a feeling of shame welling up in him, he has only himself to thank for it. He should not have stepped into De Nooijer's world.

—Adriaan Elligens

Bibliography—

De Nooijer, Paul, and Leijerzapf, Ingeborg, *Losing One's Head*, Eindhoven 1978.
De Nooijer, Paul, and Musser, Jerry King, *Losing One's Photos*, Eindhoven 1981.
De Nooijer, Paul, and Houweling, Jos, *Home Sweet Home*, Eindhoven 1982.
Leijerzapf, Ingeborg, ed., *Geschiedenis van de Nederlandse fotografie*, Alphen aan de Rijn 1984.

— to annihilate the reflex of evaluation

— to accept banality in the simplest way, without accentuating everyday exoticism

— to identify oneself with the outside world in order to get rid of the false sense of superiority in relation to the environment

— to reject the conviction of sacrificing oneself for the sake of art

— to abandon the thought about the excellence of getting rid of everything

— to be

Zbigniew Dłubak (1921–)
Untitled(Ocean), 1971
Black-and-white photograph

1948 saw the Warsaw opening of an exhibition entitled *Polish Modern Artistic Photography*. In the introduction to the catalogue, one of the contributors, Zbigniew Dłubak, wrote, ". . . The naturalistic manner made such a strong impression on our artistic consciousness that we dare not rid art of its superfluous ballast and take hold of the not yet fully utilised richness of the medium—the eloquence of the shapes of objects and their associated power. Instead of treating these elements casually, we should turn their way and look within them for new ways of managing artistic photography—turning it into a high-quality art form. . . ."

The artistic plan was formulated in this way, a plan that formally linked photographs with photography (paper as the basic creative element) and, in essence, with the fine arts or with cultural trends as a whole. The role of intellect (association) as an indispensable element in the photographic creative process was also raised. With certain modifications, Dłubak adhered to this plan throughout the whole of the post-war period.

His early photographs showed microscopic structures, enlargements of plant filaments, embryonic creatures—in short, the structure of the micro-world. Exceeding the realms of intelligibility and projecting a strange, surrealistic atmosphere, these photographs consciously utilise poetic metaphor as suggested not only by the titles of the works (for example, *Children dreaming of birds*) but also by the series illustrating Pablo Neruda's poem *Magellan's Heart*. In subsequent years Dłubak moved away from surrealistic photography, recording objects that were simple, banal, uninteresting, even ugly. This series of photographs, accomplished in opposition to non-representational art, has the typical title—*Existences*.

The next most important element in Dłubak's photography was achieved in the series—*Iconosphere* (1967). The most significant of these—*Iconosphere I*—displays a labyrinth created from chaotically hung, "drying" photographs (representing nudes) and other commonplace objects in everyday use. This was an interesting application of photography, working not through individual photographs, but functioning as the medium through which a consciously created arrangement of space forces the spectator into physical and intellectual contact with the subject matter of art (the environment).

Throughout the nineteen-seventies, Dłubak's photography is dominated by a tendency to acknowledge the need for revising the traditional view of photography (photography as a work of art) and finding new ways of depicting its essence, meaning and function. These explorations, which, especially in their early stages, came under the influence and polemics of Joseph Kosuth's conceptual art, began in 1970 with the series entitled *Gesticulations* and were continued in later years as *Tautologies* and *Systems*.

In his leading work of this period *Ocean* (1970), Dłubak records a juxtaposition of two views of the same subject (a tautological intervention). The inevitable confrontation that is perpetrated in this way, induces a shift in the centre of gravity of the art—from that of feeling and emotion to that of intellect and mentality—similar to that of works of art in the classical sense, with ideas that inspire intellectual progress replacing material accomplishments. It is exactly this process that now acquires superiority. "Only outwardly," the artist himself commented, "do I set the objects and their pictures, photographically recorded, side by side. I am really presenting two pictures. Doubt is cast on the identity of the picture with the object. Juxtaposition of two pictures of the same object is in the nature of a tautology. Conviction about the true existence of the object grows out of two questionable elements."

These and other of Dłubak's achievements led to the belief that art is a form of perception in which artistic values are neither inherent in the work of art itself nor conditional on the subjective evaluation of the spectator. Art is a way of shaping the artistic idea, an idea that emerges through visual signs and whose value is defined through shifts in understanding. ". . . The artist," Dłubak demonstrates, "does not search for meanings, for these come into being anyway over and beyond him and his created work. The artist analyses the essential mechanism of artistic symbolisation, the relation of signs, the rise and fall of paradigms, the game of morphemes. The artist's work is to investigate art. . . ."

In his numerous accomplishments, Dłubak concentrated on describing the function of art in a specific cultural context, leading to the revision of former notions and to the negation or outright destruction of the traditionally understood meaning or significance of art. Władysław Strzemiński's 1927 theory of painting played no small part in these reductionist activities, and Dłubak forever remained under his influence. Strzemiński stood out against rich, baroque compositions, his own compositions relying on radical simplification and purification of the component parts of the visual picture. Dłubak, going even further in this reductivist and then destructuralist direction, produced a series entitled *Desymbolisation* in which, through repetitions, distortions and deformations of highly valued or symbolic subjects (taken, for example, from the history of art or religious mythology) he devised a way for individual parts of the represented subject to influence each other and to cancel each other out. ". . . Through these means," he claimed, "the overall structure of art stands revealed. . . . The new avant garde can rely on consequent attempts to desymbolise both the existing and newly emerging objectives of art at all levels of meaning. New works should establish situations whose composition is such that desymbolisation results and becomes the only logical form of perception. . . ."

—Ryszard Bobrowski

Bibliography—

Olek, J., "Zbigniew Dlubak," in *Nuri* (Wroclaw), no.10, 1977.
Czartoryska, Urszula, *Photographie d'avant-garde en Pologne*, exhibition catalogue, Paris 1981.
Bobrowski, Ryszard, and others, *Fotografia Polska 1945–1985*, Gorzow Wielkopolski 1985.

© Robert Doisneau/RAPHO

Robert Doisneau (1912–)
Wanda Wiggles her Hips, 1953
Silver gelatin print photograph

Wanda Wiggles Her Hips, made by Doisneau in the mid 'fifties, is an exuberant example of the postwar production of Paris-based photodocumentarists. In Doisneau's 'fifties iconography, Paris was effectively re-made, re-visualised into a city of exotic dreams, a Paradise re-gained by an eloquent (and elegant) photography. By the seemingly innocent, ostensibly casual street photography (epitomized by Doisneau's work, but also represented by that of Willy Ronis, Henri Cartier-Bresson and Jean Charbonnier), Paris was given a new persona during the 'fifties, establishing it as charming, carefree and open. In photographs, the city became a place where anything could happen.

From the beginning of the twentieth century, Paris had become a favourite location for photographers intent on documenting the "real" world, as encapsulated in urban life. From Eugene Atget's deserted streetscapes made in the early years of the century, to Brassai's erotically romantic studies of the city at night (in the 'thirties), Paris had been recorded as a city of secrets, mysterious streets with echoing pavements, peopled by strange characters with singular pursuits.

In the 'thirties, Robert Doisneau was working as an industrial photographer for the Renault motor company in Paris. He had trained as a lithographer, and then worked with the photographer Andre Vigneau. For him, it was a decade of enormous political commitment: he joined the Communist Party and, while working for Renault, developed strong and cogent ideas about the position and conditions of working people. At Renault he began to understand the force of an interpretive documentary; picturing the workers, the machines, the making of the cars, he constructed a scenario which explored the relationship of worker to tool, man to environment.

When the Second World War began, Doisneau's life changed course. Fiercely anti-fascist, after a year in the French Army he joined the Resistance, returning to photography only when the War was over. He began to work for magazines like *Vogue, Life, Fortune* and *Paris Match* and in 1946, joined the photo-agency Rapho.

Wanda Wiggles her Hips, though not one of Doisneau's most well-known works, is certainly one of his most distinctive. When Doisneau pictured Paris, he used the life of the streets as his most constant and potent metaphorical device. Not the dark, threatening streets of Brassai's *Paris in the Thirties*, but instead, an easy, relaxed backdrop to an everyday parade of people, animals, occupations and events. Paris, a city still haunted in the 'fifties, by the ghosts of the occupation, by the spectres of collaboration, of anti-semitism and of privation, had become a more French, more insular city than it had been before the Second World War. The departure of many of its expatriate, Jewish and radical Left communities in the early 'thirties, had deprived it of much of its intellectual and aesthetic centre. Many of its photojournalistic community had departed too, drawn away first by the Spanish Civil War and then by the threat of Nazism.

Wanda Wiggles her Hips, like so many of Doisneau's 'fifties' photographs, was a trenchant re-assertion of Paris' position as Europe's capital of pleasure. As well as being part of a well-known genre of street iconography, *Wanda Wiggles her Hips* is an oblique comment on looking and seeing. While the photographer looks on to the scene, the audience enjoy their own particular voyeurism. It is a photograph within a photograph, reaching back to longstanding

dramatic traditions of the play within the play. The woman performing her erotic dance is strangely distanced from the spectacle, as the crowd of spectators merge into a pervasive darkness. Doisneau's comments on human vanities, human obsessions, are always pertinent, and beneath a seeming insouciance lies a compelling and radical view of the world. Throughout his 'fifties' photodocumentary, Doisneau returns incessantly to the idea of the spectator and the spectacle—a monkey in a cage, a painting of a nude in an art gallery, two lovers kissing in the street. In *Wanda Wiggles her Hips*, he concentrates deeply on the idea of the human sideshow, on the nature of titillation, and ponders on the carapace of sex.

So, encapsulated in this 'fifties' photograph are many of the devices and philosophies which have ensured Doisneau's eminence in the world of photodocumentary. Not just a picture of pleasure (for Doisneau never lost sight of his pre-war radicalism) but also a pointed comment about voyeurism, about sexuality.

Doisneau was a determined populist in this post-war period. The street became his favourite theatre. For Doisneau, the streetscape was open and democratic, an al fresco arena for a people's drama, played out by an ever-changing cast. In Doisneau's photographs, the street represents liberty, the antithesis of the claustrophobia of the factory floor, the tedium of the office. By re-making Paris as a city of street parties, of carnival, Doisneau gave Paris back to popular culture. To foreign audiences, Doisneau presented an idyll of Paris easily recognized from the many and vivid prewar accounts of 'twenties' expatriates. In 1951, the United States proved its enduring fascination with the city and its photographers when it gave an exhibition to Doisneau, Izis, Brassai, Cartier-Bresson and Willy Ronis at New York's prestigious Museum of Modern Art.

Wanda Wiggles her Hips is a tour de force of postwar documentary photography. Though it does not tell a momentous or newsworthy story, it has an enormously strong point of view. Doisneau has often insisted that he does not use his camera in order to photograph poverty or deprivation. Instead, he looks sideways at the human condition, assessing weaknesses, recognizing small pleasures and accidental joys. *Wanda Wiggles her Hips* is a photograph of nuance, a small story ironically told. An urban narrator of finesse, Doisneau relates a tale of human frailty, contained within the spectacle of the viewer and the viewed.

—Val Williams

Bibliography—

Doisneau, Robert, *La Banlieu de Paris*, Paris 1949.
Doisneau, Robert, *Sortileges de Paris*, Paris 1952.
Doisneau, Robert, Giraud, Robert, and Ragon, Michel, *Les Parisiens tels qu'ils sont*, Paris 1954.
Doisneau, Robert, *Instantanees de Paris*, Paris 1955.
Doisneau, Robert, and Triolet, Elsa, *Pour que Paris soit*, Paris 1956.
Doisneau, Robert, and Donques, Jean, *Gosses de Paris*, Paris 1956.
Doisneau, Robert, and Chevalier, Maurice, *My Paris*, New York 1972.
Doisneau, Robert, *Le Paris de Robert Doisneau et Max-Pol Fouchet*, Paris 1974.
Hill, Paul, and Cooper, Thomas, eds., *Dialogue with Photography*, London 1979.
Doisneau, Robert, *Robert Doisneau: Photographs*, Paris 1979, London 1980.
Chevrier, Jean-Francois, ed., *Robert Doisneau*, Paris 1983.

Photo courtesy of Ludwik Dobrzynski

Benedykt Jerzy Dorys (1901–)
Kazimierz on the Vistula: Man and Boy, 1931
Black-and-white photograph

Benedykt Jerzy Dorys occupies an unusual place in the history of Polish photography. In his youth, he studied the violin and intended to dedicate himself completely to this form of art. However, he did not become a musician—he became a photographer. The movement that influenced him in doing so was pictorialism.

Aesthetic photography, photography that was accepted as an autonomous work of art, emphasised mood, artistic interpretation and the characteristic soft tones of the photographs which, through the impressive technical skills used (for example, gum printing techniques, oil of bromide, etc), aimed to evoke aesthetic experiences in the spectator. In Poland, this movement began in Lwów in the early 1890s but did not come into its own until somewhat later, in the years between the wars. Polish impressionist painting (so-called pointillism), was particularly popular in the 1930s and played no mean part in creating an atmosphere singularly conducive to the development of this movement.

Landscape and psychological portraiture were the favourite subjects of pictorial photography. And, in fact, portraiture was Dorys' own particular preference. However, he was no ordinary portraitist. From the very start of his long and full career, Benedykt Jerzy Dorys was the portraitist of well-known and famous people—actresses and politicians, artists, elegant and cultured men and women. His photography, too, was elegant—painstakingly planned, composed, attractive. There was no room in it for the romanticism typical of pictorialism, or for ugliness or discord. Dorys wished to be liked and this desire was the source of the beauty and, from time to time, the wisdom or pensiveness in his portraits and, above all, of their joie de vivre. There is no doubt that, throughout the whole of this period, Dorys was a happy man and so was his photography.

Nevertheless, Dorys must go down in the annals of Polish photography not only as an elegant practitioner of traditional portraiture but also as one of the creators of modern photoreportage. In 1931 and 1932, Dorys took his holidays in Kazimierz on the Vistula—a town of renaissance architecture, picturesque if neglected, and inhabited, in large part, by Jewish descendents. It was not the picturesque charm that interested him most, however. As always, it was the people. Different people this time—not the fixed, formal and elegant of his portraits but the casually encountered people of the streets.

Kazimierz on the Vistula is a startling component of Dorys' creative output. Startling as much in its inelegance of subject matter as in its dynamic street photographs—impetuously and hurriedly taken with a newly bought Leica. This series embraces much that no longer exists but that formed the centre of the world for this small, provincial town at that time. A world of trade and business serving the local community. A world of circus-like attractions and gypsy music. A world of friendly interchanges whose natural setting was the street. A world of leisurely, sleepy people, seemingly transfixed in time. In these photographs, Kazimierz gives the impression of being a calm, carefree oasis, not unlike Poland itself when, through most of its history and by virtue of its religious and social tolerance and its multinational culture, it almost seemed to be the promised land for Jews from all over the continent (in 1800, 75% of the world's Jews lived in Poland).

It is interesting that, in Kazimierz, Dorys not only noted what was obvious to everyone but also that which hardly anyone then anticipated—a world suddenly halted, as if waiting for its own end, its own defeat. In his photographs—hurried, taken by stealth—he often happens to catch stillness and disquiet, a dramatic undercurrent of some imponderable misfortune. The people of Kazimierz live life to the full, wanting to rejoice in it while there is still time, while it is not yet too late.

Kazimierz on the Vistula is a sociological study of the life of a town. It is also and perhaps, primarily, a study of man. For man is the undisputed hero of all of Dorys' photographs, as much so in those where he dominates the picture as in those in which he does not feature at all. Whether through portraits of the elegant world of urban Warsaw or through the collective portrait of a dying community, Dorys, indeed, has always remained faithful to Man, his chosen subject.

—Ryszard Bobrowski

Bibliography—

Sadzewicz, M., "The Work of B. J. Dorys," in *Stolica* (Warsaw), 4 December 1960.
Grabowski, Lech, *Polish Masters of the Camera*, Warsaw 1964.
Zdzarski, Waclaw, *The History of Warsaw Photography*, Warsaw 1974.
Klosiewicz, R., "The Leica Folly in Kazimierz," in *Photography* (Warsaw), June 1977.
Dorys, Benedykt Jerzy, *Kazimierz on the Vistula, 1931*, Warsaw 1979.
Livingston, Kathryn, "Benedykt Jerzy Dorys," in *American Photographer* (New York), January 1981.

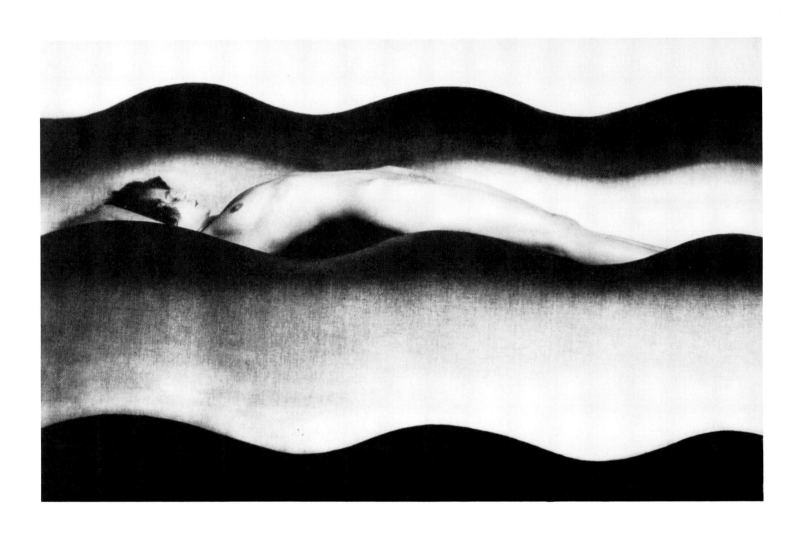

562

Frantisek Drtikol (1883–1961)
The Wave, 1926
Black-and-white photograph; 20 × 28.8cm.
Prague, Museum of Decorative Arts

Drtikol's photograph *The Wave* from 1926 provides a graphic example of the artist's second creative period, in which starry-eyed Art Nouveau-style girls or "femmes fatales" of his previous pictorialist photographs are replaced by dancers, painted backgrounds by prisms, columns, stairways or geometric space decorations, with dynamic motion prevailing over melancholy moods and wholehearted endeavours at capturing the beauty of the human body over literary symbolism.

It is indeed difficult to find a fitting term for the description of the salient features of this exceptionally prolific creative period in the years 1925–1929. True to say, the formerly widely used term "Cubist era" does sum up Drtikol's taste for decorations of simple geometric forms, which he had produced according to his own designs in the workshops of the National Theatre in Prague, but the term ignores other indisputable influences. Whereas—apart from cubism—elements of constructivism, functionalism and the art déco style found their application in his decorations and overall pictorial composition, in the poses and gestures of the models one may discern parallels with the buoyant expressionism of Munch's pictures and graphic sheets, with the almost acrobatic biomechanics of the theatre stagings by the Russian avant-garde directors Meyerhold and Tayirov and last, but certainly not least, with the style of the méthode dansante of Jaques-Dalcroze, combining gymnastics with music and modern aesthetic views. A Dalcroze club opened in Prague as early as in 1913 and Drtikol's first wife, dancer Ervína Kupferová, ran her dancing school guided by Dalcroze's principles. As a frequent model in Drtikol's numerous photos, she invariably influenced his unique conception of depicting motion in photography.

As a matter of fact, this is likewise corroborated by his photograph *The Wave*, with the motif of the curves of the female body being freely inspired by dancing, in contrast to the lines of the decorations, which Drtikol used in some other pictures as well. Several differing studies for this famous photograph have been preserved to this day, showing that Drtikol had treated this particular motif on several occasions before being quite satisfied with the final version. This succeeds in capturing—in a most captivating manner—the perfect harmony of the living body and inanimate props, linking on to Drtikol's earlier work, proceeding from the Art Nouveau style, while paving the way for the more modern concept of his prized nudes of the late 1920s, with symbolic meanings open to wide-ranging interpretations. In actual fact, Drtikol himself commented on the symbolism of the wave motif as early as 1914: "Life is like a wave. The crest of the wave signified joy and happiness, its trough epitomizing unhappiness and sorrow. If you are strong-willed you can arrange your own life into precise lines."

In the latter half of the 1920s Drtikol gradually fashioned an original style, in which he responded, with a good deal of inventiveness, to the contemporary style of art déco and also to expressionism and to a lesser degree to abstract art, while never completely abandoning the symbolic meanings of his figurative compositions. Thanks to the intrinsic nature of this style, we can usually recognize Drtikol's authorship in works of this particular period at first sight. What he managed to accomplish, to a very high standard and while evoking considerable international acclaim, was to implement his own conviction: "To take photographs means to keep on trying to capture, out of man's external forms, what by indication, by intimation of his soul, is daily bread to me in itself, not only a means for its achievement. If I am kept away from work for a long time, I suffer from hunger and thirst; I am unhappy and I'd give the world to be able to take photographs." Nevertheless, after *The Wave* František Drtikol devoted himself to photography for less than a decade.

—Vladimír Birgus

Bibliography—

Drtikol, Frantisek, and Skarda, Augustin, *The Courts and Backyards of Prague*, Prague 1911.
Drtikol, Frantisek, and de Santeul, Claude, *Les nus des Drtikol*, Paris 1929.
Drtikol, Frantisek, Marek, J. R., and Beaufort, Eduard, *Zena ve svetle/Women in Light*, Prague 1938.
Farova, Anna, *Frantisek Drtikol: Photograph des Art Deco*, Munich 1986.
Birgus, Vladimir, and Brany, Antonin, *Frantisek Drtikol*, Prague 1988, 1989.
Klaricova, Katerina, and Masin, Jiri, *Frantisek Drtikol*, Prague 1989.

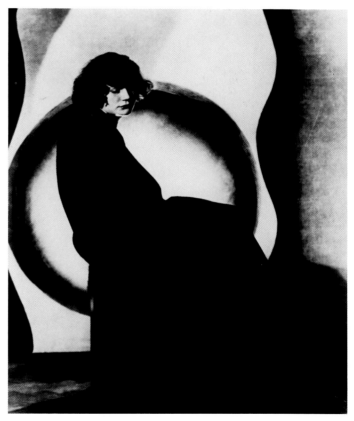

Sitting, **1925**

© Bernard Faucon

564

Bernard Faucon (1950–)
The Banquet, 1978
Colour photograph

Street photography formed one of the most powerful trends in the photography of the 'sixties and 'seventies. The movement began with Robert Frank's famous album *The Americans*, was later continued and expanded by photographers such as Garry Winnogrand or Lee Friedlander, among others, and attained new force in the 'seventies with the appearance of a whole pleiad of talented photographers working in a style that lay somewhere between pure documentation and formal photography. Situational (street) photography was no longer bound, as once (by Weege to name but one), with the social context of revealed reality—it concerned itself instead with displaying the distinctive, individual presence of the person photographed. For street photography, the significant issue centred on catching and communicating the ordinary and the simple yet, through felicitous timing, transforming it into something interesting, unexpected and other. Naturalistic formalism formed the basis of this photography which concentrated on people and the situations in which they found themselves and tried, through this and the attitudes and gestures so reflected, to portray their inner lives. Situational photography showed people in their natural environments, hence in streets, clubs, parks and gardens, and one of its classic subjects was the female onlooker.

In weighing the persistence and the merits of this method, a gradual loss of creative strength and dynamism becomes increasingly apparent. Photographers became aware that, however expert they became at spying on reality, they could not free themselves from it and, in fact, actually became its slaves or prisoners. Consequently, the way forward lay not in perfecting perceptions of reality but in breaking with reality and appealing to a different world— not the objective world that exists alongside all of us, but the photographer's own inner, subjective world. Fabricated or stage-managed photography was born in this way, and became called "Staged photography" in the 'eighties. One of its founders was Bernard Faucon.

Faucon staged his distinctive scenes in the latter half of the 'seventies in the countryside of the South of France where he was living. The star performers of these staged scenes were child mannequins arranged in situations concocted by their instigator. Everything in these pictures was a fiction, a fiction planned to the last detail and consolidated through the photographic camera. ". . . What I show," says Bernard Faucon, "is a fabrication which leaves no place whatsoever for reality . . ." The only acceptable reality was the reality of the artist's imagination. It was this that enabled progression through successive scenes and, once that complete sequence was exhausted, its replacement by others. The scenes changed, but the child mannequins and their contrived world remained. ". . . Certainly," the artist says, "there are some I prefer, whom I find more beautiful than others, to whom I give certain privileges . . ."

Faucon's most famous series is *The Banquet* of 1978. It consists of pictures showing a children's picnic. Children, dressed in the fashion of the 'forties, spending time in the open air. This commonplace occasion, centred around meals and musical games, attains dramatic proportions from a sudden outburst of fire. The blaze not only tears them away from the table and their games but also becomes incorporated into their game, forming the underlying plot of their dramatic and utterly tragic experience. The photographer's fiction, this drama that springs from his imagination, merges here with the genuine feelings we experience as involuntary witnesses of these scenes, illustrating the power with which the photographer expresses his imagination and the skill with which it is imposed on the spectator.

Playing their part in contemporary photography, the staged scenes of Bernard Faucon confound reality with fiction, authenticity with trickery and the natural with the unnatural. In one sense, this is a paradoxical situation. Going even further, present-day photography has no explicit alignment or, looked at in another way, there exists, today, a rift between photography and the photograph. Over countless decades and generations, photography fought for artistic status and for its proper place in the cultural pantheon. It certainly achieved this in the 'seventies. On the point of receiving full recognition, photography appeared to turn against itself, concerning itself not with the objective realities of art or of culture but with interpretations of personal feelings and perceptions and with attempts to express these in diverse ways—from outwardly objective narration to surrealistic fantasy and, beyond that, to neoexpressionism as in the photography of Bernard Faucon.

As with present-day photography, more questions are raised than answered by Faucon's work. Its successive and varied achievements strive, once again, for a central position both in art and in today's consumer-oriented world. At the moment, it is difficult to give unequivocal answers as to whether they succeed in doing so, to what degree they do so, or to what extent they conceal either a defeated, frustrated consciousness or the emptiness of pure formalism. These issues clearly remain open to discussion.

—Ryszard Bobrowski

Bibliography—

Pons, Phyllis, *Invented Images*, exhibition catalogue, Santa Barbara 1980.
Guibert, Herve, "Entretien avec Bernard Faucon," in *Le Monde* (Paris), 14 January 1981.
Caujolle, Christian, "Bernard Faucon," in *Photo* (Paris), February 1983.
Batho, John, *Images Imaginees*, exhibition catalogue, Champagne-Ardennes 1984.
Faucon, Bernard, *Mois de la Photo: Faucon*, exhibition catalogue, Paris 1984.

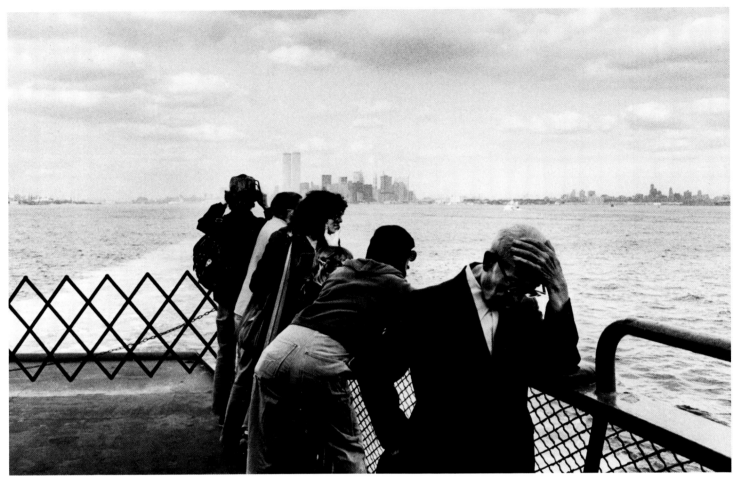

© DACS 1991

566

Arno Fischer (1927–)
Staten Island Ferry, 1978
Black-and-white photograph

At the end of the '50s television had started on its road to success. Whilst the big picture magazines were going through their first crisis, the photographers could only briefly enjoy the triumph of the exhibition *Family of Man* when they were forced to go out and search for a new kind of vision. The image of the world had ceased to be theirs alone, and from then on, whenever the course of history was to be witnessed at its "crucial moments," the photographers had to contend with the backseats. It became their task not so much to document the events themselves, but rather to report their reflections through images for posterity. The focus of the new photographic attention was not on celebrities or politically decisive scenarios, but on the anonymous encounter at an insignificant site. The face of this epoch was looked for in the mirror of the side street, the province. The place of a proclaimed sensation was taken by the unfinished story, a story still with the rest of a secret that was to be revealed by the individual spectator himself. Under the predominance of television, the best photography had become more intelligent, because more poetic.

Those years of elementary change in photographic perception were to make a lasting impression on Arno Fischer. Not yet discovered, *The Americans* by Robert Frank got dusty on the shelves, and René Burri was still collecting material for his book *The Germans* which was to become equally significant, Arno Fischer, self-taught on the camera and enfant terrible among his local colleagues, worked for a publisher in Leipzig on a book about Berlin, his home town. His photographs were uncommonly raw, obsessed by every-day life. They clearly expressed the climate of Cold War, this peculiar sensation of confrontation and occupation in the city that was cut in half. Unfortunately this book was never published because of the division of Berlin into East and West by the Wall: suddenly West Berlin had become "abroad" for the East German publisher. For this reason it was not until many years later that at least a few of Fischer's Berlin photographs became known—they bear in every aspect comparison with those of Robert Frank or René Burri.

After this depressing fiasco, Arno Fischer mostly found his important pictures when he was travelling. He visited Poland, Central Africa, the Soviet Union, and was twice in India. These journeys resulted in three photo volumes. Like a magical bracket however, his photographic work seemed to be rounded off when he discovered New York in the late '70s. All the feelings of hardness and spontaneity, which had so uniquely condensed his Berlin experiences from the time of the Cold War, overwhelmed him once more here, in the city of all cities.

Fischer has a definite sense for history. His perception comprises the historical dimension of a place; he bears the sceptical sensation of time indicative of a generation that has been brought up during a war. Therefore, in New York he did not surrender to the glass towers, but almost intuitively, registered his horror in views of Manhattan or the Bronx. Of course, as every European will understand, there was also fascination. Yet, the photographic tradition he had been loyal to for a quarter of a century still searched amongst casual details for a hint of the epoch and a symbol for the acute condition of the world.

New York, as a case study for the most extreme condition of human civilisation, seemed one step across this frontier. "The Iron Face of Freedom" is the title of the text the dramatist Heiner Mueller wrote for Arno Fischer's New York book. Therein he speaks of a double vision: "If, as a consequence of the shifting of climates (a triumph of technology), the north and south pole were to melt, then perhaps the Atlantic would unite its capital, water and concrete, and sharks would swim through the benks," and furthermore "The law of the growth of New York has become the law of the jungle: excess and decay, and from the ghettos the desert grows towards the city, while Los Angeles, growing faster in the shadow of earthquakes, takes over as the capital of the Pacific, and a new Babel."

This is the step across the frontier. Like no other city in the world, New York signifies a turning point in the biographies of all those who passed through it. A promise of the future and a taste of hell. The photograph *Staten Island Ferry* by Arno Fischer presents much more than a theatrical prologue to his book about the Atlantic metropolis. He who understands the silhouette of Manhattan on the horizon as a metaphor, will see the deck of the ferry as a raft that carries us all, drifting into the future: full of hope, waiting, resigned. A photograph as a symbol for dramatic experiences. How does Heiner Mueller conclude his text? "Everyone should see New York before they die; one of the great mistakes of mankind."

—Wolfgang Kil

Bibliography—

Kil, Wolfgang, "Faszination des Beilaufigen," in *Bildende Kunst* (Berlin), no. 2, 1987.
Fischer, Arno, *New York—Ansichten*, Berlin 1988.
"Damals in Berlin—Der Fotograf Arno Fischer," in Gillen, Eckhart, and Haarmann, Rainer, *Kunstfuhrer DDR*, Cologne 1990.
Kil, Wolfgang, "Berlin davor und danach," in *Die Tageszeitung* (Berlin), 22 June 1990.

Museum of Modern Art, New York / © Robert Frank

Robert Frank (1924–)
The Americans: Political Rally—Chicago, 1956
Gelatin silver print photograph

There is no underlying reason why Robert Frank's *Political rally—Chicago*, the 58th image from one of the great classic books of 20th-century photography should be given weight over any other in *The Americans*. More than three decades after the French edition (*Les Americains*) appeared in 1958, nearly all of the images have taken on the significance of visual icons symbolizing a disaffected American culture. The cogent socio-political narrative sequenced by Frank, predicated as much by his journey to urban centres such as Detroit, Chicago, Los Angeles, New York, as by the powerful line of his observations drawn of the roadsides. *The Americans* is not only a compelling whole, but equally compelling as a kind of anthology of parts: of despair, loneliness, boredom, futility, sorrow, wistfulness, irony, and of the idiosyncratic optimism expressed in "that crazy feeling" of Jack Kerouac's spontaneous introduction to the 1959 version. Each image holds its own tone and coherent viewpoint; successively they pulsate to rhythmic counterpoints yet forge a penetrating visual unity.

In a statement to *U.S. Camera 1958*, Frank, an emigré from Switzerland who landed in New York in 1947, made it clear that his view of America was personal, that various facets of American life and society had been ignored, and for him it was an instantaneous reaction to oneself that produced the photograph. Interestingly, one is rarely conscious of what has been left out; instead *The Americans* appears as the quintessential picture and possibly the true picture most Americans preferred not to believe. In spirit with his circle of friends, the "Beat" poets and writers, and Abstract Expressionist painters, Frank found vitality in the rough and the commonplace. As radicals of their time, they gave form to their art by seizing on the here and now, and by impulses that had greater affinity with an existential journey, rather than in conventional propositions and values.

The events upon which Frank drew and the tempo of their representation contradicted the portrayal of humanistic and naturalistic America, often featured by richly circumscribed graphic structures. The anti-establishment stance of Frank, perceived by his critics as distorted and spiteful, was not so much that his theme was of the poor, Blacks, rodeo cowboys, waitresses and rhinestoned hopefuls, or of jukeboxes, automobiles, poolhalls and funerals, but that the American social undercurrent, like the flags Frank saw, was thin, whispy, and tattered. As a symbol of nation, home and pride, it was fugitive and grainy. An American still burrowed in post-war patriotism and caught up in Cold-War resolutions, there was little comprehension of Frank's political values and of his portrayal of a people thrust together, but isolated and unaware of each other. Frank observations, like that of the player in *Political-rally, Chicago*, made the invisible visible, and the hidden meaningful.

Not unlike other events focused upon by Frank, *Political-rally* has the look of effortlessness and the capacity to emphasize the impassive in very simple terms. The person obscured by the large sousaphone is not so much a faceless player, as a mute instrument of an anonymous group. Blind to his surrounding, his presence is merely symbolic of the larger chauvinistic chant and political ritual to which masses rally for social compact. Frank succeeds to draw from an event of sparse material reality, rather than from the bustle of the mass campaigning for an Adlai Stevenson triumph, the underlying truth of the blind-spot of his aspirations and his hopeless political destiny.

Political-rally, an apt metaphor for political aphonia, is collared by Frank's blunt cropping of the images. Frank's viewpoint visually reinforced *The Americans* with a perfectly-suited transparent photographic style: a seemingly random use of the 35mm camera, wide-angle field, oblique framing, and a grainy density to suggest a kind of seeing in the rough—a style that profoundly shaped the work of many contemporary American photographers.

The impact of *The Americans* changed photography in the way of seeing the world more than any group of images. A masterpiece of social criticism, it shifted between the personal and a subtext of the larger malaise of a simple milieu trapped inside society. Yet, one must bear in mind Frank's statement that "criticism can come out of love"; accumulatively, the images are overcast with the "sad poem" of compassion. Although *The Americans* is often seen as a social epic of its time that is at once grim and graceless, and alternatively as luminous and dreamlike, it clearly reflects Frank's self-conscious quest of coming to terms with his own personal history and artistically discovering and resolving his own critical placement. Not long after completing *The Americans*, Frank gave up still photography for making films and pursuing an autobiographical vocabulary that would be generative to his subsequent photographic work. In 1969, Frank loosened his ties with U.S.A. to live in Mabou (Nova Scotia) in Canada. There he once more turned to the expressive potential of still photography by constructing panoramic views of his environment, a desolate and barren landscape, and by piecing together assemblages of stories vested in his triumphs and tragedies. Kerouac's prose was never more prophetic when he claimed Frank as one of the tragic poets of the world.

—Maia-Mari Sutnik

Bibliography—

Frank, Robert, *Les Americains* Paris 1958, New York 1959, 1969, 1978.
Bennett, Edna, "Black and White Are the Colors of Robert Frank," in *Aperture* (Rochester, New York), no. 1, 1961.
Lyons, Nathan, ed., *Photographers on Photography*, Englewood Cliffs, New Jersey 1966.
Frank, Robert, *The Lines of My Hand*, Tokyo 1971, Los Angeles 1972.
Janis, E. Parry, and MacNeil, W., eds., *Photography Within the Humanities*, Danbury, New Hampshire 1977.
Alexander, Stuart, ed., *Robert Frank: A Bibliography, filmography, and exhibition chronology 1946–1985*, Tucson, Arizona 1986.
Ginsberg, Allen, *Robert Frank: New York to Nova Scotia*, Houston 1987.

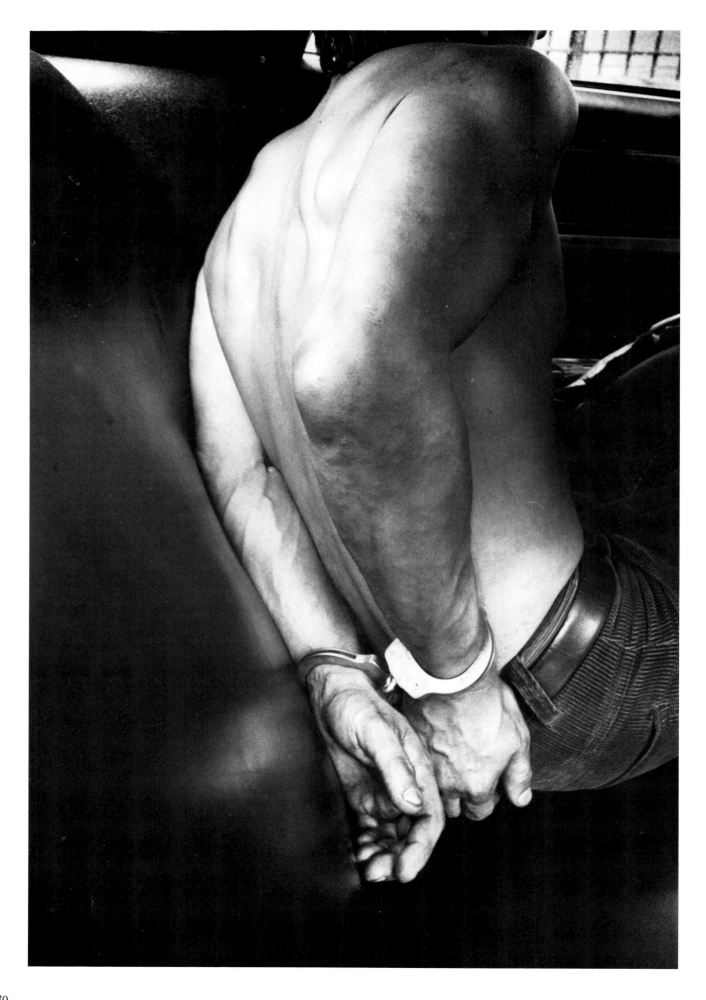

570

Leonard Freed (1929–)
Suspect in Police Car, New York City, 1980
Photograph

Suspect in a Police Car is one of Leonard Freed's most classic photographs because it synthesizes all of the elements which characterize his style of photojournalism—personal engagement in the subject, ability to capture the precise instant, an artist's sensitivity to the composition of the image and a clear perception of the language of photography. One of thousands of photographs taken by Freed over a period of several years when he dedicated himself to documenting the daily routine of average cops in New York City's Police Department, *Suspect in a Police Car* is a compelling and haunting image that symbolizes virtually every idea and feeling embodied in Freed's depiction of the subject. This photograph confirm his stature as one of the world's leading photojournalists.

Born in Brooklyn, New York in 1929, Freed bought a camera and travelled to Europe and North Africa in 1950. When he returned to New York the same year, he studied painting and soon realized that he preferred photography. On seeing Henri Cartier-Bresson's album *The Decisive Moment*, he realized that he was compelled to "create interesting photographs." He studied with the legendary magazine art director Alexey Brodovitch in 1955, and returned to Europe in the same year. He was first associated with Magnum Photos in 1956; he began traveling, accepting assignments as a free-lance photographer in 1961, and became a full member of Magnum in 1972. He settled in Amsterdam in 1958, returning to New York in 1969. He photographed the Yom Kippur War in Israel in 1972 and taught photography at The New School for Social Research in New York in 1980. New York continues to be his home base although he travels throughout the world on assignments and personal documentaries.

Suspect in a Police Car appeared in Freed's book, *Police Work*, published in the United States in 1980. The one hundred and twenty-four photographs in this book have captured the power, irony, compassion, violence, rewards and revulsion of police work. Freed said, "When asked why I became interested in the police, I have to answer, everyone should be. If we do not concern ourselves with who the police are—who they really are—not just 'cops' or 'pigs,' 'law enforcement officers' or 'boys in blue,' we run the real risk of finding that we no longer have public servants who are required to protect the public, but a lawless army from which we will all take orders . . . I worked alongside and with the police . . . What I saw were average people doing a sometimes boring, sometimes corrupting, sometimes dangerous and ugly and unhealthy job."

Suspect in a Police Car captures the reality of the situation, a man being apprehended by the police—there is no doubt about that. But it goes beyond depicting one specific moment and event because this single image serves as a metaphor for all of the other photographs in the book—the struggle to preserve order in an organized urban society. Clearly, the image in the photograph is a criminal, but there is a beauty in the way in which Freed has depicted this man being forced into the back seat of a police car. His torso takes on a sculptural, three-dimensionality because of the way in which the light illuminates his body. You don't see the man's face. This is not seen as a particular person or particular situation; rather, it is seen as a universal symbol of the apprehended criminal. Freed likes to draw comparisons between his photographs and poetry. He believes that one has to read a photograph as one reads a poem and that good photographs are like good poems. Pursuing this analogy, the car window in the upper right hand corner becomes a symbol for hope in the midst of despair. For him, good photographs are good poems; bad photographs are propaganda.

Throughout his entire career, Freed has never taken what he calls "information photos" where, he said, 99.9% of what you see isn't important. By his definition, information photos earn money;

he would include all routine photojournalism and assigned commercial photography in this category. In differentiating himself from many other photographers, he has taken only those photographs which are of passionate interest to him and which lend themselves to creating images with significant messages. In terms of assignments, he has accepted only those which permit him to take "personal" photographs. Having worked for major picture magazines and newspapers in the United States and Europe, his assignments have generally resulted from his previous pursuit of a specific subject on speculation which is either topical or of interest to the picture editor of the publication. His documentation of the New York City Police Department was done on speculation and the book, *Police Work*, in which *Suspect in a Police Car* appeared, was published after all of the photographs had been taken.

Suspect in a Police Car represents his personal photography in one of its best moments. The New York City Police Department is not a popular subject, yet it is one that deserves scrutiny and sympathetic examination. Being on hand when criminals are apprehended is not necessarily safe, so it is clear that Freed puts pursuit of the right image ahead of personal safety.

Another dimension of his personal photography is an attempt to examine and understand a new subject. Recognizing that policemen are generally not understood, he wanted to comprehend every aspect of their world, so he followed them through their daily routines on the street, during arrests, at the morgue, in the gym, while protecting foreign dignitaries, managing demonstrations, at weddings, at funerals, with their families and while having fun on the job. For Freed, it was necessary to get under the skin of the New York City police officer. The only way that he could do that was to live with them day and night. It was in the process of this engagement that *Suspect in a Police Car* emerged as a quintessential image. It was not an accident, but a classic photograph which became possible because of the intensity of Freed's involvement with the New York City police.

While virtually every other photographer works in color, Freed shoots almost exclusively in black and white. He knows how to work in color, but sees black and white as the best way to express his ideas. It would be difficult to imagine *Suspect in a Police Car* in color. In black and white, like so many of Freed's other subjects, *Suspect in a Police Car* is a serious photograph dealing with a serious subject. Had it been in color, it is hard to imagine what its impact might have been; surely, it would not have been as sombre, dramatic and poetic.

Clearly, Freed is a photographer who is not interested in fads, no is he interested in popularity for he eschews both in his selection of subjects and his self-imposed restriction of working in black and white. He has assembled an impressive body of work which encompasses a broad variety of subjects shot in all parts of the world under strenuous conditions. The hallmark of his photography is quite simple—he creates clearly defined visual images enhanced by a desire to translate photography into a personal form of poetry. These images are such appropriate visual methaphors that they persist in one's mind and vision in a haunting way guaranteeing that each one of Freed's photographs is something that one cannot easily forget.

—Allon Schoener

Bibliography—

Freed, Leonard, *Juden van Amsterdam*, Amsterdam 1959.
Freed, Leonard, *Deutsche Juden heute*, Munich 1965.
Freed, Leonard, *Black and White in America*, New York 1967.
Freed, Leonard, *Made in Germany*, New York 1970.
Freed, Leonard, *Police Work*, New York 1980.
Freed, Leonard, *La danse des fieles*, Paris 1984.
Manchester, William, *In Our Time: The World As Seen by Magnum Photographers*, New York 1989.

Lee Friedlander (1934–)
New York City 1974
Black-and-white photograph

Welcome to New York City, USA! With sunshine, skyscrapers, a true hero and Coca Cola! Whoever Father Duffy may have been, a spectacular place had been chosen to posthumously honour him. It is not only a massive stone cross that serves as a background for this man as hard as steel, in dress and pose of a general. Today he is also surrounded by the glaring chaos of modern civilization, a situation which would possibly not have won the consent of the original builders of the memorial, but nevertheless displaying a finesse in staging. Now, he is leading a remarkably dramatic army. Be it the enigmatic textplates that appear behind his back like a stammering code, or the empty posterwalls everywhere that stare back at the spectator like blank eyes, the crowded streets at the sides, towers of houses, or the outstanding table that invites pleasure but here also comes across like a call for battle. The frame of the photograph is almost bursting, so packed to the corners is it with this jumble of mostly geometric forms. The upward angle, verticals that fall into the sky confirm this impression. The question is: Does this disoriented army prepare for combat, or does it already represent the scrap of the one who has lost? But maybe we are looking at a Potemkian village, built for the pride of the leader and to be respected by his enemies. And Father Duffy is just a stuffed legend whose origin no-one remembers.

Lee Friedlander has now followed the traces of human existence for 30 years, but neither as an explorer nor as a hunter. "I always wanted to be a photographer. I was fascinated with the materials. But I never dreamed I would be having this much fun. I imagined something much less elusive, much more mundane."

Elusive they are indeed, the images that appear in his pictures, but damned substantial at the same time. It is always provisional things that tend to live longest. Photographs that Friedlander took and still takes on his endless trips and walks give evidence of these banalities. Trees and electricity poles, war memorials and television sets, people passing by and street signs, a fence and a torn down poster, a casual glance in the rear mirror and the shadow of the photographer on a chair—the eye can hardly digest these impressions in continuous motion. At first, it reacts nervously, then soon falls into indifferent lethargy. Everything is different— everything is the same. *The Democratic Forest*, title of a monograph about Friedlander's colleague William Eggleston also complements this work extremely well. Andy Grundberg sees the paradox which is central to Friedlander's images, somewhere between "specific yet vague" or "regional but universal." Friedlander actually says himself that he does not go out "to find something special," which obviously does not amount to his pictures denying their origin— America the Beautiful is omnipresent. At the same time, he insists he does not photograph the absurd, although the absurd is also part of that.

The perseverance of the artist Lee Friedlander to do without the homeground of aesthetic conventions for such a long time is admirable. Even when dealing with standard themes such as *Self portrait*, *Photographs of Flowers*, *The American Monument*, *The Nation's Capital in Photographs*, *Flowers and Trees*, which all lead to individual publications, he disappoints the expectations of some people who judge by those harmless titles. In a self portrait, one may have to search for some time for the author, and flowers and trees may lack the comforting qualities usually attributed to them; they seem to be in need of consolation themselves. Even memorials or the capital of the nation altogether are no longer suited for proud identification. In their isolation and the association to another absurd or at least indifferent neighbourhood, they lose their former aura. Ridicule is introduced without the photographer having to point it out. Everything is simple as it is; this is not the work of a world reformer. Rod Slemmons clearly describes what these photographs accomplish: "They do, however, cause us to see the world, and representations of the world, in ways sufficiently new so as to make us suspicious of social and political pronouncements based on simplistic descriptions—verbal or visual."

Beginning with his self-portraits, Lee Friedlander always made a point of including himself in his world. Be it in the form of a shadow, a reflection or a direct image—the self is assimilated into its surroundings and has to again be distilled out of its confusing connections by the spectator. The photographer is a part of the whole, but of course he as the one who photographs is also necessarily at a distance. This exceptional condition is very clear in *New York City*. On one hand the photographer, and consequentially we as the spectators, perceive the world in classical central perspective, with us as the central focus. This view is emphasized by the strong symmetry of the composition as well as the statue taking the centre place in the picture. We are confronted with an American Monument, and it is not by chance that the clenched right fist of the gentleman represents exactly the centre of the picture. This loud attack is aimed at us, and the view from below only stresses our inferiority. Here we face the accumulated American Way of Life. High and low entropy seem to match each other, the forces of chaos and order are still well balanced. But the next moment could decide the fate of this civilization. The photographer demonstrates what we see every day but have forgotten to notice. Almost unnoticed, quiet signs of loss appear behind all this abundance. A deficiency becomes apparent that the world as Lee Friedlander depicts it is unable to remedy.

—Ralph Hinterkeuser

Bibliography—

Friedlander, Lee, *Self-Portrait*, New York 1970.
Time-Life editors, *Das Photo als Dokument*, Amsterdam 1980.
Friedlander, Lee, *Photographs and Flowers*, New York 1975.
Friedlander, Lee, *The Nation's Capital in Photographs*, Washington, D.C. 1976.
Friedlander, Lee, *The American Monument*, New York 1976.
Friedlander, Lee, *Flowers and Trees*, New York 1981.
Friedlander, Lee, *Factory Valleys*, Akron 1983.
Friedlander, Lee, *Like a One-Eyed Cat*, Seattle 1989.
Eggleston, William, *The Democratic Forest*, London 1989.

© Mario Giacomelli

Mario Giacomelli (1925–)
Scanno, 1957
Black-and-white photograph

In his photographic art Mario Giacomelli proceeded from neo-realism, in painting and particularly in film-making, its pre-occupation with the life of common people and its frequent express-iveness. Nowadays, the formal aspect of his photographs does not appear to be that exceptional, but more than thirty years ago Giacomelli's boldly unconventional compositions, sharp tonal contrasts, coupled with the atmospheric fuzziness of his action scenes as well as the considerable graininess of his pictures did break many of the generally accepted rules of contemporary photography. Never in his career did Giacomelli put much trust in the absolute objectivity of photography as proclaimed—at the turn of the 1940s and 1950s—by photo-reporters of the Magnum agency or *Life* magazine; on the contrary, he was convinced that photography should express the author's own subjective view too. Together with William Klein and Robert Frank, Giacomelli belonged among those photographers who should be mainly credited with formal innovations in documentary photography and ever greater accentuation of their own viewpoint and position. He was no longer concerned solely with a description of reality, but rather with a subjective interpretation of it.

Most of Giacomelli's works are included in larger cycles which, in some cases, took several years to complete. That is the case of what is probably Giacomelli's best known photograph, *Scanno*, from 1957, which is part of an extensive cycle of expressive pictures of the same name, portraying the rustic life of villagers in the district of Abruzzo. The unique lyricism of these photos betrays signs of the influence of Giacomelli's favourite poet, Giacomo Leopardi, a love and respect for ordinary people as well as an accent placed on authenticity; however, they also seem to reflect the style of neorealist films by Luchino Visconti, Roberto Rosselini or Giuseppe De Santis and, to a certain extent, photographs from the American Farm Security Administration project.

Documentary photography succeeds in combining a humanistic content with an exceptionally expressive form. Its well thought-out composition is suggestive of paintings by Renaissance masters. Figures dressed in black form two different triangles in the photograph. The first of these is a woman on the left in the front, three small figures in the left upper corner and two female figures in the centre, the other triangle being made up of a pair of women and two individual figures in the foreground. An important role is assigned to the black squares of the windows of the house in the right upper corner, which seem to accentuate the underlying rhythm of the composition.

The genuine centrepiece of the composition, however, is a little boy in the middle of the picture, seemingly hovering in the air just a few inches above the ground. His light spring clothing is a counter-point to the warm clothes worn by the shivering women, his solitary figure symbolizing youth and optimism, which contrast with the age of the remaining figures and with the prevailing damp, cold and dismal atmosphere of the photo as a whole. Its content, packed with visual metaphors, is very difficult to transcribe into words, the decipherment of all its hidden meanings, including those epitomizing the course of life, conflict between youth and age or contrasting traditions and present-day life, depending to a great extent on the viewer's willingness to become intellectually involved in the process of decoding these messages. The whole scene strikes you as virtually metaphysical so that one inevitably feels oneself transported somewhere between dream and reality, between consciousness and subconsciousness.

Quite an indisputable contribution towards this end appears to lie in the author's ingenious effort at suppressing the spatial aspect and his use of the expressive fuzziness of his scenes depicting motion, the coarse grain of the negative material and a limitation of his tonal scale, stylizing the photograph into a veritable graphic form. Giacomelli's original profession of a printer finds expression in his taste for sharp contrasts of the black and white, achieved by blowing pictures up on a high contrast paper. This style, which appears to strike a distinctly graphic chord, was used not only in the *Scanno* cycle from the years 1957–1959 but also in a set of naturalistic, albeit deeply moving, photographs from old people's homes, a cycle he worked on during the 1955–1956 period; and then again between 1966 and 1969; in a set of photographs of frolicking seminarists in a monastery in Giacomelli's native Senigallia, in pictures of sick pilgrims in Lourdes hoping for a miraculous cure; in countless landscape photos, frequently taken from a bird's eye view in which—using bold sections, suppressing the spatial element, while underscoring elementary lines and forms—Giacomelli came close to producing highly stylized photographs reminiscent of action painting.

—Vladimir Birgus

Bibliography—

Turroni, Giuseppe, *Mario Giacomelli*, exhibition catalogue, Senigallia 1963.
Tausk, Petr, "Mario Giacomelli," in *Foto Prima* (Milan), no. 3, 1967.
Turroni, Giuseppe, *Mario Giacomelli*, exhibition catalogue, Milan 1975.
Quintavalle, Arturo Carlo, *Mario Giacomelli*, Parma 1980.
Schwartz, Angelo, *Mario Giacomelli: fotografie*, Ivrea 1980.
Crawford, Alistair, *Mario Giacomelli*, Paris 1985.

© Fay Godwin

Fay Godwin (1931–)
Moonlight on Avebury, 1985
Black-and-white photograph

Of all Fay Godwin's photographs, there is none which more quintessentially represents long standing British traditions of viewing the land, at the same time as it manifests the appearances of its subject at the moment of taking.

This photograph, in particular, demolishes at a blow the urbanite's notion that the works produced by William Blake, Samuel Palmer, Edward Calvert and the rest of the Brotherhood of Ancients were, even in their own day, an exaggerated form of special pleading in the face of early industrialisation; idealised and romanticised beyond relevance to the issues of the real world. For here it all is, not far off two centuries later, the moon and the stone; the flock and the trees; the dwellings tucked down, inconspicuous yet through their occupants vital to the organisation, organisation in the sense of organic patterning, of everything else present in the picture.

Avebury is one of the ancient centres of a part of Britain whose antiquity, or let us say, whose continuity of human usage remains palpable in marks on the land with origins stretching back to prehistoric times; and whose earth forces, many claim, are still perceptible as leylines connecting centres such as Avebury and Stonehenge with myriad others across the islands. This part of the country is indeed one of the main sources for the reports of phenomena that resist mundane explanation, such as UFO sightings, corn circles and like events. Whether or not one's tendency is to dismiss speculations on such matters as ridiculously pre-scientific and downright superstitious, it would be an unperceptive visitor indeed who did not recognise the character of atmosphere that even today survives the worst tourist onslaught, to confer a unique presence upon Avebury.

Equally, it is a notable achievement by Fay Godwin, employing her disciplined processes of photographic documentation, to have succeeded in representing the nuances of that presence in a single print on the wall; or even more so, in allowing us to retain them at the further remove of a book, how ever well produced, as indeed *Land* is. To speak of photography in terms only of resolution, of information density, of tonal range, is to suggest a determinate activity that shows without comment. Perhaps, in relation to straight photography, to the unmanipulated image, that has to be true. Perhaps, given that this photograph, with its delicately interwoven truths, so clearly echoes the presence of the land at Avebury, it is the balancing of the determinate, of the concrete, in their many aspects, to an accuracy and a subtlety that defy definition, which indicates one of the doorways through which photography is enabled to pass from the ordinary to the magical, and is exactly the measure of Fay Godwin's attainment.

Until recently, the view thus far formulated, or something like it, would have done as basis for a judgment of Fay Godwin that accepted her work at face value; as photography excellently located within the tradition of aesthetic landscape. Thus, pointing to a concept of the photographs as bounded by the notions that they are historically informed, visually refined and of a poetic which reflects the spirit of place. Another cast of mind, seeking for a judgment of a more cynical nature, might perhaps see Fay Godwin as someone working, wittingly or not, towards support for the less favourably perceived consequences of the heritage industry, that

is to say, for denial by concealment of the transformation, commercialisation and eventual erosion of the places it professes to nurture. After all, Avebury may be less ground down and fought over, especially in the literal sense, than Stonehenge, but it still incorporates museum, restaurant and other facilities that are not even hinted at in the photograph; though any who might seek to use such arguments against Fay Godwin's work should be aware that *Land* also assembles imagery very different from Moonlight at Avebury, dealing with issues of exploitation and industrial damage; albeit with the possibility of a suggestion, in the way in which the material is associated, that all things pass and that the land will heal.

It is only in the context of the 1990 book, *Our Forbidden Land* that everything becomes absolutely clear and incontrovertible. Fay Godwin's work there is an unequivocal, impassioned account of the effects of the closure of vast tracts of countryside for commercial, venal reasons, such as the rearing of animals and birds merely to shoot them. We see the final logic of the Highland Clearances, in concert with the destruction of the land by those who occupy it without regard for their longer-term responsibilities for its stewardship, on behalf of the wider population now, and in the future.

At a stroke, Fay Godwin has changed the context in which her work is to be seen. She has done it retrospectively, as well as prospectively, for *Our Forbidden Land* makes it impossible that we will ever be able to look at any of her photographs again without being aware of the passion which informs her output. Nothing is lost of the beauty and subtlety of the Avebury half light: if anything, we gain intensity, for the experience of the new work makes us savour the photograph of that unsullied moment, down to the last detail, obsessively, noting how it was, hoping that it still is, and praying that it yet will be; despite the worst efforts of the barbarians, more often witless than unwitting, whom Fay Godwin now reminds us are surging round the gate.

Whether events turn out so that we may continue to see this image as an outburst of lyrical praise for our inheritance, and war song raised in its defence, or whether eventually we must recognise it as an elegy for the passing of that which can never be regained; the connection between Fay Godwin's vision and that of William Blake and his friends is made clear. They and we have the same battle to fight. The difference is that the outcomes they predicted, are now moving towards completion at a landslide rate. How many more Averburys will be there, perfect under future moons?

The answer to that question depends in part upon the extent to which her viewers allow themselves to understand how Fay Godwin has completed the picture, and respond with sensitivity to the education in the politics of land use which she so powerfully offers them through her photographic vision.

—Philip Stokes

Bibliography—

Plowden, David, and Jeffrey, Ian, *The Library of World Photography: Landscape*, Tokyo and London 1984.
Godwin, Fay, *Land*, London 1985.
Godwin, Fay, *The Secret Forest of Dean*, Bristol 1986.
Godwin, Fay, *Our Forbidden Land*, London 1990.

© Brian Griffin

Brian Griffin (1948–)
Sliced Bread, 1986
Silver gelatin print photograph

When Brian Griffin visited the Salvador Dali Museum in northern Spain in the early summer of 1986, his attention was caught by Dali's 1926 painting, *Basket of Bread*. A luminous portrayal of a rough Spanish loaf cut into pieces and seen against a white cloth, it seemed, to Griffin, to be an ikon of wholesomeness. Up until his visit to Figueras, Griffin, along with fellow art students of the early 'seventies, had disparaged Dali's popular surrealism. But, visiting Dali's monumental, whimsical museum, he was impressed not only by the painting, but by the fantastical structure of the building itself. It seemed to encapsulate not only a singular eccentricity, but also a religiosity which engaged Griffin's interest.

The purity and divinity of the bread which Dali had pictured stood, for Griffin, in direct contrast to the processed food of a poisoned and polluted industrialised Britain—"I thought about the bread that I had got to know so well—*Wonderloaf*. I thought how *Wonderloaf*, or any sliced bread in a packet is so much like British society. It's full of chemicals, made with horrible white flour, then sliced up and put into a package, wrapped up and put on the breakfast table. I thought: that's just how our society seems to treat people."

By the time Brian Griffin photographed *Sliced Bread*, he was well-known as a maker of cogent portraits and an incisive figure in the new wave of British independent photographers. In the early 'seventies, he had studied photography at Manchester Polytechnic, alongside other future innovators like Martin Parr and Peter Fraser. He had come to art school after rejecting a traditional West Midlands' career in engineering draughtsmanship. From 1972, Griffin worked as a portraitist in London, becoming deeply involved in the music industry, and also evolving a dynamic new style of photographing industrialists, executives and businessmen, principally (under the direction of Roland Shenck) for the stylish and aggressive British business magazine *Management Today*. In Griffin's portraits from the 'seventies, captains of industry and rock mavericks became oddly synonymous citizens of his zany, but relentlessly hard-edged modern world.

Brian Griffin's photographs are highly public manifestations of personal obsessions. In his first published photo series (*Brian Griffin, Copyright 1978*), he embarked upon an intense and self-reflective autobiography. Picturing young, urban man among alone in an eerie world of illuminated squares, enigmatic doorways and ambiguous structures, he created a modern narrative for the new British photography. Aware of the legacy of Britain's recent photographic past, he owed some allegiance to the whimsy of British portraitists like Cecil Beaton, Peter Rose Pulham and Paul Tanqueray. Interested too in *Neue Sachlichkeit* methods and imaging, his photographs had emerged, by the mid-seventies, as highly idiosyncratic imaginative constructions.

His preoccupation with sacred symbols, from the bread of the Holy Communion to the mystical sword of Excalibur (preoccupations felt since childhood), formed other strong concerns constantly informing his photographs.

Sliced Bread, 1986, was one in a series of photographs in which a mass-produced loaf is seen upon a set of fantasized altars. Returning from Spain, Griffin constructed a set of different scenarios within which to play out his modern morality play. Forming a central picture in his allegorical photo-series (published in book form as *Work*, in 1988), the photograph emerges as a castigation of Britain in the eighties. On the sun-scarred back of a friend, posing in his Rotherhithe studio, Griffin arranged the *Wonderloaf*. "I thought that bread is the body of Christ, and there it was, on top of a body. I thought it was a very appropriate image. I also liked the fact that it looked like something else at the same time. Some people said it looked like a fish, others that it was like a reptile. It was like when I first began to photograph businessmen—something that no-one else wanted to photograph. When it's all sliced up and polluted, it's like death."

In *Work*, Griffin sequenced *Sliced Bread* on the page preceding his 1983 *Cenotaph* photograph, and after his heraldic, elegiac representations of Broadgate workers embracing their tools. He had been much affected by the recent death of his father, and the *Workers*, posing like the effigies of dead kings, became a symbol of his bereavement: "I thought it was very appropriate to put it after [the photographs of] the *Workers*, because *Workers* was about my father dying. There they were, lying in state, as if they were in a Cathedral. And there was the cause of the damage, the body polluted. *Sliced Bread* emphasized this within the context of the narrative of *Work*."

After Griffin had photographed the sliced loaf, he kept it in his studio to observe the process of decay. Symbolic, to him, of the rejection of wholesomeness, he became fascinated by its gradual mouldering, its metamorphosis from food to fungus.

By the mid-'eighties, Brian Griffin had become a convinced opponent of nuclear weapons. Commissioned by the Photographers Gallery in 1983 to photograph around the theme of *London By Night*, he pictured a city in the throes of holocaust. Photographing in the area around Heathrow airport, he portrayed a forsaken universe of marooned streets in the ominous half light of the night-time city. *Work*, though made up of many disparate photographs commissioned by a variety of clients, assumed a narrative role as a chronicle of the nuclear catastrophe. Within this scenario, the polluted bread, symbol of mass-production borne upon the suffering, scarred back of the working man, assumes a central and didactic position. In direct contrast to the noble bearing of arms by the working men of Broadgate, the defiled bread becomes an intolerable and unworthy burden.

From a sighting of *Basket of Bread* by Salvador Dali on a rainy afternoon on a Spanish holiday, to the photographing in his studio of *Sliced Bread*, Brian Griffin constructed an allegory of anticulture. Constructing this satirical icon to a post-war, industralized past, Griffin remonstrates on the adulteration of goodness. A highly moral, instructional work, it epitomizes Griffin's continuing view of the world as a phantasmagoria of demons and angels, the divine and the profane.

—Val Williams

Bibliography—

Griffin, Brian, *Brian Griffin: Copyright 1978*, London 1978.
Griffin, Brian, *Y*, London 1983.
Griffin, Brian, *Work*, London 1988.
Griffin, Brian, and Williams, Val, "Interview," in *Oral History of Britain*, National Sound Archive, London 1988.

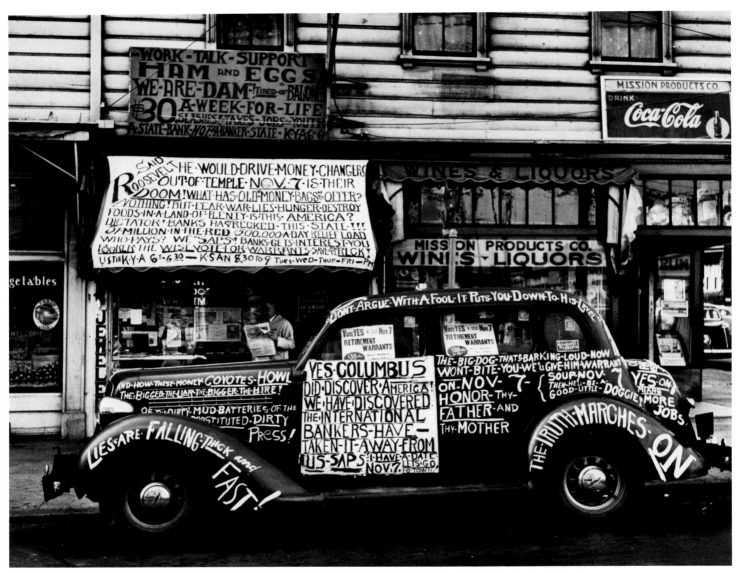

© 1986 John Gutmann

580

John Gutmann (1905–)
Yes, Columbus Did Discover America, San Francisco, 1938
Gelatin silver print photograph

Gutmann's landmark photograph of the 'thirties, *Yes, Columbus Did Discover America*, compresses four elective themes from his methodology of categorizing his images; *Documents of the Street, Automobile Culture, The Depression*, and *Graffiti: Marks and Messages* unify both its expressive and the analytical content. The spectrum of thematic categories featured in Gutmann's body of work extends to include portrayals of *Women, Death, Structured Vision*, and *Beyond Reality*, an enigmatic but pervasive substratum of his photography. The utilization of these themes and others as designated, structured Gutmann's vision contemporaneously, as well as retroactively in the organization of the content of his archive of images. Throughout the collection, some images reflect distinct categories; others crossreference, overlap, transpose, and fuse; the visually straightforward information in one image contrasts with an expressionistic gestural approach of the same subject matter in another.

Gutmann arrived in San Francisco in 1933, bringing with him a sophisticated cultural background. An expressionist painter whose career had begun to flourish in Berlin, Gutmann had been part of the artistic ferment in which experimental ideas prospered with cultural links of "Amerikanismus" during the mid-1920s; cinema, jazz, sports, and the perceived industrial efficiency of American cities emerged as a new source for artistic forms. It is not surprising that, once in America, Gutmann focused upon its metropolitan milieu. In Germany he had purchased an "automatic" Rolli camera in order to pass himself off as a photo-journalist and gain unrestricted travel. Having left the politically hazardous Germany, Gutmann landed in Depression America and began to photograph for the burgeoning European magazines.

If the legacy of the Farm Security Administration (F.S.A.) photography project is descriptive of the populist view of the Depression Years, Gutmann's view resembles none of the highly crafted and politicized despair of rural individualism. For Gutmann, America was extraordinary and his approach to all intents and purposes was remarkably matched: expressive angles, truncated framing, fleeting subjects, and with a tenacious eye on the conspicuous, his images emerged as semiotic happenings. Gutmann responded to life in America with excitement and a sharp eye to characterize its popular emblems. Having discovered the expressive polarities of the photographic medium, Gutmann amplified his images with a visual intensity that changed not only with subject matter at hand, but also with the permutations of the possibilities within the subject; often the objective and the subjective merge, and form and structure change radically from picture to picture.

No subject matter proved as limitless as the celebrated automobile—Gutmann saw it as the quintessential American icon—ever present, dominating streets, roadsides, elevated garages, beaches, drive-ins, fairs, and dumps. Seeming omnipotent, it symbolized power, wealth, glamour, and individual freedom. In contrast, it stood for an object of glossy veneration and of touching necessities: transformed automobiles became home and office for the enterprising merchants, transports for proclamations, billboards for commerce, carriers of ideological and social agendas, and gaudy trophies of their own overt ubiquitous form.

The *Columbus* image exemplifies not only the bizarre and the dazzling, or in Gutmann's own words "the marvelous extravaganza of life," but the opportunity for Gutmann to seize the complex set of circumstances and to define the interaction between thematic categories: the pervasiveness of automobile culture and the linguistic messages that polarize the image with an obsessive visual density. Black and white letters pulsate, lines underscore and emphasize, messages call for truth, honesty, and life-time wages, and scrawly slogans announce disaffection and social aspirations.

As subject matter, the language of graffiti and marks of *Yes, Columbus Did Discover America* declares its multifarious idiomatic relationship between enigmatic words and anonymous authorships. As a document of the Depression, it declares the disputation of the era. Yet, Gutmann injected a fresh sense of wonder by capturing the openness and the marvellous in everyday existence. His response to America's cultural iconography synthesized both his social and aesthetic concerns. Gutmann's unique images stress his belief in the importance of subject matter, in recurring human themes and events, and a feeling for both the irrational and the rational that polarized his photographic vision.

—Maia-Mari Sutnik

Bibliography—

Humphrey, John, *As I Saw It: Photographs by John Gutmann*, San Francisco 1976.
Kozloff, Max, *The Restless Decade: John Gutmann's Photographs of the Thirties*, New York 1984.
Sutnik, Maia-Mari, *Gutmann*, Toronto 1985.
Dupuy, Alain, ed., *John Gutmann 1934–1939*, Valencia 1985.
Gutmann, John, and Heiferman, Marvin, *99 Fotografias: John Gutmann, America 1934–1954*, Barcelona 1989.
Phillips, Sandra S., *John Gutmann: Beyond the Document*, San Franciso 1989.

Photo Museum of Fine Arts, Museum of New Mexico

582

Betty Hahn (1940–)
Starry Night Variation no. 2, 1977
Serigraph
Santa Fe, Museum of New Mexico

Historically, popular images from stories passed through generations of people tell us much about the values of a society sustained over time. Such manifestations of culture, verbally or materially, provide a wide variety of subjects for the artist. In the present world, there are endless trails of information and technology which are also extra dimensional resources for visual communication. The folk art of late twentieth-century culture can be found through electronic media, mass produced reproductions, movies, billboards, magazines, and advertising.

In 1974, Betty Hahn discovered a greeting card with two American television stars, "The Lone Ranger" and his friend "Tonto" printed on the front. This cowboy and Indian were partners in the West for a series of celebrated half-hour television episodes. The ready-made card not only brought back an era of popular culture, but distilled the myth of the western cowboy hero—statuesque white horse and hat included. The Lone Ranger was an idol different from other champions against evil. His moral deeds from week to week carried no afterlife in ceremony—only testimonials from those he rescued from the last episode. As a legendary defender, his true identity remains unknown: he wears a mask, asks for no favors, and returns only for the next tale.

The professional photographer who created this archetypal image of commercial American persona, also remains anonymous within the corporate entity that produced this electronic fable. Found in a ready-made form of a note card, the The Lone Ranger role is temporarily revived. As an emblem from the modern culture of technology, he resides in the nostalgic quarters of the mind. For those of us who watched that "masked man" and Tonto every week, they were more than a victor of the West. As a symbol of honor, he reflected an outlook on life, the right always winning against evil, and a simple means of authority that had no faults, personal problems or ulterior motives.

It is important to understand that the artist resurrected this mythology in the midst of such social turmoil. And that it came from another mass-produced source—available to all and signifying another step removed. Distance and repetition become key elements in each of Betty Hahn's variations—not unlike the episodes that were once experienced on the television screen. Postmodern dialogues aside, she offers more to the viewer than structuralist debates or lessons in semiotics, though certainly these tenets could be applied.

Later the same year, the artist spent a month working at Franconia College in New Hampshire, in residence. Almost daily, she created photographic print variations of this picture, taking this exercise "like vitamins." She began by making an 18 × 22 inch Kodalith film duplicate as a matrix from the card. Then, by using several light-sensitive processes such as cyanotype, gum-bichromate, and Van Dyke printing methods, the image was regenerated into additional monochromatic print versions.

These new generations of final prints represent yet another stage removed from the original. In fact, the notion of original is seriously brought into question. Every print—each a new version for this series—is different. Each is created from the graphic film duplicate, which was copied from the note card, that was also reproduced by the printing press from a glossy studio photograph. The traditional belief of a reproduction as something less in value or in quality, as we move further away from the source, is denied.

These pictures revalidate the performed image of these two actors dressed with horses, make-up, mask, western outfits and lighting. The television studio archetype is amplified rather than diminished from translation to translation. The historical notion of a single "master" print is correspondingly reversed—every new version is as authentic as the next. There is no hierarchy implied from the original source. Each variation comes with its own territory, as the idea of repetition helps defuse what Walter Benjamin termed the "aura of the original."

In this regard, Betty Hahn developed what has been held less sacred by traditional photographers. The quality of reproduction which is a natural part of photography is central to her aesthetic. The single print or style multiplied over and over with a specific "standard" in mind no longer carries any validity. Extending the vocabulary, breaking down the rules, liberating ideas from tradition, and thriving on other possibilities from experimentation, are principles once again valued. This becomes central to the ever-expansive American photography by artists of the second half of the twentieth century.

The two-dimensional quality of this "folk" hero, like his mask, also marks a formal element that presents more *detachment* in the transformation of each print. Within this new, less than photographic space, is a layering of ideas from the artist that beckons inventive freedoms. The black-and-white photography of past modern masters encouraged the most literal interpretation of subjects before the camera. Here such shared practices and conventions are reversed for another kind of testing ground in ideas.

During the next three years, Hahn mixed media, drawing, capabilities of color and surface to build upon the interaction of portrait and landscape genre. While the cactus and ground surrounding these two figures was a part of their glib western ambience, the "sky" is added in this "Starry Night" variation by combining a high constrast, material fabric. This is printed in contact with the Kodalith film matrix of both figures.

The cloth's snow-flaked pattern, known as "Queen Anne's Lace," depicts the leitmotif of a midwestern weed repeated over and over. This natural plant form (including the designer's copyright tab on the right that reminds us of its commercial origin) not only enlarges this vista from another imitated source, but provides other avenues of photographic representation spared from the tradition of outdoor landscape photography. This cultural landscape is established in the studio.

Henry Fox Talbot placed botanical specimens in direct contact with light sensitive paper in the 1830s as a part of his invention of "photogenic drawing." Betty Hahn opens this idea to further interpretations. Later, artists such as Man Ray and Laszlo Moholy-Nagy advanced such modern solutions as "Rayographs," "shadowgraphs," or photograms (camera-less photographs) in the innovative milieu of the 1920s. Here, a ready-made note card picture is blended with the abstract tendencies of the photogram. Image and fabric design are merged in contradistinction for this silkscreen variation.

The black mask is a symbolic veil which reoccurs in spirit throughout every part of this photographic work. We are never closer to any "original" than to the individuals who stand in television make-up and costume. Perhaps after living with photography for over one hundred and fifty years, we have learned that photographs in any form are a disclosure of truth molded by the individual purpose of the author. Betty Hahn strips the objective "drawing by nature" beliefs that were perpetuated by the pioneering inventors of photography, down to a genuine common denominator—human values. Her many forms of expression rely less on progressive linear equations or style than with multi-layered meanings that expose our ability to conceal. In so doing, we gain a better glimpse of ourselves, as well as a more genuine sense of the nature of the photographic medium in all its diversity.

—Steven Yates

Bibliography—

Asbury, Dana, "Mums and Kitsch," in *Afterimage* (Rochester), Summer 1979.
Hill, Brad, "Photo Artist Betty Hahn," in *Black and White* (Albuquerque), July 1980.
Brodsky, Judith, and Garcia, Ofelia, *Printed by Women*, Philadelphia 1983.
Bloom, John, "Interview with Betty Hahn," in *Photo Metro* (San Francisco), August 1987.

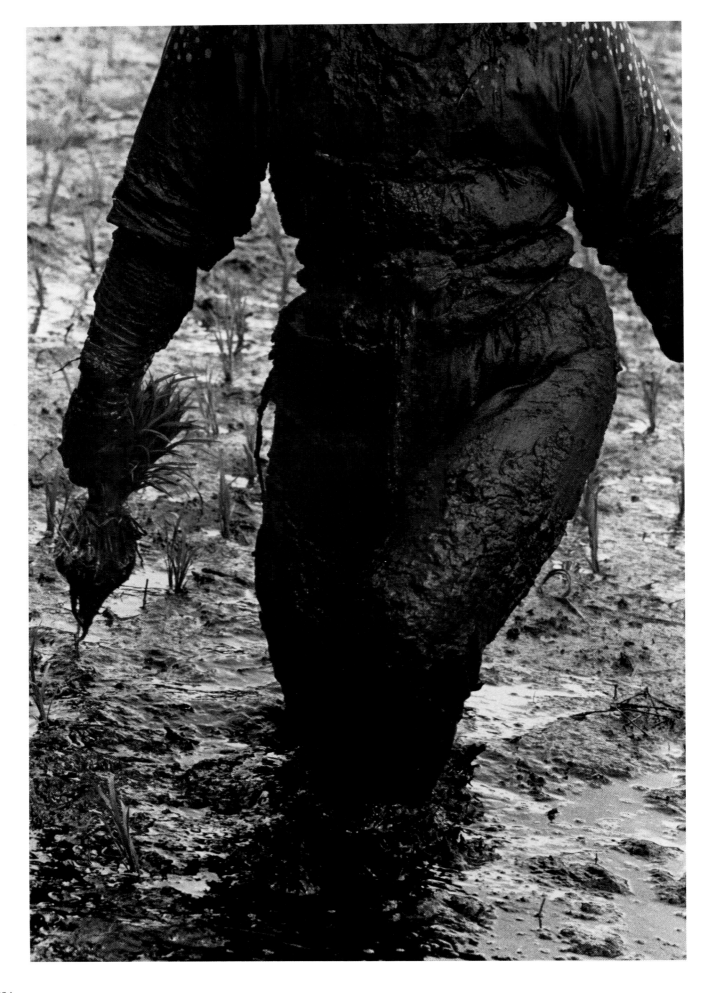

584

Hiroshi Hamaya (1915–)
The Rice-weeder, 1955
Black-and-white photograph

Before reaching the stirring and inspiring awareness that human beings may experience gliding in the open sky, Hiroshi Hamaya has followed the humble and winding earthy path that guided him from the once quiet and lively district of pre-modern Tokyo, where he was born and grew up, towards the discovery of other Worlds.

Even though, at the very beginning of his professional career as photographer, in the Photographic Department of Japanese Air-Force in 1933, he had the opportunity of flying over Ginza district in Tokyo, thus shooting his first aerial photos, he was grounded soon after, due to the fact that the Department was dissolved for being too progressive, as compared to the traditional and culturally isolated Japanese society of that time.

Hiroshi Hamaya took his first pictures when he was fifteen years old. One of his father's friends, returning from a trip abroad, brought him a camera. In those days photo equipment was very expensive in Japan. Hamaya's family was his first subject; then he started taking pictures of his neighbours. Further on, he focused on events, facts and traditional feasts taking place in his district, Ueno.

Hamaya's work may be divided into two parts, even though such a division may appear a somewhat schematic one. He starts as a photographer seeking in Europe a sort of cultural legitimacy he could not find within the boundaries of Japanese culture, photography being a new medium through which reality and fiction could be explored. When he started his professional career in 1933, photography was still a novelty in a country that, only a few decades later, would become the world leader in terms of the production and technological development of photographic equipment.

Black and white photos belong mostly to his first period. They are charged with a deep, profound, subtle and humble pathos. He travels to the northern part of Japan, into an ancient, unchanged and hard society; impermeable to the accelerated, sudden and upsetting changes that modernity carries along. Hamaya encounters people who struggle to make ends meet; trying to cope with the roughness of a poor, unrewarding, exhausting and unpredictable nature. Viewers may refer to two extraordinary pictures, among many others of that period: *The Rice-weeder*, Toyama, 1955. The clothes, or what there is of them, of the rice-weeder soak up water, mud, fatigue, untold suffering. Hamaya concentrates on the slow and obstructed movement of the body. The rice-weeder's feet are plunged into the muddy water, as if they were the roots of a water-plant; the head is cut out, for what might be considered as Hamaya's respect for the unknown woman's misery and pain. *The Divers of the cold region*, Fukui, 1958, is one more poignant, compassionate reflection on the struggles for life in northern Japan. One of the women-divers is caught suspended in the air: her feet

are just a few inches off the surface of the bitterly cold sea-water that is about to swallow her body. The fingers of her hands are wide open and stiff, and the grim look on her face tells clearly the woman's expectation of pain once the tips of her toes make contact with water.

The use of colour photography coincides with the second period of Hamaya's artistic, creative and research photographs. The cultural dependence and reference to European models become less evident. He seems to find his own way of looking at the World. Hamaya flies again. He glides in circles over his own country, like a bird rehearsing before a long flight, ready to fly up towards different skies: over waters, mountains, deserts, lands.

After having spent years observing people in their environment, now Hamaya's interest is attracted by environment itself. He has become the Sky Photographer, as immortalized in a poem the great Japanese poet Daigaku Hariguchi.

He observes and records natural phenomena (*The flash of lightning over the Amazon river*, Brazil, 1978; *Sunset over the Sahara desert*, Algeria, 1979), breathtaking views of mountains (*Fuji mountain*, Japan, 1961; *Tokachi mountain*, Japan, 1962; *Mount Everest*, Nepal, 1974). He masters colour without making use of any spectacular or overemphasized technique. Some of his colour pictures, notwithstanding the magnificence, the grandeur, the enchanting beauty of the subjects being exposed on film, recall the disarming simplicity and harmony of Japanese water-colours (*Furen Ko*, Hokkaido, Japan, 1963; *Fiji Islands*, 1975; *Death Valley*, California, USA, 1978).

In 1975, Hamaya flew over Australia. He might have seen the massive, monolithic shape of *Ayers Rock* from up above the sky, but then he must have decided to land before it; fascinated, attracted, overwhelmed by its imposing, grand, unique solemnity: a place dwelled by unknown Deities. The huge crack at the bottom of the rock is caught as the big, smiling mouth of a whale stranded in the middle of nowhere; a bluish curtain of fog conceals the top of Ayers Rock: the meeting point of one of the Songlines crisscrossing Aboriginals' lost land.

—Donato Prosdocimo

Bibliography—

Hamaya, Hiroshi, *50 Years of Photography*, 2 vols., Tokyo 1981.
Hamaya, Hiroshi, *The Collected Works of Hiroshi Hamaya*, Tokyo 1981.
I grandi fotografi: Hiroshi Hamaya, Milan 1982.
Spielmann, Heinz, *Die japanische Photographie: Geschichte, Themen, Strukturen*, Cologne 1984.

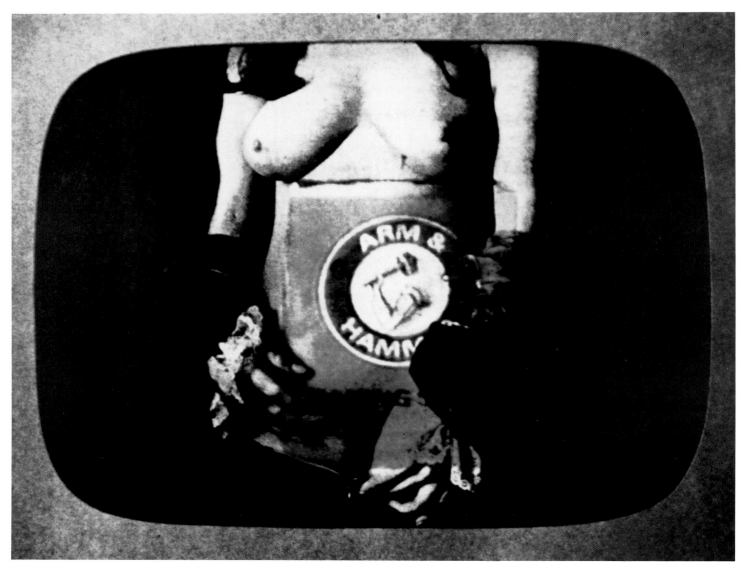

© Robert Heinecken, 1976. Photo Center for Creative Photography, Tucson

586

Robert Heinecken (1931–)
Daytime Color TV Fantasy/Arm and Hammer, 1976
Photographic colour lithograph; 48.4 × 59.7cm.
Tucson, Center for Creative Photography

Since mid-century, another history of photography has been quietly written by artists in the western United States. While they fully recognize the precedents within the medium from the past, their own work is not bound by shared practices, formed standards, master canons, defined limitations or past methods in craftsmanship. The linear progression of tradition or a chronology of styles does not apply to their varied approaches. When this history is finally drafted, it will be without the primary guidance of the scholar's conventional tools, such as delineated categories, process biases, scientific language or thematic tenets.

For decades, these artists have developed ideas outside the classic principles of modernism. There is little loyalty to the nineteenth-century doctrine of photographic materials or genre, unless these can be reused to broaden artistic potentials. They often use the language from the photography of history to pursue new directions.

In many ways, their work is already post-modern in its appropriations. While this term was first written by Leo Steinberg in *Other Criteria* in 1972, they were reapplying the popular images of culture from magazines and television. Their pluralistic forms of expression pay attention only to the beliefs that extend the medium, so it no longer stands next to art in a single dimension of self-definition. Rather than a solitary art form of expectations, their message relies on criteria that is based on inventive thought and personal judgement.

Robert Heinecken pioneered this shift in the artist's unorthodox role with photography in many ways. He does not use a camera. He employs found imagery and advances formal strategies with an unlimited array of photographic processes. Most of his work deals with a multiplication or synthesis of images. New technologies are as applicable as mixed-media approaches. But in the end, the results remain fundamentally photographic.

The reuse of found and selected materials stems from the collage of Cubism to the photomontage of Dada early in the twentieth century. In this spirit, Heinecken moves to re-contextualize photographic images into statements of contemporary values and meaning. Irony, deception, human and sensual associations are often the undertones of culture where his work prospers. For the Dadaist, "anti-art" was the mission. Heinecken's aim is expansive.

Instead of contributing to the evolution of photography as an art form, it is evolution that is the art form. In this work, the concept of each piece relates in some way to his other works from other times. Ideas remain open-ended without the closure of style or aesthetic imprint.

In the early 'seventies, Heinecken began working with the television as a continuous medium of camera stereotypes. As much as this electronic medium is used as a filter for economic and political persuasion, it is also a pervasive indicator of society. Advertisements help market materials and things for the convenience of the consumer, but they also depict those products that are regarded as worthy of the day. The viewer reciprocates by further filtering the product information into personal associations which may call for further actions or responses.

In *Arm and Hammer*, the artist allows the message to convey further meaning about the duplicities of contemporary life. In the original installation, a black and white, positive graphic-film transparency of a separate image—a nude female body photographed from a pornographic magazine—was placed inside the television's glass screen. The viewer was invited to turn the stations so that ongoing color television imagery was filtered through the female contours. Like an electronic photomontage, the changing juxtapositions remained in flux.

The artist decided to add another level of context that was even more removed in steps from reality. He began to make slides of certain combinations of commercial images from the actual screen to create a series of lithographic prints. In this case, the baking soda box with arm and hammer logo is blended in ink with the television outline and film silhouette. Paradoxically, by diffusing these photographic images through more processes, the content of the work is emphasized by attrition.

We learn that the photograph diminishes increasingly in quality by each generation of its copies. Heinecken reverses such rules. The relationship between the original camera-made commodities—the body and baking soda box—is heightened through the translations that are several times removed. Furthermore, the association of female figure and male counterpart from the logo, suggest physical contrasts that border on voyeuristic fancies. Photographic by-products and lithography bring them back to the printed page. They help to transform them like emblems—or in the artist's words, into "formalized symbolic equivalents of experience."

In this regard, the duplicity of modern culture is matched by Heinecken's strategy of artifice. Between the artist and subject, lies the opportunity for ambiguities. As a forger of cultural artifacts, the artist's hand is more freed from a true sense of the original. Active decisions lie in either choosing the proper technology to fit the particular meaning of a chosen subject, or for the artist to invent a hybrid with a combination of media that produces a desired context. Either way, tradition is entrapped. This art exposes the historical position of convention. Tradition that lives in the present is less vital to the evolution of photography as an art form.

The surrealist poet, Paul Eluard, described the alliance between the artist and ready-made pictures as: "Poetic objectivity [which] consists only in the union of all subjective elements, whose slave—and not, so far, a master—is the poet." The random consequence of a re-photographed erotic profile from a magazine and the mundane electronic image of a baking soda product, borders on surrealist tendencies. Chance plays a key role in such synthesized elements. But this is not the art of the dream or the irrational. While Dada and Surrealism eliminated what Max Ernst termed "the myth of creation" within "the fairy-tale of the artist's creativity," it is the impartial matching of Heinecken's selections that activates our imagination. Decisions of conscious levels with the unconscious allow intuitive realities.

This photographic art of ideas is not the product of a movement, school of thought or "ism." Another characteristic of this kind of photographic art in the late twentieth century is that it desires no catch-phrase for history. The pursuit of something outside tradition and convention continues to lead photography beyond its historic boundaries.

As our comprehension of truth is informed by photographic relationships to actuality, so is the change today of our understanding of reality through a photograph. Robert Heinecken is working in the wake of our shift in perception of the world through photographic ideas. As present generations of artists continue to advance similar ideas without loyalties to established criterion, photography as an expressive artform is redefined. Art history must find new strategies outside of classic means to fully interpret such changes so remote from the heritage of modern masters.

—Steven Yates

Bibliography—

"Robert Heinecken: An Interview," in *Afterimage* (Rochester), April 1976.
Enyeart, James, ed., *Heinecken*, Carmel, California 1980.
Pastor, Suzanne, and Cohen, Susan, *Robert Heinecken: Food, Sex and TV*, exhibition catalogue, Kassel 1983.
Sunny-Gate Photo Gallery, *Robert Heinecken, Photographer—The Persistence of Vision: Selected Works from 1966–1989*, exhibition catalogue, Tokyo 1989.

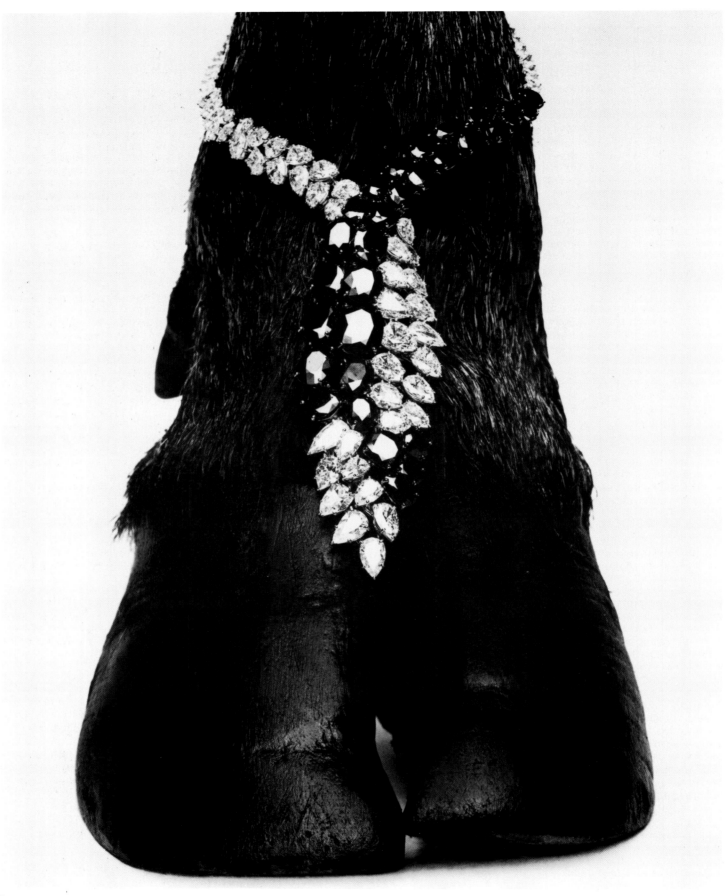

© HIRO

588

Hiro (1930–)
Jewellery on Foreleg of Black Angus, 1963
Black-and-white photograph

Hiro's photographs are not your normal run-of-the-mill excellent photograph. But this one, of rubies and diamonds wrapped down around a black angus calf's hoof, is even more daring than his others. Look at the opposites melded into a whole, black against white, roughened rustling hair against stilled rock hard jewellery, a living animal against lifeless rubies and diamonds, latent violence against an ultimate statement of controlled emotion. Before viewers have a chance to feel the butt of the hoof, they are stopped by the chain of jewellery. Before they have a chance to feel darkness and fear they feel a crystalline light. Before they have a chance to pose the possibility of violence, they are comforted by civilization's satisfactions. And before there is a chance to be struck by the disparity of the conjunctions, there is excitement from their counterpoints.

The photograph is actually the epitome of harmony—realized only after viewers are thrown into a moment of chaotic fury before being calmed onto a lush but stilled plane of appreciation. It is a voracious image. Not unexpectedly, and as is true with so much art that excites with symbolically ordered violence, it is sensually charged. Playing on emotions sitting at opposite ends of an emotional spectrum, it fuses emotions that might otherwise go off in uncontrollably explosive directions. And the result, a photographic masterpiece beyond dispute, tears into viewer expectations as it shakes out old standards. It creates a completely different set of standards for photography, for advertising, and for thinking in contemporary art.

Into its very harmony it has built the continuing possibility of disorder. It not only brings cultural objects having nothing to do with each other—as we know life—into a harmonious whole. It allows each of those—let me call them opposites—to continue their individual impact. It is a little bit like looking at someone in a mirror reflected in a mirror. There is an infinity of life. The image continues to excite and agitate the various parts of the emotional spectrum from which it was born.

Richard Avedon, the first of the modern masters of advertising photography, may have set the groundwork for this photograph when in 1946 he photographed a model in a silken evening gown languidly reaching up to two very rough-textured elephants. She stood between them, extending her one bare arm up to one of them. Hiro advances Avedon's dare. Eliminating a person from the image, he creates a similar unheard-of conjunction of objects, ending up not only with an intensity, but with an unexpected intensity drawing the viewer into its inner circle.

It is easy, in a sense, to attribute at least some of Hiro's mastery in this image to a Japanese sense of creating order and harmony out of violence—or put another way, of violence erupting into an ultimate stillness. But it is too simple, and at most only part of the story.

Up to the time Hiro made this image—in 1963 when he was 33—he had spent most of his life in China, almost twice as much as in either New York or Japan. Born in Shanghai in 1930, he lived there until 1937 when Japan invaded China and the family returned to Tokyo. After a few months it moved back to China, to Peking where he stayed until 1945, imprisoned with his family by the Chinese for a few months before returning to Tokyo. His father was a literary scholar creating a Japanese-Chinese dictionary with probable ties to the Japanese government if not to its espionage—but Hiro's environment was only partly made up of the quietude attached to oriental scholars. This was war-torn China. Destruction and devastation with its consequent fragmentation and break up of the physical structure and social fabric: that was his immediate surround. But if the break-down of life created one set of "normal" conditions for Hiro's young life, so, too, was his family's involvement with China's literati and its cultural concerns, one of which was to adapt a new energy and boldness to its traditional forms of expression. An association with Chinese culture may have been additionally supplemented by an underlying perennial Japanese respect for Chinese civilization as the parent civilization of Oriental life.

But Hiro was also living in highly politicized Japanese environment, where such respect was edged to the side in favor of things Japanese. He was living at a point of conflict between cultures, between beliefs, between countries. He was living inside of cultural and social chaos, with physical breakdown surrounding him. It's no great wonder that Hiro himself speaks of there being no order in any single moment.

I am not suggesting that the chaos of his early life is what we find in his pictures. Nor am I suggesting that an artist reproduces his life, especially his early life, in his work. But everyone incorporates life experiences. And artists, because they are artists, absorb life experiences more intensely, with greater desire for exploration, probably incorporating them more deeply.

This, and others of Hiro's images, shook up the advertising world by introducing process. The viewer becomes involved not in the advertiser's point in the image but in the dynamics between hoof and jewelry. In more traditional ways of thinking of imagery, the prize would be the rubies and diamonds: everything in the image would work the viewer's eye toward the jewelry alone. The jewelry would be the prize. Not here.

Here the prize is the process in which viewers are tossed back and forth between all the opposites that keep them engaged in the continuing tug and conjunction of elements. The image holds out an excitement in life as the prize.

Hiro was saying, in effect, that the viewer does not only identify with a product depicted. Or with a person depicted in the image in touch with the product. It is in the bunching of emotions from the individual parts of the image. He has essentially given the product greater life by hurling it through the dynamics of potential violence, as if it lived like everyone else.

Hiro has said that beauty can result in what he calls the strange circumstances of survival. Increase the chaos, increase the harmony. And the result is increased beauty. That is exactly what he has done.

—Judith Mara Gutman

Bibliography—

Caen, M, and Pledge, R., "Hiro," in special monograph issue of *Zoom* (Paris), no. 13, 1972.
Sullivan, Michael, *The Arts of China*, Berkeley and Los Angeles 1979.
An Aid to the Understanding of Japanese Art, Tokyo 1980.
Edwards, Owen, "Is This Man America's Greatest Photographer?," in special monograph issue of *American Photographer* (New York), January 1982.
Hiro, and Israel, Marvin, *Hiro*, New York 1983.
Hiro, *Fighting Fish, Fighting Birds*, New York 1990.

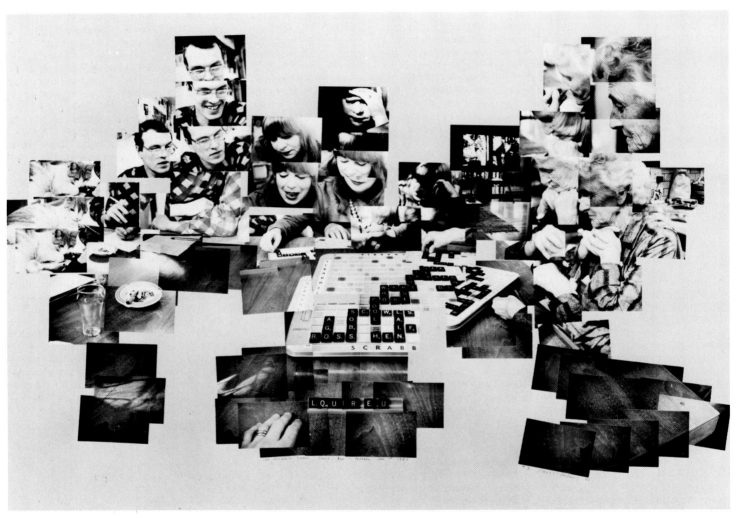

© David Hockney 1983

David Hockney (1937–)
Scrabble Game, 1983
Photomontage

Truly, David Hockney's a card. There's no other word for him. Who else would have dared, and who else would have had the sheer brass neck to have succeeded in getting ordinary photo lab colour prints on to the walls of the galleries, and even the Museums? What's more, they're prints stuck down in a manner which, as often as not, disregards all the niceties of the rectangular image and carefully butted edges. Those free-flowing photos overlap, divide and converge like the lava streams which erupt in the minds of the pillars of photographic convention when they encounter a flush of Hockney joiners.

The early Polaroid joiners at least offered the virtue, in the eyes of the world, of imposing a grid which gave the illusion, for a moment, that the piece might have had a genuine share of the temporal and spatial unities, that we were seeing no more than a coruscation (well, down to earth: a flicker) in its geometrically determined perspective. It was probably always unrealistic to have expected that David Hockney would apologise for the unevennesses in the spatial construction, would explain them as regrettable incidentals to instantaneity. It was always certain that he would never in a thousand years deny the sheer fun of the Polaroid; and it is highly probable that the first forgiveness on the part of the photographic world was not unrelated to the excellent colour fastness of the SX-70 process, which enables museums and collectors to buy them in without worrying too much about their investments fading with the dyes. At all events, although production of the gridded Polaroids and the collaged joiners does overlap in time, the former serve as stimulus (and to soften up the audience) for the latter.

Of these, *The Scrabble Game* delights as much as it excels in exemplifying the joiner mode. The visual centre is the Scrabble board. In the normal way of things, if one's a player, looking across it to the other players, the board's the focus of development, of the orderly progression of language (alright: words) towards completion, whatever the mildly riotous goings-on around it. At first sight, that is just what we have here. But study the layout of the board, note its anticlockwise rotation from what appears, or is constructed, as David's position, around to and nearly past his mother who sets out a letter just in time, before the board goes beyond her reach; and it's clear that Things Are Queer. We had better pay close attention.

To show aspects of the same object from different viewpoints is a Cubist mode of working, implying simultaneity; to arrange them in sequence is to propose its opposite, a progression through time. To make the last element in the sequence, the shot of Mrs. Hockney's hand, so ambiguous, even doubtful in the matter of the identification of which part of the game she's moving in, whether it's the same game, even, is to undercut both and to rebuke us, in the nicest possible way of course, for our foolish scrabbling after certainties.

Uncertainty rules, too, in the matter of the photographs of the players. We may be reasonably certain that they sat in the order that David Hockney shows here. Unless he's been diabolically clever beyond all belief, the odd shots shared by the arms of adjacent players confirm that. The straw of rationality thrown out by this suggestion of a logical arrangement bends rather than breaks as one wonders what David Graves is doing as a player apparently sitting *beside* Ann; though perhaps he's just keeping score. Perhaps it's the cat who's the fourth contender; Lewis

Carroll and David Hockney would have understood one another very well.

The tendency to go on looking, if not for some absolute truth—that was out of the window a long time ago—then at least for some decent relativities, may lead us to hope that the top to bottom and left to right sequencing of the players' faces indicate the progression of their expressions through time, and even, dare I suggest it, some kind of synchronisation, level by level, from person to person. The sort of viewer who's happy for their earth to move only if it's in the circumstances advocated by Papa Hemingway, will cling with passion to this little island of security, and stop their ears to the truth that any notions of synchronisation just have to be fictional, given the necessities of the method; and above all, the playful instincts of David Hockney. Others will revel in the dynamics of changing expression between David and Ann Graves; David Graves's lines of gaze converging on Ann's point of greatest animation. They will observe the careful foreground construction of Mrs. Hockney's profiles, and contrast them with the more casually seen aspects emerging, as it were, behind them, and leaving off with her doing one of those casual tweaks of the nose which often accompanies thoughts of action.

The cat, of course, gives nothing away. It leads me to reflect not only on the excellence of these animals as poker partners, but also that David Hockney, throughout his free-form joiners, of which *The Scrabble Game* is such a delightful example, has applied principles normally thought of as natural to certain modes of drawing, rather than photography. I'm referring to the approach which seeks to deal with that which is important as content, in priority to the construction of an explicit spatial framework. In terms of this photograph: the cat, undoubtedly; and the people, especially the people's actions. The Scrabble board, without which nothing; the bits and pieces such as ashtray, beer glass and so on, without which less human reality. The few shots of the distant table and the window; those little but conclusive cues that serve to build a surrounding space that a viewer might well recall as really there, not merely as figments of their own mind. A space curved, swollen or contracted by the needs of the narrative, and in that sense closer to felt reality than if it had been shaped by some perspectivist's rule.

The ultimate outcome of a prolonged study of *The Scrabble Game* will vary from viewer to viewer, and the same viewer will find different things in encounters with others of David Hockney's joiners. But here, and throughout his joiner work, David Hockney prompts us to refer our experience to some significant aspects of photographic representation, at the same time as he insists that it's at least as important—which means enjoyable—to share the pleasure he had in looking, and making them.

—Philip Stokes

Bibliography—

Haworth-Booth, Mark, *Hockney's Photographs*, exhibition catalogue, London 1983.
Sayag, Alain, *David Hockney: Fotografien 1962–1982*, exhibition catalogue, Basel and Paris 1983.
Hockney, David, *David Hockney on Photography*, New York 1984, Bradford 1985.
Hockney, David, and Joyce, Paul, *Hockney on Photography: Conversations with Paul Joyce*, London 1988.

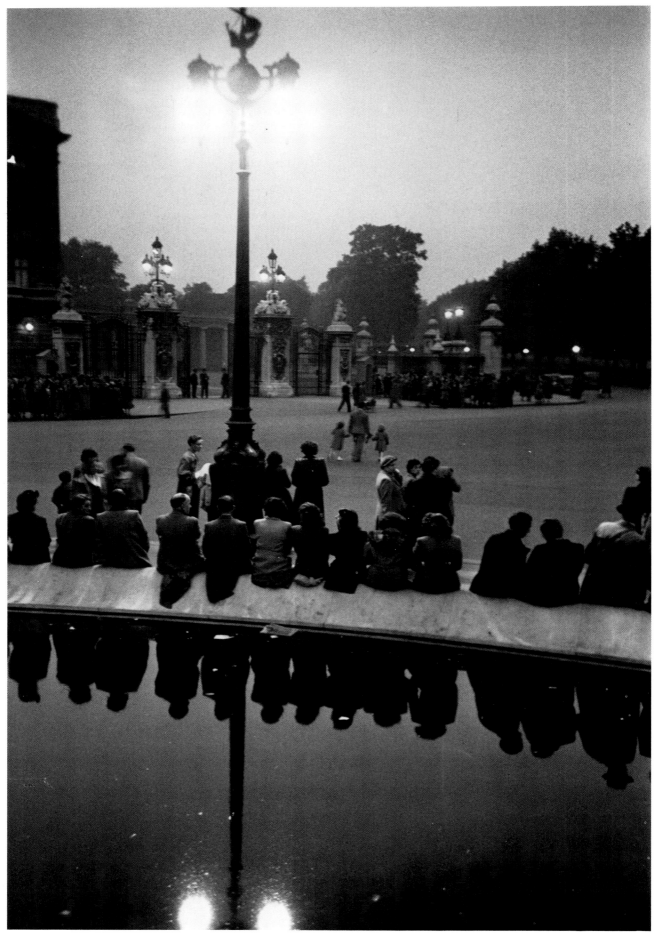

Hulton-Deutsch Collection

Thurston Hopkins (1913–)
All Night Vigil in Front of Buckingham Palace, London, 1952
Black-and-white photograph

The photograph taken during the fatal illness of King George VI who died in February 1952, is a perfect example of a sympathetic picture untainted by sentimentality. There are no weeping bystanders or mawkish children, not even a dejected dog. There is no hint of theatricality. Perhaps Thurston Hopkins waited for the little family to cross the road, perhaps not. One thing is certain. He did not ask them, let alone bribe them, to become part of a contrived scene. One also has the feeling that the small groups of people of their own volition were talking quietly as befits the occasion.

King George VI had the unenviable task in 1936 of taking on the throne of Britain from his out-going, good-looking brother Edward VIII after his abdication, following the Mrs. Simpson affair. George VI was a gentle person with a slight stammer but with the aid of his consort Elizabeth he grew more relaxed and gradually became well liked. During World War II the couple spent much of their time in London, Buckingham Palace suffered in the bombing, and his teenage daughter, now Elizabeth II, joined the ATS, not only learning to drive an army truck but how to strip down the engine.

Thurston Hopkins worked for *Picture Post* from 1949 until its sad demise in 1957. The *All Night Vigil* was part of a set of photographs taken for the magazine to illustrate the mood of the nation. Several pages of the pictures were published but this particular shot was not used, though it was the most appealing and atmospheric. As is often the way of the press, a lead picture with a horizontal format was chosen because it was more appropriate for the text and lay-out.

Luckily however, the photograph was not lost and was reproduced in the excellent monograph on Thurston Hopkins published by Gordon Fraser, in association with the Arts Council in 1977. The book has the benefit of a preface by Robert Muller, screen writer and TV playwright, who worked on a number of *Picture Post* projects with the photographer.

Some photojournalists object to going on assignment with a writer but Thurston Hopkins appreciated the material assistance and, abroad especially, the daily companionship. He worked happily with strong personalities like the late Kenneth Allsop, Brian Dowling, David Mitchell and Fyfe Robertson. There is, of course, an added advantage. The famous, and even more so the unsophisticated, tend to gaze at a camera, but while a reporter is talking to them, the photographer can shoot virtually unobserved. The reporter can also preserve you from getting involved in such a fascinating conversation that you forget to concentrate on taking pictures—a trap Thurston Hopkins admits to falling into when photographing Somerset Maugham.

Thurston started taking photographs for a Fleet Street agency, Photopress, with no formal training or instruction. He battled to gain experience with a cumbersome string-blind Goetz-Anschutz camera, his pockets weighted down with glass negatives. He was expected to use flash-powder in public places, flash bulbs were rationed, they were expensive. Even using them, there was seldom a chance of a second exposure, changing the flash bulb and plate took at least ten seconds.

Like many photographers of his era, Thurston spent the World War II years with an RAF photographic unit, working in Africa and Italy. By the time he returned to Fleet Street and succeeded in getting a job on *Picture Post*, the 35mm camera had come into being.

The All Night Vigil, Thurston Hopkins remembers, was taken with an early Leica, using a wide-angle 2.8 Heligon lens. The exposure was probably $\frac{1}{10}$ or $\frac{1}{4}$ of a second. You needed much concentration and a steady hand. Electronic flash was available and much easier to use than flash bulbs, but it was quite rightly deemed on *Picture Post* that flash of any kind falsified reality and their aim was to present human behaviour and life as it was.

Thurston Hopkins' growing reputation was built on photographs such as the *All Night Vigil*. So many of his best picture essays were taken on the edge of darkness, for him a magical time. However, betwixt day and night, it is especially necessary to be visually aware and resourceful. Successful shots such as this demand craftsmanship and practised professionalism.

After leaving school, for several years Thurston Hopkins had studied graphic illustration at the prestigious Brighton School of Art. It was to be an important factor in his creation of the imaginative *All Night Vigil* and other memorable photographs. His work was never self-indulgently arty, nor was it strident with the attention seeking convergent verticals so fashionable nowadays. Throughout his photographic career he retained the educated eye and the calm lucidity of an artist, but also he had a wonderful appreciation of the continuing drama of everyday existence.

—Anne Bolt

Bibliography—

Jay, Bill, "Thurston Hopkins," in *Album* (London), April 1970.
Muller, Robert, *Thurston Hopkins*, London 1977.
"Thurston Hopkins: Man of the Streets," in *Amateur Photographer* (London), 18 May 1977.

Eikoh Hosoe (1933–)
Barakei, or Ordeal By Roses, 1961–62
Black-and-white photographs

In September 1961, the young Japanese photographer Eikoh Hosoe was offered an unusual assignment: to photograph the internationally-famous novelist Yukio Mishima for the jacket and frontispiece of Mishima's first book of critical essays. Hosoe had never met the novelist, but it emerged that Mishima had specifically requested that Hosoe be chosen, and that the novelist had been impressed by Hosoe's photographs of the dancer Tatsumi Hijikata. The dancer, as it happened, was a devotee of Mishima's writing.

This first meeting was significant. Mishima was not interested in a mere "portrait of the author," but wanted to present himself as "the subject matter of (Hosoe's) photographs." In Hosoe's words, "he wanted to become a dancer himself." Hosoe, still in his twenties, claims that he, in turn, naive enough to be "unable to distinguish between an international literary figure and a dancer."

What this means becomes clear when one looks at the photographs collected in *Barakei, or Ordeal By Roses*, the fruits of the collaboration between Mishima and Hosoe. Encouraged by Mishima's enthusiastic response to the photographs taken at their first meeting, Hosoe suggested that Mishima "be his model." Mishima accepted without hesitation.

Hosoe's writings on the project emphasise very strongly the experimental nature of the project: "I wanted to explore a theme of life and death through Mishima's body and flesh, but the idea was never concrete at the start." Mishima, the famous writer, allowed himself in this unique situation to become a model, an almost passive figure, a "perfect body."

When Hosoe visited Mishima's house for his second session, the novelist showed him reproductions of several Italian Renaissance paintings, including Raphael's Saint Sebastian, his body transfixed by arrows—an image Mishima found particularly beautiful. Hosoe "thought the painting was marvellous," but "at the time I didn't know why the body of a man dripping blood, where his breast had been pierced by an arrow, should be beautiful." This strange combination of beauty and suffering is, however, something that suffuses the images in *Barakei*.

Hosoe was also taken by the idea of using "whatever Mishima loved or owned to form a document on the writer." Inspired by Mishima's enthusiasm for Renaissance art, Hosoe used a specially-painted backdrop, based on Giorgione's *Sleeping Venus*: "I thought that Mishima's Venus would be born by merging his flesh with the half-painted Venus." The other models in the photographs were the dancer Tatsumi Hijikata, the subject of the photographs that had so impressed Mishima, and Hijikata's lover, Akiko Motofuji. Again under the inspiration of Western Renaissance art, Hosoe sought—and found—"a woman who had the image of the holy virgin," a young film actress named Kyoko Enami.

In January 1962 some of the photographs were included in an exhibition of Japanese photography in Tokyo. It was from this that the title *Barakei* emerged, being one of eight suggestions made by Mishima at Hosoe's request. This, the photographer felt, "fully expressed the content." "Bara" means "rose" and "kei" means "punishment"; when the photographs were first published in book form in 1963, Mishima suggested that the English title should be *Killed By Roses*, but later revised this to the more accurate—and enigmatic—*Ordeal By Roses*.

The theme of the book was slowly becoming apparent—the exploration of "a theme of life and death through Mishima's body and flesh." The crystallization of this idea took place over several months, from autumn 1961 to spring 1962. In fact, the early sections of the book were shot towards the end of this period, when Hosoe had the idea of introducing a young child into the project, to symbolise birth. Just as he had suggested the title of the project, Mishima was also to decide on a name for the final chapter—*Death*. This was in autumn 1970, when the book was being revised for a second edition. Soon afterwards, on November 25, 1970, Mishima committed suicide by the traditional Japanese method of *seppuku*.

Looking at the photographs with the knowledge of this shocking event, it is tempting to see them as in some way foreshadowing Mishima's own death. Hosoe, however, refused to allow his photographs to be associated with the event, ignoring the demands of the press and postponing the publication of the second edition. He believed that "the photographs from *Barakei* had no direct relationship to his suicide."

What the photographs do reflect quite clearly is the curious and fertile mixture of Western and traditional Japanese influences which are apparent in Mishima's life and work. But in apparent contradiction to Hosoe's stated aim of creating "a document on the writer," there is nothing in the photographs which hints at Mishima's profession. What Hosoe emphasises instead is Mishima's physical being, "his gorgeous flesh and supremely powerful body." Mishima, the sickly child and the young man rejected from active army service as physically unfit, had in his thirties begun to transform himself, through rigorous exercise, into a "perfect body," and it is this that the photographs celebrate. Mishima's subtext to the exhibition of photographs used in the exhibition *River of the Flesh*, may provide a clue to his untimely suicide: "I will never admit the decay of the flesh."

Three editions of the book have appeared: the first in 1963, designed and with graphics by Kohei Sugiura. The second edition, which was postponed owing to Mishima's death, finally appeared in January 1971, redesigned by Tadanori Yokoo in consultation with Mishima and Hosoe. This edition had been changed to comply with Western design, whereby the pages are turned from the left and the text is horizontal, instead of vertical. The calligraphy for the title, credits and headings was produced by Mishima himself. At this stage, too, the subtitle was changed from *Killed By Roses* to *Ordeal By Roses*. The latest edition, published in 1985 and designed by Kiyoshi Awazu, returns to the structure, sequence and chapter titles of the first edition, and is enhanced by the use of bold colours, such as imperial purple and blood red. The book contains the original preface by Mishima.

Mishima explains the division of the book into five sections: "Prelude, Part I, Variations on a constant theme"; "Part 2, The Citizen's Daily Round . . . the madnesses of the solid, worthy, average citizen"; "Part 3, The Laughing Clock, or the Idle Witness"; "Part 4, Divers Desecrations"; and "Part 5, The Retribution of the Rose . . . the protracted torment of his execution." Mishima's elaborations on these themes do not so much explain the photographs as testify to the disturbing effect they produce: "The world to which I was abducted under the spell of his lens was abnormal, warped, sarcastic, grotesque, savage, and promiscuous . . . yet there was a clear undercurrent of lyricism murmuring gently through its unseen conduits."

Each of the sections has its own images and atmosphere, but there are common elements, such as the use of strong contrasts between light and shadow (all the images are in black and white apart from several pages in the first section, vividly-coloured symbols or details taken from paintings or drawings, suggesting birth and creation).

At times, the contrasts between light and darkness give the pictures a sinister, nightmarish quality, but they can also—when the photographs are exposed to a point at which they take on a grainy quality—cease to be a literal record of an object, and become something far more enigmatic and poignant.

There is a strong element of surrealism in Hosoe's photographs, particularly in the earlier sections, where objects appear in unusual and sometimes amusing contexts. The first time we see Mishima, he is standing almost naked in a ridiculously opulent setting of marble balustrades and staircases, furnished in a Spanish baroque style. A sinister note is introduced with the presence of a chained figure in the background. In the third section, "The Laughing Clock," the surrealism acts in a disturbingly dehumanizing way. Mishima crouches in the middle of an empty white page, encircling his eyes with forefinger and thumb, which gives him an inhuman, owl-like appearance. In the same section, Mishima's body is

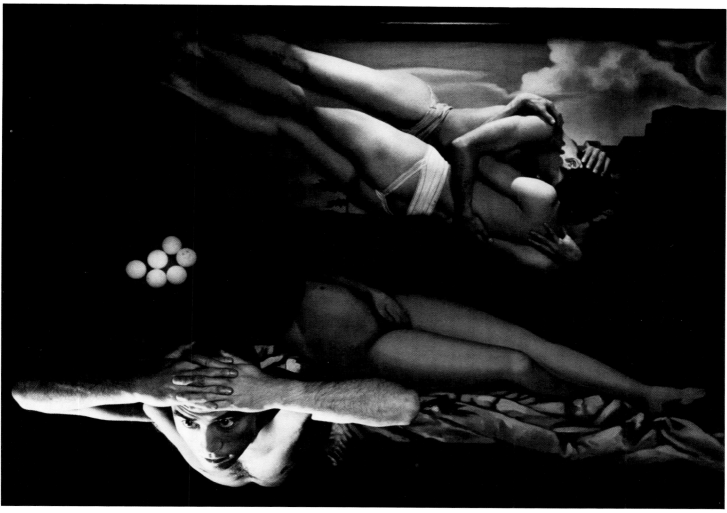

© Eikoh Hosoe

merged with the lower torso of the Sleeping Venus, transforming him into a voyeuristic dreamer looking at, but excluded from, the embrace of the lovers in the background. Symbols are used in different settings with varying meanings; an animal's tusk or horn is in one photograph primitive and phallic, in another it is like a ritual instrument.

As one section gives way to another, the images become darker—both in a literal sense and in the discarding of the element of humour, albeit mocking and alienating, that characterized some of the earlier sections. Images of bondage and torment recur with surprising frequency and emphasis: the impassive figure wrapped in a garden hose of "The Citizen's Daily Round" is replaced by torsos bound like torture victims. Faces are increasingly hidden in deep shadow and the body is thus deprived of its personal, human quality, acquiring instead the appearance of a sacrificial beast. Often only the chest, back or legs are shown, sometimes brightly-lit. In the penultimate section, "Divers Desecrations," Hosoe returns to images from Renaissance art, but this time the images are religious. Botticelli's *Birth of Venus* gives way to the Virgin Mary, the Mater Dolorosa whose son was tortured on the Cross.

In the last section, we are shown the darker significance of the rose, with its cruel thorns. In Mishima's words, "So the collection draws to its close, with death, and ascension to a dark sun."

In *Barakei*, Hosoe has succeeded in accomplishing what he set out to do, to create through destruction. He destroys complacency through sardonic humour, through exposing "the madnesses of the solid, worthy, average citizen." What he creates through this process is something of extraordinary and disturbing beauty, and of great poignancy. *Barakei* refuses to be confined to time or place, but represents a universal condition.

—Jessica Arah

Bibliography—

Hosoe, Eikoh, *Barakei, or Killed by Roses*, Tokyo 1963.
Hosoe, Eikoh, *Barakei, or Ordeal by Roses*, Tokyo 1971.
Hosoe, Eikoh, *Barakei, or Ordeal by Roses*, Millerton, New York 1985, Paris 1986.
Nori, Claude, *Eikoh Hosoe*, exhibition catalogue, Paris 1982.
Spielmann, Heinz, *Die japanische Photographie: Geschichte, Themen, Strukturen*, Cologne 1984.
Tsukuba Museum of Photography, *Paris-New York-Tokyo*, exhibition catalogue, Tsukuba 1985.
Holborn, Mark, "Yukio Mishima/Eikoh Hosoe," in *Artforum* (New York), March 1984.
Torino Fotografia 1987, exhibition catalogue, Turin 1987.
Holborn, Mark, *Beyond Japan: A Photo Theatre*, London 1991.

Graciela Iturbide (1942–)
Mujer Angel (Angel Woman), Sonora, 1980
Black-and-white photograph; 25 × 35cm.

The title adds immediate provocation to the image: Why an angel? This woman sprawls across the harsh landscape, arms outstretched, with one hand steadied on a rock as she ascends, poised. The gesture implies a certain gracefulness, as does the silhouette, dressed in a peplumed blouse and billowing full skirt (which identifies her as a Seri), her long hair hanging down her back in loose strands. Is this "winged" creature a game of imagining, like seeing shapes in cloud formations? Or does the radio she grasps in her right hand bring an announcement? Is she a messenger and the scene a visitation, with all the moral force such a moment signifies?

Transcendent, alone, she crosses a sharp diagonal that bisects the picture plane into triangles of dark foreground and distant light, two bright triads caught in the crooks of her arms. Does this contrast denote a clash between good and evil, Indian tradition and the electronic age, vegetative life and barren emptiness? Such possibilities lurk without affirmation. Any woman alone is vulnerable, endangered, and emphatically so in Mexican society, where to be without family is a form of ostracism or rebellion. Why is she unaccompanied and thereby unprotected? Either the scene holds hidden menace, or perhaps her trip is sanctioned.

What may well be an ordinary passage from place to place becomes, in the context of Graciela Iturbide's work, charged with drama and mystery. We never know if the woman is hurrying to a lover, fleeing a dilemma or carrying out an errand, merely that her hair is unbraided so it is probably a special occasion. She is unidentified, emblematic, ostensibly the "other." Certainly, Iturbide has absorbed the lessons of her mentor Manuel Alvarez Bravo, mastering both the formal values of the straight print and the heightened ceremonialism or inversion of everyday appearance that has led critics to dub Mexican work almost generically surrealist.

Not only does the unexpected occur daily in Mexico, but typical Mexican fiestas, religious processions, market stalls and street advertisements provide authentic props and costumes for the photographer alert to ironic contrasts and the peculiar blending of layers of civilization: indigenous, colonial and modern. Like her contemporaries Pablo Ortiz Monasterio and Yolanda Andrade, Iturbide adeptly captures the humor in such juxtapositions of subject and backdrop, but often she emphasizes a jarring discord between figure and surroundings, particularly the rapt inwardness of certain individuals. This physical detachment signals intense psychological states. *Sueños de Papel* (1985), the book in which Angel Woman was published, recasts reality in bizarre dreamlike vignettes. Masks and rituals inject elements of fantasy and theatricality reminiscent of Diane Arbus' sensibility. A quirky edge characterizes each situation.

Images of angels abound in this visual essay, which won her a fellowship from the Institute of Fine Arts. These include a man cradling a religious statue, various girls dressed for pageants, a wall painted with a Dracula-like angel bride, and a woman vendor winged by fuzzy arcs of sisal scouring pads strung together. Certainly one issue raised by Iturbide's work is the notion of gender stereotypes. Whereas endearments like the Spanish for doll, queen and precious one stress female dependency, the sacred context of "angel" is more complex. The diminutive, angelito, is used for (baptized) young children who die in a state of purity and whose souls return directly to heaven; and Christmas *pastorelas* (morality plays) and indigenous dances feature a male avenging Angel, Lucifer, a powerful force for good. Also, folk Catholicism permeates daily life, mingling the Virgin Mary with her retinue of angels and the Virgin of Guadalupe, Mexico's patron mother. As a symbol of spirituality, the angel suggests the special powers of women in Mexican society as healers, caregivers, nurturers and repositories of tradition.

Although children, men and animals appear frequently, her real province is the lives of indigenous women. Graciela Iturbide began her career documenting Indian communities for the National Indigenous Institute (INI) in Mexico City, an agency founded in 1930 to foster the continuity of native cultures. Of her early study of the Seris of Sonora, *Los que viven en la arena* ("those who live in the sand," 1981) she later wrote that these people were making an historical leap from nomadism to capitalism. One hardly need be reminded of the gaping economic disparities and social inequalities in Mexico to realize the extent to which being identified as Indian, or a woman, still is a disparagement. Iturbide's choice of subjects reflects an attempt to breach her own conventional bourgeois upbringing, and at the same time recognize the validity and customs of those she photographs. She never aims her lens dispassionately, a trait shared deeply with her former companion and fellow founder of the Consejo Mexicano de Fotografia, Pedro Meyer. The communal life of remote pueblos and rural towns, and increasingly among a community of women, holds a romantic fascination not untinged with eery power.

For her recent book, *Juchitán de las Mujeres* ("Juchitan of the women," 1989) Iturbide travelled to the Isthmus of Tehuantepec in coastal Oaxaca, where the beauty, lust and independence of its women is as legendary as that of mythical Amazons, a place of fierce political confrontation and uncommon vivacity. Here she is on more open terms with her subjects than in *Angel Woman*, but the same mystical sense of grace persists. The shots are tighter, composed to examine intimate moments. The forcefulness with which Juchitecas confront the camera is a tribute to Iturbide's skill as a portraitist and natural sympathy for individuals, who opened their yards and salas to her, posing with great dignity. What remains most arresting, however, is the strange tension between familiar acts and unexplained manifestations. Even when a scene is domestic and relatively benign, a cluster of women patting tortillas or a mother suckling her child in a hammock, the emotional charge within the scene places the viewer outside, as voyeur.

Then too, there are images of poetic strangeness, like secret rituals, that turn out to have perfectly simple explanations. For example, the custom of the groom abducting and deflowering his virgin bride, then waving the stained bedsheets in public evidence, is still practiced among Zapotec families, hence the symbolic scattering of blossoms around the reclining girl covered by a white sheet in *Rapture* (whose title in Spanish also means abduction or rape, *El rapto*). This mixture of ordinary and ritual acts, of traditional roles and curious aberrations, transforms many of Iturbide's works into startling epiphanies.

Like narrative painting, contemporary photography in Mexico has given vibrant expression to social concerns and a revisionist view of history. Feminists, in particular, have embraced the work of Iturbide, Flor Garduño, Mariana Yampolsky, Lourdes Grobet, as well as a younger generation, who look to indigenous groups for a reaffirmation of spiritual values and female strength. The search for what is distinctly Mexican still owes much to women pioneers like Tina Modotti, Kati Horner and Lola Alvarez Bravo. Confident in this heritage, Graciela Iturbide creates images full of angst and wonder, compelling international attention.

—Pamela Scheinman

Bibliography—

Iturbide, Graciela, and Volkow, Veronica, *Suenos de Papel*, Mexico City 1985, 1988.
Iturbide, Graciela, and Poniatowska, Elena, *Juchitan de la Mujeres*, Mexico City 1989.
Reyes Palma, Francisco, *Memoria del Tiempo: 150 anos de fotografia en Mexico*, Mexico City 1990.
Conger, Amy, *Companeras de Mexico: Women Photograph Women*, Riverside, California 1990.
Sullivan, Edward, *Women in Mexico*, Mexico City 1990.
Sullivan, Constance, ed., *Women Photographers*, New York 1990.

© Philip Jones Griffiths/MAGNUM

598

Philip Jones Griffiths (1936–)
Victim of Napalm Bombing, South Vietnam, 1967
Silver gelatin photograph

Victim of Napalm Bombing appears as the penultimate photograph in Philip Jones Griffiths' classic 1971 war reportage, *Vietnam Inc.* An episodic, cumulative forceful declaration against imperialism and its consequences, *Vietnam Inc.* stands, two decades later, as a model photo book in which photographs and text work in unison, and where the idea of a dialectical authorship effectively defeats received notions of the illustrated book. *Vietnam Inc.* is a symphonic, cumulative work of anti-war protest. Critics saw it as: "a very bitter book," and took pains to describe its singular methodology: "Griffiths worked on it for five years—three of them in Vietnam, with a break in the middle to work on the layout and read more. The writing came together in the final six months."

As a document, it is idealistic, (in its view of the Vietnamese rural economy), sometimes simplistic (in its perception of an idyllic peasantry), and acutely sensitive to the phantasmagoria of a war without battles, a citizenry oppressed, set against the background of a mutilated landscape.

More than any other photo-book of its generation, *Vietnam Inc.* reasserted the credibility of the photojournalist as a true witness, a commentator enabled to mould public opinion, to make cogent political statements in photographic form. As photoreportage emerged out of its wilderness years of the late 'fifties and 'sixties, it was Jones Griffiths with *Vietnam Inc.* who reinstated photojournalists centrally on the moral agenda.

By the time that Jones Griffiths had published *Vietnam Inc.*, Western photojournalism had established a vigorous tradition of commenting on warfare. Robert Capa, Gerda Taro and Hans Namuth had photographed the Spanish Civil War in the late 'thirties. Fashion photographer and experimentalist Lee Miller proved to be an incisive reporter when she documented the post-war liberation of Europe, while Magnum founder George Rodger delivered a searing chronicle of Nazi death camps in Eastern Europe. *Vietnam Inc.*, formed a new chapter in the history of war reportage. By placing the photographer, his conscience and his politics squarely at the centre of the narrative, Jones Griffiths opened up a revived debate within photojournalism, establishing a context for the revelatory chronicle, a new kind of photoreportage, committed, involved and partisan. "You can be objective, I suppose," he suggested, "about the structure of the hydrogen atom or something—an individual brings all that baggage, all that emotional baggage . . . The moment that you are dishonest, you will lose the whole game, you will lose everything. . . . You [must] put over information in a way that you sincerely believe to be truth, and there is not a single word in my book—or a picture—that I don't believe to be true."

In *Vietnam Inc.*, Jones Griffiths establishes the ideal of the village as his central theme. Many of the photographs, and the text which accompanies them extol the peace, harmony and spirituality of rural life: "the secret of their strength lies in the nature of their society. The foundation of their society is the village. Set amid the sea of rice fields, villages rise like identical islands, surrounded by sheer cliffs of bamboo. Inside live those who tend the rice, in great proximity to one another . . . but within a well-organized whole."

Through photographs and text, Jones Griffiths set this symmetry and tradition in direct comparison to the violent rhetoric of the American military. The book is empowered by its use of contrast—the small, smooth Vietnamese compared with the towering, hirsute American GIs, the fragility of straw roofed village huts when set against the hard gleaming weapons of the troops, the burned hand of the napalm victim contrasted with the soft purity of white bandages. It is strengthened, too, by its continuous use of paradox—country people, moved from their villages by the Americans and "saved," become scavengers, living on city rubbish heaps, posters extolling freedom form a satiric backdrop to city folk fleeing from fire and destruction.

Set within this pictorial and narrative context, *Victim of Napalm Bombing* becomes a central and apostatic icon. The burned woman, labelled like a parcel, becomes a surplus commodity of the war effort. The very facelessness of the victim, obscured by injury and by bandages becomes a metaphor for depersonalization. The hand raised to the hidden eyes, in horror or in pain, becomes symbolic of a societal blindness, a vicious obscuring of the truth.

For Jones Griffiths, the use of napalm was the final scabrous act in an unfolding saga of disrepute. *Victim of Napalm Bombing* appears at the end of the section of photographs in *Vietnam Inc.* which shows burned and damaged hospital patients. The photographs show a modern-day Hades of disfigurement and mutilation, a dire tale of death and pain and humiliation. Stepping around the bodies, Jones Griffiths makes a grim chronicle of a society made sick, crippled and deformed. Within this assemblage, *Victim of Napalm Bombing* stands as a strategic reference point, the moral of the tale. For Jones Griffiths, it was one integral part of a meticulous jigsaw of illustrative effect, political conviction and ethical outrage: "The way my brain works and my body works is to take a long calm look at things and try and answer and assess...[putting] it together, so that under your arm you can have a document that will tell you clearly, truthfully, and as meaningfully as possible what actually happened there."

Of all the powerful works of photojournalism published in Vietnam Inc., *Victim of Napalm Bombing* has the most resonance. It is a many-layered, many-levelled photograph. The blindness of its subject becomes universalized as society itself becomes blind to the wrongs of war. The photographer's task becomes that of seeing and revelation. Ruefully messianic, Jones Griffiths establishes himself, centre stage, as observer, witness and judge. *Victim of Napalm Bombing* emerges as an exercise in self-portraiture, a reflection through the lens of a troubled, doubting and damaged self.

—Val Williams

Bibliography—

Jones-Griffiths, Philip, *Vietnam Inc.*, New York 1971.
MacPherson, S., "Vietnam Inc: Philip Jones-Griffiths," in *British Journal of Photography* (London), 17 March 1972.
Lewinski, Jorge, *The Camera at War*, London and New York 1978.
Fabian, Rainer, and Adam, Hans Christian, *Bilder vom Krieg*, Hamburg 1983, London 1985.
Fulton, Marianne, *Eyes of Time: Photojournalism in America*, New York 1988.

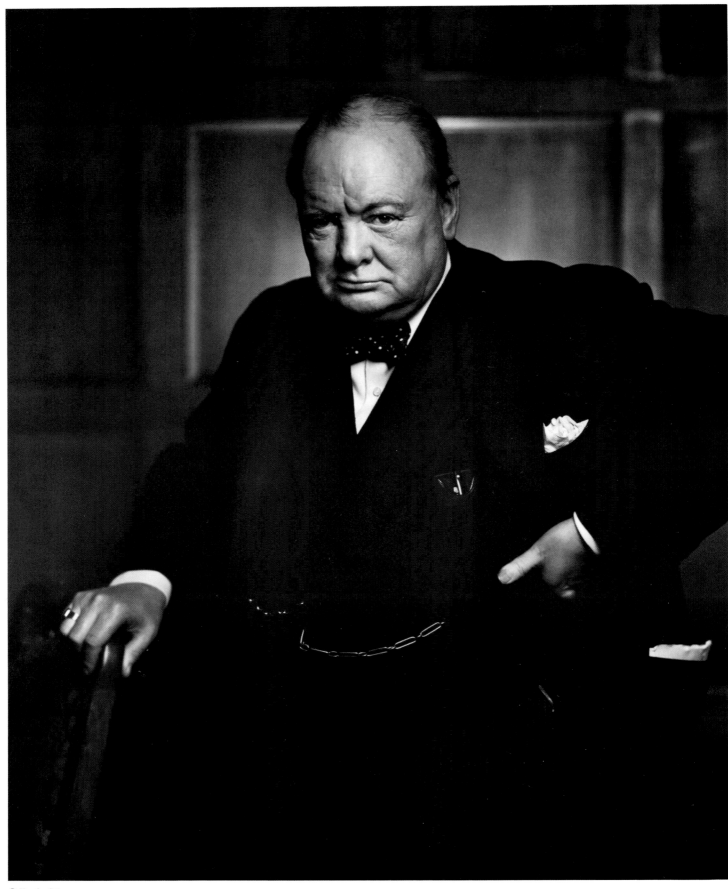

© Karsh, Ottawa

600

Yousuf Karsh (1908–)
Winston Churchill, 1941
Black-and-white photograph

Most often photographs are remembered because of the people or objects appearing in them. It is rare that a photographic image is noted for what is *not* there. However, that is the case with Yousef Karsh's *Winston Churchill*. This is a beautifully lighted, full-toned photograph dominated by a three-quarter view of Churchill standing against a background of rich wood paneling. The Prime Minister is seen glaring at the camera, his body stern. One hand clutches a chair-back, the other pulls his coat open to reveal a watch chain, and folded in his coat pocket are papers that may well have been the speech he had just delivered to Canada's House of Commons. What is *not* in the photograph is Sir Winston's usually present cigar. That was a conscious and, although he did not realize it at the time, a fortuitous decision by Yousef Karsh.

Though other artists at other times have angered or otherwise upset their subjects in order to elicit a particular reaction, my conversations with Karsh have indicated he had no inkling that the removal of the cigar would cause Churchill to give him the look that would make his fortune; he simply did not want the cigar in the photograph. This was an important sitting for the photographer from Ottawa, and he was taking it very seriously.

He had imposed upon his friend, Walter Turnbull, private secretary to Canada's Prime Minister Mackenzie King to arrange the sitting. He set up his equipment the night before, arranging his lights using a stand-in. Studying the facial expressions of Sir Winston during the speech, he planned the upcoming photo session. When Churchill finished his address, he was ushered into the room set up for the photography. Karsh remembers that he then found himself in an unexpected and awkward situation: no one had informed the P.M. that he was going to be photographed. When Churchill saw the lights he asked, "What's this, what's this?" None of the officials in attendance seemed to have the courage to explain, so Karsh stepped forward and stated his intention of making a portrait of Sir Winston. Churchill discarded his old cigar, lit a new one, and puffing away, said, "You may take one." Karsh asked Churchill to remove the cigar, but the P.M. would not. Karsh checked his camera to ensure everything was technically correct, then stepped up to Churchill, and with a "Forgive me, sir," removed the cigar. Sir Winston glared and Karsh made an exposure.

While this may seem to be entirely accidental, it is consistent with Karsh's philosophy of making portraits. As he stated in his autobiography, *In Search of Greatness*, "My quest in making a photograph is for a quality that I know exists in the personality before me, for what I sometimes call the 'inward power,' and I am more anxious to capture that, or at least to interpret it to my own satisfaction, than I am to create the facsimile of an interesting figure with no depth of soul." Karsh's sense of what was right for this subject, at this time, may or may not have caused him to pluck the cigar. But his sense of it all left no doubt that he had captured some of the Prime Minister's "inward power." He was also sure that it would be this photograph, not the one taken moments later with the P.M. smiling, that had the most "depth of soul." He had managed to record a visual idealization of Churchill's public image and his legend. An image that the world wanted to see . . . embattled England's Prime Minister portrayed as tough and unyielding, an image that America and the Allied Powers needed in those early war years. Karsh had given the world a symbol of England's tough and fighting spirit. A symbol that inspired the world.

The world's acceptance of this photograph as a political symbol empowered it beyond what it actually is—a technically excellent portrait of an important man and not much more. At another time, this photograph would probably not have had much significance. But it did become significant and so did Yousef Karsh. This photograph made Karsh's name familiar around the world and gave him access to other important personages who wanted to be turned into icons by his camera.

Yousef Karsh stepped boldly through the doors opened by his new-found fame and became *the* photographer of great people and those who wanted to be great. In the years since that fateful cigar was plucked, Karsh's camera has recorded movie stars, heads of state and others with enough money and power to afford or interest him. Included in his list of prestigious clients are such notables as Elizabeth Taylor, members of the British Royal family and Ernest Hemingway. His work has been published and exhibited widely allowing the world to see and study the faces of the rich and famous—a subject that continues to fascinate both commoners and the subjects themselves. After the Churchill session, Karsh continued to interpret his subjects as he felt best, with and without their trade-marks. He refined and polished his photographic style until its artistic values became as strong as the face values of the living legends he photographed.

—Michael Laurance

Bibliography—

Karsh, Yousuf, *Faces of Destiny*, New York and London 1946.
Karsh, Yousuf, *Portraits of Greatness*, London, Toronto and New York 1959.
Karsh, Yousuf, *In Search of Greatness*, New York 1967.
Photographs of Yousuf Karsh: Men Who Make Our World, exhibition catalogue, Montreal 1967.
"Karsh '67," in *U.S. Camera and Travel*, New York 1967.
Karsh: A Fifty-Year Retrospective, exhibition catalogue, Boston, New York and London 1983.

Courtesy The Art Institute of Chicago

602

Andre Kertesz (1894–1985)
Chez Mondrian, 1936
Black-and-white photograph

Chez Mondrian: we see a worn wooden stairway and its rail, continuing upward and past the open doorway. On our side of the mat, where planks change to tile, a coatrack with a straw hat and coat neatly hung on one of the pegs, and a narrow table supporting a vase with a single tulip in it. Strong light falls on the landing and enters the room from that direction, so that the vase casts a diagonal shadow.

According to Michel Seuphor's description, Mondrian's studio in the 1920s, on the Rue du Départ in Paris, was on the third floor, reached by a winding stairway. Opposite a recess which appears across the landing in this view was the entrance door, and in between a window. The room into which this door opened served as kitchen and bedroom combined, and had a window in it which Mondrian sheathed with curtains to control the light and partition the space; correspondingly, only a weak and diffused light filters through from this window. The studio itself was reached by a short flight of steps lying off to the left, beyond the edge of the photograph, and presented a striking contrast in both brightness and furnishings. Kertesz photographed Mondrian in that studio in 1926 also, portraying him in a wicker chair next to his easel, and did a companion still life of his pipe and glasses.

Whereas both of those images correspond to established types of photography (portrait and still life), the present photograph eludes any such traditional classification. It can be thought of as an interior view, in that it shows a corner of a closed space with household objects and a glimpse of what lies beyond; as a still life, in the qualities of composedness and composure which ordinary objects like the hat and vase take on; and as a portrait also—one could say a portrait by inference—because the sense of arrangement and ordering of the room characterize the person who lives there in terms of habits and aesthetic preferences. It is at this point that the information given by the photograph becomes inseparable from the interpretation it offers—of this room as Mondrian's.

The contribution of outside knowledge need not, to be sure, shape our perception of what such a photograph shows. Had this one been lost, to resurface without a title attached to it, one would see the room as that of an orderly person, who decorated the wall with some kind of geometric patterning and kept house very simply. The control over lighting so productive of tonal subtleties would be taken as the photographer's own choice, as would the starkness of the single, isolated flower. Nothing can be taken for granted in the way of non-pictorial determining circumstances—the photographer being the one who marshals and distills the order in question; but it's a fair assumption that Kertesz was already in sympathy with Mondrian's character and art.

What visual analysis can provide is a sense of how the different components of the image are made to fit together and work, pursuant to pictorial decisions on the photographer's part, which are themselves subsumed within his interpretation of his subject. These decisions may entail the recognition of features and properties of the subject as cohering and interacting suitably for the effect the photographer wants: an image ratifying some aspect that the world presents. A lighter wall beyond the door here comes forward to interplay with the darker inside wall in shape and texture; spaced apart equidistantly by the placement of the flower, the hat and doormat form as though by happy accident a contrast of shape and an activation of their surfaces in similar texturing. Such effects might present themselves without search, but the photographer must still recognize their potential. Where painters invent, he selects.

The loss of focus, progressing into the stairwell, suggests deeper space at the same time as the light wall denies it. The effect of this on the treatment of the handrail is particularly striking. Spatially, it hangs suspended, bridging the distance between nearer and farther wall planes, while its surface rhythm creates an arc of energy discharging itself through the vase and on along the thrust of the elongated elliptical shadow. At the same time, this curve resonates visually with other curves, each different in character, size, and substance—the hat, the vase, the bottom step. Choice of viewpoint and cropping are such that the left door frame virtually bisects the image; at the top, the angle of the lintel perceptibly climbs, as if seeking the upper right corner, to form a dark wedge. Irregular geometric forms, larger and smaller, varying in their density and covering the whole tonal scale, interact with one another. The angle of the lighting brings out moldings and projections which give interest to the edges of surfaces, and throw the flower and vase into relief against the relatively flat and internally undifferentiated background shapes.

Such are the main structural features, but one cannot talk about these without leading towards the capacity of the picture to conjure up a mood, which does not arise merely from an aggregate of parts but from their consonance and interaction. This mood is one of coldness, austerity, and stillness. The flower might have been frozen; the coat hangs as if never to be moved again; the stairway, though worn, seems unused; the directional light is clean and concentrated.

This austerity brings one back to what the photograph now carries in the way of commemorative content. Kertesz, who had moved to Paris in 1925 and had his first gallery show there in 1927, as it were creates for himself and for us, in this 1926 group of photographs, a Mondrian of his own: an artistic image of an artist's personality. The creative decision and choices described could have been prompted by that personality but need not have been. They could also have enhanced further, once visually realized, an already existing response of understanding and attunement; but such questions are finally irrelevant. The evocation of neatness and strictness without elegance which comes out in the portrait of Mondrian, in details of dress and furnishings, and the austerity evoked in the still life of pipe and glasses are both present here: their presence conveyed indirectly and also more powerfully. The final effect is that this image is not about the historical figure Mondrian, nor dependent upon the significance that his name and art have for the viewer. Rather, it crystallizes, in the independent medium of photography, how aspects of Mondrian's daily life and environment can be made to reflect what he was about as an artist. The *making* is the achievement of Kertesz.

—Mark Roskill

Bibliography—

Kertesz, Andre, and Szarkowski, John, *Andre Kertesz, Photographer*, New York 1964.
Farova, Anna, *Andre Kertesz*, New York 1964.
Kertesz, Andre, *Andre Kertesz: Sixty Years of Photography*, New York and London 1972.
Kertesz, Andre, *J'Aime Paris: Photographs Since the 1920s*, New York 1974.
Kertesz, Andre. *Kertesz on Kertesz: A Self Portait*, New York and London 1985.
Phillips, Sandra S., and others, *Andre Kertesz: Of Paris and New York*, New York and London 1985.

© Chris Killip

Chris Killip (1946–)
In Flagrante: Man and Fire, c.1982
Black-and-white photograph

I look at this picture and, just as the flames and smoke swirled about the waste ground in Chris Killip's viewfinder, so the ideas swirl, smokily, around in my mind. I think to myself, the world's end, the end of the world, *anus mundi*: the arsehole of the world. And then I begin to interrogate my language to test the validity of these choices, to look for the interconnections, and tease out the deeper levels of meaning within my first reaction.

We must first know that *In Flagrante* is a selection made by Chris Killip from his photographs taken in the North East of England between 1975 and 1987. Killip tells us that: "The book is a fiction about metaphor." He thus leaves the way clear for us to build our own general truths from his assembly of images and specific data. This is just the method of Dickens, Zola and the other social novelists; their work was investigative, questioning, shot with poetry and hardly constrained by imported dogma. It has, let us remember, lasted; not least because of the disconcerting habit of supposedly long-vanquished problems to come round again, affronting us in only slightly different form. And their novels are so readily fertile because they are based upon uncertainties of human experience beyond the powers of the statistician to conjure. So it is with Chris Killip's photography, though for a dozen reasons I resist the temptation to take the comparison further.

I return instead to the man and his fire. Whatever angle Chris Killip had chosen to shoot from, the photograph would have shown us a blighted spot of earth; vegetation struggling to semi-life against God's better judgment and in competition with a heterogeneous, dying collection of manufactured objects. Not to mention the fire. But this particular high angle gives the next best thing to a plan view, enabling some approximation of quantities as well as of the kinds of things occupying that rhombus of blasted land. The photographer's skill ensures the maximum registration of surface qualities, whether of metal, plastic, wood or merely mud. His positioning of the man near the apex of his triangle of objects gives the sense that we are in the presence of the ruler of this trashy kingdom.

The sort of kingdom indeed, which might be discovered around the limits of the known world. The kind of place where, far from the metropolitan centre, inhabitants may be left to rot, to follow trades forgotten in the prosperous south, such as the coal-finding carried out on the beaches—what bleak beaches for a kingdom by the sea—when they are not being actively persecuted by their rulers. After all, contemporary deindustrialisation may be less spectacular or physically brutal than William the Conqueror's depopulation in his Harrying of the North, but as administrative acts, they do have certain features in common, given the difference of their eras. It may seem ironically appropriate that the one object in the photograph which bears legible printing, is a bag which once contained Cornish calcified seaweed; the product of that other ancient kingdom at the southwestern tip of Britain which, were it not for tourism and a milder climate, might still compare in its austerity, and for much the same reasons, with the condition of the North East, otherwise called Northumbria.

Thus, if I am right in seeing Chris Killip as having located some of his people at the world's arsehole, it is a matter of what has been laid on them, far more than of what they have willingly done to their land. The sheer weight of broken brick and cracked concrete, the tracts of spoil, the suffocating pillows of smoke and other aerial pollution which show up even in the photographs, ought to have poisoned off whatever hope existed, and in truth, the glue sniffers and others do seem to have found their own particular Terminal Beaches. But equally, some fight back, and a few, notably children, actively enjoy themselves. The angle of this photograph does not allow us to guess at the mood of our man at his fire; but would it be too romantic to detect something active and positive in the way he appears to be going about things?

Yet, if Chris Killip has caught the true tenor of the area, then it does display a microcosm of that rise in entropy, the increase in levels of disorder and the falls in potential energy predicated by the Second Law of Thermodynamics: the fading down to universal grey, the imminence of stasis; the end of the world. It is all too appropriate that vehicle wheels should be so prominent amongst the fireside rubbish, to remind us that transport is one of the greatest consumers of energy and materials, besides being a major enabling factor in their consumption by other means.

Remember, though, that all narrative accounts are partial, that all tale tellers speak of what interests and concerns them, perforce omitting what does not. That there will be those who claim that Chris Killip exaggerates; and that there may be some who say he lies, so unbearable are his accounts for those who do not have to live with those actualities shown in *In Flagrante*, especially when they lie only just around the corner.

Think, too, that even if the circumstances of destruction and neglect common to the northeastern region direct or reinforce Chris Killip's choice of subject, the ruination explicit in these images is as implicit in any photographic essay dealing with the most glossy paradise of consumerism, whose downside of waste must by definition be even more dreadful that appears here. What bonfires, what vanities in Beaconsfield and Milton Keynes?

The whole book, and that one picture as representative of it, do in my mind stand as demonstration of the potential for eloquence of the photographic medium, and the possibilities for rhetoric in the unmodified photograph. And the subject of that eloquent rhetoric, humanity, is shown surviving every sort of exploitation, neglect, genuine mistake and fortuitous adversity the rest of the world can perpetrate upon it.

—Philip Stokes

Bibliography—

Yamagishi, Shoji, "Chris Killip," in *Camera Mainichi* (Tokyo), July 1978.
Haworth-Booth, Mark, "Chris Killip—Scenes from another Country," in *Aperture* (Millerton), no. 193, 1986.
Killip, Chris, *In Flagrante*, London 1988, Paris 1989.

Photo M.N.A.M., Paris

606

William Klein (1928–)
Four Heads, Thanksgiving Day Parade, Broadway, New York, 1954
Black-and-white photograph
Paris, Musée National d'Art Moderne

The range of different forms that encounters between people take on goes from those of inner, lasting affection, through indifference, to those of lasting enmity. For want of a deeper understanding, one calls the circumstances that determine the development of an encounter "fate". The web of conditions is too impenetrable, the cosiness of quick assertions too tempting, for there not to be compartments always open in which to place and to fix the relationships of a person, in their friendship just as in their antipathy. To each person the world is different, shaped by the picture that each person forms of it. And therefore people portrayed in photographs represent the world of their own vision as well as that of the photographer. My view of a photograph is in turn a reflection of my experiences and inferences, my view on and of the world. Life is an interweaving of dependencies and apparent interdependencies, which are for the most part simply conditions. Movement is one of these conditions and particularly characterizes the Western idea of life.

Streets are obvious highways not only for people and their goods, but also for these movements. For many photographers, dependent on the appearance of things themselves in the generative or stage-managed photograph, the street is the ideal place to find what they are looking for. Their ideal is to become totally immersed in the crowd, in the flow of movements and of time. It is their job to take note of things via the quickest and most instantaneous of all the media. Appearances themselves are only a means to an end for great photographers in their work. Their actual subject lies behind the appearances. It is the fleeting itself.

The conflict between immobility in a photograph and movement in the subject often presents a dilemma for the photographer. But it forces one to experiment continually to imbue the static quality of the photograph with dynamism. Blurred effects can be achieved by the use of a longer exposure time, while a shorter exposure can bring about an optical freezing of movements. Both serve the same purpose. Extreme views from above or below, as well as the deliberate cropping of important elements in the picture are compositional means to achieve static dynamism. Another stylistic device is to place several pictures in sequence, coursing the flow of movements and thoughts. Moving to the medium of film can be a smooth transition. These transitions have also imposed the fewest limits on those who count among the most readily experimental photographers, or if one likes, those thirstiest for knowledge.

When faster light-sensitive film material came on the market in the 1950s, the demand for it had already existed for a long time. Photographers had the opportunity a few years before the film directors to put it to use it and anticipated the themes before the films. With the handy 35mm camera, freed from the burden and inflexibility of the tripod, freed from their dependence on artificial light, pictures could now be taken unconspicuously, which had been impossible before. Pictures like that by William Klein, who was drawn like so many others into one of these wide streets, to a place where everyone hopes to distance themselves from their life and that of others, Broadway in New York. After military service, studies and painting had kept him in Europe for eight years, he returned to his home town in 1954 like a foreigner. A few years previously he had won his first camera playing poker and quite casually it began to assume more and more importance in his work. The camera now became a means of coping with overwhelming impressions, a "secret weapon" in the jungle of movements. "The kinetic quality of New York, the kids, the dirt, madness—I tried to find a photographic style that would come close to it. So I would be grainy and contrasted and black. I'd crop, blur, play with the negatives. I didn't see clean technique being right for New York. I could imagine my pictures lying in the gutter like the New York Daily News." A visual diary was the result, out of which his personal daily paper would in fact emerge later, his first book *Life is Good & Good for You in New York— Trance Witness Revels*. Never before have photographs been used so consistently and without regard for formal rules to make clear a statement, feelings and assertions. In a "crash course of what was not to be done in photography", Klein captures in pictures what seems scarcely comprehensible on the spot. The very lay-out of the book, which appeared in Paris in 1956 with the help of Chris Marker, the editor at that time of the Petite Pinète series of the Seuil publishing house, is used to serve his themes to the full. "In *New York* I had wanted to create a cartoon of photography, with photographs one within the other. It rendered the reading more difficult in appearance, but nevertheless more in keeping with the series of visual flashes one can have walking down the street." For the Americans, this portrait of their gateway to the world was unacceptable. The publishers to whom Klein presented a draft of his book turned it down: "This isn't New York—too ugly, too seedy, too one-sided. This isn't photography, this is shit!" Up until now, Klein's book has not appeared there.

Thanksgiving Day Parade, Broadway admirably demonstrates Klein's way of working. Broadway, as one of the liveliest streets in the liveliest town in the New World guaranteed close encounters with the whole world, especially on one of New York's most important public holidays. To venture out onto the streets here means submerging oneself in the crowd, surrendering to the torrent of thousands of people. Impossible to execute precision work with the camera here. And yet the photographer and his machine are like a technical instrument. What counts is intuition, speed, spontaneity and risk. "Shooting" from the hip or with the camera held high—the machine makes out of two eyes many. A 125th of a second is enough to capture the world in the rectangle of film, as though under a microscope. Gender, age, nationality, ideas, jobs, moods, hopes and fears, a single constellation of which within seconds nothing more than the separate parts will remain, completely trivial, insignificant and yet the innermost stuff which holds the world together. William Klein builds up this jazz-rhythm in the sound of the pictures and in the beat of the book. *Trance Witness Revels*—that is the theme of a great improvised piece, where the tenor is carried along by quests such as "Ecstasy," "Dream," "Family Album" or "?" The fraction of a second found on Broadway takes up the theme: unity in variety. It makes crystal-clear what Klein champions obsessively—integration, both in the individual photograph as well as in his artistic work generally, where no difference is made in the worth of painting, architecture, typography, photography or film and finally in his very own design of his films and his books. What counts is only the individual, free, uncontrolled vision: "Anybody who pretends to be objective isn't realistic." Insight is not a question of the medium. It is not surprising to hear Bob Dylan say: "Truth? They are simply pictures. Pictures of a tramp puking next to pictures of Rockefeller and one of an honest citizen driving to work in the morning. Simply a collage of pictures. That of all things . . . no one will publish." Dylan has clearly never seen them, the pictures, films and books of William Klein.

—Ralph Hinterkeuser

Bibliography—

Klein, William, *Life is Good and Good for You in New York—Trance Witness Revels*, Paris and London 1956.
Klein, William, and Heilpern, John, *William Klein: Photographs*, London and Millerton, New York 1981.
Porter, Allan, "William Klein: Apocalypse," in special monograph issue of *Camera* (Lucerne), May 1981.
Tweedie, Katherine, *William Klein: Photographer, Filmmaker*, Rochester, New York 1982.
Klein, William, and Naggar, Carole, *William Klein: Photographies*, Paris 1983.
Klein, William, *Photo Poche: William Klein*, Paris 1985.
Klein, William, *Close Up*, Heidelberg 1989.
Cinema Outsider: The Films of William Klein, Minneapolis 1989.

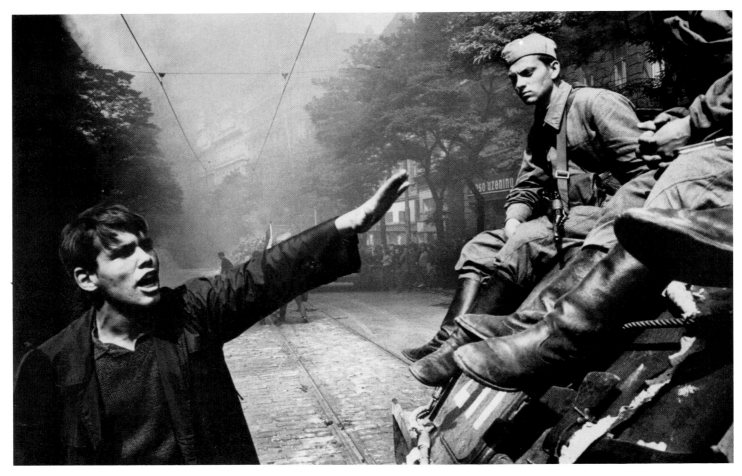

© Josef Koudelka/MAGNUM

Josef Koudelka (1938–)
August 1968, Prague, 1968
Black-and-white photograph

August 1968, as is the name of one of the most extensive of the photographer's series on the Soviet occupation of Czechoslovakia, is exclusively from Prague. According to the words of Josef Koudelka, it represents two hundred and sixty-one films. Altogether about ten thousand photographs. So it is really a kind of collected record, limited in time to the first week of the occupation, when the opposition to the army of the closest friends, who had overnight become enemies, as it were by *force majeure*, was most intensive. The thoughtful essence of this opposition is concentrated into the morning of the first day, when the completely unsuspecting people of Prague, like the other inhabitants of Czech and Slovak towns and villages, woke up in the morning to a situation that was exactly like undeclared war. A very strange war, unequal in a way, because against the powerful battle formations, so powerful that they surpassed the final offensive of the Second World War, stood only offended and mortified feeling, unarmed but determined. And something unexpected happened. It was stolid power that capitulated in embarrassment before the moral superiority of the harnessed nation.

"A miracle took place," Josef Koudelka said in an interview, remembering those incredible seven August days of 1968. "I could never have imagined that when something links people—in this case it was the threat of danger—they can change so much. People, who up till then had been very rough with one another, suddenly behaved very considerately. Thieves made a declaration that they wouldn't steal, because the police had a lot of work now. An absolutely absurd thing. And all at once I realised that, though I have lived in Prague for a long time, I didn't know it . . . And another thing—there was no feeling of hatred for the Russians. Rather I felt sorry for those boys on the tanks. I would like to have invited them for a beer, because I knew it wasn't their fault; the same thing could have happened to me . . . Those boys didn't feel at all like killing and shooting. On the contrary, they understood very quickly what was going on. But then its always a question; when an officer comes along and says: you are going to shoot, and if you don't then you're going to be the one who'll be shot, then things look a bit different."

So Koudelka's large collection from Prague in August in the first days of the Soviet occupation is a reportage on the strange war that, on the threshold of a new decade, unexpectedly came to a peak even in Russia itself. Between the Soviet power and the still-oppressed nations. It can't be said to be the only cycle. Indeed it is even questionable whether it can be considered the best one. During those days, in Prague and in Bratislava and other places in Czechoslovakia, literally everyone who had a camera at hand and a film in it became a war reporter. And, as happens at such moments, exceptional events bring quite exceptional results, without which lively direct photography can't get along. And it was only after twenty-two years (for before then people in Czechoslovakia could not see even Josef Koudelka's testimony) that another shattering collection from 21st August 1968 was exhibited in Prague for the first time ever, by an amateur photographer who up till then had been completely unknown. And if someone took the trouble, he would probably be able to find many more such photographs. But Koudelka's testimony is undoubtedly the best known.

It has become a kind of pictorial apotheosis of those moving events. It opened the door wide for the author to enter Magnum, crowned in 1969, on the first anniversary, by the award of the prominent Robert Capa prize for the most courageous reportage: given then to "an unknown Prague photographer." The worldwide publicity this gave Koudelka led in the end to his emigrating. If he had stayed in Czechoslovakia, and the fact that he was the author of the photographs had been betrayed, he would hardly have been able to avoid the repressive consequence. So when he was allowed, in 1970, to make use of the three months' grant offered him by Magnum, so that he could continue abroad in his theme *Gypsies*, which he had worked on previously in various European countries, he did not return to Czechoslovakia.

It is a question whether Josef Koudelka would have risen to the elite of world reporters concentrated in Magnum, so suddenly and unexpectedly, if it had not been for those exceptional August events, for long afterwards accompanied by exceptional political results, sharply watched by the whole world. Besides his talent, Josef Koudelka is a favoured child of fortune. When he started as an amateur at the beginning of the nineteen-sixties, having decided on leaving the Prague Technical University not to become an aeronautical engineer, he quickly won popularity as a photographer of the theatre. And that in the rather exclusive world of the fringe, avantgarde Prague theatres. Thanks to the book he was preparing, *Gypsies*, which was banned in Czechoslovakia, when he decided to emigrate, he became a legend. On the basis of a single exhibition on this theme that the public was allowed to see. Later the book was actually published, only in 1975 in New York, and it further increased his renown as an exceptionally talented photographer, who had won world fame with his August cycle on the Soviet occupation.

Till the following, no less extensive cycle, *Exiles*, revealing the psycho-social status of life in emigration, put the seal on Koudelka's unexpectedly won credit. For in the favourable climate of Magnum he had matured professionally. He got his second wind and kept pace with modern photographic development. Under the pressure of various personalities, which would certainly have been lacking in the Czechoslovakia of the nineteen-seventies and 'eighties, when it was impossible to speak of competition, he became a personality himself. Among other things, thanks to the fact that he always knew how to place his fate in the right hands at the right moment. He awakened an interest in Inge Morath when she visited Prague, in Elliott Erwitt, then president of Magnum, and the list could be continued until today. The chain of prominent acquaintants and benevolent interest, faced with recent photographs, provokes the question as to whether, concerning size, the legend of Koudelka is not almost too splendid.

—Vladimir Remeš

Bibliography—

Porter, Allan, and Sallenari, Daniel, "Josef Koudelka," special monograph issue of *Camera* (Lucerne), August 1979.
Martinez, Romeo, *I Grandi Fotografi: Josef Koudelka*, Milan 1982.
Cuau, Bernard, *Photo Poche: Josef Koudelka*, Paris 1984.
"Prague '68," in *Aperture* (Millerton, New York), no. 197, 1984.

Natalia Lach-Lachowicz (1937–)
Artificial Photography series, 1978
Photographs

The almost universal appeal of photography in the late 'sixties and early 'seventies was one of the most interesting phenomena in Polish art. The automatic recording of pictures, the trustworthiness of the method and its immense range of application afforded photography (like experimental film) great opportunities for creative invention. In truth, these factors exerted an earlier influence both between the wars (the constructivist movement) and in the post-war period (in Zbigniew Dłubak's work, for example) but it was only with the advent of conceptual art that creativity acquired a completely new dimension. The undermining of the split between artistic and nonartistic means of expression, concerted attempts to find new forms of artistic communication, exploration of methods by which visual information might be conveyed and the quest for meta-art—all this was aided, from day to day, by photography. The work of Natalia Lach-Lachowicz provides an interesting example of the advantages photography brings to the creative process.

The beginnings of Natalia L-L's conceptual work must be traced to the Wrocław movement, Perfamo, in the early 'seventies. Founded on the premise that art is an attempt at reflecting reality, this movement promoted the idea of an ongoing record of reality, apparently hoping to bridge the gap between the artistic and the commonplace as much as that between an object and its representation. Within such an "ongoing recording" framework, Natalia L-L spent twenty-four hours, for example, taking hourly photographs of the face of an alarm clock, exhibiting these as a photographic series entitled *The 24 hours of Natalia L-L*. She also undertook other projects such as *Exit/Departure Record* (1971) or *A place 1500km distant* (1971). "Consumer art" developed from this concept. "Consumer art," wrote the artist, "presents itself at every moment of reality, every event, every second in time, is singular and unrepeatable for the individual. That is why I record such simple and commonplace events as eating, sleeping, sex, leisure, expressions of feelings, and so forth." In actual fact, she portrayed trivial, everyday activities in such provocative or perverse ways (for example, attractive girls eating bananas or jelly in a most suggestive manner) that erotic undertones were rife. Her work might equally be included within the realms of contemporary advertising which also has the task of attracting the spectator's attention and imparting selected information to him.

Although her work, like all conceptual art, was primarily an intellectual undertaking, Natalia L-L did not agree completely with the ideas expressed by many of the artists in this movement. ". . . The mind's control of visual perceptual processes," she stressed, "is a fiction that art should oppose. The perceptual apparatus (eye and brain) is an indivisible whole because we cannot see unconsciously. The perceptual process is a global process and, as such, must be examined holistically. This forces me to argue that, here and now, art needs to adjust its ideas and intuitions because the accepted metalinguistic process does not embrace reality in all its diversity and richness. Conceptualism polished the spectacles—let's now put them on so that, with their help, we can see the world. I endorse art that can be derived through objective means—means that are better suited to our thought processes but that, nevertheless, depend on artistic intuition. Intellectual knowledge is appropriate to science where each hypothesis is based on a carefully proven and established previous hypothesis."

The result of this point of view, which might be described as informed intuition, was a series of photographs subsumed under the rubric "postconsumer art." "Postconsumer art," explains Natalia L-L, "is based on the creation of visual and mental rules which, although not incompatible in themselves, tend to be very 'artificial' in their imitation of complicated intellectual and intuitive processes . . ."

A famous example of this art is the series *Artificial photography* which contains successive photographs based on superimposed images of the artist sitting in an armchair. In these photographs, Lach-Lachowicz has not two but three or four legs, one pair curled under her and the other simultaneously stretched out in front of her, and so forth. The end result of these pictures is the portrayal of people and things whose actual existence is impossible in reality although the process by which the pictures are obtained is, itself, totally plausible, objective and viable. ". . . Thus, photography is not a record of reality," Natalia L-L emphasises, "but a 'real' meta-reality in which such recordings can exist even though, as entities in the real world, their existence is precluded. Nevertheless, they can be seen—they are authentically portrayed in the photographs—and they can be grasped conceptually, and we have to accept all this as an isomorphic visual and mental proof. I create artificial photography that credibly and authentically records a 'reality' that is artificial because it does not, and cannot, exist within our normal, rationally tried and tested knowledge of what is real or what can exist."

In this way, she concludes that art is a compound of the visual and the mental and that it has its own internal coherence. The merit of this impossible or artificial photography lies in the assumption that art is intentional artifice while photography itself is a dispassionate record of intuition and a way of gaining entry to the irrational world of artistic consciousness.

From these and other works, it is clear that Natalia L-L is one of the most perspicacious of the Polish artists who work with photography. While intellect is a fundamental and integral part of her work, she also opposes all overintellectualisation, all simulation, imitation and insincerity in art. Her photography, in its turn, is simultaneously intellectual and intuitive, conceptual and visual, and constitutes an interesting attempt at synthesising diverse artistic values.

—Ryszard Bobrowski

Bibliography—

Lach-Lachowicz, Natalia, and Nabakowski, Gislind, "Artificial Photography," in special issue of *Heute Kunst* (Dusseldorf), no.1, 1974.
Lachowicz, Andrzej, "Sztuka i fotografia," in *Nurt* (Wroclaw), no.10, 1976.
Neususs, Floris M., *Fotografie als Kunst—Kunst als Fotografie*, Cologne 1978.
Davis, Douglas, "The Eye of Poland," in *Newsweek* (New York), 13 August 1979.
Czartoryska, Urszula, *Photographie d'Avant-Garde en Pologne*, exhibition catalogue, Paris 1981.

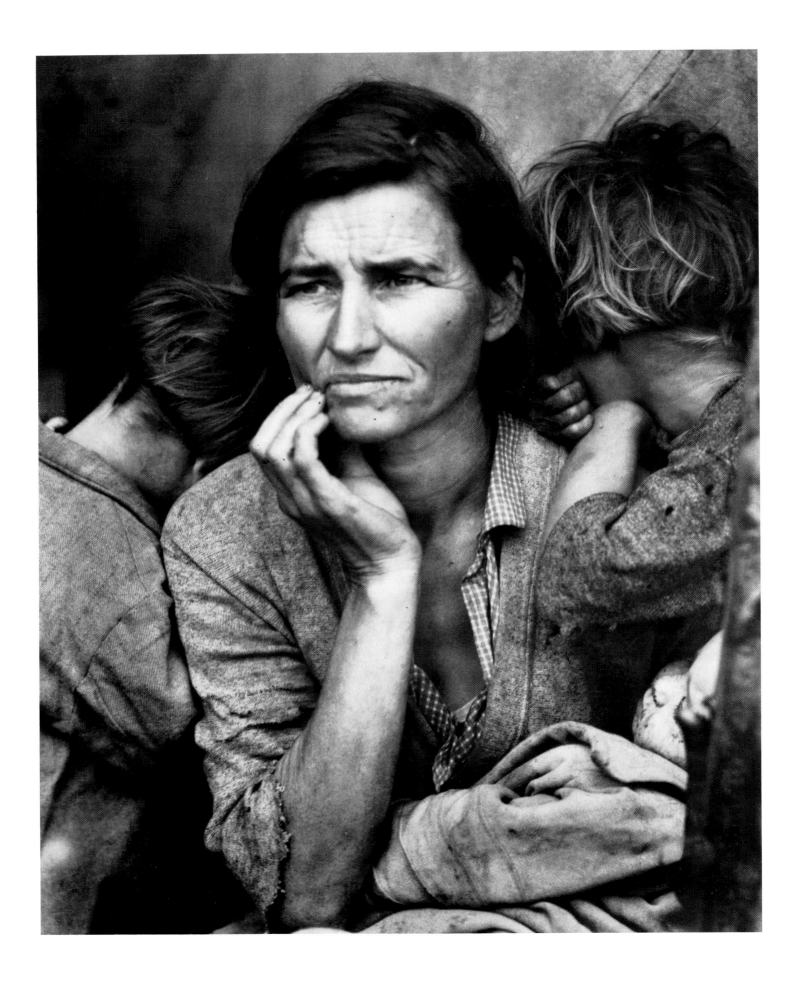

Dorothea Lange (1895–1965)
Migrant Mother 1936
Black-and-white photograph
Collection of the Exchange National Bank of Chicago

Migrant Mother is probably the best-known photograph made on the U.S. Department of Agriculture's Resettlement, Administration/Farm Security Administration photographic project. The picture was made in March, 1936, by Dorothea Lange at a migrant laborers' camp in Nipomo, California.

Dorothea Lange wrote about making this photograph for the February, 1960 issue of *Popular Photography* magazine. The story appeared as one of a series titled "The Assignment I'll Never Forget," and was reprinted in Beaumont Newhall's book, *Photography: Essays & Images*, in 1980.

She had been traveling alone, photographing migratory farm workers in California, for a month. She was tired, she felt she had finished her work, and she was driving home in the rain. At 65 miles an hour, she'd get there in seven hours, and she wanted to keep going. But on the way, she saw a roadside sign: PEA-PICKERS CAMP. She drove past it. Then the argument with herself began: "Dorothea, how about that camp back there? What is the situation back there? Are you going back? Nobody could ask this of you, now could they? To turn back certainly is not necessary. Haven't you plenty of negatives already on the subject? Isn't this just more of the same? Besides, if you take a camera out in this rain, you're just asking for trouble. Now be reasonable. . . . Having well convinced myself for twenty miles that I could continue on, I did the opposite . . . I went back those twenty miles and turned off the highway at that sign. . . . I was following instinct, not reason; I drove into that wet and soggy camp and parked my car like a homing pigeon. I saw and approached the hungry and desperate mother, as if drawn by a magnet. I do not remember how I explained my presence or my camera to her, but I do remember she asked me no questions. I made five exposures, working closer and closer from the same direction. I did not ask her name or her history. She told me her age, that she was thirty-two. She said that they had been living on frozen vegetables from the surrounding fields, and birds that the children killed. She had just sold the tires from her car to buy food. There she sat in that lean-to tent with her children huddled around her, and seemed to know that my pictures might help her, and so she helped me. There was a sort of equality about it. . . . I did not approach the tents and shelters of other stranded pea-pickers . . . I knew I had recorded the essence of my assignment. . . . Whenever I see this photograph reproduced, I give it a salute as to an old friend. I did not create it, but I was behind that big, old Graflex, using it as an instrument for recording something of importance. The woman in this picture has become a symbol to many people; until now it is her picture, not mine. . . . had I not been deeply involved in my undertaking on that field trip, I would not have had to turn back. What I am trying to say is that I believe this inner compulsion to be the vital ingredient in our work; that if our work is to carry force and meaning . . . we must be willing to go all-out. Migrant Mother always reminds me of this, although I was in that camp for only ten minutes. Then I closed my camera and *did* go straight home."

In fact she made six exposures; five of the negatives—the second through the sixth (?)—are in the Library of Congress; and the first (?) in the series was published by Dorothea Lange's husband, Paul S. Taylor, in an article, "Migrant Mother: 1936," in *American West* 7, no. 3 (May, 1970). (No one really knows the sequence of these pictures. If the manufacturer printed a number on each sheet of the film pack, this might be cleared up by examining the negatives.)

I have heard that the woman in the picture, Florence Thompson, became convinced that she was being exploited—her picture was published everywhere, but she got nothing from it—and she is said to have sued in the early 1980s for some large amount of money.

Long before the Resettlement Administration project under Roy Stryker was formed, Dorothea Lange had already begun to photograph the depression of the 1930s.

She had moved to San Francisco and opened a portrait photography business, but, the story goes, seeing a breadline from her studio window made her feel that it was more important to record the troubles of the time than to flatter people who could afford to have their portraits made. One of the first products of this conviction was the photograph, *White Angel Bread Line*, made in 1933, which has a lot in common with *Migrant Mother*. She began to work with the sociologist, Paul Taylor, making photographs to illustrate his studies, and presently she married him.

Her relations with Stryker as project director were strained, and she did not stay with the FSA as long as we might wish. This was also true of Walker Evans. I don't know the details of the conflicts, but one issue was that a self-respecting photographer naturally wants some control over the use of his or her work. Stryker apparently saw that as unacceptable temperament, and there were firings and resignations, followed by reconciliations and more conflicts.

Stryker, however, prized this photograph above the rest. As quoted by Nancy Wood in the book of his own FSA collection, *In This Proud Land*, he said: "When Dorothea Lange took that picture, that was the ultimate. She never surpassed it. To me, it was *the* picture of Farm Security. The others were marvelous but that was special. Notice I never said it was the greatest. People would say to me, that migrant woman looks posed and I'd say she does *not* look posed. That picture is as uninvolved with the camera as any picture I've ever seen. They'd say, well, you're crazy and I'd say I'm not crazy. I'll stand on that picture as long as I live. After all these years I still get that picture out and look at it. The quietness and the stillness of it. . . . Was that woman calm or not? I've never known. I cannot account for that woman. So many times I've asked myself, what is she thinking? She has all the suffering of mankind in her but all of the perseverance too. You can see anything you want to in her. She is immortal. Look at that hand. Look at the child. Look at those fingers—those two heads of hair."

There's an interesting contradiction here. In theory, a documentary photograph is a factual record that gives essential information. But of the six pictures in its set, this is the least informative. It is certainly also the most moving. Stryker's sentence, "You can see anything you want to in her," may be true, but ambiguity moves no one.

I think it's pertinent that Dorothea Lange once worked for Arnold Genthe, the favorite soft-focus photographer of Pavlova and Isadora Duncan: they felt that he understood dance. By no means limited to the studio, he had also photographed San Francisco's Chinatown and its 1906 earthquake. Arnold Genthe was steeped in German romanticism.

I believe that Dorothea Lange was also steeped in German romanticism. And in her FSA work, this is the picture where it comes through most strongly. It isn't a document, it's a personal vision—one that comes as close to being universal as a straight-on photograph can.

—David Vestal

Bibliography—

Hurley, F. Jack, *Portrait of a Decade: Roy Stryker and the Development of Documentary Photography in the Thirties*, Baton Rouge, Louisiana 1972.

Stryker, Roy Emerson, and Wood, Nancy, *In This Proud Land: America 1935–1948 as Seen in the FSA Photographs*, New York 1973.

O'Neal, Hank, *A Vision Shared: A Classic Portrait of America and its People 1935–1943*, New York 1976.

Newhall, Beaumont, ed., *Photography: Essays and Images*, New York 1980.

Rothstein, Arthur, *Documentary Photography*, London 1986.

Fleischhauer, Carl, and Brannan, Beverly W., *Documenting America 1935–1943*, Berkeley and Washington, D.C. 1988.

© Annie Leibovitz 1983/Contact Press Images

614

Annie Leibovitz (1949–)
Steve Martin in White Tails, December 1981
Colour photograph

Steve Martin in White Tails (1981), may first appear to be a joke—a whim between an actor/comedian and a photographer to capture an unusual idea: that of the art and the art collector becoming one. Actually it was serious work. Steve Martin had pushed himself in movies and in his career. What he needed was great photographs of himself—and he was interested in trying to take a new picture. *Rolling Stone* needed a cover shot for an article about Steve Martin running in the February 18, 1982 issue. Annie Leibovitz, collaborating with *Rolling Stone*, with the freedom of her ideas, created this photo. Perhaps it is not the most famous of her work. In the past decade there has been the Dolly Parton/Arnold Schwarzenegger photo; the endless series of Mick Jagger and the Rolling Stones; John Lennon and Yoko Ono; and countless other stars and performers. Annie Leibovitz has been hailed as the photojournalist of the stars. What other woman moves into their homes, their environments and their lives to get to know them? She said to photograph someone who is a star she must make such an involvement, convincing herself and her subject that she is a friend and can take pictures on that basis. Dropping her ego many times she almost has to fall in love with the person to be interested and concentrated for such a period of time. She prefers to move in with her subjects days before she starts taking pictures. It is said she has a personality like a weather front: she moves in like a Bermuda high and stays until she captures her subject on film. Who else could get so many stars to be so uninhibited? They literally take off their clothes, cover themselves in mud or roses, dress in unusual, simple attire or similarly unusual bizarre costumes. There is glamour and nostalgia. There is make-up and mud; sweat and tears. One sees the subject both stripped emotionally bare and elevated to stardom.

Annie Leibovitz attended the San Francisco Art Institute in the early 1970s. Three thousand miles from home and no contacts in the worlds of art and photography, she had spent a year in a kibbutz in Israel. Five feet eleven inches tall, with an erratic concept of time, her pictures and photographic reputation have grown strong enough to attract stars with immense egos of their own. After all, she is an artist dealing with artists.

Steve Martin had just bought the Franz Kline, the kind of painting only museums could afford. It seemed strange to have it at home. He was in love with it, and he saw himself in the painting. The story goes that Annie wanted to shoot him in white tails but realized he was already beyond the tails. Originally Steve Martin was going to be painted black and put into the painting but then Annie Leibovitz came up with the idea of painting the tux like the painting. The result was an intellectually conceived photograph—not a joke at all. David Felton says journalism is sometimes seen as an unfriendly act, out to mock the weaknesses and corruptions of being human. Fortunately, Annie Leibovitz reminds us that journalism at its best is remarkably like friendship at its best, a mutual encounter of open hearts and minds unsullied by prejudice and sentimentality.

When Steve Martin becomes one with the painting of Franz Kline we observe an intimacy that Annie Leibovitz captured between the collector and his art. He loves art so much he wants to leap into it. He has the sophisticated taste that knows how to appreciate fine art. Very few people would ever witness this intimacy if it weren't for Annie Leibovitz. In her connecting the man with the art and immortalizing it in photography we can paraphrase Phillip Roth and say for Annie Leibovitz there are no good or bad events, only potential subjects. Annie the observer, the hunter, watches how other people live. This gives her a mobile security; knowing she is there for a short while, she can enter another person's life completely. Photojournalism takes us out of our own surroundings. We become observers, voyeurs in the lives of others, and yet when we look into her photos there is a honesty of human spirit. In *Steve Martin In White Tails* we are aware of that spirit. Its energy leaps across the page. along with the humor it may evoke, we see another side of this man. Obviously his status in life now allows him to spend his money any way he wishes and he chooses to buy art. There is a sense of bizarre in trying to understand what would make this man want to become one with this two-dimensional inanimate object. Bizarre? Exotic? Eccentric? Yes. All of these, and what would capture the desires of photojournalist Annie Leibovitz better? With a sense of glamour, covered with mud or sweat we see how Annie Leibovitz transcends the business of the celebrity photograph. Her portraits are alive. *Rolling Stone* gave her the opportunity to create a look never before seen in photojournalism.

Technique enhances interpretation but the eye must decide. Annie Leibovitz experiments with light as much as possible, preferring light as natural as possible. Although the Steve Martin photograph is in color, it is a black-and-white study of motion and immobility. There is this juxtaposition of life into art and art into life—we must wonder where one begins and the other ends.

—Andrea Kalish Arsenault

Bibliography—

Leibovitz, Annie, *Shooting Stars*, New York 1973.
Masters of Contemporary Photography—The Photojournalist: Mary Ellen Mark and Annie Leibovitz, Los Angeles 1974.
"Steve Martin," in *Rolling Stone* (New York), 18 February 1982.
Leibovitz, Annie, *Photographs*, New York 1983.

© Giorgio Lotti

616

Giorgio Lotti (1937–)
Onda, 1970
Colour photograph series

This Italian photographer holds an extraordinary world record: one of his photographs, a portrait of Chou En-Lai (1979) is the most widely circulated photograph in the world; some billion copies have been printed.

This is due to the charm of a "pose," composed without rhetoric and shot quickly, and by which Giorgio Lotti manages to define that political personality, beloved in Chairman Mao's Great China. Since then, this icon has been circulated everywhere, both in black-and-white and in colour, in various formats, and repeatedly published in newspapers and magazines throughout the world as the official portrait.

As photojournalist for the weekly magazine *Epoca* from 1964, Lotti still holds that record dear, even if he particularly loves theatre and landscape photography, for which he is considered a master. He has an unsuppressable amateur attitude, but put into practice with the elegance of the old intellectual, who paradoxically (despite the fact that photography is his daily occupation) is still looking for moments of cultural escape and intense observations of reality in photography.

In 1970 he carried out his first important report on the degradation of Venice, with dramatic black-and-white photographs of an apocalyptic tone, later published as a book (*Venezia Muore* [*Venice Dies*], Milan, 1970) with an important essay by Giorgio Bassani. The same research, about the effects on architecture and works of art by pollution and negligence, was continued with the "report" on Milan Cathedral (*Il Duomo avvelenato* [*The poisoned cathedral*], Milan, 1972).

Almost in contradiction, a "liberation" from this painful analysis of the environment (these reports were among the first ecological efforts undertaken by a photographer in Italy), Lotti concentrated during the same years on a more delicate and spectacular type of photography: theatre and, above all, ballet photography, and in this case, that seen at the Teatro alla Scala in Milan. This he visualised in endless images collected in two books (*Il teatro alla Scala*, Verona, 1978 and *Balletto*, Monza, 1981), where he also discovered the "new" fascination of colour after the dramatic black-and-white effects of his earlier reports.

From that moment, for Lotti, colour became a new way of thinking reality, almost living it, not so much in a realistic or documentary fashion, but rather in an imaginary way; as a means of highlighting landscapes otherwise unknown, in spite of the fact that the world around us is naturally in colour. The colour expressed by Lotti's images is always surprising, almost unreal, since he manages to extract from chaos only the necessary and sufficient elements for defining, above all, a metaphor, an idea, a concept of reality, which photography is able to invent through its iconic structure—when the artist knows how to "make order" out of perspective, *chiaroscuro* and above all, for Lotti, colour.

In the time between a ballet and an opera, between a sports and a travel report, Lotti has lingered long on seascapes, almost searching for a refuge for the eye, which on the contrary has almost become blind in its continuous attempt to catch, by means of the quick and voracious camera, a fragment of colour, the flicker of a reflection, the glittering of foam on the crest of a wave. Lotti has always been particularly attracted by the subject of sea-waves and has concentrated especially on its sensual wrinkles, almost as if in search of anthropomorphic images, winding, bewitching like the sirens of Ulysses' tale.

He even managed to suggest in those photographs of waves the noise of the water and the wind that caresses it, in sequences that accompany the movement of the water as if the eye were hooked to it. Furthermore, in these images, Lotti tries to stabilise an unstable and ephemeral structure, such as that of the movement of water and the reflections that it fleetingly takes, quickly frees and almost dissolves into the emptiness of light, were it not for the immediacy of the camera lens which memorises the marks, whose traces last for ever in an image.

The signs that structure these coloured images (surfaces that are usually monochromatic; blue as the sky, pink as the petals of a flower, green as an improbable meadow in Arcadia . . .) are fixed as musical rhythms, sometimes highlighting the extremely bright areas of the drops of the wave until they create with them a continuous surface, sometimes letting them stretch, or rest in the lazy extension of the movement of the water and crossing the whole rectangle of the image. But suddenly, like in a symphony, the waves collide, create lively spray that rises like mythical marine figures, creating forms, vortexes that do not belong to this world, but to a more mysterious space, like that of poetry.

With these images of water, Giorgio Lotti has succeeded in surprising even a writer about the sea, such as Alberto G. Rossi, who, in the introduction to a book by Lotti (*Luce-mare*, Como, 1982), wrote that these images give the impression that the photographer has succeeded in "capturing the soul" of the sea in order "to see how it was made, whereas human eyes, unassisted, have never succeeded in seeing it."

—Italo Zannier

Bibliography—

Lotti, Giorgio, Bassani, Giorgio, and Fagioli, Gianfranco, *Venezia muore*, Milan 1970.
Lotti, Giorgio, *Il Duomo avvelenato*, Cremona 1972.
Consiglio, Fabio, "Mare," in *Nuova Fotografia* (Naples), June 1972.
Lotti, Giorgio, *Il Teatro alla Scala*, Verona 1978.
Colombo, Attilio, "Giorgio Lotti," in special monograph issue of *Progresso Fotografico* (Milan), September 1978.
Lotti, Giorgio, *La Nuova Cina*, Como 1980.
Lotti, Giorgio, *Balletto*, Monza 1981.
Lotti, Giorgio, and Rossi, Vittorio, *Luce-Mare*, Como 1982.

Markéta Luskačová (1944–)
The Sleeping Pilgrim, 1970
Black-and-white photograph

The sleeping man in Markéta Luskačová's photograph is a tired pilgrim. Every year on the day of the Annunciation of the Virgin Mary tens of thousands of people make a pilgrimage to Levoča, a little town in eastern Slovakia. They come by train, by bus, in their own cars, and in many cases they come on foot; and there they climb to the top of a hill above the town, where a church was built at the beginning of the fourteenth century, perhaps to commemorate the deliverance of the town of Levoča from the Turkish invasion in 1242. In the course of time, the Marian pilgrimages became important social and cultural events. At the beginning of June, when they are held, the meadows are already mown in the mountainous region called Spiš, but there's still time for a late harvest. So the annual pilgrimage to the Marian hill was not only a religious affair. There was a fair that attracted people with its motley sights, the opportunity to make purchases, the rare divergence from the commonplace that could be talked about and constantly remembered throughout the whole year.

These fairs gained an almost abnormal influence on matters of faith when religious life was suppressed after the take-over of power by the communists in February 1948. This touched the deeply religious Slovaks very acutely. And so, despite the fact that, especially at the beginning of the nineteen-fifties, priests were imprisoned and the government invented and organised worldly pleasures that would distract the attention of believers from the pilgrimage to Levoča, the gatherings in the forest round the church on the Marian hill lost nothing of their attraction. In the nineteen-eighties, thanks to the growing numbers of believers among young intellectuals, they even became kind of anti-demonstrations against the communist system. Quiet, non-violent gatherings that enjoyed increased attention from the police and their informers.

Of course Markéta Luskačová's picture, still typical of the character of the pilgrimage today, is much older, coming from the pilgrimage in 1968. Immediately before the soviet occupation of Czechoslovakia—not after it, although it is sometimes wrongly dated 1970. The liberalism of the second half of the 'sixties awoke a great interest in spiritual life, partly because it had earlier been suppressed. Young intellectuals, systematically brought up in the spirit of atheism, not only found the forbidden fruit of faith attractive, but especially they wanted to know what was so dangerous about religion that it was worth the communist power's while to concentrate all its forces in the fight against it. This was probably one of the motives that aroused an interest in the social status of believers in Markéta Luskačová, a student of sociology at Charles University in Prague. She had inherited from her mother an interest in ethnography, folk tradition, art and culture, and when she was writing her thesis on religious life in Slovakia, she decided to enliven it with photographs.

So in 1967 Markéta Luskačová began her cycle *Pilgrims*, which she is still extending and supplementing. Not only during her annual visits to Slovakia, which she fell in love with for its very special character, but she found a second home—especially after her mother died—with friends in the remote village of Šumiac, which is the name of another cycle of photographs, also partially devoted to the spiritual life of country people. She also paid attention to believers making pilgrimages to holy places in Ireland, when she settled in Britain. The basic theme of Pilgrims in all its variations, that is the cultural and social essence of almost over-zealous expressions of faith, penetrates other spheres of Markéta Luskačová's interests. No longer as a sociological phenomenon, but a philosophical one, as in the end the future sociologist became a photographer. And the belief and dedication of pilgrims has become a moral axis for her, a measure of values of the purity of opinion, the genuineness of every person.

The cycle *Pilgrims* (the initial part of it that originated as illustrations to a sociological thesis) brought Markéta Luskačová to the realisation that it is essential to master the secrets of photographic technique if one wants to tell about one's examination of phenomena that—as she says herself—"won't go into words." While she was still studying sociology, she began to attend lectures at the Prague Film and Television Faculty of the Academy of Fine Arts, devoted to photography. Then, still at the chair of film and television picture, which gave birth to the present chair of photography. Together with her fellow-students Pavel Štecha and Ivo Gil, who were also keen on the documentary possibilities of photography, she opened up new possibilities to photographic expression.

—Vladimir Remeš

Bibliography—

Farova, Anna, *3 Photographers*, exhibition catalogue, Roudnice 1973.
Porter, Allan, "Marketa Luskacova," in *Camera* (Lucerne), July 1974.
Luskacova, Marketa, and Berger, John, *Pilgrims*, exhibition catalogue, London 1983.
Haworth-Booth, Mark, "The Proud Pilgrims of Slovakia," in *Aperture* (Millerton, New York), no. 92, 1983.
Martinson, Dorothy, *Czechoslovakian Photography*, exhibition catalogue, San Francisco 1984.
Mrazkova, Daniela, *Masters of Photography: A Thematic History*, London 1987.
Mrazkova, Daniela, and Remes, Vladimir, *Cesty Ceskoslovenske Fotografie*, Prague 1989.

Aleksandras Macijauskas (1938–)
In the Veterinary Clinic series, 1986
Photographs

In the early 1960s the photographs of Aleksandras Macijauskas figured among works that greatly differed from the official simplistic concept of Soviet photography known as socialist realism. Together with Vitas Luckus, Antanas Sutkus, Algimantas Kunčius and other young Lithuanian photographers, Macijauskas tried his utmost to depict the world around him and, to a growing extent, the world within him, too, as truthfully as possible, to replace artificial arrangements by authenticity, stereotypes by originality, to make the best use of details, unusual compositions and higher tonal contrasts; and substantially extending his range of themes and subjects, and superseding chance origin in his individual pictures by a well conceived and coherent process of creating extensive photographic cycles. Most of these artists photographed primarily in the Lithuanian countryside, seeking there the roots of the nation and its culture, which had been subjected to increasing threat and oppression from Russian expansionism.

Aleksandras Macijauskas gained international fame particularly through his extensive and stimulating cycle of photos from open-air village fairs. In Lithuania, such fairs are not only market-places in their own right but also venues of major folk festivals or fêtes offering both the merchants and their customers a golden opportunity of showing their temperament, of celebrating a good bargain with a bottle of vodka, of being themselves and enjoying a sing-song with friends. Macijauskas managed to capture all this in his photographs, viewing fairs as colourful pageants or spectacles involving countless actors. He succeeded in depicting and putting across a certain amount of the bizarre in this milieu, a quality he accentuated by the use of wide-angle lenses, separating less pronounced details and incorporating parallel scenes or themes. He managed to combine the ridiculous with the serious, the banal with the vital, the small with the large. Probing into the faces and gestures of common villagers, he was constantly on the lookout for manifestations of their character, their innermost life, their joys and their sorrows. Notwithstanding a certain element of ironic detachment, his photographs make it abundantly clear that Macijauskas loves these people immensely, that he likes their natural, unassuming character, their earthliness, pithiness and sincerity. Although his pictures speak volumes about Lithuanians, they also say much about people in general.

Many of these features are typical of the works to be found in another major cycle entitled *In the Veterinary Clinic*, a set photographed since the second half of the 1970s. His cycle on fairs had already featured a number of pictures of farm or domestic animals. Macijauskas, who regards himself as a semi-villager, is very fond of animals. He believes that numerous parallels may be drawn between animal and human behaviour. Proceeding from this philosophy, he felt that his cycle of photographs from the Clinic of the Academy of Veterinary Medicine in Lithuania's second largest city, Kaunas, should be more than a mere reportage on the work of veterinary surgeons, that it could exercise a much broader impact.

Over several months he photographed operations on horses and cows, depicting an old woman anxiously awaiting the result of an examination of her cat, or showing vets during their well-deserved but short rest. In this way, Macijauskas has produced dozens of modern documentary photos noted for their dramatic charge and expressiveness, considerable visual culture and insightful interpretation. All these pictures bear witness to the author's sympathy for sick animals completely at the mercy of humans. The photos brim over with respect and admiration for the demanding and selfless work of surgeons. On the mundane plane, the whole cycle comes across as a tribute paid to human dedication and the ability to come to the rescue of those in need of help.

In formal terms, the expressiveness, dynamism and subjectivity of Macijauskas's method seem to be cumulative. He enforces there, more strongly than ever before, his own approach to depicting reality, accentuating his own vision, and operating with symbols and messages to a growing extent. In some motifs, eg. in that of a stork flying about an operating theatre or a dog with its injured eye agape and a sheep tied in the background, the author appears to be underscoring what may be called a surrealistic atmosphere.

Even though in the photographs from the cycle *In the Veterinary Clinic* animals prevail and indeed dominate, these are highly humanistic pictures. Generally speaking, humanism is an underlying trait of Macijauskas's art as a whole: its traces are to be found not only in both of his most important cycles so far but also in other works, eg. in the set of snapshots from Lithuanian seaside beaches, in his extensive cycle on funerals and in pictures ridiculing the manifestations of communist totalitarianism in the Soviet Union.

—Vladimír Birgus

Bibliography—

Neimantas, Romualdas, *Aleksandras Macijauskas: Veterinary Clinic*, exhibition catalogue, Kaunas 1979.
Thornton, Gene, "A Veterinarian in Close-Up," in the *New York Times*, 11 November 1979.
"Aleksandras Macijauskas," in *Camera International* (Paris), no. 3, 1985.
Skeiviene, Laima, *Aleksandras Macijauskas*, exhibition catalogue, Vilnius 1988.

© DACS 1991

Man Ray (Emanuel Rudnitzky) (1890–1976)
Portrait of Margaret, 1941
Silver gelatin photograph from solarized negative; 24.5 × 20 cm.
Santa Fe, David Bakalar Collection

"The creative force and the expressiveness of painting reside . . . in the possibilities of form invention and organization, and in the flat plane on which these elements are brought to play. . . . The artist is concerned solely with linking these absolute qualities directly to his wit, imagination and experience, without the go-between of a 'subject'. . . . The artist's work is to be measured by the vitality, the invention, and the definiteness and conviction of purpose within its own medium." (*The Forum Exhibition of Modern American Painters*; 1916)

Man Ray's first statement as an artist for the catalog at the Anderson Galleries in New York City was made at twenty-five years old. It was written two years after he met Marcel Duchamp and the same year Picabia arrived. The three would inadvertently begin the American branch of Dada and invent ideas that lived outside any single artistic medium or subject. Their loyalties sprang from the desire to liberate art with experimental vigor. This statement stands as a manifesto for Man Ray's historical contribution as a pioneering modern artist, including his work with photography.

By the next year of 1917, the artist challenged further aesthetic conventions, including his first formal work with the materials of photography. He combined drawing with photography with the nineteenth century process cliché-verre. With it, the artist joined drafting with the immediacy of the photographic process.

Man Ray drew onto unused exposed film and old negatives. The lines removed emulsion so light could pass through. He then made prints by exposing the drawings of these self-made "negatives" to light-sensitive photography paper. The camera and most of the techniques associated with conventional photography were by-passed. Non-traditional in approach, innovation released conventions with photography for new purpose. Soon after, he began making portraits, beginning with composer Edgard Varèse, so that he didn't have to "*paint* portraits anymore." The artist also worked in Cubist-like collages and a spray-gun technique that he named the "aerograph." All of these of activities would influence his future photography.

The blending of painting and light came to fruition in his re-invention of camera-less photographs—later known as *rayographs*—in the winter of 1921–22. Photographic paper was exposed to various angles of light and objects on and above the surface, then processed chemically. Everyday things created silhouettes in reverse. The outcome is a collage-like mixture of objects, where the poetic qualities of combinations and light verge on the enigmatic. Positive and negative forms of objects perform in an ambiguous space. These pictures are filled with incongruity, paradox, chance, parody, wit and satire. They are animated burlesques of abstract imagery.

This spirit of innovation followed in other works of art such as the portrait of Margaret Nieman. The eloquent use of light found in this portrayal came later in Man Ray's mastery of another related breakthrough—the exposure of light to negatives during the normal process of chemical development, scientifically known as the *Sabattier effect*. The result was a controlled edge reversal often in the contours of a subject. This discovery was made by accident with his darkroom assistant, Lee Miller, in 1929. The artist learned how to control the contrast and refined the use of procedure—which he called solarization—in subsequent portraits.

During the 1930s, Man Ray lived in Paris, the world center of art. Like many others who feared Germany's growing threat, he returned to America to reestablish himself, and moved to California in October of 1940. There he met Juliet Browner, who would become his lifelong companion. In this first year, they became close friends with textile artist Margaret Nieman and her husband, Gilbert, a poet. Margaret introduced writer Henri Miller to the couple. Miller, like the artist, was born poor in Brooklyn. While he and Man Ray lived in Paris at the same time, they never had met.

In spring of 1941, Margaret visited Juliet. During their usual gaming together, they tried on a new brand of artificial fingernails. Man Ray reached for his camera and began taking pictures, encouraging Margaret along the way. The beautiful, fair skinned woman posed in the spirit of the moment, with an impulsive highbrow profile. Her light complexion was contrast built into the picture, as she never wore cosmetics. The artist processed and re-exposed the negative to light to create the extra sense of drama and cinematic highlight.

A feeling of the negative image is introduced around the edges of the figure while the profile and simplicity of the face is marked by an embellishing quality of light. The subtlety of shapes and contours are bold in the translation. The arm on arm gesture accents the complete cameo of the face with a gem-like quality. This artwork speaks directly to the commercial society of Hollywood's movie culture. The picture was reproduced in *Harper's Magazine* later that year. It was a morale booster, as the artist gave Margaret a copy as she was recuperating from a serious illness in the hospital.

Like the rayographs and the early experiments with collage, the elements in this picture appear incongruous and super-natural. The figure is animated and seems to have different lives from the silvery-grey shoulder and arms, to the striking white face. The ambiguities of negative and positive forms coexist through "the possibilities of form invention and organization . . . in the flat plane on which these elements are brought to play"—what Man Ray described as expressive potentials in the statement of 1916.

In this regard, this work stands as an distinctive example of not only the brief California period, but as the anomaly the artist continually strove for, where the idea becomes the medium. It is pure invention which incorporates the lessons of painting, object making, photograms, lessons in light and the experiences of many materials into a single form of expression. By the time this portrait was created, the difference between painter and photographer was no longer significant.

The idea of the artist carried the full weight of expression, regardless of materials employed. "No plastic expression can ever be more than a residue of an experience," the artist later wrote. "For whether a painter, emphasizing the importance of the idea he wishes to convey, introduces bits of ready-made chromos alongside his handiwork, or whether another, working directly with light and chemistry, so deforms the subject as almost to hide the identity of the original, and create a new form, the ensuing violation of the medium employed is the most perfect assurance of the author's convictions. A certain amount of contempt for the material employed to express an idea is indispensable to the purest realization of this idea."

Seeing such a work of art, the photographer and painter are one. Created out of the spontaneous pleasures of chance, the photograph transcends the original moment. The viewer becomes a part of a new subject which begins as a portrait but ends as the enigma and irony we understand only as quintessential Man Ray.

—Steven Yates

Bibliography—

Anderson Galleries, *The Forum Exhibition of Modern American Painters*, exhibition catalogue, New York 1916.
Soby, James Thrall, ed., *Man Ray: 104 Photographs 1920–1934*, Paris and Hartford, Connecticut 1934.
Man Ray, *Man Ray: L'Oeuvre Photographique*, exhibition catalogue, Paris 1962.
Man Ray, and Gruber, L. Fritz, *Man Ray: Portraits*, Gutersloh 1963.
Penrose, Roland, *Man Ray*, London 1975.
Newhall, Beaumont, *The History of Photography, from 1839 to the present*, rev. ed., New York 1982.
Martin, Jean-Hubert, *Man Ray fotografo*, Milan 1982, 1990.
Janus, *The Great Photographers: Man Ray*, London 1984.
Baldwin, Neil, *Man Ray, American Artist*, New York 1988.

© Roger Mayne

Roger Mayne (1929–)
Image from Southam Street, London, c. 1960
Black-and-white photograph

How much the photograph shows us: how much we are tempted to bring to it.

Beginning on a mundane level; as I study the layout of the street and reckon with the extra evidence available from other images in the collection, it is possible to make a feasible enough match with a London street map of the Edwardian period. Southam Street, named there in seriffed letters, its buildings marked out by black hatching, is asymmetrical and irregularly enough divided to legitimate a guess that Roger Mayne was standing towards the east end of the street, Westbourne Park Station off to his right, the railway line at his back and looking north towards where Kensal Road and then the Grand Junction Canal would, but for the buildings, cross the line of his gaze. Given that, the shadows point to a time late in the day, probably a summer's day.

Already, even on the level of mapping out the concrete forms of a physical location, I have extrapolated, allowed myself a flight beyond the double-checked empirical evidence. Perhaps I have misread the street lines; perhaps Roger Mayne was making his photograph in an adjoining street, even merely in the general Southam Street area? What of the reading as it progresses towards the less tangible aspects of that London scene?

Formally, the image is a mass of devices which concentrate the gaze on the little girl riding her tricycle towards its centre. She is at the apex of a triangle whose base is the three children in the close foreground. Her verticality is echoed by the lamp post verticals and then by the background figures. The lines of their gaze determine the girl as the nadir of another, downward-pointing triangle, or else as the focal point of rays drawn between foreground and background. The band of sunlight ensures that as long as she keeps to her direction and stays in frame, her slightly shaded person will stand out against its bright ground, and remain delicately illuminated by light reflected from the right.

Thus, the structure is already powerful in its ability to direct a viewer's attention, and yet the content has only just begun to interact with the compositional form. That association is made more intimate by the slight inclinations, seemingly downhill for the pram, and uphill for the tricycle, matching what one reads as the efforts for speed by the black boy pushing, and the slowly delicate pedalling as the girl seeks to maintain and control her backwards ride.

History, though, will only momentarily be denied. It comes flooding back in, so strongly as to disguise the extent to which compositional factors have shaped the narrative being structured around the photograph. The slightness of movement, if indeed movement of the kind I have spoken of is happening or even will happen at all, amongst the principal figures, is sensually appropriate to the warm glow of evening light. The warmth of all light given off by objects retreating from us; whether from the physical Döppler effect which reddens the light of stars, or the emotional effect that warms the light of these memories or fictions now thirty-odd years back into the past.

Those were the days when life was lived literally in the streets, when there was space enough outside the cramped dwellings for adults to have their beings and children their playings, relatively safe from the rush of traffic, their vision unobstructed by the lines of parked vehicles and the air unpolluted by exhaust fumes. Even activities of the pavement have since become affected by the vehicle infestation. It's not half such a proposition to play pavement games if there's no room for passers-by to step into the street and avoid you; how much more difficult to swing around the lamp posts, supposing they still had cross pieces to tie your rope to? In what city now would little girls do dancing in the road?

And there's no doubt at all that everything here could be corroborated by any number of good witnesses: among the best of them is Roger Mayne himself, with the body of work from which this photograph is only one of many examples. It is the character of the Southam Street photography to present us with a vision of life as memories and observations tell us that children experience it. That is to say, very close at hand, very intense, in moments and discrete tableaux pregnant with meanings they do not quite understand, because it is all pretty new, and moving rapidly between unnoticed causes and unpredictable effects; and emotions are not yet caught and set under the harsh net of commonality. That, Roger Mayne informs us, is exactly what he was about: using the photographic medium to construct and comprehend an experience which had failed to come to him through his own early years.

When we turn to more serious history, when we put away childish things (but who has the right to deny the high seriousness of childhood?), we discover that Southam Street was condemned as a slum, that for various reasons it had fallen too far for the redemption of its buildings to be attempted. We know that even if the poison of exhaust fumes was less venomous then, the people were living not far ahead of the era of the fogs; and only just coming out from under the shadow of TB, with the other great infectious diseases put just a shortish space behind that. It was the time of CND, the flower in the manmade shadow of the bomb, whose Aldermaston marches Roger Mayne himself photographed. There had been air raids, and rockets; not to mention the constant threats and blows of poverty.

No, the picture of Southam Street is not complete; it is partial both in the sense of including only a segment of the whole, and also in that Roger Mayne exercises his own partiality for worrying through, representing; and yes, singing about those things he needs to work out to complete his own, personal history. In so doing he has given us a history that is better and grander (but in no way Grand) in more ways than there is space to tell, and is as serious as any reader cares to make it.

But allowing that the whole, photo-collection or community, must needs be represented by a part, what could be more satisfying than that one image of an ordinary girl amongst her local people, who watch her and the intent young photographer, choosing just that focussed, balanced moment on a quiet summer's evening.

—Philip Stokes

Bibliography—

MacInnes, Colin, "Poetry and Poverty in W.10," in *The Observer* (London), 21 January 1962.
Piper, David, *Roger Mayne: Photographs 1964–1973*, exhibition catalogue, London 1974.
Hughes, G., "Two Men So Different: Roger Mayne and Kurt Hutton," in *Amateur Photographer* (London), 10 July 1974.
Davies, Sue, and others, *British Photography 1955–1965: The Master Craftsmen in Print*, exhibition catalogue, London 1983.
Mayne, Roger, and Haworth-Booth, Mark, *The Street Photographs of Roger Mayne*, London 1986.
Powell, Rob, "The Street Photographs of Roger Mayne," in *Creative Camera* (London), no. 5, 1986.

Angus McBean (1904–90)
Surreal Portrait of Frances Day, 1938
Black-and-white photograph

The photograph of Frances Day is one of Angus McBean's most accomplished and subtle surrealist pictures. In front of a sinister, misty landscape, Fanny Day is cast ashore and has surfaced in a fish basket. A disembodied hand is raised from a pool, bearing not Excalibur but a mirror, so, like any mythical mermaid, she can comb her hair. But what is the egg doing in the foreground and the tiny toy yacht? If you gaze at the sparkling comedienne's face for a few moments, you feel she will certainly smile, a small secret smile.

Taken in 1938, this picture was one of a regular series of McBean's surrealist images published by the now, alas, defunct *Sketch*, a slightly more artistic glossy weekly than the society-fixated *Tatler*.

By the beginning of the 1930s surrealism was well-known to the British avant-garde but photographers were slow to become involved, with the honourable exception of Winifred Casson. She was an admirer of Cocteau and Chirico and produced some interesting images but she exhibited rarely, left London as World War II began, and none of her photography emerged thereafter.

The word "surrealism" was invented by the French poet Apollinaire. French essayist André Breton defined it as "the mobilization of the subconscious in the service of a new concept of art." Surrealism started as a literary movement and only later involved painters like Max Ernst, Man Ray and Magritte.

Salvador Dali had his first one man exhibition in England in 1934 at the Zwemmer Gallery in London, showing limp watches and paranoic objects in landscapes remembered from his childhood, painted with consummate technique. In 1936 Burlington Galleries put on a major surrealist exhibition. McBean reflected the upsurge of popular interest.

He said, "My photos owed a lot to surrealism, to the idea of surrealism, but they were really only playing with the idea. The most important thing was the person in the middle of them. When I was photographing an actress, I would often link the picture to the play she was in. Frances Day was starring in the revue *The Fleet's In* so I gave the picture a nautical flavour. I sent it off with the caption 'God help sailors on a Day like this', but of course it was rejected and they called it 'A Day Dream' instead!"

Perhaps the picture editor did not see the joke, or perhaps he did. Glossy magazines in those days were very proper.

Some of the convolutions of McBean's varied life might have been expressly planned to help him become a surrealist photographer. His family hoped Angus might be an architect and packed him off to the local 'tech! He profited from training as a draughtsman, but calculus was somewhat beyond him. He played truant in the local cinema and took up photography as a hobby—but found his camera, the Popular Pressman, expensive to run.

His father decided he should train in a bank instead. With disarming candour, Angus always admitted to being the world's worst bank clerk but he enlivened two miserable years with a new interest, making masks, which he did with some success for friends and the local amateur dramatic club. When his father sadly died of tuberculosis at forty-seven, his mother moved from Wales to Acton, taking Angus and his sister. McBean managed to get a traineeship in London's most prestigious shop, Liberty's. He learned about antiques and spent some time in the superb fabric department. His expertise in presenting and draping material was to stand him in good stead for surrealist settings. After six years at Liberty's, he decided he must move on. Symbolically clouting a particularly tiresome customer with a bolt of cloth, he contrived the sack. A brave thing to do in 1929 at the start of the Depression.

However, McBean grew a beard as a gesture to "art" and managed to earn a living making masks and other theatrical props. He mounted a small exhibition in a Mayfair teashop using some of his photographs in the background. Hugh Cecil, a well-established Bond Street photographer, saw them and, appreciating McBean's artistic flair, offered to teach him real photography.

Social photography of the 1930s was a specialised skill—as indeed it is even nowadays, albeit to a slightly more discreet degree. Glass plate negatives were large to allow considerable retouching; there was a soft-focus lens on the camera, and sometimes the image was further diffused in the printing. Doting Debs' mothers loved the flattering results; all their ugly ducklings seemed swans.

Some eighteen months later, parting amicably with Hugh Cecil, McBean set up his own studio in his modest basement flat in Victoria. In a remarkably few years he became a successful theatrical portraitist. He was a kindly person—he knew stage and film people, even stars, liked to look a little better than their best, not because of vanity but to succeed in a fiercely competitive profession. He combined the flattery he had learnt from Hugh Cecil with his own dramatic feeling for luminous whites and deep velvety blacks.

When asked by the *Sketch* to take a picture of Beatrix Lehman, McBean knew she would be very nervous; she was convinced, in spite of the fine bone structure of her face, that she was not good-looking. He liked to please his sitters and so devised a special setting. Against a background of ethereal clouds framed in a drape of gleaming satin, her disembodied head and shoulders wrapped in stiff taffeta stand out boldly. In the foreground is a giant block and tackle with an iron hook. The *Sketch* was pleased, commissioned more pictures in a similar vein and soon they were dubbed "surreal." The series ran for over two years. Some were charming, many frankly fun, as were the Christmas cards in similar style, featuring himself, that Angus was to produce for his friends and customers for many years.

A doyen of photographic magazines, the *British Journal of Photography* stormed that the pictures were a disgrace and Mr. McBean a charlatan or a crank or both, but the magazine received so many outraged letters from other photographers, they were constrained to apologise.

McBean did little manipulation in the darkroom. Drawings were essential for the precision of his surreal compositions; with a few buckets of sand and a handful of props he gave his sitters both physical and psychological gloss. Photographs he took of Vivien Leigh were included in the portfolio she sent to Hollywood as part of her successful campaign to win the role of Scarlet O'Hara in *Gone with the Wind*.

After the four bleak years of World War II, much to his surprise McBean was soon back in the limelight, his striking pictures outside many West End theatres. He photographed the stars of the 'fifties and 'sixties from Marlene Dietrich to the Beatles and continued to produce surreal pictures.

There is no doubt that McBean's pictures, such as that of Frances Day, have been a conscious and sometimes unconscious inspiration for many of the complicated advertising photographs of today's glossy pages.

He has been called "the Dali of the Darkroom," but it is not really an apt soubriquet. Interviewing Salvador Dali was like stepping into an icy stream. A sadistic streak infiltrates so much of even his most brilliant work, in his explorations of the subconscious, people are mutilated or supported by humiliating crutches.

McBean's work has no such overtones, and he is imaginative rather than gimmicky. Perhaps one should finish with his own words: "It is a little unnerving to be told at the age of 80 that I'm a genius. Which of course I don't believe."

—Anne Bolt

Bibliography—

McBean, Angus, "Photographing Beauty," in *Picture Post* (London), January 1940.
Cosh, Mary, ed., *Angus McBean in Islington*, London 1982.
Woodhouse, Adrian, *Angus McBean*, London and New York 1984.
Woodhouse, Adrian, *Masters of Photography: Angus McBean*, London 1985.

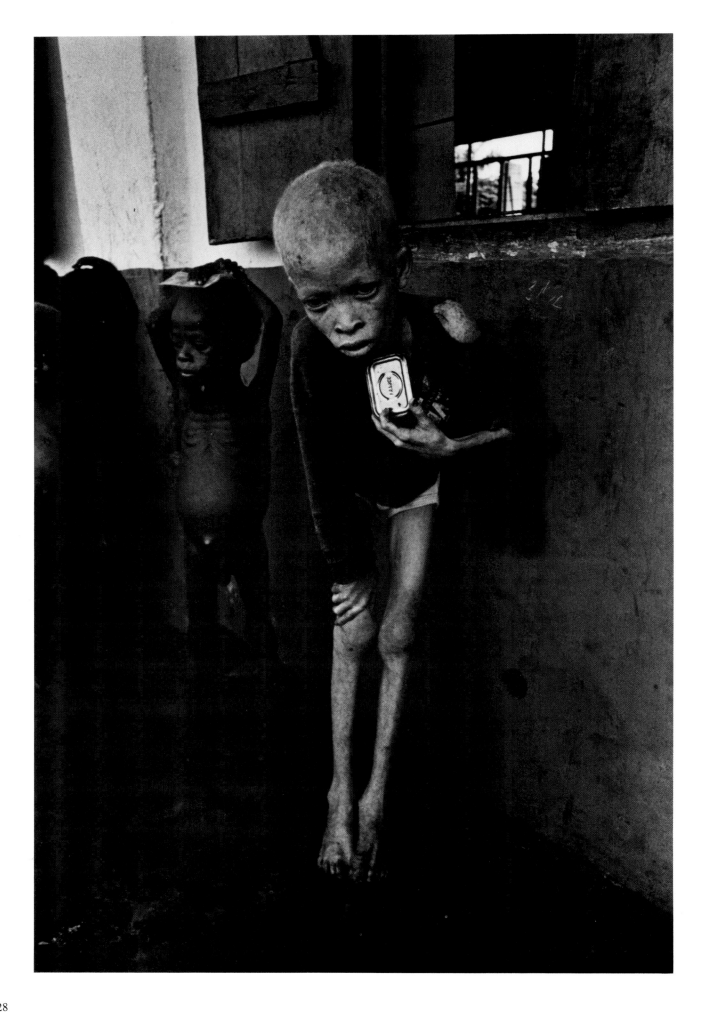

628

Don McCullin (1935–)
Albino Child in Biafra, 1970
Silver gelatin print; 39 × 25.6cm
London, Victoria & Albert Museum

For over two decades, the documentarist Don McCullin stood at the centre of British photojournalism. He has become synonymous with the picturing of war in Africa, Central America, South East Asia and Northern Ireland, and with the deprivation of the inner city in Britain. His photographs first appeared in the *Observer* in the late 'fifties. From 1961 to 1984, he was employed by *The Sunday Times Magazine*.

It was McCullin's work for *The Sunday Times* which established him effectively as photojournalism's cause celebre, outsider and enfant terrible. He became famous, justifiably or not, as a man who got high on war. As such, he was of enormous appeal to a new youthful readership which had been attracted by the *Sunday Times*' campaigning stance. McCullin was given special status. As Art Director Michael Rand remembered: "You gave him a three month assignment . . . and did not use the pictures until he was finished, even if the event that he photographed was out of date . . . what I feel about Don is that his work was a definitive statement on those particular theatres of war."

Within this contemporary setting, Rand created an *idea* of a war photographer to catch the imagination of a new audience. McCullin brought back the photographs which validated the idea. (In 1984, McCullin noted, "I was creating a public, an awareness, and, at the same time, I was being created by it"). The legend of Don McCullin—part-soldier, part-saint, part-new man, glamorous, vulnerable, damaged, reinforced the photographs which he produced.

By 1970, McCullin was a highly experienced photojournalist, and had photographed in the war zones of Cyprus, Jerusalem, the Congo and Vietnam. He had been photographing the Biafran/ Nigerian conflict from 1967, travelling across country with the Biafran rebels. A split had developed within the *Sunday Times* over Biafra—the *Magazine* supporting the rebel cause, its sister newspaper favouring the British-backed Nigerians. By 1970, McCullin had produced many incisive and pain-filled photographs of the Biafran conflict. Of these, the photograph which he made of a starving albino child at a mission hospital in the Umuiaghu region is the one which crystallises his increasingly despairing view of the world.

When McCullin visited the hospital it housed hundreds of "the orphaned and abandoned children of Biafra." Among them, he caught sight of a starving albino child, clutching an empty corned beef tin. To McCullin, the child seemed the epitome of despair. He noted the bitter irony of the situation: "To be a starving Biafran orphan was to be in a most pitiable situation, but to be a starving albino Biafran was to be in a position beyond description. Dying of starvation, he was still among his peers an object of ostracism, ridicule and insult." (Recollected in *Unreasonable Behaviour* 1990)

For McCullin the child seemed a spectre, a modern-day Marley's ghost challenging an Imperialist past, rising up from the ranks of the undead to torment the prosperous voyeurs of the western world.

"I saw this boy looking at me. He was like a living skeleton. There was a skeletal kind of whiteness about him. He moved nearer and nearer to me. He wore the remains of an ill-fitting jumper and was clutching a corned beef tin, an empty corned beef tin. The boy looked at me with a fixity that evoked the evil eye in a way which harrowed me with guilt and unease. He was moving closer. I was trying not to look at him. I tried to focus my eyes elsewhere." As the child approached, McCullin reacted with horror: "Still in the corner of my eye I could see the albino boy. I caught the flash of whiteness. He was haunting me, getting nearer . . . I felt something touch my hand. The albino boy had crept close and moved his hand into mine. I felt the tears come into my eyes as I stood there holding his hand. I thought, Don't look, think of something else, anything else. Don't cry in front of these kids. I put a hand in my pocket and found one of my barley sugar sweets. Surreptitiously I transferred it to the albino boy's hand and he went away. He stood a short distance off and slowly

unwrapped the sweet with fumbling fingers. He licked the sweet and stared at me with huge eyes . . . He looked hardly human, as if a tiny skeleton had somehow stayed alive."

Like some well-fed Gulliver in an apocalyptic Lilliput of malnourished infants, giving sweets to the starving, McCullin felt immobilised, bound by the hopelessness of his situation. "It was beyond war, it was beyond journalism, it was beyond photography." With his comprehension of the photograph as some ghastly aide memoir, he wrote, years later: "If I could, I would take this day out of my life, demolish the memory of it. But like memories of those haunting pictures of the Nazi death camps, we cannot, must not be allowed to forget the appalling things we are all capable of doing to our fellow human beings. The photograph I took of that little albino boy must remain engraved on the minds of all who see it."

The photograph was one of many which McCullin made in the late 'sixties of starving and disabled Biafran children. In June, 1969, the *Sunday Times Magazine* ran *The Accusing Face of Young Biafra*, an eighteen page story (photographs by McCullin, text by Richard West) with a colour cover.

McCullin's connection with Biafra ended in 1970. During the 'seventies, still for the *Sunday Times*, he documented war zones in Cambodia, in the Middle East, in Pakistan, Northern Ireland, Uganda, Vietnam, Israel, Beirut, and Iran. In the early 'eighties, he photographed in Central America. By the end of the decade, he experienced enormous spiritual fatigue: "Hunting for, waiting for, watching, reacting to the disasters of the world had taken a grievous toll on my spirit. You cannot walk on the waters of hunger, misery and death. You have to wade through to record them. I was chilled, numb and lonely. My head ached with the intensity of my experience, the intensity of my thinking."

In 1982, McCullin was refused access to the Falklands War. By 1984, his position at the *Sunday Times* was seriously weakened. His Central American photographs were not published, and under the new ownership (of Rupert Murdoch), he felt that the paper had become trivialist. "It's not a newspaper, it's a consumer magazine," he wrote (in *Granta* magazine) in 1984. He saw himself as, "an old Hollywood movie star who has to grow just a little older before he can discover his new role." That same year, he left *The Sunday Times*.

McCullin's *Albino Child in Biafra* was emblematic of a style of reportage which distinguished the most incisive of contemporary Western photojournalism. It established the photoreporter as crusader, sorrowing tradegian documenting the misdeeds of a corrupt and deadly world. To its critics, it represented a voyeurism which invaded and humiliated victims of catastrophe. To others, it set a dangerous precedent, portraying the Third World as an unfathomable phantasmagoria.

In the history of photography, it has become a seminal picture, used time and time again to reinforce the photojournalist's status as moralist, humanist and story teller.

—Val Williams

Bibliography—

McCullin, Don, *The Destruction Business*, London 1971.
Capa, Cornell, ed., *The Concerned Photographer 2*, London 1972.
McCullin, Don, *Hearts of Darkness*, London 1980.
Haworth-Booth, Mark, "Don McCullin," in *Creative Camera* (London), March/April 1981.
Osman, Colin, and Rand, Michael, "The Sunday Times Magazine," in *Creative Camera* (London), March 1982.
Bernard, Bruce, "My Ten Years at The Sunday Times Magazine," in *Creative Camera* (London), March 1982.
Haworth-Booth, Mark, *Donald McCullin*, London 1983.
McCullin, Don, "A Life in Photographs," in *Granta* (Cambridge), no.14, 1985.
McCullin, Don, *Unreasonable Behaviour*, London 1990.

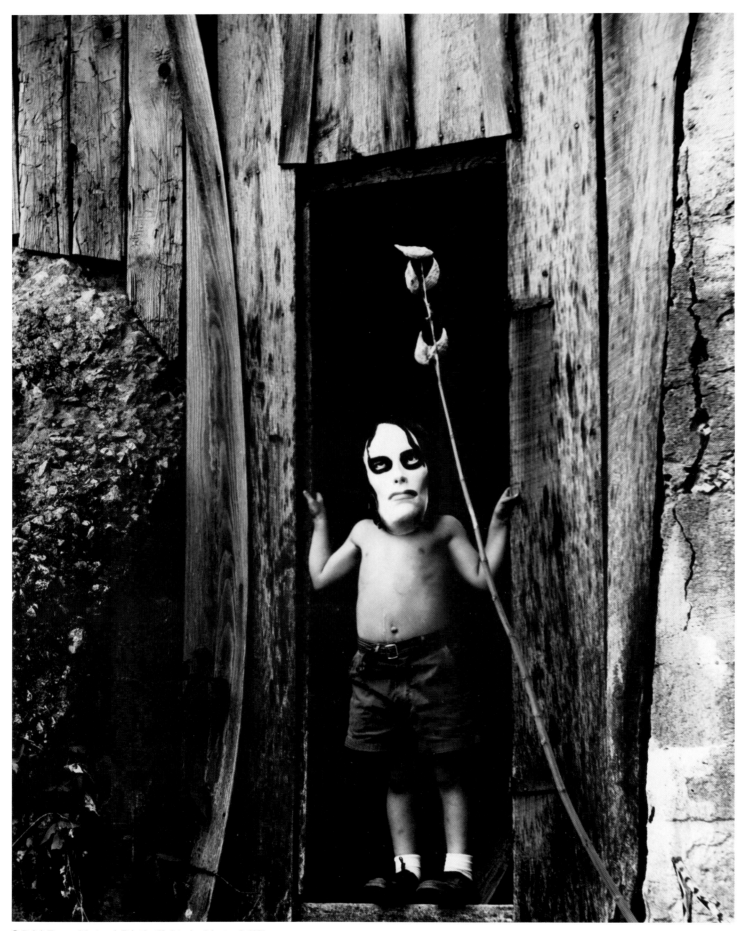

© Ralph Eugene Meatyard. Print by Christopher Meatyard, 1991

Ralph Eugene Meatyard (1925–72)
Untitled: Child with Mask, c.1959
Gelatin silver print photograph; 7 × 5⅝in. (17.8 × 14.3cm.)

Ralph Eugene Meatyard's untitled image of a child in a mask is but one of the many photographs of masked people he has made. In general, his work consists of images of the human: dolls, masks, and statues, which are often coupled with, or serve as a foil for portraits of family and friends. Typically this image uses an unusual prop for an ordinary subject; it shows a young child, probably male, whose actions are not really defined, but rather suggested. Not only is ambiguity introduced by the uncertainty of the child's sex, but it is reinforced by the child's delicate balance as it teeters between the shed's dark aperture and the light of the outside world. Springing from no apparent garden, a plant intrudes into the darkened frame surrounding the child, whose eyes gaze expectantly upward at it. The picture thus describes an encounter between two incongruous lives, a tall nearly leafless plant that springs from nowhere and a masked child whose arms are akimbo in an almost insectlike pose, while the masked head seems disproportionately large for the young body. The frailty of this body is also underscored by the pipestem legs which emerge between baggy shorts held up by a belt, and wrinkled socks which sink into shoes. This contrast between the vulnerability of the child's body and his more fearsome head produces an absurdity which is the hallmark of Meatyard's style.

Throughout his life, Meatyard collected odd personal names, odd city names, and newspaper articles about unusual events. These true but strange facts expose his environment as an interpenetration of extraordinary reality with an ostensibly ordinary and documentary one. They also reveal his world to be inherently narrative in structure, a fact shown in this image by the child's expectant gaze at the plant, the implied narrative that leads to the masking, as well as the kinetic potential of his pose.

This documentary style is known as the snapshot aesthetic, a deceptively simple approach which combines the vernacular qualities of an amateur photograph with the more sophisticated vision of the practiced photographer. In this print, it is characterized by intense lighting and large shadow areas which produce the sense of visual uncertainty found in many of Meatyard's images. This in turn contrasts with the overtness of the centrally placed subject and his ordinary environment. Additionally, the objects in this picture, and in Meatyard's work as a whole, are in no small measure defined by the frame, their relationship to it and to each other. For example, the shed door creates the conceit of a frame within the picture's frame, while the curve of the plant is echoed by the curve of a long, loose board near the door's edge. The right area of the picture which appears to be tarpaper is carefully balanced by a bush on the left. Meatyard acknowledged his debt to the photographer Alfred Stieglitz as the developer of this suggestive technique where the subjects pose themselves while the photographer waits for an appropriate gesture. Indeed, this image echoes the Stieglitz's 1921 snapshot of his niece Georgia Engelhardt who stands in a doorframe with arms akimbo and her feet placed as if ready to depart.

The apparent blandness of the snapshot aesthetic also contrasts with the mask which rivets our attention on the centrally-placed sitter who represents several levels of individuality. The mask's invulnerability and fixed features contrast with the subject's naked torso and tentative gestures, which along with the eyes are the only clue to the subject's feelings. The mask is thus used to make the figure more identifiable as a unique phenomenon, rather than a unique individual. At the same time, the implied interchangeability of the mask makes the figure more universal.

This print is but one of Meatyard's masked portraits of which he did several series throughout his photographic career. It uses a mask from a collection of approximately twenty-five commercially produced masks he assembled over the years, and which he occasionally carried in the trunk of his car to be used in his photographic outings. His subjects become both more anonymous through masking and by reflecting and absorbing certain qualities of the mask they wear. Their mask also permits them to confront the photographer and the mask he uses in his role as artist. More importantly, whoever they may be without the mask, they are changed by the wearing of it.

Indeed, the first page of Ralph Eugene Meatyard's book which features masked personages in every image: *The Family Album of Lucybelle Crater*, cites the dictionary's etymological definitions of mask. In the final text of this work, nature itself is described as "the mask we see through and that sees through us." The photographer also states in the epilogue that he is the mask and the mask is him. This is a reference to the act of photography as one which imposes a mask between the photographer and the subject, while the viewer experiences that masked interchange as the print. Thus, this photograph by Meatyard and others like it describe a situation in which the subject is exposed, but the mask is never entirely absent. It demands that we ask how well the photographer may ever know the person he photographs. The mask also transports the subject into ritual time while he remains anchored in his very ordinary surroundings: for the closed and personal world of the subject is balanced with the larger world of the mask and its meanings. In this image and others, Meatyard reveals a world that is macabre, droll, vernacular and stylized by turn.

—Diana Emery Hulick

Bibliography—

Cokse, Van Deren, "The Photographs of Ralph Eugene Meatyard," in *Aperture* (New York), Winter 1959.
Greene, Jonathan, ed., *Ralph Eugene Meatyard*, Lexington, Kentucky 1970.
Berry, Wendell, *The Unforeseen Wilderness*, Lexington, Kentucky 1971.
Hall, James Baker, ed., *Ralph Eugene Meatyard*, Millerton, New York, Dusseldorf and Toronto 1974.
Williams, Jonathan, and others, *The Family Album of Lucybelle Crater*, Millerton, New York 1974.

© Susan Meiselas

632

Susan Meiselas (1948–)
Soldiers searching bus passengers, Northern Highway, El Salvador, 1980
Silver gelatin print photograph

If any one body of work was to be selected to represent the new style and methodology of war reportage in the 'eighties, then Susan Meiselas' photo-documentary of El Salvador would make an apt choice. From Meiselas' documentation of this civil war in Central America, the photograph, *Soldiers searching bus passengers, Northern Highway, El Salvador* reveals with some precision the direction and concerns of a new generation of "post-Concerned Photographer" war reporters.

Unlike many of her predecessors (especially fellow members of the Magnum photo-agency, set up by photojournalists Robert Capa, George Rodger, David Seymour and Cartier-Bresson just after the Second World War) Meiselas did not begin as a magazine photographer, but came to photojournalism as a teacher and intellectual. She graduated from Harvard as an educationalist in the early 'seventies, worked as a film editor and went on to teach photography in schools and in the wider community. Her last teaching post (from 1975–76) was held, perhaps significantly, at the legendary photography department at the New School for Social Research in New York.

It was not until the mid-'seventies that Meiselas became involved with mainstream photojournalism, beginning to freelance for magazines which included *Geo, Life, Harpers* and *Time*. She developed a style of reportage which, though paying obeisance to the photojournalist's sense of immediacy and urgency, addressed with some finesse the questions of composition, styling and the use of colour. Meiselas' 'seventies war reportage was arresting not just because of its bold confrontations of the physical cruelties of war, but also because of its subtle and frequently alluring choreography.

Meiselas first became widely acknowledged as an important photographer when her, now classic, book of new-wave war reportage *Nicaragua* appeared in 1981. Meticulously plotted and edited, the book emerged as a persuasive, involved and engaged document of the struggle between the rebel Sandinistas and the US-funded dictatorship of the Somoza family. With *Nicaragua*, Meiselas put aside the concept of the war photographer as impartial observer more effectively than any other photographer of the post-war period. Taking and extending the method already practised by fellow Magnum photographer Philip Jones Griffiths, Meiselas positioned herself uncompromisingly as the angry, partisan witness to a dirty war. Her photographs shocked a public already accustomed to the concept of media wars: made in vivid colour, they presented without obliqueness, burning bodies, dying children, set among the poor cityscapes and shanty towns of Central America. Whereas Jones Griffith's Vietman photographs, bitter as they undoubtably were, followed a long-established line of "concerned" reportage, with death and destruction seen in deeply shadowed, richly toned black and white, Meiselas presented a visual cacophony of colour, shapes and incident. While Jones Griffiths' photographs of Vietnam (as seen in his 'seventies' photobook *Vietnam Inc*) are a lament, almost an elegy, Meiselas' work is a loud and active intervention.

Soldiers Searching Bus Passengers, Northern Highway, El Salvador was made after the *Nicaragua* project had been completed. For those who had come to associate Meiselas's work with the vivid colorations and high action of *Nicaragua*, this photograph signalled a new direction. Where her previous work was direct, full of colour and narrative, this is an ambiguous photograph. It shows a group of people ordered off a bus in order to be searched. But Meiselas chooses not to photograph the people, only their shadows etched on a peeling wall by the bright Central American sunlight. In *Nicaragua*, she had been involved in, and photographed the same event, but had studied the people themselves, their vulnerable backs, their multi-coloured clothes, the macho-

tight jeans of the men, the women's floral dresses. It was a photograph which invited suppositions, which had an uncommitted violent deed as its imagined centrepiece. In *Soldiers Searching Bus Passengers, Northern Highway, El Salvador*, Meiselas chose a different approach, more oblique, more literary, more suggestive. She invites the viewer to see the irony of the situation—shadows on a peeling wall a compositional delight, the figures, seen dark and elongated, make patterns, barred and beautiful. Like a homage to Siskind or Bravo, the photograph is a reflective memory of a light-filled afternoon, a carefully studied miniature.

Meiselas had become associated with a particular kind of war photograph in *Nicaragua*, shocking, explicit, almost bland in its presentation of headless torsos, burning bodies, mutilated children. Famous for her confrontations of the human detritus of civil war, Meiselas here takes a sidelong view and stares quizzically, almost incredulously, at the bizarre and surreal configurations of conflict.

Looking through Meiselas' photographs of El Salvador, one is conscious of her continuing subversion of the received idea of news photography. In her photograph *Guerilla Training* (featured in the special El Salvador issue of *Camerawork* in 1983) the drilling soldiers are like ballet dancers in formation. Her photograph of *Salvadorean women working in a US Bra Factory* presents cogent contrasts between the plain clothes of the workers, the frothy lace of the underwear which they produce. *Soldiers Searching Bus Passengers, Northern Highway*, draws the viewer likewise to reflect on the surreal state of El Salvador as viewed by a committed and radicalised Western imagination.

Soldiers Searching Bus Passengers, Northern Highway, El Salvador continues Meiselas' interest in the ambiguities of the *appearance* of war. In other photographs made during the late 'seventies and early 'eighties, she had looked at the *look* of war, the *style* of conflict almost as a still-life or fashion photographer would. Though followed in the 'eighties by even more "design-conscious" photojournalists (like the now renowned Sebastiao Salgado), her photographs were seen as a perhaps disturbing vanguard of a new, modish kind of documentary.

But, looking back to the history of women's photography, Meiselas can be seen to be continuing, rather than creating a tradition. When the American war photographer Margaret Bourke White entered the Nazi concentration camps at the end of the Second World War, she too used pattern and shape to make the incomprehensible communicable. Her fellow countrywoman Lee Miller working as a fashion photographer in war-torn London used the dereliction of the Blitz to make a compelling background for wartime fashions. Freed (or excluded) by their gender from the traditional world of press photography, women war photojournalists have traditionally been able to re-direct the course of conflict reportage. *Soldiers Searching Bus Passengers, Northern Highway, El Salvador*, an enigmatic, questioning exercise in war photography, is an important marker both in the development of the genre and in the history of women's photography.

—Val Williams

Bibliography—

Jones Griffiths, Philip, *Vietnam Inc*, London 1971.
Meiselas, Susan, *Nicaragua*, New York and London 1981.
Meiselas, Susan, ed., *El Salvador: The Work of Thirty Photographers*, New York 1983.
"El Salvador," special issue of *Camerawork* (London), no. 1, 1983.
Emerson, G., "Susan Meiselas—at war," in *Esquire* (New York), December 1984.
Manchester, William, *In Our Time: The World As Seen by Magnum Photographers*, London 1990.

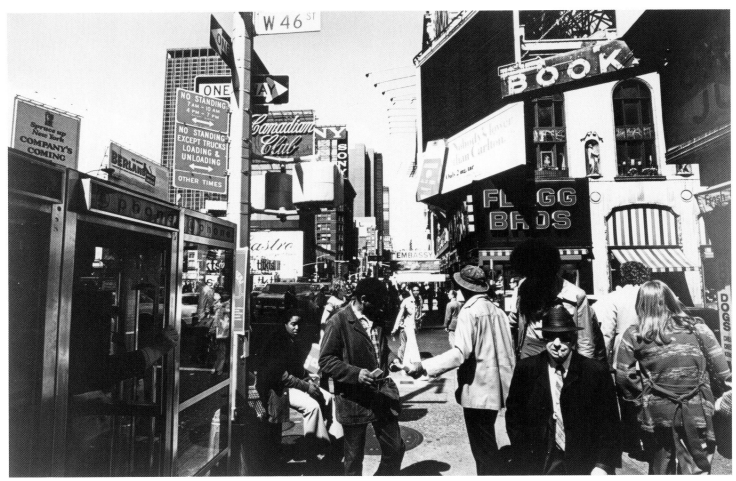

© Joel Meyerowitz

634

Joel Meyerowitz (1938–)
Broadway and 46th Street, New York City, 1976
Colour photograph

Joel Meyerowitz is one of the few photographers "who has most successfully made the transition from seeing in terms of black-and-white tonalities to seeing wholly in terms of color," says museum curator Clifford Ackley. Known primarily for his gritty black-and-white street photography and pristine color landscapes, it was not until 1983, in his book *Wild Flowers* that Meyerowitz presented his more than twenty years of color work from the street. These images of artistic transition opened a new frontier in which color and the urban scene collided with astonishing results. In contrast to the painterly quiet of color pioneer Helen Levitt, Meyerowitz' images enjoin the flow of unbounded energy emanating around him as he photographs, with an urge "to feel the thrilling human pressure of the crowd."

Broadway & 46th Street marks a turning point in Meyerowitz' photographic work and evolution, an archetype of the visual complexity his color street photography has to offer. With this over-active image, he has reached a plateau—a watershed of momentum in the color print. He displays here the strength of sheer photographic force, and brings a meaningful aesthetic to the seemingly random elements within the camera's frame. In this instantaneous moment, all relationships seem purposeful and become juxtaposed. A suspension of judgement or imposition by the photographer is betrayed by a circus of color, form and texture that belie the subject matter and the experience it depicts. All life in the picture seems squeezed together in an implosion—as the blue sky above retreats, as if moving heavenward in contrast to the dark, temporal world before our eyes.

Urban life in midtown New York has its chaotic dimension, and nowhere is that more evident than near Times Square, where the clashing of visual elements explodes. The overwhelming dissonance of billboards and neon lights, rigid skyscrapers and swarms of people are difficult, even in the mildest of moments, for the mind to process. Light and shadow become contorted by fixed objects forced upon the eyes. The fractionalizing of natural light and shadow are embodied by a myriad of every shape and substance. The scene is like a psychological nightmare for the photographer to reorganize and recreate with visual beauty.

In *Broadway & 46th Street*, Meyerowitz uses what he calls the "blasting, cutting, edgy" light to capture this arena of dramatic human pressure and visual acrobatics. He distributes the energy over the surface of the image, designing through his visceral interpretation the unwieldy, off-balance forces in the scene as they reach a fevered pitch.

This classic urban scene captures the heart of New York's untamed rhythm: a short, tough poker-faced elderly man, his cigar protruding aimlessly at the camera, a leather-jacketed young black man handing paper to an "associate," while, his back to the camera, seeming to call to another associate on the corner who faces him and the camera in a private, but public communication.

The sheer force of visual density—the obstructions and crowding of phenomena and people in the scene engage the viewer in a curiosity—with one eye toward the details of the subject (the scene) and one to the experience of the flat, painterly canvas. The relationships within the design—color, graphic shapes and angles, metal, glass and brick everywhere—can be interpreted as an instant in human evolution—almost as "a moment on earth." One identifies with the relentless demands on our attention of an ordinary midtown New York stroll, and particularly in this, the seedy, unmanageable central vortex of Manhattan.

Here are dark shadows cast across the sad face of a boy sitting—wallowing—on a box, hands clasped in mute casualness as he ponders his life, or nothing at all. An ominous dark fist emerges from a shadowed telephone booth—someone leaning on the metal frame with eerie implications. The human drama unfolds below, as overhead, the collage of billboards and street signs, traffic light boxes, telephone booths and steely buildings overwhelm the blue sky and crowd the already heavily trafficked scene. The anonymity of the scene is surpassed by the instant color palette and the highly organized process of life unfolding to which Meyerowitz has given rise. This is street photography at its boldest—raw, unselective, yet unconsciously formalized by recognition and through the photographer's vision.

Melding the organized chaos of a visual moment on the urban street, Joel Meyerowitz was one of the first color photographers to interpret city street life in all its complexity of tone, hue, emotion and psychological content in the context of the artistically designed color palette. A distinct contrast to his quiet, painterly images of Cape Cod to which he eventually succumbed, his New York City street pictures display a drama of operatic proportions, as if a curtain had just unfolded on an urban comi-tragedy, which attest to the reality of inner city New York in the 1970s. It is, however, the psychological dimension he affords the "street scene" which lends the most informative aspect to the moments he captures. Describing his own work as "centripetal"—moving inward from the edges—his images produce a rhythm of psychological and aesthetic meaning which is orchestrated by variations in visual and color density and by the direction of energetic forces within the frame. This captured force Meyerowitz calls "instaneity." We see an overlaying of meanings—the "catch" of a narrative minisecond and the open possibilities that lie ahead in the life process his images evoke. Meyerowitz displays a formal intuition for the invisible flow of street life. He establishes in *Broadway & 46th Street* a street choir of the unexpected.

Meyerowitz' greatest ability is to draw out the unconscious relationships of spontaneity in a street scene—the light and color shading playing off each other as social gestures take on a central role in the drama. He masterfully arranges visual elements into a symphony of recognition. He informs us of the beautiful process of life unfolding—giving structure to the seemingly unrecognizable character of a street's life force and creating that beauty by the formal structure he invents with color and light. He imposes a Felliniesque theatre on this midtown scene—a mixture of sensations, possibilities and faits accomplis. A certain higher form of reality seeps through—without judgement, without imposition.

Though not one of his more renowned images, *Broadway & 46th Street* represents the culmination of Meyerowitz' street photography and his theme of "organized chaos." In the frame is packed a density of information unrivaled in color photography at this point—a scene as we would experience it, yet choreographed by the eye of the photographer to make psychological sense of an instantaneous moment. Evolving from Cartier-Bresson's concept of the decisive moment, Meyerowitz interprets through the daring use of the "new" color medium. This allows us to unconsciously link the canvas and the photographic print through the well-defined realm of visual gestures and metaphors long recognized in the orchestration of street sense. Meyerowitz has thus taken the expansive work of Garry Winogrand, Lee Friedlander, and his mentor Robert Frank into an exciting and untested sphere. In this, the decisive moment has reached a new level of appreciation from a wider, more modern and spontaneous viewership.

—Bruce Poli

Bibliography—

Kozloff, Max, *Aperture 78: Joel Meyerowitz*, Millerton, New York 1977.
Meyerowitz, Joel, *Cape Light*, New York and Boston 1978.
Szarkowski, John, *Mirrors and Windows: American Photography Since 1960*, New York 1978.
Meyerowitz, Joel, *St. Louis and the Arch*, New York and Boston 1980.
Eauclaire, Sally, *New Color Photography*, New York 1981.
Diamonstein, Barbaralee, *Visions and Images*, New York 1982.
Rosenblum, Naomi, *A World History of Photography*, New York 1984.
Eauclaire, Sally, *American Independents*, New York 1987.

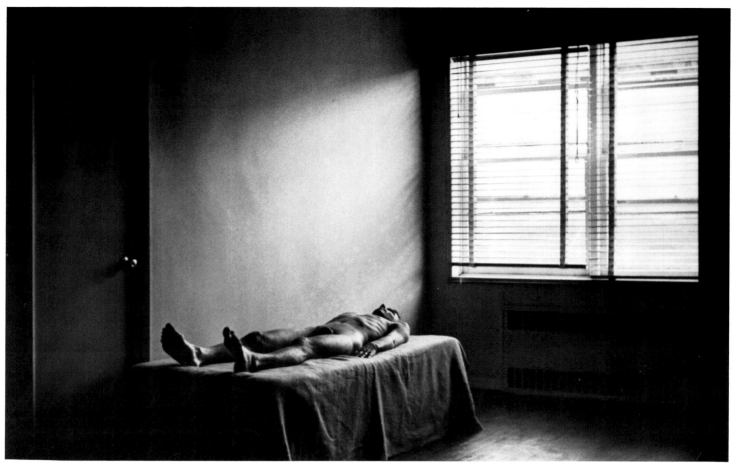

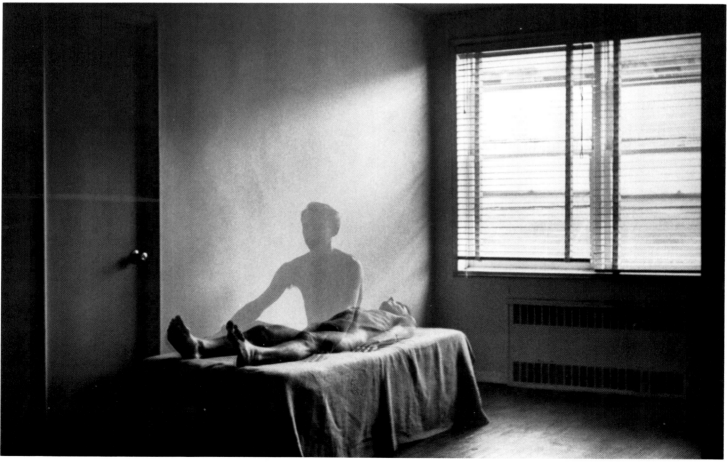

Duane Michals (1932–)
The Spirit Leaves the Body, 1968
Sequence of 7 black-and-white photographs

Photography gained recognition as an artistic genre through the pages of the great photojournalistic magazines. Stories were illustrated not by a single shot but by a series of images which traced the development of the event from beginning to end, making the reader feel he was participating at first hand. Photography is closely related to documentary cinema, but there are many differences, particularly psychological. In looking at a photograph, the viewer, without realizing it, uses his own imagination to fill in the spaces between one photograph and the next. A member of a cinema audience, caught up in the rhythm of the action, cannot do this. At the same time, on an artistic level, some photographers, for example Minor White, have decided to adopt the sequence as a means of engaging the viewer's attention. This is not so much to follow the development of an action in time, as the persistence of certain natural forms and situations which derive their meaning through the transformation of one image into another. However, in both cases, the sequence deals with real events and phenomena. When, in the 'sixties, Duane Michals started taking photographs they seemed like something new. He appeared to use photography to tell pictorial stories of spiritual events and reflections which took the form of actions and observable behaviour. They were "cinema" in the sense that they could be compared to screenplays. The photographer, using specific camera techniques such as over-printing, blurring and shooting out of focus, presented evidence of the unpredictable and mysterious connotations of mundane everyday activities.

The Spirit Leaves the Body (1968) is a sequence of eight images, the first identical to the last. In reality nothing actually happens, even though an event is seen to take place. The body of the young man lying dead or asleep on the bed can be seen all the time. But through a double exposure the young man sits up, then stands, becomes bigger and bigger, and then disappears. The action has nothing to do with reality. It is a projection of the imagination. Here, as in many other of Michals' works, reality and fantasy are superimposed on the same space. Thus, he creates a constant confrontation between optical and spiritual vision, unlike the cinema where the secondary image is a counterpoint to the primary sequence. The double exposure had often been used before, especially by the Surrealists, to indicate the presence of psychic elements far beyond pure and simple facts. But no-one before Michals had pursued dreams as they happened. This coherent representation of the development and duration of the action gives the feeling, not of an ephemeral apparition, but of something real which flees only because it is something we are not accustomed to seeing. It is enhanced by Michals' style, with its strong neo-realist influences. His images are black-and-white. His sets are bare. He chooses bleak and banal locations where there is very little to see, but where the presence of mysterious half-open doors, windows and stairs always suggests the possibility that something unusual could happen, that an unexpected visitor might appear. The dim lighting allows the interplay of shadows from which ghosts might emerge. The subjects are ordinary people, and where there are more than one, they are perfectly in tune with the social context in which they are portrayed. The dimensions of each photograph are small, about ten by fifteen centimetres. Seen in a book, each

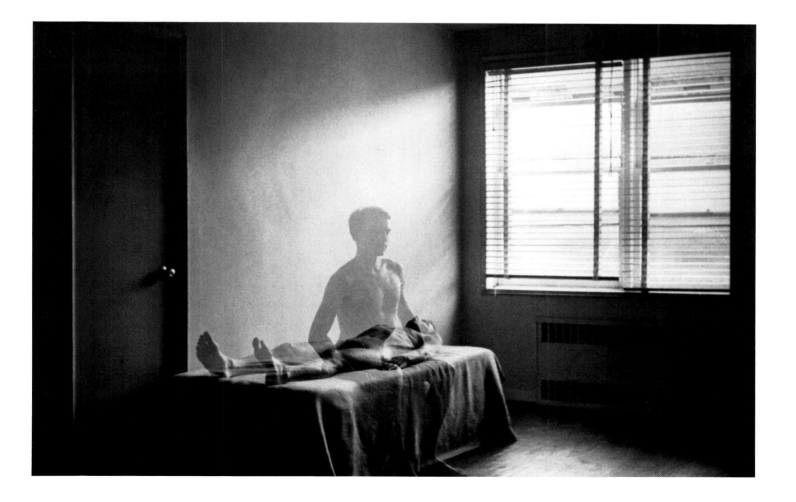

photograph can be scanned on the page. Hung on a wall, each image is isolated in a white frame, in order that it can be savoured separately before the mind of the viewer grasps the mental and psychic paradox which the story relates. So the revelation comes not like a thunderbolt but as the product of gradual persuasion by direct experience. "When I was twenty, I was immortal. Death as a fact did not exist for me. Since then, everything has fallen away to this moment when it all appears to be illusion. I see it as an experience and drama of total mystery beyond anything I can comprehend."

"I am writing this to you in my thirty-ninth year," Michals wrote in 1971. "I am in the midst of this consciousness, this life. Everything before has dissolved to this moment, and this too will become memory instantly. It all seems so ordinary and real and usual, and yet it is quite extraordinary and unreal. It will all end ultimately, and I will not be."

Duane Michals' stories are all about the incomprehensible, the extraordinary and the unreal hidden beneath the surface of the ordinary and usual, as if it were impossible that it should all end here and that there should be no more to existence than the monotony of everyday life. He is particularly fascinated by memory and death. People and events which we take for granted when we are immersed in the present become charged with meaning through recollections, reflections and nostalgia. We are all trying to solve the mystery of death, to find the reason why we all have to die and why so many of those we have loved have gone before, leaving scarcely a trace and many unseen wounds. The enigma urges us to imagine what really happens.

In *The Spirit Leaves the Body*, Michals visualizes the crucial moment of his treatise: the moment in which the spirit, represented by an invisible body, abandons the empty shell of the physical body in which it has been imprisoned. As it moves away it becomes larger and larger. We do not know where it is going, but we are comforted by the knowledge that this is not the end and that within the empty shell lying on the bed there is until that moment something more than a piece of flesh whose movement is controlled by muscles. He shows us that there is also a soul which survives the flesh and which we shall meet again in some other, unknown place. As the stars which always light the sky, even by day, need darkness in order to shine, so with photography we have to learn to turn down the light of reality in order to see more clearly. Only then will we be able to see that invisible core of man's being which the photographs of Duane Michals brings to life before our eyes.

—Daniela Palazzoli

Bibliography—

Michals, Duane, *Sequences*, New York and Milan 1970.
Michals, Duane, *The Journey of the Spirit After Death*, New York 1971.
Coleman, A. D., "Duane Michals: The Journey of the Spirit After Death," in the *Village Voice* (New York), 30 March 1972.
Michals, Duane, *The Photographic Illusion*, Los Angeles 1975.
Michals, Duane, *Real Dreams*, Paris and Danbury, New Hampshire 1977.
Michals, Duane, *Changes*, Paris 1980.
Michals, Duane, *The Book of Sleep and Dreams*, New York 1984.

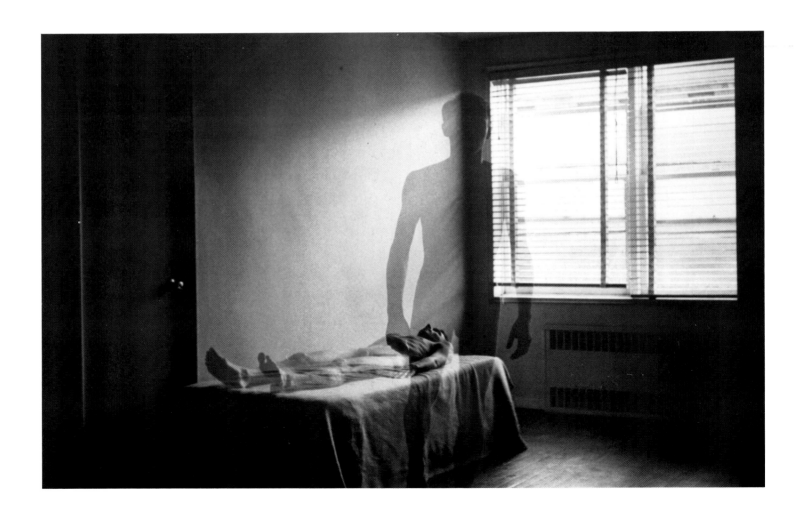

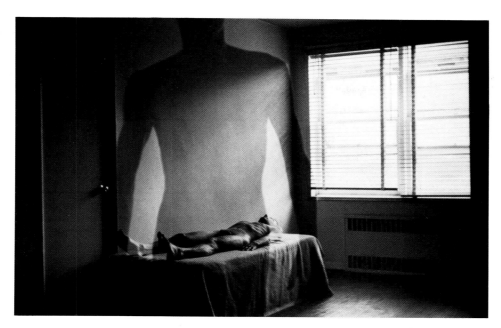

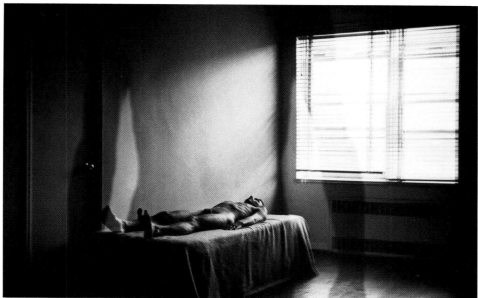

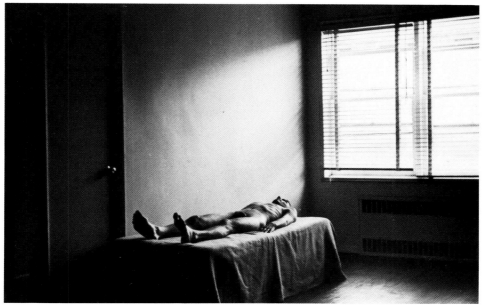

© Duane Michals

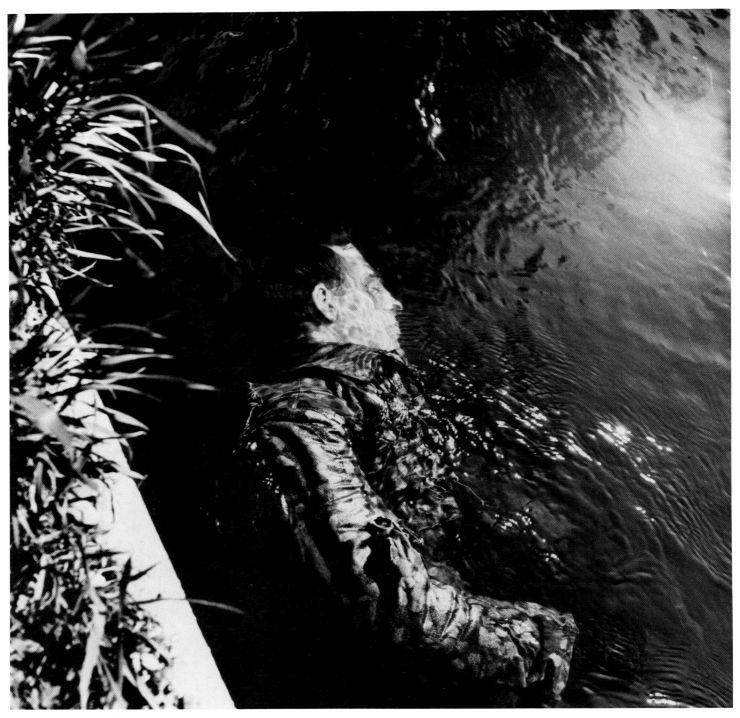

© Lee Miller Archives 1985

640

Lee Miller (1907–77)
Murdered Prison Guard in Canal, Dachau, 1945
Black-and-white photograph
Lee Miller Archive, Sussex

Lee Miller's war experience began in July 1944 when she was sent to Normandy by *Vogue* magazine to do a "Florence Nightingale" photo-reportage on the nurses in a field hospital behind the lines. She returned to England five days later with two reports on field hospitals. These were published in *Vogue* accompanied by Miller's own hard-hitting text. For the editor of *Vogue* it was a way for the magazine, which at the time seemed quite frivolous and even out of place against the background of the horrors of the conflict, to "do its bit" for the war effort. But for Lee Miller it was a revelation which was about to change her life over the following eighteen months.

On her return to France as a photojournalist, she followed the American troops as they advanced into Germany. It was more than just a job but the discovery of a deeper commitment. The assignment in which she was involved was the stuff of which history is made, and it required essentially masculine virtues like courage, physical strength and adaptability. She discovered and displayed the kind of inner resources that might not have been expected in a woman who had been one of the leading lights in the social and cultural life of Paris and New York. She was with the first of the liberation forces to enter the concentration camp at Dachau on 30 April 1945. In the face of the unspeakable horrors that the allied troops found, she showed more fortitude and self-control than many of her male colleagues. These qualities are evident in her photograph of the *Murdered Prison Guard*, killed during the disturbances that preceded the liberation of the camp. Even in the midst of the intense emotions aroused by the atrocities committed in Dachau, she managed to produce an exquisitely composed photograph whose diagonal lines emphasize the movement of the corpse in the water. This dynamic has a dual function: it bears witness to the defeat and punishment of the enemy, here frozen in watery death. At the same time the distorted face, which appears to disintegrate into the luminous ripples, underlines the idea of death as a process of purification in which a nightmare is swept away by the water.

Lee Miller was thirty-eight years old when she took this photograph. Still a very beautiful woman, she had behind her a dazzling career both as a respected photographer and as a model for other photographers. In New York she posed for Edward Steichen and Arnold Genthe. But it was in Paris, as model, assistant and companion of fellow American Man Ray, that she learned her craft and took on the role of a kind of roving ambassador between the worlds of America and Europe. Her beauty and class gave her an entrée to high society and also opened to her the doors of the fashion magazines. Her vitality and intellectual curiosity led her into firsthand involvement with the people and events of the period. She experienced in person things that others only read about. At the end of the 'twenties, when the Surrealist movement was at its height, her association with Man Ray, the great photographic artist who was one of the movement's leading exponents, convinced her that reality was something mysterious, fascinating and complex. Photography is not just a confirmation of the usual clichés which we use to represent a banal vision of the world. It can transform appearances, making them coincide with our thought processes without explanations, but also revealing their deepest nature. The premeditated choice of incongruous and unpredictable techniques and the use of shade, sunlight and camera obscura can reveal the secret side, the hidden truths of situations without any

adverse effect on the objective testimony which is the hallmark of the photographer's art.

So, as a photograph which presents reality in an innovative way excites the imagination because it confronts reality on its own ground, so the turmoil and violence of war are seen as surreal phenomena far more powerful than anything an artist might create. There is no need to control events in order to create a different level of perception. There is no longer any such thing as normality. Against the terrible and, in a sense, predictable routine of war, the encounter on a dissection table between an umbrella and a sewing machine passes unquestioned. In times of war the nightmare of living becomes usual, a social norm. Death is an ordinary everyday occurrence, no longer regarded with fear and superstition. It is a constant presence, an unfathomable mystery encompassing the whole world as exemplary punishment of the evil enemy. Lee Miller does not reject the classic method of telling a story through the confrontation of the two protagonists. But her more forceful and personal contribution is achieved through her use of light and shade and reflections as modes of expression. However, the impact of the work is achieved through the surrealist influences embodied in the creativity of the photographer.

The *Murdered Prison Guard* is caught by the camera as the water engulfs him. The image is captured as he is transformed into a ghost. Moreover, in the pages of the newspaper, the body of a fat SS man would create a stark contrast to the wretched living dead and the piles of skeletal corpses of the prisoners of Dachau. But the luminous reflections rippling through the water in which the corpse is immersed dissolve the contours of the face. The features of the dead German soldier disintegrate before our eyes. As the water threatens to obliterate him, we are left with the feeling that a kind of justice has been done, that evil has been punished and the culprit destroyed. Only then do we turn our attention to the open eye of the camera fixed on the death of the soldier. As an eye-witness, Lee Miller asks a question which can never be answered. Her eyes can never be closed to the things she has seen, she cannot remain silent, she cannot forget. We are witnessing the death of Frankenstein and that open eye focused on the corpse continues to question history. How could such things happen? How could mankind perpetrate such horrors? But it also poses the question: what now? What happens afterwards? Can we ever forget? Lee Miller had a far broader approach than the majority of contemporary war photographers. She related immediate situations to more universal questions of life and death, without losing touch with her function as chronicler of the advance of the allied forces. She used what she had learned from the Surrealists to look beyond external appearances and to search for the symbolic value of forms. Through her use of that most versatile of elements, light, and its counterpart, shade, she found a multiplicity of meanings. Light falls on objects and is reflected as in the many facets of a diamond, revealing its beauty and richness. Lee Miller's photographs do not try to extinguish that brilliance, but to underline through it the fascination and mystery of the many levels of reality.

—Daniela Palazzoli

Bibliography—

"Obituary: Lee Miller," in *The Times* (London), 25 July 1977.
Penrose, Antony, *The Lives of Lee Miller*, London 1985.
Livingston, Jane, ed., *Lee Miller, Photographer*, London 1989.

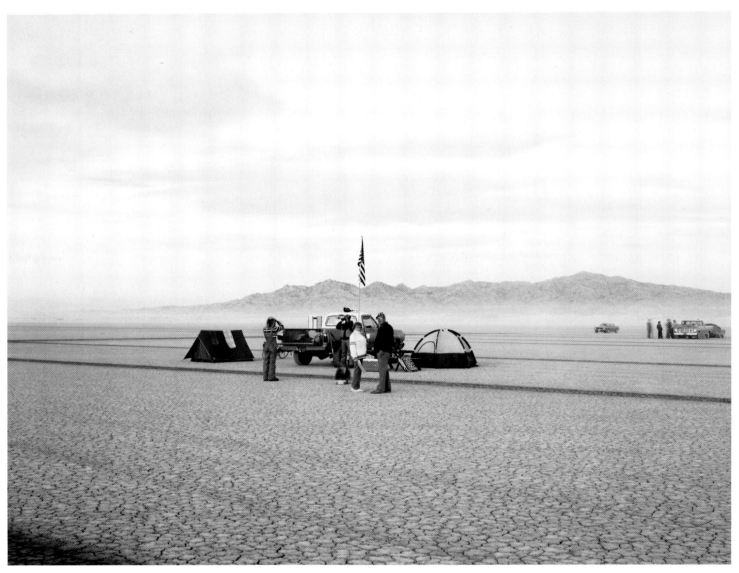

Copyright Richard Misrach 1983

Richard Misrach (1949–)
Desert Cantos: Waiting, Edwards Air Force Base, 1983
Colour photograph

Deserts have always had a very special meaning for man, because of their metaphorical and real existence. According to the bible, our world was deserted and void at the beginning of time: the desert is void, the void is deserted. In the face of the threats that the deserts imply for man and the extremes one encounters there, it is not surprising that some cultures have in their beliefs situated the underworld, the place for their dead, in the desert. However, for the living they are places of temptation and more or less voluntary tests; for here, even the gods are far.

Despite the absence of the gods, man has not been prevented from making his pact with the deserts. This was how the small and large devastations were created, about which Richard Misrach talks in his *Desert Cantos*. "Desertness" as he sees it, is not a propriety of the deserts, but a consequence of the recklessness of their human visitors. They don't even have to act like plunderers; their mere presence suffices to destroy the elementary simplicity of the deserts. We call them "adverse to life" instead of "adverse to man." This point of view allows for drawing numerous legitimations which in turn deny this form of nature its individual right to be. It has to be tamed and conquered. Now highways and railwaytracks cut through deserts, base camps in the form of motels, swimming pools and drive-in-banks are erected; test tracks for high-speed vehicles and landing runways for spacecraft are built on dried-out lakes. The military finds a space, right in front of their doorstep, ideal for manoeuvres and atom-bomb tests. Plutonium with a half-life of 235,000 years was distributed over large areas in these tests. It finally transforms the desert to what man has always looked upon as: dusty hell.

Strangely enough, such details are not exposed by landscape photographers of the old school. They don't work from the landscapes themselves, but from the preconceived images we have of them. Thus it is obvious what makes up a good picture: snow-covered mountains, roaring waterfalls, and the moon above a plain. Their paradises are void of people. Maybe it is more due to instinct rather than choice that all human traces are avoided—they would spoil their pictures. One could mistake Misrach with his large-format camera for one of these traditionalists; but it is not this principle that guides him to this working method, it is rather his personal choice of themes. Misrach's desert is never just itself; it is under an influence. The photographer is not concerned with demagogy through obvious simplifications and loud accusation. His landscapes are, on the contrary, of fascinating beauty and obsession with detail. Sorrow over the lost virginity recalls in its splendour a Dutch still-life from the 17th century. In order to decipher the message, one has to look carefully and not be blinded. Just as the maggot in the apple of the still life announces the transitoriness of all being, does the presence of man in Misrach's photographs tell about the end of the virginity of nature.

On the other hand, it is *Waiting*, and all other works of the series *Desert Cantos*, which also speaks about nature and declares the end of human immortality. It is shortly before sunrise, and a warm, indirect light still falls on the scenery without casting any hard shadows. The former bed of a lake, dried out, flat and crusty, is evenly segmented by peculiar, wide, oily black lines. Two couples have settled down with all their belongings on one of these fields. Their small premises that consist only of pick-up, bicycle, tents, folding table and chair, and food in a cool box, is watched over by a hoisted but dangling star-spangled banner. No doubt the campers are active leisurers as we can see from dungarees, checked shirts and hats as well as other vitally important utensils. *Waiting* belongs to a chapter of the Cantos entitled *The Event*. One does get the impression of relaxed tension; awaiting the sunrise; and the landing of a spaceship that will be greeted by the military and lots of visitors. In other pictures of the series, we see containers for toilets and lighting and a great number of mobile homes that give a purpose to those facilities. It is a spectacle; A spaceship returns to the lap of the mother planet after having carried the American spirit of pioneering and conquering into outer space; Whereas earthly scouts in the long-conquered west await news of success: Attack successful, advance squad back from field inspection. They have forgotten that they are in completely alien surroundings, that they are only guests in a world they will never reign but have to surrender to. Dwarfs acting like kings in the land of the giants, presumptuous and autocratic.

Since 1983 Richard Misrach has even more closely followed up the history of abuse of the deserts. The military influence, apparently confined to touristic-scientific areas in the series *The Event*, grows to truly pandemonic proportions. Large regions have been transformed into moon-like scenarios by manoeuvres and testing of weapons that had never been legalized. Scrap metal from tanks and grenades is scattered everywhere. Blood red pools of toxic chemicals give evidence of the indifference of those who produced them. But even worse are the invisible remains of the archaic brutality of our time. The first atom-bomb tests were carried out in the deserts of Nevada 40 years ago. Today, and in thousands of years to come, the sand in this desert will still be contaminated. Day by day, breeding animals perish from "inexplicable symptoms" and are buried in mass graves, a dreadful highlight in Misrach's confrontation with a dream. A romantic journey which has become a nightmare. Paradise and apocalypse united in one moment. "The world is as terrible as it is beautiful, but when you look more closely, it is as beautiful as it is terrible. We must maintain constant vigilance, to protect the world from ourselves, and to embrace the world as it exists."

Never before have we perceived screams of terror and alarm from such quiet pictures.

—Ralph Hinterkeuser

Bibliography—

Misrach, Richard, *A Photographic Book*, San Francisco 1979.
Danese, Renato, *American Images*, New York 1979.
Eauclaire, Sally, *American Independents*, New York 1987.
Misrach, Richard, *Desert Cantos*, Albuquerque 1987.
Misrach, Richard, *Photographs 1975–1987*, Tokyo 1988.

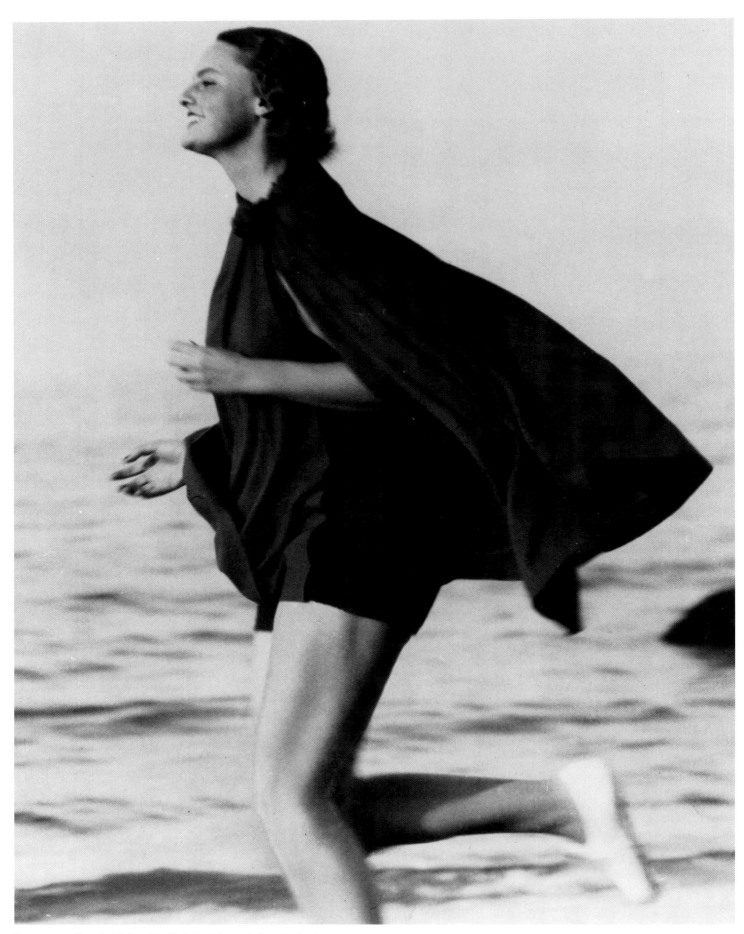

Photo courtesy Photofind Gallery, New York City/ Copyright Joan Munkacsi

Martin Munkacsi (1896–1963)
Lucile Brokaw in Beach Costume, 1933
Black-and-white photograph

As an independent theme in its own right, fashion photography emerged rather late in the evolution of photography as a whole. In actual fact, photography depicted fashionably dressed women and elegant men from its very conception, but it did so somewhat incidentally, treating it as peripheral to portraitism which was its fundamental concern. It was only at the turn of the century that developments in the media and the democratisation of so-called "haute couture" created conditions conducive to the development of a new specialisation—that of fashion photography. Coinciding as it did with the pictorial photography of the period, it was only natural that it adopted paintings of the genre of Van Dyck, Gainsborough or Sargent as models worthy of imitation. In direct consequence, the photography published in the magazines of the day was affected, posed, artificial and extremely elegant. Costly and sophisticated creations, and remarkable accessories such as expensive necklaces, bracelets or other valuables, bedazzled the reader and served to emphasise this elegance. Even such non-conformist and otherwise creative fashion photographers of the time as Baron Adolphe de Meyer, Cecil Beaton or Edward Steichen were unable to rid themselves of these "fanciful" embellishments and ornaments. In that avant-gardist and radical period, complete changes in the prevailing conventions of fashion photography had to await the work of Martin Munkacsi, work that served as a departure point for all subsequent achievements in this field.

Munkacsi was Hungarian. Interested in the press and journalism from an early age, he edited the sports section of the Budapest publication *AZ Est*. Sporting themes were also the subject of his first photographs. At the end of the 'twenties he moved to Berlin where he published numerous photographs in *Berliner Illustrierte Zeitung*, *Die Dame*, *Die Woche* and other journals. After extensive travels around Europe and further afield, Munkacsi moved to America where he embarked on a remarkable career as a fashion photographer.

Stopping off in New York on his way back to Europe, Munkacsi took photographs of William Randolph Hearst, the press magnate. Carmel Snow, the editor of the elegant fashion magazine *Harpers Bazaar*, saw these photographs and immediately commissioned Munkacsi to work on the next issue of the magazine which was to be devoted to summer fashion, bathing costumes, and so forth. Munkacsi, who had never taken a single fashion photograph in his life, accepted the assignment.

"I will never forget," Carmel Snow recollected at a later date, "the day when I took those two Hungarians to the beach. The model was Lucile Brokaw, the best I could get. It was a cold day, dull and unpleasant—not the sort to inspire wonderful photographs. Munkacsi did not know a word of English and his companion had to spend all his time interpreting. At one point, Munkacsi began to gesticulate wildly. We could not understand what he wanted . . . poor Lucile was blue with cold. It turned out that Munkacsi wanted the model to run towards him. This sort of 'pose' had never been tried before in fashion photography (even nautical themes were shot in the studio using a small boat) but we understood that this was all part of some design. The photograph that emerged, portraying a typical American girl running with her hair streaming out behind her, became a landmark in the history of photography. . . ."

Caught in motion, the model fills the whole picture, fitting into the frame with difficulty. The photograph was taken against a sea background with the model running along the beach which, however, does not appear in the picture—along with part of the running girl's leg, it has been cut out of the photograph. The picture is filled with motion, dynamism and joie de vivre.

Along with similar photographs, this formed a real turning point in fashion photography. Munkacsi rejected studios, expensive accessories and artificiality. He also discarded dazzlingly beautiful women, replacing them with ordinary, typically American girls. He gave up long and tiring sessions of posing in front of the camera and demanded spontaneity, freedom and movement. He renounced artificiality for spontaneity. The structure of these photographs was equally revolutionary. Instead of carefully composed pictures, he produced fortuitous compositions, incomplete and almost lacking in structure. The picture was deprived of its compositional focus, cut off or skewed, rather than shot "straight."

Although poses and artificiality were, in fact, never truly discarded in photography, fashion photography did move in the direction determined by Munkacsi. The homage paid to Munkacsi by later masters of this school of photography, such as Richard Avedon, bears witness to this and, above all, so does the routine practice of professional fashion photographers whose dynamism and spontaneity is admirably illustrated in Antonioni's film, *Blow-Up*.

Looking at Munkacsi's photographs, it is possible to conclude that this photography combines diametrically opposed elements. Munkacsi began his career in photoreportage, publishing pictures in Budapest, Berlin, Paris and Rio de Janerio. He showed himself to be a very observant, astute recorder of everyday events, and this is the first quality that is reflected in his photography. While he lived in Germany, in Berlin, in the late 'twenties and early 'thirties, Munkacsi also discovered so-called "new objectivity," that is, the concept of photography as something objective and realistic, using close-ups, isolating the subject matter portrayed, focussing on parts of the whole, and so forth. The ostensible theoretical foundations of this photography interested him less, it seems, than its practical, stylistic aspects, and Munkacsi became thoroughly accomplished in the use of that unconventional, non-pictorialist style. The photographs he took at that time—"Fashion at Worlds Fair, 1936," "Nude with parasol," 1935, and "Fred Astaire," 1936, among them—bear witness to this. Both these qualities—his natural flair for photoreportage and his ability to assimilate new methods—merged in the field he entered as a complete novice: fashion photography.

"We are living," Munkacsi wrote, "in the golden age of photography. Photography is the natural modern expressive medium. And, because of its spontaneity, the opportunities that this art form provides for endless, ceaseless exploration and innovation are greater than ever before."

—Ryszard Bobrowski

Bibliography—

Munkacsi, Martin, *How America Lives*, New York 1941.
Munkacsi, Martin, *Fool's Apprentice*, New York 1945.
Hall-Duncan, Nancy, *The Beginning of Realism in Fashion Photography*, exhibition catalogue, Rochester, New York 1977.
Osman, Colin, *Munkacsi: Spontaneity and Style*, exhibition catalogue, New York 1978.
White, Nancy, and Esten, John, eds., *Style in Motion: Munkacsi Photographs of the 20s and 30s*, New York 1979.
Hall-Duncan, Nancy, *The History of Fashion Photography*, New York 1979.
Hoghe, Raimund, *Retrospektive Fotografie: Munkacsi*, Bielefeld and Dusseldorf 1980.
Harrison, Martin, *Shots of Style: Great Fashion Photographs*, London 1985.

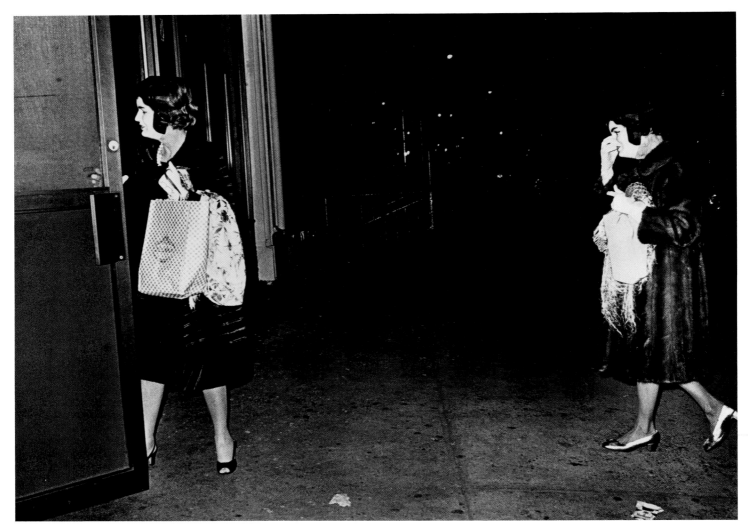

© Ikko Narahara

646

Ikko Narahara (1931–)
Two Ladies in Jackie Kennedy Masks, 1970
Black-and-white photograph

What is really impressive about Ikko Narahara's photography is the virtuosity, not simply technical (that is, not only relating to the "sharpness and instantaneity" which by now are established facts of photography) but rather, the wish to express the maximum tension of any situation that ends up as, or appears to be, a metaphysical event, often bordering on the surreal.

In this sense, it is an emblem of contemporary Japanese photography, which had been started, however, by Felix Beato, a photographer of Venetian origin. In 1860, Beato had gone to Yokohama together with his British friend Wirgham, where they set up a successful photographic studio, which in a short time became a kind of "school of photography" for the whole of Japan. In its early years, photography was treated in Japan with suspicion, primarily because it came from the West, but also because its verisimilitude was in contrast to the traditional religious ideology, which was orientated towards abstraction, as in the rest of the Oriental world.

Ikko Narahara graduated in 1954 from Chuo University, and then specialised in art history at Waseda University, while simultaneously occupying himself with photography. His first exhibition was held in 1956, the year which marks the beginning of his professional photographic career. "Zen" religious practice and philosophy is the foundation of all his work. Without this it would be impossible to understand his contemplative attitude towards reality, his long reflections on "time" ("which cancels itself and stops"), which according to his existential ideology find a coherent means of expression in photography. The mystery of reality seems to be the "leit motiv" of his photographic meditation. One example of this is the report on "Zen," recording the life of the monks of the Sojiji Temple at Tsurumi, where he attempts to express in photography the individual and social presence which exists outside the boundaries of time, according to a religious custom unknown elsewhere. It is only possible to fully understand Ikko Narahara's work if we take into consideration this logic, especially if it is compared with the photographic production of the West. The risk of seeing only the "aesthetics" of his work could lead to a limitation of the iconic message which, in this case, also has a religious message.

Narahara spent some time in the United States, in New York in particular (1970–74), after travelling in Europe in search of a "new human landscape" that, somehow, according to his vision of photography, could coincide with the rules of his Oriental piety. In Venice, for example, during one of his European trips, Narahara produced one of the most extraordinary photographic "tales" of contemporary photography: the montage of a nocturnal sequence, taken along the length of the Procuratie of Piazza San Marco (*Portici di luce* [*Porticos of light*], Tokyo, 1981). The result was a concertina book, that is a single folding page, about 40 metres long, which portrays the whole span of the square, linked, arch by arch, to the porticoes that surround it. At night, with street lights

on, and with torn curtains, it effectively expresses the degradation of an ancient city, where death seems to dwell, as if the Apocalypse were awaited here. The musicality of this interminable "Zen" story by Narahara is the outcome of this rigorous, systematic survey of an urban space, which is not intended as a document, but as a metaphoric message which the photographer wants to convey by means of the image, as abstract as music, beyond any hypocritical reference to objectivity.

During the years he spent in New York, Narahara shot endless "street" scenes—since the street is a particularly fertile ground for a photographer; street photographs taken also under the influence of masterly Western photography, such as that by Robert Frank, Garry Winogrand, Lee Friedlander, to mention just some of Narahara's contemporary masters of American photography.

In his images, always alert to capturing events, if not the "sublime moments" ("decisive" for Cartier-Bresson), there is a constant tension of surrealist character in the dynamics of the elements involved in the image (always elusive and yet frozen by the instantaneity of the shot), and in the low tone, dark and deep, apocalyptic, of his black and white prints, gauged for their expressive and not merely informative function. Ikko Narahara does not wish to give pieces of information, but wishes to communicate messages, to raise interest for the human condition, to introduce the "Zen" which can also be discovered in photography, if practised as rigorously as his.

The photograph of the two women with Jackie Kennedy masks, shot in New York in 1970, is among the emblematic pictures of those years; at a time when the grotesque found an unorthodox poet in Diane Arbus, who aimed for a realistic result, rather than one that was surreal, such as in Narahara's work. This image is theatrical as in Japanese "No" theatre; repetitive, almost obsessive in its repetition of a musical motif, which in this case is the motif of the "mask." We can trace it to the long journey of American photography (from Riis' magnesium light to Weegee's flash in particular) with its nocturnal madness, gasping at the blinding light which creates pure photographic signs; with white silhouettes outlining the significant elements against the darkness, which is not only that of the night, but of nothingness, as perhaps expressed by the philosophy followed by Narahara and defined in his cathartic and always surprising images.

—Italo Zannier

Bibliography—

Narahara, Ikko, *Where Time Has Stopped*, Tokyo 1967.
Narahara, Ikko, *Japanesque*, Tokyo 1970.
Narahara, Ikko, *Celebration of Life*, Tokyo 1972.
Yamagishi, Shioji, *New Japanese Photography*, New York 1973.
Narahara, Ikko, *Where Time Has Vanished*, Tokyo 1975.
Narahara, Ikko, *Journey to a Land So Near Yet So Far*, Tokyo 1979.
Narahara, Ikko, *Humanscape*, Tokyo 1985.

648

Helmut Newton (1920–)
Elsa Peretti, New York, 1975
Black-and-white photograph

It looks like a set created by a talented designer for an American "film noir" of the 40s and 50s. In fact the soaring skyscrapers, standing in stark contrast to each other, provide the backdrop for the photograph of a leggy young lady in the Bunny costume, trademark of the legendary "Playboy" empire. The picture's laconic title is *Elsa Peretti, New York 1975*. The composition follows the rules of classical painting. The model is leaning on the balcony of a skyscraper. A classic triangular shape is created by her body and her arm, with its elbow-length glove, as it rests on the parapet. The gently sloping façade of the balcony runs like a black bar across the entire surface of the picture. In accordance with the golden mean, the model divides the shot into three virtually equal vertical sections, while the balcony splits it into three almost equal horizontal parts. The aesthetic appeal of the scene lies neither in the costume worn by the model, her eyes covered by the characteristic mask with rabbit's ears, her head turned towards the upper right hand corner of the picture, nor in its classic overall composition. Its charm springs from the very distinctive lighting, which composition and costume merely serve to sustain and reinforce. The light which produces the dramatic contrast between black and white, between opaque shadow and the dazzling white façades of the buildings, provides the picture with its air of artificiality.

Nevertheless, there is far more to this picture than its captivating formal qualities. Elsa Peretti, the young woman of the title, serves several purposes. She is the subject of the picture, the focal point of the shot, and ultimately the main attraction for the viewer. However, the photographer has neither reduced her to an object, nor to a piece of graphic furniture, nor to a lifeless component of his composition. Once again, it is the masterly use of light which avoids any tendency to objectification. The contours of her body stand out against the carefully-balanced grey shading of the two-dimensional background. Her physical aura is unmistakable. On closer inspection, the viewer comes to realise that the eye-catching two-dimensional backdrop of the picture—although it is the real New York City where the photograph was shot—is in fact no more than a setting for Elsa Peretti herself.

Elsa Peretti, New York 1975, concentrates, like sunlight through a burning glass, the great art of its creator Helmut Newton. This "Flaubert of the Camera" does not regard his photographic work as art. He sees his profession as a craft and his mastery is based on perfect technique. Part of Newton's technical ethos is his recognition of how the statement made by a shot can vary according to how it is printed and—in the case of publication in a book or magazine—reproduction methods. Thus, in less contrasty printed or reproduced versions, the structural detail of the balcony against which Elsa Peretti poses can be seen within the shadow area of the photograph. However, the basic character of the picture remains unchanged.

The extraordinary photographic skill of Helmut Newton is based on his careful choice of locations and models, in the imagination applied in setting up his shots, and in his use of lighting. It this technical competence that has made Newton so genuinely creative and which gives his view of reality through the eye of the camera its characteristic stamp. *Elsa Peretti, New York 1975* is a fashion photograph. Elsa Peretti was something of a muse for famous New York couturier, Halston, who has since died. It was he who designed for her the costume she is wearing in the eponymous photograph. She was the subject of countless portraits and also Newton's photographic partner for a whole series of nude studies. In this particular shot, the photographer catches her on the roof of her apartment.

Unfairly, Helmut Newton is frequently chided for the misogyny of his photography. Such criticism is based on an outlook obscured by ideological prejudice. Meanwhile, he is seen as the champion of women as the stronger sex, and many independent women identify with Helmut Newton's vision of womankind. Like many important painters, playwrights, film directors and photographers, he imbues an apparently familiar reality with an air of strangeness, so that the viewer is presented with the possibility of seeing through alien eyes things that he might think he knows well. That has been the crucial point of all serious art since the beginning of time. Art is the mirror of life.

—Klaus Honnef

Bibliography—

Newton, Helmut, *White Women*, London and New York 1976.
Newton, Helmut, *World Without Men*, Paris and London 1984.
Musee d'Art Moderne de la Ville, *Helmut Newton: Mode et Portraits*, exhibition catalogue, Paris 1984.
Lagerfeld, Karl, *Helmut Newton*, Paris 1986.
Newton, Helmut, *Portraits*, London 1987.
National Portrait Gallery, *Helmut Newton: Portraits*, exhibition catalogue, London 1988.

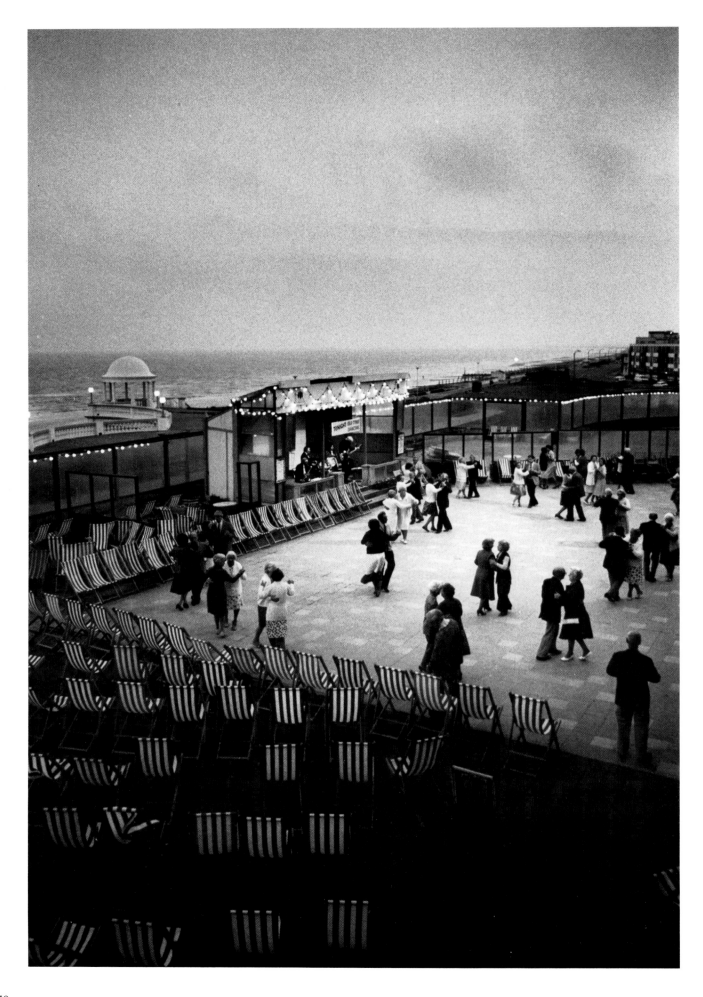

Martin Parr (1952–)
Old Tyme Dancing at the De La Warr Pavilion, Bexhill-on-Sea, 1978–79
Monochrome silver gelatin photograph

During the 1970s, Martin Parr's photographs of Britain became a familiar metaphor for Englishness. A young, independent photographer, based in the North of England, he became well known as an acute maker of cogent documentaries about populist eccentricity.

Old Tyme Dancing at the De La Warr Pavilion evidences Martin Parr's Seventies' view of the English seaside. Early in the decade, he had been much affected by the work of the English new-wave documentarist Tony Ray-Jones, whose photographs had first been shown to him, as a Manchester art student, by the photo-editor, emergent guru and Americaphile Bill Jay. Parr saw the Ray-Jones photograph of couples dancing at Blackpool when Ray-Jones' seminal photo-essay on the English (*A Day Off; An English Journal*) appeared in book form in 1974. He bought the book on the day it came out, and it seemed to re-codify the signs and symbols of an eccentric, almost pagan, postwar England. He had also, at the same time, seen the Ray-Jones photograph of couples dancing outside in Yorkshire. Through the influential small circulation photo-magazine *Creative Camera*, he became familiar with photographs by Robert Frank and Garry Winogrand. Their anarchic view of the disarray of American society was enticing. ("I bought a copy of *The Americans*. It was almost like a dirty book—it was so unofficial.")

Taking Winogrand, Ray-Jones and Friedlander as aesthetic and societal mentors, Parr began to scrutinise the world around him. Twin focuses became the English on holiday and life in the decaying industrial North. A photo-series on Blackpool (made while he was a student at Manchester Polytechnic) was followed by a summer vacation (in 1971) working as a photographer at a Butlins Holiday Camp in North Yorkshire. For Parr, who as the child of two Surrey ornithologists, had never had a holiday at the coast, the seaside seemed some forbidden paradise. Photographing it was like re-writing a personal history.

In 1978, Parr travelled down from Yorkshire to the Sussex coast. He had found himself "between projects," with no specific new work planned. Photographing *The Nonconformists* (his mid-'seventies Hebden Bridge study of a declining rural chapel congregation) had proved to be an unsettling experience. Going North to photograph the Nonconformists, he saw as "very much about my lost childhood. I'd been brought up in the Home Counties, and I'd never felt a sense of community there. When I went to the North of England, it seemed to be much more community based—more nostalgic." His wish to become fully involved in these insular Northern groupings had, however, left him only with a potent awareness of his own outsider status. Future projects, he decided, would not draw him with such intensity into community life.

Old Tyme Dancing at the De La Warr Pavilion had its genesis in that 1978 visit, to Sussex: "We travelled along the coast from Littlehampton, and I stumbled on this De La Warr Pavilion. I was very taken by it. One of the classic 1930s pavilions on the South Coast of England—it was very much to do with retired people. I asked them if they had any events where they used the outside dancing area."

Parr returned to Bexhill that summer, and photographed the dancing couples at "the magic hour. When the ambient daylight is going, and there's some artificial light as well . . . I had all the ranges of light to use. Just trying to catch this image of this lonely couple dancing away their twilight years in Bexhill."

Looking back, he sees the photograph as being very much about his own idea of "Englishness"—"I thought the English were pleasant and quirky. I was politically naive. The seaside brings out the quirkyness in the English. The glorious past, the fading Empire. You still have this grand architecture, but everything's gone down, and it's seedy. Working class people and old people. The English

seaside has been left to people who can't afford anything else. I like to see great things collapse."

Ideas of disintegrating Empire, expiring colonialism, combined with a belief in an enduring English eccentricity. Couples dancing in the half light, seen from above, deckchairs, fairy lights, a promenade grotto seen in the distance, white against a dark sky. In this elegiac photograph, Martin Parr re-invents a history, investing the Sussex seaside with a tarnished allure, making it a kaleidoscope of romantic intentions.

This paradoxical nostalgia (for something which never happened) Parr believes to be a predominant motif within the photo-series made by him and other contemporary independents in the 'seventies. Looking back on the decade, he concludes: "basically, photographers are pretty dull, unimaginative people, and it's much easier to connect with, or believe in traditional lifestyles, old values. When people go and photograph things like Old Tyme Dancing at the De La Warr Pavilion, or a factory closing down, or thatching in Norfolk . . . people are associating, saying, 'this is what I believe in.' It's easier to associate with the past, and a glamorised view of the past, than to deal with what's actually happening now."

In 1982, Martin Parr abandoned black-and-white photography, and now works entirely in colour. In 1985, he made an extensive and concentrated documentary of the Northern coastal resort of New Brighton. (Published as *The Last Resort* in 1986.) The photographs which he produced pictured an orgiastic ritual of fast food, a visual cacophony of distraught children and dislocated adults, abandoned in a sea of litter. Acutely socially critical, pugnacious and unsympathetic, the photographs were a sharp rejection of earlier nostalgia. "If I photographed at the De La Warr Pavilion now, I'd photograph that same subject in a harder and more aggressive way. Close-up, showing the sadness of growing old, rather than the pleasures."

During the 'seventies, young British documentary photographers re-visualised their own childhoods of the 'fifties. They took the ideal of an England which had been presented to them by photographers like Edwin Smith, Bill Brandt and Bert Hardy, and re-made it, using methodologies developed by American urbanites like Arbus, Frank, Winogrand and Friedlander. From the summertime somnolence of monochrome Bexhill to the alarming psychedelia of New Brighton, Martin Parr made his own political and aesthetic odyssey. In 1989, he made a seemingly abrupt change of course, when he began to photograph the consuming middle classes of the South West of England. In abandoning earlier obsessions with powerless, declining societies, he looked instead at the prosperous, the socially mobile. Interviewed when *The Cost of Living* was published, he saw his photography as being, again, autobiographical: "I'm interested in articulating elements of hypocrisy and guilt visually. My own guilt and other people's. Guilt about doing well. I'm interested in exploring my own guilt by doing this work . . . Maybe we all have to feel guilty about something. Maybe it's part of the British reserve . . . My response to people is very constant. My intention is to point out what happens . . . I don't supply the answers, I just ask certain questions."

—Val Williams

Bibliography—

Parr, Martin, Fish, Michael, and Turner, Peter, *Bad Weather*, London 1982.
Parr, Martin, and Walker, Ian, *The Last Resort: Photographs of New Brighton*, Liverpool 1986.
Parr, Martin, and Chesshyre, Robert, *The Cost of Living*, Manchester 1989.
Williams, Val, "Interview with Martin Parr," in *Creative Camera* (London), no. 11, 1989.

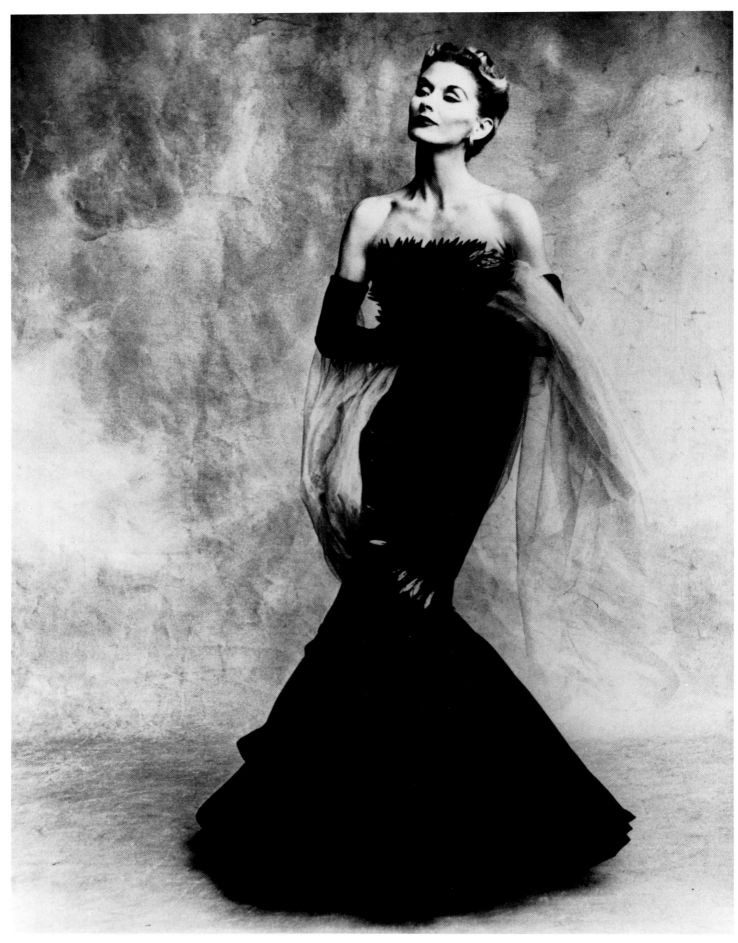

Photograph by Irving Penn © 1950, renewed 1978, by Conde Nast Publications Inc.

Irving Penn (1917–)
Lisa Fonssagrieves in Rochas Mermaid Dress, 1950
Black-and-white photograph

In 1950, during a symposium at the Museum of Modern Art, Irving Penn said of his work: "For the modern photographer, the end product of his effort is the printed page, not the photographic print. The technical limitations of his medium are the limitations not of the sensitive photographic material, but of the reproductive process by which the printed page is made. The modern photographer works within his technical limitations. He even uses them to his advantage. He is not surprised and saddened by the published result. He has, to a great extent, preenvisioned it."

Mermaid Dress was photographed in the same year for the pages of *Vogue* magazine, which wanted to persuade its American readers of the virtues of refined and civilized living. Fashion, it was argued, was not superfluous; it was the embodiment of a way of life inspired by an ideal of beauty, elegance, good taste and rarefied modernity.

Mermaid Dress is a black-and-white image, since *Vogue* did not yet use many colour plates. It plays upon strong contrasts: between the black of the gown and the white of the face and shoulders and the shades of grey of the background—a set of contrasts which is reproduced on the printed page. The flared skirt of the dress gives a subtle dynamic to the whole composition. The body stands encased in the sheath of the dress in a sinuous and supple line from which the head and shoulders emerge, projected by the light towards the viewer. The impenetrable black of the silhouette stresses through contrast the plasticity and tonal richness of the body inside it. Thus the subject of the photograph is not the dress but the woman who models it in an attitude suggesting a mermaid—but an aristocrat among mermaids. The flesh-coloured stole offsets the gown with a delicate wispy lightness and creates a link between the figure and the neutral background. And it is in the background that runs through the whole scale of tones of grey, like notes on a piano keyboard. The light is calibrated to control the interplay of contrasts and to merge the graphic, plastic and volumetric components, at the same time emphasizing the model as the centre of attention.

In the 'fifties fashion photography underwent profound changes which reflected American ideas about clothes. The French were still the great couturiers—this dress was designed by Rochas—but they were photographed not by European-trained photographers such as Beaton, Horst and Hoyningen-Huene, but Americans. More and more American models were also emerging—many of them of non-European extraction. The magazines acted as a bridge between designers and public. Art directors like Brodovitch of *Harper's Bazaar* and Alexander Liberman of *Vogue* were increasingly inclined to use outside settings for fashion shots rather than the rarefied atmosphere of the studio. Gradually, the street became the place in which to bring fashion to life in the most dynamic and modern way possible. Penn resisted this tendency and stuck to his ideal of exclusivity and elegance presented in an atmosphere of peace, serenity and enchantment, where he had complete control over the environment and all the other advantages of working in a studio. His modernity lay in not using scenery or symbols, as his predecessors had, to express the characteristics of clothes. His only criterion was to create an extraordinary, almost abstract, formal coherence. There are no distractions or false glitter in his photographs. His subjects are posed in an empty space, and attention is focused on their independence and on the sophisticated but simple elegance of their appearance. Interpretation and comment are intrinsic to the image. The point of contact with the outside world

and with the magazine's huge readership is through an exploration of form and his idiosyncratic use of a language evolved in art in the years before the war: the language of geometry. By this time, this universal language was widely used as a means of expression for a modern world that wanted to communicate, transcending barriers of language or outlook. In photography it was possible to use the abstract to present an aesthetic that had little to do with the everyday perception of what constituted beauty, without destroying that beauty. Penn was a master of the art of controlling the relationship between reason and emotion, between natural forms and manmade design. *Lisa Fonssagrieves in Mermaid Dress*, for example, is a marvellous arabesque which intertwines a triangle and a sinuous interplay of semicircles, straight lines, curves and zigzags. The clarity and unity of the composition combines line with volume, visible contours with the subtlety of the chiaroscuro accentuating the delicately rounded lines of the head. This in turn is a portrait embracing a complex system of curves—the hairstyle and the face, the spiral of the ear and the line of the eyebrow—balanced by the profile of the nose. Lisa Fonssagrieves was not only one of the most enchanting and famous models of the time, but she was also a woman whose personality and charm Penn wanted to convey. No-one was better acquainted with her qualities—she was also his wife.

In the 'sixties and 'seventies, Penn also swam against the tide, becoming an interpreter of contemporary spiritual and practical concerns. While fashion was ever more influenced by the tastes and needs of the consumer society, his ideas on civilization encouraged him to search faraway and isolated places for the survivors of cultures which over the centuries had developed a wealth of symbolic rituals and decorative art. Like the itinerant photographers of the nineteenth century, he travelled to Peru, New Guinea, East Africa, Nepal and Morocco. In the images that resulted from his journeys, collected in *Worlds in a Small Room*, he removes the subjects he has chosen to represent their culture to a place away from everyday activities and photographs them in improvised studios which enable him to control the lighting and the pose. As the printed page gradually makes way for television, photography is obliged to become an art form which communicates direct with the viewer. "A beautiful print is a thing in itself, not just a halfway house on the way to the page," insists Penn, who is an expert in the platinotype technique of printing with its very fine grain and the delicate chill of its shades of grey. Once again, it is through control of an extremely aristocratic and selective medium that he expresses his ideas about beauty and civilization by interweaving structures and decorations, the natural and the abstract, rationality and lyricism.

—Daniela Palazzoli

Bibliography—

Penn, Irving, and Vreeland, Diana, *Inventive Paris Clothes 1909–1939*, New York 1977.
Hall-Duncan, Nancy, *The History of Fashion Photography*, New York 1979.
Penn, Irving, and Szarkowski, John, *Irving Penn*, Boston and New York 1984.
Karmel, Pepe, "Penn's Beautiful People," in *Art News*(New York), December 1984.
Hodgson, Frances, "Irving Penn: for the printed page?," in *Creative Camera*(London), no. 3, 1987.

654

Josep Renau (1907–82)
Peace is with Them (*Descansen en Pau*), 1956
Photomontage
Valencia, IVAM Centre Julio Gonzalez

The photomontages of Josep Renau are some of the most brilliant and incisive social and political commentaries in the history of the medium. Along with John Heartfield, Raul Hausmann, George Grosz, and Alexander Rodchenko, Renau belongs to a tradition of photomonteurs that have used the mass media image in contadictory juxtapositions in order to comment upon various social, political, and economic issues.

The work entitled *Peace is With Them* is a photomontage that was originally included in the book publication *Fata Morgana USA: The American Way of Life* when it first appeared in Berlin in 1967. Renau began the project in 1952 and completed it fourteen years later in 1966. *Peace is With Them* is a work that deals with the trial and eventual execution of two American citizens, Julius and Ethel Rosenberg, who were erroneously accused of espionage. Renau's visual comment attempts to contextualize the circumstances of their execution within the severe anti-communist atmosphere of the early '50s in the United States.

Renau had become a member of the communist party in Spain in 1931 and four years later directed the publication of a leftist magazine, *Nueva Cultura*, during the time of Franco's rise to power. He was also the co-Director (with Max Aub) of the principle newspaper devoted to communism and socialism called *Verdad*. In addition to his political involvements, Renau, who was born in Valencia, was active as a drawing teacher after his graduation from the Art School of Sant Carlos in 1925. In 1936 he became the General Director of Arts in Spain with the charge of protecting the national artistic heritage during the time of the Spanish Civil War. Two years later Renau was named Director of Graphic Propaganda for the General Commissionate of the Central Major State. It was during this period that the artist began to work extensively with the technique of photomontage and completed a series called *Por que lucha el pueblo espanol*. In 1939, the following year, Renau was exiled from his homeland. In 1958, after extensive traveling, he became a citizen of the German Democratic Republic. He did not return to Spain until 1975, the year before he was invited to exhibit his montages at the Venice Biennial.

Peace is With Them reveals the inherent contradictions of the Rosenberg affair. Accused of conspiracy and espionage, the two defendants, husband and wife, were presented as scapegoats for a faltering legal system which had succumbed to public hysteria over the threat of communism during the so-called "cold war" in the United States. The Eisenhower '50s represented a bastion against the threat of a communist infiltration. After the infamous McCarthy hearings in 1950, America was primed for this kind of witchhunt. In was in this political climate that Julius Rosenberg was arrested by the FBI due to his association in business with one David Greenglass who worked at the Los Alamos Atomic Project during World War II. Greenglass was, in fact, Rosenberg's brother-in-law. The arrest happened shortly after the confession of a German-born, British scientist named Klaus Fuchs who had given atomic information to the Soviet Union. Once Fuch's confession reached the American press, the FBI went in search of evidence to discover whether or not any Americans may have operated as spies in a similar capacity. The presumed fact that some uranium was found missing at the Los Alamos plant implied that someone there had been doing illegal business with the enemy. Greenglass, largely to get himself off the hook, put the onus on his brother-in-law Julius. Eventually Ethel was implicated along with a former classmate of Julius Rosenberg named Morton Sobell.

Renau's *Peace is With Them* shows Ethel brutally strapped to an electric chair with a black mask tightly pulled against her face. Three white doves are positioned on the chair symbolizing the ironic peace that was suppose to ensue once the two spies had been executed. In the doorway off to the left of Ethel, the artist has montaged a photograph of her husband Julius being led by two FBI agents into the chamber where the execution will occur.

Above an adjacent closed door the sign reads "Silence" as if to suggest that nothing should be divulged about this injustice, this spurious incident that would continue to incite controversy for years to come. Clearly, Renau is interested in inciting controversy regarding the incident. He had followed the trial of the Rosenbergs from the base courts through the appeal courts, even to the Supreme Court. Eisenhower himself would do nothing to repeal the inevitability of their execution in 1953.

There is a certain horror that Renau has captured through his juxtaposition of photographs that is difficult to disregard. Irony is dominant everywhere, but the imposition of the United States government on the lives of these citizens is blatantly implied. The irony is also present in the title of the work. The white doves, representing peace, offer a phoney solace, a questionable antidote to the seething troubles implied by the American hysteria over communism. Renau has captured the humiliation of the two victims, the look of Julius as he faces his wife at the moment of execution, seeing her bound and gagged. This is a manipulation of imagery from purloined sources. Photomontage is about the art of appropriation. What becomes apparent here is the incisiveness and certainty of the message, even though the message raises a degree of ambiguity about what exactly is going on.

In contrast to other photomonteurs, particularly John Heartfield, whom Renau supported without question, the Spanish artist used color as an element in order to incite other levels of emotional response. One may say that Renau was less Brechtian than Heartfield. Renau was not so involved with alienation or with "defamiliarization" as he was with the sensation of the image, what the critic Douglas Kahn refers to as "oppositional mimicry." The concept of mimicking rightist propaganda, as used both implicitly and explicitly in magazines, was a trait used by both Heartfield and Renau; however, with Renau, there is more attention to the aestheticization of the print through air-brushed elements that heighten attention to certain areas, and thus establish a particular mood. It was in this sense that both Heartfield and Renau understood the codes of advertising, and how, in fact, advertising might work as a sublimated form of propaganda within the capitalist system. What is different between the two artists is the stylized presentation of the image. With Renau, his association with the Mexican muralists and his adoration of their works was evident. There is a kind of monumental appearance to *Peace is With Them* in the manner that the artist has positioned the photograph of Ethel in the chair in the foreground at an angle so that it functions dramatically in relation to the entry of the photograph in which Julius is about to enter the threshold into the space.

Ultimately, one cannot ignore the contextualizing of this montage as part of the entire group of montages, similar to the book of photographs of the Swiss immigrant photographer Robert Frank who did *The Americans*, published in France in 1959; thus, in terms of serial narrative, Frank precedes Renau in the concept of a photographic narration. Renau's contribution, however, is more about the incisive content of the formal strategies of internalized placement. This is where Renau succeeds in his statement about injustice through the Rosenberg affair.

—Robert C. Morgan

Bibliography—

Renau, Josep, *Fata Morgana USA: The American Way of Life*, East Berlin 1967, Valencia 1989.
Meeropol, Robert and Michael, *We Are Your Sons: The Legacy of Ethel and Julius Rosenberg*, Boston 1975.
Radosh, Ronald, and Milton, Joyce, *The Rosenberg File: A Search for the Truth*, New York 1983.
Fontcuberta, Joan, *Josep Renau, Fotomontador*, Mexico City 1985.
Kahn, Douglas, *John Heartfield: Art and Mass Media*, New York 1985.
Okun, Rob A., ed., *The Rosenbergs: Collected Visions of Artists and Writers*, New York 1988.

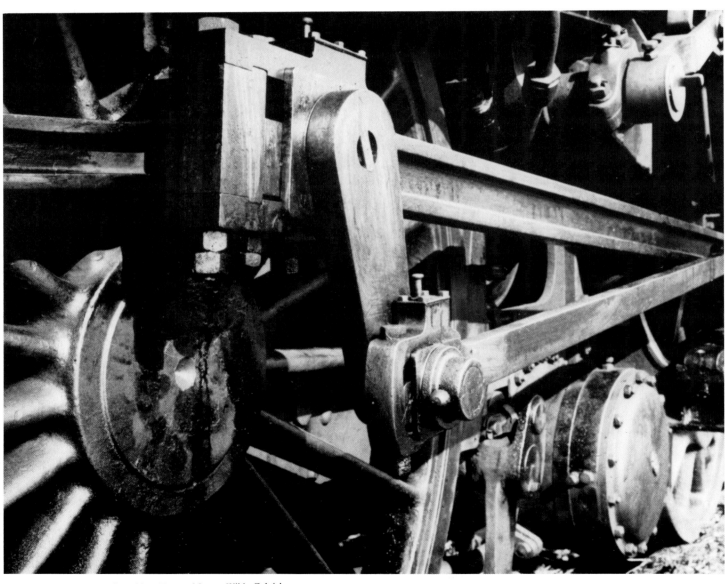

Photo Albert Renger-Patzsch Archives / Ann and Jurgen Wilde, Zulpich

Albert Renger-Patzsch (1897–1966)
Driving-Shaft of a Locomotive, 1923
Black-and-white photograph

Albert Renger-Patzsch's *Driving Shaft of a Locomotive* of 1923 is a splendid example of the fascination with the technological world that came to dominate European art in the 1920s and '30s. In Germany, this fascination is evident in the New Objectivity movement where photography held the strongest position owing to its innate ability to represent the newly industrialised world in an appropriately "objective" fashion.

Indeed, photography was itself a product of the industrial revolution, as was evident in its capacity for mass reproduction. By the 1920s, photographic images were flooding the everyday environment, introducing what we now know as the mass media. It was at this time that photojournalism was born, but so was industrial and commercial photography. Newspapers, illustrated weeklies, industrial journals, and advertisements made wide use of this new imagery. But it was images of industrial photography in particular that were the precursor for the New Objectivity of Renger-Patzsch.

It was Renger-Patzsch's intuition to discover the basis for a new aesthetic in commercial photographs of blast furnaces, factories, or machines. In this respect, we might compare his work to that of the Russian Constructivists whose art was often inspired by engineering structures in industrial architecture. A fascination with the machine age was by no means limited to Renger-Patzsch; it was in fact the Zeitgeist of the 1920s, where many saw mass production as promising a better, more egalitarian society.

Linked with Renger-Patzsch's fascination for the forms of the industrial world was a deep awareness of the affinity that photography possessed with the machine. In the nineteenth century, this had been the basis for vigorous attacks upon the new medium from critics such as Baudelaire and John Ruskin, who argued that art must express the human spirit which, they claimed, was impossible via the medium of a machine.

By the early twentieth century, the question as to whether photography could be an art was no longer considered relevant. Quite simply, photography existed and modern life without it was unthinkable. Instead of trying to compare photography with art, photographers like Renger-Patzsch saw the necessity to explore and experiment with photography's intrinsic aesthetic characteristics which would be inextricably bound up with its inherent technical qualities.

Renger-Patzsch was particularly concerned with the singular capacity of the photograph to represent machine forms. For him the superiority of the photograph over painting lay in its clarity, and precision which reflected essential characteristics of the machine. In a newspaper article in 1929 he also stressed the peculiar ability of photography to capture the dynamism of modern life: "Photographic technology is outstanding. It can conjure up things in an instant which an artist would take days slaving over, that is when it is not dealing with those areas from which the artist is entirely excluded, areas which are photography's very own. Photography is the supreme ruler over fleeting moments or the analysis of specific phases of a rapid movement, the fixation of the ephemeral forms of flowers or the representation of dynamism in the domain of technology."

In 1928 he published a book of one hundred photographs entitled *Die Welt ist Schön* (*The World is Beautiful*). He stated that he wanted his book to be, "An ABC book that will show how one can arrive at pictorial solutions in an entirely photographic manner based on the visual impact of halftones, composition within the frame, and the activity of lines."

In *Driving Shaft of a Locomotive* we see Renger-Patzsch exploring the the capacity of an innately photographic language to capture the essence of the machine, its dynamism, sharpness and precision, and the highly appropriate use of black and white as a means of rendering metallic surfaces. *Driving Shaft of a Locomotive* also displays a use of extreme close-up and exaggerated perspective which reveals unusual formal structures and the diagonal dynamism of the driving shaft itself. The camera penetrates into the very heart of the machine. Every single millimetre of the frame is filled with a rich grey-toned representation of iron expressing its tautness and weight. It is also interesting that the use of extreme close-up intensifies the innate ability of the photograph to excise segments of reality. We do not see the whole engine—there is no typical representation of a locomotive—in fact, without the title it would not be entirely evident what we were looking at. As such, there is an element of abstraction which goes beyond mere representation and allows the photographic language to express essential qualities of the machine such as weight, dynamism, and unusual forms. The engine becomes emblematic, a symbol. This phenomenon is evident in many of Renger-Patzsch's works where the industrial world becomes almost hygienic. In his photographs of machines in factories, or factory buildings, we never see any workers or pollution. We are presented instead with an abstraction or idealisation of the technological world.

In the forward to *Die Welt ist Schön* the art historian Carl Georg Heise suggested that Renger-Patzsch's photographs were never so beautiful as when they appeared as "true symbols," and there is certainly a symbolic aspect to *Driving-shaft of a Locomotive* that reflects a mystification of technology quite common at that time.

Ingeborg Güssow draws our attention to the logo on front of *Die Welt ist Schön* which shows a schematic drawing of a telegraph pole and a tree standing side by side. The initials "A. R-P" appear underneath. It is evident that Renger-Patzsch is trying to make a link between the essential natural form represented by the tree and the essential technological form represented by the telegraph pole. Such comparisons were not unusual at that time. For example, a photograph by Renger-Patzsch of a factory chimney soaring phallic-like into the sky was given the caption "the animal power of a factory chimney" by the Constructivist artist and photographer Lázló Moholy-Nagy. Seeing machines and technological forms as expressing an "animal power" was part of a mythology widespread amongst the intelligentsia at that time where technology was understood as representing a stage in natural evolution. It was the faith in technology as "natural" that enabled Renger-Patzsch to mix photographs of plants and animals with photographs of machines and industrial landscapes in *Die Welt ist Schön*. It was also the basis of the profound optimism regarding technological development prevalent at that time.

A similar symbolism is evident in *Driving Shaft of a Locomotive*. As has been mentioned, we only see this image as an abstracted fragment. It is easy to forget that it is a locomotive and see it instead as expressing the essence of the machine as an "animal power." The locomotive becomes a symbol of the technological demiurge, a strange new creature driving the human race towards Utopia.

Such optimism and faith in technology as a form of natural evolution seems naive and even irresponsible now that we are experiencing the legacy of large scale environmental pollution. But hopefully we can still appreciate the poetry of the image. Certainly, the anthropomorphism evident in *Driving Shaft of a Locomotive* lends an expressive-symbolic quality to the technological imagery of Renger-Patzsch which, when combined with the abstract, formalistic qualities of his work, totally separates it from the straight commercial photography that first inspired him.

—Graham Coulter-Smith

Bibliography—

Renger-Patzsch, Albert, *Die Welt ist Schon*, Munich 1928.

Kempe, Fritz, *Albert Renger-Patzsch: Der Fotograf der Dinge*, exhibition catalogue, Essen 1966.

Honnef, Klaus, and Kierblewsky, Gregor, *Albert Renger-Patzsch: Fotografien 1925–1960*, Cologne 1977.

Mellor, David, ed., *Germany: The New Photography 1927–33*, London 1978.

Heise, Carl Georg, and Kempe, Fritz, *Albert Renger-Patzsch: 100 Photos, 1928*, Paris, Cologne and Boston 1979.

Gussow, Ingeborg, "Die neusachliche Photographie," in *Kunst und Technik in den 20er Jahren*, exhibition catalogue, Munich 1980.

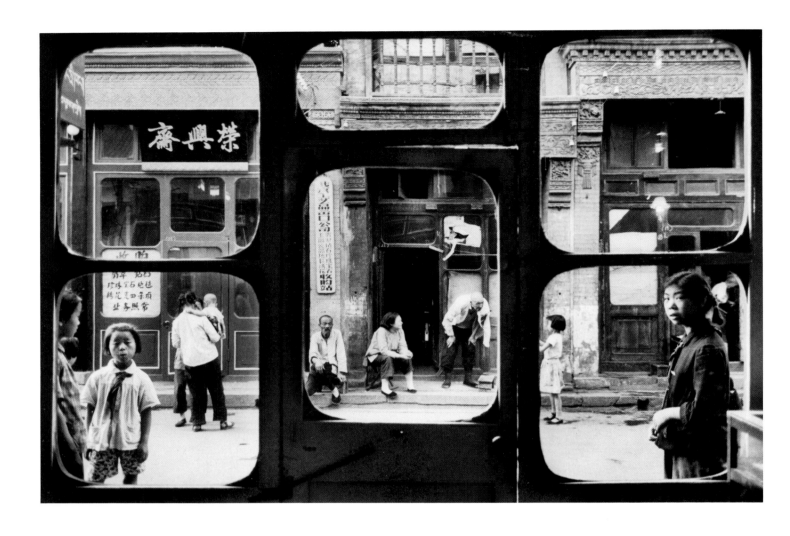

Marc Riboud (1923–)
Beijing, 1965
Photograph

An unknown world opens up through the window, materializing itself into a clear, neat and concise picture that communicates something at a first glance; it carries along a message which serves the purpose, and for sure it did back in 1965, at a time when the West knew very little about China, and was eager to know more about it. Riboud himself, as he stated on several occasions, did not pretend to know much more about China. This is why he was back there for the second time, the first one was in 1957, for a four month trip together with the journalist K. S. Karol, adding a few more details to his quest of the hidden reality of that New Ancient World.

Marc Riboud is a traveller like Marco Polo, Blaise Cendrars, Bruce Chatwin, and he is a photographer like André Kertész, Robert Doisneau, Henri Cartier-Bresson. He wanted to be a traveller ever since he read the journal of his father's round-the-world trip in 1910, and he became one when he left his job in 1950 to become a full-time photographer. Ever since, he has carried his camera to places where something was happening, or about to happen: where history was being written. He records events as they can be seen by a stranger who has no prejudice at all about different cultures, features and habits. Of course, he cannot deny his own culture, or his *Weltanschauung*; however, he tries to capture people, things and facts in the simplest, straightforward way. He is there with his reliable and basic camera and a couple of lenses—35 and 50 mm.—and that is what can be seen through the viewer of the camera and frozen on the film: one hundredth of a second of the life of a remote and unknown street of Beijing has been exposed on a film, thus being rescued from oblivion.

Far-way people and countries come to life in Riboud's pictures. His extraordinary bright and concise, yet colourful black-and-white photos witness a new encounter, an event, the shy and shifting glance of a child. He looks into this new world through a shop-window: the reality is displayed outside in the street, where people live, talk to each other and pass by. His black-and-white pictures are saturated with details that call for viewers' attention. A city life scene shown at a time when the television was not yet, at least in Europe, the nowaday omnivorous image-eater. Riboud's pictures are made to be referred to and to last; they are one more tessera of an endless mosaic work: the traveller, the observer and the photographer are never drifting apart. He does not pretend to teach viewers something; he travels to learn and try to understand something about other people and countries, reporting what he has seen, experienced and felt about a different culture, a far away country, an historical event.

Riboud has been walking through post-war recent history, seeing countries in turmoil, the ravaging effects of bombing, the frightening rise of masses, yet there is little blatantly evident violence in his pictures. In this respect, he is quite unlike Robert Capa or Donald McCullin; he has chosen to look at the world from a different angle. He prefers Doisneau's *visual tenderness*. His photos never show violence whilst it is happening. Riboud would never have taken the picture of a man being gunned down; nevertheless he is there to record the effects of human insanity on the world and on people. His photos are always taken from a distance: the camera is never placed in front of the subject, which is merged with its environment. He does not like to intrude on people's emotion, suffering, enthusiasm; he steps back to become an objective and sharp observer of human behaviours, traditions and manners.

Each one of Riboud's pictures can be viewed either separately, or as a part of a broader kaleidoscopic outlook on the world. Any of his pictures, chosen at random, will tell a lot about the peculiar significance of what has been recorded. People, things, animals, facts and events are caught as they can be seen in a particular moment of their own, without any dramatic artifice. Viewers can feel the emotion Riboud may have experienced, finding himself before an exceptional or plain event/view.

Black-and-white pictures in Riboud's work deal mostly with people and their immediate environment. People and events are observed, followed and recorded with accuracy, attention and respect, as it appears clearly in his book *The Three Banners of China*, released in 1966. When he comes to use colour, at a later stage—viewers may refer to his recent book *Huang Shan*, published in Paris in 1989—he steps back even further: people are seen from a greater distance; the environment becomes predominant. It seems that Riboud walks away from people and events, thus concentrating on a wider view of the world. People are replaced by the embroidered silhouette of Chinese landscape; political and social events by natural, enchanting and imposing sceneries. Marc Riboud continues to look at the world, but people are no longer in the foreground. It is as if he had become somewhat disenchanted about human repetitiveness and stubborness.

—Donato Prosdocimo

Bibliography—

Riboud, Marc. *Les Trois Bannieres de la Chine/The Three Banners of China*, Paris, New York and London 1966.
Freund, Gisele, *Photographie et Societe*, Turin 1976.
Farova, Anna, *I grandi fotografi: Marc Riboud*, Milan 1982.
The Gallery of World Photography: Photojournalism, Tokyo 1983.
Musee d'Art Moderne de la Ville de Paris, *Marc Riboud: Photos choisies 1953–1985*, exhibition catalogue, Paris 1985.
Nori, Claude, *La Photographie francaise des origines a nos jours*, Paris 1988.
Riboud, Marc, *Huang Shan*, Paris 1989.
Centre National de la Photographie, *Photo Poche: Marc Riboud*, Paris 1989.

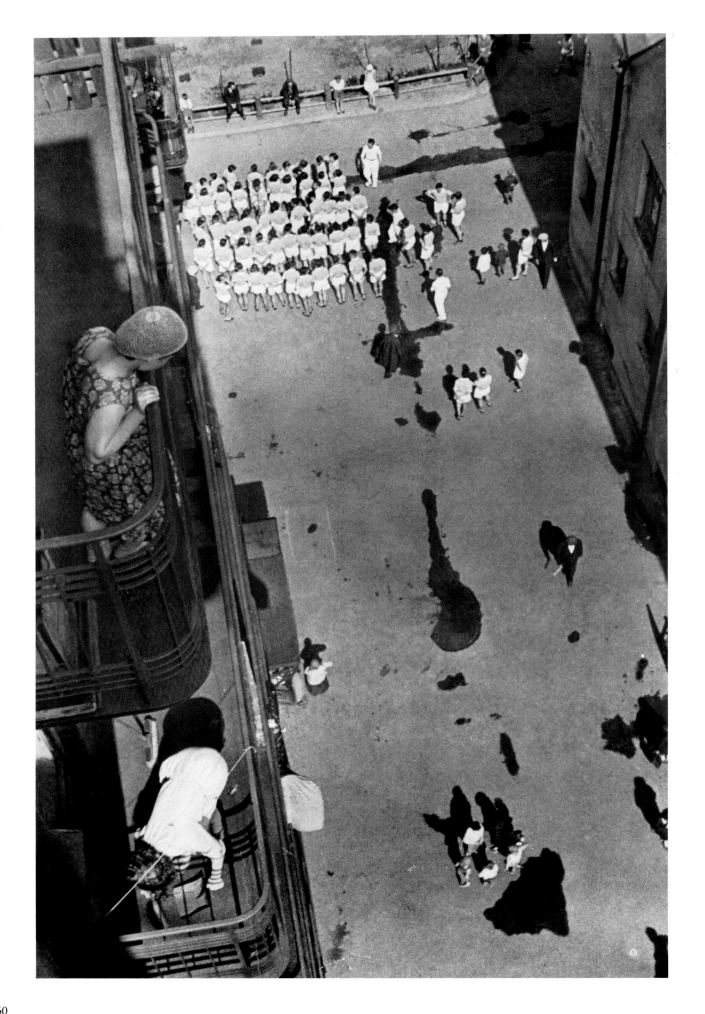

Alexander Rodchenko (1891–1956)
Assembling for a Demonstration, 1928
Gelatin silver print photograph; 49.5 × 35.2cm.
New York, Museum of Modern Art

By 1928, Russian artist Alexander Rodchenko was embroiled in some controversy about his influence. The imagery of his photographs were especially noted for their verticality, high and low viewing positions with the camera, and strong diagonals. Even though many other artists in Europe were also photographing from high angled perspectives, it was Rodchenko who saw the possibilities in dislodging the visual conventions of established art forms through photography.

He advocated that photography not follow painting's traditional orientation in looking straight ahead at the world. With the camera, such academic canons from the easel were dispensable. This was in part, a revolution against art historical hierarchies. Rodchenko would even abandon painting for the possibilities of seeing the world anew with the camera.

The artist could photograph from many viewpoints, perspectives and affect new ways of seeing. The modern world of the airplane, technology and the skyscraper were quintessential subjects for such aspirations. The camera was the ideal tool for effectively "reflecting contemporary life."

The argument began with an anonymous letter sent to the editor of the conservative publication *Sovetskoe foto* in the spring. The intentions of the unknown writer were primarily parochial. Three of Rodchenko's photographs were compared to similar, earlier avant-garde works from outside the Soviet Union in an attempt to discredit his "original" point of view. By emphasizing his inventive camera vision with the modern artist of the West, his work was associated with a freedom of expression with no purpose. The social dimensions of art which remained important to the Russian political culture, appeared unimportant to such innovations. By the late 'twenties, the individual liberty of artistic freedom was again under question, after a decade of experimental fervor by the Russian avant-garde including far-seeing artists such as Rodchenko.

Recording the new emerging society of Moscow was paramount to the government, politicians and the photojournalists. In America, government projects such as the Farm Security Administration would concentrate on similar struggles. But it was popular ideological dogma that guided many Russian photographers of the day. Anything else—such as new viewpoints with the camera—was considered formalist in exercise and could not perform any specific social purpose.

Rodchenko's deliberate attempts to help establish modern practices in art, his brief abandonment of painting for the camera, and the experiments that opened up possibilities for photography, was met with the persecution and suspicion of a closed society.

In an attempt to illustrate his position, he wrote back to the magazine without success. The editors did not publish his reply. In June, his position was printed in Moscow's *Novyi lef* (*New Left Front of the Arts*), a more enlightened journal dedicated to the literary and visual arts. In it, photography was described as a medium that could break with the past in modern terms while growing by its accomplishments internationally: "Photography possesses old points of view, those of man standing on earth and looking straight ahead. What I call 'shooting from the belly button' with the camera hanging on one's stomach. I am fighting against this standpoint and shall continue to do so, as will my comrades, the new photographers. Photograph from all viewpoints . . . until they all become acceptable. . . . I want to affirm these vantage points, expand them, get people used to them. . . . How is culture to evolve if not by the exchange and assimilation of experiences and achievements?"

The new photography could be applied to contribute to the evolution of human vision as well as to a new modern culture. Expanding how one sees the world became a principle in Rodchenko's aspirations beyond the personal art of photography. Modern photography was a way to introduce new visual ideas from life while breaking old habits in looking.

His further interest in new technologies went hand in hand with his work in film and the graphic arts. Besides his use of the relatively new 35mm Leica camera, he also began experimenting with the French Debrie-Sept film camera. The Sept combined still with moving picture combinations that allowed great freedoms in mobility, especially for popular newsreels. It utilized 35mm cartridges that ran for seventeen seconds or could be used for single shots.

Spontaneity and quick responses became important to what could be included in a picture, with less emphasis on formal attributes such as framing and light. Small in size, the photographer was free to take it anywhere without limitations of setting up pictures. It is interesting to note that American photographers such as Paul Strand were influenced during these years by similar breakthroughs in equipment design, such as the Akeley film camera. In both cases, the artists' photography was transformed. New subjects were created from the commonplace that extended imagery beyond past perceptions.

Finally, the Russian avant-garde's reverence towards space and theory was important in the advanced Russian schools of the period. Space became an open system for experiment that supported no hierarchies of art mediums or social prerogatives. Rodchenko's experience as a teacher and artist helped advance the spirit of such ideas over the norm. This photograph embodies a vision that calls for multiple points of view.

Assembling for a Demonstration conveys all of these interests that were unprecedented for the period. This photograph opens up a contrast of perspectives that had little to do with painting and drawing. It is non-perspective oriented. This everyday scene of life is transformed into a dynamic interplay of elements that challenges the eye. Where the photographer is, in relation to each part of the fabric of this picture, becomes a key to understanding its modernity.

As we look at each element—from the woman sweeping her balcony to the stains in the street—the picture is transformed. The various relationships between all the parts becomes a viewing experience that transcends the converging group demonstration. In this sense, this photograph is only partially a chronicle of the period with very little concentration on documentary values.

This high-angled scene is about the relationships that the artist creates between things with the vantage point of the camera. Space is left without a dominant point of reference for our eye to travel for any purpose in any direction. Details of life are turned into a self-sufficient means of photographic expression that maintains a *visual* existence of its own without a governing political outlook.

The title of this photograph might satisfy the social purpose of Russian political culture, but what the photographer discovered is a means to give the viewer experiences beyond dogmatic exercise. Rodchenko and his camera become invisible participants in dislocating our standard view of the world. As a result, we can return to see this picture and discover new experiences. The photograph becomes a significant vehicle for expression and exploration—a living example of modern art in this century.

—Steven Yates

Bibliography—

Szarkowski, John, *Looking at Photographs*, New York 1973.
Weiss, Evelyn, ed., *Rodtschenko: Fotografien 1920–1938*, Cologne 1978.
Elliott, David, *Alexander Rodchenko*, exhibition catalogue, Oxford 1979.
Steinorth, Karl, *Photographen der 20er Jahre*, Munich 1979.
Elliott, David, *Rodchenko and the Arts of Revolutionary Russia*, New York 1980.
Lavrentiev, Alexander, *Rodchenko Photography*, New York 1982.
Galerie Gmurzynska, *Alexander Rodtschenko: Possibilities of Photography*, Cologne 1982.

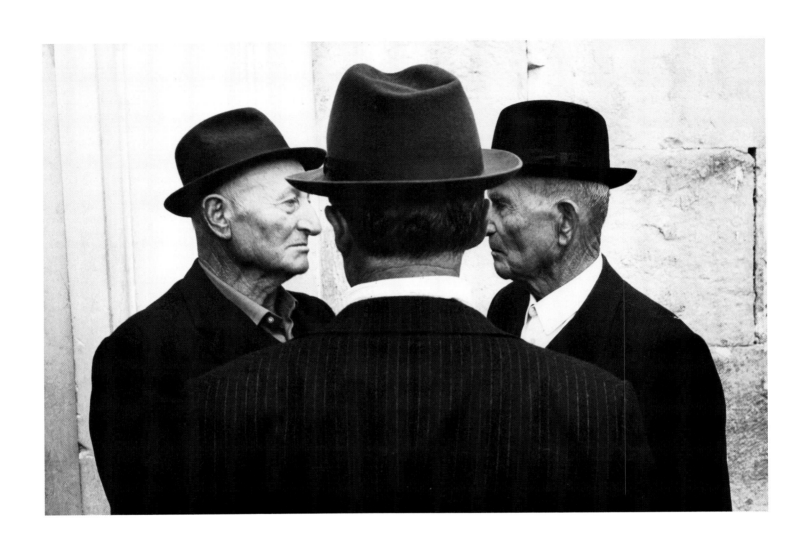

Marialba Russo (1947–)
Molise, 1981
Black-and-white photograph

The photographer Marialba Russo was born in Giugliano near Naples in 1947, but has been resident in Rome for some years, where she is involved also in architectural photography. Her work developed in Southern Italy, which in the post-war period had stimulated the attention of photographers and directors in Neo-realist circles searching for a visual identity of the poor and marginalised Italy; it was an Italy little known, apart from through the work of the novelists from the "Verismo" movement in the 19th century (Verga, Capuana) or from the novelists of the "Meridionalismo" movement in the immediate post-war period (Jovine, Scotellaro, Levi).

In photography, the Italy best represented and known was traditionally that of grand architecture and sublime landscapes, in the style of Alinari, especially emphasised after the unification of the Kingdom of Italy in 1861. From the second half of the 19th century, the human environment of popular society and rural architecture had always been the subject of many folk-lorish "genre scenes," and were part of the photographic repertory for tourists, like "documents" or souvenirs of indigenous life.

However, a sociological study into the real Italy had never been made—if we exclude rare examples such as those by Count Giuseppe Primoli, which were among the first to be concerned with popular Roman life during the final decades of the last century, or the contemporary studies made by Giovanni Cena about the life of some shepherds' communities in Lazio. It was only in 1946 that people in Italy began to explore peasant society, to study costume, to reveal by means of photography the sacred, and more often, the profane rituals, such as was first done by the team of the anthropologist, Ernesto De Martino, with whom the photographers Franco Pinna and Ando Gilardi collaborated.

After this date, other photographers were active in Southern Italy: among them Tino Petrelli, who worked especially in Calabria in the almost-abandoned hamlets in the harsh mountains; Fulvio Roiter, who in a way "discovered" rural Sicily, as usual excluded by photographers from the Grand Tour; Mario De Biasi, who executed the first reportages in Naples on the slums.

While studying at the Academy of Fine Arts in Naples (1968–72) Marialba Russo began to occupy herself ever more passionately with photography, but with a particular attention to narrative images which had little aesthetic significance. She was to some extent following the path indicated by the neorealist photographers, but committing herself to a scientifically-oriented survey of the human condition, with the aim of documenting events in a systematic fashion both spatial and chronological.

Her interests in anthropological research began to grow, to the point of definitively characterising her future activity as a photographer. From the 'seventies, Marialba Russo would be the main visual witness of many Southern Italian popular traditions, especially in the region of Campania, but also in Basilicata and Calabria. Her reportages thus became precious material for many scholars, and are collected in the archives of the Musei delle Tradizioni Popolari [Museums of Popular Tradition], principally that in Rome, with whose director, Annabella Rossi, Marialba Russo has frequently collaborated. In 1974 she published her first important book, *Immagini della Madonna dell'Arco*, in which Russo demonstrates a rare capacity to capture the event in all its dynamic phases, according to a scansion which allows her to retrace the anthropological meanings, symbolically expressed with gestures and actions, which occur in succession, as in an archaic ballet.

The writer Alberto Moravia, prefacing Marialba Russo in a recent volume (*Marialba Russo. Fotografie 1980–1987*, 1989), wrote that she "aims to surprise the manifestations, that is the epiphanies, during their first and unique appearance" and that not by chance "these manifestations of the mystery which surrounds us have all been shot in Naples and in the South in general." It is precisely in this Italy which clamours and gesticulates, continues Moravia," that daily reality is more retiring, more silent, more mysterious, in short, more epiphanic."

The cracks in the walls, like the wrinkles of a face, succeed in suggesting the mystery of time past, the long resignation of things and people who live as if in a natural uniqueness. People, like these three old peasants with their feast-day hats, resemble statues, or trees or rocks, ever present in this region like emblems of a civilisation untouched until today. Marialba Russo succeeds in synthesising and indicating these emblems with a singular plastic energy with the peremptoriness of the structure of the image: in this case, a classic *triangle*, marked symmetrically by the man seen from the shoulder. The scene is shrouded by a silence more profound than that intrinsic in the muteness of the photographic image; whereas the dialogue between the three occurs through the glance, the fold of the mouth, the ancient wrinkles of the face, expressing sentiments and concepts which are silent only for the person who is not able to understand it.

The human presence in the photographs of Marialba Russo tend always to assume an emblematic value, as if forming part of a metaphysical stage-set. It is almost as if the people were actors in a theatrical recital in which the photographer has secretly insinuated herself, always alert to capturing the most hidden meanings, which the "perspective" of her photography tends to reveal. This, not according to the ideology of the "Bressonian" decisive moment, but like so many immovable and eternal "tableaux vivants."

—Italo Zannier

Bibliography—

Russo, Marialba, and Recupero, J., *Gli eretici dell'Assunta*, Rome 1978.
Colombo, Lanfranco, ed., *11 Italian Women Photographers*, exhibition catalogue, Cologne 1984.
Russo, Marialba, and Douglas, N., *Isole d'estate*, Naples 1988.
Russo, Marialba, and Moravia, Alberto, *Marialba Russo: Fotografie 1980–1987*, Milan 1989.

© Sebastiao Salgado/MAGNUM

Sebastiao Salgado (1944–)
Women and Children Crossing Dry Lake Bed, Mali, 1985
Black-and-white photograph

Sebastiao Salgado's pictures belong to one of the West's grand artistic traditions. As in the great epics, such as Homer's *Odyssey*, where ordinary people join their leaders in a struggle against inexplicable godly forces, his images depict people confronting primal unnamed antagonists. His people often move across vast lands, work inside of canyons, or cross plains of huge physical dimensions, their movement emphasizing the classic conflict between the littleness of mankind and the enormity of nature. But as in all such universal expressions, his pictures gain strength through the specific stories they evoke, through the very people and conflicts in which they are engaged. So he sets ravaged people not against godly, but against earthly forces. He turns their quest for some sort of salvation into an identifiable search. They need food, clothes and shelter. Their quest for survival becomes an epic thrust.

In no other of his photographs is this cacophonic expression more apparent than in his photograph of women and children crossing a dry lake bed. The children skeletal, the women draped in rags, the earth parched, vegetation stripped, all pieces of the image cry out immediate pain. Reaching deep into our psyches, they echo long-held, even inarticulately-expressed understandings.

Lifted into the world of symbol, the image takes on a mythic power. Not only from its classic reach, but from the power of a myth to give sustenance to daily needs, to actually supply and fulfil them. Not unlike Borges' *Ficciones*, in which a made-up, semi-cosmic world, identifiably real yet constructed, spins symbols into realities at the same time that realities of daily existence seem to live in some realm of existence slightly removed from earthly life. Salgado's depiction of ragged dress, parched earth, skeletal bodies, and leafless trees become symbols of a universal quest for the simple needs of life as much as they evoke classic depictions of that quest.

After all, it is not in the figures' bony flesh that we feel the impending disaster of these people. Nor in their ragged garments. It is much more in the almost figure in the roll of cloth, in the almost skeleton in the limb-cut tree. It is in the fierceness of the wind, the wind we don't see but hear and feel, the wind that has dried up the lake, the wind that keeps his people from moving faster so they can be saved. The image imposes and reimposes itself not because of those clear and real facts. It is more in the suggestion of realities not actually depicted that we feel the image's intensity. Salgado has turned the wind into a sceptre, ragged clothes into ascetic armour, children with barely enough flesh to cover their bones into a purity. He has turned powerless configurations into mythic symbols confronting unseen evil.

None of this ignores the fact these are real people working against all odds to reach some source of food and shelter. But Salgado lets us know that not by setting down juxtapositions of the figures we accept from our absorption of cultural understandings. Nor by appealing solely to either our feelings or rationality. Salgado actually disturbs viewers' conscious reach for cultural responses, and rather reaches into that reservoir of barely-conceived consciousness where feelings rub up against thoughts and thoughts thrive on feelings—but act independently of each other. The emotional and rational segments of human brains are, according to neural and physiological understandings, supposed to function independently of the other. Salgado makes viewers see with their feelings, hear and touch with their thoughts. He draws one so closely upon the other that viewers are near thinking with their feelings and feeling with their thoughts. Crossing over neural boundaries, he leaves viewers defenseless. Other artists, like Samuel Beckett, have done exactly the same. But it is a new state of being for the viewer of socially responsible photographs.

Salgado has reinvented the socially responsible photograph. And has been doing so since about 1973 when he decided to become a photographer. Born in Brazil in 1944 and trained as an economist, he was working towards his Ph.D at the University of Paris—his wife, an architect, with him—and finished his course work when he took a job with the International Coffee Organization in London. It was trying to co-ordinate coffee production around the world—really trying to maximize prices. On assignment in Africa, he found the camera—he had his wife's with him—much more effective. It brought him inside his subjects' circle of life where he could "become" one with his subjects rather than, as a social scientist, circle around outside their lives, never feeling their heartbeat. He decided to continue work as a photoreporter, and in 1973 produced a photoreport for the World Council of Churches on starvation in Africa. He has since photographed miners, priests, peasants, children, Easter celebrants, weddings, communions, harvests, cities in Latin America, Europe, New York, Washington—virtually every part of life, wherever and however people live. He returned to Africa to photograph its then newest wave of starvation in 1985 when this photograph, in Mali, was taken.

In reinventing the socially responsible photograph, Salgado has infused it with contemporary myth while giving it an epic stature, placing it on a parallel with much of contemporary art and literature. In doing so, he has reclassified the nature of the aesthetic conflict inside the image itself. In most socially responsible photographs as we know them, from those made by Jacob Riis of tenement dwellers and Lewis Hine of child labor right up through the Robert Capa photographs of war-ravaged civilians and soldiers and Bruce Davidson's civil rights photographs, intensity is realized through the participants themselves, often by deepening the look into and through them. Viewers are stared down by the eyes of Lewis Hine's children, come in upon Capa's GI Joe, are stopped short by Davidson's Blacks sitting at a not-yet-integrated drug store counter. In all of these images, the aesthetic conflict was matched to the actual conflict. Not in Salgado's. The conflicts in his photographs part company with that entire tradition.

The aesthetic fury in this image is built from the powerless in conflict with the unseen. It is as if Salgado is saying that the power of the unseen wind and the dry unsqueezable earth fighting against people barely able to move is so strong that it—this unseen but surely-felt force—propels them, keeps them alive, that they will never give up. He suggests his powerless people have an unfathomable power in their fight not against seen but unseen evils.

It is the way he looks at the world, his belief in a cultural and mythic power as an arm of justice.

—Judith Mara Gutman

Bibliography—

Vasquez, Pedro, *Sebastiao Salgado: Fotografias*, exhibition catalogue, Rio de Janeiro 1982.
Dieuzaide, Jean, *Sebastiao Salgado*, exhibition catalogue, Toulouse 1986.
Galeano, Eduardo, and Ritchin, Fred, *Sebastiao Salgado: An Uncertain Grace*, San Francisco and Millerton, New York 1990.

© Jan Saudek 1991 / Art Unlimited, Amsterdam

Jan Saudek (1935–)
Another Child, David, Is Born: I Embrace Him, 1966
Black-and-white photograph

Critics have described Jan Saudek's work *Another Child, David is Born*, as "classical," which term of praise acknowledges its universal, timeless and generally humanistic dimension. The fact that it is a declaration for life.

The photograph, taken in 1966, one of the earliest in the output of the Prague workman and photographer, has long been circulated internationally, displayed at important exhibitions and published in professional and popular journals. Ironically, this is not true of the photographer's native country. Until recently, Saudek's entire oeuvre was not put on show and ostracised in other unpleasant ways, probably as a result of a secret ban, which lasted almost twenty years. Though recently lifted, the anathema left the artist embittered and full of distate. He still bears the grudge, which is evident from the interview he gave the journal *Československa Fotografie* where, among other things, he describes the absurd war waged against him by the political authorities and activists of the official Union of photographers, obedient to the former. As a result of the censorship, concealment and falsification, combined with quite considerable intolerance, Saudek was practically non-existent in Czechoslovak photography.

I first met Jan Saudek in Prague in 1983, having earlier seen and been impressed by his monographic exhibition at the Jacques Baruch Gallery in Chicago, one of those events one remembers and likes to return to in one's thoughts for a long time. Why was the exhibition exceptional or revealing? On the semantic level Saudek's photography contributes an intriguing crossing between metaphysical spirituality, purity and innocence of adolescence and ostentatious corporality and provoking eroticism. The literary and allusive mise-en-scène featuring nude or semi-nude models shocks one for its intimate and sincere penetration of intricate and morally ambiguous states of mind and modes of behaviour. All these images, properties, signs and moods were dear to the turn-of-the-century decadence and aesthetics. The grand pageant of physical ugliness, the bodies long devoid of charm, deformed and weary, all this is worthy of the author of the *Flowers of Evil* or Fellini. Decay and erosion have penetrated everything: people, objects and space. Even youth bears a stigma of old age. And, as if to keep balance, there is a transition from the strange, dark world back to hope, light and youth.

Saudek's photography conjures up images of the sinless years of childhood, the time of corporal virginity and virtue, though with an admixture of nascent spontaneous eroticism and coquetry. The successive stages of human existence ranging from birth to puberty, adolescence, maturity and twilight seem to co-exist with one another, just like corporal beauty and the decay of matter.

At the Chicago exhibition, the photograph *Another Child, David is Born* attracted my attention. Severe, economical, based on mental abbreviation, it was not unlike a poster on paternal love. Its lucid metaphor makes one think about Steichen and his famous exhibition *The Family of Man*. Small wonder. Saudek, who considers himself a pupil of the master of American photography, said, on seeing the catalogue of the exhibition: "I was personally moved, even shocked. I said to myself: that's photography." Saudek's affirmation of the world and reflection about the human condition are similar to Steichen's. Like Steichen, Saudek has raised the individual to the symbol of the all-human. Yet, unlike the American photographer, he is very emotional in his response to the surrounding reality. He has introduced personal motifs and a certain degree of intimacy into his photographic narration. Even the title of the work under discussion is a case in point. The child's name is David. We may surmise that he, Saudek, is his father. He writes to his autobiography published in *Aperture* (No. 89): "I was born in Prague, Czechoslovakia. Father was a bank clerk, Jewish. Until 1939—then the Germans made him a street cleaner . . . He also spent time in a concentration camp, where all six of his brothers were killed . . . The stories I have to tell are about love affairs, relations between parents and children, bodies, death and desire . . . I used to use members of my family as my models . . . I left my home and family; I left my children, my beloved Karolina, Sam and Dave. I left those sweet little faces behind, because I want to find an answer. In pictures of women who are on the way to bring new life into the world . . . I'd like to show the happiness that was refused to the small Jewish brothers and sisters whose name I read on the stones in the 'new' cemetery—that simple happiness called life."

As if to confirm the above, there is Saudek's penetrating photograph taken in 1972, equally well known in the world as that with the new-born baby. This one is titled *Man in Cemetery*. "My Father. It shows the wall running round a Jewish cemetery, with tombstones and falling autumn leaves. There is an old man in a coat standing by one of the stones. The Star of David bearing the inscription 'Jude' is pinned to his coat."

The peculiarity of Saudek's style consists in the combination of the act of photography with a way of living. These two orders, of art and life, cannot be separated in him. They have to be considered jointly, as one thing, also taking into account the word that accompanies the image, the comments or mini-stories so frequent in his work. He is a superb narrator, capable of rendering the mood of the moment, the tension or funny traits of the given situation.

There are several such comments in the series *The Master Collection: The World of Jan Saudek's Photographs*. His letters to his friends represent a different kind of verbal expression. During his life in enforced isolation, as if in the background, Saudek had worked out an epistolary form of communicating with the world. In his letters, verbal narration mixes with drawings which sometimes also appear on the envelopes.

After my visit to Saudek's studio in Prague (sixteen square metres in a basement with mouldy, scratched walls), I received letters from him. Each contained an exciting story and coloured drawings, and the envelopes were masterpieces of calligraphy. I hope that Jan has forgiven me my failure in convincing the editors of the only professional Polish journal on photography, *Fotografia*, that they should publish my essay on his work. It was rejected for years. Did the anathema reach Poland too?

—Szymon Bojko

Bibliography—

Freund, Gisele, "Jan Saudek," in *Zoom* (Paris), October 1977.
Bennett, Derek, "Jan Saudek: I'm Led by Instinct," in *Printletter* (Zurich), March/April 1978.
Travis, David, *The World of Jan Saudek*, exhibition catalogue, Chicago 1979.
Borhan, Pierre, "Portfolio Jan Saudek: Le Grand Photographe Tcheque," in *Photo-Cinema* (Paris), January 1980.
Saudek, Jan, and Farova, Anna, *The World of Jan Saudek*, Geneva and Millerton, New York 1983.

© Ferdinando Scianna

Ferdinando Scianna (1943–)
Refugee Camp, Makale, Ethiopia, 1984
Black-and-white photograph

"I am here in Ethiopia, in the deepest ring of this vertiginous well of famine, of thirst and of death, into which a further half of the continent of Africa is sinking," wrote Ferdinando Scianna from Makale in 1984, where he was on a report which was to make him one of the most famous Italian photojournalists. Only two years earlier he had been nominated a member of the Magnum agency, after long experience as a photographer and journalist which began in Sicily in 1960, where he was born (Bagheria, Palermo, 1943). There he had systematically documented religious feasts, with a sociological and anthropological commitment, which shunned easy folklore and the populist heritage of neo-realism, which had attracted many Italian photographers of the preceding generation. Sicily had been a human territory particularly observed by photographers in the post-war years. They had discovered a reality which until then was only little known through images, despite the success of realist [verist] literature by authors such as Giovanni Verga, Luigi Capuana, Federico De Roberto, as well as Luigi Pirandello, who had also illustrated the tragedy and human despair, within the epic beauty of its landscape.

In the past, Sicily was represented in photography above all through its archaeological aspects, those which express the ruins of Magna Grecia, whereas it is much more rare to find a sociological photograph before Luchino Visconti traced his cathartic fresco about the island in his film *La terra trema*—a fundamental work for the development of Italian post-war cinematography and photography.

In Sicily the first "neo-realist" photographer was Enzo Sellerio, and it is this author who offered the stylistic, as well as ideological, indications to the young Ferdinando Scianna while he was completing his studies at the Faculty of Letters and Philosophy at the University of Palermo. There he was beginning to work on the theme of "religious feasts," creating images which in 1965 were published in an important book (*Feste religiose in Sicilia*, with a text by Leonardo Sciascia, who from that date became his main mentor. This little volume presented a young talented author, even in international terms, and in 1966 Scianna was assigned the Prix Nadar for this work.

His career as a professional photographer began in that year, when he joined the editorial staff of the Milanese weekly magazine *L'Europeo*, for which he made many important reports all over the world. Meanwhile, he continued his anthropological studies in Southern Italy, compiling works of great importance in the still provincial environment of Italian photography, in particular *Il glorioso Alberto* (Milan, 1971), where the photographic story contains a singular stylistic intensity, which also demonstrates the overcoming of sociological neo-realism. Scianna's photographs of Southern Italy found a particularly effective editorial outlet in the book *I siciliani*, with a text by Leonardo Sciascia, published by the prestigious publishers, Einaudi, in 1977.

At this time Scianna met Henri Cartier-Bresson, always considered his ideal mentor in the history of photography, initiating a friendship based on common ideas. This is witnessed in all his works, which distinguish him as the French master's most significant "pupil," and he gathers from him substantial elements, prolonging his cultural heritage. This is seen in his eye, which is "rapid," and yet at the same time penetrates right to the heart of the event.

One of the occasions to express his talent as a photojournalist on a large theme—the almost biblical famine and depression in Africa—was the report made in the camp for refugees from Dancalia at Makale in Ethiopia in 1984, from which is drawn the present image.

The photograph, which is part of a tragic sequence on the condition in which some thousand members of the Afar tribe found themselves, is stylistically typical of this author, and was made in a "bressonian" style which tends always to tell a human event with an extreme attention to the rigour of the image's structure. Here, this is characterised by the centrality of the subject, compelling one to fix attention on the glance of the boy, while the rest is an out-of-focus background.

However, Scianna does not aim at a beautiful image, as is underlined by one of his critics, Sebastiano Addamo (*L'istante e la forma*, Siracusa, 1987), "this aesthetic and rhetorical side is missing in him. He aims for something else: for the relief, for the porosity, for the depth, for the expressiveness."

In fact, he succeeds in taking and defining in images, one after the other, a rhetorical figure who appears as a metaphor of the situation being analysed and visualised in photography. It is precisely in this attitude that the ideological inheritance of Cartier-Bresson is witnessed, aiming to tell a whole story through the uniqueness of the image, which is never partial, and because of that, capable of withstanding time like a universal testimony.

Ferdinando Scianna is also a great writer, and it is always interesting to follow in parallel what he writes to accompany his photographic reports. In this case, he tells of his emotions at the Dancalian refugee camp in November 1984, where he arrived at mid-morning, and the situation presented itself "through a turbine of dust which wounded the eyes, a seething mass of a million people crouching in holes that they had dug with their own hands." People who "hardly moved," he notes, impressed above all by the "immobility of the children." These children show, continues Scianna, as if he were writing a caption to the image here reproduced, "through small splits in the cloth which protects them, fixed stares, showing an inexpressible exhaustion, frighteningly white eyes, their lips open and cracked by the burning heat, where flies settle without them having the energy to drive them away."

With the same concern for witnessing events which appear apocalyptic, Scianna has made many more reports of emotive intensity, among which is the outstanding work produced in 1986 at Kami in Bolivia. Yet again, he records here the drama of a humanity hovering between two eras: the peasant and the industrial, and now the electronic era—finding on people's faces the same existential anxiety for which he had been looking since the beginning of his career—since the "religious festivals" in Sicily with which he discovered his talent.

His capacity for synthesising and memorising those moments in his imagination, like Cartier Bresson, is, if not unique, certainly "decisive" for making a judgement, in addition to conveying a message.

—Italo Zannier

Bibliography—

"Ferdinando Scianna," special monograph issue of *Progresso Fotografico* (Milan), October 1980.
Scianna, Ferdinando, and Sciascia, Leonardo, *I Grandi Fotografi: Ferdinando Scianna*, Milan 1983.
Scianna, Ferdinando, *Le forme del caos*, Udine 1990.

© Chim Seymour / MAGNUM

670

David Seymour (Chim) (1911–56)
Prostitute in Essen, 1947
Black-and-white photograph

The photograph *Prostitute in Essen* by David Seymour is a docu-ment of time that causes confusion. From a purely photographic point of view, it seems a strange mixture of a snapshot and brutal allegory. In the eyes of the historian, it tears apart the simple patterns of political history and forces us to take into account the complex conditions of life applied to a whole nation after losing the war it had instigated. Pictures like these do not encourage easy moral judgements that are always demanded by the younger generation: Why have the Germans learnt so little from their horrific past? Were they really capable of contemplating their responsibility or guilt in this chaos of ruins, famine, homelessness of their destroyed cities? Do grief and sorrow have a chance in the daily fight to survive?

The Germans have suppressed and forgotten those years after World War II very quickly. It is only over the last ten years that documents relating to this period have been properly investigated and published; a period that proved so vital for the future of Germany. In this short phase of total disintegration and new stabilisation, the foundations for everything to come were laid— of politics, economy, and also the social psyche of the nation. Therefore, it has only been recently that studies dealing with the photographic perception of "Post War Germany" have been published. They concentrate on an important phenomenon of the photographic inheritance of the time: on the difference in view-point of the winners and the defeated side.

It is highly instructive to compare the pictures of German pho-tographers after 1945 with documents of English, American or Russian photographers. Even if they were not supporters of the Nazi Party, German photographers reacted rather cautiously after the defeat and disintegration of their system: their pictures deplore the horrific extent of distruction in the cities, yet do not document the psychic destruction of their fellow countrymen. A kind of unconscious solidarity seems to prevent them from conserving the picture of the "hideous German" for posterity. Another motive can also be closely observed: in their own desperation, they begin to depend on hope just like all others; therefore they start very quickly to document every spark of will to survive, each new sign of a return to the normal, of reconstruction. In the general chaos there are positive signs to be found—this became the central message of most German photographers after the war.

The foreigners who came into the defeated land, either relatives of the allied troops, or later reporters for the big magazines, reacted in a significantly different way. At first they stood struck, unable to take in the unconceivable horror of the concentration camps (such as George Rodger in Bergen-Belsen, or Margaret Bourke-White in Buchenwald); then they pointed their cameras sceptically towards the unbelievable: they found emptiness in the faces of the misguided soldiers in the prison camps, but also the conceit of incorrigible nazis, and the dangerous dullness of the eternal hangers-on. They showed the world not only the effects of the lost war, but the alarming portrait of a society that apparently did not clearly see their own guilty failure and responsibility for the agony that had been caused. The insistence of being asked about the individual participation of the Germans becomes even more distinct when the photographer supplements his pictures with interviews, as Henry Ries did in his book *German faces*.

In this way, David Seymour and his photograph *Prostitute in Essen* symptomatically stands in line with the curious, astonished and quite sceptical observers of post-war scenery. From his shot of the woman who so provokingly displays the nature of her "profession" in front of a destroyed factory, we may possibly deduce his acknowledgement of the misery that leads to life becom-ing more and more brutal all over the world. At the same time, we still feel the distance he keeps from this German woman: as if he could not handle her shamelessness, through which speaks unbroken self-confidence, where modesty and sadness would rather be suited. This photograph does not ask for sympathy for the living conditions of a poverty-struck nation. It rather poses the question whether people with such an unscrupulous strategy of survival will ever learn from the catastrophies of history.

In the same year as the photograph was taken, David Seymour, Robert Capa and Henri Cartier-Bresson founded the agency Magnum. Their crede, marked by having recently overcome war and bearing the hope that mankind could be educated to the good, was to influence photography all over the world for two decades to come. Their "human interest" showed the way amongst all political fronts. It was a pladoyer for both the suffering and the happiness of the plain individual in a still war-minded world (and so it was an illusion). But one should not forget that even the founders of Magnum could not in some cases be neutral in their observation. Capa and Seymour in Spain (1936–39), Rodger in London (1942–43) or the three of them in action in defeated Germany—their pictures serve to prove that intelligent pho-tography can very well formulate questions of political morality that can still be answered anew after many years.

—Wolfgang Kil

Bibliography—

Bourke-White, Margaret, *Dear Fatherland, Rest Quietly*, New York 1946.
Ries, Henry, *German Faces*, New York 1950.
Caiger-Smith, Martin, *Bilder vom Feind—Englische Pressefotografen im Nachskriegsdeutschland*, Berlin 1988.
Kil, Wolfgang, *Hinterlassenschaft und Neubeginn—Fotografien in den Jahren nach 1945*, Leipzig 1989.
Manchester, William, *Zeitblende—Funf Jahrzehnte Magnum-Foto-grafie*, Munich 1989.

Cindy Sherman (1954–)
Untitled, no. 96 1981
Colour photograph; 24 × 48in.
London, Saatchi Collection

Untitled no. 96 (1981) is representative of Cindy Sherman's exploration of the realm of popular culture and female stereotypes. Considered by many as a postmodernist, Sherman employs explicitly past film and media images, by offering the idea of choice of identity through staged characterisations. She also promotes the idea by creating new media representations of past stereotypical identities. The multiplicity of readings is not unlike the multiple guises Sherman embraces throughout her work.

Sherman's photographs operate as "theatre" where she is both the subject (performer) and the photographer (director) of the work. In the tradition of photographers such as Alice Austen (1866–1952) and Judy Dater (1941–), Sherman confronts conventional accounts of female roles. She creates images which question governing practices of traditional documentary photography, especially through her self-presentations as well as the power of active looking. Using herself as the model, Sherman negates the idea of a documentary portrait. Her document is of the self—but of a self that has been falsified or manipulated, confronting the postmodern idea of authenticity. The multiplicity of Sherman's guises do not function as mere parody, but rather exhibit the identity of the self as concomitant with facsimile. Sherman is both herself and the assumed role.

Untitled no. 96 is a transitional image which links Sherman's early black and white *Untitled Film Stills* (1977–1980) with her recent colour investigations into the iconography of old master paintings (1990). As in Sherman's other series, the narrative draws upon the viewer's memory of film and media representations. She has created a repertory of female characters which examine a wide range of stereotypes from grade "B" Hollywood films, housewives and career girls. Sherman does not underplay the more horrific dimensions of female representations. Many of her photographs portray the vulnerability of women. Blood-stained corpses smeared with dirt, dismembered bodies, and in some cases an absence of the body, convey the aftermath of sexual crimes. These images no longer seek the conventional masculine gaze promulgated by the popular press through representations of fashion plates and pin-up girls. Furthermore, these images counter projections of masculine fantasy and lead inquiry into traditional roles of a patriarchical society.

In *Untitled no. 96*, Sherman's ostensible guise is of a lovelorn teenage girl dressed in an orange plaid skirt and shirt. The teenager, lying on a vinyl tiled kitchen floor, is viewed from above. Perhaps by an adult intruder—the mother ready to scold her daughter for not finishing her chores. This staged self-portrait undertakes a "girlish" innocence with Sherman's cropped hair, naturalness of her make-up, and young female dress. In one hand the lovelorn teenager clutches a piece of newspaper torn out of a personal column. She is dreaming of her own lost love or the love she has yet to experience.

Untitled no. 96 is one from a series of colour representations Sherman began in 1981 which were presented in a horizontal format defining the human figure within the confines of a frame. Little or no indication of a background set is found. Sherman's previous "rearscreen projections" and *Untitled Film Stills* drew upon the integration of set-up environment and figure in the demarcation of a narrative. She uses theatrical devices especially as a way of negotiating the traditional notion of femininity. In *Untitled no. 96*, meaning is conveyed by the teenager's clothing, make-up, pose and facial expressions. The face and body pose are meant to carry the emotional impact. The ambiguous nature of the teenager's facial expression emphasizes the limitations of particular forms of media imagery often selected to evoke specific emotional reactions. This editing of information is most prevalent in the process of news production where photographs cannot be a "neutral transmission" of the actual event. Sherman's work embraces such ambiguities in reading the media event and it is in this specific way that it questions contemporary cultural stereotypes of "female" in media representations.

The posture Sherman has adopted—assigned to her back—leaves her open and unprotected from the intruder above. The near life-size nature of the print establishes an uncomfortable confrontation with the viewer. The teenager's gaze does not engage with the viewer and avoids the rhetorical moment of initial eye contact. Because of the photograph's size, interaction between the teenager and viewer initiates a sense of the photographic image as mirror. The use of media images and cultural cliches are appropriated in a similar manner advancing a "false mirror" of identification. The ambiguity of who she is as well as her adopted guise is established. It is the viewer's cultural baggage which solidifies the social constructs of feminine identity. The male gaze might suggest another interpretation of the scene—that of seduction or sexual power. As with much of Sherman's later photographs the intensity of the colour plays a key function in disclosing information. In this case, the strong orange hues provide an overriding sense of warmth and security. This creates a dynamic tension with the vulnerability imparted by Sherman's position on the tiled floor. The narrative is left seemingly unresolved. Sherman's photographs display fragments in the life of the lovelorn teenager. They are captured film "stills" which cannot move forward nor backward in the normal continuum of a narrative sequence. Sherman can only examine the details of a static narrative as opposed to providing a dynamic view. Yet Sherman often presents her work as series of multiple images which collectively render a ponderous but coherent account of a story.

Sherman has asserted that her early photographs were not based on theoretical rhetoric. Instead she has suggested that the simplicity of the photographic narrative in *Untitled no. 96* is nothing more that a teenage girl pausing for a moment to think about a piece of paper ripped out of the newspaper. Her visage was to convey an uncomfortableness of dressing in costume. Whatever the interpretation or reasoning behind the creation of *Untitled no. 96*, Cindy Sherman has managed to elicit a provocative response.

—Teal Triggs

Bibliography—

Barents, Els, *Cindy Sherman*, exhibition catalogue, Amsterdam 1982.
Gambrell, Jamey, "Cindy Sherman: Metro Pictures," in *Artforum* (New York), February 1982.
Schjeldahl, Peter, "Shermanettes," in *Art in America* (New York), March 1982.
Williamson, Judith, "Images of Women," in *Screen* (London), November/December 1983.
Barents, Els, and Schjeldahl, Peter, *Cindy Sherman*, Munich 1987.
Livingston, Kathryn, "The Girl of Our Dreams," in *American Photographer* (New York), November 1987.
Sherman, Cindy, *Untitled Film Stills*, London 1990.
Kent, Sarah, *Cindy Sherman, Richard Wilson, Richard Artschwager*, exhibition catalogue, London 1991.
Graham-Dixon, Andrew, "The Self and Other Fictions," in *The Independent Magazine* (London), 19 January 1991.

Aaron Siskind (1903–91)
Terrors and Pleasures of Levitation, 37, 1953
Black-and-white photograph

Terrors and Pleasures of Levitation is the title of an extensive series of photographs that depart radically from Aaron Siskind's usual way of organizing the space in his photographs. Normally, he uses a rigorous arrangement of light and dark forms, variously textured, in flat pattern across a rectangle. The photographs are two-dimensional; the surface of the print is the plane on which everything happens. Almost always, his subjects are fixed in place and there is no hint of motion. The satisfying tonal richness typical of his work comes partly from the amount of exposure he uses: to quote Siskind, "I always overexpose three or four stops" (roughly eight to sixteen times as much exposure as manufacturers recommend giving their black-and-white films). The word "always" should not be taken literally. Siskind's craftsmanship is free but it is not casual.

Siskind defined this way of working in a statement published in the 1965 George Eastman House monograph on his work: "When I make a photograph I want it to be an altogether new object, complete and self-contained, whose basic condition is order— (unlike the world of events and actions whose permanent condition is change and disorder). . . . I accept the flat plane of the picture as the primary frame of reference of the picture. The experience itself may be described as one of total absorption in the object. But the object serves only a personal need and the requirements of the picture. Thus, rocks are sculptured forms; . . . decorative iron-work, springing rhythmic shapes; fragments of paper sticking to a wall, a conversation piece. And these forms, totems, masks, figures, shapes, images must finally take their place in the tonal field of the picture and strictly conform to their space environment. The object has entered the picture, in a sense; it has been photographed directly. But it is often unrecognizable; for it has been removed from its usual context, disassociated from its customary neighbors and forced into new relationships."

Referring to the idea that his shapes and images are drawn by association from a non-conscious level of his mind and feeling, Siskind continues: "It may be they are. The degree of emotional involvement and the amount of free association with the material being photographed would point in that direction. However, I must stress that my own interest is immediate and in the picture. What I am conscious of and what I feel is the picture I am making, the relation of that picture to others I have made and, more generally, its relation to others I have experienced."

In short, his work does not consist primarily of recording things he has seen that have moved him. That happens, but it is not his main object. He works in a more detached way, using what he sees in daily life not as subject matter to present, but as raw material to use in forming pictures that he has in mind.

In the *Terrors and Pleasures of Levitation* series, he departs from his usual formal, static, two-dimensional structure, but not from his picture-oriented way of relating to his subjects. Here human divers, usually foreshortened, are suspended in space and frozen in time as they fall. The space is ambiguous—open, white sky surrounds each figure, and the clear rendition of solid three-dimensional bodies surrounded by air is achieved by foreshortening and by the limited tonal modeling of the figure's skin and structure. The sky that surrounds the figure is featureless and would be flat if it did not have to encompass the whole height, width, and depth of the diver's body.

I don't believe anyone thinks in such terms when photographing. Taking pictures is not an intellectual activity. We are intent on what's in front of the camera and on coping with the choices that the subject and its environment present. When we photograph things that move quickly, there is no time for careful arrangement; it is done intuitively, on the spur of the moment.

Later, there is time to select, arrange, edit, and put the photographs into sequence—if that is what you want. Later, the intellect and the developed sense of form get their chance to control what impulse has produced; I think that is what Siskind has done here.

In answer to my questions, he wrote: "This series was begun in 1953 and continued (on and off) into the early '60s. They are of people diving or jumping from the same diving board set up on a concrete shelf on the Near North Side of Chicago. In 1953 I determined that I was only interested in the figures showing an experience—pleasant or unpleasant—while in the air; and the title, *Pleasures & Terrors of Levitation* came to me and controlled my selection from the many exposures made."

Although these photographs have been published as *Terrors and Pleasures*, note that Siskind also uses the words of the title turned around. Both aspects seem to be equally important to him.

In looking through these photographs to select one for this article, I saw no definite expressions of terror or of pleasure, so I suppose that Siskind assigned those feelings to the pictures on the basis of other associations of his own. That is as it should be: I believe that any picture that fits its description perfectly or that can be explained completely must lack something vital: the undefinable emotional charge that makes it worth seeing.

Personally, I welcome this series as an adventure, on Siskind's part, into immediate feeling. In the greater part of his work, the emotional charge is certainly there, but it lies more in his sure and intense handling of form than in any direct association with the subject as such, or with its condition in the world.

Here, Aaron Siskind may be revisiting an early stage of his work, the lively one in which he documented life in Harlem along with others from the Photo League. But he hasn't gone all the way back to that subject-dominated mode, where people and their places interacted in a literal way that would be hard to fit into any formal scheme. (That may be his "world of events and action whose permanent condition is change and disorder.")

Here, by floating each figure in mid air, he has both imposed visual order and introduced a large element of ambiguity. The viewer has no easy story to fall back on, but must cope with limited information, almost none of it coming from a mute environment— the blank sky.

It seems to me that these pictures are at least partly about that lack of reference. The levitation is not in the people Siskind photographed: it is in the pictures, and in what they do to us when we see them.

We hang there in space, outside time. If that pleases or terrifies us, so much the better.

—David Vestal

Bibliography—

Siskind, Aaron, and Rosenberg, Harold, *Aaron Siskind: Photographs,* New York 1959.
Lyons, Nathan, ed., *Aaron Siskind, Photographer,* New York 1965.
Siskind, Aaron, *Terrors and Pleasures of Levitation,* portfolio, New York 1972.
Zafran, Eric, *Aaron Siskind: Retrospective Exhibition,* catalogue, Norfolk, Virginia 1979.
Turner, Peter, and others, *Aaron Siskind: Photographs 1932–1978,* exhibition catalogue, Oxford 1979.
Chiarenza, Carl, *Aaron Siskind: Pleasures and Terrors,* Boston 1982.

© Skrebneski

676

Victor Skrebneski (1929–)
Vanessa Redgrave, Hollywood, 1967
Black-and-white photograph

Vanessa Redgrave, Hollywood (1967), is a photograph everyone recognizes. Perhaps the photographer is unknown, but the image is strong. Warner Bros., in producing the film *Isadora* starring Vanessa Redgrave, wanted an image unseen in movie advertising before. Trying to capture the free spirit, the unusual, the unconventional promotional image, Warner Bros. hired a slightly known photographer who had been shooting black and white portraits of actors and singers in a new artistic vision. They went the whole nine yards and had Skrebneski's single image of the profile of Vanessa Redgrave with nude torso, wrapping her arms around herself be the promotional visual material for the film *Isadora*.

The photograph *Vanessa Redgrave, Hollywood* (1967) is a paragon of Victor Skrebneski's work. Published in his book *Skrebneski* (1969), *Vanessa Redgrave, Hollywood* is a portrait and an investigation of beauty through the eye of this photographer. The book used a large square format to frame the richly toned, black and white photographs. In *Vanessa Redgrave*, props and ornate settings are dismissed for a return to the strength and beauty of an artist's subject. For Skrebneski, the human form is a source for study and awe. To quote Skrebneski, "People, timeless. They will last my time. Designed as sculpture, I have left them alone. In the human contact they live in reality. I live with them." His photographs return to a fundamental theme: the human figure, dramatically lit, in carefully controlled poses, nude, with no distractions. Their starkness and simplicity almost astonish us.

Having basically been self-taught, he studied painting and sculpture at the School of The Art Institute of Chicago and at Moholy-Nagy's Institute of Design. His love of form and Classical sculpture, coupled with an equal love of old French black-and-white films, steered him into his uniquely strong direction. Born of Polish and Russian parents in Chicago in 1929, he did his early work in Europe and New York. Returning to his native Chicago, he opened a studio close to the architectural wonders of the downtown area. His house/studio appear modest by design, but it is behind the brick walls that some of the strongest black and white imagery happens.

As a child, Skrebneski repeatedly watched French films in black and white. The beauty of the stars was hauntingly memorable. Flashbacks would return to his mind time after time in pitch blacks, blinding whites and soft grey tones. Throughout the years, he accepted film stars as real in black and white; color seemed to make them unreal. When he would photograph a portrait, there was always a momentary flashback to film stars in close-up in his mind. Always exciting and glamorous, they inspired him to produce work like the famous *Vanessa Redgrave* photograph, shot for Warner Brothers' film *Isadora*.

This portrait especially reveals the strong kinetic movement of Redgrave's figure and her flying hair, so typical of the power he produced in the portraits he created. One uses descriptions such as gentle and vulnerable, radiant and exotic, dashing in style with seemingly effortless grace when observing the photographs. Faces and bodies take shape and form, appearing and disappearing.

We see Vanessa Redgrave looking sullen but strong, defiant and vulnerable, beautiful, available to be looked at but not touched. There is no invitation to expose her. There is a pull, a contrast in the photo of a nude perhaps shy, perhaps relunctant to expose her breasts; or is it her soul? She holds on to herself tightly, her long hair like a mane surrounding her; like a halo protecting her.

Skrebneski has a breadth of vision and inventiveness, but his strength lies with always-fresh explorations in thematic series. He gives us new interpretations and revelations. His work is honest, forward. He technically masters the camera with his mental images. Simple but precise, often sculpted to minimalism he creates photos that simultaneously evoke tension and lethargy. Skrebneski is noted for taking the familiar, the usual and surprising us in different ways. He reduces the photograph to a very few elements and speaks to us with authority and power.

In 1963 Skrebneski, a new talent in the advertising market was introduced to Estee Lauder. Her small but growing cosmetic company was about to begin a national ad campaign and needed a strong visual image. On first look at Skrebneski's portfolio she hired him because she felt he had the "soul of Klimt." His distinguished and beautiful ads are still running over twenty-six years later.

Although his commercial success with Estee Lauder ads have made him recognizable his strength and unique quality lies with his portraits. Through mood and music he stimulates the photo sessions with a model until he achieves just the right moment. He is after a reciprocal portrait, not a bureaucratic one. He often enlarges these portraits to seven by seven feet to monumentally view his subjects. Simulating sitting in a theatre either in the first row or in the last he returns to his early roots of watching foreign films. To come this close he reminds us of problems that were expelled. He gives us models whose exhaustion, excitement, happiness and sorrow will be revealed forever. He stops time, but the imagination stimulated by his work continues.

Skrebneski takes us through all of these emotions in *Vanessa Redgrave, Hollywood*. He brings us close to his subject. In his favorite black, grey and white he adds an incredible realism that we as viewers must address with a mental and intellectual view finder.

—Andrea Kalish Arsenault

Bibliography—

Skrebneski, Victor, *Skrebneski: Nudes*, New York 1969.
Skrebneski, Victor, *Skrebneski Portraits: A Matter of Record*, New York 1978.
Skrebneski, Victor, and Givenchy, Hubert de, *Skrebneski: Five Beautiful Women*, Boston 1987.
Skrebneski, Victor, Zachary, Frank, and others, *Skrebneski: Black, White and Color Photographs 1949–1989*, Boston 1989.
Skrebneski, Victor, and Jones, Anthony, *Skrebneski*, Chicago 1989.
Cowles, Charles, and others, *Skrebneski*, exhibition catalogue, Chicago and New York 1990.

© The Heirs of W. Eugene Smith/Center for Creative Photography, Tucson

W. Eugene Smith (1918–78)
Tomoko and Her Mother, Minamata, 1972
Black-and-white photograph

"During his relatively brief and often painful life," says Ben Maddow of W. Eugene Smith, "he created at least fifty images so powerful that they have altered the perception of our history." With *Tomoko and Mother* (1972), Smith achieved in a single image the objective of all socially conscious artists—the gift of instant persuasion. He captured the torture caused by mercury poisoning in Minamata, Japan—and at the same time brought to the world a sense of urgency and horror that could only be achieved in the best photography. It was his last important photograph in a career of outstandingly persuasive images.

Awash in the blackness that characterizes all his work, this is one of those rare images that will live forever—or at least for the rest of our lives—with powerful impact on all its viewers. It reminds us over and over again of the nightmare of human abuse at its most tragic levels. In contrast to the inhuman, almost lifeless form of the young girl as innocent victim is the radiance of love and caring of Tomoko's mother. This life-and-death contrast was a significant factor in Smith's decision to shoot the scene and fuels its tragic quality, painting a crucified Christ-like quality to the child with her hands forcibly deformed by industrial pollution.

Smith's mastery of windowlight highlights the picture's story, adding a new dimension to the tragedy. Through daily visits to check the room's light he discovered the magic moment for exposure. Tomoko's face, tortured eyes turned heavenward, is bathed in sunlight, as are her twisted upper torso and frail, gangly legs. The sun also bathes her loving mother's arresting face, bandana-covered head and graceful shoulders as she caresses her sickly child. They are surrounded by a cave-like darkness, as if entombed but alive with God's light shafting its way into their dark chamber, lighting up their lives. The spiritual quality is profound, and for such a dyed-in-the-wool photorealist as Smith, a sort of coming home in his career and inner life.

Though all of Smith's images were personal, his Minamata essay (1971–75) struck the chord that would carry his soul to its most revered position as the radical social artist. It was a triumph of the most painful dimension, for the Minamata experience hardened his resolve to bring justice to humanity through photographic drama, in his words, "to right what is wrong."

Smith and his wife Aileen had visited many of the Minamata disease victims. Often parents had abandoned their defective children, adding to the brutality of society that Smith so deeply hated. When Smith saw Tomoko's mother cradling her mercury-poisoned daughter in her arms, the essence of his experience at Minamata was summarized in a moment. The image became his legacy, his pièce de resistance, likened to Michelangelo's *Pieta*.

More than any photographer before or after, Smith epitomized photojournalistic communication—and exhibited the fires of hate for injustice through the mastery of his eye and conscience. A connoisseur of black-and-white tonal control, he had a penchant in his exposure and printing for the very darkness he saw around him and about the world. Nowhere is this as evident as in *Tomoko and Mother*. It epitomizes all that is known of Smith's quest for perfection in print and in his artistic message. His Minamata essay is considered the sharpest expression of his art on behalf of humanity; it is hard to imagine a more perfected image than this one to represent all for which he strove in his brief, intense and passionate life.

Much controversy has surrounded the mythical figure of Eugene Smith and the question of whether his pictures—particularly his most moving and sustaining images—were captured or set up. This is like the nature-or-nurture question of maturity. We know, for instance that he took days, even weeks to make a print that met his rigorously high standards. We also know that he took many days to find the right window lighting for *Tomoko and Mother*. Yet the essence of the spirit he captured—the meaning—is real, was felt by the photographer and created through his unique talents and knowledge of his craft. His vision, his sensitivity and his maturity as a photographic artist are paramount to his ultimate persuasion. This is where we put our trust in the strength of the image. This was W. Eugene Smith's trademark as he collided with the fragile and inherently unjust world around him and as he created the masterpieces of twentieth-century photojournalism to which we pay homage.

The Japanese adored Smith for his passion. When he arrived in Minamata in 1971, they treated him like a Shinto god. He felt taken in by the country and loved in the same way that Tomoko Uemura was loved by her mother. He identified with the child being bathed—it made him feel the protection he needed in the dangerous world. "It was as if he'd finally found the ultimate image of love," says Smith biographer Jim Hughes, "for which he'd been searching his entire life. Gene had stepped across the threshold of the picture frame and into the drama that was unfolding before his lens."

Tomoko and Mother, Smith's final tragic image, stands as a hallmark of photojournalistic greatness. It will last well into a future time when such images will be considered classics in the Renaissance style.

—Bruce Poli

Bibliography—

Smith, W. Eugene, and Aileen M., *Minamata*, New York 1975.
Thornton, Gene, *Masters of the Camera*, New York 1976.
Coleman, A. D., *Light Readings*, Oxford and New York 1979.
Maddow, Ben, *Let Truth Be the Prejudice: W. Eugene Smith—His Life and Photographs*, Millerton, New York 1985.
Hughes, Jim, *W. Eugene Smith, Shadow and Substance: The Life and Work of an American Photographer*, New York 1989.

Photo Museum of New Mexico, Santa Fe

Frederick Sommer (1905–)
Pine Cone, 1947
Gelatin silver print photograph; 19.2 × 25.1cm.
Santa Fe, Museum of New Mexico

It is important to discover when looking at a Frederick Sommer photograph that the idea of *image* includes a perception of process. This is not the photography of fixed fragments of reality. Nor is it a life story, a concentration on pure formal attributes in the picture, or a record of time. Frederick Sommer's photographs are more comprehensive in make-up. They sustain an ongoing evolution of human and natural cycles and events. Metamorphosis in his art occupies a universal scale.

What dimensions of life can photographs provide outside the literal representations of reality created by the camera? The intricate structures within Sommer's photographs yield another form of understanding. As image, they convey a sense of the interworkings of architecture, through a functioning correspondence of parts. Like a constellation of thoughts surrounding a central idea, the matrix of his chosen subjects serve a purpose that transcends their individual disposition. Every detail attains a new life. In part, this is a result of what their relationships reveal in concepts. But it is also the artist that sees and makes active their presence beyond the literal. This is an art of the imagination more than metaphor.

The microscopic scene of *Pine Cone* contains decomposing elements that prompt the space of our mind. Any reference to human scale vanishes for an open-ended exchange. The exacting structure of every texture, form and reference to nature here is liberated for our own impressions.

The artist not only helps transform the image, but brings it to "a stabilized condition" for another kind of genesis. Sommer's mention of extending the image from inside human faculties with "what we find," is insightful. Like a memory, the image combines past with present and offers a sense of reflections with material substance. As such, the photograph becomes a transforming principle. It is a tangible vehicle for further realization.

The catalytic power of Sommer's elements of nature transformed is not unlike the art of fifteenth-century painter Hieronymus Bosch. The photograph sustains the complexity and transparent delicacy of the Netherlandish traditions in light, as well as an uncompromising sensitivity towards every nuance of description. Silvery, light-interpreted tonalities amplify this collage-like order of circumstance. Every change in tone modifies the intricate structure.

While the picture does not carry Bosch's religious and symbolic overtures, photographic details here float across the picture plane with all their tactile distinctions. The fabric of nature's materials is suspended with a sense of animation. A partially exposed pine cone rests as the only anchor in a small ocean of enigma.

Mind and matter are linked to extend our experience in the most certain photographic terms. The countless micro-textures and threads of nature's deposits suggest infinite readings. There is a sense of something concealed in this puzzle. The substance of reality or a dream? Such vision unites both. Like life, it speaks to our individual discovery through metamorphosis. Our imagination responds to such realms more about the fantastic.

Chance within this ready-made collage plays a special role in the luminous qualities of each ingredient. Its participation establishes a working distance for the viewer to unfold the expressive tendencies of nature's process. The pattern of creation is a consequence of universal order and interchange. The photographer's life in the American Southwest acknowledges the formations of time: Climatic conditions in the West give things time to decay and come apart slowly. They beautifully exchange characteristics from one to the other. Great accommodations take place during the time that this is happening. In New Mexico and Arizona one can find filter systems that are built when twigs that have been carried by rain form structures that continue to collect from the flow. They vary as different kinds of matter contribute to their structure. They are models of the way cell life is built.

Art becomes the substance of constellations and the forces of nature. Organization is given variety in pictorial expression by chance. The photographer combines the random facets of nature with design to create a new unity for our mediation. The lessons of Cubism and Surrealism are also allies in Sommer's working ideology. Their relatedness supports his ongoing philosophical inquiry. Both pronounce an enlarged experience of reality. In terms of photography, they open the door to spheres that had been accessible only to twentieth-century painting.

New areas of form and content, the realm of the unconscious, the hidden potentials of the inner and outer worlds of experience, and the poetic principle of collage make active the ideas of Frederick Sommer. In turn, his photography has opened the expressive potentials of the mind that maintains few boundaries.

—Steven Yates

Bibliography—

White, Minor, ed., *Aperture 10.4: Frederick Sommer*, Rochester, New York 1962.
Nordland, Gerald, *Frederick Sommer*, exhibition catalogue, Washington, D.C. 1965.
Sommer, Frederick, and Aldrich, Stephen, *The Poetic Logic of Art and Aesthetics*, Stockton, New Jersey 1972.
Weiss, John, ed., *Venus, Jupiter and Mars: The Photographs of Frederick Sommer*, exhibition catalogue, Newark, Delaware 1980.
Sommer, Frederick, *Words*, Tucson 1984.

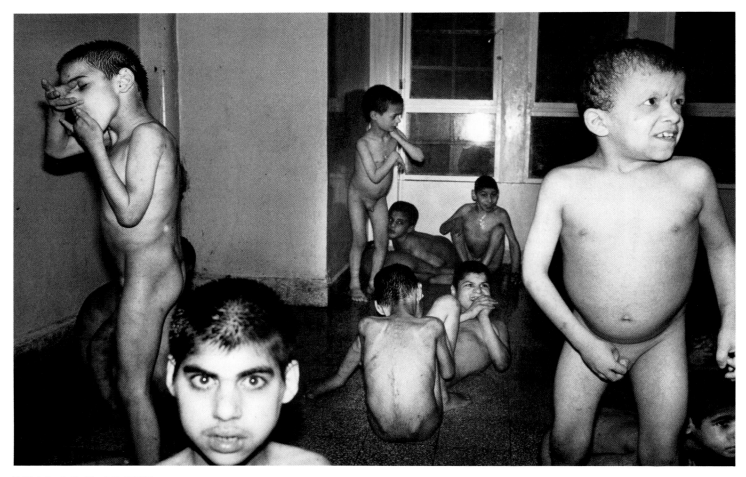

© Chris Steele-Perkins/MAGNUM

Chris Steele-Perkins (1947–)
Traumatised children in a mental hospital shelled by Israelis, Beirut, 1982.
Silver gelatin print photograph

Chris Steele-Perkins was an early activist within post-Fifties British photography. As an inquisitive, enquiring student photoreporter at Newcastle University in the late 'Sixties, he perceived photography as a passport into hitherto unknown worlds and other people's histories, a coda to social understanding.

To have such access to the world was important. His childhood was unorthodox, spent in the company of his elderly father, living in a succession of seaside guest houses on the south west of England, boarded out to school when very young. From those early years, the concept of Outsiderism was one which informed Steele-Perkins' emergent visual and political consciousness.

By the early 'Seventies, Chris Steele-Perkins was working as a photographer based in London, disseminating his photoreportage widely through exhibitions, gallery publications and through the centre leftist weekly press. Early work (exhibited in the group show *Young British Photographers* at the Photographers Gallery in 1974), showed an intense interest in the eccentric, dislocated England (originally "exposed" by documentarist Tony Ray Jones) which became the fascination of so many young independent photoreporters of the early 'Seventies.

Inherent in this fascination was an obsession with finding "real life," often in extremis—an evening picnic at the first night of Glyndebourne opera, or the peeling kitchen of a deprived Northern tenement—both expressed a documentary "equivalence" held in high esteem by the new independents.

In 1975 Steele Perkins embarked, as a member of the EXIT photo collective, on *Survival Programmes*, a documentation of life in the deprived Northern inner city. With the photographers Paul Trevor and Nicholas Battye he began a lengthy process of not only photographing inner city families, but also recording interviews on tape with them in the mode of influential American oral historian Studs Terkel. Concurrent with *Survival Programmes* was *The Teds*, a vigorous foray into the disarrayed anarchy of urban style cults. Both projects pictured those who dwelt deeply within a specific experience, for whom the idea of "society" was formed by fantastical, phantasmagorical cultural concepts.

As his career as a photographer advanced (he became a full member of Magnum in 1983) Steele-Perkins began to take part in an international as well as a domestic photojournalism. He had photographed in Bangladesh in 1972, but it was not until the early 'Eighties that his work in Africa, Central America and Lebanon began to make a significant impact. Like his near contemporaries, Don McCullin and Sebastiao Salgado, Steele-Perkins photographed a Third World under stress—strained by famine, by racism, and by power politics. Unlike them, he brought to his picturing a style which was much closer in intent to the meticulous observations of *Survival Programmes* than it was to the bravura "concern" so closely associated with an elite post-war photoreportage.

When Chris Steele-Perkins first visited Beirut in Lebanon in the early 'Eighties, he found a community defined by damage, by violence, by the breakdown of political systems. Many of the people whom he met and photographed in Lebanon were enclosed, circumscribed, imprisoned. By the time he was working in Beirut his photography, always ascerbic and ascetic, had developed a narrative which was both apocalyptic and mournful. Seeing a once elegant and harmonious Beirut collapse into ruins, become a city under siege, was, to many Western observers, not only a doleful reminder of a recent European past, but, in the nuclear age, a prophecy for catastrophe.

Steele-Perkins' *Traumatised Children in a Mental Hospital in Beirut shelled by the Israelis* is a photograph which operates on a number of very specific levels. In a 1987 interview, he remarked that: "A good photograph is the distillation of experience. It must be more articulate, more poetic, more intense, more charged with understanding than a bystander at some event would comprehend simply by being there."

In a number of ways, *Traumatised Children* meets all the quoted criteria of a "good" photograph. It is clear and concise—the children's distress is evident; it is obvious that they are confined, both within walls and within their own trauma. That they *are* children is important—the desecration of childhood has become a salient motif within Steele-Perkins' reportage. Whether in Beirut, or Derry or Africa or Bolivia, children become the focus for the social criticism around which so many of his photographs are constructed.

Beyond this initial clarity, *Traumatised Children* is an ironic statement; the protection offered by the state or by authority, is, as the photograph relates, entirely illusory. Metaphor for the divided, impotent state, the chaos of the photograph becomes symbolic of a shattered civilisation. A sharp, fatalistic cynicism dominates *Traumatised Children*. Like a tale told by some modern Thersites, Steele-Perkins' narrative is full of doom, a story of corruption and deceit in a degraded, satirised war adventure.

The strength of *Traumatised Children* lies not simply in its intent, but also in its effect. The children in the foreground, each absorbed by his own invaded imagination, frame the central group. Naked, stained, they appear as an awful parody of sociability, of normality. The photograph loses its modernity, and becomes a parable from times past, a crowded Brueghel canvas, or a scene from some melancholy medieval mystery play. The photograph is a grotesque, as much a product of an English imagination with its clowns and its mummers, its freak shows and circus acts, of Hogarth, Dickens, Waugh and Firbank as it is part of the heroic fantasy of the war correspondent.

In 1989, Chris Steele-Perkins published *The Pleasure Principle*, a book about England. In the introduction, he wrote that he: "was not interested in polemics, or a fashionable cynicism. I wanted to re-orientate myself. I found myself returning to the public rituals that we employ in the pursuit of happiness. For here we display our identity, as we would like it to be. There we make signals about who we are, and about what we believe in. Looking through this haze of signals with a tangential glance, a curious eye, reveals some unintended things."

Travelling in the Third World, through the war zones, Steele-Perkins had seen the real Outsiders—"the starving, the dispossessed, the oppressed; those with no hope but their indomitable spirit." His conviction of his own Outsiderism was lessened by his experience, it seemed now more like "posturing." After Lebanon and Ethiopia, it seemed preposterous to see himself as a victim.

Traumatised Children in a Mental Hospital in Beirut is an important landmark in an imaginative odyssey. It is illustrative of a personal politic, a well-defined aesthetic and a clear moral stance: "If I can take compassionate pictures, show how people can transcend the kind of circumstance that I would find unendurable, then I feel that this part of my work has some meaning." In *Traumatised Children*, distress and tragedy emerges clearly. But, just as evident is the photographer's stance, as documenter and educator, an amazed and chastened witness to the human condition.

—Val Williams

Bibliography—

Steele-Perkins, Chris, *The Teds*, London 1979.
"British Photography Now," in *Creative Camera* (London), March/April 1981.
Steele-Perkins, Chris, *Survival Programmes*, Milton Keynes 1982.
Steele-Perkins, Chris, *Beirut: Frontline Story*, London 1982.
Truell, Peter, "Beirut: Chris Steele-Perkins," in *Creative Camera* (London), June 1983.
"Concerning Chris Steele-Perkins," in *Creative Camera 11*, London 1987.
Manchester, William, *In Our Time: The World As Seen by Magnum Photographers*, London 1990.
Williams, Val, "Interview with Chris Steele-Perkins," in *Oral History of British Photography*, National Sound Archive, London 1991.

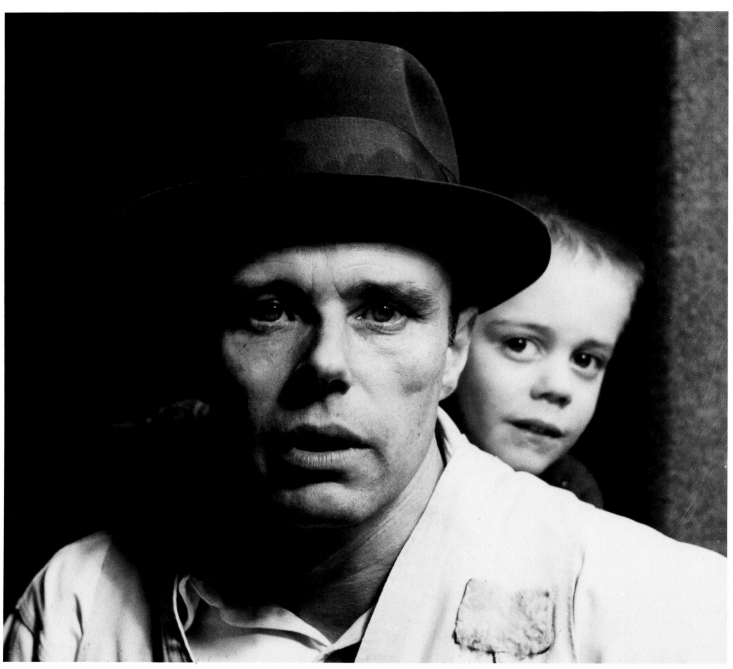

Photo Rheinisches Landesmuseum, Bonn/© DACS 1991

Liselotte Strelow (1908–81)
Joseph Beuys with his Son, 1967
Silver gelatin print photograph; 22.6 × 26cm.
Gesellschaft Photoarchiv, Bonn

Liselotte Strelow is one of the most significant representatives of German portrait- and theatre-photography of this century. Her work, mainly in the '50s and '60s, made a decisive mark on the image of German photography. Her camera was the focus for many an interesting face and personality, resulting in a comprehensive collection of pictures; one of the most striking assemblies of subjective representation—and today also part of history of our century. The protagonists of Fine Art, of literature, of theatre, as well as celebrities in politics or representatives of industry and economy—they are all to be found in the portrait archives of Liselotte Strelow.

Among Liselotte Strelow's portraits we find next to pictures of Salvador Dali, Henry Moore and Oskar Kokoschka the image of Joseph Beuys, taken in March 1967 in his flat in Duesseldorf in Oberkassel at Drakeplatz 4. At this time Joseph Beuys, who had been Professor at the Kunstakademie Duesseldorf since 1961, started working on his naive sculptures—mostly in dark felt. The transformation from his drawing period in the '50s to his work in felt and grease had already taken place.

We know today from notes and correspondence that Strelow and Beuys got on in a surprisingly harmonious way; so a number of photographs document this encounter: on one hand Beuys' self-staged representation, with his characteristic action-art, and on the other hand those directed by Liselotte Strelow. It is today regarded as one of her masterpieces: the portrait of Joseph Beuys and his son Wenzel. The double portrait reflects the whole oeuvre of Liselotte Strelow—be it in content or in technique. Liselotte Strelow conveys all her subjectivity, an essential quality in "Autorenphotographie," a term coined by Klaus Honnef.

The portrait has no accessories, it is not dressed up, but photographed in a very prosaic way, without any coquetry. The individual features of father and son are asserted without gloss. The strict frontal portrait is exemplary for such a plain presentation. With only one main light source, Liselotte Strelow accentuates the faces by strong tonal contrast from the dark, monochrome background. The eyes of the spectator concentrate directly on the landscape of the two faces. It is this Bauhaus way of thinking that consistently stayed with her throughout her photographic life: nothing must detract from the essential (as she writes herself in her unpublished memoirs). The contrast of black and white modulates and almost sculpts the faces. She consciously avoids the in-between shades that would detract from the plasticity of the picture. It is staged in a theatrical contrast of light and dark that is reminiscent of the Max Reinhardt Theatre in Berlin during the '20s and early '30s, and also the Expressionist Theatre. In this way, the work of this portrait photographer sees the emergence of Liselotte Strelow as the theatre photographer, who started her education 1932 in Berlin am Kurfuerstendamm with the Jewish photographer Suse Byk, whose work was mainly concerned with children and the opera.

In addition to this technique Liselotte Strelow manipulates by the grade of paper she uses—which in itself can accentuate different aspects. With the Beuys portrait she uses hard Baryt paper, which serves to largely eliminate unimportant details of tone, but enhances the contours of the face and expression.

It was Liselotte Strelow's conviction that portrait photography meets its purpose when it captures the characteristic, not the momentary, when there is not only a physical similarity with the person it depicts but also a likeness of that person's inner nature. Man has many faces which can be shaped by a mood of the moment or by the appearance he chooses to give himself. One then aims to break through this superficial appearance, in order to reach the characteristic personality. It is only human to fear exposure, to try and detract from the unfavourable, and give the pretence of an engaging exterior appearance. But behind this mask every person has such a variety of different character traits and colour nuances, that the photographer, with time, psychological knowledge and a secure sense of the photogenic, only has to take a pick.

In conversation and in personal contact, the face can be discovered like a landscape; it is manipulated, directed, built. Liselotte Strelow is the director who realizes it is, to a large extent, dependent on her own personality as a photographer whether she is capable of revealing the individuality of the model, to expose, to recognize, and to let it affect her. In two hours of intensive camera work, Liselotte Strelow distilled the character and physiognomy of her models. There are many single shots—sometimes 100–120—in order to assimilate as many character traits as possible in just one portrait. This desire to capture characteristic features in a face amounts to the quality of "strelowian" photography. This is her attempt to portray an image from within, and not merely to depict the surfaces.

In inconography and aesthetics, Liselotte Strelow clearly stands apart from her contemporaries. Fritz Getlinger, for instance, who had taken interest in Beuys and his photographic work since the beginning of the '50s, manages to manifest the *artist* in his picture, and not so much the human being with its history and experience. In a similar way Willy Maywald, a fashion photographer based in Paris, photographed Beuys 1958 when he returned to his hometown, Kleve. He portrays Beuys in every respect in the ambience of his atelier in Kleve. Benjamin Katz's photographs display a journalistic character, and therefore do not show an analogy but rather stress the individual approach of Liselotte Strelow.

Photographers like Getlinger, Maywald and Katz may use accessories and other attributes in order to define a character—whereas Strelow only concentrates on physiognomy and the posture of her models. She directs the focus on the human being as such, detached from all social constraints and references. "Lived life"—as Klaus Honnef put it—reflects from Liselotte Strelow's portrait of Beuys.

This masterpiece consequently stands as a reflection of Liselotte Strelow's entire work. It defines her as a psychologist photographer, as she becomes the protagonist in portrait photography in Postwar Germany. Unfortunately, even today her international reputation does not live up to the standard she deserves.

—Johanna Wolf

Bibliography—

Strelow, Liselotte, *Photogenic Portrait Management*, London 1966.
Honnef, Klaus, *Liselotte Strelow: Portraits 1933–72*, exhibition catalogue, Cologne 1977.
Klophaus, Ute, *Sein und Bleiben: Photographie zu Joseph Beuys*, exhibition catalogue, Bonn 1986.
Stachelhaus, Heiner, *Joseph Beuys*, Dusseldorf 1987.
Kaldewei, Gerhard, and others, *Getlinger photographiert Beuys*, Cologne 1990.

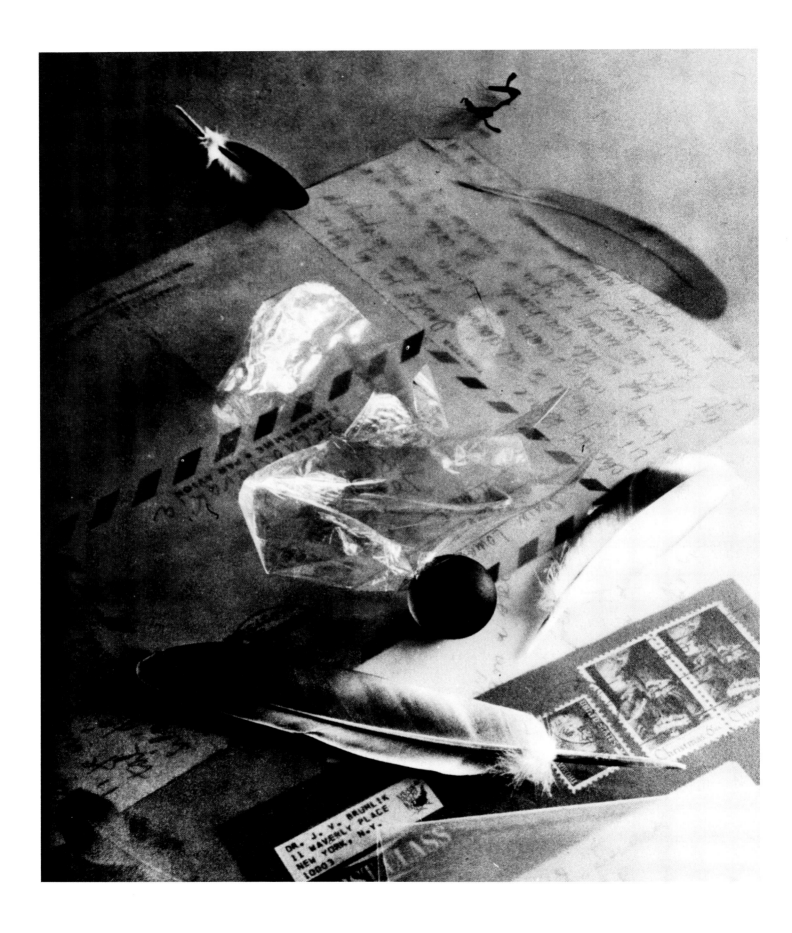

686

Josef Sudek (1896–1976)
A Memory of Dr. Brumlik, 1969
Black-and-white photograph

A Memory of Doctor Brumlík from 1969 is an image from a wider and more extensive set of Sudek's still lifes. These branch out according to purpose and moment of origin till it is almost impossible to keep track of them. So this photograph could also be classified in the basic cycle *Memories*, the oldest of which date back to 1948. Or we could equally well meet it and other similarly motivated works in the set of *Airmail Memories*, as Josef Sudek kept in touch with Doctor Brumlík, among others, by airmail. Perhaps there is a difference, in that *Airmail Memories* form a kind of frame for Sudek's reactions to the stimulus of all his friends that, from time to time, returned as memories from a great distance to Sudek's privacy in Prague; they are part of his personal world, whereas *Memories of Doctor Brumlík* belong to the more important ones. More important for both sides, because the intensity of the relationship between the two friends was also of much greater significance.

Before he settled in New York, Doctor Brumlík belonged to the very numerous and indeed changeable circle of Sudek's friends, whom the photographer's wise simplicity never ceased to attract, and which was made distinctive by the musical gatherings for listening to gramophone records, of which Sudek had a wonderful collection. From the very oldest, still with the famous trademark His Master's Voice, to the most modern recordings of leading world orchestras, musicians and conductors. And these records were an indivisible part of that remembering at a distance. Sudek lived modestly. He didn't need anything from anybody. Except perhaps for good-quality photographic requisites, which were permanently in short supply. And so his friends abroad, whose numbers increased appreciably in proportion to this exceptional man's worsening situation in life, regularly supplied him with gramophone records as well. For instance, Sonja Bullaty, Sudek's renowned "pupil", who had left Czechoslovakia in 1946. Together with her husband, Angel Lome, she made a living by taking photographs in America, and she visited Sudek several times before he died. Or again the above-mentioned Doctor Brumlík.

The very fact that Sudek dedicated a cycle of memories to him shows the importance of their mutual relationship. And so in this case, too, the aerial bridge between Prague and New York spanned the separation of the two friends and filled up Sudek's loneliness. As in other cases, of course, it meant too a regular delivery of the building material of which Sudek usually arranged his still lifes. As kind of small honours, heaped up by chance, absolutely private, intended exclusively for the friend who had remembered him. For, just like those who lived separated from home and friends in far-off countries, Sudek's loneliness represented emigration—to just his own inner, rather exceptional world, which could only be entered by those whom Josef Sudek invited in. And despite the esteem that this most important photographer enjoyed, in the same way as during the war, in protest against the Nazi occupation, he again shut himself up in voluntary isolation, made still harder by the fact that, especially during the 1970s, official honours, frequently bestowed on quite unimportant people, were denied him. Indeed, a remark made by the then Minister of Culture became generally known, that Sudek could not be named a national artist when his appearance was so unimposing.

Like the *Airmail Memories*, including those for Doctor Brumlík, all Sudek's other still lifes came into being as free and sometimes very extensive cycles. Mostly, they were composed of objects that happened to be at hand at the moment and tellingly characterized the distance and the differences between the worlds of the two friends. Sudek's world, of course, was full of a mass of junk, marbles, frames, panes of glass or mirrors (often broken), glasses, faded and fresh flowers, crumpled bits of paper, all kinds of wrappings, even bits of clothing and remains of food; and these were strikingly contrasted with what represented the friend's surroundings, usually a gift: a gramophone record, an envelope with exotic stamps, a page of manuscript. The scent of far-away places that perhaps Sudek did not even wish to know himself. For after his anabasis from the battlefield of the First World War, when he was unlucky enough to lose his right hand, which branded him tragically for life, he only once went out into the world. This was to Italy, which he knew only from the viewpoint of a young soldier imprisoned in the trenches of battle. And he also wanted to see the culture and works of art which he never ceased to admire.

The incessant accumulation of relics, returning to life in memories made tangible, irradiated by the magic light of a master of photographic poetry: that is a typical picture by Sudek. Sudek really had a permanent need to link the present with the past, and from this angle the whole of his work is one great memory. A memory of life. But of course it would be a mistake to suppose that all his memory cycles were artificially arranged and photographed in chance groupings just in order to become poetic metaphors—pictures. Sudek didn't like writing. Even a simple message, owing to his injury, meant a remarkable calligraphic feat. And it was essential to remain in contact with friends in distant foreign lands. Also for the sake of the gifts that were important to him. Why should we idealize him? And so he chose an alternate, even if rather peculiar form of communication through his still lifes. The most charming of them logically got into Sudek's books as well. They are an indivisible part of his extensive, remarkably even work.

—Vladimir Remeš

Bibliography—

"Josef Sudek: Poet of Prague," in *Life* (New York), 29 May 1970.
Farova, Anna, *Sudek*, exhibition catalogue, Prague 1976.
Tausk, Petr, and Lippert, Werner, *Josef Sudek*, exhibition catalogue, Aachen 1976.
Thornton, Gene, "Kosef Sudek's Poetic Reveries," in the *New York Times*, 19 July 1977.
Bullaty, Sonya, *Sudek*, New York 1978.
Tausk, Petr, "Josef Sudek: His Life and Work," in *History of Photography* (London/Philadelphia), January 1982.
Kirschner, Zdenek, *Josef Sudek*, Prague 1982, 1986.

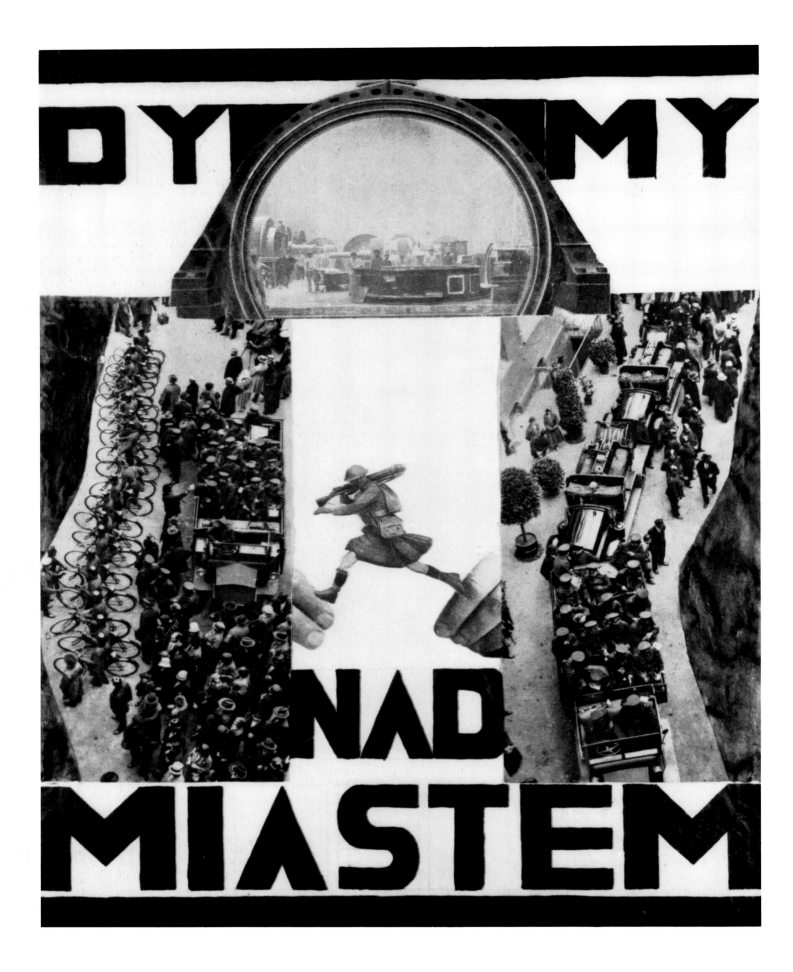

Mieczysław Szczuka (1898–1927)
Smoke Over the City, 1926
Photomontage and indian ink; 40 × 31.5cm.
Lodz, Muzeum Sztuki

In 1926 Mieczyslaw Szczuka produced a design for the cover of a volume of poetry entitled *Smoke over the City* (Dymy Nad Miastem) by Wladyslaw Broniewski which was published in Poland the following year. Broniewski was a well known Marxist poet renowned for his "proletarian" verse. He had achieved notoriety in 1925 by publishing a volume of verse entitled *Three Salvos* which was a poetic communist manifesto. As the author of poetry that lay between literary art and political agitation, it was appropriate that Broniewski asked his friend Szczuka, Poland's leading radical artist at a time of great political turmoil (1926 saw a military *coup d'etat* in Poland), to design the jacket of this book. Both Broniewski and Szczuka shared the peculiar position of being Marxist artists sympathetic to the Soviet Union in anti-communist Poland of the mid 1920s. In fact, in 1924 Szczuka was employed by the small Polish Communist Party to design its journal *New Culture*. But Szczuka's reputation as a modernist artist, filmmaker and designer (he prefered the title "artist engineer"), and a pioneer of photomontage in Poland in the 1920s does not lie in the sober layouts produced for *New Culture*, but in his dynamic designs for the avant-garde journal, *Blok*, which he co-edited betwen 1924 and 1926.

Blok was the first constructivist periodical in Poland. A celebration of the embryonic modernist culture in post-war Europe, it not only illustrated the work of prominent European abstract artists and modern designers to the Polish public but it was a thorough expression of modernism in both its form and content. Photomontage, i.e. the collaging of different and distinct photographic images, was a key graphic element in the design of *Blok*, and Szczuka was its leading exponent. In the fifth edition, for example, he produced a striking visual eulogy to Kemal Pasha and his programme of modernisation in Turkey by contrasting photographs of dramatically novel technology with images of a classical past. Although *Smoke over the City* was produced after *Blok* collapsed in an acrimonious dispute between Szczuka and his fellow editors in 1926, this late image is regarded by Polish historians of photography to be one of the most outstanding examples of photomontage by the technique's leading practitioner in inter-war Poland.

Szczuka is frequently credited as the first Polish artist to use photomontage. A graduate of the Warsaw School of Fine Arts in 1920, he had his first one-man exhibition in that city in May of the same year. This exhibition displayed a number of dada-ist characteristics; the catalogue, for example, was written phonetically and expressed, through slogans and axioms, an aesthetic ethos of the freedom of art from social mores and prescriptive codes. But by 1923, Szczuka's art had matured to a sophisticated constructivism exemplified in the photomontages he exhibited at the Exhibition of New Art in Wilno (Vilnius) that year. Szczuka's aesthetic and philosophical principles were close to those of Vladimir Tatlin in the Soviet Union (he was accused of "Tatlinism" by his major critic and rival, Wladyslaw Strzeminski): he stressed the socially affirmative character of art and advocated its strict union with revolutionary political concerns. For the Marxist Szczuka, art was "inseparable" from society, and more importantly, the future socialist society to come. His designs for a memorial to Karl Liebknecht, the murdered leader of the Spartakus Uprising in Berlin in 1918, for example, were closely modelled on Tatlin's unrealised *Monument to the Third International*.

Szczuka's cover for *Smoke over the city* was, in many ways, like a graphic exposition of his eight-point manifesto for photomontage published in *Blok* in 1924. "Photomontage" he wrote "enlarges the possibilities of the world: it allows the use of phenomena which are inaccessible to the human eye but which can be caught by a sensitised photographic plate."

Accordingly, *Smoke over the city* offers the viewer a glimpse of an urban scene from a rarely seen perspective; the crowds milling around the orderly military convoy, like spent cartridges from a gun, are seen from above. Szczuka's design for *Smoke over the city* is true to his constructivist roots in its radical visual form and the employment of modern media following new aesthetic codes, but the technique's potential for dynamic and unexpected juxtapositions of images allowed a poetic, and sometimes surrealist, aspect in the face of constructivism's utilitarian intent. The figure of the kilted soldier with a bomb slung over his shoulder leaping between two hands, out of any quiddative sense of scale, offers the viewer an unexpected visual confrontation.

The power of photomontage, for Szczuka, lay in its "Plastic-poetry"; in what Janusz Zagrodzki has called ". . . the realism or symbolism of freely arranged quotations from reality. . . ." Urban themes were pervasive amongst the Polish literary and artistic avant-garde in the 1920s. Szczuka and Broniewski were both influenced by poet and literary critic Tadeusz Peiper's essay *Modern City. Mass. Machine.* of 1922. Peiper described the modern city as the vibrant site of change in which the masses, the social dynamo of modern life, would guide the development of art. Szczuka echoed Peiper in arguing that "art should not be the expression of an artist's individual intentions but an *oeuvre* of mass effort." If the city was for Peiper the site of dramatic cultural progress then photomontage was, according to Szczuka's eight-point manifesto for photomontage, the medium of "the modern epic" in which the great conflicts and achievements of man were to be addressed. Wars and its soldiers were the harbingers of modernity; the invincible march of progress. This cover design for Broniewski's poetry can be regarded as a summary of many of the key themes of the early-modernist poetic; the city, war and the machine.

This image lies in the last phase of graphic works produced by Szczuka. In March of 1926 he joined a group of leftist activists to publish *Dzwignia*; a magazine dedicated to political agitation and social amelioration which strongly promoted modern architectural thought. In the same spirit Szczuka increasingly concerned himself with architectural plans and political works such as his famous June 1926 poster demanding an amnesty for political prisoners. Tragically, in the summer of 1927 he died in a mountaineering accident in the Tatra Mountains in the south of Poland.

—David Crowley

Bibliography—
Szczuka, Mieczyslaw, "Fotomontaz," in *Blok* (Warsaw), no. 9, 1925.
Stern, Anatol, and Berman, Mieczyslaw, *Mieczyslaw Szczuka*, Warsaw 1965.
Bogucki, Janusz, *Mieczyslaw Szczuka 1898–1927*, Poznan 1968.
Turowski, Andrzej, *Constructivism in Poland 1923–1936*, exhibition catalogue, Essen 1973.
Czartoryska, Urszula, *Photographie d'Avant-garde en Pologne*, exhibition catalogue, Paris 1981.

© Michel Szulc-Krzyzanowski

Michel Szulc-Krzyzanowski (1949–)
The Great Sand Dunes, 14 November 1979
Photograph sequence

One could call Michel Szulc-Krzyzanowski's sequences anatomies of photographic vision, being dissections that lay bare the various layers of the photograph's two-dimensional flat plane. First and foremost, these dissections are based on the degree of conditioning which governs our capacity for three-dimensional vision. Seeing three-dimensionally comes so naturally to us that we rarely give it a moment's thought. In a photograph there is absolutely no question of a third dimension. The need to gain insight into the world surrounding us demands that we also submit the flat plane of a photograph to our enquiry. Since the birth of photography, efforts have been made to subject the photograph's two-dimensional image to our three-dimensional vision. During the last decade of the nineteenth century, millions of stereographic photographs were produced and avidly looked at with the aid of a special viewer. Town views and, of course, erotically tinted genre pictures were particularly favourite subjects, satisfying the desire for a three-dimensional world and strengthening the enjoyment of being there with the image.

One finds an interesting example of this conditioned seeing in the famous book *Looking at Photographs* (1976) in which John Sarkowski writes about Edouard Boubat's photograph *Chicken and Tree* (1951): "For some years he thought that the tree in this picture grew on the top of a hill, preceding towards a misty horizon. When he finally realised that the tree stood not against the sky but against a wall, it was a momentary shock to him. But the picture refused to adapt itself for the sake of the new interpretation. It remained precisely as it had been before."

Here, one sees the conflict between our interpretation of a photographic image and the absolutely faithful rendering of reality by the camera's lens. This reproduction of truth seems self-evident, but it appears not to be the case at all. There is a peculiar difference between reality as seen by the camera and by the human eye.

In this series, *The Great Sand Dunes*, Michel Szulc-Krzyzanowski effects in us, in a most intelligent way, an awakening of consciousness. We become aware of the observation of space and distance, in the flat surface of the photograph. The use of the sequential technique is a further instrument that Szulc-Krzyzanowski employs to drive home his anatomical lesson on photographic vision. It will be clear to the reader that he chose this method deliberately "in order to ask the viewer to examine his own conventions of perception by creating a situation that is sometimes only effectively possible through a sequence."

Based on this sequential technique Szulc-Krzyzanowski is often compared to Edweard Muybridge, Etienne Marey or Duane Michals. However, it is only the outer form of his sequential method which links him to them.

Some have tried to label Szulc-Krzyzanowski a representative of conceptual photography. Here, however, the photograph is only the means to an end in which the camera is subordinated to a preconceived idea. In this respect Szulc-Krzyzanowski is not a conceptual but a conventional photographer who, through the medium of photography, simply wants to break through the conventionalities of our seeing.

Once again this places the viewer in a remarkable situation, trying to grasp what is going on in the sequences not from the images in the sequences themselves but from absorbing the camera vantage point. Michel Szulc-Krzyzanowski uses his camera to hold a mirror up to the viewer. The viewer is confronted with his own concept of reality.

The Great Sand Dunes is one of the numerous sequences taken by Szulc-Krzyzanowski in the period 1971–1984. Each one is a sober image-story in which minimal events take place. Many of the sequences have been taken on deserted beaches along the West coast of Mexico. The constant blue sky provides an intense light. The sun allows for a small diaphragm so that one can achieve a great depth of field with a 20mm wide angle lens. This depth of field is an important requirement because in a lot of sequences Szulc-Krzyzanowski allows events to take place just in front of his camera.

While *The Great Sand Dunes* is an extremely thoughtful anatomical lesson in reality, it is also an example of the perfect handling of a camera. In this respect the words of his colleague Duane Michals would be in place here: "Some photographers literally shoot everything that moves, hoping somehow, in all that confusion to discover a photograph. The difference between the artist and the amateur is a sense of control. There is a great power in knowing exactly, what you are doing . . . Get Weston off your back, forget Arbus, Frank, Adams, White, don't look at photographs. Kill the Buddha."

In the light of these remarks it is interesting to compare Michals' and Szulc-Krzyzanowski's work. The fact is a similarity exists between them which is not to be found in the outer form of the sequential technique but in the critical handling of the photographic medium. It can be said of both photographers that their thinking and obervational powers derive purely from conventional photography. Their premise is not the art of but the very essence of photography, and the intellectual treatment of the medium. They differ from their predecessors in their ability to extend the bounders of the medium without wishing to go beyond their limits.

An important aspect of Michel Szulc-Krzyzanowski's photographs is that they are more than just twin themes of landscape and observation as is the case, for example, in the Dutchman Ger Dekkers' photography. Dekkers' work is a cool analysis of observation in which the rhythm of a spatial structure is the aesthetic end-product achieved by means of a changing camera vantage point.

Szulc-Krzyzanowski's landscape registrations are no cool analysis in which the camera functions only as a technical instrument. His photographs are the result of a cleansing process to which he has forced himself during long periods of isolation in deserted regions. One can detect a profound three-cornered relationship between photographer, landscape and camera. Szulc-Krzyzanowski's photographs emanate a palpable interweaving of man and nature and form the evidence of the rebirth of the Buddha.

—Adriaan Elligens

Bibliography—

Szulc-Krzyzanowski, Michel, and Travis, David, *Sequences*, Haarlem 1984.
Leijerzapf, Ingeborg, ed., *Geschiedenis van de Nederlandse fotografie*, Alphen aan de Rijn 1984.
Szulc-Krzyzanowski, Michel, and Elligens, Adriaan, *Krzyzanowski: The First Twenty Years*, Haarlem 1989.

692

Shomei Tomatsu (1930–)
Melted Beer Bottle, 1960
Black-and-white photograph

A slaughter-house scene. In front of a metallically shimmering cold wall, in a room darkened by an ill-defined light, something, an arched, contorted form, raw and smooth, twisted convulsively, a bursting skin, slaughtered, the innards turned outwards, a suggestion of life and a silent scream of death. A glazed light shines through the scarred skin, a flicker of a nightmare, disturbing grotesque features of a face in the night.

The carcass is that of a beer bottle. It was transformed into this shape in the heat storm created by the explosion of the atomic bomb that fell on Nagasaki. Shomei Tomatsu photographed it 16 years after the event as an *objet trouvé*, an artefact. Something took place, and something has remained from this event. An immeasurable weight of memories, minds and the collective consciousness radically altered by the force of the explosion, the heat, the fire, the radiation, the rain of nuclear fall-out that darkened everything, like a veil over the land, a shroud. The horror written on the people's faces, their bodies destroyed or branded for life. Minds stupefied, pasts obliterated. Nothing will ever be as before. An uncontrollably violent axe divides the before from the after. Nuclear fission continues silently after the bombs have done their work, attacking the country like a virus. The latter attempts to separate itself from its own history, seeks to forget by giving itself over to the unconscious intoxication of the New Age, of the New World. The materialist consolation of the American way of life, more comfortable, cleaner, simpler, faster, in short, more modern than the previous life, takes over the vacuum of annihilation. What is more comforting, after all, for the defeated than to put themselves on the side of the victor?

The bomb catapulted the old, isolated Japan of the divine Emperor, of religious order, of ceremonies, into the control of materialism, of consumerism and an American-styled way of living. And it sees the end of Shomei Tomatsu's childhood, when he has just turned 15 years old. Its appearance is a vision for him. The dramatic transformations in Japanese post-war life become his themes. *11:02 Nagasaki* marks the programmatic start in 1966 of his series of publications. The book's title indicates the time of the detonation of the second atomic bomb dropped on Japan. 38 pictures make up Tomatsu's shattering retrospective work. They show remnants of the moment as well as certain of its effects up to the present, in part through the destinies of individuals from three generations. We are confronted with a *Steel helmet with part of skull stuck inside* and a *Statue of saint that was beheaded by the explosion*. We see a watch lying on satin as though internally wounded, without a strap, devoid of its wearer and showing us unambiguously: *Time stopped at 11:02*. In a photo taken in 1961, a seven-year-old child plays in a tree's foliage and stretches out in the sunlight falling through the leaves. One of her eyes was the victim of a malignant tumour. Her mother had been 1,600 metres from the epicentre at the time of the explosion. Shomei Tomatsu's

way of working and style become clear in such works. In fact his pictures leave nothing to be desired in clarity, no doubt because of his journalistic influence. He values powerful contrasts, darkness, details and instantaneous photographs. At the same time, they have a dimension—at least for the Western observer—that extends far beyond reality. Seemingly peripheral details take on central importance. A gesture, a juxtaposition—many of the pictures reveal their power only after a time delay. A surreal (in the widest sense of the word) representation does greater justice to the extent of the event than the bare portrayal that has an almost stupefying effect on the observer. Tomatsu counters this with his pictorial language: with its subtle and simultaneously intense wide-ranging observations, metaphors and symbols, whose explosive force and radical nature are preserved in pictures of great power and beauty, of calm and of tender sympathy.

"However, the terror of August is not merely an event of the past, but also a pain which still exists today. The many atom bomb victims who escaped death are living in the same present time as we are." In his work, Tomatsu accompanies the Japanese people through their identity crisis. His pictorial language becomes more graphic, more explicit, more biased, when he takes as his theme americanisation, the barbarity of over-hasty industrialisation and the attendant loss in quality of life. The traditional structures that have broken down in these processes are refound in the structures of Tomatsu's pictures. They show up in separate groups of works, *Japan under Occupation*, *Japan after the War*, or *The Evidence of High Growth* and deny the assertion that the American way of life is progress itself. Tomatsu represents an alternative. He sets the indomitability of truly spiritual culture against this outer and inner occupation. While profane superficiality and consumerism prevail in the latter, the former reveals a both self-evident and endangered consciousness of history and its significance for the individual. Japan lives within this contradiction, in this juxtaposition of extremes. Shomei Tomatsu illustrates both sides and their uncompromising confrontation. He himself is not a victim of rampant internationalisation, but adopts an unequivocal stance. In the panicking dizziness of a civilisation tumbling headlong, Shomei Tomatsu insistently urges full consciousness.

—Ralph Hinterkeuser

Bibliography—

Tomatsu, Shomei, and Tamaki, Motoi, *11.02 Nagasaki*, Tokyo 1966.
Taki, Kohgi, "On Shomei Tomatsu," in *The Camera Age* (Tokyo), July 1966.
Tomatsu, Shomei, and Nosaka, Akiyuki, *Apres-Guerre*, Tokyo 1971.
Fukushima, Tatsuo, and Moriyama, Daido, "Shomei Tomatsu," special monograph issue of *Photo Art* (Tokyo), no. 1, 1976.
Tomatsu, Shomei, *Japan 1952–1981*, Graz 1984.
Holborn, Mark, *Black Sun: The Eyes of Four—Roots and Innovation in Japanese Photography*, New York 1986.

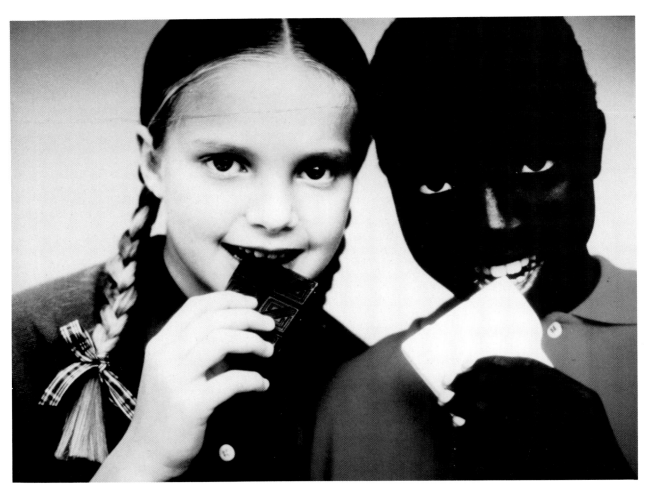

Oliviero Toscani (1942–)
United Colours of Benetton advertisement series, 1985–91
Photographs
Benetton, Ponzano Veneto

Oliviero Toscani's advertising photographs *The United Colors of Benetton* begun in 1985 in a modification of *Benetton—All the Colors in the World* are created by the photographer in close collaboration with Luciano Benetton. The images, stressing innocent, touching friendships among young people and children all over the world, function both as independent images and as part of a larger visual essay. Toscani's gentle humanistic style is demonstrated in such images of global contact and the warm harmony among peoples of different racial, ethnic, social mix. The first identification of the sportswear palette of Benetton clothing—its distinctive feature being color—is sustained and expanded in the Toscani photographs, color now bearing the social implication of multi-cultural diversity.

Like the epochal photographs of the *Family of Man* (1955; exhibition and publication organised by Edward Steichen for the Department of Photography, Museum of Modern Art, New York), Toscani's *The United Colors of Benetton* appears as a poignant suite of images suggesting the internationalism of the United Nations, the international body for which Benetton did the tour guides uniforms, now brought to racial heterogeneity. But Steichen's anthology of images was intense and veristic photojournalism whereas Toscani's images of globalism are fictions created in the hermetic, hygienic world of studio photographs. Unusual in their role as advertising photographs brought to a broad appeal for universal human understanding, their message is nonetheless so patently innocuous and ethically primary, especially in the hands and faces of children, that their expressive pleas for universal goodwill and harmony is little impediment to the joy of clothing. Toscani's world is unified, but it is also an Edenic ideal, a mild, hermetic world created in a studio without real strife, racism, or even the approximation of discord. His rhetoric is not of the dialectic or of politics, but of longing and the wish.

Fashion advertising for the mass market began in the late 1970s with the phenomenon of designer jeans. Intense identification with individual designers, a hallmark of the couture, was carried to a broad market in the previously plaid world of fashion advertising. Relatively small differentiation of merchandise was required or could be made; designers' names became the principal identification in selling. In the 1980s, fashion advertising had a proclivity to value advertising, offering emotional and moral values that bore no intrinsic or visual relationship to the clothing, but that fostered positive response. At one extreme, sexually-driven imagery seemed provocative. At another, of which *The United Colors of Benetton* is a prime example, moral value was stressed and ads became corporate epigrams and ethical convictions. Clothing could even be absent in such advertising as *The United Colors of Benetton* bears witness. Such advertising was not, however, without its own controversy: when Toscani showed two men, one black and one white, joined together by handcuffs in 1989, protests and agitation ensued, yet the content of the advertising had already entered popular culture in such bonding films as *The Defiant Ones* and the irrepressible moral rectitude of two races, once antagonistic, reconciled. Cognate advertisements brought storybook morality to the same lesson with a white dog and black cat nuzzling and a black child and a white child, eating white and dark chocolate. As Andrea Lee suggests in her *New Yorker* (10 November 1986) profile of Luciano Benetton, the advertising campaign captured the "eclectic feel of a Europe flooded with non-European races and cultures." Similarly, the advertising was apt in America newly recognizing its multicultural diversity.

Positive and rarely threatening, Toscani's *The United Colors of Benetton* campaign is nonetheless more theoretically based than the photographer's similar work for Esprit. Joy, exuberance, buoyant insouciance, and individual identity are principal features of the Esprit campaign, whereas the Benetton advertising assumes a moral probity and sincerity. At the same time, it also plays on the concept of color as a property of clothing and virtuoso aspect of

the Benetton empire (international in scope with total revenues of 1,657 billion lire in 1989) and thus returns its aphoristically moral message to the clothing, however inferentially and incidentally.

Occasionally playful, but often seen only in part so that the spectator may infer mood from the segments shown, Toscani's images are the equivalent of maxims on global joining delivered with conviction but without elaboration and/or direct intervention with the spectator. So sublimely general in their axiomatic expression, these images can hardly seem threatening to any viewer, even if he or she might practice racism or social disharmony in incidents and events. Value advertising has rarely reached such a universal, socially responsible, and grand expression, but at the same time one that may avoid direct offense. French public relations executive and political strategist Jacques Seguela said of *The United Colors of Benetton* in 1990, "My favorite international ad campaign is by Benetton, because it points out major topics in our society like racial issues. I think advertising's task is to bring out current values to the widest audience—something this campaign does well." Thus advocated by a political planner, *The United Colors of Benetton* can be seen for its undeniable popular appeal, its sense of touching current issues, and its purported decisiveness, all of which may be keenly sensitive political values. That the Benetton ads edify and glorify more than they amplify or argue is not to mitigate their effectiveness, but to see them as akin to political expressions planted in large, enduring grounds of the good and the just.

Lee, in her Benetton profile, argues that the ads "strike the exact note of the young mood in Europe in the mid-eighties" identifying that mood not as the unabashed sentiment and idealism of prior decades, but the pragmatics of contemporary young consumers. Natural fibers are used in Benetton products which are produced (some by Benetton, but the majority on commission), as well as sold, around the world. The wholesomeness of the Toscani ads offers an approximation of the sportswear ethos, a sense of the global outreach of this relatively "industrial" (so called by Luciano Benetton to define its element of uniformity) style, and immaculate cleanness of the clothing.

A visual logo in its unchanging insistence on one theme, *United Colors of Benetton* was selected for the July–August 1990 "the world's best advertising photos" issue of *American Photo*. Described there, "they make up in stopping power and tender feelings what they lack in product identification," the campaign is commended for the simplicity of its decision-making structure with the direct dialogue of Toscani and Benetton. Correspondingly, the ads possess the directness of a powerful statement made by two like minds rather than the decision of a committee. While the objective is the moral story, the narrative is so simple and direct that it seems inevitable. Figures and elements of the photos are posed in front of simple seamless settings, often the color of the sky as if to betoken the unimpaired, uninflected, near-perfect utopia that Toscani is imagining. He has created compelling images of a better world, one that functions in advertising imagery to communicate the concept of a better product, however generic, in this world. Value advertising has seldom had more beatific and beguiling images; clothing has rarely so completely shrugged off its inherent consumer culture; and fashion photography has perhaps hardly ever seen such a wondrous dream for humankind wrapped in images of apparel marketing.

—Richard Martin

Bibliography—

"Oliviero Toscani," in *Camera* (Lucerne), February 1970.
Toscani, Oliviero, and Bandini, Fernando, *Vicenza*, Padua 1977.
Lee, Andrea, "Profile: Luciano Benetton," in *The New Yorker*, 10 November 1986.
Huhn, Mary, "Is Benetton Clothing Itself in New Controversy?," in *Adweek* (New York), 6 August 1990.
Moin, David, and Struensee, Chuck, "Benetton's New Beat," in *Women's Wear Daily* (New York), 5 September 1990.

Arthur Tress (1940–)
Flood Dream, Ocean City, New Jersey, 1971
Black-and-white photograph

An early practitioner of what came to be called the directional mode, Arthur Tress explores psychological boundaries in photographs that penetrate personal dream and fantasy and the collective social ritual or ceremony. His search for visual equivalents for states of mind or imagined events, whether dramatically staged or the confluence of serendipitous elements recorded by the camera, leads into territory fraught with peril. This act of unmasking requires a fine balance between allusion and illustration. When Tress succeeds, as brilliantly exemplified by *Flood Dream*, the arresting image conveys a universal truth layered with meaning.

The title seems pure Freud, where dreams of water represent the amniotic sac and birth. Here the boy emerges up to his armpits through a mysterious rent in the decrepit shingled roof jutting up in a dark trapezoid. But he is no baby. The soft puddling of receding tide on which an ocean liner lies beached directly above him on the horizon also suggests a sexual awakening, the stiff smokestack and staining of a pre-adolescent wet dream, or perhaps the emergence of a sense of self, with the boat symbolizing life's ultimate journey. Such a vertical stacking of two images recurs throughout the published volume *The Dream Collector* as a device for juxtaposing physical and psychic realities.

Boy, ship, roof, shore (and sky)—with the spare means of a Haiku poem Tress summons up a mood of foreboding, whose source, ironically, is not the drab external world in which a worn roof gives poor shelter and a marooned hull cannot float. Rather, it is the boy's gaze, oblique, serious and abstracted, that rivets the viewer. Something outside the picture plane has put him on guard. If not an actual sight or sound, then some inner fear or preoccupation envelops him, stilling all motion.

On closer scrutiny, he hardly looks an ordinary boy. He is too beautiful, this child with fine straight features. His beauty casts him as an archetype. A deliberate contradiction of the storybook ideal of happiness, he radiates disquiet. Neither angelic nor puckish, he appears slightly tainted, even androgynous; yet contrasted with the bleakness of the landscape, his blond, pale face is a beacon. *Flood Dream* underscores in a visual metaphor the message of child analysts Bruno Bettelheim and Robert Coles, as well as anthropologist Joseph Campbell, who all wrote of childhood as a series of moral (and physical) struggles in which myths and stories point the way toward solving human dilemmas. The original title for the book, *Daymares*, along with the printed phrase accompanying the photograph, further solemnizes this apparition, echoing the tone of a turn-of-the-century textbook homily: "Resignation and peace in the midst of disaster."

Tress more explicitly than other photographers has used his medium to exorcise personal demons, or at least confront them in some palpable form, interjecting the camera and a director's eye as mediators. Always a traveller, he moved from early projects in Appalachia and the inner city of the five boroughs, directly into New York classrooms and surrounding streets, inspired by the work of poet Richard Lewis. By asking children first to recount their dreams, which Tress tape-recorded, and then to re-enact the scene or story before his lens, often searching out a locale and supplying an odd prop, like a rubber rat he carried with him, he created a stage for primal dramas of rage, fear and anxiety. Watching Tress work and aware of his confessed misery growing up in Coney Island, one critic observed how attuned and sensitive he was toward his young subjects, as if one of them on an imaginative level. Thus the act of collaboration takes on a kind of magic for which the photograph is a reliquary.

Certainly *Flood Dream* presages a number of important directions in the evolution of Tress's vision. His constant probing leads him into more bizarre and forbidden areas, both of self-revelation and other people's minds. His next book, in many respects his most subtle and lyrical, *Shadow*, is his bildungsroman. Subtitled "a novel in photographs," it consists of wordless narratives of a youth's travails. Among the multiple references evoked are Plato's dialogue of the cave, Edward Curtis's *The Shadow Catcher*, a lifework based on his quest after disappearing Native American tribes and ceremonies, and even the 1940s pop radio serial *The Shadow*, with its menacing moralistic tone.

Such literary and literal underpinnings, along with the careful sequencing of images in published works, point to the undoubted influence of Tress's mentor and friend, Duane Michals, a photographer also noted for his exploration of autobiographical themes, homoerotic fantasies and the idiom of children's classics. Michals' innovations include writing and painting on prints, whereas Tress tends to make all his manipulations before he snaps the shutter. The riskier the theme, the more theatrical the contrivance, resulting in (consenting) adults acting out scenes in *Theatre of the Mind* and *Facing Up* that often verge on the grotesque or outrageous, peppered with the kind of black humor and blatant bad taste that Les Krims has made his hallmark.

Talisman, the title of a volume of collected works in which *Flood Dream* was republished, sums up Tress's attitude toward symbolic objects as repositories of power capable of stimulating memory. In this book he makes the transition from using live subjects to concentrating on arrangements of objects to convey his ideas. Whether this is a supreme act of control or intuitive alignment with eighties' artworld issues of appropriation and acquisitiveness, the bright candy colors and passionate Victorian clutter of *Tea Pot Opera* (1988) and *Fish Tank Sonata* (1991), a parable on environmental pollution, signals a leap to a new level of fantasy play. Just as Neil Welliver selects objects to represent their owners in Cibachrome celebrity portraits, Tress lovingly assembles kitschy collectibles and flea market finds as protagonists in his cautionary tales. The Disney-like commercialism of Jeff Koons' porcelain pieces also comes to mind, placing this new work in an appropriate "low" art context. Yet these light-hearted, seductive vignettes come with a moral printed in nursery-rhyme couplets.

Flood Dream achieved a precision of stark black-and-white elements, grappling with the meaning of life, the surreal veneer of civilization. Like the film version of the *Wizard of Oz*, it serves like Kansas, as a landmark of Tress's interior poetic mythologizing, while he sets forth to explore a technicolor planet. Always a restless adventurer, Tress uses photography to express personal enthusiasms and intellectual interests, from his sixties' fascination with No theatre, ethnography and Jungian analysis, to his grappling with gender, delight in graffiti and current take on environmental conservation. His work often is raw, disturbing, unabashedly contrived, yet at the same time profoundly honest and self-revealing. These qualities distinguish all great fiction.

—Pamela Scheinman

Bibliography—

Tress, Arthur, and Minahan, John, *The Dream Collector*, Richmond, Virginia 1972.
Tress, Arthur, and Coleman, A. D., *Theatre of the Mind*, New York 1976.
Coleman, A. D., *The Grotesque in Photography*, New York 1977.
Tress, Arthur, and Livingstone, Marco, *Talisman*, Oxford and New York 1986.
Goldberg, Vicki, "Work in Progress: Have Aquarium, Will Travel," in *American Photo* (New York), September/October 1990.

Burk Uzzle (1938–)
All American: Dam Viewing Room, c.1980
Black-and-white photograph

A man watches a fish. It is on the whole unlikely that the fish watches the man, given the nature of their separation. Incidents of this kind must be taking place all the time, throughout the world. People peer down into streams and pools; they regard their aquaria. Some few take to the water themselves in order to get as close as an air-breathing creature may to life in the subaqueous kingdom.

The man in this photograph has something that none of the other watchers do. Even the most avid sharer of the water needs no more than his scuba gear. The aquarist requires an easily-made tank, and a few accessories. The person on the bank gets by on the ability to keep still. But our man has his chamber deep inside the massive concrete and stone dam. He looks through a heavy plate glass window, while being aware that, even though its position must of necessity be relatively near the surface where there is light—and fish congregate—its fracture would still release heaven knows how many thousand tons of water—and numerous fish—to wipe him out like a swatted fly.

The man's experience is extreme, for a fish watcher. It would take a trip to the deeps in a hi-tech submersible to beat that frisson; the sweet and sour experience of allowing yourself to drift off hypnotically on those fishy undulations and pulsing gill covers in that slightly mobile, blue-green light. While knowing, just knowing as you might know a dog's bark in the next road, that there's a major disaster scenario all written up with a central, small part for you; if you hang around for the falling curve of structural strength to intersect with the levels of forces acting on the window.

How very American that such a simple act as looking at fish should be taking place, specially provided for, as a side effect in the heart of a modern dam, built in furtherance of massive processes of resource control. It is very American too, that Burk Uzzle has chosen to use this image as one of the still points in a book which is about journeys, a still photographer's road movie; for the incident itself must be a moment from our fish-watching man's journey when he pauses to sit down in the cool, and finds himself face to face with the fish, as that creature nearly pauses on whatever journey it is undertaking. While Burk Uzzle makes a pause in his own travels sufficient to compose and take his photograph which will record their encounter.

Whether they spell it out, or not, I have little doubt that viewers of this photograph will react to the proportions and framing of that viewing window by making an association with the television screen. Could it be that the designer of the dam facility thought of it first? Is that a way to ensure that people stay attracted? Or feel secure? One of the main threads of the *All American* book is about spectating, and it would be too simple to launch off into a diatribe against the vicariousness of modern experience, using this photograph to berate the televisual teat on which all must suckle. A very naive evangelist for the joys of earlier days might just forget that to look at photographs is itself a vicarious practice; one slightly less naive might suppose that all photography is wholly vicarious.

An understanding study of Burk Uzzle's material makes it clear that his photographic practice includes much evidence for his subjects' acceptance, understanding and non-vicarious participation in the work. This distinguishes Uzzle's attitude from the detachment thought of as typical in photographic documentation. Perhaps he would locate himself within the (once new) New Journalism, seeking to report experience as well as to record facts.

Burk Uzzle is by this means able to show that, in all these popular spectacles and situations, there is a strong element of activity, that even if the viewers are passive in relation to what is provided for them to look at, they are constantly active vis-a-vis one another. And the people providing the spectacles spill their actions out to engage the wider world; so that even if, for a spectacle to remain a spectacle, it must retain a certain separateness, the actors and spectators interface like patterns of ripples on water (that mobilise the sunlight on the viewing room glass). The book is full of impromptu tableaux, and the acting out of small dramas. America seen thus is a land of ritual and signs, seemingly penetrating all dimensions of society, and incorporating people as easily as it does objects. So much action, so much flux, so many collisions of disparates appear in Burk Uzzle's imagery that Surrealism is the natural mode for considering all those processions, or rather, those processors in Philadelphia, those bikers in Daytona, those people standing round and sitting about wherever he found them. There is enough convulsive beauty, objective chance and black humour to keep André Breton happy for ever!

Returning to the still centre of the dam viewing room, to stare again, oneself approaching self-hypnosis, at the man staring at the fish staring at him: what's the true, hard photographic evidence for the glass we've comfortably supposed all this time? Is the fish making its way through the turgid air? Has the man learned to truly share the fish's domain? Could it be that these most disparate of creatures are about to collide? Has the staring man's inactivity become so intense as to set him in motion too? What's the ritual, what's the sign, is it our sign or Burk Uzzle's; what is signified here? Are these speculations any wilder or more fishy than the indisputable hard facts Burk Uzzle shows us throughout *All American*? Life for me, eye to eye or photographed, is just like that: but not many can see it, and even fewer can photograph or care to speak of it.

—Philip Stokes

Bibliography—

Scully, Julia, "Transposing the Ordinary," in *Modern Photography* (New York), March 1974.
Bailey, Ronald, "Burk Uzzle," in *American Photographer* (New York), March 1980.
Diamonstein, Barbaralee, *Visions and Images: American Photographers on Photography*, New York 1981.
Uzzle, Burk, *All American*, Millerton, New York 1984.
Peeps, Claire, "Burk Uzzle: All American," in *Friends of Photography Newsletter* (Carmel, California), no.10, 1985.

Ed van der Elsken (1925–90)
Sweet Life: Black Machine Operator, Africa, 1960
Black-and-white photograph

"Africa today. Mechanization, industrialization. An African and a machine—and what kind of machine? New magic. It is up to the magician—or the sorcerer's apprentice—to find out how to handle the technical innovations; what he can get out of them, and whether he knows how to use them." Such is Ed van der Elsken's comment to the above photograph in his extensive book *Sweet Life*. We don't know where and when exactly it was taken. Africa. That should be enough.

In the mid '60s, somewhere in the former British empire. The European benefactors are on their long march back from the countries that they had previously been designated to protect. As there are no more riches to be drawn from the colonies, the prestige they once had given to their occupants started to have the reverse effect. What else was there to do but act as saviours of these pagan barbarians. So "development aid" was born. Ed van der Elsken was at that time 40 years old, and had been a professional photographer for 20 years. Just ten years ago he had escaped juvenile existentialism which had kept him in Paris for a long time. His photo essay and first book *Liebe in Saint Germain des Près* from 1956 give an eloquent testimony of this experience. Such excessive resignation which was perceived by a whole generation forced him to a personal alternative: "1095 nights of living in such a deadly negative sphere are to be paid for by much doing without. Having to choose between flight or doom, I turned my back on the doomed crossroad, and made my escape from perdition and nullity." Another dark continent was to be the new aim for a search of purpose in the life of an ambitious photographer.

The world had more or less been discovered; now adventurers needed new challenges. Photographers often used the camera to legitimize adventures. Yet the camera also serves to project personal points onto the world. Elsken himself goes on to explain this form of personal photography, which has from time to time considerably bewildered his audience; "The kind of photography you do to express your feelings of beauty, or of indignation, or of despair. Or of happiness. The 'personal photographer' will do the things that he feels in a given period in his life. If he feels rotten and down, his photography will reflect it. If he feels elated, enthusiastic, also his photography will reflect it. You will see it in the style of photography and often also in the choice of subject matter."

This attitude was not as self-evident to other photographers as it may have been to other fine artists. Photography, during the 120 years of its existence, had been met with various appraisals. Initially, it had been praised as the precise means of reproduction and condemned as the murderer of painting; its supporters were soon divided into two irreconcilable camps of the artists and the documentarists. Up until today the criteria underlying this division nurture fruitless discussions, since "reality" in everyday life proves more and more identical with "fiction." In any case, at that time there was no other form of photography possible for Elsken than this spontaneous, emotional reaction, that was inevitably connected with judgement.

Africa had already occupied Elsken's mind before his trip round the world, which led him to *Man and the Machine*. In 1958 his book *Bagara* with photographs of Central Africa was published. Elsken depicts its inhabitants as human beings in their original primitive state; well adjusted to the natural conditions, spontaneous, self-confident in an instinctive, self-evident way, calm inside. By accompanying hunting parties Elsken also learnt about a different African reality. He was confronted with the detached savagery of the "civilized" white hunters. Following their whims and uncontrolled instincts, they pursued everything that moved. Their concept of the enemy was as comprehensive and far-reaching as their belief in unconditional superiority. Thus they revealed themselves to be worthy successors of the white colonialists.

In the photograph *Mann und Maschine* we witness a different and still similar encounter. Cautiously and attentively an African handles a machine; out of context at first glance in his home country, it could have fallen from the skies. Looking closer we learn, from a plaque attached to it, that its place of origin was by the banks of the British river Tyne, 5000 kilometres north. A man from Mars could not appear more out of place here than this machine with its countless supply of feed pipes and delivery pipes, velves, instruments, and smoke that escapes it. The black man approaches it with due submissiveness. He is wearing the working clothes of his new masters, the same people who had given him the machine. And a new wrist watch. Time for him had been still or at least immaterial to his well-being, whereas for the white people it is running out. They have to bear great strains in order to "do it justice." And they have used "their time" well. Power was their goal, and they have reached it. They have extended their influence that far, sparing no sacrifices, since they were not needed to be made on their side. Now it is up to the African to discover whether he can live like a white man, whether he can keep up with the new pace of time. His own existence has been declared as having an inferior quality and surrendered to strange gods. The black man does not master the machine but serves it as the deputy of his new masters.

In *Bagara* Ed van der Elsken quotes Romain Gary's *Les Racines du Ciel* whose theme is similar; the extinction of creatures, though he does refer more to the suffering of the animals: "It has to do with the gently smiling mercilessness with which modern civilization and technique clear away and spiritually kill everything that 'remains.' And there are those who remain, be they black or white, two- or four-legged. They are archaic and out of fashion, but nevertheless well conceived and developed. Ingenious creatures with their own importance, dignity, sincerity and their individual right to their existence in the big plan of nature."

Elsken conveys this knowledge with his photographs from all over the world. He always takes the position of human witness and sensitive mediator between worlds that are close and still so alien to each other. His pictures are personal and affectionate. Or as he says himself: "This personal photography is a work of love, a spiritual thing."

—Ralph Hinterkeuser

Bibliography—

van der Elsken, Ed, "Photography = Engagement," in *Camera* (Lucerne), January 1954.
van der Elsken, Ed, *Liebe in Saint Germain des Pres*, Hamburg 1956.
van der Elsken, Ed, *Bagara*, Amsterdam 1958.
van der Elsken, Ed, *Sweet Life*, Cologne 1966.
van der Elsken, Ed, *De Ontdekking van Japan*, Amsterdam 1988.

Reproduced courtesy of Wilma Wilcox

Weegee (Arthur H. Fellig) (1899–1968)
Drowned Man, Coney Island, 1940
Black-and-white photograph

Porters in the better auction houses share with butlers an amazing skill for nuancing the expressionlessness, but the reverential tinge on the features of a porter supporting a gilt framed old master painting is so much the norm that it may pass unnoticed. Let the same porter elevate a photograph, especially if it be a Weegee, and a new panoply of tiny cues will overtake his features, eyebrows rising imperceptibly with each bid, as deniable flickers multiply around the corners of his mouth. For, especially if the print be an early one by the man himself, it is probably 8″ × 10″, yellowish, slightly chipped, backstamped "Weegee the Famous" and unmounted; its subject matter and printing style of unrelieved vulgarity. That such an object should not only be rare but valuable, can be almost too much for the porter, whose face protests as only he knows how.

The extreme differences between the contexts in which Weegee's photographs exist ensure that the tensions are too great for them ever to be seen comfortably in either the art camp or amongst the throwaways of the press world. If press shots, how can it be that they don't just make statements, but persistently draw us back to the questions they pose? If art images, and Weegee was a Modern, after all, why is not their physicality, battered or pristine, significant beyond its part in the determination of provenance? Where too is the connoisseurial smokescreen?

Weegee knew just where he was, and where the photographs were. Right there amongst the gangster movies and the pulp novels that even now some people will only admit to knowing about as a kind of vicarious slumming, to be enjoyed when off-duty, unobserved. Weegee also knew exactly what he was doing, and that is as evident in his autobiography as it is in the photographs, notably *Drowned Man, Coney Island*.

We are shown the drowned man, covered by a blanket, anxiously attended by a lifeguard, perhaps the one who brought him ashore. There are two medical personnel, one of whom applies a resuscitator, while the other uses his left hand to feel for a pulse as his right hand holds a stethoscope. Two more men kneel to the right of the frame, their expressions anxious and attentive to the efforts of the others. Weegee has given us the perfect factual description of the event demanded for an exemplary press photograph; but at the centre, exactly at the visual centre, he has set that woman. That smiling woman who has fascinated and worried viewers ever since.

One might claim the conventional right to condemn her for so far forgetting the tragedy of the situation as to draw herself up into a pose for the photographer, whose attention she ensures by her welcoming expression. One might, on the other hand, excuse the woman on the grounds that a smile may not signify pleasure at all, that the woman is in truth averting her gaze from what she cannot bear, and has happened to light on the photographer, engaging him with that nervous defensiveness now so familiar in the media interview.

Whatever is read out of this grouping, we should not ignore the three men standing a little back and to the left of the frame, and note how they, especially the man on the far left, are even glaring at the photographer, with maybe a hint of threat in their posture. And the main crowd, set yet farther back, are almost entirely attending to Weegee. There must surely be a connection between circumstances here and those shown in the picture *Sardines*, also on Coney Island, where an uncountable crowd is almost unanimously looking at Weegee, with many individuals acting up to him, away nearly to the limits of readability in the photograph.

The conclusion has to be that Weegee liked to be as famous to his subjects, as in due course he was to his clients. To be photographed by him was to know it, even before the flash, and whatever the circumstances. Not for Weegee the discretion or plain furtiveness of these conscience-ridden latter days. He had a conscience, certainly, but things were more harshly coloured then, and if you were going to cover an event, why then you shot it, right up front.

And that is one of the central features of the clutch of genres Weegee fits with. Hollywood movies, crime fiction, comic books all have it. Their primary audience is made up of the people who live in limited space, work long hours, take their pleasures vigorously and look for the rugged certainties and clear outlines that can be experienced as black or white, yes or no, without the muddying greys of self-styled high culture. Weegee was one of those people himself, and lived the life so long that, when he finally hacked himself clear of its limitations, he was like a kid in a candy shop, and grabbed every high life bauble there was to grab. Unfortunately the really precious thing slipped through his fingers, and its absence from the later, gimmicky work makes it easier to see the deep significances that Weegee's best photography shares with the films and books.

For just as Weegee went straight for the story pure and simple, with the dead gangsters and the Murder Inc. "Ice Wagons" (for which Weegee tells us he specified light grey bodywork, so that it would show up better by flash) quickly wrapped up as photographs for immediate sale to the newspapers; so the Hollywood front office thought about star vehicles and grosses, and made sure the director told a tale just anyone could follow. The consequence for films was that, precisely because no one was looking, mythic themes sometimes crept in and took over the most banal vehicles. If Weegee, because he worked through single images, was debarred from narrating myth, we find him constantly rehearsing the crucial moments of great drama. Mourning queens; the warrior lying dead before the Chorus: does he quote Aeschylus, Wagner, Shakespeare? It is too much to compare the action of the woman in *Drowned Man* to the moment in *Richard III* at which Anne turns from Henry VI's bier towards Gloucester, the future Richard III, who had murdered her husband as well as her father-in-law? As she nevertheless gives, or is coerced to give, all her attention to the dominant male, think of him as Weegee or Richard?

But we know Weegee didn't play quotations at all. That's our game. He went for the shot, and that is all there was to it. Except that his instinct for drama, uninterrupted by cultural prevarications, allowed him to place his shots at the spot and moment that communicated the dark extremities of human life with unsurpassed intensity. And, as we have said, he knew what he was doing, and did it, unerringly, in full flashlight.

—Philip Stokes

Bibliography—

Weegee, *Naked City*, New York 1945, 1975.
Weegee, *Weegee by Weegee: An Autobiography*, New York 1975.
Coplans, John, and Capa, Cornell, *Weegee the Famous*, exhibition catalogue, New York 1977.
Coplans, John, *Weegee: Tater und Opfer. 85 Photographien*, Munich 1978.

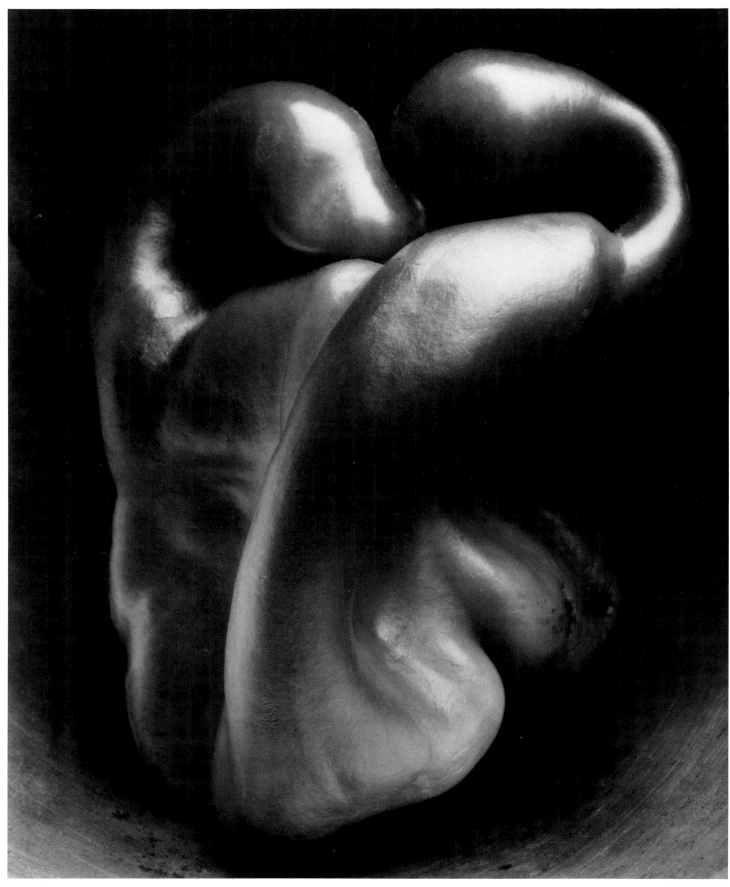

© 1981 Center for Creative Photography, Arizona, Board of Regents

Edward Weston (1886–1958)
Pepper No. 30, 1930
Black-and-white photograph; 10 × 8in.

In 1930 Edward Weston was established in Carmel, California, and was making personal photographs in the intervals between the portraits he made to earn a living. Most of this work was made with a large view camera that produced 8 × 10-inch negatives, which he contact printed. One project in 1930 was a series of closeup photographs of vegetables—squashes, artichokes, cauliflowers and, notably, peppers.

This was more difficult than a nonphotographer might imagine. It involved precariously balanced setups and extreme bellows extensions; very long exposures were required, and the slightest vibration—a passing truck—could, and repeatedly did, ruin his negatives by shaking the overextended camera and toppling the subject.

Are these pictures still-lives? I don't think so. To me they are portraits of remarkable individuals who happen to be vegetables from the grocery store. They have character and great vitality.

Of all these photographs, none excels *Pepper No. 30*, a truly extraordinary picture.

In *The Flame of Recognition*, Nancy Newhall, who knew Edward Weston well, selected excerpts from his daybooks that tell the story. It was Weston's habit to wake early in the morning, long before the rest of the household, and exorcise his frustrations by writing about them in a daybook. Then he could put resentment behind him and do his work. When he was stimulated and excited by new work he was doing, he wrote about that.

A technical note: In 1930 there were few exposure meters, and I do not think Weston had one. For those who use meters today, the problem he had to solve here is still not simple. An accurate meter reading of the subject's brightness, adjusted for the speed (relative sensitivity) of the film being used, is not enough. The long bellows extension needed for an extreme closeup not only makes the camera very shaky; it also requires greatly increased exposure, according to the inverse square law; and that calculation still doesn't get the photographer to enough exposure. Another calculation must be made to compensate for "reciprocity failure"—a matter of inertia.

In 1930 Weston was doing all that by feel. He was not a technician in the sense that Ansel Adams was one. He knew enough to get what he needed from the medium, but it was not easy. It was his practice to keep the shutter open long enough for enough light to reach the film. He had a developed sense of that time, but it wasn't always equal to situations where corrections must be piled on top of each other. Hence his troubles with "undertimed" negatives. This was a heroic labor. Here are some daybook excerpts:

July 9, 1930

". . . I have worked with peppers again, surprising myself! Sonya brought several home, and I could not resist, though I thought to have finished with peppers. But peppers never repeat themselves: shells, bananas, melons, so many forms are not inclined to experiment—not so the pepper, always excitingly individual. So I have three new negatives, and two more under way."

August 1st, 1930

"The glorious new pepper Sonya brought has kept me keyed up all week and caused me to expose eight negatives—I'm not satisfied yet! These eight were all from the same viewpoint; rare for me to go through this. I started out with an under exposure—by the time I had developed the light had failed, and though I tripled my time again I undertimed! Again I tried, desperately determined to get it because I could ill afford the time. Giving an exposure of 50 minutes at 5:00 o'clock I timed correctly but during exposure the fire siren shrieked and promptly the fire truck roared by followed by every car in town: the old porch wobbled, my wobbly old camera wobbled, the pepper shimmied, and I developed a moved negative. Next morning I went at it again: interruptions came, light weak, prolonged exposures

necessary,—result, one negative possible, but possible also to improve upon it."

The failures piled up—one due to "sheer thoughtlessness," when unwanted background details, not visible in the camera, turned out to be sharply rendered and distracting. As he told himself, he should have known.

"Today is foggy and I am faced with an entirely new approach. All this work has been done between moments of greeting tourists, printing, mounting, etc. Small wonder I've failed! But the pepper is well worth all the time, money, effort. If peppers would not wither, I certainly would not have attempted this one when so preoccupied. I must get this one today; it is beginning to show signs of strain and tonight should grace a salad. It has been suggested that I am a cannibal to eat my models after a masterpiece. But I rather like the idea that they become a part of me, enrich my blood as well as my vision. Last night we finished my now famous squash, and had several of my bananas in a salad."

He had not yet reached *Pepper No. 30*. But now he was getting there:

August 3rd

"Sonya keeps tempting me with new peppers! Two more have been added to my collection. While experimenting with one of these, which was so small I used my 21 cm Zeiss [lens] to fill the 8 × 10 size, I tried putting it in a tin funnel for background. It was a bright idea, a perfect relief for the pepper and adding reflected light to important contours. I still had the pepper which caused me a week's work. I had decided I could go no further with it, yet something kept me from taking it to the kitchen. . . . I placed it in the funnel, focused with the Zeiss, and, knowing just the viewpoint, recognized a perfect light, made an exposure of six minutes, with but a few moments preliminary work—the real preliminary was done in hours passed. I have a great negative—by far the best."

August 8, 1930

"I could wait no longer to print them—my new peppers, so I put aside several orders, and yesterday afternoon had an exciting time with seven new negatives. First I printed my favorite, the one made last Saturday, August 2, just as the light was failing—quickly made, but with a week's previous effort back of my immediate, unhesitating decision. A week? Yes, on this certain pepper—but twenty years of effort, starting with a youth on a farm in Michigan, armed with a No. 2 Bull's Eye Kodak . . . have gone into the making of this pepper, which I consider a peak of achievement. It is classic, completely satisfying,—a pepper—but more than a pepper: abstract, in that it is completely outside subject matter. It has no psychological attributes, no human emotions are aroused: this new pepper takes one beyond the world we know in the conscious mind. . . ."

After that, his daybook entry drifted into gush; but up to here, this is accurate perception, accurately stated. Weston's satisfaction with this photograph was fully justified. It is a wonderful picture—an example of that clarity and intensity of seeing that makes pictures of things that are not important to us in themselves take on significance.

—David Vestal

Bibliography—

Armitage, Merle, *The Art of Edward Weston*, New York 1932.
Weston, Edward, and Newhall, Nancy, *The Photographs of Edward Weston*, New York 1946.
Armitage, Merle, ed., *Edward Weston: 50 Photographs*, New York 1947.
Parella, Lew, ed., "Edward Weston," special monograph issue of *Camera* (Lucerne), April 1958.
Baldinger, Wallace, *The Heritage of Edward Weston*, exhibition catalogue, Eugene, Oregon 1965.
Newhall, Nancy, ed., *Edward Weston: The Flame of Recognition*, Millerton, New York 1965, 1971.
Newhall, Beaumont, and others, *Supreme Instants: The Photography of Edward Weston*, Boston and Tucson 1986.

Reproduction courtesy The Minor White Archive, Princeton University. Copyright © 1982 The Trustees of Princeton University. All rights reserved

Minor White (1908–76)
Sequence no. 4: Opposed Directions, July 1949
Black-and-white photograph

"Changing from verse to photography will only be a change of media, not the core. I have known the taste of poetry while writing; the taste will be the same in photography. If a few years pass while I learn the camera, what matter—if some day the taste of Poetry is a Photograph."

So wrote Minor White in 1937 when he decided to turn to photography. What attracted White to this different form of poetry was its authenticity, the immediacy of the images of its visible environment. It was a link with existence which he called "freedom from the tyranny of ecstasy." In order to meet the challenge of showing the invisible through physical reality, and the universal meanings present in the material which photography can capture in all its detail, he continues the exploration started by Stieglitz with Equivalents. For White, too, every image could have a multiplicity of meanings. Not only could it be the thing it sets out to represent but other things besides. With this in mind, he developed a highly personal style which blended fine descriptive detail with the possibility of slipping the moorings and sailing forth on the sea of associations and interpretations. However, he retained a form which served as a kind of musical score to regulate the logical and emotional connections between his photography: the sequence.

And so *Sequence 4* was born in 1949. In White's sequences the intervals between one photograph and the next serve to involve the viewer, as the pauses and silences in music are as eloquent as the sounds in maintaining the rhythm and engaging the attention of the listener. He uses the spaces to create his personal interpretation of the forms and symbols which appear in succession, sometimes disappearing and reappearing in a different guise, without losing sight of the trail, the "score" imposed on nature by the eyes of the photographer. The photographs in the sequence were taken at Point Lobos State Park in California, the first of them in the course of one afternoon in July 1949 . . . "out of forms I had liked for about three years but could not photograph because of their obvious sexual implications. Being a victim of an emotional storm those afternoons, sex symbols were just what I needed," White wrote.

In order to set the imagination of the viewer in motion, White had to establish a subtle and variable balance between faithfully recording reality, "things as they are," and a photographic transcription which releases them from the confines of reality and presents the possibility of interpreting them "for what else they are." Naturally the shot itself is fundamental: close-up shots remove the images from their context, making unworkable the traditional criteria of orientation. We cannot tell if these forms are large or small, whether they are lying on the ground or standing upright in front of us like a wall. Identification is also difficult: it is impossible to trace the origin of this crack or that knot that looks like an eye.

However, these abstracts of the natural world are still faithfully represented. We recognise rocks and sand, wood and pitch, stone and blades of grass. But they defy detailed or even perfunctory description. The radiant light and shadows, the delicate textures are all used to put across White's message, transmitted through this scrap of nature. The photographer plays with contrasts within the images; fissures contrast with spots, narrow cracks with large expanses of unbroken surface, lines with circles. He also uses spontaneous groupings of elements: a crack placed horizontally, close to two holes, can suggest a mouth in a face. Placed vertically with enlarged edges, it has an obvious sexual connotation. These are all very delicate operations which maintain a constant balance between description and transformation, in order that neither of the two aspects should predominate. The basic idea is one of a primordial magma, of the interplay between life and death, a chain of energy and a conflict between irreversible and irreconcilable forces which, on the physical plane, have had their violent effect on materials, solidifying sand into rock under the assault of atmospheric forces. Meanwhile on the psychic plane they allude to the similar process undergone by mankind in its split into the masculine and the feminine.

Each photograph in the sequence is like a phrase in a discourse, a link in a chain, which leads us gradually to discover within ourselves feelings and mental associations parallel to those perceived by the photographer. Fundamentally, it is the affinity and the resonance between photographer and viewer, who in order to communicate must be on the same wavelength and understand the relationship between visible reality and forces of a spiritual kind. The great mediator between physical and metaphysical reality is nature. Point Lobos State Park was for many years one of the favourite photographic hunting grounds for Ansel Adams and Edward Weston, who gave White his understanding of nature. White was drawn less towards Adam's view of nature as a manifestation of universal harmony than to Weston's dramatic and dynamic perception. The forms are not static, they are power lines in perpetual motion, in harmony with the metamorphosis of the natural world. There is no separation between the realms of animal, vegetable or mineral but a continuous transfiguration of one into the other. While Weston's photography is governed by an organic ideal, intended to show the beauty and intelligence of the natural world, White is more interested in drawing analogies between physical phenomena and mental states. His images are parables in which nature is, and will always be, a constant reference point for mankind. Nature is a point of departure and a guide, but it is up to man to make sense of it and to change the shape of the things portrayed in *Equivalents*. In the ten images which make up *Sequence 4*, beginning with *Opposed Directions*, many routes and metamorphoses are explored before reaching the final shot entitled *Resurgence*.

—Daniela Palazzoli

Bibliography—

Lyons, Nathan, ed., *Photographers on Photography*, New York 1966.
White, Minor, *Rites and Passages*, Millerton, New York 1978.
Frandlich, Abe, *Lives I've Never Lived: A Portrait of Minor White*, Cleveland, Ohio 1984.
"Minor White: A Living Remembrance," special monograph issue of *Aperture* (Millerton, New York), no. 95, 1984.
Bunnell, Peter C., and others, *Minor White: The Eye That Shapes*, Princeton, New Jersey 1989.

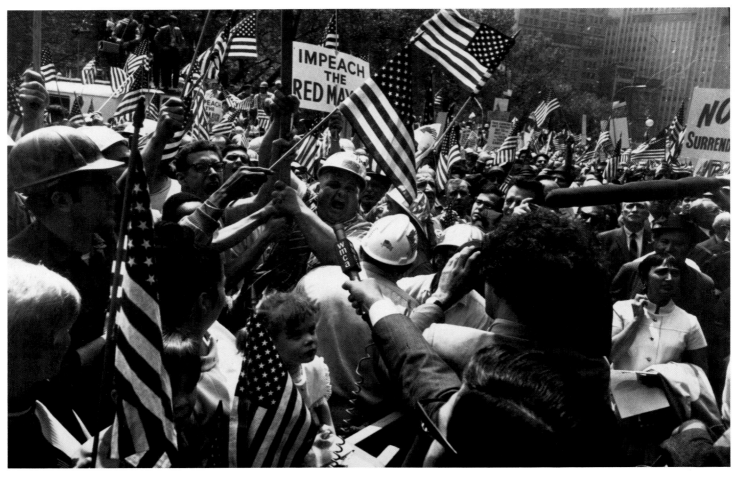

Courtesy Art Institute of Chicago

Garry Winogrand (1928–84)
Hard Hat Rally, New York, 1969
Black-and-white photograph

Hard Hat Rally, New York (1969) is representative of a genre of post-war American documentary photography practised by photographers including Garry Winogrand, Lee Friedlander and Diane Arbus. The new "snapshot aesthetic" challenged existing notions of how a photograph should look. Whereas formal qualities of design had underpinned existing photographic imagery of the 1950s, these new documentarians responded intuitively to the new conditions of social landscape.

In 1955, the same year Robert Frank began working on *The Americans*, Garry Winogrand made his first independent trip across the United States. According to John Szarkowski, Winogrand had no knowledge of Frank's work, but both photographers shared great admiration for Walker Evans (1903–75) whose photographic images were published in *American Photographs* (1941). These photographs represented a more "humanistic," anthropological-based discourse in documentary imagery. Evans considered photography as a socially progressive tool grounded in a "rhetoric of Truth" which sought to inform and persuade. The new group of social landscapists of the late 1960s, used the photograph as a device to mirror or "witness" the landscape. These photographers did not re-present idealised models; rather, these 'sixties landscapists confronted traditional ideas which reified the photograph as art object. The photograph was legitimised through increased commercial viability in art galleries and museums.

Fresh from his cross-country excursion and his continuous encounter with Evan's work, Winogrand returned to New York City possessing a renewed perspective on activities in the urban landscape. For example, his work in the early 'sixties explored the idea of women in public places (*Women Are Beautiful*, 1975), as well as and the relationships between animals and humans found in built environments (*The Animals*, 1969). Winogrand concerned himself with recording the rituals of the dominant American demeanor readily accessible on the street.

Winogrand's political activities expressed by his memberships in the American Society of Magazine Photographers and Young Democratic Club ceased in 1962—the result of personal doubts raised by the Cuban Missile Crisis. His ability, however, to capture the tension of political events was not diminished. The political climate of New York City provided Winogrand with an effective means to pursue his earlier political interest. Winogrand's "passive" participation is exemplified in a number of his images, including *Hard Hat Rally*, which document political demonstrations and gatherings across America.

In 1965, John Lindsay sought political office as a liberal Republican candidate for mayor of New York City. Narrowly defeating his democratic rival, Lindsey found himself beset by labour unrest, including strikes by policemen, teachers and sanitation workers. Lindsey often appeared as a critic of the Vietnam War, calling for greater federal aid to be diverted from defense to cope with urgent urban needs. *Hard Hat Rally* documents the political atmosphere of New York City's streets in a decade besieged by public dissension. Signs reading "Impeach the Red Mayor," suggest Lindsey's unpopularity amongst construction workers as a liberal-minded mayor. This type of rhetoric was often identified with persons who had left-wing or socialist-inspired political intentions. The

implication being Lindsey's association with what American's still considered to be a major political and social threat—communism. Scheduled events, such as those compiled in Winogrand's *Public Relations* (1972) were "designed to be reported." *Hard Hat Rally* exemplifies the immediacy of world events provided by the media generation and captured by Winogrand's photographic stills.

Hard Hat Rally is indicative of Winogrand's pictorial strategies. Winogrand was conscious of the viewing distance between himself and the subject. Not to be seen as an intruder in the event before him, Winogrand adopted the use of the wide-angle lens and the unobtrusive 35 mm format camera. As photographer, Winogrand removed himself effectively from the scene. The angle of the lens and the smallness of the camera permitted Winogrand to move into the activity of the hard hat rally without presenting himself as a threat to the potential subject. At the same time, more of the subject or scene could be captured by the wide angle within the boundary of the frame. Not unlike a "snapshooter," Winogrand considered his subject to be the most important element of his photograph. The lens provided a certain amount of distortion, accentuating the central position of the interviewed hard hat worker being impaled by micophones and American flags. Winogrand countered his critics who suggested his images resulted in a "snapshot" aesthetic, preferring to remind them even the snapshot was a carefully considered and constructed image.

Winogrand also employed the technique of tilting the photographs frame composing an image vertical with the left-hand side figure. In *Hard Hat Rally*, the figure of a woman in the left-hand corner holding an American flag squares the image. Winogrand's camera tilt also provided him with the freedom he needed to carry the intuitive nature of the photograph's meaning. *Hard Hat Rally* breaks with traditional picture assemblage controlled by the limits of a rectangular frame. The technique emphasized a captured moment of time while eliminating a formal presence of form.

The photographs of the social landscapists engendered the complexities, the humour and realities of American life. Winogrand referred often to photography as "a two-way act of respect." He did not want to invest his images with any meaning other than what the camera saw and captured at that moment. Photography, as a medium, must be responsible for describing the scene as it is and as a subject, responsible for describing the way it is. The resulting discourse presented a new relationship between form and content. Winogrand explored successfully the rituals of American street life through images which confronted the way things are represented on film.

—Teal Triggs

Bibliography—

Lifson, Ben, "About Garry Winogrand," in *Artforum* (New York), Summer 1984.
Szarkowski, John, *Winogrand: Figments from the Real World*, New York 1988.
Bishop, Helen Gary, "Looking for Mr. Winogrand," in *Aperture* (Millerton), Fall 1988.
Cooper, Emmanuel, "On Garry Winogrand," in *Time Out* (London), 9 January 1991.

Photo courtesy Collection Ewa Franczak and Stefan Okolowicz

Stanislaw Ignacy Witkiewicz (1885–1939)
Multiple Portrait, 1915–17
Celluloid negative print; 11.7 × 16.2cm.
Lodz, Muzeum Sztuki

This photograph holds an exceptional position in the history of art and photography in the twentieth century as one of the few images produced by a Polish artist known outside Poland. But its significance in the history of photography seems to have been largely misinterpreted as an early celebration of the fragmentation of modern life, contemporary with similar photographs produced by Marcel Duchamp and the Italian Futurist Umberto Boccioni. But the evidence of Witkiewicz's own writings and art historical enthusiasms seem to suggest the influence of nineteenth century neo-Romantic literary themes, rather than revolutionary aesthetics, behind the production of the *Multiple Portrait*. Within Witkiewicz's career this image stands alone between two phases of dedicated photographic activity.

Between 1911 and 1913 Witkiewicz took hundreds of portraits of his family including a series of studies of his father, a renowned writer and art critic in late-nineteenth-century Poland, and his close circle of friends in Zakopane in Southern Poland. Employing a number of novel photographic techniques, such as close-ups filling the entire frame with his subject's face, blurring and narrow fields of focus, he sought to represent the existential drama of the individual: attempts to penetrate his subject's psyche. In the early 1930s, Witkacy (a self-penned neologism, coined from his middle and last names, to distinguish son from father) returned to photography as a medium for his absurdist aesthetics. Posing in a number of theatrical guises, including a chinaman, a priest, a cowboy, Napoleon and a Mayakovskian proletarian, he performed and mimicked for the camera. His own life is widely regarded in Poland as emblematic of the national condition in the inter-war period, and these later works as a tragic expression of his own creative self-effacement that ended in suicide on the day that the Red Army invaded Poland in 1939. For many years after his death, Witkacy's photographic activities were almost unknown within Poland: most of his photographic albums from the early period of his career did not survive the Second World War, and many of the negatives have only come to light in the last twenty years. His preeminent national reputation lies in his writings as a novelist, playwright and "amateur" philosopher, and as a painter. But common to all these areas of creative activity, including photography, was his sense of disquiet with the strangeness of life, or what he called "the frightful Mystery of Existence."

When the First World War broke out, Witkacy, then aged twenty-nine, as the holder of a Russian passport went to St Petersburg to enlist with the Czarist army. This photograph was produced in that city between 1915 when he was recuperating from an injury received at the battle of Molodechno near Minsk, and 1917, although, as his uniform indicates, before the Revolution when he commanded a revolutionary guard. By careful organisation of two mirrors, five Witkacys, dressed in the uniform of the Imperial Bodyguard, appear to stare at each other around a table in a room of indeterminent space. Recent art historical investigation suggests that the photograph was probably commissioned by Witkacy at a popular portrait studio in the city. The writer, Alexander Wat, recalled seeing the *Multiple Portrait* at the time (*My Age* 1977): "Witkacy was an officer in one of the most glamorous and aristocratic regiments. We saw his photograph in uniform, he looked indeed like a young god, extremely beautiful. The photograph was quite an achievement, taken in mirrors, a set of mirrors, so that those eight Witkacys were sitting together at a table."

"Trick" photography with mirrors and other illusionary devices had been practiced in commercial portrait studios since the late nineteenth century. An American, Albert A. Hopkins, for example, wrote a book in 1897 entitled *Magic* which revealed how to produce such multiple portraits. But this image ought not to be regarded as an isolated photographic conceit but an example of Witkacy's fascination with the themes of the fractured persona, doubles, mirrors and masks which are to be found throughout his work as a writer and painter. The five figures in the portrait seem to be locked in a grim stare which Daniel Geroud has interpreted as a kind of psychological interrogation by the tense posture of the divided victim(s), rigid and mute, under a spotlight in a darkened chamber. Witkacy's question is one of existential identity: who is the interrogator? who is interrogated? where is the authentic individual? His horror of the automated, anonymous crowd, "the grey pulp" into which the individual disappears, is confronted in this photograph. Here, he literally faces his own self-diffusion. For Witkacy, recognition of the concept of "Particular Existence," outlined in his treatise *New Forms in Painting and Resulting Misunderstandings* written in 1919 after his return from the Soviet Union, was central to understanding the nature of aesthetic experience. The unity and uniqueness of each individual, each "particular existence," was the source of metaphysical sensibility. But with the march of modern civilisation, man becomes insensitive to art by "the terrible boredom of dull, mechanical life." After 1945, Witkacy's championing of the individual over the faceless collective provided Polish intellectuals, disaffected by Soviet-led ideology, with a source of inspiration and an artistic vocabulary of individualism, absurdist surrealism and "pure form." Although regarded as an eccentric outsider in Polish culture during his lifetime he became, after his death, the central figure around which critical art and theatre turned.

Alongside Witkacy's expressed concern with "particular existence," Daniel Geroud has identified in this photograph a number of parallels with neo-Romantic and symbolist themes in modern literature such as the doppelgänger found in the stories of E.T.A. Hoffman and the double found in the writings of a host of late-nineteenth century authors including Strindberg, Przybyszewski and Wilde. By 1917, the apparent date of the *Multiple Portrait*, the double seems almost overplayed; a crass literary cliché in the European radical modernist culture of the early twentieth century. But its deployment by Witkacy takes on a personal poignancy: for his own life echoed the *Multiple Portrait*, although frequently in tragic ways. Like this image, he divided himself into a number of ironic others, signing paintings and drawings with a myriad of pseudonyms, including; Witkrejus, St. Witkacy à la Fourchette, Onanislaw Spermacy Wyfuitkiewicz, Mahatma Witkac and Witkas. Less humorously, in 1913 Witkacy, deeply depressed, wrote of his inner persecution by an alter-ego whom he called "Maciej." But it would seem from the artist's correspondence that Maciej was not the result of involuntary schizophrenia, but of deep investigation of his own pychological disquiet. He wrote; "I am on the verge of madness for the first time (. . .) I can feel madness clearly and am terribly scared, A little pile of drawings is all that will be left of me. But if I survive it I shall be this third person indeed—Maciej" (February 1913). Witkacy seems to have been haunted by periods of deep existential crisis throughout his life which is reflected, albeit in highly self-conscious ways, in all aspects of his visual and literary art and no less in the *Multiple Portrait*.

—David Crowley

Bibliography—

Van Crugten, Alain, *Cahiers S. I. Witkiewicz Witkacy No. 2: Witkiewicz et la Peinture*, Paris 1979.
Franczak, Ewa, and Okolowicz, Stefan, *Przeciw Nicosci: Fotografie Stanislawa Ignacego Witkiewicza*, Krakow 1986.
Jakimowicz, Irena, *Witkacy*, Warsaw 1987.
Third Eye Centre, *S. I. Witkiewicz: Photographs 1899–1939*, exhibition catalogue, Glasgow 1989.

Mariana Yampolsky (1925–)
Huipil de Tapar (Head Covering), Oaxaca, 1965
Black-and-white photograph; 28 × 35cm.
Oaxaca, Pinotepa Nacional

Pared to essentials, the composition of *Huipil de Tapar* is all geometry and angles, abstracted, although the subject is an Indian woman in a tight wrap-skirt, her head and arms enveloped in a stiff, handwoven white garment that drapes across her back in a sharp trapezoid—the overblouse of the title. Dark shadows and the textures of earth, stone and adobe counterpoint the erect solitary figure striding briskly away. Harsh light and hard surfaces intensify the mood of quiet. The protective efficacy of this cloth, more architectural shelter than adornment, shines as an emblem of Mexican coastal life.

In these hot Oaxacan towns women still go topless at home, donning a cover for streetwear, a form of modesty no doubt associated with Christian virtue (and recalling the cloaked head of the Madonna), as well as a practical shield against the sub-tropical sun. Yampolsky finds majesty in simple, everyday acts, in the reaffirmation of communal ritual and in the tactile immediacy of physical structures. Harmony is the quality that dominates her photographs, balancing shapes, textures and rich shadings. Beyond these compositional elements, there exists a harmony of subject and surroundings, as if to underscore the harmony of rural life achieved through constant struggle.

Shot with an unblinking awareness of social realities, her subjects can be tinged with nostalgia, although this sentiment rarely is cloying. Rather, Yampolsky is capable of prying out a human beauty, a moral sense beyond mere endurance, a bearing up to life. It is not often that she captures a subject obliquely, as here, where the deliberate back view intensifies movement by freezing and depersonalizing it into a pure, monolithic form. Probably returning from market—one arm hugging a basket or burden, the other hanging cupped at her side—this woman performs a diurnal task, unimportant in its particularity, one of countless efforts and errands required of her daily, seasonally, in the cycle of her lifetime.

A relatively early work appearing in the monograph *La Raíz y el Camino* ("Root and Road," 1985), *Huipil de Tapar* unites Yampolsky's chief concerns. These fall into three categories: people and popular traditions; indigenous architecture and the landscape; and crafts objects shaped with ingenuity and bearing the imprint of the hand. Her work frequently has been likened to that of Manuel Álvarez Bravo, with whom she edited photographs for the definitive two-volume collection *Arte Popular Mexicano*, and of his former wife, Lola Álvarez Bravo, whose photography class Yampolsky attended a few years after her emigration from Chicago to Mexico City in 1944. Certainly these pioneers share obvious common interests in Oaxacan natives, documentation, portraiture and technical mastery of the black-and-white medium. Still, Yampolsky's political commitment, combined with her multiplicity of experience as engraver, teacher, editor and curator—all of which feed directly into her photographic work—suggest a parallel with another of Mexico's legendary artists, the painter Diego Rivera. The intellectual and creative ferment that crystallized after the 1910 Revolution into the Mexican mural movement sought to express a new national consciousness in visual terms, drawing on Mexico's diverse Indian heritage and skills. Bold, graphic impact, engineered for architectural volumes and geared toward a non-literate population, depicted political struggles and labor history. Some contend the goals of that revolution have yet to be achieved, while others fear displacement of campesinos from agricultural land as part of the transforming of the

Republic into a modern industrial state threatens the ethnic identity of Mexico. Yampolsky's photographic essays keep these questions before our eyes, without ever becoming strident or polemical. If the stark dignity she discovers in rural life makes her seem a Rousseauian idealist, then that must be her chosen path.

In the evolution of her photographic work the monograph best serves her intentions. Yampolsky came to photography relatively late, after careers in printmaking with the Taller Gráfica Popular, a workshop dedicated to producing art affordable to a broad audience, and in public education, where she edited natural science textbooks and founded a children's magazine, *Colibri*. Not only is the printed page of tangible importance, like images in an album that one can go back to repeatedly as touchstones, but books give range to her recording process, which is complex, nuanced and multifaceted. Not given to easy solutions, Yampolsky gathers evidence, exploring her subjects in depth over time. Some of these have included regional building techniques (*La Casa en la Tierra*, 1981, and *La Casa que Canta*: *Architectura Popular Mexicana*, 1982), a picturesque Veracruz town unmarred by the nearby oil boom (*Tlacotalpan*, 1987) and a series on formerly opulent haciendas in the states of Hidalgo and Puebla, now abandoned by proprietors who grew rich exploiting the maguey plant and peasant labor to produce *pulque*, a local liquor (*Estancias de Olvido*, 1989). The collaboration of journalist Elena Poniatowska, who has written poetic texts to accompany the photographs, has proved most fortuitous.

Recently Yampolsky returned to a much more intimate probing of women's daily struggles than is exposed in *Huipil de Tapar*, in her essay on Mazahuas in the state of Mexico. Left behind in a few scattered villages to cope with children and the aged, by husbands and peers seeking wages and other benefits of city life, the people in this series show tenderness, inventiveness, abiding faith and deep resignation. Disenfranchised and marginal, their existence exemplifies enduring family relationships, the reaffirmation of community values through rituals of purification, and the indomitable pride of survivors.

Chronological age places Yampolsky between the Alvarez Bravos and a middle generation of concerned photographers like Jose Luis Neyra, Graciela Iturbide and Pedro Meyer who search out the spirit of Mexico, its landscape and people. Although firmly in the documentary camp, her work also is exquisitely crafted, rich in tonal scale and textures. The way black-and-white prints read like the values of printer's ink partly explains Yampolsky's championing of the medium over the current vogue for color. Sunlight is another reason, the famous Mexican light that etches every stone in a wall, every wisp of straw in a thatched roof. Who can look at *Huipil de Tapar* and not sense the singeing heat?

—Pamela Scheinman

Bibliography—

Meyer, Pedro, and others, *Hecho en Latino America 2: Segundo Coloquio Latinoamericano de Fotografia*, Mexico City 1982.
Yampolsky, Mariana, and Poniatowska, Elena, *La Raiz y El Camino*, Mexico City 1985.
Conger, Amy, *Companeras de Mexico: Women Photograph Women*, Riverside, California 1990.
Sullivan, Edward, *Women in Mexico*, Mexico City 1990.
Ziff, Trisha, ed., *Between Worlds: Contemporary Mexican Photography*, New York 1990.

DESIGN

Photo Museum of Applied Arts, Helsinki

716

Alvar Aalto (1898–1976)
Savoy vase, 1936
Clear or coloured glass; 14 cm. high
Karhula-Iittala Glass, Iittala

The Savoy vase belongs to the best-known products of Finnish design in the world today. For many people the glass vase, with its asymmetric shape and freely curving tapering walls represents the quintessential qualities of Finnish design: originality, straight-forwardness, and aesthetic sophistication.

This striking vase received its name after a new luxury restaurant in Helsinki, called Savoy and opened in 1937, for which Alvar Aalto together with his wife Aino designed custom furnishings and fixtures. The restaurant was situated at the top floor of the new *Industrial Palace* building, and was complete with a liveried negro porter, and a dining terrace overlooking a park. The vases were placed on every table and their baylike forms allowed flowers to be arranged in unusual, more individual ways. With their protean identities—showing different faces at different angles—they belonged to the most remarkable features of the restaurant. The other element directly related to these forms was a kidney-shaped table on an undulating base, located in the middle of the restaurant and serving as its focal point and centerpiece.

The vase was, however, not custom-made for the restaurant. It was a part of a series of designs for vases and dishes with which Alvar Aalto entered, and won, the 1936 competition organized by Finland's prominent glassworks, Karhula and Iittala. The prime aim of the competition was to acquire designs suitable for showing at the Paris World's Fair next year. Aalto delivered a sequence of sketchy, and in several cases almost ostensibly casual, drawings, some of them reminiscent of cubist still-life collages, and gave the entry a Swedish code name of *Eskimoerindens Skinnbuxa*, i.e. Eskimo-Woman's Leather Pants. A collection of about ten objects from this series, from a shallow dish to an about one meter high vase, was produced after Aalto's sketches and first shown in summer 1937 at the Paris World's Fair, in the Finland pavilion (built after the design with which Aalto won the national competition in 1936). In the same year some vases and dishes of the *Eskimo-Woman's Leather Pants* series were chosen for the Savoy restaurant, and subsequently the most popular of them came to be known as Savoy vase.

To begin with, the winning entry was not without technological problems. Aalto wanted the forms to be blown into moulds made of thin steel sheets forced to form closed sinuous shapes with the help of steel pegs; the aim was to make the molds easily replaceable in order to make remodelling possible. He took personal part in production attempts but in the end the sharpest curves had to be modified and the casting moulds were made of wood, into which the forms were blown. This technology continued until 1954, when wooden moulds were replaced by cast-iron ones.

The original height of the Savoy vase was 140 mm, and since 1937 it was produced in clear, brown, azure blue, green and smoke coloured versions. In the 1950s and later, opal, cobalt blue and ruby red colours were introduced, beside the clear version, and since the 1960s both larger and smaller versions of the vase have been marketed. The Iittala-factory which still produces both the Savoy vase and other vases of the series, uses designation "Aalto" for all of them, and distinguishes between the different types only by their product number.

At first sight, the undulating forms of the Savoy vase seem rather capricious and whimsical. On a closer look, however, they turn out to have their logic both within Aalto's own work, and within the broader context of modern art of the time.

The sinuous lines and shapes of the vases remind one perhaps most of Aalto's experimental plywood and bentwood reliefs, which he since the early thirties conceived as aesthetical objects in their own right. Aalto's growing preoccupation with sinuous, "organic" shapes became explicit in his acoustic design for his municipal library lecture hall at Viipuri in 1935, where the ceiling of the long and narrow hall is provided with a strikingly expressive undulating wooden "lining." In Aalto's world of shapes, there was apparently going on a cross-fertilization between undulating forms of most different scales. His technological-artistic experiments with bent plywood seem to have informed his ceiling at Viipuri, while the Savoy vases apparently inspired his winning competition entry for the Finnish Pavilion at the New York World Fair of 1939: just as the undulating glass plane of the Savoy vase visibly tilts, so does the huge serpentine wood and plywood display wall at the fair. For Aalto, the undulating planes evidently had an aesthetic interest independently of their functional use.

The sinuous, undulating lines in the vases and dishes have often been seen as representing the characteristic shapes of the Finnish landscape with its myriads of lakes. The lines of the section cut through a base of a tree where roots branch out have also been mentioned as a possible source of inspiration. Others saw in the free-form shapes of the vases Aalto's intention to recall the form-less nature of the fluids they would hold. Critics pointed also to the fact that the "organic" theme of Aalto's designs could be found in the Art Nouveau designs of Eliel Saarinen, the most important Finnish architect before Aalto. Also a series of free-form vases and shallow dishes produced in 1935 by the distinguished Swedish glasswork at Orrefors have been cited as the main source of inspiration. Aalto himself is said to have alleged that the lines of the vase were prompted to him by the captivating shape of a puddle. Besides, it may have certain interest to mention in this connection that "aalto" is Finnish for "wave."

There is probably a grain of truth in all these readings. It is still important to note, however, that *the* circumstance which in the first place warranted the use of undulating forms in Aalto's modernist aesthetics was not the fact of their occurrence in Finnish lakes, or in cut trees, or puddles, nor in Art Nouveau designs, or Swedish contemporary glass—but in the world of modernist abstract painting and sculpture.

The circumstances surrounding the birth of the Savoy vase are interesting also as a case of art patronage in modern times. Since the middle 1930s Aalto's career came to be associated with two adherents of modernism with powerful positions in the Finnish industry, and society: Maire and Harry Gullichsen. Maire Gullichsen was born into the Ahlström family that controlled the Ahlström industrial corporation and both she and her husband, who was in 1932 appointed Chairman of the Board of Directors of the Ahlström Company, became Aalto's patrons and close personal friends. They "discovered" him, made him known in the Finnish capital, and helped him to receive challenging commissions. The origin of the Savoy vase is in many ways closely associated with the Gullichsens' influence. The Ahlström Company owned among other things the Karhula-Iittala glassworks, and had built the Industrial Palace with the Savoy hotel at the top. Maire Gullichsen was one of the driving forces behind the Artek Company that she and Aalto established in 1935 to manufacture and distribute Aalto's own design. Already as co-owner of Artek she sat in the 1936 Karhula-Iittala competition jury that gave the code name *Eskimoerindens Skinnbuxa* the first prize. It was probably also at her initiative that the Artek received the Savoy commission, and that the restaurant was furnished with the Aalto vases and dishes.

The lucky alliance between avantgarde designers and their sympathizers in the echelons of power came to be something of a hallmark of Finnish design, also in the years to come. The Savoy vase marks the beginning of that long fertile period.

—Jan Michl

Bibliography—

Pearson, D. P., *Alvar Aalto and the International Style*, New York 1978.
Quantrill, Malcolm, *Alvar Aalto: A Critical Study*, London 1983.
Schildt, Goran, *Alvar Aalto: The Decisive Years*, New York 1986.
Gronstrand, Satu, ed., *Alvar and Aino Aalto as Glass Designers*, Savypaino 1988.
Hawkins Opie, Jennifer, *Scandinavia: Ceramics and Glass in the Twentieth Century*, London 1989.

Courtesy of Eero Aarnio

Photo Asko Oy Museum

Eero Aarnio (1932–)
Ball/Pallotuoli (Thunderball, Bomb or *Globe) chair,* 1963–65
Laminated fibreglass and metal, with foam and leather or polyester upholstery; 120cm. high × 110cm. diameter
Asko Oy, Lahti, 1967–79, 1984–87

Only now as we start to look at the '60s in terms of lifestyle are the various "accessories" gaining the recognition they deserve. Nowhere is this more so than in the case of furniture, since although the swinging young things did spend most of their time zipping about London on scooters and MGs or discussing existentialism on the Paris boulevards, they all had pads in S.W. something or on the South bank. Pads where garish colours and materials were all the rage after the dull 'fifties. So you had your pop art posters, rugs, etc. Yet nothing could be more garish than that amazing blob of plastic, the *Thunderball* chair, which could visually set a room ablaze. And even if you were not a swinger, you could hardly avoid seeing one, since *Thunderball* became an essential prop for nearly all American and UK film directors.

Although also known as the *Ball Chair, Sphere* or *Globe,* the name *Thunderball* is particularly apt since it exploded upon the scene at the Cologne Furniture Fair of 1966. Its sheer size—well over a metre tall and wide. Orders were taken from 26 countries and the media splashed its face across the world. The *New York Times* devoted a whole article to it. Manufacture ran from 1967–79 and then again in a short revival from 1984–87. All with hardly a mention of the country of origin. Thus, *Thunderball* fills the criteria for fashion—it was international in appeal and caught the spirit of the times. The question is, does it qualify as a classic? Until now, perhaps the common consensus would have been no—from the experts who would class it as so 'sixties to the public with memories of those horrible plasticy orange things that Habitat and Laura Ashley saved them from.

However, if you look at *Thunderball* and try to imagine how Eero Aarnio the designer arrived there from an open brief of "use plastic to make a chair", the genius becomes apparent. Genius requires bravery, and Aarnio acquired it logically—he reasoned that if a small country like Finland was going to make an impact in plastic chairs they had to do something spectacular. He was also thinking not just of designing a single chair, but in terms of creating the basic lines and terms for a lifestyle.

Of course, he had a good starting point. Since plastic was a new material, there were no preconceptions to combat. Nor did it yet have its present environmentally unfriendly stigma—it was the material of the future; an advance on old-fashioned wood. On the other hand, local designers and manufacturers could churn out run-of-the-mill plastic products in their own countries as they realised the low-cost advantages of the material.

Aarnio's previous work had shown an ability and interest in combining new with traditional materials, as well as a penchant for outlandish round shapes—he had won a street furniture competition in Sweden for mushroom-shaped climbing frames for children made out of concrete. While in Italy, his armchair made from steel, plywood and leather was a prizewinner in a major furniture competition.

Practicality was the next requirement—Aarnio had a full understanding of the possibilities of plastics—sawing, grinding,

polishing, laminating and of course extruding. This had taught him that the spheres and ovals were the ideal forms for the material.

Having turned freelance, he worked first by producing one-to-one scale drawings and then making prototypes himself. And of course he also saw the possibilities of combining plastic with traditional materials such as metal and leather. *Thunderball* thus has foam rubber padding and leather upholstery along with metal feet.

The result is a paradox—it is shocking, garish yet upon closer examination simple, practical and comfortable and an example of mastercraftsmanship. Furthermore, the chairs are still around—remember how plastic was very much regarded as a brittle material.

The success of the *Thunderball* led to a whole series of plastic furniture from Aarnio. Perhaps the highlight of his career was the Cologne Fair in 1968. There, he was employed as stand designer by Asko and built a complete lifestyle set. The main feature was a giant plastic serpentine some 15 metres long made by lining up individual *Pastilli* easy chairs. These were flanked by *VSOP* chairs based on brandy glasses and *Chanterelle* tables which were mushroom shaped. Such had been the impact of *Thunderball,* that TV crews were queuing up on opening day to see what those crazy Asko people were going to do next. *Pastilli* in particular was conducive to a fairly crazy lifestyle since, according to Aarnio, it was also ideal as either a rowing boat or sledge!

The more they are studied, the more *Thunderball* and *Pastilli* come to represent a natural use of an unnatural substance brought about by applied fantasy. A use that, just when we thought plastic had been permanently relegated to garden furniture, is about to spearhead a revival. *Pastilli* is to be taken back into production by the Adelta company in Finland. Aarnio is delighted, not just for himself, but also because he hopes it will spur other companies to inject a bit of fantasy into their design by serving not just technically as a classic, but also as a classic source of inspiration.

—Richard Hayhurst

Bibliography—

Moody, Ella, *Modern Furniture,* London 1966.
Frey, Gilbert, *The Modern Chair: 1850 to Today,* London and Nie-derteufen 1970.
Hogben, Carol, and others, *Modern Chairs, 1918–1970,* exhibition catalogue, London 1970.
Meadmore, Clement, *The Modern Chair: Classics in Production,* London 1974.
Mang, Karl, *History of Modern Furniture,* Stuttgart 1978.
Russell, Frank, Garner, Philippe, and Read, John, *A Century of Chair Design,* London 1980.
Sembach, Klaus-Jurgen, *Neue Mobel 1950–1982/Contemporary Furniture,* Stuttgart, New York and London 1982.
"Eero Aarnio: siege globe," in *Architecture d'Aujourd'hui* (Paris), October 1984.

Bogenschießen
Internationales
Testturnier 1972
Bogenschießanlage
Hirschanger
Englischer Garten

22.5.	10.00- 13.00	90m Männer 70m Frauen
	14.00- 17.00	70m Männer 60m Frauen
23.5.	10.00- 13.00	50m Männer 50m Frauen
	14.00- 17.00	30m Männer 30m Frauen

Wasserball
Europäisches
Qualifikationsturnier
für München 1972
Schwimmhalle
Olympiapark

14.5.	10.00 16.00	2 Spiele 2 Spiele
15.5.	10.00 16.00	2 Spiele 2 Spiele
16.5.	10.00 16.00	2 Spiele 2 Spiele
17.5.	10.00 16.00	2 Spiele 2 Spiele
18.5.	10.00 16.00	2 Spiele 2 Spiele
19.5.	10.00 16.00	2 Spiele 2 Spiele
20.5.	10.00 16.00	2 Spiele 2 Spiele

Illustrations courtesy of Büro Aicher

Otl Aicher (1922–)
Pictograms for the XX Olympics, Munich, 1972

Otl Aicher headed the Visual Design Group of the Organizing Committee for the XX Olympics held in 1972 in Munich, Germany. This group was responsible for the entire graphic design program of the Olympics, including tickets, programs, posters, and street signs—in essence all visual expressions for the Games. As part of the whole program, Aicher designed two series of pictograms.

A pictogram is a graphic symbol which has a long history of development predating any known alphabet. The earliest form of visual communication is a picture and a pictogram is a simplified version of a picture which becomes a symbol for that picture, or an idea, or object.

Aicher developed 21 pictograms with three alternates to represent the different sporting events at the Olympics. The basic design field is a square. The human body, always shown in silhouette, is indicated by a head, torso, arms and legs. These forms move on an imaginary grid within the square. The grid is composed of lines moving in a horizontal and vertical direction and diagonally at a 45 degree angle. The different sports are then indicated by the position of the body which always lines up with the imaginary grid; arms and legs bend at a 45 degree angle, and the rider leans over the horse at a 45 degree angle. Because of their nature, additional props do not always adhere to this same grid; the horse's neck curves, the bow for archery is curved. However, in both cases the curve follows the grid. In other cases, the props do follow the established format as oars are held vertically and the hockey stick is held at a 45 degree angle.

The designs for the general information pictograms, are by definition, more complex. They convey a broader variety of information ranging from restrooms, to taxi stands, to first aid, and freight elevators. Noting this complexity, and to encourage continuity, Katzumie Masaru, the art director for the 1964 Olympic Games in Tokyo, encouraged designers of future international events to use the pictograms he had developed. Aicher did use some of the same symbols Katzumie used; he also borrowed from other pictograms in general use by 1972 at airports and other international events such as World Fairs and Expositions. Among the designs he used are a man's silhouette to indicate men's room, bills and coins to indicate currency exhange, and a silhouetted key and car to indicate car rental. All were familiar from previous events or other locations.

Though Aicher's symbols were not new, the way he used them were uniquely his own. Because of the diversity of symbols necessary, he could not establish a strict grid, nor body language to communicate the necessary information as he had with the sports symbols. He retains the basic square format and his designs are simple and geometric, so that the bill in the pictogram for currency exchange lines up with the sides of the square; and the umbrella, question mark and package in the lost-and-found pictogram are placed parallel to the sides of the square.

That Aicher's designs are geometric, simple and direct is to be expected. He was associated with the Hochschule für Gestaltung in Ulm, West Germany, where he was a lecturer in visual communication, and later served as one of the co-directors. Known as the New-Bauhaus, the Hochschule für Gestaltung was based on precepts connected with the esthetic of functionalism. This called for design to be composed of simple silhouettes, regular geometric forms with no extraneous ornament. This describes precisely the designs Aicher created for the pictograms for the 1972 Olympics.

In 1980 Aicher described a successful pictogram. He felt it should not be an illustration, but more a sign. It must be culturally neutral and understood by all educational levels. A pictogram should be as simple as possible to convey the necessary information and should follow a set of uniform rules of design.

Using Aicher's own criteria for a successful pictogram, one can evaluate the designs he created for the Olympic games. Of the two individual sets, the sports symbols are definitely the more successful. The deal with a limited amount of information having to do with sports, which gives the viewer a ready point of reference. Aicher was able to utilize the uniform rules of design he calls for, which make the images readable. The viewer decodes the rules of grid and body forms Aicher evolved, and uses these rules to interpret each pictogram.

The general information pictograms are more difficult. There is a wide range of information to convey to an audience from all segments of society and all parts of the world. Aicher worked with a group of accepted images, including those created by Katzumie. Aicher's interpretation of these accepted images, as stated earlier, are geometric. He simplified some images, eliminating all extraneous information such as a luggage tag on a suitcase. In most cases this was beneficial. In some cases this simplification makes the image difficult to understand. One example is the pictogram for exit. Katzumie used a square shape with an opening on one side, with an arrow pointing through the opening to indicate an exit. Aicher used a silhouetted person striding towards a dark line drawn along one side of the square design field to indicate an exit. By reducing the exit to one black line, it becomes difficult to decode without written interpretation. In other pictograms, English words and Roman letter forms are included in some images. These are certainly not educationally or culturally neutral. They are based on designs used at other international events, where the word taxi or tram were in common use, making them more understandable to some visitors at the 1972 Olympics. These limitations of Aicher's designs highlight the evolutionary nature of the development of a set of pictograms which are to be used by everyone.

The pictograms Aicher developed for the XX Olympic Games in Munich, Germany in 1972 helped bring more clarity to communication at international events and settings. Because of his design philosophy, Aicher is well suited to design pictograms. Through the use of simple, clear, geometric forms, he communicates ideas in a coherent and readable style, the essence of a successful pictogram.

—Nancy House

Bibliography—

Bell, Brigitte, "The Graphic Image of the XX Olympic Games," in *Graphics* (Zurich), no. 160, 1972.
Modley, Rudolf, *Handbook of Pictorial Symbols*, New York 1976.
"ERCO Pictograms," in *Mobilia* (Snekkersten), no. 295, 1980.
Hiesinger, Kathryn, and Marcus, George, *Design Since 1945*, Philadelphia and London 1983.

FORTUNE

June 1962

The Nation and Its Industry in Space

722

Walter Allner (1909–)
Fortune magazine cover design, June 1962
13 × 10in.
Time-Life Inc., New York

In *The Nation* (May 1936) Dwight Macdonald commended his old employer Henry Luce for the inception of a business magazine in the months either side of the Great Crash. "As a journalistic conception, *Fortune* ranks little below *Time*. At once shrewd and grandiose, the concept was a magazine to chronicle the world's mightiest industrial civilisation. Luce correctly envisioned great tracts of virgin territory waiting to be exploited." The first issue emerged in February 1930, 184 pages of antique paper, and, at a size of 11¼″ × 14″, it weighed nearly two pounds.

To project this bullish raw material Luce chose a wide range of non-specialist writers and editors, James Agee, Archibald Mac-Leish, Macdonald himself, noted for their objective, sometimes caustic vision of the capitalist system, the brilliance of their writing and the invention of their wit. "I know absolutely nothing about business," protested Agee. "That's why I want you," was Luce's reply. The initial format was devised by Thomas Cleland, perhaps more associated with fine printing and binding. It was recognised then as a phenomenon among magazines, targeted at influential opinion-makers in business and government, with a corresponding weight and substance in article, regular feature and commissioned artwork.

The celebration and critical estimates of other distinguished magazines are usually focused on the stewardship of one great art director, Brodovich at *Harper's Bazaar*, Snyder at *Sports Illustrated*, and Fleckhaus at *Twen* . . . Perhaps the true estimate of Henry Luce's great flagship project, *Fortune* has been difficult to project because of the sheer number of great designers entrusted with the conduct of affairs at the magazine. From the first issue until January 1938, the magazine was art directed by Eleanor Treacy, a rare opportunity for a woman in the inter-war period of design. Cleland's format was notoriously inflexible to assymetrical layout, to bleed pages (particularly of industrial photographs) and to the presentation of information in charts and diagrams. Ms. Treacy's concept was succeeded by Francis Brennan's relaxation of rules to accommodate production and then war statistics with what he called "functional graphics" from Herbert Bayer and other European design exiles. Brennan also commissioned artwork to reflect stories and even self-standing pictorial features from Charles Sheeler, Cassandre, Jean Carlu and Joseph Binder.

After 1945 there were attempts to reflect more energetically the ferment of the times. Will Burtin was appointed art director in 1946 with an exuberant page layout using free-flow structures of rich images and dynamic letterforms (see "The American Bazaar," November, 1947). He introduced the work of Lester Beall and Gjorgy Kepes but failed to moderate the sheer density and multiplicity of reference of the pre-war *Fortune*. Luce thought the magazine somewhat ponderous. "I am sick and tired of lugging around the present format . . . it is a fine look-through magazine but good intentions from looking through the magazine simply do not get resolved into reading." Part of the problem was a leisurely production schedule. A.P.Lancaster of Donnelley's, the Chicago printers, noted that Luce wanted "a more current publication with a faster editorial, close and shorter time span from editor to reader." New departments were created for Law, Labor and Business Roundups. To coordinate the new developments Leo Lionni was appointed Art Director in 1949 and initiated a radical re-design of the magazine that culminated in the September 1951 issue. The design was throughout more spare in its balance of text, image and space. The articles were more effectively integrated with greater emphasis on clarity and legibility from feature to feature. "To increase readability further, the principal text sections are set in Century Expanded. Most of the headings are Bodoni Book italic and the subheadings are from the Century family of types." In that September issue Lionni maintained that he "intended to be functional rather than merely looking functional." The cover design of nuts and bolts by Walter Allner, then Lionni's

assistant, attempted "to stop the eye with a painting at once vivid and stark that expresses an entire theme in a single trenchant symbol."

Its rejection of rhetorical flourish and the more baroque elements of capitalism in favour of the simple yet basic elements of construction marked a watershed for the magazine that is also evident in photography and artwork commissioned from 1951. Lesser known is Allner's cover for the Space issue (June 1962, and shortly before he formally became Art Director) with a simplification of shape and concept that marks the work of true poster artist. The motif even functions brilliantly on the inside pages as a small chapter heading.

Walter Allner had joined *Fortune* on 20th March 1951 and left on 31st January 1974. In 1962 he succeeded Lionni as Art Director and from that date was responsible for all visual aspects of the magazine. Allner had seen his first issue in 1934 in Paris "when I bought a secondhand copy of the magazine at Brentano's sidewalk stalls on l'Avenue de l'Opera. At that time I had been an assistant to the poster artist, Jean Carlu, for two years. I had met and befriended Cassandre, Jacques Nathan and Jean Picart Le Doux, and was about to join my Bauhaus friend Albert Mentzel in setting up the studio *Omnium Graphique*. We all agreed; the make-up, the photography and—in particular—the size of Fortune were truly impressive . . ."

Although Allner left his mark in sustaining and extending the philosophy of layout he inherited from Lionni, he made a particular contribution to the concept of what a cover for a magazine could be. In the first decade *Fortune* was available solely on subscription. It maintained a strict form of frame and upperframe which the artist would then vary as far as creatively possible. Brennan set a tradition of the commissioned image for the cover, often with admirably oblique reference to the central feature of the issue.

Allner was thus the first art director to regularly produce covers and to do so in a sustained way that defined the outward shape of the *Fortune* ethic. Rather than repeat an existing formula (a temptation for a magazine that ceased to be purely available by subscription), Allner used the cover as an inventive exploration of the materials and shapes of a new technological age. In July 1965 Allner designed the traditional July cover that announced the Directory of the Top 500 US companies using an image generated on a computer oscilloscope at MIT. "Every cover has to be something of a surprise. If anyone can point to *Fortune* and say, 'There lies a typical *Fortune* cover,' I ought to be fired." The previous year, Allner had photographed "500" picked out in lights on the side of the Time-Life building. *Fortune* registered an early interest in the constituents of Pop Art, in an assemblage of packaging and the *detritus* of industrial production (February 1965). Allner's covers were rewarded with an exhibition at the Bauhaus Archive in Darmstadt.

Any discussion of a magazine title quickly degenerates into an exercise in nostalgia, and *Fortune* soon felt the pressures of the televisual medium, the need to become bi-monthly and a corresponding diminution of interest in design. The *Fortune* of Allner and Lionni was sustained under the art direction of Ronald Campbell but in May 1982 the last "art" portfolio appeared in *Fortune*. The magazine gingerly joined the ranks of "the others."

—Chris Mullen

Bibliography—

Allner, Walter, ed., *Fifty Artists and Designers*, New York 1952.
Lahr, J., "Computer Graphics at Fortune," in *Print*(New York), November/December 1966.
Elson, Robert, *The World of Time Inc.*, New York 1973.
Burck, G., ed., *Writing for Fortune*, New York 1980.
Mullen, C., and Beard, J., *Fortune's America: The Visual Achievements of Fortune Magazine*, Norwich 1985.

Olof Backstrom (1922–)
Scissors with plastic handles, 1965–67
Fiskars

Imitation is a sure sign of a design classic—and nowhere in the field of industrial design is this more apparent than with Fiskars orange plastic-handled scissors. Every year, the Finnish-based company receives large numbers of cheap copies from around the world—which proves that, in addition to their 50 million own authentic documented users, there are countless additional millions out there. The success of the fakes, in turn, proves that the design is universally known and accepted. Quite a breakthrough when you consider that the original design sat on the shelf for seven years before being accepted by Fiskars themselves. Of course, the orange colour does now seem slightly dated, but on the other hand this has been countered by the use of red and black handles in new models. What is more important when evaluating the scissors' claim to be a classic is the combination of different materials in a traditionally one-material product. A combination so successful, in fact, that traditional scissors now seem to have something missing—the plastic has become a natural extension of the steel blade.

However, the Fiskars scissors were not born naturally. Initially, Olof Backstrom the designer was given a general brief by Fiskars to produce scissors combining plastic and steel. Backstrom had found his way into industrial design by accident. He had a general technical education and did woodworking, as most Finns do, as a hobby. After visiting several applied arts exhibitions with his wife, he decided to have to go himself. The results astounded him—his designs for salad utensils and bowls won successive Milan Triennial prizes. Naturally, he started to take things seriously and was soon employed by Fiskars in their in-house design unit beside their original iron works southwest of Helsinki. Built on the site of a waterfall in the 18th century, this beautiful traditional milieu disguises a progressive attitude that continues to this day on the part of the privately-owned company. Boosted by the demand for war reparation goods, which had provided a basis for modernisation, the company was looking in the early '60s for new products. Again the Finnishness of Finland provided another stimulus. Fiskars realised that home markets were too small to ensure survival, and that exportable products were needed. To be successful, they decided, as many other Finnish companies have, that they should offer high quality innovative products, rather than—ironically with hindsight—cheap me-too or easily imitated items. Scissors seemed to offer such an opportunity.

Working in-house in teams also reflected a trend towards the end of the 'fifties in Finland to employ people rather than relying on "star" designers because of the increasing complexity of production technology. In this way, it was reasoned, a company could learn as it went along, with design and production personnel interacting and ensuring a smooth transition from concept to finished saleable item.

Both Backstrom and his employers were excited by the use of plastic. Unlike nowadays, plastic was regarded as a clean, modern material, offering unlimited opportunities to change traditional items and objects. The environmental drawbacks so apparent today were not even a distant cloud on the horizon. Already aiming to use a new material, Backstrom realised that the more he looked

at traditional scissors, the more design faults he could see. And so he decided to go the whole way and completely redesign them. Starting with the handles. Looking at the handles you can see from the graceful lines how Backstrom's skills as a woodworker came into play. He was able to carve the actual moulds himself. His starting point was to make handles that were for once comfortable and big enough to accommodate rather than pinch real peoples' fingers and thumbs. And why not do something for that group so often overlooked by designers—the left-handed? Thus both versions are to be found in the Fiskars range as a matter of course.

Unlike the imitations, the handles actually fit over the ends of the shafts and are held in place by a unique invisible locking mechanism. This defeats the first instinct of many users who often spend hours trying to pull the handles off the ends. Good design always should always carry an element of mystery along with the "that's so obvious why didn't I think of it" element. Another feature that everyone notices, but few actually understand, is that one handle is bigger than the other. In fact, the lower handle is "flatter" so that, when cutting, your hand is closer to the surface being cut and thus more stable.

Picking up any other pair of scissors, one of the first things you'll notice is their looseness—the feeling that they are gradually going to fall apart. Fiskars, on the other hand, are much firmer because of their use of a bolt instead of a screw to form the pivotal point of the scissors. Finally, the blades and their operating arc are naturally designed to give maximum cutting power.

However, although Backstrom was able to redesign the scissors relatively quickly, a great deal of product development followed. Here, fortunately, he was able to call on the help of Olavi Linden, the first of a new generation of innovative production managers. Nevertheless it was not until the late '60s that production actually began. Success though was immediate, almost taking Fiskars by surprise. Particularly in the United States where the scissors were praised for their functionality. Such success prompted Fiskars to expand both their range and operations. All kinds of scissors have since appeared—from specialist needlework models through to heavy duty versions. Similarly the company's garden tool line was revamped using the same basic design principles. To cope with demand production was set up in the US, and recently Fiskars has also acquired several of its major competitors.

The overall impression remains of a powerful yet extremely user-friendly tool. A classic in design which can nevertheless be easily "updated" simply by changing the colour of the handles. Although the orange colour does have a certain aura of its own.

—Richard Hayhurst

Bibliography—

Seibundo Shinkosa Publishing, *Environmental Design of the World*, Tokyo 1971.
McFadden, David Revere, ed., *Scandinavian Modern Design 1880–1980*, exhibition catalogue, New York 1982.
Museum of Applied Arts, *Form Finland 1986*, Helsinki 1986.
Fehrman, Cherie and Kenneth, *Postwar Interior Design 1945–1960*, New York 1987.

Photos courtesy of Bass/Yager & Associates, Los Angeles

726

Saul Bass (1920–)
Walk on the Wild Side film title sequence, 1962
Edward Dmytryk/Columbia Pictures

For most individuals, success in one area of design would be considered a lifetime achievement. For Saul Bass it was not enough. His genius has extended over the range of two and three dimensional design which are familiar to many and have become part of our culture.

In the early 1950s Bass began to use film as a vehicle for his graphic design. He used the same basic elements and principles of good design that he had mastered as one of America's foremost graphic designers. In a 1977 interview Bass commented that, "the real job of creative people . . . is to deal with what we know and, therefore, no longer see or understand. To deal with it in a way that develops a freshness of view which enables us to have an insight into something that we know so well that we no longer think, or respond, or see it."

His early success with the films *Carmen Jones* (1954) and *Man with the Golden Arm* (1955) created a new form of visual expression in filmmaking. It culminated in the title sequences for *Walk on the Wild Side* (1962) which is considered by many to be one of the most exciting film titles ever created and still one of Bass' favorites. A fellow American filmmaker, Wayne Fitzgerald, is convinced that Bass did such a superb job that "the goddamned movie never survived it."

The film is from Nelson Algren's novel and takes place during the depression in a New Orleans brothel. One of the characters is named Kitty Twist played by Jane Fonda. Taking a clue from this Bass conceived a live action sequence using two cats. The original musical score was written to Bass' requirements which began with a solitary black cat emerging from darkness and prowling its territory. The cat's walk is carefully choreographed and photographed amid concrete drainpipes and other construction paraphernalia. The low-key lighting and the tempo of the jazz score is perfectly blended in the sequence. Later, the sinister-like quiet is broken with the staccato-like attack of another cat and for a brief moment an aerial ballet ensues. The white cat is vanquished and the black cat continues to patrol his terrain. Bass stated in a 1968 interview that, "I attempted to make a statement about a cat that would be sufficiently fresh to engage the audience in the examination of the idea of a cat all over again . . . it is a matter of transforming the known into the unknown."

His use of typography is simple and clean. The san-serif type in reverse is quietly and carefully placed so as to contrast rather than compete with the image and movement. They appear and disappear to the beat of the music and inspite of the visual activity it is both readable and legible.

This simple concept was chillingly created in the classic shower sequence in Hitchcock's 1960 thrill *Psycho* which Bass created. After that film was shown no one really felt safe taking a shower! His storyboard sketches show details of a refreshing, daily activity with close-ups of a shower curtain, a shower head, curtain rings, bath tub and checkerboard linoleum tiles. The curtain conceals the attacker leaving only a sinister silhouette. The water creates a dramatic sense of movement and tension as the victim splashes about and falls while the blood and water curls its way to the drain.

This sequence may have had a strong influence in the title for *Walk on the Wild Side*. The stark use of black and white, extreme close-ups, precisely orchestrated rhythm, music and editing display a thorough knowledge of the art of montage.

Over 25 years Bass has created over 40 film title sequences. He sees his work as an introduction or a "summarizer of the point of view and essential content of the film." In the process he has given us a few moments of humor, laughter, drama and excitement and elevated film title design to an art equal, if not sometimes surpassing, the film!

—Dennis Ichiyama

Bibliography—

"Film Titles," in *Graphis* (Zurich), no. 89, 1960.
Nelson G., *Saul Bass*, New York 1967.
Billanti, D., "The Names Behind the Titles," in *Film Comment* (New York), May/June 1982.
Harbord, J., "Bass Takes the Credit—But Not for Psycho," in *Broadcast* (London), 18 April 1986.

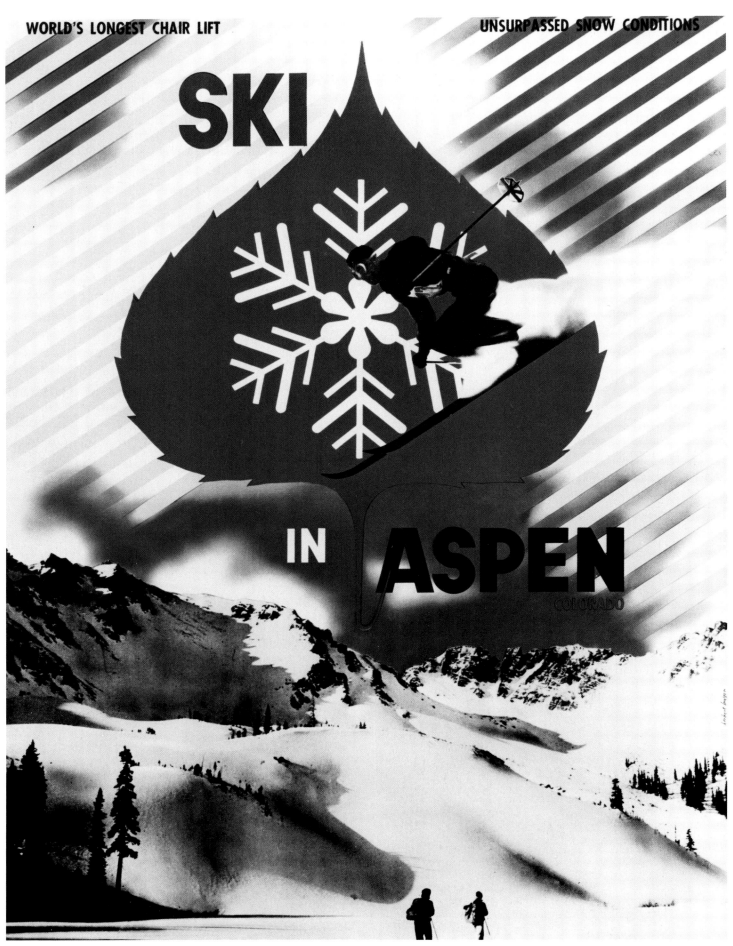

WORLD'S LONGEST CHAIR LIFT UNSURPASSED SNOW CONDITIONS

SKI

IN ASPEN
COLORADO

Photo Denver Art Museum/© DACS 1991

728

Herbert Bayer (1900–85)
Ski in Aspen poster, 1946
Colorado, Denver Art Museum

An examination of Bayer's Aspen Ski Poster provides us with access to his life and career in regard to both his philosophy of design and his personal life. It was undertaken in 1946, at a time when he had risen to a position of unique influence in American design, and also the year he got to know the little town of Aspen in Colorado, in which he was to settle and help to develop as a kind of design and life-style Utopia.

The poster may be taken as a summation of Bayer's life, training and career up to that point in time. Born in the Austrian town of Linz in 1900, his first contact with art and design was as an apprentice in an architect's office, but soon extended his interests to the fine arts and design in general. The dominant design ethos of his youth was much influenced by the movements of the late nineteenth century, of which even the progressive Secession style continued to hold fast to the idea that design could consist of applying decorative motifs and embellishment to objects and artefacts.

His reading of Kandinsky's *Concerning the Spiritual in Art* and his growing awareness of advanced art and design theory led him to register at the Bauhaus at Weimar, where he remained as a student 1921–23. It was here that he encountered the persuasive theories and influences which were to shape his professional career and personal life, and which are evident in the Aspen Ski Poster. The Bauhaus brought together in its staff, and the students which it selected, many the foremost modern influences in European art and design. At its head was Walter Gropius, one of the most radical of architects. Gropius' view that the design of a building should arise from a careful analysis of the needs of client and public was applied by Bayer in the field of design, in this instance graphic design.

Bayer rejected the notion of a poster as primarily a potentially lengthy piece of literary text supported by added illustration. His starting point was the simple kernel of the message which was to be communicated, stated in its most elemental form. This message could be conveyed at several levels simultaneously. In the case of the Aspen Ski Poster, the message is carried by the simple major text "SKI IN ASPEN" supported by two much smaller qualifying texts top left and right. Pictorially, the image of Aspen is conveyed by a montage of several different categories of imagery. These include the scenic photograph at the bottom, the montage photograph of the skier at center, which is in turn overlaid on a schematic leaf form and a magnified snow-flake.

The poster is, in fact, a virtuoso marshalling of several disparate image sources ranging from imagery which would be accessible to the eye (the scenic view), arrested movement (the skier), the schematic mental image (the leaf) and the microscopic (the snow-flake). These are overlaid and welded together by the simple verbal text. The graphic language deployed by Bayer in this poster can be traced back to its origins at the Bauhaus. It was here that he came into contact with the influences of Dada and Surrealism. Both Dada and Surrealist art utilise the evocation of the unconscious by means of juxtaposition of apparently disparate images and ideas. Experiences accessible to the waking eye are combined with memory, imagination and fantasy, thereby creating a new super-reality (the origin of the French word *Surréalisme*) more complete and persuasive than communications which confine their frame of reference to the concrete world of physical objectivity.

Bayer was an important influence upon the development of modern typography. At the Bauhaus he renounced the use of capitals in continuous texts, a practice which had greater significance for German, in which all substantives are normally capitalised. He also favoured the use of sanserif faces and letter forms, regarding the serif as an irrelevant anachronism no longer desirable in terms of style or legibility. Although Bayer did not stick religiously to such principles in all his subsequent work, the use of a bold sanserif letter form in the Aspen Ski Poster is characteristic of much of his graphic design.

The poster dates from a critical time in Bayer's personal life which is intimately concerned with Aspen. After his period as an outstanding student at the Bauhaus at Weimar (1921–23) and a short period of practice, he returned to the Bauhaus at its new location in Dessau as a Master (1925–28). With the 'thirties, the darkening political situation in Germany, and subsequently in all Europe, led many artists and designers to seek new homes abroad, especially in the USA. Bayer designed the influential retrospective exhibition *Bauhaus 1919–1928*, which was staged at the Museum of Modern Art in New York in 1938 and subsequently toured the USA. During the late 'thirties he was one of the large community of emigré designers in the USA, which included Gropius, Moholy Nagy and Mies van der Rohe. He settled in the USA in 1938 and took American citizenship in 1944.

At the time of his arrival in the USA, American graphic design was very traditional in character, favouring a "hard-sell" approach, often with lengthy explanatory or descriptive texts augmented by applied "illustration." It was Bayer, as an employee of several major industrial organisations, and as a theorist and teacher, who was largely instrumental in reforming this approach to graphic communication. Following his example, advertisers and designers in general moved to a more rational and conscious design process which drew upon the technical potential of modern printing, the artistic sources of modernism, and the scientific basis of psychology. His major clients, such as the Container Corporation of America, needed a great deal of persuasion to adopt the new graphic ethos which he stood for, and his posters of the war years are landmarks in the evolution of American design.

The Aspen Ski Poster has an even more specific significance in Bayer's personal and professional life. Until the mid-'forties Aspen was a small, forgotten ex-mining town in the Rockies of Colorado. Much of the population had left and property had been abandoned. In the late 'thirties it was identified by Walter Paepcke, chief executive of the Chicago-based Container Corporation of America, as an ideal location for a retreat and cultural centre for business people. Bayer met Paepcke in 1945, and moved there in 1946, the year of the ski poster, to become Paepcke's chief adviser on the design and architecture of this ambitious project.

It was at Aspen that Bayer could give rein to his many aspirations, not only as a designer, but as an artist, architect, planner, social theorist and educator. Paepcke was a cultivated person of German extraction. He provided the business know-how and the financial backing for Bayer's design plans. The Goethe Bicentennial Festival held in Aspen in 1949 led to the establishment of the Aspen Institute for Humanistic Studies, in which Bayer played a leading role, and the creation of an annual music festival and school.

Bayer remained in Aspen for the rest of his life, working towards the creation of a utopian dream in which the manmade environment was in perfect harmony with nature, and in which the restoration of the old lived in peace with the creation of the new. In many ways it was the fulfilment of a dream which was at the heart of the Bauhaus philosophy, but which, for cultural or financial reasons, would not have been realizable in any part of the Old World. The Aspen Ski Poster, created in the year of his arrival at Aspen, represents a milestone in Bayer's development as a designer and social theorist.

—Clive Ashwin

Bibliography—

Dorner, Alexander, *The Way Beyond Art: The Work of Herbert Bayer*, New York 1947.
van der Marck, Jan, *Herbert Bayer: From Type to Landscape*, exhibition catalogue, New York 1977.
Cohen, Arthur A., *Herbert Bayer: The Complete Work*, Cambridge, Massachusetts 1984.
Chanzit, Gwen Finkel, *Herbert Bayer and Modernist Design in America*, Ann Arbor 1987.

The 3 points of the equilateral
triangle are ¼ unit from the
inside diameter of the "ring"

ring is
1 unit

Distance
from center to
tip of triangle
is 4¼ units

1 unit

1 unit

¼ unit

1 unit

1 unit

¼ unit

6 units

11 units

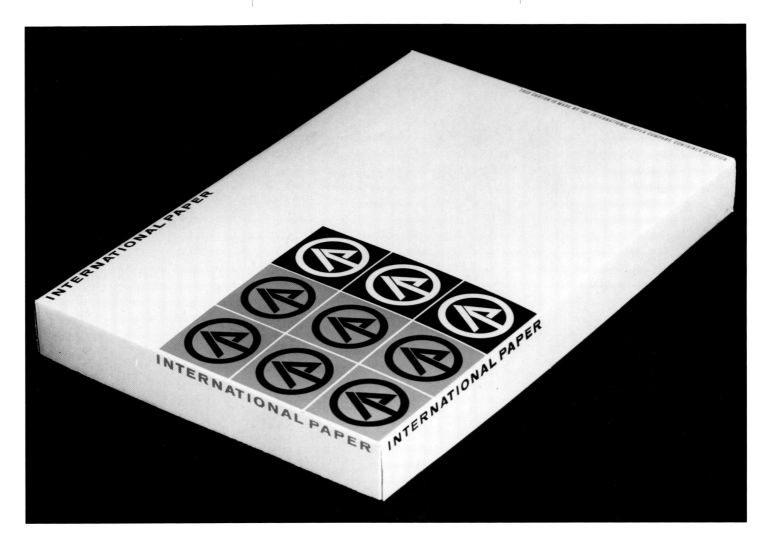

730

Lester Beall (1903–69)
International Paper Company corporate identity program, 1958
International Paper Company, Purchase, New York

Lester Beall's goal in graphic design was at one and the same time to "elevate public taste and the character of his client." His corporate identity program for International Paper Company was a key project in establishing Lester Beall as a designer with the vision and capability of shaping an identity system for a large and complex American company. He felt that the project had been notable for management cooperation and resolution of a diversity of problems that individually contribute to the constant strength of the overall concept.

A pioneer of twentieth-century American graphic design, Lester Beall (1903–69) was born in Kansas City, Missouri. His childhood years were spent in St. Louis and Chicago. Beall was educated at Chicago's Lane Technical School and began his design career there in 1927, the year following his graduation from the University of Chicago. By 1935 Beall had decided to move to New York, and in 1936 maintained an office in New York while living in Wilton, Connecticut. Most of the significant works from this period were done in his studio in Wilton. Through the 1930s and 1940s Beall produced innovative and highly regarded work for the Chicago Tribune, Sterling Engraving, The Art Directors Club of New York, Crowell Publishing Company, Hiram Walker, Abbott Laboratories, *Time* Magazine, the United States Government's Rural Electrification Administration, among others. In 1955 he moved to consolidate all his operations at Dumbarton Farm in Brookfield Center, Connecticut.

Of all the corporate identity programs designed by Lester Beall, the International Paper Company program was the most innovative not only because of his design process but also because of his understanding of business. The postwar period was a fertile time for corporations to concern themselves with identity issues as the economic activity following World War II provided an expansive business environment of growth. In Europe, the identity program designed by Giovanni Pintori for Olivetti was an early pioneering effort. In the United States, the boom years of the 1950s saw Lippincott & Margulies develop specialized corporate identity services. Raymond Loewy, an industrial designer, contributed major programs such as those for RCA, Shell and Coca-Cola. The program designed by William Golden for the Columbia Broadcasting System was another outstanding early example. The 1960s brought innovative identity projects by Eliot Noyes and Paul Rand for IBM, Charles Eames for Herman Miller and Chermayeff and Geismar for Mobil.

The International Paper Company identity by Lester Beall was an exemplary project of the 1960s. IP was at this time the largest paper company in the world with plants, mills and distributors spread across the United States. It is the producer of a wide variety of business, printing and packaging and industrial papers. Beall was originally hired to design their paper packaging but soon realized the potential of a comprehensive identity program. He has said that he learned the basics of designing corporate identity programs through his extensive experience earlier in packaging design. Packaging demands the development of a special design program, and it was from that construct that Beall was prepared to plan for the systematic identity design needs of corporations. IP had been using an antiquated pictorial symbol of a tree in front of a waterfall, contained in a oval shape. Beall's research proved that there was no visual image of the company or its products and that the company was universally referred to as "IP." His goals for the IP identity program were (1) to achieve a distinguished and memorable identity. (2) to unify the marketing of a diversity of products from different divisions. (3) to help coordinate advertising by a consistent use of the trademark and the logotype. (4) to develop a new general sales interest by consistent application of the trademark to all products, packaging, sales literature, exhibits, house organs, etc.

In a speech from the early 1960s Beall delineated his process for developing a corporate identity, one that he would later apply in the IP program. During what he called the "pre-creative phase," the designer must personally become familiar with many aspects of the corporate history, business philosophy, marketing objectives, its products and facilities, its organizational procedure, its dealer relationships and its present public and consumer image. This information should serve as background material for the creation of a design philosophy for both the trademark and the resultant corporate identity program. This study will enable the designer to establish design objectives relative to the problem. Beall said that the role of the designer was that of "the synthesizer" but first of all "the creator." The responsibility is not to give the client what they think they want, for this is almost invariably the usual, the accustomed, the obvious. The creation of an identity program for a corporation demands the establishment of a disciplined system of control, if the program is to be efficiently introduced and maintained. A prerequisite to control is the production of a style manual for those involved in usage areas and embracing a wide assortment of applications. Unless top management gives strong support to the program, a laissez-faire attitude may eventually undermine the production of a strong and clear-cut corporate image.

Lester Beall was the "businessman's designer." His pragmatic ways of looking at the world gave him much credibility when dealing with business clients. Work on the International Paper Company identity was done in close contact with Richard J. Wiechmann, the IP Advertising Manager. Once the project was initiated, Beall discussed the problems at length with management and production people. He traveled to the Moss Point Plant in Natchez, Mississippi for research. He also spent time with paper merchants from Washington, DC to Boston. "In redesigning the mark," Beall said, "it was felt that the letters IP and perhaps some form of abstraction of a tree were desirable." His use of the IP initials as a form which is ambiguous also as a tree created an isometric triangle in a circle, therefore creating a desired form of simplicity. Many rough sketches were created. "Meanwhile we experimented with the weight of lines, the use of the mark in conjunction with possible division marks and the various suggested logotypes. The typeface Venus Bold Extended was designated for the corporate name and News Gothic Extended for text type. We applied the mark to a typical package, truck and a few business forms." A presentation was made to IP's advertising agency, Ogilvy, Benson & Mather as they were definitely interested in using the new mark in their advertising campaigns for IP. Then middle management people from IP's advertising and public relations department saw it. A final meeting took place with top management. Beall decided to show top management only one mark, the one which they collectively accepted. Following the acceptance of the proposal, Beall used the symbol as a focal point for the development of paper packages of all types and sizes, as well as applying it to plant signs, office reception rooms, trucks, advertising and promotion materials.

Looking back at the IP project, Beall said "A vital and therefore effective image is created only by a controlled and consistent symbol application plus a distinguished contemporary style that is 'designed' into all types of visual material and becomes in itself a strong contributing factor to corporate identity as well as to the corporate image." Over thirty years have elapsed since Lester Beall created and implemented the progressive contemporary "style" for International Paper Company. The fact that the program continues to reveal a fresh identity attests to the functionality and inherent timelessness of the design.

—R. Roger Remington

Bibliography—

Herdeg, Walter, ed., *Packaging*, Zurich 1959.
Gottschall, Edward M., and Hawkins, Arthur, *Advertising Directions*, New York 1959.
"International Paper's Bold New Mark," in *Industrial Design* (New York), July 1963.
Pilditch, James, *Communication by Design: A Study in Corporate Identity*, Maidenhead 1970.
Plisken, Bob, "Lester Beall 1903–1969," in *Communication Arts* (Palo Alto), no.14, 1972.

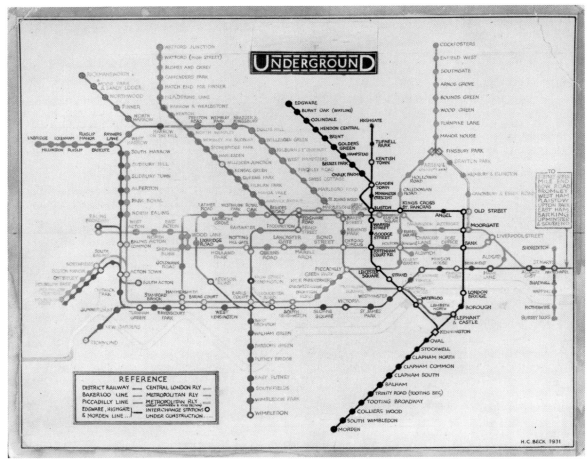

Beck's 1931 proposal (London Transport Museum)

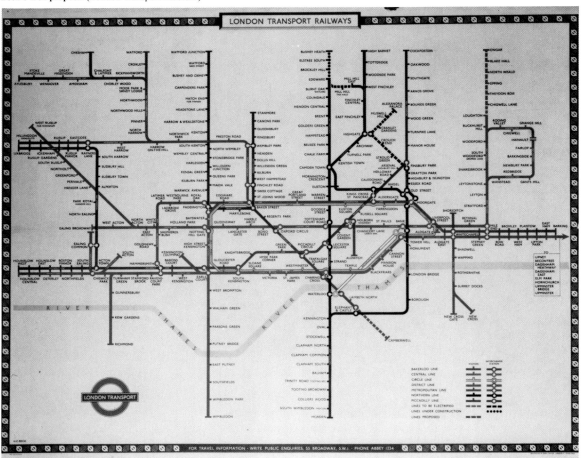

Underground map, 1949 (London Transport Museum)

Henry Beck (1902–65)
London Underground Diagram, 1931–59
London Transport

The London Underground diagram has been acclaimed as "one of the very small number of commonly accepted 'classics' of information design"; the degree of its acceptance is such that it has become a symbol of London itself, as instantly recognisable as Big Ben or Tower Bridge, and as frequently depicted on souvenirs of various kinds. But few of those to whom it is so familiar would be able to name its designer; those who do know of him know him only for this. While apparently the inspiration of a moment, it was also to occupy him on and off for much of his life. Yet it did not afford him even a portion of a livelihood; in its more recent versions it bears another's name.

Henry C. Beck had been employed as a temporary draughtsman in the Establishment Office Drawing Section of the London Underground Group, and was to spend much of his working life in the service of London Transport, but was unemployed and in his late twenties when; in 1931, he was inspired to "tidy up" the "Vermicelli" of the existing map of the Underground system. Beck's design, which he sketched first of all on a page in an exercise book, differed radically from that of F.H. Stingemore which had been in use since 1919. Stingemore had overlaid the Underground routes on a road map; even with the roads removed, the rail routes retained their topographic fidelity, and as a result the longer lines disappeared off the edge of the map. Beck in a stroke adopted the three crucial innovations which have determined the appearance of London Underground diagrams ever since. First, he abandoned all reference to the lie of the land above ground with the sole orientating exception of a stylised River Thames. Second, he dispensed with scale, enlarging the central area in order to allow more space for a clear presentation of the complicated knot of inter-connecting lines serving central London, and reeling-in the outlying reaches of the longer lines to within the diagram's frame. Thirdly, he subjected the actual and apparently wayward meandering of lines to a strict discipline of verticals, horizontals, and 45 degree diagonals. By these means, he replaced a map with a diagram.

Beck's proposal was at first regarded as "too revolutionary." But, encouraged by Stingemore, he persisted, and when he submitted his proposal a second time it was decided to print it, in the form of a folded hand-out, in a limited trial edition. For this first edition, Beck made a further change, abandoning Stingemore's convention of representing stations with circles, and substituting hollow diamonds for interchange stations while indicating other stations by the simplest of means, a short projection at right angles from the line of the route. Six colours were used, one for each separate line.

This trial edition, which appeared early in 1933, was an immediate success. A second edition was printed before the end of the year, and the diagram also made its first appearance as a poster, in station booking-halls, and beside the platforms.

Between 1933 and 1959 Harry Beck worked constantly on revising and refining his diagram, responding to suggestions from colleagues and the public while never ceasing to initiate and to experiment with changes himself. These included changing the colour of the Bakerloo Line from red to brown, and of the Central Line from orange to red, in 1936; eliminating many of the diagonals, and introducing more right-angle bends, to produce a more strongly rectilinear pattern, from 1943; trying out different ways of representing interchange stations, replacing the diamonds first with inter-linked circles and then with contiguous circles connected—as the actual stations are connected by tunnels—by white lines inter-prenetrating their hollow centres. An attempt by Beck to combine his Underground diagram with a similar representation of the rail network above ground was, sadly, not pursued. His diagram is perhaps seen in its classic form in the poster version of 1949; certainly this was Beck's own favourite version. His final design, published in 1959, incorporated a co-ordinate grid so that it could be complemented by an index to stations giving grid references—an idea first suggested to Beck by his father in 1933. Beck was much distressed when development of the diagram was taken out of his hands; the versions by Harold F. Hutchison (1960) and by Paul E. Garbutt are but variations on Beck's theme. Indeed, Garbutt's work is more successful because it is more faithful to Beck's model, and it seems unjust and inexcusable that Beck's name has not accompanied the name of Garbutt on a diagram which is his, Beck's original creation.

All of Beck's work on the Underground diagram was done on a freelance basis in his spare time, and for very little pecuniary reward. That this was so seems to have been at least partly his own choice, or rather, the result of his inability on the one hand to stop working on the diagram, and on the other, to go to the trouble of charging fees. His diagram not only provided a brilliant solution to a specific problem, but also demonstrated how similar problems could be tackled; it has been hugely successful because it is so useful and so easy-to-use, and it is useful and easy-to-use because (as Leonard Penrice has pointed out) people can play with it the kind of "game" which they actually play every time they travel on the Underground. Thanks to Beck, whose approach was intuitive and practical rather than academic and cerebral, planning and then executing one's journey can be—dare I say?—*fun*, and it may be a matter of some irony that Beck's work has not only inspired other diagrams but has also unwittingly provoked into being a body of theory—as if such pure simplicity has to be explained! The diagram *is* a masterpiece: yet to think of it as such, and especially, to focus on any one version of it, is to concentrate on a product at the expense of the process. Is it not possible that Harry Beck too had fun with his diagram? That he couldn't leave it alone because he *enjoyed* working on it so much? That his life's work was also *play*? To praise either the diagram itself, or the example of what Ken Garland has held up to other designers as Beck's "single-minded search for clarity," with nothing but the utmost seriousness, would be to miss an essential quality of its, and his, genius.

—Philip Pacey

Bibliography—

Garland, Ken, "The design of the London Underground Diagram," in *Penrose Annual* (London), no. 62, 1969.
Penrice, Leonard, "The London Underground Diagram," in *Graphic Lines* (London), no.1, 1975.
Walker, John A., "The London Underground Diagram," in *Icographic* (London), no.14/15, 1979.
Burke, Michael, and McLaren, Ian, "London's public transport diagrams—visual comparisons of some graphic conventions," in *Information Design Journal* (London), no.2, 1981.
Bedell, Geraldine, "New Tube Map Runs on Strictly Classic Lines," in *The Times* (London), 7 August 1990.

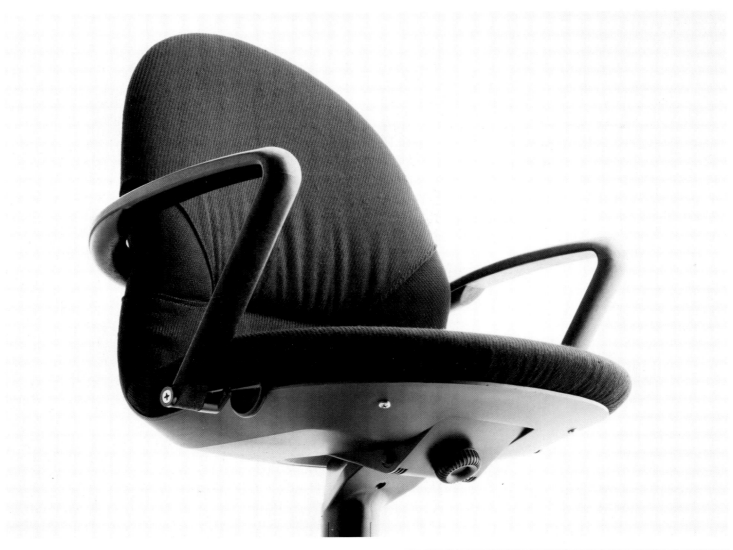

Photos courtesy Mario Bellini Architetto

Mario Bellini (1935–)
Persona chair, 1979–84
Vitra, Milan

Mario Bellini is one of the world's most respected and talented industrial designers. Towards the end of the 'seventies he also turned back to architecture, the subject in which he graduated in 1959, having studied at the Polytechnic Institute of his native city of Milan where he has his studio.

His designs for a clientele which includes such names as Olivetti, Cassina, Artemide, Vitra, Lami, Brionvega, Flos and Rosenthal, range from microcomputers and office and domestic furniture to ballpoint pens and lighting. The fact that his creations are in use worldwide is evidence enough of their efficiency. The formal quality of the design is borne out by the number of Bellini's works to be found in New York's Museum of Modern Art.

Before starting work on *Persona*, Bellini had designed armchairs and sofas, such as *932* in 1967, *684* and *685* in 1973, *Le Bambole* in 1972 and *Break* in 1976. However, he had never designed a chair, one of the oldest forms of seating known to mankind. The basic characteristics—seat, back and four legs—have remained virtually unchanged for thousands of years.

In the West, man has traditionally sat on his buttocks and heels (what sociologist Marco Romano calls the "natural seat"), specifically on a sort of "false limb" added to the body, what Romano calls the "cultural seat." Bellini says that, consciously or unconsciously, for twenty years he refused to design chairs, "until I convinced myself that a 'new chair' could only be conceived the way chairs have always been—with a back, seat and four legs." And so he designed *Cab* for Cassini in 1977. It was a structure of leather-covered steel, with which Bellini started his quest to rehumanise everyday objects, to reclaim them, in a word, to domesticate them.

The story of *Persona*—and its two successors, *Figura* and *Imago*—began a few years later when Vitra commissioned Bellini to design an ergonomic office chair, after Charles Eames had turned down the job. It is worth remembering that the history of office buildings and their internal layout goes back no more than a hundred years. It has no set pattern and is in a process of perpetual change. Office machines, which appeared as if from nowhere in the first decades of this century, symbolise this continuous state of flux.

If technological and functional considerations have never been enough to dictate the design of living space and furniture, in Bellini's opinion this is also true of machines, despite the features that distinguish them from furniture. Machines have a short history which has been deeply affected by incessant technological revolution and evolution. At the same time, their more ephemeral image is too often linked to their usefulness.

Furniture, on the other hand, has a history of thousands of years and its image, which does not have the ambiguous connection between mechanism and external appearance, is far more mature and clearly defined. Furniture is more closely related to the significance attached to the various items (religious values, their functions as an extension of the human body, and the rituals and meanings associated with their use).

"I always tended to think that the world's most difficult object to design was the chair. That was until I started to reflect on office chairs," Bellini wrote in 1986 in *Domus*, the magazine of which he was editor. "Designing a chair is harder than designing the most sophisticated electronic calculator, which can be as complicated as you like, but never as complex as a chair, which descends from countless generations of chairs. It is the result of a slow process of ceaseless experimentation in interior and exterior design. First of all, it is the outcome of the cultural decision to sit above floor level, rather than on the ground or on the heels. Moreover, no designer invented the chair, in the same way that no architect invented the house."

But, Bellini added, this plausible scheme of interpretation becomes inadequate and unnecessary when thinking about an office chair. As well as being a chair, it is also a machine, since it embodies a mechanism intended to satisfy increasingly sophisticated ergonomic requirements. And so we have a new category: a hybrid between furniture and machinery, which has to provide the facilities of both, and whose design combines the complexity of both, while seeking to make the end product as simple as possible. That is to say it is a chair on which we not only sit but on which we have to work so many hours a day; in other words it is a machine in which we not only work but live. It is the opposite of the *machine à habiter*, as Le Corbusier called his rationalist houses. This is a case of *habiter la machine*.

As a result, the office chair has to fulfil several needs. Firstly, it must provide "dynamic seating," enabling the body to assume the correct posture; secondly, it must influence and contribute to the otherwise impersonal office environment. It should provide the user with something more than a means of "dynamic seating." The chair should have its own identity, to which the user can relate and which allows him to fit comfortably into the surrounding space. Thirdly and lastly, it should provide the possibility of reactivating that series of relationships and acts of communication which belong to "domestic" objects, so often lost in undefined and ambiguous working environments.

The process which would eventually lead to the mass-production of *Persona* took six years. In that time Bellini had to work out the appropriate technology and manufacturing processes. Clearly the design went through several stages.

The first stage of development envisaged a shell in two parts—seat and back—connected by a small device to control movement. Then came the decision to adopt a mono-shell design, with a dorsal "corrugation" which would act as a plastic hinge to synchronise movement between back and seat. The mechanism was outside the shell, linked to the back by two lateral arms.

There followed an attempt to integrate the mechanism into the casing of the shell, with a second "corrugation" under the seat. Thus steps were taken to eliminate the difficulty and ungainliness of the double horizontal cylinder, initially by connecting the dorsal corrugation in a more plastic manner, and then by modifying the mechanism until it was integrated into the shell itself, and eliminating the lower cylinder. The shell was moulded in polyamide, reinforced with 30 per cent glassfibre. The supporting structure is in steel.

—Jorge Glusberg

Bibliography—

Sembach, Klaus-Jurgen, ed., *Contemporary Furniture*, Stuttgart and London 1982.
Hiesinger, Kathryn, and Marcus, George, *Design Since 1945*, Philadelphia and London 1983.
Weiley, Susan, ed., *Mario Bellini: Designer*, exhibition catalogue, New York 1987.
Sparke, Penny, *Design in Italy: 1870 to the Present*, London and New York 1988.

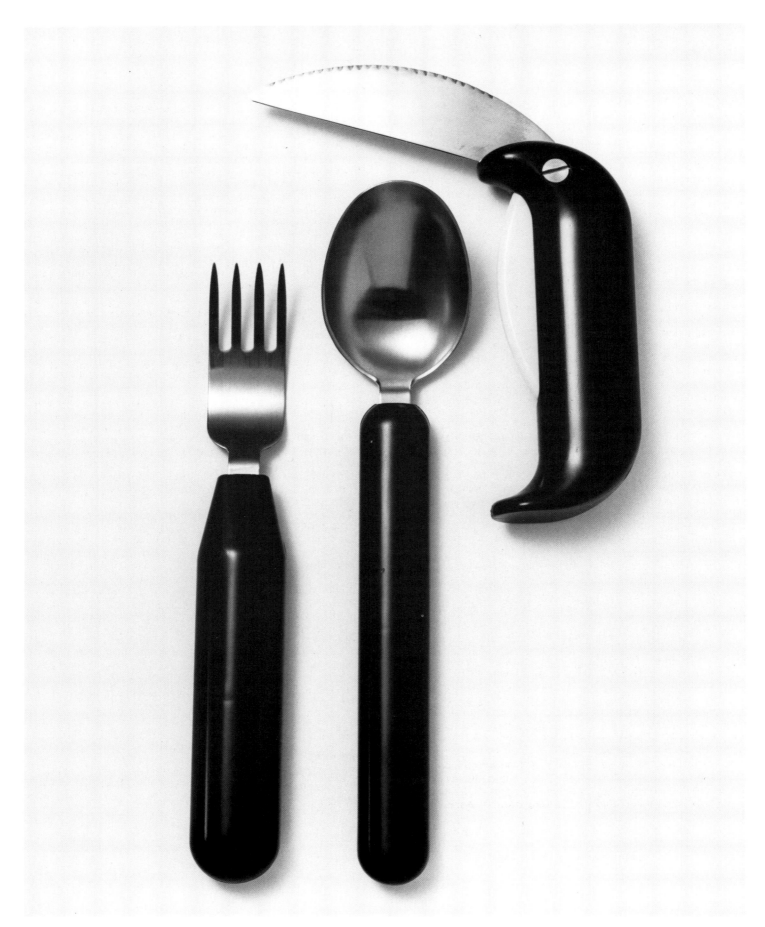

Photo courtesy Ergonomi Design Gruppen

Maria Benktzon (1946) **Sven-Eric Juhlin** (1940–)
Tablewares for the disabled, 1980
RFSU-Rehab, Stockholm

Most of us take eating and drinking for granted. They are so obvious that we only think about them in terms of taste experiences: what we'll eat, who we'll eat with, or the menu we prefer for the occasional gourmet meal. Dining is a simple, everyday matter for most of us.

The mechanics of eating—the hundreds of minor steps that take place during an everyday meal—receive even less thought than the act of eating. Few people count the number of specific, single acts required for the consumption of a meal. Some people must. For those with impaired strength and mobility, every motion can be a difficult, painful experience that robs the most basic human act of its joy.

Think of a simple business lunch: 45 grasp-scoop-and-lift motions of the wrist and arm to consume a small bowl of soup, 32 grasp-spear-and-lift motions for sliced vegetables, 100–200 minor cutting motions for a steak, followed by 30 or 40 spearing and transport motions. Several dozen different motions follow for the rolls and butter, for the salad, for dessert. Still more effort to drink—and for the disabled, it is an effort. Several hundred times a day, we perform basic mechanical work in order to eat. When the ability to handle the biomechanics of dining is impaired, the quality of life is dramatically diminished.

In 1972, Maria Benktzon and Sven-Eric Juhlin of Sweden's Ergonomi Design Gruppen began to study the act of eating. Their goal was to make eating as simple and natural a task as possible for those who had previously been condemned to a diminished quality of life. Under the sponsorship of the Swedish Institute for the Handicapped, they undertook a research project on "Handles/Grips." Their focus was eating utensils for people with impaired muscular strength and mobility. While their target group was sufferers of rheumatoid arthritis, it was clear that this project offered benefits to many people suffering similar problems as the result of accident or disease.

Benktzon and Juhlin began with research, but their goal was not a report. It was the development of working tools. Their methodology has become a classic: research, a project team approach, user-involvement in the development and testing of prototypes, thorough testing of selected models and, finally, mass production. Their Ergonomi Design Gruppen has come to embody this method in all of its product development, and Benktzon and Juhlin have become synonmous with high quality Scandinavian design for the disabled. Their method is one of Sweden's best exports, and Benktzon and Juhlin now disseminate methodology to designers around the world.

The first project, with its focus on grips and handles, studied the act of eating and the special requirements of disabled people in handling and manipulating cutlery. Where previous approaches had focused on extensions and accessories for standard products, Benktzon and Juhlin sought the development of simple products that were readily available—and could be used by all. While the cutlery for the disabled is unusual in its design, it is attractive and accessible for common use. If an average person were to be invited to the home of a disabled friend, dinner served on the Ergonomi Design products would be no problem, a sharp contrast to the difficulties the disabled often face in using ordinary ware.

Understanding the problems that the disabled face in ordinary tasks was the first step. The simple act of cutting, so ordinary for the majority, is too much for many. Cutting is the most difficult aspect of food consumption, and while it requires the greatest amount of energy, it slips by most of us without a second thought. For the impaired, it is a process that can lead to astonishing fatigue, and for some rheumatics, the process is so painful that they simply avoided all food that had to be cut. Redesigning the ordinary knife to permit a better grip was one answer. But for those who could not apply downward pressure in the ordinary way, the designers reconceived the knife in terms of its function. The solution was simple yet profound: a knife that is held downward in the palm of the hand, gripped full-hand as many of us might grip a hunting knife, using a curved, underslung blade to permit direct downward pressure based on the weight and force of the arm, rather than the muscle strength of the wrist.

Benktzon and Juhlin worked their way through an entire range of challenges, studying every aspect of food management. The weight and shifting gravity of liquids make drinking a problem for many, and the many lip designs on cups make it difficult to drink even when the lift is possible. A new goblet, raised, modelled in light plastic for single-hand or double-hand use, with a lip designed to make mouth contact easier, is the solution. The one-handed must cut and spear with the same hand. The answer was a tool combining the knife and fork into one, easy-to-use *knork*. Handles that permit multiple grips were developed for several kinds of cutlery. And a simple, light but stable plate with raised sides to permit the plate itself to function as an assisting implement rounds out the product program.

These products are now readily available in many stores in Sweden and around the world. They are marketed through RFSU Rehab of Stockholm.

These products are an important contribution to design for the disabled. The design methodology created by Maria Benktzon and Sven-Erik Juhlin is a contribution to the rest of society. Muscular mobility is a handicap to the physically impaired. Design in the industrial world is handicapped by outdated methods. The symptoms are rigid design thinking, the confusion of artistic solutions with design solutions, or—just as bad—the failure to understand the need for the union of grace and function in optimal design. Through their work for the disabled, Benktzon and Juhlin point toward the rehabilitation and enrichment of design itself.

—Ken Friedman

Bibliography—

Hiesinger, Kathryn, and Marcus, George, *Design Since 1945*, Philadelphia and London 1983.
Boman, Monica, and others, *Contemporary Swedish Design*, exhibition catalogue, Stockholm 1983.
Benktzon, Maria, and Juhlin, Sven-Eric, 'What Can Design Contribute to Human Society in the Near Future?,'' in *Design Quarterly* (Tokyo), no.2, 1984.
Boman, Monica, ed., *Faces of Swedish Design*, Stockholm 1988.
Benktzon, Maria, and Juhlin, Sven-Eric, 'The Development of Eating and Drinking Implements,'' in Edlund, Nils H., ed., *Social Design*, Stockholm 1989.

Photo © Knoll International

Harry Bertoia (1915–78)
Bertoia (Diamond-Mesh) chair, 1951–52
Steel rod and coated wire; 76 × 85 × 42 cm.
Knoll International, New York

Although in many circles, Harry Bertoia is best known for his openwork wire chairs that became one of the visual icons of the 1950s, Bertoia would have liked to be remembered more for his metal sculpture. Bertoia began his short, high impact foray into furniture design partially as an accident of propinquity.

Bertoia was born on March 10, 1915 at San Lorenzo, a village near Udine in Northeastern Italy. He emigrated to America at the age of fifteen to find instead of the American dream "America deep in Depression." After graduating from Cass Technical High School in Detroit, he won a scholarship to the newly-formed Cranbrook Academy in Michigan. Over the years, his personality changed very little from what he wrote on his Cranbrook application: "I am rather silent, resolute and industrious." Yet, the school he entered, probably more than any other school in America at that time, was designed to unleash creativity and the free play of the mind in its students. It was a newly-formed experiment in design education that produced designers and craftsman who have had a major impact on American design over five decades.

In 1939 the architect Eliel Saarinen, father of Eero and director of the Cranbrook Academy of Art, asked Bertoia to stay on and start a metal-working workshop. He was making and teaching sculpture at the same time that Charles Eames and Eero Saarinen worked on their revolutionary, prize winning furniture for the Museum of Modern Art's Edgar Kaufmann's *Organic Design Show* of 1941. Eames received some money from the Museum to put his furniture into production, and he used it start a workshop in Santa Monica. In 1942 he asked several friends to join him to help solve the problems that developed when he tried to mass produce the chair. In addition to Bertoia, the men who brought their talent and insights to bear on Eames' project were Don Albinson, who went on to work for Knoll; Herbert Matter, a photographer; and George Ayn, an architect. Each contributed something.

The original chairs in Bertoia's words "were simple, direct plywood shells done on a lathe. I told Charlie we were torturing wood and should be using metal, he said, okay, go ahead and try. I proceeded to make the three-legged chair and two position tilt-back. As I toyed with the design, Duchamp's *Nude Descending a Staircase* came to mind. Like the human body in painting, the chair should rotate, change. All the dynamics of the human body should be taken into consideration." Bertoia's contributions resulted in drastic changes in the shape of the plywood and the metal frame. Later, he would use the idea of flexibility gained from his contributions to Eames' design, as well as his vision of Duchamp's *Nude Descending a Staircase*, as a model for the use of motion in his own furniture designs.

Within a decade Eames and Saarinen's designs had been picked up by the new firm of Knoll that was to make modern design if not a household word, at least the common idiom of office design. After designing jewelry and sculpture on the West Coast, Bertoia came East at the invitation of Hans and Florence Knoll to design furniture for the new firm of Knoll Associates in 1950. They knew of his work with Eames and they basically gave him *carte blanche* to pursue basic research in design. He developed a series of visually light chairs constructed of welded steel rods. The first of these was the *Little Diamond Chair*. This revolutionary chair was at once functional, rational, transparent, casual, iconic and futuristic. The chair was made of a web of wires welded into a diamond shape placed horizontally. The center dipped down to form a basket-like seat that held the body. The edges were bent outward in wing-like protrusions to form armrests. The chair reflects the then current interest in vernacular design. Wire mesh is commonly used for industrial waste paper baskets such as those found in parks. The chair uses this material to supply a graceful receptacle for the body. The body of the chair is suspended cradle-like on a pivoting mechanism in an open metal stand. It can be completely upholstered or merely seat-padded, leaving the backrest free to reveal the repitition of the outer diamond shape in the body of the chair's diamond-shaped grid made of criss-crossed wires.

Bertoia's chairs exhibit what Hans Theodor Flemming, art critic for *Die Welt* said about Bertoia's sculpture, "a happy synthesis of 'free' and 'applied' art." The idea of a sculptor designing a chair can be seen as an extension of the idea going back to William Morris and the Arts and Crafts movement, and more recently espoused by the Bauhaus, that art and design should intermingle to produce a totally designed interior. Bertoia felt that both sculpture and furniture designs should be integral elements, rather than simple decoration, and that, "the principles of pure design apply to every aspect of the manmade world that surrounds us."

The chairs were put into production in the early 1950s and are still in production today. He said, "In sculpture I am primarily concerned with space, form and the characteristics of metal. In the chairs many functional problems have to be satisfied first—but when you get right down to it the chairs are studies in space, form and metal too . . . If you will look at them you will find that they are mostly made of air, just like sculpture. Space passes right through them." His designs were quickly taken up and used by architects and designers in the new open-plan house of the 'fifties, especially the California Case-work houses which were a laboratory for the introduction of European modernism into the American domestic landscape.

Bertoia also designed a high backed chair and ottoman, a side chair of criss crossed wires with a square rather than diamond shape, and a bench made of metal and slates for Knoll. By 1953, Bertoia had established a studio in a two-hundred-year-old stone farmhouse in Pennsylvania and, although he remained available to Knoll for consultation, he had ceased producing his own furniture designs. From this point on he devoted himself full time to sculpture. In 1957 Eero Saarinen, asked him to design a metal screen for the General Motors Tech Center. The screen was an extension of his openwork metal sculpture. It made his work visible to architects who saw that, just as his metal chairs harmonized with modern interiors, his architectural sculpture lying between fine and applied art complemented the clean lines of their buildings. He found himself in demand and could pick and choose his commissions. "But," as he says, "the *real* problem was much more basic: how much time to allow for experimentation and how much time on commissions which pay a high fee? I could easily become a slave in the wealthiest terms. If we as designers and architects want to give meaning to our freedom, we have to face this." Although he devoted much of his energy to his sculpture, he never wholly solved the problem of this dichotomy between high and low art saying, "I am forever at war with it."

—Ann-Sargent Wooster

Bibliography—

Nelson, June Compass, *Harry Bertoia, Sculptor*, Detroit 1970.
Larrabee, Eric, and Vignelli, Massimo, *Knoll Design*, New York 1981.
Sembach, Klaus-Jurgen, ed., *Contemporary Furniture*, Stuttgart, London and New York 1982.
Hiesinger, Kathryn, and Marcus, George, eds., *Design Since 1945*, Philadelphia and London 1983.
Greenberg, Cara, *Mid-Century: Furniture of the 1950s*, London 1984.
Pulos, Arthur J., *The American Design Adventure 1940–1975*, London and Cambridge, Massachusetts 1988.

Citroen advertising, 1954

Photos National Motor Museum, Beaulieu

Flaminio Bertoni (1903–)/**Pierre Boulanger** (1886–1950)
Citröen 2CV car, 1936–48
Citröen, Paris, 1949–90

It was claimed in *Motor* magazine in 1953 that "no technical development since the day of the Model T Ford has so widened the potential field of motoring as the advent of the two-cylinder Citröen." While the extent and nature of its influence are debatable, it is without doubt one of most extraordinary cars ever built. In production for an unrivalled 41 years (with few major changes to the design, moreover) the car was a result of brilliantly original yet essentially simple engineering. Its looks have always been bizarre, and along with its ruggedness have given the car a rare charm which endures.

The idea for what became the *deux chevaux* originated in the mid-1930s when Citröen chief Pierre Boulanger visited the market town where he was born. At the time, cars were the preserve of city dwellers, with France's large rural population still reliant on the horse and cart for their transport. Boulanger, with the brilliant team of engineers responsible for the *Traction Avant* saloon at his disposal, came up with a brief for a car which would fulfil the needs of French smallholders. This TPV (*toute petite voiture*) should, he insisted, resemble an umbrella in appearance, and be capable of carrying four peasants (or two peasants, a sack of potatoes and a small barrel) across a ploughed field. The ride, however, had to be smooth enough to ensure that, should said peasants also be carrying a box of eggs, these should remain intact. In conclusion, the car had to be very economical, extremely cheap, and, given its anticipated usage, virtually indestructible.

Although the car's stylist, Flaminio Bertoni, was also responsible for those paradigms of French motoring elegance, the *Traction Avant* and the DS, his adoption of Boulanger's brief resulted in a car which indeed resembled an umbrella before it resembled any other Citröens (or any other cars). The desire for originality continued among the mechanical engineers, led by André Lefebvre, who decided to adopt front wheel drive (in keeping with other Citröens), torsion bar suspension, and an aluminium chassis. Development was interrupted by the outbreak of war, with all but one of the 250 prototypes then built being deliberately destroyed to keep the car out of German hands. When the project was eventually continued in 1944, several important changes were made. The aluminium chassis and the torsion bar suspension were abandoned as too costly, and were replaced by a steel chassis, with an ingenious set of interconnected arms extending from each corner, giving the car fully independent suspension and thus superb ride quality. The water-cooled engine of the pre-war, pre-production models was replaced by a 375 cc air-cooled twin-cylinder engine designed by Walter Becchia, capable of producing 9bhp, or *deux chevaux* by French fiscal ratings.

The car which went on display at the 1948 Paris Car Show caused considerable excitement, not to mention amusement, among the French motoring public. But by 1950, Citröen could not build enough 2CVs: there was a lengthy waiting list for the car, and second-hand versions were selling at a premium. Unconventional it may have been, but it caught on—not just among the farmers for whom it had designed, but also among city-dwellers who similarly appreciated its dependability, economy, ride comfort and ease of maintenance. And even in its early days, its "ugly duckling" appearance was considered *chic* in the curious way that the most obviously functional of cars (like the Beetle) have become. Though

Citröen as a company have always been associated with avant-garde design, a Citröen's styling, however original, has always been seen to follow its design, and has never been mere frippery. Thus Bertoni's shape of the 2CV follows not only Boulanger's desire for "an umbrella on wheels," but also the numerous technical innovations which Lefebvre and his team sought to incorporate in their effort to make *the* small French car.

The power unit of the 2CV was increased in 1954 to 425 cc, producing 12 bhp, and from 1970 it was offered with a 602 cc engine producing 29 bhp. To say that the 2CV was never a fast car is something of an understatement, but Boulanger's original notion that basic indestructability was more important than high speed sustained the car's appeal through an astonishingly long production period. Within its obvious limitations, the car has proved itself an unrivalled performer. Citröen's attempts to update or replace the 2CV with the even uglier Ami of 1961, or the Dyane of 1967 with its more modern body, or even the Visa of 1978, have all been outlasted by the "tin snail." The fuel crises of the 1970s gave the car a new lease of life, especially in the British market, where it acquired a radical, slightly bohemian image. For thousands of drivers in France and elsewhere, however, the 2CV has been and continues to be a thoroughly reliable and versatile workhorse.

The 2CV's qualities are considerable: its body panels can be easily removed (allowing easy repairs), as can the seats and the roof, in order to accommodate a variety of loads; the engine can be driven flat out for hours without complaint, and will consume little fuel; and while its narrow traction allows the car to climb out of snow, it can be driven in the desert. Indeed, in the 1970s, during the initial road test of the exhaustively-researched experimental Africar (designed specifically to cope with the tough African terrain), it is rumoured that a humble 2CV, which apparently had been used happily for years, chugged by, to the consternation of the engineers concerned.

Citröen's success in the 1980s with its new range of models prompted them to transfer production of the 2CV to Portugal in 1987. In 1990, production came to an end, after nearly 7 million 2CVs (including the popular van, and the 2CV-based Dyane) had been built. The most recent Citröens are fine cars, but increasingly one feels they could have been produced by any old car firm. In an increasingly homogenised market, originality is presumably perceived to be a liability. The 2CV, however, embodies both boldly innovative design and legendary qualities of endurance. One hopes that it will not be remembered merely as an eccentric and rather charming little car. Citröen, at least, must not forget their own brilliant legacy.

—Nicholas Thomas

Bibliography—

Citröen: The Great Marque of France, Paris 1973, Brentford 1976.
Alexandre, A., "25th Anniversary of the 2CV," in *Novum* (Munich), October 1973.
De Noblet, Jocelyn, *Design*, Paris 1974.
Broad, Raymond, *Citröen*, London 1975.
Schmittel, Wolfgang, *Design, Concept, Realisation*, Zurich 1975.
Taylor, James, *The Citröen 2CV and Derivatives: A Collector's Guide*, London 1983.
Bayley, Stephen, *The Conran Directory of Design*, London 1985.
Jacobs, David, *Citröen 2CV*, London 1989.

WHEEL BASE : 123 ins.

SAFEST CAR IN THE WORLD
FRONT-WHEEL DRIVE

Grips the road

Lowest centre of gravity
Perfect visibility
Independent front and rear brakes
Power disc brakes
Foot operated emergency brake
Life-guard steering wheel and dash

Citroen advertising, 1957.
Photo National Motor Museum, Beaulieu

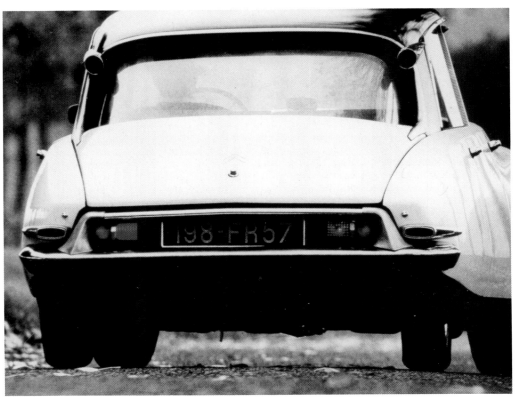

Photo Design Museum, London

Flaminio Bertoni (1903–)
Citroen, DS-19 car, 1951
Citroen, Paris, 1955–75

On 1 April 1952, the French motoring publication *l'Auto-Journal* stunned its readers, and more particularly the management of the Citroen car company on Paris's quai de Javel, with an illustrated article on a new Citroen prototype then undergoing development. Secret camera teams had snatched pictures of the prototype, and then evaded the company staff who sought to grab both cameras and film to prevent publication.

This revelation of a new model, clearly intended to replace the Citroen Traction Avant range (11CV), turned Citroen's planning on its head. Sales of the Traction Avant plummeted, and the company was obliged to bring forward the release of its successor. The short development programme for what was to become the Citroen DS, one of the most radical and influential new cars of the century, led to unfortunate problems in service for early production examples of the car. More importantly, Citroen were forced to launch the car before the production lines had been properly established. Faced with a runaway sales success, they were unable to meet demand. During the first year of production, fewer cars were delivered than had been ordered on the first day of the 1955 Paris Salon at which the model was launched.

L'Auto-Journal had one further triumph, producing an issue just before the Paris Salon which included a full, and totally accurate, artist's drawing of the DS. Citroen were obliged to conclude that their drawing office had been infiltrated by the journal, so complete was the coup pulled off in this case. *L'Auto-Journal* was able to make the most of its journalistic opportunism: a second print-run of the 15 September edition was required, with its circulation boosted to an astonishing 617,000 copies. During the launch at the Paris Salon, the interest generated was overwhelming: Citroen had to place a police guard round the stand where the car was displayed. Even the great writer, Roland Barthes, was moved to make public comment on Citroen's new phenomenon.

A point had been made: faced with the challenge of surpassing and replacing one of the icons of mid-century France, the Traction Avant, Citroen succeeded beyond even their own imagining. This was no nine day wonder, as some at the time of its launch may have predicted. Like the Traction Avant, the DS was to be kept in production continuously for 20 years. With sales success around the world, it was produced in even greater numbers than its predecessor (1.4 million examples sold in total, more than double the number of Tractions Avants).

What then was the object, indeed the cause, of such sensation, of such spectacular interest and excitement? How did Citroen contrive to better a vehicle which is even now regarded as a symbol of Frenchness to many, even outside its own country? Simply stated, the company had developed what may now be considered one of the two or three most inventive, influential, and arguably most beautiful mass-produced cars in motoring history. A major part of the credit for this achievement must rest with Flaminio Bertoni, the company designer responsible for draughting the new vehicle. Citroen had proved with the Traction Avant that the creativity of their design engineering was unsurpassed. Bertoni, in penning the DS, added spectacular external and interior styling to the recipe.

So original, so visionary, was Bertoni's design, that it took other manufacturers almost the full production life of the DS range to equal the sophistication and modernity of its appearance. Well into the next decade, only the Rover company, of the main European car manufacturers, produced in the Rover 2000 a car which could come close to standing alongside the DS in its design values.

The sensuous, streamlined shape of the DS, from the sharp nose, through the long, gracefully-curving bonnet, back to the abrupt taper of its tail, came to typify stylish motoring in France, just as the Traction Avant had before it. Not only beautiful, the design work was eminently practical. The wind-resistance of the body would have been respectable for a car of this size nearly thirty years later, as the constraints of petrol economy forced manufacturers the world over to resort to streamlined styling.

This, though, is to tell only part of the story. The Citroen DS carried innovation over to its engineering design. Few new models, at any time, have been so packed with inventive thinking. In construction, suspension, materials, braking, gearing, ventilation, hydraulics, the Citroen design team, led by Andre Lefebvre, had broken new ground. Prime example of this was the vehicle's unique hydro-pneumatic suspension system. Designed under the leadership of Paul Magès, the system replaced conventional steel springs and separate shock-absorbers with a pump-pressurised hydraulic suspension system, using gas/hydraulic spheres above each wheel and a system of valves to provide a shock absorption/damping effect. The system was self-levelling, and gave the facility for a variable ride-height, controlled by a lever inside the cabin. Hydraulic power was also taken to actuate the brakes, the clutch, and, in many examples, a semi-automatic gear selection system.

Other innovations were added in with gay abandon: the first use of disc brakes (at the front only) in a mass-production car, taking the idea from the successful Jaguar racers at Le Mans; pioneering use of plastics (cooling fan, petrol tank and dashboard) and fibre-glass (roof moulding); introduction of a fully-controllable system of face-level ventilation for the vehicle cabin (related perhaps to Bertoni's influential abandonment of the quarter light in his design for the exterior of the vehicle); the adoption of a structural design based on an internal frame, with detachable external body panels (the rear wings, which had to be removed to change the rear wheels, were held in place only by two pegs and one bolt on each side). Many of these features have come to be regarded as normal in the everyday motor vehicle of the late twentieth century. Such was the great influence of the car.

Nonetheless these elements of the design were to some degree an embarrassment of riches for Citroen, and almost proved their undoing. Virtually the only proven element in the whole vehicle was the four cylinder in-line engine taken over from the Traction Avant. All else was new, and, because of the shortening of the proving period resulting from the intervention of *l'Auto-Journal*, underdeveloped. On the road, a number of problems surfaced in the reliability of the vehicle. Worst of these was that the mineral oil in the hydraulic system tended to take up water, causing corrosion of the hydraulic piping. If not treated in time this could lead to total collapse of the suspension, and loss of power to other systems.

To end on such notes of qualification, though, would be less than fair to the originators of what must be classified truly as a masterwork. Despite the hurriedness with which it was put into production (and Bertoni was as much affected by this as anyone: the unique rear indicator lights of the car, mounted at the tops of the C posts, were only added in to the design two weeks before the launch of the vehicle), Citroen, with its team of talented engineers and designers, had stunned both its competitors and its public, home and abroad. An enduring success was achieved. Even now, forty years after the car was conceived, designers regard the design as seminal. For the present writer, born in the year it was launched, the DS was an ever-present source of delight and wonder through childhood. The voluptuous appeal of the object, now, is diluted but far from lost. There remains an ongoing, and somehow deeper sense of awe at the boldness and fertility of the minds behind the machine. How much the motor industry of today needs people who would put such a risk onto the production line!

—Andrew Parker

Bibliography—

"New Citroen", in *L'Auto-Journal* (Paris), 1 April 1952 and 15 September 1955.
Clarke, R. M., *Citroen DS and ID, 1955–1975*, London 1983.
Sabates, Fabian, *Citroen DS, 1955–1975*, Paris 1990.

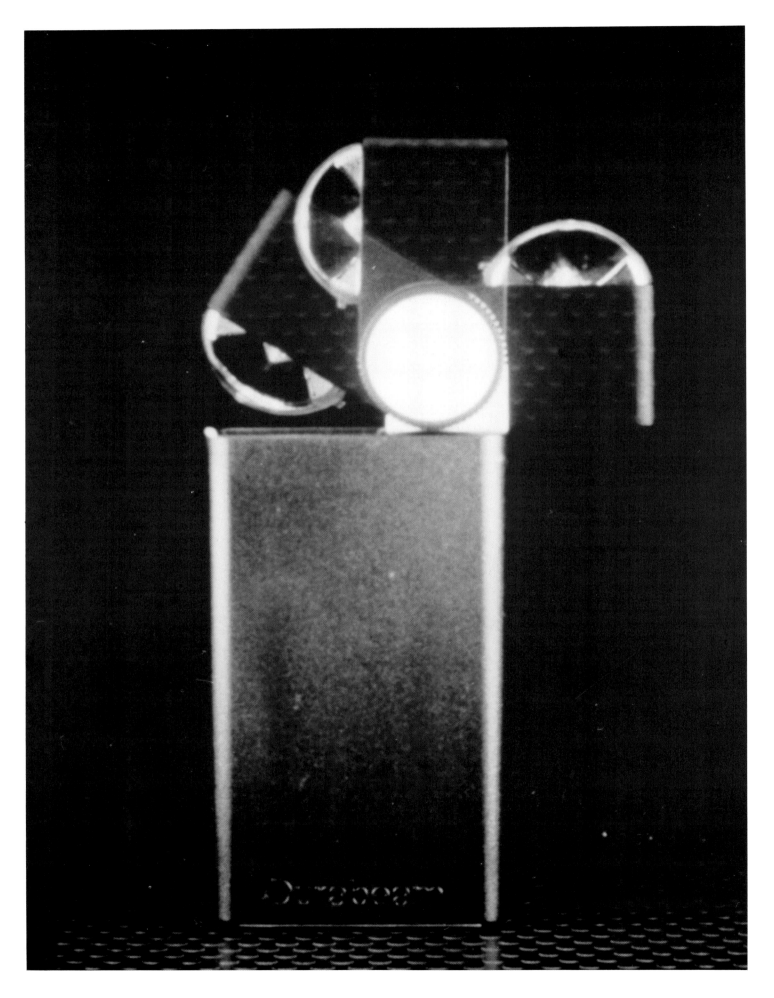

BIB Design Consultants, London (1967–)
Durabeam torch, 1980–84
Duracell UK

From the outset the Durabeam torch was revolutionary. The pocket sized flip-top design with its distinctive black and golden yellow casing posed a challenge to conventional cylindrical forms. It was launched in September 1982, and by December of that year 450,000 had been sold in the United Kingdom. Eighteen months later, the number purchased was over 3 million and production was running at a rate of 10,000 a day. Since then it has made a major impact in world markets. Not only has it been a commercial success, but in 1984 it won an award for design excellence from the British Design Council.

The Durabeam was the brainchild of two people—John Drane, its designer, and Bob Winstone, Duracell's marketing manager, who wrote the brief. In 1980 Duracell Batteries was a small British company manufacturing a limited range of batteries for use by the Ministry of Defence. Their decision to expand into other products led to them becoming the largest battery manufacturer in Europe. In order to develop their range, Duracell looked at the resources the company possessed. As a result, a list of criteria was established for product development. The first was uncompromising quality, the hallmark of the company; next came differentiated premium positioning: that is, developing something different from and better than the competitors. Any new product would have to have a strong visual appeal to the consumer, no need for after sales service, the ability to be distributed through existing battery outlets, and, finally, the potential to make large profits. The resulting free-standing "battery-operated light source," with a directional beam, which came in three sizes, met all the criteria.

Duracell recognised the importance of design in the development of any three-dimensional product. Being primarily a sales and marketing organisation, they sought a design consultancy who could take the product from design to manufacture. BIB Design Consultants were chosen and John Drane, an industrial design consultant who worked with BIB, was put in charge of the design development. Throughout the process he liased with Bob Winstone, who had provided a specific, but open, brief. Their mutual respect and co-operation played a large part in the success of the venture. Duracell wanted something completely new which would challenge the reliable, but un-progressive image of other UK torch manufacturers. The imagery of the new model had to be associated with, what its marketing department called, Duracell's "modern technological style and presence." The price was to be high, "but not prohibitive."

The flip-top model was a total product innovation and therefore very risky in commercial terms. Market research proved that the British public were ready to accept, and moreover purchase, a new style torch costing about £3 for a pocket version, and around £4 for the medium size. Duracell Europe agreed to invest the £70,000 needed for design development and in February 1981 BIB were allowed to go ahead with the design. Duracell's enthusiasm was such that they speeded up the original schedule and asked BIB to have the product ready for market testing in October of that year. During this period, three critical areas of design had to be prototyped: the sliding electric contacts, the head ratchet mechanism, and the battery shell covers. The solutions were achieved by Drane drawing on direct experience with materials and observing the solution of similar problems in alternative contexts. In order to meet the deadline, much of the design work (design development, detail design, prototyping, preparation of production drawings) was carried out concurrently rather than consecutively. The torch was launched on schedule, but only just, to meet the winter market (in Britain 70% of torch sales take place in the four winter months). Sales figures soon confirmed that the design decisions had been accurate. Design had been fundamental to its success, but design decisions did not only influence the appearance of the product. The packaging was also an innovation. Unlike their competitors, who did not spend money on advertising and sold torches in boxes, Duracell reflected its confidence in the Durabeam by allowing it to promote itself through transparent vacuum formed packages. (A leaflet was provided to tell the purchaser what the product did and how it worked.) In order to cut down on production costs, one factory was used to manufacture the same packaging for the whole of Europe. By contrast, different countries were given the opportunity to design their own styles of graphics and their retail stands. Duracell recognised that this was a complex, but important element of promotion and sales. A modular scheme was devised for the stands which could be placed on a counter top or on the floor and hold up to £100 worth of stock. This enabled the Durabeam to attract the attention of the consumer before other brands. Television advertisements were employed to promote the three lead products in the Durabeam range. The pocket came first, then the tough torch, and finally the work torch. The Business Development Manager for Duracell Ltd has described the work torch as "probably the most complicated torch in the world," utilising over 70 components. Other companies soon recognised the success of the Durabeam and Duracell have been continually approached by firms who guarantee to buy huge quantities of the torch in exchange for an "own" label version. Duracell have declined these offers in favour of preserving their classic image and long-term profitability.

To a certain extent the Durabeam was a product of the 1980s "black box" era of design. Duracell realised that the design will have a finite lifespan. Modifications to the casing have taken place, but the overall concept remains the same. The company believes that the popularity of the product was due to the fact that there was only one design worldwide. Duracell decided to maximise the profitability of the Durabeam range in favour of increasing volume. The success of the Durabeam is due to the fact that the designer and the client worked closely together and paid careful attention to every aspect of design, production, promotion and marketing.

—Hazel Clark

Bibliography—

Lott, Jane, "Flip-top torch," in *Design* (London), May 1983.
"Illuminating Design," *Engineering Design Education* (London), Autumn, 1985.

745

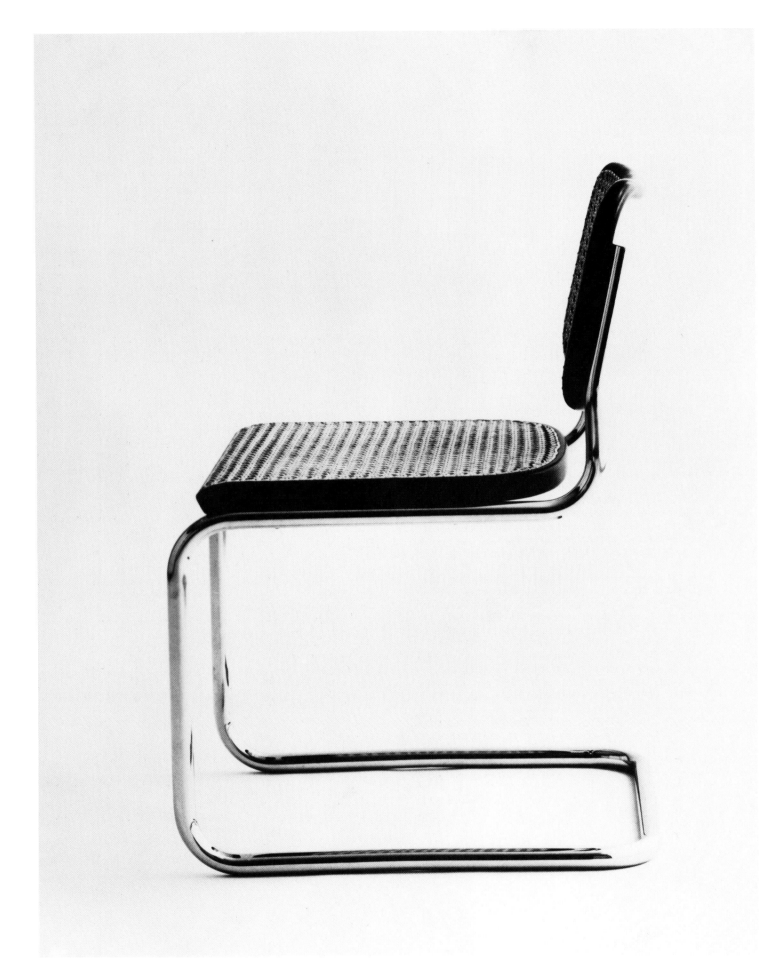

Photo © Knoll International

746

Marcel Breuer (1902–81)
B32/Cesca cantilever chair, 1924–25
Standard-Mobel 1925; Thonet 1928; Gavina/Knoll 1968

Although the tubular chair has a number of ancestors, including one made in England in 1844, there is little question that the modern version of the tubular steel chair is Breuer's invention. The idea to use chrome plated steel tubing for furniture came to Breuer while riding a bicycle. The chair is named for Breuer's daughter Cesca, just as other chairs of the era were named—the most famous other Breuer design, the Wassily chair, named for his friend Wassily Kandinsky. The first cantilevered chair prototype was developed outside the Bauhaus, even though Breuer was a faculty member there. The Bauhaus shops had no equipment for bending steel, and Breuer was also concerned about criticism of what he was doing from his colleagues. The first production of the chair was undertaken by Thonet in 1928, and by that time Breuer had also developed an armchair based on the same design. The chair was later manufactured under licensure by Gavina in Italy, and became a part of the Knoll International collection when Gavina was acquired by Knoll in 1968.

A Dutch architect, Mart Stam, designed a tubular steel and canvas chair about the same time Breuer developed his chair. It is not clear whether Stam saw Breuer's experiments on a visit to Germany in 1926. Although the question of who designed the first cantilevered steel chair is of interest, it should not matter greatly. Mies Van Der Rohe also designed a tubular steel cantilevered chair around the same time. Mies's chairs surpassed both Stam's and Breuer's in their resiliency and springy effect. Frequently in the history of furniture design several designers came up with similar new concepts without copying from each other. As it is recorded in the annuals of the history of furniture, Mart Stam's first chairs were made from pipes and pipe fittings, whereas Breuer developed the design based on continuous bent tubing. Breuer negotiated with the German firm Standard-Möbel, but at the same time with the firm of Gebrüder Thonet (makers of bentwood furniture) who ultimately became the licensed manufacturers of the Cesca chair and other pieces designed by Breuer. Negotiations with a businessman by name of Anton Lorentz on behalf of Standard-Möbel went back and forth and resulted in a number of legal actions. It is interesting to note that the Cesca chair is probably the first piece of furniture design that led to litigations early in the twentieth century. It is still today not possible to protect furniture designs adequately, and the Cesca chair is a good example. After the various legal disputes were settled, Thonet was the only licensed manufacturer until Gavina was given rights in the 1960s. There are literally hundreds of imitations made in many parts of the world. Most of these copies are cheaply and poorly made and do not stand up to wear and tear, nor do they provide the comfort, craftsmanship and appearance of the original. But if one of the imitators were to be taken to court it would be easy to claim that there are enough variations in the design to make it a new and different one. Advertisements for copies often read "Breuer type" chairs in a blatant form of unfair and dishonest business practice. The Cesca chair is made from one continuous piece of chromed tubular steel, with a single weld connecting the two ends. Because of the strength of the wooden seat and back frames, no additional support is needed. Unlike some of the earlier experiments with tubular steel chairs which had canvas seats and backs, this chair has the added textural and color contrast of the wood frame and caning. The caning makes the seat and back transparent. It was originally thought of as a reference to bentwood and cane chairs, since Thonet's main product was bentwood furniture. The wooden frame is available in natural light wood, originally beechwood, but now made in other hardwoods too. The frames also come in an ebonized finish. Years after the original design in natural caning, the chairs were also produced with a nylon caning which is stronger and more resistant to tearing. One of the important features of the wooden frame is a "waterfall" edge at the front of the seat to prevent a sharp wooden edge cutting into the users legs. None of the many copies ever bother with that kind of sensitive detail.

Over the years new methods of manufacturing were developed. For instance, with the improvement of steel technology the strength of steel tubes was increased, and gradually tubular steel could be made both stronger and thinner. These improvements resulted in less expensive and sometimes better products, and Breuer accepted some minor modifications as improvements.

In an historical context much of the modern furniture of the early 'twenties, including the Cesca chair, are not totally new concepts, but are pieces of furniture that could probably have been made during the nineteenth century too. The creative and innovative use of older materials in new ways is what has made some of these pieces so important. Breuer's Cesca chair is most likely the single most widely used contemporary classic and remains as his most influential work. Marcel Breuer was an enormously important figure in the development of the international style, first as a teacher at the Bauhaus, subsequently as a teacher at Harvard (where his students included many of this century's most influential architects) and as an architect and designer. Many experts feel that in spite of Breuer's important contributions to architecture—including the Whitney Museum in New York—his strongest interest was concerned with details and smaller scale designs, and as a result he might be remembered more for his furniture than for his other monumental contributions to twentieth-century architecture and design.

It was ironical that the Breuer chair—the first true Bauhaus product—was created outside the Bauhaus as an institution. It was "an artistically valid machine product" which could be inexpensively mass-produced. Breuer's very first tubular steel prototype chair was advertised by Standard-Möbel as being "as comfortable as well-upholstered furniture" and that "due to its durability and sanitary quality Breuer metal furniture is approximately 200 percent more economical in use than ordinary chairs." To really appreciate the importance of the Cesca chair one must keep in mind the kind of furniture that was being made in Germany and all over Europe at the time. Breuer's design was revolutionary indeed. The chair has remained a popular "classic" since its inception, and will remain so in the future.

—Arnold Friedmann

Bibliography—

Wingler, Hans Maria, *The Bauhaus*, Cambridge, Massachusetts 1969.
Pile, John F., *Modern Furniture*, New York 1979.
Campbell-Cole, Barbie, and Benton, Tim, *Tubular Steel Furniture*, London 1979.
Larrabee, Eric, and Vignelli, Massimo, *Knoll Design*, New York 1981.
Wilk, Christopher, *Marcel Breuer: Furniture and Interiors*, New York 1981.

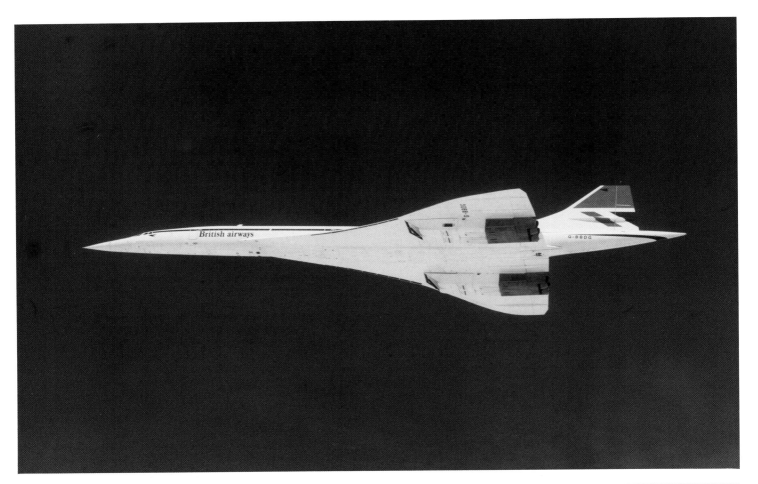

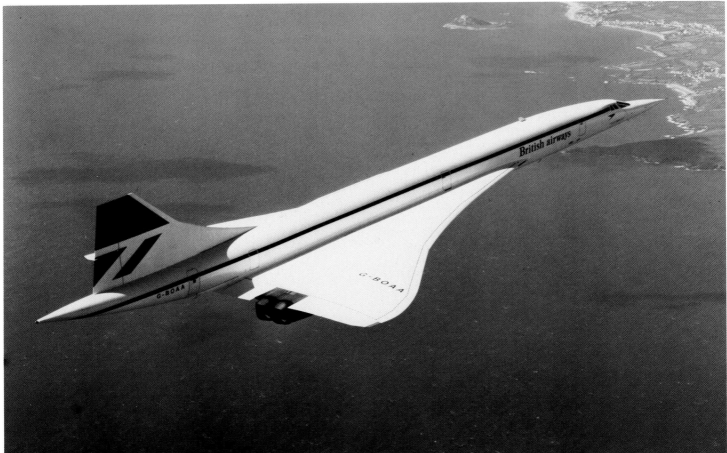

Photos British Aerospace

British Aerospace (1960–)/**Sud Aviation** (1957–)
Concorde supersonic passenger aircraft, 1962–71
61.66 × 25.6 × 12.2m.

Concorde, the only commercial aircraft capable of flying at supersonic speeds, is both an impressive technological achievement and a beautiful machine. Its beauty should not be assumed, for Concorde was not designed to be aesthetically pleasing—it was designed to function properly, and in this case function simply dictated a fine form.

Concorde was developed as a joint venture beginning in 1961 between British Aerospace and the French company Sud Aviation, although Britain had been considering the possibility of a commercial supersonic aircraft since 1956. The first prototype was completed on 11 December 1967 at Toulouse, and the first flight took place at Toulouse on 2 March 1969. The first intercontinental flight was between Toulouse and Dakar on 25 May 1971; and finally on 21 January 1976 British Airways and Air France flew the first commercial flights, from London to Bahrain and from Paris to Rio de Janeiro. The time needed between idea and first commercial flight indicates how thoroughly the design had to be tested and retested to get Concorde off the ground.

Concorde's visual trademarks are its unusual delta wing span, shaped like a narrow isosceles triangle, its pointed nose that "droops" on take-off and landing, its slender body (only four seats across), and its peculiar pointed tail. Other important though less visible design features are its engines, adapted from earlier models to reach a cruising speed of 1350 miles per hour (just over twice the speed of sound), and its extra fuel tanks (called "trim" tanks) located in the tail.

The technical feat of flying at supersonic speeds demands many modifications to standard aircraft design. When an aircraft approaches the speed of sound (660 mph at flight levels of 50-60,000 feet) the air it travels through has less time to rearrange itself, and begins to build up into a shock wave, forming a cone at the plane's nose. The rapid contraction of the air molecules into the shock wave, and their expansion once the plane has passed, cause the famous sonic boom whose disturbance bars Concorde from flying supersonically over densely populated areas. The drag—force opposite to the direction of the aircraft—caused by this shock wave is very great, and most of Concorde's features have been designed to compensate in some way for this problem. For instance, the pointed nose and tail and the slender body all cut down on air resistance. Most important, however, is the design of the wings.

The delta wing span design is ideal for supersonic flight, with low drag and large surface area for greater lift. It measures much less than the length of the body—the body is over 2.4 times longer than the wing span, as opposed to, for instance, a Boeing 737, whose body is only about 1.1 times longer than its wing span. As a result, Concorde's wing span does not cut into the shock wave

created at the speed of sound, but remains completely behind it, dramatically reducing drag. At take-off and landing, however, the delta wing span could cause the plane to stall, so the leading edges of the wings twist and droop in such a way as to separate the air over and under the wings. This separation creates two stable, slow-moving vortices over the wings, giving the aircraft the added lift it needs to fly at slower speeds.

Because the wing design makes slow flight more problematic, Concorde must also take off and land at a high "attack angle" (the angle between the aircraft and the flow of air). With a conventional design the pilots would not be able to see straight ahead at such an angle, so the nose is hinged to allow it to "droop" 5 degrees at take-off and $12\frac{1}{2}$ degrees at landing. This feature gives Concorde its unusual birdlike beak.

Concorde is powered by four Rolls-Royce/SNECMA Olympus 593 Mark 610 turbo jet engines which develop 38,050 pounds of thrust each. This engine had been developed before Concorde, and was first adapted to reach supersonic speeds for military aircraft in 1964. The engines are made of titanium and special nickel-based alloys that can handle the high temperature reached at supersonic speeds (up to 130 degrees C. at 1350 mph).

Extra fuel tanks have been placed in the tail of Concorde as a unique method of balancing the centre of pressure on the jet. As an aircraft flies faster, pressure changes and the lift moves backward, pushing the nose of the plane down. At subsonic speeds, this shift can be handled by trimming the plane with traditional aerodynamic methods; at the speed of sound, however, such methods are impracticable. On Concorde, fuel is pumped between the main fuel tanks in the centre of the plane and trim tanks in the tail in order to change the centre of gravity as needed to counterbalance the shifting pressure. The unusual pointed tail has enough extra room to accommodate these tanks.

Concorde is undoubtedly a novelty in the sky, still capable of turning heads even 15 years after its commercial inception. And as with the best designs, it is as successful aesthetically as technologically.

—Tracy Chevalier

Bibliography—

Knight, Geoffrey, *Concorde: The Inside Story*, London 1976.
Sharp, C. A., *Concorde: A Selective Bibliography 1962–1976*, London 1976.
Burnet, Charles, *Three Centuries to Concorde*, London 1979.
Calvert, Brian, *Flying Concorde*, Shrewsbury 1981.
Owen, Kenneth, *Concorde: New Shape in the Sky*, London 1982.
Orlebar, Christopher, *The Concorde Story*, Twickenham 1986.

Warhol +

THE FACE
INTERVIEW
INTERVIEW

"I have nothing to say – read my books" is Andy Warhol's standard riposte to most would-be interviewers. David Yarritu – a former assistant of his – and I were hoping Andy would say this to us because we had no intention of mentioning Edie, The Velvet Underground or soup cans, but instead he pushed an apple pie at us and suggested we joined him "working out" after we'd eaten. Andy Warhol – the quintessence of Sixties pop art and the ultimate dinner party guest – has, naturally enough, got into the new American obsession: health, fitness and diet. He has a rigorous exercise routine which he carries out daily in the new 'Factory', a former Con Edison building between 32nd and Madison. As with the old Union Square Factory, he has found another unobtrusive warehouse-type building. Valuable pieces from Andy's private art collection are propped against the walls

as you walk through the white wood corridor from the front of the building (where the Interview magazine offices are) to Andy's studio: a vast room which once housed the generators for the plant. One corner of the room is a mini-gym complete with a Yugoslavian physical fitness trainer on hand at all times. More boxes of Andy's belongings are grouped in another corner, with a large crumpled-up Jean-Michel Basquiat painting worth thousands of dollars thrown on top. On the floor are discarded silk screens of Sean Lennon. Two commissioned portraits of a Houston businessman are awaiting collection and a portrait of Jean Cocteau is propped upside down beneath a projector. Inside Andy's studio, it's like a hotel lobby. People wander in and out constantly: a woman puts some tiny galoshes on Andy's pet dog and takes it for a walk, a photographer tiptoes around the ●

abccdeefghijkllmmnoo
pqrssttuuvvwwxyz!?(+)

Neville Brody
Typeface Three, 1985
The Face magazine, London

Typeface Three (1985) is one of five alphabets created by Neville Brody for use on the editorial pages of Britain's popular style journal, *The Face*. Brody's alphabets reflect as much the cultural environment of the 1980's consumer culture as do the letters and words of the text and headlines they construct. A new vernacular of street life has materialized and is legitimized in the pages of *The Face* as much through textual content as through the specialised typefaces that Brody has produced. Brody's work has therefore generated a curious notoriety in the graphic design discipline. Indeed many critics have declared Neville Brody to be one of the 'eighties' most influential graphic designers. His work for Britain's "style bibles" *The Face*, *Arena*, and record covers for Stiff and Fetish Record provided Brody the opportunity to affect the public's understanding of their visual environment. Brody actively encouraged people to question his ideas about type and design. The media, especially *The Face*, provided Brody with a vehicle for advancing Britain's "style culture."

The immediacy of the street is incorporated throughout Brody's page spreads for *The Face*. Hastily produced fanzines of the 1970s were symptomatic of the urgency and generally recognised disposability of subcultures. These were the immediate predecessors of *The Face* whose spontaneity was emulated by founder Nick Logan and art director Neville Brody. The means of achieving this spontaneity were innovative. *The Face* deliberately restricted the amount of time permitted for writing articles as well as for design and production. In this way, *The Face* could faithfully record the style of the moment. The mood of contemporary fashion, music and design was "captured" before commodification could occur and new styles subsumed by the High Street. As consumers were legitimizing street style, *The Face* was used as a manual to guide them through the street's complex codes and language systems. Readers could operate with "street credibility" by familiarity with the pages of *The Face*.

Brody capitalized on the process of communicating the transient nature of the street in the manner in which he addressed text and image. His lack of a constrained formal typographic training enabled Brody to manipulate and create typefaces that considered the transient action and mood of the street. The moment his typefaces were assimilated into the cultural mainstream of visual language as part of an established system, Brody would immediately introduce a new *Face* alphabet. This commitment to change resulted in Brody's design of six different typefaces between 1979–86, five of which were used specifically for *The Face*.

His illustrative and "primitive" approach to type design encapsulates the subversive nature of the street reminiscent of the Punk Movement and the dynamism of Futurist and Constructivist imagery. Many of *The Face*'s headlines were hand drawn by Brody so as to stay one step ahead of his imitators. *Typeface Three* was created to replace *Typeface Two* (1984) revising an authoritative geometrical quality indicative of the 1980's social climate. Likewise *Typeface Four* (1985) and *Typeface Five* (1985) drew upon the classical nature of typographic design providing a delicate contrast to the more aggressive nature of the prior faces.

Typeface Three reflects the ephemeral quality of Britain's street culture just as the throwaway nature of general magazine formats.

The Face is designed to be "wandered" through with only occasional signposting to point the way. In order to maintain flexibility and promote the process of change, Brody built into the alphabet variants to the preferred letterforms. For example, the development of multiple alternatives for the letterforms "c," "e," "o," "m," "s," and "w" allowed headlines to be readily adapted to convey new images and ideas.

Brody based his approach on the idea that people do not read words as much as they do recognize them. *The Face* uses the letterform as a symbol or signpost to direct the reader quickly through the pages of the magazine. This approach alters the conventional language of communication. By redefining the directional symbols employed for each section of the magazine, codes are broken and appropriated with new meanings. For example, in the February 1985 issue of *The Face*, Brody designed a spread for an article on Madonna using the hand drawn M from *Typeface Three*. In the following March issue, the M was turned upside down to form a W and introduce an article on Andy Warhol. Other elements from the Madonna spread were repeated in the March spread alluding to Warhol's "use of reusables." In each instance the letterform acted as a signpost signalling the beginning of an article. A cohesive structure arises in Brody's use of typefaces. They are oblique and stretched, and subverted in *The Face*. The typefaces drawn specifically for the magazine highlight the individual nature of the publication and provide what might be understood as a "corporate identity." Similarly, a unified identity is created for the style bible's own readers.

Brody is also known for his questioning of established orders and traditional values in typeface design, particularly those produced by new technology and the development of desk top publishing. He embraces a more humanistic approach by "putting man back into the picture" and using the computer merely as a tool for experimentation. Brody's designs for *The Face* also highlight his process of drawing upon ideas and elements from history and investing them with new meanings as constructed by popular culture. His visual codes are discernable to those who already have knowledge of the language but are intriguing to those who do not. Nevertheless Brody's graphic language for *The Face* is ultimately designed for an exclusive audience, but now this language itself has been commodified and integrated into the very tradition he sought to subvert.

—Teal Triggs

Bibliography—

Farrelly, E. M., "The New Spirit," in *Architectural Review*(London), July 1986.
Wozencroft, Jon, *The Graphic Language of Neville Brody*, London 1988.
Esterson, Simon, "Brody: Lesson in Typography," in *The Face* (London), April 1988.
Poyner, Rick, "Brody on Sign Language," in *Blueprint*(London), April 1988.
McNay, Michael, "Design's Freshest Face," in *The Guardian* (London), 16 May 1988.
Brody, Neville, and Wozencroft, Jon, "Protect the Lie," in *The Guardian*(London), 2 December 1988.

Photo Finnish Society of Crafts and Design

752

Erik Bruun (1926–)
Sea Eagle poster, 1962
Offset lithography on coated paper
Finnish Association for Nature Conservation, Helsinki

Erik Bruun designed Finland's first nature conservation posters in the 1960s. These became the flagship of the Finnish Association of Nature Conservation and were shown throughout the country in numerous editions. Bruun's posters used art to speak on Nature's behalf. He drew such marvellous pictures of threatened species that they themselves became collectors' items and ended up where they were intended: in homes, schools and public places. On walls where their presence continually generated empathy and respect for Nature.

"The sea eagle was my first conservation poster and dates back to 1962. I was so enthusiastic that I got completely carried away," said Bruun. "The reason for the poster was that a tragic fate had just befallen the sea eagle: there were only 20-odd pairs left in Finland and their fertility was being adversely affected by pesticides, especially mercury, which they got from their favourite food—pike. The poisons made the birds' eggshells so thin that they broke easily during incubation. The second threat to the birds was that fishermen hated them because they took fish from their nets and salmon from streams. Thus the bird's nesting trees were chopped down."

"The first edition of my sea eagle poster, 1500 copies, was funded and printed by Finland's oldest printer, Frenchkell. Sea scouts distributed it to the areas in Southwest Finland where the sea eagles had been spotted. The Finnish Association of Nature Conservation then sponsored a second print run. We also made an agreement that the Association would sell the posters for 6 Finnmarks each, with me receiving one mark a time. As the Association's flagship, the poster became well-known and was widely distributed. One result was that the sea eagle was included in the WWF's 'red book' of endangered species. The main credit for the sea eagles' survival should go to those people who took uncontaminated food out to the islets in the archipelago in the depths of winter. Today there are about 50 pairs in Finland."

"I saw a sea eagle for the first time close up in the wilds some ten years before I made the poster. That was in 1947 when I was building a cruiser, and we were rowing in it from Helsinki across to Stockholm and back. We saw a sea eagle on the outer fringes of the archipelago and it was so magnificent it made deep impression on me."

"When I started to draw the bird for the poster I studied it in the Finnish Natural History Museum and the Helsinki Zoo. I wanted to produce a picture that would create sympathy and respect. The actual poster bird thus resembles one in the museum which has a wingspan of 2 metres 40 centimetres. I drew it with wings fully outstretched. It was done using the colours grey, brown, ochre and black. I showed the drawing to the museum's professors and they got excited. Professor Goran Bergman said that the picture showed a three-year-old bird, its age could be determined by the whiteness of its plumage; the older it got, the whiter it became. I aimed in my poster to get a graphic impression, so that it would have a more enduring value, that people would not tire of it. Some posters are after all kept for years on the wall." The poster was printed using offset-litho, to cater for a large print run. So far there have been around 15 print-runs, a total of 25,000 posters.

"Nearly all of my nature conservancy posters have been drawn. Birds and animals are often difficult to photograph, for example a diving crane or swan. Drawing can also increase the picture's effect; on an outdoor poster a drawing is far more attention-grabbing than a photograph. In the 1950s I produced a lot of drawn graphic outdoor posters, engraving them straight onto the printing plates. The development of printing techniques, however, in the '60s made this unnecessary and led to an outburst of photographic-based posters. Now, after a long period of supremacy, the graphic poster is again coming into its own."

In addition to the sea eagle, Erik Bruun has also taken the salmon, seal, and various plants as conservation poster subjects. The most widely circulated was the seal poster (1974) which carries the Finnish Nature Conservation Society's logo. The picture shows the Saimaa seal which inhabits the giant inland lake Saimaa. The actual models, however, came from the aquarium in Tampere which Bruun has studied and drawn.

Erik Bruun was one of the leading lights in Finnish poster design who did pioneering work in amongst other things modern outdoor posters. When he made the breakthrough on his own initiative with the nature conservancy posters he also opened the floodgates for a whole host of public information posters in Finland. The new generation of graphic designers started to produce antiwar, hunger and drugs posters as well as environmental ones. Text-based posters also increased. Bruun said that, "the graphic artist fraternity's skill in dealing with social issues began in the 1960s to be seen also in the improved quality of design, printing and paper. The public also became interested in posters and started to buy them for their homes." Also during the '60s Finnish poster design began to gain a worldwide reputation due to the success of artists such as Bruun in international competitions.

Erik Bruun considers it vital when designing posters to remember the target audience. The message also has to be clear if seen from a moving vehicle. Thus the graphic artist has to look for the essential, so that the message gets through. "With me, a poster is born from searching for ideas, in the best possible case when I'm in a humorous frame of mind. Success depends a lot on your own attitude. The amount of effort you put in is decisive," says Bruun.

He continues to produce nature conservancy posters on a speculative basis. Yet his work seems to have an open commission from society. The Finnish Nature Conservation Society says that: "we are always waiting to see what Bruun will think up next." He is renowned for his imagination. In recent years, Bruun has also produced work for the Finnish forest industry, including a series of pictures with forest themes. As a result of this he has started working with a camera.

—Tuula Poutasuo

Bibliography—

Fields, Jack, and Moore, David, eds., *Finland Creates*, Jyvaskyla 1977.
Amstutz, Walter, ed., *Who's Who in Graphic Art*, Dubendorf 1982.
Periainen, Tapio, and others, *Erik Bruun: Finland*, Espoo 1987.
Periainen, Tapio, *Soul in Design: Finland as an Example*, Helsinki 1990.

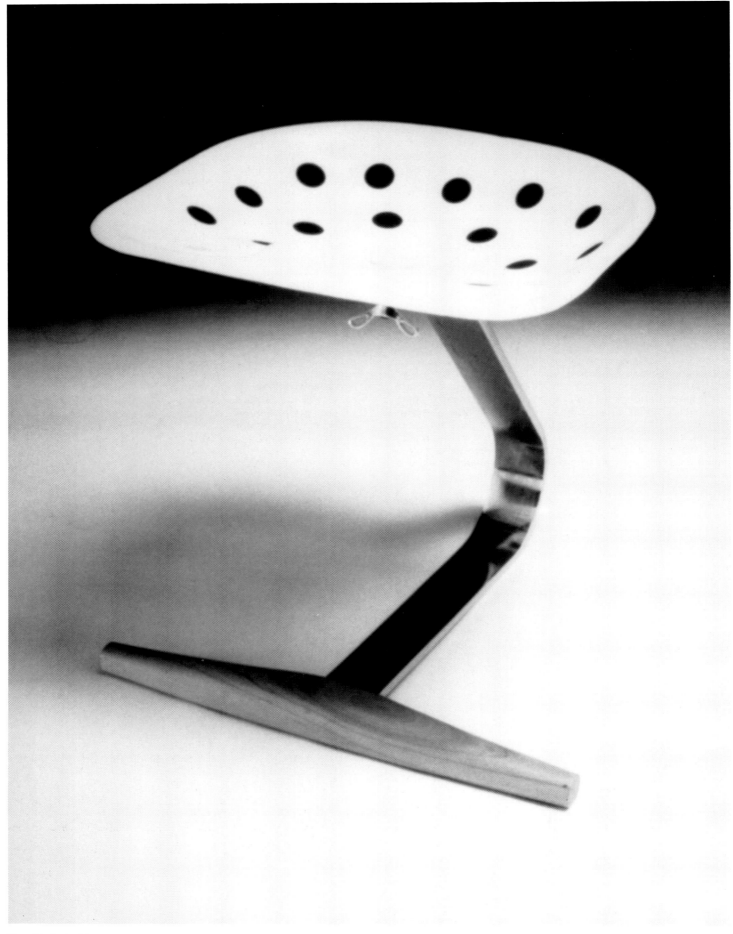

Photo The Design Museum, London

754

Achille Castiglioni (1918–)/**Pier Giacomo Castiglioni** (1913–68)
Mezzadro chair, 1957
Sheet and cast steel, with beechwood base
Zanotta, Milan

Mezzadro is one of several seats designed by brothers Achille and Pier Giacomo Castiglioni in the late 1950s and early 1960s that utilized ready-made materials. It was first publicly viewed at the X Triennale d'Milan in 1954, and appeared in its definitive version at an exhibit designed by the Castiglionis, *Colori e forme nella casa d'oggi*, at the Villa Olmo in 1957. After several minor transformations *Mezzadro* was released in its final form for production in 1971 by Zanotta, now one of the leading Milanese furniture companies. *Mezzadro*'s arresting appearance immediately indicates that it was not meant to simply blend in with the rest of one's furniture. Instead, its dramatic use of commonplace materials produced a boldly visual, and exceptionally functional, object designed explicitly for the modern interior.

Like *Sella*, another stool designed the same year by the Castiglionis which, as its Italian name implies, used a leather bicycle saddle for its seat, *Mezzadro* is made up of only a few parts, and readily reflects the playful, yet pragmatic attitude that Achille Castiglioni imparts to his designs. *Mezzadro*'s prominent feature, of course, is its bright red, stamped sheet-metal tractor seat that has been in use by farmers since the beginning of the twentieth century (now *Mezzadro*'s seat is also available in orange, yellow, white, black, or chrome-plated). The seat is attached to a chrome-plated steel stem, derived also from existing tractor parts; the tractor seat is attached to the stem with yet another ready-made part, in this case, a "butterfly" nut designed to fasten a bicycle wheel to its frame. In the same way that the stem is designed to absorb the shock of sitting on a tractor moving over rough terrain, on *Mezzadro* the stem provides the sitter with a comfortable, flexible, and slightly bouncy ride. Stabilizing the stool is a handsome foot rest, designed specifically for *Mezzadro*, made from kiln-dried beech and attached to the stem with two screws.

The use of ready-made materials in *Mezzadro* and similar works has prompted critics to examine Castiglioni's connection to Marcel Duchamp and his ready-mades. While not directly admitting to Duchamp's influence, Castiglioni does instruct his design students to pay special attention to art, because artists have fewer limitations imposed upon their work than do designers who must create within the constraints of industry. Although Castiglioni believes that artists have a wider range of possibilities available to them, he also firmly believes that these possibilities should nevertheless be considered and explored by designers when they conceive and produce their objects.

As *Mezzadro* reflects Castiglioni's appreciation and knowledge of art, it also displays other qualities constant in both the designer and his work. Castiglioni views the manufacturing process of designed objects as critically important, and his concern is expressed in *Mezzadro* by use of mostly existing parts which resolves many of the typical production problems faced by product designers. Related to the ready-made aspect of *Mezzadro* is the ease in which the seat communicates itself to its user, a tenet of great importance to Castiglioni. Any person coming upon *Mezzadro* knows at once what to expect of this seat in regard to its access, function, and comfort, and with a bit of additional common knowledge, knows also how the seat was constructed and with what materials. Castiglioni has written that he expects the appearance of his objects to immediately contribute to a person's comprehension of them, but he also believes strongly that all other aspects of the objects should work to reinforce that understanding. Thus, with *Mezzadro*, the initial surprising movement that one experiences when sitting on it, the cold sensation that one feels when first touching its metal tractor seat, and the realization of the stool's undisguised method of construction are all important factors in possessing a complete understanding of the object.

Another characteristic of *Mezzadro* shared by the best of Castiglioni's pieces, is its strong sense of wit and playfulness. The designer has noted on several occasions that pleasure and fun are vitally important aspects of his life and work. With *Mezzadro*'s name meaning "sharecropper," the audacious use of tractor parts suggests the ironic humor of a coldly functional, work-related seat used outdoors by the proletariat, transformed into an attractive, modern, fashionable seat meant for the bourgeois interior. Even when one does not consider this social analysis, however, *Mezzadro* remains a humorous, slightly odd looking piece of furniture, mainly because of the unexpected combination of parts used to produce this object of "high design." Just as humor is readily visible in Castiglioni's work, it is equally apparent in his personality, as was revealed at his warmly received "performance" at the 1989 International Design Conference in Aspen, Colorado. During his main presentation, on a stage filled with objects representing the highlights of his life's work, he discussed and demonstrated their use in an animated way that can only be described as seriously comical.

Like most Italian product designers, Achille Castiglioni was trained as an architect. Initially he worked with his two older brothers, Livio and Pier Giacomo, in their studio from 1944 until Livio left in 1952. Although Achille continued to work in close collaboration with Pier Giacomo until his brother's death in 1968, the work he produced after this maintained the characteristics and qualities of the earlier collaborative work. In addition to furniture design, Achille Castiglioni, with and without his brothers, has concentrated his efforts on lamps, electronic equipment, flatware, tableware, and exhibits, working for companies such as Alessi, Arteluce, Flos, Knoll, Lancia, Siemens, and of course, Zanotta. Founded the same year as *Mezzadro* was designed, Zanotta has consistently made a significant contribution to Italian furniture design, producing works by important architects and designers, including Andrea Branzi, Gae Aulenti, and Joe Colombo; Zanotta has also brought into production the works of earlier architects, such as Giuseppe Terragni and Piero Bottoni.

Mezzadro remains Castiglioni's best known piece, and, as such, is found in the permanent collections of numerous major museums, including the Museum of Modern Art, New York, the Victoria and Albert Museum, London, the Staatlisches Museum für Angewandte Kunst, Munich, the Israel Museum, Jerusalem, and the Uneleckoprumyslove Museum, Prague. That *Mezzadro* remains in production almost 40 years after its inception demonstrates its success as an object of seating. It also seems fitting that *Mezzadro*, Achille Castiglioni's most popular piece, appears to more closely represent its maker and his ideas about design than any other object in his oeuvre.

—James H. Carmin

Bibliography—

"Achille Castiglioni," in *Space Design*(Tokyo), November 1984.
Bayley, Stephen, ed., *The Conran Directory of Design*, New York 1985.
Ferraqri, Paolo, *Achille Castiglioni*, Milan 1985.
"Achille Castiglioni: les lumieres du design," in *Techniques et Architecture*(Paris), December 1985/January 1986.
Barbacetto, Gianni, ed., *Design Interface: How Man and Machine Communicate*, Milan 1987.
Krohn, Lisa, "The World According to Achille Castiglioni," in *Blueprint*(London), September 1989.

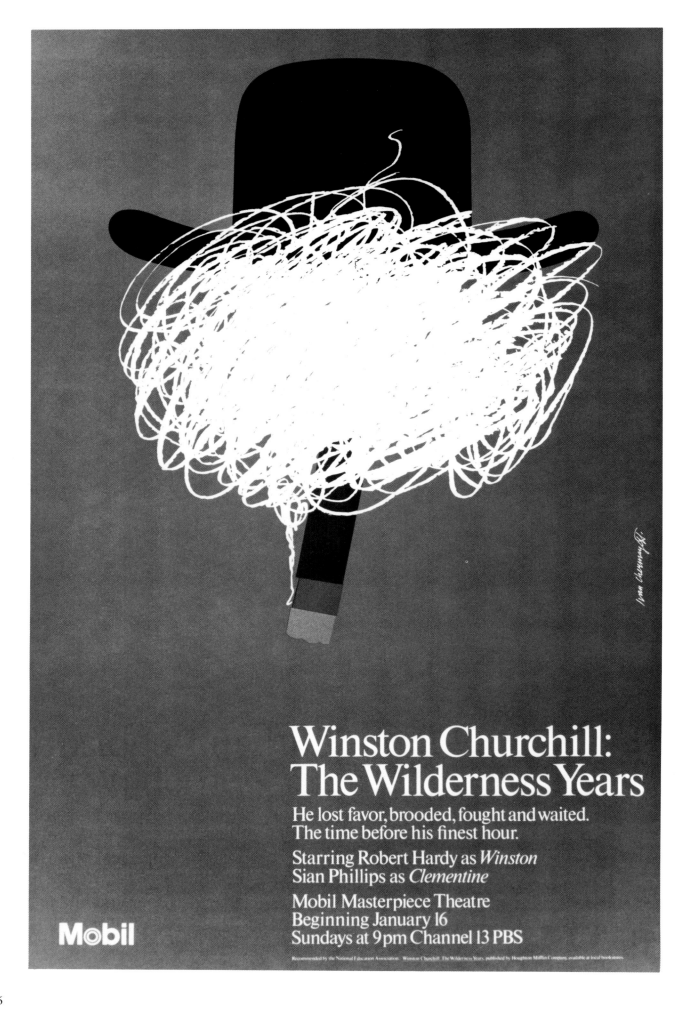

Winston Churchill:
The Wilderness Years

He lost favor, brooded, fought and waited.
The time before his finest hour.

Starring Robert Hardy as *Winston*
Sian Phillips as *Clementine*

Mobil Masterpiece Theatre
Beginning January 16
Sundays at 9pm Channel 13 PBS

Mobil

Recommended by the National Education Association. Winston Churchill: The Wilderness Years, published by Houghton Mifflin Company, available at local bookstores.

Ivan Chermayeff (1932–)
Winston Churchill: The Wilderness Years, poster, 1982
Mobil Oil Corporation, New York

This design achieves for the client what every good poster should—it communicates and compels, creating a responsive audience for the product. Using simple forms to convey a complex idea, Ivan Chermayeff has created an engaging portrait of Winston Churchill. Chermayeff has expressed visually a turbulent time in Churchill's life and he has done this in a very direct way through his use of symbol, humor, color, and style.

Chermayeff's goal with this poster is to have us watch a public television show about a historical figure. How does he pull us into this poster? He draws us in by doing the unexpected—by obscuring the face. The face is perhaps the most intriguing image in the visual arts, and by covering it up, Chermayeff piques our curiosity and leaves us wanting to know more about the person behind the smoke. He then uses two visual clues (a bowler hat and a cigar) to help us "fill in" the missing face. Remarkably, even those of us who know very little about the man, recognize this bowler and cigar to be Winston Churchill's. This is an example of how great his public fame was. Chermayeff has used these "trademarks" or "signs" to instantly tell us who we are looking at. These signs for the man are a common language understood by both the designer and by us.

Chermayeff renders the bowler and cigar with a clear style. The simple shapes of precise color, are a literal representation. The hat and cigar are simply what they are, but when placed together they belong to Churchill. Chermayeff knows his audience, people who are aware of this period in history and the man. He also assumes we have a certain level of visual experience. He uses this knowledge to create the clever and puzzling treatment of the subject. He takes what is familiar and makes it unfamiliar, by presenting it in a new way. He anticipates our reactions as we try to decipher the meaning, which is essential to the success of any graphic work.

The hat and cigar are juxtaposed with the enormous cloud of smoke rising from Churchill's cigar. There is so much of it that we cannot see a face. Thus the smoke becomes the face. Combining this image with the title "The Wilderness Years," it becomes clear that this is a visual metaphor for the conflict of this time. The method used to depict the hat, cigar and smoke reinforces the puzzling theme. The hat and cigar are flat shapes, they are all surface and you cannot see beneath them. These flat shapes contrast sharply with the texture of the smoke. The smoke is rendered by a single scribbled line that resembles a hopelessly tangled ball of kite string. You see the beginning and the end but no way to unravel it. It is also no accident that the string and the letters of the title are both white. The designer is presenting a direct link between the meaning of the words and image.

Color is used in more than just the lines and letters to enhance the meaning and the interest in this poster. The background of the poster is a large field of deep sky blue, a color that we associate with peace and tranquillity. This tranquillity is in contrast to Churchill's confusion, as depicted by the tangled white smoke. The blue also tells us that this story has its upbeat side as well. Thus, the color becomes integral to our understanding of the subject. Chermayeff knew that this serene blue would be seen in a chaotic urban environment. This thoughtfully colored poster would contrast sharply with the aggressive colors of advertising and city signs. Understanding the viewer's reaction, i.e., a natural desire for refuge amidst the clutter, he realized how powerful the blue would be in attracting someone's attention. The blue engages the viewer and compels him to take a closer look, while it adds to the understanding of the theme.

Chermayeff also uses humor to draw us into his subject. We might not expect Chermayeff to use humor to advertise a television program about the troubled times of a public figure. However, convincing someone to tune into a television program with this theme requires artful persuasion. The subject matter is not as bleak as the program's title suggests. Yes, the wilderness years were a time of both private and political setbacks, yet they were also a time of personal and public triumphs. Chermayeff's playful solution strikes the perfect balance, between the joy and sorrow of the theme. He is able to represent the subject with wit (and isn't that appropriate to Winston Churchill?) without diminishing the content. Intellectually, the solution is very pleasing to the viewer. The enormous cloud of smoke is clear hyperbole. It is exaggeration for the purpose of amusing and arousing curiosity, yet we can still appreciate the difficulty of the struggle. The style Chermayeff uses for the visual elements enhances the meaning and complements the wit of the poster. The hat and cigar are flat cut-out shapes, that contrast with the wildly drawn texture of the smoke. This contrast heightens the sense of disorder in Winston Churchill's life. The seemingly simple and spontaneous solution is a perfect means for getting the point across. If it were too complex or too formal, the humor would be lost—and with it the audience. The humor invites our participation in both the poster and television show while the graphic style reinforces it.

The playful composition and style of the poster have been influenced by some very serious art. This poster displays Chermayeff's knowledge of key movements in western 20th century modern art. The collage techniques of the cubists, the graphic shapes and colors of Matisse's cutouts, the expression of the subconscious experience of Surrealism, and the improvisation of Dada can all be seen in his solution. These references are appropriate because the designer is using a commonly understood visual vocabulary. Chermayeff knows that while we may not be able to identify these influences, we see them with a sense of having seen them before. The references to modern art also reinforce the cultured image of the client, public television.

A good poster always joins art and business. With this informative and witty poster, Ivan Chermayeff uses the aesthetics of art to satisfy the demands of the market place. He draws the viewer in, grabs his interest and then leaves him with a question, who is this man and what is he thinking? The playful composition, clean primary colors and use of "signs" that are simple yet rich in meaning are all characteristic of the best work of this gifted designer, Ivan Chermayeff.

—Stephen Chovanec

Bibliography—

Chermayeff, Ivan, and others, *The Design Necessity*, London and Cambridge, Massachusetts 1973.
Chermayeff, Ivan, *Chermayeff & Geismar Associates: Trade Marks*, New York 1979.
Lynes, Russell, "Ivan Chermayeff: A Design Anatomy," in *Design Quarterly* (Minneapolis), no. 110, 1979.
Gilbert, Martin, *Winston Churchill: The Wilderness Years*, Boston 1982.
Croft, Virginia, ed., *Posters Made Possible by a Grant from Mobil*, Zurich 1988.
Friedman, Mildred, and others, *Graphic Design in America: A Visual Language History*, New York and Minneapolis 1989.

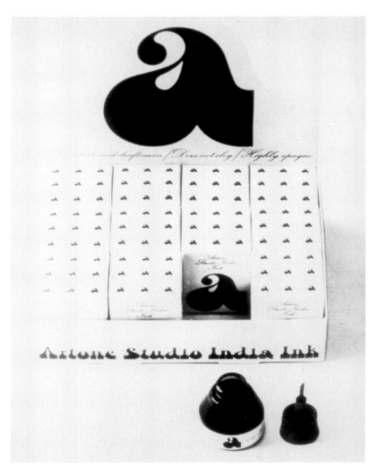 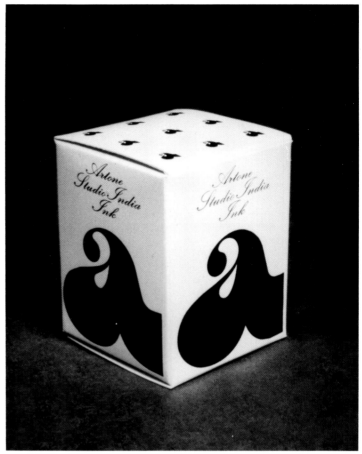

Illustrations courtesy of The Pushpin Group

Seymour Chwast (1931–)
Artone alphabet and package, 1964
Artone Studio Inks/Photolettering Inc., New York

Prefiguring Post Modernism by over a decade, the *fin de siecle*, curvolinear style known as Art Nouveau in France and Jugendstil in Germany was revived in the United States during the early 1960s as one of a number of popular historical graphic styles put to commercial use. Push Pin Studios, founded in 1954 by Seymour Chwast, Milton Glaser, Edward Sorel and Reynold Ruffins, was one of the leading proponents of this stylistic *sampling*, and was known for combining elements of Victorian, Arts and Crafts, Art Nouveau and Art Deco approaches with contemporary typography and illustration, resulting in the decidedly influential "Push Pin Style." This distinctive approach was not only a model for other American designers who were "playing" with decorative form— old and new—but fostered a return of drawing to the design process. In stark contrast to the prevailing Modern ethic applied to much American corporate communications, which rejected historicism as quaint and unresponsive to contemporary business needs, Push Pin's eclecticism was based on the idea that historical form had currency with certain mass media, including book and record covers, advertising, magazine and package design. There is probably no better example of the appropriateness of this method of historical quotation than Seymour Chwast's 1964 design of the Artone Studio India Ink carton, the logo of which was the basis for a display typeface called *Artone* issued that same year by Photolettering Inc.

In 1963 Push Pin Studios was commissioned to repackage the Artone ink carton by the new owner of the art supply company, a Wall Street businessman named Louis Strick. Since the company was small, Strick did not commission costly market research or customer profiles, but rather left the problem entirely in the hands of Chwast and Glaser (then the two remaining principals of Push Pin). As was often their procedure, each made sketches independently of the other and only later came together for reaction and critique. "We'd talk about it, do our own ideas, and then talk about it again," Chwast recalled in a 1990 interview. Glaser's proposals are lost and his ideas forgotten, but Chwast recalls doing a few variants on his best sketch showing a large "A," which, although not directly copied from an existing alphabet, echoed the fluid Art Nouveau/Jugendstil lettering he had seen in vintage issues of *Jugend*, the turn-of-the-century German art and satire magazine. In fact, the letterform was based more on the idea that "marks had to be simple and straightforward," than on replicating Art Nouveau conceits.

The impressive "A" was the boldest aspect of the design, contrasted by a delicate, lightline banknote script used to communicate all the other pertinent information. Unlike typical Art Nouveau/ Jugendstil packages on which a preponderance of florid decoration became a kind of "foriated maddness," Chwast favored a starkly unencumbered box; the only decoration was three rows of nine smaller "A"s—designed with an almost Japanese simplicity—on the boxtop. Chwast insists that using the "A" by itself was not a radical idea since making a simple, identifiable mark on a package was a proven way of establishing the identity for a product. "I knew it had to be something with graphic impact," he said. "In contrast to Windsor-Newton [a competing brand], who took a different approach by having full color paintings on their packages."

The black "A" printed on a white background was the most identifiable and menomic. In addition to being the first letter in the alphabet, and therefore memorable in its own right, its curved form was at the same time reminiscent of the Artone ink bottle and a drop of ink. Chwast, however, had acted entirely on blind intuition since he admitted that at the time he did not even realize the strong symbolic relationship until another member of the studio pointed it out to him. "Somebody said 'its sort of like an ink drop,' and I thought that was a pretty good way to sell the idea to the client."

Chwast used an existing script as the secondary typeface, but realized it would be useful for future advertising and promotional purposes to have a complete alphabet and a set of numerals. So he sketched out the capitals, lower case, and numbers over the course of one week and had a designer in the studio render the finished drawings. Chwast says the "A" was easy, while the ideoscyncratic nature of some of the other letters made them more difficult to work out. After the design was resolved it was offered to Photolettering Inc. as a display face and was immediately accepted. Yet in Chwast's mind a potential problem arose having to do with fashion. "The Art Nouveau thing had reached its peak [by 1964]," Chwast recalled, "and I thought it might be too late to put this alphabet on the market." He was wrong, however. *Artone* became very popular, if not overused. It was so popular that at least two pirated versions were issued by other photo-type houses. And the pioneer psychedelic poster artist, Victor Moscoso, credits *Artone* specifically, and Chwast generally, as influencing his own distinctive period style of design.

Chwast used the upper and lower case alphabet on the counter display box that he designed, and eventually used the alphabet on other projects having no relation to the ink, including posters and book covers. Mr. Strick was not troubled, however, that his logo was being reused as a commercial alphabet, in part because it furthered the identity of his own product. By the 1970s the popularity of the *Artone* alphabet was on the wane (though it is still used), but the Artone package and alphabet will continue to be emblematic of a era of graphic design when eclectism was at its peak, and Push Pin Studios was enlivening print communications with its creative historical revivals.

—Steven Heller

Bibliography—

Communication Arts, eds., *The Push Pin Style*, Palo Alto 1970.
Fern, A., "Seymour Chwast," in special monograph issue of *Idea* (Tokyo), January 1973.
Nishio, T., *Seymour Chwast*, Tokyo 1974.
"Profile: Seymour Chwast," in *Upper and Lower Case*(New York), September 1981.
Heller, Steven, ed., *Seymour Chwast: The Left-Handed Designer*, New York 1985.

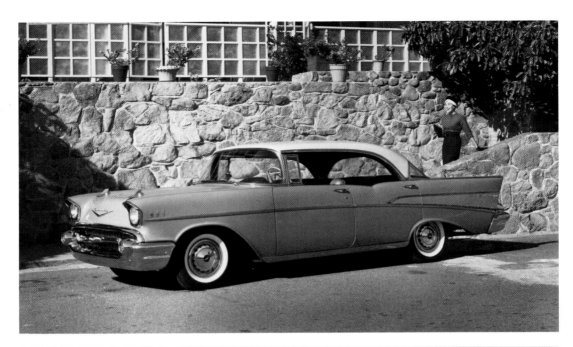

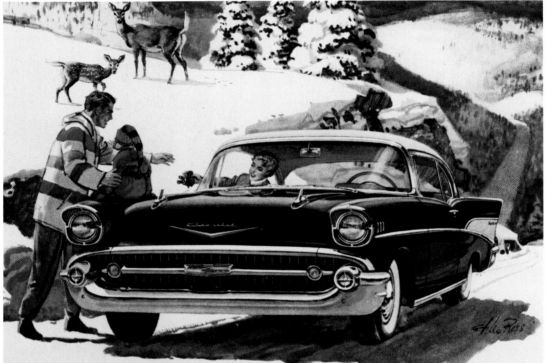

SWEET, SMOOTH AND SASSY—the beautiful Bel Air Sport Coupe. You can see and feel the solid quality of its Body by Fisher.

filled with grace and great new things

CHEVROLET

1 USA
'57 CHEVROLET

270-h.p. high-performance engine also available at extra cost. Also Ramjet fuel injection engines with up to 283 h.p. in Corvette and passenger car models.

It looks agile, graceful and easy to handle — and it more than lives up to its looks! Chevy offers fuel injection and America's first and only triple-turbine transmission.

You expect something pretty special in the way of driving pleasure the very first time you take charge of a new Chevrolet. Those clean, graceful contours hold a promise of quicksilver responsiveness. And there's something about the low, action-poised profile that tells you Chevy's a honey to handle.

It doesn't take long to find out that this car lives up to all its "advance notice"— and then some! Horsepower ranging up to 245* translates your toe-touch into cream-smooth motion. You find that turning a corner is almost as easy as making a wish. And you see how Chevrolet's solid sureness of control makes for safer, happier driving on city streets, superhighways and everything in between.

If you drive a new Chevrolet with Turbo-glide (an extra-cost option), you'll discover triple-turbine takeoff and a new flowing kind of going.

Come sample *all* these great new things!
SEE YOUR AUTHORIZED CHEVROLET DEALER

Advertisement for 1957 Chevrolet Bel Air

Ed Cole (1909–77)/ **Harley Earl** (1893–1969)
Chevrolet Bel Air car, 1957
General Motors Corporation, Detroit

From the first day in the showroom the 1957 Chevrolet Bel Air was considered a classic, the definitive "Automobilis Americanis" (*Consumer Guide*, 46). In its own ads, General Motors called the 1957 Chevrolet "sweet, smooth and sassy," a high performance automobile, with "newness" in styling. The Bel Air was the top model line for Chevrolet. Two essential prerequisites for a classic automobile are performance and styling. Ed Cole and Harley Earl were the men who provided them.

For years, Chevrolet was the largest selling car in the General Motors lineup. It provided reliable transportation at a reasonable price. An easy car to repair, it maintained a high resale value. Regardless, in December 1951 the President of GM, Charles E. Wilson, and the Vice-President, Harlow Curtice, wanted to enhance the performance of the Chevrolet and update the styling to appeal to the youth market and lose its "old fogey" image. They wanted to "turn Chevrolet around" (*Fortune*).

Edward Cole (1909–77) attended General Motors Institute in Flint, Michigan where he studied automotive engineering on a work-study program with Cadillac Motor Car. In 1949 he designed a V-8 engine for Cadillac. When the dictum came to "turn Chevrolet around," Ed Cole was called on to provide the engineering. In 1952 he became Chief Engineer for Chevrolet. His first move was to increase the staff from 850 to 2900 persons.

Using the knowledge and experience gained designing the V-8 for Cadillac, Cole and his staff developed a short block V-8 engine for the 1955 Chevrolet. Because Chevrolet was GM's lowest cost model line, the new engine had to be inexpensive to build as well as efficient and economical to run. The 1955 engine design delivered more power, with less weight than the V-6 commonly in production. By 1956, the V-8 had been refined to develop more power and by 1957 its size had been increased to 283 cubic inches displacement. For the 1957 model line, Ramjet, an innovative fuel injection system was introduced. Fuel injection delivered fuel more efficiently and smoothly to the engine. With Ramjet, the V-8 engine could deliver 283 horsepower, or one horsepower per cubic inch. This was a true competition engine. Though listed as an option in 1957, few Bel Airs were produced with it. Ramjet was a costly addition, equalling one-fifth the base cost of the automobile. In the Chevrolet sales brochure, this engine was identified as the "Corvette V-8." This was for good reason; most of the engines produced with this option were installed in the Corvette. This was the sports car first introduced in 1953, also designed by the Cole-Earl team. Though first produced in 1957, the fuel injected engine waited many years before it was in common use on the automobile. Versions of the V-8 engine designed by Ed Cole for the 1957 Chevrolet are still in production today at General Motors.

Styling is the other half of the equation which produces a classic automobile. Harley Earl (1893–1969) was Vice-President in charge of Styling for General Motors. He studied engineering at Stanford University in California. Following graduation, he designed carriages with his father, and created custom-designed cars for Hollywood stars, and race car drivers. GM hired him in 1927 to head its Art and Color Section, later to become known as the Styling Department. His staff numbered 650.

GM, along with most of the automobile industry at this time, used a three year cycle of design. Major retooling would occur every third year, and the automobiles in between would use the same basic deck, roof and door components. The 1957 Chevy was a refinement of the 1955 model. The Bel Air was available in seven different styles with either a one or two-tone finish. As with other cars of the era, the colors offered were bright, with names like Matador Red and Tropical Turquoise.

Earl commented that his primary goal as an automobile designer for 28 years was to lengthen and lower the American automobile at times in reality and always in appearance (*Saturday Evening Post*). The 1957 Chevy used the same 115-inch wheelbase of the 1955 model, but the body itself was lengthened by three inches to 200 inches long. The body was lowered through the use of 14-inch instead of 15-inch tires. With the fresh air intakes located around the front headlights, it was possible to lower the hood. Through the use of chrome and fins, the car took on a new look, one which visually made the car appear lower and longer. A strip of chrome began at the center of the front fender and carried the eye back and down to the top of the rear bumper. This was intersected with another chrome strip beginning about two-thirds of the way back, which continued on to the top of the rear fender. A wedge shape was created, which on the Bel Air was filled with brushed aluminum. The rear fender, outlined in chrome was shaped like a squared off fin of modest size. Tail fins were not unique to Chevy. Earl had used them on the 1948 Cadillac after seeing the P-38 Lockheed Lightening fighter plane. Viewed from the side, the wedge shape ending in a fin made the car seem to be moving forward, even at rest. An integrated grill and bumper, gave the front of the car a more massive feel. By also locating the parking lights on the bumper, the design gained new interest. The rear fender combined taillights, stop and directional signals and bumper guard. A panel in the left rear fender molding concealed the fuel filler cap. The Bel Air was given added interest with the use of gold anodized trim. The grill at the front, the logo and characteristic "V" symbol, and the three vents on the side of the front fenders were made of this material. Not one, but two hood ornaments were used. Overall, the car had a massive, powerful look. Earl felt a car should have interest, and called for it.

Earl's working philosophy was to "go all the way and then back off" with a design. He made the final decision, but encouraged his staff to generate and put together ideas. He felt his role was to allow them to create ideas, and stir the pot as necessary when ideas were slow in coming.

The 1957 Chevrolet Bel Air is indeed a classic automobile. One that has intrigued and drawn people to itself since its inception. Its combination of outstanding performance, and distinctive design, has made it one of the most collected cars in automobile history. Two men, Ed Cole and Harley Earl are responsible for it.

—Nancy House

Bibliography—

Earl, Harley, "I Dream Automobiles," in *Saturday Evening Post* (Indianapolis), 7 August 1954.
Chevrolet Motor Division, *Chevrolet for 1957*, sales manual, Detroit 1956.
Saunders, Dero A., "How Chevy Does It," in *Fortune*(New York), December 1956.
Chappell, Pat, *The Hot One*, Contoocook, New Hampshire 1977.
Publications International, *Chevrolet 1955–57: Consumers Guide*, New York 1987.

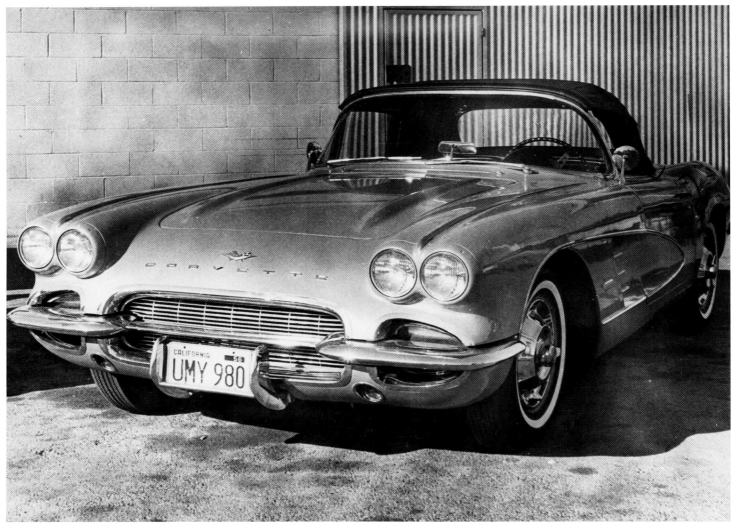

Photo National Motor Museum

Ed Cole (1909–77)/**Harley Earl** (1893–1969)
Chevrolet Corvette Mk II car, 1956
General Motors Corporation, Detroit

The Chevrolet Corvette is an automobile born of corporate faith in the idea of an indigenous, American, two-seater sportscar. In particular, the 1956 model represents the point at which this marque began to gain the degree of commercial success which ensured the continued production of the Mk2 into the early 1960s.

The first car named as a Corvette appeared as a rolling mock-up at the Manhattan "Motorama" event in January 1953, and responses to consumer questionnaires were encouraging enough to persuade Chevrolet to rush the car into production. In its pre-1956 form, the Corvette was remarkable for two reasons. Firstly, it was the only American two-seater in production, and secondly, the bodywork was manufactured entirely in glass fibre. Although General Motors' Chevrolet Division Engineering Staff, under the leadership of Ed Cole, had vacillated between using the relatively new material and tried, trusted steel, it was the perceived need to get the automobile into production as soon as possible which led to a last minute decision in favour of glass fibre. It was held that the vaccuum-bag forming process, used on the body panels of the earlier models, would facilitate the rapid production of the car.

In the event, the original Corvettes proved to be something of a disappointment. Unspectacular body styling was combined with a markedly sluggish performance. Quite simply, although the 'Vette looked as though it was a sports car, its standard, two-speed, automatic transmission coupled to a six-cylinder power plant could not deliver the necessary punch. Furthermore, in a market which was rapidly coming to expect and demand a high standard of finish, the pre-'56 Corvettes were also found wanting. No heaters, no adjustment of the passenger seat and perfunctory, clip-on plastic side windows instead of roll-down glass, all contributed to the unfavourable image of the original machines. Sales of just 183 cars in 1953, the first year of production, confirmed that if the Corvette was to survive as an idea, then a radical rethink of the design would be necessary. Sales were correspondingly dissapointing in 1954 and a 1955 surplus of over 1,000 cars led to a decision by the Chevrolet board to have a new version of the Corvette ready for launch in 1956.

Although the design for the 1956 Corvette is commonly attributed to Ed Cole and the head of General Motors' Art and Color Studio, Harley Earl, it is the work of another man, Zora Arkus-Duntov, which contributed heavily to the success of the '56 'Vette. Arkus-Duntov had been hired due to the poor initial sales and had responsibility for all facets of design save for body fabrication and styling. This was to remain in the capable hands of Harley Earl.

Arkus-Duntov instigated a range of improvements for the 1956 model, including roll-down glass side-windows, improved suspension, push-button locks, chassis improvements, an optional powered soft-top and perhaps most importantly of all, a twin-carburettor V8 engine.

He also laid plans for the introduction of the Rochester Ramjet Fuel Injection System and a range of more efficient carburettors as options. It could be argued that the Corvette did not become a successful sportscar until 1957, when fuel-injection and better carburation were combined with a close-ratio, four-speed transmission and upgraded "Positraction" axles to produce a performance car to rival the popular European marques. But certainly, Earl's re-styled 1956 body work hit the right note as far as the aesthetic of the sporting machine was concerned.

Taking full advantage of the plastic qualities of the glass-fibre panelling, Earl combined his understanding of the expectations and needs of the American car buyer with an acknowledged flair for body design. In tandem with the team at the Art and Color Studio, he produced a car which drew upon a range of influences and associations for its look; expressing at once the potential for speed, the streamform aerodynamics of jet-age influences and a sculptural massing of curved surfaces which lent the car the kerb-side stance of a thoroughbred machine.

The re-style of the Corvette for 1956 included the innovation of the concave sidewells. Picked out in a contrasting colour and edged in chrome, they begin just aft of the forward wheel arch, aping the exhaust wells of jet 'planes. The elongated curve of each semi-elliptical sidewell penetrates beyond the hinge line of the door into the door panel itself, lending the exterior geometry of the car a gracefulness usually associated with marine- or aircraft. It is worth remembering that, had the Corvette been manufactured in steel as originally intended, the curvilinear characteristics of the car may have been more subdued due to the cost involved in tooling for such designs. Fortunately, the properties of glass fibre allowed Earl to indulge in the expressive bodywork for which he had become renowned.

The 1956 Corvette looks fast. The impression of aerodynamic efficiency is re-inforced by the raked, wraparound windscreen retained from the earlier models, whilst the agressive potential of the 130mph machine is characterised by the chromed, 13-tooth radiator grille, fixed in its determined snarl. The sleek nature of the car is continued throughout the exterior styling; the twin exhaust pipes appear through holes in the curvaceous rear wings, and the rear lights are set into chromed recesses and so do not spoil the body line when viewed in profile. For the same reasons, the soft-top is hidden beneath a panel when not in use, creating an uninterrupted sweep from the rear of the cockpit to the edge of the long, curving slope of the boot.

From 1956 onward, the Corvette began to succeed in the marketplace and on the racetrack. In keeping with General Motors desire to stimulate a mandatory yearly model change, subsequent cars gained a wide variety of improvements and the combination of technological and styling innovations continued as each year a new model with an expanded range of optional extras was announced.

A stringent, mechanical assessment of the 1956 Corvette would find the car lacking in performance; with the two-speed, "Powerglide" transmission still in place, the car of that year would not have compared well with its European rivals, the Jaguars, MG's, Porsches and Ferraris, but subsequent models would more than compensate in that area. The '56 Corvette is worthy of note for other reasons; it gave Chevrolet a much needed image boost and it introduced the concept of the mass-produced glass-fibre bodied car. It is Harley Earl's styling, however, which lends the car its status as an enduring piece of 1950s, American iconography, replete with the power to prompt associations which are able to encapsulate the Zeitgeist of an era made unenthralling by dint of sheer familiarity.

—Michael Horsham

Bibliography—

Bayley, Stephen, *Harley Earl and the Dream Machine*, London and New York 1983.
Tilton, T., *Corvette: The Complete Story*, Baltimore 1984.
Koblenz, J., *Corvette: America's Sports Car*, Lincolnwood, Illinois 1984.
Langworth, R. M., *The Encyclopaedia of American Cars*, Lincolnwood, Illinois 1984.
Langworth, R. M., and Norbye, J. P., *The Complete History of General Motors 1908–1986*, Lincolnwood, Illinois 1986.

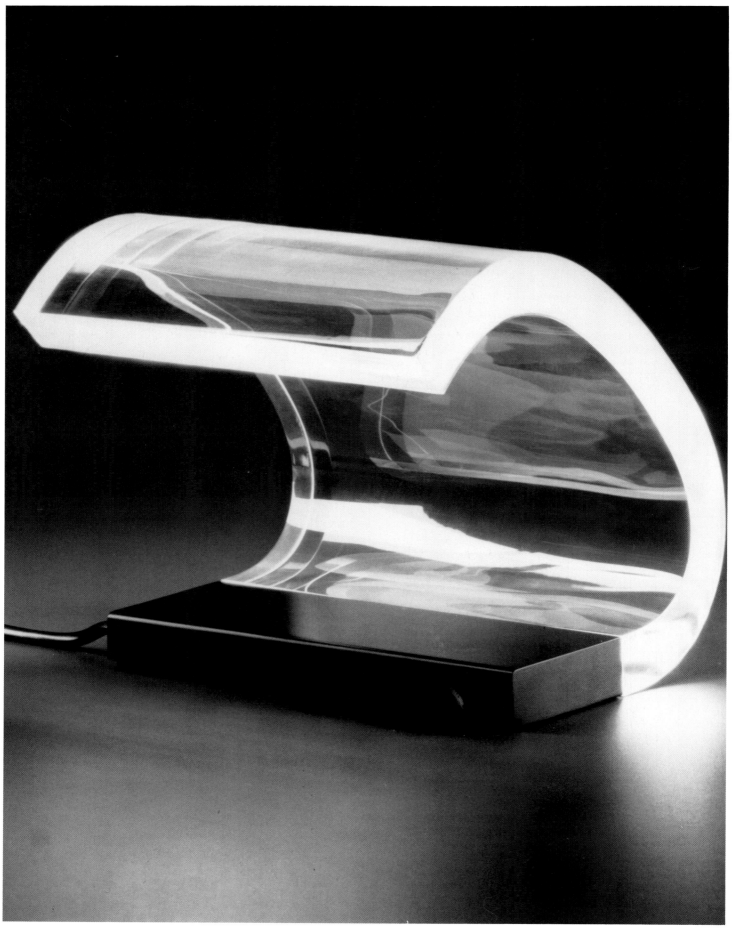

Photo O-Luce, Milan

Joe Colombo (1930–71)
Colombo 281 table lamp, 1962
Lacquered steel and perspex; 26 × 28 cm.
O-Luce, Milan

Joe Colombo was an innovative designer of furniture, glass, lighting and interiors who led Italy to prominence in industrial and interior design in the early 'sixties. Colombo was born in Milan in 1930 and died in 1971 at the age of 41, having attained international renown both for his design and his research. His investigations of new materials and concepts mirrored contemporary social developments. He studied painting at the Accademia di Belle Arti di Brera (1949) and architecture at the Politecnico in Milan (1950–54). He was the founder of the Nuclear painting movement and a member of the Concrete art movement during the 1950s.

It was only in 1962 that he turned to industrial design when he opened his own office in Milan. Collaborating with industry and department stores, he began intensive efforts to make good design widely available to all social classes. His first commission included a series of glasses for Arnolfo de Cambio and an air conditioning unit for Rheem Safin.

In the Post War era, plastics began to come into their own. By the 1960s, plastics were part of the space-age design aesthetic that dominated the era. The choice of plastics for furniture and furnishings seemed to reject the past and chart a brave new world that mixed scientific inquiry, a fascination with new materials, with elements of "fun" and freedom. Colombo was one of the pioneers in the 'sixties of new uses of plastics. For the Milan firm of Kartell who were leaders in the production of plastic furniture he designed his chair *4860*, claimed to be the first all-plastic chair produced by injection molding.

One of the reasons Italians dominated the design field was their rejection of the functional look of Bauhaus-inspired furnishings, substituting instead sleek sculptural lines. Colombo's artistic training stood him in good stead in the field of design. His clear acrylic *Colombo* lamp of 1963 is a good example of his successful marriage of architecture and art. The lamp is a transparent, curving plane cantilevered in space from its airy base made of the same material. Close inspection reveals its shape is not wholly abstract. The curves form a "C," the first initial of Colombo's last name making Colombo's lamp a precursor of adorning our bodies with fashion designers initials as a status symbol. Because of his choice of transparent materials the letter seemingly floats in space rather than being rooted in gravity. Here, Colombo eliminates the traditional apparatus of lighting fixtures. Gone are the clunky sockets and bulbs. Instead, the light is reflected upwards from a fluorescent element in its base. The curving planes of Colombo's lamp are never static. Light passes through it and it has the stylized contours of an ocean wave arrested in mid-roll. Lighting fixtures are often used by designers as keys or indexes to the total design aesthetic used. A light like this would have been equally at home in the futuristic, space-age interiors inspired by real and fictional science and the Pop interiors of swinging Mod London and New York.

Colombo's objects won international recognition for their high level of technical and aesthetic accomplishment. He received three medals at the Milan Triennale in 1964; Compasso d'Oro awards in 1967 and 1970 and the A.I.D. International Design Award in 1968. Yet, underlying all of Colombo's work is a belief in democracy—that good design belongs to everyone. His design also reflect concepts of economy and versatility as well as ergonomics, as his famous artist's storage cabinet, *The Bobby*, shows. This simple, brilliantly-colored fitted plastic cart with pivoting drawers introduced in the mid-sixties has become a standard piece of art furniture in design offices and private studios for three decades because its design is truly useful.

Although the objects he designed were acclaimed both in Italy and abroad, during the last years of his life he concentrated particularly on problems relating to man's habitats. His research

in ecology and ergonomics led him to increasingly view the individual's habitat as a microcosm, which should serve as the point of departure for the macrocosm attainable in the future by means of coordinated systems created through programmed systems of production. By the end of the decade his designs took on a more meditative and utopian quality. He began to create objects that were more like elaborate organisms than unitary objects. In his *Additional System* seating program, first shown at the Milan Triennale of 1969 and manufactured by Sormeni, he created a series of curving modular pieces, made up of polyurethane foam covered with elastic material and attached to a metal bar to give chairs or couches any shape or length desired. The pieces were stacked together like slices of toast with their upward edges becoming one of its dominate design motifs. A multi-purpose plastic table completed the ensemble. Colombo said, "The problem today is to offer furnishings that are basically autonomous, that is independent of their architectonic housing and so coordinatable and programmable they can be adapted to every present and future space situation."

As he began to emphasize flexibility and versatility, he began to think of the home as a series of interlocking component units. He designed a kitchen on wheels containing range, refrigerator, drawers, cupboard, chopping block and a stove cover that doubles as a serving tray. In 1969, Colombo made a series of rooms for the firm of Bayer A.G. at the *Visions 69* exhibit within the Cologne International Furniture Fair. These rooms were a combination of an ultra-compact yet sleek and elegant mobile home or the domestic living areas on a space ship. Based on a vision of the environmental needs of the future, they were part of his evolving social philosophy and were intended in Colombo's words, ". . . to demonstrate a suggested new way of living . . ." Philippe Garnier comments, "Freestanding furniture was rejected in favor of all inclusive capsules." Beds opened from the walls and all parts were fitted together like a jigsaw puzzle to maximize limited space.

Colombo is best remembered for the plastic living units he designed with Ignazia Favata at the 1972 Italian design show, *Italy: The New Domestic Landscape* at the Museum of Modern Art, New York. These prototypes for a *Total Furnishing Unit* featured one-piece kitchens with cylindrical cupboards and built-in television sets and dining area, as well as a "pit-type" bedroom with an attached pre-fab bathroom that anticipated the Japanese "sleeping capsules" in travelers' hotels. Colombo's early death at the age of 41 made this design stand as the culmination of his design philosophy. But, watching other designers of his generation move from futuristic social concerns back to sheer visual delight, it is not clear how Colombo's designs would have evolved if he had lived. Yet, from his love of new materials to his studies of ecology and ergonomics Colombo's work sums up the era he helped to define—the 'sixties.

—Ann-Sargent Wooster

Bibliography—

Kastholm, Jorgen, "Joe Cesare Colombo," in *Mobilia* (Snekkersten), November 1969.
Best, Alistair, "Oh, Colombo!," in *Design* (London), October 1970.
Ambasz, Emilio, ed., *Italy: The New Domestic Landscape*, New York and Florence 1972.
Mang, Karl, *History of Modern Furniture*, New York 1979.
Garnier, Philippe, *Twentieth Century Furniture*, New York and London 1980.
Grassi, Alfonso, and Pansera, Anty, *Atlante del Design Italiano 1940/1980*, Milan 1980.
Hiesinger, Kathryn, and Marcus, George, eds., *Design Since 1945*, Philadelphia and London 1983.
Favata, Ignazia, *Joe Colombo: Designer 1930–1971*, Milan, London and Cambridge, Massachusetts 1988.

Photos courtesy of Courrèges Design

André Courrèges (1923–)
Couture Future space-age clothing, 1963

In 1964 couturier André Courrèges introduced his *moon girl*. He was one of the first of a number of couturiers, including Cardin, Ungaro and Paco Rabanne, whose '60s designs were directly influenced by space travel and the moon landing.

The *moon girl* dressed in deceptively simple white or pastel dresses, coats, or trousers, worn with "space helmets," white calf-length kid boots and opaque plastic spectacles with thin slits to see through. They wore the first mini skirts to be seen in Paris. Courrèges chose fabrics with "body," such as garbardine, flat-faced tattersalls, linens, heavy cottons, and synthetics to create a sculptured effect. Silver completed the space-age "authenticity." The look depended on the superb tailoring which the young Courrèges had learned from his mentor Balenciaga. Traditional skills, perhaps ironically, were the foundation of his revolutionary design concept. Many of the dresses he created in the mid-'60s had no darts; all the shaping came from the yoke shape and the cutting of the main seam lines. Each garment was finished with extreme care. Most had enormous hems to help reinforce the rigid geometric lines.

The skill of the cutting was also demonstrated in his trousers which have been described as a *tour de force* of cut. They were seamed at the front and back for a pencil-slim fit; they curved up at the ankle in front, and dipped over the heel at the back. Worn with thigh length flared tunics or slit-backed boxy tops they, like the mini skirt, gave the visual effect of lengthening the leg. Courrèges, unlike other couturiers, envisaged women wearing trousers to any social occasion. They were not based on men's styles, as were their predecessors. Pleats, cuffs, fly fronts, side pockets and waistbands had been abolished to create a clean line from foot to hip bone. Through his originality, Courrèges had helped to liberate women from the tyranny of the skirt.

Tunics prevailed, either worn with trousers, or alone as mini dresses. His body skimming shapes came in his ubiquitous white, pale pink, ice blue, pale turquoise and cool beige. The streamlined construction was emphasised by the use of top-stitching, bias-binding, and welt seams. Courrèges was seen as the designer of "tomorrow," whose *moon girl* was to have a profound effect on future fashion. As a result he was widely copied. The geometric lines were reproduced in cheaper fabrics, which often destroyed the integrity of the original. A famous knitwear house produced Courrèges copies in double jersey which ruined the purity of line and cut. Recognising this, in 1966 he closed the doors of his salon and re-opened the following year with one couture and two ready-to-wear lines. He introduced a three-tier structure: Prototype (a couture line), Couture Future (up-market ready-to-wear) and Hyperbole (inexpensive ready-to-wear for a younger market).

The Courrèges space age look introduced boots as the ultimate fashion accessory. This surprised the designer, who commented: "With my preoccupation for the functional, I first shortened skirts for freedom, then added the boots to keep women warm in compensation. It was only then that I discovered boots to be indispensable aesthetically." His soft kid peep toe originals inspired a wealth of replicas in the high street stores. Patent leather and shiny plastic versions, often with cut outs, were worn universally, all year round. As the mini skirt became gradually shorter, fashionable boots grew from calf to thigh length.

Other couturiers interpreted the challenge of space in their own ways. In the mid '60s Pierre Cardin similarly introduced short tunics worn over tights and boots, unisex astronaut suits, hard helmets, goggles, and vinyls. Many of Cardin's designs represented the wilder excesses of haute couture. Shifts suspended from ring collars, cut out discs and squares were more sculptural than functional. As *Vogue* remarked in 1964, "Some of the occasions designers have in mind haven't happened yet." While innovatory in their own right, Cardin's futuristic garments were not to have a long term influence, unlike those of Courrèges.

At the same time Yves Saint Laurent produced shifts in sheer organza, transparent except for stripes of chevrons made of silver sequins. Ungaro, who had trained at Balenciaga and Courrèges, launched his first collection in 1965 with, what has been described as, "another leap into space." However, it was the Spanish designer Paco Rabanne who took the space theme to its furthest limits. *The Unwearables* was the appropriate title for his first couture collection of plastic and aluminium dresses, shown in Paris in 1965. The following year his repertoire extended to include dresses made of small plastic tiles linked together by chain, and a coat made of neon coloured plastic diamonds attached to white crepe. His use of synthetic fabrics and bright fluorescent colours were innovatory, but they are to be remembered for challenging the limits of fashion, rather than being influential prototypes.

Looking back with hindsight to those space age fashion years of the mid '60s, it is Courrèges who made the lasting impact. His "new look" has been compared with that of Dior twenty years before. But as Dior had looked to a romantic past for his inspiration, Courrèges preferred to set his sights on a sartorial future which would owe little to its predecessors. *Women's Wear Daily* placed him in historical context when they deemed him "the Le Corbusier of the Paris Couture". It was as a modernist and an architect of fashion that he made his greatest impact in the mid '60s. By the end of the decade "space age" had been overtaken by a nostalgic romanticism more befitting the times. A break with the past had been achieved in terms of style and attitude; it was one which would have a lasting effect.

—Hazel Clark

Bibliography—

Lynam, Ruth, ed., *Paris Fashion: The Great Designers and Their Creations*, London 1972.
Howell, Georgina, *In Vogue: Sixty Years of Celebrities and Fashion*, London 1978.
Kennett, Frances, *Secrets of the Couturiers*, London 1984.
Sparke, Penny, and others, *The Design Source Book*, London 1986.

Vespa scooter, mid-1950s. Photo National Motor Museum, Beaulieu

Corradino D'Ascanio (1891–1981)
Vespa motor-scooter, 1946
Piaggio, Genoa

Corradino D'Ascanio's design for the Vespa motor-scooter came into being partially as a response to the cultural and economic conditions prevailing at the end of the Second World War. But the impetus to manufacture such a product had arrived earlier with the bombing and virtual destruction of Piaggio's Pontedera bomber factory in 1943. With the decimation of the main factory's capacity for large-scale, heavy-industrial production and amid a chaotic rebuilding and reconstruction programme, the Piaggio company conceived the idea of the motor-scooter. Cheap to build, practical to run and easy to maintain, the motor-scooter was to combine the manouverability of the motorcycle with greater comfort and a stylish, user-friendly design.

Piaggio was a company ideally suited to the manufacture of such a machine. Having started corporate life in the late 19th century as shipfitters, Piaggio diversified into aircraft manufacture after the First World War. The lessons learnt from the continued application of small- and large-scale industrialised mass-production techniques were invaluable in the post-war atmosphere of reconstruction. To prevent the manufacture of armaments, the terms of the armistice with the former axis powers meant that no heavy industry could be operated in the defeated nations; this proviso allowed Piaggio to capitalise upon D'Ascanio's Vespa design which had been under development for two years by the time the war in Italy had come to an end.

The first production models of the Piaggio Vespa appeared in 1946, and by the mid 1950s the Vespa had eclipsed the traditional lightweight motorcycle as the favourite mode of transport of commuters and rural workers alike. After 1947, Italian industry was shorn up by the introduction of a financial aid package in the shape of the Marshall Plan, and Piaggio's future as one of the largest manufacturers of two wheeled vehicles in the post-war period was assured.

The Vespa became the flagship of the company's output and its design was, in many ways, revolutionary whilst reflecting an inherited styling redolent of the streamlining fad which had gripped the imaginations of American industrial designers in the 1930s. Like the typical designs of Loewy, Dreyfuss *et al*, the Vespa appeared modern through the device of concealing the relatively simple mechanics beneath a voluptuous and bulbous sheet metal cladding. Not only did this device distance the Vespa from the physical character of contemporary lightweight motorcycles, with their exposed engines and tendency to besmirch the user with oil,

but the fairing lent the machine a modernist character quite in keeping with the nature of Italian industrial design in the immediate post-war period. As an example of a new breed of Italian product, the Piaggio Vespa sits quite happily with Gio Ponti's design for the Gaggia Espresso Machine or Pininfarina's styling of the Cistitalia Coupé, both of which appeared in the late 1940s. The Vespa is a machine produced by harnessing the effectiveness and standards of production lines made efficient through five years of wartime operation, to a design intended to speak to consumers of modernity.

Powered by a two-stroke, single-cylinder, air-cooled engine of 90cc's capacity, the original scooter nevertheless delivered its power smoothly through a 3-speed gearbox. The fairing, which gave the scooter its original and distinctive styling also served to protect the rider from the elements in a way which no light motorcycle had yet offered. Furthermore, the sturdy construction meant that the Vespa was a durable alternative to other forms of transport and although quirky and initially difficult to ride, users soon found the machine a reliable and characterful machine.

Piaggio licensed the manufacture of Vespas to a variety of companies world-wide during the late '40s and early '50s, including Douglas in Great Britain. The ready availability of this intrinsically stylish machine underpinned the growth of the scooter mania which was to dominate youth culture in Britain during the 1960s. The Vespa, and to a lesser extent, the Lambretta, formed part of the iconic armoury of the Mods, who found their predeliction for Italian clothing complemented by the quintessentially Italian style of the motor-scooter. Its opposition to the brutish, aggressively mechanical nature of the Triumph and BSA motorcycles of their adversaries, the Rockers meant that its status as a cult object was assured.

But the functional capabilities and the flexibility of the design has meant that derivatives of the Vespa have formed the backbone of the transport policies of many emergent and newly-industrialised countries in continents from Africa to Asia. Whether as a three-wheeled Tuk-Tuk, a provincial farmer's substitute for a donkey, or a stylish mode of transport for a cashmere-suited Mod, the Piaggio Vespa is a design which has enjoyed both mechanical and cultural longevity.

—Michael Horsham

Bibliography—

Tassinari, R., "L'Alveare delle Vespe," in *Piaggio* (Genoa), January 1949.
Pica, Agnoldomenico, *Forme Nuove in Italia*, Rome 1957.
Piaggio, *Piaggio: 75 Anni di Attivita*, Pisa 1960.
Armani, R.,"Vespa e Lambretta a confronto," in *Il Piaggista* (Genoa), 7 April 1960.
Fossati, Paolo, *Il Design in Italia 1945–1972*, Milan 1973.
Heskett, John, *Industrial Design*, London 1980.
Centrokappa, ed., *Il Design Italiano degli anni '50*, Milan 1980.
Tartaglia, Daniela, *La Piaggio di Pontedera 1944/1978*, Florence 1981.
Anselmi, Angelo Tito, and others, "Vehicles 1909–1947," special issue of *Rassegna* (Milan), June 1984.
Ayton, C. J., *Guide to Italian Motorcycles*, London 1985.
Maguire, Laura, "Blame it on the Bossa Nova," in *Midweek* (London), 30 November 1989.

Vespa assembly line, Britain, 1958. Photo Hulton-Deutsch Collection

Photos courtesy of Hille International

770

Robin Day (1915–)
Hillestak stacking chair, 1949–50
Moulded plywood and beech
Hille International, London

Probably best known for his innovative design of injection-molded plastic chairs and low-cost seating, Robin Day has consistently exhibited the British propensity for producing designs of utility without forfeiting beauty. Design history is littered with the clashes of these often contradictory notions. Day has succeeded, many times, in resolving this aesthetic conflict in furniture design, in association with the British manufacturer, Hille.

Before applauding Day's successful *Hillestak* chair, we must first recognize those who paved the road for his innovative ideas. Modern design has an international foundation which is based, in part, on the Arts and Crafts movement's vernacular tradition. Mass production techniques of the industrial revolution also provide much of the impetus of modernism, and Britain played important roles in both crusades. Among the many pioneers whose innovations contributed to the development of the stacking plywood chair are Gebruder and Michael Thonet, William Morris, and Day's contemporaries Alvar Aalto and Charles Eames. These men provided some of the technological and aesthetic advancements necessary for twentieth-century architectural and decorative design.

The technical contributions of Thonet are quite obvious. The experimentations in applying mass production techniques to furniture and steam bending wood are fundamental to the innovations achieved by Day a century later. But, the contributions which led to developing aesthetic principles are not so clear. In order to appreciate Robin Day's accomplishments in context, it is important to identify the artistic and philosophical ideals which survived the industrial revolution.

England, even though a leader in the development of new materials, energy sources and mass production techniques during the industrial revolution, was reluctant to abandon the early social principals governing well designed objects of use. The late arrival of the Modern movement in Britain may be attributed to the Englishman's reticent temperament and apparent aversion to adopt extreme positions. The machine, as a result, was slow to gain acceptance as a tool of creation and production in the applied arts. This fact may have allowed the craft tradition to be maintained. As stated by Huygen's *British Design*, "Currents that set art and design on the Continent on its head, caused nary a ripple in insular Britain." And, William Morris, the acknowledged leader of the Arts & Crafts movement of the mid-nineteenth century, considered revolutionized homes in England as filled with "tons upon tons of unutterable rubbish" and that "the two virtues most needed in modern life (are) honesty and simplicity."

Through his outspokenness and his hand-crafted furnishings, Morris succeeded in reviving a level of social consciousness in the applied arts. These concepts were later applied to machine fabrication, and of course the Modern architectural movement. This served as a foundation for some of the most important and influential design of the 20th century. Architects and designers began to believe that world values could be changed through their design and philosophies, that utility should not be sacrificed to ornament.

Morris contributed the sense of craft and social consciousness to the design of everyday objects; Gebruder and Michael Thonet established quality standards in mass produced products. Robin Day, consciously or unconsciously, has continued in these traditions during a new technological revolution. This new revolution, brought about by the advancements made during and after World War II, set the stage for the "Borax" designs of the post war era. These designs could hardly meet Morris' standards for honesty or simplicity, and, similar to the aesthetic environment of the 1851 London Exhibition, fashionable aerodynamic "streamlined" styling did not promote design for lasting beauty and durability.

It was in this climate that Robin Day began the mutually beneficial relationship with the furniture manufacturer Hille. Beginning in 1950, Day's role evolved from that of consultant to one of almost total design control. Day governed all the visual aspects of Hille's business, including graphic design, logo and letterhead creation, brochures, and photography. Having supported himself through part-time teaching and exhibition design, Day assumed responsibility for the design of Hille's showrooms as well.

Appreciation of Day's furniture design was not achieved immediately. The first show exhibiting modern styled and hand-made furniture designs was poorly received. Hille had an established reputation of producing quality traditional furnishings, and this radical departure fueled negative responses from the furniture community. Hille and Day had succeded, though, in establishing a new direction; quality modern furniture which was designed by Day almost exclusively for the next two decades. The *Hillestak* chair, one of Day's first collaborations with Hille, was an important contribution to modern furniture design. Even though formed laminated woods had developed in the 1930s, new technology and glues made it possible to be widely used for mass production of furniture. Although simple in appearance, the *Hillestak* chair was somewhat labor-intensive in its assembly since it consisted of twenty two parts. In the effort to simplify assembly, and due in part to technological contributions by other furniture designers such as Charles Eames, the *Q Stak* chair was introduced about a year and a half later. This Robin Day design, while offering lumbar support, consisted of a single piece of molded plywood attached to a metal leg frame.

In spite of the conceptual doctrine of transient aesthetics which was becoming prevalent during the post-war era, Day's chair designs maintained socially accountable ideals, similar in many respects to those established by the Arts & Crafts before the turn of the 20th century. His concentration on legitimate technological advancements and experimentation, enabled mass production to support socially responsible design; to provide well made and aesthetically sophisticated products at a price within the budget of the average consumer.

—Gayla Jett Shannon

Bibliography—

Goldfinger, Erno, *British Furniture Today*, London 1951.
Pevsner, Nikolaus, *The Sources of Modern Architecture and Design*, London 1968.
Lyall, Sutherland, *Hille: 75 Years of British Furniture*, exhibition catalogue, London 1981.
Hiesinger, Kathryn, and Marcus, George, *Design Since 1945*, Philadelphia and London 1983.
Sparke, Penny, *Design in Context*, London and Seaucus, New Jersey 1987.
Huygen, Frederique, *British Design, Image and Identity*, London and New York 1989.

Photo courtesy De Harak and Poulin Associates, Inc.

Rudolph de Harak (1924–)
Metropolitan Museum Egyptian display graphics, 1974–82
New York, Metropolitan Museum of Art

To Rudy de Harak, good design is not confined to the classroom or the studio. It is a way of organizing and living one's life; it is a passion. Whether refurbishing a house in New York, where he spent the major portion of his professional life, or Maine, where he and his wife now live, or in developing plans for a new project, his convictions and commitment to aesthetic values are clearly in evidence. His life and work are all of a piece. He gives the best of himself, and expects it of others. And he has passed on these values to his students.

De Harak began his career in 1946 as a graphic designer working in studios and agencies in Los Angeles, California. In 1950 he opened his own design studio in New York. Since 1952, he has been a teacher of design and visual communications, and was chosen the first Frank Stanton Professor of Design at the Cooper Union School of Art and Architecture, this being the first permanently endowed design chair in the United States.

Reflecting his lifelong concern for perfection and excellence, and serving an extraordinarily diverse group of clients, de Harak's career has encompassed such significant projects as exhibition work for *Expo '67* in Montreal, Canada, and the United States Pavilion at *Expo '70* in Osaka, Japan. For the McGraw-Hill publishing company, he has designed more than 350 book jacket covers. Clients have also included the United Nations Plaza Hotel, the *New York Times*, the Hudson River Museum in New York, and the governments of Canada, the United States and the Philippines.

Perhaps most important of all was de Harak's innovative approach to the reinstallation of the Egyptian Collections at New York's Metropolitan Museum of Art, where, working closely with the Museum's curatorial staff and the architect, Kevin Roche, significant advances in the transmission of complex ideas and information were made.

The Metropolitan Museum's collection of Egyptian art may be the largest and most comprehensive holding of any institution outside of Cairo, surpassing in sheer numbers that of even the British Museum and including as it does great sculptures from the Temple of Queen Hatshepsut at Deir-el-Bahri, the result of excavation in the 1900s. This unique group of Hatshepsut sculptures ranges from great sphinxes to effigies of Upper and Lower Egypt. In addition, the Metropolitan's collection comprises approximately 45,000 artifacts, the beginnings of which were secured when, in 1874, the Museum's first Director, General Luigi Palma de Cesnola, sent five Egyptian objects back from a trip to Cyprus. All 45,000 objects are now on display in some 40,000 square feet of gallery space; none of the collection has been forced to go into storage, accessible only to scholars.

Thus, the completed installation provides visibility to everyone

of material from thousands of years of Egyptian art. The entire collection, in the Lila Acheson Wallace Galleries, covers a span of time from the Paleolithic Period (about 300,000 B.C.) to the Roman–Byzantine Period (31 B.C. to 641 A.D.). The Dynastic Period, to which the heart of the collection belongs, lasted more than 3,000 years (about 3100 B.C. to 332 B.C.).

In order to make the Egyptian Collection more comprehensible to the public, the objects are organized chronologically, beginning with prehistoric periods, the Paleolithic and the Neolithic, starting with the Predynastic Period (about 4300 B.C. to 3200 B.C.) and proceeding century by century. Within each gallery is an orientation area, where those who wish may study the background text of what is being displayed. Here, de Harak has designed a series of light-box tables, four feet long and twenty inches wide, of steel and glass (reiterating the polished steel and glass of the exhibit cases) at which visitors may sit (on bentwood chairs) or stand and read about what they are going to see.

At one point, mounted at eye level on a wall, is a twenty-five foot long light-box. Incorporating transparencies of maps, artifacts and diagrams, and using Caslon type, which particularly relates to the Metropolitan's image, de Harak's graphics suit both the surrounding architecture and the collection. On-site identification of artifacts is screened onto glass cases or attached to walls.

The floors are a rose-colored granite, approximately the shade and texture of Aswan granite. Throughout the exhibit, limestone forms background walls and bases on which sculpture is displayed. The materials are purposefully kept simple, and wherever possible, in keeping with those found in Egypt. Against the limestone, a green carpet runs through the exhibit space to invoke the green strip of vegetation running along the Nile.

This installation marked a major innovation in art museum display and, along with the high level of excellence in technique and the imaginative thrust of his body of work as a whole, has contributed to Rudolph de Harak's justifiable reputation as a modern designer.

—Arthur Rosenblatt

Bibliography—

Hoving, Thomas, *The Second Century: The Comprehensive Architectural Plan for the Metropolitan Museum of Art*, New York 1971.
Metropolitan Museum of Art, *Time Line of Culture in the Nile Valley and Its Relationship to Other World Cultures*, New York 1978.
Print Casebooks 3: The Best in Exhibition Design, New York 1978.
Print Casebooks 4: The Best in Exhibition Design, New York 1978.
Henrion, F. H. K., *Top Graphic Design*, Zurich 1983.

AIRFIELD

abcdefghijklm
nopqrstuvwxy
zæøå

ABCDEFGHIJK
LMNOPQRSTU
VWXYZÆØÅ

&?/!-(;.:) →

1234567890

↑ Afgang
Departures ↑

← Transit check-in
Transit check-in

Toiletter
Toilets ↘

← Butikker
Shopping

Fotografering forbudt
No photographing

Gate
Gates **27-41** →

Illustrations courtesy of Per Mollerup/Designlab

774

Designlab ApS., Valby: Per Mollerup (1942–)/**Bastian Andersen** (1948–)/**Trygve Hansen** (1952–)
Kastrup Airport signage system, Copenhagen, 1987–88
KLV Kobenhavns Lufthavnsvaesen, Copenhagen

The major developments of our time are information systems. Most of the advances in contemporary science emerge from the twinned arts of code-breaking and the restructuring of codes. Genetic engineering, molecular biology, chaos science, pharmaceuticals, molecular physics, and other non-electronic media have grown from information theory, while media born of the computer revolution include non-film photography, video, robotics and telecommunications. Of the many innovations that define life in post-industrial society, two are machines: one of them is the computer, and the other is the modern airport.

The modern airport is not quite like anything that has gone before: it is the radical descendant of primal ancestors, much as the computer saw its protozoan form in Charles Babbidge's computing engine. The crossroads, the city hub, the railway station are early cognates of the airport, preserved in fossil form in the patterns of urban life—but the airport is related to them as the modern horse is related to its dog-sized, three-toed ancestor. The railway station was the metaphor of the Victorian age: it is to the contemporary airport as the steam engine is to the computer. Its principles and its effects are so radically divergent that it is another kind of device entirely.

Today's airport is only partially connected to the environment around it. It is directly connected to the *other* airports with which it is linked in an increasingly vital network. It is estimated that over two billion people will fly annually by the year 2000 in Europe alone. That statistical sleight-of-hand counts person-trips instead of people, but it makes clear that a new civilization is forming in the skies, housed in the atmospheric shell of an Earth that is about to seed the planets and stars with life. The way we think about and organize ourselves through airports will become an organizational principle for much of our future.

In this, the Copenhagen Airport is an advanced example of what the modern airport should be. And much of this is due to the signage system, the device by which Per Mollerup and his Designlab team have given shape to the flow of human traffic.

In 1989 the Copenhagen Airports Authority (KLV) called for a signage system with a clear briefing. Managing Director Knud Heinesen wrote, "KLV shall not only be an effective but otherwise anonymous machine. KLV must be an organization with a personality which is considered attractive by employees, business relations and passengers." KLV executives recognized that an airport is a machine—and they knew that this machine must be user-friendly in order to succeed in its primary task of guiding and programming users. KLV set out to make an airport designed for the convenience of people, not of planes. Copenhagen would be to airports what the Macintosh is to computers.

If KLV recognized that an airport is a machine, Per Mollerup and Designlab recognized that it is also an information system. They based their work on modern communications theory. Mollerup later wrote that, "we used the concepts of *grazing, browsing* and *hunting*,"—the terms created by American computer expert Mark Heyer. "Grazing" means taking in all information in a passive, sometimes trance-like state, without differentiating between good information and bad. "Browsing" means scanning large bodies of information with no particular end in mind. "Hunting" means seeking specific information. While Designlab hadn't heard of Heyer when they designed the signage for Copenhagen, they had already perceived that airport as an interactive system—a system modelled on the interactive information-based technology of the computer age.

In an international airport, at least two languages are necessary. The logical choice for the first language was Danish, native language of Copenhagen and a language easily read by the twenty million residents of the Nordic nations for whom Copenhagen is the major air hub. The second language must be English, the common business language of Europe and the global air transport language. For a major Nordic, European hub, more than two languages would increase clutter without adding comprehensibility. Danish and English were deemed both necessary and sufficient. Two languages require three colors for greatest legibility. Experiment shows either black or yellow offer the greatest visibility, with white a best second color. Although black works well on yellow, such a combination is also recognized as a danger signal in many cultures—whereas white on yellow cannot be read. Both yellow and white are easily read on black, and each has a simple, elegant effect that satisfies aesthetic and well as communication standards. A slight shift of black to a dark blue adjusted the hortatory overtones of black signage, giving pleasant and calming signs with crisp, bold character. The typeface was designed for an optimum balance between space economy, the open qualities that make letters readable from all angles, and clarity. And thus the many simple and useful signs that are characteristic of Copenhagen Airport were born.

In all cases, clutter gave way to simplicity. In some cases, the reductions were drastic. On airport buses, for example, signs had been placed on the doors. The problem was simple: when the doors were open, the signs vanished into illegible abbreviations. Rushed, tired or tipsy passengers disembarking from long flights need to know where they are, so the buses were hardly a welcoming service. A simple shift to small, clear signs *over* the bus doors made all the difference. While designers are still debating the principle that "less is more," here is the one case where it is an absolute fact.

Mollerup points out in his frequent public talks that a central problem of the information age is information clutter. "The problem," he says, "is not that we lack data, but that we have too much—without being able to find precisely what we need." The creative, friendly minimalism of the Copenhagen signage system is an answer. That is why Designlab rejected the suggestion that more signs in more languages be used: 5,000 signs would not be easier to read than the 1,100 signs that are in place now.

The result is an interactive system. Bored or weary passengers in transit for several hours can graze the airport as an entertainment pasture. Passengers in search of options can browse among airport shops and services. Hurried passengers rushing to a flight—or a quick stop at tax-free shopping on the way—can find what they seek after a quick, efficient hunt. The airport is so effective and user-friendly that many passengers with transit selection choices actually book Copenhagen as their preferred hub.

Copenhagen Airport is an immense machine, and the signage works in the vast context of a vast system. The decisions of airlines, stores, service centers, architects, passenger routing experts, and a hundred more cooperating—or occasionally conflicting—factors affect what the passenger will experience between flights or on the way in and out. Designlab saw that the purpose of signage is not decorative, but functional—*and* recognized that aesthetic considerations do affect communication. In every choice, the designers sought to fulfil the briefing by achieving a signage system that ties all parts of the airport together. This is one of the world's masterpieces of design: simple, clear, bold, and as friendly to the passenger as it is efficient in communication. Friendliness and efficiency together result in an effective signage system, and information base that fulfils the KLV's requirement that its design program make Copenhagen an airport with an attractive, welcoming personality.

—Ken Friedman

Bibliography—

Mollerup. Per, "Take-off for a new design," in *Design Danmark* (Copenhagen), October 1989.
Mollerup, Per, "Communication Takes Command," in *Scandinavian Design 1990—Towards 2000*, Malmo 1990.
Backlund, Nicholas, "Pure and Simple," in *ID* (New York), May/June 1990.

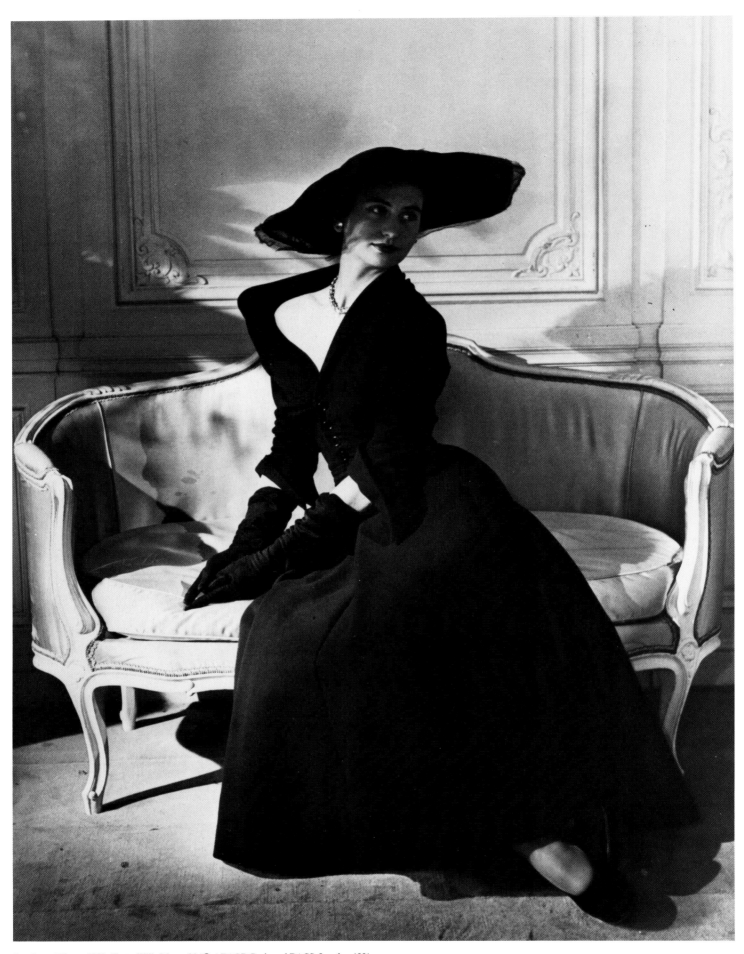

Day dress, Winter, 1948. Photo Willy Maywald/© ADAGP, Paris and DACS, London 1991

776

Christian Dior (1905–57)
New Look fashions, Paris, 1947

Christian Dior's *New Look* breathed excitement into the closets of women throughout post-World War II Europe. Introduced in February 1947 by Dior, the widely copied *New Look*, as Carmel Snow of *Harper's Bazaar* christened Dior's style, arose largely as a reaction to the deprivations of war.

During World War II, fashionable Parisian women had worn short, narrow skirts and squared shoulders. The 1947 collection, which was Dior's first, showed rounded shoulders; luxuriously long, extremely full padded A-line skirts made up in rich fabrics; full, rounded, and padded boned corsets; Edwardian-style Gibson blouses, or suit coats with generously padded hips; and high-heeled shoes. The *New Look* became as important for what it symbolized to women in the postwar era as for its artistic merit.

Dior previously had been virtually unknown as a designer, but enjoyed the support of well-known society figures such as Christian Berard. The collections that followed Dior's debut, until his death in 1957, were more innovative than evolutionary. Dior's hemlines and skirt widths varied and the A-line, which remained popular into the mid-1950s, was followed by the Y-line and the H-line, or sack dress, during the 1950s.

Although earlier collections of Parisian designers had shown aspects of the *New Look*, it was not until 1947, when Dior showed his first collection, that the *New Look* found a unified voice. Dior wrote that, "We were emerging from a period of war, of uniforms, of women-soldiers built like boxers. I drew women-flowers, soft shoulders, flowering busts, fine waists . . . and wide skirts." Dior's look was so fresh that the designer was heralded as the man that "saved the French fashion industry." Indeed, many critics have observed that World War II marked the decline of European design dominance and the rise of New York in other design fields, but in fashion, Paris and Europe in general have retained their importance. American and European women continued to follow Parisian fashion with almost unqualified enthusiasm.

Dior, once described by Cecil Beaton as "a bland country curate made out of pink marzipan," and the *New Look* that Dior championed—and of which Beaton was a fan—were at first much loathed, although the *New Look* enjoyed tremendous popularity from the time of its introduction. Many European women, subject to the restrictions of fabric rationing, were unable to follow the fashion. The British government asked designers in that country to boycott the unpatriotic *New Look*. British Board of Trade president Sir Stafford Cripps proclaimed, "It seems to me utterly stupid and irresponsible that time, labour, materials and money should be wasted on these imbecilities." After Princess Margaret adopted the fashion, however, the Board of Trade, acknowledged that it could not "dictate to women the length of their skirts." Some female politicians proclaimed the unwieldly *New Look* sexist. It is likely no coincidence that the leading designers of the *New Look* era, Dior, Pierre Balmain, Cristobal Balenciaga, and Norman Norell among them, were men. Coco Chanel, then retired, rejected the *New Look* as excessive, and observed that one could not bend over while wearing a boned bodice. Others—a minority—found the styles overly cumbersome and impractical. In some sense, it

seems that the postwar world was not yet ready for the *New Look*. Retro though it was, the *New Look* was revolutionary fashion; fuel and fabric were in short supply and the *New Look* was decadent in its excess.

The *New Look*, however, offered luxury and fantasy to the war-weary European and American women who embraced the style. The *New Look* also demonstrated the growing power of ready-to-wear mass-marketers. Department stores from Neiman Marcus to J. C. Penny's in the United States carried versions of the *New Look* by 1948. The same phenomenon occurred in the United Kingdom, where clothing rationing ended in 1948.

The arrival of the *New Look* was accompanied by—and symptomatic of—the return to traditional sex roles that women had been forced to relinquish during the war. Women's magazines once again began to address issues related to beauty and fashion almost exclusively, abandoning the more practical topics they had addressed during the war; more than half of the U.S. women enrolled in universities dropped out to reassume their domestic roles. The appearance of the *New Look*, Cecil Beaton claimed, "was one of those rare moments in the chronicle of recorded fashion when women staged an abortive revolt against the tyranny of a vastly expensive change that required the complete discarding of their old wardrobes."

It has been suggested that the Boussac textile group, Dior's financial backer, encouraged Dior to produce designs that required large quantities of fabric; and a story long has circulated that the Boussac interests pressured Dior to make use of their warehouses full of surplus wartime parachute silk. Dior himself, however, wrote of being influenced by la Belle Epoque, the last years of which he spent in Paris, and it is clear that his *New Look* designs, with their rigid corsets and padding and their curvy, romantic, and neofeminine styling recall that earlier age. Some critics have suggested the *New Look* is no such thing; that it is, in reality the old look redefined; and that its devotees were looking back to the security of the prewar era in which, as Dior wrote, "everything was directed towards the art of living."

There can be no question that the *New Look* stands alone as the most important of early postwar fashion innovations. It helped Paris and the world shake off the deprivation and emotional hardship of World War II and injected flair into Paris's faltering fashion industry. For all its controversy, Dior's *New Look* was novel and exciting at a time in which Western women felt a need to reassert their femininity.

—Diane Pascal

Bibliography—

Dior, Christian, *Talking About Fashion*, New York 1954.
Beaton, Cecil, *The Glass of Fashion*, Garden City, New York 1954.
Dior, Christian, *Christian Dior and I*, New York 1957.
Batterberry, Michael and Ariane, *Fashion: The Mirror of History*, New York 1977.
Steele, Valerie, *Paris Fashion*, New York 1988.

First of a
seven-part series

"Black History:
Lost, Stolen or Strayed."

America has camouflaged the black man. For three hundred years the attitudes of white Americans to black and black Americans to white have been subjected to misunderstandings, erasures and distortions damaging to both. The black American's achievements have been misplaced, his contributions obscured. He has been told so often who he is not that he no longer knows who he is. And the frustrations of his search for identity and recognition underlie much of today's crisis of alienation in American society.

Tonight, in the first of a seven-part series broadcast on Tuesdays in the coming weeks, CBS News tries to set the record straight to help close some of the gaps of understanding that separate black and white America.

In tonight's broadcast, Bill Cosby, actor and comedian, guides us through a history of the attitudes that have distorted the image of the Negro in America. He shows how those attitudes were formed and what they have done to us. He shows the black man's need to know who he is and what happens to him when he cannot find the answer.

On succeeding Tuesdays, Of Black America will present a study of the Negro soldier, a conference of black American and African leaders, a public opinion survey of black and white attitudes, a look at what the black American has contributed to sports and music, a history of slavery, and an examination of African life and

civilization through the eyes of three young black Americans.

Sponsored by Xerox Corporation, with Perry Wolff as Executive Producer, Of Black America presents the Negro in a new light, with balance and perspective. If it helps both black and white Americans to understand each other a little better, if it helps to change some of their attitudes toward each other, it will prove to be one of the most rewarding series ever presented on television.

OF BLACK AMERICA
10 TONIGHT CBS NEWS ⊙ 2

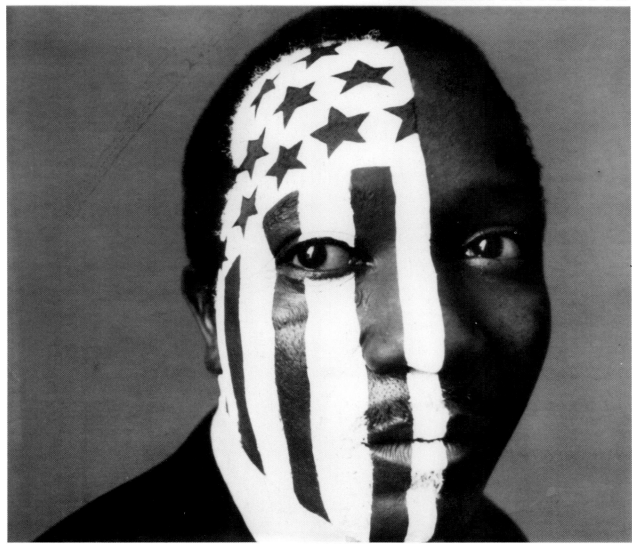

Photo courtesy of Lou Dorfsman

Louis Dorfsman (1918–)
Of Black America newspaper advertisement, July 1968
Columbia Broadcasting System, New York

Is this a portrait of Black America in 1968? Lou Dorfsman's newspaper ad posed this provocative question for a series of CBS News programs two days before the Fourth of July. CBS wanted to be seen as a network that presented not just the "news of the day," but one that presented a broader social context for that news. What makes this ad so memorable is not why Dorfsman produced it for CBS, but the results of that collaboration.

When this ad appeared in July of 1968, the Civil Rights Act was four years old, the Voting Rights Act was three years old and the Fair Housing Act had just become law. There had been 100 riots in American cities the previous year. On April 4th, the Rev. Martin Luther King, Jr. had been assassinated in Memphis, Tennessee. "The Poor People's Campaign," a march on Washington, D.C. by the nation's poor, that began after Dr. King's death and ended with the raising of Resurrection City on the Mall, was underway. The struggles of the Civil Rights movement were much on the minds of the American people and in the news.

In this ad, Dorfsman uses graphic stripes and the face as powerful metaphors that carry meaning on several levels. For example, he challenges our perceptions of the black man and confounds our knowledge and feelings about the American flag as a symbol of justice. When we consider what the American flag symbolizes, these words come to mind—justice, equality and freedom. The vertical stripes of this flag imply just the opposite. They suggest, among other things, prison bars. The stripes signify injustice, inequality and suppression in this context. Because the stripes are painted directly on the man's face, he does not simply look out from behind them—they have become a part of him, a man imprisoned by the color of his skin. This is a visual statement of the black man's feelings of oppression by an America where, as Martin Luther King, Jr. said, "the promises of freedom and justice have not been met." In addition, the very act of painting his face is an invasion of this man's privacy and thus makes us very uncomfortable. We cannot ignore what has been done to the man, and Dorfsman forces you to think about the man's plight in personal terms.

The stripes also obscure a portion of the man's face. This conveys the idea that, despite the efforts of white America to conceal the achievements and contributions of Black Americans, they are very much a part of the nation's heritage and must be recognized. Thus, Dorfsman states in visual terms another objective of the series—to expose some of these racial misrepresentations.

The expression on the black man's face is a deliberate choice by Dorfsman. The man's face does not show defiance, despair or resignation. The man does not rage in anger or cower in fear. He is neither aggressor nor victim. We cannot tell who he is, where he stands, or how he feels. His expression is explained by the words from the ad, "He has been told so often who he is not that he no longer knows who he is." However, despite the lack of expression there is a sense of dignity that is conveyed by this man's face which is in marked contrast to the indignity of the painted mask. His self-respect remains visible despite the humiliating attempt to obscure it.

Dorfsman has eliminated all but the most important elements in this portrait. He has dressed the model in a suit and tie, a symbol of success and conformity. His hair and moustache are short and well-groomed. We are not distracted by clothing, grooming or style—all are played down. These details have been neutralized so that we will focus our attention on the man's face and particularly his eyes. Dorfsman leads us to the eyes by painting a stripe directly over one of them. We are very aware of an open eye staring at us. It makes it difficult to look away. Dorfsman crops the image very tightly top and bottom to further direct our attention. By cropping the image this way, it compresses the space the figure occupies which exaggerates the tension of the composition. It can be no accident that the model has a scar under his eye that is only partially covered by the stripe. This cannot help but remind us of the suffering that the black race has endured, suffering that cannot be covered up.

In this ad, Dorfsman borrows the traditional newspaper layout—a large, bold headline with simple columns of text type accompanied by a photograph. Using photography to illustrate the ad seems a logical choice. Photography, especially in the newspaper, makes a pointed reference to the objectivity of photojournalism and reinforces the immediacy of the subject. Photography is the best choice because unlike illustration, photography is perceived as reality. To see a real black man painted with a white flag is more powerfully disturbing than any drawing or painting could be. We expect to see news handled in this way, but this thoughtful layout and artfully composed photograph are in such strong contrast to its surroundings that we cannot ignore it as we page through the newspaper.

Perhaps one of the most remarkable things about this ad was not that such an unsettling image appeared when it did, but that Dorfsman was free to produce it without interference from CBS management. He was accountable only to his own standards of excellence. Dorfsman joined CBS in 1946 as Assistant to the Art Director and worked his way up to Vice-President, Creative Director of CBS Broadcast Group. This powerful position showed that CBS recognized the profound impact that intelligent graphic design could have, especially in the gifted hands of Lou Dorfsman. CBS, in what they viewed as their own best interest, had given Dorfsman the creative power to develop a communication and marketing solution by any means that he felt appropriate. This classic work, whose impact and timeliness has not diminished since it first appeared, is an example of what can happen when an exceptionally talented designer is given the support he needs by a client with vision and courage.

—Stephen Chovanec

Bibliography—

"CBS and Lou Dorfsman," in *Idea* (Tokyo), March 1971.
Leu, Olaf, "American Designer Lou Dorfsman," in *Novum Gebrauchsgraphik* (Munich), no. 3, 1982.
Meggs, Philip B., *A History of Graphic Design*, New York 1983.
Hess, Dick, and Muller, Marion, *Dorfsman and CBS*, New York 1987.
Weisbrot, Robert, *Freedom Bound: A History of America's Civil Rights Movement*, New York and London 1990.
Heller, Steven, and Fox, Martin, "Why Design Declined at CBS: A Conversation with Lou Dorfsman," in *Print* (New York), November/December 1990.

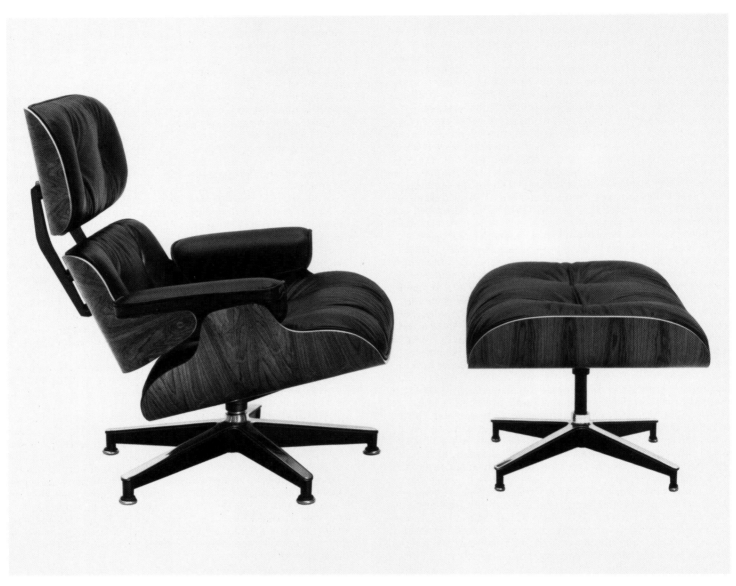

Photo courtesy Herman Miller, Inc.

Charles Eames (1907–78)
670 swivel lounge chair and ottoman, 1956
Herman Miller Inc., Zeeland, Michigan

This swivel lounge chair and ottoman is one of a number of outstanding chair designs created by Charles Eames. It is probably the best known, although due to its high price, not as widely distributed as some of his other chairs. Eames was one of the twentieth century's most creative designers of furniture, an exhibition designers and filmmaker, but his consummate interest was in the design of chairs and in the development of new technologies for manufacturing chairs. One of his earliest successes was a chair he designed jointly with Eero Saarinen for the Museum of Modern Art Organic Design Competition in 1940–41 and was awarded first place. At that time, because of problems with shaping plywood, the chair was not manufactured. All of his production designs for furniture were (and most still are) manufactured and distributed by Herman Miller, Inc. of Zeeland, Michigan. The swivel lounge chair and its companion ottoman are marketed under the catalog number 670 and 671 respectively.

One of the significant techniques developed by Charles Eames and by his wife Ray, who was his lifelong design collaborator, was the molding of plywood. Eames spent many years working on prototypes and models, and Herman Miller invested considerable sums of money for various new designs. The ultimate development in molded plywood is this famous lounge chair. Since its introduction, it has become fixed in the design field as well as in popular imagination as the archetype of the modern chair at its best. It is important to keep in mind that until the availability of the 670 chair, modern armchairs were either huge, bulky, and often ugly designs, or else they were uncomfortable compared to traditional lounge chairs. The support and comfort of the Eames chair is recognized by almost everybody who has ever sat in the chair (realizing that chairs in general evoke different reactions based on the size, weight, and expectation of the user). In spite of its considerable size, 33 inches high, 33¾ inches wide, 33 inches deep, the chair appears far less bulky than fully upholstered armchairs, and fits much more readily into apartments and houses built in the latter half of this century. Large seating units are most happily accommodated in modern interiors when they have an architectural look; that is, when they are geometric, boxy looking constructions, acting as foils to the lighter chairs which usually are used together with them. Eames is the only designer who succeeded in the creation of a lounge chair which surpasses the comfort of old fashioned club chairs, and has achieved this in terms consistent with his lighter and more casual designs. Within a period of a few years, the chair has also become a symbol of sophistication as well as a status symbol. It has been used widely in advertising as background for fashionable products or people. It is also one of the most widely imitated designs. Design patents are still hard to enforce. In a way, the endless poor copies of the 670 chair have never come near the comfort and quality of the original. Most of the copies were not accurate. For instance, the base of many copies had four prongs instead of the five as in the original. The craftsmanship and detailing were usually primitive. Hence it is likely that the numerous unlicensed copies have helped make the chair better known, and make the original more sought after.

Within one generation, the Eames lounge chair has taken its place next to the other great icons of the modern era chairs and it is destined to remain one of the all time great furniture designs.

The chair consists of a number of parts: two plywood backshells, the seat shell, seat cushion and back cushions, two arms, the star base, and various connectors and spacers. The shells are mounted on connectors with shock mounts. This technique was first developed by Eames for the earlier plywood side chair. It provides a cushioning effect for the user and makes even plywood feel softer and more giving than a simple mechanical assembly would. In view of the fact that many of the previous designs by Eames, such as the molded plastic and fiberglass chairs, were made of a minimum number of components, the many parts of the lounge chair are quite surprising. The unique appearance and the unusual comfort factor is due to the ingenuity of constructing the chair of its many component parts. The seat and back cushions are leather with latex foam, feathers, and down filling and are removable for repair or replacement. The shape of the cushions is kept by tufting the leather covers. When the chair was first introduced, it was available in various leather colors and finishes. Charles Eames quickly decided that odd and artificial colors would detract from the design and specified that only natural leather colors and black leather be used. The latter is the most frequently used cover material. The shells were until 1990 made in rosewood veneered plywood. The design of the rosewood shells is deceptive. It is curved across their width, but flat on their longitudinal axis, and the combination of straight and curved lines is skillfully echoed in the metal fittings. Herman Miller, Inc. is one of the most environmentally conscious corporations, and in 1990 decided to forego rosewood veneer in order to prevent continued depletion of a rare and non-replenishable species. It is likely that the use of other veneers such as walnut, will hardly change the appearance of the chair, and will not be perceived as a "wrong" material by the public or by designers and architects.

Charles Eames was not striving for a sculptural design such as many other designers have tried since 1956. Yet his lounge chair is large enough and sculptural enough to dominate any furniture grouping, but not too large to be arranged in groups themselves. The chair's rounded shape does not require fixed, formal placement. A truly remarkable design, destined to remain a classic in future years.

—Arnold Friedmann

Bibliography—

Drexler, Arthur, *Charles Eames*, New York 1973.
Caplan, Ralph, and Morrison, Philip, *Connections: The Work of Charles and Ray Eames*, exhibition catalogue, Los Angeles 1976.
Pile, John F., *Modern Furniture*, New York 1979.
Page, Marian, *Furniture Designed by Architects*, New York and London 1980.
Eames, Ray, and Neuhart, John and Mailyn, *Eames Design*, London 1989.

help Lepra fight Leprosy

20 MILLION PEOPLE SUFFER TODAY

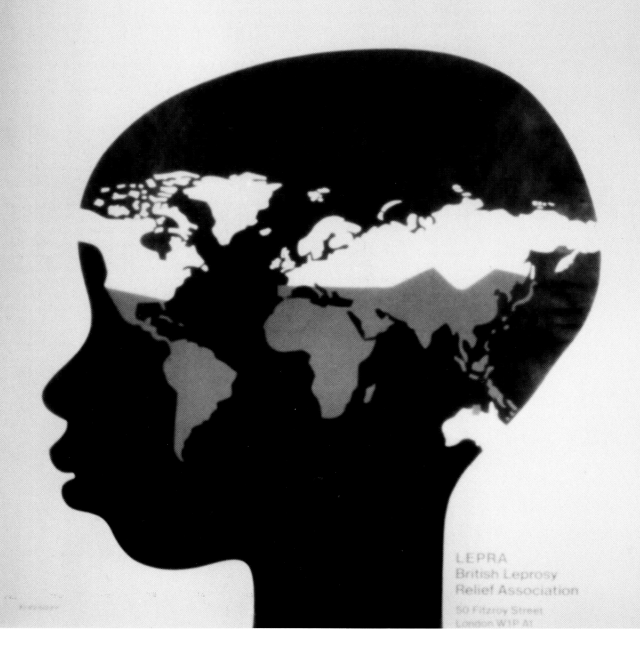

LEPRA
British Leprosy
Relief Association

50 Fitzroy Street
London W1P A1

782

Tom Eckersley (1914–)
Help Lepra Fight Leprosy poster, 1975
British Leprosy Relief Foundation, London

In the last decade of the twentieth century, clear evidence of our own technological suicide, coupled with compelling photographic and televisual evidence of existing Third World poverty and disease, has concentrated our minds on how world health and environmental messages should be put across in a crowded marketplace. Global concerts with multi-media sponsors are not always possible nor sometimes appropriate.

Since the end of the Second World War there have been noble precedents in poster campaigns that have sought to improve the environment, cut back on waste and improve public health—the One World posters for the United Nations, the posters for the Infantile Paralysis Foundation in America, for the Royal Society for the Prevention of Accidents in Britain.

Tom Eckersley is one of the last survivors of that generation that founded the profession of graphic designer in Britain. Arriving in London from Salford School of Art in 1935, Eckersley began work almost imediately for the most prestigious of commercial clients, the Post Office, London Transport, Shell and Austin Reed. At the outbreak of war this promising career as a designer went into abeyance when he joined the Royal Air Force, working mainly as a cartographer. Eager to keep working he offered his off-duty services to the Royal Society for the Prevention of Accidents. Despite shortages of paper and inks, and his personal circumstances, Eckersley produced an imaginative series of posters addressing such problems as factory absenteeism, broken tools, and accidents at work. He found a new freedom and dedication, a sense of designing for the general good of the community. Towards the end of the war he designed recruitment posters for the Air Ministry but found it difficult to identify with the cause. They lack the directness and the simplicity of visual message, the spare copy lines and technical ingenuity.

In surveys of British poster work during the war, it is clear that many other designers and artists shared that sense of *engagement*, a sense of common purpose that brought out their best work—Abram Games, Lewitt-Him, Zero (Hans Schleger), Pat Keeley and F.H.K. Henrion. This spirit in its international dimension pervaded the early meetings of the *Alliance Graphique* which Eckersley joined after the War, allowing much debate among mainly European and American designers on the role of graphic design in the post-war world.

Eckersley resumed his career with pre-war contacts (and particularly London Transport). He quickly attracted new clients such as Gillette and the Dutch airline, KLM. In 1957 he was appointed Head of Graphic Design at the London College of Printing. Contact with students and distinguished colleagues, opportunities to design his own posters for the benefit of the College and gallery gave a new impetus to his career.

It is against this background that we should see Eckersley's poster for the British Leprosy Relief Appeal (LEPRA), designing for a cause with an image of daring simplicity that sought to raise consciousness and generate support for the organisation.

In 1973 Eckersley was introduced to LEPRA by a member of the executive, Joanna Mersey, and commissioned to design a poster to mark the Silver Jubilee of the organisation in January 1974. At the initial briefing he was shown photographs of people suffering from leprosy and decided that shock tactics such as the use of photography, and particularly images of facial disfigurement would not be suitable. He decided that the three major constituents of the poster had to be the human figure, the disease itself and the world-wide spread of the disease. The designed image had to be sufficiently adaptable to appear not only on the hoardings but also

subsequently in promotional material and letter-headings. Leprosy had no identifiable symbol or graphic equivalent other than the symptoms of disfigurement. The disease was then generally believed to be found only in India and Africa whereas it can be found also in areas of Europe and the Southern states of the USA.

The human figure and its proportions had long been at the centre of Eckersley's work. In the war-time posters he also had to address the problem of damage to the body, with all consequent problems of depicting pain and suffering. In this case he felt the figure of a child had more human appeal; to be, in its disfigurement, more poignant. But how to combine the three elements?

An early and unsuccessful solution was was the overprinting of the word to break up the structure of the face. Another attempt involved a map of the world. While at work one day, Eckersley accidentally let the map fall over the design of the face. Allowing serendipity to intervene is not characteristic of Eckersley's work. He usually works methodically and patiently towards the reductive solution. On this occasion, however, the solution had come about by chance.

Once the idea was established, he then developed the face, a simple silhouette of a child made from cut paper, with no details of expression or reaction. This established the most effective fusion of the disease and its spread, while registering its impact upon the human figure. The designer thus avoided the photographic image with its more topical (and hence limited) applicability. The silhouette represented the idea of disfigurement without recourse to direct visceral shock. The overlay of the Mercator projection helped broaden the context beyond Africa.

In his pre-war work Eckersley had used cut stencils to establish clear areas for modulated paint. In the post-war work, and particularly in his London College of Printing posters, the shapes were cut from coloured paper, the shapes having being reduced to their absolute minimum in the pursuit of the immediate and readable image, in contrasts of red and black. He chose to set the copyline in a condensed type to accommodate the length of the message without swamping the image of the head.

The poster design and its subsequent appearance as logo for LEPRA have survived up to the time of writing. After 16 years of representing LEPRA, the image is now being re-considered in the light of changed public perceptions, in favour of a less specific and more typographic solution.

Eckersley's posters strive consistently for the visual expression of the basic proposition, an intention he saw triumphantly achieved in the 1930s in the work of E. McKnight Kauffer. Post-war developments in the poster—such as the rise of the design group, the slavish use of market research and the regular use of photography and TV images, did not make it an auspicious time to be a freelance designer. Against the odds, Eckersley has kept to the standards and attitudes established during a lifetime of service.

—Chris Mullen

Bibliography—

"Young Designers of Promise, 1: Tom Eckersley and Eric Lombers," in *Commercial Art* (London), January 1935.
Eckersley, Tom, *Poster Design*, London 1954.
Elvin, Rene, "Tom Eckersley," in *Graphis* (Zurich), no.56, 1954.
Rossi, Attilio, *Posters*, London 1969.
Him, George, *Tom Eckersley: Posters and Other Graphic Works*, exhibition catalogue, London 1980.
Weill, Alain, *The Poster*, London 1985.

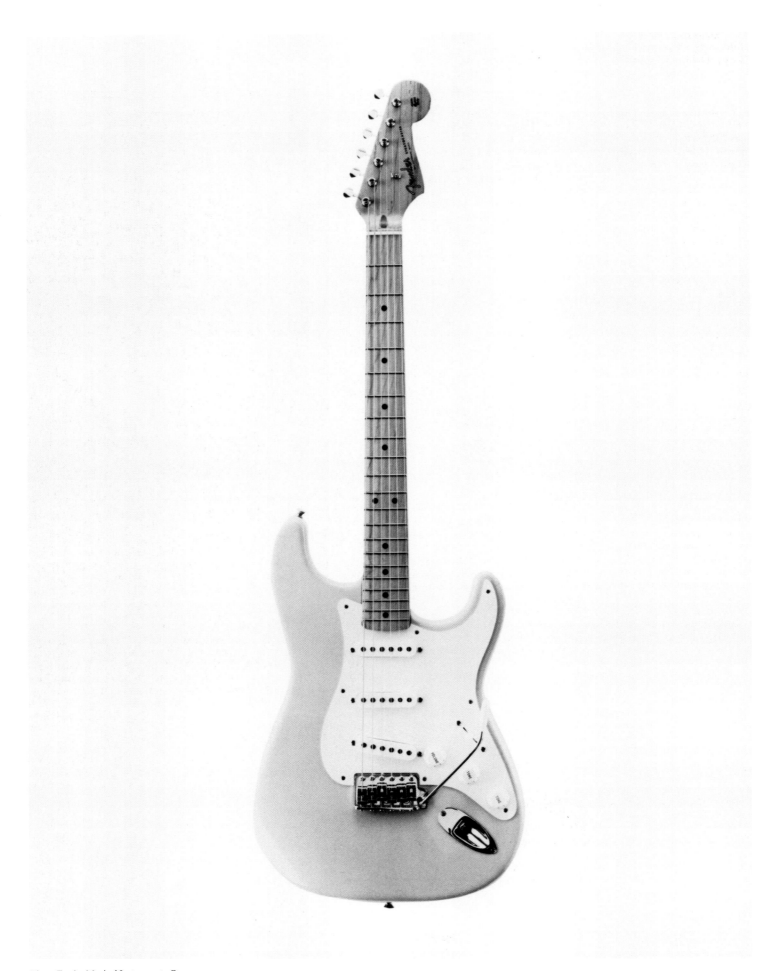

Photo Fender Musical Instruments Corp.

784

Clarence Leo Fender (1909–91)
Stratocaster electric guitar, 1954
Lacquered maple and ash, with single-coil pickup; 98.5 cm. long
Fender Musical Instruments Company, Brea, California, from 1954

Leo Fender's Stratocaster followed the Telecaster and the Broadcaster into the world of popular music-making at a time when the solid bodied electric guitar was a rarity. It was not only the radically innovative specification of the Strat which made it something of a ground-breaking oddity, it was the image projected by the sculptural curves and the ergonomic and technical considerations which had gone into the design.

The Stratocaster was made available in a range of colours not dissimilar to those offered to car buyers, and its very name spoke of the new-found preoccupations with the jet age. While Boeing Stratocruisers crossed the skies, the Stratocaster proclaimed itself an exciting addition to the lexicon of modern American objects. Furthermore, this solid-bodied, electric guitar broke with all traditional concepts of how a stringed instrument should look and sound.

Until the appearance of the Stratocaster and its cousins, the electric guitar had always been semi-acoustic. The sound produced through the combination of a resonant sound-box and a system of electronic amplification was characteristically warm and harmonically subtle, relying as much on the hollow body of the instrument as on the copper-wound magnetic poles of the small microphones positioned on the body of the the guitar—the pick-ups.

In the early 'fifties the electric guitar market was dominated by the likes of the Gretsch range of instruments, all of which were semi-acoustic; the Countryman and Country Gent captured the idea of the style of music for which they were designed in their very names. Other guitar manufacturers were no different. Gibson, before their roughly contemporary alliance with Les Paul, produced a range of Jazz and country guitars in semi- and acoustic formats. When the Stratocaster was unveiled in 1954, therefore, it represented the ultimate in modernity in guitar design.

Although made from largely traditional materials such as maple and rosewood for the neck and fingerboard, and close-grained hardwoods for the body, the use of plastics in the scratchplate, switches and pick-up housings lent the Stratocaster an air of contemporaneity; the resin coated finish applied to the curvilinear body had the same resilient shine as painted Detroit steel and the chromed machine heads echoed the finishing touches added to the most desired automobiles.

It was the combination of desirability as a radically new and innovative object as well as its outstanding qualities as a musical instrument which were to contribute to the popularity of the Stratocaster amongst musicians.

Shaped to sit easily against the torso, the asymmetry of the Stratocaster's body, with the double cutaway and sculpted body allowed for a comfort and playability which had not been achieved before. Fender's design for the neck aimed at speed and comfort for the player, the camber of the fingerboard and the narrow gauge of the frets combined to create a neck which facilitated a technique unlike that which could be achieved on more conventional guitars; it felt like a modern guitar. What is more, the Stratocaster sounded modern, but the effect which brought more and more guitarists to the Strat was not designed in; it was discovered by accident. The Stratocaster featured three, single-coil pick-ups. A warm rounded tone could be gained by selecting the pick-up nearest the neck, a slightly brighter tone by the pick-up in the centre, and a bright, cutting sound by flipping the three-position toggle switch on the scratch plate to the position for the pick-up nearest the bridge.

The toggle switch proved to be the key to the distinctive sound of the Strat. At times and often by accident, the toggle would stick between two selection positions effectively activating two pick-ups at one time. The effect produced was as a result of the pick-ups in operation being "out of phase" with each other, that is; one signal would cancel some of the frequencies of the other, creating a distinctive, powerfully harmonic, but thin sound. No other guitar could approximate the characteristic tone of the Strat, and when country stars such as Buddy Holly picked up on the new guitar it became a fashionable as well as technologically innovative instrument.

The Stratocaster is the first guitar to feature a stringing system piercing the body of the guitar, the resonance lacking through the absence of a conventional soundbox is compensated for by this simple device which uses the whole body as a resonant sound board. Together with the straight pull on each string afforded by the design of the, now characteristic, Fender headstock together with the powerful pick-ups, the Fender Stratocaster helped to rewrite the rules on what a successful, electric guitar should attempt to achieve.

—Michael Horsham

Bibliography—

Evans, Tom and Mary Anne, *Guitars: From the Renaissance to Rock*, London and New York 1977.
Marten, Neville, "Stratocaster Master," in *The Guardian* (London), 23 March 1991.

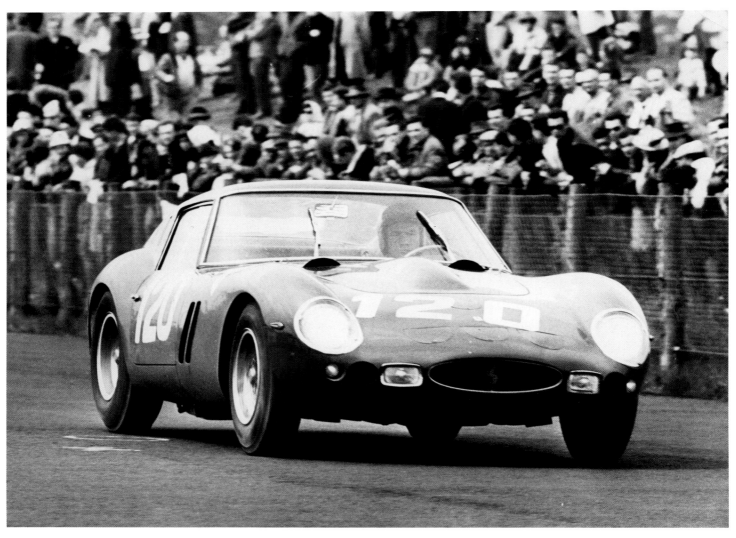

Photo Archivio Ferrari

786

Enzo Ferrari (1898–1988)
Ferrari 250GTO car, 1962
Ferrari S.p.A., Maranello

In the 1950s and early 1960s, when the major European automakers were borrowing heavily from Detroit—unfortunate stylistic side effects included both chrome plating and tail fins—connoisseurs of the exotic were turning to Turin, Modena, and Maranello. If there was a single marque which epitomized the Italian image of the day, it was Ferrari; and if there was a single car which epitomized balance, poise, and performance, it was the 1962 Ferrari 250GTO.

Owing more to Ferrari's racing heritage and the engineering demands of World Sports Car Championship competition than to aesthetic concepts, this inspired design evolved from the third-generation Pininfarina 250GT short wheelbase berlinetta, in turn derived from the long wheelbase 250GT which dominated race circuits in the 1956, 1957, and 1958.

At the end of the 1961 racing season, when the World Sports Car Championship expanded its focus to include both gran turismo and prototype cars, new requirements favored lighter, lower, more powerful automobiles. Pininfarina—up to that point, Ferrari's most favored outside coach builder—was asked to build several prototype GTOs based on the so-called Superfast II design later used for the semi-production 400SA coupes. These initial designs, however, did not find favor with Enzo Ferrari, and styling responsibilities were soon handed to Giotto Bizzarrini, a bright, up-and-coming Ferrari engineer.

Working in conjunction with Ferrari's chief engineer, Carlo Chiti, new lines were suggested to Carrozzeria Scaglietti in Modena, a small shop first used by Dino Ferrari in the production of the successful Tipo 166 Mille Miglia sports car. Scaglietti constructed coachwork for the new GTO, and the car was first introduced at a Ferrari press gathering in February 1962.

Making use of the low line provided by Ferrari's dry sump V-12 engine, the aggressive design was constructed—as were other Ferrari GTOs—of light-gauge aluminum. Although functional considerations were paramount, this was perhaps the most aesthetically appealing Ferrari berlinetta yet built.

The front overhang is greater than in previous models to accommodate an elliptical radiator air intake placed low on the front end of a long, sloping hood. The headlights are positioned low in the fenders behind fully rendered plastic covers. The car's taut, flowing lines are interrupted only by the diagonal rectangular openings on the sides just ahead of the doors, and the reverse "D"-shaped scoops behind the rear wheels. The raking windshield is supported by a gently sloping roof line that continues over the short rear deck, culminating in a functional, full-width spoiler.

The three GTOs built in 1964—the model's last year of production—were fitted with bodies reflecting minor stylistic revisions. A "tunnel-back" top, taken from the Ferrari 250LM prototype by Pininfarina was employed in place of the earlier fast-back design. Other easily identifiable changes include less exaggerated front wheel arches, an additional diagonal opening on each side ahead of the doors, and three new diagonal openings within the reverse "D"-shaped scoops. This later body style is usually referred to as the Series II.

As essentially a street-legal version of the Ferrari racing car, the Ferrari 250 GTO is a true performer. The "O" in its GTO designation stands for "omologato," meaning homologated for GT racing. The preceding type number signifies the capacity of each individual cylinder. In the case of a V-12, this adds up to just under three liters. Equipped with six dual-throat Weber carburetors—originally developed for the V-12 TestaRossa—plus special heads

and camshafts, the engine produces approximately 295–300 bhp at 7,400 rpm. These are highly respectable numbers even by 1991 performance standards. Later examples also featured five-speed gearboxes.

While the Ferrari 250GTO was surely one of the greatest GT cars ever built, the GT moniker was soon adopted by cars of less noble origins and less impressive capabilities. By the mid 1960s the GT label was something of a misnomer. Originally understood to apply to cars of sporting specifications and driving characteristics with 2+2-seater closed-body construction—such as the Lancia Granturismo Aurelia Coupe of 1953, all the Porsche designs of that period, and the XK140 and XK150 Jaguars—the GT label became just as common on family saloon cars with one or two actual performance features and even more gimmicky stylistic pretensions.

While Ferrari styling cues were "borrowed" by a few European and American performance cars of the period, the influence of Italian automotive styling in general could be seen in the mass-produced sector worldwide by the early 1960s. Pininfarina, especially, was involved in projects throughout the western hemisphere, ranging from the Anglo-American Nash, Peugeot 403 and 404 sedans, and British Austin A40, to the Argentinian IKA Torino coupe. By no means was Pininfarina alone. Ghia was involved in designing Volkswagen's line of sports coupes and cabriolets later manufactured by Karmann, as well as the Chrysler Dual-Ghia sports coupes and convertibles.

During the 1950s and 1960s, a period in which Ferrari dominated the GT racing circuit, the 250GTO was both a performance and a stylistic benchmark. Although the 250GTO was replaced before the 1964 racing season with the new 250LM rear-engined coupe, Ferrari was unable to get the newer model homologated for GT racing. Disappointed, Enzo Ferrari then abandoned further efforts at factory-sponsored GT racing except for one special lightweight 275 GTB which won the GT at Le Mans in 1965.

As the last front-engine Ferrari intended primarily for racing, the Ferrari 250GTO has appreciated rapidly as a collector's item in the exotic car market. Its comparative rarity—a total of 39 250GTOs were produced in the years 1962, 1963, and 1964 combined—only adds to its desirability. By 1991 this model could easily command prices upwards of £1 million.

It has been argued that automotive design reached its zenith in the 1950s and 1960s. Increased prosperity following World War II meant new opportunities for technical and stylistic experimentation, whether designing cars for competition or road use. Unhindered by the extensive safety and environmental restrictions of today, engineers and designers showed that even the most basic commuter cars could be imaginative. Unrestricted by economic considerations in the exotic category, they showed that anything was possible. In this category, the Ferrari 250GTO remains a symbol of automotive achievement, both for its sophisticated engineering and purity of form.

—Tim Spry

Bibliography—

Sedgwick, Michael, *Cars of the 50s and 60s*, New York 1963.
Georgano, G. N., *Complete Encyclopedia of Motor Cars*, London 1968.
Grayson, Stan, ed., *Ferrari: The Man, the Machines*, New York 1975.
Bishop, George, ed., *Grand Marques*, New York 1984.

1965 Ford Mustang I. Photo Henry Ford Museum and Greenfield Village

Ford USA (1919–)
Ford Mustang 1 car, 1964
Ford Motor Company, Detroit, 1964–73

Named for the fabled World War II fighter plane, rather than for the horse which became its mascot, the Ford Mustang was one of the most phenomenal successes in automotive history, both in terms of sales and of its influence on the car industry.

Introduced amid great excitement at the New York World's Fair of 1964, the Mustang was pictured on the covers of both *Time* and *Newsweek* magazines during its first week in showrooms. Ford's Mustang aimed to fill a yawning gap in the market for a relatively small and inexpensive, but sporty car which would appeal to the vast number of well educated and affluent post-war baby-boomers who were reaching car buying age in the mid 1960s. Ford Vice-President, Lee Iacocca was the master-mind of the Mustang project and made his reputation as "the father of the Mustang."

Iacocca formed a marketing research team, the Fairlane Committee, to study the potential for a new car which would attract a potential buying population whose average age was calculated to be falling at an unheard-of rate. Ford had done well with its four passenger Thunderbird of 1958, a moderately expensive sports coupé and convertible. The Mustang would reinterpret the theme for the growing youth market of the 1960s. The 20- to 24-year-old age group was designated the target market, and the design was calculated to appeal to them. In the end, it appealed to almost everyone.

The designer was David Ash under instructions from Iacocca, who had clear ideas of what he wanted the car to look like. He also imposed specific requirements regarding the use of an existing frame and mechanical components from the established, small Ford Falcon in order to keep down development costs and, ultimately, the sticker price.

Iacocca passed on to Ash his idea for the car's long hood, short rear deck proportional formula which he admired in the design of the classic 1939 Lincoln Continental. The long hood gave the car a powerful look and allowed space for the huge V8 engines which would become highly desirable options. Ash's handling of the short rear deck conjured a nostalgia for the sporting cars of the 1930s and the flavour of the post-war European sports cars then popular in America.

The design had a crisp, athletic look with an aggressive front end treatment and a neatly detailed, bustle back. The side panels were sculpted in the form of a long, shallow scoop, reminiscent of both the 1953 Studebaker Starliner and of the mid-1950s Corvettes. The car was sold first as a coupé and a convertible, and later a fastback model was added.

Applied ornament was kept to a minimum at front and rear, while on the sides there appeared only a jewel-like chromium accent identifying the mock air intake forward of the rear wheel arch. Simplicity, lightness and a taut energy were the hallmarks of the car's appearance. The 2 + 2 bucket seat arrangement of the Thunderbird was perfectly suited to the smaller cabin of the Mustang. The Thunderbird's twin pod dashboard configuration and transmission control console were also carried over to the Mustang, but with a simplicity and lightness of touch absent from the more pretentious Thunderbird.

The basic Mustang, introduced at a surprisingly low price of $2,368, was powered by a 2.8 litre 6 cylinder ohv engine. Standard appointments included classic stitched vinyl upholstery and pile carpeting to give every Mustang a luxurious interior. 420,000 were sold in the first year, with sales topping half a million per year by 1966. These figures broke all previous sales records for Detroit car producers. The car was undoubtedly the most successful Ford product of the decade and a car which captured the popular imagination from the start.

The success of the Mustang lay partly with the brilliant strategy of offering an attractive basic car at a very low price. Beyond this, buyers could indulge in an almost unlimited range of optional equipment to tailor the car to their personal tastes. It could be used as sprightly basic transportation, or become a luxury sports car, a hot street machine or an all-out competition car. The Mustang was equally at home being driven by the racing hero of Lalouche's film *A Man and a Woman*, by the proverbial "Little Old Lady From Pasadena" or by "Mustang Sally."

The "pony car" was a natural complement to the image of the clean-cut American college boy, or his cheer-leading girl friend. Seen jumping out of a Mustang convertible, tennis rackets in hand, they represented the popular aspirations of American youth on the eve of the Viet Nam debacle and the '60s counter-culture. Inevitably, cult status followed.

The original model survived unchanged through the 1966 model year, after which the car began to bloat with successive upscalings of both body and power train. As the "pony car" gave way to the "muscle machines" and "Boss" Mustangs of the early 1970s, the market of prospective buyers narrowed and sales fell away. Production ceased in 1973, just as the first oil crisis put an end to the days of carefree motoring that the Mustang epitomised.

The Ford Mustang quickly spawned a school of imitators; the Chevrolet Camaro, Plymouth Baracuda and Pontiac Firebird were among the earliest four place high volume sporting cars which served the seemingly bottomless well of young buyers in the mid-1960s. Its influence was soon felt even in Europe through the development of the highly successful Ford Capri.

The original Mustang has become increasingly collectible and continues to appear as a star vehicle in many films and television productions and as a familiar prop in fashion photographs. The Mustang, more than any other car of its time has acquired particular cachet in the current climate of nostalgia for the 1960s.

—Gregory Votolato

Bibliography—

Ludvigsen, K., "Ford Design Center Revisited," in *Style Auto* (Paris), November/December 1970.
"The Once and Future Ford," in *Industrial Design* (New York), October 1973.
Ball, Kenneth, *Ford Mustang V8, 1965–73*, Brighton 1978.
McComb, F. Wilson, *Ford Mustang, 1965–70*, London 1983.

Photo Museum of Applied Arts, Helsinki

Kaj Franck (1911–89)
Kilta ceramic tableware, 1948
Earthenware with green, blue, yellow, black and clear glazes
Arabia AB, Helsinki, 1952–74

Looking at *Kilta* is confusing. Depending on when and where you see this earthenware series it could be everyday or Sunday best. You can also find it for sale up alongside Rosenthal designerware or stacked up on supermarket shelves. This confusion stems from—as with most of the Finnish design featured in this book—*Kilta*'s origins. Along with Sarpaneva and Wirkkala, Kaj Franck was one of the brave new immediate-postwar Finnish designers, taught by Brummer, who looked to carry on the traditions of Aalto.

Franck's aim was to create a better world: primarily for his fellow Finns after the hardships of the war. Nevertheless, because of the prewar success of Aalto and others, and the willingness of Finnish industry to export, he was not blind to the need to appeal to international tastes. This positive energy had still however to be translated by inspiration into something concrete. There were also concrete problems in the form of shortages of both material and technical resources. Franck was devoted to simple basic forms. Which of course can be seen in the *Kilta* series, with its persistent geometry. However, this return to basics was offset by his willingness to use colour. This literally met his intention to bring a little everyday colour and warmth into homes. Thus *Kilta* was produced with green, clear, blue, black and yellow glazes. Which in turn introduced an element of choice, and enabled people to create some semblance of an individual lifestyle. Indeed, visiting Finnish homes you will often find Kilta "mixed and matched" with different coloured cups and saucers, plates etc. This works perfectly—rather than thinking "oh, they've lost or broken a cup or something", the reaction is more "what a good idea, and why not?" A definite sign of a classic design.

Kilta was also produced inexpensively. Franck was a great student of new technologies, although never for their own sakes. He would investigate and experiment, but not be afraid to stop and cut his—and the factory's—losses if unsurmountable technical difficulties appeared. However, in the case of *Kilta* he was able to use single firing in the kiln. This enabled Arabia to go into mass production and reap the economies of scale.

Another benefit of using basic geometrical shapes—squares, spheres, hemispheres, cones etc.—was that they could fulfil different functions. Thus the saucers can serve equally well as side-plates and the cups as mugs.

Kilta was an instant success. Production lasted from 1952 to 1972 and items can be found in nearly every Finnish home till this day. The idea of *Kilta* is being revived by Scandinavian chain Ikea in their starter packs for homes. The difference, however, is *Kilta*'s built-in longevity. Even the closest copies do not seem to have that extra touch of class that *Kilta* exudes. And thus, while *Kilta* can be found in the most basic of homes, it is also certain to follow in its owners' footsteps. As they move to bigger and bigger homes up the social ladder, *Kilta* finds its way into packing cases. *Kilta* can also be added to as the family grows—no need to start again

and throw out that "old stuff we've had for ages." In a way, *Kilta* takes on a classic role—the family "china" for modern dynasties.

The design also inspired other artists in the Arabia design team assembled by Franck—Kaarina Aho, Saara Hopea and Ulla Procope: a process he actively encouraged. Ulla Procope, for example, came up with a marmalade jar and cover using the same *Kilta* glazes. This was marketed as an accessory along with the basic two plates, rectangular dish, square dish, small plate, bowl, sugar bowl and cover, tea cup and saucer and two small square dishes. Procope later developed other items such as her famous teapots with cane handles can easily be used with *Kilta*. So popular was *Kilta*, that Franck reworked the design, which came out in 1981 as *Teema* and is still in production.

The odd thing about *Kilta* is that it is both representative and non-representative of Franck's work. Representative in that he always looked for basic shapes, but while he was an aesthete, he could never be accused of being colourless. Non-representative in that it perhaps hides the extent to which Franck was an experimenter, always willing to go down new avenues—although as noted previously he would never get stuck in a dead-end. Until the 1991 retrospective in Helsinki, this was not appreciated to the full in even his country of origin. However, a look at his art glass work for Nuutajarvi—particularly the multi-coloured goblets and sculptural objects—is sufficient to show Franck in a completely different light.

It is also demonstrated by *Snowball*, which he designed immediately after *Kilta* and became one of his fondest works. Whereas *Kilta* was all straight geometrical shapes, *Snowball* was round and soft. However, it was never taken into production. This reveals another apparent contradiction. We look at Franck's works, and "revolutionary" is not exactly the word that springs to mind. Rather gentle and timeless, and overall a naturalness that comes from devotion to simplicity. Nevertheless, his works aroused a lot of controversy, particularly at Arabia. *Lankkipurki* was an attempt to combine function—a joint vase and drinking glass, which was never taken into production and caused almost all-out war in the factory. Fortunately this was seen as "normal," and Franck continued a long and mutually beneficial association with Arabia until his death.

—Richard Hayhurst

Bibliography—

Maki, Olli, *Finnish Designers of Today*, Helsinki 1954.
Zahle, Erik, ed., *A Tresury of Scandinavian Design*, New York 1961.
Harrison Beer, Eileene, *Scandinavian Design: Objects of a Life Style*, New York 1975.
Mollerup, Per, ed., *One Hundred Great Finnish Designs*, Snekkersten 1979.
Hawkins Opie, Jennifer, *Scandinavia: Ceramics and Glass in the Twentieth Century*, London 1989.
Rasanen, Liisa, ed., *Kaj Franck, Designer*, exhibition catalogue, Helsinki 1991.

Schematischer Aufbau
der Univers-Schriftfamilie.

Adrian Frutiger (1928–)
Univers typefaces, 1954–55
Deberny & Peignot/Lumitype, Paris, 1954–57, Haasche Schriftgiesserei, Munchenstein, 1956–60; D. Stempel/Linotype, Frankfurt/
 Mergenthaler, New York, from 1957; Monotype-Monophoto, Salford, 1959–60

It isn't easy, within a thousand-word limit, to show the magnitude of work and to define the international significance of such a multitalented modern artist as Adrian Frutiger. Born in 1928 in Interlaken, Switzerland, compositor, typographer, wood-engraver, graphic artist, illustrator, sculptor and designer, from 1952 he has been working in Paris. His important projects, on both the micro- and macroscale, originate from his atelier in Arcueil in the capital's suburbs. As typographer, designer and graphic artist, Frutiger has been working for years on the basis of modern visual communication systems, applied in practice by numerous designers working for industrial, transport or cultural organisations. A rational and humanistic creator of lettering systems, he is also able to express himself freely in fine graphic, painting or sculpture. His renowned editions of *Genesis* and *Song of songs*, or his "engraver's suite" *Partages*, have a great artistic impact, as they show the virtuosity of his concise line shaped into incredible forms—a synthesis of primaeval yet still resonant signs. They are found too, in Frutiger's urban work—his constructions in marble, stone or concrete, which can be admired not only in the Musée National d'Art Moderne in Paris but also in the vast, 3,000-hectare area occupied by the train station and Charles de Gaulle airport in Roissy. Adrian Frutiger—creator-humanist—is an excellent interpreter and perceptor of all that is rational and new in the art of lettering, semiography and typography, the applied arts of the 20th century. I don't hesitate to say publicly that Frutiger's forecastings and their practical renderings are flawless.

In 1952, only 24 years old, Frutiger began work on two successful typefaces for the French foundry of Deberny & Peignot. *Président* (1952) and *Phoebus* (1953) were readily accepted, and immediately new matrices were cut. By that time, however, the foundry was already involved in developing work on light-setting systems, and it was with these systems in mind that Charles Peignot invited Adrian Frutiger to design a family of a new monoline typeface. Frutiger penned down his thoughts on the nature of typefaces created for the use of Lumitype (later Photon) equipment in his *Type Sign Symbol* book. Their essence was:

1. The right proportion between the counter and mass of each character;

2. medium face, bearing the number 55, to serve as a reference point (mediana) for the whole family. All other faces within the "50" group are to have the same stem thickness with counter variable. That principle was maintained in all variant fonts within the family;

3. in order to enhance harmony, lower case letters to be slightly enlarged and capitals slightly thinned down. Thus each font ensures good legibility;

4. finials in lower case "c," "s," "e" to finish horizontally;

5. bar joints to be slightly thinned down, bar terminals slightly thickened in order to eliminate blotches while over-inked;

6. optical differentiation of x-height of some capitals—"H" for example became slightly higher than "E," as H's baseline support differs from that of an E;

7. optical effect created by all characters to be the same, although to achieve that some of them—for example "B," "M," "R"—needed small corrections.

Today, after 40 years of using *Univers*, with billions of words set in it, the typeface and its author have established for themselves lasting positions in the history of 20th-century printing types.

The chosen name expresses also (nomen omen) the precious value of universalism, seen here as a symbiosis of beauty and practical purposefulness; in other words, intellectual, scientific and technical aspects. In order to achieve the most adequate form and function, Frutiger utilised optometry as well as scholarly typography in his work. As an effect, general rules governing the *Univers* family dominate over details of particular characters. He achieved what Tschichold had earlier set out, namely that "the more carefully are distinguishing details of each sign worked out, the more legible is the typeface. Its beauty grows as it reveals a special value of the characters' shape present in each letter and in their sets—words." In order to achieve the high quality of the whole family, Frutiger from early stages limited it to 21 fonts. This scale could, in my opinion, be regarded as truly genial. That is why I feel rather disturbed by the fact that numerous type producers offer up to 40 Univers fonts. Are they introduced with the author's knowledge and permission? Walter Greisner has, while honouring Frutiger, mentioned in his Laudatio the existence of some plagiarism. A full legal analysis of the present situation is called for, in order to defend the author's moral and personal interests.

Knowing that Univers had proved its suitability for all known techniques of projection with high-speed photosetting and printing equipment, Frutiger could use that experience for the benefit of his new projects. The Greek version has been drawn, as well as some weights in Cyrillic. One could ask for an adequate series of semiographic symbols. It would definitely strengthen the presence of good typography in the world.

An important experiment, the solution to which was achieved by Frutiger's team in an exceptional manner, was the *OCR-B* project. In 1973 this typeface, a victory of humanists over the machine, was officially recognised as a world standard by ISO. Today, through its acceptance by International Civil Aviation Organisation, *OCR-B*'s usage becomes more widespread.

Frutiger, however, doesn't rest on his laurels. Regularly he has introduced new typefaces designed for modern photosetting systems. To over 30 of his earlier designs he can now add *Centennial* (1986), *Avenir* (1988), *Westside* (1990)—and it's a fair guess that he's busy on new projects. Because of the newest technologies of digitisation, the time needed for introduction of new typefaces to clients has been greatly reduced.

When in the 1960s *Univers*, thanks to the Monotype Corporation, had begun to conquer British publishing and printing houses, P.M. Handover wrote that it "matched the needs of modern-day typographers, weary of unreliable, trendy and boring grotesque types." She added that anybody who studied *Univers* more closely had to realise the great artistic sensitivity evident in the project.

Frutiger's work has been presented at several individual shows: in London (1964), Prague (1965), Paris (1968), Bern (1973), Mainz (1977), Basle (1988), Gdańsk (1988), Toruń (1989), Cracow (1989), Warsaw (1989), Wrocław (1989, where his works are kept in the National Museum). For his artistic achievements, Frutiger has received several prestigious awards and distinctions: in France—Chevalier des Art et Lettres (1986); in Switzerland—the State Prize (Bern, 1950), Freedom of the City (Interlaken, 1980), Paul Haup-Preis (1985), Jäggi-Preis (Basle, 1989); in Great Britain—Honorary Membership of the Double Crown Club (London, 1970); in Germany—Gutenberg-Preis (Mainz, 1989); in USA—Type Directors Club Award (New York, 1987), Frederick W. Goudy Award (Rochester, 1988).

The widespread recognition of Adrian Frutiger's work in the world is the direct result of his rational, organised efforts, to which he devotes his whole imagination, sensitivity and a sense of order. We are thankful to the artist and wish him further successes, successes of the creative Spirit over unruly Matter, which he so perfectly applies to the cause of human mutual understanding.

—Roman Tomaszewski

Bibliography—

Zerbe, Walter, *Schrift, Signet, Symbol: Adrian Frutiger*, exhibition catalogue, Bern 1973.
Frutiger, Adrian, *Der Mensch und seine Zeichen*, 3 vols., Frankfurt and Echzel 1978–80.
Frutiger, Adrian, *Type, Sign and Symbol*, Zurich 1980.
Carter, Rob, Day, Ben, and Meggs, Philip, *Typographic Design: Form and Communication*, New York 1985.
Frutiger, Adrian, *Sign and Symbols*, London 1989.

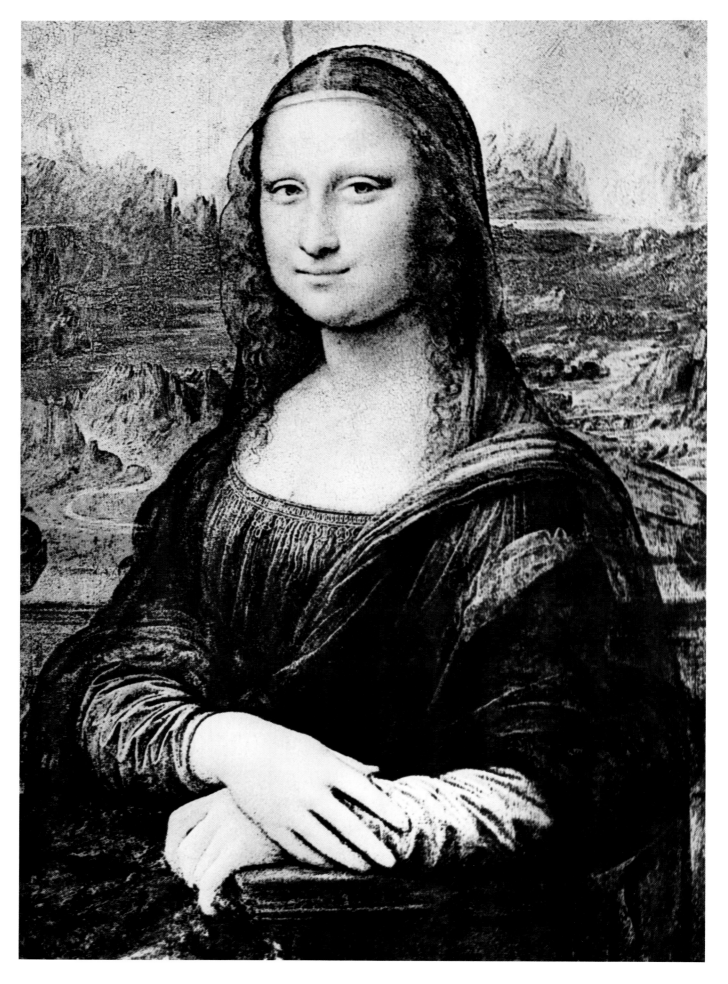

794

Shigeo Fukuda (1932–)
Mona Lisa poster series, 1970

In 1974, when I first met him in Wilanów's Poster Museum, where he arrived as a laureate of the IV International Poster Biennale in Warsaw, he seemed to be more of a joyful boy than a serious artist, well over forty at the time. Invited to the exposition, he brought with him not only the posters that we expected, but also some three-dimensional paper toys, which under his guidance we learnt to construct, and paper sculptures of parliament made of colour sheets. He showed two series of posters: one which constituted the exposition *The world of Shigeo Fukuda in USA* (1971), and another entitled *Environmental pollution* with a series of so-called "impossible objects." Both those series only signalled his unlimited imagination, and prepared us for his famous paper foldings of which we were to learn later. The Wilanów exposition confirmed the opinion of Paul Rand, that Fukuda's posters are no less intriguing than his toys.

His posters of the time announced the pleasures which awaited us in the world of his paper toys, based on the traditional Japanese paper-fold craft, origami. Each of them asked not only for manual skills, but also for brilliant intelligence, logic of visual and semantic associations, three-dimensional imagination and a sense of humour. The viewer, taking part in the act of creation of a new artistic reality, encountered the revelations towards which the artist had led him. Fukuda's toys result from a particular philosophy which links human existence with real world and immediate environment. They teach humility towards nature, unity with it, respect towards its wisdom and logical co-existence.

The play that Fukuda presents has a deeper meaning, forces us to think, makes us realise obvious truths. It seems that the ability to draw the paper-folds Fukuda inherited from his ancestors, for he was born in a family of toy-manufacturers a few years before the Second World War broke out. While most of his generation were deprived of such means, he always had enough paper and paint, which helped him to develop his talents.

Even today, he always has a pair of scissors at hand; he creates new toys while relaxing, he plays while working and smiles at his own ideas. Katsumie Masaru says that Fukuda is "a homo ludens who designs as he draws breath."

Later in Fukuda's career, three-dimensional forms took the monumental shapes of wooden sculptures which decorated parks. They had been additionally painted in bright, clear colours. Fukuda proved that a gifted designer can also have an innovative approach towards sculpture.

Some critics even claim that he is a sculptor rather than a designer. His multi-dimensional objects are as surprisingly meaningful and universal as his paper works. Depending on the spatial relation between the viewer and the object, one can see different shapes and aspects of it.

A sense of humour, which points out the origin of every idea, is one of the most significant aspects of Fukuda's art. Without that sense of humour, it would be impossible to create so many intellectual jokes enclosed in the subtle lines of his drawings.

The series of *Impossible objects* (1973) shows the artist's ingenuity and his specific sense of penetrating graphic imagination. This play is addressed to the thinking audience, with no age limits. Inspired by a serious concern with environmental pollution, it shows Fukuda's attitude towards the contemporary aspects of life.

After illustrating children's books, paper-folds, posters and wooden sculpture came another fascination. The single most famous European painting, *Mona Lisa*, had great impact on the sensitive artist. The fetish of Western civilisation made him want to analyse and fully understand its phenomenon. Using the latest in computer graphics, he electronically transformed the enigmatic smile which resulted in 50 intriguing images of the same, but varying face. Starting with perfect photography, Fukuda transformed it even further, using various printing and photographic techniques, contrasting colours, clashing against one another.

The effect, 50 printed images, turned out to be so fresh and contemporary that—in collaboration with Makoto Nakamura who, inspired by the same painting, created 50 graphics—Fukuda decided to show *A 100 smiles of Mona Lisa* in many countries.

Thus we witnessed a creation of new esthetic event—a *Japanese Gioconda*, connecting traditional painting techniques and the Western artistic standards with modern technology and eastern perfection and precision: a spirit of European culture as perceived by oriental artists.

Another game, which became possible thanks to Fukuda's sense of humour. The notion of playfulness, prevailing in his works, makes Fukuda a modern hero of Johan Huizinga's "Homo ludens," whose existence bases on his ability to play.

—Ewa Kruszewska

Bibliography—

"Mona Lisa's Hundred Smiles," in *Idea* (Tokyo), May 1971.
Gassiot-Talabot, Gerard, "Joconde cent sourires," in *Opus International* (Paris), June 1971.
Fukuda, Shigeo, *Forms of Shigeo Fukuda*, Tokyo 1977.
Fukuda, Shigeo, *Posters of Shigeo Fukuda*, Tokyo 1982.
Ades, Dawn, *The 20th-Century Poster: Design of the Avant-Garde*, New York 1984.
Sparke, Penny, *Japanese Design*, London 1987.

Photo Library of Congress

R. Buckminster Fuller (1895–1983)
United States Pavilion, at *Expo '67*, Montreal, 1966–67

More than just a building, even though one of great individuality, Buckminster Fuller's pavilion for the United States at the 1967 Montreal *Expo* was a statement of faith. Fuller was a man profoundly concerned with the potential of modern technology to address and resolve the basic human needs of shelter, warmth and physical well-being. To this end, he believed that functionally redundant elements in buildings should be eschewed, leaving the form and structure purely as that dictated in each project by pertinent requirements of strength, size, weather resistance and usage. Embellishment in conformity with passing fashion or style was simply superfluous. These ideals he endeavoured to embody in his pavilion building.

Fuller's interest in buildings grew out of personal tragedy. The loss of his first daughter during an epidemic in 1922 led to his obsession with the potential for the application of known technology in alleviating the problems of poor housing and living conditions on a worldwide scale. With such a goal, it is easy to understand his "puritan" approach to building design and construction. This approach was further reinforced by his early life, and subsequent training. Brought up in an isolated island fishing community off the North-Eastern seaboard of the United States, Fuller spent his childhood in learning seamanship and all its related skills. Here grew his fascination with the application of human intelligence and intuition in the solution of objective problems for dealing more effectively with the constraints of our environment. Periods spent in the Navy, at Harvard, and as a machine fitting apprentice, continued this fascination with problem solving, with very much an engineering emphasis.

Fuller himself refers to a teleologic process: the spontaneous response to a set of environmental conditions which leads to the conception of a new tool, or set of tools, allowing a human, or group of humans, to increase their technological advantage over the environment. Primitive man developed the flint axe, fire, the wheel, through this teleologic process. In the modern era, the process is often more complex, with whole organised human systems interacting to create the same effect on a larger scale: a more economical aircraft, superconductors, and many, many more in the same vein. Fuller's buildings, then, were his teleologic responses to the conditions of man in an environment, requiring shelter from the elements, and the provision of the various practical functions which buildings serve, whether as homes, factories, or exhibition halls.

In creating the US pavilion for *Expo 67*, Fuller had an opportunity to display his principles to a world audience. The fair had struck a chord in a way that few world expos have done since, and public attention was very much focused on the event. Even the sober commentary of the Canadian Department of Industry singled out the Fuller building as the most exciting of the various national pavilions for the expo. There was perhaps a contradiction here, however, since the ideological basis of Fuller's work could not altogether marry with the purposes of those who commissioned the building. This was an era (before the ignominy of defeat in Vietnam, and at the height of the race to the moon) when the United States remained the most powerful economic and military force in the world. The pavilion was to be the showcase for this superpower status, including a large display given over to the lunar exploration programme. The interior treatment of the exhibition areas of the building, with a showbusiness razzamattazz, hardly harmonised with the clarity and simplicity of the acrylic and steel structure of the dome. Perhaps the commission resulted from the wish of the United States that its pavilion should be, in itself, as powerful a statement of technological prowess as were the internal exhibits.

If this were so, then the dome Fuller created indeed succeeded in every way. A truly extraordinary structure, based in the geodesic structural principles which had been developed by Fuller over several decades, the dome enclosed a volume of 6.7 million cubic feet. 250 feet in diameter, and 206 feet high, the dome, in its apparent fragility, seemed to defy gravity. This was made possible by the use of a space frame, 40 inches deep, consisting of 3.5-inch diameter tubing welded to a vast array of steel hubs. Thinner-walled tubing was used towards the top of the dome, replaced by solid steel bars around the openings. The weather-proof skin of the building, mounted on the space frame, consisted of repeating patterns of acrylic hexagons and pentagons, 0.25-inches thick, and with 10-inch sides. Fuller's attention to detail extended as far as the creation of a system of automatic, powered roller blinds, which shaded the sun side of the dome, so as to prevent excessive internal heat build up. The interior of the pavilion was far less remarkable, unless one considers the inclusion of the then longest escalator in the world (rising 68 feet to the topmost platform of the display, this machine was just one of several unexpected elements, which also included a minirail, running across the floor of the dome). Otherwise, the internal structure consisted simply of four multi-level exhibit platforms, made of rolled steel sections, with tubular supporting columns, and braced by the various stair towers. Office and service accommodation was provided beneath the exhibition platform structure.

In assessing the achievement of Fuller in creating this building one has to consider a number of factors. Aesthetically the dome is, to say the least, impressive. The sheer élan of the external form of the dome, and the ingenuity of its creation, using materials in such an innovative and efficient manner, engender keen respect for the intellect and imagination of its architect. Functionally, however, the analysis must be more searching. Even during the initial use of the building for the Expo, it was never wholly weather-tight. Problems with the severity of the winter during the erection of the dome, and subsequent failures of the structure to resist thermal expansion and contraction, caused gapping between the acrylic panels, allowing ingress of water. At the same time, and in spite of the ingenious sunblinds, the building tended to warm up excessively during periods of bright sunlight.

More fundamentally, one may question the degree to which such a structure met the goals of its designer. Highly efficient in its engineering undoubtedly, and without any element of superfluous ornament, the dome is nevertheless severely limited in terms of the practical applications to which it may be extended. After the completion of *Expo 67*, and before its destruction in a fire, Fuller's pavilion was given over to use as an aviary.

The best known subsequent structure of the same type was the pavilion created for the Disney "future" world, at Epcot in Florida. It remains to be shown whether Fuller's vision for the future use of building technology to meet the practical needs of mankind will be realised in the use of buildings such as this, or whether the geodesic dome will be condemned to a marginalised existence as a fairground attraction.

—Andrew Parker

Bibliography—

Rosen, Sidney, *Wizard of the Dome: R. Buckminster Fuller, Designer for the Future*, Boston 1969.
Meller, James, ed., *The Buckminster Fuller Reader*, London 1970.
Kenner, Hugh, *Bucky: A Guided Tour of Buckminster Fuller*, New York 1973.
Robertson, Donald W., *Mind's Eye of Buckminster Fuller*, New York 1974.
Hatch, Alden, *Buckminster Fuller at Home in the Universe*, New York 1974.
Snyder, Robert, ed., *Buckminster Fuller: autobiographical monologue/scenario*, New York 1980.
"United States Pavilion, Expo 67, Montreal," in *GA Document* (Tokyo), Winter 1981.
Pawley, Martin, *Buckminster Fuller*, London 1990.
Barrick, Adrian, "Montreal to Refurbish Decaying Biosphere," in *Building Design* (London), 15 June 1990.

Cona Rex, 1952

Illustrations courtesy of Cona Ltd

New Table Model, 1959

Abram Games (1914–)
Cona New Table Model coffee-maker, 1959
Cona Group, London

Abram Games' design for the Cona Coffee Maker of the early 'fifties may appear to be a bizarre one-off departure for a designer best known for his graphic work. However its production demonstrates a rare phenomenon in the Britain of the 'fifties, that of a successful working relationship between art and industry.

Abram Games, of mixed Latvian and Polish parentage, was born Abram Gamse in the East End of London in 1914. Largely self-taught as a graphic designer, Games first came to public notice as Official War Poster Designer during the Second World War, producing some of the most dramatic and exciting designs of the period, including the well-known lithographs *Your Britain—fight for it now* posters on Schools, Health and Housing for the Army Bureau of Current Affairs. These contrasted pre-war social conditions with the bright future promised by such icons of international modernism as the former Bauhaus Director, Walter Gropius' design for the Impington Village School in Cambridgeshire and the Russian Bernard Lubetkin's recently completed design for the Finsbury Health Centre in central London.

After the War, Games won first prize in the 1948 competition to design the emblem for the 1951 Festival of Britain, which achieved international recognition and much affectionate regard in the country of its origin, appearing as it did in a variety of guises—from souvenir ceramics to Festival of Britain flowerbeds. Games' emblem, which skilfully incorporated the various aspects of the Festival in one instantly-accessible image, was not his only contribution to the Festival, which is widely regarded as having been a pivotal moment in the history of British design. Much of the graphic identity of the Exhibition was Games' work. Its boldness and recognition of international Modernism eschewed the typically whimsical style so prevalent among other British designers of the time and gave a witty dimension to the occasion.

In Games own words which are applicable to all his graphic work, including such well known corporate images as the Queen's Award to Industry (designed in 1965) "the message must be given quickly and vividly so that interest is subconsciously retained. *Originality is secured by organising known factors in new ways.*"

This organising of known factors in new ways is also the key to understanding Games' design for the Cona Coffee Maker. The known factors in this case were a physics principle applied to a very successful design of coffee-maker which had been in production since 1910. The principle on which the design is based is that water in a sealed vessel (in this case the lower glass bowl) when boiled (in the original design over a spirit lamp) will cause the remaining air, still present in the bowl, to expand. This in turn forces the water up the stem of the funnel to infuse the coffee grounds in the upper vessel. The Coffee Maker is then allowed to remain on the heat for a further periods of time (some two minutes), which allows for more of the expanding air to escape via the funnel stem and through the water in the funnel, after which the heat source is extinguished. On cooling the air remaining in the bowl will contract forming a vacuum and this, in turn, will cause the infused coffee in the funnel to be drawn back in to the lower bowl with the coffee grounds being kept in the upper vessel by a filtering device. The entire infusion process from the time the water first starts to rise in to the funnel to the brewed coffee having returned to the bowl is not normally more than approximately four minutes.

This governing principle had been used in the original designs, manufactured by the British company directed by Alfred Cohn—whose initial was put at the end of his name, with the "h" deleted to for "Cona," a name which became synonymous with the generic type of coffee maker employing the principle described above. The design, although popular both in Britain and abroad, remained virtually unchanged until Abram Games original update of 1951 the "Cona Rex" which was awarded a Design Award at the Festival of Britain and put on display in the Festival Hall Exhibition of Contemporary Design. This model consisted of a number of aluminium sandcastings and die-castings which called for a great deal of manual work in the finishing processes, and in consequence, made the model too expensive for a mass market, although its streamlined elegance was much admired.

The design was modified around 1957 in consultation with Abram Games by changing materials as well as the method of manufacture, while retaining as far as possible the overall design. In place of the all aluminium-cast components the base, drip-cup and top fork were made from a die-cast zinc based alloy, subsequently chromium plated, while the stand handle was produced from die-cast aluminium, enamelled black, with the bowl handle and clip being made from plastic. Tooling and the production of the component parts was carried out in the late 1950s and this modified design, known as the New Table Model range was marketed with considerable success throughout the world from 1959 onwards and remains unchanged today.

Interviewed in January 1991 on the occasion of the exhibition *A. Games: 60 Years of Design*, Games emphasised the importance of "simplification and clear ideas" in his work. He explained "What I did was to simplify the system so that you could pick up the machine with one hand. It happens to look good because it was designed to be functional and to be picked up with one hand and be used in the same way as the traditional coffee machine is used but is more intelligent and has become a design classic."

Games' design for the Cona Coffee Maker is extraordinary in its time in its collaboration between an artist whose work was entirely two-dimensional and an industrial manufacturer to produce a functional object for machine production. This process, familiar enough in the history of European design, particularly in Germany, even before the Bauhaus period, was a rarity in post-war Britain. The "classic" status of a design which survives unchanged for over a generation is beyond doubt.

—Doreen Ehrlich

Bibliography—

Farr, Michael, *Design in British Industry: A Mid-Century Survey*, Cambridge 1955.
Games, Abram, *Over My Shoulder*, London 1960.
MacCarthy, Fiona, *Eye for Industry: Royal Designers for Industry 1936–1986*, exhibition catalogue, London 1986.
Abram Games: 60 Years of Design, exhibition catalogue, Glamorgan 1990.

Photos National Motor Museum, Beaulieu

Marcello Gandini (1938–)/**Paolo Stanzani** (1938–)/**Robert Wallace** (1938–)
Lamborghini Countach car, 1970–74
Automobili Ferruccio Lamborghini S.p.A., Sant'Agata Bolognese, 1974–90

The Lamborghini Countach is the most striking car designed by the Bertone-schooled Marcello Gandini. His Lamborghini Miura of 1966 is more beautiful, while the designer himself prefers the Lancia Stratos of 1974. Of his less exotic projects, the Citroën BX is the car he drives himself, while the Renault Superfive is particularly admired by his great rival as Italy's leading automotive designer, Giorgio Giugiaro. But even before the world has seen Gandini's work on the new and eagerly-awaited Bugatti, those of his designs which have most captured the imagination of the motoring world are the "supercars." From the late 1960s onwards they have, in the face of oil crises and a homogeneity of mass-production car design, flaunted their very individuality.

From the prototype LP500, first shown at the Geneva Motor Show in 1971, through the first production models of 1974 and the updated and modified versions which subsequently appeared from the Sant'Agata factory, the Lamborghini Countach has remained the epitome of the 1970s "supercar." Yet, while associated irrevocably (and not always favourably) with that era, it seems to have transcended the vagaries of fashion, even in the 1990s as the Diablo threatens to replace it. For the Countach's combination of stunning looks and astonishing performance is still matched only by its impracticality as an everyday car (not to mention its daunting cost). But then, as Gandini himself has said, "I am a dreamer, and Lamborghinis are cars for dreamers."

The name Countach derives from a Piedmontese expletive (apparently uttered by a worker on seeing the prototype LP500) which roughly translates as "incredible" or "amazing," and is to be pronounced "coon-tash," with the stress on the first syllable. The history of the car of that name is intimately linked to the history of the company which the industrialist Ferruccio Lamborghini set up in 1963 with the aim of building the ultimate GT (*gran turismo*) car. He immediately recruited a team of talented young designers and engineers, including two 25-year-olds, Paolo Stanzani, who was to assist the 24-year-old Giampaolo Dallara in developing the engine and the chassis, and New Zealander Bob Wallace, who graduated from racing mechanic to become chief test engineer and troubleshooter. Together they developed the Miura, a mid-engined sportscar whose transversely mounted 3.5 litre V12 engine (designed for Lamborghini by Giotto Bizzarrini) gave it an unrivalled top speed of 187mph (300km/h). The car had originally appeared, as a chassis with an engine and gearbox, at the Turin Show in late 1965. To develop a body to match, Lamborghini turned to the styling house of Nuccio Bertone. Although their star designer, Giorgio Giugiaro, had just left, his young replacement, Marcello Gandini, took on the job and worked round the clock to come up with the body for the Miura in time for the Geneva Show in early 1966. The car was a huge success, the reputation of Lamborghini was made, and, importantly, the relationship between the company and Gandini was established.

The Miura was a sensational car, but far from perfect. Presumably those able to afford the car were not over-concerned by its unreliability or its unpredictable handling when driven fast. But Stanzani and Wallace, along with Gandini, were looking ahead when they built a protoype for the 1971 Geneva Show, the LP500. Stealing the show from the SV version of the Miura, the LP500, with a body by Gandini which echoed his earlier Carabo prototype for Alfa Romeo, attracted great interest, and plans were made to transfer the hurriedly made prototype into a production model.

The car which emerged some three years later, after a period of industrial turmoil at the Lamborghini factory, was the LP400 (*Longitudinal Posteriore 4 litri*—denoting the engine and its unique layout, in a line behind the driver's cabin). The technical inno-

vations which accompanied the impressive body on the car highlight the problem of attribution in automotive design. While it is the convention to give most credit to the designer of a car's bodywork, the Countach must properly be seen as the work not just of Gandini, but also of Paolo Stanzani and Bob Wallace.

The chassis which was developed for the production car by Stanzani in collaboration with the Modena-based Marchesi company, is itself a remarkable piece of engineering. A shoe-shaped spaceframe of lightweight tubular steel, it has to be hand-made and accounts for a large percentage of the car's cost. The massive 4971cc engine of the prototype proved unreliable, and thus the 3929cc engine from the Miura was incorporated, with the gearbox, unusually, placed in front of it. In a quest for lightness, however, many components, using expensive lightweight materials, were specially developed for the Countach. The resultant weight (just over 1000kg), in addition to the excellent front/rear weight ratio meant that the car's handling, developed by Wallace, was a improvement on the Miura. In fact, for many of the writers lucky enough to test the car, the Countach's high-speed handling attained standards then unknown among road-going cars. To achieve this handling, and to allow for proper cooling of the power unit, Gandini's original smooth lines had to be modified, most obviously to incorporate a series of air ducts. But the most notable features of the LP500 prototype (the use of trapezoidal shapes; the smooth, raking front, with a virtually straight line from the front of the car to the roof; the extraordinary doors which opened up and out of the body; the aggressively-styled rear) were apparent in the production LP400 of 1974.

In 1978, the LP400S brought with it wider wheel arches (to incorporate the new Pirelli P7 tyres), nose spoiler and a bootlid wing, which gave the car an even more muscular, aggressive, look, while 1981 saw the introduction of the LP500S, with a 4754cc engine. The Countach 5000 Quattrovalvole of 1985, not to be outdone by Ferrari's newest Testarossa, offered four valves for each of the 12 cylinders in a 5167cc unit, providing a massive 455 brake horse power. It was still clearly related to the 1971 prototype, yet refused to show its age. The Countach's outrageous collection of hard edges, raking lines and angles continue to suggest an "out of this world" quality which the chassis and engine, fortuitously, are able to match.

Stanzani and Wallace both left Lamborghini in the mid-1970s and set up on their own. Gandini left Bertone in 1979, worked for Renault for five years, and now works freelance. He works alone, without even a secretary, and has in recent years designed a chair, a clock, lamps and a bicycle. It is rumoured that his ideas for the Countach's replacement, the Diablo, have been changed by the corporate stylists from Lamborghini's new owners Chrysler. Indeed there is still debate about Gandini's exact input into various of the cars with which he has been associated. However, while he himself now considers the Countach "overdone . . . It looks baroque somehow," there can be little doubt that Gandini, along with Stanzani and Wallace, created a true classic. As the tester of the LP400S in *Road and Track* magazine in 1978 concluded, "It's a monument to automotive design, engineering and enthusiasm . . . a work of art."

—Nicholas Thomas

Bibliography—

de la Rue Box, Rob, and Crump, Richard, *Lamborghini: The Cars from Sant' Agata Bolognese*, London 1981.
Morland, Andrew, *Lamborghini: Supreme Amongst Exotics*, London 1985.
Clark, Paul, *Lamborghini Countach*, Sparkford, Devon 1986.

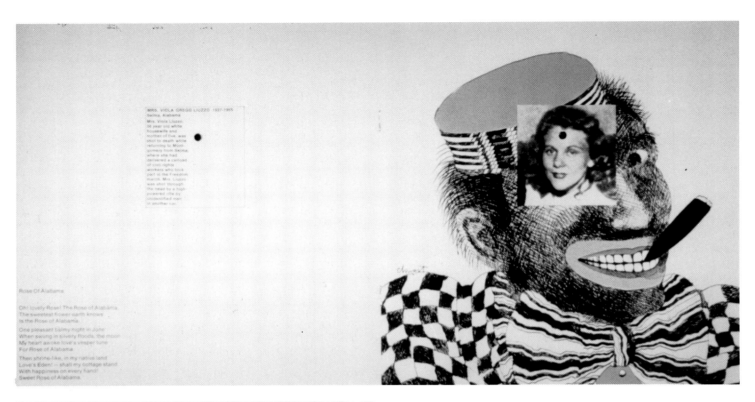

MRS. VIOLA GREGG LIUZZO 1927-1965
Selma, Alabama

Mrs. Viola Liuzzo,
39 year old white
housewife and
mother of five, was
shot to death while
returning to Mont-
gomery from Selma,
where she had
delivered a carload
of civil rights
workers who took
part in the Freedom
march. Mrs. Liuzzo
was shot through
the head by a high-
powered rifle by
unidentified men
in another car.

Rose Of Alabama

Oh! lovely Rose! The Rose of Alabama
The sweetest flower earth knows
Is the Rose of Alabama

One pleasant balmy night in June
When swung in silvery floods, the moon
My heart awoke love's vesper tune
For Rose of Alabama

Then shrine-like, in my native land
Love's Eden! — shall my cottage stand
With happiness on every hand!
Sweet Rose of Alabama.

Milton Glaser (1929–)/**Seymour Chwast** (1931–)
Push Pin Graphic, New York, 1953–80

In 1953 when the first *Push Pin Almanac* was published it would have been impossible to predict that its four princple contributors, Seymour Chwast, Milton Glaser, Reynold Ruffins and Edward Sorel, would develop a graphic style that challenged the prevailing ethic of functionalism imported from Europe (during the Bauhaus immigration), practiced by some leading American corporate and advertising designers, and manifest in work by exponents of the Swiss International Style. Yet when that first 4 × 9-inch compilation of facts, ephemera, and trivia, illustrated with woodcuts and pen and ink drawings was mailed out as a promotion for these freelancers, other New York designers and art directors began to take serious notice. Indeed the *Push Pin Almanac* brought in so much work from book, advertising, and film-strip clients that the four Cooper Union classmates decided to leave their day jobs and start Push Pin Studios, which became the major proponent of illustrative design in America.

The Almanac, originally conceived as a bimonthly mailing piece, was consistent with certain emerging historicist design fashions. Victorian, fat letter type had previously been revived for use in advertising during the 1930s, fell out of favor in the 1940s, and was revived again in the 1950s when Otto Storch, art director of McCalls, began using Victorian woodtype and ornament for editorial layouts. Indeed a taste for things old fashioned was returning, apparently as a reaction to what was perceived as cold, humorless Modernism. "It was called the *Push Pin Almanac*," Chwast said in a 1990 interview, "because it was a quaint name—and quaintness was popular in those days."

The contents were usually ephemeral tidbits excerpted from books and periodicals and illustrated in styles that evoked the past. Each issue related to seasonal themes, and included a few articles written especially for *The Almanac* on graphic design topics. Though it might be compared to Will Bradley's early 1900s *Chap Book* and other printer's keepsakes from that time, the *Push Pin Graphic* was a special publication in the early 1950s, since most commercial artists who advertised their services to the trade were doing it in very straightforward, unimaginative ways. *The Push Pin Almanac* was a paradigm of conceptual acuity.

Six issues of *The Almanac* were published before the studio was started, and two after. The printing of 3,000 copies of each issue and the typesetting were basically done for free (or at cost) in exchange for designing and publishing the supplier's ad in *The Almanac*. Other operating expenses were paid for through the sale of small space ads sold after the first issue.

The response to the *Graphic* went beyond immediate commercial success. It was historically significant in that it exerted an extraordinary influence on individual designers, and so the entire field. To this day, designers who were beginning their careers in the late 1950s and early 1960s recall how excited they were when a new issue arrived in the mail. For Push Pin included designers with varying talents sharing a distinctive methodology—a passion for what we would call mass popular culture—who had an ability to translate their particular vocabulary of forms into mass communication (and selling) tools. They did so through a marriage—long rejected by the Modernists—of drawing and typography. *The Push Pin Monthly Graphic* (and the subsequent *Push Pin Graphic*, renamed because they could never keep to the monthly publishing schedule) proved that designer/illustrators were not simply pairs of hands doing the bidding of a client divorced from the total context, but were "creatives" capable of developing ideas in totality. And Push Pin's work was not simply derivatively decorative, but originally witty.

Beginning as a newsprint tabloid *The Push Pin Graphic* eventually came in a variety of sizes and shapes, evolving into discreet books and booklets on a variety of subjects, usually six times per year. The most memorable issues were on Art Deco automobiles (what Chwast refers to as "Roxy" style), "The Kings and Queens of Europe," "Rhymes by Edward Lear," *The Push Pin Book of Dreams*, "Good and Bad," "The Kiss," "Rock and Roll," a collection of wooden targets (Paul Davis' first significant work as a junior member of Push Pin) and Chwast's *tour de force*, "The South," a series of classic (and often racist) Southern stereotypes as backdrops for photographs of slain civil rights leaders. To heighten the polemic, a diecut bullet-hole pierces through the heads of the civil rights workers until in the last picture the bullet-hole shatters the calm of an image representing the Old South, which is inset against a backdrop of the civil rights march on Washington. This poignant and caustic commentary was one of the few *Push Pin Graphic*s with such an overt political message.

By the mid-1970s, the contributions made by Push Pin Studios had become part of the mainstream and the *Push Pin Graphic* had lost some of its innovative spark. In order to rejuvenate himself and expand into different realms of design, Glaser left Push Pin in 1975 and founded his own design firm. Chwast kept the Push Pin name and in 1976 decided to revamp *The Graphic* into a standard, 9 × 12 inch magazine format, printed in full color. Chwast's goal was to make it commercially viable by rigorously selling advertising and subscriptions. He printed 11,000 copies of each issue and eventually garnered around 3,000 subscribers at the rate of $15 yearly (mostly designers in the United States and abroad who were not on the complimentary mailing list). Interest was high, but as a commercial property, *The Graphic* was losing money at a prodigious rate. Nevertheless, as a magazine it continued for four years and twenty-two issues.

Each was based on a specific theme and involved all the current Push Pin members and illustrators that Push Pin was then representing. The premiere issue (#64) was devoted to "Mothers," and included an illustrated series on famous artists' mothers (humorously rendered in the style of their progeny by Push Pin artists). Other themes included, "Food and Violence," "Exploring New Jersey," "Animal Follies," "Heroes," and "Good and Bad Luck." Each issue was more whimsical than satiric. The cover of the "Total Disaster Issue (No. 78)" was a hand-colored photograph of a hotel after the San Francisco Earthquake, while the inside, designed and illustrated in the contemporary *retro* style that Push Pin, and especially Chwast, had become known for, was a baedeker of real and imagined disasters.

Despite a seeming abundance of advertisements from graphic arts suppliers (mostly designed by Chwast and given gratis in return for their services), financial pressures ultimately took their toll. "The All New Crime Favorites" issue was the last *Push Pin Graphic*, and perhaps not coincidently it was the least interesting of all the issues. In all, 86 issues were published from 1953 to 1980, and ran the gamut from silly to profound. In its early incarnation *The Push Pin Graphic* had an incalculable influence on the conceptualization of graphic design, and provided other firms and studios a model, indeed a medium, in which to show their conceptual skills. Taken as a whole, the 86 issues show the evolution of a significant graphic style (and its makers) that not only eclecticized American graphic design, but altered the course of American illustration for years to follow.

—Steven Heller

Bibliography—

McIlhany, Sterling, "Seymour Chwast," in *Graphis* (Zurich), no.102, 1962.
Wolf, Henry, and Synder, Jerome, *The Push Pin Style*, Palo Alto 1970.
Nishio, T., *Seymour Chwast*, Tokyo 1973.
Davis, Myrna, "Push Pin Graphic: A Studio Magazine Comes of Age," in *Graphics* (Zurich), no.197, 1978.
Glaser, Milton, *Milton Glaser Graphic Design*, New York 1973.
Chwast, Seymour, *The Left-Handed Designer*, New York 1985.

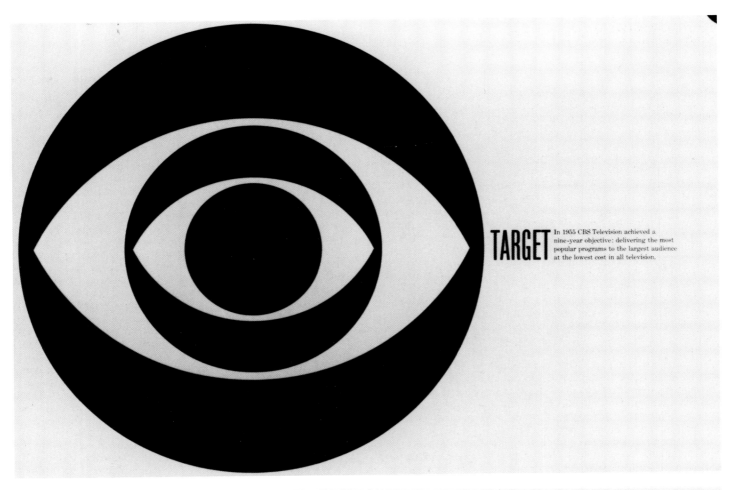

TARGET In 1955 CBS Television achieved a nine-year objective: delivering the most popular programs to the largest audience at the lowest cost in all television.

Johnson's whole ball of wax is on the CBS Television Network

Starting this Fall, S. C. Johnson will concentrate all of its network television advertising on the network which repeatedly delivers the largest nationwide audiences in advertising.

As the biggest manufacturer of wax polishes in the world, Johnson needs the biggest audiences it can get—and has found them consistently on the CBS Television Network.

For the past three years it has demonstrated the efficiency of its products to an average audience of 27 million viewers, aided and abetted by Red Skelton. In its programming plans for the Fall, it has not only announced the renewal of this popular comedy series, but has increased its product-exposure by ordering two additional nighttime programs.

Johnson underwrites its belief in the effectiveness of network television by committing most of its advertising appropriation to a medium still growing at the rate of 600,000 viewers a month.

This same confidence accounts for the current wave of renewals by America's leading advertisers on the network which in 70 consecutive Nielsen Reports issued since July 1955, has been credited with the largest audiences in all television.

William Golden (1911–59)
CBS symbol and identity programme, 1951
Columbia Broadcasting System Inc., New York

Through this work for CBS, William Golden was a visionary pioneer in graphic design. His program of identity design and promotional advertising for Columbia Broadcasting System was innovative and set a standard of excellence which has endured through the years.

The successor to William Golden at CBS, Lou Dorfsman, has provided the most enduring testimonial to the CBS Eye symbol in his comment, "Today as we watch the most transforming medium of our time, there is a Golden graphic message seen daily by more people than have seen a single mark of modern man. It is that majestically simple CBS eye, as beautifully appropriate when he designed it in 1951 as it is today. If I can interpret it in the special iconic way of Bill Golden, it is there to watch over our professional successes as well as spot our transgressions."

Golden (1911–1959) was born in New York City and trained in the newspaper business. Eventually he worked for the legendary Dr. M.F. Agha at Conde Nast Publications, designing issues of *Vogue, Vanity Fair* and *House and Garden.* In this capacity, Golden was to learn the lessons that would allow him, at CBS, to elevate the role of the graphic designer to one of decision-maker, policy-maker and implementer of creative excellence. He joined CBS in 1937 and, except for the 3 year stint in the Army in World War II, was in charge of CBS graphics until 1959.

William Golden possessed individual qualities which made him the perfect person for CBS. Talking the language of the businessperson, he said, "My solutions do not spring from aesthetic considerations but from business or marketing positions." Later he would comment on the importance of craft in design work by saying "Craftsmanship is something people have to nourish and hang on to. It is disappearing from our society. I see nothing more rewarding than to try to do something as well as you can." His friend Will Burtin commented "There is a mental dexterity and an absolute mastery of subtle details, a complete absence of graphic tricks or of intellectual gimmickry, which brings admiration wherever his work appears."

Frank Stanton, the "man at the top" at CBS, was a progressive individual who had exceptional visual sensitivities and taste. Not only was the corporate environment perfect for Golden but the timing was right for the development of a fresh, new image for CBS. The eye symbol was developed and proposed as the service mark for use in identifying the CBS Television Network from its CBS radio counterpart as well as from other competing networks. When Golden made his initial presentation of symbols, he showed three to a group of CBS executives. The immediate reaction from the majority was non-committal. However, Golden's ally Frank Stanton, reacted quickly and positively to the eye, and it was accepted. Other parts of the CBS identity used the Didot Bodoni type, which Golden had brought back from Europe and had his staff customize for CBS applications. Cipe Pineles, Golden's widow, recalls his working on the eye, "Bill felt that an eye would be the most natural symbol. He researched it and found that the eye had been a recurring symbol throughout the centuries and recently with the Masons and the Shakers." A colleague Kurt Weihs, remembers Golden commenting upon an eye symbol which appeared at that time in an article on Shaker design in Brodovitch's *Portfolio* magazine.

All was not easy in implementing the CBS identity program. Golden's colleague John Cowden remembers those days as "a thousand battles, a thousand scars, but never a negotiated peace for the sake of expediency. Simply because Bill cared so much, fought so hard, and performed so well, he prevailed and was able to give CBS advertising a distinction and quality second to none."

The eye symbol was first used in an on-air application on November 16, 1951, superimposed over a formation of clouds. Early versions of the mark included a sequential format in which the center part appears as an opening iris of the eye to reveal the CBS letters. The eye symbol was carefully adapted to work with the Didot Bodoni type in many other identification applications such as television cameras, program promotional kits and ads, rate cards, calendars, books, architecture, signage and even special cuff links and matchbooks. The eye symbol, through its extreme simplicity and impact, was distinctive in its ultimate legibility. It was also widely applied to an extensive series of trade and newspaper advertisements in the 1950s. Of these, the "target" ad showing the mark designed inside itself and the Johnson's Wax ad which featured comedian Red Skelton's face silhoutted inside the eye symbol, are but two examples of a myriad of powerful graphic statements, each one communicating its message but also transmitting a reminder of the strong CBS identity through the eye symbol. Golden put in differently "A trademark does not in itself constitute a corporate image. As I understand the phrase, it is the total impression a company makes on the public through its products, its policies, its actions, and its advertising effort."

—R. Roger Remington

Bibliography—

Golden, William, "My Eye: CBS Trademark," in *Print* (New York), June 1959.
Pineles, Cipe, and others, eds., *The Visual Craft of William Golden,* New York 1962.
Laughton, Roy, *TV Graphics,* London and New York 1966.
Coffet, D., "William Golden/CBS: The Impact of Corporate Identity," in *Print* (New York), January 1969.
Rosen, Ben, *The Corporate Search for Visual Identity,* London and New York 1970.

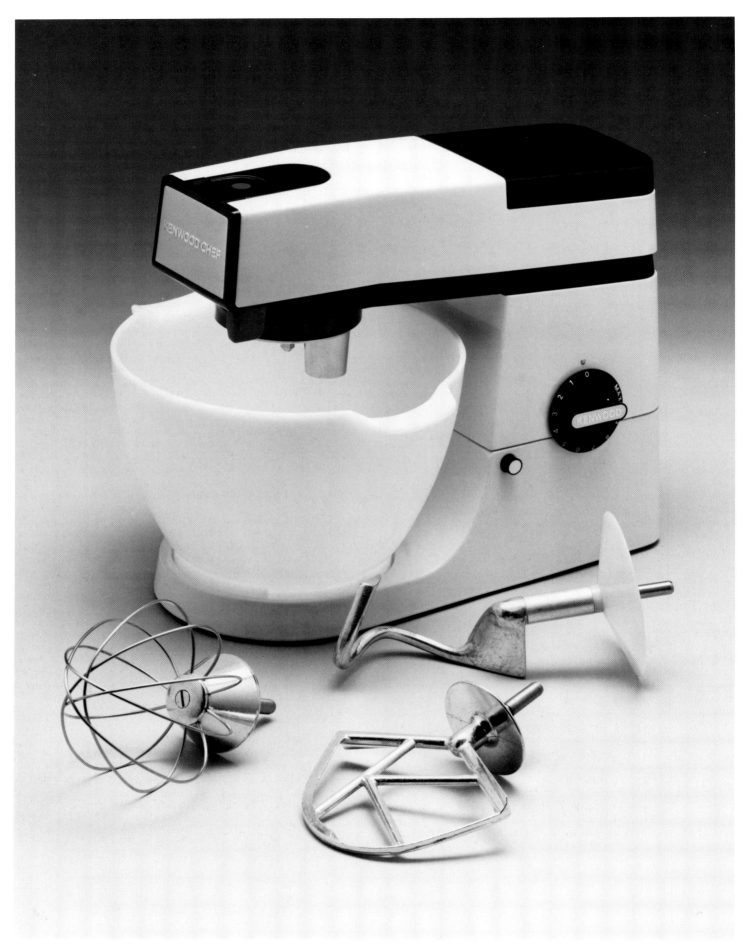

Photo courtesy of Kenwood

806

Kenneth Grange (1929–)
Kenwood Chef food processor, 1960
Thorn-EMI Kenwood, Havant

The *Kenwood Chef* has become such a familiar part of household technology, that we find there is little need to define its function. Kenneth Grange, writing for the Boilerhouse project in 1983, claimed that, when "a cartoonist draws a kitchen, a few lines suffice to indicate the ubiquitous kitchen mixer—and it is sure to be a Kenwood Chef." In part, the *Chef*'s strengths lie in its well proportioned, and simplistic styling, which, to this very day, has undergone only minor modifications since its redesign back in 1960.

Throughout the 1950s, most domestic food processing appliance manufacturers adopted expressive and curved forms, associated with American design ideology and the "glamour kitchen" promotions campaign of the post-war years. However, towards the latter half of the decade, the influence of American design began to give way to the "Rationalized" approach of German appliance styling. This new "development," pioneered by the German manufacturer Braun, and their two principle designers, Hans Gugelot and Dieter Rams—both associated with the Hochschule für Gestaltung—departed radically from the expressive styling adopted by Kenwood and other kitchen appliance manufacturers. In 1957, Braun introduced the "Küchenmaschine," described by the *Design* magazine (May 1959) as "monumental" in its appearance, with its "almost knife edge forms" and "extremely plain and simple" surfaces. The "Küchenmaschine" was to represent a new trend in kitchen furniture and appliance design. Braun's new model was to become a major influence behind Kenwood's decision to redesign its own range of food mixers, in accordance with this new trend.

In 1960, the consultant designer Kenneth Grange was brought in to restyle the *Kenwood Chef*. Grange introduced many of the design features associated with the Braun model. Gone were the "rounded curves" of the *Chef*'s power-head, which according to the *Design* magazine, looked "more like porcelain than metal." Gone, the thick parallel column, which emphasized the "heaviness of the machine." Gone too, the "old fashioned" paintbrush script of the makers name. The general effect, claimed *Design*, "was closer to hotel kitchen machinery than to the modern domestic interior." Replacing these features, Grange adopted smooth and simplified surfaces, parallel lines and a "purity of form" acknowledged by an intellectual few as being "derived from the classical tradition." Grange had effectively stripped the *Chef* of all its associations with the old styling ideologies of America, and was engaging in a German design theory that epitomized concerns with style and form as industrial metaphor.

Technical efficiency lay at the heart of German design theory. It was an approach that aimed at conveying symbolic meaning through form. The concept of form, however, was not an artistic consideration, but the result of technical and economic factors originating from the industrial process. This link between the industrial process and surface considerations lay at the heart of the educational philosophy of the Hochschule für Gestaltung. German design symbolized, through form, industrial organization, efficiency and cleanliness. Grange redesigned the *Kenwood Chef* in accordance with this design philosophy.

Grange readily acknowledges the influence the German philosophy of rationalism made on his own views on design. He had often claimed that a product's surface design should be an integral part of the manufacturing process. Nevertheless, credit must be given to Grange for recognizing the importance of this new theor-

etical mode of design styling, adopting it, and bringing it to the attention of the British manufacturing industry.

The redesigned *Chef* was simple in its construction. The main body being manufactured from an aluminium alloy, with a stove enamel finish. Various other components were finished off in plastic relief. One of the criticisms made by the *Design* magazine, prior to the *Chef*'s redesign, was its weight. It looked and actually was almost twice as heavy as any other domestic food processing appliance on the market. The old *Chef*'s thick parallel column emphasized its weight, making it look heavy and cumbersome. Grange redesigned this, allowing the column to support the power-head, without visually dominating the overall appearance of the *Chef*. A visually over-dominant column would substantially weaken the illusion of the power-head's efficient working action. For example, due to the over-dominance of the Braun Küchenmaschine's column, the power-head looks weak, almost feeble. The visual balance had to be just right. Substantially reducing both the *Kenwood Chef*'s overall dimensions to 12 × 15 inches, and its actual weight, helped to make the *Chef* look less like an industrial machine, straight from the factory shop floor, to one that was more appropriate and manageable for the domestic environment. The *Chef*'s base, although significantly weaker, was strengthened visually by the mixing bowl. Again, distributing the mass to the bottom helped give the impression of strength, but still retaining versatility. The power-head and base were fitted into an unbroken monolithic form.

Smooth, parallel surfaces, crisp hard-edges, and parallel lines, contributed substantially to the illusion of cleanliness and efficiency. The overall result was one of strength, power and versatility. Various food processing accessories, such as the *Chef* mincer, or, its liquidizer, could be attached simply and quickly. Both were seen as a must for the modern kitchen. Attention to detail, added to the overall design effect. For example, the control knob, conspicuously located, symbolized no-nonsense, technical control. The Kenwood logo, plain and simple, effectively achieved the same result. Locating screws were discreetly hidden. Whilst other external elements were contained and highlighted in coloured plastic again contributed to the *Chef*'s "harmonious entity." The overall effect was one of technological efficiency, cleanliness and organization. A machine that meant business.

Out were the kitchen appliances that looked like industrial machines. In came "Rationalism." The appliance no longer needed to look like an industrial machine, to represent machine efficiency and organization. The *Kenwood Chef*, utilizing the new German theories of "Rationalism," represented efficiency, cleanliness and organization through the subtleties of industrial metaphor. Although it may be argued that the *Kenwood Chef* was not as visually or intellectually pure as the Braun, it is still one of the most successful products on the market.

—Melanie Tomlinson

Bibliography—

Archer, L. Bruce, "Electric Food Mixers," in *Design* (London), May 1959.
Forty, Adrian, *Objects of Desire: Design and Society 1750–1980*, London 1986.
Bayley, Stephen, and Ward, Jon, eds., *Kenneth Grange at the Boilerhouse*, exhibition catalogue, London 1983.
Sparke, Penny, *Electrical Appliance*, New York 1987.

Sauce-boat from the 'Easy Grip' range introduced in the 1950s

Dishes from the 1960s, 'Harvest' casserole on right Photos Design Museum, London

Modern Pyrex. Photo Corning

Milner Gray (1899–)
Pyrex oven-to-table glasswares, 1955–65
Heatproof glass
James Jobling and Company Limited, Sunderland

The quality of Milner Gray's work for Pyrex in designing such a simple, basic and yet classic line of ware reveals a side of his work which has been unjustly neglected. Any consideration of his work to date has tended to concentrate either on his work in the field of lettering and in particular his pioneering work in what was then called "house style," or the work he did for the various official design bodies such as the Design and Industries Association and the Society of Industrial Artists—as Avril Blake comments, he seems at some point to have been "member, chairman or president of almost every committee or organisation concerned with graphic and industrial design."

This is a very partial representation of his work, however, since he always believed that product design was an vital part of the designer's work in industry, and even in his early days as a founder the Industrial Design Partnership, he saw its work as covering all aspects of design "from the styling of goods to press advertisements."

When Gray moved on to form the Design Research Unit with Misha Black and Herbert Read towards the end of World War 2, anticipating what they saw would be the increased demand for designers, product design was still perceived as a crucial part of their work. However, due to the reputations of the partners, as well as the considerable contribution they made to the Festival of Britain, the Unit became known mainly for its work in the fields of exhibition and packaging design.

To some extent, Gray's work for Pyrex between 1955 and 1965 did come out of his previous work in packaging, since he not only designed the goods but also a scheme for this, as well as the Pyrex trademark which featured prominently on the lids and base of each dish. But he had also had considerable experience in designing tableware for pottery firms such as E. Brain & Co and Royal Staffordshire, and the main contribution that he made to Pyrex was undoubtedly in his work on the basic range of Pyrex oven-to-tableware.

Pyrex heat-resistant pressed glass was produced in Britain by the Sunderland firm of James Jobling & Sons, who had obtained a licence to produce it in Britain in the 1920s, and since then their basic range of cooking equipment had not really been altered. However, the market had changed considerably in this period. Pyrex itself had received a considerable boost during the war, as the need to conserve aluminium and other metals had resulted in traditional saucepans being in short supply, and by 1945 Pyrex was accepted as an alternative. Oven-to-tableware had also increased in popularity, partly as a response to more continental eating habits, but also because the decline in the employment of domestic servants made mealtimes less formal, and the housewife became less inclined to decant vegetables and stews into serving dishes and brought them straight to the table instead.

Gray's designs reflected all these factors, and were simply designed for functionality. Previously, the casseroles had no handles, and had sat on metal cradles for serving, but he simplified the range, doing away with the separate metal pieces, instead providing the dishes with substantial handles which made the dish easy and safe to carry from oven to table, as well as being easy to manufacture. The handles also featured opposing curves on the lid and the pot, ensuring a hot lid could easily be removed from the pot. And the curved lines of all the dishes ensured that they were easy to clean. Their practicality amply fulfils the intentions that Design Research Unit set out for themselves in a little book on *Industrial Design*, published in 1949. "Industrial design does not limit itself—as some imagine—to giving an article a nice shape or colour, or improved appearance, though this is of course important. Good industrial design is more than this because it takes into account efficiency of manufacture and fitness for purpose. . . Too many articles are produced because they work, without any thought for the people who have to work them. Too many articles are produced by people who only have to make them and who never have to live with them."

But the form of the dishes was not simply a result of their function. The simple curved forms of both the bodies and the handles exploited the ductile qualities of glass, as well as being efficient to produce by pressing. Furthermore, one of the reasons for the growth of oven-to-tableware during the 'fifties was the dominant influence of Scandinavian design on British designers. Gray's work does not only fulfil the Scandinavian ethos of "beautiful things for everyday use," but the curvilinear organic forms of the dishes, as well as the neat integral handles on sauceboats and casseroles also relate it more closely to the Scandinavian tableware that was being produced in this period.

The influence that Scandinavian design undoubtedly had was made more explicit in a pattern that Gray later devised for some of the oven-to-tableware. Called "Harvest," it featured brightly-coloured sectional fruit and vegetables on a white background, and is obviously related to a range of cookware, "Picknick" produced by the Swedish company Rörstrand in the 'fifties, which was also decorated with similar, almost diagrammatic vegetables and herbs—similar ranges were also produced by other factories in Norway and elsewhere.

It was not surprising that Gray's designs was one of the winners of the Design Council's first "Design of the Year" awards in 1957. The simplicity and the appeal to more modern styles of living was exactly what the Council, as admirers of all things Scandinavian, were trying to promote in the face of the patterned and ornate styles that British manufacturers preferred. But unlike many of the Design Council's choices, Milner Gray's Pyrex goes beyond the fashions of the period. His simple straightforward designs are as functional today as they were then and are one of the few things that can justifiably lay claim to the title of a classic design.

—Susannah Walker

Bibliography—

Butler, George, "Milner Gray: Designer," in *Art and Industry* (London), November 1950.
Blake, John and Avril, *The Practical Idealists*, London 1969.
"Milner Gray," in *Idea* (Tokyo), May 1970.
Holland, James, *Minerva at Fifty: The Jubilee History of the Society of Industrial Artists and Designers 1930–1980*, London 1980.
Blake, Avril, *Milner Gray*, London 1986.
Rose, Stuart, "Milner Gray," in *Art and Artists* (London), October 1986.

Photo Finnish Society of Crafts and Design

810

Pentti Hakala (1949–)
Lily 115 chair, 1985
Birch plywood and chromed steel; 115cm. high
Martela Oy, Helsinki

Pentti Hakala's *Lily* chair's unadorned design reveals a great deal about its Finnish origins. Indeed the material itself—wood—is steeped in tradition. Previously wood formed the basis of the Finnish way of life. Forests were cleared for planting crops and the wood used for building. Used in fact for everything: cupboards, chests, tools, wheels, boats and skis. Wood still holds a place in most Finns' hearts—many continue to dream of their own wooden cottage by the side of a lake. In the furniture industry, wood has experienced a continuing renaissance and nowadays, at the beginning of the 1990s, is much favoured as a material for sculpting and handicraft.

However, wood has also become but one material amongst many and only a few, such as artists, look for its soul. Pentti Hakala, furniture designer and artist, is one of them. He realises the surface is alive; full of power and possibilities. Using hard and thick core timber he has performed a whole series of experiments, including gluing thin layers on top of each other. The *Lily* chair has twelve such layers.

Nowadays, however, he is not content just with bending glued strips. Instead he is trying to twist them to get more tension. Finland is rich in timber, a fact which encourages such open-mindedness about its use. There is room to experiment.

A great deal of expertise is needed to treat wood properly. It cannot be made to disobey its own rules: wood continues to live in finished products. Pentti Hakala is not himself a carpenter, but he has found a number of skilled craftsmen to help him in his work. Craftsmen who are willing to experiment and not just react negatively. Pentti Hakala's designs demand perfection: the simpler the lines, the more carefully they have to be created. He himself participates closely in the whole pre-production process, since he would rather make a model than drawings. New and unexpected possibilities can also occur during the work.

Nowadays he prefers solutions in which wood plays a smaller part and from which he can build a whole new shape or form. Thus Hakala is continuing the development started by Alvar Aalto in the 1930s. It is challenging to follow in Aalto's footsteps, especially since technology now opens up new horizons.

The black colour defers to modern interior design trends and has proved a good selling point in export markets. The longheld image of Finnish furniture being light and natural coloured has had to give way in Hakala's chair.

The Finnish national soul is based on Lutheran parsimony and sense of responsibility. On the other hand, these characteristics have been changed by the dawn of consumerism. In a fit of naive idealism, Pentti Hakala wanted to make *Lily* reasonably priced. Thus *Lily*'s moulded birch plywood, chromed steel body and four fastening screws do not cost much. But due to the strange laws of market forces, *Lily* turned out to be very expensive. The same fate befell her as many other "people's" designs: the original target group did not warm to *Lily*, and when more design conscious customers did, the price was raised.

In Pentti Hakala's chair, suspension replaces structure: *Lily* adopts the shape of the sitter and does not even need upholstery—which again saves on production costs. In the later models, comfort is further improved by using leather. Wood and leather are both materials that improve and become more beautiful with age. *Lily* is designed to last and not just as a fleeting phenomenon.

Sculptured, curvacious chairs such as *Lily* came into fashion in the 1980s after a long period of dominance by straight models. New young designers like Pentti Hakala especially enthused about soft lines. The young generation was represented by artist-designers who held a joint exhibition featuring prototype chairs that bordered between works of art and practical objects. Some of these 1980 youngsters such as Hakala have breathed new life into the Finnish furniture industry.

In the case of Pentti Hakala, the *Lily* chair's sculptured design is proof of Finnish determination. He should have become a sculptor, but his parents did not consider it a worthy career. He comes from central Finland where values differ from the capital Helsinki. "Become a priest or teacher," were the options, although he had had enough after three years. His entry into a new career came as a result of a television programme about the work of the well-known Finnish interior architect and furniture designer Yrjo Kukkapuro. Pentti Hakala applied for and was accepted by the Finnish University of Industrial Arts to study interior architecture and furniture design, which was taught by Kukkapuro himself.

Nowadays, Pentti Hakala is approaching the aim of original sculptors: he makes beautifully sculpted chairs. Consumers and manufacturers do not understand them, but Hakala carries on regardless. He has found his own style, and will not give in to commercial pressures. His incorruptibility is shown by the fact that he has given up teaching in the University. "I'm finishing now. Since I have nothing new to say, I've nothing else to give."

In Finland, it is typical that natural talent is not properly utilised. *Lily*'s manufacturer has not looked after sales correctly and when another large manufacturer took over, production was put in doubt. With the result that *Lily* will soon perhaps become a collector's item. And then when one goes for a huge price at auction, it will be time to think about starting production again.

—Carla Enbom

Bibliography—

Periainen, Tapio, *Soul in Design: Finland as an Example*, Helsinki 1990.

S	M	T	W	T	F	S
			1	2	3	4
5	6	7	8	9	10	11
12	13	14	15	16	17	18
19	20	21	22	23	24	25
26	27	28	29	30	31	

AUGUSTUS MARTIN LTD
PRINTWORKS

TRICKETT & WEBB LTD
DESIGNWORKS

GEORGE HARDIE
ARTWORKS

NINETEEN EIGHTY SIX
THE WORKS

812

George Hardie (1944–)
The Works calendar page for January 1986, 1985
Trickett & Webb, for Augustus Martin Ltd.

George Hardie's calendar page for *The Works* offers a working solution to the problem of mapping the macrocosm in the microcosm of the single page. It also sums up many themes explored in his work and his teaching.

George Hardie comes from an impeccable background of the Arts and the Sea. His grandfather was Martin Hardie, the painter, critic and curator, a pioneer of public understanding and appreciation of print-making and watercolour. His father was a Captain in the Royal Navy. He was educated as a graphic designer at St. Martin's School of Art in London and then at the Royal College of Art. In 1970, he began working with Bush Hollyhead and Malcolm Harrison, formalised as NTA Studios in 1973, starting a freelance career in illustration and design that also included teaching at art schools in Britain and America.

Although he worked for a wide range of commercial clients, his best known early work was for the music industry. His illustrations and designs for Storm Thorgeson and Hipgnosis in the 1970s have led to them being regarded as the Old Masters of the LP Cover. In an industry where the imagery associated with the music proved scarcely more enduring, where surface was all, their designs for the sleeve art of Black Sabbath and Led Zeppelin have a rare blend of style and substance, a flair for pastiche with embedded meaning. Hardie's early sketches for Hipgnosis LP covers have now achieved the status of *incunabula*.

In his subsequent work for advertising agencies, magazines and major corporations, he has sustained this highly personal range of imagery, often flying in the face of his clients' caution, misunderstanding and market research. From the Three Monkies ad for TDK Tapes to the 1990 Sherwood Packaging Corporation Annual Report, his work uses sharply observed, often highly stylised detail with playful observations about the act of drawing. An all-pervading interest has been the Sequential, an unravelling of meaning and significance within the single image or within a sequence of images. This experience informs his teaching on the new post-graduate course devoted to the Sequential at Brighton Polytechnic, which has recently granted him a Professorship.

The subject matter of Hardie's work performs gracefully the tasks suggested by the client but, in his best work, his sense of paradox and ambiguity, his use of a personal repertoire of symbols, survive either because of the enlightened attitude of the client, or Hardie's ability to conceal allusions. "George Hardie seems very picture orientated. . . . He also does in quick and complicated ways what fine artists do heavy-handedly . . ." wrote Ian Jeffrey in 1981. One of those enlightened clients has been Trickett and Webb.

Each year, this design firm produces a calendar for the silk-screen printing company Augustus Martin Ltd. It is an exercise in persuading Martin's current and potential clients that Martin's can provide more sophisticated surfaces in the medium of silk-screen printing than the illuminated signs for the garage forecourt with which Martin's are associated. Each year has its chosen theme, *Palindrome* (1991), *Callander* (1990), *Chain Reaction* (1989), *Too Clever By Half* (1988), *The Seven Year Itch* (1987) and, in 1986, *The Works*.

The Calendar as an art form has not had an attractive track record; twelve pouting models, snaggle-toothed fox cubs or impossibly coloured cathedrals. As a challenge within graphic design it has, nevertheless, considerable potential. The month's displayed page has a longer life than a newspaper advertisement or magazine photograph. Under the intense scrutiny often given by the wandering or distracted mind, the calendar page on the wall can afford to surrender its substance slowly in capsular form. In this, it is perhaps only rivalled by the lure of the imagery on the cigarette packet in the pockets of those that wait. "Pictures should have something as well as immediate impact. Road signs can't take four days to understand, but on the other hand book jackets and record covers could take some time to unfold." (Hardie).

The calendar page is usually aligned to the month, maybe recording the activities and festivals of the Seasons, with an appropriateness and ingenuity also expected of the magazine cover. However, more than a magazine or a cigarette packet, it remains on public or semi-public view, providing an exciting showcase for the work of those illustrators eager to reach the general or specialist public. There is, however, always danger in the enterprise, usually for January's artist whose month on the public's wall may be severely curtailed by the late delivery of the calendar.

Trickett and Webb's Calendar for 1986 then starts with George Hardie's *The Works*. The game is on, but there is a danger that any extended explanation of the constituent elements would be as plodding and dutiful as those answers to puzzles printed in small grey type at the back of a magazine, but it's worth a closer look at some features of *The Works*—that is, Everything. Here, at least are *some* clues.

The WORKS as title on the chart have become The WOIKS, a Brooklynese version achieved by the intervention in a stray tessera over the "R". Woven into this puzzle is a dialogue between figure and ground: for instance, the erogenous zone of Lust in the Seven Deadly Sins section aligned with the humanoid form with phallic match borrowed from the matchbox representing FIRE from The Four Elements. Important to the ambition of *The Works* is the tree-like diagram of The Natural Order, derived from *The Story of Living Things* written and illustrated by Eileen Mayo, a particular Hardie favourite.

The format of the richly decorated folded chart with clues is a familiar theme in Hardie's work, a sort of paradigm of his career in graphic design. The most obvious source is in Robert Louis Stevenson's novel *Treasure Island*, a commission that always asks of its illustrator a folded treasure chart with ornate compass. It appears in Hardie's own illustrated version published by Collins in 1988.

What prevents this tendency from becoming an exercise in nostalgia, or a detour into the *cul-de-sac* of the pastiche is a desire to bury the meaning deep, to supplement the more accessible the family of the imagery with the more personal element of symbolism here the use of favoured talismanic objects—the physiognomic pebble and a surrogate tree (one of a large personal collection). Significantly George Hardie still has a particular respect for the work of Marcel Duchamp whose work so excited him as a student.

The problem of fully assessing the work of contemporary British illustrators and graphic designers is that much of the work of George Hardie and others of his generation, lies scattered in the pages of annuals and trade papers with no critical context. At a time when many British makers of images are re-assessing in an serious way in the early 1990s what it means to belong to a national tradition, it is time for us all to try and establish a critical perspective.

One of the perils of contemporary illustration is that reputations and declines can only be traced in trade gossip or in the small captions of the International Annuals. Previous ages of commissioned imagery had provided effective structures for the easy availability of illustrations, even the Illustrators of the 1860s have found worthy chroniclers.

—Chris Mullen

Bibliography—

Hardie, George, and Hipgnosis, *Walk Away Rene: An ABC of the Work of Hipgnosis*, Limpsfield, Surrey 1978.
Fern, Dan, "Interview with George Hardie," in *Illustrators Magazine* (London), no.1, 1980.
Jeffrey, Ian, "Five Illustrators Interviewed," in *Images* annual, London 1981.
Hardie, George, "Illustration," in *The New Guide to Professional Illustration and Design*, London 1987.
Hardie, George, *Robert Louis Stevenson: Treasure Island*, London 1988.

Photo Danish Design Centre

Niels Jorgen Haugesen (1961–)
Haugesen folding table, 1984–87
Maple and chromed steel
Fritz Hansens Eft A/S, Allerod

"What came first, the hen or the egg?" is one of nature's classic questions, to which there will never be a simple answer. In industrial design, the equivalent question is: "What came first, the solution or the problem?"

The Haugesen table with swing leaves is a case where it is possible to give a clear answer to this classic question in the sense that it was, in fact, designed for a competition for The Scan Prize 1984, sponsored by Scan Co-Op Contemporary Furnishings in Maryland, USA.

Scan, which had done so much business selling good Danish furniture in the US, felt that it would like to stimulate the development of Danish furniture design. The company therefore asked the Danish Design Centre to launch a series of annual design competitions, each of which related to a specific product area and a specific problem as described in its programme. The second SCAN competition went back to what furniture originally was. The Latin word "mobilia" (in other languages møbler, Möbel, meubles) simply means objects which can and are meant to be moved around, objects which are mobile. The programme of the competition addressed the need of young people who live light, have a tight budget, and move a lot, by inviting proposals for lightweight, flexible and highly mobile furniture. According to the programme, it should be possible to move one's furniture in a taxi and to assemble it and take it apart without the use of tools. And later when the designers Niels Gammelgaard and Lars Mathiesen were awarded 1st prize for their Trans-It furniture system, Gammelgaard explicitly mentioned the requirement that it should be possible to assemble the furniture and take it apart without the use of tools. This, he said, was a demand which would dominate the design of knock-down furniture all over the world in the future.

Niels Jørgen Haugesen did not win the competition, yet his proposal had so much going for it that its single items are now, one by one, coming into production.

In the table, which was part of his proposal for the design competition, Haugesen addressed the problem of designing a table which would fit different group sizes. It should be possible and comfortable for one person to work at, and it should also be a good place around which anything from two to twelve persons could form a social circle. At the same time, however, the table should not take up too much space when not in use. This, of course, meant that the table should be flexible in size.

Haugesen opted for a table with swing leaves. Yet, tables with swing leaves all have the problem that nobody can sit at the ends of the table when the swing leafs are not in use. With the leaves down you cannot have your legs under the table, so nobody wants to sit there. So Haugesen simply allowed the leaves to swing a full half circle (and not just a quarter of a circle where the swing leaf of an ordinary table hits its legs, and stops) and disappear under the table when not in use.

An obvious solution, one might say. Yet, not all that obvious, the famous Haugesen table is, as far as I know, still the only table in the world which uses this construction.

In order to achieve this mechanical function, Haugesen shaped the legs of the table as a steel tube frame where the legs are outside the edges of the tabletop. This allows the leaves to swing down between the legs until they reach the underside of the table top and become invisible. Haugesen stressed the mechanical function by integrating two large hinges in the frame of the legs, thus visually making them disappear. He also added two thin diagonal rods of steel under the table to make it stable vis à vis horizontal forces, and also serve as a guiding rail for the swinging leaf.

The simplicity and sophistication of this design makes the Haugesen table one of the most elegant tables ever designed.

The mechanical requirements of the table are best met by a mechanism made from steel, so Haugesen chose steel for the legs, hinges and diagonal rods. For the tabletop he chose maple wood. He thus made the part of the table with which the user has direct contact pleasant and warm. The overall impression of the table is also one of a nice wooden table with steel parts used discretely, and for a purpose.

In addition to stating a stimulating problem, design competitions have an additional quality: They have a deadline. The history of design is full of ideas which never materialized because there was always some additional detail to take care of, some mechanical problem to sort out, some shape to sort out, or some material, colour or surface treatment still to select, and too much time to do it in. With its well-defined deadline, a design competition generates the kind of stress which is so important to help you save your life in an emergency or to get a new design finished.

Niels Jørgen Haugesen was actually exposed to this kind of stress twice during the competition. Firstly when the drawings had to be delivered three months after the competition was announced, and secondly when he was selected to have part of his proposal made up as a working prototype. Where making a working prototype in finished quality with a furniture manufacturer often takes years, Haugesen and one gifted master cabinet-maker achieved the task in two months.

The result was very close to the table manufactured today by Fritz Hansens Eft. So close, in fact, that Fritz Hansens Eft simply took the prototype table apart and sent the pieces to the workshops and had quotes for its metal parts from them. In this way, alas, the original Haugesen table was lost to the "Danish Design Museum," the collection of Danish modern classics established by the Danish Design Centre. Yet, happily, the Haugesen table moved from being just a museum prototype to becoming an excellent example of Danish industrial design, available from one of the world's leading furniture manufacturers.

The Haugesen table received the ID Prize in 1986. Ironically, even if the prize-winning table solved a classic design problem, in its manufactured version the Haugesen table did not quite solve the problem originally put forward: You could not take the table with you in a taxi because it was not yet a genuine knock-down construction. Yet, the original prototype *did* solve this problem, and the table now in production also does. The entire table comes as a package only about 3 inches (8 cm) wide.

This, ultimately, will make the first generation of Fritz Hansen's Haugesen tables not just excellent pieces of furniture but also real museum pieces.

—Jens Bernsen

Bibliography—

"Haugesen Table," in *DD Bulletin* (Copenhagen), no. 18, 1984.
Danish Design Centre, *Innovation via Design: The ID Prize—25 Years*, Copenhagen 1990.

Photo courtesy Danish Design Council

Klavs Helweg-Larsen (1939–)
Question-Mark telephone booth, 1980–84
Stainless steel and hardened glass
KTAS Copenhagen Telephone Company

The City of Copenhagen boasts one of the world's most striking pieces of public design, namely Klavs Helweg-Larsen's telephone booth in stainless steel.

The Question mark is characteristic, yet simple and somehow inevitable in shape. It clearly signals what it is—this can be nothing but a telephone booth—and has a distinct mark of quality about it through its choice of material and its good detailing. In the narrow streets of the old city it takes up a minimum of pavement space, yet it provides adequate shelter from wind, rain and snow—except perhaps under extreme conditions. And most surprising, all the "hard" and "modern" stainless steel blends harmoniously into any street scene without producing any of the clashes which ruins so many townscapes. The mattbrushed stainless steel simply diffusely reflect the colours of the surroundings, and thus makes it part of them.

The Question mark was manufactured from 1984 to 1985. In the future it may well become a sought-after collector's piece for design and art museums all over the world, a true 20th-century design classic.

The origin of the open telephone booth in Copenhagen dates back to 1979 when an unknown man mounted bombs in telephone boxes, with a device which made them explode when the would-be user opened the door. This made the Copenhagen Telephone Company, KTAS, remove the doors of their 1,800 old green telephone boxes. The bomber was ultimately caught. However, nobody at KTAS had realised in time that the green telephone boxes were made by hand over a period of nearly half a century; even if they looked alike, no two of them, including their doors, were identical. Since nobody had labeled the doors when they were taken off the telephone boxes, this meant that it would not be practically possible to put them back on.

At the same time, KTAS realised that the closed telephone box had its problems. By being a closed room with a door, it could be used for all kinds of questionable purposes—and was. This made cleaning and maintenance expensive, and still made the telephone boxes a poor "business card" for the company. The same was the case with the open telephone booths then on the market.

KTAS and the Danish Design Centre therefore decided to run a competition for a new telephone booth. The design competition was announced in the spring of 1980. A total of 196 anonymous proposals were submitted. From among these, the jury selected four to be made as working prototypes and tested before the jury made its final decision.

Klavs Helweg-Larsen's proposal, arrogantly shown as a drawing, from which sprang the characteristic profile of The Question mark on the scale of 1:10 and in stainless steel, just made it through the first round. Nobody from the jury, except perhaps professor Erik Herløw, gave it much of a chance of winning a prize. The prototypes were made on the scale on scale 1:1 during the autumn of 1980, and mounted and tested secretly in an old warehouse, with users ranging from children to oldagers, and including a handicapped user in a wheelchair. After this initial test, the four booths were mounted in three different places, photographed, and taken down immediately thereafter. The entire operation took just one quiet December weekend in central Copenhagen.

This provided striking documentation of how the four proposals would fit into three typical environments: Modern architecture, the old city, and in a mixed and somewhat messy environment.

Its performance during these tests made the jury decide to award Klavs Helweg-Larsen's proposal 1st prize.

The proposals were shown at two exhibitions and three were mounted and put to daily use on a trial basis in two of the squares of central Copenhagen. The idea was that the comments from the public were also relevant, and that only using the booths in practice could, and exposing them to the hardships of life in the street—including vandals and graffiti—would, reveal which proposal was up to standard. After these tests, and after considering architect Trolle Trap-Friis' proposal for a booth using green wiremesh with acryllic on the inner side, the Copenhagen Telephone Co finally decided that The Question mark would be the KTAS telephone booth of the future.

Product development took nearly two years, and included the expected and unexpected problems which are part of the development of any industrial product. Irritating at times, yet with hindsight a smooth process considering the complexity of the task, including acoustics, lighting, installations, mounting, emptying the money box, and not least the design of the supporting structure.

The Question mark was finally installed and presented in front of the Tivoli Gardens' main entrance and in front of the House of Industry on the Townhall Square in April 1984, where the mayor of Copenhagen made the first call from the new telephone booth—with traffic roaring by, and yet in comfort and relative privacy. With the next dozens of Question marks coming up it became obvious that Copenhagen had not only got a new telephone booth but also a new national landmark. The Danish Design Centre and KTAS even published a 120 page book on the case history of The Question mark. The book was, later, to become a real collector's item.

This could have been the end of the fairytale but wasn't. Onto the scene—a year after the presentation of The Question mark—came the then Minister of Traffic. The minister plainly did not like it. And when this argument was not strong enough to cause changes, he ruled that The Question mark was not friendly enough to people in wheelchairs, and that one could get wet when using it during a combination of wind and rain. After a struggle between the Board of KTAS and the minister which lasted for months, first behind closed doors, and then in the media, the minister forced KTAS to stop installing the question mark. Yet, the minister did not take the tenacity of the chairman of the Committee of the KTAS Subscribers into account. Mr Egon Weidekamp would have no telephone booth other than Klavs Helweg-Larsen's Question mark in the streets of Copenhagen. His argument was, of course, given emphasis by the fact that he was also the Mayor of Copenhagen.

The City of Copenhagen in 1986 actually awarded The Question mark and KTAS a plaquette normally given for good architecture only—a recognition which the chairman of KTAS at first refused to accept. The Question mark also received the prestigeous Thorvald Bindesbøll Medal in 1987.

The dispute dragged on until a ceasefire was finally agreed in 1989, whereby KTAS would mount some 50 Question marks in the heart of Copenhagen at prominent places. In other areas, KTAS would use a newly developed boxline booth, similar in size to the old green boxes, but without a door, and with the walls made from a green wiremesh protected from the inside by acryllic, like in Trolle Trap-Friis' proposal from 1980.

So the Question mark is on display and in use in some 50 selected places in the heart of Copenhagen. But there will be no more of them. Unless a manufacturer one day puts it back into production for the export markets, possibly in a slightly modified shape which gets rid of its many internal ribs and makes it easier to make.

Yet, Klavs Helweg-Larsen achieved something striking by means of this strong design with a tender touch—even if it is made in "hard" stainless steel.

—Jens Bernsen

Bibliography—

Mariager, Ann, and Moller, Henrik Sten, "Arkitekten i boksen," in *Politiken* (Copenhagen), 10 January 1981.
Skriver, Poul Erik, "KTAS' konkurrence om en ny telefonboks," in *Arkitekten* (Copenhagen), March 1981.
Bernsen, Jens, ed., *Street Signal KTAS*, Copenhagen 1985.

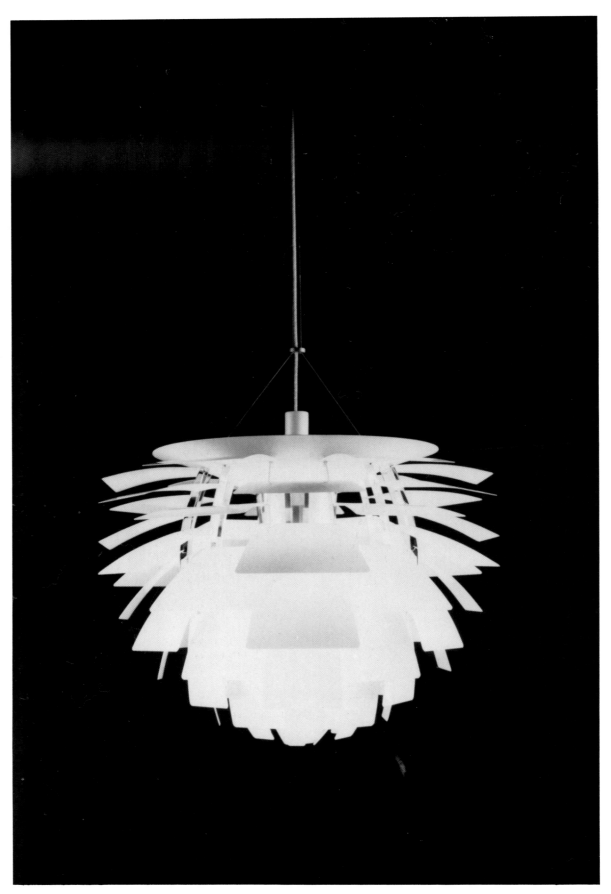

Photo courtesy Louis Poulsen

Poul Henningsen (1894–1967)
PH Artichoke pendant lamp, 1958
Pressed copper or steel sheet
Louis Poulsen & Company A/S, Copenhagen

The story has it that the architects Alvar Aalto and Poul Henningsen met after not having seen each other for several years. Aalto, being the world famous architect, talked about all his new assignments, and then asked Poul Henningsen what he was working on. Poul Henningsen's answer was: I told you the last time we met, I am working on my lamp.

To Poul Henningsen, designing lamps, or *the* lamp, was a lifelong passion.

During most of his nearly 50 years in business he pursued the idea of lighting and creating space by means of light *with culture* as his main mission in life as an architect. Yet, the success of the PH lamps, as they were all called, was not created after a lifetime's work with light. It came almost overnight, in 1925, when Louis Poulsen & Co introduced its new range of PH lamps in glass at an international lighting fair in Paris. Poul Henningsen not only won a gold medal for his lamp. He won *all* the gold medals awarded at the exhibition. He also won an almost immediate commercial success which allowed him to collect royalties for his designs which netted him an income of at least three times what the Danish Prime Minister made at the time. This commercial success, in turn, provided Poul Henningsen with a comfortable background for pursuing one of his other passions in life, being a left/liberal critic of what he saw as a "kleinbürgerlich" society. However, this is a whole different story.

The PH lamp itself, or rather all the more than 40 PH lamps he designed, are all based upon the same basic approach, namely the idea that the essential feature of a lighting is *not* the lighting fixture but *the light* itself: The shape and appearance of the lighting fixture is a secondary feature. What really matters is the quality of the illumination of the space. *This*, and not the idea of just creating beautiful lamps, is his point of departure. He simply moved his emphasis from the lighting fixture to the light itself.

Then what is the purpose of lighting?

To Poul Henningsen, lighting is not just a question of providing enough light. On the contrary, too much light, or light in the wrong places, or light of the wrong colour can be uncomfortable and effectively ruin a space. There is no one single big secret in lighting. Lighting with culture is a question of doing several things right. First of all, you should have light where you need it. Secondly, and just as important, the lighting should be free of glare. Glare is unpleasant and also prevents you from having the full benefit of the primary lighting by reducing the eye's utilisation of the light. Thirdly, the shadows should gently mold the objects in the space, and hard shadows be avoided. And fourthly, the colour of the light should be pleasant to the eye, rather the colour of the natural light at dusk or dawn than a reproduction of light of the middle of the day.

Such considerations led Poul Henningsen to introduce his famous multi-shade design. He simply determined that the complex functioning of the lighting could not be achieved by a single shade or screen. (In fact he wasn't right, at least not in principle. Half a century later, Verner Panton introduced a lamp, the VP Europa, which achieved the function of the multishade design but used a single, if complex glass shade to achieve the same function).

Poul Henningsen thus set out to find an entirely new type of lighting, and found it.

The immediate popularity of the inventor/designer in fact surprised Poul Henningsen himself. Two years after the introduction of the PH lamp he observed: "It was not to be expected that a new light fixture like the PH lamp (which does not even resemble any particular style of anything seen before), would immediately win whole-hearted praise for its appearance. From some quarters, strangely enough from technologists in particular, its contours have been found to be extraordinary. But the most surprising thing about the success of the PH lamp is precisely that so many people have been able to see the beauty that lies in an object which so completely fulfills its purpose and does not pretend to be anything other than what it is." (1927).

The lighting provided by the PH lamps in many ways have reminiscences of the Northern light, of the quality of the light which we experience during the long transition period between day and night of the Scandinavian summer. The lighting also reflects the Scandinavian tradition of assembling around the only light in the long winter evenings, forming a social circle. PH lamps are found by the millions in Danish homes, precisely for the purpose of providing light of high quality, with tender shadows, and providing the centre for forming a social circle.

This is its main reason of being, even if lighting technicians rightfully claim that an overall efficiency of the lighting of about 30% (meaning that 70% of the light stays inside the lamp) is not quite up to the requirements set forth by the need to save energy. However, with the glass PH pendant, the efficiency is much greater, namely 64%.

Yet, Poul Henningsen did not only, or not even primarily, work with the lighting of the home. He loved the opportunity to light big and impressive spaces and to provide the lighting for splendid occasions in big rooms with many people present.

The PH Artichoke lamp is one such example, and maybe the most generous and splendid modern lamp ever designed. Henningsen originally designed it for a new restaurant on the Copenhagen harbourfront, The Langelinie Pavilion. Shaped like an artichoke, and with the same precise geometry of the shales, it actually fulfills the function of his original multi-shade construction, yet gives a whole different appearance. It is a lighting for splendid spaces, and a lighting fixture to create splendid spaces—and also one of the most expensive lighting fixtures ever made. Yet its price has not prevented it from achieving a longterm popularity in important spaces and buildings, first in Denmark, and now all over the world.

It was introduced in 1958 and received the Danish Design Council's ID Classics Prize in 1985.

During its first 20 years, it existed in copper only, and in three sizes, all of which allow for the use of a 500 W bulb. In 1978 it was introduced in a stainless steel version, and in 1982 in a white version. Today, it is as successful as ever.

Poul Henningsen set out not to design a beautiful lighting fixture but to develop a fixture which provided good lighting. The irony, or the morality, of the story is, that he ended up designing a range of the world's most beautiful lighting fixtures. A PH lighting can make a beautiful woman look irresistible, yet also achieves the quality of being a romantic sculpture itself.

—Jens Bernsen

Bibliography—

Karlsen, Arne, and others, *Contemporary Danish Design*, Copenhagen 1966.
Henningsen, Poul, *Om Lys*, Copenhagen 1974.
Frandsen, Sophus, *Poul Henningsens Eksempel*, Copenhagen 1978.
McFadden, David R., ed., *Scandinavian Modern Design 1880–1980*, New York 1982.
"PH Lamp," in *DD Bulletin* (Copenhagen), no. 22, 1985.
Hammerich, Paul, *Lysmageren*, Copenhagen 1987.

Photos Knud Holscher Industriel Design

Photo Danish Design Centre

Knud Holscher (1930–)
D-Line handles and architectural fittings, 1975
Stainless steel
Carl F. Petersen, Copenhagen

Many of the most successful designs were not initiated by a manufacturer who wanted something new in his product programme. They were made because an architect or a designer needed a specific product for a specific job and could not find it in any manufacturer's catalogue.

This was also the case with the d-line system of handles and building fittings.

The roots of the d-line system date back to the '60s, to the building of St Catherine's College in Oxford, designed by Professor Arne Jacobsen. Knud Holscher, the young architect in charge of the construction site from 1960–64, simply found that there wasn't any system of building fixtures on the market which suited the building. His idea was, much in the tradition of Arne Jacobsen, that even the smallest and most technical details of a building should somehow be an expression of the idea of the entire building—or at least not distract interest from the building as poor detailing inevitably does. Knud Holscher found it a frustrating task to specify fittings which were or were not satisfactory in themselves but which didn't marry successfully with others within the building. He definitely did *not* want the building to become a dozen different manufacturers' different ideas about the looks and functioning of a series of fittings with more or less the same function.

Therefore, in cooperation with the British designer Alan Tye, he set out to design a system of fittings which would meet most types of demands in an entire building. This resulted in the highly successful *Modric* series of fittings in aluminium, which won the Duke of Edinburgh's Prize for Elegant Design in 1966.

In 1966 Knud Holscher won the competition for the new Odense University Centre in Denmark. In this connection, the firm of Carl F. Petersen, inspired by the success of *Modric*, in 1968 invited Holscher to design a series of fittings in stainless steel. For commercial and practical reasons, a split had taken place by the beginning of the '70s, whereby Alan Tye continued the design of the *Modric* series in England, in aluminium, and Knud Holscher continued the design of a similar series in Denmark, and in stainless steel. Dividing a product range along such lines is somewhat reminiscent of the Finnish story of the two men who, according to an agreement, decided to marry and share the same woman, and then discussed the use of which part, the upper or the lower, belonged to whom. Yet the division along lines marked by materials, and not design, worked in practice. The aluminium *Modric* remained a success at the low price end of the market in England, and Knud Holscher's system of fittings in stainless steel became a great success in Denmark under the name of d-line.

At least to begin with, Holscher landed with the most expensive material and the one most difficult to work with. It is difficult and expensive to mould stainless steel, and it is difficult to work. The geometry of the d-line series called for tubes of stainless steel to be bent in perfect circular arches. Yet this shape, so easy to make on the drawing board represented a manufacturing problem. Time and again, circular tubes which were bent, however gently, came out with a flattened profile along the curves, ruining both looks and strength.

In the end, an invention solved the problem. And as with most inventions, the most creative part lay in recognising the problem. In this case the fact that the tube needed support from the inside where it was going to be bent. With hindsight, of course, the solution was obvious. A simple solid tube of another metal, e.g. an aluminium alloy, was inserted into the tube of stainless steel at the point where it was going to be bent. This prevented the profile from being compressed. The aluminium insert was also used at the open end of the handles to make it appear solid, and to solve a hygienic problem.

The manufacturer, Carl F. Petersen, subsequently won both of the Danish Design Council's awards, the ID Prize 1975 for good industrial design, and the IG Prize 1987 for the graphic design of the d-line brochures.

Since then, it has been a continuous and steadily growing success. The d-line range of fittings dominated the Danish market for prestigious buildings from the beginning of the '80s, and is now becoming an export success all over Europe with annual growth rates of over 25% in total sales during the last three years. It naturally helps that d-line is specified by such architects as Norman Foster, Richard Rogers, Robert Venture, Ove Arup & Partners, Henning Larsen, and of course by Holscher's firm, KHR Architects A/S.

It may seem surprising that a design as simplistic as that of d-line, which balances on the verge of banality, can make and maintain such a success. Yet, it is precisely, its simplicity that is a great quality in a building where so many signals compete for attention. Stainless steel has the additional advantage of blending beautifully with other materials because it softly reflects the colours of its surroundings. And by being so well made, the d-line series projects an image of quality onto the whole building.

Another source of success is the fact that the system is continuously being developed to solve *all* the functions in its chosen field, and to take all practical problems seriously in its design and construction. By being complete (the system today includes some 800 different product numbers) it makes it easy for architects to specify their building fittings because all functions can be achieved within the d-line system. And by taking good care of such details as including a ballbearing in the mechanism of the door handles and preventing the handles from being too heavy and thus imposing an unnecessary burden upon the spring, the designers have to a great extent achieved the goal of allowing the customer to forget about the handles once they are installed.

Yet, simplicity may have its price in terms of function.

The most striking feature of the d-line series is that all fittings, except the door handles themselves, elegantly come out of doors and walls as a perfect tube, without any clumsy footings. This, of course, may impose big point-load at wall or door surfaces and cause the handles to come loose, even if the craftsmen mounted them properly. The d-line handles on drawers, hooks, fittings for holding towels, ashtrays or paper rolls all seem perfectly suited to their purpose. Yet, the basic d-line door handles suffer somewhat from their obvious lack of a natural relationship to the shape of the hand, and only just make it because the hand itself is such a beautiful and flexible tool.

A product often wins a place in the history of design by going to extremes. The d-line series has become almost a prototype of modernism driven to the extreme—and the exact opposite of the organic and romantic brass handles and fixtures designed by Antonio Gaudi and his contemporaries at the beginning of the century.

Somewhere in the middle are to be found Arne Jacobsen's famous door handles, also designed for the firm of Carl F Petersen in the late '50s: Organic and natural in their shape, a reflection of how the hand would want an ideal door handle to be, yet only a handle and not a whole system of building fittings—and a product which is becoming exceedingly expensive to manufacture because it requires too much work by hand.

—Jens Bernsen

Bibliography—

"Five IDD-designers," in *Mobilia* (Snekkersten), February 1974.
"Industriel Design: Arbejder af Knud Holscher," in *Arkitektur DK* (Copenhagen), no.8, 1976.
Stewart, Richard, *Modern Design in Metal*, London 1979.
Bernsen, Jens, *Design: The Problem Comes First*, Copenhagen 1982, 1990.
"D-Line System," in *DD Bulletin* (Copenhagen), no. 33, 1987.

Issigonis' sketch for the Mini. Photo National Motor Museum, Beaulieu

Austin Mini Super De Luxe Saloon, 1964. Photo Hulton-Deutsch Collection

Alec Issigonis (1906–88)
Mini (Austin Seven/Morris Mini-Minor) car, 1957–59
British Motor Corporation, Longbridge, Birmingham, from 1959

It seems incredible that a British car designed in the 1950s is still selling well today, over 30 years later. Yet the Mini's continued appeal is not merely a nostalgic one, a desire to recreate the "good old days" of British motoring amid a plethora of Euro-boxes. For the Mini remains an easy yet rewarding car to drive and own. Though modifications have been made over the years, the Mini of today is still faithful to Sir Alec Issigonis's brilliantly simple design.

Alec Issigonis, born in Turkey but with British nationality, moved to England in the 1920s, and after studying engineering joined the motor industry. His first major design, the Morris Minor of 1948, still lingers in the affection of British motorists for its reliability, practicality and sheer charm. (It is even rumoured that the now-mighty Japanese motor industry started by taking the Morris Minor as its role model, reworking it to match and eventually improve upon its qualities.) After designing, with Alex Moulton, an extraordinarily advanced suspension system for Alvis, Issigonis returned to Morris, now merged with Austin to form the British Motor Corporation, in 1956. That year saw a petrol shortage, following the Suez crisis, which prompted BMC's chairman Sir Leonard Lord to postpone all other projects in order to produce a completely new small and cheap car, to be designed by Issigonis.

The approach Issigonis took initially is now known as "packaging" and involved deciding on the size of the cabin, and engineering the car around that. After working out the smallest possible cabin area to seat four people in comfort, he needed to accommodate the engine and transmission without compromising his desire to produce the lightest, smallest car possible. Without the resources to design a new engine, Issigonis had to use a version of BMC's existing A-series engine, as used in the Morris Minor. But even when the capacity was reduced to 848 cc, the unit was over three feet long. By laying out the engine transversely across the car, he managed to produce a four-seater car of only 10 feet in length, and by employing front wheel drive ensured that the cabin was uncluttered by the usual arrangement of the prop shaft and rear axle. There was little rear or front overhang, the small boot being incorporated behind the rear seats. Further space was saved in the cabin by using tiny 10-inch wheels. Thus, though highly compact, the Mini (originally sold as the Austin Seven or Morris Mini-Minor but soon known as the Mini) offered unrivalled interior space for its overall size.

The cars which went on sale in August 1959 were not perfect. To allow for the transverse position of the engine, Issigonis had to design a complicated transfer system for the transmission, which proved noisy. The Mini's spartan interior, with minimum instrumentation, strap-handle doorpulls, and uncomfortable seats (he believed that driver comfort was dangerous rather than desirable!) reflected Issigonis's asceticism and his dislike of styling excesses but failed to please everyone. In fact the initial reaction to the new car was warm rather than rapturous. Once initial reliability problems were sorted out, however, and the car became more accepted, its qualities were recognised. Certainly those manufacturers who had been building compact cars with engines in the rear found that the front-wheel driven Mini's roadholding and responsiveness, helped by the "rubber doughnut" suspension system which Issigonis designed with Alex Moulton (which was replaced between 1964–71 by the sophisticated Hydrolastic system), was vastly superior to their own, with the result that rear-engined cars more or less died out. It is a measure of the Mini's influence that a transverse engine and front-wheel drive have become the norm in modern cars.

The potential of the Mini was explored and enhanced with the introduction of an expanded range of models. An attractive estate version, with an external ash frame (similar to that used on the Morris Minor Traveller) was more of a success than the upmarket Riley Elf and Wolseley Hornet, which achieved little by the addition of a different radiator grille and a recognisable boot. More important for the Mini's image was the introduction of the Cooper variant in 1961. With a larger (997 cc) engine, disc front brakes, and a top speed of 85 mph, it became a favourite among racing drivers, both professional (a version won the Monte Carlo Rally three times in a row until the organisers changed the rules) and amateur, and remains the most desirable of Minis. Its sporting success boosted the sales of the entire Mini range through the 1960s, and perhaps helped allay consideration of a replacement. The Clubman variant of 1969 offered a squared off nose, larger engines, and added four inches to the overall length, but the rounded headlight model continued in production even after the Clubman saloon was withdrawn in 1980. Indeed the classic front end, part of Issigonis's original design, remains in a recognisable form on the Minis produced today.

The Mini's technical advances were considerable for a small, mass-market car, but it is easy and enjoyable to drive, especially around town. And the basic, uncluttered shape of the Mini, a result of its engineering rather than an artistic vision, simply refuses to date. The Mini's "big brother," the Austin/Morris 1100/1300 series, also designed by Issigonis, outsold it in the 1960s and was in some ways a better car. But the addition of a boxed boot made it susceptible to the vagaries of taste and it now seems ugly and staid, while the Mini's most notable rival in the early 1960s, the Ford Anglia, now appears laughably kitsch with its American-style fins. 1960s trend-setters like Peter Sellers and Twiggy, who would not be seen dead in a cheap Ford, favoured the Mini. Yet somehow, with its unique profile, the Mini has always managed to transcend class (and gender), remaining both eminently practical and undeniably chic. And that was some achievement in a British car industry which, then as now, produced beautiful exotic sports cars at one end of the spectrum, and stolid, unattractive family cars at the other.

It seems now that as long as the Mini sells, it will continue in production. Sales are down considerably from the heyday of the 1960s and 1970s, but recent limited edition models, notably the updated Cooper, have been eagerly snapped up, and there is still nothing like it on the market. That it is still in production after 32 years is a great achievement, but its overall production figure, an impressive sounding 5,250,000, could surely have been more if its quality as a car had been matched by the quality of management within the British motor industry. While still fashionable on the streets of Paris and Tokyo, one wonders if the Mini could have in fact become a "world car," succeeding in the sorts of markets now dominated by the Japanese manufacturers who so admired Issigonis's work. Perhaps a car as brilliant in its conception as the Mini was more than the British motor industry deserved.

—Nicholas Thomas

Bibliography—

Golding, Rob, *Mini: After 25 Years*, London 1979.
Ball, Kenneth, ed., *Mini 1959–82 Autobook*, East Ardsley 1983.
Baker, Sue, "Mini Immortal," in *The Observer Magazine* (London), 15 February 1987.
Nahum, Andrew, *Alec Issigonis*, London 1988.
Nahum, Andrew, "Birth of the Mini," in *Blueprint* (London), May 1988.
Ingram, Jack, "Alec Issigonis," in *Design* (London), November 1988.

Photo courtesy of Fritz Hansens Eft

Arne Jacobsen (1902–71)
Butterfly chair, 1957
Moulded and lacquered plywood with steel tubing; 78 cm. high
Fritz Hansens Eft., Allerod

Settle into Arne Jacobsen's butterfly chair and today, thirty-five years after it was first produced, and you still settle into a contemporary and comfortable chair perfect for sitting back and relaxing and perfect for sitting up and adapting to the workplace. Of bent wood with a dramatically indented back, iron legs, and arm rests that seem to hang suspended in mid-air just where you want to let your arms fall, it was among the first stackable chairs. Perfect for the post World War Two society with its higher premium on space.

What has, in fact, made the chair a classic was its symbolic as well as real place in the post-war world. It had a radical new shape, used new materials, and fused shape and materials in unorthodox ways. It caught both mood and pace of the post-war industrial world. Take its unorthodox ways. What better way to start the new day than with a sample, if you will, of the new order. As for its measured advantages: of non-porous materials, it offered easy upkeep. Stackable, it was easily adapted to the post-war's buildings constructed with calculated spaces to counter increased building costs and rising prices of land. It served tangible needs and intangible wants. It was not the first of the 20th-century's dramatic new chairs. The Eames chair, also of bentwood but softer of line, was already being produced in the United States, and the Marcel Breuer chair, conceived out of Breuer's stay in the 1920s Bauhaus, was also being produced but on a small scale.

Jacobsen's chair was among those insurgent design thrusts. But it was perhaps the first to catch the attention of both arbiters of design and consumers around the world. Successfully combining sophisticated design with mass production, it became the first to appeal simultaneously to both art and commerce, edging the whole world of chair design a step closer to the industrial world. In doing so, it turned the consciousness of both designers and consumers to what we now call an industrial aesthetic.

Arne Jacobsen was not a designer by trade but an architect, and the most outstanding Danish architect of the 20th century. Architects had, with varying success, designed furniture before. Rennie MacKintosh in Glasgow, Frank Lloyd Wright in Chicago, Josef Hoffmann in Vienna—all were architects who designed the furniture for their buildings. Only for their buildings. None designed furniture to be used elsewhere, Wright, for one, tending to find the idea outright offensive. Marcel Breuer, also an architect, may have been the first. And his chair—of bent steel tubing with a variety of seats e.g. cane, leather—was also the first to be created out of an industrial aesthetic. But Jacobsen brought two distinctions to his creation of the butterfly chair. Danish, he had a proclivity to deal with of wood—working with wood carrying something close to a cultural imperative. And just as culturally determining, he inherited a characteristic Danish insistence on craftsmanship. Jacobsen fused his almost sensual feel for wood and his inbred insistence on craftsmanship to the emerging industrial aesthetic—and helped shape it. He was among the first to transform himself from architect and designer into what is now appropriately called an industrial designer.

Jacobsen had already gained an international reputation as an architect for his quiet, elegant and uncluttered designs, mainly for row houses and embassies, but also for his just as quiet, but nonetheless experimental buildings, like his 1930 Circular House of white stucco that looked as much like a piece of Henry Moore sculpture as it did a house. And though he designed this chair in Denmark and it was produced by Fritz Hansen, a Danish firm, it resulted in large measure from what can be called a collaboration of spirit which he experienced in exile in Sweden during the war years. That is where he adapted his feel for wood and sense of craftsmanship to a bolder modernism.

In 1943, while the war was on, the German army occupying Denmark, Jacobsen fled with his wife in a small rickety rowboat in the quiet of the night to Sweden. There, he joined a Scandinavian community of architects led by Alvar Aalto, Finland's leading designer/architect. Scandinavian architects, perhaps more than any other group as group, tended also to design furniture—both for their buildings and for wider more universal use. And Aalto had already designed and was having produced the chairs and tables he is still known for—chairs making use of industrial techniques. Jacobsen became part of this environment, enjoying design dialogues with Aalto, and with the Swedish architects who retained an intense respect for details in design. Jacobsen opened himself to the new, held onto his old, and out of this dialogue came the radical lines of his modernism.

It was perfect for the post-war years when major population moves took place—from country to country, and from countryside to city. Every nation had a new urban population while the world's total population increased dramatically in the next decade. A general need for furniture to replace the war's devastation was matched only by the need for it by a growing middle class in the urban centers of the world. Where architects and designers previously worked for upper classes, now there were new markets opening up—to be quickly serviced. Speedy production was needed. And the mood was perfect for radical design.

Jacobsen adapted his feel for wood to chair production, and later progressed beyond his early concerns with wood. For chairs he used textiles in combination with various plastics. But more to the point, he took the whole world of design into his hands, designing everything: lamps, cutlery, tables, chairs, beds, and so on. His most notable total design of building and furnishings is the SAS building and all its furnishings in Copenhagen. But without discounting the comfort and radical lines of the Butterfly chair, it nonetheless seems to me its success has come as much from the social and industrial (technological) revolutions as from its revolutionary design. Not to belittle its design. Just the opposite: praising its blending of high design and low price to new materials and mass production. And marketing. It could be produced and shipped quickly in large quantities around the world. After all, as a stackable chair, it was almost as cheap to ship ten as to ship one. Being lightweight similarly kept costs down. Since companies needed large numbers for conferences, waiting rooms, and offices, costs became a major consideration. Meanwhile, Fritz Hansen, keeping the price at affordable levels, has made it available for the family that needs one or two for its first house in the new suburbs that continue to appear around the world.

In a sense, it not only served the social revolution taking place, but actually helped create one. This is the first time in the history of design when high design was so quickly available and affordable.

—Judith Mara Gutman

Bibliography—

Pedersen, Johan, *Arkitekten Arne Jacobsen*, Copenhagen 1954.
Faber, Tobias, *Arne Jacobsen*, New York and London 1964.
Stephensen, Magnus, "Arne Jacobsen's Last Series of Chairs," in *Mobilia* (Snekkersten), May 1971.
Rubino, Luciano, *Arne Jacobsen: Opera Completa 1905–1971*, Rome 1980.

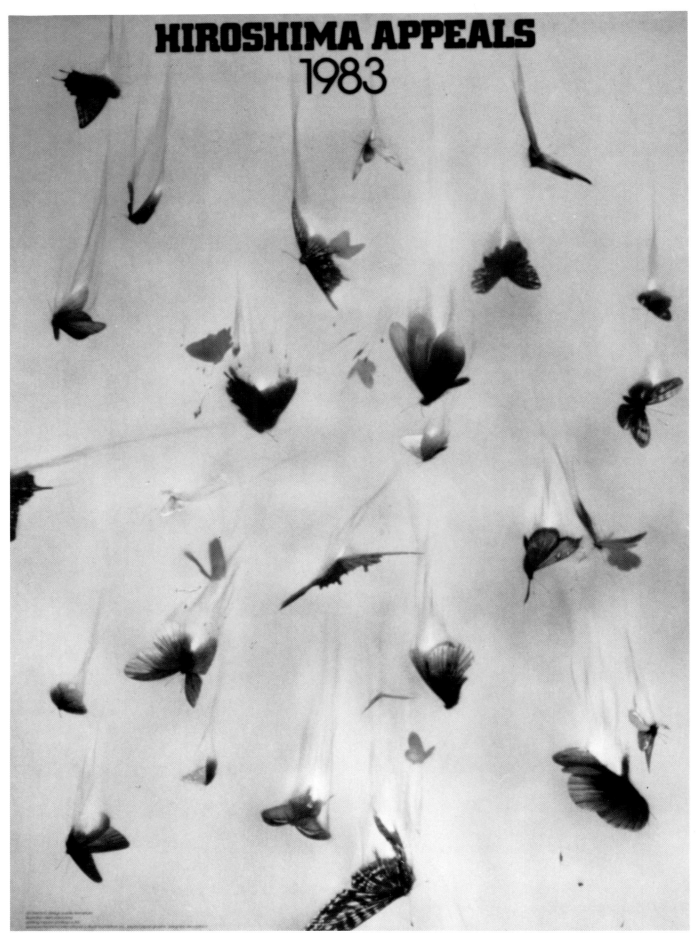

Photo courtesy Kamekura Design Office

Yusaku Kamekura (1915–)
Hiroshima Appeals poster, 1983
Colour offset on coated paper

The influence of Japanese art on the world's art begins in the 19th century, when magnificent ukiyo-e woodcuts were published. Since then far-eastern motifs became fashionable and noticeable in European works.

Japanese graphic design, on the other hand, became widely known much later, thanks to the generation to which Yusaku Kamekura belongs. His first works date back to the time before the Second World War. Later, they accompanied the industrial development of Japan. Relations between industry and graphic design could be observed in well-designed company logos, neon advertisements and posters, the best of which announced great expositions of design and drawings in Nagoya, Osaka and Tokyo.

From the mid-sixties, together with his talented colleagues (Nagai, Tanaka, Nakamura) Kamekura took part in numerous expositions in Warsaw, Lahti, Brno, Paris. During more than 35 years of artistic activity he has won almost all the significant graphic design prizes and awards.

His works have been often analysed by well known art critics, and classified as model examples of advertising. Those works dealt mainly with products of well known optical companies (Nippon Kogaku), lighting equipment (Yamagiwa), they announced sport events (*1964 Tokyo Olympics*), and popularised recreational areas.

Those interests were partially connected with his studies of architecture and technology. Most of his best known works show his professional background and graphical perfection. All critics agree that Kamekura developed his own style. In relation to European art trends of the 'fifties (purism, constructivism, functionalism) which favoured discipline in treating given objects, he created a specific notion of space. First of all he reduced space to a background which had to expose an object, while the object itself was usually shown in its simplest form.

He often used geometric blocks asymmetrically situated against an architectural background (*Design Expo '89, Nagoya*), or placed it against open-work. Extremely simplified, single signs often appeared in series of images (*Coca Cola now consumed even in Asia*, *Life now read even in Asia*). In another case, an architectural motif has been repeated three times (*Design Forum '87, Matsuya, Ginza*).

A similar approach has been adapted by Kamekura in his letter compositions for Nippon Kodaku, where he repeated not the identical module, but a letter in different realisations.

High quality Japanese photography, which often serves as a starting point for graphic design in that country, has for Kamekura served still another purpose. While designing a series of posters which were to propagate the recreational values of some ski resorts, Kamekura very carefully chose particular photographs and special composition of each picture. Similar treatment resulted in a number of posters which accompanied the official logo of *XVIII Olympics in Tokyo*.

The search for technically innovative formal solutions led him towards geometric abstraction, which he used to visualise universal ideas. In this area of interest, he liked to apply concentric forms dispersing from the center of composition.

A poster for *Expo '70 in Osaka*, which was awarded a Gold Medal at the II International Poster Biennale in Warsaw, is an example of a similar approach. Characteristic harmony of line, purity of composition, elegance of colours, limited to black and white are characteristic features of the intuitively-chosen esthetic standard.

Being a serious representative of many Japanese art institutions, a respected editor and author, he also introduced aspects of seriousness. Most of his posters are in a reduced range of colours, often rather technical: navy blue, graphite, toned-down yellow, and his favourite black and white. In some cases, black is surounded by a characteristic "halo," deepening the contrast value of the colour (*Yamagiwa lighting equipment exposition, an exposition of good drawing in Tokyo—Design for living*).

Stark, orderly and disciplined scenery is softened by sudden romanticism; first a butterfly, which is logically linked with the topic of the exposition; later, in 1968, there are two butterflies, black but with a colourful halo (*Edo Kyoko piano recital*). Several years later there appears a full-colour butterfly, placed over a geometric block, in the corner of a poster for architectural exposition. Kamekura uses the same motif, this time in full range of subtle colours, in contrast with the horror of the atom bomb which destroyed Hiroshima. The tragic beauty of dying butterflies acts as means of showing his vision of the horror.

The formal lightness of the poetic *Hiroshima appeals* poster appeals much stronger than the photographic documentation of the explosion.

The choice of motif confirms the amazing intuition of the genius, who managed to find an unconventional and expressive way of presenting such topics. This work sums up Kamekura's achievements in the use of photography, which brilliantly sets the register. In spite of the frequent use of a similar (but not the same!) module, he managed to keep intact the discipline of composition, which symbolically conveys the topic. Perfection of photography and Japanese print add to the success of this poster which is perhaps one of the most colourful among Kamekura's works.

—Ewa Kruszewska

Bibliography—

Masaru, Katsumie, *The Graphic Design of Yusaku Kamekura*, Tokyo and New York 1973.
"Ikeban Sogetsu," in *Novum Gebrauchsgraphik* (Munich), no. 11, 1984.
"Hiroshima Appeals," in *Print* (New York), November/December 1984.
"Yusaku Kamekura: Hiroshima Appeals," in *Graphis* (Zurich), November/December 1985.
Kamekura, Yusaku, ed., *CI Graphics*, Tokyo 1987.

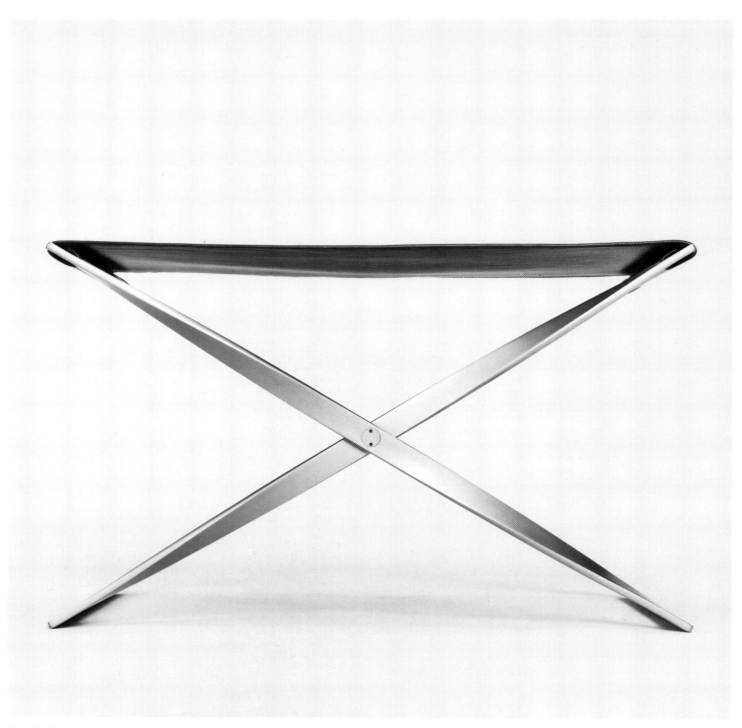

Photo Danish Design Council

Poul Kjaerholm (1929–80)
Model 91 folding stool, 1961
Matt-chromed steel and leather; 37 × 60 × 45 cm.
E. Kold Christiansen ApS, Hellerup, 1961–82; Fritz Hansens Eft, Allerod, from 1982

The folding chair is a classic in furniture design, a piece of furniture which is not only light and mobile. Being collapsible, it also allows the user to store it compactly when not in use. Like the great hammock chair, it is also the type of furniture which holds a strange appeal for some of the world's best designers despite the fact that is not a product of much, if any, commercial interest.

The folding chair dates as far back as ancient Egypt, with a design which became the prototype for all other folding chairs: Two rectangular frames, connected at the middle of their long sides by integrated hinges, and along one short side by a piece of cloth or leather which forms the seat and keeps the chair in position when unfolded. The Egyptian folding chair is featured in Professor Ole Wanscher's book on the history of furniture which became *the* reference work for so many furniture designers.

In Denmark, the folding chair also became a professor's chair in the sense that all of Denmark's, so far three, professors of furniture design designed one, and each made it a prototype example of good use of the materials they chose for the design.

The first one was professor Kaare Klint's folding chair in wood. When folded, the two long legs of Kaare Klint's chair form a perfectly turned wooden rod. Only when unfolding can it be seen to consist of two parts, separated by a propeller-blade cut. Unfortunately, making it is not as simple as sawing a turned rod up along a propeller cut. Cutting it and planing and polishing the cut surface would take away so much material that the two parts would no longer form a circular rod when folded. Each leg is therefore made from two different pieces of wood. This means that more wood is required to make the legs and that the grain of the two parts of the legs will not match.

Not including the Danish version of the "film instructor's chair" by professor Mogens Koch, the second classic Danish folding chair was the one designed by Poul Kjaerholm in 1961.

The third folding chair was designed by Jørgen Gammelgaard who succeeded Poul Kjaerholm as professor of furniture design at the Furniture Design Institute at the Royal Academy of Fine Arts in Copenhagen. Jørgen Gammelgaard used a frame made from four round steel threads for his chair and thus altogether did away with the need for a propeller cut. Due to a small displacement, one leg simply folds into the other.

In his folding chair Poul Kjaerholm opted for the propeller solution, but chose steel for the legs, a material he had used with mastery in so many of his furniture designs. The chair, model EKC 91, was developed in close cooperation with the furniture manufacturer E Kold Christensen, one of the patrons/manufacturers so crucial to the success of Danish design. In terms of manufacturing Poul Kjaerholm's folding chair suffered from the same problems as most of his furniture: Seemingly industrial, with nothing superfluous, and with the mechanical construction as its only "decoration," this simple and elegant folding chair actually required a lot of good craftmanship. Going back to the basic construction where even the most minute umbraco-screw was part of the visual expression leaves manufacturing nowhere to hide poor detailing or shoddy work. Everything has to be as well made as it can be made.

Poul Kjaerholm always based his designs on a clear and striking structural principle, and inevitably combined it with excellent detailing. The supporting structure of his furniture is, in fact, a statement of mechanical design. To this he added that certain extra which comes from tireless care for the proportions, assembly details and finishings. In his product language, Poul Kjaerholm has obvious links with modernism and the Bauhaus tradition, yet he achieved mastery in the proportioning, detailing and technical quality of his furniture which is unsurpassed by any of his predecessors. This made his work a cornerstone of 20th-century furniture design.

Yet, this was not his ambition in the first place, but something which was a side effect.

I remember once a late evening in 1979, drinking a bottle of wine with him in the kitchen of his large Copenhagen townhouse. Poul Kjaerholm talked for hours in a strangely naive fashion about getting down to the nature of the materials: The polished steel, the leather, the maple or mahogany, the cork or linoleum surfaces. He also spoke at length about how materials age, and about being true to the purpose of what you design. To him, work is a question of being honest, of doing things as well as you can, and of achieving the demanding simplicity which springs from these ideals.

Poul Kjaerholm's folding chair is one such statement. And as with so many great designs, it is a reflection and an integral part of his entire work. It reflects what he learned from, e.g., his classical easy chair, model 22 from 1955 which is also a forerunner of the chair model 20 from 1967, where the leather seat and back structurally fulfill the same function as the leather seat of the folding chair from 1961.

Poul Kjaerholm sadly died in 1980, at the age of only 51.

Yet even if he took endless care and endless time with his work, he left behind him a legacy—and a surprisingly large number of designs—which makes him one of the great furniture designers of our time. A piece of Kjaerholm furniture carries the unique touch of the master in the sense that the authorship of each design is immediately clear, just like even the tiniest part of the body of a Jaguar is, in a sense, a reflection of the design of the entire car.

—Jens Bernsen

Bibliography—

Zahle, Erik, ed., *A Treasury of Scandinavian Design*, New York 1961.
Moller, Svend Erik, *34 Scandinavian Designers*, Copenhagen 1967.
Mollerup, Per, *Poul Kjaerholm's Furniture*, Snekkersten 1981.
McFadden, David Revere, *Scandinavian Modern Design 1880–1980*, New York 1982.
Wichmann, Hans, *Industrial Design: Unikate Serienerzeugnisse*, Munich 1985.
Stimpson, Miriam, *Modern Furniture Classics*, London 1987.

© 1962 VOLKSWAGEN OF AMERICA, INC.

Think small.

Our little car isn't so much of a novelty any more.

A couple of dozen college kids don't try to squeeze inside it.

The guy at the gas station doesn't ask where the gas goes.

Nobody even stares at our shape.

In fact, some people who drive our little flivver don't even think 32 miles to the gallon is going any great guns.

Or using five pints of oil instead of five quarts.

Or never needing anti-freeze.

Or racking up 40,000 miles on a set of tires.

That's because once you get used to some of our economies, you don't even think about them any more.

Except when you squeeze into a small parking spot. Or renew your small insurance. Or pay a small repair bill. Or trade in your old VW for a new one.

Think it over.

Photo courtesy DDB Needham Worldwide Inc

Helmut Krone (1925–)
Volkswagen advertising campaign, USA, 1959–78
Volkswagen, Wolfsburg

When advertising agency Doyle Dayne Bernbach was awarded Volkswagen's passenger car account in 1959, VW Beetles were already selling briskly in the United States. Sales were approaching 200,000 units, making Volkswagen the leading automotive import in the U.S. market. The demand for compact foreign cars in general grew so rapidly during the 1950s, that by the end of the decade they accounted for approximately 10% of U.S. auto sales. When Detroit's Big Three automakers responded with their own compact cars in 1960, Volkswagen moved to protect its market share.

Chosen, in large part, for the unusual, highly creative advertising already produced for clients such as Ohrbachs department store, the Israeli airline El Al, Polaroid, and Levy's bread, Doyle Dane Bernbach was handed a four-point creative brief. First, because many Americans were still unfamiliar with VWs, DDB was given the task of boosting name recognition and making the Beetle's unique shape immediately recognizable. The second request was much more ambitious. Volkswagen wanted the American public to rethink its affection for the chrome-plated "land yachts" of the 1950s, with their constantly changing body styles and planned obsolescence. Unlike these automobiles, the VW was a common-sense car which looked the same on the outside year after year— all the while registering countless technical improvements. Here was a car that put aside fashion for function, and Volkswagen wanted all of America to know about it. Third, DDB was told to let the facts do the talking. Volkswagen felt that since its product had genuine merit, the advertising should be clear, informative, and free of the grandiose claims and romanticized artwork which typified American automotive advertising of the 1950s. Finally, Volkswagen stipulated that DDB should make appropriate use of humor to reflect the product's unique personality.

DDB sent a team of creative and account-service personnel to Volkswagen's factory in Wolfsburg, Germany, almost immediately after winning the business. They spent several days talking to executives, engineers, and even workers on the production line. The team took notes at every step of the manufacturing process and were impressed by Volkswagen's extraordinarily rigid quality-control standards. Finally, what the DDB representatives came away with was a belief in the product's high level of craftsmanship and honest value. In every aspect of the VW design, form followed function. This would also be the case with Volkswagen's advertising.

Art director Helmut Krone and copywriter Julian Koenig were the first creative team assigned to the account at DDB. Working closely with agency principal Bill Bernbach, these two men determined the course Volkswagen advertising would follow for years to come. Krone, a disciple of Paul Rand and Bauhaus-based design, insisted that the initial print advertisements be clean, simple, and straightforward—if far from predictable. Realistic photographs were chosen in place of the airbrushed illustrations found in most automotive advertising of the period. Copy spoke to the reader in an intelligent, conversational manner, free of patronizing, hard-sell language.

Technically, the print advertising established a very coherent structure. Type, photograpy, and even sentence structure—subject, verb, object—followed the philosophy of function over form. Generally, one large black-and-white photograph occupied the top three-quarters of the page, with headline and copy below. While there was nothing particularly original about any one of the visual elements, in their combination was something unique. Helmut Krone said, in an interview with *The Wall Street Journal*, "Beauty and style are qualities I count as secondary. If they are in the work, they come along for the ride. The only quality I really appreciate is newness, to see something no one has ever seen before." Most importantly, of course, the advertising attempted to communicate the unique personality of the car. In the same interview, Krone says, "The page ought to be a package for the product. It should look like the product, smell like the product and the company." Like the car, Volkswagen's advertising of the 1960s and early 1970s was well-engineered and simple.

Aimed initially at an educated and largely urban clientele, Volkswagen's advertisements appeared in a range of magazines ranging from *The New Yorker* to *Life*. To readers of these publications, the first VW ads of 1959 must have appeared quite revolutionary. Within a matter of months, industry researchers confirmed that Volkswagen advertisements were getting unusually high readership. This trend would continue for years to come. In the August 19, 1963, issue of *Sports Illustrated*, Huston Horn writes, "Volkswagen ads have won a list of prizes longer than an account executive's expense account; they are talked about at cocktail parties, read aloud at the office water cooler, analyzed and dissected in college term papers." During these years, VW dealers reported customers arriving at their showrooms with the latest ad clutched in their hands.

In 1962, Volkswagen ran an ad in *Fortune* with the headline, "Think small." Above was a tiny photograph of the VW Beetle surrounded entirely by white space. Copywriter Julian Koenig claims that the ad was inspired by a speech by VW ad director Helmut Schmitz. In the speech, Schmitz had said that Volkswagen needed to remain small in spirit, to think small in order to deal with all the important details involved in building and marketing cars. Helmut Krone says his design was motivated by the question, "How small can a headline and graphic get, before they become invisible?"

Earlier, Volkswagen had run an ad with the headline "Lemon," which explained that the particular VW in the photograph was rejected by factory inspector Kurt Kroner because of a blemished chrome strip on the glove compartment. Another ad—with no photograph at all—quipped, "No point showing the '62 Volkswagen. It still looks the same."

When Detroit launched its own compact cars in 1960, the impact on foreign imports was devastating. Sales were cut in half, from 614,131 units in 1959 to 378,622 units in 1961. Amazingly, VW's sales increased. In 1960 VW imported its 500,000th vehicle into the United States. By 1964, VW was not only outselling all other foreign passenger makes, but all U.S. compacts as well. By 1968, VW production topped 1,600,000 units, and the Beetle was on its way to overtaking the Ford Model T as the world's most-produced car.

DDB's acclaimed campaign for the VW Beetle continued to run until production of the car itself was halted in 1978. These ads—like the car—have become classics. The Volkswagen campaign is more closely associated, perhaps than any other, with American advertising's creative revolution of the 1960s. The influence of these ads was not confined to the United States, however. Following the success of the American campaign, DDB was asked to handle the Volkswagen account in several other countries, including Great Britain, France, and West Germany. Over the years, the relationship between auto manufacturer and advertising agency has survived. DDB—now DDB Needham—continues to handle VW advertising in the United States.

—Tim Spry

Bibliography—

Nelson, Walter H., *Small Wonder: The Amazing Story of the Volkswagen*, Boston 1965.
Karl, Sandra, "Creative Man Helmut Krone Talks About the Making of an Ad," in *Advertising Age* (New York), 14 October 1968.
Karl, Sandra, "An Interview with Helmut Krone," in *Idea* (Tokyo), July 1969.
Glatzer, Robert, *The New Advertising: The Great Campaigns from Avis to Volkswagen*, New York 1970.
Abbott, David, and Marcantonio, Alfredo, *Remember Those Great Volkswagen Ads?*, London 1982.

Lego Gruppen (1934–)
Lego construction toy system, 1954
Injection-moulded plastics
Interlego A/S, Billund, Denmark

"Only the best is good enough" said the sign on the wall in Ole Kirk Christiansen's workshop. This was in the '30s at his little factory for wooden toys in Billund on the borderline of the heather in Jutland, Denmark. The children were to play well, a goal that was reflected in the name he gave his firm and his product in 1934, LEg GOdt ("play well" in Danish), LEGO. Some years later he was told that the word "lego" exists in Latin and means "I study" or "I put together."

In 1947 Ole Kirk Christiansen, who was a bit of a technology buff in his day, bought the first plastics injection molding machine for toy production. The idea was to add something new to the company's range of wooden toys. The machine was bought from Britain after the manufacturer had provided a series of samples of somewhat primitive British plastics toys.

In 1949 something of consequence—but relatively unnoticed—occurred in Billund: Two plastics building components were launched in Denmark under the name of "Automatic Binding Bricks" as an addition to the product range which now included some 200 different toys in wood and plastics, including dolls, motor cars, animals, and babies' rattles.

The Automatic Binding Brick had studs on the top and the bricks could be built on top of each other but not with much clutching power. The brick had been inspired by two plastic building bricks designed by the Englishman Hilary Page and manufactured by the firm of Kiddicraft which sold them in Britain, France and Australia from 1947–51 and then stopped producing them because they did not sell well. The Kiddicraft design featured a brick of much the same dimensions as today's LEGO brick, with round knobs at the top and hollow at the bottom so that knobs would lock into the periphery of the block above. The Billund company made the measures of the brick metric and rounded the knobs and sharpened their edges in order to increase clutching power.

However, it was not until 1954 that the Billund company realised that its future could lie in the development of LEGO building bricks. Realising that there was a clear demand in the toy trade for something offering a strong idea and a system, Godtfred Kirk Christiansen drew up what were to become the 10 criteria for an ideal, future LEGO product:

—01 Unlimited play potential
—02 For girls, for boys
—03 Fun for every age
—04 Year-round play
—05 Healthy, quiet play
—06 Long hours of play
—07 Development, imagination, creativity
—08 The more LEGO, the greater value
—09 Extra sets available
—10 Quality in every detail.

The LEGO Building brick, which now accounted for 5–10% of the company's annual sales, was the only product in the existing range that could be developed into a system and mass produced. So the company added the word System to the product name in 1954.

Unfortunately, the LEGO Building Brick had a problem: It did not work well enough. The bricks stayed together when built like a vertical wall but tended to come apart when the wall was turned upside down. In order to solve this problem, Ole Kirk Christiansen's son, Godtfred, who had joined the firm in 1932, added a feature which is crucial to the function of the building block, namely a series of open, circular tubes inside the brick. These tubes touch the knobs of the block below and effectively lock it between the tube and the rim at the periphery. This invention solved the technical problem and made the LEGO bricks work. LEGO patented the design in 1958 in what became their core patent. It has, over the years, been supplemented by hundreds of other patents.

The first LEGO bricks were sold in boxes with drawings on the top of the box showing a number of simple constructions made from the LEGO brick. The bricks came in only half a dozen sizes (bottom plate + 2, 4, 6 and 8 knob bricks).

Special bricks were introduced from time to time. The slanted roof brick came along in 1958. LEGO also invented the wheel in 1962. At the insistence of toy dealers, the original wide choice of colours was limited to what you could call the Mondrian range: Bright blue, strong yellow, warm red, black and white. No green, except for the building plates. Years of intense growth and development followed, making LEGO a household word the world over.

When Kjeld Kirk Kristiansen, 3rd generation of the LEGO family, joined the LEGO company in 1973, the company had long ago abandoned wooden toys. What met him was the image of a huge, yet somewhat diffuse LEGO System which left open spaces where no LEGO product was available for special age groups. Kjeld Kirk Kristiansen therefore, as senior vice president of the company, set out in 1978 to develop what he called "a system within the systems."

Kjeld Kirk Kristiansen introduced the idea of a family of LEGO systems which should cover the entire range of ages from 1 to 16 years and beyond. The family of LEGO systems should also include products which appealed to both boys and girls. It should be closely connected to the motory and mental development of the child. And above all, it should also be great fun.

Today's range of LEGO products is a result of this product development model which features a range of LEGO brands with underlying product lines:

The double-size DUPLO product programme (including the Baby Line, the Building Line and the Play Line)
The LEGO product programme (including series such as Basic, Town, Castle, Pirates, Space, Ships, Trains and Model Team)
TECHNIC Product Programme (featuring mechanical, electro-mechanical and electronic constructions which work as they do in real life).
LEGO Dacta Product Programme for pre-schools and schools, including the LEGO Technic Control sets (whereby the LEGO product enters the computer world).

Mechanically, the LEGO Group has also taken a giant leap ahead. In today's LEGO range, it is possible to build a motorcar where the suspension, gearbox, and the steering mechanism are constructed like in real life. An electric engine and a remote control device for the car can also be added, not to mention pneumatics and/or light and sound elements. This not only gives the child an introduction to mechanical design. A toy like this is likely to set the stage one of the happiest experiences, a father or mother can have in building something together with their child.

All this, of course, is not just a problem of product design but also of product communication. The success of these complex toys is based on the fact that the LEGO Group also solved the problem of explaining—without the use of words, and thus independently of language—how such a complex toy should be built. It also added to the number of LEGO building bricks, which today include some 1,400 different elements, 462 of them in the DUPLO range. With the precision manufacturing required by the LEGO principle, these many different elements also represent an enormous investment in moulding tools manufactured by the company's three high-tech tools factories in Germany and Switzerland. However, this is not just a burden, it is also a competitive advantage.

The phenomenal success of the LEGO System has caused a whole range of crooks to steal their way into the LEGO System by building bricks and blocks which can be combined directly with

the original LEGO bricks. The great number of different elements required to build just one simple LEGO model, however, blocks the way of all but the richest copycats. In addition, each new LEGO brick is also a possible new patent. Moreover, the LEGO principle has become a prototype example of an idea which was launched in the mid '80s as a whole new concept: "Design for manufacturing."

The fact that all LEGO elements can be connected is not only an advantage to the child. It is a huge advantage to the manufacturer too. Many of LEGO's thousands of different elements are used in many different building kits. This often allows the cost of the molding tools to be distributed between several different building sets. In addition it allows the company to build up intermediate storages of elements which can be used in many different building sets.

During its many years in existence the LEGO System has established itself as a true design classic by basing its existence upon the timeless values of making a toy for the mind and the hands of children and grown-ups which demonstrates the endless possibilities which lie within a system designed with intelligence. And, of course, also by maintaining the old LEGO principle that only the best is good enough.

—Jens Bernsen

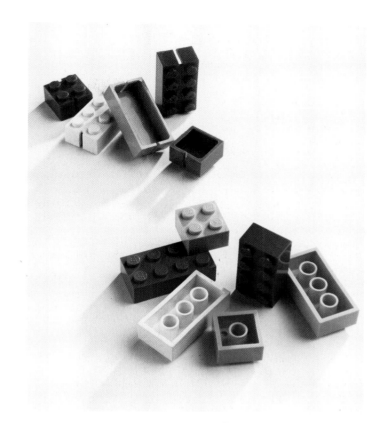

Bibliography—

"Legoland," in *Mobilia* (Snekkersten), August 1971.

Lego Group, *50 Years of Play*, Billund 1982.

Bernsen, Jens, *Innovation via Design: The ID Prize, 25 Years*, Copenhagen 1990.

Lego Group, *Developing a Product*, Billund 1991.

Lego Group, *Facts and Figures*, Billund 1991.

Photos courtesy LEGO

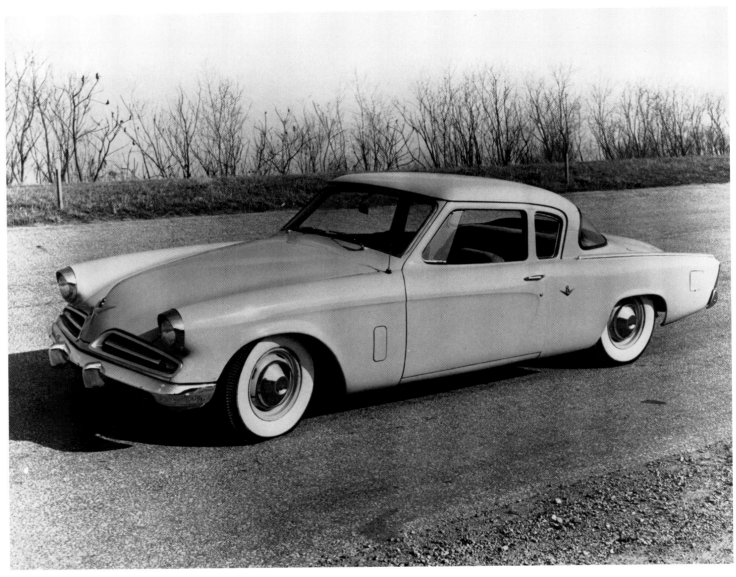

Starliner Commander V8, 1953. Photo Studebaker National Museum

Raymond Loewy (1893–1986)
Studebaker Starliner car, 1953
Studebaker-Packard Corporation, South Bend, Indiana

Perhaps the most svelte American car produced since the Second World War, The Studebaker Starliner was the brain child of Paul Hoffman, Studebaker's president, who entrusted the design to the Raymond Loewy Design Division of his small, but venerable South Bend, Indiana car company. Free from the heavy corporate control of the big three Detroit car makers, Loewy's styling department at Studebaker was given the opportunity to produce an uncompromised automobile aimed to appeal to what Hoffman perceived to be a new, affluent youth market among American car buyers.

European sports cars, such as the Jaguar XK120, the MGTC and the Porsche 356 were gaining considerable attention, in spite of their small numbers in America around 1950. Their sophisticated understatement and trim proportions were highly attractive to drivers who were becoming disaffected by the tendency of Detroit products to fatness and overdecoration.

Hoffman wanted a car which would combine the stylistic cachet of the imports with the American drivers' demand for comfort, space and reliability; in short, an American sports car. As Studebaker was traditionally a maker of relatively low priced cars, the combination of sporty, low-slung looks and a modest price tag would be a suitable combination for the young buyers of the postwar economic boom.

French by birth, Loewy had trained as an engineer, then settled in New York in 1919 where he began a career in illustration and display design before founding his pioneering industrial design consultancy in 1927. Loewy's association with Studebaker had begun in 1938 and would last up to the firm's demise in 1964. His work for Studebaker, including the 1947 Starlight coupe, the 1953 Starliner and the Avanti of 1962, is outstanding even among the many memorable designs ranging from railroad locomotives to cigarette packs produced by his internationally-based company.

The Raymond Loewy Design Division at Studebaker was headed by Robert Bourke, but the Starliner's styling was composed of a package of elements familiar throughout Loewy's work. The long, smoothly integrated form of the body with its slingshot lines can be found in his designs as far back as a patent drawing for a car, dated 1928. The most obvious direct influence, however, must be the 1947 Starlight coupe whose lean proportions and dramatically swept-around rear window made it the most strikingly futuristic American production car of the first years following the war.

Starliner's shape was characterized by a very low centre of gravity, accentuating both its length and width. Loewy constantly mocked the bloated appearance of post-war Detroit products, and so the Studebaker had to look light and quick. This was accomplished by the use of depressed (intaglio) surfaces running along the side of the car back from the headlights and sweeping down to echo the reverse slant of the front and rear roof pillars. The reverse slant is repeated in profiles of the split grillwork at the front of the car and of the discreetly trimmed tail lights. The car's long nose, sucked-in cheeks and kicked up rear end give it a look of motion, even when it is standing.

The greatest contrast between the 1953 Starliner and its Detroit contemporaries is in its rejection of symbolic chromium ornament. With the exception of restrained trim around windows and grill openings and the simple detailing of lights and bumpers, the car carries no applied decoration. Even its wheel covers are simple,

truncated cones, a device used by Loewy since the early 1930s. The simplicity of form and fineness of detailing were carried through to the interior where round, aircraft type instruments were set neatly into a flat, cowl dashboard of burnished aluminium.

The car was sold in two versions. The more economical Champion was equipped with a 6 cylinder engine and manual three-speed transmission. It is identified externally by an additional roof pillar forming a small rear quarter light. The more expensive Commander dispensed with the additional roof support to become a "hardtop convertible" and was fitted with a powerful V8 engine and automatic transmission.

Starliner was greatly admired on its launch and brisk orders followed. Unfortunately, unreliability of early models cost the car its popularity. There was also a suspicion among marketers that the car's unique character and appearance were to blame for poor sales.

Successive face-lifts robbed the car of its individuality in an effort to conventionalize the design. Applied chromium ornament was seen as the solution to disappointing sales. An egg-crate grill was added to the front end in 1954, followed by lashings of heavy chrome trim to front and sides of the body in 1955. Large fins sprouted from the rear quarters in 1956. But these misguided attempts to follow Detroit styling norms further undermined public response, although build quality and reliability had improved.

While Studebaker's main line of saloon cars was redesigned for 1956, the Starliner was once again lightly restyled and renamed Hawk, in which form it survived until the company liquidated in 1964. Hawk models became hot performers on the stock car race circuits and are sought after collector's items now. But the ultimate prize today would surely be the original 1953 Starliner Commander V8 coupe.

Ironically, although the 1953 Starliner lost its looks through an emmulation of Detroit styling, the car had a profound, long-term influence on the major American car makers by defining a new auto type; the 4/5 seater sporting coupe offering comfort and solidity, but with an image and price tag pitched at youth, or those who seek after youth. The formula was repeated with somewhat greater commercial success by the Ford Thunderbird of 1958 which used a long, sloping hood and sculpted side panels similar to Starliner's, and was advertised as a sporty, "personal" car. A string of mid-'50s G.M. "dream cars" also picked up on the Starliner formula to test consumer responses to styling innovation. But the Starliner's greatest influence can be seen in the Ford Mustang of 1964 which took the notion of a youth car to its logical extreme and perpetuated the lean, dynamic look of the Studebaker Starliner.

—Gregory Votolato

Bibliography—

Setright, L. J. K., *The Library of Motoring: The Designers*, London 1976.
Loewy, Raymond, *Industrial Design*, London and Woodstock, New York 1979.
"Raymond Loewy," special monograph feature of *Industrial Design* (New York), November/December 1986.
Schronberger, Angela, ed., *Raymond Loewy: Pionier des Amerikanischen Industriedesigns*, Munich 1990.

abcdefghijklmnopqrstu
ABCDEFGHIJKLMNOPQR
30

abcdefghijklmnopq
ABCDEFGHIJKLMNO
36

abcdefghijklm
ABCDEFGHIJKL
48

abcdefghijk
ABCDEFGHIJ
60

abcdefgij
ABCDEFG
72

abcde
ABCDE
1" on Caps

abcdefghijklmnopqrstuvwxyz
ABCDEFGHIJKLMNOPQRSTUVWXYZ
1234567890(&.,:;!?'""--$¢%/)

26
good
reasons to
use
AVANT
GARDE
GOTHIC
MEDIUM

Herbert Lubalin (1918–81)
Avant Garde Gothic typeface, 1967–70
International Typeface Corporation, New York

ITC Avant Garde Gothic is a wonderful blend of simplicity and distinctiveness. It is free of ornament, serifs and frills in its basic letters, but is graced with a large array of alternate capitals and ligatures that give it an unique and attractive look, especially in the uppercase (capital letters) when used in the large display sizes.

The typeface evolved from the masthead logo for *Avant Garde Magazine*, designed by Lubalin. In designing the magazine's interior pages, Lubalin used characters based on the logo and eventually they grew into a full alphabet. The innovative ligatures were designed by Tom Carnase. When it was decided to offer the design commercially via International Typeface Corporation (ITC) in 1970, lower case characters, numerals, accents, and punctuation marks were created as were additional weights of the design. The interlocking of letters made possible by the design of the alternate capital letters is at once the typeface's strength and a cause for caution. Herb Lubalin once said he regretted having marketed the alternate characters and ligatures as part of the design because so many type specifiers were misusing them.

Avant Garde Gothic's color is eventone. It has many of *Futura*'s characteristics such as letters based on perfect circles. Other letters, such as the M and W, are wide and angular. It's x-height is one of the largest of any typeface, thus its ascenders and descenders are comparatively short. This gives the face a large body relative to its overall size and improves its readability. The x-height of a letter is the height of the body of a lowercase letter without ascenders or descenders, the lowercase x being an ideal letter for determining this because it usually has no round strokes.

Because of its name, many believe *Avant Garde Gothic* is a new and revolutionary type concept, a bold takeoff from the geometric sans serifs of the Bauhaus and the mid-20s era. But the design has its foundation in the first sans serif produced in modern times. This was a caps only face issued by the Caslon Type Foundry in 1816.

If *Avant Garde Gothic* has achieved the status of a contemporary masterwork only 20 years after its introduction, it is because of its clean look, its ability to mix with almost every serif typeface, its wide utility, its ability to be unobtrusively simple in color and style while bringing distinction to a page, and the large size of its family.

The *ITC Avant Garde Gothic* family today consists of:

1) Five Roman weights: extra light, book, medium, demi, and bold.

2) Five Oblique versions corresponding to the Roman weights. These were designed by the "Team 77" of Letterform Research and Design in Basel, Switzerland, under the direction of Andre Gurtler, Christian Mengelt, and Erich Gschwind. (A welcome surprise of *ITC Avant Garde Gothic Oblique* is the absence of design surprises. The slope, so critical in sans serif obliques, is sufficiently pronounced to be apparent yet not excessive. The result is the retention of the flavor of the original Roman designs. The subtle shaping of the rounded letters in the oblique helps preserve the color and feel of the basic design).

3) Four weights of a condensed version: book, medium, demi, and bold. These were designed by Ed Benguiat.

One must also admire *ITC Avant Garde Gothic* because of the subtlety of its design. It appears to have been drawn completely with a ruling pen, compass and straightedge. But looks are deceiving. Yes, the straight lines are straight. But what appears to be a uniform stroke weight that contributes to the typeface's evenness of color when set in lines and paragraphs is a carefully crafted illusion. For example, horizontal and diagonal strokes are not the same thickness as the verticals. Weight varies with each group of strokes. In round shapes one or both sides of the letter are heavier than the top or bottom and the bottom is slightly heavier than the top. Careful scrutiny also reveals that curved strokes slope slightly when they join a stem. Curves that appear to be drawn with a compass are actually hand drawn and carefully molded. Another illusion is the appearance of symmetry in some characters. If you look at an S, H or B for example, you will notice they are actually bigger on the bottom half than on the top.

Subtle optical adjustments give *ITC Avant Garde Gothic* the appearance of uniform stroke weight and of character symmetry. If the characters had actually been drawn with precisely even stroke weights and absolute symmetry, the nature of the way we see things would have made them appear top heavy, of uneven weight and asymmetrical.

The typographic designer, as with artists in all visual media, painting and sculpture and architecture for example, must understand the science of seeing and create illusions in the design to compensate for or cancel out the unwanted variances that human vision would introduce into the perceived image.

ITC Avant Garde Gothic has a number of characteristics that can help one identify it and distinguish it from other geometric sans serif typefaces. Some of these characteristics add to the design's legibility. The bowl of the capital R does not close but that of the P does. The cap Q has a curved tail, most unusual among geometric sans serifs. The shortness of the descenders is particularly noticeable in the lower case g. Dots over the i and the j are rectangular instead of round. The lowercase a, on the other hand, is single storied which is normal for this kind of typeface.

Typefaces, unlike paintings and photographs but like architectural works are to be admired (or not) not only for their appearance and craftmanship, but for their utility. *ITC Avant Garde Gothic* functions equally well as a text typeface or in headlines and other display applications. The various members of the family work well together and blend well with most serif type styles. For text work in books, advertisements, magazines and many kinds of direct mail pieces the book weight is considered ideal. Other weights are used where emphasis is desired.

—Edward Gottschall

Bibliography—

Mason, S., "A Typeface with the Spark: Avant Garde Gothic," in *Graphis* (Zurich), no. 152, 1970/71.
Snyder, Gertrude, and Peckolick, Alan, *Herb Lubalin*, New York 1985.
Carter, Rob, Day, Ben, and Meggs, Philip, *Typographic Design: Form and Communication*, New York 1985.
Gottschall, Edward, *Typographic Communications Today*, Cambridge, Massachusetts 1989.
Haley, Allan, *ABC's of Type*, New York 1990.

Vico Magistretti (1920–)
Selene stacking chair, 1968–69
Artemide, Milan

In 1972 the Museum of Modern Art in New York staged a design exhibition entitled *Italy: the new domestic landscape*. This exhibition marked a change of direction in design. In the words of curator Emilio Ambasz: "Modern architecture had assumed that if all mankind's products were well designed, harmony and happiness would reign triumphant for all eternity." At the same time, of course, it was obvious that "good" design was not enough in itself to solve all humanity's problems. "No object," Ambasz continued, "is designed as a single, isolated, self-sufficient entity, but as an integral part of a great natural, socio-cultural whole." Then, as now, problems such as massive urban decay, increased world population, poverty, inflation, the energy crisis and the consumer society were causes for concern. The MOMA exhibition showed how designers could produce furniture that was convenient, cheap and easy to maintain, using the new moulded plastics and polyurethane. These objects were exceptionally practical and were made from hi-tech materials. They did not have the usual, rather unfriendly appearance—austere, angular, rigid, uncomfortable—of so-called "modern" furniture. They were good to look at, pleasant to the touch, whether made from soft or hard plastic or soft, smooth foam. This new, sybaritic domestic landscape was the reflection of increasing social freedom. Among the designs chosen for this exhibition of useful things was the *Selene* chair, designed for Artemide by Ludovico Magistretti between 1967 and 1968. This stackable chair, in a variety of cheerful colours, with its gentle curves and rounded edges which took up so little space at the MOMA, became an obvious paradigm of the spirit that inspired both the exhibition and that particular moment in the history of design.

Vico Magistretti belonged to the second generation of great designers who, from 1950 onwards, gave such impetus to design in Italy. Along with Aulenti, Gregotti, Castiglioni, Mari and Bellini, to name but a few, he was part of a group whose training was predominantly in architecture. What distinguished Magistretti from the rest was the way in which he combined his activities as a designer with those of a researcher: he experimented with shape, materials and technology, adapting them to the needs of a society which was changing from day to day. Early in his career—in the 'forties and 'fifties—he developed highly architectural prototypes in wood. Through these, he explored the traditions of craftsmanship including the principles of standardisation and mass production. During a later period—around the 'seventies—he confirmed his reputation as a major creator of industrial designs which gave practical application to the theories he had previously formulated. At this time he examined the possibilities of reinforced resins. Although plastics were not superior to wood, they proved to be a good alternative with similar creative potential.

There is no doubt that the use of plastics was a turning point in the history of the Italian chair. At the end of the 1960s, it was widely thought that new moulding techniques would enable furniture to be produced faster and more cheaply. This would mean that products would be within the reach of a wider social range of consumers. The oil crisis of 1973 put an end to this early optimism. The preference for synthetic resins was linked to a re-examination of the design-beauty-utility equation and the analysis of the relationship between design and the production process. At the same time it meant a clean break between art and manufacturing. Magistretti himself preferred to regard the manufacturing process as a source of inspiration. Clearly, both industrialists and designers were fascinated by new technology and each saw the advantages of close cooperation. Against this background, the *Selene* chair found fertile ground on which to develop. Although it was an innovative design, it did have some forerunners. The first was *Model 4999*, designed in 1963 by Marco Zanuso in collaboration with Richard Sapper. This was a chair in injection-molded polyethylene manufactured by the Kartell company. In 1968, the same firm produced Joe Colombo's *Model 4669* in injection-molded nylon. The basic difference between these prototypes and the *Selene*—which Artemide began to produce in 1969—was that the latter was molded in a single piece (the others had sturdy supports which were assembled separately). Vico's chair is conceived as a sheet which achieves shape and resistance through a series of folds, as the designer found through experimenting with a single sheet of paper, which enabled him to resolve several problems at once. Firstly, he ascertained that production would be easy, since the only operation involved was the compression-molding of a layer of glassfibre-reinforced polyester resin. At the same time, the chair's strength came not from a closed structure but from an open and undulating shape. Lastly, both the supports (bearers) and the supported (seat and back) assume an interactive and integrated role.

The *Selene* chair brought in its wake a new attitude towards design: the reinforced resin body not only evolved from a series of ergonometric and technological factors, it also offered a precise basis for a completely new form of industrial organisation. "A chair every five minutes" was its accompanying slogan. Magistretti's comment on the chair: "It is impossible to think of it being made in any other material . . . I have never stopped to think whether it is beautiful or not." Here he seems to be alluding to the proposition of Gillo Dorfles and Umberto Eco which replaced the concept of making "beautiful things" with that of "communicative design." These are the realms of the imagination of an industrialised society, whose new beliefs are founded on experience of contemporary life and on updated production procedures. It is a new definition of beauty with its feet firmly on the ground, or rather, with its feet firmly planted in industry. A little over twenty years later, we know that it never realised the dream of becoming a piece of furniture for mass consumption, suitable for every social class. Even so, the *Selene* chair represents an attitude of rapprochement between design and industrial processes, the benefits of which we continue to enjoy today.

—Diego R. Armando

Bibliography—

Magistretti, Vico, and Caballero, Alberto, "Todas las cosas a la medida del hombre," in *Diario Clarin* (Buenos Aires), 4 November 1977.
Sembach, Klaus-Jurgen, ed., *Contemporary Furniture*, Stuttgart and London 1982.
Istituto Nazionale per il Commercio Estero, *La Sedia Italiana*, Rome 1983.
Stimpson, Miriam, *Modern Furniture Classics*, London 1987.
Albera, Giovanni, and Monti, Nicloas, *Italian Modern: A Design Heritage*, New York 1989.
Russell, Beverly, ed., *New Ideas in America: Architecture and Design 1970–1990*, New York 1990.
Pasca, Vanni, *Vico Magistretti: L'eleganza della ragione*, Milan, London and New York 1991.

Chevron

Shield

Photos London Transport Museum

Enid Marx (1902–)
Textiles for London Transport, 1937–45
Cut-pile moquette
London Passenger Transport Board, London

For the designer Misha Black, writing in *The Picture Post* on 6 January 1945, Enid Marx's textiles for the London Passenger Transport Board (LPTB) had helped prove that "practical materials need not be ugly or dingy."

The fabrics which were to revolutionise the interior appearance of the underground trains originated in 1936. They were commissioned by Christian Barman, who had become Publicity Officer of the LPTB in the previous year, and was responsible for the interior design of the trains. Barman was an appointee of Frank Pick, the far-sighted Vice-Chairman and Chief Executive who made revolutionary use of modern architects and designers for the 1930s extension of the London underground. Seating fabric was one aspect of the redesign of the interiors of the New Tube Stock intended for operation in 1938. In the past, train upholstery had mimicked the styles common in the home. In the 'twenties and 'thirties, therefore, the popular vogue for florals and jazz modern styles was echoed on the trains. Before Barman took over, seating fabric had not been seen as a specific design problem, and patterns were taken from manufacturers' existing ranges.

Lozenge, introduced in 1927/8 for use on the LPTB's underground and overground trains, was the first fabric to be designed specifically for the purpose. A moquette fabric produced by Firth's Furnishings Ltd in Heckmondwike, Yorkshire, it had a small motif which enabled economy in cutting and pattern matching. It marked a point of departure in design, and remained in service into the 1930s. The fabrics were manufactured by three companies, Firth's, Lister & Co. of Bradford, and John Holdsworth & Co. of Halifax. Hard-wearing loop pile moquettes had proved to be the most durable fabrics for transport seating, as they had the greatest capacity for absorbing the impact of body pressure. The type of fabric was not at issue, but the designs did not undergo change until 1936 when Pick and Barman gained control of their production. In order to achieve an entirely new look, they approached freelance, rather than in-house, designers to create customised fabrics worthy of the modern age. Enid Marx was one of four designers approached; the others were Marion Dorn, Norbert Dutton, and Paul Nash. She was invited on the basis of an exhibition of her hand-block printed fabrics held in 1937, but the LPTB fabrics represented her first involvement with the design and production of woven fabrics. Her success in the task was both a reflection of her talent and the ability of Barman to convey his requirements.

The brief was highly specific. The fabrics had to be hard-wearing and not show dirt, work in both natural and electric light, and not be dazzling in motion. The predominant colour was green, set against deep red. It had to possess the practical quality of staying relatively constant in different lights, and was also seen as a symbol of the underground's unification of the country and the city. In Enid Marx's own words, the textiles "had to look fresh under pretty awful conditions." She created a number of designs, four of which went into production and continued in use until the late 1960s.

Miss Marx dealt with the task sympathetically. She was not in favour of using florals on the underground, due to their associations with the home. The sizes and different shapes of the seats meant that the pattern repeats should not be too large. (Miss Marx adhered to the original specification of a 12.5-inch repeat, or

multiples thereof.) Her first design, *Belize*, a cut pile moquette, was sampled by John Holdsworth & Co. in 1936. This bold and simple geometric weave illustrated a solution to the problem of "dazzle." The design was probably inspired by a request by Barman for a plaid type of fabric.

Chevron was the next fabric designed by Marx. It was used both on the underground and to upholster the seats of surface trains in 1938. Although woven in blues, according to the original design, LPTB chose to vary the tones from the original artwork thus exacerbating the "dazzle." The pattern was nevertheless successful, and was later used to re-upholster the Piccadilly and Central lines in 1949. Following this, Miss Marx designed *Shield*, a cut moquette first manufactured by Holdsworth's in 1945. Again, the fabric was used on overground and underground trains. It is known to have been woven in red and green to tone with green leather arm rests for the Bakerloo, Northern and District lines. Contemporary approbation resulted in it being included in the 1949 edition of the Society of Industrial Artists and Designers (SIAD), *Designers in Britain*.

The final Marx design for LPTB, *Brent*, was so-called according to an established practice of naming fabrics after underground stations. Miss Marx preferred the more descriptive name *Square*, which reflected the small, geometric 4×4-inch off-square pattern employed on this cut moquette. A photograph from the time suggests that it was first used on the underground trains in 1942.

The continued use of the fabrics for nearly thirty years was itself a testimony to the appropriateness and freshness of the original designs. This was a result of Miss Marx's talents, coupled with the clarity of Pick's design vision and Barman's ability to interpret it for the designer. However, their mutual relationship with the manufacturers was not unproblematic. Miss Marx's designs were frequently altered in colour and scale, often without prior consultation with the designer or with Christian Barman. It took the continued insistence of Marx, Barman, and Pick to ensure that the designs were produced as faithfully as possible to the originals. Eventually, the most effective interpretations of Miss Marx's designs were achieved. This was confirmed by Misha Black who described Enid Marx as the "designer of some of the best fabrics used in our buses and tubes."

—Hazel Clark

Bibliography—

Marshall, H. G. Hayes, *British Textile Designers Today*, Leigh-on-Sea 1939.
Lewis, Frank, *British Textiles*, Leigh-on-Sea 1951.
Daniels, Jeffery, and others, *Utility Furniture and Fashion 1941–1951*, exhibition catalogue, London 1974.
Dobson, Zuleika, *Enid Marx*, exhibition catalogue, London 1979.
Herald, Jacqueline, "A Portrait of Enid Marx," in *Crafts* (London), October 1979.
MacCarthy, Fiona, and Nuttgens, Patrick, *Eye for Industry: Royal Designers for Industry 1936–1986*, exhibition catalogue, London 1986.
Weaver, Cynthia, "Enid Marx: Designing Fabrics for the London Passenger Transport Board in the 1930s," in *Journal of Design History* (Oxford), no. 1, 1989.

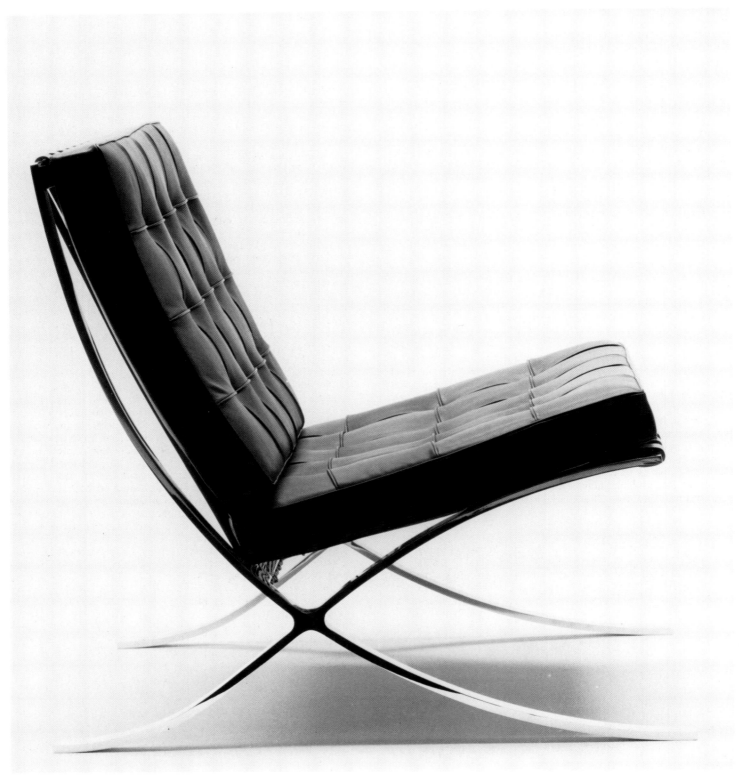

Photos © Knoll International

842

Ludwig Mies van der Rohe (1886–1969)
Barcelona Chair, 1929
welded steel with leather upholstery
Knoll International, New York

The International modernist architect Mies Van Der Rohe is known for the phrases "less is more" and "God is in the details." Both of these aphorisms can be applied to his relatively rare excursions into furniture design. Mies' first piece of furniture was the "MR" chair designed in collaboration with Lily Reich for the 1926 Werkbund exhibition. It was not the first tubular steel chair. Slightly earlier Mart Stam and Marcel Breuer had designed tubular steel chairs based on the vernacular uses of the material: Stam's chair was based on gas tubing and Breur's on the use of metal tubing in bicycles. But, Mies cantilevered chair of bent metal tubes sweeping through the air in shining curves of light was the first to exploit the material's flexibility. "I was," he wrote in his patent application, "the first to have exploited consistently the spring quality of steel tubes."

When he was asked to design the German Pavilion for the 1929 World's Fair in Barcelona, Mies created a revolutionary building that was a milestone in the development of modern architecture for its simple structures, lavish materials and pure use of space. Because there was no existing furniture that had the elegance and spareness of the architecture, he designed a set of chairs, stools and table to harmonize with its revolutionary emptiness. Based on the *sella curulis*, the Roman folding stool, the crisp, yet luxurious lines of these pieces of furniture are powerful, and yet light as air and do not interrupt the free flow of space that is part of the Pavilion's uniqueness. Known as the Barcelona chair, the chairs have become modern classics.

Q: When is a chair not a chair? A: When it is a throne. But, what a throne! Nothing in the history of design prepares us for the simplicity and majesty of Mies' Barcelona chair. Democratic, machine-like and yet, an exclusive handmade jewel. It was designed for the inaugural ceremonies and reception for the King and Queen of Spain when they signed "the golden book" officially opening the exhibition. These ceremonies were held in the Bar-

celona Pavilion. Although designed as contemporary "thrones" for the King and Queen, the Barcelona chairs were never used. "To tell the truth," Mies said, "Nobody ever used them." Although never used, their intended use shaped their design. The chairs are half again as wide as an ordinary chair to indicate their function as seats of distinction for the larger than life personages of the Spanish royalty. When not in use, they become eloquent markers of the former presence of the King and Queen. This extra width allows the chairs to effectively function as sculptural space markers, the only three-dimensional counterpoint to the interior's open spaces and floating planes. Although more commonly seen today in natural or black hide, the chairs were originally covered in white kid and deeply tufted with buttons of the same material. The cushions rest on an armature of flat, polished steel. Mies' decision to use flat steel gave the chair a more imposing quality and detached the material from its populist origins.

Designed for royalty, today its most common contemporary useage is in offices where it gives the office a sacramental, dignified character. Tom Wolfe in *From Bauhaus to Our House*, although generally hostile to the Bauhaus, calls the Barcelona chair "the Platonic idea of *chair* . . . the most perfect piece of furniture in the twentieth century."

Until its recent reconstruction, the Barcelona Pavilion was one of the most famous demolished buildings in architectural history. Standing for only eight months, the Pavilion is best known through black and white photographs. These photographs barely do justice to the rich colors and textures that were an essential part of the Pavilion. Contemporary visitors commented on the luxuriousness of the materials as often as they did on the Pavilion's oasis-like empty spaces. For the walls—both the exterior ones and the free floating planes of the interior—Mies relied on a muted, yet, rich palette. He combined Tinian and vert antique marbles; Roman travertine; a tawny onyx; clear, grey and bottle green glass; a black wool rug; a red silk drape. The Barcelona chairs were set amongst this visual splendor like ivory and silver jeweled sculptures.

While the Barcelona and its contemporary sibling, the Tugendhat chairs, appear to be machine-made objects they are really handmade structures. The materials and shapes suggest technology, but the exact shape of the curves of their chrome plated steel bars were too difficult to be made by machines. Even the connectors in the Barcelona chair are of such precision they needed to be welded, ground and polished by hand. Although it is handcrafted, the Barcelona chair, alone among all Mies' furniture, became the symbol for the technological age. As David Spaeth says, "Prized for its enduring beauty, it remains the hallmark of luxury, elegance and craftsmanship."

—Ann-Sargent Wooster

Bibliography—

Johnson, Philip, *Mies van der Rohe*, New York 1947, 1953, 1978.
Carter, Peter, *Mies van der Rohe at Work*, New York 1974.
Bonta, J. P., *Mies van der Rohe: Barcelona 1929*, Barcelona 1975.
Spaeth, David, *Mies van der Rohe*, New York 1985.

Fig. 61. ○ L. Moholy-Nagy, 1940
Circular disk of transparent material, twisted and warped, to demonstrate greater resistance against pressure.

Fig. 62. ○ Robert Brownjohn, 1944
Tactile chart in bent plastic
Tactile charts and hand sculptures lead the student towards practical applications such as the design of better steering wheels, handles for refrigerators or telephones.

Surface treatment exercise and bending and warping planes can be the introduction to the understanding of the basic elements of modeling, of the relationships of the concave and convex and compound curvatures, penetrating different spatial directions and extending to various levels.
Preexercises are made by line drawings (Fig. 29) which can easily be translated into thermoplastic sheets.

weight sculptures*

Weight sculptures enlarge the sphere of observation and experimentation prepared by hand-sculptures. They teach that we have to deal not only with visual but also with tactile illusion. In this instance, the student designs objects for *both* hands. They must appear as equivalents in weight though their actual weights may be different. They may take on various forms and structures—static or kinetic.

There are various types of hand and weight sculptures:
1. the "fruit" shape (modeled) to catch in the palm
2. tricks for the fingers (to feel holes, and thickness)
3. spring effects (through pressure)
4. motion actions (by inclusion of the joints of the wrist)
5. twisting (by turning parts)
6. changes by motion of parts

tactile structures

Tactile charts and structures represent a refinement of the exercises for the hands. They are devised for finger manipulation of the different qualities of the sense of touch like pricking, pressure, temperature, vibration.**

* *Introduced by Andi Schiltz.*
** *Many of these exercises are more thoroughly described in "Von Material zu Architektur," Albert Langen, Munich, 1928, and in "The New Vision," (Putnam, Brewer & Co., N.Y. 1930; W.W. Norton & Co., N.Y. 1938; George Wittenborn & Co., N.Y. 1946) both by L. Moholy-Nagy. These exercises can also be used for the rehabilitation of the blind.*

76

844

Laszlo Moholy-Nagy (1895–1946)
Vision in Motion 1947
Perfectbound illustrated book; $8\frac{3}{4} \times 11\frac{1}{4}$in. (22.4 × 28.8cm.)
Chicago, Paul Theobald

I've long ranked Laszlo Moholy-Nagy among the greatest contemporary artists, not only for the value of individual works but for the incomparable quality of his esthetic adventure, with exploratory consistency, through several media. Because he excelled at several non-adjacent arts, among them painting, kinetic sculpture, photography, film, book design and writing, Moholy should be considered a modern exemplar of the *polyartist*. Asked to identify a single work that epitomizes his achievement, that represents the sum of his imagination and intelligence, I would choose, without intending to deprecate anything else, not a work of primarily visual art but the big book written in Chicago that, appearing posthumously, concluded his short life as only a book can do—*Vision in Motion* (1946).

It is first of all one of the major critical essays about artistic modernism, documenting as it does the new developments not only in painting and sculpture, but in photography and even literature. The general intelligence as well as the quality of Moholy's insights is so great that you frequently pause and take notes or mark profusely. Take this passage on modernist painting: "But in analyzing the paintings of these various groups one soon finds a common denominator, the supremacy of color over 'story'; the directness of perceptional, sensorial values against the illusionistic rendering of nature; the emphasis on visual fundamentals to express a particular concept."

Or this on modernist sculpture: "In the successive stages of sculptural development, the main characteristic is the reduction and lightening of the heavy mass so that even the normal characteristics of the material disappear. This is most effectively realized on the 'mobile' or moving sculpture. Here the problem of virtual volume relationships is posed."

Or this on classic photography: "The photogram exploits the unique characteristic of the photographic process—the ability to record with delicate fidelity a great range of tonal values. The almost endless range of gradations, subtlest differences in the gray values, belongs to the fundamental properties of photographic expression. The organized use of that gradation creates photographic quality."

Or this forecasting of the principles of computer sound composition: "To develop creative possibilities of the sound film, the acoustic alphabet of sound writing will have to be mastered; in other words, we must learn to write acoustic sequences on the sound track without having to record real sound. The sound film composer must be able to compose music from a counterpoint of unheard or even nonexistent sound values, merely by means of opto-acoustic notation."

Or this on the politics of art and the function of art education: "Art may press for the sociobiological solution of problems just as energetically as the social revolutionaries do through political action. The so-called 'unpolitical' approach of art is a fallacy. Politics, freed from graft, party connotations, or more transitory tactics, is mankind's method of realizing ideas for the welfare of the community."

To my mind, the concluding section on "Literature" is one of the strongest in the book, identifying as it does the most extreme modernist developments as we know them to this day. The highest point of this chapter is Moholy's pioneering analysis of *Finnegans Wake*, which was published only a few years before. Not only did he understand Joyce's extraordinary work better than anyone else writing at that time, but Moholy also provided a chart that, as it uses his favorite visual forms of the rectangular grid and circles, remains to this day the most succinct (and inspired) presentation of the Joycean technique of multiple references.

What Moholy established in *Vision in Motion* was a model of writing about all the arts as a single entity, to be called art, whose branches (literature, painting, etc.) were merely false conveniences conducive to specialization and isolation.

Though he had come to America only a few years before, *Vision in Motion* was written in English, in contrast to his earlier books that were originally in his second language, German (and thus translated by other hands for their appearance here). Though his spoken English was reportedly imperfect, the prose in *Vision in Motion* is (or was made) remarkably vigorous and clear, as the above examples demonstrate. Indeed, you can feel Moholy's thrill in communicating his favorite post-Bauhaus ideas in yet another language new to him, for a new audience in his adopted country; you can feel his evident pleasure in writing an American book as a newly American artist. As a Hungarian critic perceived, "Each line, each analogy, each phrase in the book is, in spite of the influence of the Bauhaus tradition, one hundred per cent American."

What he understood back in the 1940s was that kinesis would become a predominant quality in contemporary visual art and thus that much innovation would occur in areas between the old arts. As a result, Moholy became a remarkably prophetic guide to the future. In writing my 1968 book on happenings, kinetic theater and other mixed-means events, I found myself citing him often. Two decades later, in writing an essay on the esthetics of holography, I turned to *Vision in Motion* again, for conceptual insight into a medium that didn't arrive under twenty years after his death! Though I have read the book perhaps two dozen times, every time I return to it I find myself, amazing though it seems, recording an insight that escaped my attention before.

It is scarcely surprising, remembering Moholy's pioneering realization of Bauhaus book design, that *Vision in Motion* should represent the epitome of his book-making style in all respects but one (the use of serif typography, rather than the sans-serif he traditionally favored). Its blocks of type, both roman and bold, with different widths, are distributed among shrewdly selected rectangular illustrations, usually in close proximity to commentary about them, under the assumption that text and image should be seen together. The pictures included modern masterpieces along with examples of his own works and, generously, those of his students. For all of its intelligence about modern art in general, *Vision in Motion* is also an "artist's book," or book-art of the highest order, about Moholy's rich esthetic experience, and needless to say, perhaps it is a book that only he had enough experience to write and design as well. If we accept the revelations of Conceptual Art that a prose description of artistic experience could constitute, in and of itself, an esthetic object, then *Vision in Motion* has other resonances that not even Moholy could have foreseen.

—Richard Kostelanetz

Bibliography—

Moholy-Nagy, Laszlo. *The New Vision and Abstract of an Artist*, New York 1947.
Moholy-Nagy, Sibyl, *Experiment in Totality*, New York 1950.
Kostelanetz, Richard, *Moholy-Nagy*, New York 1970.
Passuth, Krisztina, *Moholy-Nagy*, London 1985.
Engelbrecht, Lloyd C., and Kostelanetz, Richard, *Moyholy-Nagy: A New Vision for Chicago*, Chicago 1991.

Photos Riccardo Moncalvo, Turin

Carlo Mollino (1905–73)
Orengo House, Turin, 1949

The Orengo House in Turin represents one of the best preserved examples of interiors designed by Carlo Mollino. For this occasion, in 1949, he also designed some of his most remarkable pieces of furniture—a chair, a table and a divan.

As an architect, Mollino conceived buildings and a lot of interiors meant for apartments and houses mostly in Turin and surroundings. In this field he manifested himself as one of the few modern architects who sought inspiration in French surrealism. Also, after it had been banned from the minds of modern architects for about forty years, Art Nouveau was rediscovered by him. In this sense, Mollino followed the surrealist Salvador Dali, one of the first to draw attention to the Catalan architect, Antoni Gaudí, the creator of the Sagrada Familia in Barcelona.

Confronted with Mollino's individualistic, even extravagant designs, one has the feeling of observing the cradle of another Art Nouveau—the style of the 'fifties. The idealistic geometrical forms which were propagated by the modern pre-war architects have been substituted by irregularity; their systems planned for eternity seem suddenly replaced by sheer whims.

In the interior of the Orengo House, however, Mollino appears to be, relatively speaking, restrained. The forms and colours he applied are rather modest and subdued. In other interiors designed during the 'forties he showed more of his baroque side. The Orengo House interior even breathes a sort of tranquillity. Sliding panels, as in Japanese houses, between the rooms give an opportunity to convert the space. Indirect neon light running in one line from living room to study connects two different rooms by means of space and light. Mirrors and curtains are attached to the walls for decoration's sake, but they do not contribute to the dazzling effect Mollino sought in other interiors. One of the common features, however, is the photographic blow-up attached to one of the walls, feigning a view out of a window.

The real irregularities only start with the furniture. Passing through a large opening from the entrance hall to the living room one sees, to start with, at the left hand a low curved cupboard. Together with other cupboards and bookcases, this furniture item belongs to the fixed setting. This is not the case with the reclinable divan placed in the living room in front of the photographic landscape blow-up. The divan can be converted into a chaise longue by adjusting the upper part of the bed construction. The legs, of different lengths, can be folded back in order to make a low bed. Nevertheless, the multifunctional divan looks in whatever position like a strange animal.

The arm chair of solid maple placed before the table in the study resembles the creations of Antoni Gaudí, the Art Nouveau-architect much admired by Mollino. Still, the forms of vertebrae and spine, and a pseudo-folding support are typical for Mollino, whose furniture often resembles—in construction as well as in appearance—a human skeleton.

Perhaps the most remarkable item of the Orengo House furniture is the coffee table in the living room. The support has been made of plywood moulded into a N-form. Itself "organically" shaped, the bent plywood is perforated by holes as irregularly outlined as is the horizontal glass top. In this controlled irregular form, one clearly sees that organic shape in design of the 'fifties that has been characterized as the "kidney."

The furniture pieces for the Orengo House were later developed for distribution and sale. However, the shaped wooden armchair inspired by Gaudí, the convertible divan and the table of glass and plywood are not appropriate for mass-production or for a large consumer public. The plywood technique, also utilized by other designers in the forties and fifties, such as Alvar Aalto and Charles Eames, depends on rather complicated industrial methods. Therefore, editions of such furniture have to be big in order to make one copy cheap enough.

However, Mollino was not interested in mass-production. Unhampered by any prejudice concerning good or bad taste, he simply showed his vivid interest in sophisticated modern industrial methods and the new, unfamiliar forms they could produce. Plywood can be shaped in many different ways of which the rectangular form is only one.

Mollino discovered the application of moulded plywood in the aircraft industry. He himself produced some designs for airplanes. It was just one of his many activities. He displayed his talents in disciplines as different as architecture, car design (and racing), photography, fashion and sport. In short, he was a modern "uomo universale". The tendency he showed towards sinuous shapes in furniture can be related to some of the other terrains wherein he was active—to the "arabesques" he made as a stunt flyer in the air and to the slalom tracks he made as a skier in the snow.

His artistic and cultural background was also diverse. From Gaudí to the Italian author and flyer Gabriele D'Annunzio and Des Esseintes, the decadent hero from Joris-Karel Huysmans' novel *Against nature*, from Turinese baroque to Italian futurism and French surrealism, from Bugatti to Alvar Aalto—this amalgam forms Mollino's ancestry. Seemingly only interested in the surface of bizarre form, he was in reality a very original "engineer" whose constructions resulted in shapes which were hitherto unknown.

—Jan van Geest

Bibliography—

Dal Fabbro, Mario, *Furniture for Modern Interiors*, New York 1954.
Brino, Giovanni, *Carlo Mollino: Dernier Artisan des Annees '50*, Turin and Paris 1984.
Ferrari, F., *Carlo Mollino: Cronaca*, Turin 1985.
Brino, Giovanni, ed., *Carlo Mollino: Architecture as Autobiography*, London and New York 1987.
Centre Georges Pompidou, *L'etrange univers de l'architecte Carlo Mollino*, Paris 1989.

48
In those of the average

Appreciate at a Glance t

60
But when the princ

These perhaps, are

72
Harmony lies n

In the case of pr

14 (LONG DESCENDERS) ON 16 PT. DISPLAY MATRICES LINE T·1438

Six of the documents were judged to be
of very high quality and thus took prizes
Dexterity must be gained by quiet workers

18 PT. DISPLAY MATRICES LINE T·1948

The bank recognizes our claim
so we now expect full payment
Type with quads forming blocks
ABCDEFGHJKLMNOPQR

8 (LONG DESCENDERS) ON 9 PT. (9D) 8¼ SET U.A. 325 LINE M·1298

When jobs have type sizes fixed quickly margins of error widen
unless determining calculations are based on factual rather than
hypothetical figures. No variation in the amount of copy can affect
the degree of error once that error has been made. If instead of
ten point the estimator now specifies nine point for the type size
When jobs have their type sizes fixed quickly margins of error widen
unless all determining calculations are based on factual rather than

9 (LONG DESCENDERS) ON 10 PT. (10D) 9 SET U.A. 325 LINE M·1325

When jobs have type sizes fixed quickly margins of error
widen unless determining calculations are based on factual
rather than hypothetical figures. No variation in the amount
of copy can affect the degree of error once that error has been
made. If instead of ten point the estimator now specifies nine
When jobs have type sizes fixed quickly margins of error widen
unless determining calculations are based upon factual rather

Stanley Morison (1889–1967)
Times New Roman typeface, 1932
Times Newspapers, London

Times New Roman, arguably the most widely-used typeface in the world, was the only typeface designed by Stanley Morison, one of the leading figures in English typography from the early 1920s until his death in 1967.

Morison's interest in printing began when, as a young man, he habitually visited the exhibitions of manuscripts and early printed books at the King's Library in the British Museum. An advertisement in *The Times* printing supplement of 10 September 1912 directed him toward a new monthly magazine of printing, *The Imprint*; Morison subsequently applied, and was accepted, for the post of editorial assistant on the magazine. The intention of *The Imprint*, edited by Gerard Meynell, was to raise standards in commercial printing and proclaim the philosophy of such craftsmen/designers as Edward Johnston, who led the contemporary revival of calligraphy (this was to be continued by his pupil Eric Gill). *The Imprint* folded within the year and Meynell moved Morison to his uncle's firm, the Catholic publishers Burns and Oates, where he was to work with Francis Meynell. Morison and Francis Meynell produced trade books of "quality," using the best printers and the services of such as Gill.

During the war (both Morison and Meynell were conscientious objectors) while working for George Lansbury's left-wing, anti-war paper *The Herald*, Meynell began the Pelican Press, using *The Herald*'s printing presses. Morison was to supervise the design work of the Press. The Pelican Press produced well designed work for the socialist cause, it had Monotype machinery at its disposal and four typefaces: Old Face, Venetian, Imprint, and Plantin. When Meynell had to resign from *The Herald* Morison moved north to the Cloister Press at Heaton Mersey, which had been set up in 1920 by a Manchester advertising agent, Charles W. Hobson. Morison was engaged as typographer by the printer Walter Lewis, then general manager at the Cloister, and was in sole charge of design, ordering new type (ATF Garamond) and issuing a series of type specimens. In 1922 the Press opened a London office where Morison met Oliver Simon, who had recently begun work at the Curwen Press.

Together with Simon, Francis Meynell, Holbrook Jackson and Bernard Newdigate, Morison formed the Fleuron Society, a publishing venture which aimed at producing a book a year in order to prove that books set and printed by machine could equal private press work. The venture was short-lived, however, Meynell began his own publishing house, The Nonesuch Press, to produce fine books using commercial book printers. Simon and Morison worked together on a typographical journal, *The Fleuron*. The first four issues were edited by Simon and printed at the Curwen Press, from 1923–25; when Simon's money ran out Morison took over the editorship and the books were printed at Cambridge University Press, the seventh and last being published in 1930.

In 1922 the Cloister Press closed and Morison began his career as a freelance consultant, working for both the Monotype Corporation and Cambridge University Press. It was through the Monotype Corporation that Morison first came into contact with *The Times*; when a representative of the paper's advertising department offered to handle the design and setting of an advertisement for the Monotype Corporation, Morison is reported to have thumped the table and offer them a thousand pounds to keep their compositors away. In 1929 Morison was invited by William Lints Smith, *The Times* general manager, to discuss the typographic appearance of the newspaper.

Morison's response was to compile a report on the typefaces used at *The Times*, including their advertisement setting, and to recommend that the paper loose many of its old faces. He simultaneously wrote an article on 'Newspaper Types' for *The Times* printing supplement, and in June 1930 prepared the reforming document, *The typography of The Times*, a newspaper-sized folio with 42 full-sized reproductions of the paper, the text set in the largest possible composition size of Monotype Bembo, 24pt, from specially made matrices. This gesture was characteristic of Morison's strategy in that it combined an authoritative historical survey with the proferring, and inevitable acceptance, of his own solution. His analysis of founts suitable for the newspaper was based largely on his experience of and preference for book faces, especially those produced by the Monotype Corporation. All further trials at *The Times* were made with Monotype faces.

By October 1930 Morison had persuaded *The Times* management to set up a committee to consider the design of a new typeface for the paper; according to Morison the type would be chosen for, ". . . its effectiveness as much as for its 'beauty'; the criteria of the effectiveness being a maximum of clearness in impression and a maximum of legibility . . ." He professed, "The new types proposed for *The Times* will tend towards the 'modern,' though the body of the letter will be more or less old-face in appearance." The committee instructed Morison to prepare specimens of "modernised Plantin" and "thickened Perpetua", their preference being the former. Morison sketched the outline of the revised letters and gave them to Victor Lardent, a *Times* draughtsman, to prepare the finished drawings. Lardent was later to claim that his contribution to the type was insufficiently recognised, claiming that Morison merely gave him a photograph of a page printed in Plantin as a model. An unusually high number of over a thousand punches had to be recut by the *Times* works before the type was considered to be satisfactory. Characteristically for his reworking of Plantin Morison had returned to the pure form of the Granjon type as opposed to the model used by Monotype for their 1913 Plantin. At the same time, Morison proposed the romanisation of the mast-head; a controversial suggestion which held up the acceptance of the redesign until 3 October 1932. Times New Roman became this century's most successful typeface.

In accordance with Morison's training in book typography, Times is a face which is both condensed and very close set, as such, it is at a disadvantage on the slug casters necessary for newspaper production; the matrix walls, being thin, quickly wore out, causing the type metal to spread and create unsightly vertical lines between the letters. While, as press speeds quickened apace with rising circulation, Times failed to withstand image degradation as opposed to other types designed with a deeper understanding of the specific conditions of newspaper production. Times was best suited to magazine and book setting; however, its use did give official sanction to the idea that a newspaper face could be beautiful.

In 1972 *The Times*, under the management of Lord Thompson, asked Walter Tracy to design a new face to replace Morison's; the result was Times Europa.

—Fiona Hackney

Bibliography—

Morison, Stanley, *Printing The Times: A record of the changes introduced in the issue for October 3, 1932*, London 1932.
Morison, Stanley, *The English Newspaper*, Cambridge 1932.
Morison, Stanley, *The History of The Times*, 4 vols., London 1935–42.
Moran, James, *Stanley Morison: his typographic achievement*, London 1971.
Barker, Nicholas, *Stanley Morison*, London 1972.
Dreyfus, John, "The Evolution of Times New Roman," in *The Penrose Annual* (London), 1973.
Jones, Herbert, *Stanley Morison Displayed: An Examination of His Early Typographic Work*, London 1976.
Appleton, Tony, ed., *The Writings of Stanley Morison*, Brighton 1976.

849

Josef Muller-Brockmann (1914–)
Posters for the Zurich Concert Hall, 1955–59
Colour offset on coated paper
Zurich Tonhalle-Gesellschaft

To command attention. To convey a message clearly. That is the question. Whether it is more important to be graphically vigorous or to be crystal clear has been a major dispute among graphic designers in the 20th century. Polarized positions favoring graphic vitality over clarity, or the reverse, and many shades of compromise seeking the best of both worlds have been expressed in design schools, in periodicals and books and monographs and in the very work of graphic designers all over the world.

In 1936, 22 year-old Josef Müller-Brockmann opened his own studio in Zurich, Switzerland. His graphic philosophy, expounded in school, in books circulated worldwide, and in his own work became one of the most powerful forces showing that the best, the most communication effective, graphic design need not sacrifice energy and eye appeal to achieve orderliness and communication clarity.

In this regard his series of posters for Zurich's Tonhalle Gesellschaft truly constitute a contemporary masterwork.

A look at the posters shown here illustrates the designer's close affinity to then contemporary art, particularly constructivism. His love of geometry and his closeness and personal sensitivity to music, classical and experimental, also show through in this poster series. Whether the director of the Zurich Concert society had to be persuaded to let the enthusiastic designer experiment with these posters or encouraged him to do so, the result was that what had been a graphically dull medium came to life.

The concert poster, by its very nature, is simply an information sheet—a who, where, what, when statement. Müller-Brockmann took what could have been a drab notice and made it graphically sing. These posters convey the joy and spirit of music as well as the basic facts of a concert and are thus at once beautiful and powerfully effective, lively and clear. Examination of the posters reveals many of the design principles Müller-Brockmann expresses and has practiced for more than half a century.

Where earlier posters used many typefaces and sizes, these posters use few. The Beethoven poster employs one typeface in one text size and one display size, as does Französische musik. The other posters also use one typeface in few sizes. The typographical elements are also reduced in number and positioned most coherently and the factual information conveyed by the words is enlivened and empowered either by large and relevant illustrations or dynamic positioning of the typographic elements. Consider Beethoven. The type is off center on both axes and the illustration is large and sweeping. Its circularity suggests records.

Another poster places the type neatly across the bottom and the diagonal rows of rectangles suggest piano keys. The "keys" are in bold colors underscored by warm yellow-orange lines. Today we take such graphic liveliness for granted. But when these posters were created such treatment was fresh and daring. The Französische musik poster employs a different spectrum of colors in each of the vertical tubes (batons?) above the text.

Obvious in all the posters is the synthesis of message content and graphic form. They reinforce each other. The illustrations are not merely eye-catchers. They are the muscle behind the words, the propellant of the otherwise dry information.

Such functional design did not start in the late 1950s when these posters were designed, nor even in the Bauhaus period several decades earlier. But the Swiss school of graphic design, of which

Müller-Brockmann was a leader, gave it new visual vigor and international credibility.

Look again at the posters illustrated here. The typeface(s) used in this series are sans serifs. The letters are simple, free of ornamentation. Just as the elements in the posters employ simple geometric shapes—circles, rectangles, lines—without embellishment, the typefaces themselves are similarly plain. Müller-Brockmann believes that lettering is an expression of the spiritual and cultural atmosphere of the age and that this period required functionalism in design and typographics and that almost any job could be done as well with sans serif type as with serifed styles. Note how the formal elements in these posters are usually linked, how your eye flow is controlled. The elements seem a unity. They reinforce each. One does not distract from the other. Müller-Brockmann writes of this design approach, "This composition, for which I often used precisely proportioned subdivisions, was intended to be a symbolic expression of the conformity of music to its inner laws. The thematic, dynamic, rhythmic and metrical values of music are represented by suitable visual forms . . . the tonal color of the various works due for performance is illustrated with color arranged as dictated by emotion or a particular visual effect in a fixed sequence." The colors and rhythm of the design are related to the colors and rhythm of the music.

Some of the last of the concert posters relinquish symbolic forms in favor of typographically constructed posters. One of these, *musica viva*, is shown here. The task of expressing dynamicism, rhythm and tonal color is now left to the typography. Instead of a block of text, the text itself becomes a dynamic element. Utter typographic simplicity here, as in the other posters, uses only lower-case letters.

Less obvious behind the vibrancy of these posters is the grid system. Müller-Brockmann, as did a number of other Swiss designers at the time, advocated and employed grids in graphic designs. This brought an orderliness to their work. Shown here is the grid for one of the posters. The grid divides the working area into proportioned subdivisions and makes it possible to bring all the elements of design—type, photography, illustration, color—into a formal relationship with each other. It introduces order into a design. Each design problem requires a custom-made grid that will accommodate every element so that each is visually effective and plays its proper role in contributing to the overall effect.

It is the genius of Müller-Brockmann, as illustrated in the Tonhalle Gesellschaft posters, that his work delivers such a beautiful and effective blend of graphic orderliness and visual vitality. He proves that orderliness need not be dull and graphic energy need not be confusing.

—Edward M. Gottschall

Bibliography—

Rotzler, Willy, and others, *Josef Muller-Brockmann: Posters 1948–1981*, exhibition catalogue, Zurich 1983.
Muller-Brockmann, Josef, *Grid Systems in Graphic Design*, Teufen 1985.
Muller-Brockmann, Josef, *The Graphic Artist and his Design Problems*, Teufen 1985.
Gottschall, Edward, *Typographic Communications Today*, Cambridge, Massachusetts 1989.
Fleming, Herb, "A Program for the Zurich Concert Society," in *Novum Gebrauchsgraphik* (Munich), April 1989.

Photo courtesy Herman Miller, Inc.

George Nelson (1908–86)
Storagewall shelving and storage system, 1944–45
Herman Miller, Zeeland, Michigan

At the end of World War II, the United States of America, the military and moral victors, became major trendsetters in the field of design. They entered the fray alongside Italy and the Scandinavian countries, the traditional design leaders on the other side of the Atlantic. In the realm of architecture, the country welcomed to its shores the masters of the German avant-garde, such as Mies van der Rohe, Walter Gropius and Marcel Breuer, who found in America fertile ground on which to put their new ideas into practice. Unlike what had happened in Europe, where the emotional and nationalistic reaction of the public was against all things modern, Americans saw contemporary architecture and design as a symbol of progress. The dream of the "New Deal" had also found its way into furniture production, but in this case it was not the adventurous and heroic design of the 1920s. In the USA, public taste for modern design was linked to other factors: people were looking for what was both practical and functional. And so design lost its air of mystique, sophistication was the order of the day. Manufacturing processes and available technology determined the type of goods produced and stimulated creative activity.

These changes were reflected in the home: as living spaces became smaller there were more and better ideas as to how to make best use of what space was available.

Against this background the *Storagewall System*, designed by George Nelson in collaboration with Henry Wright, was warmly received and enjoyed considerable success. It was a wall unit of varying depth (12, 16 and 24 inches, according to need) where all sorts of things could be kept. At the same time, the *Storagewall System* was conceived as a room-divider (the original was designed to stand between hall and living room). All the bits and pieces that it could house were listed in the catalogue of Macy's, the famous New York department store. (Indeed, it is significant that in 1944 a major retail outlet should be concerned with keeping pace with modern design). The list included linen, stationery, shoes, radios, hats, collections, food, books, towels, magazines, socks, rainwear, boots, photographs, shirts, records, ties, games, blankets, pencils, tinned goods, brooms, dresses, typewriters, umbrellas, overcoats, crockery and golf clubs. In a word, anything you could think of. The storage unit received accolades from three leading magazines:

Life: "A practical solution to a basic problem. It can be used almost anywhere to ease storage problems and save space. If a family were to have wardrobes built into every one of their inside walls, they could buy all the clothes and ornaments they wanted without having the problem of where to keep them."

Interiors: "Where every inch of space counts, a family has more chance of living in peace if storage units are designed with the customer's needs in mind. But we know it is not as simple as that. Deciding whether built-in storage is economical is one question. Having it built is another. An obvious solution to this quandary is the *Storagewall System*. It is cheaper than conventional furniture of comparable quality, and built-in units can be custom made."

The Architectural Forum: "*Storagewall* offers a surprising amount of hanging- and shelf-space. It is a functional and flexible answer to problems of organised storage. The units can be used in any combination and between any two rooms to meet the particular needs of each family."

Since the dawn of the modern age, the concept of the wall has become subdivided into its two essential roles: support and enclosure. The modern notion of "free-standing" has underlined this idea in that it leaves the face of the structure free. The *Storagewall*, which conforms most directly with modern thinking and with the "five principles," capitalises on the situation. The wall, far from having the one responsibility of supporting the architecture, is capable of taking on other roles, in this case storage. It systematises the "storage" function and optimises the "living" function. Half dividing wall, half closet, this design represents the concept of functionality taken to the extreme. It is an invention as radical as it is necessary, to the extent that its possibilities and influences are still with us today.

Another factor which contributed to the success of the *Storagewall System* was the "Do it yourself" mentality, so closely identified with the "American way of life." It is fascinating how, despite the high level of standardisation of the product, each user could choose between a variety of ways of assembling the units and different finishes, according to his particular requirements. The *Storagewall* rocketed its designer George Nelson to fame. Among other things, it led to a contract with a design company at that time still in its infancy—Herman Miller, now one of the biggest in the business. While working for Miller, Nelson produced an improved version of the *Storagewall—Basic Storage Components*, manufactured by the company between 1949 and 1954. From a technological point of view, the new model represented an evolution, for the basic material was plywood. Charles Eames' "Plywood Group" dates from the same period. From the functional point of view, it had several advantages over its predecessor. Firstly, it provided housing for audio equipment (record-players, amplifiers and speakers) and television. Secondly, it incorporated drop-leaf writing desks. A third innovation was the inclusion of display cabinets in a low-level version of *Basic Storage Components*. This version incorporated a vanity unit for ladies. Maximum versatility had been achieved. As on many occasions in history, a good design (the *Storagewall System*) brought with it a worthy successor (*Basic Storage Components*).

—Carlos L. Dibar

Bibliography—

"Storagewall," in *Life* (New York), January 1945.
Nelson, George, and Wright, Henry, *Tomorrow's House*, New York 1946.
Nelson, George, *Storage*, New York 1954.
"The George Nelson Office: A Comprehensive Design Organization," in *Architectural Record* (New York), December 1957.
Nelson, George, *George Nelson on Design*, New York 1979.
Pulos, Arthur J., *The American Design Adventure 1940–1975*, London and Cambridge, Massachusetts 1988.

Erik Nitsche (1908–)
Atoms for Peace posters, 1955
Colour lithography
R. Marsdens, Lausanne, for General Dynamics Corporation, St. Louis, Missouri

In 1953, while working for a Madison Avenue advertising agency in the United States, Swiss-born and educated Erik Nitsche was assigned to head the General Dynamics Corporation account. Under the dynamic and far-sighted leadership of its President, John Jay Hopkins, General Dynamics had expanded from a small newly-incorporated company described in *Moody's Manual of Investments* of 1952 as "engaged in constructing submarine and patrol torpedo boats, naval equipment and accessories," to a megacompany, described in *Moody's Industrial Manual* of 1955 as having five divisions and one foreign subsidiary by 1955.

After Nitsche left the agency to do free-lance work, Hopkins commissioned him to prepare an exhibit for General Dynamics for the International Conference on the Peaceful Use of Atomic Energy, to take place in August of 1955 in Geneva, Switzerland.

Nitsche faced a formidable challenge. He was expected to create an exhibit which, while being worthy of the young-yet-powerful General Dynamics' leadership in atomic research, would not reveal any research secrets. Further, General Dynamics was not engaged in any tangible research on peaceful uses of the atom beyond a philosophical optimism held by its president, Hopkins. Concurrently with the Geneva conference, Hopkins had published an "Atoms for Peace" booklet with a long essay on his belief that the world should strive to "massive atomic creation rather than massive atomic destruction." Nonetheless, everything about General Dynamics' most recent accomplishment—the world's first atomic-powered submarine, the Nautilus—was secret, so nothing could be shown except, perhaps, a stylization of its exterior hull.

According to Suzanne Barry's 1957 article "Graphic Dynamics," Nitsche's exhibit installation consisted of six *Atoms for Peace* posters joined as a backdrop for a model of the Nautilus' hull. The text accompanying the display from Isaiah 2:1 appeared in six languages (English, German, Russian, French, Hindi, and Japanese): "They shall beat their swords into plowshares, and their spears into pruning hooks: nation shall not lift up sword against nation, neither shall they learn war anymore." To this, Nitsche added a timely quotation from Pope Pius XII's 1955 Easter message, which helped mitigate the irony of exhibiting a warship model at a conference on the atom's peaceful uses. In the Pope's words, the Nautilus was "the first attempt to propel a ship by means of nuclear energy—at last putting that force to the service and not to the destruction of man."

Nitsche achieved visual unity for his series in three ways: All six posters carried two sizes of text—across the top in lower case sans serif (except on the Hindu and Japanese language posters) "atoms for peace" in one of the six languages represented, and across the bottom in uppercase sans serif bold, GENERAL DYNAMICS in English on all posters. The same typeface would be used by Nitsche on three more posters for the series completed in 1956. In addition to the typeface and its placement as a visual unifier for the posters, Nitsche used a solid color background against which a simple, two-dimensional design is placed either symmetrically or asymmetrically. Each poster feature a different color background appropriate to its topic. There is a full range of colors from primaries to subtle blues, greens, greys, and dramatic blacks. The entire series featured a rectangular format within which Nitsche's scale mastery is evident, particularly because the posters were often reduced, without top "atoms for peace" phrase, in advertisements for General Dynamics.

Five of the original posters are discussed here. The first poster of the series, in English, features a symmetrically-placed pyramid of abstracted flag shapes against a soft dove-grey background. Nitsche relies on the viewer's mental association of massive Egyptian pyramids flowing like rays from the life-giving sun with the bright, occasionally transparent, pyramid of flags leading up in concert to the atom, apparently the world's new source of life and hope. Nitsche's replaces the ancient monument to the dead with a speculative monument of hope for the living.

The second poster in the series, perhaps the best-known, is the Nautilus shell with a mercator projection of the earch at its center and the first atomic submarine emerging from the shell's opening. The delicately shaded white shell floats lightly against a subdued yellow to blue-grey background. The submarine Nautilus in cool greens hovers serenely at the lip of the shell. Beginning with Plato's study of Euclid's Golden Section as the basis of exceptional beauty in both art and science to the application of the Golden Section to spiral forms by T. A. Cook in his 1914 book *The Curves of Life* there had been much written about the aesthetic superiority of the Golden Section. Nitsche uses the natural form of the nautilus shell, considered a "perfect" example of the Golden Section, to appear to give birth to the Nautilus submarine.

The line drawing of the workings of the atom, superimposed against ellipses which overlap an asymmetrically-placed circle, consitutes the third poster in the series. A jet plane flies out of the orbit of the atomic structure towards the right. General Dynamics intended to add the first atomic powered plane to its accomplishment of the Nautilus submarine, and this poster in Russian, stakes the company's claim on that intended "first." Such a plane does not yet exist.

The Hindi poster places a light bulb over a segmented mercator view of the earth seen from the North Pole. The power of the bulb is atomic, suggested by a symmetrically-placed schematic of the atom. Against a uniform black background, the earth and the light bulb convey the message that darkness can and will be dispelled by electricity generated by nuclear power. This hopeful 1950s message is being challenged today as the reality of disposing of long-lived nuclear waste weighs heavily on the minds and purses of countries using nuclear-power generators for electricity.

Three vertical segments of brightly-colored square facets, suggestive of the faceted reflectors surrounding operating room lights, cut across a black background in the fifth poster, in Japanese. Beneath the central and largest faceted segment in a diamond-shape appears a close-up photograph of surgeons in an operating room. The theme is clearly the application of nuclear power to the health sciences, to nuclear medicine. Against the darkness of sickness the sharp, crisp squares of scientific know-how march across the poster's horizon, suggesting that bit-by-bit, darkness and ignorance will be obliterated through advances of up-to-date nuclear medicine.

Nitsche solved his problematic assignment within the boundaries of an aesthetic of the 1950s which sanctioned simple clear messages as figure against solid color ground. He believed that though copy for the posters exemplified the visual matter, the design was the true carrier of the theme. He felt that the image had to be clearly stated. His own words, quoted in Suzanne Burry's "Graphic Dynamics" are a fitting summary of his aesthetic philosophy for the *Atoms for Peace* posters: "I do not want to be obscure. You know, one might easily get carried away by the science fiction temptation of this subject matter. What I am concerned to do is to establish it with a certain classicism. I would hate to have to apologize for a design, to have people puzzle and ask, 'What is it?' The posters should communicate with everyone. The favorable reaction of churches and schools requires that they have a solid explanation and an element of tradition."

—Barbara J. Hodik

Bibliography—

"General Dynamics Corporation," in *Moody's Manual of Investments*, New York 1952.
Burrey, Suzanne, "Graphic Dynamics," in *Industrial Design* (New York), June 1957.
Amstutz, Walter, ed., *Who's Who in Graphic Art*, Dubendorf 1982.
"General Dynamics Corporation," in *Moody's Industrial Manual*, New York 1990.

Mobil® Mobil®

ABCDEFGHIJKLMN
OPQRSTUVWXYZ
abcdefghijklmnop
qrstuvwxyz
¢*%/,:;"".?-...()&$!
1234567890

Mobil No.1 Spacing
Mobil No.2 Spacing
Mobil No.3 Spacing
Mobil No.4 Spacing

Illustrations courtesy Mobil Oil Company Ltd.

Eliot Noyes (1910–77)
Mobil Corporate Design Program, 1955–65
Mobil Oil Corporation, New York

The corporate design program is a company's face: it announces a firm to us, sums up corporate values and focuses corporate culture. Corporate design is as central to our experience of a company and its way of doing business as meeting the grocer in front of his store or seeing the local banker at the Sunday social.

Every company has a *personality*, also known as *culture* or *character*. When a company acknowledges its culture and character, consciously working with its personality, it creates an *identity*. Identity is an internal process. Strictly speaking, corporate identity is a company's awareness of itself. When key aspects of the identity are selected and shaped for outward *presentation*, they become the company's *profile*. The visual shape given to a firm or business is the *corporate design*. What others perceive becomes part of a company's *image*. These issues form a dynamic system. Understanding this dynamic model and using it in the service of strategic business goals is the purpose of corporate design.

Mobil Corporation was one of the first multi-national companies to understand what corporate design could mean. The Mobil Corporate Design Program has become a classic of its kind.

In 1985, Rawleigh Warner, Jr., the chairman of Mobil Corporation, recalled the beginning of the Mobil Graphic and Design Program. When he had become president of Mobil Oil in 1965, in a period when the company was emerging from a major reorganization begun in the 1950s, Warner said to his chairman: "This is a fundamentally different company from what it was, and yet no-one outside seems to realize that. From that point of view, people look at us and see no change—the same signs, same service stations, same packages."

Warner proposed bringing in a design consultant to look at the company's public face, to see if that face reflected the company that Mobil had become. He called on Eliot Noyes, the great industrial designer and architect who had worked for IBM, Cummins Engines and Westinghouse. Noyes agreed to help Mobil with its design on condition that Warner himself would serve as company-wide champion for design issues. It was a role he played with extraordinary success.

Noyes began by studying Mobil's presentation of service stations. In stations, on products, for advertisements, Noyes realized that graphics were a key component of the task. A visual vocabulary was required to express Mobil's values and to give it a distinctive look. Chermayeff & Geismar were brought in, and they became part of the design team that has stayed with Mobil through many successful years of design innovation.

Warner comments: "It seems to me that good design—and by this I mean basic, simple, straightforward, clean design—is never any more costly than improper or poor design. In many cases, a corporation will find that improper, poor or cheap design doesn't hold up in the long run; often, it doesn't even work in the *short* run, and has to be quickly and expensively re-done."

"Gradually, we brought into use the same colors, the same language, the same signs, the same alphabet—and I have no doubt that this caused an increase in the attention paid to the aesthetics of our business. Eventually, they became obvious not just to our own employees, but to the public. And this was our goal: to get the public to think better of us and to see visual evidence of the changed company we had become. We applied the same principle to our packages, our offices, whatever we put out. And we found that people inside the company were taking a new pride in the style we were assuming. Employees may not like certain particulars of what you are doing—the sign itself, the letters, the color on the trucks—but we found they liked the idea that we were attempting to present the same face everywhere, and this a clean and shining face, a reflection of the bright and intelligent company we intended to have. People were proud of what we were trying to do, and most of them eventually became enthusiastic supporters. I think many of our people also discovered that, when you look better than your competition, you sell more product, and so we learned that there were economies in the design program we had not anticipated."

This last issue is at the heart of Mobil Corporation's design program as a business case: design is one of the many strategic tools a company must use to succeed.

Designers are almost too fond of the famous maxim by IBM's Thomas Watson, Sr., "Good design is good business." They like the quote because it seems to support their art, but they rarely understand *why* good design is good business. At Mobil, Noyes and Warner made clear that good design isn't chosen merely because it is artistically appealing. Every choice serves clear goals. Several options may be equally good artistically and aesthetically, but only one or two of these choices may serve appropriate strategic ends. Of those, perhaps only one fits the overall strategy a corporation must pursue. This is why Warner suggests that design decisions made by the same process as local executives choosing office decor will always be more wasteful and costly than a strong corporate design program, and—even when they are good—the company will "appear to outsiders as a helter-skelter mess."

The Noyes design program worked through every aspect of the corporation's face to the world. Chermayeff & Geismar developed a trademark synonymous with Mobil's name: the well-known blue Mobil with the "O" in red. They found ways to use the renowned Pegasus trademark—dating back to 1911—as a secondary logo and a symbol of continuity. A clear, bold and legible alphabet was created for all signage, headlines and packaging, so that every aspect of Mobil's business would reinforce and support every other aspect. And a color program was used to express company values.

All these are enunciated in the clear and practical *Mobil Graphic Standards Manual*. The clarity of the manual creates and standardizes the high quality of the design program. It is a textbook of good design: any scholar of design management, graphic or industrial, will find it a useful and professional reference tool, a case study in itself. The manual describes how things are done, and why. It gives correct and incorrect examples, both of the standards and how to achieve them. Everything from letter-spacing and line spacing for text to headline and logo application in adverts, from the use of color swatches and color philosophy to identity signage and promotional posters is discussed. Through the application of standards in graphic, industrial, product, packaging and architectural design, Mobil transformed itself. What had been a sprawling web of companies operating in hundreds of different ways in different states, provinces and countries became a unified corporation worldwide. Mobil presented itself as the "forward-minded, well-managed, profit-oriented growth company" that the design briefing set forth as its target.

From first to last, the Mobil Corporate Design Program reflects what a design program should be. In conception, it is strategic, linked to overall corporate goals. In execution, it is supported by top-level executives working with the best outside consultants available. In operation, the program is managed by a company-wide Corporate Design and Graphics Manager, who reports directly to the chairman. The manager works with every officer and every branch of the company to ensure the successful development of the program. The success of Mobil's design program is manifest in the clear, cohesive face that Mobil offers the world. Inside and outside the company, it has become an essay on the contribution of design to the successful corporation.

—Ken Friedman

Bibliography—

Henrion, F. H. K., and Parkin, Alan, *Design Co-ordination and Corporate Image*, London and New York 1967.
Rosen, Ben, *The Corporate Search for Visual Identity*, New York 1970.
Pulos, Arthur J., *The American Design Adventure 1940–1975*, London and Cambridge, Massachusetts 1988.
Mobil Corporation, *Mobil Graphic Standards Manual*, Fairfax, Virginia 1988.

Photo Finnish Society of Crafts and Design

Antti Nurmesniemi (1927–)
Antti telephone, 1983–84
Electronic components and plastic housing
Fujitsu Limited, Tokyo

When Antti Nurmesniemi was commissioned by the Japanese electronics giant Fujitsu to design a telephone, the hope was that it would become a classic. "A challenge, but one which demonstrated faith in the ability of Finnish designers to create classics," said Nurmesniemi, who mainly plans interiors for new public buildings and restaurants. Although he had no previous experience of telephone design, he was considered a heavyweight industrial designer. Throughout nearly all the 1970s he worked on the Helsinki metro project. Together with Borje Rajalin, Nurmesniemi designed the trains along with their colour schemes and interiors. The metro entered traffic in 1982.

"After the long metro project I had a taste of the express speed at which Japanese product design moves. The first brief for the telephone was given in Helsinki in the spring of 1983 and the product was scheduled for production already in the autumn of 1984. That first meeting was a nightmare. Two members of Fujitsu's management and our Tokyo agent's representative came to visit me. The Fujitsu people handed over a small bag of electronic components, a short technical explanation and timetable in graphic form. My brief was to design a functional general phone for both home and office use. The components in the plastic bag were intended as the technical basis for the design. 75 days were given for the working model and alternatives, and another 100 for further development," said Nurmesniemi.

"With that kind of timetable there was no time to waste. I got started and concentrated on the initial design for two months without a break. I drew sketches from which my model maker Perttu Rista made some prototypes. These were ready in time and approved in Tokyo for further development. During the allocated 100 days I did component drawings and finalised the working models and colour scheme. At the same time the initial technical development was underway at Fujitsu. I was assisted at this point not only by my model maker, but also Bjorn Selenius and my wife Vuokko Nurmesniemi who acted as colour coordinator. The telephone was intended for production in a range of colours."

Nurmesniemi's telephone was in production on schedule. It was named "*Antti*" after its designer and displayed publicly in Tokyo in November 1984. It soon received a Japanese "Good Design" award.

Antti Nurmesniemi has produced a phone which combined a classical, clean-lined design with his own personal touch. The way the receiver lies bent on top of the apparatus introduces tension to the simple design. The curve of the receiver also creates a gentle image. *Antti*'s profile then brings to mind an arched bridge or a stylish car.

"The idea of the receiver is that the corners can be used to set it on a tabletop to act as a microphone. The need for a design that would sit well on a table also played its own part," reveals the designer.

"I had a free hand to plan whichever kind of telephone I needed as long as I took the 'classic' requirement into account. Just then, telephone design was becoming freer as the telephone equipment monopolies were broken up and competition started. The new technologies available also helped liberate designers. The components are nowadays so small that traditional ideas can be ditched. Manufacturers at the cheap end of the market have taken greatest advantage of this, resulting in a flood of Donald Duck, tomato and other fun phones. Design of proper telephones, however, is still restricted to some extent by the more expensive technology and ergonomic requirements. Handheld phones such as *Antti* have to take account of human dimensions. These dictate paying particular attention to both the distance between the microphone and hearing device, and the angle at which they are set to one another. Ergonomic dimensions are to some extent international, but in Japan they work to smaller ones than in the West. Weight also affected the receiver design: it had to be manageable, balanced in the right way.

"One fact still restricted the phone's freedom of design: the need for privacy (that only you could hear your calls). If a noisy intercom-type phone was allowed, it would really allow new shapes. Technology would not set any limits. The technical components of the *Antti*-phone could be fitted into a matchbox and it would be technically possible to make such a tiny phone—if there were something to be gained in that. A person's hand, which raises the receiver and presses numbers, also determines the size of the equipment," Nurmesniemi reveals.

The *Antti*-phone turned into a prototype for new telephone design in Finland as well. Equipment sales were taken out of the telephone companies' monopoly, and competition between manufacturers began. There are several public phone manufacturers in the country. The *Antti*-phone became an example of the need for design in phones. And an example of Japanese Fujitsu showing the way to Finnish manufacturers. Antti Nurmesniemi's phone received plenty of publicity in his home country and attracted attention in exhibitions throughout Scandinavia. Fujitsu also brought out a specially adapted model for the small Finnish market in which the apparatus' long straight form was shortened.

The *Antti*-phone follows the clean design guidelines Nurmesniemi has logically developed for decades. His style is unadorned and harmonious, but there is also an elegant sparkle. His work is typified by careful finishing. His design is international, but with a Finnish Nurmesniemi touch. Fujitsu's *Antti*-phone is proof of the internationalism of his design. Nurmesniemi states that aesthetic criteria have become international; the main reason being that the same technologies and production techniques are now in use throughout the industrialised world. Products are beginning to resemble one another, even though they are manufactured in different countries. According to Nurmesniemi, national characteristics only show in the quality of the product. There is still, however, always room for giving a product some individualism.

How did Fujitsu find Nurmesniemi? Fujitsu, one of the world's leading manufacturers of telecommunication systems and equipment as well as computers, was looking for a Scandinavian designer for a telephone classic. They turned for advice to the famous Tokyo design agency GK Incorporated. The agency recommended Nurmesniemi, who was known both personally and as a designer. Their recommendation carried weight. GK also acted as go-betweens, as mentioned previously. Nurmesniemi was well known because of his many visits to Japan. During his career, he had both taught and lectured there. In addition, he had long represented Finland on the International Council of Societies of Industrial Design (ICSID). Indeed, he is at present chairman.

A common feature of Finnish and Japanese design is aesthetic detail. A deep attachment to nature is also shared. Nowadays there are even closer links between the two countries.

How then does Antti Nurmesniemi see the future of telephone design? "I hope that technical development will change the telephone into a sensitive communication device. Such devices need to be personalised, and I am looking to industry to take this into account. Designers can add such personal touches and intimacy. Furthermore, the keys to success in international business these days are well-finished products and individuality. Designers are needed because the quality of design and finish will become more and more important," believes Antti Nurmesniemi.

—Tuula Poutasuo

Bibliography—

Hiesinger, Kathryn, and Marcus, George, eds., *Design Since 1945*, Philadelphia and London 1983.
Bayley, Stephen, ed., *The Conran Directory of Design*, London 1985.
Sparke, Penny, and others, *Design Source Book*, London 1986.
Poutasuo, Tuula, *Finnish Industrial Design*, Helsinki 1987.

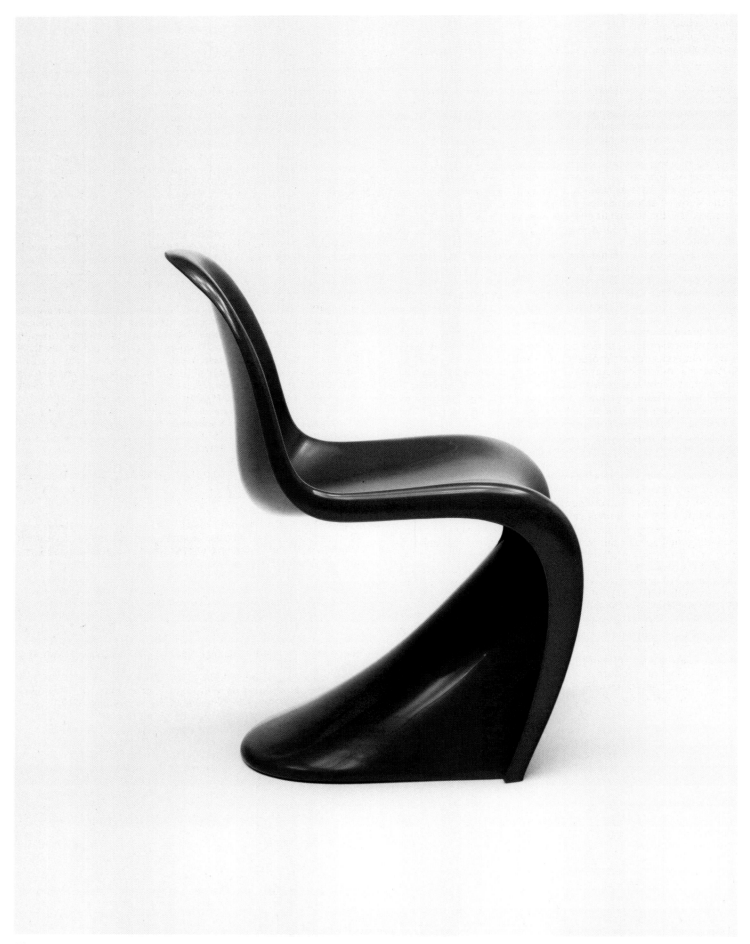

Photo courtesy Herman Miller, Inc.

860

Verner Panton (1926–)
Panton chair, 1959–67
Baydur plastic
Vitra Fehlbaum, for Herman Miller, Zeeland, Michigan, 1967–80; Vitra Fehlbaum, Weil am Rhein, from 1983

Some of the world's most striking designs found their shape in a trial-and-error process which lasted for centuries until the object finally achieved its archetypal form. They are design classics, yet we do not know their creators. They are anonymous designs. Yet, there is also a strange mechanism in life which often leads the originator of a new idea to make it achieve its definite shape at the first attempt. A shape which is ultimate in the sense that it feels right and cannot be improved on by altering it slightly. Any small deviation from its shape will damage the form.

The Verner Panton plastics chair for Herman Miller is one such example. It is the first chair ever to be manufactured in one piece in plastics, and yet its form alone has made it a cornerstone of 20th-century design.

Strangely enough, Verner Panton sees himself *not* as a form-giver but as a concept-maker. To him, the shape of an object as such is not the issue. The concept is. The essence of Panton's design is the fact that it is perceived as a monolithic chair to be made in one shot, in plastics, free of any references to the shape of chairs made in other materials.

This made it unique.

Innovations spring from new challenges or from new ways, such as new materials or new processes, of solving old problems. One of Panton's sources of inspiration for the chair was in fact, technological, namely seeing how crash helmets in glass fibre were made, and learning how little they cost. This caused Panton to start working on the monolithic plastics chair in the early '50s, and making the first prototypes in glass fibre in 1959. With the emergence of a huge range of plastics materials in the '50s and '60s, the all-in-one-piece plastics chair was, of course, in the air. And not unexpectedly, when Herman Miller finally put it into production in 1967, others claimed authorship to parts of its concept and shape, referring to unpublished drafts, prototypes made from wire mesh and old newspapers, or mentioning the idea of an all plastics chair among students or pundits.

The Danish design magazine 'mobilia' devoted a whole issue to presenting the Panton chair in 1967, and subsequently became the forum for a discussion about the authorship of the chair which dragged on issue after issue in a ferocious feud. The magazine's editorial board ultimately concluded that the originator of the Herman Miller chair was, of course, Verner Panton. They rightfully stressed the fact that even if many people had in one way or another worked with the concept of the monolithic plastics chair, Panton was the only one to realise the idea.

The ultimate Panton chair is so simple and elegant, yet it took an exorbitant amount of work to get that far. Whereas many of Panton's works are, indeed, concepts which express a principal thought rather than forms which seek their ultimate shape, Panton worked with the shape of the Herman Miller chair for endless hours over several years. He worked with several plastics manufacturers just to find the most suitable material. A whole range of materials were tried out over the years, including glass fibre (first prototype), Baydur, and Luran-S by BASF, a thermoplastics material.

However, the original chair was not without problems. For a start, it wasn't strong enough and sometimes broke under heavy loads. And in addition, moulding the chair in coloured plastics saved the costs of painting it in the colour the customer wanted, but at the same time created storage problems and limited the choice of colours to just a few.

The Panton chair was in production with Vitra Fehlbaum GmbH in Weil am Rhein for Herman Miller until 1980. Several hundreds of thousand of chairs were sold. The Panton chair came back into production again in 1987 in a slightly modified design. In order to achieve strength, 22 ribs had been added under the bend by the front of the seat. This somewhat deviated from the structural simplicity of the chair, at least to those who took a look under it.

The new Panton chair made from Baydur allows much greater dimensions. Verner Panton used this feature to add thickness to the body of the chair exactly where it is needed for structural purposes, such as at the edges. He thus got rid of the ribs and added a natural sense of structurally determined proportions to the chair. Touching the edges when sitting on the chair simply gives you a feeling of the structure as being just right. This, finally, ends the development of the work of a designer who does not see himself as a form-giver, yet achieved one of the most beautiful and striking forms ever made in the world of design by sensing what an old product in a new material aspires to be.

The Panton chair is now being manufactured by Vitra in Germany. It is moulded in one colour only and then painted in a range of standard colours. This reduces the need for storing the moulded chair in many different colours and adds greatly to the finishing quality of the surface.

A 20th-century furniture classic was thus reborn in much the same way as Verner Panton's famous Cone chair among others which was brought back into production by Fritz Hansen in Denmark in 1989.

—Jens Bernsen

Bibliography—

Centre de Creation Industrielle, *Qu'est ce que le design?*, Paris 1969.
Meadmore, Clement, *The Modern Chair: Classics in Production*, London 1974.
Blaich, Jan, "Color by Number," in *Industrial Design* (New York), May/June 1984.
"Verner Panton," in *Du* (Zurich), no. 5, 1984.
Panton, Verner, *Verner Panton*, Copenhagen 1986.
Stimpson, Miriam, *Modern Furniture Classics*, London 1987.

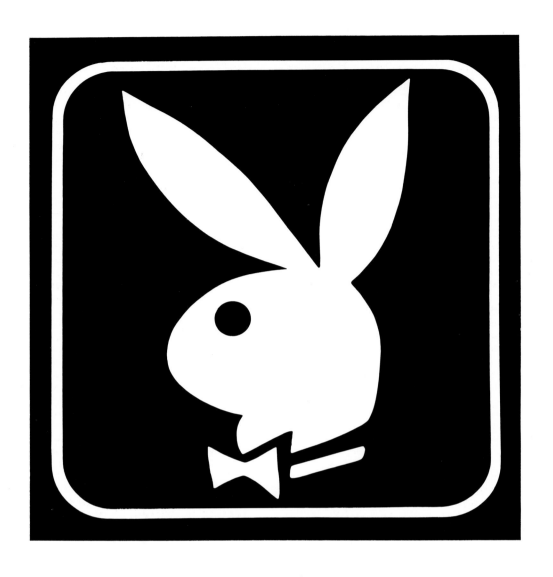

862

Art Paul (1925–)
Playboy logo and graphic identity, 1953
Playboy Corporation, Chicago

If instant recognisability and identification are the yardsticks by which a corporate logo is judged, then Art Paul's rabbit symbol for the Playboy organisation must be considered one of the most successful (or most notorious) of the last 35 years. Indeed, it has gone beyond simply identifying the various Playboy commercial enterprises, passing into the European and American iconographic vocabulary to connote a whole world of "playboyism" above and beyond the organisation itself. A discussion of the aesthetic properties of the symbol requires a consideration of what it symbolises—and that, itself, has been mutable.

In its original context—America in the mid 1950s—the logo came to encapsulate the audaciousness and zeal of Hugh Hefner's fledgling magazine, *Playboy*, for which it was designed. Fired by the Kinsey Report, Freud, and by a perception of American society as being restrictive and puritanical, Hefner set about defining a counter-image of American male aspirations deliberately contrary to those existing stereotypes that celebrated the stoic, pioneering spirit of the early settlers and the heroes of Hollywood westerns, grappling with nature and the elements in the "great outdoors." Hefner's first *Playboy* editorial (described by Russell Miller as "a masterly piece which intuitively touched base with his generation") summed up the ideal lifestyle to be envisaged by its target readership: "We like our apartment. We enjoy mixing up cocktails and an *hors d'oeuvre* or two, putting a little mood music on the phonograph and inviting in a female acquaintance for a quiet discussion on Picasso, Nietzsche, jazz, sex." Hefner and his team set about forging a *Playboy* identity by espousing a synthesis of seemingly contradictory components. This identity rested on a number of careful distinctions: as Hefner wrote, looking back from 1965, *Playboy* was to "reflect a masculine (though not hairy-chested) zest for all of life . . . that was urban and urbane (not jaded or blasé), sophisticated (not effete), candidly frisky (not sniggering or risqué)."

These values found visual embodiment in the tensions inherent in Art Paul's logo, which originally appeared as a signature for *Playboy*'s articles. Paul's design suggested the dignified pleasure associated with evening dress, through the rabbit's bow-tie and and the stark, black-and-white simplicity. Moreover, the image had a definite, formal containment by virtue of its frame. Yet this apparent restraint was countered by the rabbit itself, an animal (and thus free from man-made, societal restrictions) and moreover one often associated with cheekiness and fecundity, whose ears, drawn with a "roguish slant" (as Sarah Bodine has commented), undermine the bow-tie's formality. Paul created an image which evoked the parameters of "playboyism," yet cleverly maintained a balance in its contrasting components.

Playboy's contents juggled the various constituents of its ethos, juxtaposing serialised works of modern fiction (from P.G. Wodehouse to Vladimir Nabokov, Ray Bradbury to Somerset Maugham) with the nude (though discreetly photographed and obviously retouched), fold-out "playmate of the month," interviews with Martin Luther King and John-Paul Sartre with advertisements for whisky and airlines. While seeing itself as modern in its appeal, the magazine did invoke figures from the past (partly, perhaps, an acknowledgement of its debt to the intellectual and hedonistic traditions of libertinism, and partly an outrageous sales technique) in its temptations to readers to subscribe, so that, for example, Molière was "a man of good humor, with a broad mind and a great capacity for pleasure; a sophisticated man; an aware man; a man of taste . . .," and, *ipso facto*, a forerunner of the ideal *Playboy* reader. In the midst of all this potentially conflicting material, a unifying thread was maintained by *Playboy*'s self-consciousness (such as Hefner's series of articles in the early 1960s defining the "Playboy Philosophy") and, visually, by the rabbit symbol—both in its "pure" form as the logo, and, freed from its frame, in various

other guises, very often on the cover: as a human-size "lounge-lizard," in the apartment serving the aforementioned cocktail; audaciously posed, replacing the emblem on the bonnet of a Rolls Royce car; or, more subtly and suggestively, as a pale outline of a head and two ears on an otherwise sun-tanned, female back.

The 1960s saw an expansion and consolidation of *Playboy*'s activities, including the opening of Playboy clubs and the advent of a female conterpart to the rabbit logo in the "bunny girl." In 1984, Russell Miller's unofficial history of the organisation appeared. The cover utilised the rabbit logo, but cleverly parodied its design. The once confident, cocked ears now drooped, a tear rolled down from the rabbit's eye, and the inscrutable, slightly aloof expressionlessness of the original rabbit's face was replaced by a pencil-thin frown. This forlorn Playboy symbol, deprived of its self-confidence and *joie-de-vivre*, was a visual metaphor for the troubles encountered by both the Playboy organisation and the very concept of "playboyism" in the 1970s and 1980s.

As the character of *Playboy* changed—or was perceived to change—so too did the climate of opinion in Europe and America, with the result that the logo came to connote qualities often contrary to those of its original context of the 1950s. One key component in the "metamorphosis" of the Playboy image was the successful percolation throughout society of attitudes most forcefully voiced by the women's liberation movement, which attacked *Playboy*'s presentation of women as sexual accessories for men—a presentation seen increasingly as incompatible with refinement, sophistication, taste, and modernity: values which "playboyism" also laid claim to.

The other principal factor challenging the potency of the logo has been its increasingly random propagation. In all aspects of *Playboy*'s self-definition was an implicit social elitism—the ideal playboy was a member of an exclusive set. He was a kind of Renaissance man—cosmopolitan, rootless, unshackled by bourgeois conventions—whose breadth of vision and activity, encompassing everything from Miss April to Bertrand Russell, was supported by the kind of income enabling him to take pleasure seriously. In the early 1960s one could identify oneself with the ideal by purchasing, through the magazine's mail-order service, a lapel badge or a cravat bearing the logo. By the 1980s however, the expansion of the Playboy's marketing activities had rendered the availability of the logo so widespread and indiscriminate that one could, only with a great effort of will, convince oneself that possessing the image conferred any kind of membership of a higher stratum of society. If *anyone* can walk into a novelty store and pick up a packet of Playboy mints, or a cheap, badly-made Playboy mug, then the logo itself becomes little more than a trademark, devoid of its original resonances.

Perhaps commercial success made such a development inevitable. But while the connotations of the logo have been subject to a changing context, its success, especially in the 1950s and 1960s, in synthesising the inherently fragile balance of components constituting Hefner's concept of "playboyism" has secured its place in the world of "classic designs."

—Mark Hawkins-Dady

Bibliography—

Hefner, Hugh, ed., *The 12th Anniversary Playboy Reader*, Chicago 1965.
Paul, Art, *Beyond Illustration: The Art of Playboy*, exhibition catalogue, Chicago 1971.
Paul, Art, *The Art of Playboy: The First 25 Years*, exhibition catalogue, Chicago 1978.
Miller, Russell, *Bunny*, London 1984.
Bradbury, Ray, *The Art of Playboy*, Chicago 1985.
Bodine, Sarah, "Art Paul," in Naylor, Colin, ed., *Contemporary Designers*, Chicago and London 1990.

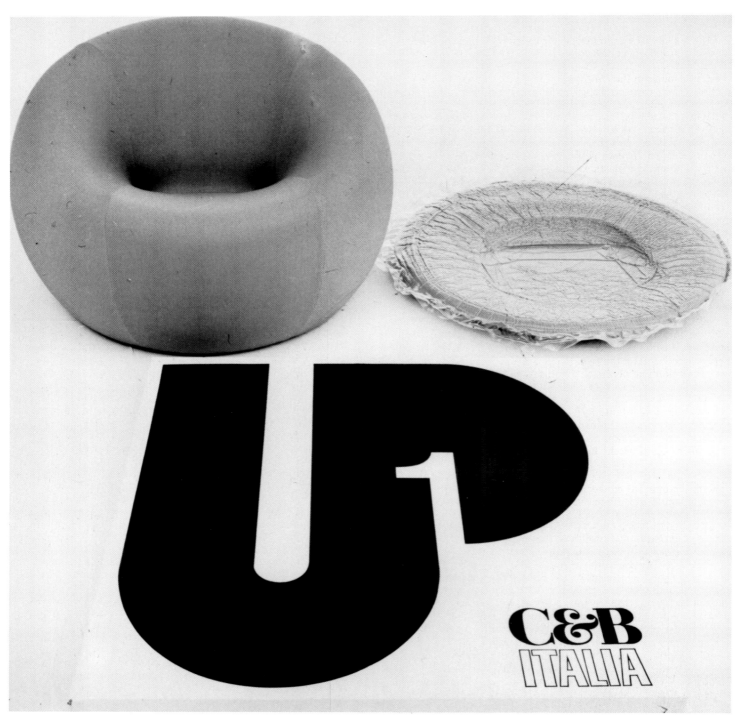

Photos courtesy of B&B Italia

864

Gaetano Pesce (1939–)
Up-1 chair, 1959
Polyurethane foam with stretch wool-nylon cover
B & B Italia, Como

Up-1 is the name of a chair designed by Gaetano Pesce in 1969. It is one of a group of six different designs for chairs and ottomans Pesce called the *Up Series*. Each style was referred to by number.

The furnishings in the *Up-Series* were made without an internal structure. They were packaged individually compressed to one-tenth their original size, sealed in a plastic envelope and shipped in a flat cardboard box. To achieve this, the manufacturer put each piece of furniture between two sheets of vinyl. This was put into a vacuum chamber, and the air was withdrawn until the desired size was achieved. The vinyl was than heat-sealed. Upon arrival at its destination, the plastic is opened, and the chair assumes its orignal shape and size. The cover is put on, and the furniture is ready for use.

The *Up-1* chair is 65 centimetres high, 98 centimetres deep, 98 centimetres wide, with a seat height of 27 centimetres. As with the entire *Up-Series*, it is made of polyurethane foam and covered with a stretch wool-nylon jersey. It came in various colors, and stripes. The cover is held in place with two buttons tied to a plywood base. These buttons also serve to pull the cover smoothly down into the foam seat.

The style of the chair is clean and direct, there is no ornamentation to it; no decorative buttons, no cording, no fringe. It is a simple design of an organic nature, with no straight lines. However, the chair is not irregular in shape, and it cannot be related to the amorphic images of Jean Arp or Joan Miro. It is a simple rounded shape that would be at ease in any location in a room. It wouldn't be necessary to place it against a wall, or in line with a table. It appears to be lightweight and readily movable. Pesce himself says, "it loves everything which is mobile, endless, nonrepeatable, inconstant, not blocked, diverse, relative, improbable, not programmed, unforeseen, not desired, not chosen, incoherent, discontinued, new . . ."

The chair, *Up-1*, seems to have been created with a sense of humor, meant to evoke a smile from the viewer. Though the design is simple, the way it is shipped is uniquely its own. Space-age like, it is tempting to connect this with the dehydrated food the astronauts would use. Pierce the plastic envelope and—woosh—the chair explodes into shape. It is one of a group of designs from the 'sixties, including the so-called beanbag chair or the chair one inflates, produced by Zanotta, which snub their nose at historical styles. These designs take on an aspect of throw-away, or temporary. They don't evoke in the viewer the same sense of stability that a wing-chair or Queen Anne style chair does. These new designs seem to be made for the person on the move, who has small living spaces. Though the *Up-1* is of seemingly little consequence in

the design realm, merely a simple design, shipped in a kitschy plastic envelope, it is much more.

Gaetano Pesce studied both architecture and industrial design in Venice. Designs for furniture, including the *Up Series*, place him in the mainstream of Italian counter-design in the 1960s: the so-called anti-design group of designers who rejected the concept of functionalism and mass production. They worked instead for a more personal market, utilizing new technologies and materials for design. Their work did not reflect any previous design movements in history. It was entirely new, entirely unique, dealing with the materials and technologies available to them.

"Form follows function" is the phrase associated with the designs of the Bauhaus and later the Hochschule fur Gestaltung at Ulm, West Germany, which was considered the New Bauhaus. Pesce worked there in 1961, and was acquainted with their design theories. They adhered to the esthetic of functionalism, with designs which served a purpose in a direct manner without ornamentation, and which could be mass-produced for the mass populace.

Pesce agrees that a piece of furniture serves a function and so has an inherent form. However, he moves beyond this. The concept of the design is as important as the final product. He does not feel that one design is suitable for every member of society. He in fact challenges the commercialism of mass production. If anything, Pesce feels this attempt at mass-production is debilitating to many who don't respond to a particular style, leading to a loss of identity. Pesce designs with the philosophy that there are no universal solutions. There are no rules. The designer works with what is available to him in terms of materials and technologies, realizing that there is no final solution.

Whether Pesce would have been able to develop his philosophy of design anywhere but Italy is questionable, since furniture manufacture in Italy is unique. Much of it depends on small, independent workshops where the designer can be part of the manufacturing process, not several steps removed with other people working as translators between him and the factory technician. The industrial revolution had split up the functions of design and manufacture; Pesce, and the other Italian designers, were able to recombine them. They could see how their designs worked with the materials and how they react in production, making adjustments as necessary. A small workshop can respond to changes, with greater alacrity than a large factory.

Simple in form, unique in packaging, the *Up-1* chair is Pesce's statement about furniture design in Italy during the 1960s. The reason for its design is not explainable; it is.

He has continued to create designs which challenge the status-quo, and questions the design solutions people reach. He is not concerned with mass consumerism (read production) but with meeting the needs of a select group of people, similar to himself. Because he works in small quantities, and constantly experiments, he opens up new avenues of production and design.

—Nancy House

Bibliography—

"Instant Furniture . . . Woosh!," in *Life* (New York), 21 November 1969.
Hogben, Carol, and others, *Modern Chairs 1918–1970*, exhibition catalogue, London 1970.
Meadmore, Clement, *The Modern Chair: Classics in Production*, London 1974.
"Domus Interviews Gaetano Pesce," in *Domus* (Milan), June 1984.
Irace, Fulvio, "Le sedie di Gaetano Pesce," in *Domus* (Milan), May 1985.
Musee d'Art Moderne de Strasbourg, *Gaetano Pesce 1975–1985*, exhibition catalogue, Strasbourg 1986.
"Gaetano Pesce," in *Interior Design* (New York), February 1987.
Vanlaethem, France, ed., *Gaetano Pesce: Architetturadesignarte*, Milan, London and New York 1989.

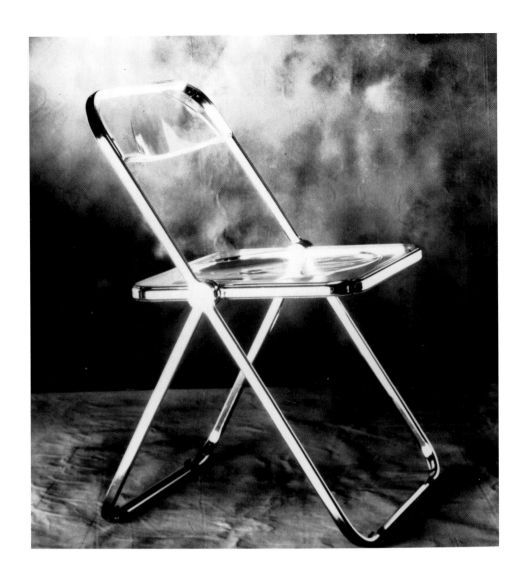

Photos courtesy Castelli

866

Giancarlo Piretti (1940–)
Plia folding chair, 1969
Cellidor plastic and aluminium; 75 × 46.5 × 50 cm.
Castelli, Bologna

The design of a chair is often used to illustrate the stage of cultural and technological development of the society which has produced it. This is because a chair in its conception, manufacture and use is the encapsulation of the style which typifies a particular period. If we accept this hypothesis, the *Plia* chair, designed by Giancarlo Piretti in 1969, has a lot to tell us about Italy in the late 'sixties.

The 1960s saw a virtually unexpected economic boom which presented an opportunity for huge advances in design in every area of production on the Italian peninsular. Gillo Dorfles in his article "Análisis crítico del Diseño Italiano" [A critical analysis of Italian Design] writes: "This sector provided, after the war, one of the greatest and most exciting adventures in contemporary Italian thought. Its continuous, energetic and visible evolution at the beginning of the 'fifties became increasingly intense until it came to be—including from an economic standpoint—one of the pillars of our creative and productive activity." Those years saw the end of the idea that design was dependent purely and exclusively on architecture. Italy faced the future with optimism, firm in her belief in the strength of her artistic tradition and confident of her ability to produce the goods.

That prodigious decade in which man travelled through space and landed on the Moon was marked by research into the applications of a revolutionary new material: plastic. It could be compared with what happened in the nineteenth century when the technique of using glass was explored. Every new product expressed society's need to find fresh alternatives to traditional materials. After the oil crisis of 1973, the use of plastics was seriously re-examined, both for economic reasons and because of the perishability of the material. Nevertheless, it is worth pointing out that the best designs from that period still enjoy the same prestige in the international market of today.

In its external configuration, the *Plia* obviously has nothing new to offer (the first folding chairs date back to fifteenth-century Tuscany). The novelty is to be found in the technical and tech-

nological sphere. Like every invention with a touch of genius, it is also very simple: the system of front and rear supports, the seat and the back radiate from a single joint, a sort of ball-and-socket arrangement around which each member revolves. The basis of the design is an unseen circle, similar to Leonardo da Vinci's man. The size of each component is dictated by the radius of the circle. The ball and socket joint is located where the umbilicus would be.

In design and expression, the *Plia* chair is one of the last descendants of the school of Modern Design. It is a worthy representative of Mies van der Rohe's old adage "Less is more" (originally referring to architecture, but applied here to design). Its greatest virtues are that it is both physically and visually light, the transparence of the plastic contrasting with the shine of the chromium-plated steel; and it is easy to fold and store. Over all, the *Plia* chair shows a high level of rationality applied to design. At the same time, it presents a delicate balance between the modern tradition—through its rational steel structure—and commitment to the future—clearly stated through the presence of plastic. But this chair has not been the subject of experiments with form like its contemporaries *Selene* or *Gaudí*, by Vico Magistretti, or Joe Colombo's *4869*. Here, plastic resins tangibly and realistically achieve the rank of "alternative material," in a manner far removed from the schizophrenia of the futurists. As far as its application is concerned, the *Plia* confirms its Hegelian condition: it is the ideal standard chair, suitable for a number of uses, both domestic and public, pleasant enough to have wide consumer appeal, practical enough to be stacked and stored with ease. Unobtrusive and convenient. Indispensable and thus infallible.

Giancarlo Piretti demonstrated through the *Plia* his subtle and sophisticated sense of how to design a technical component to meet an ergonomic need. This was to be confirmed ten years later with the internationally famous, prize-winning *Vertebra* chair, which was designed in collaboration with the Argentinian Emilio Ambasz. The creator of the *Plia* has become established not only as a true design engineer but as one who is able to achieve harmony between geometry and technical precision. Folded and seen in profile, the chair is reduced to no more than a single line. Unfolded, it describes a perfect circle. In the purest Italian style, investigation of a perceptible and meaningful geometric principle underscores the validity of the design, turning it into something timeless—because geometry itself is timeless. When a model so aptly fulfils its function and completely and exactly responds to society's needs, it is possible to use the word "classic." This is the case with the *Plia* chair which two decades after its conception has reached the realms of classicism. It belongs to an aesthetic hierarchy into which few are admitted.

—Diego R. Armando

Bibliography—

Landesgewerbeamt Baden-Wurttemberg, *Design aus Italien*, exhibition catalogue, Karlsruhe 1970.
Eckstein, Hans, *Der Stuhl: Funktion, Konstruktion, Form*, Munjhich 1977.
Istituto Nazionale per Commerzio Esteriore, *La Sedia Italiana*, Rome 1983.
Wichmann, Hans, *Industrial Design: Unikate Serienerzeugnisse*, Munich 1985.
"Giancarlo Piretti," in *Interior Design* (New York), March 1987.
Russell, Beverly, "Profile of an Italian Genius: Giancarlo Piretti," in *Interiors* (New York), October 1988.
"Storia di sedie: il progetto italiano dopo il 1947," in *Domus* (Milan), September 1989.

Photo Cassina

Gio Ponti (1891–1979)
Chiaravari Superleggera chair, 1949–55
Lacquered ash with rush seat; 83 × 41 × 47 cm.
Cassina, Milan

The *Chiaravari Superleggera chair* (1949) designed for Figli de Amedeo Cassina is representative of Ponti's conviction that "the home is made for life: We must give to life the best home." This conviction best explains his venture into interior furnishings. Ponti postulated that his isolation from other children in his youth (due to frail health), and the fact that he was an only child, centered his existence on his immediate environment and kept him from being influenced by the extreme reforms and changes of the twentieth-century's theoretical modern movements. He was apparently unaffected by his frequent contacts with Le Corbusier and Oscar Niemeyer, although he considered Le Corbusier the major modern architect. These contacts appear to have clarified his own design values sometimes in opposition to those of Le Corbusier. Ponti was seeking a means to express and clarify his inner judgments which centered on quality.

Ponti had a thirst for knowledge, and his graduation from the Milan Polytechnic School of Architecture was the beginning of his life long interest in design. His entry into the field of applied arts, design and architecture seems to have been a natural outgrowth of his aspiration to be a painter which remained with him until the end of his life. This ability allowed him to sketch rapidly and to refine his ideas since, in his words: "Imagination is restless . . . imagination is the ecstasy of a vision."

Ponti's influence on other designers and architects was profound. His pursuit of cultural projects led to the direction of the Monza Biennale which became the Milan Triennial Exhibition of Modern Art and Architecture (1933). Many designers were inspired by this prestigious show which he directed until his death in 1979. His editorship of *Domus*, an architectural, design and art periodical which was published continuously under his guidance until 1979, except for 1941–48, was one of the most widely read publications in its field. It was a stimulus to design and produced a cumulative influence on contemporary culture. He welcomed to its pages any design he believed merited it.

Ponti's furniture masterpiece for mass-production was the *Chiaravari Superleggera chair*. The chair typified the characteristics of his own modern classicism which had as its foundation his early training in neo-classicism. Ponti's love of molded wood is apparent in the design, but there is also a mechanical linearism. The slender, elegant forms in the back and tapering legs are typical of Ponti's furniture such as his designs for Singer (1952), Altamira (1953), Giordano Chiesa (1953) and his other designs for Cassina such as the *Letizia* folding chair. The legs are firm and slender without sacrificing stability. The gracefulness at floor level allows the viewer to perceive the leg forms as a cluster rather than clutter. The tilted back of the seat was later adopted for many chair designs after numerous egonometric studies of the needs of the human body for seating. Its influence may be discerned in the furniture of Scandinavian designers such as Juhl, Jacobsen, Panton, Pajamies; Italian designer Rinaldi; and German designer Leowald. The resilient woven rush seat emphasizes Ponti's belief that fashion should be ignored and that refining a design, rather than experimenting with it, is the most significant element in its development.

The Superleggera chair clarified Ponti's distinction between "true form" and "real form." He defined "real form" as austere form, such as Mies van der Rohe's "less is more." The concept of "true form" was all-inclusive of Ponti's personal experiences and his imagination. He quickly formulated the problem, searched his inner sources of ideas and, from numerous rapid sketches, selected the final solution. His rational approach to the functional needs of seating and desire for simplicity resulted in an elegant refinement of the forms. In his first sketches he captured the bare form of the *Superleggera chair* which he remodeled corresponding to its function eliminating every inconsistency, finally obtaining "the true form." The *Superleggera chair*, which has many characteristics in common with the peasant furniture of Italy, is a superb example of Ponti's deftness of touch and his belief that "every piece must speak to the imagination of both the design and viewer." It is a simple chair and all the possibilities of wood have been explored, every irrelevance discarded, resulting in Ponti's "true form."

Ponti exemplified a special quality of the Italian genius which through an absorption of a great artistic heritage has yielded complete artists. His virtuosity transformed the Milan skyline with architecture, provided both settings and costumes for the La Scala opera, enriched interiors through elegant furniture and decoration, and stimulated worldwide progress in design and industrial reform with his involvement in writing, particularly in *Domus*, and in the direction of the Milan Triennial art and industrial design exhibitions.

—Mary Jo Weale

Bibliography—

Rogers, Meyric, *Italy at Work: Her Renaissance in Design Today*, Rome 1950.
Plaut, James S., *Espressione di Gio Ponti*, Milan 1954.
Labo, Mario, *Ponti: Summing Up*, Milan 1958.
Greenberg, Cara, *Mid-Century: Furniture of the 1950s*, London 1984.
Stimpson, Miriam, *Modern Furniture Classics*, London 1987.
Universo, Mario, *Gio Ponti, Designer: Padova 1936–1941*, Padua 1989.

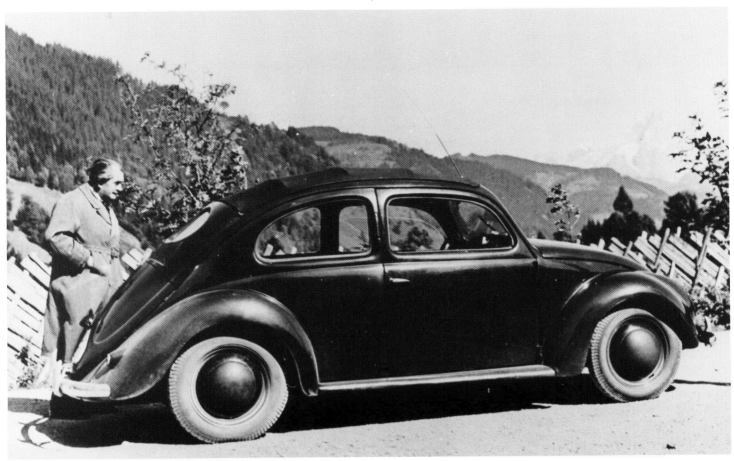

Ferdinand Porsche with the VW Type 38, July 1939

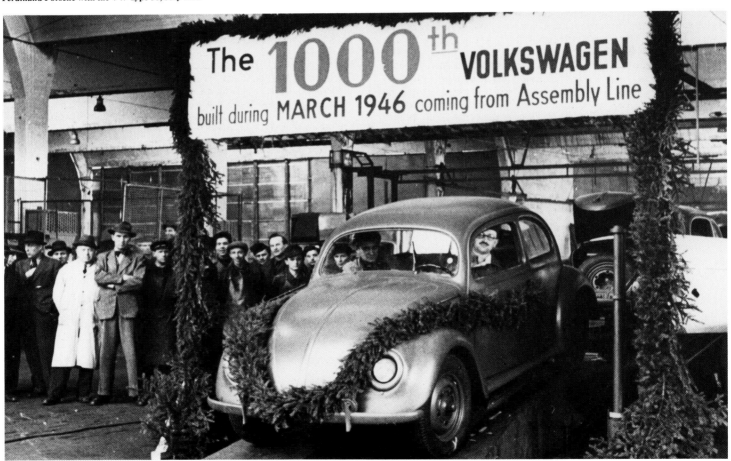

The **1000**th VOLKSWAGEN
built during MARCH 1946 coming from Assembly Line

Photo courtesy of Volkswagen AG

Ferdinand Porsche (1875–1951)/**Erwin Komenda** (1904–66)
Volkswagen Type 1 "Beetle" car, 1933–38
Volkswagen AG, Wolfsburg, from 1945

The Volkswagen Beetle was recently voted "Car of the Century" in a survey of motoring journalists. It is a title hard to deny, for no other car has spanned the century in such a way. The Beetle built in Mexico in the 1990s is recognisably similar to the prototypes designed by Ferdinand Porsche and others in Germany in the 1930s. Its bug-like shape, and the distinct tone of its air-cooled engine are familiar throughout the world. Some 21 million have been built, a figure which is itself testament to the brilliant design that the Beetle embodies.

The story of the Beetle began with the rise to power of Adolf Hitler in 1933. Keen to implement a pioneering road network, and apparently a keen admirer of Henry Ford, Hitler demanded that a German car be built, to the following brief: the car was to have a selling price of less than 1000 RM, have a top speed of 100km/h, and a fuel consumption of seven litres of petrol per 100km. In addition the car was to have an air-cooled engine. These specifications were almost met by two designs from the company run by Ferdinand Porsche. Porsche, like Hitler an Austrian, had established a reputation as technical director at Daimler-Benz, before leaving that company in 1929 and setting up his own consultancy the following year.

Through the mid-1930s a succession of prototypes were assembled by Porsche's team and subjected to rigorous testing. From May 1937, the Volkswagen (literally "people's car" but bearing also the Nazi connotations of the *Völkisch* Idea) became a state-funded project. In 1938 work began on the factory that would produce what was to be known as the KdF-Wagen (Strength through Joy Car), recognisable now as the Beetle. Its essential features were established: a 985cc, rear-mounted, four-cylinder, air-cooled engine designed by Franz Xavier Reimspiess; swing axles; all independent suspension by transverse torsion bars; a tubular "backbone" chassis; and the classic streamlined, beetle-like shape, styled by Erwin Komenda, who also designed the VW logo. And, after the fashion of Henry Ford, it was available in one colour only: a bluish grey.

There has been some debate about the "authorship" of the Volkswagen. It is one of several areas of the car's history still ripe for historical research. But it is surely not in dispute that Ferdinand Porsche was the engineering mastermind who brought the various elements of the car together. And while earlier cars, such as the Tatra, with its central-tube body designed by Hans Ledwinka, had incorporated some of the features associated with the Volkswagen, it was the way in which Porsche combined these elements which proved ultimately to be successful.

The outbreak of World War II in September 1939 led to resources being diverted elsewhere. By 1944 only 630 KdF-Wagens had been built, although the Wolfsburg factory did produce several military vehicles based on the KdF's floorpan, including the cross-country Kubelwagen and the amphibious Schwimmwagen. These acquired a reputation for toughness, and when, after the end of the war, the Wolfsburg works came under British control, it was decided to resume production of the saloon, by now known as the Volkswagen. The future of the car in the immediate postwar period was uncertain, with major manufacturers in Britain and America being invited to take over its production. Engineers from the British firm Humber (like most of the British motor industry, long since defunct) concluded of the Volkswagen: "We do not consider that the design represents any special brilliance . . . and it is suggested that it is not to be regarded as an example of first class modern design to be copied by the British industry." And Ernest Breech, an advisor to Ford, suggested that, "I don't think what we're being offered here is worth a damn," words which he may have pondered 20 years later when Volkswagen, on the strength of the Beetle, became Germany's biggest company.

After Heinz Nordhoff took over as General Manager at Wolfsburg in 1948, sales of the Beetle increased rapidly, with efforts made in the important export markets. Through the 1950s the Beetle not only sold well in Europe, but was becoming a world car, with Volkswagen manufacturing plants being set up in South Africa, Brazil, Australia, and Mexico, where, incredibly, the Beetle is still produced in the 1990s. Gradual improvements to the car were made, notably in the size of the engine—but the basic design of the car, throughout its life indeed, was to remain unchanged.

Of major significance in the car's history was the founding of Volkswagen of America in 1955, the year when the Beetle became that continent's best selling import. The car's success in an American market in the 1950s and 1960s was remarkable, when one compares its very European qualities of frugality and functionalism with the extravagance of Detroit during this time. By choosing to play on this incongruity, Helmut Krone created, from 1959, a series of Beetle advertisements for the agency Doyle Dane Bernbach which have become legendary in their own right. Sales of the car in the U.S. peaked at 423,008 in 1968, the year which saw a further mythologisation of the car with the Disney film *The Love Bug*, featuring an anthropomorphosised Beetle called Herbie.

However, by the early 1970s the Beetle was finally showing its age. Upgraded suspension and a larger engine helped maintain the car's status, with a million Beetles being produced in 1971 alone, but in 1974, for the first time, Volkswagen recorded a loss. There had been several attempts to replace the Beetle, but the 1500 saloon of 1961, the 411/12 of 1968 and the front-wheel drive K70 of 1970 all failed to catch on with the public. The Giugiaro-styled Golf (Rabbit in the U.S.) of 1974 had nothing in common with the Beetle except that it too was, and still is, a huge success. Although the car continues in production around the world, with over 21 million having been produced, the last German Beetle left the Emden factory in 1978.

Today the Beetle and its variants, with their combination of ruggedness, cheapness, and ease of maintenance, continue to appeal. It is perhaps ironic that a car so essentially functional, even spartan, should be so feted by the fashionable young, in the 1990s as in the 1960s. Yet, whether it is the chic cabriolet, the bus-like camper, the Type 3 fastback, the elegant Karmann Ghia coupe, or the classic saloon, whether customised or authentically original, the essence of the Beetle transcends and endures. By meeting the requirements of a brief as simply and as economically as possible, Ferdinand Porsche and his fellow engineers created one of this century's most important and enduring pieces of industrial design.

—Nicholas Thomas

Bibliography—

Hopfinger, K. B., *Beyond Expectation: The Volkswagen Story*, London 1954.
Nitke, W. R., *Amazing Porsche and VW Story*, New York 1958.
Ullyett, Kenneth, *The Porsche and VW Companion*, Slough 1962.
Sloniger, Jerrold E., *The VW Story*, Cambridge 1980.
Borgeson, Griffith, "Origins of the Beetle," in *Automobile Quarterly* (Princeton, New Jersey), no.4, 1980.
Boddy, William, *Volkswagen Beetle: Type 1, the Traditional Beetle*, London 1982.
Sharkey, Alix, "Beetlemania," in *I-D* (London), October 1988.
Prew, Clive, *VW Beetle*, London 1990.

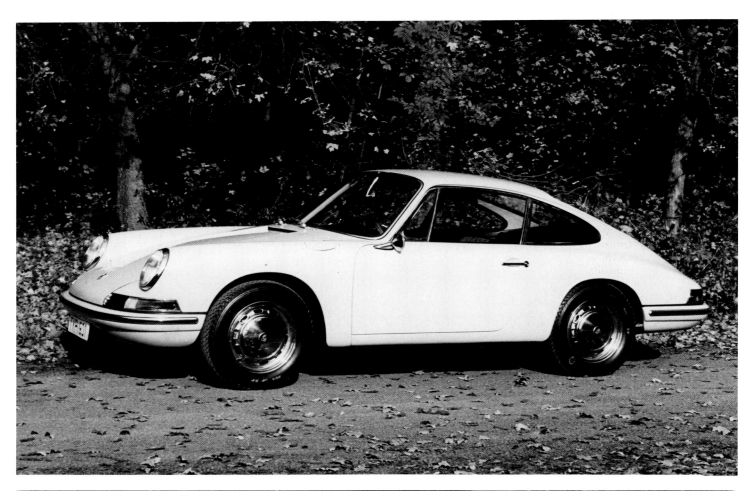

Photos courtesy Porsche Aktiengesellschaft

872

Ferdinand (Ferry) Alexander Porsche (1909–)/**Ferdinand (Butzi) Alexander Porsche** (1935–)
Porsche 911 car, 1963
Porsche GmbH, Zuffenhausen, Stuttgart, from 1963

The most practical of contemporary supercars, the Porsche 911 is perhaps most remarkable, in a sector unusually sensitive to technological developments, for its longevity. The car of 1991 is recognisably the car which was launched in 1963. In layout and shape little has changed: changes (models are continually updated) have been evolutionary rather than revolutionary. The engine, positioned over the rear axle, is in principle the same horizontally-opposed six-cylinder air-cooled engine which powered the 1963 version, although it has been "stretched" ingeniously from a capacity of 2 litres to the current 3.6, with resultant power being increased from 130 bhp to roughly twice that. Such is the achievement of the Porsche 911. While other post-war cars have remained in production for 30 years or so, their shortcomings in performance and refinement towards the end of their production life have been outweighed by other qualities, such as "character." While the Porsche 911 has undeniable character, and still looks like no other car, it is also resolutely at the cutting edge of technology and performance, in 1991 as in 1963.

The Porsche 911 of today, though capable of 0–60 mph in some 5 seconds, is essentially, as its body shape (however disguised) still testifies, a descendant of the humble Volkswagen Beetle. It was always Ferdinand Porsche's notion to build a sporting version of the original Volkswagen he developed in the 1930s. After the war, his son Ferry, along with his old associates Erwin Komenda and Karl Rabe, built and designed a coupé which would carry the Porsche name, and which owed much to a one-off prototype which the elder Porsche has built in 1939. The Porsche 356 was shown to the world at the 1949 Geneva Motor show, and went on to become a great success, both on the road and in competition racing. Its Volkswagen roots gave it a reliability other sports cars lacked, while its sleek, if bug-like shape (its sloping nose in particular being a feature of its rear-engined layout) enabled it to exact more than respectable performance from a relatively small engine.

The 911 (originally the 901, but Peugeot held the rights to that number), was launched in 1963. It resembled the 356 in its rear-engined layout and in its outline, but the body, as styled by "Butzi" Porsche, grandson of Ferdinand, was sleeker than the rather bulbous 356, losing weight especially around the middle of the car. But the most significant development lay with the engine. Incorporating the use of alloys to keep the weight down, its true potential has really been explored in the subsequent developments offered to the Porsche customer over the years. The restyling of 1969, which, by increasing the length of the car and offering updated MacPherson strut suspension, ensured that the car could handle the increased power now available from the power unit.

However, the first lightweight Carrera model, with a glassfibre body and a two-litre engine producing 210 bhp, was offered in 1966. By 1982, the Carrera became the standard 911, this time with an engine of 3164 cc (now 3600 cc). A Turbo version was introduced in 1975, and a Cabriolet version (as opposed to the Targa model), in 1983. The current range includes a four-wheel drive version, and on the latest Carrera 2, Tiptronic transmission, offering fully automatic or four-speed manual gears. The list of permutations offered and advances incorporated is bewildering, but through all of these the car has remained remarkably similar in its appearance, its unique, almost crustacean shape, its sloping, grille-less front and low roofline being instantly recognisable, whatever the variant.

Since Porsche was, until the 1970s, a one-car firm, the characteristics of the 911 and its predecessor the 356 came to represent those of the Porsche name. While displaying admirable build quality and reliability, the rear-engined Porsches have transcended mere Teutonic efficiency. The sporting achievements of the cars, testament to the cars' considerable qualities, have been considerable, and together with celebrity ownership (most infamously by James Dean) have lent the marque an undeniable glamour. And while the built-in safety features of the cars have been pioneering, the combination of considerable power and the weight over the rear axle has tended to create a tail-heaviness which, while pleasing the professional racer, has been known to cause handling problems for the inexperienced driver. Yet this "drawback" in the design has been essential to the success of the Porsche 911 especially, for while compared to its rivals it remains a relatively practical car to own and drive, its potentially quirky characteristics are inevitably seen as a "challenge" (even though the latest four-wheel drive Carrera corners as if on rails).

The 1970s brought an adoption of some "macho" body kit (spoilers in both senses of the word) which did little to enhance the 911's classic lines, while in the 1980s the 911 became closely associated with the now-discredited world of the yuppie. Yet it is just possible that in the greener, caring 1990s, the Porsche 911 will be seen as the greener, caring car to own, while benefiting also from the supreme desirability (and technological innovation) that the limited edition 959, the ultimate 911 variant, has brought to the marque. But for the foreseeable future, the "humble" 911 will remain in demand, for its design, brilliant yet rooted in functionalism, has managed to transcend the vagaries of fashion. The 928 and 944 models brought out in the 1970s were supposed to replace the 911, but all three have remained in production since then. Indeed it is a testament to the classic engineering design behind the 911 that, nearly thirty years after its launch, there are no plans as yet to stop production.

—Nicholas Thomas

Bibliography—

Porsche, Ferry, *We at Porsche*, Yeovil 1977.
Harvey, Chris, *Porsche 911*, Oxford 1980.
Cotton, Michael, *The Porsche 911 and Derivatives: A Collector's Guide*, London 1980.
Harvey, Chris, *Porsche: The Complete Story*, Yeovil 1983.
Porsche, Ferry, *Cars Are My Life*, Wellingborough 1989.
Prew, Clive, *Porsche 911*, London 1989.
Frere, Paul, *Porsche 911 Story*, Cambridge 1989.

Photos courtesy of Andree Putman/Ecart SA

Andrée Putman (1925–)
Minister of Finance office furnishings, Paris, 1988–89
Mobilier National, Paris

Andrée Putman followed a rather unusual and erratic path into her eventual profession of interior design. Almost entirely self-taught in design, she started work as a design journalist for FEMINA and ELLE magazines in the 'fifties and then became a stylist and designer for the store chain Prisunic, where the intention was to produce "beautiful things for next to nothing." She turned her attention to the other end of the market when, after working as both a designer and as director of the Createurs designer furniture store in Paris, she started her own company, Écart, in 1977. Écart produced reproductions of "classic" furniture designs by people such as Fortuny, Mallet-Stevens, Gaudi and, in particular, Eileen Gray. As well as initiating a considerable reassessment of Gray's work, these reproductions have been an important influence on Putman's own style of coolly modern but luxurious design, as well as her palette of beiges and greys, light woods and chrome. Neither historical or wholeheartedly modern, her style is an unusual synthesis of past and present.

As her work with Écart diversified into interior design as well as furniture production, she was very rapidly assimilated into the mainstream culture of design in France. From the first, the commissions that she received were highly prestigious, and included designing the shops and show rooms of a number of France's aristocracy of fashion designers, such as Thierry Mugler, Karl Lagerfeld and Azzedine Alaïa, where her understated style flattered the clothes rather than competing with them.

Her work for the government started in 1984 when she designed museum interiors and furniture for the regional administration in Bordeaux, as well as Jack Lang's office at the Ministere de la Culture. The latter was a rather unusual commission; Putman's cool modern style forming a surprisingly effective contrast with the baroque gilding and deep colours of the interiors of the Louvre.

It was a year after this, in 1985, that Putman won the competition to design the interiors of the new offices for the Ministry of Finance at Bercy, finally completed in 1989. These new offices form a part of Francois Mitterand's *grands travaux*, the extensive commissioning of new public buildings that have characterised Paris under his rule. The patronage of architecture and design by the French government over the last decade is almost without parallel in its scale; what makes it even more unusual is the way in which it encompasses not only public spaces such as the Louvre, but also the private spaces of the Finance Ministry offices.

Putman's work at Bercy is in the new suite of offices for the Minister and Deputy Minister. The design marks a new departure for her work since, unlike many of her commissions, her interiors here do not use any of Écart International's reproductions. With the exception of a single Fortuny lamp on the Deputy Minister's desk, all the furniture has been designed by Putman herself for the offices and manufactured by the Mobilier National, the French equivalent of the Crown Suppliers.

Despite the absence of any Gray or Mallet-Stevens reproductions, the rooms do still quote from the taste and style of the 1930s, the decade which has had the most impact on Putman's work. The influence can be felt, indirectly, in the whole layout of the room, with its uncluttered expanses of space, plain walls and simple arrangement of furniture, and, again she uses her preferred colour scheme, the muted creams and browns of the period which emphasise the sense of space and airiness. Perhaps the most obviously historically-inspired designs are the light fittings, which employ typically Art Deco shapes and materials in their spheres of frosted glass and cones of chrome. These are perhaps the most ornamental elements in the whole design; the chairs and sofas are luxurious, but simple and clean in shape and upholstered in fabric which is also very plain, woven in geometric textures and neutral colours which underlines the simplicity of its lines.

Andrée Putman is insistent that her style of interior decoration, although it uses the past, is not historical recreation, as her collaborator George Grenier insists, "She's not aiming for a nostalgic or a retro look. The worst insult you could give Andrée would be to associate her with Art Deco." Indeed, in the Finance Ministry offices, Putman also quotes from a very different era in her use of horsehair on the doors of the offices.

Traditionally, it was used in this manner in nineteenth-century offices to convey the idea of luxury and privacy. She would see herself as employing these ideas from the past in order to achieve the effect that she requires, rather than attempting a faithful reconstruction of the style of one particular era. And wherever she feels it appropriate, she can also work in a very modern idiom, as in the private bathrooms of the Finance Minister's suite, where she uses the glass and stainless steel basins of her own design which have become a signature of her work.

Overall, her simple style is obviously a direct descendant of the modernism of the 'thirties and she will freely acknowledge the influence of interior designers such as Jean-Michel Frank, but unlike the designers of that period, she does not feel that modernity requires her to reject everything that has come before and redesign every object from scratch. Putman could also be considered to be, in a very understated fashion, a post-modernist in the way she is prepared to quote from other historical periods. What is perhaps most important about Andrée Putman's work, however, is not her historicism but her love of luxury without ostentation and it is this which sends her back to periods where these ideals can be found, to interpret them in her own way. It is this sense of her own vision and aesthetics rather than her historical references which sets her work apart and makes it so distinctive in the world of interior design.

—Susannah Walker

Bibliography—

"Hall of Fame: Andrée Putman," *Interior Design* (New York), December 1987.
Truppin, Andrea, "French Accent: The World According to Andrée Putman," in *Interiors* (New York), December 1987.
Isozaki, Arata, ed., *International Design Yearbook 1988/89*, London 1988.
Mousseau, Francois Olivier, *Andrée Putman*, Paris 1990.
"Ministry of Finance, France," in *Contract Magazine* (Concord, Ontario), February/March 1990.

Mary Quant/Ginger Group Mini dress, 1967. Photo Hulton-Deutsch Collection

Mary Quant (1934–)
Mini-dress and skirt, 1962

The word "mini" originated in the 1960s. It was initially associated with two products, the car designed by Alec Issigonis and produced by Morris Motors, and the skirt which is the subject of this essay. The mini skirt, like its namesake, became a symbol of the youthful "Swinging Sixties." Skirt lengths had never risen so high before or provided women with such personal freedom. The mini skirt marked the post-war emergence of women under twenty-five as fashion leaders. Short, knee revealing skirts first appeared in 1962 and gradually rose until 1966 when "micro" skirts were showing twelve inches of thigh. "Minis" were introduced simultaneously by Mary Quant, a young London fashion designer, and the Parisian couturier, André Courrèges, but it is virtually impossible to say who had the idea first.

Courrèges opened his Paris salon in 1961 and his collection of the following year included the shortest skirts in Paris. By 1963 his fellow couturiers were beginning to raise hemlines whilst Courrèges took his skirts even higher. His lines were clean cut and architectural, frequently expressed in pale pink, ice blue, or white gabardine. At the same time, in London, Mary Quant was democratising the mini skirt by making it available more cheaply to a wider, younger market.

Some of Quant's sketches of 1958–61 show designs for very short sleeveless shifts. However, her made-up garments for those years ended on or just below the knee. In 1962 she went into wholesale production and her streamlined, increasingly short skirts started making news. The British fashion journalist Ernestine Carter designated 1963 "the year of the leg." As thighs were more on view, stockings became a fashion item, sporting bold colours and interesting textures. Tights (or panty hose, as they were known in the USA) were introduced in 1960, by Morley, for warmth, not fashion. They were intended for sportswear and did not take over in popularity from stockings until skirt lengths rose to the level where a gap between the skirt and stocking was virtually inevitable. For reasons of convenience and propriety, tights became *de rigeur* with the short skirt.

By 1965 the term "mini skirt" was in common usage. The new skirt lengths achieved popularity worldwide. In 1965 it arrived in New York with a British fashion show held on board the *Queen Elizabeth*. It took the city by storm, stopping the traffic on Broadway and in Times Square. In the same year a large American company, Puritan, shipped Mary Quant, designers Marion Foale and Sally Tuffin, some fashion models and crates of clothes across the Atlantic for a whistle stop tour of 12 cities in 14 days. This marked the coming of the mini skirt and the fashions of "Swinging London" (as coined by American journalist John Crosby, writing in England in 1964). *Harper's Bazaar* devoted a whole issue to the mini, edited by Richard Avedon. The *New Yorker* magazine published a picture of two young women in mini fur coats with the caption "I can't think why, but winters seem to be getting colder." The media played a considerable role in publicising the mini skirt. It was *the* controversial subject of 1966, a frequent topic of conversation and newspaper coverage. One of its champions was Cathy McGowan, compere of the British television pop music programme *Ready Steady Go*, first shown in 1964. Her threat to appear in a long coat, rather than the familiar mini, led to the formation of the British Society for the Preservation of the Mini Skirt and a demonstration outside of the television studio. September 1966 saw the same group rallying outside of Christian Dior's salon in protest at his new collection which featured long coats and dresses. The banners carried by the four demonstrators proclaimed "Mini Skirts Forever" and "Support the Mini." Their president, Bill Scharf, claimed a membership of four hundred and fifty mini skirt supporters and that the society existed "for the good of mankind." But their cause was safe: the mini skirt had become established as the fashion of the decade. When *Time Magazine* came to London in 1966 to document the "look," it described the city as "pulsating with half a dozen separate veins of excitement" where skirts were worn three to six inches above the knee.

It was evident that the mini had come of age when, at the end of 1966, Mary Quant went to Buckingham Palace to receive an OBE, wearing a mini skirt. As it became establishment, the mini inevitably lost its impact. By the summer of 1967 long flowing ethnic-inspired robes appeared, care of the hippy flower people. Short skirts were still being worn and promoted, but they were no longer top fashion news. Variations were introduced to keep the mini alive. *Hot pants*, or shorts, were a transitory vogue in 1971. But like the most extreme mini skirts they were only a success on thin and youthful figures. For the young the mini had been the liberator which had helped establish them a place in the fashion market. To older women and those with feminine curves, it had represented the ultimate challenge. As the late '60s recession took its hold and a more serious mood prevailed, skirt lengths dropped dramatically and often swept the floor. The era of the mini had passed, but its impact was everlasting.

Coinciding, as it did, with the rise of feminism, the mini skirt can be seen as a social as well as a fashion statement. It broke down taboos as it allowed more of the female body to be on show. The 1970s trend for wearing sportswear as streetwear has, it can be argued, much to owe to the mini. The continued appeal of the mini to the young is without question. As new generations enter the fashion arena the mini will once again receive popular acclaim. In the late 1980s, it appeared on the streets in summer worn by the daughters of its 1960s afficionados. For the young, slim and liberated the mini skirt will always have a strong appeal.

—Hazel Clark

Bibliography—

Quant, Mary, *Quant by Quant*, London 1966, Bath 1974.
Ewing, Elizabeth, *History of Twentieth Century Fashion*, London 1974.
Howell, Georgina, *In Vogue: Sixty Years of Celebrities and Fashion*, London 1975.
Bernard, Barbara, *Fashion in the 60s*, London 1978.
McDowell, Colin, *McDowell's Directory of Twentieth Century Fashion*, London 1984.

Varldens Fred
Genom
Varldens Handle

IBM Svenska Aktiebolag
Sveavagen 149
104 35 Stockholm 23

Report for '74

878

Paul Rand (1914–)
IBM corporate identity program, 1956
IBM Corporation, Armonk, New York

Around the middle of the 20th Century, many companies became increasingly concerned about the impression their corporate entity was making—on consumers, stockholders, employees, the government, and the communities in which they were located. They became aware that whether they did anything about it or not, they did have an image and they began to take steps to assure that the image they projected would be favorable to the success of their products and services then and in the future.

The programs they developed to project such images became known as corporate identity programs. It didn't take long to realize that everything about a company contributes to its image—favorably or unfavorably, coherently or haphazardly. Everything—the corporate logo, the wide range of graphics, the appearance and functional quality of products, company buildings, the dress, personality and manner of its employees, packaging, displays, advertising—the list goes on and on.

One of the first major corporations to recognize the need for a favorable and meaningful corporate identity was IBM, and IBM's program has proved to be most successful and enduring.

In 1956 Thomas J. Watson, Jr., who had recently taken over the helm of IBM, asked Eliot Noyes, IBM's consultant design director, to initiate a corporate identity program. Noyes called in Paul Rand. The first project Rand tackled was the redesign of the IBM logo. Rand was then retained as design consultant for all graphics and Noyes focused on architecture, interiors and product design.

The logo was to have a fresher, cleaner appearance but was not to be a radically new design. Commenting on the centrality of the logo design to the corporate identity program Rand says: "The basis unifying element that ties all IBM printed material together, such as packaging, brochures, office forms, etc., is the IBM trademark. The other unifying elements are the use, wherever possible, of a standard typeface (City Medium) as well as a simple and functional design solution. Beyond this there are no other mandatories. The designer's originality is given full scope and freedom based on these simple rules."

Rand sought a trademark that would be reduced to elementary shapes and that would be visually unique, yet styleless. He developed the mark from a typeface designed by Georg Trump in 1930 called City Medium. City Medium is a geometric slab serif typeface analogous to the geometric sans serif type styles. Looking at the logo, the original design and its later variations in outline and in its currently used eight-stripe and thirteen-stripe versions and its adaptability to colors, one can readily appreciate the simple brilliance of this concept and its execution. Today everyone knows the logo and the company it represents. The square serif letters and the square negative spaces in the B gave the logo just the right degree of unity and uniqueness.

The stripes, which have been part of the logo since the mid 1970s, did not occur to Rand when the original was designed. Rand explains, "I added stripes because I felt that the letters in themselves were not sufficiently interesting. . . . I thought . . . why not make the three letters out of stripes, or into a series of lines? That satisfies both content and form. Since each letter is different, the parallel lines, which are the same, are the harmonious elements that link the letters together."

The 8 line logo was designed principally for display purposes: for signs, packaging, newspaper ads and for reproduction on papers that will not be receptive to fine lines. The 13 line logo was designed to be used when a more subdued effect is required. It mixes more easily with type and is more suitable for engraving. It is appropriate for stationery, business forms, official documents, and certificates, etc.

In the late 1950s and subsequent years Rand designed IBM corporate literature that set the standards and influenced the style and approach to corporate literature around the world and for many years that followed.

For IBM, the logo and the literature using it expressed advanced technology and organizational efficiency. IBM has this image today. Of course, this is the result of much more than the graphic design program, or even the entire corporate identity program. Anyone looking at the IBM products, ads, displays, buildings, and their interiors, promotional material, packaging, annual reports, for example, over the years, recognizes that the clean, strong, persuasive logo and the flexibility of the ways it can be incorporated into product, package, and graphic design plays a major role in the success and desirability of the corporate program.

The unifying thread of countless pieces designed over the years is not a graphic theme but a consistency of design quality which in itself becomes a theme, albeit a very flexible one, one that permits IBM's many designers over the decades to exercise great freedom and creativity in their work, yet stay within the parameters of the sought-after image.

The applications of the logo to the various kinds of printed pieces have given it and the identity program a restrained elegance which one might also consider IBM's trademark. Here we have graphics that are at once functional, systematic, often elegant, always appropriate.

Rand also developed a graphic design guide for IBM's designers. In great detail it spells out and illustrates how the logo should and could be used, includes standards and explains that black stripes are drawn thicker than white stripes so they will appear similar optically. White stripes tend to appear thicker than they are, especially when lit as in some signs and on TV. The guide covers the house style for different sizes of the logo, its use on envelopes, stationery, forms, labels, and business cards. It also shows it used with accompanying data in various sizes and weights of the Helvetica type family and other typefaces and a range of company publications and other printed matter, on packaging and on signs and in combination with other symbols as well as specifying preferred colors, using the Pantone system.

An aim of the original design concept was to achieve maximum design quality with minimum design obsolence. Another was to offer the various designers great freedom, yet achieve design coherence from product to product, from design office to design office, from year to year. Outside designers and agency art directors also worked within the general framework of the design approach yet constantly achieved freshness in their work, a great tribute to Rand's striving for graphic coherence with design freedom.

If the overriding goal of the IBM corporate identity program was to help establish a favorable image, one that makes the primary statement that the company wants it to, and reaches the targeted audiences, by any measure of success the IBM program has succeeded brilliantly from its inception in 1956 and continues to do so today.

—Edward Gottschall

Bibliography—

Kamekura, Yusaku, and others, *Paul Rand*, New York and Tokyo 1959.
Rand, Paul, *The Trademarks of Paul Rand*, New York 1960.
"Paul Rand: Art Director of a Great IBM Image," in *Revue de Reclame* (Amsterdam), July 1964.
Rosen, Ben, *The Corporate Search for Visual Identity*, London and New York 1970.
Woods, Gerald, and others, *Communication by Design: A Study in Corporate Identity*, London 1972.
Rand, Paul, *Paul Rand: A Designer's Art*, New Haven and London 1985.
Anceschi, Giovanni, "Il premio Firenze a Paul Rand," in *Domus* (Milan), March 1987.
Heller, Steven, "Paul Rand: The Master of Twentieth-Century Graphic Design," in *ID* (New York), November/December 1988.
Meggs, Philip B., "The 1940s: Rise of the Modernists," in *Print* (New York), November/December 1989.

Photo The Design Museum, London/© DACS 1991

880

Gerrit Thomas Rietveld (1888–1964)
Red/Blue Chair, 1917–18
Painted wood; 60 × 84 × 86 cm.

In the course of the seventy-odd years since its first appearance, the Red/Blue Chair has attained an iconic status above and beyond that which could have been intended or envisaged by the designer, Gerrit Thomas Rietveld.

Born in Utrecht, Holland in 1888, Rietveld was the son of a cabinet maker and was apprenticed to his father at the age of 11 learning the basic skills of the jobbing joiner. At this time, Rietveld would have found himself working within the craft-oriented confines of a traditional and largely unmechanised Netherlands industry. Having set up his own cabinet-making business in 1911, Rietveld also attended architectural school and the Red/Blue Chair can be seen predominantly as a product of these conditioning factors.

Initially, the chair can be viewed as an exercise in tectonic reductivism. Rietveld's original object of 1917 served to reduce the structural elements of a chair into an easily readable orthoganality, which, Rietveld hoped, would allow anyone with basic joinery skills to construct a similar piece of furniture. The fact that this was intended to be a piece of furniture for the home is evidenced by the inclusion of side-panels in the original models. Their use dramatically alters the character of the object so familiar to us today. Their presence turns what has been subsequently analysed as a sculptural form and philosophical touchstone into an, albeit skeletal version of, a living-room chair in which a newspaper could be read or a pipe smoked. But this is not to suggest that this object, still in its plain wood finish at this point, was simply an ordinary chair.

The thought processes which Rietveld had applied to design and then construct this mysterious modular object were not of the norm. After all, most ideas of furniture for the home were bound up with the predominant bourgeois ideologies of the acquisition and display of expensive, well-upholstered parlour furniture. Save for the materials used, Rietveld's chair patently has little to do with traditional ideas of furnishing. Instead, with its inherent rationalism and clarity of structure, Rietveld's approach to the design of the chair could be said to be verging on that of the proto-modernist.

It was not until Rietveld's chair came into direct contact with the members of the De Stijl group that it gained the colours which were to lend it the name by which it is now known.

Theo van Doesburg's De Stijl group had first appeared in Holland in 1917 as a result of a peculiar accidental conjunction of time, place and culture. Holland, surrounded but relatively untouched by the mayhem of the first world war, provided a peaceful grandstand from which to assess the world and its problems. To the philosophically-minded van Doesburg, the evidence of war, death and destruction suggested that a radically new way of looking at the world was called for. According to van Doesburg, the starting point was to be found in an elemental, pure and universal aesthetic which would express the hoped-for, new world order. De Stijl, through its eponymous, monthly journal would provide the arena for the definition of this aesthetic.

Rietveld's chair, conceived independently of van Doesburg's philosophy, fits neatly into the De Stijl world-view. It is free of natural form, and the elemental, modular nature of its design makes it free of the maker's mark and therefore a universal object. To van Doesburg it represented further, three-dimensional proof that the new aesthetic was realisable on a human scale and in the form of what is potentially one of the most utilitarian and mundane of objects: a chair.

It is not known precisely who suggested the colour scheme for the chair once it had finally passed to De Stijl in 1918–19. But in painting the back red, the seat blue and the thirteen structural members black, it was as if the object had assumed the team colours of the loosely organised De Stijl group. The final touch, colouring the ends of the members yellow, cut the chair away from the ordinary world of wooden furniture and placed it firmly within the lexicon of De Stijl objects. From then on, the continuous association of the chair with a clear philosophical voice, together with a growing armoury of other De Stijl paintings, sculptures and architectural projects led to the Red/Blue chair assuming the status of a philosophically-loaded, sculptural object.

The avowed aims of the De Stijl group can be read in the manifesto of 1918, this, together with continuous, post-factum analysis of their output has contributed to an iconic status which belies function of the chair as simply something to sit on. If the chair became a piece of sculpture through its association with De Stijl, then there are some solid parallels and meaning which can be drawn from a comparison with other works in the De Stijl repertoire. The use of primary and neutral colours, orthogonality and the encapsulation of space through the intersection of planar surfaces and lines drawn from infinity are familiar leitmotifs in both the intention behind, and the analysis of De Stijl artefacts and projects. The chair undoubtedly belongs to this category of objects and shares the meanings attributed to them in the large and comprehensive literature on the subject. But the Red/Blue Chair also belongs to a greater taxonomy, that of furniture design.

As the chair remains in (re)production today, its iconic status as evidence of an auspicious moment in art and design history is assured and it is the range of ways in which the viewer or user can interact with the Red/Blue Chair which is the key to its longevity as a meaningful object. If it is treated, as van Doesburg and later, Rietveld himself would have it, as a part of the "mystique of space," a small section of the infinite mastered and humanised, then this simple, elemental chair assumes a character and meaning of awesome scale. If it is treated as an exemplar for Gestalt theories it works equally well; as a chair painted red, blue, black and yellow, it is sufficiently different to demand that we challenge our perceptions of what such a familiar object as a chair should be.

It is, quite literally, a multi-faceted object; a true product of the elision of the grand and the quotidian and it is this universality which is the key to its success and importance. It is also rumoured that, contrary to popular belief, it is a surprisingly comfortable chair to sit upon.

—Michael Horsham

Bibliography—

Buffinga, A., *Gerrit Rietveld*, Amsterdam 1971.

Jaffe, H. L. C., *De Stijl*, New York 1971.

Hogben, Carol, and others, *Modern Chairs 1918–1970*, exhibition catalogue, London 1971.

"Tornano due sedie di Gerrit Rietveld," in *Ottagono* (Milan), September 1972.

Naylor, Gillian, "De Stijl: Abstraction or Architecture," in *Studio International* (London), September/October 1976.

Baroni, Daniele, *The Furniture of Gerrit Thomas Rietveld*, Milan 1977, London and New York 1978.

Bless, Frits, *Gerrit Rietveld, 1888–1964: een biografie*, Amsterdam 1982.

Photo © Knoll International

Jens Risom (1916–)
Model 650 chair, 1941–42
Wood frame with webbing seat
Knoll International, New York

In 1941–42 Jens Risom designed a chair that shifted the design world, moved it in unforeseen directions. It had three things going for it: it was relatively cheap to produce, it had a totally new *sense* of design, and it could be produced at a time when war-time needs placed such stringent demands on materials that furniture production was practically brought to a stand-still. It was ingenious, and it came from a designer new to America who, with a combination of youthful dash and solid conservatism, introduced America to the possibilities not only of Scandinavian design, but of large-scale production of Scandinavian-derived design.

Jens Risom had barely passed his twentieth birthday when he designed this chair. Risom is a designer pure and simple. He is not an architect, not a painter-turned-designer. Not an interior decorator. He couples his innate sense of form and shape to an unbeatable appreciation for the texture and individuality of materials. And he knows how to use space, make it part of design. So much so that he can design textiles, chairs, tables, even houses, work his sensibilities into varying and diverse objects. But he has always worked best and has most fully honed his sensibilities when he designs with wood—solid, not industrially bent and produced wood. And it was as a designer of wooden chairs that he made his mark and opened new possibilities for the design world, this wooden chair with a webbed seat being one of his first designs and a benchmark in the history of design.

Risom was born in Denmark where an appreciation for wooden furnishings is something close to a cultural characteristic. Schooled in Denmark, he expected, when he came to the United States, to get a job with furniture makers. That was in 1938 when the US, although rising out of the bottom of a depression, was still trudging along at a low subsistence level. No-one was ready to venture into new furniture-making businesses. And there was little need, either for new designs or for increasing production of old models. Risom turned to textile design, got a job with Dan Cooper in New York, then convinced Cooper to branch out into furniture design, starting with designs for then-young architect, Ed Stone. The following year, 1940, when Stone's model home was built on a terrace of the recently-built and still awesome Rockefeller Center, Risom designed all its furniture. It brought him notice—as well it might. Though it stayed pretty close to Danish designs, it was new to Americans.

Actually, by then, the air had begun to clear for change in design. Images of Scandinavian designs began to trickle into the United States. And the Eames chair, designed by Charles and Ray Eames and made of molded plywood bent in two opposing directions, had just won The Museum of Modern Art's design competition. Risom had met Hans Knoll, a German immigrant, and his wife Florence, both of whom had a rare enthusiasm and wanted to produce something new in furniture. But frustrated, they started business by producing what American buyers, up to that time, expressly wanted: overstuffed chairs. Risom teamed up with Knoll, who was one year older to the day than Risom. Setting out across the country, they talked to architects and designers trying to determine if there was room for the new. This chair, designed by Risom and manufactured by Knoll, was produced a year later in 1941–42, and proved there was not only an untapped market, but that new designs could be profitably produced.

Using soft woods, which unlike hardwoods were non-critical and not used for war, and surplus goods, Risom melded his conservatism to his dash. This chair, as every chair Risom has ever designed, is a pleasure to sit in. A person sinks in and sits back, the incline of the seat and placement of the arm rests allowing perfect comfort. In part, he gets it through sheer design: the incline, the solid wood frame, and the fact of sitting in a solid and warmed wood frame, a conservative reminder of old world comfort. But setting that comfort into a newly-angled form, Risom added his ingenuity. Turning to materials that were available in 1941, he found surplus parachute goods and, using it, devised a webbed seat which, as all upholstered chairs do, allow a person to move with the material rather than conform to a fixed form. It had give, and more, it was a material that broke from the past: it was not thick and overstuffed. His true ingenuity shone, however, when in combination with the wood frame, the chair could be put into production easily and simply.

And it sold. In large measure because there was a huge new demand created by the war. The armed forces, never before such a sizable institution in American life, needed furniture for army posts, USO lounges, airports, and more, while industrial and arms manufacturers, expanding to meet production for war, needed furniture for relocated workers, offices. Of course, Knoll and Risom were most interested in selling to that untapped sensibility for the new, and for developing a market for post-war life. Knoll hedged his bets. He produced Risom's new line, and maintained his old well-made Victorian furniture—for the next two years or so before dropping it to develop the lean Knoll look. Risom himself went into the US Army in 1943 and started his own firm after the war.

Risom's chair marks more, however, than its designer's dash and ingenuity. It marks the point when American manufacturers opened their eyes to international design, and actually heralds the introduction of what soon came to be dubbed the international style. That style, emulating Le Corbusier's sparse but strong lines, recognized space as an ingredient in design in new ways. It suggested that the space between a frame was as necessary for the form and shape as the obvious lines structuring the object. Risom's chair with a webbed seat and the back opening up to the wide top band of wood connecting the chair's two major uprights, was among the first of the emerging international style to be produced in America. But made of solid wood—a kind of Danish birthmark that exudes artisanship—and not of the new bent plywood, it combined a material bearing the feel of craftsmanship to the lean strong lines of the international style. It was this design that opened American eyes, not only to combining craftsmanship with modernity, and not only of proving it feasible to produce craftsmanship with modernity, but of jolting American manufacturers into a world-wide view, of spinning American manufacturers out of the cocoon of traditionalism into the world at large.

—Judith Mara Gutman

Bibliography—

Rae, Christine, *Knoll au Louvre*, exhibition catalogue, Paris and New York 1971.
Russell, Frank, ed., *A Century of Chair Design*, New York 1980, 1985.
Larrabee, Eric, and Vignelli, Massimo, *Knoll Design*, New York 1981.
Mackintosh to Mollino: fifty years of chair design, exhibition catalogue, New York 1984.

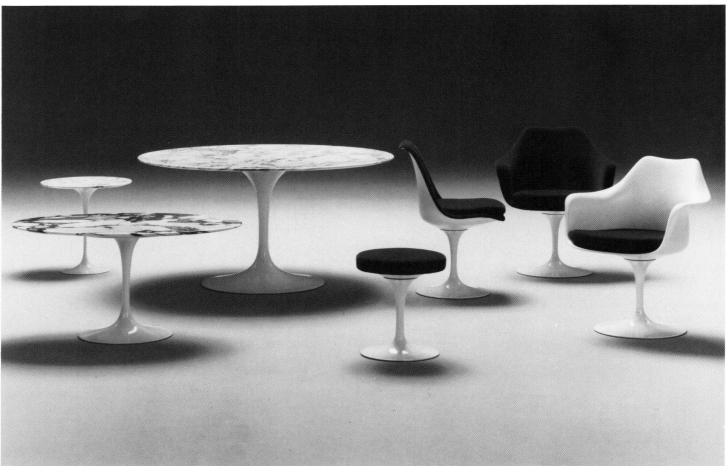

Photos © Knoll International

Eero Saarinen (1910–61)
Model 151/Tulip chair, 1953–56
White moulded plastic with laminated steel support; 81 × 51 × 54cm.
Knoll International, New York

Eero Saarinen's name brings several monuments of modern architecture to mind—the space age yet Surrealist flowing contours of the T.W.A terminal at J.F.K International Airport, New York and the huge, steel parabolic curve of the Gateway Arch in St. Louis—a monument that did for St. Louis what the Eiffel tower did for Paris. Saarinen's name is also indelibly linked to several pieces of furniture that became design icons of their era—the *Womb Chair* (1947) and the Pedestal furniture of 1957.

Yet, Saarinen is often not given the credit he deserves because his fate was to fall between two eras. He was born in 1910, 41 years after Frank Lloyd Wright, 24 years after Mies Van Der Rohe, 23 years after Le Corbusier and 27 years after Gropious. His death at age 51 occurred only two years after Wright and before the other giants of the modern movement. Rupert Spade points out, "Thus while not by birth a member of the heroic generation, he was by death."

Saarinen was born in Finland and in 1923 moved with his family to Bloomfield Hills, Michigan where his father Eliel designed and later became the director of Cranbrook Academy of Art. From boyhood, Saarinen had wanted to be a sculptor but his boyhood love of creating form was later subsumed into his architecture and furniture design, giving it a greater sculptural presence than other architects and designers of his time. After studying sculpture in Paris in the late 'twenties, he studied architecture at Yale University. He worked for the industrial designer, Norman Bel Geddes, before returning to Cranbrook where he entered his father's architectural firm. Saarinen's independent career as an architect only dates from his father's death. Saarinen said, "Until his death in 1950, when I started to create my own forms, I worked within the form of my father."

Saarinen had met Charles Eames in Norman Bel Geddes' Office, and invited him to come to Cranbrook to head the Experimental Furniture workshop. In 1940 Saarinen and Eames won first prize at the Museum of Modern Art's "Organic Design in home furnishings" for their collaboration on ten chairs using rubber bonded to plywood and steel. These chairs wedded technology with biomorphic surrealism. America's entry into World War II postponed the exhibition of these chairs until 1946.

Pivotal for Saarinen's later work was their use of fat, bulging plywood shells like amoebas, molded in double curves (versus the single curves of bentwood and Aalto furniture) balanced on thin wooden legs. In designing these chairs, Saarinen was actively involved in revising the canon of modern furniture design. Modern architecture demanded a sleek, airiness in shapes but, Saarinen was no longer content of the machine aesthetic of the Bauhaus in which he had been trained and began to use the new technology evolved during World War II to re-define the chair.

He said, "The chair is a three-dimensional object always seen within a room, which is essentially a box. How do you best relate this object to the box? The Cubists, the De Stilj designers have solved it by their light steel furniture—truly beautiful thinking and truly beautiful furniture. Somehow technology and taste have shifted. New materials and techniques have given us great opportunities with structural shells of plywood, plastic and metal. For me, the compound shell of plastic is most appropriate for twentieth century furniture."

Yet, his innovations were rooted in an appreciation of how people were moving and acting differently in the mid-twentieth century than their ancestors, saying, "People sit differently today from the Victorian era. They want to sit lower and they like to slouch." In his *Womb chair*, he set out to replace the bulky mass of the overstuffed chair, which no longer suited modern interiors, with a chair that retained its sense of comfort and psychological well-being while dieting its contours to more streamlined forms.

Saarinen was forward-looking in his ability to assimilate developing technologies and give them new expression. In 1955 he began to design the pedestal series of furniture. The 'fifties was an age of informality that was reflected in their choice of plastics for dishes and furniture. It was a material that was versatile, hard to break, easy to clean and made people feel like they were truly contemporary. Saarinen's designs further pared down the volume of chairs, reducing their shapes to free-flowing contours in which a gleaming white flower-like plastic cup that cradled the body rested on a single stalk that was center balanced on a metal base. The range of "Tulip" chairs and their complementary tables were first manufactured in 1957. The chairs had shells of glass fiber and column stems and bases of flared aluminum. Top and bottom were colored all white and drawn in a series of fluid curves. The tables were designed in varying sizes and heights to suit every purpose, with options for tops in natural wood or elegant white marble.

Although the use of the pedestal has occurred in furniture design going back to ancient Roman tables and more recently in Eames' pedestal furniture, Saarinen's sculptural background gave the pedestal a more organic and sculptural presence. Saarinen wrote: "As to the pedestal furniture. The undercarriage of chairs and tables in a typical interior makes an ugly, unrestful world. I wanted to clear up the slum of legs." The chair's futuristic contours looked equally good clustered around a formal or informal table indoors or sitting on the edge of a pool outdoors. Their shiny white color was prophetic, anticipating space age interiors of the next decade. A version of the table is found in the Space Hilton in the 1968 movie, *2001, a Space Odyssey*. The color was still popular ten years after its initial appearance when in an article in *Vogue* in August 1966, "The Late Sixties Look" described shiny white as, "The basic leveler of this age . . . No color is more accommodating, no color makes a better foil or background . . . or static as accent colors." They called for its use in furniture, walls and floors.

Yet, Saarinen's desire for a unitary object made of a single material was never realized. Unlike Eames and other designers of the 'fifties, Saarinen discarded the watchword of the previous generation, "truth to materials," and emphasized the totality of the form by coloring the top and bottom the same color. His great sorrow was his inability to make them of the same material. He said, "I wanted to make the chair one thing again. All great furniture of the past from Tutankhamun's chair to Thomas Chippendale's have always been a structural total. With our excitement over plastic and plywood shells, we grew away from this structural total. As now manufactured, the pedestal furniture is half-plastic, half-metal. I look forward to the point where the chair will be one material, as designed." His dream was never realized. His untimely death at the age of fifty-one cut short one of the great architectural and design careers.

—Ann-Sargent Wooster

Bibliography—

"Dining on a Stem," in *Time* (New York), 13 May 1957.
"Sarinen Places Furniture on a Pedestal," in *Architectural Record* (New York), July 1957.
Saarinen, Eero, *Eero Saarinen on His Work*, London and New Haven, Connecticut 1962.
Temko, Allan, *Eero Saarinen*, New York and London 1962.
Iglesia, E. J., *Eero Saarinen*, Buenos Aires 1966.
Spade, Rupert, *Eero Saarinen*, New York and London 1971.
Page, Marian, *Furniture Designed by Architects*, New York and London 1980.
Wichmann, Hans, *Industrial Design: Unikate Serienerzeugnisse*, Munich 1985.

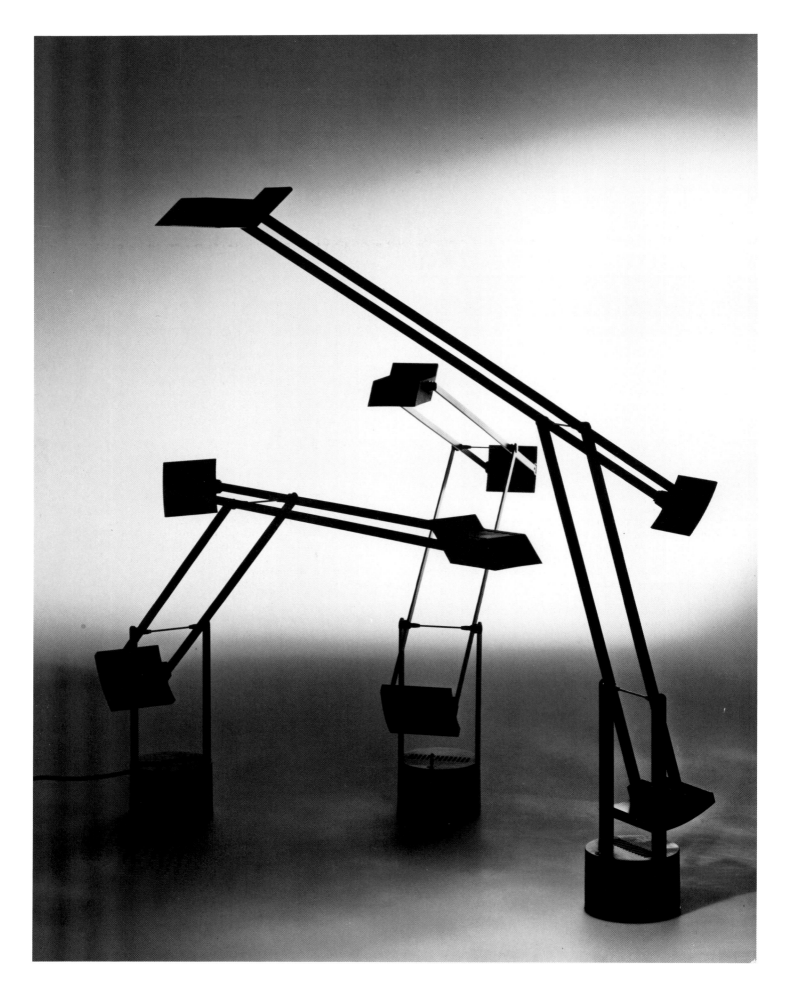

Richard Sapper (1932–)
Tizio adjustable desk lamp, 1972
Black lacquered steel; 113cm. maximum height
Artemide, Milan

The *Tizio* desk light has established itself as a legend in the design world and has been labeled as the most successful product produced by the Italian manufacturer Artemide. It was designed and introduced amid drastic change in architecture, art, and industrial design. Few periods in history would be unable to make a similar claim. Richard Sapper's lamp made its debut immediately after the radical 'sixties. That it took the form it did, a neo-functionalist design, during an era intently re-examining the Modern movement, probably helped it attain its near cult status today. It is an important design. Honored with permanent inclusion in the Twentieth Century Design Collections of the Museum of Modern Art and the Metropolitan Museum in New York, it has maintained a high level of consumer popularity across nearly thirty years and has weathered that fickle storm, "good taste."

In the early 1970s, Modernism and the doctrine of functionalism were facing a severe crisis. The post World War II neo-functionalist philosophy advocating bareness, simplicity, and impersonal aesthetics was waning in popularity. According to Charles Jencks' book, *The Language of Post-Modern Architecture*, Modernism died an official death in 1972 with the destruction of the Pruitt-Igoe high rise apartments. The practice of machine-worship and product standardization was considered a failure in the light of the new desire for a return to design respecting human values and employing symbolic and expressive form. The single-mindedness of Modernism was rejected in favor of Pluralism, a multiplicity of directions. Principles fundamental to the philosophy of Modernism were found short-sighted. Mass consumption, mass culture and taste had not been sufficiently considered. Modern design in mass was uninteresting. Humanity turned inward, seeking local and more personal concerns. Man was replacing the machine as the new deity to worship.

How did the *Tizio* survive in this environment hostile to its bare, simple and impersonal appearance? Interest in vernacular, classical, and historical design was growing, and Sapper's desk lamp was not synchronous with these concepts. A grim fate for the *Tizio* may have been averted, and notoriety achieved, through two of the many Pluralistic approaches established during the late 1960s and into the 1970s. Minimalism and Industrial Pop (journalistically and popularly called High-Tech) came to the rescue of designers still exploring Modern design theory.

Minimalism, as the term suggests, describes environments that are almost bare. Furniture is used sparingly or built in, and frivolous decoration is seldom employed. The composition of such spaces must be detailed with extreme care, since the balance and proportion would be drastically changed with the addition of any component. Such a description is befitting the design of the *Tizio* as well. Balance plays a crucial role in the arrangement of its unadorned components, both aesthetically and functionally.

American Pop Art is credited with providing the greatest and most direct influence on Italian furniture design of the late twentieth century. And, Sapper, although German by birth, was directly influenced by the Italians. Working in Italy, Sapper and Marco Zanuso were the first to produce an all-plastic chair. They embraced this new material of Pop culture's "plastic revolution," which is compared to the tubular steel revolution of the 1920s. Sapper actively participated in the development of the Italian Pop product aesthetic. The Italians, since their recovery from World War II, were anxious to demonstrate national industrial prowess. This rapid industrialization created a culture catering to the desires of the nouveau-riche. This new group of consumers were more individualistic than collective and became increasingly concerned with formal innovation rather than practical necessity and function. *Tizio* manifests only one of these consistent themes; preoccupation with design of the isolated object. Many of those becoming interested in product design at this time were originally from the architecture profession, fashioning objects as an extension of a totally designed environment. Sapper's lamp was designed as an individual, unconnected to a specific environment or higher "order." Perhaps as credit to its design as an independent object, it is still featured in traditional, eclectic, and minimal interiors.

A forceful movement in architecture as well, Industrial Pop (or High-Tech) impacted interior and industrial design powerfully. The movement was popular for its emphasis on industrial equipment and surfaces. These products and materials were often employed in the most elegant surroundings, incorporated with minimalistic principles. The bold expression of structure, technology and mechanical components recall the Modern principles of standardization and mass production. Modernism was resurrected to a certain degree.

Unique engineering and technological features prove important to the configuration of the *Tizio*. Function was not sacrificed to the expression of innovation. It was the first lamp to engage the structural system as the conductor of electrical current, eliminating wires encumbering the design. Today, the low-voltage lighting design industry is saturated with fixtures utilizing this, then revolutionary, feature. Its range of movement and adjustability, counter-balanced design, and the compact dimension of its base are aptly exploited resulting in its sleek profile. This inspiring work is an excellent example of what man can achieve, even when the environment is inhospitable.

—Gayla Jett Shannon

Bibliography—

Grassi, Alfonso, and Pansera, Anty, *Atlante del Design Italiano 1940/1980*, Milan 1980.
Jencks, Charles, *The Language of Post-Modern Architecture*, London 1977, 1981.
Friedmann, Arnold, and others, *Interior Design*, New York 1982.
Collins, Michael, *Towards Post-Modernism*, Boston 1987.
Sparke, Penny, *Design in Context*, London and Seaucus, New Jersey 1987.
Bangert, Albrecht, *Italian Furniture Design*, Munich 1988.
Sparke, Penny, *Italian Design: 1870 to the Present*, London and New York 1988.
Sambonet, Roberto, *Richard Sapper: 40 Progetti di Design 1958–1988*, exhibition catalogue, Milan 1988.

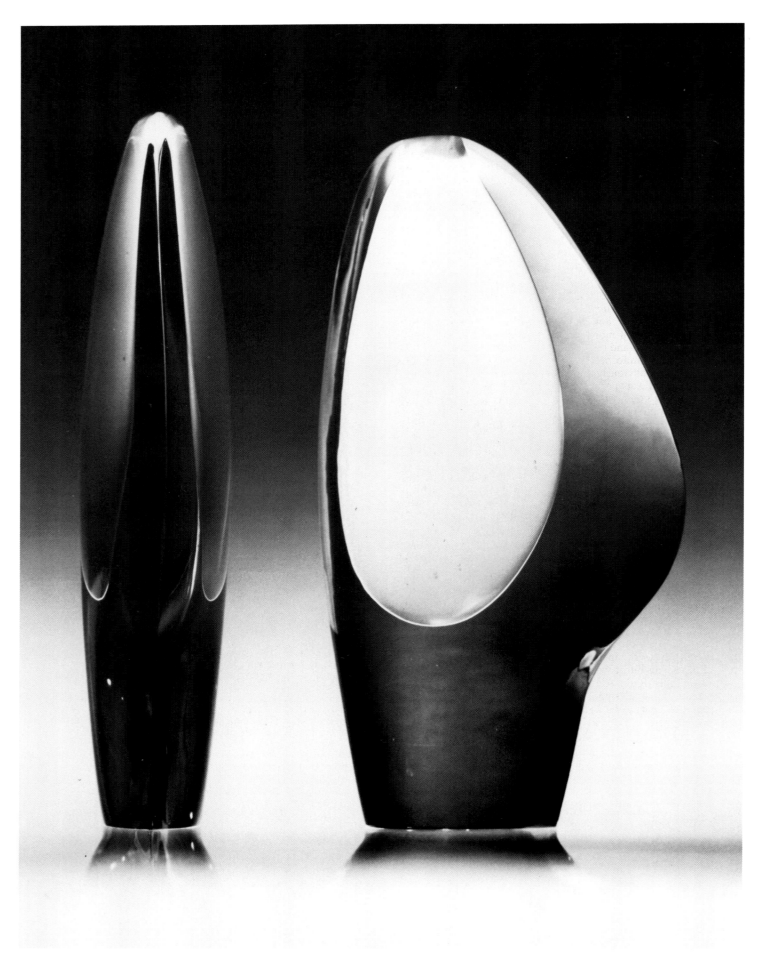

Photo Museum of Applied Arts, Helsinki

Timo Sarpaneva (1926–)
Lansett II glassware/sculpture, 1952
Colourless and opaque white glass 25.5 cm. high
Iittala Glassworks, Finland, 1952–60

Lansett—either *I* or *II*—immediately stikes you as a receptacle of some kind, filled by the use of clouded glass with some substance both strong and gentle at the same time. What could this substance be? Or, indeed, the receptacle? There is also a mystical quality, more futuristic and forward-looking than shrouded in the mists of time. Obviously due to the smooth flowing lines, the substance is "welcomed" by the receptacle and accommodated. The whole emits love and empathy, in fact *Lansett* could, if we did not know Sarpaneva's actual meaning, quite easily represent love—the filling of body, mind and soul.

However, Sarpaneva is portraying something with many similarities to love—music. The inspiration came at a classical concert, where for the first time he felt himself becoming truly receptive to the music he was hearing. As the melodies flowed over, around and through his mind and body, he suddenly saw the intangible take on a tangible shape. To Sarpaneva, glass then seemed the perfect medium to capture this fleeting form for eternity.

Once we accept this musical interpretation, the positiveness of *Lansett* becomes even more apparent. The music is not seen as "invading" the mind and body; rather, it gently enters and spreads out in a relaxed uniform way. No harsh jagged edges or dark sombre colours—obviously the concert was Bach rather than Wagner. The futuristic shape conveys the belief that music is a continuing force for good, with a vital role to play, rather than simply a nostalgic reminder of times past. By choosing such a shape Sarpaneva also seems to be hinting that music breaks down barriers between peoples and even worlds.

Of course, every work has a frame of reference, and it is interesting to see how Sarpaneva escaped from the clutches of time to produce such a classic. He was helped by the fact that the early 1950s were a period of great opportunity for Finnish designers. At last they were able to wholeheartedly rally to the cause of "creating beautiful objects" first proclaimed by the Swedish designer in 1017. At first the constraints of the Depression and then the war had stifled the generation inspired by Aalto and Brummer. Now, however, with a domestic industry geared to rebuilding at home and capturing export markets, there were ample opportunities for them to develop their ideas and talents. In 1950, Sarpaneva was employed by the Iittala factory which had, in fact, been responsible for the famous *Savoy* vases of Aalto. Along with Wirkkala, he strove to break new ground, but in his own way. Sarpaneva immediately showed what has been since his trademark—a passion for textures. He soon developed favourites which can be found throughout his work, including stone-like smoothness, a rough bark effect using burnt wood moulds, a frosty-ice surface and a pure liquid glass look. All these were applied with classical precision until the late 'sixties, when he moved towards a freer interpretation as with the *Finlandia* series. Today he continues as Senior Designer.

The internal studio rivalry notwithstanding, there is no disputing the fact that—however distasteful it may seem to pure artists—industrial designers thrive on competition. And the early 'fifties were full of them—both domestically and internationally. In fact, the Milan triennials became almost a kind of Olympic for the Finns, and it would be naive to think that designers did not relish the opportunity of becoming not only national but worldwide celebrities. With *Lansett*, which won a grand prix in 1954, Sarpaneva did just that. Fame led him to undertake many international commissions, including designing for the Rosenthal line and Corning.

These were the positive pressures, yet they also had negative aspects. Sarpaneva could easily have become a prisoner of fashion—for every classic from a triennial, there are many more long forgotten prize winners. Along with other designers, he also had to cope with domestic criticism which accused him of straying from the functionalist path. What was the point of producing pure aesthetic pieces? Sarpaneva was irritated by this and was eventually to respond by designing in the mid-'fifties, the *I-line* of drinking glasses and other vessels. This proved he could provide "useful" pieces if he "really wanted to."

However, with *Lansett* he was first and foremost true to his own beliefs. He approached his subject as a sculptor and then realised that glass could be a perfect medium. Not only was this a breakthrough (*Lansett* can be described as a meeting of pure art and industrial art) but also Sarpaneva was interpreting the brief to provide beautiful objects for everyone as applying to works of art. This has resulted in a peculiarly Finnish phenomenon that to this day would have many seasoned marketeers shaking their heads in disbelief. *Lansett I* and *II* were in production and best sellers until 1960. And now vases such as *Lansett* can be found for sale in the humblest kiosk or cheapest supermarket as well as the most up market store or boutique in Finland, so much has the idea of buying art as a "commodity" taken hold. It is a tribute to Sarpaneva that he has been able to convey his intensely personal vision of music in such a universally understandable way. As well as changing our conception of the use of glass and gaining acceptance for its use as a sculpting medium.

—Richard Hayhurst

Bibliography—

Polak, Ada, *Modern Glass*, London 1962.
Niilonen, Kerttu, *Finnish Glass*, Helsinki 1967.
Sarpaneva, Timo, *Sarpaneva*, Helsinki 1984.
Museum of Applied Arts, *Timo Sarpaneva: Sculpture in Vetro*, exhibition catalogue, Helsinki 1987.
Iittala Glass, *Iittala in the Triennials of Milan*, Iittala 1987.
Hawkins Opie, Jennifer, *Scandinavia: Ceramics and Glass in the Twentieth Century*, London 1989.

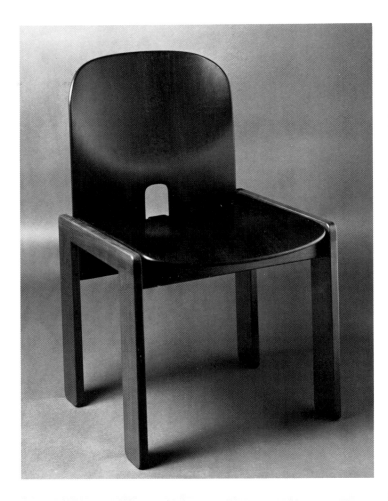

Photos Cassina

890

Afra Scarpa (1937–)/**Tobia Scarpa** (1935–)
Model 121 chair, 1965
Walnut or ash with leather; 80cm. high
Model 925 lounge chair, 1966
Walnut or ash with leather; 69cm. high
Cassina, Milan

In 1965, Afra and Tobia Scarpa were commissioned by the Cassina company to design *Chair 121*. A year later, as part of the same commission, they completed the design of *Chair 925*. Both these products had certain things in common with two chairs designed by Carlo Scarpa in 1942 and 1976 respectively. Together they make up what might be called a family of chairs created by a family of designers.

The influence of Carlo Scarpa on Italian design is to some extent indirect, since until 1968 none of his furniture was mass-produced. Nevertheless, Italians acknowledge their debt of gratitude to him, in particular for his sharp criticism of the practice of mass design. This is not the place to go into a detailed analysis of the scale and influence of his prolific production, but it is interesting to note the way in which Tobia and Afra took up some of the themes introduced by Scarpa the Elder. The work of his son and daughter-in-law is marked by the same attempt to dignify design. It is evident not only in their use of material but also in the way details are worked out. Theirs is a silent statement which might have passed unnoticed but which eventually revived the feeling of craftsmanship to the peninsula's industrial design.

The story began in 1942 when Carlo Scarpa made a sketch for a chair made of "single panels." Made of wood, its structure consists of series of thin panels placed with their edges in the same direction. In its textile seat and back, the embryo of the basic notion of *Chair 121* can be detected. This first sketch reveals some of the themes which recur in Carlo's work. We refer to the deliberate timelessness, which make it difficult to see definite connections between the work and the moment in history when it was executed. All that can be said is that it is a product of modern thought. Here the shape is reduced right down to a rudimentary expression of the function of the object. It is a chair—pure and simple.

In the euphoric days of the 'sixties, Afra and Tobia's chair and armchair picked up the same theme as Carlo's design. The Scarpa family worked in wood, although this was the time when experimentation with plastic, a material in which all designers placed their trust, was at its peak. In this case the "panels" are laid out on a cubic matrix, which means the structure conforms to a specific geometric law. The most outstanding feature of the chair is not its wooden "trestle," but the leather back-rest and seat which curve gently to correspond with the ergonometric coordinates. Compared to its predecessor, it is a more comfortable and attractive design. Even if the "single panel" chair denotes an albeit unconscious break with the past (as befits the cultural turning point at which it was conceived), neither of the models—designed over twenty years apart—shows any intention of becoming the prototype for an era. Quite the reverse, they fit silently and unheroically into a private world. *Chair 121* incorporates a subtle detail into the back-rest—a verticle aperture where the back meets the seat robs it of its function as a back-rest since there is no point of contact with the body. This is yet another facet of the exploration of shape and sculpture embodied in the craftsmanship of the "single panel" chair. This aperture relieves the sensation of bulkiness and adds lightness to the chair. In the *125 Armchair*, the cut in the back-rest is more pronounced, in proportion to its size.

The third version of this "theme with variations" dates from 1976. This is *Chair 1934*, designed by Carlo Scarpa for Bernini. The conceptual continuity with his son's model is remarkable: it is as though shortly before his death in 1978 the old master asked himself "How would I do it?" and went ahead and did it. Once again we have the plain structure using simple panels, but these are set within two more solid and rigid frames. It has only a single stretcher instead of three, as the seat is made of wood and contributes to the structural function. Conversely, the back, with its free, extended lines, is the most sculptured of the series. The aperture appears as a tapered crevice ending, with a voluptuous flourish, in a circle.

Through its three stages, the same design continues to emphasise the character and independence of its two component parts: the wooden structure (becoming more and more rigid, geometric and abstract) and the weight-bearing parts (which evolve towards organic forms). In none of the three instances is there any move towards innovation or the use of a new material such as plastic. Indeed, this is a group of chairs whose components are firmly rooted in the traditions of Italian craftsmanship. From this point of view, these designs seem to represent serene reinterpretations. It has to be said that it is noticeable that the chairs are not intended to be seen in isolation but as part of a set, integrated with other examples of design. Sketch (1942), design (1965 and 1966) and redesign (1976): three readings, three instances of working with the same concept at different moments. The historical development of a single design.

—Carlos L. Dibar

Bibliography—

Ritter, Enrichetta, *Design Italiano: i mobili*, Milan and Rome 1968.
Lane, Terence, *One Hundred Modern Chairs*, exhibition catalogue, Melbourne 1974.
Instituto Nazionale per Commerzio Esteriore, *La Sedia Italiana*, Rome 1983.
Piva, Antonio, *Afra e Tobia Scarpa: architetti e designers*, Milan 1985.

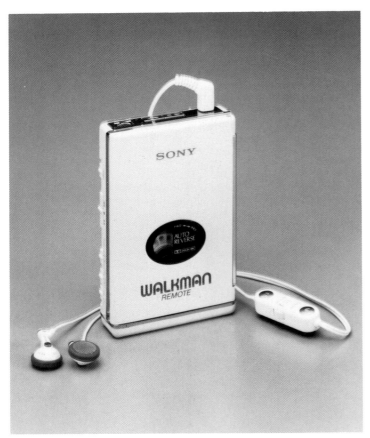

Sony WM 2

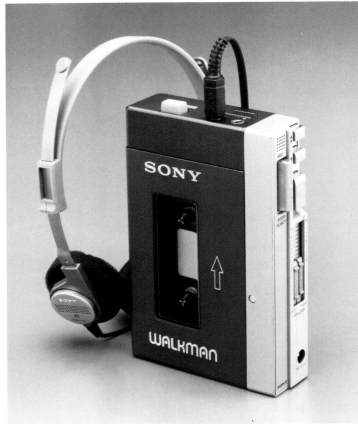

Sony WM 109

Photos courtesy of Sony Corporation

Sony Corporation (1946–)
Sony Walkman personal radio/cassette player, 1978–79
Sony Corporation, Tokyo

The Sony Walkman was a product innovation which transformed the listening habits of millions of people around the world. Since its launch on 1 July 1979, it has spawned 150 million imitations, but none have managed to capture the market from the original.

The idea for the Walkman came from Akio Morita, the chairman of the Sony Corporation which he also founded, in 1946, with Masaru Ibuka. Mythology attributes the Walkman to Morita wishing to listen to music whilst playing tennis; in reality, the scenario was much more pragmatic. 1978 witnessed organisational changes in Sony's audio division with the transference of the highly profitable radio cassette recorders from the tape to the radio division. At the same time, the divisions were designated as internal profit centres. The tape recorder division, once the company's major earner, had been overtaken by video and needed a new product. The division already produced the Pressman, a semi-professional tape recorder used by journalists, and this provided the basis for the Walkman, the first "tape recorder" which did not record, but only played back. The production prototype was completed on 24 March 1979, within five months of the internal reorganisation of the company.

The Walkman benefited from the technological innovations which facilitated Sony's post war development. Miniaturisation had become a significant part of the company's policy in the race to develop new products. Finding commercial application for the transistor, invented in the USA, enabled Japanese manufacturers to capture world markets. In 1955 Sony's TR-55 was the first mass-produced transistor radio. It signified the early importance of portable sound. From the beginning, the company laid stress on the importance of integrating technology, thinking and design. However they could not anticipate the overwhelming impact of the Walkman. Seen within the company merely as an adaptation of old stock, it was not carefully launched or targetted. There was no coordinated attempt to find a single name for the product. It appeared initially in Japan as the Walkman, in the USA it was the Soundabout, in Sweden the Freestyle, and in the United Kingdom the Stowaway. For the first three months it did not sell, but when it did there was no doubting its potential and the need to have a concerted marketing campaign. The name was consolidated to Walkman, a unique Japanese-invented English word (like Pentax), which represented the character of the product.

The commercial success of the Walkman emphasises the importance of timing to design innovation. During the 1970s the rise of youth and street culture resulted in large portable stereo systems being carried and played in public. The following decade saw the emergence of what American writer Tom Wolfe has called, "The Me Decade." People were tending to isolate themselves from one another; the Walkman helped them to create personal barriers of sound. The shape and size of the machine had cultural roots, as well as technological significance. Its size and appearance related to traditional Japanese design where compactness is valued and simple shapes and colours, such as black, white and red, prevail. The tactile qualities of objects are also part of the Japanese aesthetic. Each of these are seen reflected in the Walkman which has itself become a cultural icon.

Within eighteen months of its launch, two million machines had been sold and other Japanese manufacturers struggled to compete. Radio cassettes were introduced to extend the potential of the product, but they also adversely affected its overall dimensions. A race had already begun to produce increasingly smaller Walkmans. Eventually size was only limited by the dimensions of the cassette tape. The Walkman underwent many styling changes after the launch of the WM-1. The chrome grey WM-2 was universally popular, although many 80s style victims preferred its successor, the matt black WM-3. Other more gimicky and market specific designs followed. The Sports Walkman stood out for its bright yellow case, inspired by diver's equipment (although it was actually only water-resistant). "My First Sony" arrived in the late 1980s; it was brightly coloured, eye catching, tactile and aimed specifically at children. This and its pastel toned contemporaries, aimed at adults, signified that the Walkman had become a fashion product. By the end of the '80s there was a Walkman for every age and lifestyle.

Sony has continued to introduce innovations in order to retain its primary place in the market. The WM-109 marked a distinct break with the feature-loaded high tech styling of its competitors in favour of a sleek, simple, compact design. Product semantics indicated that a market saturated with gadgetry would welcome the alternative. The solution was the introduction of a smooth white casing to signify a sophisticated image which would be associated with quality. The price was kept relatively low, but the perceived value of the design to the consumer was high, particularly to the college students who form a large percentage of the Walkman market. It achieved success and became the first Walkman design to be carried over through three model-year changes. This was no mean achievement in a market where new designs typically lasted for six months.

By the middle of the 1980s, "Walkman" had become one of those names, like Biro (ballpoint pen) or Hoover (vacuum cleaner) before it, which are synonymous with a product, not just a brand. Its impact has been swift and universal, and it has changed habits across the world. The Walkman is evidence of Sony's recognition that the success of technology-driven innovation depends on the ability to anticipate and exploit changing social behaviour. As Yasuo Kuroki, of Sony, stated in 1983: "up to now Japan has only produced *products*, paying little attention to considerations of culture and life style. We must change." (Christopher Lorenz, *The Design Dimension*, 1986,). The unforeseen popularity of the Sony Walkman underlines the appropriateness of this approach to product design in the late twentieth century.

—Hazel Clark

Bibliography—

Bayley, Stephen, *Sony Design*, London 1982.
Lorenz, Christopher, *The Design Dimension*, Oxford 1982.
Sudjic, Deyan, *Cult Objects*, London 1985.

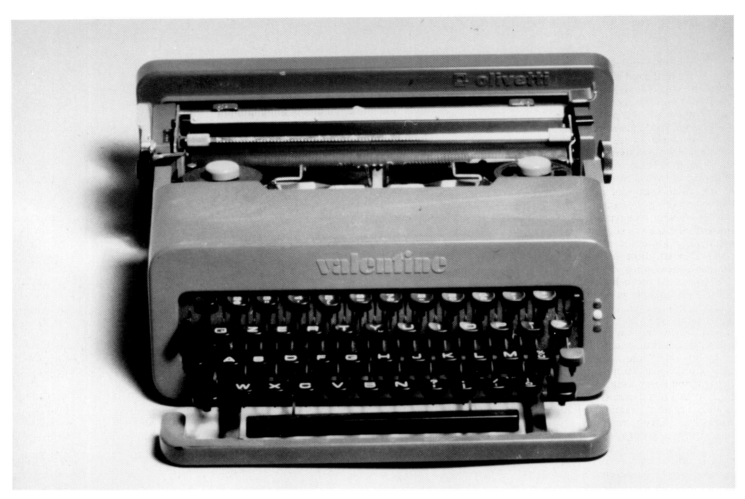

Photo Design Museum, London

Ettore Sottsass, Jr. (1917–)
Valentine portable typewriter, 1969
Red ABS plastic $4\frac{1}{2} \times 13\frac{1}{2} \times 13\frac{1}{2}$ in.
Olivetti, Ivrea, Turin

Imagine a typewriter like a kiss: lipstick red with raised letters spelling out the word VALENTINE printed across the front like a Pop Art painting by Robert Indiana. This typewriter was revolutionary when it was introduced in 1969. Avant garde for its time, it would have continued to be a revolutionary writing tool if word processors, its dull cousins with faster innards had not replaced portable typewriters. Historically, business and domestic machines, like sculpture tended to be dull in tone, often simply the color of their materials. Occasionally, in the nineteenth century they might be dusted with gold or silver filigree lace-work to imply decorative luxury but, with few exceptions, machines tend to be bland and those exceptions can be counted on the fingers of one hand—there are the plastic art deco radios of the 'thirties and the avocado and sunset gold appliances of the early 'sixties, but generally machines are seen as serious, anything but fun.

Ettore Sottsass charts out a new landscape for machines with the *Valentine Typewriter*. Hot-colored, the typewriter suggests a world far removed from invoices and business letters. The typewriter calls up images of a world like that of the Italian Renaissance where creativity was considered a necessary adjunct to everyday life. By making the typewriter the color of fast sports cars and lipstick, Sotsass was suggesting a man or woman might use it for personal pleasure; for writing anything from love letters to the novels that will allow them to escape the confines of corporate life. Many machines prior to the 'sixties were barely portable (anything that you could put a handle on and three grown men could lift without the handle coming off was often called portable back then). A little larger than a long playing record, this streamlined, lightweight typewriter is truly portable, freeing its user from specific spaces, allowing him or her to embark on a nomadic life of artistic adventure, much as Sottsass's own.

"Aware of all the commitment of open minded but rigorous design, which starts from a secure knowledge of good technology," Sottsass and Perry King Jr. invented the *Valentine Typewriter* and transformed it in Sottsass's words for use "anyplace except in an office, so as not to remind anyone of monotonous working hours, but rather to keep amateur poets company on quiet Sundays in the country or to provide a highly-colored object on a table in a studio apartment. An anti-machine, built around the commonest mass produced mechanism. The works inside the typewriter may also be seen to be an unpretentious toy . . . the two elements of the machine itself, which is all one with the handle and cover, and its container with the two black rubber hooks are made of orange and red ABS. Yellow and also in ABS are the two buttons of the ribbon spools like two eyes of a robot."

Sottsass says, "There are destinies that may be discussed and need not be taken for granted . . . destinies given by others and destinies invented by us . . ." His career encompasses all these "destinies." If not strictly predictable, Sottsass's journey to the invention of the *Valentine Typewriter* and beyond to the founding of *Memphis* can be seen in retrospect to have mirrored the social and philosophical geography of the last six decades. It also reflects Sottsass's courage in following his own inner star. Sottsass was born in Innsbruck, Austria on September 14, 1917. He moved to Trento to be with his architect father, a former pupil of Otto Wagner. In 1928 he began studying at the Faculty of Architecture in Turin, where he graduated in 1939. From the beginning, he experienced conflict between his training in the ideas of the Bauhaus and his feeling that there should be an emotional and ritual link between man and his environment. In his notebooks of the time he wrote, ". . . perhaps more than ever before, the task of artists is to break with conformity, to point out the paths that lead to the imagination, to humor, to surprise and to independence." The difficult five years he spent helping to rebuild Montenegro after the war convinced him of the importance of concentrating, in his words, on the "fragile scenery of the private domain." He saw the paintings of Jackson Pollock, Arshile Gorky and Willem De Kooning on his first visit to the United States in 1956. They confirmed his commitment to the use of color in home furnishings and architecture.

By the 'sixties, Italy was a world leader in design, but the world of design was in turmoil, reflecting contemporary social changes. Many saw good design as a way of challenging the status quo and changing the world. Designers like Sottsass used the freedom offered by the new political and social climate to apply the principals of Pop Art and Mod fashion to the creation of witty, ironic interiors and appliances with bright colors, bold graphics and seductive surfaces. When Sottsass first began working in this manner, he felt as if popular culture had upstaged the design process. He says of the women of Paris, "They had beaten me to the mark, because what I wanted to do with furniture they had already done with their white canvas boots, with their multi-colored fancy stockings, decorated with stripes, colored squares and dots." The *Valentine Typewriter* was created against this background and was a reflection of new lifestyles.

By 1970, Sottsass joined with other radical architects in the Anti-Design movement that paralleled counter-culture concerns. For them, design started, as Sottsass says, "When it becomes a visual, physical, sensorial representation of the existential metaphor on which we base our lives." At first, Sottsass made grey plastic "mobili grigi," and for the 1972 exhibition at the Museum of Modern Art, *Italy, the New Domestic Landscape*, conceived of an environmental living space made up of grey plastic containers on wheels.

Sottsass's most successful contribution to the history of design occurred less than a decade later with the invention of the multi-faceted design movement called *Memphis* in 1981. Memphis used color, pattern, irregularity, creativity and "vulgar" materials like plastic laminates to create a new style that attacked the traditions of good design and replaced them with a new palette of ideas heavily loaded with color and fun. The *Valentine Typewriter* is a symbol of the 'sixties, and an important signpost in Sottsass's unique design career that culminated in the invention of *Memphis*.

—Ann-Sargent Wooster

Bibliography—

"Two New Typewriters," in *Domus* (Milan), June 1969.
"Design in Action," in *Industrial Design* (New York), July/August 1969.
Waterhouse, Robert, "A Valentine for your Thoughts," in *Design* (London), October 1969.
Best, Alistair, "Of Machines and Men," in *Design* (London), January 1973.
Di Castro, Frederica, ed., *Sottsass's Scrapbook*, Milan 1976.
Sottsass, Ettore, *De l'Objet Fini a la Fin de l'Objet*, exhibition catalogue, Paris 1977.
Gaon, Izzika, *Ettore Sottsass*, exhibition catalogue, Jerusalem 1978.
Sparke, Penny, *Ettore Sottsass, Jr.*, London 1982.
Zorzi, Renzo, *Design Process Olivetti 1908–83*, Milan 1983.
Radice, Barbara, ed., *Ettore Sottsass: Design Metaphors*, Milan 1987.
Sottsass, Ettore, and others, *Sottsass Associati*, New York 1988.

Photos STARCK

Philippe Starck (1949–)
Cafe Costes chair, 1984

Alongside the development of what is known in France as "Architecture of the Mitterand Era," there were also official but less spectacular efforts to encourage innovation in industrial and furniture design. To celebrate the bicentenary of the French Revolution, the government commissioned the Grand Arc de La Défense, the Louvre Pyramid and the other "Great Works," using the services of "imported" architects. However the attitude towards design was much less internationalist: Italian design had to be ousted from its dominant position and interest in French designers awakened. Against this background were set up, with ministerial backing, l'Institut pour la Valorisation de la Innovation dans l'Ammeublement (VIA), l'Ecole Nationale Superieure pour la Creation Industriel and an annual exhibition of decorative arts.

In order to trace the ancestry of the *Costes* chair, we have to go back to Francois Mitterrand's decision to change the layout of his private appartments at the Elysée Palace. It was a step never previously taken by any other president of the republic. In the style of Baron Haussmann or the various Louis, Mitterand insisted that both the professionals hired and the technology used should be entirely of French origin. And so there appeared on the scene Philippe Starck, the "enfant terrible" of French design in the eighties. As happened during the Empire period, a commission from the head of state sowed the seeds of a new style in furniture design. What Philippe Starck's creations lack in solemnity, they make up for in quality. This tendency has earned him the label of "court jester," on which is based his worldwide reputation, his name having become a byword in modern French design.

Few designers are endowed with a thought process as logical and at the same time uninhibited as Philippe Starck's. His repertory is based on ironic variations and recreations of the principles of modernity, to such a point that these geometric games have turned into an easily-recognisable Starck style. This personal style is distinguished by motifs and themes rooted in history which are then recycled and mixed into a magnificent cocktail. From this point of view it is possible to undertake an analysis of the *Costes* chair, created for the Parisian café of the same name, which Starck chose to base on a chair he designed in 1982. He adapted the *Pratfall* armchair to meet the functional requirements of a café chair and to fit in with its postmodernist setting. The usual four legs of a café chair are reduced to three "so the waiters don't bump into each other" (sic). The width of the *Pratfall* is compressed to save space, the curve of the back-rest is gentler and the third support is closer-set. And so the transformation is complete. The flavour of the Parisian café is tempered with "the noble and melancholy look of the restaurant on Prague railway station." The *Costes* chair reflects, thirty years later, the same optimistic outlook of the 'fifties: different materials—wood, leather, metal—coexist in unpretentious harmony. Its light and asymmetrical lines reflect the stylistic dictates of that decade. Harking back to French Art Deco of the 1920s, we find the same curving movement in the laminated wooden back. The *Pratfall* armchair is more strongly reminiscent of Art Deco—compared to Pierre Chareau's 1932 armchairs for the Maison de Verre.

But in Starck's work there are no fixed rules or too obvious influences: his main inspiration comes from intuition and his genial tendency to combine the most varied sources. Philippe is insistent that his cultural background is not really French, but "the product of a childhood full of dreams of the United States." His highly Americanised father was an outstanding aircraft designer. This may account for the airy images and the aerodynamic appearance of his furniture, doubtless inspired by the streamline shapes popular in the USA in the 'forties. Starck acknowledges: "I started to design furniture at a time when France seemed to have little faith in the future. Many of us thought that, from a cultural point of view, our country had ceased to exist. Nevertheless, it was important for me to design 'à la française.' There was no point in copying the Italians." Starck's way of working on furniture differs from that of the Italians, particularly where his ideas of geometry are concerned. Modern Italian design appeals to the laws of geometry as a means of capturing form or of associating the idea of measure with the science of design. Starck, on the other hand, uses geometry in an ironic and paradoxical way. The proportions dictated by tradition are violated, contrasts exaggerated, pure forms are manipulated until they become extravagant and complex. Bearing in mind that when Starck designed the *Costes* chair, attention in Italy was focussed on Ettore Sottsass's Memphis, the difference in the criteria underlying the two perspectives is clear to see. While Milan-based designers value the sensory perception of pure shape and colour, Starck represents the other extreme in not proposing anything new, either in the sensory or the technological sense. Rather, he presents a rational perception of the object viewed with refined irony by way of an uninhibited reinterpretation of the principles of modern design.

The validity of the *Costes* chair may be as fleeting as fashion, the laws of which Starck knows like the palm of his hand. But he does not claim to lead the way to pastures new but to express an individuality with its own coherent pattern. So his creations bear a characteristic and highly personal stamp which is expressed through elegant shapes, skilfully transformed to accord with "the spirit of the age." Starck is more than an "enfant terrible." He is a highly creative individual, whose creativity is not directed towards revolution. His aim is to charm. It is this very charm that is the hallmark of his work and which affirms its unparallelled validity.

—Hernán Barbero Sarzábal

Bibliography—

Starck, Philippe, "Cafe Costes," in *Passion* (Paris), February 1985.
Smart, C., "Designing Furniture in the Fast Lane," in *Christian Science Monitor* (Boston), 24 December 1985.
Starck, Philippe, "The New Modern Design," in Isozaki, Arata, ed., *International Design Yearbook 1988/89*, London 1988.
Colin, Christine, *Starck*, Liege 1988.
"Starck por Mariscal," in special monograph issue of *Casa Vogue* (Barcelona), July/August 1989.

market-specialized catalog services

for the plant engineering market

Ladislav Sutnar (1897–1976)
Sweet's Catalog Service Program, 1943–60
Sweet's Catalogs, New York

Ladislav Sutnar's design for Sweet's Catalog Service between 1943 and 1960 made a monumental contribution to the field of graphic design in demonstrating that it was possible to develop a graphic design language which provided a methodology for organizing an extremely diverse group of visual and textual components varying in size, color and texture into a coherent design which functioned effectively in transmitting information. Sutnar was not the first twentieth-century graphic designer to create such a visual vocabulary, but he carried this methodology to one of its highest degrees of refinement in his designs for the Sweet's Catalog Service creating a model that is often studied and replicated.

Although Ladislav Sutnar commands a significant position in post-World War II graphic design in the United States, his contributions are not generally recognized, and he himself remains an enigma. He was loquacious in discussing graphic design, but reticent about himself. We know that he was born in Czechoslovakia, studied at the School of Industrial Art, Charles University, served as professor of design from 1923 to 1932 and director of the State School of Graphic Arts from 1932 to 1939, designed a number of foreign exhibitions for the Czech government, and was in charge of design of all publications for one of Prague's leading publishing houses. He came to America to install his design of the Czech pavilion at the 1939 New York World's Fair. Remaining in the United States after Hitler's invasion of Czechoslovakia, he established his own design office in New York where he created innovative designs for a considerable number of commercial, industrial and publishing clients including the Swedish adding machine firm, Addo-X, the furniture manufacturer, Knoll International, the textile firm, Vera Scarves, The Golden Griffin bookstore, the United Nations and *Fortune* magazine. He died in New York in 1980.

Somewhat younger than Le Corbusier, Walter Gropius, Josef Albers, Herbert Bayer and Laszlo Moholy-Nagy, major figures in the modern art movement who introduced new concepts of design and visual organization to architecture, painting, furniture, product and graphic design, Ladislav Sutnar was not one of the pioneers who created a new visual language during the first decades of this century. Inheriting the innovative ideas generated by earlier generations, Sutnar created his own style of visual communication. Because Prague was a crossroads between Eastern and Western Europe, he would have been exposed to the visual ideas of the Wiener Werstatte, de Stijl, School of Paris, the Bauhaus and Russian constructivism, all of which found a common denominator in geometrical structure, a touchstone of Sutnar's style. Also, he is known to have had contact with the Swiss designer Jan Tschichold in the 1920s when Tschichold was influenced by the Bauhaus.

Ladislav Sutnar's significant achievement can be found in his ability to apply the newly articulated principles of visual organization to graphic design problems. Recently, we have become conditioned to accepting ordered visual messages in newspapers, magazines, books, films and television; it is difficult to believe that seventy years ago clutter and confusion, possible carryovers from a Victorian sensibility, dominated the field of visual communication.

With the visual reference systems that Sutnar created for Sweet's Catalog Service in 1943, he developed a model that has become an integral part of the graphic design vocabulary. The diversity of information contained in Sweet's old files was encyclopedic, so he had to figure out how to make "order out of chaos," one of his favorite exclamations. The narrative and diffused text of the old catalog format was replaced by brief, precise statements which were easier to locate, read and integrate with pictures. By exercising control over verbal text by establishing consistent formats for headlines, body copy and annotations, he created a style in which the verbal text was treated as a visual element integrated into the total design. He might have been the first graphic designer to demand control over the character and dimensions of verbal text! Rather than permitting text to dominate his designs, he manipulated verbal messages so that they functioned effectively in his

information-oriented designs. He said, "To meet the demands for fast perception, visual simplicity requires selectivity of design means for direct visual performance . . . In some cases the visual clarity of simple facts demands dramatic distortion, in others replacing long words with quickly understandable visual symbols." His Sweet's Catalog Service design utilized type, size, color and images as visual signifiers and enumerated product features in a clear visual sequence, which fused information into an optical unity. Product descriptions included extensive tables studded with technical data. These tables made use of imaginative type, color, line and blank spaces to facilitate sorting information.

In an age in which everyone is inundated with huge quantities of information from a variety of sources, we often struggle to read signs, to identify products, to digest advertising or to locate information in newspapers, books and catalogs. Sutnar created a style of visual communication in which precision and clarity were paramount. His design for Sweet's Catalog Service demonstrated a superlative ability to communicate visually through symbolic differentiations in which visual interest, visual simplification and visual continuity became guiding performance standards.

His Sweet's Catalog Service designs demonstrating the creation of a house style for one client served as the genesis of another idea—the corporate image. Some forty years ago, long before the concept of corporate identity programs had been considered by other designers, Sutnar was moving in this direction. Describing his philosophy of corporate identity, he said, "In terms of visual design, it means devising a design system that visually coordinates all forms of internal and external communications. The system must include all information on products, processes, policies, and services to customers, dealers, employees, stockholders, public groups and government. It must cover all elements from business forms to advertising and point-of-sale displays to product design and store architecture."

In his corporate design program for the Swedish adding machine firm, Addo-X, he was able to go beyond his Sweet's Catalog Service designs and develop a comprehensive program in which he could control the design of all elements associated with a product. Applying his philosophical approach to this situation, he created a comprehensive series of visual symbols that functioned effectively in every possible situation. For Addo-X, he created one visual symbol, the Addo-X logo, a strong corporate image, which dominated his designs for showrooms, product literature and advertisements.

Many of Sutnar's innovations and philosophical ideas have been assimilated unconsciously by the graphic design profession. Although never formally credited for it, he created the prototype design for the Customer Guide which appears in every American telephone book. Like the Sweet's Catalog Service designs, this is another demonstration of his unique ability to create an ordered system for processing and sorting a huge amount of visual and text data making it possible to locate the particular element of information which is desired. The hallmark of Sutnar's work, whether it be manifested in the Sweet's Catalog Service designs, his corporate identity program for Addo-X, or his designs for other clients was the ability to sort and evaluate visual and textual information and to create coherent design solutions in which precision and clarity are dominant.

—Allon Schoener

Bibliography—

Sutnar, Ladislav, *Catalogue Design Progress: Advancing Standards in Visual Communication*, New York, n.d.
Sutnar, Ladislav, *Design in Action: Principles, Purposes*, New York 1961.
"Ladislav Sutnar," in *Idea* (Tokyo), May 1970.
Ades, Dawn, *The Twentieth Century Poster: Design of the Avant-Garde*, New York 1984.
Wilson, Guy R., and Pilgrim, Dianne H., *The Machine Age in America 1918–1941*, New York 1986.

Photo Museum of Applied Arts, Helsinki

Ilmari Tapiovaara (1914–)
Domus stacking chair, 1946–65
Plywood
Schauman; Knoll International, New York

Stacking chairs provide one of the great challenges to industrial designers. Firstly there is the need to produce a chair that will actually stack—not just in ones or twos but, if necessary, ten plus high. Safely and tidily. And, of course, you have to be able to unstack them just as easily. Since a concert hall is just as likely as a school or youth club to need such chairs, they also have to have a certain aesthetic appeal. Once laid out in rows, they must blend with their surroundings—however spartan or luxurious. Furthermore, despite the claims of some that you can always squat or sit on the floor, chairs are generally accepted as necessities of life and thus one of the key elements in planning a lifestyle.

This is certainly how Ilmari Tapiovaara viewed them when, after the Second World War, he started to plan the furnishings for a new hall of residence for students in the capital of Finland, Helsinki. Two thoughts were uppermost in his mind—to design a chair aesthetically pleasing, yet versatile and easy to mass produce. The immediate inspiration was the general feeling in Finland after the long hard war to create a better future for the young. As well as providing educational opportunities, the Finns decided that this also extended to providing students with comfortable modern living conditions. However, Tapiovaara was not starting afresh—indeed he himself had been one of many prewar designers in Finland experimenting with lifestyle concepts to meet and even form the aspirations of the rapidly growing new nation (Finland only became independent in 1917). In this, they were greatly influenced by the Bauhaus ideas of functionalism and the pioneering work of their own Alvar Aalto. Equally important, however, was the call of the Swedish designers in the '20s to create beautiful things within reach of everyone. And on top of this had to be added the Finnish love for nature and relatively untouched reservoir of traditional handicraft skills. Since Finland was industrialising late, many of the workers had existing traditional skills they could adapt. This applied to the furniture industry in particular. The challenge was still, however, how to get to mass-production levels. The opening up of export markets proved an even greater incentive, not only for manufacturers but also for designers.

Nevertheless, traditional furniture which Tapiovaara criticised for blindly catering to middle and upper class taste still predominated in Finland in the prewar years. Thus, Tapiovaara designed living room and childrens' room furniture which attracted great attention at exhibitions, but did not prove a major commercial success. He did start working with Asko and produced *Chair 21* as a forerunner of *Domus*, but a change of management in the company led him to resign. Fortunately, a small company called Kerava Wood Industries stepped into the breach and commissioned him to both design products and set up the actual production of them.

Then came the war.

Tapiovaara was fortunately able to use the war as an opportunity to go back to basics—design at zero level, as he called it. He was called up and became involved in designing bunkers, saunas, mess halls and the furniture for them. Working on-site, only with available materials, taught him a great deal about simplifying designs and the characteristics of different kinds of wood. On the other hand, he also realised the importance of bringing some comfort and homeliness to the front line. One other factor heightened his awareness. He was stationed in Eastern Karelia—an area of rich folk tradition. Tapiovaara was fascinated by the carvings he found there and carried out detailed studies. Before the war he had already demonstrated a willingness to combine different cultural elements in, for example, his *Safari* chair which incorporated African elements. However, this fascination did not lead to copying—rather he was interested in the ways different cultures used materials, and isolating the basic shapes and forms. All during the war, however, Tapiovaara was retained by Kerava Wood Industries, and he continued during leave periods to supervise the installation of their new production line. Amazingly, by the end of the war it was ready—now he needed the orders. The opportunity came when he was asked to design for Saloma's Domus Academia.

The Domus project called for furnishings for a hall of residence for 750 students. The residence comprised "boxes"—small living/sleeping/studying rooms to be shared by two people. The key, Tapiovaara quickly realised, was to double up the functions of each item. Thus, the desk is also a dining table. He also modernised the traditional Finnish bench bed, turning it into the forerunner of the modern sofabed. The *Domus* chair was to be a central item—strong and rigid enough to keep the student awake while studying, yet also comfortable enough for more relaxed socialising. Comfort had to come from the form and contours, since cloth was in short supply and the chair could not be upholstered. To Tapiovaara, the answer was to use plywood which he had discovered could be moulded as required.

Having studied the human physique, he came up with the basic shape he wanted. The stroke of genius—which is immediately apparent and still sets *Domus* apart to this day—was to extend the back legs and use them to support the arm rests. In this way, apart from adding a distinct design element, he guaranteed the chair's safe stackability. The arrangement also successfully overcomes the problem of how to inject a mass product with a sense of individuality. Looking at the graceful lines, it is hard to believe that the chair was manufactured—rather each seems to have been individually sculpted, albeit with uncanny repitition. All of the *Domus* furniture was an instant success and led to its adoption not only in student residences, but schools, libraries, public buildings and offices, not only in Finland but also throughout Europe and the States, where it became known as the *Finnchair*. The chair also found its way into private houses and thus became a classic crossover piece. Tapiovaara himself built on this success and later developed a metal equivalent of *Domus* called the *Lukki*. He also successfully combined work in both the public and private sector carrying out assignments as diverse as interior design for banks and setting up furniture industries in the Third World.

—Richard Hayhurst

Bibliography—

Kaufmann, Edgar, Jr., *Prize Designs for Modern Furniture*, New York 1950.
Zahle, Erik, ed., *A Treasury of Scandinavian Design*, New York 1961.
Ratia, Armi, and others, eds., *The Ornamo Book of Finnish Design*, Helsinki 1962.
Hard af Segerstad, Ulf, *Modern Scandinavian Furniture*, Copenhagen 1963, London 1964.
Russell, Frank, Garner, Philippe, and Read, John, *A Century of Chair Design*, London 1980.
Larrabee, Eric, and Vignelli, Massimo, *Knoll Design*, New York 1981.
Sembach, Klaus-Jurgen, *Neue Mobel 1950–1982/Contemporary Furniture*, Stuttgart, New York and London 1982.
Peltonen, Jarno, *Ilmari Tapiovaara—Interior Architect*, Helsinki 1984.

The First Book of Moses called Genesis

Genesis

1:1 In the beginning
God created the heaven and the earth.
2 And the earth was without form, and void;
and darkness was upon the face of the deep.
And the Spirit of God
moved upon the face of the waters.

3 And God said,
Let there be light:
and there was light.
4 And God saw the light, that it was good:
and God divided the light from the darkness.
5 And God called the light Day,
and the darkness he called Night.
And the evening and the morning
were the first day.

6 And God said,
Let there be a firmament
in the midst of the waters,
and let it divide the waters from the waters.
7 And God made the firmament,
and divided the waters
which were under the firmament
from the waters
which were above the firmament:
and it was so.

8 And God called the firmament Heaven.
And the evening and the morning
were the second day.

9 And God said,
Let the waters under the heaven
be gathered together unto one place,
and let the dry land appear:
and it was so.
10 And God called the dry land Earth;
and the gathering together of the waters
called he Seas:
and God saw that it was good.
11 And God said,
Let the earth bring forth grass,
the herb yielding seed,
and the fruit tree yielding fruit after his kind,
whose seed is in itself, upon the earth:
and it was so.
12 And the earth brought forth grass,
and herb yielding seed after his kind,
and the tree yielding fruit,
whose seed was in itself, after his kind:
and God saw that it was good.

Bradbury Thompson (1911–)
The Washburn Bible, 1979
Leather-bound books in redwood slipcase; 3 vols.; 10 × 14 in.
Washburn College, Topeka, Kansas, 1969; Oxford University Press, Oxford and New York, 1980

The *Washburn College Bible* is a culmination of Bradbury Thompson's innovative and creative typographic style. Published by Washburn College, the Modern Phrased King James Version is a unique combination of clarity, harmony, and beauty in its use of typography and art masterpieces. Thompson, a graphic designer, brings forth the freshness, elegance, sensitivity, and vitality of his typographic style to the concept and design of the *Washburn College Bible.*

Bradbury Thompson has spent a lifetime blending type and pictures into fresh, new forms of visual imagery. His appreciation of classic images and typographic history are pulled together into the Bible to bring forth a dynamic and sensitive work on the printed page. Thompson, along with other pioneers of American graphic design of the 20th century, e.g., Louis Dorfsman, Herbert Lubalin, William Golden, and Lester Beall, approaches typographic design with inspiration and vitality. His work comes alive on the page. From the early typographic movements of the European Avant Garde, such as Dada, De Stijl, and Futurism, there were dynamic and innovative approaches taken in typography as an expressive form. The playful placement of type on the page, depiction of visual "sounds," mixing of typefaces on the page, and experimentation were key parts of those styles. Thompson has accomplished his own unique style in his typography, such as in his printed work for Westvaco Corporation. Thompson fuses together type, vibrant colors, photographs and line-art, masterworks, and sensitivity to create exciting images that relay specific information to the audience. The grouping of elements on the page, directional layouts, and use of generous white space and balance of form and structure to achieve strong communication. Advances in technology and materials have enhanced his typographic design. From magazines to postal stamps to book designs, Thompson has distinguished himself as an innovator of typographic design.

The *Washburn College Bible* is a mixture of typography, abstract designs, and art treasures. A unique example of 20th-century typographic communication design, the bible was first produced as a three volume set in 1979, then in a one volume book by Oxford Press in 1980. The Bible is divided into three sections in both editions. An abstract geometric cross, derived from an early mosaic of the Santa Constanza masoleum (A.D. 350) built during the reign of Constantine, is the symbol used on the covers and front and back leaves of each book. The motif was reproduced in religious art and architecture in 1540 and 1638, and later in the aisles of the Cathedral of St. Peter. The use of the cross symbol accentuates the historical context of the *Washburn College Bible's* design.

In his typography and design of the page, Thompson provides a visual reorganization of text. The format of the bible is a two-column grid that uses four main horizontal lines that control the placement of all the type, including titles, subtitles, captions, and the text. The typeface used for the text is 14 point Sabon Antiqua Roman. Originally cut by Claude Garamond in 1532, it was updated by Jan Tschichold in 1967, then revised for phototype-setting in 1972 specifically for this bible. It is an elegant serif typeface that reflects the historic aspect of the bible, while allowing easy readability. In contrast to earlier King James Version Bibles in which the type is set in equal line lengths with phrases running into each other, the *Washburn College Bible* text is set flush left-ragged right in lines of varying length which accommodates complete phrases. This "thought-unit" or "phrased" typography allows for a more natural cadence to reading and visual readability as well. Use of uniform spacing, no hyphenation of words, and chapter and verse numbers placed in the left margin of the text

serve to strengthen the rhythm and visual organization of the Bible. This is a revolutionary approach to typographic concept in Bible publishing.

In contrast to older Bibles, italics are used only in the sub-headings below the main titles, running heads and not in the main text. This serves to further the clarity of the phrased text apart from other type in the book. Upper and lower case type is consistent in the phrasing. The only exception is in the use of the words LORD, Lord GOD, JEHOVAH, and the words of God to Moses, I AM THAT I AM, and I AM. Thompson has reorganized the visual concept of this Bible, but in no way is the language of the King James version altered.

Thompson's use of the phrased typography in the Bible provides a positive example of the correlation between typographic design and the effective communication of the written word. A sensitive use of space and type arrangement offers a flow across the pages that is unmatched in other Bibles. Not only is the text clear and readable, it is pleasing to the eye and offers visual variety, in contrast to rigid regularity, to strengthen meaning and interpretation.

Bradbury Thompson is a master at incorporating imagery and typography into successful unity on the printed page. The Bible is no exception. Three screen prints by Josef Albers (1888–1976) serve as frontispieces for the three volumes: 1) *Introitus,* 2) *Seclusion,* and 3) *Ascension.* These images are very striking in their abstract linear quality and bright color. They supply a contemporary feeling to the Bible, yet complement Thompson's unique approach to the text. In contrast to these abstract visions are the plates featuring religious art masterpieces that precede each of the sixty-six books of the Bible. The illustrations were selected by the Director of the National Gallery of Art in Washington, J. Carter Brown. Michelangelo's *Creation of the Sun and the Moon* (1511), a ceiling fresco detail from the Sistine Chapel at The Vatican in Rome, appears within a white page frame at the beginning of the chapter of Genesis, providing an appropriate visual introduction to the Bible. Each frontispiece and illustration is preceded by a page that provides a caption citing a verse from the Biblical text that inspired its creation, along with information on the artist and the collection from which the illustration came.

The *Washburn College Bible* is an excellent piece that combines the oldest text of the Christian religion and new approaches to typographic communication in its presentation. The words of the Holy Bible, being a timeless piece that has been revered for centuries, are brought to new vibrancy in the *Washburn College Bible.* It is indisputably an aesthetically pleasing book that renews one's interest and reverence for the printed word. Bradbury Thompson has mastered the printed page by turning aspects of old styles of design into well-organized, contemporary visual dimensions. Thompson's sense of order and clarity of communication prevails in this historic work *The Washburn College Bible* is a classic design solution that will be difficult to surpass.

—Nancy Ciolek

Bibliography—

"Type: Bradbury Thompson, 1986," in *Print* (New York), November/December 1986.
Thompson, Bradbury, *The Art of Graphic Design,* New Haven, Connecticut 1988.
Gottschall, Edward, *Typographic Communications Today,* Cambridge, Massachusetts 1989.
"Pearlman, Chee, and Kalman, Tibor, "Bradbury Thompson," in *ID* (New York), March/April 1989.
"Bradbury Thompson," in *Artforum* (New York), October 1990.

Wystawa
rzeźb
Henry
Moore'a

Henryk Tomaszewski (1914-)
Henry Moore exhibition poster, 1959
Ministry of Culture and Art, Warsaw

I saw the poster from the window of a moving city bus, out of the corner of my eye. I left the bus at the very next station and ran back to find it. I stood in front of the poster for a long time, fascinated by its magnetic power. I was experiencing the shock of confronting a work of art whose magic went beyond my ability to define it, an image that attacked the subconscious and subverted all attempts to categorize it with sophisticated formulas of definition.

It was a very modest poster: a deep blue background ending at the top with a white strip of the horizon. Across the middle were the letters M O O R E cut out of white paper. Near the bottom on the left was a narrow rectangular of gray color. There were two other textual elements: near the top, in an almost invisible black, "Ministerstwo Kultury i Sztuki . . .", and against a black plate in white text "Wystawa Rzezb Henry Moore'a." In the middle, on the pedestal created by the second letter O, was a photograph of a sculpture. That was all.

The reality of Tomaszewski's poster was not the questions so characteristic of the works of Moore, such as the relationship between a human figure and the currents in the space that surrounded that figure. The reality of Tomaszewski's poster was the answers included in the English artist's sculptures themselves. Tomaszewski's poster was a double-sign: it stood for the Moore exhibition and for his art.

The second half of the 'fifties and the beginning of the 'sixties were the best years for the Polish poster. If something like a Polish School of the Poster ever existed, it was during this time. For various reasons the Polish poster survived the dogmatic aesthetics of social realism. Even in the darkest years of Stalinism, designers were able to employ metaphor and allegory in their work. They could fight with the propaganda bureaucrats, and, when submitting their commissions, still make use of elements of visual language that stimulated independent connections in the mind of the receiver, an effect contradictory to the idea of totalitarian thought control so vividly described by Orwell. When the political thaw of 1956 arrived, poster designers were well prepared. They did not have to develop their aesthetics again from scratch.

Tomaszewski is an artist of form. He believes that for each of the contents there exists one adequate form, and it is the duty of the designer to identify it. The catalog of visual means is open-ended. All combinations are possible, and the designer must catch the viewer's attention with attractive form in order to convince him to receive the content. The designer is continuously challenged to refresh his visual technique, and he is free to add his fingerprints to any given message, to make a poster more personal and subjective. This philosophy assumes the kind of visual virtuosity of which Tomaszewski is a master.

In 1959, Tomaszewski was already well accepted and famous for his intelligence, his acute opinions, and the sharpness of his sense of humor. He had behind him the study of music and painting, careers as a cartoonist, as an illustrator of children's books, as a stage and exhibition designer, and above all as a prominent poster designer. His independent approach to problem solving marked everything he designed. I should mention here a few characteristics of his work:

Theatre: Tomaszewski presents reality using conventions similar to those of the theatre. Like actors on the stage who create an illusion of the real world using characterization and other stage methods understandable to their audience, the ideas in Tomaszewski's posters are not reality as such, but only signs from which the viewer is expected to recreate reality in his imagination. Tomaszewski's is a theatre which knows many different conventions: from Greek tragedy to the pantomime and comedia dell'arte to the methods of Brecht or Stanislavsky. Here the designer is engaged in a dialogue with reality, mixing and changing conventions to suit his purpose. Looking at his posters is like participating in a performance, being fascinated by its magic and amazed by its beauty. Only after a while do we see clearly that he has shown us theatrical props while what remains in our imagination are real objects.

Irony: It is trivial to speak directly about emotions. It is better to use the cover of form. In Poland, the country of the Counter-Reformation, where emotional dissolutions are rarely controlled by reason, such an approach is not very common. Tomaszewski is a philosopher who understands very well how close the sublime is to the ridiculous, and being blessed with impeccable taste, he knows where the boundaries are that should not be crossed over. The irony visible in his works is like a shield being held out against the obviousness of direct speech. His questioning of existing canons and stereotypes is an intellectual game elevated to the rank of poetry.

Word: In all of Tomaszewski's projects the word is an image (or the image is a word). Word and Image are not contradictory notions here. Slogans and texts are woven together with the image to create a total unity. Tomaszewski rarely used printing type. More frequently he imitates it, giving a more personal look to the texts in his posters. Sometimes he creates his own font to best produce his intended effect. This was the case for MOORE.

In the second half of the 'fifties, the art of Henry Moore was a revelation for the artists of Poland, searching for a path towards Modernism. A human figure confronted with surrounding space is an eternal subject of sculpture, and the abstract forms raised by Moore had their own reference to the world of man. What was fascinating in his case was the shift of focus from the figure itself to the interplay between an internal and external space that the figure defined. This interplay itself became the subject of his compositions.

The five letters of the name MOORE are presented like five sculptures in a dark garden, illuminated by a frontal light. The sculptures are located in a space defined by the white line of horizon behind them and a strip of gray color the front, giving the sculptures a middle place in the field. Each of the five letters is different, each presents a different personality: M is angular, extracted from a square. The first O is frivolous and light. The second functions as a solid pedestal for a sculpture and simultaneously as a dark oval through which one sees a garden in the background. R is like a dancer doing pirouettes. Its whiteness is misshapen, inviting our eye to focus on the blue shapes it creates, playing the triangle, dot, and left edge against each other. The E seems to remember the sign of the British pound. Its two inside rectangles are quite different. The sharp edges of the top one are contrasted with the arching back and oval corners of the second one, underlining the flatness of the letter's foot. In the same way that sculpting requires eliminating the unnecessary parts of the stone, Tomaszewski captures the space that penetrates these letters, cutting out the unnecessary shapes of white paper.

The artist speaks reluctantly about the creation of this poster. He discloses only that under the pressure of outside circumstance he created and produced this poster in less than one hour, in a series of spontaneous gestures, directed by his intuition, rather than his conscious intent.

The artist must have noticed that something unusual had happened, that his gestures had opened before him new horizons. Since that time, for over thirty years a dialog between spontaneous gesture and controlling consciousness has fascinated Tomaszewski, rewarding us with dozens of delightful posters.

—Krzysztof Lenk

Bibliography—

Bialostocki, Jan, *The Graphic Arts in Poland 1845–1955*, Warsaw 1956.
Kwiatkowskia, Barbara, *Henryk Tomaszewski*, Warsaw 1959.
Bojko, Szymon, *Polska Sztuka Plakatu*, Warsaw 1971.
Meggs, Philip B., *A History of Graphic Design*, New York and London 1983.
Boczar, Danuta, "The Polish Poster," in *Art Journal* (New York), Spring 1984.

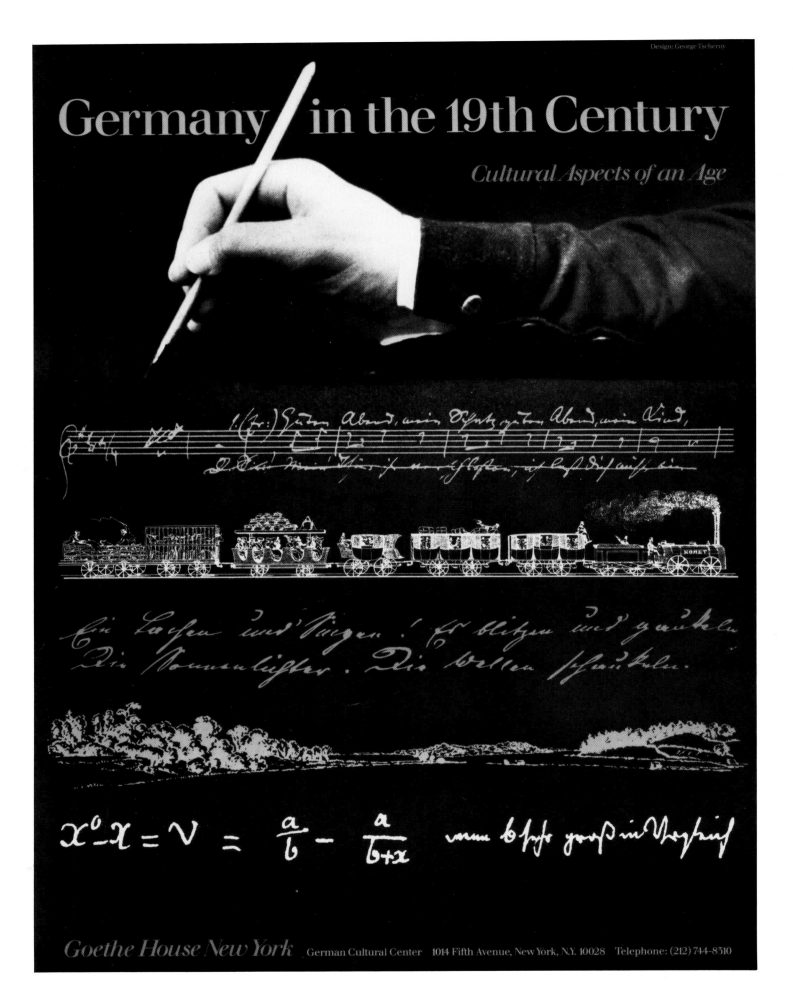

Design: George Tscherny

Germany / in the 19th Century

Cultural Aspects of an Age

Goethe House New York German Cultural Center 1014 Fifth Avenue, New York, N.Y. 10028 Telephone: (212) 744-8310

906

George Tscherny (1924–)
Germany in the 19th Century poster, 1980
Offset on coated paper; 22 × 29in.
Goethe House, New York

If there is a single characteristic which identifies the graphic design of George Tscherny, it is economy—an elegant simplicity of form which achieves, as he has expressed his ideal, "communication in its most intensified form." A classic illustration of Tscherny's gift for visual metaphor is his series of three posters for Goethe House New York produced between 1977 and 1980.

Goethe House, an American affiliate of the Goethe Institute in Munich, is a German cultural center which sponsors a variety of exhibitions, lectures, films, concerts, and other activities, and when it organized a series of events called "Berlin Now: Cultural Aspects of a City" in 1977, Tscherny was selected to create the poster announcing it. The designer had an advantage over his competitors for the assignment: raised in Berlin from the age of two and with German as his mother tongue, he had a natural feeling for the style and rhythm of the city. His design—a simple, vibrant abstraction comprising four irregular swirls of harmoniously contrastive color surmounting a concise text in clean, unembellished typography—was a compelling realization of the dynamic German capital. The 46-in. × 60-in. posters were fixed on the transparent walls of bus shelters all over New York City, their bright, dancing squiggles of orange-red, forest green, pea green, and (appropriately) Prussian blue glowing with the electric light behind them.

The success of this poster prompted Goethe House to call on Tscherny for another, somewhat more challenging project a year later. Its sophisticated series of expressionist films, plays, art exhibitions, literary seminars, and concerts, which ran from September, 1978, to January, 1979, was announced by a folded 16-in. × 25-in. poster which effectively conveyed the spirit of the artistic movement the series exhibited. Folded to an eight-by-eight-inch square, it confronted the viewer with a baleful eye, white against black, under the title. Unfolded, the poster revealed a stark, stylized human face, filling the entire 400 square inches, its brief text, in an austere sans-serif type, once more subordinated to the powerful image which symbolized its content. Like the art of *Berlin Now*, it was offset on uncoated stock from an original Tscherny painting in tempera.

Although known in the trade for his dedication to the principle of *multum in parvo*, Tscherny permits himself to violate the law of parsimony when it seems called for, and varies his methods and typography with his aesthetic and thematic purposes. The third and most complex of his Goethe House posters, created in 1980, echoed the title of his first, but the subject included more than the culture of a single city, even a city as richly diverse as Berlin. His client's ambitious program of events in 1981–82 was called *Germany in the 19th Century: Cultural Aspects of an Age*, and Tscherny felt that the poster announcing it (later used as the cover for a 14-page brochure) required more than the single image which had sufficed for its two predecessors. Offset on heavy coated stock, the 22-in. × 29-in. design undertook to represent separately all of the various elements of the series.

As the complex program of events sponsored by Goethe House (in conjunction with no fewer than 19 institutions in New York City and 15 in Germany) reflected work done in a variety of disparate fields, Tscherny had to discover a unifying image which applied to them all. He chose an arm clad in the sleeve of a 19th-century jacket, the hand holding a staff pen. The elements of German culture the series encompassed—music, technology, literature, art, and science—are all illustrated below, as if flowing from the pen.

Music is represented by a passage from Johannes Brahms's *lied* "A Serenade in Vain" in the composer's hand; an 1838 drawing of the projected Hamburg-Bergedorf Railroad Line illustrates German engineering; two lines of verse, photographed from the holograph of Heinrich Heine's "Life's Journey," exemplify literature; for art, Tscherny selected a horizontal detail from Caspar David Friedrich's romantic 1802–03 landscape *Lake Shore*; and a line of mathematical notation taken from the manuscript diary of physicist Georg Simon Ohm represents pure science. In each, Tscherny has found an image which might have been done by the pen depicted above, and one which fitted the format of the overall design.

It is characteristic of Tscherny that every element of this design was carefully researched and scrupulously accurate. The jacket sleeve, photographed by Tscherny on the arm of his assistant, was on a genuine garment, borrowed from a New York museum. For the Heine manuscript, Tscherny went to the Leo Baeck Institute in New York. All the other images he photographed personally at the Deutsches Museum in Munich.

Because such a complex combination of material might have been seen as a single, confusing symbol if it had all been presented in white on black, Tscherny introduced a delicate element of color to provide some contrast. The title is in gray, the subtitle and institutional credit in orange-red (in italic type rather than the Roman of the title), and the Brahms and Heine lines are in pale lavender, a color subtly in harmony with the sensitive music and poetry reproduced. The result is a series of independent symbols, clearly differentiated but organically related to a single theme. Without a single word of text beyond the title and institutional name, *Germany in the 19th Century* ingeniously summarizes 100 years of cultural achievement by symbols alone.

A series widely cited as a model of succinct communication, the stylish Goethe House posters are both rich in information and striking in visual impact. Each in its own way, they all convey their messages with simplicity and grace.

—Dennis Wepman

Bibliography—

Meggs, Philip B., *A History of Graphic Design*, New York 1983.
Meggs, Philip B., "George Tscherny," in *Graphis* (Zurich), March/April 1984.
Tscherny, George, "Design Philosophy," in *High Quality* (Munich), no. 4, 1986.
Craig, James, and Barton, Bruce, *Thirty Centuries of Graphic Design*, New York 1987.
Urban, Dieter, "George Tscherny, USA," in *Novum Gebrauchsgraphik* (Munich), April 1988.
Gottschall, Edward M., *Typographic Communications Today*, Cambridge, Massachusetts 1989.
Henrion, F. H. K., *AGI Annals*, Tokyo 1989.
Heller, Steven, "The Disarmingly Simple Design of George Tscherny," in *Graphic Design USA, no. 10*, New York 1989.

Massimo Vignelli (1931–)
Unigrid Design Program, 1976–77
The National Park Service, Washington, D.C.

Vincent Gleason joined the National Park Service as its publications officer in 1962. Previously, he had worked at the Pittsburgh advertising agency of Ketchum, MacLeod, & Grove, Inc., where he was involved in the Westinghouse visual identification program directed by Paul Rand, a project that permitted him to experience firsthand the value of graphic-design standards. Coming to the Park Service, Gleason advanced the idea of a uniform graphics program, and in 1964 initiated a program standardizing publications in a pocket-sized "minifolder" format utilizing Univers type and flat-color covers without illustrative material. Although this program responded to limited production budgets and Park Service cost-cutting efforts, it did not meet the diverse needs of parks for adequate information, particularly in the area of maps.

With the approach of the American Revolution Bicentennial in 1976, the Park Service experienced a surge of support enabling it to produce better quality publications and exhibits presenting the early history of the country. Within a few short months, the Park Service was able to improve its publications program through better paper, full-color printing, more detailed maps and illustrations, and opportunities to work more directly with printers. The 1970s also witnessed the imaginative but now-defunct Federal Design Improvement Program of the United States Government, which prompted more than 40 different Federal departments and agencies to initiate visual identification programs. Many of America's leading designers contributed to this improvement program.

At a 1976 design conference, Gleason attended an illustrated presentation about typography by graphic designer Tom Geismar, who discussed the merits of the format designed by Massimo Vignelli for *The Herald*, an innovative New York City newspaper. Impressed by the clarity and order of *The Herald*'s page makeup, Gleason retained Vignelli as a consultant to assist in developing a unified format for Park Service publications. Gleason asked Vignelli to help create a graphic system establishing basic design criteria for hundreds of Park Service publications, so that staff designers could concentrate on content, not "re-invent the wheel" with each new publication.

Vignelli worked closely with Gleason and his staff, not only in developing new design standards, but in implementing them as well. The resulting system of graphics was called the Unigrid Design Program to make it recognizable at some 370 parks across the country. A folder describing this new folder program was prepared by the NPS staff even before the program began. Specifications and standard formats were described on one side of the folder. Graphic components were specified and demonstrated on the other. The circulation of this instructional broadside throughout the Park System helped introduce the program and create good will for its methods.

The sustained energy of the Unigrid Program owes much to Vignelli's continuing interest and participation in Park Service work as well as to the fact that the original NPS design team of Vincent Gleason, Dennis McLaughlin, Nicholas Kirilloff, Melissa Cronyn, Linda Meyers, Phillip Musselwhite, and Mitchell Zetlin, remained unchanged through the first dozen years of work.

The Unigrid system standardized the design of hundreds of informational folders used at Park Service sites. It is based on exquisitely simple elements: ten basic format sizes, all derived from the basic unigrid; black title bands with park names serving as logotypes; horizontal organization of illustrations, maps, and text; standardized typographic specifications; black bars or bands separating pages into zones of information; and a master grid coordinating design in the studio with production at the printing plant. Each folder is treated as a single surface rather than a series of folded panels, since experience had shown that most people completely unfold a folder just as they do a map before reading it. A single white dull-coated 70-pound text paper in two standard sizes is used, allowing economical carload purchases. Typography is restricted to two faces in a limited number of sizes and weights. Helvetica, the principle typeface for Unigrid maps and folders, proved to be a sound choice for both legibility and ease of maintenance.

The standardized format of the Unigrid system, much like a daily newspaper, enables the publications staff to focus on the organization and presentation of pictorial and typographic information. The program proved so successful that Vignelli developed another unifying graphics system for Park Service handbooks, a series expected to reach 150 titles. During the decade and a half since the unigrid methodology began, its continued vitality and effectiveness demonstrate the value of design systems for large organizations. Most Park Service folders having been redesigned using the Unigrid concept, the Park Service is now planning for their extended use as in Atlas of the National Park System.

For the Park Service, publications have long been a primary force in the agency's public-service work. Each year it issues about 250 titles, often with corrections, which keep them current, and in quantities of about 25 million pieces. To amortize the investment in texts, maps, and illustrations, most titles are long-lasting, remaining in print for some 10 to 20 years. The unigrid approach has not only put the agency's studio work on a sounder economic basis, it likewise has increased the program's popularity with park managers and park-users.

Vignelli notes that most of the identification systems he has designed have gradually disintegrated with changes in corporate staffs and priorities. The Park Service Unigrid Program, however, has flourished for 15 years while maintaining the high standards advanced in the original graphic specifications. Consistency in its publications program has also provided the Park Service with a strong, unifying graphic identity.

In 1984 a distinguished jury cited the National Park Service with a Presidential Design Award for its implementation of the Unigrid Design Program. The jury citation proclaimed: "The Unigrid Design Program brings uniformity and quality to the communications of the National Park Service. This agency, one of the most advanced in its use of design, has a communications program which is admirable in many aspects. The Unigrid Design Program, however, is the cornerstone of the overall program. The program fulfils the primary objective of a design system: reducing routine decisions so that effort can be concentrated on quality. The implementation of the program demonstrates sensitivity to the wide variety of subject matter and attention to detail. It is an example to others and has already achieved international recognition."

—Philip B. Meggs

Bibliography—

National Park Service, *Unigrid Design Specifications*, Washington, D.C. 1977.
Gleason, Vincent, "National Parks USA," in *Graphis* (Zurich), no. 229, 1984.
Dykeman, Wilma, "Documenting National Parks," in the *New York Times*, 14 April 1985.
Gleason, Vincent, "Maps for Parklands," in *The American Cartographer* (Washington, D.C.), July 1987.
"Hall of Fame: Lella and Massimo Vignelli," in *Interior Design* (New York), December 1988.
Herndon, Constance, "Designers in Space," in *Print* (New York), September/October 1989.

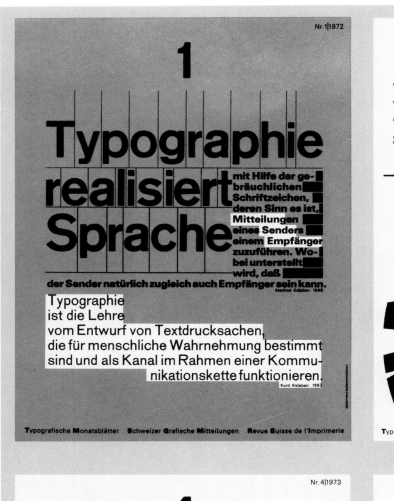
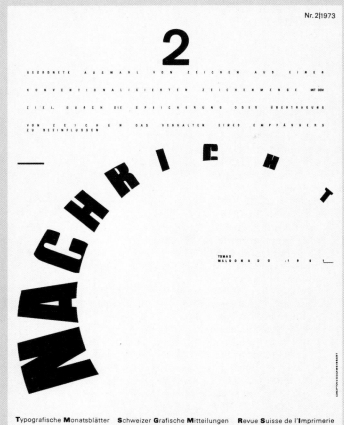

Illustrations courtesy of Wolfgang Weingart

Wolfgang Weingart (1941–)
Typographische Monatsblatter magazine cover designs, 1972–76
Zollikofer AG, St. Gall, Switzerland

"Typography is not only for reading; typography can be a game, and a lot of fun." (Wolfgang Weingart, 1985).

For almost 25 years these thoughts were part of the guiding principles in typography at the Basel School of Design in Switzerland. To know Wolfgang Weingart is to appreciate his unique thoughts on type, typography and learning. Since 1968 his impact has been considerable and, along with Emil Ruder and Armin Hofmann, Basel has emerged as an international center for creative and innovative approach to teaching and learning about typography and design.

Between 1972 and 1976 a series of magazine covers appeared for a publication entitled "*Typographische Monatsblatter*" (aka "Schweitzer Graphische Mitteilungen," "Revue Suisse de l'Imprimerie"). Weingart proposed a bold experiment in cover design which he describes as a basic change over from "seeing-covers" (or "seh umschlaege") to "learning covers" (or "lern umschlaege"). He sought to confront and deliberately provoke the theorists and the practitioners by creating a form of "anti-typography." All rules about legibility, readability and communication were re-examined and re-interpreted: "What good is readability when nothing in the text attracts one to even read it." Subjectivity was encouraged; imagery which irritated and even confused was employed to jolt and stimulate the viewer to reconsider the role of communication and type. The approach was reactionary, controversial and to his critics it seemed even self-serving: "We attempt to experimentally test the semantic and syntactic possibilities of typography, and to break through its ideological borders by consciously ignoring the traditional hints and recipes for typographic design." He embraces no philosophy but exhorts process and proclaims that learning typography can be fun. In a revealing article in *Design Quarterly* (1985) he further underscores this by listing a series of bizarre adjectives that describe typography as classical, systematic, ugly, rigid, crazy, Swiss, etc.

The 1972 *TM* covers are definitive, explanatory, learning covers. Type is a "noiseless" (Weingart's term for uncluttered approach to typography best achieved with sans serif type) sans serif combined with simple, linear diagram. Point sizes vary, rules, grids and borders are devices for emphasis and all covers are rendered in black and white. Each cover analyzes typographically and visually a quotation on an aspect of communication; speech, the alphabet, writing, etc. In 1973, the covers begin to take on a more textural feel. The format and themes are similar to the previous year. In issue number 5, Emil Ruder's 1967 quote is composed in three languages and reproduced in varying levels of focus to dramatically amplify the relationship of the purpose and role of typography and readability. An issue featuring a quote by Kurt Schwitters obliterates and obscures the text, heightening its visual impact. The final cover for the series is the most provocative and begs the question, "What is typography?" Its reply is a 1964 Carl Dair definition and homage to type arranged in an Albers-like composition. The effect is one of simple elegance and symmetry.

The covers for 1974–76 deal with very specific themes. Issues 1 and 2 for 1974 described the nature of a *TM* cover series competition and a solicitation for entries. The 1975 series display various examples of non-verbal communication systems; hand-signing, semaphores, braille, morse code, a computer card and computer punched tapes. Each system employed in the design is used to spell out the title, issue number, month and year of the magazine.

Whatever you see in Weingart's work, whether it's a poster or a cover, whether you've heard his lecture or sat in his classroom in Basel you come away with more questions than answers to "How Can One Make Swiss Typography?" One of his critics have said that "one must swim against the current to discover the source of the stream." These covers coerce viewers to read and learn. They sometimes challenge you as in a game and some even evoke a sense of playfulness.

—Dennis Ichiyama

Bibliography—

Weingart, Wolfgang, *How Can One Make Swiss Typography?*, Basel 1972, London 1987.
Henrion, F. H. K., *Top Graphic Design*, Zurich 1983.
Weingart, Wolfgang, "My Typography Instruction at the Basel School of Design," in *Design Quarterly* (Minneapolis), no. 130, 1985.

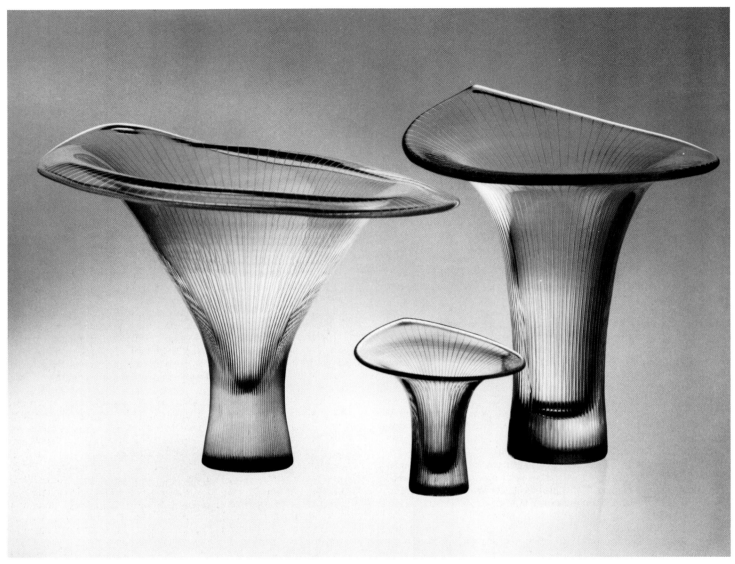

Photo Iittala Glass Museum

Tapio Wirkkala (1915–85)
Chanterelle glass vases, 1947
Blown colourless glass with cut decoration 21.4 cm. wide
Iittala Glass, Finland

The name *Chanterelle* gives a clue to the botanists and culinarists amongst us about this delicate curved work's origins. The shape—with the long stem and the fact that balance has been retained and it does not topple over—hints at function. And the beauty reveals the passion that has gone into *Chanterelle*'s creation. Together these three characteristics give all of us at least a superficial appreciation of one of the great classics of applied art in glass—the *Chanterelle* vase by the Finnish master Tapio Wirkkala. *Chanterelle* is also a work which arouses passions in a different way since it represents one of classic dilemmas facing applied arts—how much of a balance to retain between form and function. This debate raged with a vengeance—or at least as much as Scandinavians can get heated up about such things—during the postwar years in Finland, both because of the prewar addiction to Bauhaus and its Finnish variant Funkis, and immediate shortages of materials and resources at the end of the war which meant design had to be literally rationed.

Wirkkala and his fellow designer at the Iittala Glassworks, Timo Sarpeneva, believed, however, as the country got back on its feet in an astonishingly quick time, that people should be "rewarded" with more elegant choices in applied art design. The balance should be tipped more in favour of art than applied. While with many artists philosophical pretensions should perhaps be taken with a pinch of salt to say the least, it is important never to underestimate the philosophical content of not only Finnish, but also Scandinavian applied art in general. Fortunately Iittala agreed—and they were perhaps also looking to repeat their prewar international successes with Alvar Aalto and his asymmetrical *Savoy* works and the utility glass series designed by his wife Aino Aalto. Thus *Chanterelle* found itself as part of Wirkkala's contribution to the incredible Finnish exhibit at the 1951 Milan Triennale which carried off a total of seven gold and eight silver medals. The limited editions were soon sold, and *Chanterelle* went into series production for some 15 years and soon almost every Finnish home.

International sales were also healthy. *Chanterelle* was also one of the first results of the 40-year cooperation between Wirkkala and the Iittala glassworks. Cooperation that was to lead to other masterpieces such as his *Ultima Thule* sculpture. However, it is to the credit of Finnish employers—and perhaps a secret of their relative success—that he was also free to work with other companies abroad. Thus he spent successful periods with both Rosenthal and Venini.

What a mixture of relief and elation the Milan success must have brought! Although Finland had a reasonable tradition of design and of course the great name of Aalto, for such a small country, relatively undeveloped, to take on the rest of the world still requires courage to say the least. It is perhaps difficult for us to imagine how someone like Wirkkala could have the confidence or, perhaps cynically, we even might think, nerve to even try. Yet paradoxically Finland's smallness is one of its greatest strengths—it was far easier for a genuine talent to be spotted, nurtured and given a chance to compete at international level. The facilities to support its artists almost with sporting fervour. The latter probably because they could see both where their applied artists were coming from and going to. Thus, Wirkkala was able to make a quantum leap with *Chanterelle* and say, "here is a vase that is no longer a vase if you do not want it be one. Instead it can be a pure art object." Which, of course, is so much easier than going the other way.

The other great help to the public was that they knew where Wirkkala drew his inspiration from—the same place as they did—Finnish nature. Yet his elegant sophisticated curves perhaps helped them see it in a different light—as it helps us. Think of Finland, and you probably conjur up snow and ice, long freezing winters, wild untamed wildernesses in Lapland, dense forests, jagged rocks, and a very arctic flora and fauna, etc. Overall a rather bleak rugged picture. Which is true—yet if you then take another look through Wirkkala's eyes you see beautiful natural intricate forms, such as rocks rounded and smoothed by the elements over thousands of years—Finland has some of the oldest rock formations in Europe. Or ice and snow sculpted by nature into wonderful shapes. Or flowers skilfully adapted for survival yet still stunningly attractive. Also very clearly defined lasting forms—nature has not been transformed by agriculture, man, etc. to the same extent as elsewhere. And from this simplicity comes beauty—beauty which can be equally appreciated by Finns and outsiders, when captured in Tapio Wirkkala's *Chanterelle*. An equally powerful ingredient is Finnish folklore—the national epic, the Kalevala, is on a par with the great myths of mankind and its themes run through Wirkkala's work. He also went on to become just as committed to preserving Finnish glassware, and was a driving force behind the creation of the Finnish Glass Museum in the 1980s.

On a purely technical level after all this waxing lyrical, it is worth noting Wirkkala's mastery of his materials. His use of engraved lines to capture the texture of the *Chanterelle*—so simple, yet effective and a device used in many of his later works. Wirkkala's own unwritten rule was that all materials have their own unwritten laws and that the artist should never violate the material he/she works with. And of course the curved, asymmetric mouth which immediately challenges our (usually) most cherished preconception of applied art—that if something is in series production it must be straight-lined. Put four or five *Chanterelles* in a row and no matter what measuring devices tell you, your eye will convince you that each and every one is an individual masterpiece. The ultimate illusion, which no doubt is worthy of a debate of its own.

—Richard Hayhurst

Bibliography—

Polak, Ada, *Modern Glass*, London 1962.
Moller, Svend Erik, *34 Scandinavian Designers*, Copenhagen 1967.
Beard, Geoffrey, *International Modern Glass*, London 1976.
Finnish Museum of Applied Arts, *Form Finland 1986*, Helsinki 1986.
Hawkins Opie, Jennifer, *Scandinavia: Ceramics and Glass in the Twentieth Century*, London 1989.

Photos courtesy of Benno Wissing

Benno Wissing (1922–)/**Total Design** (1963–)
Schiphol Airport Identity Program, Amsterdam, 1963
Municipality of Amsterdam

The Schiphol guidance system job did not come directly to Benno Wissing—co-founder and partner in the Total Design group—from the municipality of Amsterdam, owner of the airport, but through Kho Liang Ie, an Indonesian-born Chinese interior architect who had accepted the interior design commission on the provision that he could count on Wissing's analysis for the development of a reliable guidance system; Ie's designs were to focus on the anticipated mass-traffic aspects of the commission. Ie and Wissing decided to do as little "designer's design" as possible, which meant limiting themselves to the smallest number of style types required after the overall grand plan and layout had been selected. Airport design—especially the floor plan—is influenced to a great extent by the need to service as many aircraft as possible at any given time, a factor directly related to the City of Amsterdam's investment in and anticipated revenue from the building.

The design work took place in the early 1960s, and coincided with an awareness that larger and larger planes were under construction; planning the size of aircraft berthing areas had become a gamble to be countered by adding space which, in turn, lengthened access routes for passengers. Although moving walkways were an untried innovation at the time, their installation was nonetheless planned.

When a reasonable balance between the length of access routes and the minimum-capacity of berthing areas had been established, Wissing and Ie had to create a feasible and user-friendly transformation of a three-armed pod system constructed mainly from steel, concrete and aluminium. Ie concluded that a sheathing material to cover the steel and concrete components was needed. He spent a considerable time working out the design with potential manufacturers of three variations of a white tile which would allow him to create many different types of surface skin. The concept of an all-white interior, in stark contrast to the durable black rubber flooring, provided a perfectly neutral background for Wissing's signage system.

The characteristic of "readability" was a prime concern for Wissing, who proceeded to make an indexed study of the distances over which certain information should remain clearly legible. This index of visibility became the method and criterion by which he could select a single typeface to uniquely express relevant information to the airport's users.

During visits to foreign airports, Wissing focused on two types of information for which sign-systems would be required: the most demanding is departure and time-related information; the other is all non-flight related terminology, such as restaurants, toilets, shops, telephones, etc. The latter category might even contain information with only a temporary value, such as: "This desk will re-open at 2 am." It was concluded that the differentiation between semantically-different message types could be indicated by two colours. The problem was complicated by the stringent requirement that information should be displayed in both Dutch and English, with priority given to Dutch.

Bearing in mind that there are people for whom even the Roman alphabet, the carrier of most European and American languages, is an alien form, Wissing wanted to provide a fail-safe solution for passenger guidance signage. He reasoned that, instead of trying to make foreign people understand a semantically-laden word, it might be more "international" to offer an extremely simple set of alphanumerical characters like A5, B12, C22—short and memorable indications wherein the letter part did not carry semantic suggestion, but which would formally coincide with a sign to be encountered later in the flight-boarding process.

So that potential passengers would at the earliest moment connect plane identification, flight number and flight-time with the alphanumerical indication of the aircraft berthing location, the signage device was required to: (a) chronologically list a number of scheduled flights, and (b) by its appearance, attract enough attention to indicate that the device contained imperative information.

Although it was known that people familiar with Roman lettering find a conventional analog clock face easier to read, the requirement to supply up-to-date schedule information meant that a digitized system with electronic updating facility was needed. Among the commercially-available digital systems at the time, there was not much choice. Only one type had the advantage of being able to easily delete the near-departure information and to display delay-time and cancellation data, so making the updating process a lively visual adventure. Despite Wissing's dislike of the thin Gill typeface that was employed as standard for the original product, the choice went to a recently-invented system by Solari SA of Italy. Solari was willing to produce a trial model displaying two complete lines of departure information—using the letter type of Wissing's choice.

The typeface that emerged as number one in readability tests was not Helvetica—as widely quoted by professional commentators in their praise of Schiphol's signage system—but a lighter weight predecessor designed and cast by Bertholt in Berlin in 1896. So admirably suited was this Bertholt grotesque font to the purposes of the signage that, to make the typeface fit the standard width of the Solari units, Wissing made corrections only to letter-spacing and to the letters M and W.

The system resulted in Schiphol being cited as *the* classic airport signage program of the western world. Wissing subsequently produced signage and identity programs for numerous institutions worldwide, including the University of Louvain, Belgium, Ahoy Sports Stadium and De Doelen Concert Hall in Rotterdam, the Martini exhibition complex in Groningen, SNS Transport of Algeria, Tel Aviv Transport Centre in Isreal, Rhode Island Hospital in Providence, King Khalid Military City in Iran, Banco De Edwards in Santiago de Chile, and the Hub Terminal of Raleigh-Durham, North Carolina.

—Garance Nienhuis

Bibliography—

Broos, Kees, *Design: Total Design*, Utrecht 1983.
Staal, Gert, and Wolters, Hester, eds., *Holland in Vorm*, The Hague 1987.
Henrion, F. H. K., *AGI Annals*, Zurich 1989.
Baxter, Lynn, "Airport Graphics: Raleigh-Durham," in *Identity* (New York), Spring 1989.

Photo Philadelphia Museum of Art, Gift of Kartell, USA

916

Marco Zanuso (1916–)/**Richard Sapper** (1932–)
Model 4999 child's stacking chair, 1964
Low-density polyethylene; 10½ × 10½ × 19½in. (27 × 27 × 49.5cm.)
Kartell, Noviglio, Milan

The significance of the *Child's Stacking Chair*, designed by Marco Zanuso and Richard Sapper, has not been clearly articulated in the literature. We presume this is partially because of the object's scale. So many adult-sized chairs have overshadowed this small, but very relative and important product. Both Joe Colombo's *4867 Chair* (1965) and Carlo Bartoli's *4875 Chair* (1974), also manufactured by Kartell, used the *Child's Stacking Chair* structural approach (backrest and seat made from a single piece with the legs inserted into the body of the chair) as their inspiration.

This product was the result of a commission to design durable classroom furniture that could also be safely used for heavy play. The end-users were children of Kindergarten and First Grade Level. The client for the project was the city of Milan.

The design process for the *Child's Stacking Chair* started in 1960 and found full realization in 1964. The resulting design became the first mass-produced chair in the world completely made of a plastic (polymer) material. The *Panton Chair*, also designed in 1960 by the Dane, Verner Panton, was conceived as a one-piece all plastic chair. However, the *Panton Chair* was not put into production until 1967, by which time the man-made glass-reinforced plastic material used for the chair had sufficiently been developed and refined for the purpose. Thus, the realization of the *Child's Stacking Chair* predates the *Panton Chair*.

This design also became the first piece of furniture produced by Kartell. Before this chair design, Kartell had been a manufacturer of housewares. Since the early 1950s, Kartell evolved as one of the most influential Italian manufactures of high quality designed household products.

The model number for the *Child's Stacking Chair* was 4999. The chair was not marked or signed in the mold with any indication of manufacturer, country of origin, model number, or name of designer. The design is extremely unique and complex, requiring costly production methods; thus it was never subject to being imitated or knocked off. Kartell made the *Child's Stacking Chair* available in four colors: white, red, yellow, and signal blue.

The chair was conceived as a simple geometric shape and was to have flat external surfaces to meet the requirements of modularity. The seat and back were designed as a single element and molded in a single operation. The corrugated or ribbed surface on the seat and back allow for circulation of air around the body. This linear design of the seat and back is complex within itself. The ribs are continuous, flowing from the seat up to the back. The top edge of the back is finished off with the ribbed openings terminating as radiused voids. The seat front, however, is terminated at the front edge as radiused solid ribs.

The seat is contoured in section with a lumbar support for the back and a well for the buttocks. The back, rear elevation, has an exaggerated deeper rib that appears very structural, but at the same time very delicate. The large cylindrical legs balance visually with the concave or hollowed upper corner supports. This void accepts the rear legs when the chairs are stacked.

Because of the eight-millimeter material thickness required for structural stability with the use of low density polyethylene, the chair evolved as a stronger element than conventional children's chairs. This enabled the chair to be used in the building of various stackable play structures. Spatial modularity could be achieved by inserting the legs of one chair into the backrest of another. The leg is a large elongated cylinder with small, inset terminal feet. The legs were demountable for shipping purposes. The scale of the leg is manageable for a child to easily grip and construct castles, towers, trains, etc. At the same time, the chair is indestructible and soft enough not to harm anyone, yet too heavy to be thrown. The chair weighs 5 pounds (2.25 kilograms).

At the beginning of the project, sheet metal was considered for the design; however, it was thought to be too heavy and unsafe. Wood was also considered, but it lacked the durability of polyethylene and required too much maintenance. Ultimately, an all-synthetic chair design was pursued.

Production of injection-molded polyethylene began in 1953. In the mid 1960s, the international patents on the polymer, polyethylene expired, causing a drop in the price of the material. The lowered cost and the material's durability satisfied Marco Zanuso's and Richard Sapper's need for a synthetic material suited to the performance specifications of the project. During the 1940s, low density polyethylene was primarily used in the production of ice cube trays, dish pans, and wash pails. It is an extremely tough material that is resistant to breakage and staining. The material is also easily washable.

The injection molding process is as follows: the plastic (polymer), in powder or granule form, is fed into the heated area of the machine where it is converted into a liquid. The liquid plastic is forced under pressure into a cool steel mold, which is made up of two or more parts. After the liquid plastic hardens to a solid, the mold is separated, releasing the fabricated component.

It is important to maintain a consistent thickness in the material and to limit the depth of molding cavities. The *Child's Stacking Chair* established high standards for the quality detailing of plastic furniture products.

The *Child's Stacking Chair* won the Compasso d' Oro in 1964, a Gold Medal at the Milano Triennale in 1965, and was exhibited at *Italy: The New Domestic Landscape* at the Museum of Modern Art in New York in 1972. It is also included in the Design Collection of the Philadelphia Museum of Art as a result of the *Design Since 1945* exhibit held there in 1983.

Kartell, as a company, won a Compasso d' Oro in 1979 for its policy based on coherence of product design and high level of research and development.

The *Child's Stacking Chair* initially was sold through wholesalers. As a result, the chair had low sales volume because of wholesalers reluctance to promote new, innovative, and different products. Kartell then set up new sales channels directly to furnishings stores. Although sales increased considerably, they did not justify the cost of fabricating new molds. The production of the *Child's Stacking Chair* ended in 1980, when the old molds were worn beyond continued use. The chair retailed in 1980 for 30 United States Dollars. The chair was available in the United States for a few years after production ceased from Kartell's inventory.

The form of the *Child's Stacking Chair* clearly expresses the basic idea of the product and thus encourages the creative use of the chair.

—Jerryll Habegger and Joseph H. Osman

Bibliography—

Mang, Karl, *History of Modern Furniture*, New York 1979.
Sembach, Klaus-Jurgen, *Contemporary Furniture*, New York 1982.
Mastropietro, Mario, *An Industry for Design: The Research, Designers and Corporate Image of B+B Italia*, Milan 1982.
Hiesinger, Kathryn, and Marcus, George, *Design Since 1945*, Philadelphia and London 1983.
Di Natale, Marina, *The Italian Chair*, Rome 1983.
Ferrieri, Anna Castelli, and Morello, Augusto, *Plastic and Design: From Project to Product*, Milan 1988.

NOTES ON ADVISERS AND CONTRIBUTORS

AMMANN, Jean-Christophe. Adviser. Director, Museum fur Moderne Kunst, Frankfurt am Main. Formerly, Director of the Kunstmuseum, Lucerne, 1969–77, and Kunsthalle, Basel, 1978–88. Author of *Von Hodler zur Antiform*, with Harald Szeemann, 1968; *Louis Mollet: Das Gesamtwerk*, 1972.

ANDREOTTI, Libero. Essayist. Professor of Architecture, Georgia Institute of Technology, Atlanta. Editorial Board Member, *Journal of Architectural Education*. **Essays:** Grassi: Chieti Student Centre; Von Spreckelsen: Arche de La Defense, Paris.

ARAH, Jessica. Essayist. Freelance writer and student of twentieth-century Japanese culture, London. Formerly, editor of *Zasshi* magazine, and *Japanese Investment Manager*. **Essay:** Hosoe: Barakei, or Ordeal by Roses.

ARMANDO, Diego R. Essayist. Practising architect and architectural writer, Buenos Aires. Formerly, architectural editor of *El Cronista Comercial*. Contributor to *Architecture + Urbanism*, *Diseno y Decoracion*, and *Noticias*. **Essays:** Magistretti: Selene chair; Piretti: Plia chair.

ARSENAULT, Andrea. Adviser and essayist. Fashion instructor, School of the Art Institute of Chicago; also freelance fashion designer. **Essays:** Jahn: United Airlines Terminal, Chicago; Leibovitz: Steve Martin portrait; Mies van der Rohe: Farnsworth House; Skrebneski: Vanessa Redgrave portrait.

ASHWIN, Clive. Essayist. Freelance writer and consultant on art, design and education, Hertfordshire. Formerly, Professor and Dean of Education, Middlesex Polytechnic. Author of *Drawing and Education in German-Speaking Europe*, 1981; *Encyclopaedia of Drawing*, 1982; *History of Graphic Design and Communication*, 1983; *Education for Crafts*, 1989. **Essays:** Aalto: Paimio Tuberculosis Sanatorium; Bayer: Ski in Aspen poster.

BELLOLI, Carlo. Essayist. Freelance writer, critic and historian of art, Milan. Conservator of the International Institute for Studies on Futurism, and director of the Plastic Arts Studies Program of the Accademia del Mediterraneo. Author of *Filologia cibernetica e linguaggio dell'estetica*, 1953; *Per una estetica neomediterranea*, 1958; *Telespazialita di Vasarely*, 1961; *L'opera grafica di Robert e Sonia Delaunay*, 1962; *Magnelli fra 44 protagonisti della visualita struttura*, 1964; *Il contributo russo alle avanguardie plastiche*, 1964; *Iconografia di F. T. Marinetti. fondatore del Futurismo*, 1982; *Pour un ballet cinevisuel*, 1986; *Arte costruita: incidenza italiana*, 1989. **Essays:** Delaunay: Colour Rhythms; Magnelli: Equilibre; Vasarely: Orion MC.

BERNSEN, Jens. Essayist. Director of the Danish Design Centre, and the Danish Design Council,

Copenhagen. Formerly, operations research project manager, with Christian Rovsing International, 1968–77. Author of *The Structure and Dynamics of Cities*, 1976; *Design: The Problem Comes First*, 1982; *The Spirit of the Trademark*, 1985; *ABC Design*, 1988; *Innovation via Design*, 1990. **Essays:** Haugesen: Haugesen table; Helweg-Larsen: Question-mark telephone booth; Henningsen: PH Artichoke Lamp; Holscher: D-Line system; Lego Gruppen: LEGO Brick System; Kjaerholm: Model 91 folding chair; Panton: Panton fibreglass chair.

BIRGUS, Vladimir. Essayist. Freelance photographer and writer, Prague. Director of the Institute of Creative Photography, Silesian University, Opava; instructor in photography, FAMU Film and Television Academy, Prague. Author of *Frantisek Drtikol*, 1988; *Contemporary Czechoslovak Photography*, 1990; *The Development of Czechoslovak Photography 1945–1989*, 1990. **Essays:** Drtikol: Wave; Giacomelli: Scanno; Macijauskas: Veterinary Clinic.

BOBROWSKI, Ryszard. Essayist. Freelance art critic and exhibition curator, Warsaw. Formerly, Director of the Hybrydy Photo Art Gallery, Warsaw University, 1985–90. Contributor to *Kultura*, *Literatura*, *Projekt*, *Fotografia*, and *European Photography*. **Essays:** A. Adams: Moon and Half Dome over Yosemite; Bujak: Funeral of Our Lady; Dlubak: Onda; Dorys: Kazimierz on the Vistula; Faucon: The Banquet; Lach-Lachowicz: Artificial Photography; Munkacsi: Lucile Brokaw in Beach Costume.

BOGNAR, Botond. Essayist. Freelance architectural writer and photographer, Illinois. Professor of Architecture, University of Illinois. Formerly, Architect in Charge, Design Institute for Public Buildings, Budapest, and designer with Design System Company, Tokyo. Author of *Japanese Architecture of Today*, 1979; *Contemporary Japanese Architecture*, 1985; *New Japanese Architecture*, 1990. **Essays:** Ando: Koshino House, Ashiya; Hara: Yamoto International Building, Tokyo; Maki: Municipal Gymnasium, Fujisawa; Hasegawa: Shonandai Cultural Center, Fujisawa; Ito: Silver Hut, Tokyo; Kurokawa: Nagakin Capsule Tower, Tokyo; Maki: Municipal Gymnasium, fujisawa; Spiral Building, Tokyo; Makovecz: Catholic Church, Paks; Mayekawa: Tokyo Metropolitan Festival Hall; Kikutake: Hotel Tokoen, Yonago; Shinohara: Tokyo Institute of Technology; Tange: National Olympic Gymnasium, Tokyo.

BOJKO, Szymon. Essayist. Freelance art and design critic, Warsaw. Board member, State Council of Industrial Design, Warsaw, 1960–67; editorial board member, *Projekt* magazine, Warsaw, 1969–74; editor, *Polish Art Review*, Warsaw, 1971–72. Author of *Art of the Polish Poster*, 1972; *New Graphic Design in Revolutionary Russia*, 1972; *The Polish Poster*, 1973. **Essay:** Saudek: Another Child Is Born.

BOLT, Anne. Essayist. Freelance photo-journalist and writer on photography, London. **Essays:** Bown: Portrait of Cilla Black; Hopkins: All Night Vigil at Buckingham Palace; McBean: Surreal Portrait of Frances Day.

BOODLE, Camilla. Essayist. Freelance writer and art historian, Oxford. Formerly, editor of *Museum News*, 1985–90. Author of *Eureka! Guidebook to Museums and Galleries*, 1991. **Essays:** de Stael: Marathon; Francis: In Lovely Blueness; Frankenthaler: Flood; Guston: The Clock; Manzu: Christ with General; Shahn: Red Stairway; Spencer: Blast Furnaces; Riley: Cataract 3; Smith: Cubi XIX; Stella: Tahkt I-Sulayman I.

BRIERLEY, Edwin S. Essayist. Senior Lecturer in Architecture, Leicester Polytechnic. Author of *De Stijl and the Amsterdam School*, 1979; *J. L. M. Lauwerik's Proportional Systems and Geometrical Structure Drawings*, 1980; *J. B. Bakema, an Architect's Social Attitude to Design*, 1985. **Essays:** Bo/Wohlert: Louisiana Museum; Botta: Casa Rotonda, Stabio; Hertzberger: Central Beheer, Apeldoorn; Van Eyck: Hubertus House, Amsterdam.

BRYANT, Edward. Essayist. Professor of Art, University of New Mexico. **Essay:** Golub: Interrogation II.

CALDWELL, Susan Havens. Essayist. Associate Professor of Art, University of Oklahoma. Author of *Ken D. Little*, exhibition catalogue, 1983; *Songs of Glory*, exhibition catalogue, 1985; *And They Sang a New Song*, television script, 1988. **Essays:** De Maria: Lightning Field; Oppenheim: Dejeuner en Fourrure.

CARMIN, James H. Essayist. Architecture and Allied Arts Librarian, University of Oregon. Contributor to *Art Documentation*, *Art Libraries Journal*, *Choice*, *Visual Resources*, and *Landscape Architecture*. **Essay:** Castiglioni: Mezzadro Chair.

CAWS, Mary-Ann. Essayist. Distinguished Professor of English, French and Comparative Literature, City University of New York. Author of *Poetry of Dada and Surrealism*, 1970; *Presence of Rene Char*, 1976; *Textual Analysis*, 1988; *Women and Surrealism*, 1991. **Essays:** Adami: Sigmund Freud in Viaggio verso Londra; Cornell: Untitled Construction; Schwitters: Merz 19.

CHALUMEAU, Jean-Luc. Essayist. Director, *Opus International* review, Paris; Head of Art Studies, University of Paris VIII. Formerly, Conference Chief, Institute d'Etudes Politiques, Paris, 1972–88. Author of *Introduction a l'Art d'Aujourd'hui*, 1971; *L'Art au Present*, 1985; *Lectures de l'Art*, 1991. **Essays:** Braque: Le Billard; Cesar: Compression Plastique; Buren: Pavillon Coupe, Decoupe, Taille, Grave; Esteve: Aquarium; Soulages: Painting, 1948–49.

CHELAZZI, Giuliano. Essayist. Architect in pri-

vate practice, and independent painter, Florence. Formerly, instructor in architectonic composition, University of Florence, 1984–85. **Essays:** De Carlo: Faculty of Education, Urbino; Valle: Zanussi Factory, Pordenone.

CHEVALIER, Tracy. Essayist. Editor and freelance writer, London. Editor of *Twentieth-Century Children's Writers*, 1990, and *Contemporary Poets*, 1991. **Essay:** British Aerospace: Concorde supersonic aircraft.

CHOVANEC, Stephen. Essayist. Assistant Professor of Design, Oregon State University. Formerly, graphic designer, Crestar Bank Marketing Department, Virginia, 1985–87; Senior designer, Virginia Museum of Fine Arts, 1987-90. Co-author of *The Art of Graphic Design*, exhibition catalogue, 1990. **Essays:** I. Chermayeff: Mobil Masterpiece Theatre posters; Dorfsman: Of Black America advert.

CIEZKOWSKI, Krzyzstof. Essayist. Acquisitions Librarian, Tate Gallery, London. **Essays:** Bacon: Three Studies for Crucifixion; Bravo: Madonna; Butler: Monument to Unknown Political Prisoner; Wesselmann: Great American Nude 57.

CIOLEK, Nancy. Essayist. Freelance graphic designer, Rochester, New York; Assistant Professor of Graphic Design, Rochester Institute of Technology. **Essay:** Thompson: Washburn Bible.

CLARK, Hazel. Essayist. Head of Historical and Theoretical Studies, Ravensbourne College of Design and Communication; Chairperson of the Design History Society. Author of *Textile Printing*, 1985; *Fashion Design*, 1991. **Essays:** BIB Design: Durabeam Torch; Courreges: Couture Future fashions; Marx: London Transport textiles; Quant: Mini-skirt; Sony Corp: Walkman radio/cassette player.

CORBINO, Marcia. Essayist. Freelance writer and art consultant, Sarasota, Florida. **Essay:** Chamberlain: Sweet William.

CORMIER, Leslie Humm. Essayist. Freelance architectural historian and critic, Wellsesly, Massachusetts. **Essay:** Gwathmey/Siegel: Busch-Reisinger Museum, Cambridge, Massachusetts.

COULTER-SMITH, Graham. Essayist. Lecturer in Art History and Theory, Queensland College of Art, Brisbane; founding editor, *Eyeline* magazine, Brisbane. Author of *Mike Parr*, 1991. **Essays:** Parr: Language and Chaos II; Renger-Patzsch: Driving-Shaft of a Locomotive; Richter: 18 Oktober 1977.

CROWE, Ann Glenn. Essayist. Assistant Professor of Art History, Virginia Commonwealth University; contributor to *Art Papers*, *Art Week*, *Art Space*, and *Weekend Magazine*. **Essays:** Armajani: Irene Hixon Whitney Bridge, Minneapolis; Aycock: The One Thousand and One Nights; Heizer: Double Negative.

CROWLEY, David. Essayist. Researcher on East European design for Tempus Design for Industry, London. Formerly, member of the research department at the Victoria and Albert Museum, London. Author of *Nationalism and Design in Poland*, 1992. **Essays:** Szczuka: Smoke Over the City; Witkiewicz: Multiple Self-Portrait.

CURL, James Stevens. Essayist. Architect and town planning consultant, Leicestershire. Author of *European Cities and Society*, 1970; *The Victorian Celebration of Death*, 1972; *City of London Pubs*, with T.M. Richards, 1973; *Victorian Architecture: Its Practical Aspects*, 1973; *The Cemeteries and Burial Grounds of Glasgow*, 1975; *The Erosion of*

Oxford, 1977; *English Architecture*, 1977; *Mausolea in Ulster*, 1978; *The Architecture, Planning and History of the Estates of the Drapers' Company in Ulster*, 1979; *A Celebration of Death*, 1980; *Classical Churches in Ulster*, 1980; *The History, Architecture and Planning of the Estates of the Fishmongers' Company in Ulster*, 1981; *The Egyptian Revival*, 1982; *The Life and Work of Henry Roberts*, 1983; *The Londonderry Plantation 1609–1914*, 1985. **Essays:** Bofill: La Fabrica, Barcelona; Brinkman: Van Nelle Factory, Rotterdam; Gropius: Bauhaus Buildings, Dessau; Stirling: Staatsgalerie, Stuttgart.

DAVENPORT, Kimberly. Essayist. Curator of Contemporary Art at the Wadsworth Atheneum, Connecticut. **Essay:** Rothko: Green & Maroon.

DAY, Melvin. Essayist. Independent artist, art historian and writer, Wellington, New Zealand. Formerly, Director of the National Art Gallery of New Zealand, 1968–78; Government Art Historian, New Zealand, 1978–83. Author of *Nicholas Chevalier, Artist*, 1980. **Essays:** Freud: Large Interior (After Watteau); Tapies: Grey with Red Streak at Base.

DIBAR, Carlos L. Essayist. Architect and architectural critic, Buenos Aires; architectural editor, *El Cronista Comercial*, Buenos Aires. Contributor to *Architecture + Urbanism*, *Diseno y Decoracion* and *Noticias*. **Essays:** A. and T. Scarpa: chairs for Cassina; Nelson: Storagewall.

DREW, Philip. Essayist. Freelance architectural writer, Annandale, New South Wales. Author of *Third Generation*, 1973; *Frei Otto: Form and Structure*, 1976; *Tensile Architecture*, 1979; *Two Towers: Harry Seidler*, 1980; *The Architecture of Arata Isozaki*, 1982; *Leaves of Iron: Glenn Murcutt*, 1985; *Veranda*, 1991; *Real Space: Martorell/Bohigas/Mackay*, 1992. **Essays:** Calatrava: Felip II/Bach de Roda bridge, Barcelona; Martorell/Bohigas/Mackay: Housing at Mollet, Barcelona; Mitchell/Giurgola: Australian Parliament Building.

DUNNING, William V. Essayist. Professor of Art, Central Washington University. Author of *Changing Images of Pictorial Space*, 1991. **Essay:** Safdie: Habitat '67.

EHRLICH, Doreen. Essayist. Tutor in Art and Design History, Hillcroft College. Author of *Twentieth Century Painting*, 1989; *The Bauhaus*, 1991. **Essays:** Boltanski: Monument/La Fete de Pourim; Games: Cona coffee maker; Miro: Women and Bird in Moonlight.

EKUAN, Kenji. Essayist. President of GK Design Associates, Tokyo; Board member, Japan Design Foundation. Author of *Industrial Design*, 1971; *Design: The Relationship Between Man and Technology*, 1972; *The History of Kitchen Utensils*, 1976; *The Philosophy of Tools*, 1980; *The Buddhist Altar and the Automobile*, 1986. **Essay:** Isozaki: Tsukuba Civic Center.

ELLIGENS, Adriaan. Essayist. Art historian, Printroom of Leiden University. **Essays:** Szulc-Krzyzanowski: The Great Sand Dunes; de Nooijer: Warmte Bronnen/Heat Sources.

ELLIS, Mary. Essayist. Freelance writer, London; guide-lecturer at the Tate Gallery and the Wallace Collection, London. **Essays:** Delvaux: La Venus Endormie; Gabo: Linear Construction no. 2; Moore: Reclining Figure.

EMANUEL, Muriel. Essayist. Freelance researcher, editor and writer, London. Editor of *Israel: A Survey and Bibliography*, 1971; *Contem-*

porary Architects, 1980. **Essay:** Hockney: Man in Shower, Beverly Hills.

ENBOM, Carla. Essayist. Freelance writer and design historian, Helsinki. **Essay:** Hakala: Lily 115 chair.

FEREBEE, Ann. Essayist. Director of the Institute for Urban Design, San Diego. Formerly, Senior Editor, *Industrial Design* magazine, 1958–64; Picture Editor, Time-Life Books, 1964–70. Author of *A History of Design from the Victorian Era to the Present*, 1970; *Urban Design Case Studies*, 1977; *Education for Urban Design*, 1982. **Essay:** Legorreta: Hotel Camino Real, Mexico City.

FINKELSTEIN, Louis. Essayist. Artist and writer, New York; Professor Emeritus, Queens College, City University of New York; Lecturer, New York Studio School. **Essays:** de Kooning: Woman I; Kokoschka: View of Jerusalem.

FITZGERALD, Quentin W. Essayist. Professor of Art, Central Washington University. **Essay:** Safdie: Habitat '67.

FRANZKE, Andreas. Essayist. Professor of Art History, Karlsruhe. Formerly, Head of the Art History Department, Academy of Fine Arts, Karlsruhe. Author of *Dubuffet*, 1974; *Antoni Tapies: Werk und Zeit*, 1978; *Boltanski: Reconstitution*, 1978; *Dubuffet Zeichnungen*, 1980; *Skulpturen und Objekte von Malern des 20. Jahrhunderts*, 1982; *Max Beckmann: Skulpturen*, 1987; *Georg Baselitz*, 1988. **Essays:** Baselitz: Supper in Dresden; Dubuffet: La Metafysik.

FRIEDMAN, Ken. Essayist. Freelance artist, designer and planner, Oslo; President of Friedman Associates strategic planning and design consultants. Formerly, president of the Art Economist Corporation, New York, 1981–85; visiting artist and designer, at Oy Wartsila Ab Arabia, Helsinki. **Essays:** Benktzon and Juhlin: Tableware for the Disabled; Designlab: Kastrup Airport signage program; Maciunas: Expanded Arts Diagram; Noyes: Mobil Corporate Design Program.

FRIEDMANN, Arnold. Adviser and essayist. Emeritus Professor of Art and Design, University of Massachusets. Author of *Interior Design: Introduction to Architectural Interiors*, 1970, 1982; *Commonsense Design*, 1976; *Construction Materials for Interior Design*, 1989. **Essays:** Breuer: Cesca Chair; Johnson: Johnson Glass House; Eames: 670 swivel chair; Kallman/McKinnell/Knowles: Boston City Hall; Piano/Rogers: Centre Pompidou, Paris; Saarinen: TWA Terminal, Kennedy Airport; Stubbins: Citicorp Center, NYC.

FRITSCH, Gerolf. Essayist. Professor of German Language and Literatur, Chur, Switzerland. Editor of *Lebenskunde fur die Zukunft*, 1985; *An den Grenzen der Machbarkeit*, 1988; *Bausteine fur eine andere Zukunft*, 1988; *Erziehung in der offenen Gesellschaft*, 1990. **Essays:** Giacometti: Landschaft bei Stampa; Klee: Motiv aus Hammamet; Picasso: Guernica.

GERNSHEIM, Helmut. Adviser. Photographer, photo-historian and collector, Lugano, Switzerland. Author of *New Photo Vision*, 1942; *The Man Behind the Camera*, 1948; *Focus on Architecture and Sculpture*, 1949; *Masterpieces of Victorian Photography*, 1951; *The History of Photography*, 1955. 1969, 1983; *Creative Photography: Aesthetic Trends*, 1962, 1986; *A Concise History of Photography*, 1965, 1986; *The Origins of Photography*, 1982; *The Rise of Photography*, 1986.

GIPSON, Lynn M. Essayist. Professor of Liberal Studies, Memphis College of Art. **Essay:** Candela:

Church of the Miraculous Virgin, Mexico City.

GLEYE, Paul. Essayist. Associate Professor of Architecture, Montana State University. Author of *The Architecture of Los Angeles*, 1981. **Essay:** Howell/Lescaze: PSFS Building, Philadelphia.

GLUSBERG, Jorge. Adviser and essayist. Director of the Center of Art and Communication, Buenos Aires; Professor of Art, New York University; Director of the International Committee of Architectural Critics. Author of *Rhetorics of Latin American Art*, 1978; *Myths and Magic of Fire, Gold and Art*, 1979; *The Art of Performance*, 1979; *Mario Botta*, 1981; *The Last Museum*, 1984; *Del Pop Art a la Nueva Imagen*, 1985; *Art in Argentina*, 1985. **Essays:** Ambasz: Lucile Halsell Conservatory, San Antonio; Aulenti: Musee d'Orsay, Paris; Barragan: San Cristobal, Mexico City; Bellini: Persona Chair; Nouvel: World Arab Institute, Paris; Pelli: World Financial Center, New York; Roca: Cordoba Pedestrian Area; Siza: Borges e Irmao Bank, Portugal; Tamayo: UNESCO Prometheus Mural, Paris; Testa: Banco de Londres, Buenos Aires; Torre: Fire Station 5, Columbus.

GOTTSCHALL, Edward M. Essayist. Vice-chairman, International Typeface Corporation, New York. Formerly, editor of *Art Direction*, 1952–69; executive director, American Institute of Graphic Arts, 1969–75. Author of *Commercial Art as a Business*, 1972; *Vision '80s*, 1980; *Graphic Communication '80s*, 1981; *Typographic Communications Today*, 1989. **Essays:** Lubalin: Avantgarde Gothic typeface; Muller-Brockmann: Zurich Tonhalle posters; Rand: IBM Identity Program.

GRAD, Bonnie L. Essayist. Associate Professor of Art History, and Curator of the University Art Collections, at Clark University, Worcester, Massachusetts. Author of *Milton Avery Monotypes*, 1977; *Visions of City and Country*, 1982. **Essay:** Cartier-Bresson: Sunday on the River Marne.

GUTMAN, Judith Mara. Essayist. Freelance writer, New York; Adjunct Professor, New School for Social Research, New York. Author of *The Colonial Venture*, 1966; *Lewis W. Hine and the American Social Conscience*, 1967; *The Making of American Society*, 1972, 1973; *Is America Used Up?*, 1973; *Lewis W. Hine: Two Perspectives*, 1975; *Buying*, 1975; *Through Indian Eyes*, 1982. **Essays:** E. Adams: Vietnamese General Executing Vietcong; Hiro: Jewellery on Black Angus; Jacobsen: Butterfly stacking chair; Risom: 650 Armchair; Salgado: Women and Children on Dry Lake Bed, Mali.

HABEGGER, Jerryll. Essayist. Freelance writer and interior designer, Chicago; Instructor in Advanced Design, Harrington Institute of Interior Design, Chicago. Author of *Europe: Architectural Guide, 1860 to Today*, 1974; *Sourcebook of Modern Furniture*, 1988. **Essay:** Zanuso: Model 4999 child's stacking chair.

HACKNEY, Fiona. Essayist. Freelance writer on art and design, London. **Essays:** Chicago: The Dinner Party; Morison: Times New Roman typeface.

HAWKINS-DADY, Mark. Essayist. Editor and freelance writer, London. Editor of *International Dictionary of Theatre*, 1991–93. **Essay:** Paul: Playboy logo and corporate identity.

HAWORTH-BOOTH, Mark. Adviser. Assistant Keeper of Photographs, Victoria & Albert Museum, London. Editor of *The Land: 20th Century Landscape Photographs*, 1975; *Bill Brandt's Literary Britain*, 1984; *The Street Photographs of Roger Mayne*, 1985; author of *E.*

McKnight Kauffer, 1979; *Old and Modern Masters of Photography*, 1983; *The Golden Age of British Photography*, 1839–1900, 1984; *A Guide to Early Photographic Processes*, 1984.

HAYHURST, Richard. Essayist. Freelance writer on design, London; Director of Hayhurst, Conington, Cripps advertising agency, Surrey. Formerly, copywriter at AC-Mainos, Helsinki, 1984–87; marketing and communications manager at Labsystems, Helsinki, 1987–89. **Essays:** Aarnio: Ball chair; Backstrom: Fiskars Scissors; Franck: Kilta tablewares; Sarpaneva: Lansett vase/sculpture; Tapiovaara: Domus stacking chair; Wirkkala: Kantarelli glass vases.

HELLER, Steven. Essayist. Senior Art Director, the *New York Times*; editor, *American Institute of Graphic Arts Journal*, and *Design and Style* magazines. Author of *The Art of New York*, 1983; *The Art of Satire*, 1984; *Art Against War*, 1984; *Seymour Chwast: The Left Handed Designer*, 1987; *Innovators of American Illustration*, 1987; *Graphic Style*, 1988; *Low Budget High Quality Design*, 1990. **Essays:** Chwast: Artone alphabet; Glaser/Chwast: Pushpin Graphic.

HINTERKEUSER, Ralph. Essayist. Freelance photographer, writer and exhibition curator, Cologne. **Essays:** Burri: Men on Rooftop, Sao Paulo; Friedlander: New York City no. 87; Klein: Four Heads, Broadway; Misrach: Waiting at Edwards Air Force Base; Tomatsu: Melted Beer Bottle; Van der Elsen: Black Machinist.

HODIK, Barbara. Essayist. Professor of Art History, Rochester Institute of Technology, New York. Co-author of *Guide to Photographic Design*, 1983; *Nine Pioneers in American Graphic Design*, 1989. **Essay:** Nitsche: Atoms for Peace posters.

HONNEF, Klaus. Adviser and essayist. Chief Exhibitions Officer, Rheinisches Landesmuseum, Bonn; Professor of Art, Gesamthochschule, University of Kassel. Formerly, director of the Westfalischer Kunstverein, Munster, 1970–74. Author of *Concept Art*, 1971; *Gerhard Richter*, 1972; *Lichtbildnisse*, 1982; *Contemporary Art*, 1989; *Andy Warhol*, 1990; *John Heartfield*, 1991. **Essay:** Newton: Elsa Peretti in New York.

HORSHAM, Michael. Essayist. Freelance writer and lecturer on design, London. Author of *20s and 30s Style*, 1989; *The Art of the Shakers*, 1990. **Essays:** Chermayeff/Mendelsohn: De La Warr Pavilion, Bexhill; Cole/Earl: Chevrolet Corvette Mk II; D'Ascanio: Vespa motor scooter; Fender: Stratocaster electric guitar; Holden: Arnos Grove Station, London; Lubetkin/Tecton: Highpoint Flats, London; Rietveld: Red/Blue chair; Williams: Boots Wet Goods Factory, Nottingham.

HOUSE, Nancy. Essayist. Freelance artist and writer, Cincinnati; instructor in art history, Wilmington College. **Essays:** Aicher: Pictograms for Munich Olympics; Cole/Earl: Chevrolet Bel Air; Pesce: Up-1 Chair.

HULICK, Diana Emery. Essayist. Assistant Professor of Art, Arizona State University. Formerly, director and curator of the University Art Museum, University of Maine, 1983–86. Author of *Waldo Peirce: A New Assessment*, 1984; *Continuity and Revolution: The Work of Ansel Adams and Edward Weston*, 1990. **Essays:** Davidson: East 100th Street, NYC, no. 5; Meatyard: Boy with Mask.

ICHIYAMA, Dennis. Essayist. Professor of Visual Communications Design, Purdue University, Indiana. **Essays:** Bass: Walk on the Wild Side film titles; Weingart: Typographische Monatsblatter covers.

JOPPOLO, Giovanni. Essayist. Freelance art critic, Paris; Professor of Art History, Ecole Nationale des Beaux-Arts, Dijon, and Universite de Paris VIII; editorial board member, *Opus International*. Author of *Matiere Premiere*, 1986; *Arte Povera*, 1988. **Essays:** Anselmo: Struttura che mangia; de Chirico: Mystere et Melancholie d'une rue; Hopper: Office in a Small City; Kandinsky: Composition no. 6.

JUHASZ, Joseph B. Essayist. Associate Professor of Environmental Design, University of Colorado. Co-author of *Environments: Notes and Selections*, 1989. **Essays:** Kahn: Salk Institute Laboratories, La Jolla; Lin: Vietnam Veterans Memorial, Washington, DC; Moore: Piazza d'Italia, New Orleans; SITE: Best Products Showroom, Houston.

KELLER, Victoria. Essayist. Freelance art critic and historian, Edinburgh. Formerly, Assistant Director, 369 Gallery, Edinburgh. **Essays:** Long: Circle in the Andes; Marini: Riding Horseman; Merz: Double Igloo; Smithson: Spiral Jetty.

KEPINSKA, Alicja. Essayist. Freelance art critic and theoretician, Warsaw; Professor, Academy of Visual Arts, Poznan. Author of *Jean-Pierre Norblin*, 1978; *New Polish Art 1954–78*, 1981; *Element and Myth*, 1983; *Energies of Art*, 1991. **Essays:** Hofmann: Effervescence; Newman: Vir Heroicus Sublimis; Segal: Cinema.

KIL, Wolfgang. Essayist. Freelance journalist and publicist, Berlin. Author of *Postwar Photography in East Germany*, 1989; *Ostkreuz*, 1990. **Essays:** Fischer: Staten Island Ferry; Seymour: Prostitute in Essen.

KIND, Joshua. Essayist. Professor of Art History, Northern Illinois University, DeKalb. Author of *Naive Painting in Illinois 1830–1976*, 1976; *Geometry as Abstract Art*, 1980; *The Geometric Impulse*, 1981. **Essay:** Callahan: Eleanor.

KLOS, Sheila. Essayist. Associate Professor and Head of the Architecture and Allied Arts Library, University of Oregon. Formerly, Serials Librarian, Cleveland Museum of Art, 1983–85. Author of *Historical Bibliography of Art Museum Serials from the United States and Canada*, 1987. Contributor to *Art Documentation*. **Essay:** Erickson: Museum of Anthropology, Vancouver.

KOERBLE, Barbara L.. Essayist. Independent exhibition curator and writer, Fort Worth, Texas; Curator of Visual Resources, University of Texas at Arlington. Author of *American Architecture of the 1980s*, 1990. **Essays:** Barnes: Walker Art Center Sculpture Garden, Minneapolis; Johansen: Mummers Theatre, Oklahoma City.

KOSTELANETZ, Richard. Essayist. Independent writer, artist and composer, New York; founder of Future Press and *Precisely: A Critical Journal*. Author of *Moholy-Nagy*, 1970; *John Cage*, 1970; *The New Poetries and Some Olds*, 1981; *Conversing with Cage*, 1988; *On Innovative Music*, 1989; *On Innovative Art*, 1991. **Essays:** Cage: Not Wanting to Say Anything About Marcel; Moholy-Nagy: Vision in Motion; Tsai: Dancing Rods; Turrell: Meeting.

KRSTIC, Vladimir. Essayist. Assistant Professor of Architecture, Kansas State University. Formerly, designer at Tadao Ando Architect and Associates, Osaka, 1982–85; Assistant Professor of Architecture, University of Illinois. Contributor to *Oz* magazine. **Essays:** Fujii: Ushimado International Arts Festival Building; Takeyama: Ichiban-kan Building, Tokyo.

KRUSZEWSKA, Ewa. Essayist. Freelance art and

graphic design critic, Warsaw; art historian and custodian, Royal Castle of Warsaw. Formerly, manager of the Polish Poster department, Wilanow Poster Museum, Warsaw. Author of *Wojciech Zamecznik*, 1977; *Plakat Olimpijski*, 1978; *Das Polnische Plakat von 1892 bis heute*, 1980; *Lengyel Kulturalis Plakat*, 1981; *Ignacy J. Paderewski*, 1985. **Essays:** Fukuda: Mona Lisa poster series; Kamekura: Hiroshima Appeals poster.

KULTERMANN, Udo. Adviser and essayist. Ruth and Norman Moore Professor of Architecture, Washington University, St. Louis. Formerly, Director of the City Art Museum, Leverkusen, 1959–64; Architecture Commission member, Venice Biennale, 1979–82. Author of *Architecture of Today*, 1958; *New Japanese Architecture*, 1960, 1967; *New Architecture in Africa*, 1963; *History of Art History*, 1966; 1981; *The New Sculpture*, 1969, 1977; *The New Painting*, 1969, 1977; *New Realism*, 1972; *Contemporary Architecture in Eastern Europe*, 1985. **Essay:** Rosenbach: Ten Thousand Years I Have Been Sleeping.

LAHIJI, Nadir. Essayist. Independent architect, Atlanta, Georgia; Professor of Architecture, Georgia Institute of Technology. **Essays:** Coop Himmelblau: Rooftop Office conversion, Vienna; Moneo: Bankinter Building, Madrid.

LAMBARELLI, Roberto. Essayist. Freelance art critic and wirter, Rome. Author of *L'Avanguardia Plurale*, 1983; *Le Scuole Romane 1960–1980*, 1988. **Essays:** Burri: Sack IV; Fontana: Concetto Spaziale: Attese; Guttuso: Crucifixion; Kounellis: Civil Tragedy; Paladino: Round Earth/Frugal Repast; Rotella: Assault.

LAURANCE, D. Michael. Essayist. Curator of the Visual Resource Library, New Mexico State University. Formerly, Associate Editor, *US Camera* magazine, 1966–67; manager of Photo Press, Eastman Kodak Company, 1968. Author of *The Canon Guide*, 1977. **Essay:** Karsh: Portrait of Winston Churchill.

LENK, Krzyzstof. Essayist. Freelance graphic designer, Providence, Rhode Island; Professor of Graphic Design, Rhode Island School of Design. Formerly, Professor of Graphic Design at the School of Art and Design, Lodz, Poland, 1973–92. **Essay:** Tomaszewski: Henry Moore poster.

LEWIS, Adrian. Essayist. Senior Lecturer, School of Arts, Leicester Polytechnic. Formerly, instructor in art history, Bristol Polytechnic, 1975–76; Education Officer, Walker Art Gallery, Liverpool, 1976–79. Author of *Roger Hilton: The Early Years*, 1984; *Painterly Abstraction*, 1991. **Essay:** Still: 1957–K(PH-149).

LOFTING, Claire. Essayist. Freelance art historian, lecturer and writer, London. **Essays:** Caro: Emma Dipper; Kiefer: Father, Son and Holy Ghost; Nauman: Self Portrait as a Fountain.

LOWENTHAL, Cecily. Essayist. Freelance lecturer and writer on art, London; guide at the Tate Gallery, London; executive committee member, Contemporary Art Society, London. Formerly, tutor at the Open University, 1985–86. **Essays:** Kitaj: The Refugees; Matisse: The Snail.

MACEL, Otakar. Essayist. Associate Professor of Architectural History, Technical University, Delft. Author of *Stuhle aus Stahl*, 1980; *Museum of the Continuous Line*, 1986. **Essays:** Asplund: Woodland Crematorium, Stockholm; Gehry: Vitra Museum, Weil am Rhein; Oud: Kiefhoek Workers' Village, Rotterdam; Rietveld: Schroeder House, Utrecht.

MACKAY, David. Adviser. Principal Architect, Martorell/Bohigas/Mackay partnership, Barcelona. Author of *World Architecture*, with others, 1967; *Contradictions in Living Environment*, 1971; *The Anti-Rationalists*, with others, 1973; *Wohnungsbau im Wandel*, 1977; *The Modern House*, 1984.

MANOLA, Enzostefano. Essayist. Independent architect and writer on design, London. **Essays:** Albini/Helg: La Rinascente, Rome; Gregotti: IACP Zen Housing, Palermo; Snozzi: Parliament Building, Lichtenstein.

MARECHAL-WORKMAN, Andree. Essayist. Curator at the Berkeley Art Center; instructor, University of California, Berkeley. Formerly, Curator at the Center for Visual Arts, Oakland, 1977–80, and Creative Growth Gallery, Oakland, 1984–86. Author of *The Siegriests*, 1980; *Robert DeNiro*, 1981; *Chris Ranes*, 1983. **Essay:** Ramos: Hippo/Bathing Beauty.

MARTIN, Henry. Essayist. Freelance art critic and translator, Bolzano, Italy. Author *Arman*, 1972. *Adami*, with Hubert Damisch, 1974; *Renato Mambor's Evidenziatore*, 1975; *An Introduction to George Brecht's Book of the Tumbler on Fire*, 1978; *Fragments of a Possible Apocalypse*, with Gianfranco Baruchello, 1978; *Favorisca: On the Work of Gianfranco Baruchello*, 1982; *How to Imagine*, with Gianfranco Baruchello, 1984; *Daniel Spoerri's Bronzes*, 1986; *One Hundred Skies for Geoffrey Hendricks*, 1986. **Essays:** Brecht: Water Yam; Schneemann: Meat Joy.

MARTIN, Richard. Essayist. Executive Director of the Educational Foundation for the Fashion Industries, and of the Shirley Goodman Resource Center, Fashion Institute of Technology, New York; Adjunct Professor of Art, New York University; editor, *Textile and Text*, and *Design and Sign*. Formerly, editor, *Arts Magazine*, New York, 1974–88. Author of *Fashion and Surrealism*, 1987; *Jocks and Nerds*, with Harold Koda, 1989; *The Historical Mode*, with Harold Koda, 1989; *Splash! A History of Swimwear*, with Harold Koda, 1990; *Giorgio Armani: Images of Man*, with Harold Koda, 1991; editor of *The New Urban Landscape*, 1989. **Essays:** Avedon: Davina with Elephants; Hamilton: Just What is it ...; Toscani: United Colors of Benetton.

MEGGS, Philip B. Essayist. Professor of Communication Arts and Design, Virginia Commonwealth University; contributing editor, *Print* magazine. Formerly, Senior Designer, Reynolds Aluminium, 1965–66; Art Director, A. H. Robins, 1966–68. Author of *A History of Graphic Design*, 1983; *Typographic Design: Form and Communication*, with others, 1985; *Type and Image*, 1989. **Essay:** Vignelli: US National Parks publications.

MERKEL, Jayne. Essayist. Adjunct Assistant Professor of English Writing, University of Cincinnati; contributing editor, *Inland Architect* magazine. Formerly, Curator at the Contemporary Arts Center, Cincinnati, 1968–69; director of education, Taft Museum, Cincinnati, 1969–74; instructor in art history, Art Academy of Cincinnati, 1973–78; architecture critic, *The Cincinnati Enquirer*, 1977–78. Author of *In Its Place: The Architecture of Carl Strauss and Ray Roush*, 1985; *Michael Graves and the Riverbend Music Center*, 1987. **Essays:** Eisenman: Wexner Center, Ohio State University; Tschumi: Parc de la Villette, Paris; Venturi: Vanna Venturi House, Philadelphia.

MEYER, Pedro. Adviser. Freelance photographer and photo-historian, Mexico City; President of the Consejo Mexicano de Fotografia. Author of *La Noche de Tlatelolco*, 1971; *Y las Cosas que le Pason*

al Homore, 1977; *Negromex en Blanco y Negro*, 1977; *Hecho en Latinoamerica*, 1978, 1981.

MICHL, Jan. Essayist. Senior Lecturer in the History and Theory of Industrial Design, SHKS Institute for Industrial Design, Oslo. Author of *Contemporary Czech Architecture*, 1978. **Essay:** Aalto: Savoy Vase.

MOFFITT, John F. Essayist. Professor of Art History, New Mexico State University. Author of *Spanish Painting*, 1973; *Occultism in Avant-Garde Art*, 1988. **Essays:** Beuys: How To Explain Pictures to a Dead Hare; Klein: Relief Eponge Bleu; Kupka: Vertical Planes I; Masson: Landscape with Precipices; Orozco: Zapatistas.

MOLLERUP, Per. Adviser. Director, DesignLab ApS, Denmark. Formerly, editor and publisher of *Mobilia* design magazine, 1974–84, and *Tools* design journal, 1984–88. Author of *Design for Life*, 1986; *The Corporate Design Programme*, 1987; *Good Enough Is Not Enough*, 1991.

MORGAN, Robert C. Essayist. Professor of the History and Theory of Art, Rochester Institute of Technology, New York; Visiting Professor, School of the Visual Arts, New York; Contributing Editor, *Arts Magazine*, and *Tema Celeste*. Author of *Conceptual Art*, 1983; *Robert Barry*, 1986; *Duchamp, Androgyny, Etc.*, 1990. **Essays:** Bunshaft: Lever House, New York; Noguchi: Even the Centipede; Renau: Peace is with Them.

MORGENTHALER, Hans R. Essayist. Assistant Professor of Architecture, University of Colorado. Formerly, Visiting Assistant Professor of Art History, University of Oregon, 1987–89. Author of *The Early Sketches of Erich Mendelsohn*, 1991. **Essay:** Reichlin/Reinhart: Casa Tonini, Torricella.

MULLEN, Chris. Adviser and essayist. Senior Lecturer in Design, Brighton Polytechnic. Author of *Cigarette Pack Art*, 1979; *Fortune's America*, 1985; *Cars and Corporate Culture*, 1989. **Essays:** Allner: Fortune Magazine design; Eckersley: Help Lepra Fight Leprosy poster; Hardie: The Works calendar.

MULLER-POHLE, Andreas. Adviser. Independent photographer, Gottingen; founder-editor, *European Photography* magazine. Formerly, editor of *Fotografie* magazine, Gottingen, 1978–79. Author of *Fotografie in Europa heute*, 1982; *Transformance*, 1983.

MURRAY, Joan. Essayist. Director of the Robert McLaughlin Gallery, Oshawa, Ontario. Formerly, Curator of Canadian Art, Art Gallery of Ontario, Toronto, 1969–74. Author of *Letters Home: William Blair Bruce 1859–1906*, 1982; *Kurelek's Vision of Canada*, 1983; *The Best of the Group of Seven*, 1984; *The Best of Thom Thomson*, 1986; *The Best Contemporary Canadian Art*, 1987. **Essay:** Snow: Walking Woman-Turn.

NAEF, Weston J. Essayist. Curator of Photographs, The J. Paul Getty Museum, Malibu, California. Formerly, Curator of Photography, Metropolitan Museum of Art, New York. Author of *Era of Exploration*, with James N. Wood, 1975; *The Collection of Alfred Stieglitz*, 1978; *Counterparts: Form and Emotion in Photographs*, 1982. **Essay:** Becher: Water Towers, France.

NIENHUIS, Garance. Essayist. Freelance writer and dance teacher, Rhode Island. Author of *Fear Strikes Back*, 1991. **Essay:** Wissing/Total Design: Schiphol Airport graphics.

O'LEARY, John T. Essayist. Freelance writer, London. **Essays:** Birkerts: Federal Reserve Bank,

Minneapolis; Erskine: Byker Wall Housing, Newcastle; Meier: Museum fur Kunsthandwerk, Frankfurt; Ponti/Nervi: Pirelli Tower, Milan.

OSMAN, Joseph H. Essayist. Independent writer and researcher in modern design, Chicago; Principal administrator, Art and Industry, Chicago. Author of *Sourcebook of Modern Furniture*, with Jerryll Habegger, 1988. **Essay:** Zanuso: Model 4999 stacking chair.

PACEY, Philip. Essayist. Art Librarian, Preston Polytechnic, Lancashire. **Essay:** Beck: London Underground Diagram.

PALAZZOLI, Daniela. Adviser and essayist. Director of the Academy of Visual Arts of Brera, Milan; editor in charge of photographic books, for Electa Editrice and Bompiani Editore, Milan. Formerly, director of the Turin Photography Biennale, 1987, 1989. Author of *Fotografia, cinema, videotape: l'uso artistico dei nuovi media*, 1977; *Giuseppe Primoli*, 1979; *Giorgio Sommer*, 1980. **Essays:** Arbus: Retired Man and Wife in Nudist Camp, New Jersey; Michals: Spirit Leaves the Body; Miller: Dead German Guard in Canal; Penn: Lisa Fonssagrieves in Rochas Mermaid Dress; White: Sequence no. 4/Opposed Directions.

PARKER, Andrew. Essayist. Freelance writer and architectural historian, London. **Essays:** Bertoni: Citroen DS-19; Fuller/Sadao Inc.: US Pavilion at Expo 67; Nervi/Piacentini: Palazzo dello Sport, Rome.

PASCAL, Diane. Essayist. Associate Editor, St. James Press, Chicago. **Essay:** Dior: New Look.

PEHNT, Wolfgang. Adviser and essayist. Editor for Arts and Architecture, Deutschlandfunk, Cologne. Editor of *Encyclopedia of Modern Architecture*, 1964; *Die Stadt in der Bundesrepublik*, 1974; and author of *New German Architecture 1960–1970*, 1970; *Expressionist Architecture*, 1973; *Der Anfang der Bescheidenheit*, 1983; *Das Ende der Zuversicht*, 1983. **Essays:** Behnisch: Hysolar Institute, Stuttgart; Bohm: Bensberg Town Hall; Eiermann: Olivetti Headquarters, Frankfurt; Kleihues: Municipal Refuse Depot, Berlin; Otto: Retractable Tents, Cologne; Scharoun: Philharmonie, Berlin; Ungers: Deutsches Architekturmuseum, Frankfurt.

PELLINEN, Jukka. Adviser. Designer, Helsinki. Editor, *Ornamo 1950–54: Finnish Decorative Arts*, with others, 1955; *History of the Porin Puuvilla cotton Mill*, with Timo Sarpaneva, 1957.

PERIAINEN, Tapio. Adviser. Managing Director of Design Forum Finland, Helsinki. Formerly, architect in private practice, Helsinki, 1955–75. Author of *Nature, Man, Architecture*, 1969; *Goals for Housing Policy*, 1971; *Recommendations for Playgrounds*, 1972; *Soul in Design*, 1990.

PHIPPS, Brian. Essayist. Head of Visual Arts, Ascham School, Sydney. **Essays:** Burgee/Johnson: AT&T Headquarters, New York; Pei: National Gallery East Building, Washington, DC; Roche/Dinkeloo: General Foods Headquarters, Rye; Utzon/Arup: Sydney Opera House; Wright: Guggenheim Museum, New York.

POLI, Bruce. Essayist. Freelance editor and copywriter, New York. Formerly, Assistant Curator, Witkin Gallery, New York, 1980–81; Associate Editor, *Studio Photography* magazine, 1981–82; Associate Editor, *Photo/Design* magazine, 1988–89. Author of *Suffolk County: A Place in Time*, 1983. **Essays:** Meyerowitz: Broadway and

46th Street, New York; Smith: Tomoko and Her Mother, Minamata.

POUTASUO, Tuula. Essayist. Freelance writer and design critic, Helsinki. Author of *Finnish Industrial Design*, 1987. **Essays:** Bruun: Sea Eagle poster; Nurmesniemi: Antti telephone.

PROSDOCIMO, Donato. Essayist. Freelance writer and literary translator, Turin. **Essays:** Hamaya: Rice-weeder; Riboud: Peking.

REMES, Vladimir. Essayist. Freelance writer on photography and contributor to *Revue Fotografie*, Prague; Chief Dramatist, Czechoslovak Radio, Prague. Formerly, member of the cultural section, Czechoslovak Radio, 1960–68; film critic and screenwriter, 1968–72. Author, with Daniela Mrazkova, of *Soviet War Photography 1941–45*, 1975; *The Russian War*, 1977; *Von Moskau nach Berlin*, 1979; *Dei Sowjetunion zwischen den Kriegen 1917–1941*, 1981; *Tschechoslowakische Fotografen 1900–1939*, 1982; *Josef Sudek*, 1983; Jaromir Funke, 1986; *Another Russia*, 1986. **Essays:** Koudelka: Invasion of Prague; Luskacova: Sleeping Pilgrim; Macijauskas: In the Veterinary Clinic; Sudek: A Memory of Dr. Brumlik.

REMINGTON, R. Roger. Adviser and essayist. Professor of Graphic Design, Rochester Institute of Technology, New York. Author of *Nine Pioneers in American Graphic Design*, with Barbara Hodik, 1989. **Essays:** Beall: International Paper Company identity; Golden: CBS Eye Logo and graphics.

RIES, Martin. Essayist. Professor of Art and Art History, Long Island University, Brooklyn. Formerly, Assistant Director, Hudson River Museum, 1957–67; Art Editor, *Greenwich Village News*, 1976–77. Contributor to *The New Republic*, *Art Voices*, and *Art Journal*. **Essays:** Andre: Equivalent VIII; Dali: Persistence of Memory; Kline: Accent Grave.

ROBINSON, John. Essayist. Professor of English, Rutgers University, New York. Formerly, editor of *Archives of American Art*; editor, New York Historical Society. Author of *Ship Desert Boat Cargo*, 1981. Contributor to *Tableau*, *Artforum*, *Flash Art*, and *Arts Magazine*. **Essays:** Broodthaers: La Soupe de Daguerre; Close: Self Portrait; Hollein: Stadtisches Museum, Monchengladbach.

ROBINSON, Marlee. Essayist. Lecturer, Tate Gallery, London; personal assistant to the artist Eduardo Paolozzi, London. **Essay:** Paolozzi: Last of the Idols.

ROSENBLATT, Arthur. Essayist. Architect and Vice-President of the Grand Central Partnership, New York; Associate Director, Bryant Park Restoration Corporation, New York. Formerly, Vice-President, Metropolitan Museum of Art, New York 1967–86; Director of Capital Projects, New York Public Library, 1981–86; Director, United States Holocaust Memorial Museum, Washington, D.C., 1986–88. Author of *Time Line of Culture in the Nile Valley*, 1978. **Essay:** de Harak: Metropolitan Museum Egyptian Graphics.

ROSKILL, Mark. Essayist. Professor of the History of Modern Art, University of Massachusetts, Amherst. Author of *English Painting from 1500 to 1865*, 1959; *The Letters of Vincent Van Gogh*, 1963; *Dolce's "Aretino" and Venetian Art Theory of the Cinquecento*, 1968; *Van Gogh, Gauguin and the Impressionist Circle*, 1970; *What Is Art History?*, 1976. **Essay:** Kertesz: Chez Mondrian.

ROSS, Charles. Freelance editor and writer on

architecture and interior design, Chicago. Editor of *Commercial Renovation*, 1988; *Kitchen and Bath Concepts*, 1989; *Better Homes and Gardens Bedroom and Bath Ideas*, 1990. **Essay:** Neutra: Kaufmann House, Palm Springs.

RUSSELL, Douglas. (died in 1991). Essayist. Professor of Design and Drama, Stanford University, California. Formerly, Visiting Professor of Drama, University of Vienna, 1989, and Texas Christian University, 1990. Author of *Stage Costume Design*, 1973, 1986; *Theatrical Style*, 1976; *Period Style for the Theatre*, 1980, 1987; *Costume History and Style*, 1982. **Essays:** Beckmann: Two Spanish Women; Christo: Valley Curtain; Duchamp: Large Glass; Gris: Pierrot; Kaprow: 18 Happenings in 6 Parts; Kienholz: State Hospital; Pollock: Autumn Rhythm.

SARZABAL, Hernan Barbero. Essayist. Independent architect, Buenos Aires; architectural correspondent, *El Cronista Comercial*. **Essay:** Starck: Cafe Costes chair.

SAYRE, Henry M. Essayist. Associate Professor of Art, Oregon State University. Author of *The Visual Text of William Carlos Williams*, 1983; *The Object of Performance: The American Avant-Garde Since 1970*, 1989; *Writing About Art*, 1989. **Essays:** Gorky: Agony; Twombly: Untitled Grey Painting (Bolsena).

SCARPA, Lawrence. Essayist. Principal architect in the firm Pugh + Scarpa, Santa Monica. Formerly, Assistant Professor of Architecture, University of Florida, 1986–87; Professor, College of Fine Arts, California State University, 1988–90. Author of *Traces: Appunti Vincenti*, 1986; *Carlo Scarpa: Metaphorical Exploration of Drawing in the Process of Design*, 1987. **Essay:** C. Scarpa: Querini Stampalia Library, Venice.

SCHARF, Aaron. Adviser. Writer and photography historian, Melton Constable, Norfolk. Formerly, Professor of Art History, The Open University, 1969–82. Author of *Creative Photography*, 1965; *Art and Photography*, 1968; *Pioneers of Photography*, 1975.

SCHEINMAN, Pamela. Essayist. Adjunct Professor of Fine Arts, Montclair State College, New Jersey. Author of *With Patriot's Pride*, 1976. Contributor to *American Craft*, *Surface Design Journal*, and *Craft International*. **Essays:** Iturbide: Angel Woman; Tress: Flood Dream; Yampolsky: Huipil de Tapar.

SCHOENER, Allon. Essayist. Freelance writer, critic and exhibition designer, Grafton, Vermont. Formerly, visual arts program director, New York State Council on the Arts, 1967–72; consultant to the Smithsonian Institution, Washington, D.C., 1972–74. Author of *Portal to America: The Lower East Side*, 1967; *Harlem On My Mind*, 1969; *The American Jewish Album*, 1983; *The Italian Americans*, 1987; *Gli Italo-Americani*, 1988. **Essays:** Freed: Suspect in Police Car, New York; Sutnar: Sweets Catalog Program.

SELZ, Peter. Adviser and essayist. Professor Emeritus of Art History, University of California, Berkeley. Formerly, Chief Curator of Painting and Sculpture Exhibitions, Museum of Modern Art, New York, 1958–73; Director of the University Art Museum, University of California, Berkeley, 1965–73. Author of *German Expressionism*, 1957; *New Image of Man*, 1959; *The Work of Jean Dubuffet*, 1962; *Emil Nolde*, 1963; *Max Beckmann*, 1964; *Sam Francis*, 1975; *Art in a Turbulent Era*, 1981; *Art in Our Times*, 1981; *Chillida*, 1986. **Essay:** Chillida: Wind Combs, San Sebastian.

SHANNON, Gayla Jett. Essayist. Freelance writer and interior designer, Fort Worth, Texas; Assistant Professor of Art and Interior Design, University of North Texas. **Essays:** Day: Hillestak stacking chair; Sapper: Tizio desk lamp.

SPAETH, David. Essayist. Professor of Architecture, University of Kentucky. Formerly, Visiting Professor, University of Florida, 1985–86. Author of *Ludwig Mies van der Rohe: An Annotated Bibliography and Chronology*, 1979; *Ludwig K. Hilberseimer: An Annotated Bibliography and Chronology*, 1981; *Mies van der Rohe*, 1985; editor of *Inside the Bauhaus*, with Howard Dearstyne, 1986. **Essay:** Eames: House in Pacific Palisades.

SPRY, Tim. Essayist. Advertising copywriter, at Bentley, Parnes and Lynn, Chicago. **Essays:** Ferrari: Ferrari 250GT car; Krone: Volkswagen advertising.

STOKES, Philip. Essayist. Senior Lecturer in Photography and Visual Arts, Nottingham Polytechnic. **Essays:** Alvarez Bravo: El Trapo Negro; Bullock: Black Tree and Mountain; Clark: Tulsa; Cooper: Ceremonial Veil, Nesscliffe; Ernst: Temptation of Saint Anthony; Godwin: Moonlight on Avebury; Hockney: Scrabble Game photomontage; Killip: In Flagrante; Mayne: Southam Street; Uzzle: All American–Dam Viewing Room; Weegee: Drowned Man, Coney Island.

SUTNIK, Maia-Mari. Essayist. Photographic Coordinator, Art Gallery of Ontario, Toronto. Formerly, audio-visual librarian, 1969–73, and instructor in photography, 1984–88, at Ontario College of Art. Author of *E. Haanel Cassidy: Photographs 1933–1945*, 1981; *Responding to Photography*, 1984; *Gutmann*, 1985; *Linnaeus Tripe: Photographer of British India*, 1987; *Photographs by Charles Macnamara and M. O. Hammond*, 1989. **Essays:** Baltz: Industrial Structure, Irvine; Frank: Political Rally, Chicago; Gutmann: Yes, Columbus Did Discover America.

THOMAS, Nicholas. Essayist. Writer and editor, London. Editor of the *International Dictionary of Films and Filmmakers*, 1990–92. **Essays:** Gandini/ Stanzani/Wallace: Lamborghini Countach; Issigonis: Mini car; Porsche: VW Beetle; Porsche: Porsche 911 car; Bertoni/Boulanger/Lefebvre: Citroen 2CV, 1948.

TOLOSANO, Elisabetta. Essayist. Freelance art journalist and teacher, Turin. Contributor to *La Stampa* and *Stampa Sera*. **Essay:** Gilardi: Inverosimile.

TOMASZEWSKI, Roman. Essayist. Consultant in lettering, typography and semiography, Warsaw. Formerly, Chief of typography and design, Czytelnik publishing cooperative, 1947–68; chief editor of *Littera*, 1966–78; lecturer, Academy of Fine Arts, Warsaw and Krakow, 1968–75, and Higher School of Art and Design, Lodz, 1982–84. Author of *Polish Book Illustration*, with others, 1964; *International Bibliography on Legibility of Type Faces*, 1974; *Printed Lettering and the Aesthetics of Print*, 1983. **Essay:** Frutiger: Univers typeface.

TOMLINSON, Melanie. Essayist. Freelance writer and lecturer in art history, London. **Essay:** Grange: Kenwood Chef food processor.

TRIGGS, Teal. Essayist. Lecturer in Historical and Theoretical Studies, Ravensbourne College of Design and Communication, Kent. Formerly, book designer and teaching assistant at the University of Texas, Austin, 1981–85; tutor in contextual studies, Epsom School of Art, Surrey, 1990. **Essays:** Brody: Typeface Three; Kruger: When I

Hear the Word Culture; Sherman: Untitled no. 96; Winogrand: Hard Hat Rally, New York.

UNDERWOOD, David K. Essayist. Assistant Professor of Art History, Rutgers University; contributing editor, *Latin American Art* magazine. Formerly, lecturer at Philadelphia Museum of Art, 1985, and University of Pennsylvania, 1987. **Essay:** Niemeyer/Costa: Ministry of Health & Education, Rio de Janeiro.

VAN GEEST, Jan. Essayist. Assistant Professor of Art History, Technological University, Delft. Author of *Stuhl aus Stahl*, with Otakar Macel, 1980; *Aldo van Eyck*, 1983; *The Museum of the Continuous Line*, with Otakar Macel, 1986; editor, *Jean Prouve, constructeur*, 1981. **Essays:** Bonnard: The Breakfast Room; Leger: La Grande Parade; Magritte: L'Assassin Menace; Mollino: Orengo House, Turin; Mondriaan: Composition with Yellow Lines; Prouve: School in Villejuif, 1957.

VASUDEVAN, Aruna. Essayist. Freelance writer and researcher, London. **Essay:** Peichl: ORF Radio Stations, Austria.

VERZOTTI, Giorgio. Essayist. Freelance writer and art critic, Milan; temporary exhibitions curator, Castello di Rivoli, Milan. Formerly, curator at the Pinacoteca di Brera, Milan. Author of *Paesaggio Metropolitano*, 1982; *Imago*, 1983; *In Labirinto*, 1983; *John Armleder/Alberto Garutti*, 1987; *Lucio Fontana*, 1987; *Presi per incantamento*, 1988; *Umberto Boccioni*, 1989. Contributor to *Flash Art*, *Artforum*, and *Artscribe*. **Essays:** Boetti: Tutto quattro lati; Fabro: Attaccapanni; Paolini: Giovane che guarda Lorenzo Lotto; Pistoletto: Venere degli Stracci.

VESTAL, David. Essayist. Instructor in photography, at the Parsons School of Design, the Pratt Institute, and the School of Visual Arts, New York; contributing editor, *Darkroom Techniques* magazine. Author of *The Craft of Photography*, 1975; *The Art of Black-and-White Enlarging*, 1984. **Essays:** Lange: Migrant Mother; Siskind: Terrors and Pleasures of Levitation; Weston: Pepper no. 30.

VOLKMAR, Karl F. Essayist. Professor, New Mexico State University, Las Cruces. **Essays:** Abramovic/Ulay: Gold Found by the Artist; Horn: Paradise Widow; Jonas: He Saw Her Burning.

VOTOLATO, Gregory. Essayist. Head of Art History, Buckinghamshire College, High Wycombe. **Essays:** Ford Design Studio: Ford Mustang I; Loewy: Studebaker Starliner.

WALDEN, Russell. Essayist. Reader in the History of Contemporary Architecture, Victoria University of Wellington, New Zealand. Formerly, Senior Lecturer, Birmingham School of Architecture, England. Editor of *The Open Hand: Essays on Le Corbusier*, 1977; author of *The Voices of Silence: The Chapel of Futuna*, 1986. **Essay:** Le Corbusier: Chapel of Notre Dame du Haut, Ronchamp.

WALKER, Susannah. Essayist. Freelance writer and researcher, London. Author of *Queensberry Hunt*, 1991. **Essays:** Gray: Pyrex oven and tablewares; Putman: Minister of Finance office interiors, Paris.

WEALE, Mary Jo. Essayist. Freelance writer, teacher and watercolour artist, Tallahassee, Florida. Formerly, Chairman of the Department of Interior Design, 1973–85, and Professor, 1985–90, Florida State University. Author of *Rendering for Interior Designers*, 1965; *Environmental Interiors*, with others, 1982; *History of Architecture and*

Interiors, 1983. Contributor of *Interiors, Interior Design, Contract, The Designer, Environmental Management Association Journal* and *Journal of Interior Design Education Research*. **Essay:** Ponti: Chiaravari Superleggera chair.

WEPMAN, Dennis. Essayist. Cultural Affairs Editor, *New York Daily News*; assistant editor, *Witty World* magazine, New York. Formerly, Senior Editor, *Manhattan Arts*, 1979–90. Author of *Simon Bolivar*, 1985; *Jomo Kenyatta*, 1985; *Adolf Hitler*, 1985; *Hernan Cortes*, 1986; *Benito Juarez*, 1987; *Desmond Tutu*, 1989. **Essays:** Rivers: Washington Crossing the Delaware; Tscherny: Goethe House posters.

WESTON, Neville. Essayist. Senior Lecturer in Art, University of South Australia, Adelaide. Formerly, lecturer at Liverpool College of Art, England, 1960–75; Principal Lecturer, North Cheshire College of Higher Education, 1967–75. Author of *Kaleidoscope of Modern Art*, 1968; *The Reach of Modern Art*, 1970; *Lawrence Daws*, 1982; *Franz Kempf*, 1984; *In the Public Eye*, 1985. **Essay:** Nolan: Ned Kelly.

WILKINS, David G. Essayist. Professor of Fine Arts and Director of the University Art Gallery, University of Pittsburgh. Author of *Donatello*, with Bonnie Bennett, 1984; *Maso di Banco*, 1985; *The Illustrated Bartsch*, with Kahren Hellerstedt, 1985; *Paintings and Sculpture of the Duquesne Club*, 1986; *History of the Duquesne Club*, 1989; *Art Past/Art Present*, with others, 1990. **Essay:** Pope: National Gallery of Art, Washington, D.C.

WILLIAMS, Sheldon. Essayist. English correspondent of *l'Art Naive*, Italy; artistic adviser to Rona, London. Formerly, editor, *Art Illustrated*, 1969–71. Author of *Situation Humaine*, 1967; *Verlon*, 1969; *A Background to Sfumato*, 1969; *Voodoo and the Art of Haiti*, 1971; *20th Century British Naive and Primitive Artists*, with Eric Lister, 1975; editor of *Ronabook*, 1978, and *A Quiet Thunder*, 1978. **Essays:** Alechinsky: Le Doute; Appel: Questioning Children; de Saint-Phalle: Hon; Richier: Praying Mantis.

WILLIAMS, Stephanie. Essayist. Freelance writer and architectural critic, London. Formerly, features editor, *Building Design*, London, 1975–77; Hong Kong correspondent, the *Sunday Times*, London, 1980–82. Author of *Hongkong Bank: The Building of Norman Foster's Masterpiece*, 1989; *Docklands*, 1990. Contributor to *Apollo, Architectural Review, Architects' Journal, South China Morning Post*, and *RIBA Journal*. **Essay:** Foster: Hongkong & Shanghai Bank.

WILLIAMS, Val. Essayist. Photographic historian and archivist, London. Formerly, director of the Impressions Gallery of Photography, York. Author of *Women Photographers: The Other Observers, 1900 to the Present*, 1986; *Ida Kar: Photographer, 1908–1974*, 1989. Contributor to *The Independent, Creative Camera*, and *British Journal of Photography*. **Essays:** Beaton: Gertrude Stein and Alice B. Toklas; Blakemore: Sound of Sea sequence, Friog; Brassai: La Belle de Nuit; Capa: Collaborator, Chartres; Doisneau: Wanda Wiggles Her Hips; Griffin: Sliced Bread; Jones-Griffiths: Napalm Bomb Victim, South Vietnam; McCullin: Biafra–Albino Boy in Queue; Meiselas: Bus Passengers Being Searched, El Salvador; Parr: Old Tyme Dancing at the De La Warr Pavilion; Steele-Perkins: Children in Mental Hospital, Beirut.

WILLIS, Alfred. Essayist. Architecture Librarian, Kent State University, Ohio. **Essays:** Kroll: Medical Faculty, University of Louvain; O'Gorman: National Library, State University of Mexico;

Tigerman: Anti-Cruelty Society Building, Chicago.

WOLF, Gary. Essayist. Principal Architect, Adams and Wolf Architects, Belmont, Massachusetts. Formerly, architect with Michael Graves, 1978–79, and Graham Gund Architects, 1983–87. Contributor to *Architectural Review, Boston Review,* and *Journal of the Society of Architectural Historians.* **Essay:** Stern: Point West Place Offices, Framingham, Massachusetts.

WOLF, Johanna. Essayist. Curator, Gesellschaft Photo Archiv, Rheinisches Landesmuseum, Bonn. **Essay:** Strelow: Joseph Beuys and Son.

WOOSTER, Ann-Sargent. Essayist. Instructor, at the School of Visual Arts, New York, and the New York School of Interior Design. Contributor to *Express* and *High Performance.* **Essays:** Bertoia: Bertoia Diamond-mesh chair; Colombo: Colombo perspex Lamp; Gilbert and George: Wanker; Kelly: Red, Blue and Green; Mies van der Rohe: Barcelona chair; Morris: Observatory earthwork, Ijmuiden; Saarinen: Tulip chair and table; Serra: Rubber Belts and Neon; Sottsass: Valentine typewriter; Tinguely: Homage to New York.

YATES, Steven. Essayist. Curator of Photography, Museum of New Mexico. Formerly, Head of Photography, Pomona College, Claremont, California. Author of *The Essential Landscape,* 1985; *The Transition Years: Paul Strand in New Mexico,* 1989; *Betty Hahn: Inside and Outside,* 1988; editor of *Poetics of Space,* 1992. **Essays:** Caponigro: Pentre-Ifan Dolmen; Coke: Dentist's Office; Hahn: Lone Ranger; Heinecken: Daytime Color TV–Arm & Hammer; Man Ray: Portrait of Margaret; Rodchenko: Assembling for a Demonstration; Sommer: Pine Cone.

YOUNG, Joseph E. Essayist. Associate Professor of Art History, and Director of the Harry Wood Art Gallery, Arizona State University; art critic, *Scottsdale Progress.* Formerly, Assistant Curator of Prints and Drawings, Los Angeles County Museum of Art, 1965–79; West Coast Editor, *Art International,* 1970–71; art critic of *The Arizona Republic,* 1979–80, and *Phoenix Magazine,* 1980–81. **Essays:** Johns: Flag; Lichtenstein: Whaam; Oldenburg: Giant Hamburger; Rauschenberg: Monogram; Warhol: Marilyn Monroe.

ZANCHETTI, Giorgio. Essayist. Curator of Archivio Della Grazia di Nuova Scrittura, Milan; curator of the contemporary art videotheque, University of Milan. **Essays:** Spoerri: Mr. Bitos; Vostell: You.

ZANNIER, Italo. Essayist. Professor of the History and Technique of Photography, University of Venice. Formerly, Professor, University of Bologna, 1974–83. Author of *Storia e Tecnica della Fotografia,* 1982; *Storia della Fotografia Italiana,* 1986; *L'Occhio della Fotografia,* 1988. Romano Cagnoni: Biafran Mother and Children, 1968. **Essays:** Lotti: Onda/Wave; Narahara: Two Ladies in Jackie Kennedy Masks; Russo: Molise; Scianna: Makale, Ethiopia.

ZURBRUGG, Nicholas. Essayist. Senior Lecturer in Comparative Literature, Griffith University, Brisbane; editor, *Stereo Headphones* magazine. Author of *Beckett and Proust,* 1988; *Positively Postmodern,* 1991. **Essays:** Finlay: Le Circus; Holzer: Expiring for Love; Kosuth: One and Three Chairs; Paik: TV Bra for Living Sculpture.

INDEX

DATE DUE

PRINTED IN U.S.A.